Anna Bower
Creative Director, Gibson Greetings
Page 446

David Cherry
Fantasy Artist
Page 166

C.F. Payne
Editorial Illustrator
Page 528

1996
Artist's & Graphic
Designer's Market

1996
Artist's & Graphic Designer's Market

Where & how to sell your illustration, fine art, graphic design & cartoons

Edited by
Mary Cox

Assisted by
Alice P. Buening

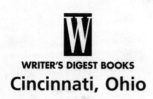

WRITER'S DIGEST BOOKS
Cincinnati, Ohio

Distributed in Canada by McGraw-Hill Ryerson,
300 Water Street
Whitby Ontario L1N 9B6.
Also distributed in Australia by Kirby Books, Private Bag No. 19, P.O. Alexandria NSW 2015.

Managing Editor, Market Books Department:
Constance J. Achabal;
Supervising Editor: Michael Willins.

This 1996 hardcover edition of Artist's & Graphic Designer's Market *features a "self-jacket" that eliminates the need for a separate dust jacket. It provides sturdy protection for your book while it saves paper, trees and energy.*

International Standard Serial Number
1075-0894
International Standard Book Number
0-89879-710-1

Portrait Artist: Phil Ruxton.
Cover illustration: Mercedes McDonald.

Attention Booksellers: This is an annual directory of F&W Publications. Return deadline for this edition is December 31, 1996.

Contents

© Sarah Sloane

The Markets

JAN 09 1996

Page 603

Resources

From the Editor

All year, as I plan, research and edit *Artist's & Graphic Designer's Market*, you are on my mind. It's funny, but I always try to picture you when I have a decision to make about the book. There are things I wonder about you. Do you think of yourself as an artist, designer, illustrator or cartoonist? Do you spend your days toiling at a non-art-related job and head for your studio on weekends? Perhaps you create layouts for newsletters, but yearn to be an illustrator. Maybe you are a freelance greeting card artist looking for additional markets. Are you new to this book, or have you bought each updated edition for years?

Much of my curiosity was satisfied when I poured over hundreds of responses to our most recent reader survey, and met some of you face to face at our focus group. One aspect of the survey really surprised me. Two-thirds of respondents indicated that they are fine artists *and* commercial artists. I guess it's no coincidence that the most widely used section of the book happens to be Greeting Cards—a perfect crossover market. Our survey also showed that 60 percent of respondents were repeat buyers of *Artist's & Graphic Designer's Market*—information that's music to an editor's ears.

Thanks to your thoughtful feedback we added to this edition two sales-related articles, Powerful Sales Techniques That Really Work (see page 3) and Act Like the Artist You Hope to Become and Sales Will Follow (on page 12). Because of your input we now list design firms by state, and we added e-mail addresses and other helpful information to each listing. When we learned the most popular section with readers is Greeting Cards, we added a feature article by greeting card artist Jerry King (page 30), interviewed successful entrepreneur Barbara Dale (page 468), and talked to Anna Bower of Gibson Greetings (page 446).

We've filled this book with marketing information for artists. It amazes me how 2,500 listings, plus articles on business, marketing, submissions, and a dozen interviews get squeezed into one book. We used every morsel of space available.

As we go to press I'm already wondering how we could do better. So, do me a favor. If you find any aspect of marketing we missed, or if you have any ideas for improving the book, please write to me at the address in front of this book, or e-mail me at wdigest@aol.com. (Specify *Artist's & Graphic Designer's Market* in the subject line to make sure it gets to me.) I'm also anxious to hear any experiences (positive or negative) you've had as a freelancer, any trends you spot, or any new markets you've discovered.

This is *your* book. We provide information and a little inspiration. You provide the hours of research, hard work and patience it takes to launch a rewarding freelance career. And if I know anything about you at all, you've already begun.

Mary Cox

How to Use Your *Artist's & Graphic Designer's Market*

Within the pages of this book you will find where you can sell your artwork—and how you can go about it. But before you begin your search for markets, read this section. It will help you make the best use of all the information in this book.

Our number one priority is providing you with potential buyers for your artwork. So you will find the bulk of each updated edition contains page after page of listings for a wide variety of art buyers. Each listing includes a brief description of the buyer, the specific types of materials it seeks, submission procedures, payment information and other helpful tips. The front of the book contains information on marketing, sales, self-promotion, pricing, taxes and other critical business tips.

The most efficient way to use this book is to move from the very general to the very specific. First, refer to the sections in the book that correspond to the area in which you work. For example, if you are an illustrator, go to the major markets for this work: Advertising/Public Relations, Book Publishers, Design Firms, Greeting Cards, Magazines and Record Companies. If you are a fine artist, refer to Galleries, Greeting Cards and, perhaps, Art Publishers and Distributors. If it is cartooning you do, turn to Magazines and Syndicates. Also take note of the special Humor Index in the back of the book, listing markets open to humor. Markets for designers can be found in almost every section of the book, with the exception of Syndicates.

Don't be too quick to discount any option. Take some time to read through other sections you may not have considered. You may find a perfect place to branch out.

Once you determine which markets interest you, the next step is to research within each section and identify buyers that will be most receptive to your work.

Each market section begins with an introduction telling you specifics pertaining to the market, including the latest trends. Market sections also contain Insider Reports, brief interviews with art directors or experienced artists in the field. Look to these for advice and insights into the marketplace you are pursuing.

For the most part, you'll want to check four main items in the listings: location of the market, the type of material they are interested in seeing, submission requirements, and rights and payment policies. Pay close attention to any tips in listings. They provide valuable clues on impressing target markets.

The acronym "SASE" in a listing refers to a self-addressed, stamped envelope. You must include a SASE with each submission if you wish to have your work returned. If you are making unsolicited submissions, it's a good idea to always include a SASE, regardless of whether or not one has been requested. See the Glossary at the end of this book for complete explanations of other terms that may be unfamiliar to you.

You'll also find that many listings have symbols. For an explanation, see the Key to Symbols and Abbreviations on page 32.

Read each listing carefully. Art buyers become irritated when inappropriate samples arrive from artists who are unfamiliar with the needs of their market. Whenever possible, obtain artist's guidelines and conduct research on your own. For example, if you identify a book publisher that might be interested in your work, it would be wise to send for a catalog and browse through its titles in a bookstore—before making contact.

Powerful Sales Techniques That Really Work

by Mary Cox

Most artists shy away from sales. The word conjures up images of fast-talking salesmen hawking cutlery on late night TV. We are reminded of the pushy salesperson trying to force a sale, or worse, the one who ignores us completely when we are ready to buy.

But think back to the last time you splurged on something expensive. Weren't you pleased as you left the store with your purchase? Maybe it was a professional portfolio or a new laser printer for your Mac. Do you remember rushing home to set up your new printer, or how you felt carrying your portfolio?

Looking back, your purchase seems effortless, almost exciting. You may not recall a salesperson trying to "sell" you at all. But chances are a friendly, knowledgeable salesperson facilitated the sale. Maybe all she did was smile, listen, ask a few questions, and eliminate your doubts by pointing out benefits. If that's all she did, she employed the most powerful weapons in any salesperson's arsenal—the techniques of the consultive salesperson.

Think of yourself as a consultant

"Consultive selling" is the '90s buzzword for helping someone get something he or she wants and needs. The method is being touted in seminars under names like "interactive selling" and "the soft sell," but this friendly persuasion has been around for years.

This customer-based style of selling is particularly suited to artists and designers. The traditional techniques of praising a product's features ("it slices, it dices . . . ") just don't apply to the services and products artists sell.

The difference between traditional and consultive methods is subtle. A traditional salesperson uses techniques to talk you into buying something. A consultant salesperson helps you buy only what you want and/or need. A consultant listens more than he or she talks. A consultant looks at things from the client's point of view.

Most people avoid selling because they fear rejection; rejection hurts. It's hard hearing the words "I'm not interested," if your product is aluminum siding or Girl Scout cookies. But it's fairly easy to accept because you don't have any personal attachment to the product. Artists feel a sharper sting. Your artwork, after all, is a reflection of you. How can you *not* take it personally? When you think of yourself as a consultant, it gets a lot easier. The beauty of consultive selling is that you never risk forcing an unwanted product on a customer. First you find out what the prospect needs, then—if you have it—strategically offer it to them. Help them picture owning the product, or to imagine how using a service will benefit them. Any rejection becomes valuable information about your prospect's needs.

If this approach appeals to you, try some of the secrets of the consultive salesperson. Knowing these techniques can boost your confidence in any selling situation.

Act friendly, professional and poised. Small talk is encouraged if your prospect seems open to it. *Briefly* chatting back and forth about the weather, sports, or an award

your client received, establishes a friendly rapport before bringing up business. If you sense your prospect is pressed for time, quickly get to the point.

Listen. The client/customer should do 70 percent of the talking, you should stick to 30 percent. Without probing, find out as much as you can about your prospect. If at an art opening, you notice someone admiring your work, don't pounce! Aim for information. Instead of convincing her how great your work is, find out more about the person. You might discover she's redecorating and needs several paintings. If she gives you a compliment, accept it graciously and direct the conversation back to *her* needs. Say, "You have a great appreciation of color. Did you study art?" A simple question is enough to get the person talking.

Identify problems or needs. Listen for a problem you can solve. If you make a follow-up call to a local magazine and the art director tells you he's too busy to review your samples because he's short-staffed, you've identified a problem. Here's a perfect opportunity to tell him you are available for freelance production work as well.

Phrase your offer in terms of benefits. Ask not what your client can do for you, ask what you can do for your client. Artist Susan Rios, profiled on page 118, provided a unique service early in her career. She offered to visit clients' homes and create paintings especially for them, incorporating color schemes and fabric designs from the rooms. Not all artists are willing to create art with the customer in mind, but if you provide such a service, let people know!

Educate your client. In some cases, the client has a problem but doesn't know a solution exists. In other cases, a client doesn't even know he has a problem. Perhaps a restaurant in your neighborhood serves fantastic Indian food, but hand-printed signs and menus give the wrong impression. You could call the owner, tell him how much you love the food, then explain how a better graphic image could attract more people to the restaurant.

Watch for body language. Notice if the prospect's eyes light up when you mention an offer. That's your cue to take it further. If the prospect leans forward, that also indicates interest. If he's glancing at his watch or folding his arms, ask if he wants to continue the conversation later. Those are signals he wants to conclude your talk.

Consider objections as buying signals. If you don't get a response after submitting samples to a book publisher, give a follow-up call. The art director might tell you it wasn't clear from your samples if you could draw figures in action. That's valuable information! Now you can send another sample to alleviate her doubts.

Don't burn your bridges. If the customer, art director, gallery owner, or whomever the prospect happens to be, decides not to buy your artwork or services, thank him and graciously offer your business card. At exhibitions ask visitors to sign a guest book, then add their names to your mailing list. If you strike out on a follow-up call to an art director or gallery owner, thank him for his time and try another mailing later. People's situations change. They might need your artwork in the future.

Trade secrets give you an edge

In her article on page 12, Margaret Lewis, a successful portrait artist, suggests something unthinkable to most artists. Rehearse your words! We artists are sensitive types, often shy about stating our worth to others. Plan simple phrases and practice them *before* you pick up the phone or face a customer. Rehearse your "script" with a relative or friend, or even on a tape recorder until you sound relaxed and natural. Eliminate the "er, um, ah" syndrome. Your script could be as simple as "Hi, this is Mark James. I sent you some samples of my illustrations and I'm just checking to see if you got them. I really like your publication and I was hoping to do some work for you." Then keep quiet and listen!

Every professional salesperson knows a well-kept secret: sales is basically a numbers game. Every rejection brings you closer to a sale because statistics are on your side. If you try long enough and don't let rejection dampen your spirits, sooner or later you *will* make some sales. The more submissions you send, the more phone calls you make, the more shows you enter, the greater your chances are.

Closing the sale

Confirming or "closing" the sale, as it is known by sales professionals, is the most crucial aspect of selling. As sales legend has it, 80 percent of all sales are lost because people are afraid to ask for the sale. Dozens of books about salesmanship explain closing techniques like "the porcupine close," the "Benjamin Franklin close," "the alternative close," and "the racoon close." If you want to learn more specifics, the business section of your public library is a good source. But the bottom line is, if you don't get a clear "yes" from the customer or client, you've lost the sale. Any salesperson can tell you "closing" is the trickiest part of selling, and the most crucial.

Consultive salespeople employ "trial closes," testing the waters to make sure they are on the right track. Sometimes the customer or client is a bit vague. If an art director says, "Yes, I really liked your samples and I'm keeping them on file," that's not an assignment. You still have to close the deal. Say "I'm really anxious to work for your magazine. Do you have anything I can work on now?" That simple question could prompt him to respond, "Well, there is one article that needs a spot illustration, but I'm not sure your work is appropriate." Still not a close. Try again, but instead of questioning his judgment, try another approach. Ask what the article is about. As he discusses the article, and your mind races with ideas for illustrations, head in for another trial close. Say, "That sounds really interesting! Would it be OK if I work up a couple of rough sketches for you? I could fax them to you by tomorrow afternoon." If he agrees, follow with "All I need is a purchase order number and I'll get started right away!" You've just closed the sale!

Role play with friends until you have practiced several scenarios for natural-sounding trial closes. Think of other trial questions like, "Are you thinking in terms of a line drawing or a painting?" You want to ask casual questions about the assignment, so that before he knows it, the art director starts enjoying the creative process and begins asking you questions, too. In selling jargon, this is sometimes called "assuming the close." Act like you already have the assignment, and often you'll get it!

"Assuming the close" works well when selling fine art, too. At openings browsers often make comments like, "I really love that painting! It would look great in my den." Instead of asking, "Would you like to buy it?" assume the sale and say "I'd be free to deliver it on Thursday or Friday of next week, or you could pick it up after the show closes." If the customer responds with "Friday would be better for me," start writing up a sales slip.

Non-obtrusive, "consultive selling" really works. Just give it a try! For more information about this sales method, read *Soft Selling in a Hard World*, by Jerry Vass (Running Press) and *Stop Telling Start Selling*, by Linda Richardson (McGraw-Hill). Once you realize you don't have to be pushy to sell your work, you'll be sold on selling.

Negotiating the Best Deal

You've already interested an art buyer or gallery in your work, now all you have to do is agree on terms. Before you sign on the dotted line, or even give your verbal consent, familiarize yourself with basic copyright and fee-setting information. Take a little time to discuss the terms of your assignment (or show) with your client. Doing so will only improve your image as a professional in the client's eyes. Most importantly, a little communication will protect both you and the client in the long run. The sections that follow cover some important points to keep in mind during business negotiations.

Reproduction rights

As creator of your artwork, you have certain inherent rights over your work and can control how it is used. When someone buys "rights" to your work, they are buying the right to reproduce your work for a certain duration of time. Unless all rights are purchased, the artwork will be temporarily given to the client in order to make reproductions. The artwork must be returned to you unless otherwise specified. Once the buyer has used the rights purchased, he has no further claim to your work. If he wants to use it a second or third time, he must pay additional fees for that privilege.

The more rights you sell to one client, the more money you should receive. Negotiate this upfront with the art buyer before agreeing on a price. Try to find out how long they intend to use it and where so that you will not relinquish too many rights. If the work is going to be used internationally, for example, you can definitely charge a higher fee. Because the copyright law is frequently misunderstood by both artists and art buyers, it is paramount to know your rights under this law and to make sure every art buyer you deal with understands them too. Here is a list of rights typically sold in the art marketplace:

- **One-time rights**. The artwork is "leased" on a one-time basis. One fee is paid for one use. The buyer has no guarantee he is the first to use the piece. Rights revert back to the creator after use.
- **First rights**. This is generally the same as purchase of one-time rights though the art buyer is paying a bit more for the privilege of being the first to use the image. He may use it only once unless other rights are negotiated.
- **Exclusive rights**. These guarantee the buyer's exclusive right to use the artwork in his particular market or for a particular product. A greeting card company, for example, may purchase these rights to an image with the stipulation that it not be sold to a competing card company for a certain time period. The artist, however, may retain rights to sell the image to other, noncompeting markets.
- **Second serial (reprint) rights**. These give a newspaper or magazine the opportunity to print your work after it has already appeared in another publication.
- **Subsidiary rights**. This category covers a lot of ground, but each right must be specified in the contract. For example, a publisher might want to include the right to use your illustration for the second printing or paperback edition of a book. Most U.S. magazines ask for "first North American serial rights" which gives them the right to publish your work in North America.
- **Promotion rights**. Such rights allow a publisher to use the artist's work for promotion of a publication in which the artwork appeared. The artist should be paid for

promotional use in addition to the rights first sold to reproduce the image.

- **Works for hire**. Under the Copyright Act of 1976, section 101, a "work for hire" (as applied to artwork) is defined as: "a work prepared by an employee within the scope of his or her employment; or a work specifically ordered or commissioned for use as a contribution to a collective work, as part of a motion picture or audiovisual work, or as a supplementary work if the parties expressly agree in a written instrument signed by them that the work shall be considered a work made for hire."
- **All rights**. This involves selling or assigning all rights to a piece of artwork for a specified period of time. It differs from work for hire, which means the artist surrenders all rights to an image and any claims to royalties or other future compensation. Terms for all rights—including time period of usage and compensation—should always be negotiated and confirmed in a written agreement with the client.

Copyright specifics

The following questions touch upon the basics of copyright. For further information on copyright, refer to *The Legal Guide for the Visual Artist*, by Tad Crawford (Allworth Press) and *The Artist's Friendly Legal Guide* (North Light Books).

What can you copyright? You can copyright any work that has sprung from your creative efforts and is fixed on paper or any other tangible medium such as canvas or even in computer memory. Reproductions are copyrightable under the category of compilations and derivative works.

What can't be copyrighted? Ideas are not copyrightable. To protect an idea, you must use nondisclosure agreements or apply for a patent. Copyright protects the form but not the mechanical aspects of utilitarian objects. While you can copyright the form of your "Wally the Whale" lamp, you can't stop other people from making lamps. You can also copyright the illustration of Wally painted on the lamp.

What is a copyright notice? A copyright notice consists of the word "Copyright" or its symbol ©, the year of first publication and the full name of the copyright owner. It must be placed where it can easily be seen, preferably on the front of your work. You can place it on the back of a painting as long as it won't be covered by a backing or a frame. Always place your copyright notice on slides or photographs sent to potential clients or galleries. Affix it on the mounts of slides and on the backs of photographs (preferably on a label).

If you omit the notice, you can still copyright the work if you have registered the work before publication and you make a reasonable effort to add the notice to all copies. If you've omitted the notice from a work that will be published, you can ask in your contract that the notice be placed on all copies.

When is a work "published"? Publication occurs when a work is displayed publicly or made available to public view. Your work is "published" when it is exhibited in a gallery; reproduced in a magazine, on a poster or on your promotional pieces.

How do you get copyright protection? Although you will own the copyright from the time your work is expressed in tangible form, you must register your copyright with the U.S. Copyright Office in order to be able to enforce your rights against infringers. While there is no deadline for filing a copyright registration application, you may lose important recourse to infringement if the copyright for an artwork is not registered within 90 days of publication or before infringement begins.

How do I register a work? Write to the Copyright Office, Library of Congress, Washington DC 20559 and ask for form VA (works of visual arts). After you receive the form, you can call the Copyright Office information number, (202)479-0700, if you need any help. You can also write to the Copyright Office for information, forms and circulars (address your letter to Information and Publications, Section LM-455). After

you fill out the form, return it to the Copyright Office with a check or money order for the required amount, a deposit copy or copies of the work and a cover letter explaining your request. For almost all artistic works, deposits consist of transparencies (35mm or 2¼×2¼) or photographic prints (preferably 8×10). For unpublished works, send one copy; send two copies for published works.

How does registration protect the artist? Patricia A. Felch, a creative arts and entertainment lawyer in Chicago, explains the remedies to infringement in an article written for *The Guild News*, published by the Graphic Artists Guild: "First, copyright owners can prevent infringers from continuing to use infringed works, have the infringing copies destroyed and even have the infringers criminally prosecuted. Second, copyright owners can choose their damages: either (1) actual damages (what would have been earned), plus a percentage of the infringer's profits resulting from the infringement, or (2) statutory damages (for each infringing use, between $200 and $20,000 from innocent infringers or between $500 and $100,000 from willful infringers). Third, the infringers can be forced to pay a copyright owner's legal costs (filing fees, expert deposition fees and transcripts, etc.) and, sometimes, even attorney's fees."

What constitutes an infringement? Anyone who copies a protected work owned by someone else or who exercises an exclusive right without authorization is liable for infringement. In an infringement case, you can sue for an injunction, which means you can stop the infringer from reproducing your work; for damages (you must prove how much money you've lost); and to prevent distribution of the infringing material.

How long does copyright protection last? Once registered, copyright protection lasts for the life of the artist plus 50 years. For works created by two or more people, protection lasts for the life of the last survivor plus 50 years. For works created anonymously or under a pseudonym, protection lasts for 100 years after the work is completed or 75 years after publication, whichever is shorter.

What is a transfer of copyright? Ownership of all or some of your exclusive rights can be transferred by selling, donating or trading them and signing a document as evidence that the transfer has taken place. For example, when you sign an agreement with a magazine for one-time use of an illustration, you are transferring part of your copyright to the magazine. The transfer is called a license. An exclusive license is a transfer that's usually limited by time, place or form of reproduction, such as first North American serial rights. A nonexclusive license gives several people the right to reproduce your work for specific purposes for a limited amount of time. For example, you can grant a nonexclusive license for your polar bear design, originally reproduced on a greeting card, to a manufacturer of plush toys, to an art publisher for posters of the polar bear, or to a manufacturer of novelty items for a polar bear mug.

Fee-setting in commercial art markets

It's difficult to make blanket statements about what to charge for illustration and design. Every slice of the industry is somewhat different as is each client. Nevertheless, there is one recurring pattern of note: hourly rates are generally only paid to designers working inhouse on a client's equipment. (Clients are only willing to pay hourly if they are in a position to keep track of the hours being put in by the freelancer.) Designers and illustrators working out of their own studios (this is nearly always the arrangement for illustrators) are almost always paid a flat fee or an advance against royalties. For more information about payment structures in specialized areas of business, refer to the beginning of each market chapter in this book.

If you're starting out as a graphic artist and are unsure about what to charge for a job, begin by devising an hourly rate, taking into consideration the cost of your materials and overhead, plus whatever you think your time is worth. (If you are a designer, you

Bartering

Take note that cash payment is not the only currency available on the market these days. Bartering is popular and can be advantageous if you find the right deals. You may find it worthwhile at some point to offer your services in exchange for studio space, new equipment, printing services or a number of other benefits.

may want to find out what the average salary would be for a fulltime employee doing the same job.) Then estimate how many hours you think the job will take and quote a flat fee to the client based on these calculations. *Setting the Right Price for Your Design & Illustration*, by Barbara Ganim (North Light Books) includes easy-to-use worksheets which can help you set prices for 33 kinds of projects.

Note that there is a distinct difference between giving the client a job estimate vs. a job quotation. An estimate gives the client a "ballpark" figure of what the job will cost, but is subject to change. A quotation, on the other hand, is a set fee which, once agreed upon, is pretty much set in stone. Make sure the client understands upfront which you are negotiating. Estimates are most often used by designers as a preliminary step in itemizing costs for a combination of design services such as concepting, typesetting, photography and printing. Flat quotations, on the other hand, are usually used by illustrators, as there are fewer factors involved in arriving at an illustration fee.

For actual recommendations on what to charge for different services, refer to the Graphic Artists Guild *Handbook of Pricing and Ethical Guidelines*. Also, keep in mind that many artists' organizations have hotlines you can call for advice. Talk with other artists in your area whenever possible and ask what they consider standard payment for the job you're doing.

Keep in mind as you are setting your fees, that certain stipulations will allow you to charge higher rates. Consider some of the following bargaining tools:

● **Usage (rights)**. The more exclusive the rights bought, the more you can charge. For example, if the client wishes to make a "buyout" (to buy all rights), you can charge more since you will be relinquishing all rights to future use of your work (and hence will be losing out on resale potential).

● **Turnaround time**. If the client asks you to turn the job around in a short amount of time, charge more. The rush may mean overtime for you.

● **Budget**. If a client asks you to quote a job, don't be afraid to ask how much they have budgeted for the project. You won't want to charge $500 for a print ad illustration if the ad agency you're working with has a budget of $40,000 for that ad. If the budget is that big, you may be able to ask for higher payment.

● **Reputation**. Naturally, the more well-known you become, the more you'll be able to charge for your creations. As you become more established, periodically raise your rates (in small increments) and see what happens.

Pricing your fine art

One of the questions most frequently asked by artists beginning to market their fine art is "What do I charge?" There are no hard and fast rules for how to price your work. The French have devised a system for working out the price of any given painting by any given artist. A point value is assigned to considerations such as size, subject matter,

reputation of artist and medium. The painting is then priced per square inch. Most American artists and galleries base prices on market value, that is, what the buying public is currently paying for similar work. You can learn the market value for certain works by visiting galleries and checking prices of works similar to yours. If you paint impressionistic landscapes, don't compare your prices to Renoir's, but to an emerging talent working in your region. As you study prices, you'll see there are many factors involved in determining price:

- **Medium.** Oils and acrylics generally cost more than watercolors or pastels done by the same artist. Price paintings higher than pencil drawings and sketches.
- **Expense of materials.** Charge more for work done on expensive handmade paper with imported pastels, for instance, than for work of a similar size on a lesser grade paper using crayons. Is the work matted and framed? Build your costs into the price.
- **Size.** Though a larger work isn't necessarily better than a smaller one, it's a rule of thumb that you can charge more for the larger work.
- **Scarcity.** You can charge more for your one-of-a-kind works like paintings and drawings, than for multiples or works printed in an edition, such as lithographs and woodcuts.
- **Status of artist.** Established artists can charge more than lesser-known artists.
- **Status of gallery.** It may not be fair or logical, but the fact remains that prestigious galleries can charge higher prices.
- **Region.** Although this is changing, works sell for more in larger cities like New York and Chicago.
- **Gallery commission.** Remember that the gallery representing you will charge from 30 to 50 percent commission for your work. Your cut must at the very least cover the cost of materials, studio space, taxes and perhaps shipping and insurance, and enough extra to make the venture profitable to you. If the materials for a painting cost you $25, matting and framing cost $37 and you spent 5 hours in the studio working on it, make sure you get at least the cost of material and labor back before the gallery takes their share. Once you set your bottom-line price, maintain the same price structure wherever you show your work. A $500 painting by you should cost a prospective buyer $500 whether it is bought in a gallery or directly from you. To do otherwise is not fair to your gallery and devalues your work.

As you establish a reputation, you can begin to raise your rates—but do so cautiously. Remember that each time you "graduate" to a new price level, you will not be able to come back down.

Contracts

As the saying goes, "Always get it in writing." Whether you are a fine artist, designer, cartoonist or illustrator, you should have a contract any time you enter into a business agreement. Even if you take an assignment by phone, arrange for the specifics in writing, either requesting a contract or providing your own. A letter stating the terms of agreement signed at the bottom by both parties can serve as an informal contract. There are several excellent books such as *The Artist's Friendly Legal Guide* (North Light Books) which provide sample contracts that you can copy and use. *Business and Legal Forms for Illustrators*, by Tad Crawford (Allworth Press) contains negotiation checklists and tear-out forms. With a minimum of legalese, the sample contracts in these books cover practically any situation you might run into from renting your fine art to spelling out royalties in a contract with a book publisher.

Don't let contracts intimidate you. They are simply business tools to make sure everyone is in agreement. The items specified in your contract will vary according to the nature of the business you are dealing with and the complexity of the project.

Nevertheless, there are some basic points you'll want to cover.

If you are working on an assignment for a commercial market, your contract should include:
- *A description of the service you are providing.*
- *Deadlines for finished work.*
- *Rights sold.*
- *Your fee.* Hourly rate, flat fee, or royalty.
- *Kill fee.* Compensatory payment to be received by you in the event that the project is cancelled.
- *Changes fees.* Penalty fees to be paid by the client for any last-minute changes (these are most often imposed by designers).
- *Advances.* Any funds paid to you before you begin working on the project.
- *Payment schedule.* When and how often you will be paid for the assignment.
- *Statement regarding expense compensation.* Includes reimbursement for travel, phone calls, materials and the like.
- *Statement regarding return of original art.* Unless you are doing work for hire, your artwork should always be returned to you.

If you are working with a gallery, check your contract for specifics relating to:
- *Terms of acquisition or representation.* Will the work be handled on consignment or purchased outright? If handled on consignment, what is the gallery's commission? If purchased outright, what is the fee? Or is this a co-op arrangement? Will you pay a membership fee?
- *Nature of the show(s).* Will the work be exhibited in group or solo shows or both?
- *Time frames.* At what point will the gallery return unsold works to you? When will the contract cease to be in effect? If a work is sold, when will you be paid?
- *Promotion.* Who will coordinate and pay for promotion? What will this promotion entail? If costs are to be shared, what is the breakdown?
- *Insurance.* Will the gallery insure the work while it is being exhibited?
- *Shipping.* Who will pay for shipping costs to and from the gallery?
- *Geographic restrictions.* If your work is handled by this gallery, will you relinquish the rights to show your work elsewhere in a specified area? If so, what are the boundaries of this area?

Act Like the Artist You Hope to Become and Sales Will Follow

by Margaret Lewis

When I was in art school, no one warned me that a sense of failure is an inevitable part of the creative process. If you are a striving and sincere artist you will often feel a twinge of disappointment when you look upon your finished work. Perhaps you expect this sense of failure to ease up as you gain experience. I'm sorry to say it will not.

I don't mean you can never see your work objectively. Time takes care of that. Six months after I finish a portrait I find I have forgotten the impossible goal I was striving for and can, therefore, appreciate my work. But if you ever reach the point where you finish a painting with great self-satisfaction, you've started to slip. The learning process has stopped. Winston Churchill, a fair amateur painter, once said, "When I get to heaven, I intend to spend the first hundred thousand years on color." There are no limits to what we can do. We can never learn it all.

Part of being a professional artist is resolving the dichotomy between humility and confidence. Humility is vital if we are to improve. It keeps us striving, keeps us exploring, keeps us moving upward in our craft. Yet you must exude a quiet confidence in your work before you can sell it to others.

Never show your doubts to a client

As an artist you are a highly-skilled craftsman, unique. No computer can replace you. Anyone seeking your services already knows that not one person in a thousand can do what you do.

Here's a secret to help you achieve confidence. Though painting and drawing are second nature to you, realize there is a touch of awe in the average person's attitude toward artists. This admiration reaches far back in time to the Ice Age cavemen standing open-mouthed by torchlight before the walls of Lascaux. Be armed with this knowledge when anyone opens a discussion with those magic words, "I'd like a painting." Be careful how you phrase your response.

Believe me, nobody was better than I at talking myself out of commissions without realizing it. I would say, "I think I can do it. I'd like to try.", to a client who isn't too sure of her own judgment in the matter to begin with! She's wondering if she has picked the right artist. She's thinking time, price, results and recourse. What she needs from you is encouragement and enthusiasm, *not* your doubts. It took me a long time to learn that all-important lesson. Now when a client shows interest I say, "I'd love to do it! Let's get going on it!"

In my work as a portrait artist I've learned the importance of developing strong artist-client ties. Treat your relationship with clients as a partnership, the two of you

Margaret Lewis, a Cincinnati-based artist, studied at the Arts Students League in New York. She has painted hundreds of commissioned portraits and lectures frequently on art.

This work featuring young Jennifer and her dog Peanuts is an example of the kind of casual portrait parents love. Margaret Lewis's portraits of children often include their pets or favorite toys.

© Margaret Lewis

working together to produce something good. In your discussion of time involved, sittings, etc., let her know that she will be working on this as well as you; that you know she may find it tiring sometimes, but she must invest her energies in it, too. Try to find out as much as possible about your client when designing a portrait, which may take two or three days. Never choose a pose before getting to know her. As you work along in the preparatory stages she will find the right pose. She will relax and enjoy helping you in any way she can to make it a good portrait.

Never work for nothing. If you work without pay, your paintings won't be valued. At least get your materials paid for. Always get a down payment before you begin a commissioned work. This definitely binds the contract. Be careful how you phrase it. Don't say, "Would you like to make a down payment?" Say, "I require (or expect) a down payment of " Rehearse this beforehand and listen to your own voice saying it. Do you sound at ease and offhandedly confident, as if this is customary? Or do you sound nervous, worried and apologetic? Practice it. How you phrase a question is vital in getting the response you want.

I often hear parents lament, "I always wanted my children's portraits painted, but I never had the money and now they're grown up." It never occurred to them artists take time payments. Explain to clients that you can arrange time payments. Treat it as a matter of course. Let them set their own payment schedule, as to time and amounts. Write down dates and particulars of each schedule and give them a copy. This puts everybody at ease.

I consider myself among the most fortunate people in the world, since I work at what I love *and* get paid for it. If you strive to do the same, more power to you! You have ahead of you the never-ending trail to the mountain top. The ascent is yours. Don't get sidetracked.

What Should I Submit?

By now, your work is really good. Relatives and friends urge you to take your talent further. They say, "You should send that sketch to *The New Yorker*—it would make a perfect cover!" or "You should send that drawing to a gallery—I bet they'd give you a show!"

Your friends are right—but they are only *partly* right. It is true, you *are* a talented artist. And it's true, nobody will come knocking on your door, so you have to submit your work to find buyers. Sending original artwork, however, is extremely unprofessional and will not get results. Appropriate samples, submitted professionally, will greatly increase your odds.

Most successful freelancers cringe when recalling their first submission efforts. Jerry King, whose article appears on page 30, remembers drawing cartoons on sheets of paper, folding them in half and sending them off to *Playboy* and *Sports Illustrated*. Although he does pat himself on the back for trying, he regrets nobody ever taught him how to submit his work professionally. He didn't start getting freelance jobs until he bought *Artist's & Graphic Designer's Market* and discovered how to create professional samples.

We divided this article into three sections, so whether you are a fine artist, illustrator or designer, check under the appropriate heading for general guidelines. In addition to the following suggestions, read those listings that interest you for more specific instructions on submissions.

As you read the listings, you'll see the term SASE, short for self-addressed, stamped envelope. Send a SASE with your submissions if you want your material returned. Many freelancers send postcards or tearsheets as samples, which they hope art directors will keep on file. In that case, no return envelope is necessary. If you send expensive samples, such as slides, a SASE will increase your odds of getting them back.

Guidelines for fine artists

If you are a painter, sculptor, printmaker, or fine artist, you should send a 9×12 envelope containing material gallery directors request in their listings. Usually that means a query letter, slides and bio, but check each listing. Some galleries like to see more. The following is an explanation of the various components you can include in your submissions:

- **Slides.** Send eight to twelve mounted slides of your work in a plastic slide sleeve (available at art supply stores). Ideally, your slides should be taken by a professional photographer, but if you must take your own slides, refer to *Photographing Your Artwork*, by Russell Hart (North Light Books). Mark each slide with a small arrow indicating the top of the slide. Label each slide with your name, the title of the work, media, and dimensions of the work. Some galleries like to see photographs rather than slides. Refer to the listings to find out which they prefer. When choosing artwork to photograph, choose only your very best work.

Provide gallery directors with a list of your artwork so they can refer to it if they review slides. Make sure the artwork on the list is in the same order as the slides. Type your name, address and phone number at the top of the list, and it's helpful to include suggested prices.

- **Query letter or cover letter.** Type one or two paragraphs stating your interest in showing at the gallery, and include a date and time when you will follow-up.
- **Résumé or bio.** Some artists include a typed résumé or bio with their submissions. Your résumé needn't list every summer job you've ever had—concentrate on your art related-experience. Be sure to list any shows your work has been included in and the dates. A bio is a paragraph describing where you were born, your education, the type of work you do and where you have shown your work in the past.
- **Artist's statement.** Some galleries require an artist's statement, which is simply a short statement about your work, your vision and the themes you are exploring. A few paragraphs are all that is necessary.
- **Brochures and business cards.** Some artists who are very savvy self-promoters design attractive brochures with color samples of their artwork along with biographical information. Business cards are another way to show you are professional. If you can invest in either of these extras, they make a good impression in your submission package, but they are optional.
- **SASE.** If you need the material back, don't forget to include your SASE.
- **Cardboard backing.** To protect slides from being damaged in the mail, some artists insert slide sheets between two pieces of cardboard.

Guidelines for illustrators and cartoonists

Illustrators have several choices when submitting to markets. Because art directors are so busy, they prefer submissions that are simple and professional, with as few pieces as possible. Many illustrators send only a cover letter and one or two samples in initial mailings. In follow-up mailings they send an additional sample, such as a simple postcard showing one of their illustrations. Here are just a few of your options:

- **Postcard.** This is a great way for an illustrator to introduce herself to a market. Choose one (or more) of your illustrations that is representative of your style, then have the image printed on postcards. Have your name, address and phone number printed on either the front of the postcard, or in the return address corner. Somewhere on the card should be printed the word "Illustrator." Your postcard need not be expensive to print. If you use one or two colors you can keep the cost below $200. Art directors like postcard samples because they are easy to file or tack on a bulletin board. If the art director likes what she sees, she can always call you for more samples. (See two examples of illustrators' postcards on page 16.)
- **Promotional sheet.** If you want to show more of your work, you can opt for an 8×12 color or black & white photocopy of your work. (See Justin Menchen's promotional sheet on page 17.)
- **Tearsheets.** After you complete assignments for magazines, acquire copies of the pages on which your illustration appears. Tearsheets are impressive to art directors because they are proof positive that you are experienced and have met deadlines on previous projects.
- **Photographs and slides.** Some illustrators for greeting cards have been successful sending photographs or slides of their work, but printed or photocopied samples are preferred by most art directors.
- **Query or cover letter.** A query letter is a nice way to introduce yourself to an art director for the first time. One or two paragraphs telling him you are available for freelance work is all you need. Be sure to include your name and phone number, samples of your work or tearsheets.

If you send 8×12 photocopies or tearsheets, do not fold them in thirds and stuff in a small envelope. It is more professional to send them flat, not folded, in a 9×12

© Sarah Sloane.

© Harriet Golden.

When Sarah Sloane, Providence, Rhode Island, sends out samples, she chooses a simple postcard format (above). She designs an attractive image, which shows off her fanciful style and incorporates her name and number into the design. Harriet Golden, New York City, (below, left) also chooses the postcard format, but uses one of her past assignments for the front (making sure she has her client's permission to do so). Justin Menchen, Venice, California, wanted to show a variety of work, so he designed a promotional sheet (opposite page) containing six images and simply added his name and phone number to the bottom. Menchen saves printing costs by sending photocopies to prospective clients. All three artists have had success sending out their samples to buyers listed in Artist's & Graphic Designer's Market. Several months after a mailing they design new samples and send follow-up mailings.

JUSTIN MENCHEN (310) 827-9666

envelope, along with a typed query letter, preferably on your own professional stationery.

Humorous illustrators and cartoonists should follow the same guidelines suggested for illustrators when submitting to publishers, greeting card companies, ad agencies and design firms. Cartoonists sending gags to magazines, however, would be better off sending professional looking photocopies of their cartoons. When submitting to syndicates, please refer to the section introduction for submission information.

Guidelines for designers and computer artists

A designer should plan and create his submission package as if it were a paying assignment from a client. In your submission piece you want to show your skill as a designer, in order to make a great first impression. Include one or both of the following:

● **Cover letter.** This is your opportunity to show you can design a beautiful, simple logo or letterhead for your own stationery. Have the stationery you designed for yourself printed on good paper. Then write a simple cover letter stating your experience and skills.

● **Sample.** As a designer, your sample can be a copy of an assignment you have done for another client, or a clever self-promotional piece. Pull out all the stops and make a great design which will show off your capabilities. There are some excellent books which reprint successful promotional pieces. One of the best we've seen is *Fresh Ideas in Promotion*, edited by Lynn Haller (North Light Books). Another great title from North Light is *Creative Self-Promotion on a Limited Budget*, by Sally Prince Davis.

Are portfolios necessary?

You do not need to send a portfolio when you first contact a market. But after buyers see samples of your work they may request a portfolio review to see more, so you will want to have a portfolio ready to show.

Many successful illustrators, like Chris Payne interviewed on page 528, started their careers by showing portfolios. But it is often enough for art directors to see your samples. Ad agencies and book publishers might request portfolio reviews after seeing your initial samples. Gallery directors sometimes ask to see your portfolio, but they can usually judge from your slides whether your work would be appropriate for their galleries. Never visit a gallery to show your portfolio without first setting up an appointment.

Some magazines, ad agencies and other markets in this book have drop-off policies for artists. They generally accept portfolios one or two days a week. You will not be present for the review and you will pick up the work a few days later, after they've had a chance to look at it.

Most businesses are honorable and you don't have to worry about your case being stolen. However, since things do get lost, be sure to include only duplicates that can be insured at a reasonable cost. Only show originals when you can be present for the review. Remember to label your portfolio with your name, address and phone number.

What should I include in my portfolio?

The overall appearance of your portfolio affects your professional presentation. Your portfolio need not be made of high-grade leather to leave a good impression. Neatness and careful organization are essential whether you are using a three-ring binder or a leather case. The most popular portfolios are simulated leather with puncture-proof sides that allow the inclusion of loose samples.

The size of your portfolio depends on your work, but choose one that can be handled easily by the art director. Avoid the large, "student" size books which are too big and bulky to fit easily on a director's desk. Most artists choose 11×14 or 18×24. Work

can be mounted, if appropriate. If you are a fine artist and your work is too large for a portfolio, bring your slides and a few small samples.

Avoid including everything you've done in your portfolio. Select only your best work and choose pieces germane to the company or gallery you are approaching. If you're showing your book to an ad agency, for example, don't bring a lot of greeting card illustrations. Similarly, if you are showing your work to a gallery that specializes in abstract and conceptual work, avoid including realistic or figurative images.

In reviewing portfolios, art directors are looking for consistency of style and skill. They want to be sure your images are solid and you can produce good work on a regular basis. Art directors in commercial markets sometimes like to see work in different stages (roughs, comps and finished pieces) to see the progression of ideas and how you handle certain problems.

Gallery directors are looking for a sense of vision or direction and a body of work to demonstrate this. It's not enough to just skim several subjects briefly and show a collection of unrelated work. You'll need to show you are capable of cultivating an idea into an entire exhibition's worth of work.

When presenting your portfolio, allow your work to speak for itself. It's best to keep explanations to a minimum and be available for questions if asked. Be sure to prepare for the review by taking along notes on each piece. If the buyer asks a question, take the opportunity to talk a little bit about the piece in question. If you're a designer or illustrator, mention the budget, time frame and any problems you faced and solved. If you are a fine artist, talk about how the piece fits into the evolution of a concept, and how it relates to other pieces you've shown.

If you've been called in to talk about a specific job or show, this is the time to find out about its scope, budget and schedule. If, on the other hand, you're introducing your work to the client (or gallery) for future assignments or shows, leave samples (labeled with your name, address and phone number) and your business card. Don't ever walk out of a portfolio review without leaving the buyer something to remember you by. A few weeks after your review, follow up by sending a small promo postcard or other sample as a reminder.

For information on portfolios, see *The Ultimate Portfolio*, by Martha Metzdorf and *The Fine Artist's Guide to Showing and Selling Your Work*, by Sally Prince Davis, both published by North Light Books.

What is self-promotion?

Self-promotion goes beyond mere submission of your work. It is an ongoing process of building name recognition and reputation. Not only are you introducing yourself and your work to new clients, but you're also reminding past clients you are still available.

Experts suggest artists spend about one-third of each week and up to 10 percent of their gross income on self-promotion. Whether you decide to spend this much time and expense depends on your resources and the size of your business, but it is important to set aside at least a portion of your time for promoting your work. Building the time into your regular work schedule will make it seem less painful.

Besides sending out promotional mailers and submissions, it's a good idea to supplement your direct-mail promotions and portfolio reviews with other forms of self-promotion. Remember self-promotion is not necessarily hard-sell. It's anything you do to make prospective clients aware of you and your work. Consider some of these options:

• **Talent Directories.** Many graphic designers and illustrators buy pages in illustration and design annuals such as *The Creative Black Book*, *The American Showcase* and *RSVP*. These go to thousands of art directors across the country and many keep their directories for up to five years.

For many artists price is a big obstacle. A page in one of these directories can run from $2,000 to $3,500 and you have no control over who receives them—not everyone who receives these books will be a market for your work. Yet, some artists who have bought pages claim they've made their money back and more, up to several times the amount they've spent. One added bonus to these directories is they provide you with up to 2,000 loose pages, depending on the book, to use as samples.

Be sure you are ready for such an investment. It helps to have some professional experience first. You should have developed a consistent style and have a portfolio with enough samples showing that style.

● **Media relations.** The media is always looking for good public interest stories. If you've done something unique with your work, send a press release to magazines, newspapers and radio. This kind of exposure is free and will help increase public awareness of you and your work, even if it doesn't result in immediate sales.

● **Pro bono work.** Creating work for your favorite charity or cause not only makes you feel good and helps your cause, it can be good public relations. These jobs can also help give you added exposure and experience. Certain jobs may present you with an opportunity to reach an audience of potential clients and acquaint them with your work. For example, a poster designed for your local ballet company may put your work in front of area business communicators, gallery directors and shop owners in need of artistic services. If you design a brochure for an upcoming charity event, you'll reach everyone on the charity's mailing list. Generally you only donate free services to non-profit organizations in need of help—don't give away work to a client who has the means to pay.

● **Networking.** Attending seminars, organization meetings, trade shows, gallery openings and fundraisers is a good way to get your name out. Don't be afraid to talk about your work, because you never know when someone might need your services. It doesn't hurt to keep a business card and possibly some postcards on hand. If possible, volunteer to organize some events yourself. This will give you an even better opportunity to meet and work with new people.

● **Contests and juried shows.** Even if you don't win, contests provide good exposure. Judges of design and illustration contests are usually art directors and editors who may need work in the future. Judges of fine art shows are often gallery directors. Entering a juried show will also allow you to show your work to the community.

● **Home shows.** If you are a fine artist and have a body of work nearly complete, go over your mailing list and invite a select number of people to your home to preview the work. Personalized home shows may improve your chances of securing commission work and you retain all the profits of any sales. (Before pursuing this option, however, make sure you are not violating any contracts you already have with galleries).

Business Nuts & Bolts

Although business seems the antithesis of the creative spirit, successful artists, designers and illustrators deal with business details on a daily basis. Having a little business savvy will put you head and shoulders above your competition and will increase your self-confidence. You will see yourself as a professional, and others will react to you in kind. In regards to what follows, ignorance is *not* bliss. Not knowing about shipping, billing and taxes can result in lost artwork, time and money, or a visit from the IRS.

Packaging and shipping your work

For the most part, you should send your submissions via first class mail. This makes for quicker service and better handling. (See What Should I Submit?, page 14, for submission guidelines.) Flat work can be packaged between heavy cardboard or foam core, or it can be rolled in a cardboard tube. Include your business card or a label with your name and address on the outside of the packaging material in case the outer wrapper becomes separated from the inner packing in transit.

Once you start getting assignments and begin sending original artwork at the request of clients or galleries, take even greater care. Larger works—particularly those that are matted or framed—should be protected with a strong outer surface, such as laminated cardboard, masonite or light plywood. The actual work should be wrapped in polyfoam, heavy cloth or bubble wrap and cushioned against the outer container with spacers (a spacer can be any object that keeps the work from moving). Whenever possible, ship work before it is glassed. If the glass breaks en route, it may destroy your original image. If you are shipping a particularly large framed work, you may want to contact a museum in your area and ask for more suggestions on packaging.

The U.S. Postal Service will not automatically insure your work, but you can purchase up to $600 worth of coverage upon request. Artworks exceeding this value should be sent by registered mail. Many artists also use certified mail. Certified packages are logged in at each destination en route. They travel a little slower, but are much easier to track down in the event of a mishap.

If time is of the essence, consider the special services offered by the post office, such as Priority Mail, Express Mail Next Day Service and Special Delivery. For overnight delivery, check to see which air freight services are available in your area (the most familiar of which is probably Federal Express). FedEx automatically insures packages for $100 and will ship art valued up to $500. They also have a 24-hour computer tracking system that will enable you to locate your package at any time.

UPS also automatically insures work for $100, but you can purchase additional insurance for work valued as high as $25,000 for items shipped by air (there is no limit for items sent on the ground). UPS cannot guarantee the time it will take a package to arrive at its destination but will track lost packages. It also offers Two-Day Blue Label Air Service to any destination in the U.S. and Next Day Service in specific zip code zones.

Before sending any original work, make sure you have a copy (photostat, photocopy, slide or transparency) in your file at home. If your work is lost, you'll at least have a duplicate in some form. To ensure the safe arrival of your submission, always make a quick address check by phone before putting your package in the mail.

Billing

If you are a designer or illustrator, you will be responsible for sending out invoices for your services. Commercial buyers generally will not issue checks without having first received an invoice. Most graphic artists arrange to be paid in thirds and bill accordingly. The first payment is received before starting the project, the second after the client approves the initial roughs, and the third upon completion of the project.

If you are a designer, it's wise to have a standard invoice form that allows you to itemize your services. The more you spell out the charges, the easier it will be for your clients to understand what they are paying for—and the more likely they will be to pay on time without arguing. Most designers charge extra for changes made to a project after approval of the initial layout and copy. Keep a separate form for change orders and attach it to your final invoice.

A note about galleries

If you are working with a gallery, you will not need to send invoices. The gallery will be responsible for sending you a check each time one of your pieces is sold (generally within 30 days). To ensure that you are paid promptly, make a point of calling the gallery periodically just to touch base. Let the director or business manager know that you are keeping an eye on your work.

If you are an illustrator, the billing process will be much simpler, as you'll generally only be charging a flat fee. Nevertheless, it may be helpful for you, in determining your original quoted fee, to itemize charges according to time, materials and expenses (the client need not see this itemization—it is for your own purposes). Illustrators generally don't charge fees for changes unless the changes are extensive.

Most businesses will need to have your social security number or tax ID number before they can cut a check for you. You can speed up the process by including this information in your first bill. Also, be sure to put a payment due date on each invoice. Most artists ask for payment within 10-30 days. One way to encourage clients to pay on time is to charge interest on any fees paid after the due date.

Sample invoices for designers are featured in *The Designer's Commonsense Business Book*, by Barbara Ganim (North Light Books); an invoice for illustrators is shown in *Business and Legal Forms for Illustrators*, by Tad Crawford (Allworth Press).

Record keeping

If you haven't kept good business records, all your talent will mean nothing when it comes time to give an account of your business profitability to the IRS. Remember that you are an independent businessperson and, like any other entrepreneur, must be financially accountable.

Your bookkeeping system need not be a complicated one. Visit an office supply store to determine which type of journal, ledger or computer software is most suited to your needs. Each time you make a sale or receive an assignment, assign a job number to the project. Then record the date of the project, the client's name, any expenses incurred, sales tax and payments due.

For tax purposes, save all receipts, invoices and canceled checks related to your business. A handy method is to label your records with the same categories listed on

Schedule C of the 1040 tax form. This will allow you to transfer figures from your books to the tax form without much hassle. Always make an effort to keep your files in chronological order.

As your business grows, you may find it worthwhile to consult with or hire an expert. If you choose this route, try to find a professional who specializes in working with creative people or small business operators. Find someone who understands your needs and keeps track of current legislation affecting freelance artists.

Taxes

You have the right to take advantage of deducting legitimate business expenses from your taxable income. If your business requires numerous supplies, rental of studio space, advertising and printing costs, these expenses are deductible against your gross art-related income. It is imperative to seek the help of an accountant in preparing your return. In the event your deductions exceed profits, the loss will lower your taxable income from other sources. To guard against taxpayers fraudulently claiming hobby expenses as business losses in order to offset other income, the IRS requires taxpayers to demonstrate a "profit motive." As a general rule, you must show a profit three out of five years to retain a business status. This is a guideline, not a rule. The IRS looks at nine factors when evaluating your status. The IRS looks at losses very closely. If you are ever audited by the IRS, the burden of proof will be on you to demonstrate your work is a business and not a hobby. You must keep accurate records and receipts of all your expenses and sales.

The nine criteria the IRS uses to distinguish a business from a hobby are: the manner is which you conduct your business, expertise, amount of time and effort put into your work, expectation of future profits, success in similar ventures, history of profit and losses, amount of occasional profits, financial status, and element of personal pleasure or recreation. If the IRS rules that you paint for pure enjoyment rather than profit, they will consider you a hobbyist.

Even if you are a "hobbyist," you can deduct expenses such as paint, canvas and supplies on a Schedule A, but you can only take art-related deductions equal to art-related income. That is, if you sold two $500 paintings, you can deduct expenses such as art supplies, art books, magazines and seminars only up to $1,000. You should itemize deductions only if your total itemized deductions exceed your standard deduction. You will not be allowed to deduct a loss from your other source of income.

Document each transaction by keeping all receipts, canceled checks, contracts and records of sale. It is best to keep a journal or diary and record your expenses daily, showing what was purchased, from whom, for whom, for how much and the date. Keep your automobile expenses in a separate log showing date, mileage, gas purchased and reason for trip. Complete and accurate records will demonstrate to the IRS that you take your career seriously.

If your accountant agrees it is advisable to deduct business expenses, he or she will fill out a regular 1040 tax form (not 1040EZ) and prepare a Schedule C. Schedule C is a separate form used to calculate the profit or loss from your business. The income (or loss) from Schedule C is then reported on the 1040 form. In regard to business expenses, the standard deduction does not come into play as it would for a hobbyist. The total of your business expenses need not exceed the standard deduction.

There is a new, shorter form called Schedule C-EZ which can be used by self-employed people in service industries. It can be applicable to illustrators and designers who have receipts of $25,000 or less and deductible expenses of $2,000 or less. Check with your accountant to see if you can use this shorter form.

Home office deduction

If you are freelancing fulltime from your home, and can devote a separate area to your business, take advantage of a home office deduction. Not only will you be able to deduct a percentage of your rent and utilities, but your business will benefit from deductions on expenses such as office supplies, business-related telephone calls and equipment such as computers and certain furnishings.

The IRS is very strict about home offices and does not allow deductions if the space is used for reasons other than business. In order to deduct expenses for a studio or office in your home the area must meet three criteria:

* *The space must be used exclusively for your business.*
* *The space must be used regularly as a place of business.*
* *The space must be your principle place of business.*

The IRS might question a home office deduction if you are employed full-time elsewhere and complete freelance assignments at home. If you do claim a home office, the area must be clearly divided from your living area. A desk in your bedroom will not qualify. To figure out the percentage of your home used for business, divide the total square footage of your home by the total square footage of your office. (To determine square footage, multiply length by width.) This will give you a percentage to work with when figuring deductions. If the home office is 10 percent of the square footage of your home, deduct 10 percent of expenses such as rent, heat and air conditioning.

Note that your total office deduction for the business use of your home cannot exceed the gross income that you derive from its business use. In other words, you cannot take a net business loss resulting from a home office deduction. The law also requires that your business be profitable three out of five years. Otherwise, you will be classified as a hobbyist and will not be entitled to this deduction.

Consult a tax advisor to be certain you meet all of the requirements before attempting to take this deduction, since its interpretations frequently change. Refer to IRS Publication 587, Business Use of Your Home, for additional information. Homemade Money, *by Barbara Brabec (Betterway Books), provides several formulas for determining percentages for deductions and provides checklists of direct and indirect expenses.*

Deductible expenses include advertising costs, brochures, business cards, professional group dues, subscriptions to trade journals and arts magazines, legal and professional services, leased office equipment, office supplies, business travel expenses and many other expenses. Your accountant can give you a list of all 100 percent and 50 percent deductible expenses (such as entertainment).

Another reason your accountant is so important is that as a self-employed "sole proprieter" there is no employer regularly taking tax out of your paycheck. Your taxes must be paid on your income as you earn it. Your accountant will help you put money away to meet your tax obligations, and estimate your tax and file quarterly returns.

Your accountant also will be knowledgeable about another annual tax called the Social Security Self-Employment tax. You must pay this tax if your net freelance income is $400 or more, even if you have other employment.

The fees of tax professionals are relatively low, and they are deductible. To find a good accountant, ask colleagues for recommendations, look for advertisements in trade publications or ask your local Small Business Association. And don't forget to deduct the cost of this book.

You can obtain more information about federal taxes by ordering free publications from the IRS. Some helpful booklets available include Publication 334—Tax Guide for Small Business; Publication 505—Tax Withholding and Estimated Tax; and Publication 533—Self Employment Tax. Order by phone at (800)829-3676.

Independent contractor or employee?

Some companies and agencies automatically classify freelancers as employees and require them to file Form W-4. If you are placed on employee status, you may be entitled to certain benefits, but this will also mean that a portion of your earnings will be withheld by the client until the end of the tax year (and hence not readily available to cover overhead expenses). Moreover, your business expenses will be subject to certain limitations. In short, you may end up taking home less than you would if you were classified as an independent contractor.

The IRS uses a list of 20 factors to determine whether or not a person should be classified as an independent contractor or an employee. This list can be found in Publication 937. Note, however, that your client will be the first to decide whether or not you will be so classified.

The $600 question

Did you receive a 1099 form from that major client? Illustrators and designers take note: if you bill any client in excess of $600, the IRS requires the client to provide independent contractors with a form 1099 at the end of the year. Your client must send one copy to the IRS and a copy to you to attach to your income tax return. Likewise, if you pay a freelancer over $600, you must issue a 1099 form. This procedure is one way the IRS cuts down on unreported income.

Sales tax

The good news is, you could be tax exempt when buying art supplies. The bad news is you have to collect and report sales tax.

Most states require a sales tax, ranging from 2 to 7 percent, on artwork you sell directly from your studio, or at art fairs, or on work created for a client, such as finished art for a logo. You are required to register with the state sales tax department, which will issue you a sales permit, or a resale number, and send you appropriate forms and instructions for collecting the tax. Getting a sales permit usually involves filling out a form and paying a small fee. Collecting sales tax is a relatively simple procedure. Record all sales taxes on invoices and in your sales journal. Every three months total the taxes collected and send the tax to the state sales tax department.

The art supplies you buy to create paintings and complete assignments for clients are tax exempt to you. As long as you have the above sales permit number, you can buy materials without paying sales tax. You will probably have to fill out a tax-exempt form with your permit number at the sales desk where you buy materials. The reason you do not have to pay sales tax on your art supplies is that sales tax is only charged on the final product. However, you must then add the cost of materials into the cost of your finished painting or the final artwork for your client. Keep all of your purchase receipts for these items in case of a tax audit. If the state discovers that you have not collected sales tax, you will be liable for tax and penalties.

If you sell all your work through galleries they will charge sales tax, but you will

still need a tax exempt number so you can get a tax exemption on supplies.

Investigate the specifics regarding your state's regulations on sales tax. Some states claim that "creativity" is a service rendered and cannot be taxed, while others view it as a product you are selling and therefore taxable. Be certain you understand the sales tax laws to avoid being held liable for uncollected money at tax time. Write to your state auditor for sales tax information.

In most states, if you are selling to a customer outside of your sales tax area, you do not have to collect sales tax. However, check to see if this holds true for your state. You may also need a business license or permit. Call your state tax office to find out what is required.

Background information and further assistance

Depending on the level of your business and tax expertise, you may want to have a professional tax advisor to consult with or to complete your tax form. Most IRS offices have walk-in centers open year-round and offer over 90 free IRS publications containing tax information to help in the preparation of your return. The booklet that comes with your tax return forms contains names and addresses of Forms Distribution Centers by region which you can write for further information. Also the U.S. Small Business Administration offers seminars on taxes, and arts organizations hold many workshops covering business management, often including detailed tax information. Inquire at your local arts council, arts organization or university to see if a workshop is scheduled.

Breaking Into Product Design

by Neil Burns

Function is the main goal of the product designer. What good is a toothbrush that can't effectively reach the nooks and crannies in your mouth? How well does a phone work when it doesn't fit the contour of your face? How useful is a candlestick that doesn't hold a candle?

These may seem like overly simplified examples of poorly designed products, but that is exactly what happens all too often when the designer of a product throws concern for the consumer out the proverbial window. Too often we see furniture designed solely to be fashionable; it looks great, but is it functional? Can you actually sit on it?

Industrial/product design is the one area of all the design disciplines where function must be rigidly adhered to. The most compelling reason for this is the laws governing consumer products. No one would intentionally market a product that could have dangerous, even life-threatening, ramifications if it did not operate in a safe manner. Imagine wooden bowls covered in a chemical that contaminated food; electronics that caught fire after extended use; or imagine the liability of an improperly designed wheelchair. All of these examples bring us back to function—the product must be designed so it functions in the manner for which it was intended. But it is the talented designer who can incorporate design, function and safety into a product.

Product design can be a very lucrative and very exciting field. With technology and consumers' hunger for new products increasing at breakneck speed, there will be an ever-increasing need for industrial designers.

The following categories are some that fall under the umbrella of industrial/product design:

- **Tabletop:** utensils, plates, cups and glasses, decanters, trays, kettles
- **Electronics:** radios, CD players, headphones, TVs, guitars
- **Furniture:** couches, chairs, desks, cabinets, coat racks
- **Computers:** hard drives, ergonomic keyboards, mouses, monitors, PDAs, printers
- **Medical equipment:** microscopes, X-ray systems, MRI systems
- **Sports equipment:** rowing machines, baseball gloves, shoes, weights
- **Appliances:** phones, clocks, toasters, scissors, irons, nozzles for hoses

Many of these products are well out of the range of the designer looking to enter the market, such as a MRI system, but there are plenty that would be perfect for getting your feet wet.

"What's good about being an industrial designer is that you can theoretically design anything," says Tucker Viemeister, a partner in Smart Design, a New York firm whose award winning designs have earned a permanent spot in the Cooper Hewitt Museum. "I like calling what I do *industrial* design, instead of product design," says Viemeister, who admits the terms are confusing. By calling it "industrial design," he explains, you can design environmental graphics, packaging, electronic products, furniture, or just about anything. "If you call it product design, it seems like it should be hair dryers and radios."

Neil Burns *is a freelance writer specializing in design.*

There are several routes to take to become a product/industrial designer. The traditional route is through education. Many universities offer tracks in industrial design. Because there are many laws governing consumer products, you will probably be advised to take some engineering, architectural and law courses.

Industrial design is a discipline that often involves other professionals, such as engineers and manufacturers. It is the designer's job to transform research, need and scientific evidence into a functional consumer product.

If you are a working designer already, going back to school may not be realistic. Another route is hooking up on a freelance basis with a firm that already works in the field. Once you get in the door, ask to be involved with product design projects and bit by bit increase your role. If you have your own firm, work in conjunction with an industial design firm on a project.

Another way to enter the field is simply to convince clients you can do the job. "The whole thing about design is that the actual function is pretty easy. In all these fields there is a technical part and a conceptual part. The hardest part is the conceptual part—coming up with the ideas. If you have good ideas, when it gets down to the physical stuff, you get help from somebody," says Viemeister.

Presenting your ideas

If you succeed in convincing a manufacturer to hire you to help develop a new product, they will eventually want to see a prototype of your design. If you haven't had experience creating presentations in 3-D, you'll need to consult with an experienced industrial designer or engineer for guidance. For these types of assignments, industrial design firms are generally paid a fee for the project.

Another option open to you is to come up with a great design for a product and then approach an appropriate manufacturer/marketer with your idea. If they like your design, you could either sell it outright, or work out a licensing agreement to receive a percentage of total sales, ranging from 2 to 10 percent. The best part about this arrangement is that after you bring them a successful prototype, your part of the job is done. It's up to the company to finance the project, have it mass produced, marketed and distributed to stores.

Yet another way (albeit riskier) is to produce and market your own idea. You'll have more control, and you could see more profits if the product is successful, but there are a lot more details and expenses to juggle. Just as an example, if your product is made out of several parts, each part must be made from some kind of material, be it plastic, steel, metal, glass, fabric or ceramics. You'll need to find out which material will work, locate reliable suppliers for the various parts of the product, then locate a company who can assemble and mass produce it. It gets even more confusing when the product needs to be manufactured in various colors. You have to make sure the paint you specify is available in large quantities at a cost-effective price. And you'll need to finance the manufacturing stage before you see any profit, so cash-flow is a major concern. Then there is the marketing, advertising and distribution to think of!

To find suppliers, manufacturers and distributors for their products, designers look under manufacturers in the Yellow Pages or go to the library and consult the Sweet's catalogs for references. Getting some recommendations from experienced industrial designers will help you avoid many mistakes.

Besides consulting with colleagues, you can find help along the way in the myriad of industrial design publications available in either magazine or book format. Perhaps the leader in covering the field is *ID Magazine*. PBC International publishes numerous industrial design books and product design annuals.

Products can be both functional and beautiful. This elegant toaster was designed by Tucker Viemeister of Smart Design in collaboration with Black & Decker. Dubbed "The Metropolitan," it's a perfect example of form following function.

Smart Design Inc.

According to Viemeister, many designers already possess the necessary skills to transfer themselves from one discipline to another. "Graphic designers have a lot more in common with product designers than they would think. Basically, all designers are concerned with what and how they are communicating with the user of the product. So if the product is a magazine, their concern is how the design communicates the story. If the product is a telephone, then they are communicating through the form of it. As long as you keep that in mind, it really doesn't matter what you are designing."

The most important skill in product design is listening—whether it be listening to your client, or listening to the customer. Once you find out who is going to use the product and how they are going to use it, you are basically solving a design problem. If you can create a solution that is workable, and can be manufactured, packaged and marketed within the desired budget, you might just see your design on store shelves some day.

Make a Big Splash in the Greeting Card Market!

by Jerry King

As far back as I can remember I wanted to be a political cartoonist. My goal was simple—to gain employment with a large newspaper, be nationally syndicated and then win the Pulitzer Prize. It became quite clear the economy had other plans for me. Reality told me I had a better chance of finding an honest politician than a job with a large daily. So, faced with the horrible possibility of getting a "real job," I desperately searched the pages of *Artist's & Graphic Designer's Market* for companies that would buy my work and thus keep me out of the work force. When I discovered the Greeting Cards section, I had found my new calling.

With my dreams of becoming a political cartoonist on the back burner, I focused on greeting card companies and found them perfect for cartoonists—many rely entirely on cartoonists for their products. So I grabbed my pen, drew some samples, photocopied and submitted them to several companies, then waited anxiously for replies. My first inquiries were unprofessional to say the least. I still had that political-cartoon bug in me that I just couldn't shake. Fortunately, West Graphics saw a glimmer of potential in my samples and they gave me the opportunity to show what I could do.

Before developing any cards of my own, I spent a lot of time in stores studying the trends of the business. I called this research. Some store managers called it loitering. On one occasion a suspicious lady (who probably thought I was going to steal something) let me know she was watching me. Oh well, loitering or not I had to get a feel for how the professionals were doing cards. Being new at this business, I knew I had to get an "education" in order to make money at my endeavor.

After hours of studying the work of others, I felt ready to develop my own cards. And develop I did. I brain-stormed on every sending occasion—birthdays, holidays, "not writing," even relationships. I was on my way and making money, but it took some time before I really took my job seriously and began to improve my writing. In fact, I still have a lot of improving to do, 600 published cards later. Like most things in life, the more cards I create, the better I get. I'm very lucky to have editors who saw my potential and believed in me enough to give me a chance.

Rejection didn't get me down. I'd send out samples and hope for the best, knowing I was bound to get rejections. I had nothing to lose. If my submissions were rejected, I knew they had to be better. Through experience and studying cards in stores, I learned how to improve my cards. You can't just put a joke on a card, like "A man walked into a bar . . ."—then put the punchline on the inside. Even if it's really funny, card companies won't want it. A card should express a message one person wants to send to another. And since women send 90 percent of all cards, I had to think like a woman. I pictured the people a woman might send a card to. Maybe she's sending an anniversary card to a man who is sloppy, or a Christmas card to a guy who only thinks about golf,

Jerry King is a freelance humorous illustrator based in North Canton, Ohio. His cartoons appear in children's books, on greeting cards, in magazines and on T-shirts.

This eye-popping Santa is an example of Jerry King's lively style. King sent samples to CardMakers (formerly Diebold Designs) after finding the company's listing in **Artist's & Graphic Designer's Market.**

or a birthday card to her roommate from college. When I imagined what she might want to say to each person, it was a lot easier to develop punchlines card companies accepted.

I don't have to write punchlines for some companies. Gibson has writers on staff who come up with the ideas and punchlines, so they just ask me to draw a cartoon to illustrate their words. Sometimes West Graphics is interested in a card, but offers suggestions to improve the writing. Usually that means cutting down on some words. Often an idea will pop in my head for a greeting, but I'm not exactly sure how to phrase it. So I twist the words around, saying the same thing a hundred different ways until I hit on the funniest words to express a thought. When I run out of ideas, that's when I need to take a break. I won't even think about greeting cards for a week. Instead of being discouraged when I run out of ideas, I use that time to step away from my work and recharge my batteries.

I started freelancing for West Graphics in 1991 and I'm still with them. Soon after came Brandywine Art, Comstock Cards and then Gibson. I will continue working for these companies for many years. Some offer royalties while others offer outright fees. As a greeting card cartoonist, it's important to have both. It's difficult to live on royalties unless you have a zillion cards out. However, royalty checks are a great supplement to your income and royalty statements let you know how well each card is selling.

When I reflect on my early work, I must admit I'm a little embarrassed. At first, my inquiries were unprofessional, my ideas were unpolished and my artwork was sloppy. But I quickly realized that if I wanted to make a living at cartooning, I had to get my act together and be professional. People often ask me why I'm so motivated in my work and my reply is always the same: "I'm lazy! God forbid I ever get a 'real job!' "

Important note on the markets

● *The majority of markets listed in this book are those which are actively seeking new talent. Some well-known companies which have declined complete listings are included within their appropriate section with a brief statement of their policies. In addition, firms which for various reasons have not renewed their listings from the 1995 edition are listed in the " '95-'96 changes" lists at the end of each section.*

● *Listings are based on editorial questionnaires and interviews. They are not advertisements (markets do not pay for their listings), nor are listings endorsed by the* Artist's & Graphic Designer's Market *editor.*

● *Listings are verified prior to the publication of this book. If a listing has not changed from last year, then the art buyer has told us that his needs have not changed—and the previous information still accurately reflects what he buys.*

● *Remember, information in the listings is as current as possible, but art directors come and go; companies and publications move; and art needs fluctuate between the publication of this directory and when you use it.*

● Artist's & Graphic Designer's Market *reserves the right to exclude any listing that does not meet its requirements.*

Key to symbols and abbreviations

‡ New listing
● Comment from *Artist's & Graphic Designer's Market* editor
❦ Canadian listing
* listing outside U.S. and Canada
ASAP As soon as possible
b&w Black and white
IRC International Reply Coupon
P-O-P Point-of-purchase display
SASE Self-addressed, stamped envelope
SAE Self-addressed envelope

The Markets

Advertising, Audiovisual & Public Relations Firms

If you are an illustrator who can work in a consistent style, or a designer with excellent computer skills, have we got a market for you! Advertising agencies and their close cousins, public relations and audiovisual firms, are the most lucrative markets for freelancers. You can make more money in these fields than in magazines, book publishing or greeting cards.

The firms listed in this section hire freelancers to do all kinds of projects, from lettering to airbrushing, model making, illustration, charts, production, storyboards and a myriad of other services. You will most likely be paid by the hour for work done on the firm's premises (inhouse), and by the project if you take the assignment back to your studio. Most checks are issued 40-60 days after completion of assignments. Fees depend on the client's budget, but most agencies are willing to negotiate, taking into consideration the experience of the freelancer, the lead time given, and the complexity of the project. Be prepared to offer a fee estimate for your services before you take an assignment.

Some ad agencies will ask you to provide a preliminary sketch, which, if approved by the client, can land you a plum assignment. If you are asked to create something "on spec," you will not receive payment if the project falls through. (For more insight into agencies' payment practices see Bill Allen's advice on page 74.)

If you're hoping to retain usage rights to your work, you'll want to discuss this up front. You can generally charge more if the client is requesting a buyout. If research and travel are required, make sure you find out ahead of time who will cover these expenses.

Where to start

The person responsible for hiring freelancers at ad agencies is the art director or creative director. Some audiovisual and public relations firms may not be large enough to have an art director on staff so you could be dealing with anyone from an account executive to a company's president. Look for the contact name in the listings to find out who to approach. The companies listed in this section are accustomed to receiving samples from freelancers, but before you send that first mailing, follow these tips to increase your odds of winning an assignment.

Contact local agencies first. Although fax and modem have made it easier for agencies to work with out-of-town illustrators, most prefer to work with local freelancers for design projects.

Design an attractive self-promotional mailer to send to art directors. Consider your mailer as an assignment. Create a memorable piece that is a "keeper." Art directors

say postcard-size mailers are easy to file or tack onto a bulletin board. Don't depend on one mailing to place your name firmly in art directors' minds. Send out follow-up mailings at least twice a year. Be sure to spell the contact person's name correctly. Keep a record of all your mailings. (For more tips on self-promotional mailings see article on page 14.)

Research each agency before you submit. Look at the listings in this section and see what type of clients they have. Do they specialize in retail? Perhaps their client base consists of financial institutions, restaurants or health care providers. Find agencies whose focus is compatible with your interests and background.

Some freelancers prefer to approach larger agencies while others have better luck with smaller firms. To help you find a good fit, we've added information to the listings which will help determine their size. Within the first paragraph we now show the number of employees on staff and the firm's annual billing. Whenever possible, we also list professional affiliations of each agency. Readers tell us it is useful to know if an agency ia a member of the Graphic Artists Guild (GAG), the American Institute of Graphic Arts (AIGA), or is a member of a local chapter of the Art Directors Club or the Ad Club.

Read industry trade publications. If you are at all serious about freelancing for ad agencies it is absolutely imperative that you read at least a few issues of *Advertising Age* and *Adweek*. These magazines will give you a feel for the industry. Current issues can be found in most public libraries.

Become familiar with design annuals. Sometimes called creative service books or sourcebooks, these thick reference books are used by art directors looking for fresh styles. Exploring the sourcebooks will give you a realistic picture of the competition. Though graphic artists pay thousands of dollars to place ads in the commercial source-books like *Showcase*, many of the annuals, like those published yearly by the Society of Illustrators and the American Institute of Graphic Artists (AIGA), showcase the winners of annual competitions. A small entry fee and some innovative designs or illustrations could put your work in front of thousands of art directors. A list of competitions and their deadlines is published in *HOW* magazine's business annual each fall. If you cannot find these books in your public library, a university library should carry them.

If you are an illustrator, aim for consistency in style. "A freelancer should never have more than two styles in one portfolio," advises Patti Harris, art buying manager at Grey Advertising's New York office. "Otherwise it gets too confusing and the person won't be remembered."

Freelance designers must be versatile. Agencies seek jacks-of-all-trades, experienced in design, computer graphics, typesetting and production work. You also should be able to meet tight deadlines.

Learn the lingo. An illustrator or designer is a "creative"; a brochure is just one of many "collateral" pieces; your portfolio is your "book"; your contact at the agency could be an art director or, in the larger agencies, an "art buyer." If you don't already know the meaning of "comp," "rough" and "on spec," check the glossary of this book or pick up a copy of *HOW*, *Communication Arts* or *Print* and take a crash course.

Get editorial assignments first. It is easier to break into advertising if you can show some tearsheets of previous editorial (magazine or newspaper) work.

Portfolios must be clean, logical and easy to read. Each piece should be accompanied by a brief description of the project: the time it took to produce, the budget constraints and what your instructions were. If you schedule an appointment to show your book, try to find out ahead of time what the art director likes to see. Some may be interested in reviewing different steps of a project (from roughs, to comps, to final

product) while others are interested only in the finished piece. Some like to see a wide variety of work, while others look for a portfolio that's been tailored to their specialties.

Network with your peers. In most cities there are local chapters of the Art Directors Club, the American Insitute of Graphic Arts (AIGA) and the Graphic Artists Guild (GAG). Join one of these groups and become an *active* member.

Don't put all your eggs in one basket. Send mailings to design studios, magazines, or greeting cards as well as to advertising and public relations agencies. In the advertising field, the work depends more on the state of the economy and may not always be steady, so have some back up work in other areas.

Public relations firms

It's sometimes difficult to distinguish between ad agencies and PR firms. Some ad agencies offer public relations as one item on their menu of services, while other houses specialize only in PR.

The main difference between advertising and public relations work is the mission: it's a matter of hard sell versus soft sell. Advertising urges the public to buy a company's product or service, whereas PR simply encourages the public to feel positively about the company. Thus, PR firms handle a wide variety of tasks, ranging from development of corporate identity systems, to production of public service announcements, and planning community events and fundraisers. This can mean just about anything under the sun for a freelance designer or illustrator.

Audiovisual firms

Many ad agencies offer multimedia production services, but there is also a definite niche in the marketplace for firms that specialize in this type of work. A house working exclusively in audiovisuals may produce instructional motion pictures, filmstrips, special effects, test commercials and corporate slide presentations for employee training and advertising. Computer graphics and electronic design are gaining importance as audiovisual vehicles, and there are a growing number of video houses being established as animation specialists. Closely associated with this trend is television art. Many networks and local television stations need out-of-house help in designing slide shows, news maps, promotional materials and "bumpers" that are squeezed between commercials.

Arizona

ARIZONA CINE EQUIPMENT, INC., 2125 E. 20th St., Tucson AZ 85719. (602)623-8268. Vice President: Linda A. Bierk. Estab. 1967. Number of employees: 11. Approximate annual billing: $850,000. AV firm. Full-service, multimedia firm. Specializes in video. Product specialty is industrial.
Needs: Approached by 5 freelancers/year. Works with 3 freelance illustrators and 3 designers/year. Prefers local artists. Uses freelancers mainly for graphic design. Also for brochure and slide illustration, catalog design and illustration, print ad design, storyboards, animation and retouching. 20% of work is with print ads. Needs computer-literate freelancers for design, illustration, production and presentation. 60% of freelance work demands knowledge of Aldus PageMaker, QuarkXPress, Aldus FreeHand, Adobe Illustrator or Adobe Photoshop.
First Contact & Terms: Send query letter with brochure, résumé, transparencies, photographs and slides. Samples are filed. Reports back to the artist only if interested. Art Director will contact artist for portfolio review if interested. Portfolio should include color thumbnails, final art, tearsheets, slides, photostats, photographs and transparencies. Pays for design by the project, $100-5,000. Pays for illustration by the project, $25-5,000. Buys first rights or negotiates rights purchased.

‡CBI ADVERTISING, 7580 E. Gray Rd., Suite 203, Phoenix AZ 85260. (602)948-0440. Fax: (602)443-1263. Contact: Gail Cross, Graphic Dept. Estab. 1987. Number of employees: 4. Approximate annual billing: $500,000. Ad agency. Full-service, multimedia firm. Specializes in graphic design, computer graphics. Product specialty is high technology. Client list available upon request. Professional affiliations: AIN.
Needs: Approached by 100 freelance artists/year. Works with 10 freelance illustrators and 10 designers/year. Prefers local artists with experience in Macintosh computer graphics. Uses freelancers mainly for special projects and overflow. Also uses freelancers for brochure and catalog design and illustration, lettering, logos, model making, posters, retouching, signage and TV/film graphics. 50% of work is with print ads. Needs computer-literate freelancers for design, illustration and production. 85% of freelance work demands knowledge of Aldus PageMaker, Adobe Photoshop, QuarkXPress, Adobe Illustrator and Painter.
First Contact & Terms: Send query letter with photocopies, résumé and tearsheets. Samples are filed or returned. Reports back to the artist only if interested. Portfolio should include b&w and color final art, roughs and thumbnails. Pays for design and illustration by the project. Rights purchased vary according to project.

CHARLES DUFF ADVERTISING, Dept. AM, 301 W. Osborn Rd., Suite 2000, Phoenix AZ 85013. (602)285-1660. Fax: (602)285-1803. Creative Director: Trish Spencer. Estab. 1948. Number of employees: 10. Approximate annual billing: $1 million. Ad agency. Full-service multimedia firm. Specializes in agri-marketing promotional materials—literature, audio, video, trade literature. Specializes in animal health. Current clients include Farnam, Veterinary Products Inc., Bee-Smart Products.
Needs: Approached by 36 freelancers/year. Works with 25 freelance illustrators and 10 designers/month. Prefers freelancers with experience in animal illustration: equine, pets and livestock. Uses freelancers mainly for brochure, catalog and print ad illustration and retouching, billboards and posters. 35% of work is with print ads. Needs computer-literate freelancers for design, illustration, production and presentation. 25% of freelance work demands knowledge of Aldus PageMaker, Photoshop, QuarkXPress, Aldus FreeHand and Adobe Illustrator.
First Contact & Terms Send query letter with brochure, photocopies, SASE, résumé, photographs, tearsheets, slides and transparencies. Samples are filed or are returned by SASE if requested by artist. Reports back within 2 weeks. Reviews portfolios "only by our request." Pays by the project, $100-500 for design; $100-700 for illustration. Buys one-time rights.

FILMS FOR CHRIST, 2628 W. Birchwood Circle, Mesa AZ 85202. E-mail: 71742.2074@compuserve.com. Contact: Paul S. Taylor. Number of empoyees: 6. Motion picture producer and book publisher. Audience: educational, religious and secular. Produces and distributes motion pictures, videos and books.
• Design and computer work are done inhouse. Will work with out-of-town illustrators.
Needs: Works with 1-5 freelance illustrators/year. Works on assignment only. Uses illustrators for books, catalogs and motion pictures. Also for storyboards, animation, cartoons, slide illustration and ads.
First Contact & Terms: Send query letter with résumé, photocopies, slides, tearsheets or snapshots. Samples are filed or are returned by SASE. Reports in 1 month. All assignments are on a work-for-hire basis. Originals are not returned. Considers complexity of project and skill and experience of artist when establishing payment.

How to Use Your **Artist's & Graphic Designer's Market** *offers suggestions for understanding and using the information in these listings. Read this and other articles in the front of this book for important business tips.*

‡HARDAWAY MARKETING SERVICES, 777 E. Thomas Rd., #210, Phoenix AZ 85014. (602)252-2050. Fax: (602)252-1331. E-mail: wurdis@aol.com. Art Director: Wesley R. Porter. Estab. 1993. Number of employees: 3. Ad agency, PR and marketing firm. Specializes in brochures, business systems, ads, annual reports, strategic planning, public relations. Product specialties are high-tech, medical, real estate. Current clients include Alexander Group, Dr. Steven Gitt, LMB Construction, Vodavi, Time Systems, Intergroup. Client list available upon request. Professional affiliations: AMUG, MAC.
Needs: Approached by 6-12 freelancers/year. Works with 2-3 freelance illustrators and 1-2 designers/year. Works only with artist reps. Prefers local artists ony. Uses freelancers mainly for illustration. Also for annual reports, brochure design and illustration, catalog illustration. 25% of work is with print ads. Needs computer-literate freelancers for illustration and production. Freelancers should be familiar with Aldus Free-Hand, Adobe Photoshop, QuarkXPress.
First Contact & Terms: Send query with brochure, résumé. Samples are filed. Art Director will contact artist for portfolio review if interested. Portfolio should include b&w and color, final art. Pays for design by the hour, $20-80. Pays for illustration by the hour. Buys all rights.
Tips: Finds artists through artist reps, *Arizona Portfolio, Creative Black Book*. "Send out direct mail pieces."

‡PAUL S. KARR PRODUCTIONS, 2925 W. Indian School Rd., Box 11711, Phoenix AZ 85017. Phone/fax: (602)266-4198. Contact: Paul Karr. Utah Division: 1024 N. 300 East, Box 1254, Orem UT 84057. Phone/fax: (801)226-3001. Contact: Michael Karr. Film and video producer. Clients: industry, business, education, TV, cable and feature films.
Needs: Occasionally works with freelance filmmakers in motion picture and video projects. Works on assignment only.
First Contact & Terms: Advise of experience, abilities, and funding for project.
Tips: "If you know about motion pictures and video or are serious about breaking into the field, there are three avenues: 1) have relatives in the business; 2) be at the right place at the right time; or 3) take upon yourself the marketing of your idea, or develop a film or video idea for a sponsor who will finance the project. Go to a film or video production company, such as ours, and tell them you have a client and the money. They will be delighted to work with you on making the production. Work, and approve the various phases as it is being made. Have your name listed as the producer on the credits. With the knowledge and track record you have gained you will be able to present yourself and your abilities to others in the film and video business and to sponsors."

‡KC MARKETING GROUP, INC., 2321 W. Royal Palm Rd., Suite 113, Phoenix AZ 85021. (602)995-0990. Fax: (602)864-0369. Product Manager: Patrice Agliata. Estab. 1977. Number of employees: 30. Approximate annual billing: $3 million. Marketing promotions firm. Full-service multimedia firm. Specializes in promotional material. Product specialties are food, drugs. Client list available upon request. Professional affiliations: PMAA, PIAZ, AISB.
Needs: Approached by 10-15 freelancers/year. Works with 5 freelance illustrators and 2 designers/year. Prefers artists with experience in designing and rendering tight comps and Mac knowledge. Uses freelancers for illustrations and comps. Also for brochure and catalog design and illustration, logos. 35% of work is with print ads. Needs computer-literate freelancers for design and illustration. 98% of freelance work demands knowledge of Aldus PageMaker, Aldus FreeHand, Adobe Photoshop, QuarkXPress, Adobe Illustrator.
First Contact & Terms: Send query letter with tearsheets. Samples are filed. Does not report back. Artist should continue to send new pieces. Art Director will contact artist for portfolio review if interested. Portfolio should include color photographs, slides, transparencies, final art. Pays for design by the project, $100-1,000. Pays for illustration by the project, $100-3,000. Buys all rights.
Tips: Finds artists through sourcebooks, reps, submissions and word of mouth.

‡MILES & ASSOCIATES ADVERTISING, 380 E. Fort Lowell Rd., Suite 239, Tucson AZ 85705. (602)623-4944. Contact: Bill Miles. Estab. 1973. Number of employees: 2. Approximate annual billing: $750,000. Ad agency. Full-service, multimedia firm. Specializes in local TV advertising, outdoor. Product specialty is automotive. Client list available upon request.
Needs: Approached by 30 freelancers/year. Works with 1 freelance illustrator and 3 designers/year. Prefers local freelancers only. Uses freelancers mainly for newspaper and outdoor design and layout, plus television graphics. Also for signage. 20% of work is with print ads. Needs computer-literate freelancers for design and production.
First Contact & Terms: Send query letter with photocopies. Samples are filed and are not returned. Art Director will contact artist for portfolio review if interested. Portfolio should include b&w and color final art and roughs. Pays for design by the project, $40-2,500. Pays for illustration by the project. Buys all rights.

‡ON-LOCATION VIDEO & AUDIO, (formerly Sweetwater Sound & Video, Inc.), Box 1866, Prescott AZ 86302. (602)445-5050. Fax: (602)445-5910. E-mail: av___steve@sizzle.yavapai.cc.az.us. President: Steve LaVigne. Estab. 1971. Number of employees: 2. Approximate annual billing: $150,000. AV firm. Full-service, multimedia firm handling video and audio production for various clients, as well as some print. Specializes in documentaries, educational, cable and direct distribution. Product specialties are educational,

nature, old West, entertainment. Current clients include Ralph Rose Productions, Prism Productions and Current Productions.

Needs: Approached by 7-8 freelancers/year. Works with 3 freelance illustrators and 4 designers/year. Prefers artists with experience in video, computer graphics, animation on Amiga and Mac. Uses freelance artists mainly for graphics and animation. Also for print ad and slide illustration, storyboards, posters, TV/film graphics, lettering and logos. 20% of work is with print ads. 90% of freelance work demands knowledge of Amiga software: D Paint, Calagari, Toaster; and Power Mac: Premiere, Photoshop, Strata, Studio.

First Contact & Terms: Send query letter with brochure, photocopies, SASE, résumé, photographs, slides, computer disks or VHS videotape. Samples are filed or are returned by SASE if requested by artist. Reports back within 2 weeks. To show portfolio, mail photographs, computer disks (Amiga), VHS or SVHS video tape. Payment for design and illustration varies by job and client.

Arkansas

KIRKPATRICK, WILLIAMS, GURLEY ASSOCIATES, (formerly Gurley Associates), 111½ W. Walnut, Rogers AR 72756. (501)636-4037. Fax: (501)636-9457. Art Director: Michelle Serfass. Estab. 1960. Ad agency. Full-service, multimedia firm. Specializes in packaging and print material. Product specialties are toys and sporting goods.

Needs: Approached by 2-3 freelancers/month. Works with 1-2 illustrators/month. Prefers artists with experience in toys, automotive, military and space products. Works on assignment only. Uses freelancers mainly for illustration for packaging. Also for brochure, catalog and print ad illustration and retouching and posters. Needs computer literate freelancers for design and production. 75% of freelance work demands knowledge of QuarkXPress, Aldus FreeHand, Adobe Illustrator and Photoshop. Needs technical illustration. 8-10% of work is with print ads.

First Contact & Terms: Send query letter with brochure, résumé, photographs and slides. Samples are filed or are returned by SASE only if requested by artist. Does not report back. Artist should "contact by letter." Call for appointment to show portfolio of "whatever best shows the artist's strengths." Pays for design by the hour, $50 maximum. Pays for illustration by the project, $250-3,000. Buys all rights.

MANGAN/HOLCOMB & PARTNERS, 320 W. Capitol Ave., Suite 911, Little Rock AR 72201. Contact: Steve Mangan (by mail only). Number of employees: 17. Approximate annual billing: $3 million. Ad agency. Clients: recreation, financial, tourism, utilities.

Needs: Approached by 50 freelancers/year. Works with 8 freelance illustrators and 20 designers/year. Uses freelancers for consumer magazines, stationery design, direct mail, brochures/flyers, trade magazines and newspapers. Also needs illustrations for print materials. Needs computer-literate freelancers for production and presentation. 30% of freelance work demands knowledge of Macintosh page layout and illustration software.

First Contact & Terms: Query with brochure, flier and business card to be kept on file. Include SASE. Reports in 2 weeks. Call or write for appointment to show portfolio of final reproduction/product. Pays by the project, $250 minimum.

California

ADVANCE ADVERTISING AGENCY, 606 E. Belmont Ave., Suite 202, Fresno CA 93701. (209)445-0383. Creative Director: M. Nissen. Estab. 1950. Ad agency. Full-service, multimedia firm. Current clients include Picd Computors, Sound Investment Recording Studio, Howard Leach Auctions, Mr. G's Carpets, Allied Floorcovering, Fresno Dixieland Society. Client list not available.

Needs: Approached by 2-5 freelancers/month. Prefers local freelancers with experience in all media graphics and techniques. Works on assignment only. Uses freelancers mainly for direct mail, cartoons, caricatures. Also for brochure design and illustration, catalog and print ad design, storyboards, mechanicals, retouching, billboards and logos. 75% of work is with print ads. 25% of freelance work demands computer skills.

First Contact & Terms: Send query letter with résumé, photocopies and SASE. Samples are filed or returned by SASE. Reports back within 2 weeks only if interested. Creative Director will contact artist for portfolio review if interested. Portfolio should include roughs, tearsheets and/or printed samples. Pays for design and illustration by the project, rate varies. Buys all rights.

Tips: Finds artists through artists' submissions.

The double dagger before a listing indicates that the listing is new in this edition. New markets are often more receptive to freelance submissions.

ASAP ADVERTISING, P.O. Box 250, Porterville CA 93258-0250. (209)783-2727. Fax: (209)781-0712. Owner: Brian Dillon. Estab. 1982. Number of employees: 1. Approximate annual billing: $250,000. Ad agency. Full-service, multimedia firm. Specializes in print advertising, brochures, sales kits, mailers and PR. Product specialties are high tech, OEM and industrial. Primary clients include Aleph International, American Nucleonics Corp., and Downs Crane & Hoist. Professional affiliations: AAF.
Needs: Approached by 60 freelaners/year. Works with 3-5 freelance illustrators and 2 designers/year. Prefers local freelancers with experience in mechanicals, tight concepts and comps. Currently needs technical illustration. Works on assignment only. No staff art department, uses freelancers for all artwork—brochure, catalog and print ad design and illustration; retouching; lettering; and logos. 60% of work is with print ads.
First Contact & Terms: Send query letter with business card, résumé and photocopies. Samples are filed or are returned by SASE. Reports back within 1 week only if interested. Art Director will contact artist for portfolio review if interested. Portfolio should include thumbnails, roughs and b&w samples showing full range of ability (photocopies OK). Pays for design by the project, $40-200. Pays for illustration by the project, $100-800. Buys all rights.
Tips: Finds artists through creative director's source file of samples.

B&A DESIGN GROUP, 634-C W. Broadway, Glendale CA 91204-1008. (818)547-4080. Fax: (818)547-1629. Creative Director: Barry Anklam. Full-service advertising and design agency providing ads, brochures, P-O-P displays, posters and menus. Product specialties are food products, electronics, hi-tech, real estate and medical. Clients: high-tech, electronic, photographic accessory companies and restaurants. Current clients include Syncor International, California Egg Commission, Neptune Foods, Viktor Benes Continental Pastries, MCA/Universal Merchandising, NTC/National Teleconsultants, Pasadena Tournament of Roses, Amgen and Pinkerton.
Needs: Works with 8 freelancers/year. Assigns 15-20 jobs/year. Uses freelancers mainly for brochure, editorial newspaper and magazine ad illustration; mechanicals; retouching; direct mail packages; lettering; charts/graphs. Needs editorial, technical and medical illustration and editorial cartoons. Needs computer-literate freelancers for design, illustration and production. 95% of freelance work demands knowledge of QuarkXPress, Photoshop and Aldus FreeHand.
First Contact & Terms: Contact through artist's agent or send query letter with brochure showing art style. Samples are filed. Reports back only if interested. To show a portfolio, mail color and b&w tearsheets and photographs. Pays for production by the hour, $20-25. Pays for design by the hour, $75-150; or by the project, $500-2,000. Pays for illustration by the project, $250-3,000. Considers complexity of project, client's budget and turnaround time when establishing payment. Rights purchased vary according to project.
Tips: Finds artists through agents, sourcebooks and sometimes by submissions.

THE BASS GROUP, Dept. AGDM, 102 Willow Ave., Fairfax CA 94930. (415)455-8090. Producer: Herbert Bass. Number of employees: 2. Approximate annual billing: $150,000. "A multi-media, full-service production company providing corporate communications to a wide range of clients. Specializes in multi-media presentations video/film, and events productions for corporations."
Needs: Approached by 30 freelancers/year. Works with 5 freelance illustrators and 5 designers/year. Prefers solid experience in multi-image and film/video production. Works on assignment only. Uses freelancers for mechanicals, lettering, logos, charts/graphs and multi-image designs. Needs technical illustration, graphic, meeting theme logo and slide design. Needs computer-literate freelancers for design, illustration and production. 90% of freelance work demands knowledge of QuarkXPress, Aldus FreeHand, Adobe Illustrator and Photoshop. Prefers loose or impressionistic style.
First Contact & Terms: Send résumé and slides. Samples are filed and are not returned. Reports back within 1 month if interested. Art Director will contact artist for portfolio review if interested. Sometimes requests work on spec before assigning a job. Pays by the project. Considers turnaround time, skill and experience of artist and how work will be used when establishing payment. Rights purchased vary according to project.
Tips: Finds illustrators and designers mainly through word-of-mouth recommendations. "Send résumé, samples, rates. Highlight examples in speaker support—both slide and electronic media—and include meeting logo design."

COAKLEY HEAGERTY, 1155 N. First St., San Jose CA 95112-4925. (408)275-9400. Director, Creative Services: Tundra Alex. Creative Directors: Susann Rivera and J. D. Keser. Art Directors: Thien Do, Ray Bauer and Carrie Schiro. Number of employees: 27. Approximate annual billing: $20 million. Full-service ad agency. Clients: consumer, high-tech, banking/financial, insurance, automotive, real estate, public service. Client list available upon request. Professional affiliation: MAAN.
Needs: Approached by 100 freelancers/year. Works with 50 freelance illustrators and 3 designers/year. Works on assignment only. Uses freelancers for illustration, retouching, animation, lettering, logos and charts/graphs. 10% of freelance work demands knowledge of Adobe Illustrator, Photoshop or QuarkXPress.
First Contact & Terms: Send query letter with brochure showing art style or résumé, slides and photographs. Samples are filed or are returned by SASE. Does not report back. Call for an appointment to show portfolio. Pays for design and illustration by the project, $600-5,000.

DIMON CREATIVE COMMUNICATION SERVICES, 3515 W. Pacific Ave., Burbank CA 91505. (818)845-3748. Fax: (818)954-8916. Art Director: Armin Krumbach. Number of employees: 14. Approximate annual billing: $2 million. Ad agency/printing firm. Serves clients in industry, finance, computers, electronics, health care and pharmaceutical.

Needs: Works with 3 freelance illustrators and 2 designers/year. Needs computer-literate freelancers for design, illustration, production and presentation. 40% of freelance work demands knowledge of Aldus Page-Maker, QuarkXPress, Aldus FreeHand, Adobe Illustrator and Photoshop. Need editorial and technical illustration.

First Contact & Terms: Send query letter with tearsheets, finished art samples, photocopies and SASE. Provide brochure, flier, business card, résumé and tearsheets to be kept on file for future assignments. Portfolio should include comps. Pays for design by the hour, $20-50. Pays for illustration by the project, $75 minimum.

Tips: "We have cut staff so we rely more on freelancers to fill in the gaps when work load requires it."

EVANS & PARTNERS INC., 1961 Oxford Ave., Cardiff CA 92007-1636. (619)944-9400. Fax: (619)944-9422. President/Creative Director: David Evans. Estab. 1988. Number of employees: 7. Approximate annual billing: $1.5 million. Ad agency. Full-service, multimedia firm. Specializes in marketing communications from strategies and planning through implementation in any media. Product specialties are marketing and graphics design for high-tech, high-tech medical, manufacturing. Current clients include Procare, Novus Technologies, Orincon, Verticle Market Software, various credit unions.

● Very interested in CD-ROM combination photography illustration—typographic work.

Needs: Approached by 24-36 freelancers/year. Works with 5-7 freelance illustrators and 4-6 designers/year. Works only with artist reps/illustrators. Prefers local freelancers with experience in listening, concepts, print and collateral. Uses freelancers mainly for comps, design and production (brochure and print ad design and illustration, storyboards, mechanicals, retouching, billboards, posters, TV/film graphics, lettering and logos). Needs editorial, technical and medical illustration. 40% of work is with print ads. Needs computer-literate freelancers for design, illustration, production and presentation. 90% of freelance work demands knowledge of Adobe Illustrator, Photoshop, QuarkXPress or Corel Draw.

First Contact & Terms: Send query letter with brochure, photocopies, résumé and photographs. "Send samples that have an appreciation for dynamic design but are still reader friendly." Samples are filed. Reports back to the artist only if interested. Art Director will contact artist for portfolio review if interested. Portfolio should include roughs, photostats, tearsheets, transparencies and actual produced pieces. Very rarely may request work or spec. Pays for design by the project, $100-24,000. Pays for illustration by the project, $100-18,000. Rights purchased vary according to project.

Tips: Finds artists through word of mouth, magazines, submissions, source books and agents.

‡FINGEROTE AND FINGEROTE, 482 Alvarado St., Monterey CA 93940. (408)649-4499. Fax: (408)649-1104. Senior Art Director: Judy Anderson. Number of employees: 6. Approximate annual billing: $800,000. Ad agency. Full-service, multimedia firm. Product specialties are hospitality, hospitals and agriculture. Current clients include Community Hospital Recovery Center, Frank Capurro & Son, Boskovich Farms, DPIC, Monterey-Salinas Transit, Monterey Jazz Festival, March Confectionery Company. Professional affiliation: AAAA.

Needs: Approached by 7 freelancers/year. Works with 4 freelance illustrators and 3 designers/year. Works on assignment only. Uses freelance artists mainly for design and/or production. 40% of work is with print ads. Needs computer-literate freelancers for design and production. 85% of freelance work demands knowledge of QuarkXPress 3.3, Illustrator 5.5 and Photoshop 3.0.

First Contact & Terms: Send query letter with samples or work. Samples are filed. Does not report back. Artist should inquire. Write for appointment to show portfolio of final art, b&w and color photostats, tearsheets, photographs and transparencies. Pays for design and illustration by the hour, $30 minimum. Rights purchased vary according to project.

JUDY GANULIN PUBLIC RELATIONS, 1117 W. San Jose, Fresno CA 93711-3112. (209)222-7411. Fax: (209)226-7326. Owner: Judy Ganulin. Estab. 1984. Number of employees: 1. PR firm. Full-service, multimedia firm. Specializes in brochures. Product specialties are political, nonprofit and small business. Professional affiliation: PRSA.

Needs: Approached by 20 freelancers/year. Works with 3-4 freelance illustrators and 1-2 designers/year. Prefers local freelancers only. Works on assignment only. Uses freelancers mainly for layout, logo development and design. Also for brochure and print ad design and illustration, billboards, posters, TV/film graphics, lettering and logos. 5% of work is with print ads. Needs computer-literate freelancers for design, editorial illustration, production and presentation. 10% of freelance work demands computer skills.

First Contact & Terms: Send query letter with tearsheets. Samples are returned by SASE only if requested by artist. Reports back within 10 days. Request portfolio review in original query and follow-up with call. Portfolio should include thumbnails, roughs, finished art, color tearsheets. Pays for design and illustration by the hour, $25-60. Negotiates rights purchased.

Tips: Finds artists through word of mouth and cold calls. "In the future I think clients will be very specific about what they will pay for, but they will insist on quality work and excellent service."

‡KVCR-TV RADIO, 701 S. Mount Vernon Ave., San Bernardino CA 92410. (909)888-6511 or 825-3103. Station Manager: Lew Warren. Number of employees: 19. Specializes in public and educational radio/TV. **Needs:** Approached by 1 freelancer/year. Assigns 1-10 jobs/year. Uses freelancers for graphic/set design and set design painting.
First Contact & Terms: Query and mail photos or slides. Reports in 2 weeks. Samples returned by SASE.

LINEAR CYCLE PRODUCTIONS, P.O. Box 2608, San Fernando CA 91393-0608. Producer: Rich Brown. Production Manager: R. Borowy. Estab. 1980. Number of employees: 30. Approximate annual billing: $200,000. AV firm. Specializes in audiovisual sales and marketing programs and also in teleproduction for CATV. Current clients include Katz, Inc. and McDave and Associates.
Needs: Works with 7-10 freelance illustrators and 7-10 designers/year. Prefers freelancers with experience in teleproductions (broadcast/CATV/non-broadcast). Works on assignment only. Uses freelancers for story-boards, animation, TV/film graphics, editorial illustration, lettering and logos. 10% of work is with print ads. Needs computer-literate freelancers for illustration and production. 25% of freelance work demands knowledge of Aldus FreeHand, Photoshop or Tobis IV.
First Contact & Terms: Send query letter with résumé, photocopies, photographs, slides, transparencies, video demo reel and SASE. Samples are filed or are returned by SASE if requested by artist. Reports back to the artist only if interested. To show portfolio, mail audio/videotapes, photographs and slides; include color and b&w samples. Pays for design and illustration by the project, $100 minimum. Considers skill and experience of artist, how work will be used and rights purchased when establishing payment. Negotiates rights purchased.
Tips: Finds artists through reviewing portfolios and published material. "We see a lot of sloppy work and samples, portfolios in fields not requested or wanted, poor photos, photocopies, graphics, etc. Make sure your materials are presentable."

‡LUTAT, BATTEY & ASSOC., INC., 910 Campisi Way, Suite 2-A, Campbell CA 95008. (408)559-3030. Creative Director: Bruce Battey. Estab. 1976. Number of employees: 12. Ad agency. Specializes in print advertising, both consumer and trade; also collaterals. Product specialties are high-tech and food. Professional affiliation: AAAA.
Needs: Approached by 50 freelancers/year. Works with 10 freelance illustrators and 5 designers/year. Prefers freelancers with experience in high technology, food and fashion. Works on assignment only. Uses freelancers for all clients: brochure, catalog and print ad design and illustration, storyboards, slide illustration, mechanicals, retouching, billboards, posters, lettering and logos. Needs editorial and technical illustration. 60% of work is with print ads. Needs computer-literate freelancers for design and illustration. 95% of freelance work demands knowledge of Aldus PageMaker, Adobe Photoshop and Illustrator, QuarkXPress, Aldus FreeHand or "all other" programs.
First Contact & Terms: Send query letter with brochure, résumé, photographs and tearsheets. Samples are filed or returned by SASE only if requested by artist. Reports back within days if interested. Write for appointment to show portfolio or mail thumbnails, roughs, b&w and color tearsheets, photographs and transparencies. Pays for design by the hour, $50-150; by the project, $200-5,000. Pays for illustration by the project, $300-5,000. Rights purchased vary according to project.

LEE MAGID MANAGEMENT AND PRODUCTIONS, Box 532, Malibu CA 90265. (213)463-5998. President: Lee Magid. Estab. 1963. AV and PR firm. "We produce music specials, videos and recordings."
Needs: Works with 48 freelance illustrators/year. Works on assignment only. Uses freelancers for "anything print." Also for brochure, catalog and print ad design; storyboards; posters; TV/film graphics and logos. 50% of work is with print ads.
First Contact & Terms: Send query letter with brochure, photostats and SASE. Samples are filed or are returned by SASE if requested by artist. Reports back to the artist only if interested. To show portfolio, mail photostats; include color and b&w samples. Pays for design and illustration by the project. Considers how work will be used when establishing payment. Buys all rights or reprint rights.
Tips: "Send your work in, but keep originals. Send clear copy of work."

MATHEWS & CLARK COMMUNICATIONS, 710 Lakeway, Suite 170, Sunnyvale CA 94086-4013. (408)736-1120. E-mail: mathwsclrk@aol.com. Fax: (408)736-2523. Production Supervisor: Stuart Oishi.

A bullet introduces comments by the editor of** Artist's & Graphic Designer's Market **indicating special information about the listing.

Estab. 1975. Number of employees: 19. Advertising/PR firm. Full-service, multimedia firm. Specializes in annual reports, collateral, ads. Product specialties are high-tech, electronics. Current clients include KLA Instruments, Genus, Tencor Instruments, Johnson Matthey Electronics, ASM Lithography, OKI Semiconductor and Gasomick International.

Needs: Approached by 6-8 freelancers/year. Works with illustrators on a project basis. Works with 1-2 freelance designers and 1-2 illustrators/year. Prefers artists with experience in high-tech accounts. Works on assignment only. Uses freelancers mainly for ad concepts, annual reports, collateral. Also for brochure and print ad design and illustration, technical illustration, mechanicals, logos, catalog and newsletter design. 10% of work is with print ads. Needs computer-literate freelancers for design, illustration and production. 75% of freelance work demands knowledge of Aldus Pagemaker, Adobe Illustrator, QuarkXpress or Aldus Freehand.

First Contact & Terms: Send query letter with brochure. Request portfolio review in original query, follow up with letter. Portfolios may be dropped off on Mondays and Tuesdays at request of firm, and should include b&w and color printed samples. Samples are filed. Sometimes requests work on spec before assigning a job. Pays for design by the hour, $30 minimum or by the project. Pays for illustration by the project. Rights purchased vary according to project.

Tips: Finds artists through word of mouth and sourcebooks.

NEW & UNIQUE VIDEOS, 2336 Sumac Dr., San Diego CA 92105. (619)282-6126. Fax: (619)283-8264. Estab. 1982. Number of employees: 3. AV firm. Full-service, multimedia firm. Specializes in special interest video titles—documentaries, how-to, etc. Current clients include Coleman Company, Caribou, DuPont, Canari Cyclewear, Giant Bicycles, Motiv Bicycles. Client list available upon request.

Needs: Approached by 5-10 freelancers/year. Works with 2-3 freelance illustrators/year. Prefers freelancers with experience in computer animation. Works on assignment only. Uses freelancers mainly for video box covers, video animation. Also for catalog and print ad design, animation, posters and TV/film graphics. 10% of work is with print ads. Needs computer-literate freelancers for design and illustration. 50% of freelance work demands compatability with Macintosh.

First Contact & Terms: Send query letter with brochure, résumé and SASE. Samples are filed or returned by SASE. Reports back in 1 month only if interested. Artist should follow up. Art Director will contact artist for portfolio review if interested. Portfolio should include thumbnails, photographs and tearsheets. Pays for design and illustration by the project (negotiated). Buys one-time rights.

ON-Q PRODUCTIONS, INC., 618 E. Gutierrez St., Santa Barbara CA 93103. President: Vincent Quaranta. AV firm. "We are producers of multi-projector slide presentations. We produce computer-generated slides for business presentations." Clients: banks, ad agencies, R&D firms and hospitals.

Needs: Works with 10 freelancers/year. Uses freelancers mainly for slide presentations. Also for editorial and medical illustration, retouching, animation and lettering. Needs computer-literate freelancers for design, illustration, production and presentation. 75% of freelance work demands knowledge of QuarkXPress, Aldus FreeHand or Aldus Persuasion.

First Contact & Terms: Send query letter with brochure or résumé. Reports back only if interested. Write for appointment to show portfolio of original/final art and slides. Pays for design and illustration by the hour, $25 minimum; or by the project, $100 minimum.

Tips: "Artist must be *experienced* in computer graphics and on the board. The most common mistakes freelancers make are poor presentation of a portfolio (small pieces fall out, scratches on cover acetate) and they do not know how to price out a job. Know the rates you're going to charge and how quickly you can deliver a job. Client budgets are tight."

PALKO ADVERTISING, INC., 2075 Palos Verdes Dr. N., Suite 207, Lomita CA 90717. (310)530-6800. Art Director: Chuck Waldman. Number of employees: 6. Ad agency. Specializes in business-to-business, retail and high-tech. Professional affiliation: ADLA.
● Palko's illustration needs vary widely from fashion to high tech to architectural.

Needs: Approached by 20-30 freelancers/year. Works with 5-10 freelance illustrators and 1-5 designers/year. Prefers local freelancers. Uses freelancers mainly for layout, illustration, paste-up, mechanicals, copywriting and photography. Also for Mac production and pre-press; must be Mac literate in QuarkXPress, Illustrator, Pagemaker, FreeHand and Photoshop. Produces ads, brochures and collateral material.

First Contact & Terms: Send query letter with brochure, résumé, business card, "where you saw our address" and samples to be kept on file. Accepts tearsheets, photographs, photocopies, printed material or slides as samples. Samples not filed returned only if requested. Art Director will contact artists for portfolio review if interested. Artist should follow-up with letter after initial query. Sometimes requests work on spec before assigning a job. Pays for design by the project. Pays for illustration by the project, $50-1,500. Pays for production $15-20/hour or by the project. Negotiates rights purchased.

Tips: Finds artists through sourcebooks. "Send us something memorable which is indicative of your capabilities. Include one or two business cards and a word about what you do. The advertising field continues to be tough, but positive—no end in sight for higher level of service for least amount of money."

PRISCOMM, 3183 Airway, Suite G, Costa Mesa CA 92626. (714)433-7400. Fax: (714)433-7306. Contact: Creative Director. Estab. 1987. Ad agency/PR firm. Full-service, multimedia firm. Specializes in print ads, interactive presentations, collateral, corporate magazines and newsletters. Product specialties are high-tech and audio-video.

• This agency looks for designers who can carry a project from initial concept through production.

Needs: Approached by 1-2 freelancers/month. Works with 2-3 freelance illustrators and 2-3 designers/month. Prefers local freelancers with 3 years experience in Macintosh computers. Uses freelancers mainly for design and production. Also for brochures and logos. 70% of work is with print ads. Needs computer-literate freelancers with knowledge of Aldus PageMaker, Adobe Illustrator, QuarkXPress, Photoshop, Aldus FreeHand, Macromind Director, Multimedia.

First Contact & Terms: Send query letter with photocopies, SASE, slides and transparencies. Samples are filed and are returned by SASE. Reports back to artist only if interested. Pays for design by the hour. Pays for illustration by the project. Buys all rights.

‡RUBIN POSTAER & ASSOCIATES, Dept. AGDM, 1333 Second St., Santa Monica CA 90401. (310)917-2425. Manager, Art Services: Annie Ross. Ad agency. Serves clients in automobile and heavy equipment industries, savings and loans, hotels and cable television.

Needs: Works with about 24 freelance illustrators/year. Uses freelancers for all media.

First Contact & Terms: Contact manager of art services for appointment to show portfolio. Selection based on portfolio review. Negotiates payment.

Tips: Wants to see a variety of techniques.

DONALD S. SMITH, P.O. Box 1545, Whittier CA 90609. (310)690-3700. Fax: (310)690-9045. Art Director: Fred Hartson. Estab. 1965. Ad agency. Full-service, multimedia firm. Specializes in magazine ads and collateral. Product specialties are technical services and products. Current clients include Christie Electronics, Preston Scientific, Polara Engineering, Ardrox, Selco Products, Standard Enterprises, National Irrigation Systems.

Needs: Approached by 1-2 freelancers/month. Works with 2 freelance illustrators/year. Works on assignment only. Uses freelancers mainly for illustration. Also for brochure and print ad illustration. 60% of work is with print ads.

First Contact & Terms: Send tearsheets, photographs, slides and transparencies. Samples are filed or are returned by SASE if requested. Reports back to the artist only if interested. Art Director will contact artist for portfolio review if interested. Pays for illustration by the project, $200-1,500. Buys all rights.

Tips: Finds artists through sourcebooks, word of mouth and artists' submissions.

‡VIDEO RESOURCES, Box 18642, Irvine CA 92713. (714)261-7266. E-mail: bradvr@eworld.com. Producer: Brad Hagen. Number of employees: 5. AV firm. Specializes in automotive, banks, restaurants, computer, health care, transportation and energy.

Needs: Approached by 10-20 freelancers/year. Works with 5-10 freelance illustrators and 5-10 designers/year. Prefers southern California freelancers only with minimum 5 years of experience. Works on assignment only. Uses freelancers for graphics, multimedia, animation, etc.

First Contact & Terms: Send query letter with brochure showing art style or résumé, business card, photostats and tearsheets to be kept on file. Samples not filed are returned by SASE. Considers complexity of the project and client's budget when establishing payment. Buys all rights.

VISION STUDIOS, 3765 Marwick Ave., Long Beach CA 90808. (310)429-1042. Contact: Arlan H. Boll. Estab. 1990. AV firm. Full-service, multimedia firm. Specializes in audio project studio sound design for all media. Current clients include NBC, AT&T, KLOS, Toyota and Honda. Client list available upon request.

Needs: Approached by 2-4 freelancers/year. Works with 2-4 freelance designers/year. 50% of freelance work demands knowledge of Aldus PageMaker.

First Contact & Terms: Send query letter with brochure. Samples are filed. Reports back within 10 days.

VISUAL AID/VISAID MARKETING, Box 4502, Inglewood CA 90309. (310)473-0286. Manager: Lee Clapp. Estab. 1961. Number of employees: 3. Distributor of promotion aids, marketing consultant service, "involved in all phases." Specializes in manufacturers, distributors, publishers and graphics firms (printing and promotion) in 23 SIC code areas.

Needs: Approached by 25-50 freelancers/year. Works with 1-2 freelance illustrators and 6-12 designers/year. Uses freelancers for advertising, brochure and catalog design, illustration and layout; product design; illustration on product; P-O-P display; display fixture design; and posters. Buys some cartoons and humorous cartoon-style illustrations. Additional media: fiber optics, display/signage, design/fabrication.

First Contact & Terms: Works on assignment only. Send query letter with brochure, résumé, business card, photostats, duplicate photographs, photocopies and tearsheets to be kept on file. Reports back if interested and has assignment. Write for appointment to show portfolio. Pays for design by the hour, $5-75. Pays for illustration by the project, $100-500. Considers skill and experience of artist and turnaround time when establishing payment.

Tips: "Do not say 'I can do anything.' We want to know the best media you work in (pen & ink, line drawing, illustration, layout, etc.).''

Los Angeles

ANCHOR DIRECT MARKETING, 7926 Cowan Ave., Suite 100, Los Angeles CA 90045. (310)216-7855. Fax: (310)337-0542. President: Robert Singer. Estab. 1986. Ad agency. Specializes in direct marketing.
Needs: Prefers local freelancers with experience in direct response and illustration. Works on assignment only. Uses freelancers mainly for layout. Needs computer-literate freelancers for design, illustration and production. 80% of freelance work demands knowledge of Aldus PageMaker, Adobe Illustrator, Aldus FreeHand or QuarkXPress.
First Contact & Terms: Call for appointment to show portfolio of direct response work. Sometimes requests work on spec before assigning job. Pays for design and illustration by the project.

BRAMSON (+ ASSOC.), 7400 Beverly Blvd., Los Angeles CA 90036. (213)938-3595. Fax: (213)938-0852. Art Directors: Alex or Gene. Estab. 1970. Number of employees: 12. Approximate annual billing: more than $2 million. Advertising agency. Specializes in magazine ads, collateral, I.D., signage, graphic design, imaging, campaigns. Product specialties are healthcare, consumer, business to business. Current clients include Johnson & Johnson, Lawry's, IOLAB Corp. and Surgin, Inc.
Needs: Approached by 150 freelancers/year. Works with 10 freelance illustrators and 5 designers/year. Prefers local freelancers. Works on assignment only. Uses freelancers for brochure and print ad design; brochure, technical, medical and print ad illustration; storyboards; mechanicals; retouching; lettering; logos. 30% of work is with print ads. Needs computer-literate freelancers for design, illustration, production and presentation. 50% of freelance work "prefers" knowledge of Aldus Pagemaker, Adobe Illustrator, QuarkX-Press, Photoshop or Aldus Freehand.
First Contact & Terms: Send query letter with brochure, photocopies, résumé, photographs, tearsheets, SASE. Samples are filed. Art Director will contact artist for portfolio review if interested. Portfolio should include roughs, color tearsheets. Sometimes requests work on spec before assigning job. Pays for design by the hour, $15-25. Pays for illustration by the project, $250-2,000. Buys all rights or negotiates rights purchased.
Tips: Finds artists through sourcebooks.

‡DIGITAL FACADES, 1140 Westwood Blvd., Suite 201, Los Angeles CA 90024. (310)208-0776. Fax: (310)208-0776. E-mail: info@difacades.com. Project Manager: Greg Holland. Estab. 1992. Number of employees: 10. Approximate annual billing: $1 million. Full-service, multimedia firm. Specializes in ad and marketing Kiosk, CD-ROM, Web Sites, floppy disk promos, presentation. Current clients include Acura/ Honda, Sony, Arthur D. Little, Ketchum Advertising, *Premiere Magazine*, Oakley Sunglasses. Client list available upon request. Professional affiliations: Apple Developers Group.
Needs: Aproached by 50 freelancers/year. Works with 10 freelance illustrators and 10 designers/year. Prefers freelancers with experience in interactive multimedia; computer expert capabilities only. Uses freelancers mainly for animation, interface design, screen graphics. Also for logos, retouching. 5% of work is with print ads. Needs computer-literate freelancers for design, illustration, production, presentation. 100% of freelance work demands knowledge of Aldus FreeHand, Adobe Photoshop, QuarkXPress, Adobe Illustrator, Director, Infini-D, Premiere, Sound Edit 16.
First Contact & Terms: Send query letter with résumé, laser prints. Samples are filed and are returned by SASE if requested by artist. Does not report back. Artist should follow-up with call and/or letter after initial query. Portfolio should include director samples, color laser output. Pays for design and illustration by the hour, $15-50. Buys all rights.
Tips: Impressed by "perfect résumé, cover letter and presentation versatility. Outstanding multimedia skills. Whether they like it or not, artist/designers wishing to forge a career in multimedia need to master basic programming (i.e. lingo) in addition to design and computer graphics software.''

GARIN AGENCY, 6253 Hollywood Blvd., Suite 614, Los Angeles CA 90028. (213)465-6249. Manager: P. Bogart. Number of employees: 3. Ad agency/PR firm. Clients: real estate, banks.
Needs: Approached by 10 freelancers/year. Works with 1 freelance illustrator and 2 designers/year. Prefers local freelancers only. Works on assignment only. Uses freelancers for "creative work and TV commercials.''
First Contact & Terms: Send query letter with photostats or tearsheets to be kept on file for one year. Samples not filed are not returned. Does not report back. Pays by the hour (rates negotiable). Considers client's budget and turnaround time when establishing payment. Buys all rights.
Tips: "Don't be too pushy and don't overprice yourself.''

RHYTHMS PRODUCTIONS, P.O. Box 34485, Los Angeles CA 90034. President: Ruth White. Estab. 1955. AV firm. Specializes in CD-ROM and music production/publication. Product specialty is educational materials for children. Client list not available.

Needs: Prefers local artists with experience in cartoon animation and graphic design. Works on assignment only. Uses freelancers artists mainly for cassette covers, books, character design. Also for catalog design, animation and album covers. 2% of work is with print ads. Needs computer-literate freelancers for design, illustration and production. Freelancers should be familiar with Adobe Illustrator, Adobe Photoshop or Macromind Director.

First Contact & Terms: Send query letter with brochure, résumé, photocopies, photographs, SASE (if you want material returned) and tearsheets. Samples are returned by SASE if requested. Reports back within 2 months only if interested. Art Director will contact artist for portfolio review if interested. Pays for design and illustration by the project. Buys all rights.

Tips: Finds artists through word of mouth and artists' submissions.

DANA WHITE PRODUCTIONS, INC., 2623 29th St., Santa Monica CA 90405. (310)450-9101. Owner/Producer: Dana C. White. AV firm. "We are a full-service audiovisual production company, providing multi-image and slide-tape, video and audio presentations for training, marketing, awards, historical and public relations uses. We have complete inhouse production resources, including slidemaking, soundtrack production, photography, and AV multi-image programming. We serve major industries, such as GTE, Occidental Petroleum; medical, such as Whittier Hospital, Florida Hospital; schools, such as University of Southern California, Pepperdine University, Clairbourne School; publishers, such as McGraw-Hill, West Publishing; and public service efforts, including fundraising."

Needs: Works with 4-6 freelancers/year. Prefers freelancers local to greater Los Angeles, "with timely turnaround, ability to keep elements in accurate registration, neatness, design quality, imagination and price." Uses freelancers for design, illustration, retouching, characterization/animation, lettering and charts. Needs computer-literate freelancers for design and illustration. 50% of freelance work demands knowledge of Adobe Illustrator or Aldus FreeHand.

First Contact & Terms: Send query letter with brochure or tearsheets, photostats, photocopies, slides and photographs. Samples are filed or are returned only if requested. Reports back within 2 weeks only if interested. Call or write for appointment to show portfolio. Pays by the project. Payment negotiable by job.

Tips: "These are tough times. Be flexible. Negotiate. Deliver quality work on time!"

San Francisco

THE AD AGENCY, P.O. Box 470572, San Francisco CA 94147. (415)928-2264 . Creative Director: Michael Carden. Estab. 1972. Ad agency. Full-service, multimedia firm. Specializes in print, collateral, magazine ads. Client list available upon request.

Needs: Approached by 120 freelancers/year. Works with 120 freelance illustrators and designers/year. Uses freelancers mainly for collateral, magazine ads, print ads. Also for brochure, catalog and print ad design and illustration; mechanicals; billboards; posters; TV/film graphics; lettering; and logos. 60% of freelance work is with print ads. Needs computer-literate freelancers for design and illustration. 25% of freelance work demands computer skills.

First Contact & Terms: Send query letter with brochure, photocopies and SASE. Samples are filed or returned by SASE. Reports back in 1 month. Portfolio should include color final art, photostats and photographs. Buys first rights or negotiates rights purchased.

Tips: Finds artists through word of mouth and submissions. "We are an eclectic agency with a variety of artistic needs."

‡COMMUNICATIONS WEST, 1426 18th St, San Francisco CA 94107. (415)863-7220. Fax: (415)621-2907. Contact: Creative Director. Estab. 1983. Number of employees: 6. Approximate annual billing: $4 million. Ad agency/PR firm. Product specialties are transportation and consumer. Specializes in magazine ads and collateral. Current clients include Blue Star Line, Sector Watches, Syntex, Hewlett Packard, Wollongang, Finnigan MAT.

Needs: Approached by 48 freelancers/year. Works with 2-4 freelance illustrators and 6-8 designers/year. Prefers local freelancers with experience. Works on assignment only. Uses freelancers mainly for brochure and print ad design and illustration, slide illustration, mechanicals, retouching, posters, lettering and logos. 50% of work is with print ads. Needs computer-literate freelancers for design, illustration, production and presentation. 50% of freelance work demands knowledge of Adobe Illustrator, QuarkXPress and Photoshop.

First Contact & Terms: Send query letter with brochure, résumé, photocopies and tearsheets. Samples are filed. Reports back to the artist only if interested. Call for appointment to show portfolio of color tearsheets and finished art samples. Pays for design by the project, $250-5,000. Pays for illustration by the project, $500-2,500. Buys all rights.

‡PURDOM PUBLIC RELATIONS, 395 Oyster Point, S. San Francisco, CA 94080. (415)588-5700. Fax: (415)588-1643. E-mail: purdompr@netcom.com. President: Paul Purdom. Estab. 1962. Number of employees: 18. Approximate annual billing: $2 million. PR firm. Full-service, multimedia firm. Specializes in high-

tech and business-to-business. Current clients include Sun Microsystems and Varian Associates. Professional affiliation: PRSA.

Needs: Approached by 20 freelancers/year. Works with 10 freelance designers/year. Works on assignment only. Prefers local freelancers for work on brochure and catalog design; slide, editorial and technical illustration; mechanicals; and TV/film graphics. Needs computer-literate freelancers for production and design. 75% of freelance work demands knowledge of Aldus PageMaker, Aldus FreeHand or Adobe Illustrator.

First Contact & Terms: Samples are not filed and are returned. Call for appointment to show portfolio of completed projects. Pays for design by the project. Buys all rights.

‡REALTIME VIDEO, 60 Broadway, San Francisco CA 94111. (415)705-0188. Fax: (415)705-0171. Number of employees: 27. Post production studio. Specializes in advertising (broadcast). Product specialty is consumer. Current clients include Hal Riney, Colossal Pictures, Goodby Silverstein & Partners. Client list not available. Professional affiliations: AICP, ESIG.

Needs: Works with 1-2 freelance designers/year. 1% of work is with print ads. Needs computer-literate freelancers for design. 100% of freelance work demands knowledge of QuarkXPress; clients use mostly Aurora Paintbox, Quantel Henry.

First Contact & Terms: Send résumé. Samples are filed or returned. Art Director will contact artist for portfolio review if interested. Portfolio should include video. Buys reprint rights or all rights.

Colorado

CINE DESIGN FILMS, Box 6495, Denver CO 80206. (303)777-4222. Producer/Director: Jon Husband. AV firm. Clients: automotive companies, banks, restaurants, etc.

Needs: Works with 3-7 freelancers/year. Works on assignment only. Uses freelancers for layout, titles, animation and still photography. Clear concept ideas that relate to the client in question are important.

First Contact & Terms: Send query letter to be kept on file. Reports only if interested. Write for appointment to show portfolio. Pays by the hour, $20-50; by the project, $300-1,000; by the day, $75-100. Considers complexity of project, client's budget and rights purchased when establishing payment. Rights purchased vary according to project.

‡RONALD JAMES DIRECT, 6400 S. Fiddlers Green Circle, Suite 1050, Englewood CO 80111. (303)220-1996. Fax: (303)721-0129. Senior Art Director: Dan Bulleit. Estab. 1983. Number of employees: 23. Approximate annual billing: $10 million. Ad agency, direct marketing agency. Specializes in direct marketing mailings and print. Product specialties are high tech and consumer. Current clients include US West, Ritz Carlton, Mattel, several software companies, Adobe, PED, XUT, Mustang. Professional affiliations: DMA.

Needs: Approached by 20 freelancers/year. Works with 6-8 freelance illustrators and 4 designers/year. Uses freelancers mainly for illustration and computer design/promotion. Also for brochure design and illustration, lettering, mechanicals, retouching. 25% of work is with print ads. Needs computer-literate freelancers for design and production. 85% of freelance work demands knowledge of Photoshop, QuarkXPress, Adobe Illustrator.

First Contact & Terms: Send postcard-size sample of work or query letter with brochure, photocopies, tearsheets. Samples are filed. Art Director will contact artist for portfolio review if interested. Portfolio should include b&w and color roughs, tearsheets, thumbnails. Pay for design and illustration by the project (varies). Rights purchased vary according to project.

Tips: Finds artists through agents, sourcebooks, word of mouth. "Be on time, flexible, have input, flexible, on budget, flexible, understand business, research, flexible; be able to sketch ideas and communicate. Computers in most cases seem to be threatening originality and creative thought. Some of the most creative people aren't as 'attracted' to the industry—and some who are not creative but are computer-literate are being pulled in. Be sure you can draw (sketch) ideas; that will always be valuable."

‡MITCHELL ADVERTISING, 545 Collyer St., Longmont CO 80501. (303)443-3306. Fax: (303)678-0895. Associate Creative Director: Bo Ganz. Estab. 1974. Number of employees: 6. Ad agency. Full-service, multimedia firm. Specializes in print and broadcast advertising, creative, production, strategic planning, media planning, collateral, PR. Product specialties are sports and fitness. Current clients include Tecnica, Connelly Skis, Gerry Sportswear, Nevica Skiwear, Schuller Ecotherm, Volki Skis, Tennus.

Needs: Approached by hundreds of freelancers/year. Works with 6-10 freelance illustrators and 5-8 designers/year. Uses freelancers mainly for ads, collateral. Also for animation, billboards, brochure and catalog design and illustration, logos, mechanicals, posters, retouching, signage, TV/film graphics. 75% of work is with print ads. 90% of work demands knowledge of Adobe Photoshop, QuarkXPress and Adobe Illustrator.
First Contact & Terms: Send query letter with brochure, photostats, résumé, SASE, tearsheets and transparencies. Samples are filed. Art Director will contact artist for portfolio review if interested. Rights purchased vary according to project.
Tips: Finds artists through *Creative Black Book*, word of mouth and artists' submissions.

Connecticut

DONAHUE, INC., 227 Lawrence St., Hartford CT 06106. (203)728-0000. Fax: (203)247-9247. Art Director: Ellen Maurer. Estab. 1979. Number of employees: 7. Ad agency. Full-service, multimedia firm. Specializes in collateral, trade ads, packaging and PR. Product specialties are computer, tool and interior design.
Needs: Approached by 15 freelancers/year. Works with 3 freelance illustrators and 3 designers/year. Prefers freelancers with experience in reproduction, tight comps and mechanicals. Uses freelancers mainly for in-house work: brochure and print ad design, catalog design and illustration, technical and editorial illustration, mechanicals, posters, lettering and logos. 40% of work is with print ads. Needs computer-literate freelancers for design, illustration, production and presentation. 50% of freelance work demands knowledge of QuarkXPress, Aldus FreeHand, Adobe Illustrator and Photoshop.
First Contact & Terms: Send query letter with résumé and tearsheets. Samples are filed. Art Director will contact artist for portfolio review if interested. Portfolio should include thumbnails, roughs, original/final art and tearsheets. Sometimes requests work on spec before assigning a job. Pays for design by the hour, $20-65. Pays for illustration by the project, $200-5,000 maximum. Rights purchased vary according to project.

EFFECTIVE COMMUNICATION ARTS, INC., 149 Dudley Rd., P.O. Box 250, Wilton CT 06897-0250. (203)761-8787. President: David Jacobson. Estab. 1965. Number of employees: 4. AV firm. Produces films, videotapes and interactive videodiscs on science, medicine and technology. Specialize in pharmaceuticals, medical devices and electronics. Current clients include ICI Pharma, AT&T, Burroughs Wellcome and SmithKline Beecham.
• This president predicts the audiovisual field will continue to see growth of CD-ROM projects and the need for more art.
Needs: Approached by 8 freelancers/year. Works with 4 freelance illustrators and 2 designers/year. Prefers freelancers with experience in science and medicine. Works on assignment only. Uses freelancers mainly for animation and computer graphics. Also for editorial, technical and medical illustration, brochure design, storyboards, slide illustration, mechanicals and TV/film graphics. Needs computer-literate freelancers for design, illustration and production. 75% of freelance work demands knowledge of computer graphics packages.
First Contact & Terms: Send query letter with résumé, photographs and videotape. Samples are filed or are returned by SASE only if requested by artist. Reports back to the artist only if interested. Portfolio review not required. Pays for design by the project or by the day, $200 minimum. Pays for illustration by the project, $150 minimum. Considers complexity of project, client's budget and skill and experience of artist when establishing payment. Buys all rights.
Tips: "Show good work and have good references."

ERIC HOLCH/ADVERTISING, 49 Gerrish Lane, New Canaan CT 06840. President: Eric Holch. Number of employees: 3. Approximate annual billing: $600,000. Full-service ad agency. Product specialties are packaging, food, candy, machinery and real estate. Current clients include Raymond Automation, H.L. Thomas, International Insurance Brokers and McDonald Long & Associates. Professional affiliation: AAN.
Needs: Approached by 35 freelancers/year. Works with 5 freelance illustrators and 5 designers/year. Works on assignment only. Uses freelancers mainly for technical and commercial ads and brochure illustration. Prefers food, candy, packages and seascapes as themes. "No cartoons." Needs computer-literate freelancers for design and production. 10% of freelance work demands knowledge of Aldus PageMaker, Quark, Photoshop, Illustrator and PageMaker.
First Contact & Terms: Send query letter with brochure showing art style or 8½×11 samples to be kept on file. Art director will contact artist for portfolio review if interested. Portfolio should include roughs, photocopies and original/final art. Sometimes requests work on spec before assigning job. Pays for design and illustration by the project, $100-3,000. Negotiates rights purchased depending on project.
Tips: Finds artists through submissions.

‡INFOVIEW CORPORATION, INC., 124 Framingdale Rd., Wethersfield CT 06109. Phone/fax: (203)721-0270. General Manager: Larry Bell. Estab. 1985. Number of employees: 3. Advertising specialties firm. Specializes in personalized products for organization identity—logos on jackets, sweatshirts, blazers. Product specialties apparel/leather goods.

Needs: Prefers freelancers with experience in developing computer-generated stylized logos on Windows/PC Platform. Uses freelancers mainly for logos. Needs computer-literate freelancers for design and illustration. 100% of freelance work demands knowledge of Aldus PageMaker, Aldus FreeHand, Adobe Photoshop, QuarkXPress and Adobe Illustrator.

First Contact & Terms: Send query letter with photocopies. Samples are not returned. Art Director will contact artist for portfolio review if interested. Portfolio should include b&w and color final art. Pays for design and illustration by the project.

Tips: Finds artists through word of mouth, artists' agents submissions. "Show us a range of experience with logo design."

REALLY GOOD COPY CO., 92 Moseley Terrace, Glastonbury CT 06033. (203)659-9487. Fax: (203)633-3238. E-mail: copyqueen@aol.com. President: Donna Donovan. Estab. 1982. Number of employees: 2. Ad agency. Full-service, multimedia firm. Specializes in print ads, collateral, direct mail and catalogs. Product specialties are medical/health care, consumer products and services. Current clients include Tobacco Shed Antiques, Ross-Simons, The Globe-Pequot Press, Novametrix Medical Systems and The Music Sound Exchange. Professional affiliations: Connecticut Art Directors Association, Direct Marketing Association of Connecticut.

Needs: Approached by 40-50 freelancers/year. Works with 1-2 freelance illustrators and 4-5 designers/year. Prefers local freelancers whenever possible. Works on assignment only. Uses freelancers for all projects. "There are no on-staff artists." 50% of work is with print ads. 90% of freelance work demands knowledge of QuarkXPress, Adobe Illustrator or Photoshop.

First Contact & Terms: Send query letter with description of background and experience. Samples are filed or are returned by SASE only if requested. Reports back to the artist only if interested. Portfolio review not required, but portfolio should include roughs and original/final art. Pays for design by the hour, $25-80. Pays for illustration by the project, $100-750.

Tips: "I file interesting samples and call when an appropriate project comes up. The best source of artists for me is word of mouth from others who have been happy with someone's work. Computer access and skills are more important than ever. I think the dog-eat-dog climate in this business has had its day! I hope we're going to see practitioners becoming more socially and personally responsible and that doing business will be fun again."

‡THE WOLFE GROUP, INC., 1 Corporate Dr., Suite 206, Shelton CT 06484. (203)925-9251. Fax: (203)925-9430. Contact: Art Director. Estab. 1977. Number of employees: 12. Approximate annual billing: $6.1 million. Ad agency. Full-service, multimedia firm. Specializes in business-to-business—ads, collateral, PR and annual reports. Product specialty is industrial. Current clients include Fraser Paper, World Color Press, McGraw-Hill. Client list available upon request.

Needs: Approached by 25 freelancers/year. Works with 10 freelance illustrators and 15 designers/year. Prefers local artists only. Uses freelancers mainly for design, production and illustration. Also for brochure design and illustration and retouching. 30% of work is with print ads. Needs computer-literate freelancers for design illustration and production. 95% of freelance work demands knowledge of Aldus FreeHand, Adobe Photoshop, QuarkXPress and Adobe Illustrator.

First Contact & Terms: Send query letter with brochure, photographs and résumé. Samples are filed. Art Director will contact artist for portfolio review if interested. Portfolio should include color tearsheets. Pays for design by the hour. Pays for illustration by the project. Buys all rights.

Tips: Finds artists through sourcebooks, direct contacts. Impressed by "a clean presentation, strong communication skills, ability to take and understand direction. A freelancer must know Mac environment and be able to adapt to the client's design and production protocol."

Delaware

CUSTOM CRAFT STUDIO, 310 Edgewood St., Bridgeville DE 19933. (302)337-3347. Fax: (302)337-3444. AV producer. Vice President: Eleanor H. Bennett.

Needs: Works with 12 freelance illustrators and 12 designers/year. Works on assignment only. Uses freelancers mainly for work on filmstrips, slide sets, trade magazines and newspapers. Also for print finishing, color negative retouching and airbrush work. Prefers pen & ink, airbrush, watercolor and calligraphy. Needs computer-literate freelancers for design and presentation. 10% of freelance work demands knowledge of Adobe Illustrator. Needs editorial and technical illustration.

First Contact & Terms: Send query letter with résumé, slides or photographs, brochure/flyer and tearsheets to be kept on file. Samples returned by SASE. Reports back in 2 weeks. Originals not returned. Pays for design and illustration by the project, $25 minimum.

‡GLYPHIX ADVERTISING, 105 Second St., Lewes DE 19958. (302)645-0706. Fax: (302)645-2726. Creative Director: Richard Jundt. Estab. 1981. Number of employees: 2. Approximate annual billing: $200,000. Ad

Artwork © McNamara Associates. Illustrator Paul Manz. Design © 1994 Gold & Associates.

Artist Paul Manz of McNamara Associates in Troy, Michigan, went for a "1930-ish Art Deco feel" for this gouache illustration for a poster, designed by Gold & Associates, commemorating 60 years of greyhound racing at the Jacksonville Kennel Club. "The poster was used as part of an invitation package which resulted in 50% more responses than anticipated," says Keith Gold of Gold & Associates. "Our client could not have been more pleased."

agency. Specializes in collateral and advertising. Current clients include Cytec Industries, CasChem, Lansco Colors. Client list available upon request.

Needs: Approached by 10-20 freelancers/year. Works with 2-3 freelance illustrators and 2-3 designers/year. Prefers local artists only. Uses freelancers mainly for "work I can't do." Also for brochure and catalog design and illustration and logos. 20% of work is with print ads. Needs computer-literate freelancers for design, illustration and production. 100% of freelance work demands knowledge of Adobe Photoshop, Quark-XPress, Adobe Illustrator and Delta Graph.

First Contact & Terms: Send query letter with samples. Reports back within 10 days if interested. Artist should follow-up with call. Portfolio should include b&w and color final art, photographs and roughs. Buys all rights.

Tips: Finds artists through word of mouth and artists' submissions.

Florida

‡AD CONSULTANT GROUP INC., 3111 University Dr., #408, Coral Springs FL 33065. (305)340-0883. Fax: (305)340-0996. President: B. Weisblum. Estab. 1994. Number of employees: 3. Ad agency. Full-service, multimedia firm.

Needs: Prefers local artists only. Also uses freelancers for animation, brochure and catalog design and illustration, posters and TV/film graphics. 25% of work is with print ads. Needs computer-literate freelancers for design, illustration, production and presentation. 100% of freelance work demands computer skills.

First Contact & Terms: Send query letter. Samples are filed. Reports back within 1 week. Artist should follow-up with call. Portfolio should include final art. Buys first rights or all rights.

GOLD & ASSOCIATES INC., 100 Executive Way, Ponte Vedra Beach FL 32082. (904)285-5669. Fax: (904)285-1579. Creative Director/President: Keith Gold. Estab. 1988. Ad agency. Full-service, multimedia firm. Specializes in graphic design. Product specialties are publishing, health care, entertainment and fashion.

● The president of Gold & Associates believes agencies will offer more services than ever before, as commissions are reduced by clients.

Needs: Approached by 120-140 freelancers/year. Works with 24-36 freelance illustrators and 24-36 designers/year. Works only with artist reps. Works on assignment only. Uses freelancers for brochure, catalog, medical, editorial, technical, slide and print ad illustration; storyboards; animatics; animation; mechanicals; retouching. 50% of work is with print ads. Needs computer-literate freelancers for illustration, production and presentation. 50% of freelance work demands knowledge of Aldus PageMaker, Adobe Illustrator, Quark-XPress and Photoshop.

First Contact & Terms: Contact through artist rep or send query letter with photocopies, tearsheets and capabilities brochure. Samples are filed. Reports back to the artist only if interested. Request portfolio review in original query. Art Director will contact artists for portfolio review if interested. Follow-up with letter after initial query. Portfolio should include tearsheets. Pays for design by the hour, $35-125. "Maximum number of hours is negotiated up front." Pays for illustration by the project, $200-7,500. Buys all rights.

Tips: Finds artists primarily through sourcebooks and reps.

‡MYERS, MYERS & ADAMS ADVERTISING, INC., 938 N. Victoria Park Rd., Fort Lauderdale FL 33304. (305)523-6262. Fax: (305)523-3517. Creative Director: Virginia Myers. Estab. 1986. Number of employees: 6. Approximate annual billing: $2 million. Ad agency. Full-service, multimedia firm. Specializes in magazines and newspaper ads; radio and TV; brochures; and various collateral. Product specialties are consumer and business-to-business. Current clients include Marine Industries Association and Advanced Games & Engineering. Professional affiliation: Advertising Federation.

Needs: Approached by 10-15 freelancers/year. Works with 3-5 freelance illustrators and 3-5 designers/year. Uses freelancers mainly for overflow. Also for animation, brochure and catalog illustration, model making, posters, retouching and TV/film graphics. 55% of work is with print ads. Needs computer-literate freelancers for illustration and production. 20% of freelance work demands knowledge of Aldus PageMaker, Adobe Photoshop, QuarkXPress and Adobe Illustrator.

First Contact & Terms: Send postcard-size sample of work or send query letter with tearsheets. Samples are filed and are returned by SASE if requested by artist. Art Director will contact artist for portfolio review if interested. Portfolio should include b&w and color final art, roughs, tearsheets and thumbnails. Pays for design and illustration by the project, $50-1,500. Buys all rights.

Tips: Finds artists through *Creative Black Book*, *Workbook* and artists' submissions.

STEVE POSTAL PRODUCTIONS, P.O. Box 428, Carraway St., Bostwick FL 32007-0428. (904)325-5254. Director: Steve Postal. Estab. 1958. Number of employees: 8. Approximate annual billing: $1 million. AV firm. Full-service, multimedia firm. Specializes in documentaries, feature films. Product specialty is films and videos. Client list not available. Professional affiliations: Directors Guild of Canada, FMPTA.

Needs: Approached by 150 freelancers/year. Works with 10 freelance illustrators and 6 designers/year. Prefers artists with experience in advertising, animation, design for posters. Works on assignment only. Uses

freelancers mainly for films and film ads/VHS boxes. Also for brochure, catalog and print ad design and illustration; animation; TV/film graphics; and lettering. 10% of work is with print ads. Needs computer-literate freelancers for production. 10% of freelance work demands knowledge of Aldus FreeHand.

First Contact & Terms: Send query letter with résumé, photostats, photocopies, SASE and tearsheets. Samples are filed. Reports back to the artist only if interested. "Artists should follow-up their mailings with at least two telephone calls within two weeks of mailing." Portfolio should include b&w and color final art, tearsheets and photographs. Pays for design and illustration by the project. Buys all rights.

Tips: Finds artists through submissions.

‡ROBERTS & CLINE, 5405 Cypress Center Dr., Suite 250, Tampa FL 33609-1025. (813)281-0088. Fax: (813)281-0271. Art Director: Amy Phillips. Estab. 1986. Number of employees: 9. Ad agency, PR firm. Full-service, multimedia firm. Specializes in integrated communications compaigns using multiple media and promotion. Professional affiliations: AIGA, PRSA, AAF.

Needs: Approached by 50 freelancers/year. Works with 10 freelance illustrators and designers/year. Prefers local artists with experience in conceptualization and production knowledge. Uses freelancers for billboards, brochure design and illustration, lettering, logos, mechanicals, posters, retouching and signage. 60% of work is with print ads. Needs computer-literate freelancers for design, illustration, production and presentation. 95% of freelance work demands knowledge of Adobe Photoshop 2.5, QuarkXPress 3.3 and Adobe Illustrator 5.0.

First Contact & Terms: Send postcard-size sample of work. Send query letter with photocopies, résumé and SASE. Samples are filed or are returned by SASE if requested by artist. Portfolios may be dropped off every Monday. Art Director will contact artist for portfolio review if interested. Portfolio should include b&w and color final art, roughs and thumbnails. Pays for design by the hour, $20-85; by the project, $100 minimum; by the day, $150-500. Pays for illustration by the project, "as appropriate." Rights purchased vary according to project.

Tips: Finds artists through agents, sourcebooks, seeing actual work done for others, annuals (*Communication Arts*, *Print*, *One Show*, etc.). Impressed by "work that demonstrates knowledge of product, willingness to work within budget, contribution to creative process, on-time delivery. Continuing development of digital technology hand-in-hand with new breed of traditional illustrators sensitive to needs of computer production is good news."

Georgia

THE ASLAN GROUP, LTD., 3595 Webb Bridge Rd., Alpharetta GA 30202. (404)442-1500. Fax: (404)442-1844. Creative Director: Lon Foster. Estab. 1984. Ad agency. Full-service, multimedia firm. Specializes in direct response print advertising, magazine ads and direct mail. Product specialty is software and building products. Current clients include Peachtree Software, Zondervan Publishing, Christian Publishing. Client list available upon request.

Needs: Approached by 8-10 freelancers/month. Works with 1 illustrator and 3-4 designers/month. Prefers local freelancers only with experience in direct response mailings. Uses freelancers mainly for production from conceptual sketches. Also uses freelancers for brochure and print ad design and illustration. 60% of work is with print ads. Needs computer-literate freelancers for design and production. 90% of work demands computer skills in Adobe Illustrator, QuarkXPress or Adobe Photoshop.

First Contact & Terms: Send query letter with résumé and photocopies. Samples are filed or returned by SASE. Reports back to the artist only if interested. Artist should call for an appointment. Art director will contact for portfolio review if interested. Portfolio should include color final art and tearsheets. Pays for design by the hour, $20-50; by the day, $120-300. Pays for illustration by the project, $200 minimum. Rights purchased vary according to project.

Tips: "We find designers primarily through referral from freelancers we trust. We will try unfamiliar (new) talent on low-risk work before turning over a priority job. Trust and reliability are paramount, along with speed and initiative."

COMPRO PRODUCTIONS, 2080 Peachtree Industrial Court, Suite 114, Atlanta GA 30341-2281. (404)455-1943. Fax: (404)455-3356. Creative Director: Nels Anderson. Estab. 1977. AV firm. Specializes in film and video. Product specialties are travel industry and airlines.

Needs: Approached by 12-24 freelancers/year. Uses freelancers mainly for animation.

First Contact & Terms: Send query letter with videotape demo reel, VHS, ¾", betacam sp. Samples are filed. Reports back only if interested. Call or write for appointment to show portfolio. Buys all rights.

‡FILMAMERICA, INC., 3177 Peachtree Rd. NE, Suite 209, Atlanta GA 30305. (404)261-3718. President: Avrum M. Fine. Number of employees: 1. AV firm. Clients: corporate and ad agencies. Professional affiliations: TARA.

Needs: Approached by 2 freelancers/year. Works with 2 freelance illustrators and 2 designers/year. Works on assignment only. Uses freelancers for film campaigns. "Especially important are illustration and layout skills."

First Contact & Terms: Send query letter with résumé and photographs or tearsheets to be kept on file. Samples not filed are returned only if requested. Reports back only if interested. Write for appointment to show portfolio. Pays for design by the project, $1,000-2,000. Pays for illustration by the project, $1,500-2,500. Considers complexity of the project and rights purchased when establishing payment. Rights purchased vary according to project.
Tips: "Be very patient!"

J. WALTER THOMPSON COMPANY, One Atlanta Plaza, 950 E. Paces Ferry Rd., Atlanta GA 30326. (404)365-7300. Fax: (404)365-7399. Executive Art Director: Bill Tomassi. Executive Creative Director: Mike Lollis. Ad agency. Clients: mainly financial, industrial and consumer. "This office does creative work for Atlanta and the southeastern U.S."
Needs: Works on assignment only. Uses freelancers for billboards, consumer and trade magazines and newspapers. Needs computer-literate freelancers for design, production and presentation. 60% of freelance work demands knowledge of Adobe Illustrator, Photoshop or QuarkXPress.
First Contact & Terms: Deals with artist reps only. Send slides, original work, stats. Samples returned by SASE. Reports only if interested. Originals not returned. Call for appointment to show portfolio. Pays by the hour, $20-80; by the project, $100-6,000; by the day, $140-500.
Tips: Wants to see samples of work done for different clients. Likes to see work done in different mediums, variety and versatility. Freelancers interested in working here should "be *professional* and do top-grade work."

EMIL J. WALCEK ASSOCIATES & TRADE PR SERVICE, Dept. AGDM, 1031 Cambridge Square, Suite D, Alpharetta GA 30201. (404)664-9322. Fax: (404)664-9324. President: Emil Walcek. Estab. 1980. Ad agency. Specializes in magazine ads and collateral. Product specialty is business-to-business.
Needs: Works with 24 freelance illustrators and 12 designers/year. Prefers local freelancers only with experience in Mac computer design and illustration and Photoshop expertise. Works on assignment only. Uses freelancers for brochure, catalog and print ad design and illustration; editorial, technical and slide illustration; retouching; and logos. 50% of work is with print ads. Needs computer-literate freelancers for design, illustration, production and presentation. 75% of freelance work demands knowledge of Aldus PageMaker, Aldus FreeHand, Adobe Illustrator or Photoshop.
First Contact & Terms: Send query letter with résumé, photostats and slides. Samples are filed or are returned by SASE if requested by artist. Reports back to the artist only if interested. Write for appointment to show portfolio of thumbnails, roughs, final art, tearsheets. Pays for design by the hour or by the project. Pays for illustration by the project. Buys all rights.

Idaho

CIPRA, Dept. AGDM, 314 E. Curling Dr., Boise ID 83702. (208)344-7770. President: Ed Gellert. Estab. 1979. Ad agency. Full-service, multimedia firm. Specializes in trade magazines, TV and logos.
Needs: Works with illustrators once/year. Prefers freelancers with experience in airbrushing. Works on assignment only. Uses freelancers mainly for retouching and logos.
First Contact & Terms: Send query letter. Samples are filed for reference. Does not report back unless needed. To show portfolio, mail appropriate materials, including color photocopies. Pays for design and illustration by the project. Payment negotiated for each job. Buys all rights.

MEDIA ASSOCIATES ADV., 3808 W. Dorian St., P.O. Box 5791, Boise ID 83705. (208)384-9278. President: Danny Jensen. Estab. 1990. Ad agency. Full-service, multimedia firm. Specializes in electronic media, radio and TV, video corporate and industrial productions. Product specialty is consumer. Client list not available.
Needs: Works with 24-36 freelance illustrators and designers/year. Prefers local freelancers, but works with out-of-town also. Works on assignment only. Uses freelancers mainly for commercials. Also for brochure design, print ad design and illustration, storyboards, slide illustration, animation, billboards, posters and logos. 30% of work is with print ads. Needs computer-literate freelancers for design, illustration and production. 20% of freelance work demands knowledge of Aldus FreeHand.
First Contact & Terms: Send query letter with brochure and photocopies. Samples are filed or returned by SASE. Reports back to the artist only if interested. Pays for design and illustration by the hour, $35-50. Rights purchased vary according to project.

Illinois

BRAGAW PUBLIC RELATIONS SERVICES, 800 E. Northwest Hwy., Palatine IL 60067. (708)934-5580. Fax: (708)934-5596. Principal: Richard S. Bragaw. Number of employees: 3. PR firm. Specializes in newsletters and brochures. Clients: professional service firms, associations and industry. Current clients include

Arthur Anderson, KPT Kaiser Precision Tooling, Inc. and Nykiel-Carlin and Co. Ltd.
Needs: Approached by 12 freelancers/year. Works with 2 freelance illustrators and 2 designers/year. Prefers local freelancers only. Works on assignment only. Uses freelancers for direct mail packages, brochures, signage, AV presentations and press releases. Needs computer-literate freelancers for design and production. 90% of freelance work demands knowledge of Aldus PageMaker. Needs editorial and medical illustration.
First Contact & Terms: Send query letter with brochure to be kept on file. Reports back only if interested. Pays by the hour, $25-75 average. Considers complexity of project, skill and experience of artist and turn-around time when establishing payment. Buys all rights.
Tips: "We do not spend much time with portfolios."

JOHN CROWE ADVERTISING AGENCY, INC., 2319½ N. 15th St., Springfield IL 62702-1226. Phone/fax: (217)528-1076. President: Bryan J. Crowe. Ad/art agency. Number of employees: 3. Approximate annual billing: $250. Specializes in industries, manufacturers, retailers, banks, publishers, insurance firms, packaging firms, state agencies, aviation and law enforcement agencies. Product specialty is creative advertising. Current clients include Systems 2000 Ltd., Silhouette American Health Spas.
Needs: Approached by 250-300 freelancers/year. Works with 12-15 freelance illustrators and 5-10 designers/year. Works on assignment only. Uses freelancers for color separation, animation, lettering, paste-up and type specing for work with consumer magazines, stationery design, direct mail, slide sets, brochures/flyers, trade magazines and newspapers. Especially needs layout, camera-ready art and photo retouching. Needs technical illustration. Prefers pen & ink, airbrush, watercolor and marker. Needs computer-literate freelancers for design and illustration. 25% of freelance work demands computer skills.
First Contact & Terms: "Send a letter to us regarding available work at agency. Tell us about yourself. We will reply if work is needed and request samples of work." Prefers tearsheets, original art, photocopies, brochure, business card and résumé to be kept on file. Samples not filed are returned by SASE. Reports back in 2 weeks. Pays for design and illustration by the hour, $15-25. Originals not returned. No payment for unused assigned illustrations.
Tips: "Current works are best. Show your strengths and do away with poor pieces that aren't your stonghold. A portfolio should not be messy and cluttered. There has been a notable slowdown across the board in our use of freelance artists."

‡LEE DeFOREST COMMUNICATIONS, 300 W. Lake St., Elmhurst IL 60126. (708)834-7855. Fax: (708)834-0908. Account Executive: Glen Skrzypek. Estab. 1983. Number of employees: 6. AV firm. Full-service, multimedia firm. Specializes in electronic speaker support and meeting modules. Professional affiliations: President's Resource Group.
Needs: Approached by 50 freelance artists/year. Works with 3 freelance designers/year. Prefers artists with experience in TVL, Corel Draw, PowerPoint (PC). Uses freelancers mainly for TVL and PowerPoint. Needs computer-literate freelancers production and presentation. 75% of work demands knowledge of PowerPoint 4.0, Corel Draw 5.0, TVL.
First Contact & Terms: Send query letter with résumé, slides and video. Samples are filed or returned by SASE if requested by artist. To arrange for portfolio review artist should follow-up with call after initial query. Pays for production by the hour, $25-50.
Tips: Finds designers through word of mouth and artists' submissions. "Be hardworking, honest, and good at your craft."

‡ELVING JOHNSON ADVERTISING INC., 11740 Brookside Dr., Palos Park IL 60464. (708)361-2850. Fax: (708)361-2851. Art/Creative Director: Michael McNicholas. Ad agency. Serves clients in industrial machinery, construction materials, material handling and finance.
Needs: Works with 24 illustrators/year. Prefers local freelancers only. Uses freelancers for direct mail, brochures/flyers, trade magazines and newspapers. Also for layout, illustration, technical illustration, paste-up and retouching. Prefers pen & ink, airbrush, watercolor and markers. Needs computer-literate freelancers for production. 20% of freelance work demands computer skills.
First Contact & Terms: Call for interview. Payment for design depends on the project, $100 minimum. Pays for illustration by the project, $50-1,000.
Tips: "We are using more freelancers."

‡DAN GLAUBKE, INC., 189 Lowell, Glen Ellyn IL 60137. (708)953-2300. Fax: (708)953-2714. Estab. 1995. Number of employees: 2. Approximate annual billing: $500,000. Ad agency. Specializes in trade, consumer, retail ads, sales brochures, newsletters, catalogs and AV presentations. Product specialties are trade, consumer and retail. Client list available upon request.
Needs: Approached by 25-50 freelance artists/year. Works with 5 freelance illustrators and 5 designers/year. Prefers local artists only. Uses freelancers mainly for ads/collateral pieces. Also for brochure and catalog design and illustration, lettering, mechanicals, model making and retouching. 70% of work is with print ads. Needs computer-literate freelancers. Freelancers should be familiar with Aldus PageMaker 5.0, Aldus FreeHand 4.0, Adobe Photoshop 3.8 and Adobe Illustrator 4.0.

First Contact & Terms: Send query letter with brochure, photocopies and photographs. Samples are filed. Reports back within 1 week. Art Director will contact artist for portfolio review if interested. Portfolio should include "representative samples of capabilities." Pays for design by the hour, $55-125. Illustration rates negotiable. Buys all rights.

Tips: Finds artists through sourcebook library.

‡GUERTIN ASSOCIATES, 500 Park Blvd., Suite 450, Itasca IL 60143. (708)775-1111. Fax: (708)775-1143. Vice President Creative: Mark Cramer. Estab. 1987. Number of employees: 10. Approximate annual billing: $3 million. Marketing service agency. Specializes in P.O.S. materials, magazine ads, direct mail and business-to-business communications. Product specialties are boating, gasolines, financial and pharmaceuticals. Current clients include Unocal, Outboard Marine Corp. Effidac. Client list available upon request.

Needs: Approached by 50 freelancers/year. Works with 10 freelance illustrators/year. Prefers freelancers with experience in Mac Quark, Illustrator, Freehand, Photoshop who can work off-site. Uses freelancers mainly for keyline and layout. Also for billboards, brochure design, catalog design and illustration, logos, mechanicals, posters and signage. 10% of work is with print ads. Needs computer-literate freelancers for illustration and production. 90% of freelance work demands knowledge of Aldus FreeHand, Adobe Photoshop, QuarkXPress and Adobe Illustrator.

First Contact & Terms: Send query letter with photocopies and résumé. Samples are not returned. Art Director will contact artist for portfolio review if interested. Pays for design by the project, $100-1,000. Pays for illustration by the project. Buys all rights.

WALTER P. LUEDKE & ASSOCIATES, INC., 3105 Lardstrom Rd., Rockford IL 61107. (815)637-4266. Fax: (815)637-4200. President: W. P. Luedke. Estab. 1959. Ad agency. Full-service multimedia firm. Specializes in magazine ads, brochures, catalogs and consultation. Product specialty is industry.

Needs: Approached by 24 freelancers/year. Works with 24 freelance illustrators and 24 designers/year. Prefers freelancers with experience in technical layout. Works on assignment only. Uses freelancers mainly for layout and keylines. Also for brochure, catalog and print ad design and illustration; storyboards; slide illustration; animatics; animation; mechanicals; retouching; billboards; posters; TV/film graphics; lettering; and logos. 30% of work is with print ads.

First Contact & Terms: Send query letter with résumé, photographs, tearsheets, photostats and slides. Samples are filed and are not returned. Reports back to the artist only if interested. Call for appointment to show portfolio of thumbnails, roughs, original/final art, b&w and color photostats, tearsheets, photographs or slides. Pays for design and illustration by the hour, by the project or by the day (negotiable). Buys all rights.

OMNI ENTERPRISES, INC., 430 W. Roosevelt Rd., Wheaton IL 60187-5072. (708)653-8200. Fax: (708)653-8218. President: Steve Jacobs. Estab. 1962. Ad and marketing agency. Specializes in all collateral, ads, AV, marketing consulting, etc. Product specialties include business-to-business, professional and some consumer. Current clients include Schweppe, Rose Laboratories, Illinois Benedictine College, Thomas Engineering, Overton Gear.

Needs: Approached by 120 freelancers/year. Works with 36 freelance illustrators and 60 designers/year. Prefers local freelancers with experience in typesetting, color selection. Uses freelancers for "all we do. We have no in-house art staff"—brochure, catalog and print ad design and illustration; storyboards; slide illustration; mechanicals; retouching; billboards; posters; TV/film graphics; lettering; logos; displays; and P-O-P. 20% of work is with print ads. Needs computer-literate freelancers for design, illustration, production and presentation. 60% of freelance work demands computer skills.

First Contact & Terms: Send query letter and call for appointment. Samples sometimes filed, returned by SASE if not filed. Does not report back. Artist should follow-up with call. Art Director will contact artist for portfolio review if interested. Portfolio should include b&w and color thumbnails, roughs, tearsheets, slides, photostats, photographs and transparencies. Pays for design by the hour, $20-50; by the project. Pays for illustration by the project, $25-15,000. Buys all rights.

Tips: Finds artists through submissions. "We like long-term relationships; may take time to initiate."

‡TEMKIN & TEMKIN, INC., 450 Skokie Blvd., Bldg. 800, Northbrook IL 60062. (708)498-1700. E-mail: stemkin@rec.pc.com. CompuServe: 70446,752. President: Laura Temkin. Estab. 1945. Number of employees: 10. Ad agency. Specializes in business-to-business collateral, consumer direct mail. Product specialties are food, gifts, electronics and professional services. Current clients include Kraft Foodservice, Foster & Gallagher, Michigan Bulb.

Needs: Approached by 100 freelancers/year. Works with 5-10 freelance illustrators and 10 designers/year. Prefers local artists only. Uses freelancers mainly for design, concept and comps. Also for brochure and catalog design, mechanicals and retouching. 95% of work is with print ads. Needs computer-literate freelancers for design and production. 75% of freelance work demands knowledge of Aldus PageMaker 5.0, Adobe Photoshop 3.0, QuarkXPress 3.31 and Adobe Illustrator.

First Contact & Terms: Send query letter with photocopies and résumé. Samples returned by SASE if requested by artist. To arrange portfolio review artist should follow-up with call or letter after initial query.

Portfolio should include roughs, tearsheets and thumbnails. Pays for design by the project, $250-5,000. Rights purchased vary according to project.

Tips: "Present evidence of hands-on involvement with concept and project development."

‡WATERS & WOLFE, 1603 Orrington, Suite 990, Evanston IL 60201. (708)475-4500. Fax: (708)475-3947. E-mail: wnwolfe@aol.com. Art Director: Julie Niedan. President: Paul Frankel. Estab. 1984. Number of employees: 10. Approximate annual billing: $2 million. Ad agency, AV firm, PR firm. Full-service, multimedia firm. Specializes in collateral, annual reports, magazine ads, trade show booth design, videos, PR. "We are full service from logo design to implementation of design." Product specialty is business-to-business. Current clients include Nazdar, 3D Image Technology. Client list not available. Professional affiliation: BMA

Needs: Approached by 50 freelancers/year. Works with 5 freelance illustrators and 5 designers/year. Uses freelancers mainly for layout and illustrations. Also for animation, lettering, logos, mechanicals, retouching, signage and TV/film graphics. 25% of work is with print ads. Needs computer-literate freelancers for design, illustration, production and presentation. 90% of freelance work demands knowledge of Aldus PageMaker 4.2, Aldus FreeHand 3.0, Adobe Photoshop 3.0, QuarkXPress 3.31, Adobe Illustrator 5.0 and Ray Dream Designer.

First Contact & Terms: Send query letter with brochure, photocopies, photographs, résumé and tearsheets. Samples are filed. Art Director will contact artist for portfolio review if interested. Portfolio should include color final art, roughs, tearsheets and thumbnails. Pays for design by the hour or by the project. Pays for illustration by the project. Rights purchased vary according to project.

Tips: Finds artists through sourcebooks, word of mouth, artists' submissions and agents. "I am impressed by professionalism. Complete projects on timely basis, have thorough knowledge of task at hand."

Chicago

DeFRANCESCO/GOODFRIEND, 444 N. Michigan Ave., Suite 1000, Chicago IL 60611. (312)644-4409. Fax: (312)644-7651. Partner: John DeFrancesco. Estab. 1985. Number of employees: 8. Approximate annual billing: $700,000. PR firm. Full-service, multimedia firm. Specializes in marketing, communication, publicity, direct mail, brochures, newsletters, trade magazine ads, AV presentations. Product specialty is consumer home products. Current clients include S-B Power Tool Co., Plantation Baking, ITW Brand Merchandising, Promotional Products Association International. Professional affiliations: Chicago Direct Marketing Association, Sales & Marketing Executives of Chicago, Public Relations Society of America.

Needs: Approached by 15-20 freelancers/year. Works with 2-5 freelance illustrators and 2-5 designers/year. Works on assignment only. Uses freelancers mainly for brochures, ads, newsletters. Also for print ad design and illustration, editorial and technical illustration, mechanicals, retouching and logos. Needs computer-literate freelancers for design, illustration, production and presentation. 75% of freelance work demands computer skills.

First Contact & Terms: Send query letter with brochure and résumé. Samples are filed. Does not report back. Request portfolio review in original query. Artist should call within 1 week. Portfolio should include printed pieces. Pays for design and illustration by the project, $50 minimum. Rights purchased vary according to project.

Tips: Finds artists "through word of mouth and queries to us. I think there is a slow but steady upward trend in the field. Computerization is adding to fragmentation: many new people opening shop."

‡DAVE DILGER, 1467 N. Elston, Suite 200, Chicago IL 60622. (312)772-3200. Fax: (312)772-3244. Contact: Dave Dilger. Estab. 1951. Number of employees: 8. Ad agency. Full-service, multimedia firm. Specializes in print ads, collateral and other print material. Product specialty is industrial.

Needs: Approached by 5-10 freelancers/year. Works with 3-4 freelance illustrators and 10 designers/year. Prefers local artists only. Uses freelancers mainly for design and illustration. Also for brochure and catalog design; and retouching. 100% of work is with print ads. Needs computer-literate freelancers for design and production. 85% of freelance work demands knowledge of Adobe Photoshop 3.0.1, QuarkXPress 3.3 and Adobe Illustrator 5.X.

First Contact & Terms: Send query letter with résumé. Samples are filed or returned. Request portfolio review in original query. Portfolio should include b&w and color final art and roughs. Pays for design and illustration by the hour or by the project. "We work with the artist." Buys all rights or negotiates rights purchased.

Always enclose a self-addressed, stamped envelope (SASE) with queries and sample packages.

‡**DOWLING & POPE ADVERTISING**, 311 W. Superior, Suite 308, Chicago IL 60610. (312)573-0600. Fax: (312)573-0071. Estab. 1988. Number of employees: 16. Approximate annual billing: $4.5 million. Ad agency. Full-service multimedia firm. Specializes in magazine ads and collateral. Product specialty is recruitment. Client list not available.

Needs: Approached by 6-12 freelance artists/year. Works with 6-12 freelance illustrators/year. Uses freelancers mainly for collateral. Also for annual reports, brochure design and illustration, catalog illustration, lettering and posters. 80% of work is with print ads. Needs computer-literate freelancers for illustration and production. 90% of freelance work demands knowledge of Aldus PageMaker, Aldus FreeHand, Adobe Photoshop, Quark-XPress, Adobe Illustrator.

First Contact & Terms: Send sample of work. Samples are filed. Reports back with 2 weeks. Portfolios may be dropped off every Monday. Art Director will contact artist for portfolio review if interested. Portfolio should include b&w and color final art. Pays for design and illustration by the project. Negotiates rights purchased.

Tips: Finds artists through *Creative Black Book*, *Workbook* and *Chicago Source Book*.

‡**GETER ADVERTISING INC.**, 75 E. Wacker Dr., #410, Chicago IL 60601. (312)782-7300. Vice President: Georgia Karones. Estab. 1978. Ad agency. Full-service, multimedia firm. Product specialty is retail. Client list not available.

Needs: Approached by 20-50 freelancers/year. Permanent part-time positions in design available. Prefers artists with experience in computer layout—work done at our office. Uses freelancers mainly for print ads, brochures and outdoor design. Also uses freelancers for billboards, brochure design, logos, posters, signage and TV/film graphics. 50% of work is with print ads. Needs computer-literate freelancers for design, illustration, production and presentation. 100% of freelance work demands knowledge of Aldus PageMaker, Aldus FreeHand, Adobe Photoshop, QuarkXPress, Adobe Illustrator and Corel Draw (latest versions).

First Contact & Terms: Send query letter with photocopies and résumé. Samples are reviewed immediately and filed or returned. Agency will contact artist for portfolio review if interested. Portfolio should include b&w and color final art and tearsheets. Pays for design by the hour, $15-25; by the project, $50-2,000; by the day, $100-200. Buys all rights.

Tips: Impressed with freelancers who possess "skill on computer, good artistic judgment, speed, and who can work with our team."

GRIFFIN & BOYLE, 445 E. Illinois, #345, Chicago IL 60611. (312)836-5900. Fax: (312)836-5920. E-mail: orgelbau@aol.com. Vice President, Operations: W.R. Milligan. Estab. 1974. Number of employees: 20. Approximate annual billing: $4 million. Integrated marketing firm. Specializes in collateral, direct mail, multimedia. Product specialty is industrial. Current clients include Hyatt, USX, McDonalds.

Needs: Works with 20-30 freelance illustrators and 20-30 designers/year. Prefers artists with experience in computer graphics. Uses freelancers mainly for design and illustration. Also uses freelancers for animation, model making and TV/film graphics. 20% of work is with print ads. Needs computer-literate freelancers for design, illustration, production and presentation. 95% of freelance work demands knowledge of Aldus PageMaker, Aldus FreeHand, Adobe Photoshop, QuarkXPress and Adobe Illustrator.

First Contact & Terms: Send query letter with SASE. Samples are not filed and are returned by SASE if requested by artist. Reports back within 1 month. Art Director will contact artist for portfolio review if interested. Pays for design and illustration by the hour, $20-80; or by the project.

Tips: Finds artists through *Creative Black Book*.

KAUFMAN RYAN STRAL INC., 600 N. Dearborn St., Suite 700, Chicago IL 60610. (312)467-9494. Fax: (312)467-0298. Vice President/Creative Director: Robert Ryan. Estab. 1993. Number of employees: 7. Ad agency. Specializes in all materials in print. Product specialty is business-to-business. Client list available upon request. Professional affiliations: BMA.

Needs: Approached by 30 freelancers/year. Works with 6 freelance illustrators and 5 designers/year. Prefers local freelancers only. Uses freelancers for design, production, illustration and computer work. Also for brochure, catalog and print ad design and illustration; animation; mechanicals; retouching; model making; posters; lettering; and logos. 30% of work is with print ads. Needs computer-literate freelancers for design, illustration and production. 75% of freelance work demands knowledge of QuarkXPress, Photoshop or Illustrator.

First Contact & Terms: Send query letter with résumé and photostats. Samples are filed or returned by SASE. Reports back to the artist only if interested. Artist should follow-up with call and/or letter after initial query. Art Director will contact artist for portfolio review if interested. Portfolio should include b&w and color roughs and final art. Pays for design by the hour, $35-75; or by the project. Pays for illustration by the project, $75-8,000. Buys all rights.

Tips: Finds artists through sourcebooks, word of mouth, submissions.

‡**MEYER/FREDERICKS & ASSOCIATES**, 333 N. Michigan Ave., #1300, Chicago IL 60601. (312)782-9722. Fax: (312)782-1802. Estab. 1972. Number of employees: 15. Ad agency, PR firm. Full-service, multimedia firm.

Needs: Prefers local freelancers only. Freelancers should be familiar with Adobe Photoshop 3.0, QuarkX-Press 3.31 and Adobe Illustrator 5.
First Contact & Terms: Send query letter with samples. Art Director will contact artist for portfolio review if interested.

MSR ADVERTISING, INC., P.O. Box 10214, Chicago IL 60610-0214. (312)573-0001. Fax: (312)573-1907. President: Barry Waterman. Art Director: Margaret Wilkins. Estab. 1983. Number of employees: 6. Approximate annual billing: $2.5 million. Ad agency. Full-service, multimedia firm. Specializes in collateral. Product specialties are medical, food, industrial and aerospace. Current clients include Baxter Healthcare, Mama Tish's, Pizza Hut, hospitals, healthcare, Helene Curtis, Colgate-Palmolive.
Needs: Approached by 6-10 freelancers/year. Works with 2-4 freelance illustrators and 5-10 designers/year. Prefers local artists who are "innovative, resourceful and hungry." Works on assignment only. Uses freelancers mainly for creative through boards. Also for brochure, catalog and print ad design and illustration; storyboards; mechanicals; billboards; posters; lettering; and logos. 30% of work is with print ads. Needs computer-literate freelancers for design, illustration, production and presentation. 75% of freelance work demands computer skills.
First Contact & Terms: Send query letter with brochure, SASE and résumé. Samples are filed and returned. Reports back within 1-2 weeks. Write for appointment to show portfolio or mail appropriate materials: thumbnails, roughs, finished samples. Artist should follow up with call. Buys all rights.
Tips: Finds artists through submissions and agents. "We maintain a relaxed environment designed to encourage creativity, however, work must be produced timely and accurately. Normally the best way for a freelancer to meet with us is through an introductory letter and a follow-up phone call a week later."

S.C. MARKETING, INC., 101 W. Grand Ave., Suite 402, Chicago IL 60610. (312)464-0460. Fax: (312)464-0463. President: Susie Cohn. Estab. 1990. Number of employees: 3. Ad agency, concentrating on print. Specializes in magazine ads, collateral, and miscellaneous print materials. Product specialty is food service. Current clients include Keebler Co., Bernardi Italian Foods, Original Chili Bowl Co., Golden Tiger Co. and Bri-al, Inc.
Needs: Approached by 25 freelances/year. Works with 36 freelance illustrators and 72 designers/year. Prefers artists with experience in food industry. Works on assignment only. Uses freelancers mainly for layout/creative development, type specing, production coordination, photography supervision. Also for brochure, catalog and print ad design and illustration; storyboards; posters; packaging; food illustration; lettering; and logos. 40% of work is with print ads. Needs computer-literate freelancers for design, illustration, production and presentation. 30% of freelance work demands computer skills.
First Contact & Terms: Send query letter with résumé, photocopies, photographs and tearsheets. Samples are filed. Art Director will contact artist for portfolio review if interested. Portfolios may be dropped off or mailed. Portfolio should include roughs and b&w or color tearsheets and photographs. Pays for design and illustration by the project. Buys all rights.
Tips: Finds artists through referrals.

Indiana

ADVANCED DESIGNS CORPORATION, 1169 W. Second St., Bloomington IN 47403. (812)333-1922. Fax: (812)333-2030. President: Martin Riess. Estab. 1982. AV firm. Weather radar systems and associated graphics. Specializes in TV news broadcasts. Product specialties are the Doppler Radar and Display Systems.
Needs: Prefers freelancers with experience. Works on assignment only. Uses freelancers mainly for TV/film (weather) and cartographic graphics. Needs computer-literate freelancers for production. 100% of freelance work demands knowledge of ADC Graphics.
First Contact & Terms: Send query letter with résumé and SASE. Samples are not filed and are returned by SASE. Pays for design and illustration by the hour, $7 minimum. Art Director will contact artist for portfolio review if interested. Rights purchased vary according to project.
Tips: Finds artists through classifieds.

‡BOYDEN & YOUNGBLUTT ADVERTISING & MARKETING., 120 W. Superior St., Fort Wayne IN 46802. (219)422-4499. Fax: (219)422-4044. Vice President: Jerry Youngblutt. Estab. 1990. Number of employees: 10. Ad agency. Full-service, multimedia firm. Specializes in magazine ads and collateral.
Needs: Approached by 10 freelancers/year. Works with 3-4 freelance illustrators and 5-6 designers/year. Uses freelancers mainly for collateral layout. Also for annual reports, billboards, brochure design and illustration, logos and model making. 70% of work is with print ads. Needs computer-literate freelancers for design. 100% of freelance work demands knowledge of Aldus PageMaker, Aldus FreeHand, Adobe Photoshop, QuarkXPress and Adobe Ilustrator.
First Contact & Terms: Send query letter with photostats and résumé. Samples are filed. Art Director will contact artist for portfolio review if interested. Portfolio should include b&w and color final art. Pays for design and illustration by the project. Buys all rights.

Tips: Finds artists through sourcebooks, word of mouth and artists' submissions. "Send a precise résumé with what you feel are your 'best' samples—less is more."

‡C.R.E. INC., 400 Victoria Centre, 22 E. Washington St., Indianapolis IN 46204. (317)631-0260. Creative Director: Mark Gause. Senior Art Director: Rich Lunsech. Number of employees: 34. Approximate annual billing: $13 million. Ad agency. Specializes in business-to-business, computer equipment, biochemicals and electronics. Clients: primarily business-to-business.
Needs: Approached by 50 freelancers/year. Works with 10-20 freelance illustrators and 0-3 designers/year. Works on assignment only. Uses freelancers for technical line art, color illustrations and airbrushing.
First Contact & Terms: Send query letter with résumé and photocopies. Samples not filed are returned. Reports back only if interested. Call or write for appointment to show portfolio, or mail final reproduction/product and tearsheets. Pays for design and illustration by the project, $100 minimum. Buys all rights.
Tips: "Show samples of good creative talent."

‡THE MAJESTIC GROUP, INC., 70 E. 91st St., Suite 200, Indianapolis IN 46240. (317)580-7540. Fax: (317)580-7550. Art Director: Debra Pohl. Estab. 1979. Number of employees: 15. Approximate annual billing: $12 million. Specializes in direct, satellite transmission. Product specialty is agriculture. Client list not available. Professional affiliations: ADCI.
Needs: Approached by 20 freelancers/year. Works with 6-15 freelance illustrators/year. Uses freelancers mainly for illustration. Also for brochure design and illustration, catalog illustration and model making. 40% of work is with print ads. Needs computer-literate freelancers for illustration. 80% of freelance work demands knowledge of Aldus PageMaker 5.0, Aldus FreeHand 4.0, Adobe Photoshop 3.1, QuarkXPress and Adobe Illustrator 5.0.
First Contact & Terms: Send query letter with brochure, postcard-size sample of work, or other keepable, filable samples. Samples are filed or are returned by SASE if requested by artist. Art Director will contact artist for portfolio review if interested. Portfolio should include color photographs. Pays for illustration by the project, $100-8,500. "Payment varies job to job." Buys all rights.
Tips: Finds artists through *Chicago Sourcebook*, *CA Illustration*. "Digital/digitalized work is easier to use. Consider providing work on CD-ROM."

OMNI PRODUCTIONS, 12955 Meridan St., P.O. Box 302, Carmel IN 46032. (317)848-3456. President: Winston Long. Estab. 1987. AV firm. Full-service, multimedia firm. Specializes in video, multi-image, slides. Current clients include "a variety of industrial clients, international."
Needs: Works on assignment only. Uses freelancers for brochure design and illustration, storyboards, slide illustration, animation, and TV/film graphics. Needs computer-literate freelancers for design, illustration and production. Most of freelance work demands computer skills.
First Contact & Terms: Send résumé. Samples are filed and are not returned. Artist should follow-up with call and/or letter after initial query.
Tips: Finds artists through agents, word of mouth and submissions.

Iowa

‡F.A.C. MARKETING, 719 Columbia St., Burlington IA 52601. (319)752-9422. Fax: (319)752-7091. President: Roger Sheagren. Estab. 1952. Number of employees: 5. Approximate annual billing: $500,000. Ad agency. Full-service, multimedia firm. Specializes in newspaper, television, direct mail. Product specialty is funeral home to consumer.
Needs: Approached by 30 freelancers/year. Works with 1-2 freelance illustrators and 4-6 designers/year. Prefers freelancers with experience in newspaper and direct mail. Uses freelancers mainly for newspaper design. Also for brochure design and illustration, logos, signage and TV/film graphics. Work demands knowledge of Aldus PageMaker, Adobe Photoshop, Corel Draw and QuarkXPress.
First Contact & Terms: Send query letter with brochure, photostats, SASE, tearsheets and photocopies. Samples are filed or returned by SASE if requested by artist. Request portfolio review in original query. Portfolio should include b&w photostats, tearsheets and thumbnails. Pays by the project, $100-500. Rights purchased vary according to project.

HELLMAN ANIMATES, LTD., 1225 W. Fourth St., P.O. Box 627, Waterloo IA 50702. (319)234-7055. Animation studio. Specializes in animated TV commercials and programs.
Needs: Approached by 1 freelancer/month. Works with 3 animators/month. Prefers freelancers with experience in animation. Works on assignment only. Uses freelancers for storyboards and animatics.
First Contact & Terms: Send query letter with demo reel. Samples are filed or are returned. Reports back to the artist only if interested. Pays by foot of production, $35-135. Buys all rights.

Kansas

BRYANT, LAHEY & BARNES, INC., 5300 Foxridge Dr., Shawnee Mission KS 66202. (913)262-7075. Art Director: Terry Pritchett. Ad agency. Clients: agriculture and veterinary firms.
Needs: Prefers local freelancers only. Uses freelancers for illustration and production, including keyline and paste-up; consumer and trade magazines and brochures/flyers.
First Contact & Terms: Query by phone. Send business card and résumé to be kept on file for future assignments. Originals not returned. Negotiates pay.

Louisiana

PETER O'CARROLL ADVERTISING, 710 W. Drien Lake Rd., Suite 209, Lake Charles LA 70601. (318)478-7396. Fax: (318)478-0503. Art Director: Kathlene Deaville. Estab. 1977. Ad agency. Specializes in newspaper, magazine, outdoor, radio and TV ads. Product specialty is consumer. Current clients include Players Riverboat Casino, First Federal Savings & Loan, Charter Hospital. Client list available upon request.
Needs: Approached by 2 freelancers/month. Works with 1 illustrator/month. Prefers freelancers with experience in computer graphics. Works on assignment only. Uses freelancers mainly for time consuming computer graphics. Also for brochure and print ad illustration and storyboards. 65% of work is with print ads. Needs computer-literate freelancers for design and illustration. 50% of freelance work demands knowledge of Adobe Illustrator, Adobe Photoshop or Aldus FreeHand.
First Contact & Terms: Send query letter wtih résumé, transparencies, photographs, slides and tearsheets. Samples are filed or returned by SASE if requested. Reports back to the artist only if interested. Art Director will contact artist for portfolio review if interested. Portfolio should include color roughs, final art, tearsheets, slides, photostats and transparencies. Pays for design by the project, $30-300. Pays for illustration by the project, $50-275. Rights purchased vary according to project.
Tips: Finds artists through "viewing portfolios, artists' submissions, word of mouth, district advertising conferences and conventions."

SACKETT EXECUTIVE CONSULTANTS, 1001 Howard Ave., Suite 3400, New Orleans LA 70113-2036. (504)522-4040. Fax: 524-8839. Art Director: Matt Spisak. Estab. 1980. Ad agency and PR firm. Full-service, multimedia firm. Specializes in magazine/newspaper ads, direct mail, audiovisual TV/radio/film productions and political campaigns. Product specialties are retail, political and legal.
Needs: Approached by 10 freelancers/month. Works with 2 illustrators and 1 designer/month. Prefers freelancers with experience in architectural rendering and technical illustration. Works on assignment only. Uses freelancers mainly for illustration and presentation (or crash jobs). Also for brochure, catalog and print ad design and illustration and animatics, animation, mechanicals, retouching, billboards, posters, TV/film graphics, lettering and logos. 40% of work is with print ads.
First Contact & Terms: Send query letter with brochure, photocopies, résumé, tearsheets and photostats. Samples are filed and are not returned. Reports back within 1 week. Call for appointment to show portfolio of original/final art, b&w and color photostats. Pays for design by the hour, $10-50; by the project, $100 minimum; by the day, $80-400. Pays for illustration by the project, $500-3,000. Buys first rights and all rights.

Maryland

SAMUEL R. BLATE ASSOCIATES, 10331 Watkins Mill Dr., Gaithersburg MD 20879-2935. Phone/fax: (301)840-2248. President: Samuel R. Blate. Number of employees: 2. Approximate annual billing: $70,000. AV and editorial services firm. Clients: business/professional, US government, some private.
Needs: Approached by 6-10 freelancers/year. Works with 1-5 freelance illustrators and 1-2 designers/year. Only works with freelancers in the Washington DC metropolitan area. Works on assignment only. Uses freelancers for cartoons (especially for certain types of audiovisual presentations), editorial and technical illustrations (graphs, etc.) for 35mm slides, pamphlet and book design. Especially important are "technical and aesthetic excellence and ability to meet deadlines." Needs computer-literate freelancers for design, illustration, production and presentation. 60% of freelance work demands knowledge of Corel Draw, Aldus PageMaker or Harvard Graphics for Windows.
First Contact & Terms: Send query letter with résumé and tearsheets, photostats, photocopies, slides or photographs to be kept on file. "No original art." Samples are returned only by SASE. Reports back only if interested. Pays by the hour, $20-40. Rights purchased vary according to project, "but we prefer to purchase first rights only. This is sometimes not possible due to client demand, in which case we attempt to negotiate a financial adjustment for the artist."
Tips: "The demand for technically oriented artwork has increased."

‡**HARTT & COMPANY**, 3600 Clipper Mill Rd., Suite 401, Baltimore MD 21211. (410)467-3267. Contact: Creative Director. Estab. 1986. Number of employees: 7. Approximate annual billing: $2 million. AD, PR

firm. Specializes in print advertising, collateral and radio. Product specialties are retail, education and business-to-business.

Needs: Approached by 5-15 freelance artists/year. Works with 2-3 freelance illustrators and 3-5 designers/year. Uses freelancers for annual reports, billboards, brochure design and illustration, logos, posters and signage. 20% of work is with print ads. Needs computer-literate freelancers for design and production. 95% of freelance work demands knowledge of Aldus PageMaker, Adobe Photoshop and QuarkXPress.

First Contact & Terms: Send query letter with photocopies and résumé. Samples are filed. Artist should follow-up with letter after initial query. Portfolio should include "whatever seems appropriate." Payment for design "depends on the situation and talent." Rights purchased vary according to project.

Tips: Finds artists through artists' submissions, word of mouth, reps. Impress creative director by "being on time; listening to directions; intelligence; sense of collaboration; talent raw and clear."

‡NORTH LIGHT COMMUNICATIONS, 7100 Baltimore Ave., #307, College Park MD 20740. (301)864-2626. Fax: (301)864-2629. Vice President: Hal Kowenski. Estab. 1989. Number of employees: 6. Approximate annual billing: $6.9 million. Ad agency. Product specialties are business-to-business and consumer durables. Current clients include Sundance Spas, Olin Corporation, INSL-X and Egg Harbor Yachts. Client list not available.

Needs: Approached by 6 freelancers/year. Works with 4 freelance illustrators and 2 designers/year. Prefers artists with experience in collateral and agency background. Also uses freelancers for annual reports, brochure design and illustration, mechanicals, posters and signage. 20% of work is with print ads. Needs computer-literate freelancers for design and production. 90% of freelance work demands knowledge of Aldus Page-Maker 4.2, Aldus FreeHand 3, Adobe Photoshop, QuarkXPress and Adobe Illustrator.

First Contact & Terms: Send query letter with brochure, photocopies, résumé and SASE. Samples are filed or are returned by SASE if requested by artist. Art Director will contact artist for portfolio review if interested. Portfolio should include: b&w and color final art, tearsheets and thumbnails. Pays for design by the hour, $20-60; by the day, $150-500. Pays for illustration by the project. Buys all rights.

Tips: Finds artists through *Creative Black Book*, *Sourcebook*, classified ads.

MARC SMITH CO., INC., Box 5005, Severna Park MD 21146. (410)647-2606. Art/Creative Director: Marc Smith. Number of employees: 3. Ad agency. Clients: consumer and industrial products.

Needs: Approached by 12 freelancers/year. Works with 3 freelance illustrators and 3 designers/year. Prefers local artists only. Uses freelancers for layout, lettering, technical art, type specing, paste-up and retouching. Also for illustration and design of direct mail, slide sets, brochures/flyers, trade magazines and newspapers; design of film strips, stationery, multimedia kits. Occasionally buys humorous and cartoon-style illustrations. Needs computer-literate freelancers for design, illustration and production. 50% of freelance work demands computer skills.

First Contact & Terms: Send query letter with brochure showing art style or tearsheets, photostats, photocopies, slides or photographs. Keeps file on artists. Originals not returned. Negotiates payment.

Tips: "More sophisticated techniques and equipment are being used in art and design. Our use of freelance material has intensified. Project honesty, clarity and patience."

Massachusetts

THE CRAMER PRODUCTION CENTER, 335 Wood Rd., Braintree MA 02184. Operations Manager: Tim Martin. Estab. 1982. AV firm. Film/video production. Specializes in full-service film/video production, presentation graphics, events services, AV, multimedia, broadcast commercials, corporate marketing and training. Product specialties are retail, medical, high-tech. Current clients include Boston Scientific, Talbots, Peace Corp. Client list available upon request.

Needs: Approached by 3-4 freelancers/month. Works with 1 illustrator and designer/month. Prefers local freelancers only. Works on assignment only. Uses freelancers mainly for storyboards and set illustrations. Also for brochure illustration, storyboards, animation and TV/film graphics. 2% of work is with print ads. Needs computer-literate freelancers for design. 40% of freelance work demands computer skills.

First Contact & Terms: Send query letter with samples. Samples are filed or returned by SASE if requested. Does not report back. Artist should follow up within 1-2 weeks. Art Director will contact artist for portfolio review if interested. Portfolio should include thumbnails and tearsheets. Pays for design and illustration by the project, $100 minimum. "Pay really varies depending on the project." Buys all rights.

GREENBAUM & GREENBAUM, One South Ave., Natick MA 01760. (508)651-8158. Fax: (508)655-1637. Estab. 1975. Number of employees: 2. Approximate annual billing: $350,000. Ad Agency. Specializes in annual reports, corporate identity and publication design. Product specialty is corporate. Current clients include Lite Control, Intrepid Software, Gold Hill, AVP and Faxon.

Needs: Approached by 50 freelancers/year. Works with 10 freelance illustrators and 2 designers/year. Prefers working through artists' reps. Uses freelancers mainly for advertising and literature. Also for brochure and print ad illustration.

First Contact & Terms: Contact through artist rep or send query letter with résumé, SASE and photocopies, photographs or slides. Samples are filed or are returned by SASE if requested by artist. Does not report back. Portfolio review not required. Pays for illustration by the project, $500-3,500.
Tips: Finds artists through annuals and sourcebooks.

‡HELIOTROPE STUDIOS LTD., 21 Erie St., Cambridge MA 02139. (617)868-0171. Production Coordinator: Susan Mabbett. Estab. 1984. Number of employees: 3. AV firm. "We are a full-service, sophisticated facility for film and video production and post-production." Current projects include NBC-TV "Unsolved Mysteries" series; "Nova"-WGBH-TV, BBC-TV and corporate video projects.
Needs: Approached by 50 freelancers/year. Works with 0-10 freelance illustrators and 0-10 designers/year. Works on assignment only. Uses freelancers mainly for set design and animation. Also for brochure design and storyboards. Needs technical and medical illustration. Needs computer-literate freelancers for illustration. 50% of freelance work demands computer skills.
First Contact & Terms: Send query letter with brochure. Samples are filed. Reports back to the artist only if interested. To show portfolio, mail appropriate materials. Pays for design and illustration by the hour, $20 minimum; by the day, $200 minimum. Considers client's budget and turnaround time when establishing payment. Rights purchased vary according to project.
Tips: "Have excellent referrals and a solid demo tape of work."

JEF FILMS INC., 143 Hickory Hill Circle, Osterville MA 02655-1322. (508)428-7198. Fax: (508)428-7198. President: Jeffrey H. Aikman. Vice President: Elsie Aikman. Estab. 1973. AV firm. Full-service, multimedia firm. Specializes in covers for home videotapes, magazine ads (trade and consumer) and movie posters. Current clients include VIP Video, TAM Productions, XTC Video. Client list not available.
Needs: Approached by 400-500 freelancers/month. Works with 10-12 illustrators and designers/month. Prefers freelancers with movie and video background. Uses freelancers for all promotional design and editorial and technical illustration. Also for brochure, catalog and print ad design and illustration and slide illustration, storyboards, animatics, animation, mechanicals, retouching, TV/film graphics, lettering and logos. 20% of work is with print ads. Needs computer literate freelancers for design, illustration, production and presentation. 40% of freelance work demands knowledge of Aldus PageMaker, Quark XPress, Aldus FreeHand, Adobe Illustrator and Adobe Photoshop.
First Contact & Terms: Send query letter with SASE and any of the following: brochure, photocopies, résumé, photographs, photostats, slides, tearsheets and transparencies. Samples are filed or returned by SASE if requested by artist. Reports back only if interested. Art director will contact for portfolio review if interested. Portfolio should include thumbnails, b&w or color photostats, tearsheets, photographs and slides. Sometimes requests work on spec before assigning job. Pays for design and illustration by the project, $50-300. Buys all rights.
Tips: Finds artists through word of mouth, agents, sourcebooks, magazines.

RUTH MORRISON ASSOCIATES, INC., 22 Wendell St., Cambridge MA 02138. (617)354-4536. Fax: (617)354-6943. Assistant Account Executive: Marinelle Hervas. Estab. 1972. PR firm. Specializes in food, travel, hotel/restaurant, education, non-profit. Assignments include logo/letterhead design, invitations and brochures.
Needs: Prefers local freelancers with experience in advertising and/or publishing. Uses freelancers mainly for brochure design, P-O-P materials and direct mail. Also for catalog and print ad design, mechanicals, editorial illustration, posters, lettering and logos. 5% of work is with print ads. 10% of freelance work demands computer skills.
First Contact & Terms: Send query letter with photocopies. Samples are filed or returned by SASE only if requested by artist. Does not report back. Portfolios may be dropped off every Wednesday. Sometimes requests work on spec before assigning a job. Pays for design and illustration by the project. Rights purchased vary according to project.
Tips: Finds artists through word of mouth, magazines and advertising.

THE PHILIPSON AGENCY, 241 Perkins St., Suite B201, Boston MA 02130. (617)566-3334. Fax: (617)566-3363. President and Creative Director: Joe Philipson. Marketing design firm. Specializes in packaging, collateral, P-O-P, corporate image, sales presentations, direct mail, business-to-business and high-tech.
Needs: Approached by 3-4 freelancers/month. Works with 1 illustrator and 3 designers/month. Prefers freelancers with experience in design, illustration, comps and production. Works on assignment only. Uses freelancers mainly for overflow and special jobs. Also for brochure, catalog and print ad design and illustration; packaging; mechanicals; retouching; posters; lettering; and logos. Needs editorial illustration. 65% of work is with print ads. Needs computer-literate freelancers for design, illustration; and production. 95% of freelance work demands knowledge of Aldus PageMaker, QuarkXPress, Aldus FreeHand, Adobe Illustrator or Photoshop.
First Contact & Terms: Send query letter with brochure, SASE, résumé. Samples are filed or are returned by SASE. Reports back to the artist only if interested. To show a portfolio, mail roughs, photostats, tearsheets, photographs and slides. Pays for design by the hour, $25-50. Pays for illustration by the hour. Buys all rights.

RSVP MARKETING, INC., 450 Plain St., Suite 5, Marshfield MA 02050. (617)837-2804. Fax: (617)837-5389. President: Edward C. Hicks. Direct marketing consultant services—catalogs, direct mail, brochures and telemarketing. Clients: insurance, wholesale, manufacturers and equipment distributors.
Needs: Works with 7-8 freelancers/year. Prefers local freelancers with direct marketing skills. Uses freelancers for advertising, copy and catalog design, illustration and layout; and technical illustration. Needs line art for direct mail. Needs computer-literate freelancers for design and illustration. 50% of freelance work demands knowledge of Aldus PageMaker.
First Contact & Terms: Send query letter with résumé and finished, printed work to be kept on file. Art Director will contact artist for portfolio review if interested. Sometimes requests work on spec before assigning a job. Pays for design and illustration by the hour, $25-70; or by the project $300-5,000. Considers skill and experience of artist when establishing payment.

TR PRODUCTIONS, 1031 Commonwealth Ave., Boston MA 02215. (617)783-0200. Fax: (617)783-4844. Creative Director: Cary M. Benjamin. Estab. 1947. Number of employees: 12. AV firm. Full-service, multimedia firm. Specializes in slides, collateral, AV shows.
Needs: Approached by 15 freelancers/year. Works with 5 freelance illustrators and 5 designers/year. Prefers local freelancers with experience in slides. Works on assignment only. Uses freelancers mainly for slides, collateral. Also for brochure and print ad design and illustration, slide illustration, animation and mechanicals. 25% of work is with print ads. Needs computer-literate freelancers for design, production and presentation. 95% of work demands knowledge of Aldus FreeHand, Adobe Photoshop, Microsoft Powerpoint, Aldus Persuasion, QuarkXPress or Adobe Illustrator.
First Contact & Terms: Send query letter. Samples are filed. Does not report back. Artist should follow-up with call. Art Director will contact artist for portfolio review if interested. Rights purchased vary according to project.

TVN-THE VIDEO NETWORK, 31 Cutler Dr., Ashland MA 01721-1210. (508)881-1800. Producer: Gregg McAllister. Estab. 1986. AV firm. Full-service multimedia firm. Specializes in video production for business, broadcast and special events. Product specialties "cover a broad range of categories." Current clients include Marriott, Digital, IBM, Waters Corp., National Park Service.
Needs: Approached by 1 freelancer/month. Works with 1 illustrator/month. Prefers freelancers with experience in Amiga PC, The Video Toaster, D paint III, 2D and 3D programs. Works on assignment only. Uses freelancers mainly for video production, technical illustration, flying logos and 3-D work. Also for storyboards, animation, TV/film graphics and logos.
First Contact & Terms: Send query letter with videotape or computer disk. Samples are filed or are returned. Reports back within 2 weeks. Art Director will contact artist for portfolio review if interested. Portfolio should include videotape and computer disk (Amiga). Pays for design and illustration by the project, $500-5,000; by the day, $250 minimum. Buys all rights.
Tips: Finds artists through word of mouth, magazines and submissions.

VIP VIDEO, 143 Hickory Hill Circle, Osterville MA 02655-1322. Phone/fax: (508)428-7198. President: Jeffrey H. Aikman. Estab. 1980. AV firm. Full-service, multimedia firm. Specializes in magazine ads, video jackets, brochures. Product specialty is videotapes. Current clients include TAM Products and USAmericana Films. Client list not available.
Needs: Approached by 10-12 freelancers/month. Works with 5-6 illustrators and designers/month. Prefers freelancers with experience in video and film business. Works on assignment only. Uses freelancers mainly for video covers, brochures. Also for brochure, catalog and print ad design and illustration and storyboards, slide illustration, animation, retouching, billboards, posters, TV/film graphics, lettering and logos. 50% of work is with print ads. Needs computer-literate freelancers for design, illustration, production and presentation. 25% of work demands knowledge of Aldus PageMaker, QuarkXPress, Aldus FreeHand, Adobe Illustrator or Adobe Photoshop.
First Contact & Terms: Send query letter with brochure and photographs. Samples are filed or are returned by SASE. Reports back to the artist only if interested. Art Director will contact artist for portfolio review if interested. Portfolio should include b&w and color final art, slides, photographs and transparencies. Pays for design and illustration by the project, $50-300. Buys all rights.
Tips: Finds artists through agents, word of mouth, submissions and sourcebooks.

Michigan

CLASSIC ANIMATION, 1800 S. 35th St., Galesburg MI 49053-9688. (616)665-4800. Creative Director: David Baker. Estab. 1986. AV firm. Specializes in animation—computer (Topas, Lumena, Wavefront SGI, Rio) and traditional. Current clients include Amway, Upjohn, Armstrong, NBC.
Needs: Approached by 60 freelancers/year. Works with 36 illustrators and 12 designers/year. Prefers artists with experience in animation. Uses freelancers for animation and technical, medical and legal illustration. Also for storyboards, slide illustration, animatics, animation, TV/film graphics and logos. 10% of work is

with print ads. Needs computer-literate freelancers for design and production. 50% of freelance work demands computer skills.

First Contact & Terms: Send query letter with résumé, photocopies and ½″ VHS. Samples are filed or are returned by SASE. Reports back within 1 week only if interested. Write for appointment to show portfolio or mail appropriate materials. Portfolio should include slides and ½″ VHS. Pays for design and illustration by the hour, $25 minimum; or by the project, $250 minimum. Rights purchased vary according to project.

COMMUNICATIONS ELECTRONICS, INC., Dept AGDM, Box 2797, Ann Arbor MI 48106-2797. (313)996-8888. E-mail: ken@cyberspace.org. Editor: Ken Ascher. Estab. 1969. Number of employees: 38. Approximate annual billing: $2 million. Manufacturer, distributor and ad agency (12 company divisions). Specializes in marketing. Clients: electronics, computers.

Needs: Approached by 150 freelancers/year. Works with 20 freelance illustrators and 20 designers/year. Uses freelancers for brochure and catalog design, illustration and layout; advertising; product design; illustration on product; P-O-P displays; posters; and renderings. Needs editorial and technical illustration. Prefers pen & ink, airbrush, charcoal/pencil, watercolor, acrylic, marker and computer illustration. Needs computer-literate freelancers for design and illustration. 30% of freelance work demands knowledge of Aldus PageMaker or Quark.

First Contact & Terms: Send query letter with brochure, résumé, business card, samples and tearsheets to be kept on file. Samples not filed are returned by SASE. Reports within 1 month. Art Director will contact artist for portfolio review if interested. Pays for design and illustration by the hour, $15-100; by the project, $10-15,000; by the day, $40-800.

‡JMK & ASSOCIATES, INC., 146 Monroe Center St., 418, Grand Rapids MI 49503. (616)774-0923. Fax: (616)774-2802. President: Joel Jetzer. Estab. 1974. Number of employees: 4. Approximate annual billing: $1 million. Ad agency. Specializes in magazine ads, book covers and collateral. Product specialty is publishing. Current clients include World Publishing, Kirkbride Publishers. Client list available upon request.

Needs: Approached by 10-25 freelancers/year. Works with 5 freelance illustrators and 7 designers/year. Uses freelancers for brochure and catalog design and illustration, lettering, logos, mechanicals, retouching and signage. Needs computer-literate freelancers for design, illustration and production. 100% of freelance work demands knowledge of Aldus PageMaker, Aldus FreeHand, Adobe Photoshop, QuarkXPress, Adobe Illustrator and Corel Draw.

First Contact & Terms: Samples are filed. Does not report back. Artist should call. Portfolio review not required. Pays for design and illustration by the project. Buys all rights.

‡THE MARKETING CONNECTION, 93 Piquette, Detroit MI 48202. (313)873-7744. Fax: (313)873-0799. Contact: Leon Lebeau. Estab. 1958. Number of employees: 10. AV firm. Full-service, multimedia firm. Specializes in electronic presentations/business meetings. Product specialties are automotive, boating and restaurant. Client list available upon request.

Needs: Approached by 20-50 freelancers/year. Works with 20-30 freelance illustrators and 10-20 designers/year. Prefers artists with experience in Windows/Mac. Uses freelancers for computer graphics. Also for animation, annual reports, brochure design and illustration, retouching, TV/film graphics and AV/presentations. 5% of work is with prints ads. Needs computer-literate freelancers for design, illustration, production and presentation. 90% of freelance work demands knowledge of Adobe Photoshop, Adobe Illustrator and all window applications.

First Contact & Terms: Send query letter with résumé. Samples are filed. Reports back to the artist only if interested. Artist should follow-up with call after initial query. Payment negotiable. Buys all rights.

PHOTO COMMUNICATION SERVICES, INC., 6055 Robert Dr., Traverse City MI 49864. (616)943-8800. Contact: M'Lynn Hartwell. Estab. 1970. Full-service, multimedia AV firm. Specializes in corporate and industrial products.

Needs: Approached by 24-36 freelancers/year. Works with 12 illustrators/year. Works on assignment only. Uses freelancers mainly for animated illustration. Also for brochure, catalog and print ad design and illustration; storyboards; slide illustration; animation; retouching; lettering; and logos. 30% of work is with print ads.

First Contact & Term: Send query with brochure, SASE and tearsheets. Samples are filed or returned by SASE if requested by artist. Reports back only if interested. To show portfolio, mail tearsheets and transparencies. Pays for design and illustration by the project, $25 minimum. Rights purchased vary according to project.

J. WALTER THOMPSON USA, One Detroit Center, 500 Woodward Ave., Detroit MI 48226-3428. (313)964-3800. Art Administrator: Maryann Inson. Number of employees: 450. Approximate annual billing: $50 million. Ad agency. Clients: automotive, consumer, industry, media and retail-related accounts.

Needs: Approached by 50 freelancers/year. Works with 25 freelance illustrators/year. "Prefer using local talent. Will use out-of-town talent based on unique style." Deals primarily with established artists' representatives and art/design studios. Uses in-house computer/graphic studio.

First Contact & Terms: Contact only through artist's agent. Assignments awarded on lowest bid. Call for appointment to show portfolio of thumbnails, roughs, original/final art, final reproduction/product, color tearsheets, photostats and photographs. Pays for design and illustration by the project.

Tips: "Portfolio should be comprehensive but not too large. Organization of the portfolio is as important as the sample. Mainly, consult professional rep."

Minnesota

‡BADIYAN PRODUCTIONS INC., Dept. AM, 720 W. 94 St., Minneapolis MN 55420. (612)888-5507. President: Fred Badiyan. Number of employees: 13. AV firm. Client list provided upon request.

Needs: Approached by 30 freelancers/year. Works with 8 freelance illustrators and 4 designers/year. Works on assignment only. Uses freelancers for design, brochures, mechanicals, press releases and motion pictures.

First Contact & Terms: Send query letter with brochure or résumé, tearsheets, photocopies and slides. Samples are filed or are returned. Write for appointment to show portfolio or mail appropriate materials. Pays for design and illustration by the hour or by the project.

Tips: "Send a letter and sample of work."

‡LAYTON MARKETING GROUP, 1212 Red Fox Rd., Arden Hills MN 55112. (612)779-8000. Fax: (612)779-8409. Estab. 1984. Number of employees: 20. Approximate annual billing: $200,000. Ad agency. Specializes in direct mail, direct response and market research. Product specialty is business-to-business. Professional affiliations: MDMA and DMA.

Needs: Approached by 15 freelancers/year. Works with 3 freelance illustrators and 2 designers/year. Prefers local artists only. Uses freelancers for brochure design and illustration. 10% of work is with print ads. Needs computer-literate freelancers for production. 50% of freelance work demands knowledge of Aldus PageMaker, Adobe Photoshop, QuarkXPress and Adobe Illustrator for IBM PC.

First Contact & Terms: Send postcard-size sample of work. Samples are filed or returned by SASE if requested by artist. Art Director will contact artist for portfolio review if interested. Portfolio should include color photostats, tearsheets and thumbnails. Pays for design and illustration by the project, $250-5,000. Rights purchased vary according to project.

RENNER-BURNS ADVERTISING, INC., 7600 Parklawn Ave., Suite 400, Edina MN 55435. (612)831-7725. Art Director: Mike Christiansen. Estab. 1977. Number of employees: 4. Approximate annual billing: $2.1 million. Full-service ad agency providing finished materials to client (publication, radio or TV station). Specializes in public utilities and home services. Current clients include Northern States Power Co.-Wisconsin, R.C. Smith Co., Sedgwick Heating & Air Conditioning and American Linen. Professional affiliations: Utilities Communicators International, American Advertising Federation.

Needs: Approached by 50 freelancers/year. Works with 4-6 illustrators and 1-2 designers/year. Prefers local freelancers. Works on assignment only. Uses freelancers mainly for technical and editorial illustration and photography. Also for brochure, catalog and print ad illustration; animation; mechanicals; retouching; TV/film graphics; lettering; and logos. 40% of work is with print ads. Does not require computer-literate freelancers.

First Contact & Terms: Send query letter with brochure and photographs. Samples are filed or are returned by SASE if requested by artist. Reports back to the artist only if interested. Call for appointment to show portfolio of original/final art, final reproduction/product, photographs and slides. Include color and b&w samples. Pays for design by the project, $100-1,000. Pays for illustration by the project, $100-2,500. Considers complexity of project, client's budget and turnaround time when establishing payment. Buys all rights.

Tips: Finds artists primarily through agents/artists reps and sourcebook/mailers. "Send representative samples. Be flexible about pricing. Be persistent with mailings but not pushy about showing a portfolio."

‡TAKE 1 PRODUCTIONS, 5325 W. 74th St., Minneapolis MN 55439. (612)831-7757. Fax: (612)831-2193. Producer: Rob Hewitt. Estab. 1985. Number of employees: 5. Approximate annual billing: $500,000. AV firm. Full-service, multimedia firm. Specializes in video productions. Specialty is industrial. Current clients include 3M, NordicTrack and Kraft. Client list available upon request. Professional affiliations: ITVA, SME.

Needs: Approached by 100 freelancers/year. Works with 10 freelance illustrators/year. Prefers freelancers with experience in video production. Uses freelancers for graphics, sets. Also for animation, brochure design, logos, model making, signage and TV/film graphics. 2% of work is with print ads. Needs computer-literate freelancers for production. 90% of freelance work demands knowledge of Adobe Photoshop and Lightwave.

First Contact & Terms: Send query letter with video. Samples are filed. Art Director will contact artist for portfolio review if interested. Pays for design and illustration by the hour or by the project. Rights purchased vary according to project.

Tips: Finds artists through sourcebooks, word of mouth. "Tell me about work you have done with videos."

Mississippi

‡VON SUTHÖFF & CO. ADVERTISING INC., 811 Tucker Ave., Pascagoula MS 39567. (601)762-9674. Fax: (601)762-7363. Creative Director: Eric Suthöff. Estab. 1987. Number of employees: 4. Ad agency. Full-service, multimedia firm. Specializes in broadcast and corporate film/video, magazine, billboard, logos. Specialties are financial, auto, event, electronics, defense, industrial. Client list not available. Professional affiliations: American Ad Federation (AAF).
Needs: Approached by 20 freelancers/year. Works with 12 freelance illustrators and 6 designers/year. Uses freelancers mainly for magazine ads, billboard, logo, brochures. Also for animation, brochure illustration, posters, signage and TV/film graphics. 50% of work is with print ads. Needs computer-literate freelancers for design. 75% of freelance work demands knowledge of Aldus PageMaker 5.0, Adobe Photoshop 2.5, QuarkXPress 3.1 and Corel Draw 5.0.
First Contact & Terms: Send postcard-size sample of work. Samples are filed. Art Director will contact artist for portfolio review if interested. Pays for design by the hour, $15-80; by the project, $100 minimum. Pays for illustration by the hour, $15 minimum; by the hour, $100 minimum. Rights purchased vary according to project.
Tips: Finds artists through sourcebooks like *Workbook* and word of mouth. "Send us a package, postcard or other sample and follow up with a phone call within the week of anticipated arrival."

Missouri

ANGEL FILMS COMPANY, 967 Hwy. 40, New Franklin MO 65274-9778. Phone/fax: Vice President of Marketing/Advertising: Linda G. Grotzinger. Estab. 1980. Number of employees: 9. Approximate annual billing: more than $10 million. Ad agency, AV firm, PR firm. Full-service, multi-media firm. Specializes in "all forms of television and film work plus animation (both computer and art work)." Product specialties are feature films, TV productions, cosmetics. Current clients include Azian, Mesn, Angel One Records.
Needs: Approached by 100 freelancers/year. Works with 10 freelance illustrators and 10 designers/year. Prefers freelancers with experience in graphic arts and computers. Works on assignment only. Uses freelancers mainly for primary work ("then we computerize the work"). Also for brochure and print ad design and illustration, storyboards, animation, model making, posters and TV/film graphics. 45% of work is with print ads. Needs computer-literate freelancers for design, illustration and production. 40% of freelance work demands knowledge of Adobe Illustrator, Adobe Photoshop or Corel Draw.
First Contact & Terms: Send query letter with résumé and SASE. Samples are filed. Reports back within 1 month. Art Director will contact artist for portfolio review if interested. Portfolio should include b&w and color slides and computer disks (IBM). Pays for design and llustration by the hour, $8.19 minimum. Buys all rights.
Tips: "You can best impress us with what you can do now not what you did ten years ago. Times change; the way people want work done changes also with the times. Disney of today is not the same as Disney of ten or even five years ago."

BRYAN/DONALD, INC. ADVERTISING, 2345 Grand, Suite 1625, Kansas City MO 64108. (816)471-4866. E-mail: 76443.3156@compserve.com. President: Don Funk. Number of employees: 9. Approximate annual billing: $3.5 million.
Multimedia, full-service ad agency. Clients: food, pharmaceutical chemicals, insurance, hotels, franchises.
Needs: Works with 6 freelance illuatrators and 2 designers/year. Works on assignment only. Uses freelancers for design, illustration, brochures, catalogs, books, newspapers, consumer and trade magazines, P-O-P display, mechanicals, retouching, animation, billboards, posters, direct mail packages, lettering, logos, charts/graphs and ads.
First Contact & Terms: Send samples showing your style. Samples are not filed and are not returned. Reports back only if interested. Call for appointment to show portfolio. Considers complexity of project and skill and experience of artist when establishing payment. Buys all rights.

‡DRONE AND MUELLER AND ASSOCIATES, 12977 N. Forty Dr., Suite 100, St. Louis MO 63141. (314)434-3141. Fax: (314)434-7741. Vice President Creative Services: Paul F. Renna. Estab. 1984. Number of employees: 22. Ad agency. Specializes in ads, catalogs and collateral. Product specialty is manufacturing.
Needs: Works with 3 freelance illustrators/year. Prefers local artists only. Uses freelancers for brochure and catalog illustration and retouching. 20% of work is with print ads. Needs computer-literate freelancers for design, illustration and production. 50% of freelance work demands knowledge of Adobe Photoshop, Quark-XPress and Adobe Illustrator.
First Contact & Terms: Send query letter. Samples are filed. Reports back to artist only if interested. Request portfolio review in original query. Pays for design and illustration by the project. Buys all rights.

‡GILBERT, CHRISTOPHER & ASSOCIATES MARKETING COMMUNICATIONS, 4717 Central St., Kansas City MO 64112. (816)561-8120. Fax: (816)561-8087. Contact: Creative Director. Estab. 1990. Number

of employees: 14. Approximate annual billing: $2 million. Ad agency. Full-service, multimedia firm. Specializes in magazine and newspaper ads, collateral, annual reports, packaging, direct marketing, point of sale displays. Product specialties are healthcare, consumer, manufacturing and financial. Client list not available. Professional affiliations: PRSA.

Needs: Approached by 20 freelancers/year. Works with 4 freelance illustrators and 6 designers/year. Prefers local artists only. Uses freelancers mainly for design and illustration. Also for annual reports, billboards, brochure and catalog design and illustration, logos, mechanicals, model making, posters, retouching, signage, TV/film graphics and packaging. 50% of work is with print ads. Needs computer-literate freelancers for design, illustration and production. 95% of freelance work demands knowledge of Aldus FreeHand, Adobe Photoshop, QuarkXPress and Adobe Illustrator.

First Contact & Terms: Send postcard-size sample of work or send query letter with brochure, photocopies, résumé and tearsheets. Samples are filed and are not returned. Art Director will contact artist for portfolio review if interested. Portfolio should include b&w and color final art, roughs, tearsheets and thumbnails. Pays for design and illustration by the project. Rights purchased vary according to project.

Tips: Finds artists through word of mouth, artists' submissions. "Show diversity."

MEDIA CONSULTANTS, P.O. Box 130, Sikeston MO 63801. (314)472-1116. Fax: (314)472-3299. President: Rich Wrather. Estab. 1981. Number of employees: 10. Ad agency, AV and PR firm. Full-service, multimedia firm. Specializes in print, magazines, AV. Product specialty is business-to-business. Client list not available.

Needs: Appoached by 25 freelancers/year. Works with 10-15 freelance illustrators and 5-10 designers/year. Works on assignment only. Uses freelancers mainly for layout and final art. Also for brochure, catalog and print ad design and illustration; storyboards; animation; billboards; TV/film graphics; and logos. 40% of work is with print ads. Needs computer-literate freelancers for design, illustration, production and presentation. 100% of freelance work demands knowledge of Aldus PageMaker, Aldus FreeHand or Adobe Photoshop.

First Contact & Terms: Send query letter with brochure, résumé, photocopies, photographs, SASE and tearsheets. Samples are filed or are returned by SASE. Art Director will contact artist for portfolio review if interested. Portfolio should include b&w and color roughs, final art, tearsheets, photostats and photographs. Pays for design by the project, $150-1,000. Pays for illustration by the project, $25-250. Buys all rights.

Tips: Finds artists through word of mouth.

PHOENIX FILMS, 2349 Chaffee Dr., St. Louis MO 63146. (314)569-0211. President: Heinz Gelles. Vice President: Barbara Bryant. Number of employees: 50. Clients: libraries, museums, religious institutions, US government, schools, universities, film societies and businesses. Produces and distributes educational films.

Needs: Works with 2-3 freelance illustrators and 1-2 designers/year. Prefers local freelancers only. Uses artists for motion picture catalog sheets, direct mail brochures, posters and study guides.

First Contact & Terms: Query with samples (tearsheets and photocopies). Send SASE. Send recent samples of artwork and rates to director of promotions. "No telephone calls please." Reports if need arises. Buys all rights. Keeps all original art "but will loan to artist for use as a sample." Pays for design and illustration by the hour or by the project. Rates negotiable. Free catalog upon written request.

STOBIE BRACE, 240 Sovereign Court, St. Louis MO 63011. (314)256-9400. Fax: (314)256-0943. Creative Director: Mary Tuttle. Estab. 1935. Number of employees: 10. Approximate annual billing: $3.5 million. Ad agency. Full-service, multimedia firm. Product specialties are business-to-business, industrial and consumer services. Current clients include Brown-Forman Co. (Korbel Champagne), Dine-Mor Foods, Star Manufacturing. Professional affiliation: AAAA.

Needs: Approached by 100-150 freelancers/year. Works with 12 freelance illustrators and 6 designers/year. Uses freelancers for illustration, production and retouching. Also for brochure, catalog, print ad and slide illustration; storyboards; mechanicals; and lettering. 40% of work is with print ads. Needs computer-literate freelancers for design, illustration, production and presentation. 75% of freelance work demands knowledge of QuarkXPress or Adobe Illustrator. Needs technical, medical and creative illustration.

First Contact & Terms: Send query letter with résumé, photostats, photocopies, and slides. Samples are filed or are returned by SASE if requested by artist. Art Director will contact artist for portfolio review if interested. Portfolios may be dropped off Monday-Friday. Portfolio should include thumbnails, roughs, original/final art and tearsheets. Sometimes requests work on spec before assigning a job. Pays for design by the project, $150-5,000. Pays for illustration by the project. Negotiates rights purchased.

Tips: Finds artists through word of mouth, reps and work samples. Freelancers "must be well organized; meet deadlines; listen well; have concise portfolio of abilities."

‡WEST ASSOCIATES ADVERTISING AND DESIGN, INC., 4144 Pennsylvania, Kansas City MO 64111. (816)561-2022. Fax: (816)561-2688. Creative Director: Stan Chrzanowski. Estab. 1974. Number of employees: 8. Approximate annual billing: $600,000. Design firm and agency. Full-service, multimedia firm. Client list available upon request. Professional affiliation: AIGA.

Needs: Approached by 50 freelancers/year. Works with 4-6 freelance illustrators and 1-2 designers/year. Uses freelancers mainly for illustration. Also for animation, lettering, mechanicals, model making, retouching and TV/film graphics. 20% of work is with print ads. Needs computer-literate freelancers for design, illustration and production. 95% of freelance work demands knowledge of Aldus FreeHand, Adobe Photoshop, QuarkXPress and Adobe Illustrator.

First Contact & Terms: Send postcard-size sample of work or send query letter with brochure, photocopies, résumé, SASE, slides, tearsheets and transparencies. Samples are filed or returned by SASE if requested by artist. Reports back to the artist only if interested. Portfolios may be dropped off every Monday-Thursday. Portfolios should include color photographs, roughs, slides and tearsheets. "Each project is bid." Rights purchased vary according to project.

Tips: Finds artists through *Creative Black Book* and *Workbook*.

Nebraska

BAUER, KAHLER & MORSE COMMUNICATIONS, 2407 S. 130th Circle, Omaha NE 68144. (402)334-6900. Chief Operating Officer: Linda Morse. Ad agency/PR firm. Clients: bank, industry, restaurant, tourist and retail.

Needs: Works on assignment only. Uses freelancers for consumer and trade magazines, billboards, direct mail packages, brochures, newspapers, stationery, signage, P-O-P displays, AV presentations, posters, press releases, trade show displays and TV graphics. "Freelancing is based on heavy workloads. Most freelancing is paste-up but secondary is illustration for designed element."

First Contact & Terms: Send query letter with résumé and slides to be kept on file. Samples not filed are returned by SASE. Reports back within 10 days. Write for appointment to show portfolio, "if regional/national; call if local." Portfolio should include thumbnails, roughs, original/final art, final reproduction/product, color tearsheets and photostats. Pays by the project, $100-1,500 average. Buys all rights.

Tips: "Be prompt and be able to price your project work accurately. Make quality first."

J. GREG SMITH, 1004 Farnam St., Burlington Place, Suite 102, Omaha NE 68102. (402)444-1600. Senior Art Director: Karen Gehrki. Estab. 1974. Number of employees: 8. Approximate annual billing: $1.5 million. Ad agency. Clients: financial, banking, associations, agricultural, travel and tourism, insurance. Professional affiliation: AAAA.

Needs: Approached by 1 freelancer/year. Works with 4-5 freelancers illustrators and 1-2 designers/year. Works on assignment only. Uses freelancers mainly for mailers, brochures and projects. Also for consumer and trade magazines, catalogs and AV presentations. Needs illustrations of farming, nature, travel.

First Contact & Terms: Send query letter with brochure showing art style or photocopies. Reports only if interested. To show portfolio, mail final reproduction/product, color and b&w. Pays for design and illustration by the project, $500-5,000. Buys first, reprint or all rights.

New Hampshire

CORPORATE COMMUNICATIONS, INC., Main St. Box 854, N. Conway NH 03860. (603)356-7011. President: Kim Beals. Estab. 1983. Ad agency and PR firm. Specializes in advertising, marketing and public relations. Product specialties are hospitality, sports events, insurance, real estate. Client list not available.

Needs: Approached by 36-60 freelancers/yaer. Works with 12-24 freelance illustrators and 24-36 designers/year. Works on assignment only. Uses freelancers for brochure, catalog and print ad design and illustration; storyboards; mechanicals; billboards; posters; TV/film graphics; lettering; and logos. 15% of work is with print ads. Needs computer-literate freelancers for design, illustration, production and presentation. 50% of work demands knowledge of Aldus PageMaker, QuarkXPress, Aldus FreeHand, Adobe Illustrator or Adobe Photoshop. "Freehand skills also required."

First Contact & Terms: Send query letter with brochure, résumé, photocopies, photographs and tearsheets. Samples are filed. Reports back to the artist only if interested. Artist should follow-up with a letter after initial query. Art Director will contact artist for portfolio review if interested. Portfolio should include b&w and color thumbnails, roughs, final art, tearsheets, slides, photostats, photographs and transparencies. Pays for design and illustration by the hour or by the project. "Rates vary." Buys all rights.

New Jersey

AM/PM ADVERTISING INC., 345 Claremont Ave., Suite 26, Montclair NJ 07042. (201)824-8600. Fax: (201)824-6631. President: Bob Saks. Estab. 1962. Number of employees: 130. Approximate annual billing: $18 million. Ad agency. Full-service, multimedia firm. Specializes in national TV commercials and print ads. Product specialties are health and beauty aids. Current clients include J&J, Bristol Myers, Colgate

Palmolive. Client list available upon request. Professional affiliations: AIGA, Art Directors Club, Illustration Club.

Needs: Approached by 35 freelancers/year. Works with 15 freelance illustrators and 15 designers/year. Works only with artist reps. Works on assignment only. Uses freelancers mainly for illustration and design. Also for brochure and print ad design and illustration, storyboards, slide illustration, animation, mechanicals, retouching, model making, billboards, posters, TV/film graphics, lettering and logos. 30% of work is with print ads. Needs computer-literate freelancers for design, illustration, production and presentation. 50% of work demands knowledge of Aldus PageMaker, QuarkXPress, Aldus FreeHand, Adobe Illustrator or Adobe Photoshop.

First Contact & Terms: Send query letter with brochure, résumé, photostats, transparencies, photocopies, photographs, slides and tearsheets. Samples are filed or returned. Reports back within 10 days. Portfolios may be dropped off every Friday. Artist should follow up after initial query. Portfolio should include b&w and color thumbnails, roughs, final art, tearsheets, photographs and transparencies. Pays for design by the hour, $40-200; by the project, $500-5,000; or by the day, $200-1,000. Pays for illustration by the project, $200-5,000. Rights purchased vary according to project.

BLOCK ADVERTISING & MARKETING, INC., 3 Clairidge Dr., Verona NJ 07044. (201)857-3900. Fax: (201)857-4041. Senior VP/Creative Director: Karen DeLuca. Estab. 1939. Number of employees: 23. Approximate annual billing: $6 million. Product specialties are electronics, finance, home fashion, healthcare and industrial manufacturing. Professional affiliations: Ad Club of New Jersey.

Needs: Approached by 100 freelancers/year. Works with 25 freelance illustrators and 25 designers/year. Prefers to work with "freelancers with at least 3-5 years experience as Mac comp artists and 'on premises' work as Mac artists." Uses freelancers for "consumer friendly" technical illustration, layout, lettering, type spec, mechanicals and retouching for ads, annual reports, billboards, catalogs, letterhead, brochures and trademarks. Needs computer-literate freelancers for design and presentation. 90% of freelance work demands knowledge of QuarkXPress, Adobe Illustrator, Type-Styler or Photoshop.

First Contact & Terms: To show portfolio, mail appropriate samples and follow up with a phone call. Include SASE. Reports in 2 weeks. Pays for design by the hour, $20-50. Pays for illustration by the project, $150-5,000.

Tips: "Please send some kind of sample of work. If mechanical artist, send line art printed sample. If layout artist, send composition of some type and photographs or illustrations. We are fortunately busy—we use 4-6 freelancers daily."

CREATIVE ASSOCIATES, Dept. AM, 44 Park Ave., Madison NJ 07044. (201)377-4440. Producer: Harrison Feather. Estab. 1970. AV firm. "We are a multimedia production facility providing photography, video post-production, slide shows, computer graphics, desktop publishing, scriptwriting services for sales meetings, trade shows, speaker support and entertainment." Clients: high-tech, pharmaceutical, computer, R&D labs, engineering and marine.

Needs: Works with 5 freelancers/year. Assigns 10 jobs/year. Works on assignment only. Uses freelancers for design, illustration, motion pictures and charts/graphs.

First Contact & Terms: Send query letter with brochure or résumé and slides. Samples are filed or are returned by SASE. Call for appointment to show portfolio of original/final art, slides and video cassette. Pays for design (computer-generated art) by the project, $500 minimum. Pays for illustration by the project, $300 minimum. Rights purchased vary according to project.

NORMAN DIEGNAN & ASSOCIATES, 343 Martens Rd., Lebanon NJ 08833. (908)832-7951. President: N. Diegnan. Estab. 1977. Number of employees: 5. Approximate annual billing: $1 million. PR firm. Specializes in magazine ads. Product specialty is industrial.

Needs: Approached by 10 freelancers/year. Works with 20 freelance illustrators/year. Works on assignment only. Uses freelancers for brochure, catalog and print ad design and illustration; storyboards; slide illustration; animatics; animation; mechanicals; retouching; and posters. 50% of work is with print ads. Needs computer-literate freelancers for design and illustration. Needs editorial and technical illustration.

First Contact & Terms: Send query letter with brochure and tearsheets. Samples are filed and are not returned. Reports back within 1 week. To show portfolio, mail roughs. Pays for design and illustration by the project. Rights purchased vary according to project.

GARDEN STATE MARKETING SERVICES, INC., Box 343, Oakland NJ 07436. (201)337-3888. Fax: (201)337-8164. President: Jack Doherty. Estab. 1976. Service-related firm providing public relations and advertising services, mailing services and fulfillment. Specializes in direct mail. Clients: associations, publishers, manufacturers.

Needs: Approached by 15 freelancers/year. Works with 4 illustrators and 4 designers/year. Assigns 10 jobs to freelancers/year. Works on assignment only. Uses freelancers for advertising and brochure design, illustration and layout and display fixture design, P-O-P displays and posters. Needs editorial, medical and technical illustrations, realistic style.

First Contact & Terms: Send query letter with résumé, business card and copies to be kept on file. Samples not filed are returned. Art Director will contact artist for portfolio review if interested. Portfolio should include thumbnails, final reproduction/product, b&w and color tearsheets and photographs. Sometimes requests work on spec before assigning job. Pays for design and illustration by the hour, $50 minimum; by the project, $200 minimum. Considers complexity of project, skill and experience of artist and how work will be used when establishing payment.
Tips: Finds artists through word of mouth and submissions.

‡IMPACT COMMUNICATIONS, INC., 1300 Mt. Kemble Ave., Morristown NJ 07960. (201)425-0700. Fax: (201)425-0505. E-mail: impact@planet.net. Vice President: Fred Lawless. Estab. 1983. Number of employees: 15. Marketing communications firm. Full-service, multimedia firm. Specializes in electronic media, business-to-business and print design. Current clients include AT&T, BASF, Schering-Plough, Warner-Lambert and Ricoh. Client list not available. Professional affiliations: IICS, NCCC and ITVA.
Needs: Approached by 12 freelancers/year. Works with 4 freelance illustrators and 2 designers/year. Uses freelancers mainly for illustration, design and computer production. Also for brochure and catalog design and illustration, logos. 10% of work is with print ads. Needs computer-literate freelancers for design, illustration, production and presentation. 70% of freelance work demands knowledge of Adobe Photoshop, QuarkXPress and Macro Media Director.
First Contact & Terms: Send query letter with brochure, photocopies, photographs, photostats, résumé and tearsheets. Samples are filed and are not returned. Art Director will contact artist for portfolio review if interested. Portfolio should include b&w and color final art, photographs, photostats, roughs, slides, tearsheets and thumbnails. Pays for design and illustration by the project, depending on budget. Rights purchased vary according to project.
Tips: Finds artists through sourcebooks and self-promotion pieces received in mail. "Be flexible."

‡INSIGHT ASSOCIATES, 149 Rita Lane, Oak Ridge NJ 07438. (201)697-0880. Fax: (201)697-6904. President: Raymond Valente. Estab. 1979. Business communications firm. Full-service, multimedia firm. Specializes in video programs, manuals, interactive media. Product specialties are training, meetings. Client list available upon request.
Needs: Approached by 6 freelancers/year. Prefers freelancers with experience in design for video and ancillary materials. Uses freelancers for catalog design and illustration and TV/film graphics. Needs computer-literate freelancers for design and illustration. 60% of freelance work demands knowledge of Aldus PageMaker and QuarkXPress.
First Contact & Terms: Send query letter with résumé. Samples are filed or returned by SASE if requested by artist. Art Director will contact artist for portfolio review if interested. Pays for design and illustration by the project.
Tips: Finds artists through associated vendors, i.e., print shops, etc.

JANUARY PRODUCTIONS, INC., 210 Sixth Ave., Hawthorne NJ 07507. (201)423-4666. Fax: (201)423-5569. Art Director: Karen Neulinger. Estab. 1973. Number of employees: 7. AV producer. Serves clients in education. Produces children's educational materials—videos, sound filmstrips and read-along books and cassettes.
Needs: Works with 1-2 freelance illustrators/year. "While not a requirement, a freelancer living in the same geographic area is a plus." Works on assignment only, "although if someone had a project already put together, we would consider it." Uses freelancers mainly for illustrating children's books. Also for artwork for filmstrips, sketches for books and layout work. Freelancers should be familiar with Mac programs—Quark, FreeHand, Photoshop.
First Contact & Terms: Send query letter with résumé, tearsheets, photocopies and photographs. Art Director will contact artist for portfolio review if interested. "Include child-oriented drawings in your portfolio." Requests work on spec before assigning a job. Pays for design and illustration by the project, $20 minimum. Originals not returned. Buys all rights.
Tips: Finds artists through submissions.

KJD TELEPRODUCTIONS, 30 Whyte Dr., Voorhees NJ 08043. (609)751-3500. Fax: (609)751-7729. President: Larry Scott. Estab. 1989. Ad agency/AV firm. Full-service, multimedia firm. Specializes in magazine, radio and television. Current clients include ICI America's and Taylors Nightclub.
Needs: Works with 12-48 freelance illustrators and 12-48 designers/year. Prefers freelancers with experience in TV. Works on assignment only. Uses freelancers for brochure and print ad design and illustration, storyboards, animatics, animation, TV/film graphics. 70% of work is with print ads.
First Contact & Terms: Send query letter with brochure, résumé, photographs, slides and videotape. Samples are filed or are returned by SASE. Reports back to the artist only if interested. To show portfolio, mail roughs, photographs and slides. Pays for design and illustration by the project; rate varies. Buys first rights or all rights.

MCS, INC., 86 Summit Ave., Summit NJ 07901. (908)273-9626. Fax: (908)273-6487. Executive Vice President: Valerie Irkin. Estab. 1985. PR firm. Full-service, multimedia firm. Specializes in brochures, videos,

monographs, press kits, special events, newsletters. Product specialty is health care. Current clients include Lederle Laboratories, Genentech, Amgen and Zeneca.

Needs: Approached by 24 freelancers/year. Works with 12 freelance illustrators and 24 designers/year. Prefers local freelancers with experience in logo design and layout. Works on assignment only. Uses freelancers mainly for design of logos, brochures and collateral material. Also for mechanicals and presentation boards. Needs computer-literate freelancers for design, production and presentation. 50% of freelance work demands computer skills.

First Contact & Terms: Send query letter with brochure, SASE, résumé, photographs and samples. Samples are filed and are returned by SASE only if requested by artist. Does not report back. Artist should follow up. Call for appointment to show portfolio of roughs, final art, b&w and color tearsheets, photographs and printed samples. Sometimes requests work on spec before assigning a job. Pays for design and illustration by the project, $500 minimum. Rights purchased vary according to project.

Tips: Finds artists through word of mouth, printers, artists' mailings. "Creative design is going to be more sensitive to the needs of the audience—legibility, color selection."

OXFORD COMMUNICATIONS, INC., 287 S. Main St., Lambertville NJ 08530. (609)397-4242. Fax: (609)397-8863. Creative Director: Chuck Whitmore. Estab. 1986. Ad agency. Full-service, multimedia firm. Specializes in print advertising and collateral. Product specialties are health care, real estate and hightech.

Needs: Approached by 6 freelancers/month. Works with 1 illustrator and 3 designers every 6 months. Prefers local freelancers with experience in comping and desktop publishing. Uses freelancers mainly for mechanicals. Also for brochure design and illustration, technical and fashion illustration, print ad illustration, mechanicals, retouching and logos. 75% of work is with print ads.

First Contact & Terms: Send query letter with photocopies and résumé. Samples are filed. Reports back to the artist only if interested. Art Director will contact artist for portfolio review if interested. Portfolio should include b&w and/or color photostats, tearsheets, photographs and slides. Pays for design and illustration by the project, negotiable. Rights purchased vary according to project.

SUEDE COMMUNICATION CENTER, 685 Main St., Hackensack NJ 07601. (201)646-0416. Estab. 1971. Number of employees: 4. Approximate annual billing: $125,000. AV firm. Full-service, multimedia firm. Specializes in radio and TV documentaries, corporate videos, CD-ROM. Current clients include AT&T, IBM. Client list available upon request. Professional affiliation: SAG.

Needs: Approached by 2 freelancers/year. Works with 3 freelance illustrators and 3 designers/year. Prefers local freelancers only. Works on assignment only. Uses freelancers mainly for TV and magazine ads. Also for brochure and catalog design, print ad illustration, storyboards, slide illustration, TV/film graphics and logos. 20% of work is with print ads. Needs computer-literate freelancers for production and presentation. 90% of freelance work demands knowledge of Aldus PageMaker or Adobe Illustrator.

First Contact & Terms: Contact through artist rep or send query letter. Samples are filed. Reports back within 3 weeks. Request portfolio review in original query. Portfolio should include b&w and color thumbnails, photographs, roughs, transparencies, tearsheets and photostats. Pays for design and illustration by the project. Rights purchased vary according to project.

New Mexico

‡R H POWER AND ASSOCIATES, 6616 Gulton Ct., N.E., Albuquerque NM 87109. (505)761-3150. Fax: (503)761-3153. Art Director: Mark Hellyer. Estab. 1989. Number of employees: 12. Ad agency. Full-service, multimedia firm. Specializes in TV, magazine, billboard, direct mail, newspaper, radio. Product specialties are recreational vehicles and automotive. Current clients include Holiday RV Super Stores, Venture Out RV, Frost Mortgage. Client list available upon request.

Needs: Approached by 10-50 freelancers/year. Works with 5-10 freelance illustrators and 5-10 designers/year. Prefers freelancers with experience in retail automotive layout and design. Uses freelancers mainly for work overload, special projects and illustrations. Also for annual reports, billboards, brochure and catalog design and illustration, logos, mechanicals, posters and TV/film graphics. 50% of work is with print ads. Needs computer-literate freelancers for design, production and presentation. 75% of freelance work demands knowledge of Adobe Photoshop, Corel Draw 5.0 and Ventura Publisher.

First Contact & Terms: Send query letter with photocopies or photographs and résumé. Samples are filed and are not returned. Art Director will contact artist for portfolio review if interested. Portfolio should include b&w and color final art, roughs and thumbnails. Pays for design and illustration by the hour, $8 minimum; by the project, $50 minimum. Buys all rights.

Tips: Impressed by work ethic and quality of finished product. "Deliver on time and within budget. Do it until it's right without charging for your own corrections."

New York

CHANNEL ONE PRODUCTIONS, INC., 82-03 Utopia Pkwy., Jamaica Estates NY 11432. (718)380-2525. President: Burton M. Putterman. AV firm. "We are a multimedia, film and video production company for broadcast, image enhancement and P-O-P displays." Clients: multi-national corporations, recreational industry and PBS.
Needs: Works with 25 freelancers/year. Assigns 100 jobs/year. Prefers local freelancers. Works on assignment only. Uses freelancers mainly for work on brochures, catalogs, P-O-P displays, animation, direct mail packages, motion pictures, logos and advertisements. Needs technical illustration. Needs computer-literate freelancers for design, production and presentation. 100% of freelance work demands knowledge of Aldus PageMaker, Aldus FreeHand or Adobe Illustrator.
First Contact & Terms: Send query letter with résumé, slides and photographs. Samples are not filed and are returned by SASE. Reports back within 2 weeks only if interested. Call to schedule an appointment to show a portfolio of original/final art, final reproduction/product, slides, video disks and videotape. Pays for design by the project, $400 minimum. Considers complexity of project and client's budget when establishing payment. Rights purchased vary according to project.
Tips: "Our freelance needs have increased."

FASTFORWARD COMMUNICATIONS INC., 401 Columbus Ave., Valhalla NY 10595. (914)741-0555. Fax: (914)741-0597. Vice President: J. Martorano. Estab. 1986. Ad agency/PR firm. Specialties are high technology and entertainment. Current clients include Nynex, AT&T, Chesebrough-Ponds, Farberware and Philip Morris International.
Needs: Approached by 72 freelancers/year. Works with 12 freelance illustrators and 12-24 designers/year. Works on assignment only. Uses freelancers mainly for Macintosh work. Also for brochure and catalog design and illustration and TV/film graphics. 90% of work is with printed material. 75% of freelance work demands knowledge of QuarkXPress, Aldus Freehand, Adobe Illustrator and Photoshop.
First Contact & Terms: Send query letter with samples, rates and résumé. Samples are filed or are returned by SASE. Reports back to the artist only if interested. To show portfolio, mail thumbnails, roughs and b&w or color tearsheets. Pays for design and illustration by the project. Rights purchased vary according to project.

FINE ART PRODUCTIONS, 67 Maple St., Newburgh NY 12550. Phone/fax: (914)561-5866. Contact: Richie Suraci. Estab. 1990. Ad agency, AV and PR firm. Full-service, multimedia firm. Specializes in film, video, print, magazine, documentaries and collateral. "Product specialties cover a broad range of categories."
● Fine Art Productions is looking for artists who specialize in science fiction and erotic art for upcoming projects.
Needs: Approached by 288 freelancers/year. Works with 12-48 freelance illustrators and 12-48 designers/year. "Everyone is welcome to submit work for consideration in all media." Works on assignment only. Uses freelancers for brochure, catalog and print ad design and illustration; storyboards; slide illustration; animatics; animation; mechanicals; retouching; billboards; posters; TV/film graphics; lettering; and logos. Needs editorial, technical, science fiction, jungle, adventure, children's, fantasy and erotic illustration. 20% of work is with print ads. Needs computer-literate freelancers for design, illustration, production and presentation. 20% of freelance work demands knowledge of Aldus PageMaker, QuarkXPress, Aldus FreeHand, Adobe Illustrator or Adobe Photoshop.
First Contact & Terms: Send query letter with brochure, photocopies, résumé, photographs, tearsheets, photostats, slides, transparencies and SASE. Samples are filed or returned by SASE if requested by artist. Reports back in 4-6 months if interested. Art Director will contact artist for portfolio review if interested. Portfolio should include thumbnails, roughs, b&w and color photostats, tearsheets, photographs, slides and transparencies. Requests work on spec before assigning a job. Pays for design and illustration by the project; negotiable. Rights purchased vary according to project.
Tips: "We need more freelance artists."

‡HUMAN RELATIONS MEDIA, 175 Tompkins Ave., Pleasantville NY 10570. (914)769-6900. E-mail: 71036.415@compuserve.com. Editor-in-Chief, President: Anson W. Schloat. Number of employees: 18. Approximate annual billing: $5 million. AV firm. Clients: junior and senior high schools, colleges.
Needs: Approached by 25 freelancers/year. Works with 10-15 freelance illustrators and 10-15 designers/year. Prefers local freelancers. Uses freelancers for illustration for print, video and advertising. Computer graphics preferred for video. Increasing need for illustrators.
First Contact & Terms: Send query letter with résumé and samples to be kept on file. Samples not filed are returned by SASE. Reports back only if interested. Call for appointment to show portfolio of videotape, slides or tearsheets. Pays for illustration by the project, $65-15,000. Rights purchased vary according to project.
Tips: "We're looking for talented artists, illustrators and graphics arts personnel with experience."

IMAC, Inter-Media Art Center, 370 New York Ave., Huntington NY 11743. (516)549-9666. Fax: (516)549-9423. Executive Director: Michael Rothbard. Estab. 1974. AV firm. Full-service, multimedia firm. Specializes in TV and multimedia productions.
Needs: Approached by 12 freelancers/month. Works with 3 illustrators and 2 designers/month. Prefers freelancers with experience in computer graphics. Uses freelancers mainly for animation, TV/film graphics and computer graphics. 50% of work is with print ads.
First Contact & Terms: Send query letter with photographs. Samples are not filed and are not returned. Reports back within 10 days. Rights purchased vary according to project.

JACK SCHECTERSON ASSOCIATES, 5316 251 Place, Little Neck NY 11362. (718)225-3536. Fax: (718)423-3478. Principal: Jack Schecterson. Estab. 1967. Ad agency. Specializes in packaging, product marketing, design and new product introduction.
Needs: Works only with artist reps. Prefers local freelancers only. Works on assignment only. Uses freelancers for package and product design and illustration, brochures, catalogs, retouching, lettering, logos.
First Contact & Terms: Send query letter with SASE and "whatever best illustrates work". Samples not filed are returned by SASE only if requested by artist. Request portfolio review in original query. Art Director will contact artist for portfolio review if interested. Portfolio should include roughs, b&w and color—"whatever best illustrates abilities/work." Pays for design and illustration by the project; depends on budget. Buys all rights.

SINGER ADVERTISING & MARKETING INC., 1035 Delaware Ave., Buffalo NY 14209. (716)884-8885. Fax: (716)888-7685. Traffic/Production Manager: Kathy Dorey-Pohrte. Estab. 1969. Number of employees: 18. Ad agency. Specializes in advertising (print ads, radio/TV, collateral), telemarketing, public relations services. Product specialties are business and consumer. Current clients include NFL Buffalo Bills, ITT Automotive, Armstrong Pumps, Acme Electric Corp., Kenny Rogers Roasters—NY, Erie Roasters, Inc., Gollum International, Al Tech Specialty Steel, RE/Max of NY, Inc. Client list available upon request.
Needs: Approached by 50-100 freelancers/year. Works with 3-10 freelance illustrators and 5 designers/month. Prefers local freelancers only. Works on assignment only. Uses freelancers for brochure, catalog and print ad design and illustration. 60% of work is with print ads. Needs computer-literate freelancers for design, illustration and production. 95% of freelance work demands demands knowledge of Aldus PageMaker, QuarkXPress, Aldus FreeHand, Adobe Illustrator or Adobe Photoshop.
First Contact & Terms: Send query letter with tearsheets. "Don't send photocopies, send printed samples." Samples are filed. Art Director will contact artist for portfolio review if interested. Portfolio should include b&w and color thumbnails, roughs, final art and tearsheets. Pays for design by the hour or by the project. Pays for illustration by the project. Buys all rights.
Tips: Finds artists through submissions and word of mouth.

STROMBERG COMMUNICATION & CONSULTING, 2500 Westchester Ave., Suite 109, Purchase NY 10577. (914)215-1515. Contact: Studio Manager. Number of employees: 4. Product specialties are direct marketing and internal communicating. Clients: industrial and corporate. Produces multimedia, presentations, videotapes and print materials.
Needs: Assigns 25 jobs/year. Prefers local freelancers only (New York City, Manhattan and Westchester). Uses freelancers for design catalogs, corporate brochures, presentations, annual reports, slide shows, layouts, mechanicals, illustrations, computer graphics and desk-top publishing.
First Contact & Terms: "Send note on availability and previous work;" include SASE. Reports back in 2 weeks. Provide materials to be kept on file for future assignments. Originals are not returned. Pays by the project.
Tips: Finds artists through word of mouth, sourcebooks and submissions.

‡THOMAS DESIGN, INC., 81 N. Broadway, Suite 205, Hicksville NY 11801. (516)933-8944. Fax: (516)933-8294. E-mail: t3design@aol.com. Owner: Tom Civitillo. Number of employees: 3. Ad agency. Full-service, multimedia firm. Specializes in advertising and promotion. "We also design and produce two magazines with combined circulation of 175,000." Current clients include Publishers Clearing House, Enesco, CMP Publications. Client list available upon request.
Needs: Approached by 20 freelancers/year. Works with 5 freelance illustrators/year. Prefers freelancers with experience in computer/printing production. Uses freelancers mainly for illustration and production. Also for animation, brochure and catalog illustration, logos, mechanicals and retouching. 40% of work is with print ads. Needs computer-literate freelancers for illustration and production. 90% of freelance work demands knowledge of Adobe Photoshop 3.0, QuarkXPress 3.0, Adobe Illustrator 5.0 and Director 4.3 (Mac or Windows).
First Contact & Terms: Send postcard sample of work or send query letter with SASE, tearsheets and photocopies. Samples are not filed and are returned by SASE. Reports back within 1 month. Art Director will contact artist for portfolio review if interested. Payment varies depending on type of work. Rights purchased vary according to project.

VISUAL HORIZONS, 180 Metro Park, Rochester NY 14623. (716)424-5300. Fax: (716)424-5313. Estab. 1971. AV firm. Full-service, multimedia firm. Specializes in presentation products. Current clients include US government agencies, corporations and universities. Client list not available.
Needs: Works on assignment only. Uses freelancers mainly for slide illustration. 10% of work is with print ads. Needs computer-literate freelancers for presentation. 100% of freelance work demands knowledge of Aldus PageMaker, Aldus FreeHand, Adobe Illustrator or Arts and Letters.
First Contact & Terms: Send query letter with tearsheets. Samples are not filed and are not returned. Reports back to the artist only if interested. Portfolio review not required. Pays for design and illustration by the hour or project, negotiated. Buys all rights.

New York City

ANITA HELEN BROOKS ASSOCIATES, PUBLIC RELATIONS, 155 E. 55th St., New York NY 10022. (212)755-4498. President: Anita Helen Brooks. PR firm. Specializes in fashion, "society," travel, restaurant, political and diplomatic and publishing. Product specialties are events, health and health campaigns.
Needs: Works on assignment only. Uses freelancers for consumer magazines, newspapers and press releases. "We're currently using more abstract designs."
First Contact & Terms: Call for appointment to show portfolio. Reports back only if interested. Considers client's budget and skill and experience of artist when establishing payment.
Tips: "Artists interested in working with us must provide rate schedule, partial list of clients and media outlets. We look for graphic appeal when reviewing samples."

CANON & SHEA ASSOCIATES, INC., 224 W. 35th St., Suite 1500, New York NY 10001. (212)564-8822. Art Buyer: Sal Graci. Estab. 1978. Technical advertising/PR/marketing firm. Specializes in business-to-business and financial services.
Needs: Works with 20-30 freelance illustrators and 2-3 designers/year. Mostly local freelancers. Uses freelancers mainly for mechanicals and technical illustrations. 85% of work is with print ads.
First Contact & Terms: Send query letter with brochure showing art style or send résumé and tearsheets. Art Director will contact artist for portfolio review if interested. Pays by the hour: $25-35 for animation, annual reports, catalogs, trade and consumer magazines; $25-50 for packaging; $50-250 for corporate identification/graphics; $10-45 for layout, lettering and paste-up.
Tips: Finds artists through art schools, design schools and colleges. "Artists should have business-to-business materials as samples and should understand the marketplace. Do not include fashion or liquor ads. Common mistakes in showing a portfolio include showing the wrong materials, not following up and lacking understanding of the audience."

ERICKSEN/BASLOE ADVERTISING, LTD., 12 W. 37th St., New York NY 10018. Fax: (212)239-3321. Director of Creative Services: Robert Ericksen. Full-service ad agency providing all promotional materials and commercial services for clients. Product specialties are promotional, commercial and advertising materials. Current clients include Turner Home Entertainment, Buena Vista Home Video and ABC News International.
Needs: Works with 50 freelancers/year. Assigns 50 jobs/year. Works on assignment only. Uses freelancers mainly for illustration, advertising, video packaging, brochures, catalogs, trade magazines, P-O-P displays, mechanicals, posters, lettering and logos. "Must be able to render celebrity likenesses." Prefers oils, airbrush, composited and computer-generated artwork.
First Contact & Terms: Contact through artist's agent or send query letter with brochure or tearsheets and slides. Samples are filed and are not returned unless requested with SASE; unsolicited samples are not returned. Reports back within 1 week if interested or when artist is needed for a project. Does not report back to all unsolicited samples. "Only on request should a portfolio be sent. I need to see accurate celebrity likenesses in your portfolio." Pays for illustration by the project, $500-5,000. Buys all rights and retains ownership of original.
Tips: Finds artists through word of mouth, magazines, submissions and sourcebooks. "Advertising artwork is becoming increasingly 'commercial' in response to very tightly targeted marketing in a poor economy (i.e., the artist has to respond to increased creative team input versus the fine art approach of the past—except with style-driven products such as fashion and perfume)."

GREY ADVERTISING INC., 777 Third Ave., New York NY 10017. Fax: (212)546-2379. Vice President/Art Buying Manager: Patti Harris. Number of employees: 1,800. Specializes in cosmetics, food, china, toys and shoe accounts. Professional affiliations: Arts Buyers Club, 4A Art Services Committee, NAFE.
 • This company has four art buyers, each of whom makes about 50 assignments per year. Freelancers are needed mostly for illustration and photography, but also for set building, fashion styling and lettering.
Needs: Approached by hundreds of freelancers/year. Works with 30 freelance illustrators and few designers/year. Needs realistic and graphic illustration.

INSIDER REPORT

Know Your Worth When Approaching Ad Agencies

For Bill Allen, senior vice president and director of creative services for UniWorld Group, inspiration is an everyday thing. After many hours listening to clients' goals and researching customers' preferences, members of UniWorld's creative team toss around ideas until they hit on the right words and images to coax customers to switch to Burger King, quench their thirst with Gatorade, try AT&T for international calls, or run around in Reeboks.

Bill Allen

"As an ad agency, our main purpose is conceiving the idea," says Allen from his office in Manhattan's Soho district. But once the idea is born, he often turns to freelance talent to transform the idea into a tangible form. "I might visualize a train skidding 90 miles an hour across a banana. If I have an idea in mind for a certain style of illustration, I'll flip through the sourcebooks in my office until I find an illustrator whose style matches the vision in my head." Sometimes he'll find that style in a magazine, or from samples he gets in the mail. In advertising, he explains, freelancers should have a unique style and be able to stick to that style when working on assignments, otherwise the visual won't match the agency's vision.

Before approaching ad agencies, says Allen, freelancers should have a clear sense of their own worth and an understanding of how the industry works. Agencies often solicit accounts by presenting ad campaign ideas to clients. It's not uncommon for as many as five agencies to pitch one account, but ultimately, only one is chosen. Before an agency wins an account, it might hire artists to execute visuals to show the client. Artists must realize their preliminary sketches might not be chosen for the final campaign. Decisions are made not based on which artwork is best, but whether the client is convinced the campaign will sell the product. So freelancers should develop a thick skin to survive and not feel their work is poor because it wasn't chosen for a campaign.

If your work is not used most agencies will pay you for your time, says Allen. "We don't say, 'Nice try but we didn't use it.' We pay $500 or $1,000 or whatever fee we negotiated ahead of time for the artist's time and talent."

Some agencies ask several illustrators or designers to create visuals on speculation, but only pay for the version their client likes best. If you accept a job on spec, you won't get paid unless your artwork is chosen. (The very word "speculation" implies risk, notes Allen.) Luckily, UniWorld and most agencies expect to pay artists for their time, and therefore build artists' fees into the cost of business. It is to your benefit to negotiate fees in advance to ensure you will be compensated

for your time if your work isn't used. Some clients require ownership as a condition of the assignment. Unless you retain rights to your work you can't use it for future projects.

Allen offers a simple secret to protect yourself and make assignments run smoother. "Always request a purchase order when you get an assignment." A purchase order (P.O.) is a written agreement from buyer to seller, outlining the parameters of a job. Most agencies are happy to provide one if it's requested. (Any hesitation should be a red flag, warns Allen.) If they ask you to start work first, and promise to mail you a P.O. later, ask the agency to fax you a handwritten one. They can mail a more formal agreement later. Once you have the P.O. in your hands, make sure you understand the terms of the assignment. The P.O. should list what the agency needs from you, the time frame, how much you'll be paid, and which rights to your work the agency is buying.

"The first time you deal with an agency, you'll be understandably insecure, but don't be afraid to ask questions." Once the terms of the assignment are crystal clear, you can relax and concentrate on giving the assignment your all.

—*Mary Cox*

Reprinted with permission of UniWorld.

To enhance an ad for AT&T, UniWorld contacted freelancer Bill Sloan, who created this exhilarating image.

First Contact & Terms: Works on assignment only. Call at beginning of the month for appointment to show portfolio of original/final art. Pays by the project. Considers client's budget and rights purchased when establishing fees.

Tips: "Be prepared and very professional" when showing a portfolio. "Show your work in a neat and organized manner. Have sample leave-behinds and do not expect to leave with a job. It takes time to plant your ideas and have them accepted."

GT GROUP, a division of Griffith & Tekushan, Inc., 630 Ninth Ave., #1000, New York NY 10036. (212)246-0154. Fax: (212)581-4827. Estab. 1985. AV firm. Full-service, multimedia firm. Specializes in TV, video, advertising, design and production of promos, show openings and graphics. Current clients include ESPN and CBS.

Needs: Approached by 48 freelancers/year. Works with 24-36 designers/year. Prefers freelancers with experience in television or advertising production. Works on assignment only. Uses freelancers mainly for design and production. Also for storyboards, animation, TV/film graphics and logos. Needs computer-literate freelancers for design, production and presentation.

First Contact & Terms: Send query letter with résumé and demo reels. Samples are filed. Art Director will contact artist for portfolio review if interested. Portfolio should include 3/4" video or VHS. Pays for design by the hour, $18; by the project; or by the day. Pays for illustration by the project.

Tips: Finds artists through word of mouth.

‡HERMAN ASSOCIATES INC., 360 Lexington Ave., New York NY 10017. (212)338-0700. CEO: Paula Herman. Estab. 1966. Serves clients in insurance, electronics/computers, travel and tourism.

Needs: Works with 6-10 freelancers/year. Works with 4 designers/year. Prefers local freelancers who have worked on at least 2-3 professional assignments previously. Works on assignment only. Uses artists for computer-generated technical illustration and retouching for newspapers and magazines. 55% of work is with print ads.

First Contact & Terms: Send brochure showing art style and "whatever best represents artist's work." Samples returned by SASE. Reporting time "depends on clients." Reports back on whether to expect possible future assignments. Write to schedule an appointment to show a portfolio. Pays by the project, $250 minimum; by the day, $400-500. Pays for illustration by the project, $300-2,000.

Tips: "The illustrator should be an 'idea' contributor as well. Add to the concept or see another possiblity. Freelancers need to provide leave-behinds, reminders of their work. We are using more illustration, especially in the high-tech, electronics and travel-related areas (architecture, buildings, etc.) Send samples that show your versatility."

HILL AND KNOWLTON, INC., Dept. AGDM, 466 Lexington Ave., New York NY 10017. (212)885-0300. Corporate Design Group: Michael Aldinger, Bob Barber and Jim Stanton. Estab. 1927. Number of employees: 1,200 (worldwide). PR firm. Full-service, multimedia firm. Specializes in annual reports, collateral, corporate identity, advertisements.

Needs: Works with 0-10 freelance illustrators/month. Works on assignment only. Uses freelancers for editorial, technical and medical illustration. Also for storyboards, slide illustration, animatics, mechanicals, retouching and lettering. 10% of work is with print ads. Needs computer-literate freelancers for illustration. Freelancers should be familiar with QuarkXPress, Aldus FreeHand, Adobe Illustrator, Photoshop or Delta Graph.

First Contact & Terms: Send query letter with promo and samples. Samples are filed. Does not report back, in which case the artist should "keep in touch by mail—do not call." Call and drop-off only for a portfolio review. Portfolio should include dupe photographs. Pays for illustration by the project, $250-5,000. Negotiates rights purchased.

Tips: Looks for "variety; unique but marketable styles are always appreciated."

KEN LIEBERMAN LABORATORIES, INC., 118 W. 22 St., New York NY 10011. (212)633-0500. Fax: (212)675-8269. President: Ken Lieberman. Estab. 1972. AV firm. Full-service, multimedia firm. Specializes in custom lab services, prints, dupes and mounting.

Needs: Approached by 60 freelancers/month. Works with 10 illustrators and 10 designers/month. Use freelancers for slide illustration and retouching. 98% of work is with print ads.

First Contact & Terms: "Must call prior to sending any submission." Send query letter with photographs, slides and transparencies. Samples are not filed and are returned by SASE only if requested by artist. Portfolio review not required. Pays for design and illustration by the project.

McANDREW ADVERTISING, 2125 St. Raymond Ave., P.O. Box 254, Bronx NY 10462. Phone/fax: (718)892-8660. Art/Creative Director: Robert McAndrew. Estab. 1961. Number of employees: 3. Approximate annual billing: $130,000. Ad agency. Clients: industrial and technical firms. Current clients include Yula Corp. and Electronic Devices.

Needs: Approached by 20 freelancers/year. Works with 3 freelance illustrators and 5 designers/year. Uses mostly local freelancers. Uses freelancers mainly for design, direct mail, brochures/flyers and trade magazine

ads. Needs technical illustration. Prefers realistic, precise style. Prefers pen & ink, airbrush and occasionally markers. 50% of work is with print ads. Needs computer-literate freelancers for design, production and presentation. 5% of freelance work demands computer skills.

First Contact & Terms: Query with photocopies, business card and brochure/flyer to be kept on file. Samples not returned. Reports in 1 month. Originals not returned. Art Director will contact artist for portfolio review if interested. Portfolio should include roughs and final reproduction. Pays for illustration by the project, $35-300. Pays for design by the project. Considers complexity of project, client's budget and skill and experience of artist when establishing payment.

Tips: Finds artists through sourcebooks, word of mouth and business cards in local commercial art supply stores. Artist needs "an understanding of the product and the importance of selling it."

MIZEREK DESIGN INC., 318 Lexington Ave., New York NY 10016. (212)689-4885. President: Leonard Mizerek.
● See listing in Design Firms section for Mizerek's needs and contact information.

NAPOLEON ART STUDIO, 460 W. 42 St., New York NY 10036. (212)967-6655. Fax: (212)268-1548. Director of Art Studio Services: Jane Carter. Estab. 1985. Number of employees: 10. AV firm. Full-service, multimedia firm. Specializes in storyboards, magazine ads, mechanicals. Product specialty is consumer. Current clients include "all major New York City ad agencies." Client list not available.

Needs: Approached by 60 freelancers/year. Works with 15 freelance illustrators and 2 designers/year. Prefers local freelancers with experience in advertising art. Works on assignment only. Uses freelancers for brochure, catalog and print ad design and illustration; storyboards; mechanicals; billboards; posters; TV/film graphics; lettering; and logos. 50% of work is with print ads. Needs computer-literate freelancers for design, illustration, production and presentation. 50% of freelance work demands knowledge of Adobe Illustrator or Adobe Photoshop.

First Contact & Terms: Send query letter with photocopies, tearsheets and ¾" or VHS tape. Samples are filed. Reports back to the artist only if interested. Art Director will contact artist for portfolio review if interested. Portfolio should include b&w and color thumbnails. Pays for design and illustration by the project; or by the day, $400. Rights purchased vary acording to project.

Tips: Finds artists through word of mouth and submissions.

PRO/CREATIVES COMPANY, 25 W. Burda Place, New York NY 10956-7116. President: D. Rapp. Estab. 1986. Ad agency and marketing/promotion PR firm. Specializes in direct mail, ads, collateral. Product specialties are consumer/trade, goods/services.

Needs: Works on assignment only. Uses freelancers for brochure and print ad design and illustration. 30% of work is with print ads.

First Contact & Terms: Samples are filed and are returned by SASE. Portfolio review not required. Pays for design and illustration by the project.

PETER ROTHHOLZ ASSOCIATES INC., 380 Lexington Ave., New York NY 10017. (212)687-6565. President: Peter Rothholz. PR firm. Specializes in government (tourism and industrial development), publishing, pharmaceuticals (health and beauty products) and business services.

Needs: Works with 24 freelance illustrators and 24 designers/year. Works on assignment only. Needs editorial illustration.

First Contact & Terms: Call for appointment to show portfolio of résumé or brochure/flyer to be kept on file. Samples are returned by SASE. Reports back in 2 weeks. Assignments made based on freelancer's experience, cost, style and whether he/she is local. Originals are not returned. Sometimes requests work on spec before assigning a job. Negotiates payment based on client's budget.

Tips: Finds artists through word of mouth and submissions.

‡JASPER SAMUEL ADVERTISING, 406 W. 31st St., New York NY 10001. (212)239-9544. Fax: (212)594-0931. Art Director: Joseph Samuel. Ad agency. Clients: health centers, travel agencies, churches, sports magazines, hair salons, etc.

Needs: Works with 5-10 freelancers/year. Works on assignment only. Uses freelancers for advertising, brochure and catalog design, illustration and layout; product design; and illustration on product. Needs computer-literate freelancers for design, illustration and presentation. 15% of freelance work demands computer literacy in Adobe Illustrator.

First Contact & Terms: Send query letter with brochure, résumé, business card, photographs and tearsheets to be kept on file. Samples not filed are returned by SASE. Reports within 1 month. Call or write for appointment to show portfolio. Pays for design by the project, $75-300. Pays for illustration by the project, $25-200. Considers complexity of project and skill and experience of the artist when establishing payment.

DAVID SCHIFFER DESIGN, INC., 156 Fifth Ave., New York NY 10010. (212)255-3464. President: David Schiffer. Estab. 1986. Ad agency. Specializes in print only: magazine ads, collateral, catalogs. Product specialties are industrial, publishing.

Needs: Approached by 3 freelancers/month. Works with 1 illustrator and 1 designer/month. Works on assignment only. Uses freelancers mainly for illustration. Also for mechanicals, retouching and desktop publishing. 20% of work is with print ads. Needs computer-literate freelancers for design, illustration and production. 75% of freelance work demands knowledge of QuarkXPress, Adobe Photoshop, Aldus Page-Maker, Adobe Illustrator or Aldus FreeHand.
First Contact & Terms: Send query letter with résumé, photographs and tearsheets. Samples are filed. Reports back to the artist only if interested. Write for appointment to show portfolio of roughs or final art. Pays for illustration by the project, $250-2,500. Rights purchased vary according to project.

SHADOW LIGHT PRODUCTIONS INC., 245 W. 19th St., New York NY 10011. (212)647-1765. Fax: (212)463-0852. Director/Producer: Marc Chelnik. AV, film/TV commercials, 3-D computer animation firm. Client list not available.
Needs: Uses freelancers mainly for illustration, animation and 3-D computer animation. Also for storyboards, animation, model making, TV/film graphics and logos. Needs computer-literate freelancers for design, illustration and production. Freelancers should be familiar with Adobe Photoshop, Quick Time, HyperCard, Adobe Premiere, Soft Image.
First Contact & Terms: Send query letter with résumé. Samples are not returned. Reports back to the artist only if interested. Artist should follow up with call.

STRATEGIC COMMUNICATIONS, 276 Fifth Ave., New York NY 10001. (212)779-7240. Fax: (212)779-7248. Estab. 1981. PR firm. Specializes in corporate and press materials, worldwide web-based environments, VNRs and presentation materials. Specializes in service businesses.
Needs: Approached by 3-4 freelancers/month. Works with 3 illustrators and 4 designers/month. Prefers local freelancers only. Works on assignment only. Uses freelancers for brochure design and illustration, slide illustration, mechanicals, posters, video graphics and computer-mediated communications, lettering, logos, corporate ID programs, annual reports, collateral and press materials.
First Contact & Terms: Send query letter with brochure, résumé, photographs and nonreturnable samples only. Samples are filed. Does not report back, in which case the artist should send follow-up communication every 6-9 months to keep file active. Portfolio should include original, final art. Pays for design and illustration by the project. Rights purchased vary according to project.

‡TALCO PRODUCTIONS, 279 E. 44th St., New York NY 10017. (212)697-4015. Fax: (212)697-4827. President: Alan Lawrence. Number of employees: 5. TV/film producer. Specializes in nonprofit organizations, industry, associations and PR firms. Produces videotapes, motion pictures and some filmstrips and sound-slide sets. Professional affiliation: DGA.
Needs: Works with 1-2 freelance illustrators and 1-2 designers/year. Prefers local freelancers with professional experience. Needs computer-literate freelancers for design. 15% of freelance work demands knowledge of Aldus FreeHand or Adobe Illustrator.
First Contact & Terms: Send query letter with résumé and SASE. Reports back only if interested. Portfolio should include roughs, final reproduction/product, and color photostats and photographs. Payment varies according to assignment. Pays on production. Originals sometimes returned at job's completion. Buys all rights. Considers complexity of project, client's budget and rights purchased when establishing payment.
Tips: "Do not send anything but a résumé—no samples."

VAN VECHTEN & ASSOCIATES PUBLIC RELATIONS, The Carriage House, 142 E. 30th St., New York NY 10016. (212)684-4646. President: Jay Van Vechten. Number of employees: 8. Approximate annual billing: $1.1 million. PR firm. Clients: medical, consumer products, industry. Client list available for SASE.
Needs: Approached by 20 freelancers/year. Works with 8 freelance illustrators and 8 designers/year. Works on assignment only. Uses artists for editorial and medical illustration, consumer and trade magazines, brochures, newspapers, stationery, signage, AV presentations and press releases. Needs computer-literate freelancers for presentation. 20% of freelance work demands computer skills.
First Contact & Terms: Send query letter with brochure, résumé, business card, photographs or photostats. Samples not filed are returned by SASE. Reports back only if interested. Write for appointment to show portfolio. Pays for design and illustration by the project. Considers client's budget when establishing payment. Buys all rights.

AL WASSERMAN, %TMP Worldwide, 1633 Broadway, New York NY 10019. (212)527-8664. Fax: (212)940-6990. Designer/Director: Al Wasserman. Estab. 1990. Approximate annual billing: $100,000. Ad agency. Full-service, multimedia firm. Specializes in magazine ads and all types of collateral. Product specialties are business, industry and real estate. Client list not available.
Needs: Approached by 12 freelancers/year. Works with 3-4 freelance illustrators/year. Prefers local freelancers. Uses freelancers mainly for follow through. Also for brochure and print ad illustration, animation, mechanicals, retouching, model making, billboards, TV/film graphics and lettering. 75% of work is with print ads. Needs computer-literate freelancers for production. 10% of freelance work demands knowledge of Aldus PageMaker.

First Contact & Terms: Contact only through artist rep. Send query letter with photocopies and tearsheets. Copies are filed or returned by SASE if requested by artist. Reports back to the artist only if interested. Artist should follow up with call and/or letter after initial query. Portfolio should include final art. Pays for illustration by the project, $250-3,000. Rights purchased vary according to project.

Tips: "We find designers through agents, sourcebooks and magazines or other publications such as annual reports."

North Carolina

‡APPLE ROCK ADVERTISING & PROMOTIONS, INC., 1200 Eastchester Dr., High Point NC 27265. (910)883-7199. Fax: (910)883-7198. President: Eric Burg. Estab. 1988. Number of employees: 4. Approximate annual billing: $1 million. Ad agency. Full-service, multimedia firm. Specializes in trade show advertising exhibits, collateral, video. Current clients include Weyerhaeuser, Center for Creative Leadership. Client list not available. Professional affiliations: AAF, PNAF.

Needs: Approached by 20-30 freelancers/year. Works with 2-3 freelance illustrators and 5-7 designers/year. Prefers local artists with experience in film work and pre-press. Uses freelancers mainly for print and renderings. Also for billboards, brochure design and illustration, lettering, logos, mechanicals, model making, posters, retouching, signage and TV/film graphics. 10% of work is with print ads. Needs computer-literate freelancers for design, illustration, production and presentation. 90% of freelance work demands knowledge of Aldus PageMaker 5.0, Aldus FreeHand 3.2, Adobe Photoshop 2.5, QuarkXPress 3.2 and Adobe Illustrator 4.0.

First Contact & Terms: Send postcard-size sample of work or query letter with brochure, résumé and SASE. Samples are filed and are returned. Request portfolio review in original query. Artist should follow-up with call and/or letter after initial query. Portfolio should include b&w and color final art and photographs. Pays for design and illustration by the hour, $20-80; by the project, $100-5,000; or by the day. Buys all rights.

Tips: Finds artists through temp agencies. "Impress us by being dependable."

‡BARRINGER & ASSOCIATES, LTD., P.O. Box 2525, 224 Third Ave. NW, Hickory NC 28603. (704)322-5550. Fax: (704)327-8440. Art Directors: Mark Sellers, Carol Morrow. Estb. 1979. Number of employees: 7. Approximate annual billing: $5 million. Ad agency. Full-service, multimedia firm. Specializes in magazine ads and collateral for business-to-business and industrial corporations. Client list available upon request.

Needs: Approached by 30 freelancers/year. Works with 6 freelance illustrators and 2 designers/year. Prefers freelancers with experience in computer illustration, airbrush, pastel. Uses freelancers mainly for ads, brochures. Also for catalog illustration and retouching. 40% of work is with print ads. Needs computer-literate freelancers for design and illustration. 80% of freelance work demands knowledge of Adobe Photoshop, QuarkXPress, Adobe Illustrator, Ray Dream Designer and Adobe Dimensions.

First Contact & Terms: Send query letter with brochure, photographs and tearsheets. Samples are filed. Reports back only if interested. Request portfolio review in original query. Artist should follow-up with call after initial query. Portfolio should include b&w and color final art, photostats and tearsheets. Pays for design by the hour, $20-35. Pays for illustration by the project, $300-4,000. Negotiates rights purchased. Rights purchased vary according to project.

Tips: Finds artists through CD-ROM and stock houses (catalogs). Not interested in retail (i.e. fashion). "Airbrush artists for photo retouching are history. Professional comprehensive artists with no computer skills are history. Any artists without computer skills are on the endangered species list."

‡CHISHOLM & ASSOCIATES, 4505 Falls of Neuse Rd., Suite 650, Raleigh NC 27607. (919)876-2065. Fax: (919)876-2344. E-mail: chisassocusa@delphi.com. Art Director: David Markovsky. Estab. 1993. Number of employees: 20. Approximate annual billing: $10 million. Ad agency. Full-service, multimedia firm. Specializes in ads, collateral, full service TV, broadcast. Product specialties are industrial and hi-tech. Client list not available.

Needs: Approached by 25-50 freelancers/year. Works with 10-12 freelance illustrators and 20-30 designers/year. Prefers local artists only. Uses freelancers for brochure design and illustration, catalog design, logos, mechanicals, posters, signage and P-O-P. 40% of work is with print ads. Needs computer-literate freelancers for design, illustration, production and presentation. 100% of freelance work demands knowledge of Adobe Photoshop 3.0, QuarkXPress 3.31 and Adobe Illustrator 5.5

First Contact & Terms: Send postcard-size sample of work or query letter with photocopies. Samples are filed. Request portfolio review in original query. Art Director will contact artist for portfolio review if interested. Portfolio should include b&w and color final art. Pays for design by the hour, $25-65. Payment for illustration varies by project. Buys all rights or negotiates rights purchased.

Tips: Finds artists through word or mouth, *Workbook*. "Be professional!"

‡IMAGE ASSOCIATES INC., 4909 Windy Hill Dr., Raleigh NC 27609. (919)876-6400. Fax: (919)876-7064. President: David Churchill. Estab. 1984. Number of employees: 35. AV firm. "Visual communications

firm specializing in computer graphics and AV, multi-image, interactive multimedia, print and photographic applications."

Needs: Approached by 10 freelancers/year. Works with 4 freelance illustrators and 4 designers/year. Prefers freelancers with experience in high-tech orientations and computer-graphics. Works on assignment only. Uses freelancers mainly for brochure design and illustration. Also for print ad design and illustration, slide illustration, animation and retouching. 25% of work is with print ads. Needs computer-literate freelancers for design, illustration, production and presentation. 90% of freelance work demands knowledge of Aldus FreeHand, Photoshop and Macromind Director.

First Contact & Terms: Send query letter with brochure, résumé and tearsheets. Samples are filed or are returned by SASE if requested by artist. Reports back to the artist only if interested. To show portfolio, mail roughs, finished art samples, tearsheets, final reproduction/product and slides. Pays for design and illustration by the project, $100 minimum. Consider complexity of project, client's budget and how work will be used when establishing payment. Rights purchased vary according to project.

‡POTTER & ASSOCIATES, 904-C Norwalk St., Greensboro NC 27407. (910)854-0800. Fax: (910)854-2216. Contact: Alex Potter. Estab. 1982. Number of employees: 5. Approximate annual billing: $3 million. Ad agency. Full-service, multimedia firm. Specializes in collateral, direct mail, client campaigns including print and broadcast. Product specialties are consumer and business-to-business. Client list available upon request.

Needs: Approached by 15-20 freelancers/year. Works with 4-5 freelance illustrators and 3-4 designers/year. Prefers freelancers with experience in computer graphics. Uses freelancers mainly for computer illustrations, mechanicals, design. Also for brochure design and illustration, logos, mechanicals, posters, retouching and TV/film graphics. 20% of work is with print ads. Needs computer-literate freelancers for production and presentation. 95% of freelance work demands knowledge of Adobe Photoshop, QuarkXPress and Adobe Illustrator.

First Contact & Terms: Send query letter with brochure, photocopies, résumé, tearsheets and transparencies. Samples are filed or returned by SASE if requested by artist. Reports back within 1 week. Art Director will contact artist for portfolio review if interested. Portfolio should include b&w and color final art and roughs. Pays for design and illustration by the hour and by the project. Rights purchased vary according to project.

Tips: Finds artists through *Creative Black Book*, word of mouth and artists' submissions. Impressed by "clean, professional/organized and creative" portfolios.

North Dakota

‡FLINT COMMUNICATIONS, 101 Tenth St. N., Fargo ND 58102. (701)237-4850. Fax: (701)234-9080. Art Director: Gerri Lien. Estab. 1947. Number of employees: 25. Approximate annual billing: $9 million. Ad agency. Full-service, multimedia firm. Product specialties are agriculture, manufacturing, healthcare, insurance and banking. Client list available upon request. Professional affiliations: AIGA.

Needs: Approached by 50 freelancers/year. Works with 6-10 freelance illustrators and 3-4 designers/year. Uses freelancers for annual reports, brochure design and illustration, lettering, logos and TV/film graphics. 40% of work is with print ads. Needs computer-literate freelancers for design, illustration and production. 20% of freelance work demands knowledge of Aldus PageMaker, Adobe Photoshop, QuarkXPress and Adobe Illustrator.

First Contact & Terms: Send postcard-size sample of work and query letter. Samples are filed. Art Director will contact artist for portfolio review if interested. Pays for illustration by the project, $100-2,000. Rights purchased vary according to project.

‡INK INC., 520 First Ave. N., Fargo ND 58102. (701)241-9204. Contact: Linda Stevens. Number of employees: 9. Approximate annual billing: $600,000. Newsletter printer and publisher. Full-service, multimedia firm. Specializes in direct mail advertising and newsletters. "We produce industry specific newsletters that local printers re-sell to small businesses in their area." Current clients include more than 700 printers nationwide. Client list not available.

Needs: Approached by 12-15 freelancers/year. Works with 5 freelance illustrators and 4 designers/year. Uses freelancers mainly for illustration and line art. Also for brochure design and illustration, lettering and logos. 80% of work is with print ads. Knowledge of Aldus PageMaker and Adobe Photoshop helpful but not necessary.

First Contact & Terms: Send query letter with photocopies. Samples are filed. "Will return if necessary." Reports back within 1 month. Portfolio review not required. Pays for design and illustration by the project. Rights purchsed vary according to project.

Tips: "Do good work, be friendly but not cocky, meet deadlines, and charge small town prices. I can't afford New York City rates. We buy lots of artwork and design. Our artists love us because we're easy to work with and pay fast!"

SIMMONS ADVERTISING, 125 S. Fourth St., Grand Forks ND 58201. (701)746-4573. Fax: (701)746-8067. Art Director: John Lapsitis. Estab. 1947. Number of employees: 13. Approximate annual billing: $5.5

million. Ad agency. Specializes in magazine ads, collateral, documentaries, etc. Product specialty is consumer. Client list available upon request.

Needs: Approached by 3-6 freelancers/year. Works with 3 freelance illustrators and 2 designer/year. Works on assignment only. Uses freelancers mainly for illustration. Also for brochure, catalog and print ad design and illustration; storyboards; billboards; and logos. 10% of work is with print ads. 10% of freelance work demands knowledge of Aldus PageMaker or QuarkXPress.

First Contact & Terms: Send query letter with brochure, résumé, slides and tearsheets. Samples are filed or are returned. Reports back within 5 days. Art Director will contact artist for portfolio review if interested. Portfolio should include color thumbnails, roughs, tearsheets, photostats and photographs. Pays for design and illustration by the hour, by the project, or by the day. Rights purchased vary according to project.

Ohio

‡BELDON/FRENZ/LEHMAN, INC., 24500 Center Ridge Rd., Westlake OH 44145. (216)835-4000. Fax: (216)835-9641. President: Dennis Pavan. Estab. 1955. Number of employees: 12. Approximate annual billing: $6.5 million. Marketing communications firm. Full-service, multimedia firm. Specializes in new product marketing, direct response television, interactive media. Product specialty is consumer home products. Client list available upon request. Professional affiliations: North American Advertising Agency Network, BPAA.

Needs: Approached by 20 freelancers/year. Works with 5 freelance illustrators and 5 designers/year. Prefers freelancers with experience in advertising design. Uses freelancers mainly for graphic design, illustration. Also for brochure and catalog design and illustration, lettering, logos, model making, posters, retouching, TV/film graphics. 80% of work is with print ads. Needs computer-literate freelancers for design, illustration, production and presentation. 50% of freelance work demands knowledge of Aldus FreeHand, Adobe Photoshop, QuarkXPress, Adobe Illustrator.

First Contact & Terms: Send postcard-size sample of work or send query letter with brochure, photostats, tearsheets, photocopies, résumé, slides and photographs. Samples are filed or returned by SASE. Reports back within 2 weeks. Artist should follow-up with call and/or letter after initial query. Art Director will contact artist for portfolio review if interested. Portfolio should include b&w and color final art, photographs, photostats, roughs, slides and thumbnails. Pays by the project, $200 minimum.

Tips: Finds artists through *Creative Black Book, Illustration Annual, Communication Arts*, local interviews. "A trend is developing for creating graphics for CD-ROM computer presentations and interactive media."

‡DAVID ADVERTISING, 300 Leader Bldg., Cleveland OH 44114. (216)687-1818. Fax: (216)687-0115. Creative Director: Carol Blankenship. Ad agency. Specializes in recruitment advertising and collateral.

Needs: 95% of work is with print ads. Needs computer-literate freelancers for design and illustration.

First Contact & Terms: Send query letter with photocopies and photostats. Samples are filed. Reports back to the artist only if interested. Art Director will contact artist for portfolio review if interested. Rights purchased vary according to project.

‡HOLLAND ADVERTISING, 252 Ludlow Ave., Cincinnati OH 45220. (513)221-1252. Fax: (513)221-0758. Estab. 1937. Number of employees: 12. Approximate annual billing: $6 million. Ad agency. Full-service, multimedia firm. Specializes in magazine trade, print, newspaper and direct mail. Product specialty is consumer. Professional affiliation: TAAN.

Needs: Approached by 6-12 freelancers/year. Works with 5-10 freelance illustrators and 2-3 designers/year. Prefers artists with experience in Macintosh. Uses freelancers for brochure illustration, logos, retouching and TV/film graphics. Needs computer-literate freelancers for production. 90% of freelance work demands knowledge of Aldus PageMaker, Aldus FreeHand, Adobe Photoshop, QuarkXPress and Adobe Illustrator.

First Contact & Terms: Send query letter with photostats and résumé. Samples are filed and are not returned. Art Director will contact artist for portfolio review if interested. Portfolio should include b&w and color final art, photographs, roughs, tearsheets and thumbnails. Pays for design by the hour, by the project and by the day. Pays for illustration by the project. Rights purchased vary according to project.

‡LIGGETT-STASHOWER, 1228 Euclid Ave., Cleveland OH 44115. (216)348-8500. Fax: (216)736-8113. Art Buyer: Kelly McNamara. Estab. 1940. Ad agency. Full-service, multimedia firm. Works in all formats. Handles all product categories. Current clients include Sears Optical, Babcock & Wilson and Evenflo.

Needs: Approached by 120 freelancers/year. Works with 12 freelance illustrators and 12 designers/year. Prefers local freelancers. Works on assignment only. Uses freelancers mainly for brochure, catalog and print ad design and illustration; storyboards; slide illustration; animatics; animation; mechanicals; retouching; billboards; posters; TV/film graphics; lettering; and logos. Needs computer-literate freelancers for illustration and production. 30% of freelance work demands knowledge of Aldus PageMaker, QuarkXPress, Aldus FreeHand, Photoshop or Adobe Illustrator.

First Contact & Terms: Send query letter. Samples are filed. Reports back to the artist only if interested. To show portfolio, mail tearsheets and transparencies. Pays for design and illustration by the project. Negotiates rights purchased.

‡**LOHRE & ASSOCIATES**, 2330 Victory Parkway, Suite 701, Cincinnati OH 45206. (513)961-1174. E-mail: girfaucon@aol.com. President: Chuck Lohre. Number of employees: 8. Approximate annual billing: $1 million. Ad agency. Specializes in industrial firms. Professional affiliation: BMA.
Needs: Approached by 24 freelancers/year. Works with 3 freelance illustrators and 6 designers/year. Works on assignment only. Uses freelance artists for trade magazines, direct mail, P-O-P displays, brochures and catalogs. Needs computer-literate freelancers for illustration and production. 100% of freelance work demands Knowledge of Aldus PageMaker, Aldus FreeHand and Photoshop.
First Contact & Terms: Send query letter with résumé and samples. Pays for design and illustration by the hour, $10 minimum.
Tips: Looks for artists who "have experience in chemical and mining industry, can read blueprints and have worked with metal fabrication. Needs Macintosh-literate artists who are willing to work at office, during day or evenings."

CHARLES MAYER STUDIOS INC., 168 E. Market St., Akron OH 44308. (216)535-6121. President: C.W. Mayer, Jr. AV producer. Estab. 1934. Number of employees: 65. Approximate annual billing: $2 million. Clients: mostly industrial. Produces film and manufactures visual aids for trade show exhibits.
Needs: Uses illustrators for catalogs, filmstrips, brochures and slides. Also for brochures/layout, photo retouching and cartooning for charts/visuals. In addition, has a large gallery and accepts paintings, watercolors, etc. on a consignment basis, 33%-40% commissions.
First Contact & Terms: Send slides, photographs, photostats or b&w line drawings or arrange interview to show portfolio. Samples not filed are returned by SASE. Reports back in 1 week. Provide résumé and a sample or tearsheet to be kept on file. Originals returned to artist at job's completion. Negotiates payment.

MENDERSON & MAIER, INC., 2260 Park Ave., Cincinnati OH 45206. (513)221-2980. Art Director: Barb Phillips. Estab. 1954. Number of employees: 5. Full-service ad agency in all aspects of media. Professional affiliations: Cincinnati Ad Club.
● This art director predicts there will be more catalog and brochure work.
Needs: Approached by 15-30 freelancers/year. Works with 5-10 freelance illustrators and 5-10 designers/year. Prefers local artists only. Uses freelancers mainly for editorial, technical, fashion and general line illustrations and production. Also for brochure, catalog and print ad design and illustration; slide illustration; mechanicals; retouching; and logos. Prefers mostly b&w art, line or wash. Needs computer-literate freelancers for design and production. 85% of freelance work demands knowledge of Aldus PageMaker, Aldus FreeHand and Word 5.0. 50% of work is with print ads.
First Contact & Terms: Contact only through artist rep. Send résumé and photocopies. Samples are filed and are not returned. Reports back within 6 days. Art Director will contact artist for portfolio review if interested. Artist should follow up with call. Portfolio should include b&w and color photostats, tearsheets, final reproduction/product and photographs. Sometimes requests work on spec before assigning a job. Pays for design by the hour, $12 minimum, or by the project. Pays for illustration by the project. Considers complexity of project and client's budget when establishing payment. Buys all rights.
Tips: Finds artists through résumés and word of mouth. The most effective way for a freelancer to get started in advertising is "by any means that build a sample portfolio. Have a well-designed résumé and nice samples of work whether they be illustrations, graphic design or logo design."

ART MERIMS COMMUNICATIONS, Bank One Center, Suite 1300, 600 Superior Ave., Cleveland OH 44114-2650. (216)522-1909. Fax: (216)479-6801. President: Arthur M. Merims. Number of employees: 4. Approximate annual billing: $800,000. Ad agency/PR firm. Current clients include Ohio Pest Control Association, HQ Business Centers, Osborn Engineering, Patrick Douglas, Inc., Woodruff Foundation.
Needs: Approached by 10 freelancers/year. Works with 1-2 freelance illustrators and 3 designers/year. Prefers local freelancers. Works on assignment only. Uses freelancers mainly for work on trade magazines, brochures, catalogs, signage, editorial illustrations and AV presentations. Needs computer-literate freelancers for production. 20% of freelance work demands computer skills.
First Contact & Terms: Send query letter with samples to be kept on file. Call for appointment to show portfolio of "copies of any kind" as samples. Sometimes requests work on spec before assigning a job. Pays for design and illustration by the hour, $20-60, or by the design project, $300-1,200. Considers complexity of project, client's budget and skill and experience of artist when establishing payment.
Tips: Finds artists through contact by phone or mail. When reviewing samples, looks for "creativity and reasonableness of cost."

‡**PARKER ADVERTISING COMPANY**, 2447 W. Mound St., Columbus OH 43204. (614)275-3113. Art Director: Chuck Woelfel. Estab. 1932. Number of employees: 10. Ad agency. Specializes in magazine ads, annual reports, spec sheets and catalogs. Product specialty is industrial. Client list not available.
Needs: Approached by 10 freelancers/year. Works with 4 freelance illustrators and 2 designers/year. Prefers artists with experience in industrial advertising. Uses freelancers for brochure and catalog illustration. 60% of work is with print ads. Needs computer-literate freelancers for production. Freelancers should be familiar with Aldus PageMaker, Adobe Photoshop and QuarkXPress.

Theresa Pindroh's cartoon-style illustration appeared on the cover of a catalog produced by Menderson & Maier featuring such wares as popcorn machines and candy apples for sale to carnivals and amusement parks. The artist created a happy, light feeling, taking inspiration from the subject—popcorn that smells and tastes great. Pindroh used Freehand 5.0 to create the illustration.

First Contact & Terms: Send postcard-size sample of work. Samples are filed and are not returned. Does not report back. Portfolio review not required. Pays for design and illustration by the project. Buys all rights.

‡PIHERA ADVERTISING ASSOCIATES, INC, 1605 Ambridge Rd., Dayton OH 45459. (513)433-9814. President: Larry Pihera. Estab. 1970. Ad agency, PR firm. Full-service multimedia firm. Specializes in magazine ads, collateral, corporate video production. Product specialties are industrial and retail. Client list not available.
Needs: Approached by 10 freelancers/year. Works with 5 freelance illustrators/year. Uses freelancers for animation, annual reports, billboards, brochure design and illustration, catalog illustration, lettering, mechanicals, retouching and signage. 50% of work is with print ads. 10% of freelance work demands computer skills.
First Contact & Terms: Send query letter with brochure and photostats. Samples are filed and are not returned. Does not report back. Artist should follow up. Art Director will contact artist for portfolio review if interested. Portfolio should include b&w and color photographs. Pays for design and illustration by the project. Buys all rights.
Tips: Finds artists through artists' submissions.

Oklahoma

‡A. BROWN & CO., 5314 S. Yale, Suite 205, Tulsa OK 74136. (918)492-0270. Fax: (918)492-0430. Vice President: Debi Lerkins. Estab. 1991. Number of employees: 5. Approximate annual billing: $800,000. Ad agency. Full-service, multimedia firm. Specializes in newspaper ads, brochures, annual reports, broadcast copywriting, media briefing. Product specialties are services, newspaper and auto. Professional affiliations: Tulsa Advertising Federation and PRSA.
Needs: Approached by 10-15 freelance artists/year. Works with 2 freelance illustrators and 2 designers/year. Prefers local artists only. Uses freelancers for annual reports, billboards, brochure design and illustration, lettering, logos, posters and signage. 20% of work is with print ads. Needs computer-literate freelancers for design, illustration, production and presentation. 100% of freelance work demands knowledge of Aldus FreeHand, Adobe Photoshop, QuarkXPress 3.3 and Adobe Illustrator.
First Contact & Terms: Send query letter with brochure, photocopies and résumé. Samples are filed. Does not report back. Artist should consult the agency for portfolio review information. Portfolio should include final art and tearsheets. Pays for design and illustration by the hour, $50-75. Buys all rights.
Tips: Finds artists through other agencies.

Oregon

ADFILIATION ADVERTISING & DESIGN, 323 W. 13th Ave., Eugene OR 97401. (503)687-8262. Fax: (503)687-8576. President/Creative Director: Gary Schubert. Media Director/VP: Gwen Schubert. Estab.

1976. Ad agency. "We provide full-service advertising to a wide variety of regional and national accounts. Our specialty is print media, serving predominantly industrial and business-to-business advertisers." Product specialties are forest products, heavy equipment, software, sporting equipment, food and medical.

Needs: Works with approximately 4 freelance illustrators and 2 designers/year. Works on assignment only. Uses freelancers mainly for specialty styles. Also for brochure and magazine ad illustration (editorial, technical and medical), retouching, animation, films and lettering. 80% of work is with print ads. Needs computer-literate freelancers for design, illustration, production and presentation. 80% of freelance work demands knowledge of Adobe Illustrator, QuarkXPress, Aldus FreeHand, MultiMedia, PowerPaint, 3D Renderman or PhotoShop.

First Contact & Terms: Send query letter, brochure, résumé, slides and photographs. Samples are filed or are returned by SASE only if requested. Reports back only if interested. Write for appointment to show portfolio. Pays for design illustration and by the hour, $25-100. Rights purchased vary according to project.

Tips: "We're busy. So follow up with reminders of your specialty, current samples of your work and the convenience of dealing with you. We are looking at more electronic illustration. Find out what the agency does most often and produce a relative example for indication that you are up for doing the real thing! Follow-up after initial interview of samples. Do not send fine art, abstract subjects."

‡**PRIDEAUX SULLIVAN PATTISON**, 1425 S.W. 20th Ave., Portland OR 97201. (503)226-4553. Fax: (503)273-8052. Partner: Harry Pattison. Art Director: Lynn LaLonde Allen. Estab. 1988. Number of employees: 12. Approximate annual billing: $8-10 million. Ad agency, PR firm. Full-service, multimedia firm. Specializes in print, broadcast and PR. Product specialties are health care, resort, restaurant, real estate and lumber. Client list available upon request. Professional affiliations: PAF, PAAA.

Needs: Approached by over 100 freelancers/year. Works with 10-20 freelance illustrators/year. Uses freelancers for billboards, brochure and catalog illustration, retouching and TV/film graphics. 80% of work is with print ads. Needs computer-literate freelancers for illustration. 50% of freelance work demands knowledge of Adobe Photoshop, QuarkXPress and Adobe Illustrator.

First Contact & Terms: Send postcard-size sample of work, photocopies and tearsheets. Art Director will contact artist for portfolio review if interested. Portfolio should include "anything in a good creative presentation." Payment for illustration depends on the project. Rights purchased vary according to project.

Tips: Finds artists through *Creative Black Book*, *Workbook*, magazines, word of mouth, artists' submissions. Impress art director "with intelligence; open-minded attitude; creative, break-through work only; and flexibility with budget."

Pennsylvania

‡**CHUCK BENSON DESIGN**, 4014 Wood St., Erie PA 16509. Phone/fax: (814)864-5043. Owner: Chuck Benson. Estab. 1992. Number of employees: 2. Approximate annual billing: $100,000. Ad agency/design firm. Specializes in collateral, magazine ads and sales promotion. Product specialties are consumer and industrial. Current clients include International Paper, United Refining and Lord Corp. Client list not available. Professional affiliation: Erie Ad Club.

Needs: Approached by 3-5 freelancers/year. Works with 5 freelance illustrators and 2 designers/year. Uses freelancers for brochure design and illustration, catalog design, mechanicals, retouching and signage. 20% of work is with print ads. Needs computer-literate freelancers for design, illustration and production. 80% of freelance work demands knowledge of Aldus PageMaker, Aldus FreeHand, Adobe Photoshop, QuarkXPress and Adobe Illustrator.

First Contact & Terms: Send postcard-size sample of work or send query letter with brochure, photocopies and tearsheets. Samples are filed or returned by SASE if requested by artist. Reports back to the artist only if interested. Artist should follow-up. Portfolio should include b&w and color roughs, tearsheets and thumbnails. Pays for design by the hour, $25-50; by the project, $1,000-3,000. Pays for illustration by the hour, $50-80; by the project, $100-2,000. Buys all rights or negotiates rights purchased.

Tips: Finds artists through submissions, word of mouth. "Clients seem to be waking up from a few years of sleep—spending more money again."

‡**CROSS KEYS ADVERTISING & MARKETING CO., INC.**, 329 S. Main St., Doylestown PA 18901. (215)345-5435. Fax: (215)345-4570. President: Laura T. Bames. Estab. 1981. Number of employees: 9. Approximate annual billing: $2 million. Ad agency.

Needs: Approached by 30 freelancers/year. Works with 4 freelance illustrators and 5 designers/year. Prefers local freelancers. Uses freelancers for brochure design and illustration, logos, mechanicals and retouching. 80% of work is with print ads. Needs computer-literate freelancers for design, illustration, production and presentation. 50% of freelance work demands knowledge of Adobe Photoshop, QuarkXPress and Adobe Illustrator.

First Contact & Terms: Send query letter with photocopies and résumé. Samples are filed. Art Director will contact artist for portfolio review if interested. Portfolio should include b&w and color final art, roughs. Pays for design and illustration by the project. Rights purchased vary according to project.

KINGSWOOD ADVERTISING, INC., Cricket Terrace Center, Ardmore PA 19003. Fax: (215)896-9242. Senior Vice President/Creative Director: John F. Tucker, Jr. Executive Art Director: Ed Dahl. Specializes in consumer, industrial, electronics, pharmaceuticals, publishing and scientific products and services.
Needs: Works with 5 freelance illustrators and 5 designers/year. Prefers local freelancers. Works on assignment only. Uses freelancers mainly for commercial, technical and medical illustration and occasional comps from roughs. Also for retouching, P-O-P displays, stationery design and newspapers. Needs computer-literate freelancers for design, illustration, production and presentation. 60% of freelance work demands knowledge of Aldus PageMaker, QuarkXPress, Aldus FreeHand, Adobe Illustrator and Photoshop.
First Contact & Terms: Provide business card, brochure/flyer and samples to be kept on file. Prefers roughs through final as samples. Samples returned by SASE. Purchased originals not returned. Request portfolio review in original query. Pays for design by the project, $300-1,000. Pays for illustration by the project, $300-2,000.
Tips: Finds artists through word of mouth and agents. "Learn a little about our clients' products and their current ad and literature style, and possibly suggest an improvement here and there. Know where your work appeared and what market it addressed. It's getting harder to convince young freelancers that they must first be artists and then technologists. Technology tends to diminish creativity, but an *artist* can control it to everyone's benefit."

‡NAISH, COHEN & ASSOC. (NC&A INC.), 1420 Locust St., Suite 310, Philadelphia PA 19102. (215)985-1144. Fax: (215)985-1077. Vice President: Frank Naish. Estab. 1969. Number of employees: 7. Approximate annual billing: $3.5 million. Ad agency. Full-service, multimedia firm. Specializes in business-to-business ads, radio and TV, brochures. Product specialty is healthcare. Client list not available.
Needs: Approached by 20-30 freelancers/year. Works with 5-10 freelance illustrators/year. Prefers local freelancers only. Uses freelancers mainly for brochures. Also for lettering, logos and TV/film graphics. 30% of work is with print ads. Needs computer-literate freelancers for design. 50% of freelance work demands knowledge of Aldus PageMaker, Aldus FreeHand, Adobe Photoshop, QuarkXPress and Adobe Illustrator.
First Contact & Terms: Send postcard-size sample of work or query letter with brochure and photocopies. Samples are filed and are not returned. Artist should follow-up with call after initial query to arrange portfolio review. Portfolio should include b&w and color photographs. Pays for design by the hour $15; by the project, $200. Pays for illustration by the project. Negotiates rights purchased.

‡PERCEPTIVE MARKETERS AGENCY LTD., 1100 E. Hector St., Suite 301, Conshohocken PA 19428-2394. (610)825-8710. Fax: (610)825-9186. Creative Director: Jason Solovitz. Estab. 1972. Number of employees: 8. Approximate annual billing: $4 million. Ad agency. Product specialties are communications, sports, hospitals, health care consulting, computers (software and hardware), environmental products, automotive, insurance, financial and food products, lighting distribution, publishing. Professional Affiliations: Philadelphia Ad Club, Philadelphia Direct Marketing Association, AAN.
Needs: Approached by 20 freelancers/year. Works with 10 freelance illustrators and 5 designers/year. Uses 80% local talent. In order of priority, uses freelancers for computer production, photography, illustration, comps/layout and design/art direction. "Concepts, ability to follow instructions/layouts and precision/accuracy are important." Needs computer-literate freelancers for for illustration and production. 100% of freelance work demands knowledge of QuarkXPress, Adobe Illustrator or Adobe Photoshop. 50% of work is with print ads.
First Contact & Terms: Send résumé and photostats, photographs and tearsheets to be kept on file. Accepts as samples "whatever best represents artist's work—but preferably not slides." Samples not filed are returned by SASE only. Reports back only if interested. Call for appointment to show portfolio. Pays for design by the hour or by the project. Pays for illustration by the project, up to $3,500. Considers complexity of the project, client's budget and turnaround time when establishing payment. Buys all rights.
Tips: "Freelance artists should approach us with unique, creative and professional work. And it's especially helpful to follow-up interviews with new samples of work, (i.e., to send a month later a 'reminder' card or sample of current work to keep on file)."

Rhode Island

‡LANDES AND ASSOCIATES, INC., 160 Midway Rd., Cranston RI 02920. (401)946-3636. Fax: (401)946-0031. Art Director: Peter Spameni. Estab. 1982. Number of employees: 10. Approximate annual billing $1 million. Ad agency. Specializes in collateral, newspaper, radio, trade and retail ads. Professional affiliations: Boston Ad Club.
Needs: Uses freelancers mainly for pre-production and illustration. Needs computer-literate freelancers for production. Freelancers should be familiar with Adobe Photoshop, QuarkXPress and Fontagrapher.
First Contact & Terms: Send postcard-size sample work. Samples are filed. Art Director will contact artist for portfolio review if interested. Payment for design and illustration depends on level of finish required for assignment.
Tips: Finds artists through *Creative Black Book* and *Workbook*.

‡**MANCINI ASSOCIATES**, 551 S. Main St., Providence RI 02903. (401)421-8490. Fax: (401)273-2808. President/Creative Director: Stephen M. Mancini. Estab. 1980. Number of employees: 5. Ad agency. Full-service, multimedia firm. Product specialties are jewelry and consumer.
Needs: Approached by many freelancers/year. Works with several freelance illustrators and designers/year. Needs computer-literate freelancers for design, illustration and production. Most work demands computer skills.
First Contact & Terms: Send postcard-size sample of work. Samples are filed. Art Director will contact artist for portfolio review if interested.

‡**MARTIN THOMAS, INC.**, One Smith Hill, Providence RI 02903. (401)331-8850. Production Manager: Richard E. Rounds. Estab. 1987. Number of employees: 12. Approximate annual billing: $7 million. Ad agency, PR firm. Specializes in industrial, business-to-business. Product specialties are plastics, medical and automotive. Professional affiliations: AAAA, Boston Ad Club.
Needs: Approached by 10-15 freelancers/year. Works with 5-6 freelance illustrators and designers/year. Prefers freelancers with experience in business-to-business/industrial. Uses freelancers mainly for design of ads, literature and direct mail. Also for brochure and catalog design and illustration. 85% of work is print ads. Needs computer-literate freelancers for design and illustration. 40% of freelance work demands knowledge of QuarkXPress.
First Contact & Terms: Send query letter with brochure and photocopies. Samples are filed and are returned. Reports back within 3 weeks. Art Director will contact artist for portfolio review if interested. Portfolio should include b&w and color final art. Pays for design and illustration by the hour and by the project. Buys all rights.
Tips: Finds artists through *Creative Black Book*. Impress agency by "knowing industries we serve."

South Carolina

‡**EISON GOOT GROUP**, 105 E. North St., Suite 200, Greenville SC 29601. (803)240-7400. Fax: (803)240-7405. Contact: Janice Antley or Alison Quarles. Estab. 1981. Number of employees: 16. Ad agency. Full-service, multimedia firm. Specializes in magazine and newspaper ads, radio, TV, collateral. Product specialties are banking, hospitals and kayaking. Current clients include American Federal, St. Francis Hospital, MOM, Bankers First, Perception Kayaks. Client list available upon request.
Needs: Approached by many freelancers/year. Works with 3 freelance illustrators and 1 designer/year. Prefers local freelancers with experience in illustration. Uses freelancers mainly "when we're slammed" and for special illustration needs. Also for mechanicals. 80% of work is with print ads. Needs computer-literate freelancers for design, illustration and production. 75% of freelance work demands knowledge of QuarkXPress 3.3 and Adobe Illustrator 5.0.
First Contact & Terms: Send query letter with samples of work. Samples are filed or are returned by SASE if requested by artist. Art Director will contact artist for portfolio review if interested. Portfolio should include final art. Payment for design and illustration depends on artist and job. Rights purchased vary according to project.
Tips: "We are seriously in search of production freelancers who are willing to come to our office and work."

‡**THE SOUTHER AGENCY**, 518 E. Main St., Spartanburg SC 29302. (803)583-2959. Fax: (803)583-1389. President: Larry Souther. Estab. 1981. Number of employees: 5. Approximate annual billing: $1 million. Ad agency. Full-service, multimedia firm. Specializes in collateral, newspaper ads, outdoor. Product specialties are shopping malls, automotive, banks and colleges. Current clients include Westgate Mall, Spartanburg National Bank, Anderson National Bank, Peachtree Ford, Converse College, Erskine College. Professional affiliations: American Advertising Federation.
Needs: Approached by 50 freelancers/year. Works with 3-4 freelance illustrators and 3-4 designers/year. Prefers local artists (or close) with computer experience. Uses freelancers mainly for layout, design and mechanicals. Also for animation, annual reports, billboards, brochure and catalog design, lettering, logos, posters, retouching, signage and TV/film graphics. 50-75% of work is with print ads. Needs computer-literate freelancers for design and production. 100% of freelance work demands knowledge of Aldus PageMaker, Adobe Photoshop, QuarkXPress and Adobe Illustrator.
First Contact & Terms: Send postcard-size sample of work or query letter with brochure, photocopies, résumé and tearsheets. Samples are filed and are not returned. Art Director will contact artist for portfolio review if interested. Portfolio should include b&w and color photostats and roughs. Pays for design and illustration by the hour, by the project or by the day. Buys first rights.
Tips: Finds artists through word of mouth, artists' submissions. Impressed by "great portfolio! good attitude!"

Tennessee

CASCOM INTERNATIONAL, Dept. AM, 806 Fourth Ave. S., Nashville TN 37210. (615)242-8900. Fax: (615)256-7890. President: Vic Rumore. Estab. 1977. Diversified firm specializing in film graphics and cell animation, live-action cinematography and stock archival footage for video productions. Also involved in production and distribution of home videos and CD-ROMs.
Needs: Works with 1-2 illustrators and 1-2 designers/month. Prefers freelancers with experience in film graphics. Works on assignment only. Uses freelancers mainly for print and graphic cell design and layout. Also for brochure, catalog and packaging design and illustration; storyboards; animation; mechanicals; and TV/film graphics. 5% of work is with print ads. Freelancers should be familiar with Photoshop, etc.
First Contact & Terms: Send query letter with brochure, résumé, photographs, slides and transparencies. Samples are filed or are returned by SASE only if requested by artist. Reports back within 1 month if interested. To show portfolio, mail "anything that shows ability." Pays by the project. Negotiates payment. Considers complexity of project, turnaround time and skill and experience of artist when establishing payment. Buys all rights.
Tips: "Although our business and product line have expanded, we rely 100% on freelancers for our graphics/art needs."

THOMPSON & COMPANY, 65 Union Ave., Memphis TN 38103. Creative Director: Trace Hallowell. Estab. 1981. Full-service ad agency. Current clients include Insituform Technologies, Crews Safety Glasses, Lustrasilla, Seabrook Wallcoverings, Rotary Lift.
Needs: Works with various number of illustrators and designers/month. Works on assignment only. Uses freelancers mainly for ads. Also for brochure design and illustration, slide illustration, storyboards, animatics, animation, mechanicals, retouching, billboards, posters, TV/film graphics, lettering and logos. 80% of work is with print ads.
First Contact & Terms: Send query letter with samples. Samples are filed or are returned by SASE only if requested by artist. Art Director will contact artist for portfolio review if intereted. Portfolio should include fresh ideas. Rights purchased vary according to project.

‡THE TOMBAS GROUP, 630 Concord St., Knoxville TN 37919. (615)524-5376. Fax: (615)524-5667. Creative Director: Mitch McCampbell. Estab. 1946. Number of employees: 50. Approximate annual billing: $18 million. Ad agency. Full-service, multimedia firm. Specializes in full media advertising, collateral, PR. Current clients include Blue Cross Blue Shield of Tennessee and Eastman Chemical. Client list available upon request. Professional affiliations: AAAA, 3AI, PRSA.
Needs: Approached by 20-25 freelancers/year. Works with 5-10 freelance illustrators and 2-5 designers/year. Uses freelancers mainly for illustration. Also for brochure design and illustration, model making and retouching. 60% of work is with print ads. Needs computer-literate freelancers for design and presentation. 25% of freelance work demands knowledge of Aldus FreeHand, Adobe Photoshop and QuarkXPress.
First Contact & Terms: Send query letter with photocopies and résumé. Samples are filed. Art Director will contact artist for portfolio review if interested. Portfolio should include b&w and color samples. Pays for design by the hour, $25-40; by the project, $250-2,500. Pays for illustration by the project, $100-10,000. Rights purchased vary according to project.
Tips: "Stay in touch with quality promotion. 'Service me to death' when you get a job."

Texas

‡THOMAS S. BELL ADVERTISING & DESIGN, 485 Milam, Beaumont TX 77701. (409)832-5901. Fax: (409)833-2625. Owner: Tom Bell. Estab. 1977. Number of employees: 3. Approximate annual billing: $1 million. Ad agency. Full-service, multimedia firm. Specializes in graphics, logo designs, brochures and magazine ads. Product specialty is manufactured products. Current clients include: Modern Manufacturing, Marine & Petroleum Manufacturing and Transcon. Client list available upon request.
Needs: Approached by 10-20 freelancers/year. Works with 2 freelance illustrators and 2 designers/year. Uses freelancers for billboards, brochure and catalog design and illustration, posters and TV/film graphics. 30% of work is with print ads. Computer-literate freelancers are helpful for design and production. "They don't have to be computer experts."
First Contact & Terms: Send query letter. Samples are not filed and are not returned. "I will return samples if needed." To arrange portfolio review artist should follow-up with call after initial query. Portfolio should include "whatever is available." Pays for design and illustration by the project, $100 minimum. Rights purchased vary according to project.
Tips: Finds artists through word of mouth and artists' submissions. "Show me good work. Computers don't make you a designer. I'm more interested in design and illustration skills than knowledge of computers."

DYKEMAN ASSOCIATES INC., 4115 Rawlins, Dallas TX 75219. (214)528-2991. Fax: (214)528-0241. Contact: Alice Dykeman. PR/marketing firm. Specializes in business, industry, sports, environmental, energy, health.

Needs: Works with 60 illustrators and designers/year. "We prefer artists who can both design and illustrate." Local freelancers only. Uses freelancers for editorial and technical illustration, brochure design, exhibits, corporate identification, signs, posters, ads and all design and finished artwork for graphics and printed materials. Needs computer-literate freelancers for design, production and presentation.
First Contact & Terms: Request portfolio review in original query. Pays by the project, $250-3,000. "Artist makes an estimate; we approve or negotiate."
Tips: "Be enthusiastic. Present an organized portfolio with a variety of work. Portfolio should reflect all that an artist can do. Don't include examples of projects for which you only did a small part of the creative work. Have a price structure but be willing to negotiate per project. We prefer to use artists/designers/illustrators who will work with barter (trade) dollars and join one of our associations. We see steady growth ahead."

EMERY & MARTINEZ ADVERTISING, Dept. AM, 1519 Montana, El Paso TX 79902. (915)532-3636. E-mail: gothman@aol.com. Art Directors: Henry Martinez and Charles C. Fensch. Number of employees: 25. Ad agency. Specializes in automotive and architectural firms, banks and restaurants. Current clients include Ford Dealers Association and Speaking Rock Casino.
Needs: Approached by 3-4 freelancers/year. Works with 2-3 freelance illustrators and 4-5 designers/year. Uses freelancers mainly for design, illustration and production. Needs technical illustration and cartoons.
First Contact & Terms: Works on assignment only. Send query letter with résumé and samples to be kept on file. Art Director will contact artist for portfolio review if interested. Prefers tearsheets as samples. Samples not filed are returned by SASE. Reports back. Sometimes requests work on spec before assigning a job. Pays for design by the hour, $15 minimum; by the project, $100 minimum; by the day, $300 minimum. Pays for illustration by the hour, $15 minimum; by the project, $100 minimum. Considers complexity of project, client's budget and turnaround time when establishing payment. Rights purchased vary according to project.
Tips: Especially looks for "consistency and dependability; high creativity; familiarity with retail, Southwestern and Southern California look."

FUTURETALK TELECOMMUNICATIONS COMPANY, INC., P.O. Box 270942, Dallas TX 75227-0942. Contact: Marketing Department Manager. Estab. 1993. Ad agency and PR firm. Full-service, multimedia firm and telecommunications company. Specializes in MCI videophone sales (authorized MCI dealer). Current clients include small to medium businesses and individuals. Client list not available.
Needs: Approached by 20-30 freelancers/year. Works with 10-15 illustrators and 2-3 designers/year. Prefers freelancers with experience in computer graphics. Works on assignment only. Uses freelancers mainly for promotional projects. Also for brochure and catalog illustration, storyboards, animation, model making, billboards and TV/film graphics. 20% of work is with print ads. Needs computer-literate freelancers for design, illustration and production. 60% of freelance work demands computer skills.
First Contact & Terms: Send query letter with résumé, photocopies, photographs and SASE. Samples are filed or are returned by SASE if requested by artist. Reports back within 3 weeks. Art Director will contact artist for portfolio review if interested. Portfolio should include b&w and color final art, tearsheets and photostats. Pays for design by the hour, $10-25; by the project, $250-2,500; by the day, $250-2,500. Pays for illustration by the hour, $20-40; by the project, $250-2,500; by the day, $250-2,500. Rights purchased vary according to project.
Tips: "Please either write for Job Package (include $3) or dial from fax machine line and press start to (800)934-1618." Finds artists through sourcebooks, word of mouth and artists' submissions.

McNEE PRODUCTIONS, INC., (formerly McNee Photo Communications Inc.), 3301 W. Alabama, Houston TX 77098. (713)526-5333. President: Jim McNee. Video producer. Serves clients in industry and advertising.
Needs: Assigns 20 freelance jobs/year. Works with 4 freelancers/month. Prefers local freelancers with previous work experience. Uses freelancers for video shoots.
First Contact & Terms: "Will review samples by appointment only." Provide résumé, brochure/flier and business card to be kept on file for possible future assignments. Works on assignment only. Reports within 1 month. Method of payment is negotiated with the individual artist. Pays by the hour, $30-60 average. Considers client's budget when establishing payment. No originals returned after publication. Buys all rights, but will negotiate.

VISCON, INC., (formerly Cooley, Shillinglaw & Dadd, Inc.), 10500 Richmond Ave., Suite 114, Houston TX 77042. (713)783-8724. Fax: (713)783-0568. Production Manager: Terri Chin. Estab. 1963. Ad agency. Full-service, multimedia firm. Specializes in magazine ads, interactive multimedia presentation, data sheets, mailings and brochures. Product specialty is industrial.
Needs: Approached by 5 freelancers/month. Works with 2 illustrators and 1 designer/month. Prefers freelancers with experience in industrial design. Works on assignment only. Uses freelancers for "everything," including brochure, catalog and print ad design; technical and slide illustration; animation; mechanicals; retouching; TV/film graphics and logos. 40% of work is with print ads.
First Contact & Terms: Send query letter with brochure, résumé and photocopies. Samples are filed. Art Director will contact artist for portfolio review if interested. Portfolio should include thumbnails, roughs,

original, final art, b&w and color photographs. Sometimes requests work on spec before assigning job. Pays for design by the project, $500-750. Pays for illustration by the project, $1,200-1,400. Buys all rights.
Tips: Finds artists through referrals from other artists.

Utah

BROWNING ADVERTISING, 1 Browning Place, Morgan UT 84050. (801)876-2711, ext. 336. Fax: (801)876-3331. Senior Art Director: Brent Evans. Estab. 1878. Distributor and marketer of outdoor sports products, particularly firearms. Inhouse agency for 3 main clients. Inhouse divisions include non-gun hunting products, firearms and accessories.
Needs: Approached by 50 freelancers/year. Works with 20 freelance illustrators and 20 designers/year. Prefers freelancers with experience in outdoor sports—hunting, shooting, fishing. Works on assignment only. Uses freelancers mainly for design, illustration and production. Also for advertising and brochure layout, catalogs, product rendering and design, signage, P-O-P displays and posters.
First Contact & Terms: Send query letter with résumé and tearsheets, slides, photographs and transparencies. Samples are not filed and are not returned. Reports back to the artist only if interested. To show portfolio, mail photostats, slides, tearsheets, transparencies and photographs. Pays for design by the hour, $50-75. Pays for illustration by the project. Buys all rights or reprint rights.

‡HARRIS•VOLSIC CREATIVE, 262 South 200 West, Salt Lake City UT 84101. (801)595-1013. Fax: (801)595-1014. Account Manager: Michelle DeCol. Estab. 1987. Number of employees: 7. Approximate annual billing: $1 million. Creative boutique. Specializes in print, radio and TV. Product specialties are retail, consumer and fashion. Client list available upon request. Professional affiliations: UAF, AAF and ADSLC.
Needs: Approached by 50 freelancers/year. Works with 5 freelance illustrators/year. Uses illustrators for animation, annual reports, billboards, brochure design and illustration, catalog illustration, lettering, logos, model making, posters and TV/film graphics. 50% of work is with print ads. Needs computer-literate freelancers for design, illustration and production. 50% of freelance work demands knowledge of Aldus PageMaker, Aldus FreeHand, Adobe Photoshop, QuarkXPress and Adobe Illustrator.
First Contact & Terms: Send query letter with appropriate samples. Samples are filed or returned by SASE if requested by artist. Reports back within 10 days. Artist should follow-up with letter after initial query. Pays for design and illustration by the project.
Tips: "Be original and do great work. Business is booming."

‡NORD ADVERTISING ASSOCIATES, 225 South 200 East, #350, Salt Lake City UT 84111. (801)521-8383. Fax: (801)521-8407. Creative Director: Donald E. Hallock. Estab. 1954. Number of employees: 5. Ad agency. Full-service, multimedia firm. Product specialties include manufacturing, retail, service (full spectrum). Client list not available.
Needs: Approached by 8-12 freelancers/year. Works with 4-5 freelance illustrators and 1-2 designers/year. Prefers local artists with experience in IBM computers. Uses freelancers mainly for overflow work. Also for brochure design, mechanicals and signage. 80% of work is with print ads. Needs computer-literate freelancers for production. 95% of freelance work demands knowledge of Aldus PageMaker, Aldus FreeHand and Corel Draw.
First Contact & Terms: Send query letter with résumé. Samples are filed. Art Director will contact artist for portfolio review if interested. Portfolio should include b&w and color tearsheets and samples of collateral. Pays for design and illustration by the project. Buys all rights.
Tips: Finds artists locally through word of mouth, or through sourcebooks and artists' reps. Impress creative director "by finding creative solutions to specific challenges. There is too much reliance on computers at creative level. The tool is best applied where it serves most efficiently—typesetting, prepress applications and other time-saving functions."

Virginia

CARLTON COMMUNICATIONS, INC., 300 W. Franklin St., Richmond VA 23220. (804)780-1701. Fax: (804)225-8036. President: Dick Carlton. Estab. 1975. Full-service ad and PR agencies specializing in economic development, hotels, health care, travel, real estate and insurance.
Needs: Works with 2 illustrators/month. 50% of work is with print ads. Needs computer-literate illustrators. 95% of freelance work demands knowledge of Adobe Illustrator and Photoshop.
First Contact & Terms: Send query letter with brochure, résumé, tearsheets and photocopies. Samples are filed and are not returned. Reports back to the artist only if interested. Call or write for appointment to show portfolio of original/final art. Payment is negotiable. Considers complexity of project and client's budget when establishing payment.

‡KREATIVE DESIGN, 11203 Silverleaf Dr., Fairfax Station VA 22039. (703)503-8133. Fax: (703)503-0935. Contact: Kay Walsh. Estab. 1994. Number of employees: 2. Ad agency. Specializes in advertising for print,

and marketing to the hospitality industry. Product specialty is hotels. Current clients include Ramada, Sheraton and Marriott. Client list available upon request. Professional affiliation: Ad Club of Metropolitan Washington.
Needs: Approached by 10 freelancers/year. Works with 6 freelance illustrators/year. Uses freelancers mainly for production and illustration. Also uses freelancers for mechanicals and cartooning. 50% of work is with print ads. Needs computer-literate freelancers for production. 100% of freelance work demands knowledge of Aldus FreeHand, Adobe Photoshop, QuarkXPress and Adobe Illustrator.
First Contact & Terms: Send query letter with photocopies. Samples are filed and are not returned. Portfolio review not required. Art Director will contact artist for portfolio review if interested. Portfolio should include final art. Pays for design by the project, $20-45. Pays for illustration by the project, $250-1,000. Rights purchased vary according to project.
Tips: Finds artists through sourcebooks.

‡**LONGLEY/BABB & ASSOCIATES**, Box 32107, Hillsboro VA 22312. (703)668-6039. Fax: (703)668-9018. Partner: Drew Babb. Estab. 1993. Number of employees: 3. Ad agency, PR firm. Full-service, multimedia firm. Specializes in advertising and PR in all media. Also marketing counsel, advocacy, public service advertising, the arts and education. Current clients include National Public Radio, Music Educators National Conference, Thelonious Monk Institute of Jazz, Very Special Arts. Client list available upon request.
Needs: Approached by 12-25 freelancers/year. Works with 10-20 freelance illustrators and 5-15 designers/year. Uses freelancers mainly for design and production. Also uses freelancers for annual reports, brochure design and illustration, logos, mechanicals, posters and retouching. 75% of work is with print ads. Needs computer-literate freelancers for design and production. 85% of freelance work demands knowledge of QuarkXPress.
First Contact & Terms: Send postcard-size sample of work or brochure. Samples are filed and are not returned. Does not report back. Artist should "send updated sample(s) about once a year." Pays for design and illustration by the project. Negotiates rights purchased.
Tips: Finds artists through *Communication Arts*, *Ad Week* and *Creative Source Book*. "Send great samples! Computer design is often the crippler of the written word."

Washington

JERI McDONALD & ASSOC., INC., 2200 Sixth Ave., #430, Seattle WA 98275 (206)728-8570. Fax: (206)728-7109. Art Director: Tami Taylor. Estab. 1979. Number of employees: 3. Ad agency, PR firm. Full-service, multimedia firm. Specializes in collateral, print ads and video. Product specialties are consumer, food and travel. Current clients include Tillicum. Client list available upon request. Professional affiliations: PRSA, SKUCCB, BVCB.
Needs: Approached by 6-12 freelancers/year. Works with 1-3 freelance illustrators/year. Uses freelancers mainly for special needs of clients, work overload. Also for brochure design, logos and TV/film graphics. 5% of work is with print ads. Needs computer-literate freelancers for design and production. 100% of freelance work demands knowledge of Aldus PageMaker, Aldus FreeHand and Adobe Photoshop.
First Contact & Terms: Send postcard-size sample of work or query letter with résumé and samples. Art Director will contact artist for portfolio review if interested. Pays for design and illustration by the project depending on need. Buys all rights.
Tips: Finds artists through professional networking. "Keep in touch by sending postcards showing samples of work."

‡**PARALLEL COMMUNICATIONS & PARALLEL INTERACTIVE**, 8440 154th Ave. NE, Redmond WA 98052. E-mail: parallel@parallel.interactive.com. Creative Director: John Jerome. Estab. 1984. Number of employees: 17. Approximate annual billing: $16 million. Ad agency. Full-service, multimedia firm. Product specialties are high tech, software and game companies. Professional affiliations: MIT, WSA, AMA, AAF, IICS.
Needs: Approached by 200-400 freelancers/year. Works with 30-50 freelance illustrators and 2-5 designers/year. Designers must work inhouse. Uses freelancers mainly for handling overflow. Also for annual reports, brochure design and illustration, logos, mechanicals and model making. 25% of work is with print ads. Needs computer-literate freelancers for design, illustration, production and presentation. 99% of freelance work demands knowledge of Aldus FreeHand, Adobe Photoshop and QuarkXPress.
First Contact & Terms: Send query letter with brochure, photocopies, photographs, photostats, résumé, slides, tearsheets and transparencies. Samples are not filed. Portfolios may be dropped off Monday-Friday. Art Director will contact artist for portfolio review if interested. Portfolio should include b&w and color final art, photographs, photostats, roughs, slides, tearsheets, thumbnails and transparencies. Pays for design by the hour, $15-20. Pays for illustration by the project, $50-10,000. Rights purchased vary according to project.
Tips: Finds artists through agents, sourcebooks (*Creative Black Book*, *Workbook*), magazines, word of mouth and artists' submissions. Impress creative director by being multi-dimensional. "We are looking for freelancers with experience in multimedia."

West Virginia

GUTMAN ADVERTISING AGENCY, 500 Klos Tower, Wheeling WV 26003-2844. (304)233-4700. President: J. Milton Gutman. Ad agency. Specializes in finance, resort, media, industrial supplies (tools, pipes) and furniture.
Needs: Works with 3-4 illustrators/month. Uses local freelancers only, except for infrequent and special needs. Uses freelancers for billboards, stationery design, TV, brochures/fliers, trade magazines and newspapers. Also for retouching..
First Contact & Terms: Send materials to be kept on file for possible future assignments. Call for appointment to show portfolio. Originals not returned. Negotiates payment.

Wisconsin

GREINKE, EIERS & ASSOCIATES, 2557-C N. Terrace Ave., Milwaukee WI 53211-3822. (414)962-9810. Fax: (414)352-3233. President: Patrick Eiers. Estab. 1984. Number of employees: 9. Ad agency, PR firm. Full-service multimedia firm. Specializes in special events (large display and photo work), print ads, TV ads, radio, all types of printed material (T-shirts, newsletters, etc.). Current clients include Great Circus Parade, Eastside Compact Disc and Landmark Theatre Chain. Professional affiliations: PRSA, IABC, NARAS.
Needs: Approached by 125 freelancers/year. Works with 25 freelance illustrators and 25 designers/year. Uses freelancers for "everything and anything," such as brochure and print ad design and illustration, storyboards, slide illustration, retouching, model making, billboards, posters, TV/film graphics, lettering and logos. 40% of work is with print ads. Needs computer-literate freelancers for design, illustration and presentation. 75% of freelance work demands knowledge of Aldus PageMaker, Adobe Illustrator, QuarkXPress, Adobe Photoshop, Aldus Freehand or Powerpoint.
First Contact & Terms: Send samples. Samples are filed and are not returned. Reports back only if interested. Art Director will contact artists for portfolio review if interested. Portfolio should include b&w and color thumbnails, roughs, final art, tearsheets, photographs, transparencies, etc. Pays by personal contract. Rights purchased vary according to project.
Tips: Finds artists through submissions and word of mouth. "We look for stunning, eye-catching work—surprise us!"

Canada

✤**THE CABER FILM & VIDEO CO. LTD.**, 160 Wilkinson Rd., Unit 39, Brampton, Ontario L6T 4Z4 Canada. (905)454-5141. Fax: (905)454-5936. Producer: Chuck Scott. Estab. 1988. AV firm. Full-service, multimedia firm. Specializes in TV, commercials and corporate videos.
Needs: Approached by 60 freelancers/year. Works with 24 freelance illustrators and 24 designers/year. Prefers freelancers with experience in animation, film and video design (graphics). Works on assignment only. Uses freelancers for storyboards, slide illustration, animation, and TV/film graphics. 5% of work is with print ads.
First Contact & Terms: Send query letter with brochure, résumé, photocopies and video reel. Samples are filed or are returned by SASE. Reports back within 1 week. Call for appointment to show portfolio. Pays for design and illustration by the project. Rights purchased vary according to project.

✤**NORTHWEST IMAGING & F.X.**, 2339 Columbia St., Suite 100, Vancouver, British Columbia V5Y 3Y3 Canada. (604)873-9330. Fax: (604)873-9339. General Manager: Alex Tkach. Estab. 1956. AV firm. Specializes in graphics and visual special effects for TV and motion pictures, including storyboards and animation. Product specialties are TV commercials and shows. Current clients include: NBC, CBC, CBS, CTV, Fox, MGM, Paramount, Cannell and MTV.
Needs: Approached by 5 freelancers/month. Works with 2 illustrators and 2 designers/month. Prefers freelancers with experience in computer design. Works on assignment only. Uses freelancers mainly for backup and computer design. Also for brochure design and illustration, print ad design, storyboards, animatics, animation, TV/film graphics, lettering and logos. 10% of work is with print ads.
First Contact & Terms: Send query letter with résumé. Samples are filed. Reports back within 3 days. Art Director will contact artist for portfolio review if interested. Pays for design by the hour, $10-45; by the

The maple leaf before a listing indicates that the market is Canadian.

project, $100-2,500; also short term contract work by the week and by the day, $100-750. Pays for illustration by the project, $250 minimum. Buys all rights.

Tips: "I look for young, affordable artists we can train. Attitude plays an important role in development."

♣**WARNE MARKETING & COMMUNICATIONS**, 111 Avenue Rd., Suite 810, Toronto, Ontario M5R 3J8 Canada. (416)927-0881. Graphics Studio Manager: John Coljee. Number of employees: 11. Approximate annual billing: $4 million. Specializes in business-to-business promotion. Current clients: The Raymond Corporation (and dealers), Wellesley Hospital and Johnston Equipment. Professional affiliations: INBA, IMM, BMA, CCAB.

Needs: Approached by 5-6 freelancers/year. Works with 4-5 freelance illustrators and 1-2 designers/year. Works on assignment only. Uses freelancers for design, technical and medical illustrations, brochures, catalogs, P-O-P displays, retouching, billboards, posters, direct mail packages, logos. Artists should have "creative concept thinking." Prefers charcoal/pencil, colored pencil and markers. Needs computer-literate freelancers for design. 10% of freelance work demands knowledge of Adobe Illustrator.

First Contact & Terms: Send query letter with résumé and photocopies. Samples are not returned. Reports back only if interested. Pays for design by the hour, $100-150 or by the project, $500-1,000. Pays for illustration by the hour, $100-150. Considers complexity of project, client's budget and skill and experience of artist when establishing payment. Buys all rights.

AD, AV, PR Firms/'95-'96 changes

The following firms were listed in the 1995 edition but do not have listings in this edition. The majority did not respond to our request to update their listings. If a reason was given for exclusion, it appears in parentheses after the firm's name.

A.V. Media Craftsman, Inc.
AB&C Marketing Communications
Ad Enterprise Advertising Agency, Inc.
The Advertising Consortium
Alpine Marketing Communications Ltd.
Angle Films
Aries Productions
Arnold & Associates Productions
Asher Agency
Atlantic File Production
Automatic Mail Services, Inc.
Augustus Barnett Advertising/ Design
Beber Silverstein & Partners
Benjamin & Novich Inc., Advertising
Aleon Bennett & Assoc.
Beon Advertising, Inc.
Blattner/Brunner
Leo J. Brennan, Inc.
Bridger Productions, Inc.
Bright Light Productions, Inc.
Butwin & Associates Advertising, Inc.
Century III at Universal Studios
Charter Communications
Cinevision Corporation (per request)
Clearvue, Inc.

The Concepts Corp.
Cornerstone Associates (out of business)
Cosmopulos Crowley Daly/CKG
Crawley Haskins & Rodgers Public Relations
Creative Company, Inc.
Creative House Advertising Inc.
Creative Resources, Inc.
Essex Advertising Group, Inc.
Evans Wyatt Advertising
Film Classic Exchange
Flexsteel Industries Inc.
Fogleman & Partners Advertising & Marketing
Alan Frank & Associates Inc.
Freedman, Gibson & White Advertising
Garrity Communications, Inc.
Gordon Gelfond Associates, Inc.
Gra-Mark Advertising
Graff Advertising
Grant/Garrett Communications, Inc.
Green, Lind & McNulty, Inc.
Group Atlanta Creative (unable to contact)
Hamilton Sweeney Advertising
Instant Replay
Keating Magee Long
Knox Public Relations
Kobasic Fine Hadley

Krisch Hotels, Inc.
Lewis Advertising, Inc.
Listening Library, Inc.
Lord & Bentley Persuasive Marketing
McCann-Erickson Worldwide
Meridian Communications
Morphis & Friends, Inc.
Multi-Image Productions
The Neiman Group
Nostradamus Advertising
Edwin Neuger & Associates
Paragon Advertising
Partners Meany
Prime Productions, Inc.
Red Hots Entertainment
Saffitz Alpert & Associates
The Senses Bureau, Inc.
Smith Advertising & Associates
The Softness Group, Inc.
Sorin Productions Inc.
Speer, Young & Hollander
Sprint Integrated Marketing Services
Steen Advertising Corp.
Stewart Digital Video
Tassani & Paglia
Teleproductions
BJ Thompson Associates, Inc.
Triad
21st Century Video Productions
Webber, Cohn & Riley

Art Publishers

Have you ever noticed, perhaps at an opening of an exhibition, or at an art fair, that though you have many paintings on display, everybody wants to buy the same one? Do friends, relatives and co-workers ask you to paint duplicates of work you already sold? That's one reason many artists turn to the print market. With experience, they find certain images have a wide appeal and will sell again and again. And did you know that once there is a print of a painting, the original becomes more valuable?

This section lists art publishers and distributors who might publish your work as a print or poster and market the images to framers, interior decorators and other outlets. In order to be accepted for publication, however, your work must fit in with the current trends in the industry.

Explore your options

There are several different ways to get prints of your work published. One option is to submit your work to art publishers, such as the firms listed in this section. If the company chooses to publish your print, they will supervise the printing process for you and will market the work to various outlets. You will receive a percentage of the sales or a royalty, depending on the terms of your contract.

Another option is publishing the print yourself. Self-publication is a risky venture that requires lots of preliminary research, like visiting trade shows, reading trade publications, making a thorough study of outlets for your work, and contacting those outlets to buy your print. You also must be knowledgeable about printing, color separations, buying paper, and other technicalities of the production process. The first print run of a self-published print usually is a learning process, and a rule of thumb seems to be you won't see a profit until your second print. Some artists end up with stacks of prints taking up space in their basements and a huge bill from the printer, but many become successful entrepreneurs.

Still another option is self-publishing your print and submitting it to a distributor who will market it to various outlets for you. Most art publishers are also distributors, but not all distributors are publishers.

The publishing process

An art publisher usually contracts with an artist to put a piece of that artist's work in print form, and then pays for and supervises the production and marketing of the work. Sometimes a publisher will agree to run prints of a pre-existing image, while other times the artist will be asked to create a new piece of art for publication purposes. A print will generally be classified as an original print or offset reproduction, depending on how it is produced and where it is sold.

Original prints may be woodcuts, engravings, linocuts, mezzotints, etchings, lithographs or serigraphs. What distinguishes them is that they are produced by hand (and consequently often referred to as handpulled prints). The market for original prints has been growing steadily for the last few years. Although prints have traditionally been sold through specialized print galleries, frame shops and high-end decorating outlets, more and more fine art galleries are now handling them in addition to original artwork. A gallery will often handle prints of an artist with whom it has already established a working relationship.

Original prints are always sold in limited editions and consequently command higher prices. Since plates for original prints are made by hand, and as a result can only withstand a certain amount of use, the number of prints that can be pulled is limited by the number of impressions that can be made before the plate wears out. Some publishers impose their own limits on the number of impressions to increase a print's value. These limits may be set as high as 700 to 1,000 impressions, but some prints are limited to just 250 to 500, making them highly prized by collectors.

Offset reproductions, also known as posters, are reproduced by photomechanical means. Since plates used in offset reproduction do not wear out, there are no physical limits on the number of prints made. Quantities, however, may still be limited by the publisher in order to add value to the edition.

Prices for reproductions vary widely depending on the quantity available; the artist's reputation; the popularity of the image; and the quality of the paper, ink and printing process. Since prices are lower than those for original prints, publishers tend to select images with high-volume sales potential.

If your artwork has wide appeal, and you are flexible, success might be waiting for you in the multi-million-dollar plates and collectibles market. You will be asked to adjust your work to fit a circular format if it is chosen for a collectible plate, so be prepared to work with the company's creative director to develop the final image. Consult the Greeting Cards, Gift Items & Paper Products section for companies specializing in collectibles.

A special note about sculpture

Some publishers also handle limited editions of sculptural pieces and market them through fine art galleries. Sculptural editions are made by casting several forms from the same mold. Check the listings in this section for more targeted information about this publishing option.

What's hot

According to *USArt* the three most popular printing methods for original prints currently are etching, serigraphy and lithography. In the past few years colors tended to be quiet hues and neutrals with clean pastels. The Color Association of America (CAUS) forecasts warm terra cotta oranges, green-cast turquoises, light celadon and olive greens to be the popular interior colors for 1996-97. CAUS also picks deep moss green, charcoal gray, burgundy, burnt sienna orange, maroon, brown and teal to be hip hues. (For more information about CAUS, call Margaret Walch, associate director, at (212)582-6884.) Country and Victorian themes are big these days. Other popular subjects include Native American images—especially those with spiritual undertones, fantasy art, African and African-American themes, angels and children. Sports images continue to do well, particularly golf prints.

Canvas transfers are becoming increasingly popular. Instead of, and often in addition to, printing an image on paper, the publisher transfers the image onto canvas so the work has the look and feel of a painting. Some publishers market limited editions of 750 prints on paper, along with a smaller edition of 100 of the same work on canvas.

The edition on paper might sell for $150 per print, while the canvas transfer would be priced higher, perhaps selling for $395.

Finding the right publisher

Like any business venture, finding the right publisher requires careful research. Visit galleries, frame shops and other retail outlets that carry prints to see what is selling. You may also want to visit designer showrooms, interior decoration outlets and trade shows such as Art Expo in New York City and Art Buyers Caravan (known as the ABC show) in Atlanta, to get a sense of what's out there.

Once you've selected a list of potential publishers, send for artist's guidelines or catalogs if they are available. Some larger publishers will not send their catalogs because they are too expensive, but you can often ask to see one at your local poster shop, print gallery or frame shop.

Approaching and working with publishers

To approach a publisher, send a brief query letter, a short bio, a list of galleries that represent your work and five to ten slides. It helps to send printed pieces or tearsheets as samples, as these show publishers that your work can be reproduced effectively and that you have some understanding of the publication process.

A few publishers will buy work outright for a flat fee, but most pay on a royalty basis. Royalties for handpulled prints are usually based on retail price and range from 5 to 20 percent, while percentages for offset reproductions are lower (from 2½ to 5 percent) and are based on the wholesale price. Be aware that some publishers may hold back royalties to cover promotion and production costs. This is not uncommon.

As in other business transactions, make sure you understand all the terms of your contract before you sign. The publisher should provide a description of the print ahead of time, including the size, printing method, paper and number of images to be produced. Other things to watch for include insurance terms, marketing plans, and a guarantee of a credit line and copyright notice.

Always retain ownership of your original work, and try to work out an arrangement in which you're selling publication rights only. You'll also want to sell rights only for a limited period of time. Such arrangements will leave you with the option to sell the image later as a reprint, or to license it for other use (for example as a calendar or note card).

Most publishers will arrange for the artist to see a press proof and will give the artist final approval of a print. The more you know about the printing process and what can and cannot be done in certain processes, the better. If possible, talk to a printer ahead of time about your concerns. Knowing what to expect beforehand will eliminate surprises and headaches for the printer, publisher and you.

AARON ASHLEY, INC., 230 Fifth Ave., Suite 1905, New York NY 10001. (212)532-9227. Fax: (212)481-4214. Contact: Philip D. Ginsburg or Budd Wiesenburg. Produces unlimited editions, 4-color offset and hand-colored reproductions for distributors, manufacturers, museums, schools and galleries. Clients: major US and overseas distributors, museums, galleries and frame manufacturers.

Needs: Seeking decorative art for the designer market. Considers oil paintings and watercolor. Prefers realistic or representational works. Artists represented include French-American Impressionists, Bierstadt, Russell Remington, Jacqueline Penney, Ron McKee, Carolyn Blish and Urania Christy Tarbot. Editions created by working from an existing painting or chrome. Approached by 100 artists/year. Publishes and distributes the work of 12 emerging artists/year. Publishes more than 100 editions/year.

First Contact & Terms: Query with SASE and slides or photos. "Do not send originals." Artist should follow up with call and/or letter after initial query. Reports immediately. Pays royalties or fee. Offers advance. Negotiates rights purchased. Requires exclusive representation for unlimited editions. Provides written contract.

Tips: Advises artists to attend Art Expo and Galeria, both in New York City.

‡AARON FINE ARTS, 1809 Reisterstown Rd., #134, Baltimore MD 21208. (410)484-8900. Fax: (410)484-3965. Contact: Aaron Young or Jennifer Barroll. Art publisher, distributor, gallery. Publishes and distributes handpulled originals, limited editions, offset reproductions and posters. Clients: wholesale, retail; national, international.
Needs: Seeking creative and decorative art for the commercial and designer markets. Considers oil, watercolor, mixed media, pastel and acrylic. Prefers contemporary, colorful abstracts, unusual landscapes, florals, figuratives. Artists represented include Laurie Fields, Zule, Alvarez, Susan Mackey, John O'Brien, Barbieri, Ghambaro, Amanda Watt. Editions created by collaborating with the artist or by working from an existing painting. Approached by 50 artists/year.
First Contact & Terms: Send query letter with brochure, résumé, tearsheets, slides, photographs and photocopies. Samples are filed or returned by SASE if requested by artist. Reports back within 2 weeks. Publisher/Distributor will contact artist for portfolio review if interested. Portfolio should include color thumbnails, final art and photographs. Negotiates payment. No advance. Requires exclusive reprentation of artist. Provides advertising, insurance while work is at firm and shipping from firm.
Tips: Recommends artists attend Art Expo in New York City.

ADDI FINE ART PUBLISHING, 961 Matley Lane, Suite 105, Reno NV 89502. (800)845-2950. Fax: (702)324-4066. Director: Andrejs Van Nostrand. Estab. 1989. Art publisher, distributor and gallery. Publishes posters, canvas reproductions and limited editions. Clients: galleries and distributors. Current clients include Prints Plus, London Contemporary Art and Endangered Species Stores.
Needs: Seeking art for the serious collector and the commercial market. Considers oil and acrylic. Prefers wildlife, landscapes and marine themes. Artists represented include David Miller, Ken Conragan and John Cosby. Editions created by collaborating with the artist or by working from an existing painting. Approached by 25 artists/year. Publishes/distributes the work of 1-2 emerging, 1-2 mid-career and 2-3 established artists/year. Distributes the work of 2-3 established artists/year.
First Contact & Terms: Send query letter with slides, photocopies, résumé, transparencies, tearsheets and photographs. Samples are not filed and are returned. Reports back within 1 month. Publisher/Distributor will contact artists for portfolio review if interested. Pays variable royalties. Does not offer advance. Buys reprint rights. Provides promotion, shipping from firm, insurance while work is at firm, and written contract.
Tips: Advises artists to attend Art Expo in New York and Las Vegas and ABC in Atlanta. "Submit photos or slides of work presently available. We usually request that originals be sent if we are interested in art."

‡AEROPRINT, (AKA SPOFFORD HOUSE), South Shore Rd., Box 154, Spofford NH 03462. (603)363-4713. Owner: H. Westervelt. Estab. 1972. Art publisher/distributor handling limited editions (maximum 250 prints) of offset reproductions and unlimited editions for galleries and collectors. Clients: aviation art collectors.
Needs: Seeking creative art. Considers pen & ink, oil, acrylic, pastel, watercolor, tempera or mixed media. Prefers representational, event-oriented subject matter of historical nature. Artists represented include Merv Corning, Jo Kotula, Terry Ryan and Gil Cohen. Publishes the work of 1 emerging and 8 established artists/year. Distributes the work of 5 emerging and 32 established artists/year.
First Contact & Terms: To show a portfolio, mail color or b&w thumbnails, roughs, original/final art, photostats, tearsheets, slides, transparencies or final reproduction/product. Payment method is negotiated. Offers an advance. Negotiates rights purchased. Provides written contract and shipping from firm.
Tips: A common problem is "incomplete or underdeveloped talent, prematurely presented for publishing or introduction to a project."

AKASHA, 2919 Como Ave. SE, Minneapolis MN 55414. (612)379-2781. Fax: (612)379-2251. Contact: Steve Andersen. Fine art printing and publishing workshop. Estab. 1977.
Needs: Considers sculpture, original handpulled prints, painting and mixed media. Artists represented include Red Grooms, Wegman, Africano, Ed Moses, Solien. Publishes the work of 2-3 emerging, 5-10 mid-career and 2-3 established artists.
First Contact & Terms: Write for appointment to show portfolio of slides. Replies if interested within 1 month. Files résumés and reviews. "Artists are invited to the studio on the merits of their original work to produce an edition or a portfolio of monotypes, etc. The proceeds from the sale of the work are split between the publisher and artist. We are also open to other negotiated deals."
Tips: Advises artists to attend the Chicago Pier Show.

♣KEITH ALEXANDER EDITIONS, 102-1445 W. Georgia St., Vancouver, British Columbia V6G 2T3 Canada. (604)682-1234. President: Barrie Mowatt. Estab. 1978. Art publisher, distributor and gallery. Publishes and distributes limited editions, handpulled originals and posters. Clients: galleries and other distributors.
Needs: Prefers original themes. Publishes and distributes the work of 11 artists/year.
First Contact & Terms: Send query letter with résumé, tearsheets and transparencies. Samples are not filed and are returned. Reports back within 6-12 weeks. Write for appointment to show portfolio of transparencies. Pays flat fee or on consignment basis; payment method is negotiated. Buys all rights. Requires exclusive representation of the artist. Provides insurance, promotion, shipping from firm and a written contract.

Tips: "Present a professional portfolio which accurately reflects the real work. Also have goals and objectives about lifestyle expectations."

ALL SALES CO./PRIME PRODUCTS, 5772 N. Ocean Shore Blvd., Palm Coast FL 32137. Phone/fax: (904)445-6057. Owners: Tim Curry and Dee Abraham. Art publisher and distributor. Publishes and distributes limited and unlimited editions.
Needs: Considers oil, watercolor and acrylic. Prefers wildlife, birds, sport dogs, florals and golf themes. Artists represented include John Akers, Robert Cook, Della Storms and Barbra Louque. Editions created by collaborating with the artist. Publishes and distributes 12 new prints each year.
First Contact & Terms: Send query letter with tearsheets, photographs and photocopies. Samples returned on request. Reports back within 1 month. Call for appointment to show portfolio or mail tearsheets and photographs. Payment method is negotiated. Offers advance when appropriate. Negotiates rights purchased.
Tips: "Color remains a key factor in our determination for works published."

‡ALTERNATIVES, 5528 N. Lacasita, Tuscon AZ 85718. (602)529-8847. Marketing Rep: Stan Everhart. Estab. 1979. Art publisher, distributor. Publishes and distributes handpulled originals and marbled papers. Clients: galleries, design and trade.
Needs: Seeking decorative art for the serious collector and commercial market. Considers original prints. Prefers landscapes and florals. Artists represented include Loudermilk, Howard, Fare. Editions created by collaborating with the artist. Approached by 3-6 artists/year. Publishes the work of 1-2 and distributes the work of 3-4 established artists/year.
First Contact & Terms: Send postcard size sample of work or send query letter with brochure and tearsheets. Samples are returned. Publisher/Distributor will contact artist for portfolio review if interested. Portfolio should include final art. Buys work outright (50% of wholesale). No advance. Rights purchased vary according to project. Provides promotion and shipping from firm.
Tips: Finds artists through trade shows. Suggests artists "work through agent or sales force."

‡AMCAL FINE ART, 2500 Bisso Lane, Bldg. 500, Concord CA 94520. (510)689-9930. Fax: (510)689-0108. Development Manager: Julianna Ross. Art publisher. Publishes limited editions and offset reproductions. Clients: galleries.
Needs: Seeking creative art for the serious collector. Considers oil, watercolor, mixed media, pastel and acrylic. Prefers realistic, impressionistic, nostalgic work. Artists represented include Charles Wysocki. Editions created by collaborating with the artist or by working from an existing painting. Approached by hundreds of artists/year. Publishes the work of 0-1 emerging, 0-2 mid-career and 2-3 established artists/year.
First Contact & Terms: Send postcard size sample of work or send query letter with brochure, slides, photocopies, transparencies, tearsheets and photographs. Samples are not filed and are returned by SASE if requested by artist. Reports back within 3 months. Publisher will contact artist for portfolio review if interested. Portfolio should include color slides, tearsheets, transparencies, final art and photographs. Negotiates payment. Offers advance when appropriate. Provides advertising, in-transit insurance, insurance while work is at firm, promotion, shipping and written contract.
Tips: Finds artists through researching trade, art magazines, attending shows, visiting galleries. Suggests artists read *USArt* magazine, *Art Business News*, *GSB*, also home decor magazines.

AMERICAN VISION GALLERY, 625 Broadway, 4th Floor, New York NY 10012. (212)925-4799. Fax: (212)431-9267. Contact: Acquisitions. Estab. 1974. Art publisher and distributor. Publishes and distributes posters and limited editions. Clients: galleries, frame shops, museum shops. Current clients include Museum of Modern Art, The Studio Museum.
Needs: Seeking African-American art. Prefers depictions of African-Americans, Carribean scenes or African themes. Artists represented include Romare Bearden, Jacob Lawrence and several Hatian artists.
First Contact & Terms: Send query letter with slides and bio. Samples are returned by SASE if requested by artist. Reports back only if interested. Pays flat fee, $400-1,500 maximum, or royalties of 10%. Offers advance when appropriate. Negotiates rights purchased. Interested in buying second rights (reprint rights) to previously published artwork.
Tips: "If you don't think you're excellent, wait until you have something excellent."

HERBERT ARNOT, INC., 250 W. 57th St., New York NY 10107. (212)245-8287. President: Peter Arnot. Vice President: Vicki Arnot. Art distributor of original oil paintings. Clients: galleries, design firms.

 The double dagger before a listing indicates that the listing is new in this edition. New markets are often more receptive to freelance submissions.

Needs: Seeking creative and decorative art for the serious collector and designer market. Considers oil and acrylic paintings. Has wide range of themes and styles—"mostly traditional/impressionistic, not modern." Artists represented include An He, Malva, Willi Bauer, Gordon, Yoli and Lucien Delarue. Distributes the work of 250 artists/year.

First Contact & Terms: Send query letter with brochure, résumé, business card, slides or photographs to be kept on file. Samples are filed or are returned by SASE. Reports within 1 month. Portfolios may be dropped off every Monday-Friday or mailed. Pays flat fee, $100-1,000. Provides promotion and shipping to and from distributor.

Tips: "Check colors currently in vogue."

ART BEATS, INC., 33 River Rd., Suite A, Cos Cob CT 06807. (800)338-3315. Fax: (203)661-2480. Managing Director: Josh Fleischmann. Estab. 1983. Art publisher. Publishes and distributes unlimited editions, posters, limited editions, offset reproductions and gift/fine art cards. Clients: framers, gallery owners, gift shops. Current clients include Prints Plus, Intercontinental Art.

Needs: Seeking creative, fashionable and decorative art for the commercial and designer markets. Considers oil, watercolor, mixed media, pastel and acrylic. Artists represented include Gary Collins, Nancy Lund, Mark Arian, Robert Duncan and Tracy Taylor. Approached by 1,000 artists/year. Publishes the work of 45 established artists/year.

First Contact & Terms: Send query letter with slides, photocopies, résumé, photostats, transparencies and tearsheets. Samples are not filed and are returned by SASE if requested by artist. Reports back within 1 month. Publisher will contact artist for portfolio review if interested. Portfolio should include photostats, slides, tearsheets, photographs and transparencies; "no originals please." Pays royalties of 10% gross sales. No advance. Buys first rights, one-time rights or reprint rights. Provides promotion and written contract.

Tips: Finds artists through art shows, exhibits, word of mouth and submissions.

ART BOOM LIMITED EDITIONS, 2516 Ivan Hill Terrace, Los Angeles CA 90039. (213)913-0162. Fax: (213)666-2367. Publisher: Steve Rinehart. Art publisher. Publishes and distributes limited editions. Clients: 1,100 galleries.

Needs: Considers oil, mixed media and acrylic. Prefers representational art. Artists represented include Steve Kushner, Alan Murray. Editions created by collaborating with the artist and working from an existing painting. Approached by 100/year. Publishes the work of 2-3 emerging, 1 mid-career and 6-10 established artists/year. Distributes the work of 1-2 emerging and 1-2 established artists/year.

First Contact & Terms: Send query letter with brochure, slides, photocopies, résumé, transparencies, tearsheets and photographs. Samples are not filed and returned by SASE if requested by artist. Portfolio review not required. Publisher will contact artist for portfolio review if interested. Portfolio should include slides and 4×5 or 8×10 transparencies. Pays royalties of 12-15% or negotiates payment. No advance. Buys reprint rights. Requires exclusive representation of artist. Provides in-transit insurance, promotion, shipping from firm and written contract.

Tips: Finds artists through attending art exhibitions.

ART BROKERS OF COLORADO, 1010 W. Colorado Ave., Colorado Springs CO 80904. (719)520-9177. Contact: Nancy Anderson. Estab. 1990. Art publisher and gallery. Publishes limited editions and offset reproductions. Clients: galleries, commercial and retail.

Needs: Seeking decorative art by established artists for the serious collector. Prefers oil, watercolor, acrylic and pastel. Open to most themes and styles (no abstract). Editions created by collaborating with the artist or working from an existing painting. Approached by 50-75 artists/year. Publishes and distributes the work of 8 established artists/year.

First Contact & Terms: Send query letter with résumé, slides and photographs. Samples are filed or are returned by SASE if requested by artist. Reports back within 2-4 weeks. Call or write for appointment to show portfolio of slides and photographs. Payment method is negotiated. Buys all rights. Provides insurance while work is at firm and shipping from firm.

Tips: Advises artists to attend all the trade shows and to participate as often as possible.

ART EDITIONS, INC., 352 W. Paxton Ave., Salt Lake City UT 84101. (801)466-6088. Contact: Ruby Reece. Art printer for limited and unlimited editions, offset reproductions, posters, advertising materials, art labels, business cards, magazine ad set up and art folios. Clients: artists, distributors, galleries, publishers and representatives.

First Contact & Terms: Send photographs, slides, transparencies (size 4×5—8×10) and/or originals. "Contact offices for specific pricing information. Free information packet available upon request."

Tips: "We see trends going to softness of prints and advertising materials. Less and less do we get requests for super shiny 'glitzy' type of sales aids. The art seems to be the statement now, not the hype of glossy papers."

ART EMOTION, 729 Pinecrest St., Prospect Heights IL 60070. (708)459-0209. Fax: (708)397-0206. E-mail: gperez@interaccess.com. President: Gerard V. Perez. Estab. 1977. Art publisher and distributor. Publishes

and distributes limited editions. Clients: corporate/residential designers, consultants and retail galleries.

Needs: Seeking decorative art. Considers oil, watercolor, acrylic, pastel and mixed media. Prefers representational, traditional and impressionistic styles. Artists represented include Garcia, Johnson and Sullivan. Editions created by working from an existing painting. Approached by 50-75 artists/year. Publishes and distributes the work of 2-5 artists/year.

First Contact & Terms: Send query letter with slides or photographs. Samples are filed. Does not necessarily report back. Pays royalties of 10%.

Tips: "Send visuals first."

***THE ART GROUP**, 146 Royal College St., London NW1 OTA England. (01)482-3206. Contact: Art Director. Fine art card and poster publisher/distributor handling posters for framers, galleries, museums, department stores and gift shops.

Needs: Considers all media and broad subject matter. Fine art contemporary; abstracts; color photography (no b&w). Publishes the work of 100-200 mid-career and 200-400 established artists/year. Distributes the work of more than 1,000 artists/year.

First Contact & Terms: Send query letter with brochure, photostats, photographs, photocopies, slides and transparencies. Samples are filed or are returned. Reports back within 1 month. Publisher/Distributor will contact artists for portfolio review if interested. Pays royalties of 10% of world distribution price. Offers an advance when appropriate. Provides insurance while work is at firm and written contract.

ART IMAGE INC., 1400 Everman Pkwy., Ft. Worth TX 76140. (817)568-5222. Fax: (817)568-5254. President: Charles Albany. Art publisher and distributor. Publishes and produces unlimited and limited editions that are pencil signed and numbered by the artist. Also distributes etchings, serigraphs, lithographs and watercolor paintings. "We also publish and distribute handmade paper, cast paper, paper weavings and paper construction." All work sold to galleries, frame shops, framed picture manufacturers, interior decorators and auctioneers.

Needs: Seeking decorative art for the designer market and art galleries. "We prefer subject matter in all media in pairs or series of companion pieces." Prefers contemporary, traditional and transitional artists. Artists represented include Robert White, Peter Wong, Larry Crawford, David Olson, Marsha Kramer and Ron Dianno. Editions created by collaborating with the artist. Approached by 36 artists/year. Publishes and distributes the work of 18 emerging, 18 mid-career and 18 established artists/year.

First Contact & Terms: Send query letter with brochure showing art style, tearsheets, slides, photographs and SASE. Reports within 1 month. Write for appointment to show portfolio or mail appropriate materials. Portfolio should include photographs. Negotiates payment. Requires exclusive representation. Provides shipping and a written contract.

Tips: "We are publishing and distributing more and more subject matter from offset limited editions to monoprints, etchings, serigraphs, lithographs and original watercolor paintings. We will consider any work that is commercially acceptable."

✦ART IN MOTION, 800 Fifth Ave., Suite 150, Seattle WA 98104; or 1612 Ingleton, Burnaby, British Columbia V5C 5R9 Canada. (604)299-8787. Fax: (604)299-5975. President: Garry Peters. Art publisher and distributor. Publishes and distributes limited editions, original prints, offset reproductions and posters. Clients: galleries, distributors world wide and picture frame manufacturers.

• Garry Peters reports that business is up 30%.

Needs: Seeking creative, fashionable and decorative art for the serious collector, commercial and designer markets. Considers oil, watercolor, acrylic, and mixed media. Prefers decorative styles. Artists represented include Marilyn Simandle, Corinne Hartley and Art LaMay. Editions created by collaborating with the artist or by working from an existing painting. Approached by 100 artists/year. Publishes the work of 5-7 emerging, mid-career and established artists/year. Distributes the work of 2-3 emerging and established artists/year.

First Contact & Terms: Send query letter with brochure showing art style or résumé and tearsheets, slides, photostats, photos and transparencies. Samples are filed or are returned by SASE if requested by artist. Reports back within 2 weeks if interested. If does not report back the artist should call. Call for appointment to show portfolio, or mail photostats, slides, tearsheets, transparencies and photographs. Pays royalties up to 15%. Payment method is negotiated. "It has to work for both parties. We have artists making $200 a month and some that make $10,000 a month or more." Offers an advance when appropriate. Negotiates rights purchased. Requires exclusive representation of artist. Provides in-transit insurance, insurance while work is at firm, promotion, shipping to and from firm and a written contract.

Tips: "We are looking for a few good artists; make sure you know your goals, and hopefully we can help you accomplish them, along with ours."

 The maple leaf before a listing indicates that the market is Canadian.

ART RESOURCES INTERNATIONAL, LTD./BON ART, Fields Lane, Brewster NY 10509. (914)277-8888. Fax: (914)277-8602. Vice President: Robin E. Bonnist. Estab. 1980. Art publisher. Publishes unlimited edition offset lithographs and posters. Does not distribute previously published work. Clients: galleries, department stores, distributors, framers worldwide.

Needs: Considers oil, acrylic, pastel, watercolor, mixed media and photography. Artists represented include Tony Macchiarulo, Ruane Manning, Lucy Davies, Bill Hobson, Floyd Newkirk, Rafael, Guttke, Ken Shotwell, Carlos Rios, Halessie, Pamela Patrick, Hulan Fleming and Nicky Boehme. Editions created by collaborating with the artist or by working from an existing painting. Approached by hundreds of artists/year. Publishes the work of 10-20 emerging, 5-10 mid-career and 5-10 established artists/year.

First Contact & Terms: Send query letter with bio, brochure, tearsheets, slides and photographs to be kept on file. Samples returned by SASE only if requested. Portfolio review not required. Prefers to see slides or transparencies initially as samples, then reviews originals. Reports within 1 month. Appointments arranged only after work has been sent with SASE. Pays flat fee, $250-1,000 or 3-10% royalties. Offers advance in some cases. Requires exclusive representation for prints/posters during period of contract. Provides in-transit insurance, insurance while work is at publisher, shipping to and from firm, promotion and a written contract. Artist owns original work.

Tips: "Please submit decorative, fine quality artwork. We prefer to work with artists who are creative, professional and open to art direction." Advises artists to attend all art buyers caravan shows and Art Expo New York City.

ARTHURIAN ART GALLERY, 4646 Oakton St., Skokie IL 60076-3145. Owner: Art Sahagian. Estab. 1985. Art distributor and gallery. Handles limited editions, handpulled originals, bronze, watercolor, oil and pastel. Current clients include Gerald Ford, Nancy Reagan, John Budnik and Dave Powers.

Needs: Seeking creative, fashionable and decorative art for the serious collector and commercial market. Artists represented include Robert Barnum, Nancy Fortunato, Art Sahagian and Christiana. Editions created by collaborating with the artist. Approached by 25-35 artists/year. Publishes and distributes the work of 5-10 emerging, 1-3 mid-career and 2-5 established artists/year.

First Contact & Terms: Send query letter with brochure showing art style and résumé, slides and prices. Samples not filed returned by SASE. Reports within 30 days. Write for appointment to show portfolio of original/final art, final reproduction/product and color photographs. Pays flat fee of $25-2,500; royalties of 3-5%; or on a consignment basis (firm receives 25% commission). Rights purchased vary. Provides insurance while work is at firm, promotion and written contract.

Tips: Sees trend toward animal images and bright colors.

ARTHUR'S INTERNATIONAL, 2613 High Range Dr., Las Vegas NV 89134. President: Marvin C. Arthur. Estab. 1959. Art distributor handling original oil paintings primarily. Publishes and distributes limited and unlimited edition prints. Clients: galleries, corporate and private collectors, etc.

Needs: Seeking creative art for the serious collector. Considers all types of original work. Artists represented include Wayne Takazono, Wayne Stuart Shilson, Paul J. Lopez, Ray Shry-Ock and Casimir Gradomski. Editions created by collaborating with the artist or by working from an existing painting. Purchases have been made in pen & ink, charcoal, pencil, tempera, watercolor, acrylic, oil, gouache and pastel. "All paintings should be realistic to view, though may be expressed in various manners."

First Contact & Terms: Send brochure, slides or photographs to be kept on file; no originals unless requested. Artist biographies appreciated. Samples not filed are returned by SASE. Reports back normally within 1 week. "We pay a flat fee to purchase the original. Payment made within 5 days. Then we pay 30% of our net profit made on reproductions. The reproduction royalty is paid after we are paid. We automatically raise artist's flat fee as demand increases."

Tips: "Do not send any original paintings unless we have requested them. Having a track record is nice, but it is not a requirement."

‡ARTISTIC PROMOTIONS, 30336 Chapala Court, Laguna Niguel CA 92677. (714)363-1449. Owner: Colleen J. Duddleston. Estab. 1990. Art publisher, distributor and gallery. Publishes and distributes handpulled originals, limited editions and posters. Clients: corporate, private collectors.

Needs: Seeking artwork for the serious collector, commercial and designer markets. Considers pastel, pen & ink and acrylic. Artists represented include Claude Vandelli, Richard Paul Gailey. Editions created by collaborating with the artist and by working from an existing painting. Approached by 10 artists/year. Publishes the work of 2 emerging, 2 mid-career and 5 established artists/year. Distributes the work of 5 emerging, 10 mid-career and 50 established artists/year.

First Contact & Terms: Send brochure, résumé, tearsheets and photographs. Samples are filed. Reports back within 30 days. Artist should follow-up with call. Publisher/Distributor will contact artist for portfolio review if interested. Portfolio should include color final art and tearsheets. Negotiates payment. No advance. Negotiates rights purchased. Provides advertising, insurance while work is at firm and promotion.

Tips: Finds artists through Art Expo. Recommends artists attend Art Expo and read *Decor* and *Art Business News*.

Lucy Davies's Sunshine *is part of a collection of "refreshing and uplifting contemporary images," says Robin Bonnist of Art Resources International, Ltd. The artist, who works in watercolor, also did a companion piece,* Night Time. *Art Resources often publishes images in pairs or series.*

ARTISTS' MARKETING SERVICE, 160 Dresser Ave., Prince Frederick MD 20678. President: Jim Chidester. Estab. 1987. Distributor of limited and unlimited editions, offset reproductions and posters. Clients: galleries, frame shops and gift shops.

Needs: Seeking decorative art for the commercial and designer markets. Prefers traditional themes: landscapes, seascapes, nautical, floral, wildlife, Americana, impressionistic and country themes. Artists represented include Lena Liu and Barbara Hails. Approached by 200-250 artists/year. Distributes the work of 10-15 emerging artists and 5-10 mid-career artists/year.

First Contact & Terms: Send query letter with brochure, tearsheets and photographs. Samples are filed or returned by SASE if requested by artist. Reports back within weeks. To show portfolio, mail tearsheets and slides. Pays on consignment basis (50% commission). Offers an advance when appropriate. Purchases one-time rights. Does not require exclusive representation of artist.

Tips: "We are only interested in seeing work from self-published artists who are interested in distribution of their prints. We are presently *not* reviewing originals for publication. A trend seems to be for larger edition sizes for limited edition prints."

‡ARTISTWORKS WHOLESALE INC., 32 S. Lansdowne Ave., Lansdowne PA 19050. (610)626-7770. Fax: (610)626-2778. Art Coordinator: Helen Casale. Estab. 1981. Art publisher. Publishes and distributes posters and cards. Clients: galleries, decorators and distributors worldwide.
Needs: Seeking creative, fashionable and decorative art for the commercial and designer markets. Considers oil, watercolor, acrylic, pastel, mixed media and photography. Prefers contemporary and popular themes, realistic and abstract. Artists represented include Margaret Babbitt, Martha Bradford, Yoli Salmona and Harry Bartnick. Editions created by collaborating with artist and by working from an existing painting. Approached by 100 artists/year. Publishes and distributes the work of 1-2 emerging, 1-2 mid-career and 1-2 established artists/year.
First Contact & Terms: Send query letter with brochure showing art style or résumé, slides, photographs and transparencies. Samples are not filed and are returned by SASE. Reports back within 1 month. Write for appointment to show portfolio or mail finished art samples, photographs and slides. Payment method is negotiated. Offers advance when appropriate. Negotiates rights purchased. Requires exclusive representation of artist. Provides in-transit insurance, insurance while work is at firm, promotion, shipping to and from firm and a written contract.
Tips: "Publishers are now more discriminating about what they publish. Distributors are much more careful about what and how much they buy. Everyone is more conservative."

BENJAMANS ART GALLERY, 419 Elmwood Ave., Buffalo NY 14222. (716)886-0898. Fax: (716)886-0546. Estab. 1970. Art publisher, distributor, gallery, frame shop and appraiser. Publishes and distributes handpulled originals limited and unlimited editions, posters, offset reproductions and sculpture. Clients come from every walk of life.
Needs: Seeking creative, fashionable and decorative art for the serious collector and the commercial and designer markets. Considers oil, watercolor, mixed media and sculpture. Prefers traditional to abstract work. Artists represented include J.C. Litz, Mike Hamby and Smadar Livine. Editions created by collaborating with the artist or by working from an existing painting. Approached by 20-30 artists/year. Publishes and distributes the work of 2 emerging, 2 mid-career and 2 established artists/year.
First Contact & Terms: Send query letter with brochure showing art style, slides, photocopies, résumé, photostats, transparencies, tearsheets and/or photographs. Samples are filed. Reports back within 2 weeks. Write for appointment to show portfolio. Pays royalties of 30-50% on consignment basis. No advance. Buys all rights. Sometimes requires exclusive representation of artist. Provides promotion, shipping from firm and insurance while work is at firm.
Tips: "Keep trying to join a group of artists."

BENTLEY HOUSE FINE ART PUBLISHERS, Box 5551, Walnut Creek CA 94596. (510)935-3186. Fax: (510)935-0213. Director of Artist Relations, Licensing Division: Mary Sher. Estab. 1986. Art publisher of limited and unlimited editions of offset reproductions, posters and canvas transfers; also agency (Art Licensing Partners) for cross-licensing of artists' images worldwide. Clients: framers, galleries, distributors and framed picture manufacturers.
Needs: Seeking decorative fine art for the residential, commercial and designer markets. Considers oil, watercolor, acrylic, gouache and mixed media from accomplished artists. Prefers traditional, classic, or contemporary styles in realism and impressionism. Artists represented include B. Mock, C. Valente, E. Dertner, R.J. Zolan, L. Entz, P. Abrams, W. Schwarzbek and E. Antonaccio. Editions created by collaborating with the artist or by working from an existing painting. Approached by 300 artists/year. Publishes the work of 35 established and emerging artists/year.
First Contact & Terms: Send query letter with brochure showing art style or résumé, tearsheets, slides and photographs. Samples are filed or are returned by SASE if requested by artist. Reports back within 3 months. "We will call artist if we are interested." Pays royalties of 10% monthly plus 50 artist proofs of each edition. Does not offer an advance. Obtains all reproduction rights. Usually requires exclusive representation of artist. Provides national trade magazine promotion, a written contract, worldwide agent representation, 6 annual trade show presentations, insurance while work is at firm and shipping from firm.
Tips: Advises artists to attend the Art Buyers' Caravan. "Customers know that fine art prints from Bentley are 'from a market leader in decorative art and with the quality they have come to expect.' Bentley is looking for experienced artists to continue filling that need."

‡BERGQUIST IMPORTS INC., 1412 Hwy. 33 S., Cloquet MN 55720. (218)879-3343. Fax: (218)879-0010. President: Barry Bergquist. Estab. 1946. Distributor. Distributes unlimited editions. Clients: gift shops.
Needs: Seeking creative and decorative art for the commercial market. Considers oil, watercolor, mixed media and acrylic. Prefers Scandinavian or European styles. Artists represented include Jacky Briggs and Cyndi Nelson. Editions created by collaborating with the artist or by working from an existing painting. Approached by 20 artists/year. Publishes the work of 2-3 emerging, 2-3 mid-career and 2 established artists/

year. Distributes the work of 2-3 emerging, 2-3 mid-career and 2 established artists/year.
First Contact & Terms: Send brochure, résumé and tearsheets. Samples are not filed and are returned. Reports back within 2 months. Artist should follow-up. Portfolio should include color thumbnails, final art, photostats, tearsheets and photographs. Pays flat fee: $50-300, royalties of 5%. Offers advance when appropriate. Negotiates rights purchased. Provides advertising, promotion, shipping from firm and written contract.
Tips: Finds artists through art fairs. Suggests artists read *Giftware News Magazine*.

BERKSHIRE ORIGINALS, % Marian Helpers, Eden Hill, Stockbridge MA 01263. (413)298-3691. Fax: (413)298-3583. Program Design Assistant: Stephanie Wilcox-Hughes. Estab. 1991. Art publisher and distributor of offset reproductions and greeting cards.
Needs: Seeking creative art for the commercial market. Considers oil, watercolor, acrylic, pastel and pen & ink. Prefers religious themes, but also considers florals, holiday and nature scenes.
First Contact & Terms: Send query letter with brochure showing art style or other art samples. Samples are filed or are returned by SASE if requested by artist. Reports within 1 month. Write for appointment to show portfolio of slides, color tearsheets, transparencies, original/final art and photographs. Pays flat fee; $50-500. Buys all rights.
Tips: "Good draftsmanship is a must, particularly with figures and faces. Colors must be harmonious and clearly executed."

BERNARD PICTURE COMPANY, Box 4744, Largo Park, Stamford CT 06907. (203)357-7600. Fax: (203)967-9100. Art Director: Michael Katz. Estab. 1953. Art publisher and distributor. Publishes unlimited editions and posters. Clients: picture frame manufacturers, distributors, manufacturers, galleries and frame shops.
Needs: Seeking creative, fashionable and decorative art for commercial and designer markets. Considers oil, watercolor, acrylic, pastel, mixed media and printmaking (all forms). Prefers multicultural themes, cultural artifacts, inspirational art, contemporary nonobjective abstracts. Editions created by collaborating with the artist or by working from an existing painting. Artists represented include Bob Bates, Lily Chang, Shelly Rasche, Steven Klein and Ron Jenkins. Approached by hundreds of artists/year. Publishes the work of 8-10 emerging, 10-15 mid-career and 100-200 established artists/year.
First Contact & Terms: Send query letter with brochure showing art style and/or résumé, tearsheets, photostats, photocopies, slides, photographs or transparencies. Samples are returned by SASE. "I will hold potential information only with the artist's permission." Reports back within 2-8 weeks. Call or write for appointment to show portfolio of thumbnails, roughs, original/final art; b&w and color photostats, tearsheets, photographs, slides and transparencies. Pays royalties of 10%. Offers an advance when appropriate. Buys all rights. Usually requires exclusive representation of artist. Provides in-transit insurance, insurance while work is at firm, promotion, shipping from firm and a written contract.
Tips: Finds artists through submissions, sourcebooks, agents, art shows, galleries and word of mouth. "We try to look for subjects with a universal appeal. Some subjects that would be appropriate are landscapes, still lifes, animals in natural settings, religious themes and florals to name a few. Please send enough examples of your work that we can get a feel for your style and technique."

BIG, (Division of the Press Chapeau), Govans Station, Box 4591, Baltimore City MD 21212-4591. Director: Elspeth Lightfoot. Estab. 1976. Specifier of original tapestries, sculptures, crafts and paintings to architects, interior designers, facility planners and corporate curators. Makes individual presentations to clients.
Needs: Seeking art for the serious and commercial collector and the designer market. "We distribute what corporate America hangs in its board rooms; highest quality traditional, landscapes, contemporary abstracts. But don't hesitate with unique statements, folk art or regional themes. In other words, we'll consider all categories as long as the craftsmanship is there." Prefers individual works of art. Editions created by collaborating with the artist. Approached by 50-150 artists/year. Distributes the work of 10 emerging, 10 mid-career and 10 established artists/year.
First Contact & Terms: Send query letter with slides. Samples are filed or are returned by SASE. Reports back within 5 days. Request portfolio review in original query. Artist should follow up with letter after initial query. Pays $500-30,000. Payment method is negotiated (artist sets net pricing). Offers advance. Does not require exclusive representation. Provides in-transit insurance, insurance while work is at firm, promotion, shipping to firm, and a written contract.
Tips: Finds artists through agents.

THE BILLIARD LIBRARY CO., 1570 Seabright Ave., Long Beach CA 90813. (310)432-8264. Fax: (310)436-8817. Production Coordinator: Darian Baskin. Estab. 1972. Art publisher and distributor. Publishes unlimited and limited editions and posters. Clients: poster print stores, billiard retailers. Current clients include Deck the Walls, Prints Plus, Adventure Shops.

Needs: Seeking creative, fashionable and decorative art for the commercial and designer markets. Considers oil, watercolor, mixed media, pastel, pen & ink and acrylic. Prefers themes that center on billiard-related ideas. Artists represented include Melia Taylor, ProShot Gallery and Lance Slaton. Approached by 10-15 artists/year. Publishes and distributes the work of 3-5 emerging artists/year. Distributes the work of 10 mid-career and 10 established artists/year.

First Contact & Terms: Send query letter with slides, photocopies, résumé, photostats, transparencies, tearsheets and photographs. Samples are filed or are returned by SASE if requested. Reports back within 1 month. Publisher/Distributor will contact artists for portfolio review if interested. Pays flat fee, $500 minimum; or royalties of 10%. Negotiates rights purchased. Provides promotion, insurance while work is at firm and a written contract.

Tips: "The Billiard Library Co. publishes and distributes artwork of all media relating to the sport of pool and billiards. Themes and styles of any type are reviewed with an eye towards how the image will appeal to a general audience of enthusiasts. We are experiencing an increasing interest in nostalgic pieces, especially oils. Will also review any image relating to bowling or darts."

TOM BINDER FINE ARTS/ALEXANDER'S WORLD, 2218 Main St., Santa Monica CA 90405. (310)452-4095. Fax: (310)452-1260. Owner: Tom Binder. Estab. 1983. Art publisher, distributor and broker. Publishes and distributes handpulled originals and limited editions. Clients: dealers, private collectors, and art galleries.

Needs: Considers oil, watercolor, acrylic, pastel, pen & ink, mixed media. Prefers various contemporary themes. Artists represented include Aldo Luongo and Linnea Pergola. Editions created by working from an existing painting. Approached by 10-20 artists/year. Publishes and distributes the work of 1 emerging, 1 mid-career and 1 established artist/year.

First Contact & Terms: Send query letter with brochure showing art style or résumé and tearsheets, photostats, photocopies, slides, photographs and transparencies. Samples are filed or are returned. Reports back within a few days. Mail appropriate samples. Portfolio should include slides, color tearsheets, transparencies and photographs. Offers advance when appropriate. Negotiates payment and rights purchased. Provides insurance while work is at firm, promotion, shipping to and from firm and written contract.

Tips: "There is a trend toward higher quality, smaller editions. Our clients are looking for brightly colored pieces, in quality-printed, low-cost editions."

WM. BLACKWELL & ASSOCIATES, 638 S. Governor St., Iowa City IA 52240-5626. (800)366-5208. Fax: (319)338-1247. Contact: William Blackwell. Estab. 1979. Distributor. Distributes handpulled originals. Clients: gallery and design (trade only).

Needs: Seeking decorative art for the designer market. Considers etchings (hand-colored). Prefers traditional and representational. Artists represented include Alice Scott, Jeri Fischer, Charles Leonard, Dan Mitra, Rick Loudermilk. Approached by 10-15 artists/year.

First Contact & Terms: Send query letter with photographs, samples of actual impressions. Samples are not filed and are returned by SASE if requested by artist. Reports back within 1 month. Distributor will contact artists for portfolio review if interested. Portfolio should include final art. Pays on consignment basis or buys work outright. No advance. Provides promotion, shipping from firm and distribution (primarily eastern and central US).

Tips: "Artists generally approach us via trade shows, trade ads or referral."

✦BUSCHLEN MOWATT GALLERY, 1445 W. Georgia St., Vancouver, British Columbia V6G 2T3 Canada. (604)682-1234. Fax: (604)682-6004. Gallery Director: Ingunn Kemble. Estab. 1979 (gallery opened 1987). Art publisher, distributor and gallery. Publishes and distributes handpulled originals and limited editions. Clients are beginning to advanced international collectors and dealers.

Needs: Seeking creative art for the serious collector and the designer market. Considers all media. Artists represented include Cathelin, Brasilier, Moore, Motherwell, Frankenthaler, Olitski, Cassigneul. Editions created by collaborating with the artist. Approached by 1,000 artists/year. Publishes the work of 2 emerging and 5 established artists/year. Distributes the work of 4 emerging and 5-10 established artists/year.

First Contact & Terms: Send query letter with résumé and photographs. Do not contact through agent. Samples are filed or are returned by SASE if requested by artist. Reports back within 3 months. Publisher/distributor will contact artist for portfolio review if interested. Portfolio should include color tearsheets and photographs. Negotiates payment. No advance. Buys all rights. Requires exclusive representation of artist. Provides advertising, insurance while work is at firm, promotion and written contract.

Tips: Finds artists through art exhibitions, art fairs, word of mouth, agents, sourcebooks, publications, and artists' submissions.

❦**CANADIAN GALLERY PRINTS LTD.**, 2720 St. Johns St., Port Moody BC V3H 2B7 Canada. (604)936-3470. Fax: (604)936-3716. President: John de Jong. Art publisher of limited editions, offset reproductions and 'art cards.' Clients: galleries and giftshops.
Needs: Considers oil, watercolor, acrylic and mixed media. Prefers realism. Editions created by working from an existing painting.
First Contact & Terms: Send query letter with tearsheets, slides, photographs and transparencies. Samples are not filed and are returned by SASE. Reports back within 1 month. Payment method is negotiated. Buys all rights. Requires exclusive representation of artist. Provides shipping from firm.
Tips: "Be able to supply commercially viable realism that has proven to be popular to the general public."

‡**CARIBE CONCEPTS GALLERY**, 14135 SW 142nd Ave., Miami FL 33186. Phone/fax: (305)235-8919. President: Diane Emerick. Estab. 1992. Art publisher, distributor and artist representative. Publishes and distributes unlimited editions, offset reproductions, posters and t-shirts. Clients: stores. Current clients include: Hightide Gallery, Ocean Reef Dive Shop, Sherman's Paradise Trading Co.
Needs: Seeking creative art for the commercial market. Considers oil, watercolor, mixed media, pastel, pen & ink and acrylic. Artists represented include Philip Rote and Darlene Emerick. Editions created by collaborating with the artist or by working from an existing painting. Approached by 4 artists/year. Publishes and distributes the work of 2 emerging artists/year.
First Contact & Terms: Send query letter with brochure, résumé, tearsheets, photographs and photocopies. Samples are filed or returned (if rejected). Reports back within 2 weeks. Publisher/Distributor will contact artist for portfolio review if interested. Portfolio should include color final art, photostats, tearsheets and photographs. Negotiates payment. Offers advance when appropriate. Rights purchased vary according to project. Provides promotion and written contract.
Tips: Finds artists through juried art shows, word of mouth, artists' submissions. Suggests artists read *Art Business News*.

CHALK & VERMILION FINE ARTS, 200 Greenwich Ave., Greenwich CT 06830. (203)869-9500. Fax: (203)869-9520. Contact: Michael Lisi. Estab. 1975. Art publisher. Publishes original paintings, handpulled serigraphs and lithographs, posters, limited editions and offset reproductions. Clients: international retailers, distributors, art brokers.
Needs: Publishes creative and decorative art for the serious collector and the commercial and designer markets. Considers oil, watercolor, mixed media, pastel and acrylic. Artists represented include Erte, McKnight, Alex Katz, Hallam, Kiraly, Sally Caldwell Fisher, Brennan and Robert Williams. Editions created by collaborating with the artist or working from an existing painting. Approached by 500-1,000 artists/year.
First Contact & Terms: Send query letter with slides, résumé and photographs. Samples are filed or are returned by SASE if requested by artist. Reports back within 3 months. Publisher will contact artist for portfolio review if interested. Pay "varies with artist, generally fees and royalties." Offers advance. Requires exclusive representation of artist. Provides in-transit insurance, promotion, shipping from firm, insurance while work is at firm and written contract.
Tips: Finds artists through exhibitions, trade publications, catalogs, submissions.

CIRRUS EDITIONS, 542 S. Alameda St., Los Angeles CA 90013. President: Jean R. Milant. Produces limited edition handpulled originals. Clients: museums, galleries and private collectors.
Needs: Seeking contemporary paintings and sculpture. Prefers abstract, conceptual work. Artists represented include Lari Pittman, Joan Nelson, John Millei, Charles C. Hill and Bruce Nauman. Publishes and distributes the work of 6 emerging, 2 mid-career and 1 established artists/year.
First Contact & Terms: Prefers slides as samples. Samples are returned by SASE.

CRAZY HORSE PRINTS, 23026 N. Main St., Prairie View IL 60069. (708)634-0963. Owner: Margaret Becker. Estab. 1976. Art publisher and gallery. Publishes limited editions, offset reproductions and greeting cards. Clients: Indian art collectors.
Needs: "We publish only Indian authored subjects." Considers oil, pen & ink and acrylic. Prefers Indian and nature themes. Editions created by working from an existing painting. Approached by 10 artists/year. Publishes the work of 2 and distributes the work of 20 established artists/year.
First Contact & Terms: Send résumé and photographs. Samples are filed. Reports back to the artist only if interested. Portfolio review not required. Publisher will contact artist for portfolio review if interested. Portfolio should include photographs and bio. Pays flat fee: $250-1,500 or royalties of 5%. Offers advance when appropriate. Buys all rights. Provides promotion and written contract.
Tips: Finds artists through art shows and artists' submissions.

Always enclose a self-addressed, stamped envelope (SASE) with queries and sample packages.

THE CREATIVE AGE, 2824 Rhodes Circle, Birmingham AL 35205. (205)933-5003. President: Finley Eversole. Creative Director: Anastasia Rose Eversole. Estab. 1991. Art publisher. Publishes and distributes unlimited editions. Clients: distributors, ready-framers, frame stores and decorators. Current clients include Paragon, Carolina Mirror, Art Dreams, Art Image Inc., Galleries International, Inc., Graphique de France, The Bombay Co. Mainly publishes master artists of the 19th and early 20th centuries.
 • The Creative Age will soon be moving into the fine art T-shirt field and will be looking for appropriate designs.
Needs: Seeking creative art for the serious collector, commercial, ready-framed and designer markets. Considers oil, watercolor, acrylic, pastel, lithographs and engravings. Prefers animals, children, romantic themes, landscapes, sports, seascapes, marines, still lifes and florals. Editions created by collaborating with the artist or working from an existing painting. Publishes the work of 1-2 emerging and 1-2 mid-career artists/year.
First Contact & Terms: Send query letter with résumé and tearsheets, slides, photographs and transparencies. Samples are filed or are returned by SASE if requested by artist. Reports back only if interested. Pays royalties of 10%. Offers advance when appropriate. Provides return in-transit insurance, promotion, shipping from firm and written contract.
Tips: Advises artists to attend Atlanta ABC show, which is the largest in the industry. Finds mid-career and emerging artists through submissions. "Work must be of very high quality with good sense of color, light and design. Artist should be willing to grow with young company. Possible commissioned work if we like your art. We are looking for work in the styles of 19th century florals, still lifes, landscapes; Victorian art; and French and American Impressionism."

‡CROSS GALLERY, INC., 180 N. Center, P.O. Box 4181, Jackson Hole WY 83001. (307)733-2200. Fax: (307)733-1414. Director: Mary Schmidt. Estab. 1982. Art publisher and gallery. Publishes handpulled originals, limited and unlimited editions, offset reproductions and canvas reproductions. Clients: wholesale and retail.
Needs: Seeking creative art for the serious collector. Considers oil, watercolor, mixed media, pastel, pen & ink, sculpture and acrylic. Prefers realism, contemporary, western and portraits. Artists represented include Penni Anne Cross, Val Lewis, Joe Beshick, Michael Chee, Ully Szell, Andreas Goft and Kevin Smith. Editions created by collaborating with the artist or by work from an existing painting. Approached by 100 artists/year.
First Contact & Terms: Send query letter with brochure, résumé, tearsheets, slides, photostats, photographs, photocopies and transparencies. Samples are not filed and are returned by SASE if requested by artist. Reports back within 2 days. Publisher will contact artist for portfolio review if interested. Portfolio should include b&w and color thumbnails, roughs, final art, photostats, tearsheets, photographs, slides and transparencies. Pays royalties or on consignment basis (firm receives 33⅓% commission). No advance. Rights purchased vary according to project. Requires exclusive representation of artist. Provides advertising, insurance while work is at firm, promotion, shipping from firm and written contract.

CUPPS OF CHICAGO, INC., 831 Oakton St., Elk Grove IL 60007. (708)593-5655. Fax: (708)593-5550. President: Gregory Cupp. Estab. 1967. Art publisher, distributor and wholesaler of original oil paintings. Clients: galleries, frame shops, designers and home shows.
 • Pay attention to contemporary/popular colors when creating work for this design-oriented market.
Needs: Seeking creative, fashionable and decorative art for the serious collector, commercial and designer markets. Artists represented include Gloria Rose and Jorge Tarallo Braun. Editions created by collaborating with the artist. Considers oil and acrylic paintings in "almost any style—only criterion is that it must be well done." Prefers individual works of art. Approached by 50 artists/year. Publishes and distributes the work of 6 emerging, 2 mid-career and 2 established artists/year.
First Contact & Terms: Send query letter with brochure showing art style or résumé and photographs. Do not submit slides. Samples are filed or are returned by SASE if requested. Reports back only if interested. Call or write for appointment to show portfolio of original/final art. Pays royalties of 10%. No advance. Buys first rights or reprint rights. Provides advertising, in-transit insurance, promotion shipping from firm, insurance while work is at firm and written contract.
Tips: This distributor sees a trend to traditional work.

‡CUSTOM & LIMITED EDITIONS, 41 Sutter, #1634, San Francisco CA 94104. (415)337-0177. Fax: (415)337-0808. Director: Ron Fouts. Estab. 1986. Art publisher. Publishes handpulled originals, limited and unlimited editions, offset reproductions and posters.
Needs: Seeking creative art for the serious collector and the designer market. Considers oil, watercolor, mixed media, pastel, pen & ink, sculpture and acrylic. Editions created by collaborating with the artist. Approached by 10-20 artists/year.
First Contact & Terms: Send query letter with résumé and photocopies or photographs. Sample are not filed and are returned by SASE if requested by artist. Reports back to the artist only if interested. Negotiates payment. Offers advance when appropriate. Rights purchased vary according to project. Provides advertising,

in-transit insurance, insurance while work is at firm, promotion, shipping to firm, shipping from firm and written contract.
Tips: Finds artists through word of mouth.

DAUPHIN ISLAND ART CENTER, 1406 Cadillac Ave., Box 699, Dauphin Island AL 36528. Fax: (334)861-5701. Owner: Nick Colquitt. Estab. 1984. Wholesale producer and distributor of marine and nautical decorative art. Clients: West, Gulf and eastern coastline retailers.
Needs: Approached by 12-14 freelance artists/year. Works with 8-10 freelance artists/year. Prefers local artists with experience in marine and nautical themes. Uses freelancers mainly for wholesale items to be retailed. Also for advertising, brochure and catalog illustration.
First Contact & Terms: Send query letter with brochure and samples. Samples not filed are returned only if requested by artist. Reports back within 3 weeks. To show portfolio, mail final reproduction/product. Pays for design and illustration by the finished piece price. Considers skill and experience of artist and "retailability" when establishing payment. Negotiates rights purchased.
Tips: Advises artists to attend any of the Art Expo events especially those held in Atlanta Merchandise Mart. "We're noticing a move away from white as mat or decorative bordering. Use complimentary colors instead of white."

‡DAVID MARSHALL, Box 410246, St. Louis MO 63141. (314)781-5224. President: Marshall Gross. Estab. 1972. Art distributor/gallery handling original acrylic paintings, serigraphs, paper construction, cast paper and sculpture. Clients: designer showrooms, architects, interior designers, galleries, furniture and department stores.
Needs: "We're seeking product designs for decorative mirrors, lamps, tables and chairs (wood or wrought iron), rugs, pedestals, cocktail tables, wall placques, large ceramic urns, vases. Special consideration to South American Native designs and themes. After reviewing your work we will advise product groups we wish you to develop for us to purchase."
First Contact & Terms: Send query letter with brochure showing art style or photographs. Samples are not filed and are returned only if requested by artist. Reports within 7 days. Call for instructions to show portfolio of roughs, slides and color photos. Distribution items pay flat fee of $15-$50 each if artists will reproduce.
Tips: "Glass and mirror designs are given special consideration. We represent all types of art from professional gallery quality to street fairs. We're especially looking for ethnic South American designs. Awareness of current color trend in the home furnishings industry is a must. Artist must be willing to reproduce his or her own work for the duration of our catalog—2-3 years."

DAY DREAMS, (formerly American Arts & Graphics, Inc.), 7555 N. Woodland Dr., Indianapolis IN 46278. (317)388-1212. Fax: (317)388-1717. Licensing Manager: Chris Conk. Estab. 1948. Publishes posters for the teenage market; minimum 5,000 run. Clients: mass market retailers. "Our main market is family variety stores, record and tape stores and discount drug stores." Current clients include Walmart, K-Mart, Toys R Us, Fred Meyer, Longs and Osco.
Needs: Seeking decorative art (popular trends). Prefers 16 × 20 originals; full-size posters are 23 × 35. Prefers airbrush, then acrylic and oil. Artists represented include Gail Gastfield, Mark Watts, Kurt C. Burmann, Jonnie Chardonn and Jenny Newland. Editions created by working from an existing painting. Approached by 100 artists/year. Publishes the work of 2-3 emerging, 2-3 mid-career and 3-4 established artists/year. Distributes the work of 20 artists/year. Artist's guidelines available.
First Contact & Terms: Send query letter with tearsheets, photostats, photocopies and production quality duplicate slides; then submit sketch or photo of art. Include SASE. Reports in 2 weeks. Usually pays royalties of 10¢/poster sold and an advance of $500-1,000 against future royalties. Payment schedule varies according to how well known the artist is, how complete the work is and the skill level of the artist.
Tips: "Research popular poster trends; request a copy of our guidelines. Our posters are an inexpensive way to decorate, so art sales during recession don't show any significant decreases."

‡DECORATIVE EXPRESSIONS, INC., 2158 Tucker Industrial Blvd., Tucker GA 30084. (404)493-6858. Fax: (404)493-6838. President: Robert Harris. Estab. 1984. Distributor. Distributes original oils. Clients: galleries, designers, antique dealers.
Needs: Seeking creative and decorative art for the designer market. Styles range from traditional to contemporary to impressionistic. Artists represented include Henri Hess, J. Hovener, Yelenia Rezenik, D. Karasek, Ad DeRoo, E. Payes, J. Ripoll, Barbera, Gerry Groeneveld. Approached by 6 artists/year. Distributes the work of 2-6 emerging, 2-4 mid-career and 10-20 established artists/year.
First Contact & Terms: Send photographs. Samples are returned by SASE if requested by artist. Reports back to the artist only if interested. Portfolios may be dropped off every Monday. Portfolio should include final art and photographs. Negotiates payment. Offers advance when appropriate. Negotiates rights purchased. Requires exclusive representation of artist. Provides advertising, in-transit insurance, promotion and distribution through sale force and trade shows.
Tips: Finds artists through word of mouth, exhibitions, travel. "The design market is major source for placing art. We seek art that appeals to designers."

✦**DEL BELLO GALLERY**, 788 King St. W., Toronto, Ontario 1N6 M5V Canada. (416)504-2422. Fax: (416)504-2433. Owner: Egidio Del Bello. Art publisher and gallery handling handpulled originals for private buyers, department stores and galleries.
 • Del Bello is organizer of the Annual International Exhibition of Miniature Art. Send $2 postage and handling for prospectus.
First Contact & Terms: Send query letter with résumé, photographs and slides. Samples are filed or are returned by SASE within 2 weeks. Call for appointment to show portfolio of original/final art and slides. Payment method is negotiated. Offers an advance when appropriate. Negotiates rights purchased. Provides promotion. Publishes the work of 10 artists/year.

DIRECTIONAL PUBLISHING, INC., 2616 Commerce Circle, Birmingham AL 35210. (205)951-1965. Fax: (205)951-3250. President: David Nichols. Estab. 1986. Art publisher. Publishes limited and unlimited editions and offset reproductions. Clients: galleries, frame shops and picture manufacturers.
Needs: Seeking decorative art for the designer market. Considers oil, watercolor, acrylic and pastel. Prefers floral, sporting, landscapes and still life themes. Artists represented include Evans, Neubauer, M. Parker, A. Nichols, D. Nichols, M.B. Zeitz and N. Raborn. Editions created by working from an existing painting. Approached by 50 artists/year. Publishes and distributes the work of 5-10 emerging, 5-10 mid-career and 3-5 established artists/year.
First Contact & Terms: Send query letter with slides and photographs. Samples are not filed and are returned by SASE. Reports back within 3 months. Pays royalties. Buys all rights. Provides in-transit insurance, insurance while work is at firm, promotion, shipping from firm and written contract.
Tips: Likes color palette that is "rich but not dark."

DODO GRAPHICS, INC., 145 Cornelia St., P.O. Box 585, Plattsburgh NY 12901. (518)561-7294. Fax: (518)561-6720. Manager: Frank How. Art publisher of offset reproductions, posters and etchings for galleries and frame shops.
Needs: Considers pastel, watercolor, tempera, mixed media, airbrush and photographs. Prefers contemporary themes and styles. Prefers individual works of art, 16 × 20 maximum. Publishes the work of 5 artists/year.
First Contact & Terms: Send query letter with brochure showing art style or photographs and slides. Samples are filed or are returned by SASE. Reports back within 3 months. Write for appointment to show portfolio of original/final art and slides. Payment method is negotiated. Offers an advance when appropriate. Buys all rights. Requires exclusive representation of the artist. Provides written contract.
Tips: "Do not send any originals unless agreed upon by publisher."

‡**DOUBLE J ART & FRAME SHOP**, P.O. Box 66304, Baltimore MD 21239. Phone/fax: (410)433-2137. Owner: Jesse Johnson. Estab. 1989. Art publisher, distributor and custom framer. Publishes and distributes handpulled originals and limited editions. Clients: retail customers, galleries, frame shops and distributors.
Needs: Needs creative art for the serious collector, commercial and designer markets. Considers oil, watercolor, mixed media, pastel, pen & ink, sculpture and acrylic. Prefers African-American themes. Artists published include Wynston Edun, Poncho Brown. Editions created by collaborating with the artist or working from an existing painting. Approached by 5-10 artists/year. Publishes the work of 1-2 emerging, 1-2 mid-career and 1-2 established artists/year. Distributes the work of 10 emerging, 5 mid-career and 3 established artists/year.
First Contact & Terms: Send query letter with brochure, résumé, tearsheets, photostats, photographs and photocopies. Samples are not filed and are returned. Reports back within 2 weeks. Publisher/Distributor will contact artist for portfolio review if interested. Portfolio should include b&w and color thumbnails, roughs, final art, photostats, tearsheets, photographs, slides and transparencies. Negotiates payment. Offers advance when appropriate. Rights purchased vary according to project. Provides advertising, promotion, shipping to firm, shipping from firm and written contract.
Tips: Finds artists through word of mouth, referral by other artists. Recommends *Decor* and Art Buyers Caravan shows.

***DUTCH ART STUDIOS BV.**, 210 Industrieweg 210, 5683 Ch Best, Netherlands. Phone: 01131 4998 97300. Fax: 01131 4998 99660. President: Hem Brekoo. Estab. 1972. Art publisher and distributor. Publishes and distributes handpulled originals, limited and unlimited editions and offset reproductions. Clients: art galleries, art shops. Current clients include: Decorative Expressions.
 • Hem Brekoo urges artists to keep up with the latest trends in furniture and upholstery markets and to create work that will lend itself well to decorative purposes. He is particularly interested in publishing print series (four at a time).
Needs: Seeking fashionable and decorative art for the commercial market. Considers oil, watercolor, acrylic and mixed media. Prefers contemporary interpretation of landscapes, seascapes, florals, townscenes, etc. Artists represented include Corsius, Le Mair, Groeneveld and Hovener. Editions created by collaborating with the artist. Approached by 50 artists/year. Publishes the work of 10 emerging, 10 mid-career and 5 established artists/year. Distributes the work of 20 emerging, 20 mid-career and 15 established artists/year.

First Contact & Terms: Send query letter with brochure showing art style. Samples are filed or are returned by SASE (nonresidents include IRC) if requested by artist. Reports back within 1 month. Artist should follow up with letter after initial query. To show portfolio, mail photographs and slides. Payment method is negotiated. No advance. Requires exclusive representation of artist. Provides promotion and written contract.
Tips: Advises artists to attend Art Expo show.

EDELMAN FINE ARTS, LTD., 386 W. Broadway, Third Floor, New York NY 10012. (212)226-1198. Vice President: H. Heather Edelman. Art distributor of original oil paintings. "We now handle watercolors, lithographs, serigraphs, sculpture and 'works on paper' as well as original oil paintings." Clients: galleries, dealers, consultants, interior designers and furniture stores worldwide.
• The president of Edelman Fine Arts says the mainstream art market is demanding traditional work with great attention to detail. She feels impressionism is still in vogue but with a coral, peach color tone with a Cortes, Couret or Turner feel. She says Renaissance large nudes, pictured in a typical scene are being requested.
Needs: Seeking creative and decorative art for the serious collector and designer markets. Considers oil and acrylic paintings, watercolor, sculpture and mixed media. Especially likes Old World themes and impressionist style. Distributes the work of 150 emerging, 70 mid-career and 150 established artists.
First Contact & Terms: Send six 3×5 photos (no slides), résumé, tearsheets. Samples are filed. Portfolios may be dropped off every Monday-Thursday upon request. Portfolio should include original/final art and photographs. Reports as soon as possible. Pays royalties of 40% or works on consignment basis (20% commission). Buys all rights. Provides in-transit insurance, insurance while work is at firm, promotion and shipping from firm.

‡EDITION D'ART PONT-AVEN, 2746 Feirfield Ave., Bridgeport CT 06605. (203)333-1099. Fax: (203)366-2925. Manager: Danica. Estab. 1984. Art publisher and gallery. Publishes limited and unlimited editions, offset productions. Clients: galleries and framers.
Needs: Needs decorative art for the commercial and designer markets. Considers oil, watercolor and pastel. Artists represented include Glazer, Huskett and Ransend. Editions created by collaborating with the artist. Approached by 5 artists/year. Publishes the work of 2 emerging, 2 mid-career and 2 established artists/year.
First Contact & Terms: Send tearsheets, slides and photographs. Samples are filed. Reports back within 3 months. Portfolios may be dropped off every Thursday. Portfolio should include photostats, photographs and slides. Negotiates payment. No advance. Buys first or all rights. Provides advertising, in-transit insurance and promotion.
Tips: Finds artists through artists' submissions.

EDITIONS LIMITED GALLERIES, INC., 625 Second St., Suite 400, San Francisco CA 94107. (415)543-9811. Fax: (415)777-1390. Director: Michael Ogura. Art publisher and distributor of limited edition graphics and fine art posters. Clients: galleries, framing stores, art consultants and interior designers.
Needs: Seeking creative art for the designer market. Considers oil, acrylic and watercolor painting, monoprint, monotype, photography and mixed media. Prefers landscape and abstract imagery. Artists represented include Peter Kitchell, Elba Alvarez and Jack Roberts. Editions created by collaborating with the artist or by working from an existing painting.
First Contact & Terms: Send query letter with résumé, slides and photographs. Samples are filed or are returned by SASE. Reports back within 2 months. Publisher/distributor will contact artist for portfolio review if interested. Payment method is negotiated. Offers advance when appropriate. Negotiates rights purchased. Provides in-transit insurance, insurance while work is at firm, promotion, shipping to and from firm and written contract.
Tips: "We deal both nationally and internationally, so we need work with wide appeal. No figurative or cute animals. When sending slides or photos, send at least six so we can see an overview of the work. We publish artists, not just images." Advises artists to attend Art Expo, New York City and Art Buyers Caravan, Atlanta.

ELEANOR ETTINGER INCORPORATED, 155 Avenue of the Americas, New York NY 10013. (212)807-7607. Fax: (212)691-3508. President: Eleanor Ettinger. Estab. 1975. Art publisher of limited edition lithographs, limited edition sculpture and unique works (oil, watercolor, drawings, etc.).
Needs: Seeks creative, fashionable and decorative art for the serious collector, commercial collector and designer markets. Considers oil, watercolor, acrylic, pastel, mixed media, pen & ink and pencil drawings. Prefers American realism. Editions created by collaborating with the artist. Approached by 100-150 artists/year. Currently distributes the work of 12 artists.

The asterisk before a listing indicates that the market is located outside the United States and Canada.

First Contact & Terms: Send query letter with visuals (slides, photographs, etc.), a brief biography, résumé (including a list of exhibitions and collections) and SASE for return of the materials. Reports within 2 weeks.
Tips: "All lithographs are printed on one of our Voirin presses, flat bed lithographic presses hand built in France over 100 years ago. The work must be unique and non-derivative. We look for artists who can create 35-50 medium to large scale works per year and who are not already represented in the fine art field."

THE FOUNDATION FINE ARTS LTD., 8840 N.W. Sesame St., Silverdale WA 98383. (360)698-0396. Fax: (360)692-3019. Director: Christopher Law. Estab. 1972. Art publisher of hands-on original graphics. Clients: fine art collectors.
Needs: Seeking creative art for the serious collector. "We publish the highest quality continuous tone original graphics." Prefers wildlife, African, "both loose and tight styles." Artists represented include Dennis Curry, Valerie Hinz, Victoria Denslow and Toni Ringo. Editions created by collaborating with the artist. Approached by 25 artists/year. Publishes and distributes the work of 1 emerging, 4 mid-career and 1 established artists/year.
First Contact & Terms: Send query letter with résumé, slides and transparencies. Samples are filed or are returned by SASE. Reports back within 2 weeks. Request portfolio review in original query. Portfolio should include slides and transparencies. Pays royalties of 10-30%. No advance. Negotiates payment and rights purchased. Provides promotion.
Tips: Advises artist to attend Pacific Rim Wildlife Art Show. Sees trend in canvas transfers.

FOXMAN'S OIL PAINTINGS LTD., 1550 Carmen Dr., Elk Grove Village IL 60007. (708)427-8555. Fax: (708)427-8594. President: Wayne Westfall. Art distributor of limited and unlimited editions and oil paintings. Clients: galleries and national chains.
Needs: Considers oil, airbrush and acrylic. Prefers simple themes: children, barns, countrysides; African-American art and other contemporary themes and styles. Prefers individual works of art. Maximum size 36×48. Artists represented include H. Hargrove, Kugler, D. Michelle, Betty Wolf. Publishes the work of 3-5 emerging, 3-5 mid-career and 3-5 established artists/year. Distributes the work of 5-10 emerging, 5-10 mid-career and 5-10 established artists/year.
First Contact & Terms: Send query letter with résumé, tearsheets, photographs and slides. Samples are not filed and are returned. Reports back within 1 month. Negotiates payment method and rights purchased. Requires exclusive representation. Provides promotion, shipping from firm and a written contract.
Tips: Finds artists through word of mouth.

FRONT LINE GRAPHICS, INC., 9808 Waples St., San Diego CA 92121. (619)552-0944. Creative Director: Todd Haile. Estab. 1981. Publisher/distributor of posters, prints and limited editions. Clients: galleries, decorators and poster distributors worldwide.
Needs: Seeking fashionable and decorative art reflecting popular trends for the commercial collector and designer market. Considers oil, acrylic, pastel, watercolor and mixed media. Prefers contemporary interpretations of landscapes, seascapes, florals abstracts and African-American subjects. Prefers pairs. Minimum size 22×30. Editions created by collaborating with the artist. Approached by 300 artists/year. Publishes the work of 50 and distributes the work of 100 artists/year.
First Contact & Terms: Send query letter with slides. Samples not filed are returned if requested by artist. Reports back within 1 month. Call for appointment to show portfolio of original/final art and slides. Payment method is negotiated. Requires exclusive representation of the artist. Provides promotion and a written contract.
Tips: "Front Line Graphics is looking for artists who are flexible and willing to work with us to develop art that meets the specific needs of the print and poster marketplace. We actively seek out fresh new art and artists on an on-going basis."

GALAXY OF GRAPHICS, LTD., 460 W. 34th St., New York NY 10001. (212)947-8989. Art Director: Elizabeth Tuckman. Estab. 1983. Art publisher and distributor of unlimited editions. Clients: galleries, distributors, and picture frame manufacturers. Current clients include Marcel and Crystal Art.
Needs: Seeking creative, fashionable and decorative art for the commerical market. Artists represented include Hal and Fran Larsen, Glenna Kurz and Christa Keiffer. Editions created by collaborating with the artist or by working from an existing painting. Considers any media. "Any currently popular and generally accepted themes." Approached by several hundred artists/year. Publishes and distributes the work of 20 emerging and 20 mid-career and established artists/year.
First Contact & Terms: Send query letter with résumé, tearsheets, slides, photographs and transparencies. Samples are not filed and are returned by SASE. Reports back within 1-2 weeks. Call for appointment to show portfolio. Pays royalties of 10%. Offers advance. Buys rights only for prints and posters. Provides insurance while material is in house and while in transit from publisher to artist/photographer. Provides written contract to each artist.
Tips: "There is a trend toward strong jewel-tone colors."

ROBERT GALITZ FINE ART, 166 Hilltop Court, Sleepy Hollow IL 60118. (708)426-8842. Fax: (708)426-8846. Owner: Robert Galitz. Estab. 1986. Distributor of handpulled originals, limited editions and watercol-

ors. Clients: designers, architects, consultants and galleries—in major cities of seven states.
Needs: Seeking creative, fashionable and decorative art for the serious collector and commercial and designer markets. Considers all media. Prefers contemporary and representational imagery. Editions created by collaborating with the artist. Publishes the work of 1-2 established artists/year. Distributes the work of 100 established artists/year.
First Contact & Terms: Send query letter with slides and photographs. Samples are filed or are returned by SASE. Reports back within 1 month. Call for appointment to show portfolio of original/final art. Pays flat fee of $200 minimum, or pays on consignment basis (25-40% commission). No advance. Buys all rights. Provides a written contract.
Tips: Advises artists to attend an Art Expo event in New York City, Las Vegas, Miami or Chicago. Finds artists through galleries, sourcebooks, word of mouth, art fairs. "Be professional. I've been an art broker or gallery agent for 26 years and very much enjoy bringing artist and client together!"

‡GALLERY GRAPHICS, 227 Main, P.O. Box 502, Noel MO 64854. (417)475-6191. Fax: (417)475-3542. Graphics Specialist: Don Spenner. Estab. 1980. Wholesale producer and distributor of Victorian memorabilia. Clients: frame shops and gift shops.
Needs: Seeking decorative Victorian art. Especially looking for Victorian guardian angels. Considers oil, watercolor, mixed media, pastel and pen & ink. 10% of editions created by collaborating with artist. 90% created by working from an existing painting.
First Contact & Terms: Send query letter with brochure showing art style and slides (dupes only) and tearsheets. Samples are filed and are returned by SASE. Reports back within 2 month. To show portfolio, mail finished art samples, slides, color tearsheets. Pays flat fee: $100 minimum. Offers advance when appropriate. Buys all rights. Provides insurance while work is at firm, promotion and a written contract.
Tips: "Study Victorian art. Know Victorian art. Submit Victorian art."

GALLERY IN A VINEYARD, P.O. Box 549, Benmarl Vineyards, Marlboro NY 12542. (914)236-4265. Owner: Mark Miller. Art publisher, gallery and studio handling limited editions, offset reproductions, unlimited editions, handpulled originals, posters and original paintings and sculpture. Clients: galleries and collectors.
● The owner started out as a self-published artist, but has expanded to consider work by other artists.
Needs: Considers any media. Prefers contemporary, original themes in illustrative style and has begun to add digital images. Publishes/distributes the work of 1-2 artists/year.
First Contact & Terms: Send appropriate samples. Samples are not filed and returned only if requested. Reports back within 3 weeks only if interested. Pays on consignment basis (firm receives 50% commission). Negotiates rights purchased. Provides a written contract.
Tips: "Subjects related to the 50s and 60s period of illustrative art are especially interesting. There seems to be a renewed interest in nostalgia."

GANGO EDITIONS, 351 NW 12th, Portland OR 97209. (800)852-3662. (503)223-9694. Co-owner: Debi Gango. Estab. 1982. Publishes posters. Clients: poster galleries, art galleries, contract framers and major distributors. Current clients include Bruce McGaw Graphics, Graphique de France, Image Conscious and In Graphic Detail.
Needs: Seeking creative and decorative art for the commercial and designer markets. Considers, oil, watercolor, acrylic, pastel and mixed media. Prefers whimsical, abstract and landscape styles. Artists represented include Carol Grigg, Nancy Coffelt, Bill Kucha, Jennifer Winship Mark, Linda Holt, Roberta Nadeau, C.W. Potzz, Gregg Robinson, Lise Shearer, Irana Shepherd. Editions created by working from an existing painting. Approached by more than 100 artists/year. Publishes the work of 5 and distributes the work of 15 emerging artists/year. Publishes the work of 5 emerging, 10 mid-career and 80 established artists/year. Distributes the work of 15 emerging, 50 mid-career and 45 established artists/year.
First Contact & Terms: Send query letter with slides and/or photographs. Artist is contacted "if we see potential." Otherwise, samples are returned by SASE. Reports back within 6 weeks. Write for appointment to show portfolio or mail appropriate materials. Pays royalties (or payment method is negotiated). Offers advance when appropriate. Negotiates rights purchased. Requires exclusive representation of artist. Provides insurance while work is at firm, promotion and a written contract.
Tips: "We are interested in fresh ideas for the poster market rather than reworked old ideas. We are always actively seeking new artists. Artists need to be aware of current fashion colors."

A bullet introduces comments by the editor of Artist's & Graphic Designer's Market *indicating special information about the listing.*

GEME ART INC., 209 W. Sixth St., Vancouver WA 98660. (206)693-7772. Fax: (206)695-9795. Art Director: Gene Will. Estab. 1966. Art publisher. Publishes fine art prints and reproductions in unlimited and limited editions. Clients: galleries, frame shops, art museums.
Needs: Considers oil, acrylic, pastel, watercolor and mixed media. "We use a variety of styles from realistic to whimsical." Artists represented include Lois Thayer, Crystal Skelley, Rice-Bonin, Campbell and Susan Scheewe.
First Contact & Terms: Send color slides, photocopies or brochure. Include SASE. Publisher will contact artist for portfolio review if interested. Simultaneous submissions OK. Payment is negotiated on a royalty basis. Normally purchases all rights. Provides promotion, shipping from publisher and contract.
Tips: Caters to "Mid-America art market."

GENESIS FINE ARTS, 4808 164th St., SE, Bothell WA 98012. (206)481-1581. Fax: (206)487-6766. Art Consultant: Marcia Strickland. Art publisher handling limited editions (maximum 250 prints), offset reproductions and posters for residential and commercial clients.
Needs: Considers watercolor, mixed media and oil—abstract and traditional landscapes. Also interested in artists who specialize in stationery design. Prefers individual works of art. Maximum size 38 × 50. Artists represented include Steve Strickland, Nancy Rankin and Melinda Cowdery. Publishes and distributes the work of 2-3 emerging and 1 mid-career artist/year.
First Contact & Terms: Send query letter with transparencies. Samples not filed are returned. Reports back within 2 months. Payment method is negotiated. Provides promotion, a written contract and shipping. Buys first rights.

GESTATION PERIOD, Box 2408, Columbus OH 43216-2408. (800)800-1562. General Manager: John R. Ryan. Estab. 1971. Importer and distributor of unlimited editions and posters. Clients: art galleries, framers, campus stores, museum shops and bookstores.
Needs: Seeking published creative art—especially fantasy and surrealism.
First Contact & Terms: Send query letter with résumé, tearsheets, pricing list and published samples. Samples are filed or returned by SASE. Reports back within 2 months. Negotiates rights purchased. Provides promotion.
Tips: "We are seeking pre-published open edition prints that will retail from $5-30."

‡GOES LITHOGRAPHING CO. EST 1879, 42 W. 61st St., Chicago IL 60621-3999. (312)684-6700. Fax: (312)684-2065. Contact: W.J. Goes. Estab. 1879. Supplier to printers/office product stores. Current clients include: Kwik Kopy, Sir Speedy.
Needs: Seeking creative art. Considers watercolor, mixed media and acrylic. Prefers holiday themes.
First Contact & Terms: Send samples. Reports back within 1 month. Publisher/distributor will contact artist for portfolio review if interested. Portfolio should include color thumbnails, roughs and final art. Pays flat fee $150 maximum or negotiates payment. No advance. Rights purchased vary according to project.
Tips: Finds artists through artists' submissions.

THE GRAPHIC EDGE, 911 Hope St., P.O. Box 4669, Stamford CT 06907. (800)243-6615. Fax: (203)967-9100. President: Michael Katz. Art publisher of unlimited editions, posters and offset reproductions. Clients: galleries, framers, distributers, manufacturers worldwide.
● The Graphic Edge has a sister company called Springdale Graphics.
Needs: Seeking creative and decorative art for the commercial and designer markets. Considers oil, watercolor, mixed media, pastel and acrylic. Artists represented include Silvia Edwards, Herb-Ritts. Editions created by collaborating with artist or by working from an existing painting. Publishes the work of 20 and distributes the work of 5 emerging artists/year. Publishes the work of 20 emerging, 50 mid-career and 50 established artists/year. Distributes the work of 5 emerging, 10 mid-career and 10 established artists/year.
First Contact & Terms: Send query letter with brochures showing art style, slides, photocopies, résumé, transparencies, tearsheets and photographs. Samples are returned by SASE if requested. Reports back within 3-4 weeks. Call for appointment to show portfolio of slides, tearsheets and photographs. Pays royalties of 10%. Buys all rights or reproduction rights. Requires exclusive representation of artist. Provides in-transit insurance, promotion, shipping from firm, insurance while work is at firm and a written contract.
Tips: Finds artists through word of mouth, magazines, artists' submissions/self-promotions, sourcebooks, agents, by visiting art galleries and attending art fairs and shows.

‡GRAPHIQUE DE FRANCE, 9 State St., Woburn MA 01801. (617)935-3405. Contact: Nick Dubrule. Estab. 1979. Art publisher and distributor handling offset reproductions, posters, notecards, gift and stationery products and silkscreens. Clients: galleries and foreign distributors.
● Graphique de France prefers not to receive unsolicited submissions.

GRAPHIQUE DU JOUR, INC., 1661 Defoor Ave. NW, Atlanta GA 30318. President: Daniel Deljou. Estab. 1980. Art publisher/distributor of limited editions (maximum 250 prints), handpulled originals and monoprints/monotypes and paintings on paper. Clients: galleries, designers, corporate buyers and architects. Cur-

rent clients include Coca Cola, Xerox, Exxon, Marriott Hotels, General Electric, Charter Hospitals, AT&T and more than 3,000 galleries worldwide, "forming a strong network throughout the world."
Needs: Seeking creative and decorative art for the serious and commercial collector and designer market. Considers oil, acrylic, pastel, watercolor and mixed media. Prefers corporate art and transitional contemporary themes. Prefers individual works of art pairs or unframed series. Maximum size 38×50 image of published pieces. Artists represented include Lee White, Ken Weaver, Lyda Claire, Sergey Cherepakhin, John Pittman, Matt Lively, Alexa Kelemen, Ralph Groff, Yasharel, Denis Assayac, Cameron Scott and T.L. Lange. Editions created by collaborating with the artist or by working from an existing painting. Approached by 100 artists/year. Publishes and distributes the work of 25 emerging, 15 mid-career and 50 established artists/year.
First Contact & Terms: Send query letter with photographs, slides and transparencies. Samples not filed are returned only if requested by artist. Reports back only if interested. Publisher/Distributor will contact artist for portfolio review if interested. Pays flat fee or royalties; also sells on consignment basis or commission. Payment method is negotiated. Offers an advance when appropriate. Negotiates rights purchased. Has exclusive and non-exclusive representation. Provides promotion, a written contract and shipping from firm.
Tips: Finds artists through visiting galleries. "We would like to add a line of traditional art with a contemporary flair. Earth-tone and jewel-tone colors are in. We need landscape artists, monoprint artists, strong figurative artists, strong abstracts and soft-edge abstracts. We are also beginning to publish sculptures and are interested in seeing slides of such. We have had a record year in sales, and have recently relocated into a brand new gallery, framing and studio complex."

‡**THE GREENWICH WORKSHOP, INC.**, One Greenwich Place, Shelton CT 06484. Marketing Assistant: Beth Griswold. Art publisher and gallery. Publishes limited and unlimited editions, offset productions. Clients: independent galleries in US, Canada and United Kingdom.
Needs: Seeking creative, fashionable and decorative art for the serious collector, commercial and designer markets. Considers oil, watercolor, mixed media, pastel and acrylic. Considers all but abstract. Artists represented include James Christensen, Mo Da Feng, Howard Terpning, James Reynolds, James Bama, Thomas Blackshear. Editions created by collaborating with the artist or by working from an existing painting. Approached by 100 artists/year. Publishes the work of 4-5 emerging, 15 mid-career and 25 established artists. Distributes the work of 4-5 emerging, 15 mid-career and 25 established artists/year.
First Contact & Terms: Send query letter with brochure, slides, photographs and transparencies. Samples not filed and are returned. Reports back within 1-2 months. Publisher will contact artist for portfolio review if interested. Portfolio should include final art, tearsheets, photographs, slides and transparencies. Pays royalties. No advance. Rights purchased vary according to project. Requires exclusive representation of artist. Provides advertising, insurance while work is at firm, promotion, shipping to and from firm, and written contract.
Tips: Finds artists through art exhibits, submissions and word of mouth.

‡**GREGORY EDITIONS**, 18333 Hatteras St., Unit 32, Tarzana CA 91356. (818)705-3820. Fax: (818)705-2824. President: Mark Eaker. Estab. 1988. Art publisher and distributor of originals, limited editions, serigraphs and bronze sculptures. Clients: Retail art galleries. Current clients include (but not limited to) Billy Hork Galleries, Chasen Portfolio, Renaissance Fine Art, Images International of Hawaii, Simic Galleries.
Needs: Seeking contemporary, creative artwork. Considers oil and acrylic. Artists represented include Stan Solomon, James Talmadge, Denis Paul Noyer, Liliana Frasca and sculptures by Ting Shao Kuang. Editions created by working from an existing painting. Publishes and distributes the work of 5 emerging, 2 mid-career and 2 established artists/year.
First Contact & Terms: Send query letter with brochure showing art style. Call for appointment to show portfolio of photographs and transparencies. Purchases paintings outright; pays percentage of sales. Requires exclusive representation of artist. Provides in-transit insurance, insurance while work is at firm, promotion, shipping from firm and written contract.
Tips: "People are looking to buy something that looks and has the feel of an original, but do not want to pay the price. Canvas transfers are an excellent way to fullfill that need."

‡**GUILDHALL, INC.**, Dept. AGDM, 3505-07 NW Loop 820, Fort Worth TX 76106. (817)740-0000, (800)356-6733. Fax: (817)740-9600. President: John M. Thompson III. Art publisher/distributor of limited and unlimited editions, offset reproductions and handpulled originals for galleries, decorators, offices and department stores. Current clients include over 500 galleries and collectors nationwide.
Needs: Seeking creative art for the serious and commercial collector and designer market. Considers pen & ink, oil, acrylic, watercolor, and bronze and stone sculptures. Prefers historical Native American, Western, equine, wildlife, landscapes and religious themes. Prefers individual works of art. Artists represented include Chuck DeHaan, Wayne Baize, Greg Beecham, Lisa Danielle, Jack Hines, Ralph Wall, John Potocschnik and Jessica Zemski. Editions created by collaborating with the artist and by working from an existing painting. Approached by 150 artists/year.
First Contact & Terms: Send query letter with résumé, tearsheets, photographs, slides and 4×5 transparencies. Samples are not filed and are returned only if requested. Reports back within 1 month. Call or write for appointment to show portfolio, or mail thumbnails, color and b&w tearsheets, slides and 4×5 transparen-

cies. Pays $200-15,000 flat fee; 10-20% royalties; 35% commission on consignment; or payment method is negotiated. Negotiates rights purchased. Requires exclusive representation for contract artists. Provides insurance while work is at firm, promotion, shipping from firm and written contract.

Tips: "The new technologies in printing are changing the nature of publishing. Self-publishing artists have flooded the print market. Many artists are being told to print themselves. Most of them, in order to sell their work, have to price it very low. In many markets this has caused a glut. Some art would be best served if it was only one of a kind. There is no substitute for scarcity and quality."

HADDAD'S FINE ARTS INC., 3855 E. Miraloma Ave., Anaheim CA 92806. President: Paula Haddad. Estab. 1953. Art publisher and distributor. Produces unlimited edition offset reproductions and posters. Clients: galleries, art stores, museum stores and manufacturers. Sells to the trade only—no retail.

Needs: Seeking creative and decorative art for the commercial and designer markets. Prefers traditional, realism with contemporary flair; unframed individual works and pairs; all media. Artists represented include Tim Ashkar, David Coolidge, Gerald Merfeld, Barbara Nichols and Joan Hansen. Editions created by collaborating with the artist or by working from an existing painting. Approached by 200-300 artists/year. Publishes the work of 10-15 emerging artists/year.

First Contact & Terms: Send query letter with brochure, transparencies, slides, photos representative of work for publication consideration. Include SASE. Reports back within 90 days. Publisher/distributor will contact artist for portfolio review if interested. Portfolio should include slides, roughs, final art, transparencies. Pays royalties quarterly, 10% of base net price. No advance. Rights purchased vary according to project. Provides advertising and written contract.

Tips: Advises artists to attend Art Buyers Caravan and Art Expo.

‡HOOF PRINTS, Dept. A & G., P.O. Box 1917, Lenox MA 01240. Phone/fax: (413)637-4334. Proprietor: Judith Sprague. Estab. 1991. Mail order art retailer and wholesaler. Handles handpulled originals, limited and unlimited editions, offset reproductions, posters and engravings. Clients: individuals, galleries, tack shops and pet stores.

Needs: Considers only horse, dog, fox and cat prints.

First Contact & Terms: Send brochure, tearsheets, photographs and samples. Samples are filed. Will contact artist for portfolio review if interested. Pays per print. No advance. Provides advertising and shipping from firm.

Tips: Finds artists through sourcebooks, magazine ads, word of mouth.

ICART VENDOR GRAPHICS, 8512 Whitworth Dr., Suite 103, Los Angeles CA 90035. (310)659-1023. Fax: (310)659-1025. Director: John Pace. Estab. 1972. Art publisher and distributor of limited and unlimited editions of offset reproductions and handpulled original prints. Clients: galleries, picture framers, decorators, corporations, collectors.

Needs: Considers oil, acrylic, airbrush, watercolor and mixed media, also serigraphy and lithography. Seeking unusual, appealing subjects in Art Deco period styles as well as wildlife and African-American art. Prefers individual works of art, pairs, series; 30×40 maximum. Artists represented include J.W. Ford, Neely Taugher, Louis Icart and Maxfield Parrish. Publishes the work of 2 emerging, 3 mid-career and 1 established artist/year. Distributes the work of 4 emerging, 20 mid-career and 50 established artists/year.

First Contact & Terms: Send brochure and photographs. Do not send slides. Samples returned by SASE. Reports back within 1 month. Pays flat fee, $500-1,000; royalties (5-10%) or negotiates payment method. Sometimes offers advance. Buys all rights. Usually requires exclusive representation of the artist. Provides insurance while work is at publisher. Negotiates ownership of original art.

Tips: "Be original with your own ideas. Give clean, neat presentations in original or photographic form (no slides). No abstracts please. Popular styles include impressionism and landscapes. Posters are becoming less graphic; more of a fine art look is popular."

IMAGE CONSCIOUS, 147 Tenth St., San Francisco CA 94103. (415)626-1555. Creative Director: Simone Becker. Estab. 1980. Art publisher and domestic and international distributor of offset and poster reproductions. Clients: poster galleries, frame shops, department stores, design consultants, interior designers and gift stores. Current clients include Z Gallerie, Deck the Walls and Decor Corporation.

Needs: Seeking creative and decorative art for the designer market. Considers oil, acrylic, pastel, watercolor, tempera, mixed media and photography. Prefers individual works of art, pairs or unframed series. Artists represented include Mary Silverwood, Aleah Koury, Doug Keith, Jim Tanaka, Joseph Holmes and Dorothy

The double dagger before a listing indicates that the listing is new in this edition. New markets are often more receptive to freelance submissions.

Spangler. Editions created by collaborating with the artist and by working from an existing painting. Approached by hundreds of artists/year. Publishes the work of 2-3 emerging, 2-3 mid-career and 4-5 established artists/year. Distributes the work of 50 emerging, 200 mid-career and 700 established artists/year.
First Contact & Terms: Send query letter with brochure, résumé, tearsheets, photographs, slides and/or transparencies. Samples are filed or are returned by SASE. Reports back within 1 month. Publisher/distributor will contact artist for portfolio review if interested. No original art. Payment method is negotiated. Negotiates rights purchased. Provides promotion, shipping from firm and a written contract.
Tips: "Research the type of product currently in poster shops. Note colors, sizes and subject matter trends."

IMAGES INTERNATIONAL DIRECT SALES CORPORATION, P.O. Box 1130, Honolulu HI 96807. (808)531-7051. Fax: (808)521-4341. President: Stevenson C. Higa. Estab. 1977. Art publisher and gallery. Publishes limited editions, offset reproductions and originals. Clients: retail galleries, shows and wholesale galleries. Current clients include Hansons Galleries, The Mas Charles Gallery and Lahaina Galleries.
Needs: Seeking decorative art for the serious collector and commercial market. Considers oil, watercolor, acrylic and painting on fabric. Prefers oriental themes. Artists represented include Otsuka, Caroline Young and Chan. Editions created by collaborating with the artist or by working from an existing painting. Publishes the work of 1 emerging, 1 mid-career and 2 established artists/year.
First Contact & Terms: Send query letter with brochure showing art style or résumé and photographs. Samples are not filed and are returned by SASE if requested by artist. Reports back within 2 months. Payment method is negotiated. Offers an advance when appropriate. Buys one-time rights. Provides in-transit insurance, insurance while work is at firm, promotion, shipping to firm and written contract.

IMCON, RR 3, Box, Oxford NY 13830. (607)843-5130. Fax: (607)843-2130. President: Fred Dankert. Estab. 1986. Fine art printer of handpulled originals. "We invented the waterless litho plate, and we make our own inks." Clients: galleries, distributors.
Needs: Seeking creative art for the serious collector. Editions created by collaborating with the artist "who must produce image on my plate. Artist given proper instruction."
First Contact & Terms: Call or send query letter with résumé, photographs and transparencies.
Tips: "Artists should be willing to work with me to produce original prints. We do *not* reproduce; we create new images. Artists should have market experience."

IMPACT, 4961 Windplay Dr., El Dorado Hills CA 95762. (916)933-4700. Fax: (916)933-4717. Contact: Benny Wilkins. Estab. 1975. Publishes calendars, postcards, posters and 5×7, 8×10 and 16×20 prints. Clients: international distributors, poster stores, framers, plaque companies, tourist businesses, retailers, national parks, history associations and theme parks. Current clients inlcude Royal Doulton, Image Conscious, Prints Plus, Plaquefactory and Deck the Walls.
Needs: Seeking traditional and contemporary artwork. Considers acrylics, pastels, watercolors, mixed media and airbrush. Prefers contemporary, original themes, humor, fantasy, autos, animals, children, western, country, floral, aviation, ethnic, wildlife and suitable poster subject matter. Prefers individual works of art. "Interested in licensed subject matter." Artists represented include Jonnie Kostoff, Tom Kidd, Richard Henson and Scott Wilson. Publishes the work of 5-10 emerging and 2-4 mid-career artists/year.
First Contact & Terms: Send query letter with brochure, tearsheets, photographs, slides and transparencies. Samples are filed. Reports back within 2 weeks. Call or write for appointment to show portfolio, or mail original/final art, tearsheets, slides, transparencies, final reproduction/product, color and b&w. Pays flat fee; $100-700; royalties of 7%; payment method is negotiated. Offers an advance when appropriate. Negotiates rights purchased. Does not require exclusive representation of the aritst. Provides insurance while work is at firm, shipping from firm, written contract and artist credit.
Tips: "In the past we have been 'trendy' in our art; now we are a little more conservative and traditional."

INSPIRATIONART & SCRIPTURE, P.O. Box 5550, Cedar Rapids IA 52406. (319)365-4350. Fax: (319)366-2573. Division Manager: Lisa Edwards. Produces greeting cards, posters and calendars.
 ● This company produces jumbo-sized posters targeted at pre-teens, teens and young adults, some fine art and some commercial. See their listing in the Greeting Cards section for more information.

‡INTERCONTINENTAL GREETINGS LTD., 176 Madison Ave., New York NY 10016. Art Director: Robin Lipner. Estab. 1967. Sells reproduction rights of design to publisher/manufacturers. Handles offset reproductions, greeting cards, stationery and gift items. Clients: paper product, gift tin, ceramic and textile manufacturers. Current clients include: Scandecor, Verkerke, Simon Elvin, others in Europe, Latin America and Asia.
Needs: Seeking creative, fashionable and decorative art for the commercial and designer markets. Considers oil, watercolor, mixed media, pastel, acrylic, computer and photos. Approached by several hundred artists/ year. Publishes the work of 30 emerging, 100 mid-career and 100 established artists/year.
First Contact & Terms: Send query letter with brochure, tearsheets, slides, photographs, photocopies and transparencies. Samples are filed or returned by SASE if requested by artist. Artist should follow-up with call. Portfolio should include color final art, photographs and slides. Pays flat fee: $30-500, or royalties of 20%. Offers advance when appropriate. Rights purchased vary according to project. Requires exclusive

representation of artist, "but only on the artwork we represent." Provides promotion, shipping to firm and written contract.

Tips: Finds artists through attending art exhibitions, word of mouth, sourcebooks or other publications and artists' submissions. Recommends New York Stationery Show held annually in New York. "In addition to having good painting/designing skills, artists should be aware of market needs."

‡❧ISLAND ART, 6687 Mirah Rd., Saanichton, British Columbia Y8M 1Z4 Canada. (604)652-5181. Fax: (604)652-2711. E-mail: islandart@dataflux.bc.ca. President: Myron D. Arndt. Estab. 1985. Art publisher and distributor. Publishes and distributes limited and unlimited editions, offset reproductions, posters and art cards. Clients: galleries, department stores, distributors, gift shops. Current clients include: Disney, Host-Marriott, Ben Franklin..

Needs: Seeking creative and decorative art for the serious collector, commercial and designer markets. Considers oil, watercolor and acrylic. Prefers lifestyle themes/Pacific Northwest. Artists represented include Sue Coleman, Lissa Calvers and Ted Harrison. Editions created by working from an existing painting. Approached by 100 artists/year. Publishes the work of 2 emerging, 2 mid-career and 2 established artists/year. Distributes the work of 4 emerging, 10 mid-career and 5 established artists/year.

First Contact & Terms: Send résumé, tearsheets, slides and photographs. Samples are not filed and are returned by SASE if requested by artist. Reports back within 3 months. Publisher/distributor will contact artist for portfolio review if interested. Portfolio should include color roughs, final art, slides and 4×5 transparencies. Pays royalties of 5-10%. Offers advance when appropriate. Buys reprint rights. Requires exclusive representation of artist. Provides insurance while work is at firm, promotion, shipping from firm, written contract, trade fair representation and Internet service.

Tips: Finds artists through art fairs, referrals and submissions. Recommends artists attend Art Expo. "Color trends vary—artists should consider vivid colors and representational images."

‡J.B. FINE ARTS/CENTRAL GALLERIES, 420 Central Ave., Cedarhurst NY 11516. (516)569-5686. Fax: (516)569-7114. President: Jeff Beja. Estab. 1983. Art publisher, distributor and gallery. Publishes and distributes limited editions.

Needs: Seeking creative art for the serious collector and commercial market. Considers oil, mixed media and acrylic. Editions created by collaborating with the artist or working from an existing painting. Approached by 100 artists/year. Publishes the work of 1 emerging artist/year. Distributes the work of 5 emerging, 10 mid-career and 20 established artists/year.

First Contact & Terms: Send query letter with résumé, tearsheets and photographs. Samples are filed or returned by SASE if requested by artist. Reports back within 2 months if interested. Portfolio review not required. Publisher/distributor will contact artist for portfolio review if interested. Negotiates payment. Offers advance when appropriate. Rights purchased vary according to project. Requires exclusive representation of artist. Provides advertising, in-transit insurance, insurance while work is at firm, promotion, shipping from firm and written contract.

‡JANNES ART PUBLISHING, INC., 3318 N. Lincoln Ave., Chicago IL 60657. (312)404-5090. Fax: (312)404-0150. Owner: Nicholas Jannes. Estab. 1986. Art publisher and distributor. Publishes and distributes limited editions and posters. Clients: galleries, art shops, framing shops and retail. Current clients include: Graphique de France and Modernart Editions.

Needs: Seeking creative art for the serious collector and the commercial market. Considers oil and watercolor. Prefers automotive, floral and landscape. Artists represented include Scott Mutter, G. Pedginton and Gary Michael. Editions created by working from an existing painting. Approached by 10 artists/year. Publishes the work of 1 emerging, 10 mid-career and 3 established artists/year. Distributes the work of 5 emerging, 23 mid-career and 5 established artists/year.

First Contact & Terms: Send brochure and tearsheets. Samples are filed and are returned. Publisher/Distributor will contact artist for portfolio review if interested. Portfolio should include slides and transparencies. Pays royalties of 10-20%; negotiates payment. No advance. Rights purchased vary according to project. Provides advertising, promotion and shipping from firm.

Tips: Recommends artist attend Art Expo.

ARTHUR A. KAPLAN CO. INC., 460 W. 34th St., New York NY 10001. (212)947-8989. Fax: (212)629-4317. Art Director: Elizabeth Tuckman. Estab. 1956. Art publisher of unlimited editions of offset reproduction prints. Clients: galleries and framers.

Needs: Seeking creative and decorative art for the designer market. Considers all media. Artists represented include Lena Liu, Charles Murphy and Gloria Eriksen. Editions created by collaborating with artist or by working from an existing painting. Approached by 1,550 artists/year. Publishes and distributes the work of "as many good artists as we can find."

First Contact & Terms: Send résumé, tearsheets, slides and photographs to be kept on file. Material not filed is returned by SASE. Reports within 2-3 weeks. Call for appointment to show portfolio, or mail appropriate materials. Portfolio should include final reproduction/product, color tearsheets and photographs.

Pays a royalty of 5-10%. Offers advance. Buys rights for prints and posters only. Provides insurance while work is at firm and in transit from plant to artist.

Tips: "We cater to a mass market and require fine quality art with decorative and appealing subject matter. Don't be afraid to submit work—we'll consider anything and everything."

‡MARTIN LAWRENCE LIMITED EDITIONS, 16250 Stagg St., Van Nuys CA 91406. (818)988-0630. Fax: (818)785-4330. President: Barry R. Levine. Estab. 1976. Art publisher, distributor and gallery. Publishes and distributes limited editions, offset reproductions and posters.

Needs: Seeking creative and decorative art for the serious collector and commercial market. Considers oil, watercolor, mixed media, pastel, sculpture and acrylic. Prefers impressionist, naive, Americana, pop art. Artists represented include Mark King, Susan Rios, Linnea Percola, Laurie Zeszut and Mark Kostabi. Editions created by collaborating with the artist or working from an existing painting. Approached by 100 artists/ year. Publishes and distributes the work of 2 emerging artists/year.

First Contact & Terms: Send slides, photographs and transparencies. Samples are not filed and are returned by SASE if requested by artist. Publisher/Distributor will contact artist for portfolio review if interested. Portfolio should include photographs. Requires exclusive representation of artist. Provides advertising.

Tips: Suggests artist attend Art Expo New York.

‡LESLI ART, INC., Box 6693, Woodland Hills CA 91365. (818)999-9228. President: Stan Shevrin. Estab. 1965. Artist agent handling paintings for art galleries and the trade.

Needs Considers oil paintings and acrylic paintings. Prefers realism and impressionism—figures costumed, narrative content, landscapes, still lifes and florals. Maximum size 36 × 48, unframed. Works with 20 artists/ year.

First Contact & Terms: Send query letter with photographs and slides. Samples not filed are returned by SASE. Reports back within 1 month. To show portfolio, mail slides and color photographs. Payment method is negotiated. Offers an advance. Provides national distribution, promotion and written contract.

Tips: "Considers only those artists who are serious about having their work exhibited in important galleries throughout the United States and Europe."

‡LESLIE LEVY FINE ART PUBLISHING, INC., 1505 N. Hayden, Suite J10, Scottsdale AZ 85257. (602)945-8491. Fax: (602)945-8104. Director: Gary Massey. Estab. 1976. Art publisher and distributor of limited and unlimited editions, offset reproductions, posters and miniature prints. "Our art gallery has a wide mix of artists, mostly from out of state. The publishing customers are mainly frame shops, galleries, designers, distributors and department stores. Current major distributors include Art Source, Bruce McGaw, Graphique de France, Waterline, Joan Cawley, ImageMasters, Poster Porters, Lieberman's, Vanguard, Poster Gallery and Paragon. We distribute in over 30 countries."

Needs Seeking creative, fashionable and decorative art for the serious and commercial collector and designer market. Artists represented include: Steve Hanks, Doug Oliver, Robert Staffolino, Kent Wallis, Michael Workman, Doug West, Patricia Hunter, Jean Crane, Jamie Perry and James Harrill. Editions created by collaborating with the artist or by working from an existing painting. Considers oil, acrylic, pastel, watercolor, tempera, mixed media and photographs. Prefers art with a universal appeal and popular colors. Approached by hundreds of artists/year. Publishes the work of 5-8 emerging, 15 mid-career and 10 established artists/ year.

First Contact & Terms: Send query letter with résumé, slides or transparencies. Samples are returned by SASE. "Portfolio will not be seen unless interest is generated by the materials sent in advance." Posters and prints "are sold quarterly. Pays royalties based on retail and popularity of artist." Sells original art on a consignment basis: (firm receives 50% commission). Insists on acquiring reprint rights for posters. Requires exclusive representation of the artist for the image being published.

Tips: "First, don't call us. After we review your materials, we will contact you or return materials within 6-8 weeks. We are known in the industry for our high-quality prints and excellent skilled artists. Also, we are always looking for artists to represent in our Scottsdale art gallery. We are looking for floral, figurative, impressionist, 1800s Old West (paintings and b&w photos) landscapes, children's art and any art of exceptional quality. Please, if you are a beginner or are in the process of meeting your potential, do not go through the time and expense of sending materials."

‡LIGHTPOST PUBLISHING, 10 Almaden Blvd., 9th Floor, San Jose CA 95113. (408)279-4777. Product Manager: Brent Higginson. Estab. 1989. Art Publisher. Publishes unlimited and limited editions and offset reproductions.

Needs: Seeking decorative art for the commercial market. Considers oil, watercolor and acrylic. Prefers traditional, classic styles. Aritsts represented include Thomas Kincaid and Susan Rios. Editions created by collaborating with the artist and by working from an existing painting. Approached by more than 100 artists/ year. Publishes the work of 2 and distributes the work of 2 established artists/year.

First Contact & Terms: Send résumé, slides, photographs, transparencies. Samples are filed or are returned by SASE if requested by artist. Reports back only if interested. Negotiates payment. Offers advance when

Awaken Emotions to Increase Sales

Looking at Susan Rios's paintings, you might imagine the artist to be a sentimental sort, someone who creates soothing renditions of childhood memories or brushed fantasy snapshots from her love of creating. While her art reflects her love of nature and children, there is another side to this Californian.

A self-taught artist, Rios is also a practical woman with indefatigable drive and a no-nonsense business savvy that has guided her from sidewalk art shows to the creation of limited edition prints, serigraphs, lithographs, a collector's plate and soon, a series of licensed products. Her original acrylic-on-linen-and-canvas paintings garner an average of $17,000 each. Her secret? "Be flexible. Go with what other people want," she says.

Susan Rios

Rios learned people buy artwork which touches their emotions. Whether her scene is a cozy interior or an ocean view, she makes sure it stirs memories and wishes. She creates a scene her collectors can project themselves into very easily. For instance, she once painted a white clapboard house that looked so homey it reminded people of the house they grew up in. She'll paint a beautiful, empty room with overstuffed furniture and light streaming through a window onto a vase full of colorful fresh flowers—then she'll add an element that seems to invite the viewer to enter, like a cup of steaming hot tea on a table, or an open book on a chair. She often portrays children from the back. Because the face is not visible, viewers recognize their own child or recall themselves at that age.

If you want to achieve success in this business, "you don't necessarily indulge yourself all the time. You can do the best artwork in the world, but if nobody buys it, who cares?" says Rios.

Rios developed a dollars-and-cents attitude out of necessity when she was divorced and, at age 26, faced with supporting herself and a young daughter. Although she dabbled in art throughout her life, she had no formal art education. She was working in a flower shop when a friend with business experience convinced her to take a chance selling her artwork. Rios sold her paintings through sidewalk art shows, and eventually went to work full-time in her own studio, often holding open houses to attract new customers. Early in her career, she realized she could sell more images by working with an art publisher to produce limited edition prints from her canvases.

Her advice to artists seeking success in the limited-edition market is as simple as her attitude. "Be humble," she says. "Listen to people." Start by selling at

sidewalk art shows and festivals where you can meet people and get feedback. Accept suggestions as constructive criticism. Encourage browsers to sign a client book, then wait a week or two and call them to gauge interest.

Although Lightpost Publishing now markets her work, during the early years of her career, Rios adhered to the "hunt-and-peck method of marketing," following every possible lead. She phoned prospective clients, and presented herself personally, portfolio in hand, at the doors of gallery owners when necessary. If customers requested, she created paintings to match their decorating schemes, sometimes incorporating fabrics from their rooms into paintings.

Once you have some commissioned pieces under your belt, you can approach a gallery about representation. Call first to set an appointment, but if you don't get a response, opt for Rios's method: tuck your portfolio under your arm and walk right in. "You gotta have a little guts," she says.

Just remember not to sign any contract without having an attorney study it first. Although there is always a certain amount of compromise when you do commercial work, "some compromises are just too great," Rios states. The same holds when approaching print publishers. "Don't make decisions based on fear." Sometimes you have to bypass what looks like a good opportunity for "financial health" to maintain your mental health, she adds.

But if you make mistakes—and everyone does—just make sure you learn from them. "Say to yourself, 'OK, this happened, now what can I do to make it better?' You'll undoubtedly take two steps forward for every step back if you remember that there is no right or wrong way to approach this market, just as there is no right or wrong way to create art," says Rios.

—*Jennifer Hogan-Redmond*

Susan Rios's print Taking Care of Teddy *is typical of the artist's work, which includes sentimental details, young children, soft colors and inviting florals.*

appropriate. Rights purchased vary according to project. Requires exclusive representation of artist. Provides advertising, promotion, shipping from firm and written contract.

Tips: Finds artists through attending exhibitions, art fairs, word of mouth, sourcebooks, publications and artists' submissions. Recommends artists attend Art Expo.

‡✤LIPMAN PUBLISHING, 76 Roxborough St. W., Toronto, Ontario M5R 1T8 Canada. (800)561-4260. Owner: Louise Lipman. Estab. 1976. Art publisher. Publishes unlimited editions, offset reproductions and posters. Clients: wholesale framers, distributors, hospitality. Current clients include: Pier One, Avey and Avey, Spiegel.

Needs: Seeking decorative art for the commercial and designer markets. Considers all 2-dimensional media. Prefers garden, kitchen, landscape, floral themes. Artists represented include William Buffett, Patrick Nagel and Anna Pugh. Editions created by collaborating with the artist or by working from an existing painting.

First Contact & Terms: Send slides, photographs, photocopies or any low-cost facsimile. Samples are filed or returned by SASE if requested by artist. Reports back within a few weeks. Publisher will contact artist for portfolio review if interested. Portfolio should include color thumbnails, photographs and slides. Pays royalties of 10%. Offers advance. Negotiates rights purchased. Requires exclusive representation of artist. Provides advertising, promotion and written contract.

Tips: "There's a trend to small pictures of garden-, kitchen- and bathroom-related material."

LOLA LTD./LT'EE, 1811 Egret St. SW, S. Brunswick Islands, Shallotte NC 28470. (910)754-8002. Owner: Lola Jackson. Art publisher and distributor of limited editions, offset reproductions, unlimited editions and handpulled originals. Clients: art galleries, architects, picture frame shops, interior designers, major furniture and department stores, industry and antique gallery dealers.

• This art publisher also carries antique prints, etchings and original art on paper and is interested in buying/selling to trade.

Needs: Seeking creative and decorative art for the commercial and designer markets. "Handpulled graphics are our main area." Also considers oil, acrylic, pastel, watercolor, tempera or mixed media. Prefers unframed series, 30×40 maximum. Artists represented include White, Brent, Jackson, Mohn, Baily, Carlson, Coleman. Approached by 100 artists/year. Publishes the work of 5 emerging, 5 mid-career and 5 established artists/year. Distributes the work of 40 emerging, 40 mid-career and 5 established artists/year.

First Contact & Terms: Send query letter with brochure showing art style or résumé, tearsheets, photostats, photographs, photocopies or transparencies as well as the price the artists needs. "Actual sample is best." Samples are filed or are returned only if requested. Reports back within 2 weeks. Payment method is negotiated. "Our standard commission is 50% less 50% off retail." Offers an advance when appropriate. Provides insurance while work is at firm, shipping from firm and written contract.

Tips: "We find we cannot sell b&w only; red, orange and yellow are also hard to sell unless included in abstract subjects. Best colors: emerald, mauve, pastels, blues."

‡LONDON CONTEMPORARY ART, 729 Pinecrest Dr., Prospect Heights IL 60070. (708)459-3990. Fax: (708)459-3997. Sales Manager: Susan Gibson Brown. Estab. 1978. Art publisher. Publishes limited editions. Clients: art galleries, dealers, distributors and designers.

Needs: Seeking art for the commercial market. Prefers figurative, some abstract expressionism. Artists represented include Roy Fairchild, David Dodsworth, Janet Treby, Alexander Ivanov and Csaba Markus. Editions created by working from an existing painting. Approached by hundreds of artists/year. Publishes the work of 1-10 emerging, 1-10 mid-career and 20 established artists/year. Distributes the work of 1-10 emerging, 1-10 mid-career, 20-50 established artists/year.

First Contact & Terms: Send brochure, résumé, tearsheets, photographs and photocopies. Samples are filed or returned by SASE. Publisher/Distributor will contact artist for portfolio review if interested. Portfolio should include final art, tearsheets and photographs. Negotiates payment. Rights purchased vary according to project. Provides advertising, in-transit insurance, insurance while work is at firm, promotion, shipping from firm and written contract.

Tips: Finds artists through attending art exhibitions and art fairs, word of mouth and artists' submissions. Recommends artists read *Art Business News* and *USArt*. "Pay attention to color trends and interior design trends. Artists need discipline and business sense and must be productive."

‡LYNESE OCTOBRE, INC., 22121 US 19 N. Clearwater FL 34625. (813)724-8800. Fax: (813)724-8352. President: Jerry Emmons. Estab. 1982. Distributor. Distributes unlimited editions, offset reproductions and posters. Clients: picture framers and gift shops. Current clients include: Deck the Walls, Michaels Stores.

Needs: Seeking fashionable and decorative art for the commercial and designer markets. Considers oil, watercolor, mixed media, pastel, pen & ink and acrylic. Artists represented include James W. Harris, Mark Winter, Roger Isphording, Betsy Monroe, Paul Brent, Sherry Vintson, Jean Grastorf, AWS. Approached by 50 artists/year. Publishes the work of 2-5 emerging and 1-3 established artists/year. Distributes the work of 2-5 emerging and 1-3 established artists.

First Contact & Terms: Send brochure, tearsheets, photographs and photocopies. Samples are sometimes filed or are returned. Reports back within 1 month. Distributor will contact artist for portfolio review if

interested. Portfolio should include final art, photographs and transparencies. Negotiates payment. No advance. Rights purchased vary according to project. Provides written contract.

Tips: Recommends artists attend Art Buyers Caravan by *Decor*. "The trend is toward quality, color-oriented regional works."

BRUCE MCGAW GRAPHICS, INC., 389 West Nyack Rd., West Nyack NY 10994. (914)353-8600. Fax: (914)353-3155. Acquisitions: Martin Lawlor. Clients: poster shops, galleries, I.D., frame shops.

Needs: Artists represented include Ty Wilson, Betsy Cameron, Yuriko Takata, Art Wolfe, Diane Romanello, Bart Forbes, Patricia Wyatt, Donna Lacey-Derstine, Peter Kitchell and Terry Rose. Publishes the work of 10 emerging and 20 established artists/year.

First Contact & Terms: Send slides, transparencies or any other visual material that shows the work in the best light. "We review all types of art with no limitation on media or subject. Review period is 1 month, after which time we will contact you with our decision. If you wish the material to be returned, enclose a SASE. Contractual terms are discussed if work is accepted for publication."

Tips: "Simplicity is very important in today's market (yet there still needs to be 'a story' to the image). Form and palette are critical to our decision process. We have a tremendous need for decorative pieces, especially new abstracts and gastronomy-related images. We have also seen a return to artwork which deals with back-to-nature subject matter as well as palette."

MACH 1, INC., P.O. Box 7360, Chico CA 95927. (916)893-4000. Fax: (916)893-9737. Vice President Marketing: Paul Farsai. Estab. 1987. Art publisher. Publishes unlimited and limited editions and posters. Clients: museums, galleries, frame shops and mail order customers. Current clients include the Smithsonian Museum, the Intrepid Museum, Deck the Walls franchisers and Sky's The Limit.

Needs: Seeking creative and decorative art for the commercial and designer markets. Considers mixed media. Prefers aviation related themes. Artists represented include Jarrett Holderby and Jay Haiden. Editions created by collaborating with the artist or by working from an existing painting. Publishes the work of 2-3 emerging, 2-3 mid-career and 2-3 established artists/year.

First Contact & Terms: Send query letter with résumé, slides and photographs. Samples are not filed and are returned. Reports back within 1 month. To show a portfolio, mail slides and photographs. Pays royalties. Offers an advance when appropriate. Requires exclusive representation of the artist. Provides promotion, shipping to and from firm and a written contract.

Second Coming, this striking work in oil and acrylic by Reginald Webster, is the number one selling print carried by Mahogany Art Galleries. The original painting, which is available in 17×22 and desk-size prints as well as on a medallion, was donated by the artist to a Los Angeles church. Mahogany runs a gallery showing original works by their artists in addition to a publication and distribution center.

© Mahogany Art Galleries

‡**MAHOGANY ART GALLERY**, 7250 Melrose Ave., Los Angeles CA 90046. (213)936-3211. Fax: (213)936-2447. Art Director: Aneesah Al-Ghani. Estab. 1994. Art publisher, distributor and gallery. Publishes and distributes handpulled originals, limited and unlimited editions. Clients: movie industry and sports figures.

Needs: Seeking creative, fashionable and decorative art for the serious collector and commercial market. Considers mixed media, pastel, pen & ink and acrylic. Exhibits all styles and genres but interested in seeing contemporary styles, abstracts. Approached by 25 artists/year. Publishes the work of 4-8 emerging, 4-8 mid-

career and 3 established artists/year. Distributes the work of 4-8 emerging, 4-8 mid-career and 3 established artists/year.

First Contact & Terms: Send query letter with brochure, résumé/bio, tearsheets, slides and photocopies. Samples are filed or returned by SASE if requested by artist. Reports back within 2 months. Publisher/Distributor will contact artist for portfolio review if interested. Portfolio should include tearsheets and slides. Pays royalties of 15%, on consignment basis (firm receives 40% commission) or negotiates payment. No advance. Rights purchased vary according to project. Requires exclusive representation of artist. Provides advertising, insurance while work is at firm, promotion and written contract.

Tips: Finds artists through attending art exhibitions, art fairs, word of mouth, agents, sourcebooks and publications, artists' submissions. Recommends artists attend ABC Shows.

MIXED-MEDIA, LTD., Box 15510, Las Vegas NV 89114. (702)796-8282 or (800)772-8282. Fax: (702)796-8282. Estab. 1969. Distributor of posters. Clients: galleries, frame shops, decorators, hotels, architects and department stores.

Needs: Considers posters only. Artists represented include Will Barnet, G.H. Rothe, Castellon and Cuevas. Distributes the work of hundreds of artists/year.

First Contact & Terms: Send finished poster samples. Samples not returned. Negotiates payment method and rights purchased. Does not require exclusive representation.

MODERNART EDITIONS, 100 Snake Hill Rd., West Nyack NY 10994. (914)358-7605. Contact: Jim Nicoletti. Estab. 1973. Art publisher and distributor of "top of the line" unlimited edition posters and offset reproductions. Clients: galleries and custom frame shops nationwide.

Needs: Seeking decorative art for the commercial and designer markets. Considers oil, watercolor, mixed media, pastel and acrylic. Prefers fine art landscapes, abstracts, representational, still life, decorative, collage, mixed media. Minimum size 18×24. Artists represented include M.J. Mayer, Carol Ann Curran, Diane Romanello, Pat Woodworth, Jean Thomas and Carlos Rios. Editions created by collaboration with the artist or by working from an existing painting. Approached by 150 artists/year. Publishes the work of 10-15 emerging artists/year. Distributes the work of 300 emerging artists/year.

First Contact & Terms: Send postcard size sample of work, contact through artist rep, or send query letter with slides, photographs, brochure, photocopies, résumé, photostats, transparencies. Reports within 6 weeks. Request portfolio review in original query. Publisher/Distributor will contact artist for portfolio review if interested. Portfolio should include color photostats, photographs, slides and trasparencies. Pays flat fee of $200-300 or royalties of 10%. Offers advance against royalties. Buys all rights. Requires exclusive representation of artist. Provides insurance while work is at firm, shipping to firm and written contract.

Tips: Advises artists to attend Art Expo New York City and Atlanta ABC.

MONTMARTRE ART COMPANY, INC., 24 S. Front St., Bergenfield NJ 07621. (201)387-7313 President: Ann B. Sullivan. Estab. 1959. Wholesale art dealer to trade. Clients: galleries, decorators, designers and art consultants.

Needs: Considers oil, acrylic, watercolor and mixed media. Prefers contemporary, traditional themes in unframed series. Distributes the work of 25 artists/year. Artists represented include Carol Ann Curran, Raul Conti, Laforet, Salizar, Takazi.

First Contact & Terms: Send query letter with brochure showing art style or any of the following: résumé, tearsheets, photostats, photographs, photocopies, slides and transparencies. Samples not filed are returned by SASE. Reports back within 7-10 days. Call for appointment to show portfolio of original/final art, slides and transparencies. Pays flat fee of $50-750 or royalties of 10%. Offers an advance when appropriate. Requires exclusive representation. Provides insurance while work is at firm and shipping from firm.

Tips: Finds artists through word of mouth, artists' submissions/self-promotions, sourcebooks, visiting art galleries, attending art fairs and shows. Recommends artists attend Art Expo. "Montmartre will work with artists to help make certain works are more saleable to our client market. We also help artists get their work published in the print and poster market." Currently "bright jewel-tone colors" are popular.

‡MORIAH PUBLISHING, INC., 23500 Mercantile Rd., Unit B, Beechwood OH 44122. (216)289-9653. Fax: (216)595-3140. Contact: President. Estab. 1989. Art publisher and distributor of limited editions. Clients: wildlife art galleries.

Needs: Seeking artwork for the serious collector. Editions created by working from an existing painting. Approached by 100 artists/year. Publishes the work of 6 and distributes the work of 15 emerging artists/year. Publishes and distributes the work of 10 mid-career artists/year. Publishes the work of 30 and distributes the work of 10 established artists/year.

First Contact & Terms: Send query letter with brochure showing art style, slides, photocopies, résumé, photostats, transparencies, tearsheets and photographs. Reports back within 2 months. Write for appointment to show portfolio or mail appropriate materials: rough, b&w, color photostats, slides, tearsheets, transparencies and photographs. Pays royalties. No advance. Buys reprint rights. Requires exclusive representation of artist. Provides in-transit insurance, promotion, shipping to and from firm, insurance while work is at firm, and a written contract.

Tips: "Artists should be honest, be patient, be courteous, be themselves, and make good art."

‡NATIONAL ART PUBLISHING CORP., 11000-32 Metro Pkwy., Ft. Meyers FL 33912. Fax: (813)939-7518. (813)936-2788. Contact: Marti Trimble or President: David Boshart. Estab. 1978. Art publisher, catalog publisher/marketer. Publishes limited and unlimited editions, offset reproductions, posters, sculpture and photos.
Needs: Seeking artwork for the serious collector, commercial and designer markets. Considers oil, watercolor, mixed media, pastel, sculpture and acrylic. Considers all styles from realism to impressionism. Artists represented include Vivi Crandall, Richard Luce, Diane Pierce, Brent Townsend and Plasschaert. Editions created by working from an existing painting. Approached by 100 artists/year. Publishes 2-3 emerging, 2-3 mid-career and 2-3 established artists/year. Distributes the work of 10 emerging, 20 mid-career and 30 established artists/year.
First Contact & Terms: Send brochure, résumé, slides, photographs and transparencies. Samples returned by SASE if requested by artist. Reports back within 2 weeks. Publisher will contact artist for portfolio review if interested. Portfolio should include slides. Pays on consignment basis or negotiates payment. No advance. Rights purchased vary according to project. Provides advertising, in-transit insurance, shipping from firm, written contract, color catalog, videotape and Art Access on the internet.
Tips: Finds artists through sourcebooks, other publications and artists' submissions.

NEW DECO, INC., 7840 Glades Rd., Suite 165, Boca Raton FL 33434. (407)482-2995 or (800)543-3326. Fax: (407)487-1044. President: Brad Morris. Estab. 1984. Art publisher and distributor of limited editions using lithography and silkscreen for galleries. Also publishes/distributes unlimited editions. Clients: art galleries and designers.
Needs: Interested in contemporary work. Artists represented are Robin Morris, Nico Vrielink and Lee Bomhoff. Needs new designs for reproduction. Publishes and distributes the work of 1-2 emerging, 1-2 mid-career and 1-2 established artists/year.
First Contact & Terms: Send brochure, résumé and tearsheets, photostats or photographs to be kept on file. Samples not filed are returned. Reports only if interested. Portfolio review not required. Publisher/Distributor will contact artist for portfolio review if interested. Pays flat fee or royalties of 5-7%. Also accepts work on consignment (firm receives 50% commission). Offers advance. Negotiates rights purchased. Provides promotion, shipping and a written contract. Negotiates ownership of original art.
Tips: "We find most of our artists through *Artist's & Graphic Designer's Market*, advertising, trade shows and referrals." Advises artists to attend the New York Art Expo.

NEW YORK GRAPHIC SOCIETY, Box 1469, Greenwich CT 06836. (203)661-2400. President: Richard Fleischmann. Publisher of offset reproductions, limited editions, posters and handpulled originals. Clients: galleries, frame shops and museums shops. Current clients include Deck The Walls, Ben Franklin.
Needs: Considers oil, acrylic, pastel, watercolor, mixed media and colored pencil drawings. Publishes reproductions, posters, serigraphs, stone lithographs, plate lithographs and woodcuts. Publishes and distributes the work of numerous emerging artists/year.
First Contact & Terms: Send query letter with transparencies, slides or photographs. Write for artist's guidelines. All submissions returned to artists by SASE after review. Reports within 3 weeks. Pays flat fee or royalty. Offers advance. Buys all print reproduction rights. Provides in-transit insurance from firm to artist, insurance while work is at firm, promotion, shipping from firm and a written contract; provides insurance for art if requested.
Tips: Finds artists through submissions/self promotions, magazines, visiting art galleries, art fairs and shows. "We publish a broad variety of styles and themes. We actively seek all sorts of fine decorative art."

NORTH BEACH FINE ART, INC., 9025 131st Place N., Largo FL 34643. (813)587-0049. Fax: (813)586-6769. President: James Cournoyer. Art dealer and importer, handling original graphics, prints, etchings, posters and uniques. Clients: art galleries, architects, interior designers and art consultants.
Needs: Considers mixed media serigraphs, stone lithographs, plate lithographs, etchings, woodcuts and linocuts. Especially likes contemporary, unusual and original themes or styles. Artists represented include Burnett, Bukovnik, Franklin Pettegrew. Looking for artists doing own original graphics and high quality prints to distribute.
First Contact & Terms: Send query letter with brochure, résumé, tearsheets, photostats, photocopies, slides or photographs to be kept on file. Accepts any sample showing reasonable reproduction. Samples returned by SASE only. Reports back within 2 months. To show a portfolio, mail finished art samples, color and b&w tearsheets, photostats and photographs. Provides insurance when work is at firm, promotion and written contract. Markets expressly-select original handmade editions of a small number of contemporary artists.
Tips: Wants "original prints by serious, experienced, career-oriented artists with well-developed and thought-out style. If you make your own prints or have inventory please send photos."

NORTHLAND POSTER COLLECTIVE, Dept. AM, 1613 E. Lake St., Minneapolis MN 55407. (612)721-2273. Manager: Ricardo Levins Morales. Estab. 1979. Art publisher and distributor of handpulled originals,

unlimited editions, posters and offset reproductions. Clients: mail order customers, teachers, bookstores, galleries, unions.

Needs: "Our posters reflect themes of social justice and cultural affirmation, history, peace." Artists represented include Ralph Fasanella, Karin Jacobson, Betty La Duke, Ricardo Levins Morales and Lee Hoover. Editions created by collaborating with the artist or by working from an existing painting.

First Contact & Terms: Send query letter with tearsheets, slides and photographs. Samples are filed or are returned by SASE. Reports back within months; if does not report back, the artist should write or call to inquire. Write for appointment to show portfolio. Payment method is negotiated. Offers an advance when appropriate. Negotiates rights purchased. Contracts vary but artist always retains ownership of artwork. Provides promotion and a written contract.

Tips: "We distribute work that we publish as well as pieces already printed. We print screen prints inhouse and publish 1-4 offset posters per year."

OLD WORLD PRINTS, LTD., 468 South Lake Blvd., Richmond VA 23236. (804)378-7833. Fax: (804)378-7834. President: John Wurdeman. Estab. 1973. Art publisher and distributor of primarily open edition hand printed reproductions of antique engravings. Clients: retail galleries, frame shops and manufacturers.

• Old World Prints reports the top-selling art in their 1,300-piece collection includes African animals, urns and parrots.

Needs: Seeking traditional and decorative art for the commercial and designer markets. Specializes in handpainted prints. Considers "b&w (pen & ink or engraved) art which can stand by itself or be hand painted by our artists or originating artist." Prefers traditional, representational, decorative work. Editions created by collaborating with the artist. Distributes the work of more than 500 artists.

First Contact & Terms: Send query letter with brochure showing art style or résumé and tearsheets and slides. Samples are filed. Reports back within 6 weeks. Write for appointment to show portfolio of photographs, slides and transparencies. Pays flat fee of $100 and royalties of 10% or on a consignment basis: firm receives 50% commission. Offers an advance when appropriate. Negotiates rights purchased. Provides in-transit insurance, insurance while work is at firm, promotion, shipping from firm and a written contract.

Tips: Finds artists through word of mouth. "We are a specialty art publisher, the largest of our kind in the world. We reproduce only b&w engraving, pen & ink and b&w photogravures. All of our pieces are hand painted."

PACIFIC EDGE PUBLISHING, INC., 540 S. Coast Hwy., Suite 112, Laguna Beach CA 92651. (714)497-5630. President: Paul C. Jillson Estab. 1988. Art publisher and distributor of handpulled serigraphs and oils.

Needs: Seeking art for the serious collector and commercial market. Prefers contemporary impressionism in oil. Artists represented include Maria Bertrán and Tom Swimm. Editions created by working from an existing painting. Approached by 20 artists/year. Publishes and distributes the work of 1 emerging and 1 mid-career artist/year.

First Contact & Terms: Send query letter with brochure showing art style or résumé with tearsheets and photographs. Samples not filed are returned by SASE if requested by artist. Reports back within 10 days. Call for appointment to show portfolio of photographs. Pays for prints in royalties of 10%; for oils, on a consignment basis (firm receives 50% commission). Negotiates rights purchased. Requires exclusive representation of artist. Provides in-transit insurance, insurance while work is at firm, promotion, shipping from firm and a written contract.

PANACHE EDITIONS LTD, 234 Dennis Lane, Glencoe IL 60022. (312)835-1574. President: Donna MacLeod. Estab. 1981. Art publisher and distributor of offset reproductions and posters. Clients: galleries, frame shops, domestic and international distributors. Current clients are mostly individual collectors.

Needs: Considers acrylic, pastel, watercolor and mixed media. "Looking for contemporary compositions in soft pastel color palettes; also renderings of children on beach, in park, etc." Artists represented include Bart Forbes, Peter Eastwood and Carolyn Anderson. Prefers individual works of art and unframed series. Publishes and distrubtes work of 1-2 emerging, 2-3 mid-career and 1-2 established artists/year.

First Contact & Terms: Send query letter with brochure showing art style or photographs, photocopies and transparencies. Samples are filed. Reports back only if interested. To show portfolio, mail roughs and final reproduction/product. Pays royalties of 10%. Negotiates rights purchased. Requires exclusive representation of artist. Provides in-transit insurance, insurance while work is at firm, promotion, shipping to and from firm and written contract.

Tips: "We are looking for artists who have not previously been published (in the poster market) with a strong sense of current color palettes. We want to see a range of style and coloration. Looking for a unique and fine art approach to collegiate type events, i.e. Saturday afternoon football games, Founders Day celebrations, homecomings, etc. We do not want illustrative work but rather an impressionistic style that captures the tradition and heritage of one's university. We are very interested in artists who can render figures."

***PORTER DESIGN—EDITIONS PORTER**, 19 Circus Place, Bath Avon BA1 2PE, England. (01144)225-424910. Fax: (01144)225-447146. Partners: Henry Porter, Mary Porter. Estab. 1985. Publishes limited and unlimited editions and offset productions and hand-colored reproductions. Clients: international distributors,

interior designers and hotel contract art suppliers. Current clients include Devon Editions, Art Group and Harrods.
Needs: Seeking fashionable and decorative art for the designer market. Considers watercolor. Prefers 17th-19th century traditional styles. Artists represented include Victor Postolle, Joseph Hooker and Adrien Chancel. Editions created by working from an existing painting. Approached by 10 artists/year. Publishes and distributes the work of 10-20 established artists/year.
First Contact & Terms: Send query letter with brochure showing art style or résumé and photographs. Samples are filed or are returned. Reports back only if interested. To show portfolio, mail photographs. Pays flat fee or royalties. Offers an advance when appropriate. Negotiates rights purchased.

PORTFOLIO GRAPHICS, INC., 4060 S. 500 W., Salt Lake City UT 84123. (800)843-0402. Fax: (801)263-1076. Creative Director: Kent Barton. Estab. 1986. Publishes and distributes limited editions, unlimited editions and posters. Clients: galleries, designers, poster distributors (worldwide) and framers.
Needs: Seeking creative, fashionable and decorative art for commercial and designer markets. Considers oil, watercolor, acrylic, pastel, mixed media and photography. Publishes 30-50 new works/year. Artists represented include Dawna Barton, Ovanes Berberian, Del Gish, Jodi Jensen and Kent Wallis. Editions created by working from an existing painting or transparency.
First Contact & Terms: Send query letter with résumé, biography, slides and photographs. Samples are not filed. Reports back within months. To show portfolio, mail slides, transparencies and photographs with SASE. Pays $100 advance against royalties of 10%. Buys reprint rights. Provides promotion and a written contract.
Tips: "We released a 20-page supplement to our 200-page ring binder catalog and we'll continue to add new supplemental pages twice yearly. We find artists through galleries, magazines, art exhibits, submissions. We're looking for a variety of artists and styles/subjects." Advises artists to attend Art Expo New York City and Art Buyer Caravan (at various locations throughout the year).

THE PRESS CHAPEAU, Govans Station, Box 4591, Baltimore City MD 21212-4591. Director: Elspeth Lightfoot. Estab. 1976. Publishes and distributes original prints only, "in our own atelier or from printmaker." Clients: architects, interior designers, corporations, institutions and galleries.
Needs: Considers original handpulled etchings, lithographs, woodcuts and serigraphs. Prefers professional, highest museum quality work in any style or theme. "Suites of prints are also viewed with enthusiasm." Prefers unframed series. Publishes the work of 2 emerging, 5 mid-career and 10 established artists/year.
First Contact & Terms: Send query letter with slides. Samples are filed. Samples not filed are returned by SASE. Reports back within 5 days. Write for appointment to show portfolio of slides. Pays flat fee of $100-2,000. Payment method is negotiated. Offers advance. Purchases 51% of edition or right of first refusal. Does not require exclusive representation. Provides insurance, promotion, shipping to and from firm and a written contract.
Tips: Finds artists through agents. "Our clients are interested in investment quality original handpulled prints. Your résumé is not as important as the quality and craftsmanship of your work."

PRESTIGE ART GALLERIES, INC., 3909 W. Howard St., Skokie IL 60076. (708)679-2555. President: Louis Schutz. Estab. 1960. Art gallery. Publishes and distributes paintings and mixed media artwork. Clients: retail professionals and designers.
● This gallery represents a combination of 18th and 19th century work and contemporary material. Clientele seems to be currently most interested in figurative art and realism.
Needs: Seeking art for the serious collector. Prefers realism and French Impressionism in oil. Artists represented include Erte, Simbari, Agam and King. Editions created by collaborating with the artist or by working from an existing painting. Approached by 100 artists/year. Publishes 1 emerging, 1 mid-career and 1 established artist/year. Distributes the work of 5 emerging, 7 mid-career and 15 established artists/year.
First Contact & Terms: Send query letter with résumé and tearsheets, photostats, photocopies, slides, photographs and transparencies. Samples are not filed and are returned by SASE. Reports back within 2 weeks. Pays on consignment (firm receives 50% commission). Offers an advance. Buys all rights. Provides insurance while work is at firm, promotion, shipping from firm and written contract.
Tips: "Be professional. People are seeking better quality, lower-sized editions, less numbers per edition—1/100 instead of 1/750."

‡PRIMROSE PRESS, Box 302, New Hope PA 18938. (215)862-5518. President: Patricia Knight. Art publisher. Publishes limited edition reproductions for galleries. Clients: galleries, framers, designers, consultants, distributors, manufacturers and catalogs.
Needs: Seeks art for the serious collector, commercial and designer markets. Considers pen & ink line drawings, oil and acrylic paintings, watercolor and mixed media. Prefers traditional landscapes. Publishes representational themes. Prefers individual works of art. Editions created by working from an existing painting. Approached by 300 artists/year. Publishes and distributes the work of 33 artists.
First Contact & Terms: Send query letter with tearsheets and slides to be kept on file. Prefers slides as samples. Do not send original art. Samples returned by SASE if not kept on file. Reports within 1 month.

Pays royalties to artist. Provides in-transit insurance, insurance while work is at publisher, shipping from publisher and a written contract. Artist owns original art.

ROMM ART CREATIONS, LTD., Maple Lane, P.O. Box 1426, Bridgehampton NY 11932. (516)537-1827. Fax: (516)537-1752. Contact: Steven Romm. Estab. 1987. Art publisher. Publishes unlimited editions, posters and offset reproductions. Clients: distributors, galleries, frame shops.
Needs: Seeking decorative art for the commercial and designer markets. Considers oil, watercolor, mixed media, pastel, acrylic and photography. Prefers traditional and contemporary. Artists represented include Tarkay, Wohlfelder, Switzer. Editions created by collaborating with the artist or by working from an existing painting. Publishes the work of 10 emerging, 10 mid-career and 10 established artists/year.
First Contact & Terms: Send query letter with slides and photographs. Samples are not filed and are returned by SASE if requested by artist. Reports back to the artist only if interested. Publisher will contact artist for portfolio review if interested. Pays royalties of 10%. Offers advance. Rights purchased vary according to project. Requires exclusive representation of artist for posters only. Provides promotion and written contract.
Tips: Advises artists to attend Art Expo and to visit poster galleries to study trends. Finds artists through attending art exhibitions, agents, sourcebooks, publications, artists' submissions.

‡RUSHMORE HOUSE PUBLISHING, 1600 S. Western Ave., Suite B, Box 1591, Sioux Falls SD 57101. (605)338-6172. Fax: (605)334-6630. Publisher: Stan Caldwell. Estab. 1989. Art publisher and distributor of limited editions. Clients: art galleries and picture framers.
Needs: Seeking artwork for the serious collector and commercial market. Considers oil, watercolor, acrylic, pastel and mixed media. Prefers realism, all genres. Artists represented include John C. Green, Mary Groth and Tom Phillips. Editions created by collaborating with the artist. Approached by 100 artists/year. Publishes the work of 1-5 emerging artists and 1-5 established artists/year.
First Contact & Terms: Send query letter with résumé, tearsheets, photographs and transparencies. Samples are filed or are returned by SASE if requested by artist. Reports back within 1 month. Write for appointment to show portfolio of original/final art, tearsheets, photographs and transparencies. Payment method is negotiated. Offers an advance when appropriate. Negotiates rights purchased. Exclusive representation of artist is negotiable. Provides in-transit insurance, insurance while work is at firm, promotion, shipping and written contract. "We market the artists and their work."
Tips: "We are looking for artists who have perfected their skills and have a definite direction in their work. We work with the artist on developing images and themes that will succeed in the print market and aggressively promote our product to the market. Current interests include: wildlife, sports, Native American, Western, landscapes and florals."

‡ST. ARGOS CO., INC., 11040 W. Hondo Pkwy., Temple City CA 91780. (818)448-8886. Fax: (818)579-9133. Manager: Roy Liang. Estab. 1987. Manufacturer, publishes gift catalog. Clients: gift shops.
Needs: Seeking decorative art. Prefers Victorian, sculpture and seasonal. Editions created by working from an existing painting. Approached by 6-8 artists/year. Publishes the work or 3 emerging and 2 established artists/year.
First Contact & Terms: Send résumé, slides and photographs. Samples not filed and are returned by SASE if requested by artist. Will contact artist for portfolio review if interested. Portfolio should include color slides and transparencies. Pays royalties of 10%. No advance. Rights purchased vary according to project. Provides advertising.
Tips: Finds artists through attending art exhibitions.

THE SAWYIER ART COLLECTION, INC., 3445-D Versailles Rd., Frankfort KY 40601. (800)456-1390. Fax: (502)695-1984. President: William H. Coffey. Distributor. Distributes limited and unlimited editions, posters and offset reproductions. Clients: retail art print and framing galleries.
Needs: Seeking fashionable and decorative art. Prefers floral and landscape. Artist represented include Lena Liu, Mary Bertrand. Approached by 100 artists/year. Distributes the work of 10 emerging, 50 mid-career and 10 established artists/year.
First Contact & Terms: Send query letter with tearsheets. Samples are not filed and are returned by SASE if requested by artist. Reports back to the artist only if interested. Distributor will contact artist for portfolio review if interested. Portfolio should include color tearsheets. Buys work outright. No advance.
Tips: Finds artists through publications (*Decor, Art Business News*), retail outlets.

SCAFA-TORNABENE ART PUBLISHING CO. INC., 100 Snake Hill Rd., West Nyack NY 10994. (914)358-7600. Fax: (914)358-3208. Art Coordinator: Susan Murphy. Produces unlimited edition offset reproductions. Clients: framers, commercial art trade and manufacturers worldwide.
Needs: Seeking decorative art for the wall decor market. Considers unframed decorative paintings, posters, photos and drawings. Prefers pairs and series. Artists represented include T.C. Chiu, Nancy Matthews and Marianne Caroselli. Editions created by collaborating with the artist and by working from a pre-determined subject. Approached by 100 artists/year. Publishes and distributes the work of dozens of artists/year. "We

work constantly with our established artists, but are always on the lookout for something new."
First Contact & Terms: Send query letter first with slides or photos and SASE and call approximately 3 weeks from contact. Reports in about 3-4 weeks. Pays $200-350 flat fee for some accepted pieces. Royalty arrangements with advance against 5-10% royalty is standard. Buys only reproduction rights. Provides written contract. Artist maintains ownership of original art. Requires exclusive publication rights to all accepted work.
Tips: "Do not limit your submission. We know what we are looking for better than you do. Sometimes we do not even know until we see it. In submitting, more is better. Please be patient. All inquiries will be answered."

‡SCANDECOR DEVELOPMENT AB, 790 Riverside Dr., Suite 2E, New York NY 10032. (212)862-4095. Fax: (212)862-3767. Publishing Director: James Munro. Estab. 1970. Art Publisher. Publishes unlimited editions, offset reproductions, posters, cards and calenders.
Needs: Seeking creative, fashionable and decorative art for the commercial and designer markets. Considers all media. Artists represented include Kate Frieman, Jack Roberts, licensed characters such as Disney, Harley Davidson. Approached by 100 artists/year. Publishes the work of 20% emerging, 20% mid-career and 60% established artists.
First Contact & Terms: Send brochure, tearsheets, slides, photographs, photocopies, transparencies. Samples are not filed and are returned. Reports back within 1 month. Artist should follow up with call after initial query. Portfolio should include final art, slides, transparencies. Negotiates payment. Offers advance when appropriate. Rights purchased vary according to project.
Tips: "Please attend the Art Expo New York City trade show."

SCANDECOR INC., 430 Pike Rd., Southampton PA 18966. (215)355-2410. Fax: (215)364-8737. Creative Director: Lauren H. Karp. Estab. 1968. Produces posters. Target market is young people, infants-teens.
• See listing in Greeting Cards, Gift Items & Paper Products section for description of needs.

‡SCHLUMBERGER GALLERY, P.O. Box 2864, Santa Rosa CA 95405. (707)544-8356. Fax: (707)538-1953. Owner: Sande Schlumberger. Estab. 1986. Art publisher, distributor and gallery. Publishes and distributes limited editions, posters, original paintings and sculpture. Clients: collectors, designers, distributors, museums and galleries. Current clients include: B of American Collection, Fairmount Hotel, Editions Ltd.
Needs: Seeking decorative art for the serious collector and the designer market. Prefers trompe l'oeil, realist, architectural, figure, portrait. Artists represented include Charles Giulioli, Deborah Deichter, Gail Packer. Editions created by collaborating with the artist or by working from an existing painting. Approached by 50 artists/year.
First Contact & Terms: Send query letter with tearsheets and photographs. Samples are not filed and are returned by SASE if requested by artist. Publisher/Distributor will contact artist for portfolio review if interested. Portfolio should include color photographs and transparencies. Negotiates payment. Offers advance when appropriate. Rights purchased vary according to project. Provides advertising, in-transit insurance, insurance while work is at firm, promotion, shipping to and from firm, written contract and shows.
Tips: Finds artists through exhibits, referrals, artists' submissions, "pure blind luck." Trends "seem to tend more toward realism—old school techniques."

SEGAL FINE ART, 4760 Walnut St., #100, Boulder CO 80301. (303)939-8930. Fax: (303)939-8969. Artist Liason: Andrea Bianco. Estab. 1986. Art publisher. Publishes limited editions. Clients: galleries.
Needs: Seeking creative and fashionable art for the serious collector and commercial market. Considers oil, watercolor, mixed media and pastel. Artists represented include Ting Shao Kuang, Lu Hong, Sassone, Jacobs. Editions created by working from an existing painting. Publishes and distributes the work of 1 emerging artist/year. Publishes the work of 7 and distributes the work of 3 established artists/year.
First Contact & Terms: Send query letter with slides, résumé and photographs. Samples are not filed and are returned by SASE. Reports back in 2 months. To show portfolio, mail slides, color photographs, bio and résumé. Offers advance when appropriate. Negotiates payment method and rights purchased. Requires exclusive representation of artist. Provides promotion.
Tips: Advises artists to attend New Trends Expos and Art Expo in New York and Las Vegas.

‡SGL, 190 Shepard Ave., Suite A, Wheeling IL 60090. (708)215-2911. Vice President: Mr. Rami Ron. Estab. 1984. Art publisher/distributor handling art for qualified art galleries.
Needs: Seeking creative art for the serious collector. Open to all media. Prefers original themes and individual works of art. Artists represented include Frederick Hart and Leonardo Nierman. Editions created by collabo-

Always enclose a self-addressed, stamped envelope (SASE) with queries and sample packages.

rating with the artist. Approached by 50 artists/year. Publishes and distributes the work of 2 established artists/year.

First Contact & Terms: Send query letter with résumé, tearsheets, photographs, slides and "all possible materials defining work." Samples are not filed and are returned. Reports back within 1 month. To show a portfolio, mail color tearsheets and slides. Payment method is negotiated. Negotiates rights purchased. Requires exclusive representation of artist. Provides written contract.

Tips: "We look for new, exciting ideas. We find most artists through personal recommendations, trade shows and magazines."

‡SILVER RIVER GRAPHICS, 317 Mallard Court, Mt. Pleasant SC 29464. (803)849-0342. Fax: (800)968-7099. E-mail: 75147.1644@compuserve.com. Contact: Owner. Art publisher and distributor. Publishes and distributes handpulled originals, limited and unlimited editions, offset reproductions and posters. Clients: galleries, designers, framed picture distributors.

Needs: Seeking creative, fashionable and decorative art for the serious collector, commercial and designer markets. Considers oil, watercolor, mixed media, pastel and acrylic. Prefers animals, birds, florals, foods, nautical or beach scenes, regional (southeastern US), lighthouses, military, coastal, sports (fishing, golf, tennis), maps (contemporary or antique), dogs. Artists represented include Jim Booth, Blanche Sumrall, B. Shipman, Lamay, Abrams, Alice S. Grimsley, R. Dollar, J. Deloney, Steve Jordan. Editions created by collaborating with the artist or by working from an existing painting. Approached by 180 artists/year.

First Contact & Terms: Send postcard size sample of work, e-mail, or send brochure, tearsheets, slides, photographs and photocopies. Samples are filed and are not returned. Reports back to the artist only if interested. Portfolio review not required. Pays royalties of 10% or negotiates payment. No advance. Rights purchased vary according to project. Provides advertising, promotion, shipping from firm, written contract, trade show representation.

Tips: Finds artists "mostly by word of mouth from our own customers. Sometimes it becomes apparent there is a market for a particular product in which case we will seek an artist out." Looks for artists at Atlanta ABC Show and Southeastern Wildlife Exposition. "Stronger colors are most popular—along with competitive price points."

‡SOHO GRAPHIC ARTS WORKSHOP, 433 W. Broadway, Suite 5, New York NY 10012. (212)966-7292. Director: Xavier H. Rivera. Estab. 1977. Art publisher, distributor and gallery. Publishes and distributes limited editions.

Needs: Seeking art for the serious collector. Considers prints. Editions created by collaborating with the artist or working from an existing painting. Approached by 10-15 artists/year.

First Contact & Terms: Send résumé. Reports back within 2 weeks. Artist should follow-up with letter after initial query. Portfolio should include slides and 35mm transparencies. Negotiates payment. No advance. Buys first rights. Provides written contract.

SOMERSET HOUSE PUBLISHING, 10688 Haddington Dr., Houston TX 77043. (713)932-6847. Fax: (713)932-7861. Contact: Jinx J. Jenkins. Estab. 1972. Art publisher of fine art limited editions, handpulled originals, offset reproductions and canvas transfers.

Needs: Seeking creative, fashionable and decorative art for the serious collector and designer market. Artists represented include G. Harvey, Charles Fracé, Larry Dyke, L. Gordon, Nancy Glazier, Phillip Crowe, Michael Atkinson. Editions created by collaborating with the artist or by working from an existing painting. Approached by 150-200 artists/year.

First Contact & Terms: Send query letter with brochure, tearsheets, résumé, slides or photographs with SASE. Samples are not filed and are returned by SASE if requested by artist. Reports back in 45 days. Publisher will contact artist for portfolio review if interested. Portfolio should include color tearsheets, photographs and slides. Pays royalties. Rights purchased vary according to project. Provides advertising, in-transit insurance, promotion, shipping to and from firm, written contract.

Tips: "Artists should be aware of colors which affect the decorator market and subject matter trends. I recommend artists attend the Art Buyers Caravan trade shows in cities near them." Recommends artists read *Decor* and *Art Business News*. "These publications follow current trends in styles, color, subject matter, etc."

SPRINGDALE GRAPHICS, 911 Hope St., Box 4816, Stamford CT 06907. (203)357-7600. Fax: (203)967-9100. President: Burt Katz. Estab. 1985. Art publisher and distributor of unlimited editions and posters. Clients: galleries, museum shops, worldwide distributors, frame shops and design consultants.

Needs: Seeking creative, fashionable and decorative art for the serious collector, commercial and designer markets. Considers oil, watercolor, acrylic, pastel, pen & ink, mixed media and printmaking (all forms). Artists represented include Marcia Burtt, William Hunnum, Chagall, Klee, Miro. Editions created by collaborating with the artist or by working from an existing painting. Approached by hundreds of artists/year. Publishes the work of 6-10 emerging, 15-20 mid-career and 100 established artists/year.

First Contact & Terms: Send query letter with brochure showing art style or résumé and tearsheets, slides, photostats, photographs, photocopies and transparencies. Samples are filed or are returned by SASE. Reports

back within 2 weeks. Pays royalties of 10%. Offers an advance when appropriate. Buys all rights. Sometimes requires exclusive representation of the artist. Provides in-transit insurance, insurance while work is at firm, promotion, shipping to firm and a written contract.

Tips: Finds artists through word of mouth, magazines, artists' submissions/self-promotions, sourcebooks, agents, by visiting art galleries and attending art fairs and shows. "We are looking for highly skilled artists with a fresh approach to one or all of the following: painting (all mediums), pastel, collage, printmaking (all forms), mixed media and photography."

STANTON ARTS, INC., P.O. Box 290234, Ft. Lauderdale FL 33320. (305)423-9292. Fax: (305)423-9680. President: Stan Hoff. Estab. 1986. Art publisher handling limited editions, posters and figurines. Clients: galleries, framers, department stores and mass merchandisers.

Needs: Seeking creative art for commercial and designer markets. Considers sculpture, watercolor, oil, pastel, pen & ink and acrylic. Prefers children, sports, professions, celebrities, period costumes, clowns/circus and Western subjects. Artists represented include Leighton-Jones, Mary Vickers, David Wenzel, Daniel Lovatt and Dom Mingolla. Editions created by collaborating with the artist. Approached by 100 artists/year.

First Contact & Terms: Send query letter with brochure, tearsheets, photographs and résumé. Samples are returned by SASE if requested by artist. Call or write for appointment to show portfolio of roughs or original/final art, photostats, tearsheets, slides or transparencies. Payment method is negotiated. Offers an advance when appropriate. Negotiates rights purchased. Provides insurance while work is at firm and a written contract.

‡STAR FINE ART PUBLISHERS, 18333 Hatteras St., Unit 32, Tarzana CA 91356. (818)705-3820. Fax: (818)705-2824. Director of Operations: Sue Powless. Estab. 1991. Art publisher and distributor of limited editions and artagraph™. Clients: retail art galleries, decorators and designers.

Needs: Seeking creative art for the commercial market. Considers oil and acrylic. Prefers landscape, comtemporary, floral. Artists represented include Liliana Frasca. Editions created by working from an existing painting. Approached by 50 artists/year. Publishes and distributes the work of 3 emerging, 2 mid-career and 1 established artist/year.

First Contact & Terms: Send query letter with slides, résumé and photographs. Samples are not filed and are returned by SASE. Reports back within 2 weeks. To show portfolio, mail slides and photographs. Payment method is negotiated. Offers advance when appropriate. Buys all rights. Requires exclusive representation of artist. Provides in-transit insurance, promotion, shipping from firm, insurance while work is at firm and a written contract.

Tips: "Canvas transfers are becoming increasingly popular, especially ones personally enhanced by the artist."

SULIER ART PUBLISHING, 111 Conn Terrace, Lexington KY 40508-3205. (606)259-1688. Estab. 1969. Art publisher and distributor. Publishes and distributes handpulled originals, limited and unlimited editions, posters, offset reproductions and originals. Clients: design.

Needs: Seeking creative, fashionable and decorative art for the serious collector and the commercial and designer markets. Considers oil, watercolor, mixed media, pastel and acrylic. Prefers impressionist. Artists represented include Judith Webb, Neil Sulier, Eva Macie, Neil Davidson, William Zappone, Zoltan Szabo, Henry Faulconer, Mariana McDonald. Editions created by collaborating with the artist or by working from an existing painting. Approached by 20 artists/year. Publishes the work of 5 emerging, 30 mid-career and 6 established artists/year. Distributes the work of 5 emerging artists/year.

First Contact & Terms: Send query letter with brochure, slides, photocopies, résumé, photostats, transparencies, tearsheets and photographs. Samples are filed and are returned. Reports back only if interested. Request portfolio review in original query. Artist should follow up with call. Publisher will contact artist for portfolio review if interested. Portfolio should include slides, tearsheets, final art and photographs. Pays royalties of 10%, on consignment basis or negotiates payment. Offers advance when appropriate. Negotiates rights purchased (usually one-time or all rights). Provides in-transit insurance, promotion, shipping to and from firm, insurance while work is at firm and written contract.

‡SUMMIT PUBLISHING, 746 Higuera, #4, San Luis Obispo CA 93401. (805)549-9700. Fax: (805)543-6482. Owner: Ralph Gorton. Estab. 1987. Art publisher, distributor and gallery. Publishes and distributes handpulled originals and limited editions.

Needs: Seeking creative, fashionable and decorative art for the serious collector. Considers oil, watercolor, mixed media and acrylic. Prefers fashion, contemporary work. Artists represented include Nunez, Cassidy. Editions created by collaborating with the artist or by working from an existing painting. Approached by 10 artists/year. Publishes and distributes the work of emerging, mid-career and established artists.

First Contact & Terms: Send postcard size sample of work or send query letter with brochure, résumé, tearsheets, slides, photographs and transparencies. Samples are filed. Reports back within 5 days. Artist should follow-up with call. Publisher/Distributor will contact artist for portfolio review if interested. Portfolio should include color thumbnails, roughs, final art, tearsheets and transparencies. Pays royalties of 10-15%, 60% commission or negotiates payment. Offers advance when appropriate. Buys first rights or all rights.

Requires exclusive representation of artist. Provides advertising, in-transit insurance, insurance while work is at firm, promotion, shipping to and from firm and written contract.
Tips: Finds artists through art exhibitions, art fairs, word of mouth and artists' submission. Recommends artists attend New York Art Expo, ABC Shows. Looks for artists at Los Angeles Expo and New York Expo.

SUNDAY COMICS STORE™, 1200 High Ridge Rd., Stamford CT 06905. (203)461-8413. Fax: (203)461-8415. E-mail: Kasanoff@ix.netcom.com. Chairman: Bruce Kasanoff. Estab. 1989. Catalog publisher; operates retail stores. Sells wide variety of merchandise imprinted with artwork.
Needs: Seeking artists who can capture America's favorite cartoon characters. "We assign projects to artists based on their demonstrated abilities."
First Contact & Terms: Send query letter with résumé and tearsheets, slides and photographs. Samples are filed or are returned by SASE if requested by artist. Reports back within 1 week. Call for appointment or show portfolio of original/final art, slides, photographs and transparencies. No advance. Negotiates rights purchased. Provides insurance while work is at firm, promotion, shipping to firm and a written contract.
Tips: "We use designers and artists who know how to create products. We have plenty of cartoons; we need talented people to help bring the characters alive on merchandise."

JOHN SZOKE GRAPHICS INC., 164 Mercer St., New York NY 10012. Director: John Szoke. Produces limited edition handpulled originals for galleries, museums and private collectors.
Needs: Original prints, mostly in middle price range, by up-and-coming artists. Artists represented include James Rizzi, Jean Richardson, Asoma, Scott Sandell and Bauman. Publishes the work of 2 emerging, 10 mid-career and 2 established artists/year. Distributes the work of 10 emerging, 10 mid-career and 5 established artists/year.
First Contact & Terms: Send slides with SASE. Request portfolio review in original query. Reports within 1 week. Charges commission, negotiates royalties or pays flat fee. Provides promotion and written contract.

‡TEE-MARK LTD., Box 410765, Charlotte NC 28241. (704)588-4038. Vice-President: Harvey Plummer. Estab. 1982. Art publisher/distributor handling limited editions (maximum 950 prints) of offset reproductions and handpulled originals for galleries and golf pro shops. Current clients include: USGA, PGA/World Golf Hall of Fame, TPC, *Golf Magazine*.
Needs Seeking creative and decorative art for the serious collector. Considers oil, acrylic, watercolor and mixed media. Tee-Mark specializes in golf artwork. Prefers individual works of art and pairs. Maximum size 40×50. Artists represented include Ken Reed and Marci Role. Editions created by collaborating with the artist. Approached by 10 artists/year. Publishes the work of 1 emerging, 2 mid-career and 1 established artist/year. Distributes the work of 1 emerging, 2 mid-career and 4 established artists/year.
First Contact & Terms: Send query letter with brochure showing art style and tearsheets, photographs, photocopies and transparencies. Samples are filed. Reports back within 1 month. Call or write for appointment to show portfolio of original/final art, tearsheets, slides, transparencies and final reproduction/product. Pays flat fee; $100-1,000, royalties of 10% or on consignment basis (firm receives 35% commission). Payment method is negotiated. Buys all rights. Requires exclusive representation of artist. Provides in-transit insurance, insurance while work is at firm, promotion, shipping to and from firm and written contract.
Tips: "At the present time we are only looking for artists to produce golf-related works, portraits or landscapes. Scenes from high-traffic resort-type courses most saleable (Pebble Beach, Augusta National, Pinehurst, etc.). Also, we would be interested in acting as a distributor for other publishers' golf artwork. Tee-Mark Ltd. has a network of 20 salesmen across the U.S. and Canada as well as 600 gallery customers. Business seems to be picking up."

‡TELE GRAPHICS, 153 E. Lake Brantley Dr., Longwood FL 32779. President: Ron Rybak. Art publisher/distributor handling limited and unlimited editions, offset reproductions and handpulled originals. Clients: galleries, picture framers, interior designers and regional distributors.
Needs: Seeking decorative art for the serious collector. Artists represented include Beverly Crawford, Diane Lacom, Joy Broe and W.E. Coombs. Editions created by collaborating with the artist or by working from an existing painting. Approached by 30-40 artists/year. Publishes the work of 1-4 emerging artists/year.
First Contact & Terms: Send query letter with résumé and samples. Samples are not filed and are returned only if requested. Reports within 30 days. Call or write for appointment to show portfolio of original/final art. Pays by the project. Considers skill and experience of artist and rights purchased when establishing payment. Offers advance. Negotiates rights purchased. Requires exclusive representation. Provide promotions, shipping from firm and written contract.
Tips: "Be prepared to show as many varied examples of work as possible. Forget trends—be yourself. Show transparencies or slides plus photographs in a consistent style. We are not interested in seeing only one or two pieces."

VARGAS & ASSOCIATES ART PUBLISHING, INC., 4461 Nicole Dr., Lanham MD 20706. (301)731-5175. Fax: (301)731-5712. President: Elba Vargas-Colbert. Estab. 1988. Art publisher and worldwide distributor

of serigraphs, limited and open edition offset reproductions. Clients: galleries, frame shops, museums, decorators, movie sets and TV.

Needs: Seeking creative art for the serious collector and commercial market. Considers oil, watercolor, acrylic, pastel pen & ink and mixed media. Prefers ethnic themes. Artists represented include Joseph Holston, Kenneth Gatewood, Tod Haskin Fredericks, Betty Biggs, Norman Williams, Sylvia Walker, James Ransome, Leroy Campbell, William Tolliver, Sylvia Walker and Paul Goodnight. Approached by 100 artists/year. Publishes/distributes the work of about 30 artists.

First Contact & Terms: Send query letter with résumé, slides and/or photographs. Samples are filed. Reports back only if interested. To show portfolio, mail photographs. Payment method is negotiated. Requires exclusive representation of the artist.

Tips: "Vargas & Associates Art Publishing is standing as a major publisher committed to publishing artists of the highest caliber, totally committed to their craft and artistic development."

‡VERNON FINE ART AND EDITIONS, 1738 Treble Dr., 504, Humble TX 77338. (713)446-4340. Fax: (413)446-4657. Owner: Karen Vernon. Estab. 1978. Art publisher and distributor. Publishes and distributes handpulled originals, limited and unlimited editions, offset reproductions and posters. Clients: galleries, frame shops, designers, hotels. Current clients include: Hospitality Galleries (Orlando), Artcorp (Taiwan), Baldwin Art (Highpoint), Ashton (Houston, Atlanta, Dallas, Highpoint).

Needs: Seeking creative art for the serious collector, commercial and designer markets. Considers oil, watercolor, pastel and acrylic. Prefers realism ("color is important"). Artists represented include Vernon, Archer, Muenzemayer, Spann, Eckard, Jackson, Johnson, Stanford. Editions created by working from an existing painting. Approached by 50 artists/year. Publishes the work of 5 mid-career and 2 established artists/year. Distributes the work of 10 established artist/year.

First Contact & Terms: Send query letter with résumé, slides, photographs and photocopies. Samples are not filed and are returned by SASE if requested by artist. Reports back within 2 weeks. Publisher/Distributor will contact artist for portfolio review if interested. Portfolio should include b&w and color photographs and slides. Pays royalties. Offers advance when appropriate. Rights purchased vary according to project. Provides advertising, in-transit insurance, insurance while work is at firm, promotion, shipping from firm and written contract.

Tips: Finds artists through submissions, art fairs and trade shows. Recommends artists attend ABC Show and Art Expo and read *Decor* and *Art Business News*.

‡VIBRANT FINE ART, 3444 Hillcrest Dr., Los Angeles CA 90016. (213)766-0818. Fax: (213)737-4025. Art Director: Phyliss Stevens. Estab. 1990. Art pubisher and distributor. Publishes and distributes handpulled originals, limited and unlimited editions and offset reproductions. Clients: galleries, designers, giftshops and frame shops. Current clients include MTM Productions (Hollywood), Kaiser Hospital (Los Angeles), McPherson Enterprises (Los Angeles).

Needs: Seeking decorative and ethnic art for the commercial and designer markets. Considers oil, watercolor, mixed media, pastel and acrylic. Prefers African-American, Native American, Latino. Artists represented include Sonya A. Spears, Van Johnson, Tom Feelings, Ma Yemba, Williaim Crite. Editions created by collaborating with the artist or by working from an existing painting. Approached by 30 artists/year. Publishes the work of 15 emerging and 10 established artists/year. Distributes the work of 30 emerging and 20 established artists/year.

First Contact & Terms: Send postcard size sample of work or send query letter with brochure, résumé, tearsheets and slides. Samples not filed and are returned by SASE. Publisher/Distributor will contact artist for portfolio review if interested. Portfolio should include color tearsheets, photographs, slides and biographical sketch. Negotiates payment. Offers advance when appropriate. Rights vary according to project. Provides advertising, in-transit insurance, promotion, written contract and publication in catalog.

Tips: Finds artists through trade shows, art exhibitions and referrals. "Pay attention to current color trends." Recommends artists attend Art Buyers Caravan and Art Expo and read *Decor*, *American Visions* and *Sunshine Artist Magazine*.

WATERLINE PUBLICATIONS, INC., 60 K St, Boston MA 02127. (617)268-8792. E-mail: thomasc617@aol. com. Contact: Tom Chiginsky. Estab. 1984. Art publisher of limited editions, note cards and art posters. Clients: galleries, framers, gift shops, card shops, furniture stores and distributors overseas.

Needs: Seeking creative and decorative art. Considers all media, including oil, watercolor, acrylic, pastel and mixed media. Open to all categories of artwork. Artists represented include Kemon, William Ternes, Mary Beth Baxter. Currently publishes florals, landscapes, still lifes, marine art, sports, old masters, children's, animals, whimsical and decorative. All publications are created from original artwork supplied by the artist. Publishes a maximum of 12 artists/year.

First Contact & Terms: Send query letter with slides, printed samples or transparencies of artwork. Do not send originals unless they are requested. Samples are filed unless otherwise specified. All artwork sent in will be reviewed. Send SASE to have samples returned. Reports back within 2 months. Provides written contract to be signed and agreed upon by publisher and artist. Royalties are paid based on sales of the item. Promotes published art through catalogs, advertising, trade shows and sales reps.

Tips: "Read current trade magazines, home decor magazines and art publications to pick up on latest trends in the market. Classic imagery has always been our strongest selling items since trends change." Advises artists to attend Art Expo New York, Atlanta Gift Show, High Point furniture market.

WATERMARK FINE ARTS, Lafayette Court, Suite 402, Kennebunk ME 04043. (207)985-6134. Fax: (207)985-7633. Publisher: Alexander Bridge. Estab. 1989. Art publisher. Publishes and distributes limited and unlimited editions, posters, offset reproductions and stationery. Clients: framers, galleries.
Needs: Seeking creative art for the commercial market. Specializes in sporting and wildlife art. Considers oil, watercolor, mixed media, pen & ink, acrylic and b&w photography. Artists and photographers represented include John Gable, Walter Kessel and David Foster. Editions created by collaborating with the artist. Approached by 30 artists/year. Publishes and distributes the work of 3 mid-career artists and photographers 2 established artists/year.

JAMES D. WERLINE STUDIO, 119 W. Main St., Amelia OH 45102. (513)753-8004. Partner: Dee A. Werline. Estab. 1978. Art publisher handling limited editions of offset reproductions. Clients: galleries and museums.
Needs: Seeking creative art for the serious collector. Considers oil, acrylic, pastel, watercolor and tempera. Prefers original themes and individual works of art. Artists represented include Debbie Hook, James D. Werline and Don Paul Kirk. Approached by 8-10 artists/year. Publishes the work of 2 established artists/year.
First Contact & Terms: Send query letter with brochure, résumé, tearsheets and slides. Samples are filed or returned if requested by artist. Reports back within 3-4 weeks. Call for appointment to show portfolio, or mail color tearsheets, slides and final reproduction/product. Pays royalties of 10% (wholesale). Buys reprint rights. Requires exclusive representation. Provides insurance, shipping from firm and a written contract.
Tips: "Be totally dedicated to the promotion of your art."

Artwork © Warren Kimble. Print © Wild Apple Graphics, Ltd.

Wild Apple Graphics found Warren Kimble's highly-stylized folk art through a local gallery in 1991, and now sells his work, such as Front Porch, worldwide. In this piece, painted in acrylic on antique architectural board, the artist sought to create the feeling of "a peaceful Vermont front porch on the day after Fourth of July." Kimble's art often features quaint scenes from rural Vermont, his home of more than two decades.

‡WHITEGATE FEATURES SYNDICATE, 71 Faunce Dr., Providence RI 02906. (401)274-2149. Talent Manager: Eve Green.
● This syndicate is looking for fine artists and illustrators. See listing in Syndicates & Clip Art Firms section for information on its needs.

WILD APPLE GRAPHICS, LTD., HCR 68 Box 131, Woodstock VT 05091. (802)457-3003. Fax: (802)457-3214. Art Director: Laurie Chester. Estab. 1989. Art publisher and distributor of posters and unlimited editions. Clients: frame shops, interior designers and furniture companies. Current clients include Deck the Walls, Pier 1, Bed & Bath Shops, The Bombay Company, The Nature Company and many catalog and furniture companies.

Needs: Seeking decorative art for the commercial and designer markets. Considers all media. Artists represented include Warren Kimble, Charles Lynn Bragg, Kathy Jakobsen, Nancy Pallan and Coco Dowley. Editions created by working from an existing painting or transparency. Approached by 1,000 artists/year. Publishes and distributes the work of 4-6 emerging and mid-career and 10-12 established artists/year.

First Contact & Terms: Send query letter with résumé and slides, photographs or transparencies. Samples are returned by SASE. Reports back within 2 months. Negotiates payment method and rights purchased. Provides in-transit insurance, insurance while work is at firm, promotion, shipping to and from firm and a written contract.

Tips: "Don't be trendy. Paint images that will have broad appeal and can stay on walls for a long time. Power Ranger or alien art (which we have, in fact, received) is not saleable for a company like ours." Advises artists to attend Art Expo, but also says, "trade shows where we are selling is not the time for artists to meet publishers. We are too busy."

WILD WINGS INC., S. Highway 61, Lake City MN 55041. (612)345-5355. Fax: (612)345-2981. Merchandising Manager: Sara Koller. Estab. 1968. Art publisher, distributor and gallery. Publishes and distributes limited editions and offset reproductions. Clients: retail and wholesale.

Needs: Seeking artwork for the commercial market. Considers oil, watercolor, mixed media, pastel and acrylic. Prefers fantasy, military, golf, variety and wildlife. Artists represented include David Maass, Lee Kromschroeder, Ron Van Gilder, Robert Abbett, Michael Sieve and Clayton Weirs. Editions created by working from an existing painting. Approached by 300 artists/year. Publishes the work of 36 artists/year. Distributes the work of numerous emerging artists/year.

First Contact & Terms: Send query letter with slides and résumé. Samples are filed and held for 6 months then returned. Reports back within 3 weeks if uninterested or 6 months if interested. Publisher will contact artist for portfolio review if interested. Pays royalties for prints. Accepts original art on consignment and takes 40% commission. No advance. Buys first-rights or reprint rights. Requires exclusive representation of artist. Provides in-transit insurance, promotion, shipping to and from firm, insurance while work is at firm and a written contract.

WINN ART GROUP, 6015 Sixth Ave. S., Seattle WA 98108. (206)763-9544. Fax: (206)762-1389. Direct Product Develop: Buster Morris. Estab. 1976. Art publisher and wholesaler. Publishes limited editions and posters. Clients: mostly trade, designer, decorators, galleries, poster shops. Current clients include: Pier 1, Homestead House, Designer Picture Framers.

Needs: Seeking decorative art for the designer market. "Country themes, quiet hues and neutrals with clean pastels seem to be in." Considers oil, water, mixed media, pastel, pen & ink and acrylic. Artists represented include Buffet, Gunn, Wadlington, Schofield, Schaar. Editions created by working from an existing painting. Approached by 300-400 artists/year. Publishes and distributes the work of 0-3 emerging, 3-8 mid-career and 3-5 established artists/year.

First Contact & Terms: Send query letter with brochure, slides, photocopies, résumé, photostats, transparencies, tearsheets or photographs. Samples are returned by SASE if requested by artist. Reports back within 4-6 weeks. Publisher will contact artist for portfolio review if interested. Portfolio should include "whatever is appropriate to communicate the artist's talents." Pay varies. Offers advance when appropriate. Rights purchased vary according to project. Provides written contract.

Tips: Advises artists to attend Art Expo in New York City and ABC in Atlanta just to see what is selling and being shown. This is not a good time to approach publishers/exhibitors with your artwork." Finds artists through attending art exhibitions, agents, sourcebooks, publications, artists' submissions.

Art Publishers/'95-'96 changes

The following companies were listed in the 1995 edition but do not have listings in this edition. The majority did not respond to our request to update their listings. If a reason was given for exclusion, it appears in parentheses after the company's name.

Alexandre A du M
American Graphic Arts
American Quilting Art
Angel Graphics
Art Dallas Inc.
Artists' Enterprises (no longer distributes)
Arts Uniq' Inc.

Arts Unique International
C & M Fine Art, Inc. (unable to contact)
The Chasen Portfolio
Class Publications, Inc.
The Colonial Art Co.
Colville Publishing
Har-El Printers & Publishers

Seymour Mann, Inc.
Multiple Impressions, Ltd.
Nahrgang Collection (unable to contact)
The Obsession of Dance Co.
Porter Design—Editions Porter
Salem Graphics, Inc.(unable to contact)

Book Publishers

Walk into any bookstore and start counting the number of images you see on books and calendars. Publishers don't have enough artists on staff to generate such a vast array of styles. The illustrations you see on covers and within the pages of books are for the most part created by freelance artists. If you like to read and work creatively to solve problems, the world of publishing could be a great market for you.

Every year thousands of books are published, and each must compete with all the other titles for the public's attention. Though the saying goes "You can't judge a book by its cover," an intriguing cover can coax the reader to pick up a book and look inside.

The interior of a book is important, too. Designers create the page layouts that direct us through the text. This is particularly important in children's books and text books. Many publishing companies hire freelance designers to design interiors of books on a contract basis. Publishers large and small now use computers to streamline production and keep costs down. Look within each listing for the subheading Book Design, to find the number of design jobs assigned each year, and how much is paid per project. Look under the Needs heading to find out what computer software the company uses. If you have a home computer with compatible software, your chances of winning an assignment increase.

Most assignments for freelance work are for jackets/covers. The illustration on the cover, combined with typography and the layout choices of the designer, announce to the prospective reader at a glance the style and content of a book. If it is a romance novel, it will show a windswept couple and the title is usually done in calligraphy. Suspenseful spy novels tend to feature stark, dramatic lettering and symbolic covers. Covers for fantasy and science fiction novels, as well as murder mysteries and historical fiction tend to show a scene from the story. Visit a bookstore and then decide which kind of book you'd like to work on.

Targeting your market

As you read the listings in this section, you'll see that within the first paragraph of each listing, we describe the type of books each publisher specializes in. This may seem obvious, but submit only to publishers who specialize in the type of book you want to illustrate or design. There's no use submitting to a publisher of textbooks on higher geometry if you want to illustrate bunny rabbits and puppy dogs for children's picture books.

You'll notice a few terms, such as "trade books" and "mass market," keep cropping up in our listings. Though it's hard to pin down accurate definitions because the terms overlap a bit, here's a short overview of market terms that might clear up some confusion:

• **Mass market** books are sold everywhere, in supermarkets, newsstands, drugstores, bookstores and department stores. Picture the racks of shiny covered paperbacks by popular authors like Stephen King, hardcover "unauthorized" biographies, and books describing the latest diet craze. Mass market outlets also carry colorful picture books for preschoolers, often featuring licensed characters like Barney, Bugs Bunny, Mickey and Minnie.

• **Trade books** are the hardcover and paperback kind you generally find only in book-

stores and libraries. The paperbacks are larger than those on the mass market racks. Often tagged "quality" paperbacks, they are printed on higher quality paper, and feature matte-paper jackets. Children's trade books are of a superior quality and feature beautiful illustrations.

- **Text books** are, of course, sold to schools and colleges. They feature plenty of illustrations, photographs, and charts to explain their subjects.
- **Small press** books are books not produced by a larger, commercial house, but by a small, independent publisher. Many are literary or scholarly in theme, and often feature fine art on the cover.
- **Backlist titles** or **reprints** refer to publishers' titles from past seasons which continue to sell year after year. These books are often updated and republished with freshly designed covers to make them more attractive to readers.

For further information on book publishing refer to *Writer's Market, Novel & Short Story Writer's Market, Literary Market Place* and *Books in Print*. The trade magazines *Publishers Weekly* and *Small Press* provide updates on the industry.

Illustrating for children's books

The children's book industry has experienced a boom in recent years, and is a growing hotbed for freelance designers and illustrators. More and more kids' books now include unique design elements such as acetate overlay inserts, textured pages, pop out projects and die cuts. Illustrations, of course, continue to be in high demand as well, simply because more kids' books are being published.

It's important to understand, however, that working in children's books requires a specific set of skills. Illustrators, for example, must have a consistent style and must be able to draw the same characters in a variety of action poses and situations. Refer to *Children's Writer's & Illustrator's Market*, published by Writer's Digest Books.

Approaching publishers

Most publishers keep extensive files of art samples and refer to these files each time they're ready to make an assignment. To earn a place in these files, first target your submission to match the unique style of the publisher you're approaching. Send 5 to 10 nonreturnable samples along with a brief letter and a SASE. Never send originals (see What Should I Submit? on page 14). Most art directors prefer samples that are 8½×11 or smaller that can fit in file drawers. Bulky submissions are often considered a nuisance.

Fees

A few publishers purchase existing art, but most will make assignments for specific projects. Payment for freelance design and illustration varies depending on the size of the publisher, the type of project and the rights bought. Most publishers pay on a per-project basis, although some publishers of highly illustrated books (such as children's books) pay an advance plus royalties. A few very small presses may only pay in copies.

‡**HARRY N. ABRAMS, INC.,** 100 Fifth Ave., New York NY 10011. (212)206-7715. Art Director: Dirk Luykx. Estab. 1951. Company publishes hardcover originals, trade paperback originals and reprints. Types of books include coffee table books and textbooks. Publishes 150 titles/year. 2% require freelance illustration; 5% require freelance design. Book catalog available for $3.
Needs: Approached by 250 freelancers/year. Works with less than 10 freelance illustrators and less than 10 designers/year. Buys 100 freelance illustrations/year. Uses freelancers mainly for textbook diagrams and maps. Also for text illustration. Needs computer-literate freelancers for design and illustration. Freelancers should be familiar with Adobe Illustrator, QuarkXPress and Adobe Photoshop. Works on assignment only.
First Contact & Terms: Send query letter with résumé, tearsheets and slides. Samples are filed "if work is appropriate." Samples are returned by SASE if requested by artist. Portfolios may be dropped off every

Monday-Thursday. Art Director will contact artist for portfolio review if interested. Portfolio should include final art, photographs, slides, tearsheets and transparencies. Buys all rights. Originals are returned at job's completion.

Book Design: Assigns 10 freelance design jobs/year. Pays by the project.

Text Illustration: Assigns up to 100 freelance illustration jobs/year. Pays by the project.

Tips: Finds artists through word or mouth, artists' submissions, attending art exhibitions and seeing published work.

‡ADAMS PUBLISHING, 260 Center St., Holbrook MA 02343. (617)767-8100. Fax: (617)767-0994. Managing Editor: Christopher Ciaschini. Estab. 1980. Company publishes hardcover originals, trade paperback originals and reprints. Types of books include biography, cookbooks, history, humor, instructional, New Age, nonfiction, reference, self help and travel. Specializes in business and careers. Publishes 100 titles/year. 10% require freelance illustration; 100% require freelance design. Book catalog free by request.

Needs: Approached by 20 freelancers/year. Works with 3 freelance illustrators and 7-10 designers/year. Buys less than 100 freelance illustrations/year. Uses freelancers mainly for jacket/cover illustration, text illustration and jacket/cover design. Needs computer-literate freelancers for design. 100% of freelance work demands computer skills. Freelancers should be familiar with QuarkXPress 3.3 and Adobe Photoshop, preferably Windows-based.

First Contact & Terms: Send postcard sample of work. Samples are filed. Art Director will contact artist for portfolio review if interested. Portfolio should include tearsheets. Rights purchased vary according to project, but usually buys all rights.

Jackets/Covers: Assigns 70 freelance design jobs/year. Pays by the project, $700-1,500.

Text Illustration: Assigns 10 freelance illustration jobs/year.

AEGINA PRESS, INC., 59 Oak Lane, Spring Valley, Huntington WV 25704. Art Coordinator: Claire Nudd. Estab. 1984. Publishes hardcover and trade paperback originals, and trade paperback reprints. Types of books include contemporary, experimental, mainstream, historical, science fiction, adventure, fantasy, mystery, young adult and travel. Publishes 25 titles/year. Recent titles include *Silvercreek City*, by James Jensen; and *Ants in My Plants*, by Denell Hilgendorf. 50% require freelance illustration. Book catalog available for $3 and 9×12 SAE with 4 first-class stamps.

Needs: Works with 30 freelance illustrators/year. Prefers freelancers with experience in color separation and graphic layout. Uses freelancers mainly for covers and some interior illustrations. 5% of freelance work demands computer skills. Works on assignment only.

First Contact & Terms: Send query letter with photographs and 8½×11 photocopies. Samples are filed and are not returned. Reports back within 2 weeks if interested. To show portfolio, mail appropriate materials. Buys one-time rights. Originals not returned.

Jackets/Covers: Assigns 20 freelance and 5 illustration jobs/year. Pays by the project, $60-100.

Text Illustration: Assigns 5 freelance illustration jobs/year. Pays by the project, $25-1,000. Prefers pen & ink.

Tips: Finds artists through referrals and submissions.

‡AFRICA WORLD PRESS, INC., 11 Princess Rd., Suite D, Lawrenceville NJ 08648. (609)844-9583. Fax: (609)844-0198. E-mail: africawpress@nyo.com. Art Director: Carles J. Juzang. Estab. 1984. Publishes hardcover and trade paperback originals. Types of books include biography, pre-school, juvenile, young adult and history. Specializes in any and all subjects that appeal to an Afrocentric market. Publishes 50 titles/year. Recent titles include *Blacks Before America*, by Mark Hyman; and *Too Much Schooling Too Little Education*, by Mwalimu J. Shujaa. 60% require freelance illustration; 10% require freelance design. Book catalog available by request. Approached by 50-100 freelancers/year. Works with 5-10 illustrators and 4 designers/year. Buys 50-75 illustrations/year. Prefers artists with experience in 4-color separation and IBM PageMaker. Uses freelancers mainly for book illustration. Also for jacket/cover design and illustration. Uses designers for typesetting and formatting.

Needs: Needs computer-literate freelancers for design, illustration and presentation. "We look for freelancers who have access to or own their own computer for design and illustration purposes but are still familiar and proficient in creating mechanicals, mock-ups and new ideas by hand." 50% of freelance work demands knowledge of Aldus PageMaker 5.0, Coreldraw 4.0 and WordPerfect 6.0. Works on assignment only.

First Contact & Terms: Send query letter with brochure, tearsheets, photostats, bio, résumé, SASE, photocopies and transparencies. Samples are filed or are returned by SASE if requested by artist. Reports back within 4-6 weeks. Write for appointment to show portfolio, or mail b&w and color photostats, tearsheets and 8½×11 transparencies. Rights purchased vary according to project. Originals are returned at job's completion if artist provides SASE and instructions.

Book Design: Assigns 100 freelance design jobs/year. Pays by the project, $400-3,000.

Jackets/Covers: Assigns 100 freelance design and 50-75 illustration jobs/year. Prefers 2- or 4-color process covers. Pays by the project.

Text Illustration: Assigns 25 illustration jobs/year. Prefers "boards and film with proper registration and color specification." Pays by the project.

Tips: "Artists should have a working knowledge of the Windows 3.1 platform of the IBM computer; be familiar with the four-color process (CMYK) mixtures and changes (5-100%) and how to manipulate them mechanically as well as on the computer; have a working knowledge of typefaces and styles, the ability to design them in an appealing manner; swift turn around time on projects from preliminary through the manipulation of changes and a clear understanding of African-centered thinking, using it to promote and professionally market books and other cultural items creatively. Work should be colorful, eyecatching and controversial."

‡ALFRED PUBLISHING CO., INC., 16380 Roscoe Blvd., Box 10003, Van Nuys CA 91410-0003. (818)891-5999. Fax: (818)891-2182. Art Director: Ted Engelbart. Estab. 1922. Book publisher. Publishes trade paperback originals. Types of books include instructional, juvenile, young adult, reference and music. Specializes in music books. Publishes approximately 300 titles/year. Recent titles include *Heavy Metal Lead Guitar*; *Bach: An Introduction to His Keyboard Works*; and *Singing with Young Children*. Book catalog free by request.
Needs: Approached by 40-50 freelancers/year. Works with 10 freelance illustrators and 15 designers/year. "We prefer to work directly with artist—local, if possible." Uses freelancers mainly for cover art, marketing material, book design and production. Also for jacket/cover and text illustration. Works on assignment only.
First Contact & Terms: Send résumé, SASE and tearsheets. "Photocopies are fine for line art." Samples are filed. Reports back only if interested. "I appreciate paid reply cards." To show portfolio, include "whatever shows off your work and is easily viewed." Originals are returned at job's completion.
Book Design: Assigns 10 freelance design jobs/year. Pays by the hour, $20-25, or by the project.
Jackets/Covers: Assigns 20 freelance design and 50 illustration jobs/year. Pays by the project, $150-800. "We generally prefer fairly representational styles for covers, but anything upbeat in nature is considered."
Text Illustration: Assigns 15 freelance illustration jobs/year. Pays by the project, $350-2,500. "We use a lot of line art for b&w text, watercolor or gouache for 4-color text."

ALLYN AND BACON INC., College Division, 160 Gould St., Needham MA 02194. (617)455-1200. Fax: (617)455-1294. Cover Administrator: Linda Knowles. Publishes more than 250 hardcover and paperback textbooks/year. 60% require freelance cover designs. Subject areas include education, psychology and sociology, political science, theater, music and public speaking.
Needs: Approached by 80-100 freelancers/year. Designers must be strong in book cover design and contemporary type treatment. Needs computer-literate freelancers for design, illustration and production. 50% of freelance work demands knowledge of Adobe Illustrator, Photoshop and Aldus FreeHand.
Jackets/Covers: Assigns 100 design jobs and 2-3 illustration jobs/year. Pays for design by the project, $300-750. Pays for illustration by the project, $150-500. Prefers sophisticated, abstract style in pen & ink, airbrush, charcoal/pencil, watercolor, acrylic, oil, collage and calligraphy. "Always looking for good calligraphers."
Tips: "Keep stylistically and technically up to date. Learn *not* to over-design: read instructions and ask questions. Introductory letter must state experience and include at least photocopies of your work. If I like what I see, and you can stay on budget, you'll probably get an assignment. Being pushy closes the door. We primarily use designers based in the Boston area."

ALYSON PUBLICATIONS, INC., 40 Plympton St., Boston MA 02118. Publisher: Sasha Alyson. Director: Alistair Williamson. Estab. 1977. Book publisher emphasizing gay and lesbian concerns. Publishes 20 titles/year. Recent titles include *One Dad, Two Dads, Brown Dad, Blue Dads*, by Johnny Valentine; and *B-Boy Blues*, by James Carl Hardy. For sample catalog, send 9×12 SAE with 2 first-class stamps.
First Contact & Terms: Works on assignment only. Send query letter with brochure showing art style or tearsheets, photostats, photocopies and photographs. Samples returned by SASE. Reports only if interested.
Jackets/Covers: Buys 6 cover illustrations/year. Pays $200-500 for b&w, $300-500 for color. **Pays on acceptance**.
Text Illustration: "Illustrator for kids' books usually acts as co-author and is paid royalties."
Tips: "We are planning several children's books a year aimed at the kids of lesbian and gay parents. Many styles will be needed, from b&w drawings to full-color work. Send samples to be kept on file."

AMERICA WEST PUBLISHERS, INC., P.O. Box 3300, Bozeman MT 59772. (406)585-0700. Fax: (406)585-0703. Manager: G. Green. Estab. 1985. Publishes trade paperback originals. Types of books include reference and history. Specializes in history. Publishes 40 titles/year. Recent titles include *Chalice and the Dove*, by Gillian De Armond; and *Chaos in America*, by John King. 10% require freelance illustration; 10% require freelance design. Book catalog available by request.
Needs: Approached by 5 freelancers/year. Works with 2 freelance designers/year. Buys 15 illustrations/year. Uses freelancers for jacket/cover illustration. Works on assignment only.
First Contact & Terms: Send query letter with samples of work, photographs and photocopies. Samples are filed or are returned by SASE if requested by artist. Reports back to the artist only if interested. To show portfolio, mail roughs. Buys all rights. Originals are not returned.

Book Design: Assigns 5 freelance illustration jobs/year. Pays by the project, $200-500.
Jackets/Covers: Assigns 10 freelance design and 10 illustration jobs/year. Prefers 4-color work. Pays by the project, $200-500.
Text Illustration: Assigns 2 freelance design and 2 illustration jobs/year. Prefers b&w illustration. Pays according to contract.

‡THE AMERICAN BIBLE SOCIETY, 1865 Broadway, New York NY 10023. (212)408-1441. Fax: (212)408-1435. Product Development: Christina Murphy. Estab. 1868. Company publishes religious products including Bibles/books, portions, leaflets, calendars, bookmarks. Types of books include religious children's books. Specializes in contemporary applications to the Bible. Publishes 60-80 titles/year. Recent titles include *God is Our Shelter & Strength: Victims of Natural Disasters Portion*. 70% require freelance illustration; 90% require freelance design. Book catalog free by request.
Needs: Approached by 100 freelancers/year. Works with 20-30 freelance illustrators and 20 designers/year. Uses freelancers for jacket/cover illustration and design, text illustration, book design and children's activity books. Needs computer-literate freelancers for design and illustration. 10% of freelance work demands knowledge of Adobe Illustrator, QuarkXPress, Adobe Photoshop. Works on assignment only.
First Contact & Terms: Send postcard sample of work or send query letter with brochure and tearsheets. Samples are filed and are returned. Reports back within 2 months. Art Director will contact artist for portfolio review if interested. Portfolio should include final art and tearsheets. Buys all rights. Originals are returned at job's completion.
Book Design: Assigns 5 freelance design jobs/year. Pays by the project, $350-1,000.
Jackets/Covers: Assigns 60 freelance design and 40 freelance illustration jobs/year. Pays by the project, $350-2,000.
Text Illustration: Assigns 2 freelance illustration jobs/year. Pays by the project.
Tips: Finds artists through artists' submissions, *The Workbook* (by Scott & Daughters Publishing) and *RSVP Illustrator*. "Looking for younger, up-and-coming new talent!"

‡AMERICAN INSTITUTE OF CHEMICAL ENGINEERING, 345 E. 47th St., New York NY 10017-2395. (212)705-7966. E-mail: joro361@aol.com. Creative Director: Joseph A. Rosetti. Estab. 1925. Book and magazine publisher of hardcover originals and reprints, trade paperback originals and reprints and magazines. Specializes in chemical engineering. Publishes 50 titles/year. 70% require freelance illustration; 20% require freelance design. Book catalog free by request.
Needs: Approached by 30 freelancers/year. Works with 17-20 freelance illustrators and 3 designers/year. Prefers freelancers with experience in technical illustration. Macintosh experience a must. Uses freelancers for jacket/cover illustration. Needs computer-literate freelancers for design and illustration. 100% of freelance work demands knowledge of Adobe Illustrator 5.0, QuarkXPress 3.0, Photoshop 3.0. Works on assignment only.
First Contact & Terms: Send query letter with tearsheets. Samples are filed. Reports back only if interested. Call for appointment to show portfolio of color tearsheets and 3.5 Mac disk. Buys first rights or one-time rights. Originals are returned at job's completion.
Book Design: Pays by the hour, $35-50.
Jackets/Covers: Assigns 2 design and 8 illustration jobs/year. Payment depends on experience, style.
Text Illustration: Assigns 250 jobs/year. Pays by the hour, $15-40.

‡AMERICAN PSYCHIATRIC PRESS, INC., 1400 K St. NW, 11th Floor, Washington DC 20005. (202)682-6115. Fax: (202)682-6341. Electronic Prepress Director: Jan Davenport. Estab. 1981. Imprint of American Psychiatric Association. Company publishes hardcover originals and textbooks. Specializes in psychiatry and its subspecialties. Publishes 60 titles/year. Recent titles include *Posttraumatic Stress Disorder, Textbook of Psychiatry* and *Textbook of Psychopharmacology*. 10% require freelance illustration; 10% require freelance design. Book catalog free by request.
Needs: Uses freelancers for jacket/cover design and illustration. Needs computer-literate freelancers for design. 90% of freelance work demands computer skills. Works on assignment only.
First Contact & Terms: Send query letter with brochure, tearsheets and samples. Samples are filed. Art Director will contact artist for portfolio review if interested. Portfolio should include final art, slides and tearsheets. Rights purchased vary according to project.

How to Use Your **Artist's & Graphic Designer's Market** *offers suggestions for understanding and using the information in these listings. Read this and other articles in the front of this book for important business tips.*

Book Design: Pays by the project.
Jackets/Covers: Assigns 10 freelance design and 10 illustation jobs/year. Pays by the project.
Tips: Finds artists through sourcebooks. "Book covers are now being done in Corel Draw! 5.0 but will work with Mac happily. Book covers are for professional books with clean designs. Type treatment design are done in-house."

AMHERST MEDIA, INC., 418 Homecrest Dr., Amherst NY 14226. (716)874-4450. Fax: (716)874-4508. Publisher: Craig Alesse. Estab. 1985. Company publishes trade paperback originals. Types of books include instructional and reference. Specializes in photography, videography, how-to. Publishes 8 titles/year. Recent titles include *Camcorder Tricks*, by Michael Staries; and *McBroan's Camera Bluebook*, by Mike McBroan. 20% require freelance illustration; 50% require freelance design. Book catalog free for 9×12 SAE with 3 first-class stamps.
Needs: Approached by 12 freelancers/year. Works with 3 freelance illustrators and 3 designers/year. Uses freelance artists mainly for illustration and cover design. Also for jacket/cover illustration and design and book design. Needs computer-literate freelancers for design and production. 80% of freelance work demands knowledge of QuarkXPress or Adobe Photoshop. Works on assignment only.
First Contact & Terms: Send brochure, résumé and photographs. Samples are filed. Reports back only if interested. Art Director will contact artist for portfolio review if interested. Portfolio should include slides. Rights purchased vary according to project. Originals are returned at job's completion.
Book Design: Assigns 4 freelance design jobs/year. Pays by the project, $200-800.
Jackets/Covers: Assigns 4 freelance design and 4 illustration jobs/year. Pays by the project, $200-750. Prefers computer illustration (Quark/Photoshop).
Text Illustration: Assigns 1 freelance illustration job/year. Pays by the project. Prefers computer illustration (Quark).
Tips: First-time assignments are usually covers. Finds artists through word of mouth.

‡AMISTAD PRESS, 1271 Avenue of the Americas, Room 4634, New York NY 10020. (212)522-2675. Fax: (212)522-7282. Creative Director: Gilbert Flectcher. Estab. 1991. Company publishes hardcover originals, trade paperback originals and reprints and mass market paperback originals. Types of books include biography, cookbooks, experimental fiction, historical fiction, history, mainstream fiction, nonfiction and reference. Publishes 25 titles/year. Recent titles include *Essence Brings You Great Cooking*; and *Bruised Hibiscus*. 40% require freelance illustration; 20% require freelance design. Book catalog free by request.
Needs: Approached 30 freelancers/year. Works with 7 freelance illustrators and 3 designers/year. Buys 8-12 freelance illustrations/year. Uses freelancers for jacket/cover illustration and design, text illustration, book and catalog design. Needs computer-literate freelancers for design, illustration and production. 80% of freelance work demands knowledge of Adobe Illustrator, QuarkXPress and Adobe Photoshop. Works on assignment only.
First Contact & Terms: Send postcard sample of work. Samples are filed or are returned. Portfolios may be dropped off every Monday. Art Director will contact artist for portfolio review if interested. Portfolio should include final art, photographs, photostats, slides and tearsheets. Rights purchased vary according to project. Originals are returned at job's completion.
Book Design: Pays by the project, $500-2,500.
Jacket Covers: Assigns 3-5 freelance design and 4-7 illustration jobs/year. Pays by the project, $750-2,500.
Text Illustration: Assigns 10 freelance illustration jobs/year. Pays by the project, $750-2,500.
Tips: Finds artists mainly through artist directories such as *Graphic Artist Guild's Directory of Illustration*, *The Workbook* and *American Showcase*.

ARDSLEY HOUSE PUBLISHERS, INC., 320 Central Park W., New York NY 10025. (212)496-7040. Assistant Editor: Linda Jarkesy. Publishes college textbooks. Specializes in math and music. Publishes 8 titles/year. Recent titles include *Music Melting Round*, by Edith Borroff; and *Ethics in Thought and Action*, by Warren Cohen. 100% require freelance illustration and design. Book catalog not available.
Needs: Works with 3-4 freelance illustrators and 3-4 designers/year. Prefers experienced local freelancers. Uses freelancers mainly for cover illustrations and technical drawing. Also for direct mail and book design. Needs computer-literate freelancers for design. 50% of freelance work demands computer skills. Works on assignment only.
First Contact & Terms: Send query letter with brochure and résumé. Samples are not filed and are not returned. Reports back only if interested.
Book Design: Assigns 3-4 freelance design jobs/year. Pays by the project.
Jackets/Covers: Assigns 8 freelance design jobs/year. Pays by the project.
Text Illustration: Assigns 8 freelance jobs/year. Pays by the project.
Tips: "We'd like to see snappy, exciting, but clear designs. We expect freelancers to have a sense of responsibility and show evidence of ability to meet deadlines."

‡ARJUNA LIBRARY PRESS, 1025 Garner St., D, Space 18, Colorado Springs CO 80905-1774. Director: Captain Baron Joseph A. Uphoff, Jr.. Estab. 1979. Company publishes trade paperback originals and mono-

graphs. Types of books include experimental fiction, fantasy, horror, nonfiction and science fiction. Specializes in surrealism and metamathematics. Publishes 1 or more titles/year. Recent titles include *English Is a Second Language* and *The Davenport Constellation*. 100% require freelance illustration. Book catalog available for $1.

Needs: Approached by 1-2 freelancers/year. Works with 1-2 freelance illustrators/year. Buys 1-2 freelance illustrations/year. Uses freelancers for jacket/cover and text illustration.

First Contact & Terms: Send query letter with brochure, résumé, SASE, tearsheets, photographs and photocopies. Samples are filed. Reports back if interested. Portfolio review not required. Originals are not returned.

Book Design: Pays contributor's copy and "royalties by agreement if work becomes profitable."

Jackets/Covers: Pays contributor's copy and "royalties by agreement if work becomes profitable."

Text Illustration: Pays contributor's copy and "royalties by agreement if work becomes profitable."

ART DIRECTION BOOK CO., 10 E. 39th St., 6th Floor, New York NY 10157-0002. (212)889-6500. Fax: (212)889-6504. Art Director: Doris Gordon. Publishes hardcover and paperback originals on advertising design and photography. Publishes 12-15 titles/year. Titles include disks *Scan This Book* and of *Most Happy Clip Art*; book and disk of *101 Absolutely Superb Icons* and *American Corporate Identity #9*. Book catalog free on request.

Needs: Works with 2-4 freelance designers/year. Uses freelancers mainly for graphic design.

First Contact & Terms: Send query letter to be filed, and arrange to show portfolio of 4-10 tearsheets. Portfolios may be dropped off Monday-Friday. Samples returned by SASE. Buys first rights. Originals are returned to artist at job's completion. Advertising design must be contemporary.

Book Design: Pays $100 minimum.

Jackets/Covers: Pays $100 minimum.

Tips: Finds artists through word of mouth.

ARTIST'S & GRAPHIC DESIGNER'S MARKET, Writer's Digest Books, 1507 Dana Ave., Cincinnati OH 45207. Editor: Mary Cox. Annual hardcover directory of markets for designers, illustrators and fine artists. Buys one-time rights.

Needs: Buys 35-45 illustrations/year. "I need examples of art that have been sold to the listings in *Artist's & Graphic Designer's Market*. Look through this book for examples. The art must have been freelanced; it cannot have been done as staff work. Include the name of the listing that purchased or exhibited the work, what the art was used for and, if possible, the payment you received. Bear in mind that interior art is reproduced in b&w, so the higher the contrast, the better."

First Contact & Terms: Send printed piece, photographs or tearsheets. "Since *Artist's & Graphic Designer's Market* is published only once a year, submissions are kept on file for the upcoming edition until selections are made. Material is then returned by SASE if requested." Pays $50 to holder of reproduction rights and free copy of *Artist's & Graphic Designer's Market* when published.

ASSOCIATION OF COLLEGE UNIONS-INTERNATIONAL, 400 E. Seventh St., Bloomington IN 47405. (812)332-8017. Fax: (812)333-8050. E-mail: avest@ucs.indiana.edu. Assistant Director of Publishing and Marketing: Ann Vest. Estab. 1914. Professional education association. Publishes hardcover and trade paperback originals. Specializes in multicultural issues, creating community on campus, union and activities programming, managing staff, union operations, and professional and student development. Recent titles include *Building Community on Campus*, by Susan Young Maul. Book catalog free for SAE with 6 first-class stamps.

● This association also publishes a magazine (see Magazines section for listing). Note that most illustration and design are accepted on a volunteer basis. This is a good market if you're just looking to build or expand your portfolio.

Needs: "We are a volunteer-driven association. Most people submit work on that basis." Uses freelancers mainly for illustration. Needs computer-literate freelancers for illustration. Freelancers should be familiar with CorelDraw. Works on assignment only.

First Contact & Terms: Send query letter with tearsheets. Samples are filed. Reports back to the artist only if interested. Negotiates rights purchased. Originals are returned at job's completion.

Tips: Looking for color transparencies of college student union activities.

‡ATHENEUM BOOKS FOR YOUNG READERS, 866 Third Ave., 25th Floor, New York NY 10022. (212)702-5656. Art Assistant: Ethan Trask. Imprint of Simon & Schuster. Imprint publishes hardcover originals, picture books for young kids, nonfiction for ages 8-12. Types of books include biography, fantasy, historical fiction, history, instructional, nonfiction, and reference for pre-school, juvenile and young adult. Publishes 60 titles/year. Recent titles include *Tutankhamen's Gift*; *The Alphabet from Z to A*; and *Bats, Bugs and Biodiversity*. 100% require freelance illustration; 25% require freelance design. Book catalog free by request.

Needs: Approached by hundreds of freelance artists/year. Works with 40-60 freelance illustrators and 3-5 designers/year. Buys 40 freelance illustrations/year. "We are interested in artists of varying media and are

trying to cultivate those with a fresh look appropriate to each title." Uses freelancers for jacket design and illustration for novels; picture books in their entirety. Needs computer-literate freelancers for design and production. 90% of freelance work demands knowledge of Adobe Illustrator 5.5, QuarkXPress 3.31 and Adobe Photoshop 2.5.1. Works on assignment only.

First Contact & Terms: Send postcard sample of work or send query letter with tearsheets, résumé and photocopies. Samples are filed. Portfolios may be dropped off every Thursday between 9 a.m. and noon. Art Director will contact artist for portfolio review if interested. Portfolio should include final art if appropriate, tearsheets and folded & gathered sheets from any picture books you've had published. Rights purchased vary according to project. Originals are returned at job's completion.

Book Design: Assigns 2-5 freelance design jobs/year. Pays by the project, $750-1,500.

Jackets/Covers: Assigns 1-2 freelance design and 20 freelance illustration jobs/year. Pays by the project, $1,200-1,800. "I am not interested in generic young adult illustrators."

Text Illustration: Pays by the project, $500-2,000.

Tips: Finds artists through artists' submissions, magazines ("I look for interesting editorial illustrators"), word of mouth.

‡AUGSBURG FORTRESS PUBLISHERS, (formerly Augsburg Publishing House), Box 1209, 426 S. Fifth St., Minneapolis MN 55440. (612)330-3300. E-mail: malye@aol.com. Contact: Director of Design, Design Services. Publishes hard cover and paperback Protestant/Lutheran books (90 titles/year), religious education materials, audiovisual resources, periodicals. Recent titles include *God Beyond Gender*, by Gail Ramshaw; and *Potter*, by Walter Wangerin.

Needs: Uses freelancers for advertising layout, design, illustration and circulars and catalog cover design. Freelancers should be familiar with QuarkXPress 3.31, Photoshop 3.0 and Illustrator 5.0.

First Contact & Terms: "Majority, but not all, of our freelancers are local." Works on assignment only. Reports back on future assignment possibilities in 5-8 weeks. Call, write or send brochure, flier, tearsheet, good photocopies and 35mm transparencies; if artist is not willing to have samples filed, they are returned by SASE. Buys all rights on a work-for-hire basis. May require designers to supply overlays on color work.

Jackets/Covers: Uses designers primarily for cover design. Pays by the project, $600-900. Prefers covers on disk using QuarkXPress.

Text Illustration: Negotiates pay for 1-, 2- and 4-color. Generally pays by the project, $25-500.

Tips: Be knowledgeable "of company product and the somewhat conservative contemporary Christian market."

‡AUGUST HOUSE, INC., 201 E. Markham, Plaza Level, Little Rock AR 72201. (501)372-5450. Fax: (501)372-5579. Art Director: Ted Parkhurst. Estab. 1980. Company publishes hardcover and trade paperback originals. Types of books include humor and juvenile. Specializes in folktales, folklore and storytelling. Publishes 15-20 titles/year. Recent titles include *Fair is Fair* and *Still Catholic After all These Fears*. 90% require freelance illustration; 90% require freelance design. Book catalog free by request.

Needs: Approached by 50 freelancers/year. Works with 10 freelance illustrators and 10 designers/year. Prefers artists with experience in watercolor, pen & ink. Uses freelancers mainly jacket/cover illustration. Also for jacket/cover design. Needs computer-literate freelancers for illustration. 70% of freelance work demands knowledge of QuarkXPress and Adobe Photoshop. Works on assignment only.

First Contact & Terms: Send query letter with brochure, photographs and photocopies. Samples are returned by SASE if requested artist. Art Director will contact artist for portfolio review if interested. Portfolio should include book dummy and photographs. Rights purchased vary according to project. Originals are returned at job's completion.

Book Design: Assigns 10 freelance design jobs/year.

Jackets: Covers: Assigns less than 5 freelance design and 5-10 illustration jobs/year.

Text Illustration: Assigns 8 freelance illustration jobs/year.

Tips: Finds artists through word of mouth and artists' submissions.

‡AVALON BOOKS, 401 Lafayette St., New York NY 10003. Publisher: Marcia Markland. Estab. 1953. Company publishes hardcover originals. Types of books include romance, western and mystery. Publishes 60 titles/year. 100% require freelance illustration. Book catalog not available.

Needs: Prefers local freelancers only. Uses freelancers for jacket/cover illustration. Works on assignment only.

The double dagger before a listing indicates that the listing is new in this edition. New markets are often more receptive to freelance submissions.

First Contact & Terms: Send postcard sample of work. Samples are not filed and are not returned. Reports back only if interested. Portfolio review not required. Rights purchased vary according to project. Originals are returned at job's completion.

Jackets/Covers: Assigns 60 freelance design jobs/year.

Tips: Finds artists through artists' submissions.

BAEN BOOKS, Box 1403, Riverdale NY 10471. (718)548-3100. Publisher: Jim Baen. Editor: Toni Weisskopf. Estab. 1983. Publishes science fiction and fantasy. Publishes 84-96 titles/year. Titles include *Mars Plus Man Plus* and *The City Who Fought*. 75% require freelance illustration; 80% require freelance design. Book catalog free on request.

First Contact & Terms: Approached by 1,000 freelancers/year. Works with 10 freelance illustrators and 4 designers/year. Needs computer-literate freelancers for design. 10% of work demands computer skills. Send query letter with slides, transparencies (color only) and SASE. Samples are filed. Originals are returned to artist at job's completion. Buys exclusive North American book rights.

Jackets/Covers: Assigns 64 freelance design and 64 illustration jobs/year. Pays by the project—$200 minimum, design; $1,000 minimum, illustration.

Tips: Wants to see samples within science fiction, fantasy genre only. "Do not send b&w illustrations or surreal art. Please do not waste our time and your postage with postcards. Serious submissions only."

BANDANNA BOOKS, 319B Anacapa St., Santa Barbara CA 93101. Fax: (805)564-3278. Publisher: Sasha Newborn. Estab. 1981. Publishes supplementary textbooks, nonfiction and fiction trade paperback originals and reprints. Types of books include language, classics. Publishes 3 titles/year. Recent titles include *Benigna Machiavelli*, by Charlotte Perkins Gilman; and *The First Detective*, by E.A. Poe. 25% require freelance illustration.

Needs: Approached by 50 freelancers/year. Uses illustrators mainly for woodblock or scratchboard and pen & ink art. Also for cover and text illustration.

First Contact & Terms: Send query letter with SASE and samples. Samples are filed and are returned by SASE only if requested. Reports back within 6 weeks if interested. Originals are not returned. To show portfolio mail thumbnails and sample work. Considers project's budget when establishing payment.

Jackets/Covers: Prefers b&w (scratchboard, woodblock, silhouettes). Considering collage (specific to title). Pays by the project, $50-200.

Text Illustration: Pays by the project, $50-200.

Tips: "Include at least five samples in your submission. Make sure work done for us is equal in quality and style to the samples sent. Make sure samples are generally related to our topics published. We're interested in work that is innovative without being bizarre, quality without looking too 'slick' or commercial."

BANTAM BOOKS, 666 Fifth Ave., New York NY 10103. Does not need freelancers at this time.

BARBOUR & CO., INC., 1810 Barbour Dr., P.O. Box 719, Uhrichsville OH 44683. (614)922-6045, ext. 125. Fax: (614)922-5948. Vice President, Editor: Stephen Reginald. Estab. 1981. Publishes hardcover, trade paperback and mass market paperback originals and reprints. Types of books include contemporary and historical fiction, romance, self help, young adult, reference and juvenile. Publishes 60 titles/year. Titles include *That Morals Thing* and *Eyes of the Heart*. 60% require freelance illustration. Book catalog available for $1.

Needs: Approached by 15 freelancers/year. Works with 5 freelance illustrators/year. Prefers freelancers with experience in people illustration. Uses freelancers mainly for fiction romance jacket/cover illustration. Needs computer-literate freelancers for design, illustration and production. 20% of freelance work demands knowledge of QuarkXPress. Works on assignment only.

First Contact & Terms: Send query letter with brochure. Samples are filed. Reports back within 1 week. Write for appointment to show portfolio of thumbnails, roughs, final art, dummies. Sometimes requests work on spec before assigning a job. Buys all rights. Originals are not returned.

Jackets/Covers: Pays by the project, $300-1,000.

Tips: Finds artists through word of mouth, recommendations and placing ads. "Submit a great illustration of people suitable for a romance cover."

BEHRMAN HOUSE, INC., 235 Watchung Ave., West Orange NJ 07052. (201)669-0447. Fax: (201)669-9769. Projects Editor: Adam Siegel. Estab. 1921. Book publisher. Publishes textbooks. Types of books include pre-school, juvenile, young adult, history (all of Jewish subject matter) and Jewish texts. Specializes in Jewish books for children and adults. Publishes 12 titles/year. Recent titles include *It's a Mitzvah*, by Brad Artson. "Books are contemporary with lots of photographs and artwork; colorful and lively. Design of textbooks is very complicated." 50% require freelance illustration; 100% require freelance design. Book catalog free by request.

Needs: Approached by 6 freelancers/year. Works with 6 freelance illustrators and 6 designers/year. Prefers freelancers with experience in illustrating for children; "Jewish background helpful." Uses freelancers for

textbook illustration and book design. Needs computer-literate freelancers for design. 25% of freelance work demands knowledge of QuarkXPress. Works on assignment only.

First Contact & Terms: Send query letter with brochure, résumé and tearsheets. Samples are filed. Reports back only if interested. Buys reprint rights. Sometimes requests work on spec before assigning a job. Originals are returned at job's completion.

Book Design: Assigns 6 freelance design and 3 illustration jobs/year. Pays by project, $800-1,500.

Jackets/Covers: Assigns 6 freelance design and 4 illustration jobs/year. Pays by the project.

Text Illustration: Assigns 6 freelance design and 4 illustration jobs/year. Pays by the project.

ROBERT BENTLEY PUBLISHERS, 1033 Massachusetts Ave., Cambridge MA 02138. (617)547-4170. Publisher: Michael Bentley. Publishes hardcover originals and reprints and trade paperback originals—reference books. Specializes in automotive technology and automotive how-to. Publishes 20 titles/year. Recent titles include *Jeep Owner's Bible*. 50% require freelance illustration; 80% require freelance design and layout. Book catalog for 9 × 12 SAE.

Needs: Works with 5-10 illustrators and 15-20 designers/year. Buys 1,000 illustrations/year. Prefers artists with "technical illustration background, although a down-to-earth, user-friendly style is welcome." Uses freelancers for jacket/cover illustration and design, text illustration, book design, page layout, direct mail and catalog design. Works on assignment only.

First Contact & Terms: Send query letter with résumé, SASE, tearsheets and photocopies. Samples are filed. Reports in 3-5 weeks. To show portfolio, mail thumbnails, roughs and b&w tearsheets and photographs. Buys all rights. Originals are not returned.

Book Design: Assigns 10-15 freelance design and 20-25 illustration jobs/year. Pays by the project.

Jackets/Covers: Pays by the project.

Text Illustration: Prefers ink on mylar or Adobe Postscript files.

Tips: "Send us photocopies of your line artwork and résumé."

BLUE BIRD PUBLISHING, 1739 E. Broadway, Suite 306, Tempe AZ 85282. (602)968-4088. Owner/Publisher: Cheryl Gorder. Estab. 1985. Publishes trade paperback originals. Types of books include young adult, reference and general adult nonfiction. Specializes in parenting and home education. Publishes 6 titles/year. Titles include: *Green Earth Resource Guide*. 50% require freelance illustration; 25% require freelance design. Book catalog free for #10 SASE.

Needs: Approached by 12 freelancers/year. Works with 3 freelance illustrators and 1 designer/year. Uses freelancers for illustration. Also for jacket/cover and catalog design. Works on assignment only.

First Contact & Terms: Send query letter with brochure and photocopies. Samples are filed. To show portfolio, mail b&w samples and color tearsheets. Rights purchased vary according to project. Originals not returned.

Jackets/Covers: Assigns 1 freelance design and 1 illustration job/year. Pays by the project, $50-200. Style preferences vary per project."

Text Illustration: Assigns 3 freelance illustration jobs/year. Pays by the project, $20-250. Prefers line art.

BONUS BOOKS, INC., 160 E. Illinois St., Chicago IL 60611. (312)467-0580. Fax: (312)467-9271. Art Director: Shane R. McCall. Imprints include Precept Press, Teach'em. Company publishes textbooks and hardcover and trade paperback originals. Types of books include instruction, biography, self help, cookbooks and sports. Specializes in sports, biography, medical, fundraising. Publishes 40 titles/year. Recent titles include *Second to Home*, by Ryne Sandberg; and *Call of the Game*, by Gary Bender. 1% require freelance illustration; 80% require freelance design. Book catalog free by request.

Needs: Approached by 30 freelancers/year. Works with 0-1 freelance illustrator and 10 designers/year. Prefers local freelancers with experience in designing on the computer. Uses freelancers for jacket/cover illustration and design and direct mail design. Needs computer-literate freelancers for design. 95% of freelance work demands computer skills. Works on assignment only.

First Contact & Terms: Send query letter with tearsheets, photostats and photocopies. "We would like to see all rough sketches and all design process, not only final product." Samples are filed. Reports back only if interested. Artist should follow up with call. Portfolio should include color final art, photostats and tearsheets. Rights purchased vary according to project.

Book Design: Assigns 4 freelance design jobs/year.

Jackets/Covers: Assigns 10 freelance design and 0-1 illustration job/year. Pays by the project, $250-1,000.

Tips: First-time assignments are usually regional, paperback book covers; book jackets for national books are given to "proven" freelancers. Finds artists through artists' submissions and authors' contacts.

BOOK DESIGN, Box 193, Moose WY 83012. Art Director: Robin Graham. Specializes in hardcover and paperback originals of nonfiction, natural history. Publishes more than 3 titles/year. Recent titles include *Tales of the Wolf* and *Wildflowers of the Rocky Mountains*.

Needs: Works with 20 freelance illustrators and 10 designers/year. Works on assignment only. "We are looking for top-notch quality only." Needs computer-literate freelancers for design and production. 90% of freelance work demands knowledge of Aldus PageMaker and Aldus FreeHand.

First Contact & Terms: Send query letter with "examples of past work and one piece of original artwork which can be returned." Samples not filed are returned by SASE if requested. Reports back within 20 days. Originals are not returned. Write for appointment to show portfolio. Negotiates rights purchased.
Book Design: Assigns 6 freelance design jobs/year. Pays by the project, $50-3,500.
Jackets/Covers: Assigns 2 freelance design and 4 illustration jobs/year. Pays by the project, $50-3,500.
Text Illustration: Assigns 26 freelance jobs/year. Prefers technical pen illustration, maps (using airbrush, overlays etc.), watercolor illustration for children's books, calligraphy and lettering for titles and headings. Pays by the hour, $5-20 or; by the project, $50-3,500.

‡DON BOSCO MULTIMEDIA, 130 Main St., New Rochelle NY 10801. (914)576-0122. Fax: (914)654-0443. Contact: Production Manager. Specializes in religious hardcover and paperback originals and video-tapes. Publishes 20 titles/year. Recent titles include *A Spirituality of Relationships*, by Don Kimball; and *Women in Youth Ministry*, by Lisa Walker. 20% require freelance illustration. "Covers are bright with multiple graphic elements; text is conservative but friendly."
Needs: Looking for fun and interesting covers to appeal to adolescents, young adults and the people who minister to them. Works with 3-5 freelance illustrators and 3-5 designers/year. Works on assignment only. Needs computer-literate freelancers for design, illustration and production. 80% of freelance work demands knowledge of QuarkXPress 3.0, Aldus FreeHand or Adobe Illustrator.
First Contact & Terms: Send query letter with brochure showing art style. Samples are filed. Reports back within 3 weeks. Call for appointment to show portfolio of thumbnails, roughs, original/final art, tearsheets and slides. Considers complexity of project, skill and experience of artist and project's budget. Buys one-time rights.
Book Design: Pays by the project, $100-200.
Jackets/Covers: Assigns 8 freelance design jobs/year. Prefers religious, realistic style. Pays by the project, $150-450.
Text Illustration: Pays by the project, $100-300.
Tips: "More art is now provided on disk rather than camera ready. Computers are keeping costs down by providing the opportunity to go directly from computer to film."

BOYDS MILLS PRESS, 815 Church St., Honesdale PA 18431. Art Director: Tim Gillner. Estab. 1990. A division of Highlights for Children, Inc. Imprint publishes hardcover originals and reprints. Types of books include fiction, picture books and poetry. Publishes 50 titles/year. Recent titles include *Bitter Bananas*, by Isaac Olaleye (illustrated by Ed Young); *Bingleman's Midway*, by Karen Ackerman (illustrated by Barry Moser).
Needs: Approached by hundreds of freelancers/year. Works with 25-30 freelance illustrators and 5 designers/year. Prefers freelancers with experience in book publishing. Uses freelancers mainly for picture books. Also for jacket/cover design and illustration, text illustration and book design. Needs computer-literate freelancers for design. 25% of freelance work demands knowledge of QuarkXPress. Works on assignment only.
First Contact & Terms: Send query letter with tearsheets, photographs, photocopies, slides and transparencies. Samples are files and not returned. Artist should follow up with call. Portfolio should include b&w and color final art, photostats, tearsheets and photographs. Rights purchased vary according to project. Originals are returned at job's completion.
Book Design: Assigns 10 freelance design jobs/year. Pays by the project.
Jackets/Covers: Assigns 6 freelance design/illustration jobs/year. Pays by the project.
Text Illustration: Pays by the project.
Tips: First-time assignments are usually poetry books (b&w illustrations); picture books are given to "proven" freelancers. Finds artists through agents, sourcebooks, submissions, other publications.

BRIGHTON PUBLICATIONS, INC., 151 Silver Lake Rd., Suite 5, St. Paul MN 55112. Phone/fax: (612)636-2220. Editor: Sharon Dlugosch. Estab. 1978. Company publishes trade paperback originals. Types of books include instructional and self help. Specializes in business, tabletop, event planning. Publishes 3 titles/year. Recent titles include *Don't Slurp Your Soup* and *Reunions for Fun-Loving Families*. 10% require freelance illustration; 50% require freelance design. Book catalog free for business sized SAE with 1 first-class stamp.
Needs: Works with 3 freelance illustrators and 3 designers/year. Uses freelancers for jacket/cover design and illustration; text illustration; direct mail, book and catalog design. Needs computer-literate freelancers. 75% of freelance work demands knowledge of QuarkXPress. Works on assignment only.
First Contact & Terms: Send query letter with résumé. Samples are filed. Reports back only if interested. Art Director will contact artist for portfolio review if interested.

Always enclose a self-addressed, stamped envelope (SASE) with queries and sample packages.

Book Design: Assigns 3 freelance design jobs/year.
Jackets/Covers: Assigns 3 freelance design jobs/year.

BROOKE-HOUSE PUBLISHING COMPANY, Division of A.B. Cowles, Inc., 25 W. 31st St., Suite 901, New York NY 10001. (212)967-7700. Fax: (212)967-7779. Publisher: Stephen Konopka. Estab. 1986. Independent book producer/packager of hardcover originals and board books. Types of books include pre-school and juvenile. Specializes in juvenile fiction, board books and "gimmick books for preschoolers." Produces 20 titles/year. Recent titles include *Tooth Fairy Magic*, by Joanne Barkan; and *Little Lost Bunny*, by Joanne Barkan. 75% require freelance illustration; 50% require freelance design.
Needs: Approached by 15-20 freelancers/year. Works with 12 illustrators and 6 designers/year. Buys 240 illustrations/year. Prefers artists with experience in all fields of juvenile interest. Uses freelancers for text illustration. Works on assignment only.
First Contact & Terms: Send query letter with brochure, tearsheets, photocopies and photostats. Samples are filed. Reports back to the artist only if interested. Call for appointment to show portfolio of color tearsheets. Buys all rights. Originals are returned at job's completion.
Book Design: Assigns 20 freelance design jobs/year. Pays by the project.
Text Illustration: Assigns 12 freelance illustration jobs/year. Pays by the project.
Tips: "Show samples of art styles which are conventional and up-market. Board-book art should be gentle, clean, cute and cuddly."

BUDDHA ROSE PUBLICATIONS, P.O. Box 500, Redondo Beach CA 90277. (310)543-9673. Editor-in-Chief: Dr. Scott Shaw. Estab. 1988. Publishes hardcover and trade paperback originals and textbooks. Types of books include contemporary fiction, self help, reference, biography, history. Specializes in mysticism, poetry, modern lifestyle. Publishes 10 titles/year. Titles include *The Passionate Kiss of Illusion* and *No Kisses for the Sinner*. 1% require freelance illustration.
Needs: Approached by 100 freelancers/year. Works with 7 freelance illustrators and 8 designers/year. Works with artist reps only. Uses freelancers mainly for covers. 15% of freelance work demands knowledge of Aldus FreeHand, Adobe Illustrator and Photoshop, Quark. Works on assignment only.
First Contact & Terms: Contact only through artist rep. Samples are filed and are not returned. Reports back within 2 months only if interested. To show portfolio, mail final art samples, b&w and color photographs, slides and 8×10 transparencies. Buys all rights. Originals not returned.
Book Design: Assigns 10 freelance design jobs/year. Pays by the project, $100 minimum.
Jackets/Covers: Assigns 3 freelance design and 3 illustration jobs/year. Pays by the project, $500 minimum. Prefers oil and/or acrylic painting on board.

‡CAROLINA WREN PRESS/LOLLIPOP POWER BOOKS, 120 Morris St., Durham NC 27701. (919)560-2738. Art Director: Martha Scotford. Estab. 1973. Publishes trade paperback originals. Types of books include contemporary fiction, experimental fiction, pre-school and juvenile. Specializes in books for children in a multi-racial and non-sexist manner, and women's and black literature. Publishes 3 titles/year. Recent titles include *Journey Proud*, edited by Agnes MacDonald; and *In the Arms of Our Elders*, by W.H. Lewis. 50% require freelance illustration. Book catalog available for 9½×12 SASE.
Needs: Approached by 20 freelancers/year. Works with 2 freelance illustrators/year. Prefers freelancers with experience in children's literature. Uses freelancers for jacket/cover and text illustration. Works on assignment only.
First Contact & Terms: Send query letter with résumé, tearsheets, photocopies and illustrations of children and adults. No cartoons. Samples are filed or are returned by SASE if requested by artist. To show portfolio, mail b&w and color tearsheets. Rights purchased vary according to project. Originals returned at job's completion.
Jacket/Covers: Assigns 2 freelance jobs/year. Pays by the project, $50-150.
Text Illustration: Assigns 2 freelance illustration jobs/year. Payment is 10% of print run.
Tips: "Understand the world of children in the 1990s. Draw realistically so racial types are accurately represented and the expressions can be interpreted. Our books have a classical, modern and restrained look."

CCC PUBLICATIONS, 1111 Rancho Conejo Blvd., Suite 411, Newbury Park CA 91320-1415. (805)375-7700. Fax: (805)375-7707. Senior Editorial Director: Cliff Carle. Estab. 1984. Company publishes trade paperback originals and manufactures accessories (T-shirts, mugs, caps). Types of books include self help and humor. Specializes in humor. Publishes 20 titles/year. Recent titles include *Younger Men Are Better Than Retin-A*, by Allia Zobel (illustrated by Steve Skelton); and *Marital Bliss & Other Oxymorons*, written and illustrated by Joe Kohl. 90% require freelance illustration; 90% require freelance design. Book catalog free for SAE with $1 postage.
Needs: Approached by 200 freelancers/year. Works with 20-30 freelance illustrators and 10-20 designers/year. Buys 50 freelance illustrations/year. Prefers artists with experience in humorous or cartoon illustration. Uses freelancers mainly for color covers and b&w interior drawings. Also for jacket/cover and book design. Needs computer-literate freelancers for design, production and presentation. 50% of freelance work demands knowledge of QuarkXPress.

First Contact & Terms: Send query letter with brochure, résumé, SASE and photocopies. Samples are filed or are returned by SASE if requested by artist. Reports back only if interested. Art Director will contact artist for portfolio review if interested. Portfolio should include b&w and color samples. Rights purchased vary according to project.

Book Design: Assigns 20-30 freelance design jobs/year. Pay negotiated based on artist's experience and notoriety.

Jackets/Covers: Assigns 20-30 freelance design and 20-30 illustration jobs/year. Pay negotiated on project by project basis.

Text Illustration: Assigns 30-40 freelance illustration jobs/year. Pay negotiated.

Tips: First-time assignments are usually b&w text illustration; cover illustration are given to "proven" freelancers. Finds artists through agents and unsolicited submissions.

THE CENTER FOR WESTERN STUDIES, Box 727, Augustana College, Sioux Falls SD 57197. (605)336-4007. Managing Editor: Harry F. Thompson. Estab. 1970. Publishes hardcover originals and trade paperback originals and reprints. Types of books include western history. Specializes in history and cultures of the Northern Plains, especially Plains Indians, such as the Sioux and Cheyenne. Publishes 2-3 titles/year. Recent titles include *Princes, Potentates, and Plain People*, by Reuben Goertz; and *Driftwood in Time of War*, by Marie Christopherson. 75% require freelance design. Books are conservative, scholarly and documentary. Book catalog free by request.

Needs: Approached by 4 freelancers/year. Works with 1-2 freelance designers and 1-2 illustrators/year. Uses freelancers mainly for cover design. Also for book design and text illustration. Needs computer-literate freelancers for design. 25% of freelance work demands knowledge of QuarkXPress. Works on assignment only.

First Contact & Terms: Send query letter with résumé, SASE and photocopies. Samples are filed. Request portfolio review in original query. Reports back only if interested. Portfolio should include roughs and final art. Sometimes requests work on spec before assigning a job. Rights purchased vary according to project. Originals are not returned.

Book Design: Assigns 1-2 freelance design jobs/year. Pays by the project, $500-750.

Jackets/Covers: Assigns 2-3 freelance design jobs/year. Pays by the project, $250-500.

Text Illustration: Pays by the project, $100-500.

Tips: Finds illustrators and designers through word of mouth and artists' submissions/self promotion. "We are a small house, and publishing is only one of our functions, so we usually rely on the work of graphic artists with whom we have contracted previously. Send samples."

CHICAGO REVIEW PRESS, Dept. AGDM, 814 N. Franklin, Chicago IL 60610. (312)337-0747. Fax: (312)337-5985. Art Director: Fran Lee. Editor: Linda Matthews. Publishes hardcover and paperback originals. Specializes in trade nonfiction: how-to, travel, cookery, popular science, Midwest regional. Publishes 12 titles/year. Recent titles include *Kids Camp*, by Laurie Carlson; and *The Book Group Book*, by Ellen Slezak. 30% require freelance illustration; 100% require jacket cover design.

Needs: Approached by 50 freelancers/year. Works with 15 freelance illustrators and 5 designers/year. Uses freelancers for jacket/cover illustration and design, text illustration.

First Contact & Terms: Call or send query letter with résumé and color tearsheets. Samples are filed or are returned by SASE. Art Director will contact artist for portfolio review if interested. Call for appointment to show portfolio of tearsheets, final reproduction/product and slides. Considers project's budget when establishing payment. Buys one-time rights.

Jackets/Covers: Assigns 10 freelance design and 10 illustration jobs/year. Pays by project, $500-1,000.

Text Illustration: Pays by the project, $500-3,000.

Tips: Finds artists through magazines, artists' submissions/self promotions, sourcebooks and galleries. "Our books are interesting and innovative. Design and illustration we use is sophisticated, above average and unusual. Fine art has become very marketable in the publishing industry."

‡CHINA BOOKS & PERIODICALS, 2929 24th St., San Francisco CA 94110. (415)282-2994. Fax: (415)282-0994. Art Director: Linda Revel. Estab. 1960. Publishes hardcover and trade paperback originals. Types of books include contemporary fiction, instrumental, biography, juvenile, reference, history and travel. Specializes in China-related books. Publishes 5-7 titles/year. Recent titles include *Moon Maiden*, by Hua Long; and *Outrageous Chinese*, by James Wang. 10% require freelance illustration; 75% require freelance design. Books are "tastefully designed for the general book trade." Free book catalog.

Needs: Approached by 50 freelancers/year. Works with 5 freelancers illustrators and 3 designers/year. Prefers freelancers with experience in Chinese topics. Uses freelancers mainly for illustration, graphs and maps. Needs computer-literate freelancers for illustration, design and production. 50% of freelance work demands knowledge of Aldus PageMaker.

First Contact & Terms: Send query letter with brochure, résumé and SASE. Samples are filed. Reports back within 1 month. Write for appointment to show portfolio of thumbnails, b&w slides and photographs. Originals are returned at job's completion.

Book Design: Assigns 5 freelance jobs/year. Pays by the hour, $15-30; or by the project, $500-2,000.
Jackets/Covers: Assigns 5 freelance design and 5 illustration jobs/year. Pays by the project, $700-2,000.
Text Illustration: Assigns 2 freelance jobs/year. Pays by the hour, $15-30; or by the project, $100-2,000.
Prefers line drawings, computer graphics and photos.

CHRONICLE BOOKS, 275 Fifth St., San Francisco CA 94103. Design Director: Michael Carabetta. Estab.
1979. Company publishes high quality, affordably priced hardcover and trade paperback originals and re-
prints. Types of books include cookbooks, art, design, architecture, contemporary fiction, travel guides,
gardening and humor. Publishes approximately 150 titles/year. Recent best-selling titles include the *Griffin
& Sabine* trilogy, by Nick Bantock. Book catalog free on request (call 1-800-722-6657).
 • Chronicle has a separate children's book division, and has launched a new division called Gift
 Works™, to produce letter boxes and a variety of other gift items.
Needs: Approached by hundreds of freelancer/year. Works with 15-20 illustrators and 30-40 designers/year.
Uses artists for cover and interior design and illustration. Also for GiftWorks™ items. Needs computer-
literate freelancers for design and production. 99% of design work demands knowledge of Aldus PageMaker,
QuarkXPress, Aldus FreeHand, Adobe Illustrator or Adobe Photoshop; "mostly QuarkXPress—software is
up to discretion of designer." Works on assignment only.
First Contact & Terms: Send query letter with tearsheets, color photocopies or printed samples no larger
than 8½×11. Samples are filed or are returned by SASE. Reports back only if interested. Art Director will
contact artist for portfolio review if interested. Portfolio should include thumbnails, roughs, final art, photo-
stats, tearsheets, slides, tearsheets and transparencies. Buys all rights. Originals are returned at job's comple-
tion.
Book Design: Assigns 30-50 freelance design jobs/year. Pays by the project; $750-1200 for covers; varying
rates for book design depending on page count.
Jackets/Covers: Assigns 30 freelance design and 30 illustration jobs/year. Pays by the project, $750-1200.
Text Illustration: Assigns 25 freelance illustration jobs/year. Pays by the project.
Tips: Finds artists through artists' submissions, *Communication Arts* and sourcebooks. "Please write instead
of calling; don't send original material."

CIRCLET PRESS, INC., P.O. Box 15143, Boston MA 02215. Phone/fax: (617)262-5272. E-mail: ctan@world.
std.com. Publisher: Cecilia Tan. Estab. 1992. Company publishes trade paperback originals. Types of books
include science fiction and fantasy. Specializes in erotic science fiction/fantasy. Publishes 8 titles/year. Recent
titles include *S/M Futures*, edited by Cecilia Tan; and *Virtual Girls*, by Evan Hollander. 100% require freelance
illustration. Book catalog free for business size SAE with 1 first-class stamp.
Needs: Approached by 4-5 freelancers/year. Works with 4-5 freelance illustrators/year. Prefers local freelanc-
ers with experience in b&w science fiction illustration. Uses freelancers for cover art. Needs computer-
literate freelancers for illustration. 10% of freelance work demands knowledge of Aldus FreeHand or Adobe
Illustrator. Works on assignment only.
First Contact & Terms: Send query letter with photocopies. Samples are filed. Reports back within 2
weeks. Portfolio review not required. Portfolio must include b&w samples. Buys one-time rights or reprint
rights. Originals are returned at job's completion.
Jackets/Covers: Assigns 8 freelance illustration jobs/year. Pays by the project, $10-50. Prefers b&w, pen
& ink, (no halftones; zip-a-tone OK).
Tips: "Follow the instructions in this listing: Don't send me color samples of slides. I use only b&w art,
therefore that is what I want to see. Freelancers who can use b&w effectively for a striking graphic effect
are most sought after. Any jacket and book design experience is also helpful. For examples of the flavor of
art we prefer, seek out the work of Michael Manning (*The Spider Garden*) and J. O'Barr (*The Crow*)." First-
time assignments are usually front piece with no design elements, big book jackets, wrap-arounds are given
to "proven" freelancers. Finds artists through art shows at science fiction conventions and submission
samples.

CLARION BOOKS, 215 Park Ave., 11th Floor, New York NY 10003. (212)420-5889. Fax: (212)420-5855.
Designer: Eleanor Hoyt. Imprint of Houghton Mifflin Company. Imprint publishes hardcover originals and
trade paperback reprints. Specializes in picture books, chapter books, middle grade novels and nonfiction,
including historical and animal behavior. Publishes 60 titles/year. Titles include *Tuesday*, by David Wiesner;
and *Eleanor Roosevelt*, by Russell Freedman. 90% of titles require freelance illustration. Book catalog free
for SASE.
Needs: Approached by "countless" freelancers. Works with 48 freelance illustrators/year. Uses freelancers
mainly for picture books and novel jackets. Also for jacket/cover and text illustration.
First Contact & Terms: Send query letter with tearsheets, photocopies and SASE. Samples are filed "if
suitable to our needs." Reports back only if interested. Portfolios may be dropped off every Thursday. Art
Director will contact artist for portfolio review if interested. Rights purchased vary according to project.
Originals are returned at job's completion.

Text Illustration: Assigns 48 freelance illustration jobs/year. Pays by the project.

‡**COLONIAL PRESS**, 3325 Burning Tree Dr., Birmingham AL 35226. (205)822-6654. President: Carl Murray. Estab. 1957. Publishes hardcover and trade paperback originals and reprints, and textbooks. Types of books include biography, poetry, juvenile, history, self help, humor and cookbooks. Recent titles include *Minor Miracles*, by Sandra Shapard; and *The Extinction of the Species*, by Robert Sims. Publishes 10-20 titles/year. 5-25% require freelance illustration. Book catalog free for SASE.
Needs: Works with 5 (usually local) illustrators/year. Works on assignment only.
First Contact & Terms: Send query letter with photocopies. Samples are filed or are returned by SASE if requested by artist. Reports back within 2 weeks. Originals are returned at job's completion.
Jackets: Assigns 10-15 illustration jobs/year. Prefers 2-color, simple line drawings. Pays royalty.
Text Illustration: Assigns 10-15 illustration jobs/year. Prefers b&w or 2-color. Pays royalty.

‡**CONARI PRESS**, 1144 65th St., Suite B, Emeryville CA 94608-1053. (510)596-4040. Fax: (510)654-7259. Editor: Mary Jane Ryan. Art Director: Karen Bouris. Estab. 1987. Publishes hardcover and trade paperback originals. Types of books include self help, women's issues and general non-fiction. Publishes 10 titles/year. Titles include *True Love* and *Random Acts of Kindness*. 10% require freelance illustration. Book catalog free.
Needs: Approached by 100 freelancers/year. Uses freelancers for jacket/cover illustration and design. Works on assignment only.
First Contact & Terms: Send query letter with samples. Samples are filed. Reports back to the artist only if interested. Rights purchased vary according to project. Originals returned at job's completion.
Jackets/Covers: Assigns 20-30 freelance design jobs/year. Pays by the project, $250-1,200.
Text Illustration: Assigns 1-3 freelance jobs/year. Pays by the project, $100-1,000.
Tips: "To get an assignment with me you need dynamic designs and reasonable prices."

THE CONSULTANT PRESS, LTD., 163 Amsterdam Ave., #201, New York NY 10023. (212)838-8640. Fax: (212)873-7065. Editor: Bob Persky. Estab. 1980. Imprints include The Photographic Arts Center, The Photograph Collector. Publishes hardcover and trade paperback originals and textbooks. Types of books include instruction, self help and reference. Specializes in art marketing and sales, photography. Publishes 6 titles/year. Recent titles include *Creating Effective Advertising*, by Mihai Nadin and Richard D. Zakia. 50% require freelance illustration; 50% require freelance design. Book catalog free by request.
Needs: Approached by 20 freelancers. Works with 3 freelance illustrators and 3 designers/year. Uses freelance artists mainly for jacket/cover illustration. Also for direct mail, book and catalog design. Needs computer-literate freelancers for design. 80% of freelance work demands knowledge of Aldus PageMaker or QuarkXPress. Works on assignment only.
First Contact & Terms: Send query letter with tearsheets, résumé and SASE, Samples are not filed and are returned by SASE. Reports back only if interested. Art Director will contact artist for portfolio review if interested. Portfolio should include color tearsheets. Rights purchased vary according to project. Originals are not returned.
Book Design: Assigns 4 freelance design jobs/year. Pays by the project, $500-1,000.
Jackets/Covers: Assigns 6 freelance design and 6 illustration jobs/year. Pays by the project, $350-750.
Text Illustration: Assigns 3 freelance illustration jobs/year. Pays by the project, $100-250.
Tips: First-time assignments are usually text illustration; book covers and jackets are given to "proven" freelancers. Finds artists through word of mouth and submissions.

‡**CONTEMPORARY BOOKS**, Dept. AGDM, 180 N. Stetson, Chicago IL 60601. (312)540-4590. Art Director: Kim Bartko. Book publisher. Publishes hardcover originals and trade paperback originals. Publishes nonfiction and fiction. Types of books include biography, cookbooks, instructional, humor, reference, self help, romance, historical and mainstream/contemporary. Publishes 70 titles/year. 5% require freelance illustration. Recent titles include *Camilla*, by Caroline Graham; and *Smart Parenting*, by Dr. Peter Favaro. Book catalog not available.
Needs: Approached by 150 freelancers/year. Works with 10 freelance illustrators/year. Works with freelance illustrators mainly for covers. Also for jacket/cover and text illustration. Works on assignment only. Freelancers should be familiar with QuarkXPress 3.31, Photoshop 3.0.1 and Illustrator 5.5.
First Contact & Terms: Send query letter with brochure and résumé. Samples are filed or are not returned. Does not report back. Originals sometimes returned to artist at job's completion when requested. To show

Market conditions are constantly changing! If you're still using this book and it is 1997 or later, buy the newest edition of Artist's & Graphic Designer's Market at your favorite bookstore or order directly from Writer's Digest Books.

portfolio, mail tearsheets and final reproduction/product. Considers complexity of project, skill and experience of artist and project's budget when establishing payment. Buys reprint rights.

Jackets/Covers: Assigns 7 freelance illustration jobs/year. Pays by the project, $500-1,000.

Text Illustration: Assigns 3 freelance jobs/year. Prefers computer generated art. Pays $25-55/hour.

Tips: "Several samples of the same technique aren't really necessary unless they treat vastly different subjects. Plese send samples first, then follow up with a call."

COOL HAND COMMUNICATIONS, INC., 1098 NW Boca Raton Blvd., Suite #1, Boca Raton FL 33432. (407)750-9826. Fax: (407)750-9869. Art Director: Cheryl Nathan. Estab. 1992. Company publishes hardcover, trade paperback and mass market paperback originals and trade paperback reprints. Types of books include contemporary, experimental, mainstream and historical fiction, western, adventure, mystery, biography, travel, self help, history, humor, coffee table books and cookbook. Publishes 15-20 titles/year. Recent titles include *Men The Handbook*, by Mindi Rudan; and *The College Student's Cookbook*, by David Bahr. 25% require freelance illustration; 10% require freelance design. Book catalog free for 9×12 SAE with 4 first-class stamps.

Needs: Approached by 50 freelancers/year. Works with 10 freelance illustrators and 5 designers/year. Uses freelancers for jacket/cover design and illustration, catalog design, text illustration, promotion and advertising. Needs computer-literate freelancers for design, illustration and production. 75% of freelance work demands knowledge of Adobe Illustrator, QuarkXPress, Adobe Photoshop or Aldus FreeHand. Works on assignment only.

First Contact & Terms: Send query letter with brochure, résumé, SASE, tearsheets and photocopies. Samples are filed or returned by SASE if requested by artist. Reports back only if interested. Art Director will contact artist for portfolio review if interested. Portfolio should include roughs, final art, slides, mock-ups, tearsheets, transparencies and photographs. Rights purchased vary according to project. Originals are not returned.

Book Design: Assigns 2-4 freelance design jobs/year. Pays by the project, $100-5,000.

Jackets/Covers: Assigns 2-4 freelance design and 5-10 illustration jobs/year. Pays by the project, $250-1,000. Prefers computer-generated designs for covers or mixed media.

Text Illustration: Assigns 5-10 freelance illustration jobs/year. Pays by the project, $100-1,000. Prefers b&w line art, either hand drawn or computer-generated.

Tips: First-time assignments are usually text illustrations; book jacket designs are given to "proven" freelancers. Finds artists through word of mouth and artists' submissions.

THE COUNTRYMAN PRESS, INC., Box 175, Woodstock VT 05091-0175. (802)457-1049. Production Manager: Fred Lee. Production Editor: Margaret Hanshaw. Estab. 1976. Book publisher. Publishes hardcover originals and reprints, and trade paperback originals and reprints. Types of books include contemporary and mainstream fiction, mystery, biography, history, travel, humor, cookbooks and recreational guides. Specializes in mysteries, recreational (biking/hiking) guides. Publishes 35 titles/year. Recent titles include *One Dead Tory* and *Connecticut, An Explorer's Guide*. 10% require freelance illustration; 100% require freelance cover design. Book catalog free by request.

Needs: Works with 4 freelance illustrators and 7 designers/year. Uses freelancers for jacket/cover and book design. Works on assignment only. Prefers working with computer-literate artists/designers within New England/New York with knowledge of Pagemaker 5.0, Photoshop 2.5, Illustrator 3.2, QuarkXPress 3.3 or FreeHand 3.1.

First Contact & Terms: Send query letter with appropriate samples. Samples are filed. Reports back to the artist only if interested. To show portfolio, mail best representations of style and subjects. Negotiates rights purchased. Originals are returned at job's completion.

Jackets/Covers: Assigns 30 freelance design jobs/year.

CRC PRODUCT SERVICES, (formerly CRC Publications), 2850 Kalamazoo Ave. SE, Grand Rapids MI 49560. (616)246-0780. Fax: (616)246-0834. Art Director: Dean Heetderks. Estab. 1866. Publishes hardcover and trade paperback originals. Types of books include instructional, religious, young adult, reference, juvenile and pre-school. Specializes in religious educational materials. Publishes 8-12 titles/year. Titles include *Grabbed by God* and *Too Close for Comfort*. 85% require freelance illustration.

Needs: Approached by 30-45 freelancers/year. Works with 12-16 freelance illustrators/year. Prefers freelancers with religious education, cross-cultural sensitivities. Uses freelancers for jacket/cover and text illustration. Needs computer-literate freelancers for illustration. 95% of freelance work demands knowledge of Adobe Illustrator, QuarkXPress, Photoshop or Aldus FreeHand. Works on assignment only.

First Contact & Terms: Send query letter with brochure, résumé, tearsheets, photographs, photocopies, photostats, slides and transparencies. Samples are filed. Request portfolio review in original query. Portfolio should include thumbnails, roughs, finished samples, color slides, tearsheets, transparencies and photographs. Buys one-time rights. Interested in buying second rights (reprint rights) to previously published artwork. Originals are returned at job's completion.

Jackets/Covers: Assigns 2-3 freelance illustration jobs/year. Pays by the project, $200-1,000.

Text Illustration: Assigns 50-100 freelance illustration jobs/year. Pays by the project, $75-100. "This is high volume work. We publish many pieces by the same artist."

Tips: Finds artists through word of mouth. "Be absolutely professional. Know how people learn and be able to communicate a concept clearly in your art."

CROSS CULTURAL PUBLICATIONS, INC., P.O. Box 506, Notre Dame IN 46556. Estab. 1980. Imprint is Cross Roads Books. Company publishes hardcover and trade paperback originals and textbooks. Types of books include biography, religious and history. Specializes in scholarly books on cross-cultural topics. Publishes 10 titles/year. Recent titles include *New Testament of the Inclusive Language Bible*, edited by Charles Stiles; and *Scaling the Dragon*, by Janice Moulton and George Robinson. Book catalog free for SASE.

Needs: Approached by 25 freelancers/year. Works with 2 freelance illustrators/year. Prefers local artists only. Uses freelance artists mainly for jacket/cover illustration.

First Contact & Terms: Send query letter with résumé and photocopies. Samples are not filed and are not returned. Reports back only if interested. Art Director will contact artist for portfolio review if interested. Portfolio should include b&w samples. Rights purchased vary according to project. Originals are not returned.

Jackets/Covers: Assigns 4-5 freelance illustration jobs/year. Pays by the project.

Tips: First-time assignments are usually book jackets. Finds artists through word of mouth.

CROSSWAY BOOKS, A Division of Good News Publishers, 1300 Crescent St., Wheaton IL 60187. Contact: Arthur Guye. "Please, no phone calls." Nonprofit Christian book publisher. Publishes hardcover and trade paperback originals and reprints. Specializes in Christian fiction (contemporary, mainstream, historical, science fiction, fantasy, adventure, mystery). Also publishes biography, juvenile, young adult, reference, history, self help, humor, and books on issues relevant to contemporary Christians. Publishes 40-50 titles/year. Titles include *Prophet , Tell Me the Secrets, Ashamed of the Gospel, The Singreale Chronicles, Always in September* and *Never Dance With a Bobcat*. 65% require freelance illustration; 35% require freelance design. Book catalog free for 9 × 12 SAE with adequate postage.

Needs: Approached by 150-200 freelancers/year. Works with 15 freelance illustrators and 8 designers/year. Uses freelancers mainly for book cover illustration/design. Also for text illustration (minimal), catalog design, advertising, brochure design, promotional materials, layout and production. Needs computer-literate freelancers for design and production. 20% of freelance work demands knowledge of QuarkXPress, Aldus FreeHand or Adobe Illustrator.

First Contact & Terms: Send query letter with 5-10 nonreturnable samples or quality color photocopies of printed or original art for files. Reports back only if interested. Portfolio review not required. Buys "all book and promotional rights." Considers buying second rights (reprint rights) to previously published work "depending on the original context of the art." Originals are returned at job's completion. Considers complexity of project, proficiency of artist and the project's budget when establishing payment.

Book Design: Pays by the hour, $15 minimum; by the project, $100 minimum.

Jackets/Covers: Assigns 26 freelance illustration and 20 design jobs/year. Prefers realistic and semi-realistic color illustration in all media. Looks for ability to consistently render the same children or people in various poses and situations (as in series books). Pays by the project, $200-2,000. Average budget: $1,000.

Text Illustration: Pays by the project, $100-750.

Tips: Finds artists through word of mouth, magazines, artists' submissions/self promotions, sourcebooks. "We are looking for Christian artists who are committed to spreading the Gospel of Jesus Christ through quality literature. Since we are a nonprofit organization, we may not always be able to afford an artist's 'going rate.' Quality and the ability to meet deadlines are critical. A plus would be a designer who could handle all aspects of a job from art direction to illustration to final keyline/mechanical. If you are interested in production work (type spec and keylining) please include your hourly rate and a list of references. Also looking for designers who can create imaginative typographic design treatments and inspired calligraphic approaches for covers."

CROWN PUBLISHERS, INC., 201 E. 50th St., New York NY 10022. Design Director: Ken Sansone. Art Director: Jim Davis. Specializes in fiction, nonfiction and illustrated nonfiction. Publishes 250 titles/year. Recent titles include *Pigtown*, by William J. Caunitz; *Daughters of Cain*, by Colin Dexter; and *The Information*, by Martin Amis.

Needs: Approached by several hundred freelancers/year. Works with 50 illustrators and 25 designers/year. Prefers local artists. Needs computer-literate freelancers for design. Freelancers should be familiar with QuarkXPress and Adobe Illustrator. Works on assignment only.

First Contact & Terms: Send query letter with samples showing art style. Reports only if interested. Originals are not returned. Rights purchased vary according to project.

Book Design: Assigns 20-30 design jobs/year. Pays by the project.

Jackets/Covers: Assigns 100 design and/or illustration jobs/year. Pays by the project.

Tips: "There is no single style. We use different styles depending on nature of the book and its perceived market. Become familiar with the types of books we publish. For example, don't send juvenile, sci-fi or romance. Book design has changed to Mac-generated layout."

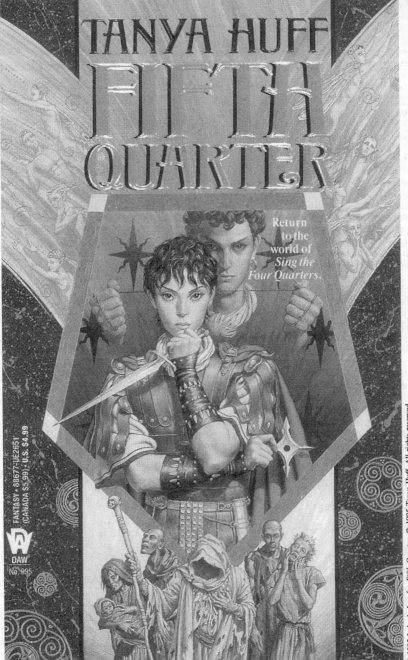

Jody A. Lee created this mystical cover image for Daw Books' Fifth Quarter, by Tanya Huff. This fantasy novel tells the story of brother and sister Imperial assassins forced to share the same body when the brother's is stolen by an evil magical enemy. Daw Art Director Betsy Wollheim likes Lee's "singular and well-defined style, excellently executed."

‡CRUMB ELBOW PUBLISHING, P.O. Box 294, Rhododendron OR 97049. (503)622-4798. Publisher: Michael P. Jones. Estab. 1982. Imprints include Oregon Fever Books, Tyee Press, Research Centrex, Read'n Run Books. Silhouette Imprints, Wildlife Research Group. Company publishes hardcover, trade paperback and mass market originals and reprints, textbooks, coloring books, poetry, cards, calendars, prints and maps. Types of books include adventure, biography, coffee table books, cookbooks, experimental fiction, fantasy, historical fiction, history, horror, humor, instructional, juvenile, mainstream fiction, New Age, nonfiction, pre-school, reference, religious, romance, science fiction, self help, textbooks, travel, western, and young adult. Specializes in Indians, environment, American history. Publishes 50 titles/year. Recent titles include *Oregon Trail & Its Pioneers*, and *Whispers to the Wind*. 75% require freelance illustration; 75% require freelance design. Book catalog available for $3.

Needs: Approached by 250 freelancers/year. Works with 50 freelancers and 35 designers/year. Uses freelancers for jacket/cover design and illustration, text illustration, book and catalog design, calendars, prints, note cards. Needs computer-literate freelancers for design and illustration. 50% of freelance work demands computer skills. Works on assignment only.

First Contact & Terms: Sene query letter with brochure, résumé, SASE, tearsheets, photographs, photocopies and slides. Samples are filed or returned by SASE if requested by artist. Reports back within 1 month. Request portfolio review in original query. Portfolio should include book dummy, final art, photographs, roughs, slides and tearsheets. Buys one-time rights. Originals are returned at job's completion.

Book Design: Assigns 60 freelance design jobs/year. Pays in published copies.

Jackets/Covers: Assigns 30 freelance design and 50 illustration jobs/year. Pays in published copies.

Text Illustration: Assigns 50 freelance illustration jobs/year. Pays in published copies. Prefers pen & ink.

Tips: "We find talented individuals to illustrate our projects any way we can. Generally artists hear about us and want to work with us. We are a very small company who gives beginners a chance to showcase their talents in a book project; and yet, more established artists are in touch with us because our projects are interesting (like American Indian mythology, The Oregon Trail, wildlife, etc.) and we do not art-direct anyone to death."

CUSTOM COMIC SERVICES, P.O. Box 1684, Austin TX 78767. Contact: Scott Deschaine. Estab. 1985. Specializes in educational comic books for promotion and advertising for use by business, education and government. "Our main product is full-color comic books, 16-32 pages long." Prefers pen & ink, airbrush and watercolor. Publishes 12 titles/year. Titles include *Light of Liberty* and *Visit To a Green Planet*.

Needs: Approached by 150 freelancers/year. Works with 24 freelancers/year. "We are looking for freelancers who can produce finished artwork for educational comic books from layouts provided by the publisher. They should be able to produce consistently high-quality illustrations for mutually agreeable deadlines, with no exceptions." Works on assignment only.

First Contact & Terms: Send query letter with business card and nonreturnable samples to be kept on file. Samples should be of finished comic book pages; prefers photostats. Reports within 6 weeks; must include SASE for reply. Considers complexity of project and skill and experience of artist when establishing payment. Buys all rights.

Text Illustration: Assigns 18 freelance jobs/year. "Finished artwork will be b&w, clean and uncluttered. Artists can have styles ranging from the highly cartoony to the highly realistic." Pays $100-250/comic book page of art.

Tips: "Send only samples of comic book pages. No reply without a SASE."

‡THE DANCING JESTER PRESS, 3411 Garth Rd., Suite 208, Baytown Texas 77521. (713)427-9560. Fax: (713)428-8685. Art Director: Nile Leirbag Lienad. Imprints include Dancing Dagger Publications, Third Millenium Spicery & Herb Publications, Gesture Graphic Design Books and Dancing See-Saw Press; also publishes *The Trickster Review of Cultural Censorship: Literature, Art Politics, Communications* (biannual periodical). Company publishes hardcover and trade paperback originals and reprints. Types of books include coffee table books, cookbooks, historical fiction, history, humor, instructional, juvenile, mainstream fiction, pre-school, reference, religious, romance, science fiction, self help, textbooks, western and young adult. Specializes in fiction, mystery, nonfiction, texts, nutrition/cookbook (low-fat vegetarian). Publishes 15 titles/year. Recent titles include *Blue-Atomic Heart-Eating Women Quantum Blue Soul-Eating Men*, by Gabriel Thomson (poetry, 23 illustrations). 50% require freelance design. Book catalog free by request with 4×9½ SASE with 2 first-class stamps.

Needs: Uses freelancers for book and catalog design, jacket/cover and text illustration. Needs computer-literate freelancers for design, illustration, production and presentation. 100% of freelance work demands knowledge of Aldus PageMaker, Adobe Illustrator, Adobe Photoshop and Aldus FreeHand.

First Contact & Terms: Send postcard sample of work or send query letter with brochure, résumé, SASE, tearsheets, photographs, photocopies and slides. Samples are returned by SASE if requested by artist. Art Director will contact artist for portfolio review if interested. Portfolio should include book dummy, final art, photographs, photostats, roughs, slides and tearsheets. Rights purchased vary according to projects. Originals are not returned.

Book Design: "The fee is negotiable. We are a new press. If we are not yet able to pay what we both agree your work is worth we prefer to wait until we can."

Jackets/Covers: Payment is negotiable. Considers all media.
Text Illustration: Assigns 10 freelance illustration jobs/year. Payment is negotiable. considera all media.
Tips: "We are looking everywhere for talent! We are new. We want to hear from artists with original ideas. We needed 200 illustrations in 1995."

JONATHAN DAVID PUBLISHERS, 68-22 Eliot Ave., Middle Village NY 11379. (718)456-8611. Fax: (718)894-2818. Production Coordinator: Fiorella de Lima. Estab. 1948. Company publishes hardcover originals. Types of books include biography, religious, young adult, reference, juvenile and cookbooks. Specializes in Judaica, sports, cooking. Publishes 25 titles/year. Recent titles include *Classic Bible Stories for Jewish Children*, by Alfred Kolatch; and *Great Jewish Women*, by Robert Slater. 50% require freelance illustration; 50% require freelance design. Book catalog free by request.
Needs: Approached by 15-20 freelancers/year. Works with 5 freelance illustrators and 5 designers/year. Prefers local freelancers with experience in book jacket design and jacket/cover illustration. Needs computer-literate freelancers for design. 50% of freelance work demands knowledge of Adobe Illustrator, QuarkXPress or Adobe Photoshop. Works on assignment only.
First Contact & Terms: Send query letter with résumé and photocopies. Samples are filed. Reports back within 2 weeks. Production Coordinator will contact artist for portfolio review if interested. Portfolio should include color final art and photographs. Buys all rights. Originals are not returned.
Book Design: Assigns 3 freelance design jobs/year. Pays by the project.
Jackets/Covers: Assigns 4-5 freelance design and 4-5 illustration jobs/year. Pays by the project.
Tips: First-time assignments are usually book jackets, mechanicals and artwork. Finds artists through submissions.

DAW BOOKS, INC., 3rd Floor, 375 Hudson St., New York NY 10014-3658. (212)366-2096. Fax: (212)366-2090. Art Director: Betsy Wollheim. Estab. 1971. Publishes hardcover and mass market paperback originals and reprints. Specializes in science fiction and fantasy. Publishes 72 titles/year. Recent titles include *Invader*, by C.J. Cherryh; *World Without End*, by Sean Russell; and *The White Gryphon*, by Mercedes Lackey and Larry Dixon. 50% require freelance illustration. Book catalog free by request.
Needs: Works with several illustrators and 1 designer/year. Buys more than 36 illustrations/year. Works with illustrators for covers. Works on assignment only.
First Contact & Terms: Send query letter with brochure, résumé, tearsheets, transparencies and SASE. Samples are filed or are returned by SASE only if requested. Reports back about queries/submissions within 2-3 days. Originals returned at job's completion. Call for appointment to show portfolio of original/final art, final reproduction/product and transparencies. Considers complexity of project, skill and experience of artist and project's budget when establishing payment. Buys first rights and reprint rights.
Jacket/Covers: Pays by the project, $1,500-8,000. "Our covers illustrate the story."
Tips: "We have a drop-off policy for portfolios. We accept them on Tuesdays, Wednesdays and Thursdays and report back within a day or so. Portfolios should contain science fiction and fantasy color illustrations *only*. We do not want to see anything else."

DELPHI PRESS, INC., P.O. Box 267990, Chicago IL 60626. (312)247-7910. Fax: (312)247-7912. President: Karen Jackson. Estab. 1989. Publishes trade paperback originals and reprints. Specializes in goddess spirituality, pagan theology, witchcraft. Publishes 10-15 titles/year. Recent titles include *The Wildman, the Earth and the Stars*, by Daniel E. Lorey; and *Godess of the Metropolis*, by Irene Javors. 100% require freelance illustration and design. Book catalog free by request.
Needs: Approached by 10-15 freelancers/year. Works with 8-12 illustrators/year. Buys 10-20 illustrations/year. Uses freelancers mainly for covers. Works on assignment only.
First Contact & Terms: Send query letter with any samples. Samples are filed. Art Director will contact artist for portfolio review if interested. Portfolio should include thumbnails, roughs, final art. Sometimes requests work on spec before assigning a job. Rights purchased vary according to project. Considers buying second rights (reprint rights) to previously published work. Originals are returned.
Jackets/Covers: Assigns 10-15 freelance illustration jobs/year. Pays by the project, $100-500.

‡T.S. DENISON & CO., INC., 9601 Newton Ave., Minneapolis MN 55024. (612)888-6404. Fax: (612)888-6318. Art Director: Darcy Myers. Estab. 1876. Publishes trade paperback originals and textbooks. Types of books include instructional, pre-school and reference. Specializes in teacher resource books, pre-kindergarten to grade 6. Recent titles include *Civil War* series, by Jane Pofahl; and *Library Safari*, by Linda Bolton. Publishes 50 titles/year. 70% require freelance illustration; 10% require freelance design. Book catalog free with SASE with first-class postage.
Needs: Approached by 20 freelancers/year. Works with 10 freelance illustrators and 2 designers/year. Prefers freelancers with experience. Uses freelancers mainly for 4-color covers and inside b&w line drawings. 25% of freelance work demands knowledge of Aldus PageMaker, Adobe Illustrator, QuarkXPress or Aldus FreeHand.

First Contact & Terms: Send query letter with SASE and photocopies. Samples are filed or are returned by SASE. Reports back within 1 month. Call or write for appointment to show portfolio of "what best shows work." Buys all rights. Originals are not returned.
Jackets/Covers: Assigns 5 freelance design and 50 illustration jobs/year. Prefers oil, watercolor, markers and computer art. Pays by the project, $300-400 for color cover.
Text Illustration: Pays by the hour, $20-25 for b&w interior.
Tips: Looking for "bright color work, quick turnaround and versatility. Style covers wide range—from 'cute' for preschool to graphic for upper elementary."

DIAL BOOKS FOR YOUNG READERS, 375 Hudson St., New York NY 10014. (212)366-2803. Fax: (212)366-2020. Editor: Toby Sherry. Specializes in juvenile and young adult hardcovers. Publishes 80 titles/year. Titles include *Brother Eagle, Sister Sky*; *Amazing Grace*; *Ryan White: My Own Story*; and *Rosa Parks*. 100% require freelance illustration. Books are "distinguished children's books."
Needs: Approached by 400 freelancers/year.Works with 40 freelance illustrators and 10 designers/year. Prefers freelancers with some book experience. Works on assignment only.
First Contact & Terms: Send query letter with brochure, tearsheets, photostats, slides and photographs. Samples are filed and not returned. Reports only if interested. Originals returned at job's completion. Call for appointment to show portfolio of original/final art and tearsheets. Considers complexity of project, skill and experience of artist and project's budget when establishing payment. Rights purchased vary.
Book Design: Assigns 10 freelance design jobs/year. Pays by the project.
Jackets/Covers: Assigns 2 freelance design and 8 illustration jobs/year. Pays by the project.
Text Illustration: Assigns 40 freelance illustration jobs/year. Pays by the project.

DOVE AUDIO, 301 N. Canon Dr., Suite 207, Beverly Hills CA 90210. (310)273-7722. Art Director: Rick Penn-Kraus. Publishes books and tapes. Needs illustrators and designers.

EDUCATIONAL IMPRESSIONS, INC., 210 Sixth Ave., Hawthorne NJ 07507. (201)423-4666. Fax: (201)423-5569. Art Director: Karen Neulinger. Estab. 1983. Publishes original workbooks with 2-4 color covers and b&w text. Types of books include instructional, juvenile, young adult, reference, history and educational. Specializes in all educational topics. Publishes 4-12 titles/year. Recent titles include *A Pot Full of Tales*, by Vowery Dodd Carlile; and *The Middle Ages*, by Rebecca Stark. Books are bright and bold with eye-catching, juvenile designs/illustrations. Book catalog free by request.
Needs: Works with 1-5 freelance illustrators/year. Prefers freelancers who specialize in children's book illustration. Uses freelancers for jacket/cover and text illustration. Also for jacket/cover design. Works on assignment only.
First Contact & Terms: Send query letter with tearsheets, photostats, résumé and photocopies. Samples are filed. Art Director will contact artist for portfolio review if interested. Buys all rights. Interested in buying second rights (reprint rights) to previously published work. Originals are not returned. Prefers line art for the juvenile market. Sometimes requests work on spec before assigning a job.
Book Design: Pays by the project, $20 minimum.
Jackets/Covers: Pays by the project, $20 minimum.
Text Illustration: Pays by the project, $20 minimum.

ELYSIUM GROWTH PRESS, 700 Robinson Rd., Toranga CA 90290. (310)455-1000. Fax: (310)455-2007. Art Director: Chris Moran. Estab. 1961. Small press. Publishes hardcover originals and reprints and trade paperback originals and reprints. Specializes in nudism/naturism, travel and lifestyle. Publishes 4 titles/year. Titles include *Nudist Magazines of the '50s and '60s*, Books 1, 2 and 3. 10% require freelance illustration; 10% require freelance design. Book catalog free for SAE with 2 first-class stamps.
Needs: Approached by 5 freelancers/year. Works with 2 freelance illustrators and 2 designers/year. Prefers freelancers with experience in rendering the human body and clothing. Uses freelancers mainly for covers and interior illustration. Also for jacket and book design. Needs computer-literate freelancers for illustration. 100% of freelance work demands knowledge of Macintosh. Works on assignment only.
First Contact & Terms: Send query letter with brochure, tearsheets and photocopies. Samples are filed. Reports back within 2 weeks. Artist should follow up with call after initial query. Sometimes requests work on spec before assigning a job. Buys one-time rights. Interested in buying second rights (reprint rights) to previously published artwork.
Book Design: Assigns 1 freelance design job/year. Pays by the hour, $20-50.
Jackets/Covers: Assigns 2 freelance design and 2 illustration jobs/year. Pays by the hour, $20-50.
Text Illustration: Assigns 8 freelance jobs/year. Pays by the hour, $20-50.
Tips: Finds artists through submissions ("nonreturnable color photocopies preferred").

M. EVANS AND COMPANY, INC., 216 E. 49th St., New York NY 10016. (212)688-2810. Fax: (212)486-4544. Managing Editor: Charles de Kay. Estab. 1956. Publishes hardcover and trade paperback originals.

Types of books include contemporary fiction, biography, health and fitness, history, self help, cookbooks and western. Specializes in western and general nonfiction. Publishes 30 titles/year. Recent titles include *Robert Crayhon's Nutrition Made Simple*, by Robert Crayhon; and *An Inquiry into the Existence of Guardian Angels*, by Pierre Jovanovic. 50% require freelance illustration and design.

Needs: Approached by 25 freelancers/year. Works with approximately 3 freelance illustrators and 10 designers/year. Buys 20 illustrations/year. Prefers local artists. Uses freelance artists mainly for jacket/cover illustration. Also for text illustration and jacket/cover design. Works on assignment only.

First Contact & Terms: Send query letter with brochure and résumé. Samples are filed. Art Director will contact artist for portfolio review if interested. Portfolios may be dropped off every Friday. Portfolio should include original/final art and photographs. Rights purchased vary according to project. Originals are returned at job's completion upon request.

Book Design: Assigns 20 freelance jobs/year. Pays by project, $200-500.

Jackets/Covers: Assigns 20 freelance design jobs/year. Pays by the project, $600-1,200.

Text Illustration: Pays by the project, $50-500.

FAIRCHILD FASHION & MERCHANDISING GROUP, BOOK DIVISION, Dept. AM, 7 W. 34th St., New York NY 10010. (212)630-3880. Fax: (212)630-3868. Art Director: David Jaenisch. Estab. 1966. Book publisher. Publishes "highly visual and design sensitive" hardcover originals and reprints and textbooks. Types of books include fashion, instruction, reference and history. Specializes in all areas of fashion, textiles and merchandising. Publishes 5-10 titles/year. Recent titles include *Dress & Identity*, by Roach-Higgins/Eicher/Johnson; and *Fashion Sketchbook*, 2nd edition, by Abling. 50% require freelance illustration; 50% require freelance design. Book catalog free by request.

Needs: Works with freelance illustrators and 8 designers/year. Prefers, but not restricted to freelancers with experience in fashion illustration, technical drawing, clothing and design. Uses freelancers mainly for book design. Also for jacket/cover design, text illustration and direct mail design. Needs computer-literate freelancers for design illustration and production. 75% of freelance work demands knowledge of Adobe Illustrator, QuarkXPress or Photoshop.

First Contact & Terms: Send résumé, tearsheets and photocopies. Samples are filed. Reports back to the artist only if interested. Write for appointment to show portfolio, or mail color tearsheets and as many printed samples as possible. Buys all rights. Originals not returned.

Book Design: Assigns 6 freelance design jobs/year. Pays by the project, $3,000-7,000.

Jackets/Covers: Assigns 4 freelance design and 4 illustration jobs/year. Pays by the project, $1,000-3,000. "Work is usually computer-generated but could also be done traditionally. Must have very strong type sensibilities."

Text Illustration: "Prefers computer-generated work for technical illustration; any media for fashion." Pays by the project, $500-5,000.

Tips: "Be punctual; bring portfolio and ask questions about the project. We'd like to see more fashion illustrations and renditions and drafted art."

F&W PUBLICATIONS INC., 1507 Dana Ave., Cincinnati OH 45207. Art Director: Clare Finney. Imprints: Writers Digest Books, North Light Books, Betterway Books, Story Press. Publishes 100-120 books annually for writers, artists and photographers, plus selected trade (lifestyle, home improvement) titles. Recent titles include: *The Fiction Dictionary, Capturing Light in Oils* and *Creative Bedroom Decorating*. Books are heavy on type-sensitive design. Book catalog available for 6×9 SASE.

Needs: Works with 10-20 freelance illustrators and 5-10 designers/year. Uses freelancers for text illustration and cartoons. Also for jacket/cover design and illustration, text illustration, direct mail and book design. Needs computer-literate freelancers for design and production. 95% of freelance work demands knowledge of QuarkXPress. Works on assignment only.

First Contact & Terms: Send nonreturnable photocopies of printed work to be kept on file. Art Director will contact artist for portfolio review if interested. Interested in buying second rights (reprint rights) to previously published. "We like to know where art was previously published."

Book Design: Pays by the project, $500-1,000.

Jackets/Covers: Pays by the project, $400-850.

Text Illustration: Pays by the project, $100 minimum.

Tips: Finds illustrators and designers through word of mouth and artists' submissions/self promotions. "Don't call. Send a brief letter with appropriate samples we can keep. Clearly indicate what type of work you are looking for. If you're looking for design work, don't send illustration samples."

FANTAGRAPHICS BOOKS, INC., 7563 Lake City Way, Seattle WA 98115. Phone/fax: (206)524-1967. Publisher: Gary Groth. Estab. 1976. Publishes hardcover and trade paperback originals and reprints. Types of books include contemporary, experimental, mainstream, historical, humor and erotic. "All our books are comic books or graphic stories." Publishes 100 titles/year. Recent titles include *Love & Rockets, Hate, Eightball, Acme Novelty Library, JIM* and *Naughty Bits*. 10% require freelance illustration. Book catalog free by request.

Needs: Approached by 500 freelancers/year. Works with 25 freelance illustrators/year. Must be interested in and willing to do comics. Uses freelancers for comic book interiors and covers.

First Contact & Terms: Send query letter addressed to Submissions Editor with résumé, SASE, photocopies and finished comics work. Samples are not filed and are returned by SASE. Reports back to the artist only if interested. Call or write for appointment to show portfolio of original/final art and b&w samples. Buys one-time rights or negotiates rights purchased. Originals are returned at job's completion. Pays royalties.

Tips: "We want to see completed comics stories. We don't make assignments, but instead look for interesting material to publish that is pre-existing. We want cartoonists who have an individual style, who create stories that are personal expressions."

‡FARRAR, STRAUS & GIROUX, INC., Dept. AGDM, 19 Union Square W., New York NY 10003. (212)741-6900. Art Director: Michael Kaye. Production Coordinator: Harvey Hoffman. Book publisher. Estab. 1946. Publishes hardcover and trade paperback originals and trade paperback reprints. Publishes nonfiction and fiction. Types of books include biography, cookbooks, juvenile, self-help, historical and mainstream/contemporary. Publishes 120 titles/year. 40% require freelance illustration; 40% freelance design.

Needs: Works with 12 freelance designers/year. Uses artists for jacket/cover and book design.

First Contact & Terms: Send brochure, tearsheets and photostats. Samples are filed and are not returned. Reports back only if interested. Originals are returned at job's completion. Call or write for appointment to show portfolio of photostats and final reproduction/product. Considers complexity of project and budget when establishing payment. Buys one-time rights.

Book Design: Assigns 40 freelance design jobs/year. Pays by the project, $300-450.

Jackets/Covers: Assigns 40 freelance design jobs/year. Pays by the project, $750-1,500.

Tips: The best way for a freelance illustrator to get an assignment is "to have a great portfolio and referrals."

‡FOREIGN SERVICES RESEARCH INSTITUTE/WHEAT FORDERS, Box 6317, Washington DC 20015-0317. (202)362-1588. Director: John E. Whiteford Boyle. Specializes in paperback originals of modern thought, nonfiction and philosophical poetry.

Needs: Works with 2 freelancers/year. Freelancers should understand the principles of book jacket design. Works on assignment only.

First Contact & Terms: Send query letter to be kept on file. Reports within 15 days. Originals not returned. Considers project's budget when establishing payment. Buys first rights or reprint rights.

Book Design: Assigns 1-2 freelance jobs/year. Pays by the hour, $25-35 average.

Jackets/Covers: Assigns 1-2 freelance design jobs/year. Pays by the project, $250 minimum.

Tips: "Submit samples of book jackets designed for and accepted by other clients. Include SASE, please."

FOREST HOUSE PUBLISHING CO., INC. & HTS BOOKS, P.O. Box 738, Lake Forest IL 60045-0738. (708)295-8287. President: Dianne Spahr. Children's book publisher. Types of books include instructional, fantasy, mystery, self-help, young adult, reference, history, juvenile, pre-school and cookbooks. Specializes in early readers, sign language, bilingual dictionaries, Spanish children's titles, moral lessons by P.K. Hallinan and Stephen Cosgrove, history. Publishes 5-10 titles inhouse, and as many as 26 titles with other trade publishers. Recent titles include *The Missing Money* and *Mystery of the UFO* (both in The Red Door Detective Club series by Janet Riehecky, illustrated by Lydia Halverson). 90% require freelance illustration and design. Book catalog free by request.

Needs: Approached by 20 freelance artists/year. Works with 5 illustrators and 5 designers/year. Prefers artists with experience in children's illustration. Uses freelancers for jacket/cover and text illustration, book and catalog design. Needs computer-literate freelancers for design, illustration and production. 25% of freelance work demands computer skills. Works on assignment only.

First Contact & Terms: Send query letter with brochure, résumé, photographs, photocopies and 4-color and b&w illustrations. Samples are not filed and are returned by SASE if requested by artist. Reports back within 2 months only if interested. Call for appointment to show portfolio or mail b&w and color roughs, one piece of final art, dummies. Rights purchased vary according to project. Originals are returned at job's completion if requested.

Book Design: Assigns 10 freelance design jobs/year. Pays by the project.

Jackets/Covers: Assigns 10 freelance design and 10 illustration jobs/year. Pays by the project.

Text Illustration: Assigns 10 freelance jobs/year. Pays by the project.

Tips: "Send samples with a SASE which we will keep on file. Please do not call us."

FORWARD MOVEMENT PUBLICATIONS, 412 Sycamore St., Cincinnati OH 45202. (513)721-6659. Fax: (513)421-0315. Associate Director: Sally B. Sedgwick. Estab. 1934. Publishes trade paperback originals. Types of books include religious. Publishes 24 titles/year. Recent titles include *Larger than Life*, by Robert Horine; and *Seasons of the Heart*, by Edward West. 75% require freelance illustration. Book illustration is usually suggestive, not realistic. Book catalog free for SAE with 3 first-class stamps.

Needs: Approached by 2 freelancers/year. Works with 2-4 freelance illustrators and 1-2 designers/year. Uses freelancers mainly for illustrations required by designer. "We also keep original clip art-type drawings on file to be paid for as used."

First Contact & Terms: Send query letter with tearsheets, photographs, photocopies and slides. Samples are sometimes filed. Art Director will contact artist for portfolio review if interested. Sometimes requests work on spec before assigning a job. Interested in buying second rights (reprint rights) to previously published work. Rights purchased vary according to project. Originals sometimes returned at job's completion.
Jackets/Covers: Assigns 18 freelance design and 6 illustration jobs/year. Pays by the project, $25-175.
Text Illustration: Assigns 1-4 freelance jobs/year. Pays by the project, $10-200; pays $5-25/picture. Prefers pen & ink.
Tips: Finds artists mainly through word of mouth. If you send clip art, include fee you charge for use.

‡**FRIENDSHIP PRESS PUBLISHING CO.**, 475 Riverside Dr., New York NY 10115. (212)870-2280. Art Director: E. Paul Lansdale (Room 552). Specializes in hardcover and paperback originals, reprints and textbooks; "adult and children's books on social issues from an ecumenical perspective." Publishes more than 10 titles/year; many require freelance illustration. Recent titles include *Choices, Claiming the Promise, The Community of Nations* and *Remembering the Future*.
Needs: Approached by more than 50 freelancers/year. Works with 10-20 freelance illustrators and 8-10 designers/year. Works on assignment only. Freelancers should be familiar with Aldus PageMaker, Quark XPress or Adobe Illustrator.
First Contact & Terms: Send brochure showing art style or résumé, tearsheets, photostats, slides, photographs and "even black & white photocopies. Send nonreturnable samples." Samples are filed and are not returned. Reports back only if interested. Originals are returned to artist at job's completion. Call or write for appointment to show portfolio, or mail thumbnails, roughs, original/final art, photostats, tearsheets, final reproduction/product, photographs, slides, transparencies or dummies. Considers skill and experience of artist, project's budget and rights purchased when establishing payment.
Book Design: Pays by the hour, $12-20.
Jackets/Covers: Assigns 10 freelance design and over 5 illustration jobs/year. Pays by the project, $300-400.
Text Illustration: Assigns more than 8 freelance jobs/year. Pays by the project, $25-75, b&w.

‡**FULCRUM PUBLISHING**, 350 Indiana St., Suite 350, Golden CO 80401. (303)277-1623. Fax: (303)279-7111. Production Director: Jay Staten. Estab. 1986. Book publisher. Publishes hardcover originals and trade paperback originals and reprints. Types of books include biography, reference, history, self help, travel, humor, gardening and nature. Specializes in history, nature, travel and gardening. Publishes 50 titles/year. Recent titles include *The Undaunted Garden*, by Lauren Springer; and *Stifled Laughter*, by Claudia Johnson. 15% require freelance illustration; 85% require freelance design. Book catalog free by request.
Needs: Approached by 50 freelancers/year. Works with 4 freelance illustrators and 6 designers/year. Prefers local freelancers only. Uses freelancers mainly for cover and interior illustrations for gardening books. Also for other jacket/covers, text illustration and book design. Works on assignment only.
First Contact & Terms: Send query letter with résumé, tearsheets, photographs, photocopies and photostats. Samples are filed. Reports back to the artist only if interested. To show portfolio, mail b&w photostats. Buys one-time rights. Originals are returned at job's completion.
Book Design: Assigns 25 freelance design and 6 illustration jobs/year. Pays by the project, $350-2,000.
Jackets/Covers: Assigns 20 freelance design and 4 illustration jobs/year. Pays by the project.
Text Illustration: Assigns 10 freelance design and 1 illustration jobs/year. Pays by the project.

‡**GALLAUDET UNIVERSITY PRESS**, 800 Florida Ave. NE, Washington DC 20002. (202)651-5488. Fax: (202)651-5489. E-mail: mercarew@gallua.gallaudet.edu. Production Manager: Mary Ellen Carew. Estab. 1980. Publishes hardcover originals and reprints, textbooks and children's books. Types of books include instructional, pre-school, history and American sign language/deaf-related. Specializes in topics pertaining to deafness and American sign language. Publishes 12 titles/year. Recent titles include *Deaf President Now!*, by John B. Christiansen and Sharon N. Barnartt; and *The Night Before Christmas Told in Signed English*, by Harry Borustein and Karen Saulnier. 5% require freelance illustration; 100% require freelance design. Book catalog free by request.
Needs: Approached by 75-100 freelancers/year. Works with 1-2 freelance illustrators and 10 designers/year. Freelancers must be "willing to work for our modest fee." Uses freelancers mainly for children's books. Also for jacket/cover illustration. Needs computer-literate freelancers for design and production. Freelancers should be familiar with PostScript, WordPerfect 5.3 and up for PC, Microsoft Word for Mac. Works on assignment only.
First Contact & Terms: Send query letter with résumé, photocopies and a few examples of color work. "Don't send slides, please." Samples are filed or are returned if requested by artist. Fax or write for appointment to show portfolio of roughs and final art. Negotiates rights purchased. Originals are returned at job's completion.
Book Design: Assigns 10-12 freelance design jobs/year. Pays by the project, $350-2,500 (for multi-volume works). Works with experienced designers of high quality books.
Jackets/Covers: Assigns 10-12 freelance design jobs/year. Pays by the project, $350 minimum. "We tend to be somewhat traditional."

Text Illustration: Assigns 1 illustration job/year. Pays by the project $150 minimum or pays fee for illustrating children's book: $3,000 advance against 5% royalties. Nothing "cartoonish or saccharine, and please, no science fiction or rock 'n' roll."

GEM GUIDES BOOK CO., 315 Cloverleaf Dr., Suite F, Baldwin Park CA 91706. (818)855-1611. Fax: (818)855-1610. Editor: Robin Nordhues. Estab. 1964. Book publisher and wholesaler of trade paperback originals and reprints. Types of books include earth sciences, western, instructional, travel, history and regional (western US). Specializes in travel and local interest (western Americana). Publishes 6 titles/year. Recent titles include *San Francisco Street Secrets*, by David Eames; and *50 Hikes in New Mexico*, by Harry Evans. 75% require freelance illustration and design. Book catalog free for SASE.
Needs: Approached by 24 freelancers/year. Works with 3 freelance illustrators and 3 designers/year. Buys 12 illustrations/year. Uses freelancers mainly for covers. Also for text illustratin and book design. Needs computer-literate freelancers for design, illustration and production. 100% of freelance work demands knowledge of Aldus PageMaker, Aldus FreeHand, Appleone Scanner and Omnipage Professional. Works on assignment only.
First Contact & Terms: Send query letter with brochure, résumé and SASE. Samples are filed. Art Director will contact artist for portfolio review if interested. Requests work on spec before assigning a job. Buys all rights. Originals are not returned.
Book Design: Assigns 6 freelance design jobs/year. Pays by the project.
Jackets/Covers: Pays by the project.
Text Illustration: Assigns 2 freelance jobs/year. Pays by the project.
Tips: Finds artists through word of mouth and "our files."

GENEALOGICAL INSTITUTE/FAMILY HISTORY WORLD, Box 22045, Salt Lake City UT 84122. (801)257-6174. Manager: JoAnn Jackson. Estab. 1972. Publishes trade paperback originals and textbooks. Types of books include instructional, self help and reference. Specializes in genealogy. Publishes 3-5 titles/year. Recent titles include *Immigration Digest II* and *Early Settlers*, both by Arlene H. Eakle, Ph.D. 10% require freelance illustration and design. Book catalog free for SAE with 2 first-class stamps.
Needs: Approached by 1 freelancer/year. Works with 1 freelance illustrator and 1 designer/year. Prefers local freelancers with experience in maps. Uses freelancers mainly for covers. Also for text illustration. Works on assignment only.
First Contact & Terms: Send query letter with brochure and résumé. Samples are filed. Reports back only if interested. To show portfolio mail copies of final art. Rights purchased vary according to project. Originals are not returned.
Jackets/Covers: Assigns 3-5 freelance design and 3-5 illustration jobs/year. Pays by the project.

GIBBS SMITH, PUBLISHER, P.O. Box 667, Layton UT 84041. (801)544-9800. Editorial Director: Madge Baird. Estab. 1969. Company publishes hardcover and trade paperback originals, textbooks. Types of books include western, gardening, humor, juvenile, cookbooks, design/interior. Specializes in humor, western, architecture and interior design, nature. Publishes 30 titles/year. Recent titles include *Sunflowers* and *The Log Home Book*. Book catalog available for 9×12 SAE with $1.48 first-class postage.
Needs: Approached by 50 freelancers/year. Works with 10 freelance illustrators and 10 designers/year. Buys 100 freelance illustrations/year. Uses freelancers mainly for jacket/cover illustrations and interior line illustrations. Also for text illustration, jacket/cover and book design. Needs computer-literate freelancers for design and production. 75% of freelance work demands knowledge of Aldus PageMaker or QuarkXPress. Works on assignment only.
First Contact & Terms: Send brochure, photocopies and slides. Samples are filed. Reports back only if interested. Art Director will contact artist for portfolio review if interested. Portfolio should include color thumbnails, tearsheets and photographs. Rights purchased vary according to project. Originals are returned at job's completion if requested.
Book Design: Assigns 50 freelance design jobs/year. Pays by the project, average $700 plus layout.
Jackets/Covers: Assigns 50 freelance design jobs and 5 illustration jobs/year. Pays by the project, $300-500.
Text Illustration: Pays by the project or by the piece, $40-50. Prefers ink or pastel.
Tips: First-time assignments are usually text illustration; book design, jacket/cover are given to "proven" freelancers. Finds artists through submissions and word of mouth.

C.R. GIBSON, 32 Knight St., Norwalk CT 06856. (203)847-4543. Creative Services Coordinator: Harriet Richards. Publishes 100 titles/year. 95% require freelance illustration.
Needs: Works with approximately 70 freelancers/year. Works on assignment "most of the time."
First Contact & Terms: Send tearsheets, slides and/or published work. Samples are filed or are returned by SASE. Reports back within 1 month only if interested. Considers complexity of project, project's budget and rights purchased when establishing payment. Negotiates rights purchased.

Book Design: Assigns at least 65 freelance design jobs/year. Pay by the project, $1,200 minimum.
Jackets/Covers: Assigns 20 freelance design jobs/year. Pays by the project, $500 minimum.
Text Illustration: Assigns 20 freelance jobs/year. Pays by the hour, $15 minimum; or by the project, $1,500 minimum.

GLENCOE/McGRAW-HILL PUBLISHING COMPANY, Dept. AGDM, 15319 Chatsworth St., Mission Hills CA 91345. (818)898-1391. Fax: (818)837-3668. Art/Design/Production Manager: Sally Hobert. Vice President, Art/Design/Production: Donna Faull. Estab. 1965. Book publisher. Publishes textbooks. Types of books include foreign language, career education, art and music, religious education. Specializes in most el-hi (grades 7-12) subject areas. Publishes 250 titles/year. Recent titles include *Art Talk* and *Teen Health*. 80% require freelance illustration; 40% require freelance design.
Needs: Approached by 50 freelancers/year. Works with 20-30 freelance illustrators and 10-20 designers/year. Prefers experienced artists. Uses freelance artists mainly for illustration and production. Also for jacket/cover design and illustration, text illustration and book design. Works on assignment only.
First Contact & Terms: Send query letter with brochure, tearsheets, photocopies or slides to Sally Hobeft. Samples are filed. Sometimes requests work on spec before assigning a job. Negotiates rights purchased. Originals are not returned.
Book Design: Assigns 10-20 freelance design and many illustration jobs/year. Pays by the project.
Jackets/Covers: Assigns 5-10 freelance design and 5-20 illustration jobs/year. Pays by the project.
Text Illustration: Assigns 20-30 freelance design jobs/year. Pays by the project.

‡GLENCOE/McGRAW-HILL PUBLISHING COMPANY, 3008 W. Willow Knolls Rd., Peoria IL 61615. (309)689-3200. Fax: (309)689-3211. Contact: Ardis Parker, Design and Production Manager, and Art and Photo Editors. Specializes in secondary educational materials (hardcover, paperback, filmstrips, software), especially in industrial and computer technology, home economics and family living, social studies, career education, etc. Publishes more than 100 titles/year.
Needs: Works with over 30 freelancers/year. Needs computer-literate freelancers for design, illustration and production. 60% of freelance work demands knowledge of Adobe Illustrator, QuarkXPress or Photoshop. Works on assignment only.
First Contact & Terms: Send query letter with brochure, résumé and "any type of samples." Samples not filed are returned if requested. Reports back in weeks. Originals are not returned; works on work-for-hire basis with rights to publisher. Considers complexity of the project, skill and experience of the artist, project's budget, turnaround time and rights purchased when establishing payment. Buys all rights.
Book Design: Assigns 30 freelance design jobs/year. Pays by the project.
Jackets/Covers: Assigns 50 freelance design jobs/year. Pays by the project.
Text Illustration: Assigns 50 freelance jobs/year. Pays by the hour or by the project.
Tips: "Try not to cold call and never drop in without an appointment."

GLOBE PEQUOT PRESS, 6 Business Park Rd., P.O. Box 833, Old Saybrook CT 06475. (203)395-0440. Production manager: Kevin Lynch. Estab. 1947. Publishes hardcover and trade paperback originals and reprints. Types of books include business, cookbooks, instruction, self-help, history and travel. Specializes in regional subjects: New England, Northwest, Southeast bed-and-board country inn guides. Publishes 100 titles/year. 20% require freelance illustration; 40% require freelance design. Recent titles include *Recommened Country Inns* series; *Travel Smarts*, by Herbert Teisen and Nancy Dunnan; and *Guide to Cape Cod*, by Frederich Pratsen, revised by Jerry Morris. Design of books is "classic and traditional, but fun." Book catalog free.
Needs: Works with 5-10 freelance illustrators and 5-10 designers/year. Uses freelancers mainly for cover and text design and production. Also for jacket/cover and text illustration and direct mail design. Needs computer-literate freelancers for production. 100% freelance work demands knowledge of QuarkXPress, Adobe Illustrator or Adobe Photoshop. Works on assignment only.
First Contact & Terms: Send query letter with brochure, résumé and photostats. Samples are filed and not returned. Request portfolio review in original query. Artist should follow up with call after initial query. Art Director will contact artist for portfolio review if interested. Portfolio should include roughs, original/final art, photostats, tearsheets and dummies. Requests work on spec before assigning a job. Considers complexity of project, project's budget and turnaround time when establishing payment. Buys all rights. Originals are not returned.
Book Design: Pays by the hour, $15-25 for production; or by the project, $200-600 for cover design.
Jackets/Covers: Prefers realistic style. Pays by the hour, $20-35; or by the project, $500 maximum.
Text Illustration: Prefers pen & ink line drawings. Pays by the project, $25-100.
Tips: Finds artists through word of mouth, submissions, self promotion and sourcebooks. "More books are being produced using the Macintosh. We like designers who can use the Mac competently enough that their design looks as if it *hasn't* been done on the Mac."

‡❀GOOSE LANE EDITIONS LTD., 469 King St., Fredericton, New Brunswick E3B 1E5 Canada. (506)450-4251. Art Director: Julie Scriver. Estab. 1958. Publishes hardcover originals and trade paperback originals

of poetry, fiction and nonfiction. Types of books include biography, cookbooks, fiction, reference and history. Publishes 10-15 titles/year. 10% require freelance illustration. Titles include *A Guide to Animal Behavior* and *Pete Luckett's Complete Guide to Fresh Fruit and Vegetables*. Books are "high quality, elegant, generally with full-color fine art reproduction on cover." Book catalog free for SAE with Canadian first-class stamp or IRC.

Needs: Approached by 3 freelancers/year. Works with 1-2 illustrators/year. Prefers to work with freelancers in the region. Works on assignment only.

First Contact & Terms: Send query letter with résumé, slides, transparencies and SASE. Samples are filed or are returned by SASE. Reports back in 1 month. Call or write for appointment to show portfolio of roughs, original/final art, final reproduction/product and slides. Negotiates rights purchased.

Jackets/Covers: Assigns 1-2 freelance illustration jobs/year. Prefers painting (dependent on nature of book). Pays by the project, $200-400.

Text Illustration: Assigns 1-2 freelance jobs/year. Prefers line drawing. Pays by the project, $300-1,500.

Tips: "A sensibility to individual house styles *and* market trends is a real asset."

GOSPEL LIGHT PUBLICATIONS, 2300 Knoll Dr., Ventura CA 93003. (805)644-9721. Fax: (805)644-4729. Creative Director: B. Denzel. Estab. 1932. Book publisher. Publishes hardcover, trade paperback and mass market paperback originals. Types of books include contemporary fiction, instructional, pre-school, juvenile, young adult, reference, self help and history. Specializes in Christian issues. Publishes 15 titles/year. Recent titles include *Victory Over the Darkness*, by Neil Anderson; *The Measure of a Man*, by Gene Getz; and *Bible Verse Coloring Pages*. 25% require freelance illustration; 10% require freelance design. Book catalog available for SASE.

Needs: Approached by 300 artists/year. Works with 10 illustrators and 4 designers/year. Buys 10 illustrations/year. Uses freelancers mainly for jacket/cover illustration and design. Also for text illustration; direct mail, book and catalog design. Works on assignment only.

First Contact & Terms: Send SASE, tearsheets, photographs and samples. Samples are filed or are returned by SASE if requested by artist. Reports back to the artist only if interested. Art Director will contact artist for portfolio review if interested. Portfolio should include color photostats, tearsheets, photographs, slides or transparencies. Negotiates rights purchased. Originals are returned to artist at job's completion.

Book Design: Assigns 4 freelance design and 5 illustration jobs/year. Pays by the project.

Jackets/Covers: Assigns 5 freelance design and 5 freelance illustration jobs/year. Accepts all types of styles and media for jacket/cover design and illustration. Pays by the project.

Text Illustration: Assigns 6 freelance design and 8 illustration jobs/year. Prefers line art and cartoons. Pays by the project.

Tips: "Computer operators are not necessarily good designers, yet many are designing books. Know the basics of good typography before trying to use the computer."

THE GRADUATE GROUP, 86 Norwood Rd., W. Hartford CT 06117-2236. (203)232-3100. President: Mara Whitman. Estab. 1967. Publishes trade paperback originals. Types of books include instructional and reference. Specializes in internships and career planning. Publishes 25 titles/year. Recent titles include *New Internships for 1994-1995*, by Robert Whitman; and *Careers in Law Enforcement*, by Lt. Jim Nelson. 10% require freelance illustration and design. Book catalog free by request.

Needs: Approached by 20 freelancers/year. Works with 1 freelance illustrator and 1 designer/year. Prefers local freelancers only. Uses freelancers for jacket/cover illustration and design; direct mail, book and catalog design. Needs computer-literate freelancers for illustration and presentation. 5% of freelance work demands computer skills. Works on assignment only.

First Contact & Terms: Send query letter with brochure and résumé. Samples are not filed. Reports back only if interested. Write for appointment to show portfolio.

‡GREAT QUOTATIONS PUBLISHING, 1967 Quincy Court, Glendale Heights IL 60139. (708)582-2800. Fax: (708)582-2813. Editor: Ringo Suek. Estab. 1985. Imprint of Greatime Offset Printing. Company publishes hardcover, trade paperback and mass market paperback originals. Types of books include coffee table books, humor and self help. Specializes in humor and inspiration. Publishes 40 titles/year. Recent titles include *Mrs. Webster Dictionary* (paperback, humorous definition book). 90% require freelance illustration and design. Book catalog available for $1.50 with SASE.

Needs: Approached by 100 freelancers/year. Works with 10 freelance illustrators/year and 10 designers/year. Prefers local artists. Uses freelancers for jacket/cover illustration and design; book and catalog design. Needs computer-literate freelancers for design, illustration and production. 50% of freelance work demands knowledge of QuarkXPress and Adobe Photoshop. Works on assignment only.

First Contact & Terms: Send query letter with brochure, résumé, SASE, photographs and photocopies. Samples are filed or returned by SASE if requested by artist. Reports back within 1 month. Art Director will contact artist for portfolio review if interested. Portfolio should include book dummy and final art. Rights purchased vary according to project. Originals are returned at job's completion.

Book Design: Assigns 20 freelance design jobs/year. Pays by the project, $300-3,000.
Jackets/Covers: Assigns 10 freelance design jobs/year and 10 illustration jobs/year. Pays by the project, $300-3,000.
Text Illustration: Assigns 10 freelance illustration jobs/year. Pays by the project, $100-1,000.
Tips: Finds artists through word of mouth and *Creative Black Book*. "We're looking for bright, colorful cover design on a small size book cover (around 6×6)."

GROSSET & DUNLAP, 200 Madison Ave., New York NY 10016. (212)951-8736. Art Director: Ronnie Ann Herman. Publishes hardcover, trade paperback and mass market paperback originals and board books for pre-school and juvenile audience (ages 1-10). Specializes in "very young mass market children's books." Publishes 90 titles/year. Recent titles include *Spider's Lunch*, by Joanna Cole and *Color*, by Ruth Heller. 100% require freelance illustration; 10% require freelance design.
• Many books by this publisher feature unique design components such as acetate overlays, 3-D pop-up pages, or actual projects/toys that can be cut out of the book.
Needs: Works with 50 freelance illustrators and 1-2 freelance designers/year. Buys 80 books' worth of illustrations/year. "Be sure your work is appropriate for our list." Uses freelance artists mainly for book illustration. Also for jacket/cover and text illustration.
First Contact & Terms: Send query letter with tearsheets, slides, photocopies and transparencies. Samples are filed. Reports back to the artist only if interested. Call for appointment to show portfolio, or mail slides, color tearsheets, transparencies and dummies. Rights purchased vary according to project. Originals are returned at job's completion.
Book Design: Assigns 20 design jobs/year (mechanicals only). Pays by the hour, $15-22 for mechanicals.
Jackets/Covers: Assigns approximately 10 cover illustration jobs/year. Pays by the project, $1,500-2,500.
Text Illustration: Assigns approximately 80 projects/year. Pays by the project, $4,000-10,000.
Tips: "We are always looking for people who can illustrate wonderful babies and children. We are looking for good strong art."

‡GROUP PUBLISHING—BOOK & CURRICULUM DIVISION, 2890 N. Monroe, Loveland CO 80539. (303)669-3836. Fax: (303)669-3269. Art Director: Lisa Smith. Company publishes books, Bible curriculum products (including puzzles and posters), clip art resources and audiovisual materials for use in Christian education for children, youth and adults.
• This company also produces magazines. See listing in Magazines section for more information.
Needs: Uses freelancers for cover illustration and design. Occasionally uses cartoons in books and teacher's guides. Uses b&w and color illustration on covers and in book interiors.
First Contact & Terms: Contact Liz Howe, Marketing Director, if interested in cover design or illustration. Send query letter with b&w or color photocopies, slides, tearsheets or other samples. Samples are filed or returned by SASE if requested by artist. Reports back only if interested. Rights purchased vary according to project.
Text Illustration: Pays on acceptance: $35-150 for b&w (from small spot illustrations to full page). Fees for color illustration vary and are negotiable. Prefers b&w line or line and wash illustrations to accompany lesson activities.
Tips: "We prefer contemporary, nontraditional styles appropriate for our innovative and upbeat products and the creative Christian teachers and students who use them. We seek artists who can help us achieve our goal of presenting biblical material in fresh, new and engaging ways."

GRYPHON PUBLICATIONS, P.O. Box 209, Brooklyn NY 11228. Publisher: Gary Lovisi. Estab. 1983. Book and magazine publisher of hardcover originals, trade paperback originals and reprints, reference and magazines. Types of books include science fiction, fantasy, mystery and reference. Specializes in crime fiction and bibliography. Publishes 10 titles/year. Titles include *Difficult Lives*, by James Sallis; *Vampire Junkies*, by Norman Spinrad. 40% require freelance illustration; 10% require freelance design. Book catalog free for #10 SASE.
• Also publishes *Hardboiled*, a quarterly magazine of noir fiction and *Paperback Parade* on collectible paperbacks.
Needs: Approached by 50-100 freelancers/year. Works with 6 freelance illustrators and 1 designer/year. Prefers freelancers with "professional attitude." Uses freelancers mainly for book and magazine cover and interior illustrations. Also for jacket/cover, book and catalog design. Works on assignment only.

A bullet introduces comments by the editor of Artist's & Graphic Designer's Market *indicating special information about the listing.*

First Contact & Terms: Send query letter with brochure, résumé, SASE, tearsheets, photographs and photocopies. Samples are filed. Reports back within 2 weeks only if interested. Portfolio should include thumbnails, roughs, b&w tearsheets. Buys one-time rights. "I will look at reprints if they are of high quality and cost effective." Originals are returned at job's completion if requested.
Jackets/Covers: Assigns 2 freelance design and 6 illustration jobs/year. Pays by the project, $25-150.
Text Illustration: Assigns 4 freelance jobs/year. Pays by the project, $10-100. Prefers b&w line drawings.

♣GUERNICA EDITIONS, P.O. Box 117, Station P, Toronto, Ontario M5S 2S6 Canada. (416)657-8885. Fax: (416)657-8885. Publisher/Editor: Antonio D'Alfonso. Estab. 1978. Book publisher and literary press specializing in translation. Publishes trade paperback originals and reprints. Types of books include contemporary and experimental fiction, biography, young adult and history. Specializes in ethnic/multicultural writing and translation of European and Quebecois writers into English and Italian/Canadian and Italian/American. Publishes 16-20 titles/year. Recent titles include *Benedetta in Guysterland*, by G. Rimanelli; *The Voices We Carry*, edited by M.J. Bona; and *The World at Noon*, by E. Mirabelli. 40-50% require freelance illustration. Book catalog available for SAE; nonresidents send IRC.
Needs: Approached by 6 freelancers/year. Works with 6 freelance illustrators/year. Uses freelancers mainly for jacket/cover illustration.
First Contact & Terms: Send query letter with résumé, SASE (or SAE with IRC), tearsheets, photographs and photocopies. Samples are filed or are returned by SASE if requested by artist. Reports back only if interested. To show portfolio, mail photostats, tearsheets and dummies. Buys one-time rights. Originals are not returned at job completion.
Jackets/Covers: Assigns 10 freelance illustration jobs/year. Pays by the project, $150-200.

HARMONY HOUSE PUBLISHERS—LOUISVILLE, P.O. Box 90, Prospect KY 40059. (502)228-4446. Fax: (502)228-2010. Art Director: William Strode. Estab. 1980. Publishes hardcover originals. Specializes in general books, cookbooks and education. Publishes 20 titles/year. Titles include *The Saddlebred—America's Horse of Distinction* and *Sandhurst—The Royal Military Academy*. 10% require freelance illustration. Book catalog not available.
Needs: Approached by 10 freelancers/year. Works with 2-3 freelance illustrators/year. Prefers freelancers with experience in each specific book's topic. Uses freelancers mainly for text illustration. Also for jacket/cover illustration. Usually works on assignment basis.
First Contact & Terms: Send query letter with brochure, résumé, SASE and appropriate samples. Samples are filed or are returned. Reports back to the artist only if interested. "We don't usually review portfolios, but we will contact the artist if the query interests us." Buys one-time rights. Sometimes returns originals at job's completion. Assigns 2 freelance design and 2 illustration jobs/year. Pays by the project.

HARPERCOLLINS PUBLISHING, 10 E. 53rd St., New York NY 10022-5299. (212)207-7835. Art Director: Mary McDonnel. Company publishes hardcover, trade paperback and mass market paperback originals and reprints and textbooks. Types of books include adventure, biography, coffee table books, cookbooks, experimental fiction, fantasy, historical fiction, history, horror, humor, instructional, juvenile, mainstream fiction, New Age, nonfiction, pre-school, reference, religious, romance, science fiction, self help, textbooks, travel, western and young adult. Specializes in college textbooks. Publishes 250-300 titles/year. 50% require freelance illustration; 60% require freelance design. Book catalog free by request.
Needs: Approached by 40-70 freelancers/year. Works with 20 freelance illustrators and 20 designers/year. Buys more than 1,000 freelance illustrations/year. Uses freelancers for jacket/cover design and illustration, text illustration and book design. Needs computer-literate freelancers for design, illustration and production. 100% of freelance work demands knowledge of Adobe Illustrator 5.0, QuarkXPress 3.2 and Adobe Photoshop 2.5. Works on assignment only.
First Contact & Terms: Send postcard sample of work or send query letter with brochure, résumé and tearsheets. Samples are filed and are not returned. Art Director will contact artist for portfolio review if interested. Portfolio should include final art and tearsheets. Rights purchased vary according to project.
Book Design: Assigns 100 freelance design jobs/year. Pays by the project.
Jackets/Covers: Assigns 200 freelance design and 80 illustration jobs/year. Pays by the project. Prefers Quark/Illustrator.
Text Illustration: Assigns 150 freelance illustration jobs/year. Pays by the project. Prefers Quark/Illustrator.
Tips: Finds artists through agents, sourcebooks, word of mouth, artists' submissoins and attending art exhibitions.

HARVEST HOUSE PUBLISHERS, 1075 Arrowsmith, Eugene OR 97402. (503)343-0123. Fax: (503)342-6410. Production Manager: Barbara Sherrill. Specializes in hardcover and paperback editions of adult fiction and nonfiction, children's books and youth material. Publishes 95 titles/year. Recent titles include *The Knight & the Dove*; *Jerusalem—The City of God*; and *To My Dear Slimeball*. Books are of contemporary designs which compete with the current book market.
Needs: Works with 10 freelance illustrators and 4-5 freelance designers/year. Uses freelance artists mainly for cover art. Also uses freelance artists for text illustration. Works on assignment only.

First Contact & Terms: Send query letter with brochure, résumé, tearsheets and photographs. Art Director will contact artist for portfolio review if interested. Requests work on spec before assigning a job. Originals may be returned at job's completion. Buys all rights.
Book Design: Pays by the project.
Jackets/Covers: Assigns 65 design and 10 illustration jobs/year. Pays by the project.
Text Illustration: Assigns 5 jobs/year. Pays by the project, $25-125.
Tips: Finds artists through word of mouth and artists' submissions/self-promotions.

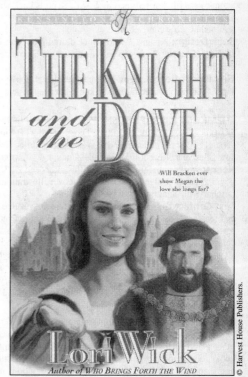

The cover of Lori Wick's Christian fiction bestseller The Knight and the Dove, *from Harvest House Publishers, features a painting by Frank Ordaz. "The montage picks out the intriguing elements from the story and captures the characters of the book," says Harvest House Art Director Barbara Sherrill.*

© Harvest House Publishers.

HEARTLAND SAMPLERS, INC., 5555 W. 78th St., Suite. P, Edina MN 55439. (612)942-7754. Fax: (612)942-6307. Art Director: Nancy Lund. Estab. 1987. Book publisher. Types of products include perpetual calendars, books and inspirational gifts. Publishes 50 titles/year. Titles include *Share the Hope* and *Tea Time Thoughts*. 100% require freelance illustration and design. Book catalog for SAE with first-class postage.
Needs: Approached by 4 freelancers/year. Works with 10-12 freelance illustrators and 2-4 designers/year. Prefers freelancers with experience in the gift and card market. Uses freelancers for illustrations; jacket/cover illustration and design; direct mail, book and catalog design.
First Contact & Terms: Send query letter with brochure, résumé, SASE, tearsheets, photographs, slides and photocopies. Samples are filed or are returned by SASE if requested by artist. Art Director will contact artist for portfolio review if interested. Portfolio should include thumbnails, roughs, 4-color photographs and dummies. Sometimes requests work on spec before assigning a job. Rights purchased vary according to project.
Book Design: Assigns 12 freelance design jobs/year. Pays by the project, $35-300.
Jackets/Covers: Assigns 15-40 freelance design jobs/year. Prefers watercolor, gouache and acrylic. Pays by the project, $50-350.
Text Illustration: Assigns 2 freelance design jobs/year. Prefers watercolor, gouache and acrylic. Pays by the project, $50-200.

HEAVEN BONE PRESS, Box 486, Chester NY 10918. (914)469-9018. E-mail: 71340.520@compuser ve.com. President/Editor: Steve Hirsch. Estab. 1987. Book and magazine publisher of trade paperback originals. Types of books include poetry and contemporary and experimental fiction. Publishes 4-6 titles/year. Recent titles include *Down with the Move*, by Kirpal Gordon. Design of books is "off-beat, eclectic and stimulating." 80% require freelance illustration. Book catalog available for SASE.

• This publisher often pays in copies. Approach this market if you're seeking to build your portfolio and are not concerned with payment. The press also publishes *Heaven Bone* magazine for which illustrations are needed.

Needs: Approached by 10-12 freelancers/year. Works with 3-4 freelance illustrators. Uses freelancers mainly for illustrations. Needs computer-literate freelancers for illustration. 5% of work demands knowledge of QuarkXPress, Aldus FreeHand, Adobe Illustrator or Photoshop.

First Contact & Terms: Send query letter with brochure, tearsheets, photostats, photographs and slides. Samples are filed or returned by SASE. Reports back within 3 months. To show portfolio, mail finished art, photostats, tearsheets, photographs and slides. Rights purchased vary according to project. Originals are returned at job's completion.

Book Design: Assigns 1-2 freelance design jobs/year. Prefers to pay in copies, but has made exceptions.

Jackets/Covers: Prefers to pay in copies, but has made exceptions. Prefers pen & ink, woodcuts and b&w drawings.

Text Illustration: Assigns 1-2 freelance design jobs/year.

Tips: "Know our specific needs, know our magazine and be patient."

***HEMKUNT PRESS PUBLISHERS**, A-78 Naraina Indl. Area Ph.I, New Delhi 110028 India. Phone: 505079, 541-0083. Fax: 505079, 541-0032. Director: Mr. G.P. Singh. Specializes in educational text books, illustrated general books for children and also books for adults. Subjects include religion and history. Publishes 30-50 new titles/year. Recent titles include *Aladdin & Alibaba*, by Vernon Thomas.

Needs: Works with 30-40 freelance illustrators and 20-30 designers/year. Uses freelancers mainly for illustration and cover design. Also for jacket/cover illustration. Works on assignment only. Freelancers should be familiar with Ventura.

First Contact & Terms: Send query letter with résumé and samples to be kept on file. Prefers photographs and tearsheets as samples. Samples not filed are not returned. Art Director will contact artist for portfolio review if interested. Requests work on spec before assigning a job. Originals are not returned. Considers complexity of project, skill and experience of artist and project's budget when establishing payment. Buys all rights. Interested in buying second rights (reprint rights) to previously published artwork.

Book Design: Assigns 40-50 freelance design jobs/year. Payment varies.

Jackets/Covers: Assigns 30-40 freelance design jobs/year. Pays $20-50.

Text Illustration: Assigns 30-40 freelance jobs/year. Pays by the project, $50-600.

‡HILL AND WANG, 19 Union Square West, New York NY 10003. (212)741-6900. Fax: (212)633-9385. Art Director: Michael Ian Kay. Imprint of Farrar, Straus & Giroux. Imprint publishes hardcover, trade and mass market paperback originals and hardcover reprints. Types of books include biography, coffee table books, cookbooks, experimental fiction, historical fiction, history, humor, mainstream fiction, New Age, nonfiction and self help. Specializes in literary fiction and nonfiction. Publishes 120 titles/year. Recent titles include *Bird Artist, Grace Paley Collected Stories*. 20% require freelance illustration; 10% require freelance design.

Needs: Approached by hundreds of freelancers/year. Works with 10-20 freelance illustrators and 10-20 designers/year. Prefer artist without rep with a strong portfolio. Uses freelancers for jacket/cover illustration and design. Works on assignment only.

First Contact & Terms: Send postcard sample of work or query letter with portfolio samples. Samples are filed and are not returned. Reports back only if interested. Artist should continue to send new samples. Portfolios may be dropped off every Tuesday and should include printed jackets. Rights purchased vary according to project. Originals are returned at job's completion.

Book Design: Pays by the project.

Jackets/Covers: Assign 10-20 freelance design and 10-20 illustration jobs/year. Pays by the project, $500-1,500.

Text Illustration: Assigns 10-20 freelance illustration jobs/year. Pays by the project, $500-1,500.

Tips: Finds artists through word of mouth and artists' submissions.

HOLIDAY HOUSE, 425 Madison Ave., New York NY 10017. (212)688-0085. Editorial Director: Margery Cuyler. Specializes in hardcover children's books. Publishes 50 titles/year. 75% require freelance illustration. Recent titles include *From Pictures to Words*, by Janet Stevens; and *I'm the Boss*, by Elizabeth Winthrop.

Needs: Approached by more than 125 freelancers/year. Works with 20-25 freelancers/year. Prefers art suitable for children and young adults. Uses freelancers mainly for interior illustration. Also for jacket/cover illustration. Works on assignment only.

First Contact & Terms: Samples are filed or are returned by SASE. Request portfolio review in original query. Artist should follow up with call after initial query. Reports back only if interested. Considers complexity of project, skill and experience of artist and project's budget when establishing payment. Buys one-time rights. Originals are returned at job's completion.

Jackets/Covers: Assigns 5-10 freelance illustration jobs/year. Pays by the project, $900-1,200.
Text Illustrations: Assigns 5-10 freelance jobs/year. Pays royalty.
Tips: Finds artists through artists' submissions, agents and sourcebooks. "Show samples of everything you do well and like to do."

HOLLOW EARTH PUBLISHING, P.O. Box 1355, Boston MA 02205-1355. (603)433-8735. Fax: (603)433-8735. Publisher: Helian Yvette Grimes. Estab. 1983. Company publishes hardcover, trade paperback and mass market paperback originals and reprints, textbooks, electronic books and CD-ROMs. Types of books include contemporary, experimental, mainstream, historical and science fiction, instruction, fantasy, travel, and reference. Specializes in mythology, photography, computers (Macintosh). Publishes 5 titles/year. Titles include *Norse Mythology, Legend of the Niebelungenlied.* 50% require freelance illustration; 50% require freelance design. Book catalog free for #10 SAE with 1 first-class stamp.
Needs: Approached by 250 freelancers/year. Prefers freelancers with experience in computer graphics. Uses freelancers mainly for graphics. Also for jacket/cover design and illustration, text illustration and book design. Needs computer-literate freelancers for design, illustration, production and presentation. 100% of freelance work demands knowledge of Adobe Illustrator, QuarkXPress, Adobe Photoshop, Aldus FreeHand or rendering programs. Works on assignment only.
First Contact & Terms: Send query letter with brochure, résumé and SASE. Samples are filed or are returned by SASE if requested by artist. Reports back within 1 month. Art Director will contact artist for portfolio review if interested. Portfolio should include color thumbnails, roughs, tearsheets and photographs. Buys all rights. Originals are returned at job's completion.
Book Design: Assigns 12 book and magazine covers/year. Pays by the project, $100 minimum.
Jackets/Covers: Assigns 12 freelance design and 12 illustration jobs/year. Pays by the project, $100 minimum.
Text Illustration: Assigns 12 freelance illustration jobs/year. Pays by the project, $100 minimum.
Tips: First-time assignments are usually article illustrations; covers are given to "proven" freelancers. Finds artists through submissions and word of mouth.

‡HENRY HOLT BOOKS FOR YOUNG READERS, 115 W. 18th St., 6th Floor, New York NY 10011. (212)886-9200. Fax: (212)645-5832. Art Director: Martha Rago. Estab. 1866. Imprint of Henry Holt and Company, Inc. Imprint publishes hardcover and trade paperback originals and reprints. Types of books include juvenile, pre-school and young adult. Specializes in picture books and young adult nonfiction and fiction. Publishes 75-100 titles/year. Recent titles include *The Maestro Plays, Cool Salsa, My House, Barnyard Banter* and *Phoenix Rising.* 100% require freelance illustration. Book catalog free by request.
Needs: Approached by 1,300 freelancers/year. Works with 30-50 freelance illustrators and designers/year. Uses freelancers for jacket/cover and text illustration. Works on assignment only.
First Contact & Terms: Send postcard sample of work or query letter with tearsheets, photostats and SASE. Samples are filed or returned by SASE if requested by artist. Reports back within 1-3 months if interested. Portfolios may be dropped off every Monday. Art Director will contact artist for portfolio review if interested. Portfolio should include photostats, final art, roughs and tearsheets. "Anything artist feels represents style, ability and interests." Rights purchased vary according to project. Originals are returned at job's completion.
Jackets/Covers: Assigns 20-30 freelance illustration jobs/year. Pays $800-1,000.
Text Illustration: Assigns 30-50 freelance illustration jobs/year. Pays $5,000 minimum.
Tips: Finds artists through word of mouth, artists' submissions and attending art exhibitions.

HOMESTEAD PUBLISHING, Box 193, Moose WY 83012. Art Director: Carl Schreier. Estab. 1980. Publishes hardcover and paperback originals. Types of books include nonfiction, natural history, Western art and general Western regional literature. Publishes more than 30 titles/year. Recent titles include *Tales of the Grizzly, Wildflowers of the Rocky Mountains* and *The Ape & The Whale.* 75% require freelance illustration. Book catalog free for SAE with 4 first-class stamps.
Needs: Works with 20 freelance illustrators and 10 designers/year. Prefers pen & ink, airbrush, charcoal/pencil and watercolor. Needs computer-literate freelancers for design and production. 25% of freelance work demands knowledge of Aldus PageMaker or Aldus FreeHand. Works on assignment only.
First Contact & Terms: Send query letter with printed samples to be kept on file or write for appointment to show portfolio. For color work, slides are suitable; for b&w, technical pen, photostats. "Include one piece of original artwork to be returned." Samples not filed are returned by SASE only if requested. Reports back within 10 days. Rights purchased vary according to project. Originals are not returned.
Book Design: Assigns 6 freelance design jobs/year. Pays by the project, $50-3,500.
Jackets/Covers: Assigns 2 freelance design and 4 illustration jobs/year. Pays by the project, $50-3,500.
Text Illustration: Assigns 50 freelance illustration jobs/year. Prefers technical pen illustration, maps (using airbrush, overlays, etc.), watercolor illustrations for children's books, calligraphy and lettering for titles and headings. Pays by the hour, $5-20 or by the project, $50-3,500.
Tips: "We are using more graphic, contemporary designs and looking for the best quality."

Research Turns Fantasy into Reality

David Cherry

Science fiction and fantasy artist David Cherry didn't set out to become an artist, although he had always enjoyed drawing. In college he studied the classics and then went for a lucrative law degree. Yet two or three years into his law practice, something happened to change his life forever.

His sister, a Latin teacher by day, had been writing science fiction by night under the name C.J. Cherryh. "All the evenings I thought she was up late typing the next day's lesson plan, she had been writing books and, by golly, she'd sold one," Cherry says.

When his sister was nominated for an award in 1976, she asked him to go with her to the World Science Fiction Convention in Kansas City where they would announce the winners.

"When we got there I walked into an area almost the length of a football field packed with beautiful paintings, many of which I had seen on book covers. These were all fantasy subjects, but the painting style was representational, the style I really wanted to do. The subject matter, too, tied together with my interests in ancient history, myth and legend."

Cherry couldn't get the convention art show out of his mind. Gradually, he made the switch from lawyer to full-time, professional artist. As a lawyer, Cherry learned the importance of research and applied this to his new career. Since he was most interested in doing paintings for fantasy books, he attended conventions and talked with others in the field. He also researched the market by studying the covers of books on bookstore shelves.

"I pretended I had assignments to do book covers. I felt it was just a matter of trying and failing and trying again. I would get very excited when I had a failure. It would give me a target for what I needed to learn."

Cherry turned to books or to other artists to learn how to fix problems. "But mostly, I spent a lot of hours working at it, giving up most of my social life. It was push, push, push."

After a few years of practice, Cherry felt he was ready to approach publishers. He found some art directors were willing to look over his portfolio in person, while others had drop-off policies, so he put together two portfolios, one to drop off while he was taking another on interviews.

"I told them I really wanted to work for them but knew my portfolio wasn't good enough yet. I asked them to show me where I was failing so the next time I could show them a portfolio that would please them. I got a lot of instructive

comments tucked into the portfolios and many busy art directors took time to help me."

As time went on, he began filling his portfolio with work from real cover art jobs. "One bit of advice on creating pieces for your portfolio—make sure the painting is done in the same proportions, while not necessarily the same size, as a real book cover. Paperback book covers are about 4¼ by 7 inches. Your work is much better received if you leave the top third of your painting free for type."

Sometimes artists are given free reign to choose which scene to illustrate, says Cherry. Other times they are given very specific instructions. "In general, you are sent a manuscript, you read it and, as you read it, you take note of pages and scenes that would do well for a cover," Cherry explains. "Then you work out quick thumbnail sketches as to how you would structure composition, what the characters might look like, what accessories or accoutrements they might have. You may have to invent them as you draw or create costumes and hire models for a photo shoot."

Cherry works at moderate speed. "I can do two covers a month, maybe three, but that's pushing it. You have to add in time for reading the manuscript, coming up with five or six really good sketches and coming to some agreement on which one you will actually paint."

Cherry puts most of his effort up front, long before he does the actual painting. "I spend a lot of time on the drawing stage and I'll spend time finding models,

Fantasy artist David Cherry strives to keep his characters authentic looking by taking great care in creating details such as dress, accoutrements and background, obvious in his ready-for-action heroine, "Bladeswoman."

© David Cherry. Reprinted with permission.

taking references of them, getting the perspectives right, the costuming right, setting the lighting correctly—all the things that go into a top-notch piece."

Working with art directors can be rewarding, Cherry says, but the art director often does not have the final say. "More and more it's a committee decision involving the editor, and the marketing department as well as the art director." This, he says, can be very frustrating and artists must be prepared to compromise.

Science fiction artists face different challenges than those working in other genres, says Cherry. "Romance cover artists have it easier because they are painting things that exist in everyday life. They may have to invent a little costuming but mostly they work very closely from their photographs. When you've got to paint a spaceship, a space station, one or a number of aliens, an alien environment, you've got to stop and invent it. You have to ask yourself things like, 'How are these aliens' legs jointed? How does the musculature work? What's the skin texture? Do they have hair?' You have to invent everything."

Art directors look for specific things in the science fiction and fantasy realm. "In our field you must be able to do people representationally, realistically. And you have to do animals well if you are doing fantasy, because most involve either animals or aliens that look like people or animals. You need to be able to handle different lighting situations and you've got to be able to put figures in an environment and make them look like they belong there."

Once relegated to pulp fiction paperback and magazine art, science fiction and fantasy art has gained respect in the art world. "When I started, selling work for book covers or at conventions was about it," explains Cherry. "Now galleries from all over call me to display work. You can do sculpture, figurines, porcelain work, bronzes. You can work in movies with special effects and matte paintings or do matte paintings for CD-ROM games—backgrounds for characters to walk across. There's T-shirts, jigsaw puzzles, computer animated art. Some of the biggest fine art print companies are interested in science fiction and fantasy."

Anyone considering becoming a full-time artist, should be prepared to be a one-person company as well, says Cherry. "You won't make most of your living by just doing a painting and selling it. You make it, especially if you are doing book covers, by selling and reselling the rights to your paintings. You not only have to know how to price your paintings, but also how to handle selling the different rights to your work. And you don't spend all your time painting. You spend a lot of time packing and shipping, preparing boards for painting, hauling materials, studying new techniques, soliciting work, going to social functions and networking—about 1,000 different things."

Cherry has a lot of help from his wife, Davette. His work has become a family business, he says. Thanks to Davette's help, Cherry is working on a set of art trading cards, a number of limited edition plates, a series of backgrounds for a CD-ROM game and a screen saver as well as book covers.

Book covers take the most time and make him the least money of all his endeavors, but Cherry says he finds doing them a special experience. "Science fiction and fantasy are hopeful genres. These are stories in which man continues to exist and has a future; they not only identify man's problems but show him overcoming them with style and nobility. I like being a part of something like that. Art, like literature, is communication and I like communicating positive things—that it's worth getting up in the morning and fighting the fight."

—Robin Gee

‡**HOUGHTON MIFFLIN COMPANY**, Children's Book Department, 215 Park Ave. S., New York NY 10003. (212)420-5800. Art Director: David Saylor. Estab. 1940. Company publishes hardcover originals. Types of books include juvenile, pre-school and young adult. Publishes 50 titles/year. Recent titles include *Our Granny*, *One Cow Coughs*, *A Book of Fruit*, *The Egyptian Polar Bear* and *Fireman Small*. 100% require freelance illustration; 10% require freelance design. Book catalog not available.

Needs: Approached by 400 freelancers/year. Works with 50 freelance illustrators and 10 designers/year. Prefer artists with interest in or experience with children's books. Uses freelancers mainly for jackets, picture books. Also for jacket/cover design and illustration, text illustration, book and catalog design. Needs computer-literate freelancers for design and production. 100% of freelance work demands knowledge of QuarkXPress.

First Contact & Terms: Send postcard sample of work or send query letter with tearsheets, photographs, slides, SASE, photocopies and transparencies. Samples are filed or returned by SASE. Reports back within 1 month. Art Director will contact artist for portfolio review if interested. Portfolios may be dropped off every Wednesday. Portfolio should include book dummy, slides, transparencies, roughs and tearsheets. Rights purchased vary according to project. Works on assignment only.

Book Design: Assigns 10 freelance design jobs/year. Pays by the project.

Jackets/Covers: Assigns 8 freelance illustration jobs/year. Pays by the project.

Text Illustration: Assigns 40 freelance illustration jobs/year. Pays by the project.

Tips: Finds artists through sourcebooks, word of mouth, artists' submissions.

HOWELL PRESS, INC., 1147 River Rd., Suite 2, Charlottesville VA 22901. (804)977-4006. Fax: (804)971-7204. President: Ross Howell. Estab. 1985. Company publishes hardcover and trade paperback originals. Types of books include history, coffee table books, cookbooks, gardening and transportation. Publishes 5-6 titles/year. Recent titles include *A Wartime Log*, by Art and Lee Beltone; and *Sunday Drivers*, by Frank Monarty. 100% requires freelance illustration and design. Book catalog free by request.

Needs: Approached by 6-8 freelancers/year. Works with 0-1 freelance illustrator and 1-2 designers/year. "It's most convenient for us to work with local freelance designers." Uses freelancers mainly for graphic design. Also for jacket/cover, direct mail, book and catalog design. Needs computer-literate freelancers for design and production. 80% of freelance work demands knowledge of Aldus PageMaker, Adobe Illustrator or QuarkXPress.

First Contact & Terms: Send query letter with SASE, tearsheets and slides. Samples are not filed and are returned by SASE if requested by artist. Reports back within 1 month. Art Director will contact artist for portfolio review if interested. Portfolio should include color tearsheets and slides. Negotiates rights purchased. Originals are returned at job's completion.

Book Design: Assigns 5-6 freelance design jobs/year. Pays for design by the hour, $15-25; by the project, $500-5,000.

Tips: Finds artists through submissions.

HUMANICS LIMITED, 1482 Mecaslin St. NW, Atlanta GA 30309. (404)874-2176. Fax: (404)874-1976. Acquisitions Editor: W. Arthur Bligh. Estab. 1976. Publishes soft and hardcover children's books, trade paperback originals and educational activity books. Publishes 12 titles/year. Recent titles include *Creatures of an Exceptional Kind*, by Dorothy B. Whitney; and *The Tao of Learning*, by Pamela Metz and Jacqueline Tobin. Learning books are workbooks with 4-color covers and line art within; Children's House books are high-quality books with full color; trade paperbacks are 6×9 with 4-color covers. Book catalog for 9×12 SASE. Specify which imprint when requesting catalog: Learning, Children's House or trade paperbacks.

Needs: Works with 3-5 freelance illustrators and designers/year. Needs computer-literate freelancers for design, production and presentation. "Artists must provide physical mechanicals or work on PC compatible disk." Works on assignment only.

First Contact & Terms: Send query letter with résumé, SASE and photocopies. Samples are filed or are returned by SASE if requested by artist. Rights purchased vary according to project. Originals are not returned.

Book Design: Pays by the project, $250 minimum.

Jackets/Covers: Pays by the project, $150 minimum.

Text Illustration: Pays by the project, $150 minimum.

‡**HUNTER HOUSE PUBLISHERS**, P.O. Box 2914, Alameda CA 94501-0914. Production Manager: Paul J. Frindt. Specializes in hardcover and paperback originals; adult and young adult nonfiction. Specializes in health and psychology. Publishes 6-11 titles/year.

Needs: Works with 2-3 freelancers/year. Prefers local freelancers. Needs computer-literate freelancers for design and production. 80% of work demands knowledge of Ventura Publisher and IBM-compatible programs. Works on assignment only.

First Contact & Terms: Send query letter with résumé, slides and photographs. Samples are filed or are returned by SASE. Reports back within weeks. Write for appointment to show portfolio of thumbnails, roughs, original/final art, photographs, slides, transparencies and dummies. Buys all rights. Originals are not returned.

Book Design: Assigns 2-3 freelance design jobs/year. Pays by the hour, $7.50-15; or by the project, $250-750.

Jackets/Covers: Assigns 3-6 freelance design and 4-8 illustration jobs/year. Pays by the hour, $10-25; or by the project, $250-750.

Text Illustration: Assigns 1-3 jobs/year. Pays by the hour, $10-18; or by the project, $150-450.

Tips: "We work closely with freelancers and prefer those who are open to suggestion, feedback and creative direction. Much of the time may be spent consulting; we don't appreciate impatient or excessively defensive responses. In book design we are conservative; in cover and illustration rather conceptual and somewhat understated, but interested in originality."

‡HUNTINGTON HOUSE PUBLISHERS, P.O. Box 53788, Lafayette LA 70505. (318)237-7049. Fax: (318)237-7060. Managing Editor: Mark Anthony. Estab. 1979. Book publisher. Publishes hardcover, trade paperback and mass market paperback originals. Types of books include contemporary fiction, juvenile, religious and political issues. Specializes in politics, personal stories and religion. Publishes 30 titles/year. Recent titles include *The Demonic Roots of Globalism*, by Gary Kah; and *Out of Control*, by Brenda Scott. 5% require freelance illustration. Book catalog free on request.

Needs: Approached by 15 freelancers/year. Works with 2 freelance illustrators/year. Uses freelancers for jacket/cover illustration and design and text illustration. Works on assignment only.

First Contact & Terms: Send query letter with brochure, résumé and photocopies. Samples are filed. Reports back to the artist only if interested. To show a portfolio, mail thumbnails, roughs and dummies. Buys all rights. Originals are returned at job's completion.

Text Illustration: Assigns 1 freelance design and 1 illustration job/year. Payment "is arranged through author."

‡IDEALS PUBLICATIONS INC., P.O. Box 305300, Nashville TN 37230. (615)781-1421. Editor: Lisa C. Thompson. Estab. 1944. Company publishes hardcover originals and *Ideals* magazine. Specializes in nostalgia and holiday themes. Publishes 5-7 titles/year. Recent titles include *Valentine Ideals* and *First Ladies of the White House*. 100% require freelance illustration; 30% require freelance design. Guidelines free for #10 SASE with 1 first-class stamp.

Needs: Approached by 300 freelancers/year. Works with 10-12 freelance illustrators and 1-3 designers/year. Prefers freelancers with experience in illustrating people, nostalgia, botanical flowers. Uses freelancers mainly for flower borders (color), people and spot art. Also for text illustration, jacket/cover and book design. 10% of freelance work demands computer knowledge of Adobe Illustrator, QuarkXPress and Adobe Photoshop. Works on assignment only.

First Contact & Terms: Send query letter with tearsheets and SASE. Samples are filed or returned by SASE. Reports back only if interested. Buys all rights.

Book Design: Assigns 3 freelance design jobs/year.

Jackets/Covers: Assigns 3 freelance design jobs/year.

Text Illustration: Assigns 75 freelance illustration jobs/year. Pays by the project, $125-400. Prefers oil, watercolor, gouache, colored pencil or pastels.

Tips: Finds artists through artists' submissions.

‡IGNATIUS PRESS, Catholic Publisher, 2515 McAllister St., San Francisco CA 94118. Production Editor: Carolyn Lemon. Art Editor: Roxanne Lum. Estab. 1978. Company publishes Catholic theology and devotional books for lay people, priests and religious readers. Recent titles include *C.S. Lewis for the Third Millennium*, by Peter Kreeft; and *God's Human Face: The Christ Icon*, by Christoph Schönborn.

Needs: Works with 2-3 freelance illustrators/year. Works on assignment only.

First Contact & Terms: Will send art guidelines "if we are interested in the artist's work." Accepts previously published material. Send brochure showing art style or résumé and photocopies. Samples not filed are not returned. Reports only if interested. To show a portfolio, mail appropriate materials; "we will contact you if interested." **Pays on acceptance.**

Jackets/Covers: Buys cover art from freelance artists. Prefers Christian symbols/calligraphy and religious illustrations of Jesus, saints, etc. (used on cover or in text). "Simplicity, clarity, and elegance are the rule. We like calligraphy, occasionally incorporated with Christian symbols. We also do covers with type and photography." Pays by the project.

Text Illustration: Pays by the project.

Tips: "I do not want to see any schmaltzy religious art. Since we are a nonprofit Catholic press, we cannot always afford to pay the going rate for freelance art, so we are always appreciative when artists can give us a break on prices and work *ad maiorem Dei gloriam*."

INCENTIVE PUBLICATIONS INC., 3835 Cleghorn Ave., Nashville TN 37215. (615)385-2934. Art Director: Marta Johnson Drayton. Specializes in supplemental teacher resource material, workbooks and arts and crafts books for children K-8. Publishes 15-30 titles/year. Recent titles include *Challenges & Choices*, by Nancy Ullinskey and Lorri Hibbert; and *How to Write a Great Research Paper*, by Leland Graham and Darriel

Ledbetter. 40% require freelance illustration. Books are "cheerful, warm, colorful, uncomplicated and spontaneous."

Needs: Works with 3-6 freelance illustrators and 1-2 designers/year. Uses freelancers mainly for covers and text illustraion. Also for promo items (very occasionally). Works on assignment only primarily with local artists. 10% of freelance work demands knowledge of Adobe Illustrator, QuarkXPress or Aldus FreeHand.

First Contact & Terms: Send query letter with brochure showing art style, résumé, tearsheets and/or photostats. Samples are filed. Samples not filed are returned by SASE. Art Director will contact artist for portfolio review if interested. Portfolio should include original/final art, photostats, tearsheets and final reproduction/product. Sometimes requests work on spec before assigning a job. Considers complexity of project, project's budget and rights purchased when establishing payment. Buys all rights. Originals are not returned.

Jackets/Covers: Assigns 4-6 freelance illustration jobs/year. Prefers 4-color covers in any medium. Pays by the project, $200-350.

Text Illustration: Assigns 4-6 freelance jobs/year. Black & white line art only. Pays by the project, $175-1,250.

Tips: "We look for a warm and whimsical style of art that respects the integrity of the child. Freelancers should be able to illustrate to specific age-groups and be aware that in this particular field immediate visual impact and legibility of title are important."

INSTRUCTIONAL FAIR, INC., Box 1650, Grand Rapids MI 49501. Product Development/Creative Director: Annette Hollister Papp. Publishes supplemental education materials for elementary/middle school levels in all curriculum areas for elementary and middle school teachers, parents and home schoolers.

Needs: Works with several freelancers/year. Need computer-literate as well as fine art freelancers for illustration and production. 20% of freelance work demands knowledge of Aldus PageMaker, Adobe Illustrator, QuarkXPress or Aldus FreeHand. Works on assignment only.

First Contact & Terms: Send query letter with photostats. Samples are filed or are returned if requested. Reports back within 1-2 months only if interested. Write for appointment to show portfolio, or mail samples. Pays by the project (amount negotiated). Considers client's budget and how work will be used when establishing payment. Buys all rights.

INTERCULTURAL PRESS, INC., 16 U.S. Route 1, Yarmouth ME 04096. (207)846-5168. Fax: (207)846-5181. Production Manager: Patty Topel. Estab. 1982. Company publishes trade paperback originals. Types of books include contemporary fiction, travel and reference. Specializes in intercultural and multicultural. Publishes 12 titles/year. Recent titles include *Whole World Guide to Culture Learning*, by Dan Hess; and *Global Winners*, by Drum, Huges and Otero. 100% require freelance illustration. Book catalog free by request.

Needs: Approached by 20 freelancers/year. Works with 10 freelance illustrators/year. Prefers freelancers with experience in trade books, multicultural field. Uses freelancers mainly for jacket/cover design and illustration. Also for book design. Needs computer-literate freelancers for design, illustration and production. 50% of freelance work demands knowledge of Aldus PageMaker or Adobe Illustrator. "If a freelancer is conventional (i.e., not computer driven) they should understand production and pre-press."

First Contact & Terms: Send query letter with brochure, tearsheets, résumé and photocopies. Samples are filed or are returned by SASE if requested by artist. Does not report back. Art Director will contact artist for portfolio review if interested. Portfolio should include b&w final art. Buys all rights. Originals are not returned.

Jackets/Covers: Assigns 10 freelance illustration jobs/year. Pays by the project, $300-500.

Text Illustration: Assigns 1 freelance illustration job/year. Pays "by the piece depending on complexity." Prefers b&w line art.

Tips: First-time assignments are usually book jackets only; book jackets with interiors are (complete projects) given to "proven" freelancers. Finds artists through submissions and word of mouth.

‡INTERNATIONAL MARINE/RUGGED MOUNTAIN PRESS (formerly International Marine Publishing Co.), Box 220, Camden ME 04843. (207)236-4837. Art & Production Director: Molly Mulhern. Estab. 1969. Imprint of McGraw-Hill. Specializes in hardcovers and paperbacks on marine (nautical) topics. Publishes 35 titles/year. Recent titles include *Sailmaker's Apprentice*, by Marino; *A Snowalker's Companion*, by Conover. 50% require freelance illustration. Book catalog free by request.

Needs: Works with 20 freelance illustrators and 20 designers/year. Uses freelancers mainly for interior illustration. Prefers local freelancers. Works on assignment only.

First Contact & Terms: Send résumé and tearsheets. Samples are filed. Reports back within 1 month. Considers project's budget when establishing payment. Buys one-time rights. Originals are not returned.

Book Design: Assigns 20 freelance design jobs/year. Pays by the project, $150-550; or by the hour, $12-30.

Jackets/Covers: Assigns 20 freelance design and 3 illustration jobs/year. Pays by the project, $100-500; or by the hour, $12-30.

Text Illustration: Assigns 20 jobs/year. Prefers technical drawings. Pays by the hour, $12-30; or by the project, $30-80/piece.

Tips: "Do your research. See if your work fits with what we publish. Write with a résumé and sample; then follow with a call; then come by to visit."

‡IRON CROWN ENTERPRISES, P.O. Box 1605, Charlottesville VA 22902. (804)295-3918. Fax: (804)977-4811. Art Director: Jessica Ney-Grimm. Estab. 1980. Company publishes fantasy role playing games and supplements. Specializes in fantasy in a variety of genres. Publishes 24 titles/year. Recent titles include *Moria, Elves, Dol Guldur, Spell Law* and *The Ultimate Martial Artist*. 100% require freelance illustration; 50% require freelance design. Book catalog free by request.

Needs: Approached by 120 freelancers/year. Works with 20 freelance illustrators and 4 designers/year. Buys 1,000 freelance illustrations/year. Prefers freelancers with experience in fantasy illustration and sci-fi illustration; prefer local freelancers for book design. Uses freelancers mainly for full color cover art and b&w interior illustration. Also for jacket/cover and text illustration and page design for interior. Needs computer-literate freelancers for interior page design and layout, cover design. 20% of freelance work demands knowledge of Aldus PageMaker, QuarkXPress, Aldus FreeHand and Adobe Photoshop.

First Contact & Terms: Send query letter with résumé, slides, SASE and photocopies. Samples are filed or returned by SASE if requested by artist. Reports back within 2 months. Art Director will contact artist for portfolio review if interested. Portfolio should include photographs, slides and tearsheets. Buys all rights. Originals are returned at job's completion.

Book Design: Assigns 20 freelance design jobs/year. Pays by the hour, $8.

Jackets/Covers: Assigns 24 freelance illustration jobs/year. Pays by the hour, $15. Prefers paintings for cover illustrations, QuarkXPress for cover design.

Text Illustration: Assigns 24 freelance jobs/year. Pays per published page. Prefers pen & ink.

Tips: Finds artists through artists' submissions.

JAIN PUBLISHING CO., (formerly Asian Humanities Press), Box 3523, Fremont CA 94539. (510)659-8272. Fax: (510)659-0501. Publisher: M.K. Jain. Estab. 1986. Publishes hardcover originals, trade paperback originals and reprints and textbooks. Types of books include business, gift, cookbooks and computer. Publishes 10 titles/year. Recent titles include *Your Personal Computer*, by Andreas Ramos; and *The Little Book of Inspiration*, by Jim Beggs. Books are "uncluttered, elegant, using simple yet refined art." 25% require freelance illustration; 100% require freelance design. Free book catalog.

Needs: Approached by 50 freelancers/year. Works with 4 freelance illustrators and designers/year. Prefers freelancers with experience in cartoons and computer art. Uses freelancers mainly for jacket/cover design. Also for jacket/cover illustration and catalog design.

First Contact & Terms: Send query letter with brochure, résumé, tearsheets and photostats. Samples are filed. Reports back to the artist only if interested. Rights purchased vary according to project. Originals are not returned.

Book Design: Assigns 10 freelance design jobs/year. Pays by the project.

Jackets/Covers: Assigns 10 freelance design and 20 illustration jobs/year. Prefers "camera ready mechanicals with all type in place." Pays by the project, $200-500.

Tips: Expects "a demonstrable knowledge of art suitable to use with business, computers, cookbooks and gift books."

JALMAR PRESS, 2675 Skypark Dr., Suite 204, Torrance CA 90505-5330. (310)784-0016. Fax: (310)784-1379. President: Bradley L. Winch. Project and Production Director: Jeanne Iler. Estab. 1971. Publishes books emphasizing positive self-esteem. Recent titles include *Hilde Knows Someone Cries for the Children*, by Lisa Kent, illustrated by Nickki Machlin; and *Vortex of Fear*, by Al Benson. Books are contemporary, yet simple.

Needs: Works with 3-5 freelance illustrators and 5 designers/year. Uses freelancers mainly for cover design and illustration. Also for direct mail and book design. Works on assignment only.

First Contact & Terms: Send query letter with brochure showing art style. Samples not filed are returned by SASE. Artist should follow up after initial query. Needs computer-literate freelancers for design and illustration. 80% of freelance work demands knowledge of Photoshop, Adobe Illustrator and QuarkXPress. Buys all rights. Considers reprints but prefers original works. Considers complexity of project, budget and turnaround time when establishing payment.

Book Design: Pays by the project, $200 minimum.

Jackets/Covers: Pay by the project, $400 minimum.

Text Illustration: Pays by the project, $25 minimum.

Tips: "Portfolio should include samples that show experience. Don't include 27 pages of 'stuff.' Stay away from the 'cartoonish' look. If you don't have any computer design and/or illustration knowledge—get some! If you can't work on computers, at least understand the process of using traditional artwork with computer generated film. For us to economically get more of our product out (with fast turnaround and a minimum of rough drafts), we've gone exclusively to computers for total book design; when working with traditional artists, we'll scan their artwork and place it within the computer generated document."

JSA PUBLICATIONS, INC., Box 37175, Oak Park MI 48237. (810)932-0090. Director: Joe Ajlouny. Estab. 1985. Book producer and packager. Specializes in humor. Recent titles include *Why Do They Call it Topeka? How Places Got Their Names*, by John W. Pursell; and *Famous People's Cats*, by Ronna Mogelon.
Needs: Works with approximately 10 freelance illustrators and designers/year. Uses freelancers mainly for book illustration. Also accepts fully completed book proposals.
First Contact & Terms: Send query letter with résumé and enough samples to accurately express artist's talent and styles. Samples are filed or are returned by SASE only if requested. Director will contact artist if interested. Sometimes requests work on spec before assigning a job.
Text Illustration: Pay by the project, $25-100/illustration.
Tips: Artists' submissions must be of professional quality and have a superior method of expression. Completed book proposals should have wide appeal and be accompanied by a manuscript-size SASE.

KALMBACH PUBLISHING CO., 21027 Crossroads Circle, P.O. Box 1612, Waukesha WI 53187. (414)796-8776. Fax: (414)796-1142. Books Art Director: Kristi L. Ludwig. Estab. 1934. Imprints include Greenberg Books. Company publishes hardcover and trade paperback originals. Types of books include instruction, reference and history. Specializes in hobby books. Publishes 26 titles/year. Recent titles include *20 Custom Designed Track Plans*, by John Armstrong; and *Tips & Tricks for Toy Train Operators*, by Peter H. Riddle. 20-30% require freelance illustration; 10-20% require freelance design. Book catalog free by request.
Needs: Approached by 10 freelancers/year. Works with 5 freelance illustrators and 2 designers/year. Prefers freelancers with experience in the hobby field. Uses freelance artists mainly for book layout, line art illustrations. Also for book design. Needs computer-literate freelancers for design and illustration. 90% of freelance work demands knowledge of Adobe Illustrator, QuarkXPress or Adobe Photoshop. "Freelancers should have most updated versions." Works on assignment only.
First Contact & Terms: Send query letter with résumé, tearsheets and photocopies. Samples are filed. Reports back within 2 weeks. Art Director will contact artist for portfolio review if interested. Portfolio should include slides and final art. Rights purchased vary according to project. Originals are returned at job's completion.
Book Design: Assigns 5 freelance design jobs/year. Pays by the project, $1,000-3,000.
Text Illustration: Assigns 10-20 freelance illustration jobs/year. Pays by the project, $500-2,000.
Tips: First-time assignments are usually text illustration, simple book layout; complex track plans, etc., are given to "proven" freelancers. Finds artists through word of mouth, artists' submissions. Admires freelancers who "present an organized and visually strong portfolio; meet deadlines (especially when first working with them) and listen to instructions."

KAR-BEN COPIES, INC., 6800 Tildenwood Lane, Rockville MD 20852. Fax: (301)881-9195. Editor: Madeline Wikler. Estab. 1975. Company publishes hardcovers and paperbacks on juvenile Judaica. Publishes 10-12 titles/year. Recent titles include *Sammy Spider's First Passover*, by Sylvia Rouss and *Israel Fun for Little Hands*, by Sally Springer. Books contain "colorful illustraions to appeal to young readers." 100% require freelance illustration. Book catalog free on request.
Needs: Uses 10-12 freelance illustrators/year. Uses freelancers mainly for book illustration. Also for jacket/cover design and illustration, book design and text illustration.
First Contact & Terms: Send query letter with photostats or tearsheets to be kept on file or returned. Samples not filed are returned by SASE. Reports within 2 weeks only if SASE included. Originals are returned at job's completion. Sometimes requests work on spec before assigning a job. Considers skill and experience of artist and turnaround time when establishing payment. Pays by the project, $500-3,000 average, or advance plus royalty. Buys all rights. Considers buying second rights (reprint rights) to previously published artwork.
Tips: Send samples showing active children, not animals or still life. "We are using more full-color as color separation costs have gone down."

‡KITCHEN SINK PRESS, 320 Riverside Dr., North Hampton MA 01060. (413)586-9525. Fax: (413)586-7040. Editors: Philip Amara and Chris Couch. Art Director: Tamara Sibert. Estab. 1969. Book and comic book publisher of hardcover and and trade paperback originals and reprints. Types of books include science fiction, adventure, humor, graphic novels and comic books. Publishes 24 books and 48 comic books/year. Recent titles include Al Capp's *Li'l Abner*, Mark Schultz's *Cadillacs & Dinosaurs*® and *Twisted Sisters*. 10% require freelance illustration; 10% require freelance design.
Needs: Approached by more than 100 freelancers/year. Works with 10-20 illustrators and 4-5 designers/year. Buys 300 illustrations/year. Prefers artists with experience in comics. Uses freelancers mainly for covers, contributions to anthologies and new series. Also for comic book covers and text illustration. Works on assignment only, although "sometimes a submission is accepted as is."
First Contact & Terms: Send query letter with tearsheets, SASE and photocopies. Samples are filed or are returned by SASE. Reports back within 3-4 weeks. Rights purchased vary according to project. Originals are returned at job's completion.

Book Design: Assigns 2-3 freelance design jobs/year. Pays by the project, $600-1,000.
Jackets/Covers: Assigns 6-8 freelance design jobs/year. Pays by the project, $200-600. Prefers line art with color overlays.
Tips: "We are looking for artist-writers."

‡B. KLEIN PUBLICATIONS INC., Box 8503, Coral Springs FL 33075. (305)752-1708. Fax: (305)752-2547. Editor: Bernard Klein. Estab. 1955. Publishes reference books, such as the *Guide to American Directories*. Publishes approximately 15-20 titles/year. 25% require freelance illustration. Book catalog free on request.
Needs: Works with 1-3 freelance illustrators and 1-3 designers/year. Uses freelancers for jacket design and direct mail brochures.
First Contact & Terms: Submit résumé and samples. Pays $50-300.

‡KRUZA KALEIDOSCOPIX INC., Box 389, Franklin MA 02038. (508)528-6211. Editor: J.A. Kruza. Estab. 1980. Publishes hardcover and mass market paperback originals. Types of books include adventure, biography, juvenile, reference and history. Specializes in children's books for ages 3-10 and regional history for tourists and locals. Publishes 12 titles/year. Titles include *Lighthouse Handbook for New England*. 75% require freelance illustration. Book catalog not available.
 • The children's book division's budget has been curtailed drastically. Emphasis will be buying artwork for their magazines (i.e. *Collision*, *Wheelings*, *Craftwood* and more).
Needs: Approached by 150 freelancers/year. Works with 8 freelance illustrators/year. Uses freelancers for magazine editorial. Also for text illustration. Works on assignment only.
First Contact & Terms: Send query letter with brochure, tearsheets, photostats and SASE. Samples are filed or returned by SASE. Reports back to the artist only if interested. Buys all rights.
Book Design: Pays by the project.
Text Illustration: Assigns 30 freelance illustration jobs/year. Pays $50-100/illustration. Prefers watercolor, airbrush, pastel, pen & ink.
Tips: "Submit sample color photocopies of your work every five or six months. We're looking to fit an illustrator together with submitted and accepted manuscripts. Each manuscript calls for different techniques."

LEE & LOW BOOKS, 95 Madison Ave., New York NY 10016-7801. (212)779-4400. Editor-in-Chief: Elizabeth Szabla. Publisher: Philip Lee. Estab. 1991. Book publisher. Publishes hardcover originals and reprints for the juvenile market. Specializes in multicultural children's books. Publishes 6-10 titles/year. First list published in spring 1993. Recent titles include *Zora Hurston and the Chinaberry Tree*, by William Miller; and *Heroes*, by Ken Mochizuki. 100% require freelance illustration and design. Book catalog available.
Needs: Approached by 100 freelancers/year. Works with 6-10 freelance illustrators and 1-3 designers/year. Uses freelancers mainly for illustration of children's picture books. Also for direct mail and catalog design. Needs computer-literate freelancers for design. 100% of design work demands computer skills. Works on assignment only.
First Contact & Terms: Contact through artist rep or send query letter with brochure, résumé, SASE, tearsheets, photocopies and slides. Samples are filed. Reports back within 1-2 months. Art Director will contact artist for portfolio review if interested. Portfolio should include b&w and color tearsheets, slides and dummies. Rights purchased vary according to project. Originals are returned at job's completion.
Book Design: Pays by the project.
Text Illustration: Pays by the project.
Tips: "We want an artist who can tell a story through pictures and is familiar with the children's book genre. Lee & Low Books makes a special effort to work with writers and artists of color and encourages new voices. We prefer filing samples that feature children."

LEISURE BOOKS, Division of Dorchester Publishing Co., Inc., 276 Fifth Ave., Suite 1008, New York NY 10001. (212)725-8811. Managing Editor: Katherine Carlon. Estab. 1970. Specializes in paperback, originals and reprints, especially mass market category fiction—realistic historical romance, western, adventure, horror. Publishes 144 titles/year. Recent titles include *Apache Runaway*, by Madeline Baker; and *Savage Secrets*, by Cassie Edwards. 90% require freelance illustration.
Needs: Works with 24 freelance illustrators and 6 designers/year. Uses freelancers mainly for covers. "We work with freelance art directors; editorial department views all art initially and refers artists to art directors. We need highly realistic, paperback illustration; oil or acrylic. No graphics, fine art or photography." Works on assignment only.
First Contact & Terms: Send samples by mail. No samples will be returned without SASE. Reports only if samples are appropriate and if SASE is enclosed. Call for appointment to drop off portfolio. Portfolios may be dropped off Monday-Thursday. Sometimes requests work on spec before assigning a job. Considers complexity of project and project's budget when establishing payment. Usually buys first rights, but rights purchased vary according to project. Interested in buying second rights (reprint rights) to previously published work "for contemporary romance only." Originals returned at job's completion.

Jackets/Covers: Pays by the project.
Tips: "Talented new artists are welcome. Be familiar with the kind of artwork we use on our covers. If it's not your style, don't waste your time and ours."

LIFETIME BOOKS, 2131 Hollywood Blvd., Hollywood FL 33020. (305)925-5242. President: Donald L. Lessne. Specializes in hardcovers, paperbacks and magazines—mostly trade books. Publishes 20 titles/year. Recent titles include *All the Secrets of Magic Revealed, Og Mandino's Great Trilogy* and *How to Be the Complete Professional Salesperson.* Books have a striking look.
Needs: Works with 3 freelance illustrators and 3 freelance designers/year. Uses freelance artists mainly for cover, jacket and book design. Also for jacket/cover and text illustration, catalog design, tip sheets and direct mail. Prefers local artists only. Needs computer-literate freelancers for design, illustration and production. 50% of freelance work demands knowledge of Aldus PageMaker. Works on assignment only.
First Contact & Terms: Send brochure showing art style or photocopies and résumé. Samples not filed are returned only if requested. Editor will contact artists for portfolio review if interested. Originals are returned at job's completion. Considers rights purchased when establishing payment. Rights purchased vary according to project. Interested in buying second rights (reprint rights) to previously published work.
Book Design: Assigns 20 freelance design and 20 illustration jobs/year. Pays by the project, $400-1,000.
Jackets/Covers: Assigns 20 freelance design and a variable amount of illustration jobs/year. Pays by the project, $400-1,000.
Tips: "As the trade market becomes more competitive, the need for striking, attention-grabbing covers increases. Be ready to generate multiple ideas on a subject and to create something professional and unique."

LITTLE AMERICA PUBLISHING CO., 9725 SW Commerce Circle, Wilsonville OR 97070. (503)682-0173. Fax: (503)682-0175. Production Manager: Heather Kier. Estab. 1986. Imprint of Beautiful America Publishing Co. Publishes hardcover originals for pre-school and juvenile markets. Titles include *Melody's Mystery* and *Journey of Hope* both by Diane Kelsay Harvey and Bob Harvey. 50% require freelance illustration. Book catalog available by request.
Needs: Approached by 20 freelancers/year. Uses 3 freelance illustrators and 2 designers/year. Uses freelancers for jacket/cover and text illustration. Works on assignment only.
First Contact & Terms: Send query letter with brochure, résumé, tearsheets and photostats. Samples are filed or are returned by SASE. Art Director will contact artist for portfolio review if interested. Portfolio should include tearsheets and color copies. Sometimes requests work on spec before assigning a job. Generally pays royalty. Negotiates rights purchased. Originals are returned at job's completion.
Tips: Finds artists generally through word of mouth. "Most artists find us."

THE LITURGICAL PRESS, St. John's Abbey, Collegeville MN 56321. (612)363-2213. Fax: (612)363-3278. Art Director: Ann Blattner. Estab. 1926. Publishes hardcover and trade paperback originals and textbooks. Specializes in liturgy and scripture. Publishes 150 titles/year. 50% require freelance illustration and design. Book catalog available for SASE.
Needs: Approached by 100 freelancers/year. Works with 20 freelance illustrators and 25 designers/year. Uses freelancers for book cover design, jacket/cover illustration and design and text illustration. 50% of freelance work demands computer knowledge.
First Contact & Terms: Send query letter with brochure, photograph, photocopies and slides. Samples are filed. Reports back to the artist only if interested. To show portfolio, mail b&w photostats and photographs. Rights purchased vary according to project. Originals are returned at job's completion.
Jackets/Covers: Assigns 100 freelance design and 50 illustration jobs/year. Pays by the project, $150-450.
Text Illustration: Assigns 25 freelance illustration jobs/year. Pays by the project, $45-500.

LLEWELLYN PUBLICATIONS, Box 64383, St. Paul MN 55164. Art Director: Lynne Menturweck. Estab. 1901. Book publisher. Publishes hardcover originals, trade paperback and mass market originals and reprints and calendars. Types of books include reference, self help, metaphysical, occult, mythology, health, women's spirituality and New Age. Publishes 80 titles/year. Recent titles include *Journey of Souls*, by Newton; and *Sexuality in the Horoscope*, by Noel Tyl. Books have photography, realistic painting and computer generated graphics. 60% require freelance illustration. Book catalog available for large SASE and 5 first-class stamps.
Needs: Approached by 200 freelancers/year. Buys 150 freelance illustrations/year. Prefers freelancers with experience in book covers, New Age material and realism. Uses freelancers mainly for realistic paintings and drawings. Works on assignment only.

For a list of markets interested in humorous illustration, cartooning and caricatures, refer to the Humor Index at the back of this book.

First Contact & Terms: Send query letter with brochure, SASE, tearsheets, photographs and photocopies. Samples are filed or are returned by SASE. Art Director will contact artist for portfolio review if interested. Sometimes requests work on spec before assigning a job. Negotiates rights purchased.

Jackets/Covers: Assigns 40 freelance illustration jobs/year. Pays by the illustration, $150-700. Media and style preferred "are usually realistic, well-researched, airbrush, watercolor, acrylic, oil, colored pencil. Artist should know our subjects."

Text Illustration: Assigns 25 freelance illustration jobs/year. Pays by the project, or $30-100/illustration. Media and style preferred are pencil and pen & ink, "usually very realistic; there are usually people in the illustrations."

Tips: "I need artists who are aware of occult themes, knowledgeable in the areas of metaphysics, divination, alternative religions, women's spirituality, and who are professional and able to present very refined and polished finished pieces. Knowledge of history, mythology and ancient civilization is a big plus."

LUCENT BOOKS, Box 289011, San Diego CA 92128-9011. (619)485-7424. Managing Editor: Bonnie Szumski. Estab. 1988. Book publisher. Publishes nonfiction for libraries and classrooms. Types of books include juvenile and young adult. Specializes in controversial issues, discovery and invention, history and biography. Publishes 30 titles/year. Titles include *Telescopes: Encyclopedia of Discovery and Invention* and *Eating Disorders*. Book catalog free for SASE.

First Contact & Terms: Approached by 50-75 freelancers/year. Works with 1-2 freelance designers/year. Prefers freelancers with experience in "young adult books with a realistic style in pen & ink or pencil, able to draw creatively, not from photographs." Uses freelancers mainly for technical drawings for the encyclopedia series. Also for jacket/cover and text illustration. Works on assignment only. Send query letter with résumé, tearsheets and photocopies. Samples are filed. Reports back to the artist only if interested. To show portfolio, mail appropriate materials. Buys all rights. Originals are not returned.

Book Design: Pays by the project, $100-1,500.

Jackets/Covers: Pays by the project, $350-600.

Text Illustration: Assigns 8-10 freelance illustration jobs/year. Pays by the project, $100-1,500. Prefers pencil and pen & ink.

Tips: "We have a very specific style in mind and can usually tell immediately from samples whether or not an artist's style suits our needs."

McFARLAND & COMPANY, INC., PUBLISHERS, Box 611, Jefferson NC 28640. (910)246-4460. Fax: (910)246-5018. Sales Manager: Chris Robinson. Estab. 1979. Company publishes hardcover and trade paperback originals. Specializes in nonfiction reference and scholarly monographs, including film and sports. Publishes 120 titles/year. Recent titles include *Riding the Video Range*, *Amusement Parks* and *Recycling Tips for Teachers and Librarians*. Book catalog free by request.

Needs: Approached by 50 freelancers/year. Works with 5-8 freelance illustrators/year. Prefers freelancers with experience in catalog and brochure work in performing arts and school market. Uses freelancers mainly for promotional material. Also for direct mail and catalog design. Works on assignment only.

First Contact & Terms: Send query letter with résumé, SASE and photocopies. "Send relevant samples. We aren't interested in children's book illustrators, for example, so we do not need such samples." Samples are filed. Reports back within 2 weeks. Portfolio review not required. Buys all rights. Originals are not returned.

Tips: First-time assignments are usually school promotional materials; performing arts promotional materials are given to "proven" freelancers.

McKINZIE PUBLISHING COMPANY, 11000 Wilshire Blvd., P.O. Box 241777, Los Angeles CA 90024-9577. (213)934-7685. Fax: (213)931-7217. Director of Art: Nancy Freeman. Estab. 1969. Publishes hardcover, trade and mass market paperback originals and textbooks. Publishes all types of fiction and nonfiction. Publishes 15 titles/year. Recent titles include *A Message from Elvis*, by Harry McKinzie; and *USMC Force Recon: A Black Hero's Story*, by Amankwa Adeduro. Book catalog for SASE.

Needs: Uses freelancers for jacket/cover design and illustration. Also for text illustration and direct mail and book catalog design. Works on assignment only.

First Contact & Terms: Send query letter with SASE, photographs and photocopies. Samples are filed or are returned by SASE. Portfolio should include thumbnails and roughs. Sometimes requests work on spec before assigning a job. Buys all rights. Originals are not returned. Pays by the project, negotiated.

Tips: "Looking for design and illustration that is appropriate for the general public. Book design is becoming smoother, softer and more down to nature with expression of love of all—humanity, animals and earth."

‡MACMILLAN COMPUTER PUBLISHING, 201 W. 103rd St., Indianapolis IN 46290. (317)581-3500. Design Manager: Robin Brandenburg. Imprints include Que, New Riders, Sams, Alpha, Hayden, Adobe Press, Que College. Company publishes computer books. Types of books include instructional. Specializes in computer topics. Publishes 550 titles/year. 5-10% require freelance illustration; 3-5% require freelance design. Book catalog free by request.

Needs: Approached by 100 freelancers/year. Works with 20 freelance illustrators and 10 designers/year. Buys 100 freelance illustrations/year. Uses freelancers for jacket/cover illustration and design, text illustration, direct mail and book design. Needs computer-literate freelancers for design, illustration and production. 50% of freelance work demands knowledge of Aldus PageMaker, QuarkXPress, Aldus FreeHand, Adobe Illustrator and Adobe Photoshop.

First Contact & Terms: Send query letter with brochure, tearsheets, photostats, résumé, photographs, slides, photocopies and transparencies. Samples are filed or returned by SASE if requested by artist. Art Director will contact artist for portfolio review if interested. Portfolio should include final art, photographs, photostats, roughs, slides, tearsheets and transparencies. Rights purchased vary according to project.

Book Design: Assigns 10 freelance design jobs/year. Pays by the project, $2,000-6,000.

Jackets/Covers: Assigns 15 freelance design and 25 illustration jobs/year. Pays by the project, $1,000-3,000.

Text Illustration: Pays by the project, $100-300.

Tips: Finds artists through agents, sourcebooks, word of mouth, artists' submissions and attending art exhibitions.

MADISON BOOKS, Dept. AGDM, 4720 Boston Way, Lanham MD 20706. (301)459-5308. Fax: (301)459-2118. Vice President, Design: Gisele Byrd. Estab. 1984. Publishes hardcover and trade paperback originals. Specializes in biography, history and popular culture. Publishes 16 titles/year. Titles include *Ships That Changed History, Abandoned* and *The Ambassador From Wall Street*. 40% require freelance illustration; 100% require freelance jacket design. Book catalog free by request.

Needs: Approached by 20 freelancers/year. Works with 4 freelancers illustrators and 12 designers/year. Prefers freelancers with experience in book jacket design. Uses freelancers mainly for book jackets. Also for book and catalog design. Needs computer-literate freelancers for design, illustration, production and presentation. 80% of freelance work demands knowledge of Adobe Illustrator, QuarkXPress, Photoshop or Aldus FreeHand. Works on assignment only.

First Contact & Terms: Send query letter with tearsheets, photocopies and photostats. Samples are filed or are returned by SASE if requested by artist. Reports back to the artist only if interested. Call for appointment to show portfolio of roughs, original/final art, tearsheets, photographs, slides and dummies. Buys all rights. Interested in buying second rights (reprint rights) to previously published work.

Book Design: Assigns 2 freelance design jobs/year. Pays by the project, $1,000-2,000.

Jackets/Covers: Assigns 16 freelance design and 2 illustration jobs/year. Pays by the project, $200-500. Prefers typographic design, photography and line art.

Text Illustration: Pays by project, $100 minimum.

Tips: "We are looking to produce trade-quality designs within a limited budget. Covers have large type, clean lines; they 'breathe.' If you have not designed jackets for a publishing house but want to break into that area, have at least five 'fake' titles designed to show ability. I would like to see more Eastern European style incorporated into American design. It seems like typography on jackets is becoming more assertive, as it competes for attention on bookstore shelf. Also, trends are richer colors, use of metallics."

MEADOWBROOK PRESS, 18318 Minnetonka Blvd., Deephaven MN 55391. (612)473-5400. Fax: (612)475-0736. Production Manager: Amy Unger. Company publishes hardcover and trade paperback originals. Types of books include instruction, humor, juvenile, pre-school and parenting. Specializes in parenting, humor. Publishes 10-15 titles/year. Titles include *New Adventures of Mother Goose, Funny Side of Parenthood* and *Practical Parenting Tips*. 80% require freelance illustration; 30% require freelance design. Book catalog free by request.

Needs: Approached by 100 freelancers/year. Works with 5 freelance illustrators and 3 designers/year. Uses freelancers mainly for children's fiction, medical-type illustrations, activity books, spot art. Also for jacket/cover and text illustration. Needs computer-literate freelancers for design and production. 30% of freelance work demands knowledge of QuarkXPress or Adobe Photoshop. Works on assignment only.

First Contact & Terms: Send query letter with tearsheets, photocopies and business card. Samples are filed and are not returned. Reports back only if interested. Art Director will contact artist for portfolio review if interested. Portfolio should include b&w and color final art and transparencies. Buys all rights. Originals are returned at job's completion.

Book Design: Assigns 2 freelance design jobs/year. "Pay varies with complexity of project."

Jackets/Covers: Assigns 3 freelance design and 6 freelance illustration jobs/year. Pays by the project, $300-600.

Text Illustration: Assigns 6 freelance illustration jobs/year. Pays by the project, $80-150.

Tips: First-time assignments are usually text illustration; cover art is given to "proven" illustrators. Finds artists through agents, sourcebooks and artists' submissions.

MENNONITE PUBLISHING HOUSE/HERALD PRESS, 616 Walnut Ave., Scottdale PA 15683. (412)887-8500, ext. 244. Fax: (412)887-3111. E-mail: jim%5904477@mcimail.com. Art Director: James M. Butti. Estab. 1918. Publishes hardcover and paperback originals and reprints; textbooks and church curriculum. Specializes in religious, inspirational, historical, juvenile, theological, biographical, fiction and nonfiction

books. Publishes 24 titles/year. Recent titles include *Ellie* series, *A Winding Path* and *A Joyous Heart*. Books are "fresh and well illustrated." 30% require freelance illustration. Catalog available free by request.
Needs: Approached by 150 freelancers/year. Works with 8-10 illustrators/year. Prefers oil, pen & ink, colored pencil, watercolor, and acrylic in realistic style. "Prefer artists with experience in publishing guidelines who are able to draw faces and people well." Uses freelancers mainly for book covers. Has occasional need for computer-literate freelancers for illustration. 10% of freelance work demands knowledge of Adobe Illustrator, QuarkXPress or Corel Draw. Works on assignment only.
First Contact & Terms: Send query letter with résumé, tearsheets, photostats, slides, photocopies, photographs and SASE. Samples are filed ("if we feel freelancer is qualified") and are returned by SASE if requested by artist. Reports back only if interested. Art Director will contact artist for portfolio review of final art, photographs, roughs and tearsheets. Buys one-time or reprint rights. Originals are not returned at job's completion "except in special arrangements." To show portfolio, mail photostats, tearsheets, final reproduction/product, photographs and slides and also approximate time required for each project. Considers complexity of project, skill and experience of artist and project's budget when establishing payment. Buys all rights.
Jackets/Covers: Assigns 8-10 illustration jobs/year. Pays by the project, $200 minimum. "Any medium except layered paper illustration will be considered."
Text Illustration: Assigns 6 jobs/year. Pays by the project. Prefers b&w, pen & ink or pencil.
Tips: "Design we use is colorful, realistic and religious. When sending samples, show a wide range of styles and subject matter—otherwise you limit yourself."

MERIWETHER PUBLISHING LTD., Box 7710, Colorado Springs CO 80907. (719)594-4422. Executive Art Director: Tom Myers. Estab. 1969. Publishes plays, musicals and theatrical books for schools and churches. Recent titles include *Acting Games*, by Marsh Cassady; and *Joy to the World!*, by L.G. and Annie Enscoe.
Needs: Approached by 10-20 freelancers/year. Works with 1-2 freelance illustrators/year. Uses freelancers for jacket/cover and text illustration. Also local freelancers for catalog production using QuarkXPress 3.31. Needs computer-literate freelancers with knowledge of Adobe Photoshop 2.5.1 and Aldus FreeHand 3.11.
First Contact & Terms: Send photostats and photographs (Mac files are okay). Rarely needs loose line humorous cartooning. Samples are returned by SASE if requested by artist. Portfolio review not required.
Text Illustration: Negotiable rate.

MILLS & SANDERSON, PUBLISHERS, P.O. Box 833, Bedford MA 01730-0833. (617)275-1410. Fax: (617)275-1713. Publisher: Jan H. Anthony. Estab. 1986. Company publishes trade paperback originals. Types of books include self help and wellness/mental health. Specializes in family problem solving. Publishes 2-4 titles/year. Recent titles include *Understanding the Trauma of Childhood Psycho-Sexual Abuse*, by Elizabeth Adams; and *Re-Nurturing*, by Janice C. Tracht, MSW, ASCW. 10% of interior work and 100% of cover work require freelance illustration. Book catalog free with SASE. "while supplies last."
Needs: Approached by 75 freelancers/year. Works with 2 freelance illustrators/year. Uses freelance artists mainly for covers. Also for jacket/cover illustration and design, charts and sketches. Needs computer-literate freelancers for design, illustration and production. 50% of freelance work demands knowledge of Aldus PageMaker or Aldus FreeHand. Works on assignment only.
First Contact & Terms: Send query letter with résumé, SASE, photocopies and pricing guide. Samples are filed or are returned by SASE if requested by artist. Reports back only if interested. Art Director will contact artist for portfolio review if interested. Portfolio should include b&w and color thumbnails, roughs and final art. Originals returned "only if artist has special need."
Jackets/Covers: Assigns 1 freelance design and 2-4 freelance illustration jobs/year. Pays by the project, $150-500.
Tips: First-time assignments are usually book covers (2-color, mechanical only); book cover, back and spine (2- to 4-color) are given to "proven" freelancers. Finds artists through word of mouth, colleague referral and artist query.

MODERN LANGUAGE ASSOCIATION, 10 Astor Place, New York NY 10003-6981. (212)475-9500. Fax: (212)477-9863. Promotions Coordinator: David Cloyce Smith. Estab. 1883. Non-profit educational association. Publishes hardcover and trade paperback originals, trade paperback reprints and textbooks. Types of books include instructional, reference and literary criticism. Specializes in language and literature studies. Publishes 15 titles/year. Recent titles include *MLA Handbook for Writers of Research Papers*, 4th edition, by Joseph Bigaldi; and *Ourika*, by Claire de Duras. 5-10% require freelance design. Book catalog free by request.
Needs: Approached by 5-10 freelancers/year. Works with 2-3 freelance designers/year. Prefers freelancers with experience in academic book publishing and textbook promotion. Uses freelancers mainly for jackets and direct mail. Also for book and catalog design. 100% of freelance work demands knowledge of QuarkXPress. Works on assignment only.
First Contact & Terms: Send query letter with brochure. Reports back to the artist only if interested. To show portfolio, mail finished art samples and tearsheets. Originals returned at job's completion if requested.

Book Design: Assigns 1-2 freelance design jobs/year. Payment "depends upon complexity and length."
Jackets/Covers: Assigns 3-4 freelance design jobs/year. Pays by the project, $750-1,500.
Tips: "Most freelance designers with whom we work produce our marketing materials rather than our books. We are interested in seeing samples only of direct mail pieces related to publishing. We do not use illustrations for any of our publications."

‡MODERN PUBLISHING, Dept. AGDM, 155 E. 55th St., New York NY 10022. (212)826-0850. Editorial Director: Kathy O'Hehir. Specializes in children's hardcovers, paperbacks, coloring books and novelty books. Publishes approximately 200 titles/year. Recent titles include *World of Knowledge*, and Power Rangers' books.
Needs: Approached by 10-30 freelancers/year. Works with 25-30 freelancers/year. Works on assignment and royalty.
First Contact & Terms: Send query letter with résumé and samples. Samples not filed are returned only if requested. Reports only if interested. Originals are not returned. Considers turnaround time and rights purchased when establishing payment.
Jackets/Covers: Pays by the project, $150-250/cover, "usually four books/series."
Text Illustration: Pays by the project, $15-25/page; line art, "24-382 pages per book, always four books in series." Pays $5-125/page; full color art.
Tips: "Do not show samples which don't reflect the techniques and styles we use. Reference our books and book stores to know our product line better."

MOREHOUSE PUBLISHING, 871 Ethan Allen Hwy., Suite 204, Ridgefield CT 06877. (203)431-3927. Fax: (203)431-3964. Promotion/Production Director: Gail Eltringham. Estab. 1884. Company publishes trade paperback originals and reprints. Books are religious. Specializes in spirituality, religious history, Christianity/contemporary issues. Publishes 20 titles/year. Recent titles include *A Good Day for Listening*, by Maryellen King; and *Knowing Jesus in Your Life*, by Carol Anderson. 50% require freelance illustration; 40% require freelance design. Book catalog free by request.
Needs: Works with 7-8 illustrators and 7-8 designers/year. Prefers freelancers with experience in religious (particularly Christian) topics. Uses freelancers for jacket/cover illustration and design. Needs computer-literate freelancers for design and illustration. Freelancers should be familiar with Aldus PageMaker, Adobe Illustrator, QuarkXPress, Adobe Photoshop or Aldus FreeHand. Also uses original art—all media. Works on assignment only.
First Contact & Terms: Send query letter with tearsheets, photographs, photocopies and photostats. "Show samples particularly geared for our 'religious' market." Samples are filed or are returned. Reports back only if interested but returns slides/transparencies that are submitted. Portfolio review not required. Usually buys one-time rights. Originals are returned at job's completion.
Jackets/Covers: Pays by the hour, $25 minimum; by the project, $450 maximum. "We are looking for diversity in our books covers, although all are of a religious nature."
Tips: Finds artists through freelance submissions, *Literary Market Place* and mostly word of mouth.

‡MORGAN KAUFMANN PUBLISHERS, INC., 340 Pine St., Sixth Floor, San Francisco CA 94104. (415)392-2665. Fax: (415)982-2665. E-mail: design@mkp.com. Production Manager: Yonie Overton. Estab. 1984. Company publishes hardcover and trade paperback originals (technical trade in computer science) and textbooks. Types of books include reference (technical), textbooks and professional monographs. Specializes in computer science. Publishes 30 titles/year. Recent titles include *Database: Principles, Programming, and Performance*, by Patrick O'Neil; *Computer Organization and Design: The Hardware/Software Interface*, by David A. Patterson and John L. Hennessy; *Principles of Digital Image Synthesis*, by Andrews S. Glassner; and *The PowerPC Architecture*, by IBM, Inc. 50% require freelance illustration; 80-100% require freelance design. Book catalog free for 8½ × 11 SASE with $1.44 postage.
Needs: Approached by 150-200 freelancers/year. Works with 7-10 freelance illustrators and 20 designers/year. Prefers local freelancers in book design. Uses freelancers mainly for covers, text design and technical illustration. Also for jacket/cover illustration. Needs computer-literate freelancers for design, illustration and production. 100% of freelance work demands knowledge of either Adobe Illustrator, QuarkXPress, Adobe Photoshop, Pagemaker, Ventura, Framemaker, laTEX (multiple software platform). Works on assignment only.
First Contact & Terms: Send query letter with tearsheets, photostats, résumé, photographs, slides, photocopies, transparencies or printed samples. "No calls, please." Samples are filed. Production Manager will contact artist for portfolio review if interested. Portfolio should include final art. Buys reprint or all rights (dependent upon the book, its promotion and extent of design job.
Book Design: Assigns freelance design jobs for 25-30 books/year. Pays by the project.
Jackets/Covers: Assigns 30-40 freelance design; 3-5 illustration jobs/year. Pays by the project. Prefers QuarkXPress file for covers; Adobe Illustrator for art programs; modern; emphasis on typography. "We're interested in an approach that is different from the typical technical publication." Prefers modern clean, spare design, fine line weight, very readable labels in illustrations.

Tips: Finds artists primarily through word of mouth and artists' submissions. "However, I have found some of the best designers I currently work with through having contacted them after seeing a printed piece that I admired in a bookstore, on a poster, or in a mailing I received. Although experience with book design is an advantage, sometimes artists from another field bring a fresh approach, especially to cover design. We also use all of the sourcebooks and attend the major computer shows like Mac World and Seybold."

‡JOHN MUIR PUBLICATIONS, Box 613, Santa Fe NM 87504. (505)982-4078. Design and Production Manager: Kathryn Lloyd-Strongin. Publishes trade paperback nonfiction. "We specialize in travel books and children's books, and are always actively looking for new illustrations in these fields." Prefers pen & ink, colored pencil and acrylic. Publishes 60 titles/year. Recent titles include *101 Crafty Creatures in the Wetlands* (kids) and *Unique Washington* (travel).
Needs: Works with 10-15 freelancers/year and 3-4 designers/year. Prefers local freelancers. Sometimes needs computer-literate freelancers for design, illustration and production. 80% of freelance work demands knowledge of QuarkXPress, Photoshop, Aldus FreeHand or Adobe Illustrator.
First Contact & Terms: Send query letter with résumé and samples to be kept on file. Write for appointment to show portfolio. Accepts any type of sample "as long as it's professionally presented." Samples not filed are returned by SASE. Originals are not returned.
Book Design: Pays by the hour, $20-25; by the project, $200-$350; or pays $350 for initial design and $15/ each additional hour. Considers complexity of project, skill and experience of artist, project's budget, turnaround time and rights purchased when establishing payment. Buys all rights.
Jackets/Covers: Assigns 10-20 freelance design and illustration jobs/year, mostly 4-color. Pays by the project, $250 minimum. Work should be "bold and dynamic."
Text Illustration: Assigns approximately 20 freelance jobs/year. Usually prefers pen & ink. Pays $35/ illustration.

NBM PUBLISHING CO., 185 Madison Ave., Suite 1504, New York NY 10016. (212)545-1223. Publisher: Terry Nantier. Publishes graphic novels for an audience of 18-24 year olds. Types of books include adventure, fantasy, mystery, science fiction, horror and social parodies. Recent titles include *Jack the Ripper*, by Rick Geary; and *Kafka Stories*, by Peter Kuper. Circ. 5,000-10,000.
Needs: Approached by 60-70 freelancers/year. Works with 2 freelance designers/year. Uses freelancers for lettering, paste-up, layout design and coloring. Prefers pen & ink, watercolor and oil for graphic novels submissions.
First Contact & Terms: Send query letter with résumé and samples. Samples are filed or are returned by SASE. Reports back within 2 weeks. To show portfolio, mail photocopies of original pencil or ink art. Originals are returned at job's completion.
Tips: "We are interested in submissions for graphic novels. We do not need illustrations or covers only!"

‡❀NELSON CANADA, 1120 Birchmount Rd., Scarborough, Ontario M1K 5G4 Canada. (416)752-9100, ext. 343. Fax: (416)752-7144. Art Director: Liz Harasymczak. Estab. 1931. Company publishes hardcover originals and reprints and textbooks. Types of books include instructional, juvenile, pre-school, reference, textbooks and young adult. Specializes in a wide variety of education publishing. Publishes 150 titles/year. Recent titles include *Financial Account*, *Science Probe*, *Language to Go* and *The Clean Path*. 70% require freelance illustration; 25% require freelance design. Book catalog free by request.
Needs: Approached by 50 freelancers/year. Works with 30 freelance illustrators and 10-15 designers/year. Prefers Canadian artists, but not a necessity. Uses freelancers for jacket/cover design and illustration, text illustration and book design. Needs computer-literate freelancers for design, illustration and production. 100% of design work and 15% of illustration demands knowledge of Adobe Illustrator, QuarkXPress and Adobe Photoshop. Works on assignment only.
First Contact & Terms: Illustrators send postcard sample of work, tearsheets, photographs, photocopies; designers send query letter with brochure, tearsheets, résumé and samples. Samples are filed. Art Director will contact artist for portfolio review if interested. Portfolio should include book dummy, transparencies, final art, tearsheets and photographs. Rights purchased vary according to project. Originals usually returned at the job's completion.
Book Design: Assigns 15 freelance design jobs/year. Pays by the project, $800-1,200 for interior design, $800-1,200 for cover design.
Jackets/Covers: Assigns 15 freelance design and 40 illustration jobs/year. Pays by the project, $800-1,300.
Text Illustration: Pays by the project, $30-450.
Tips: Finds artists through *American Showcase*, *Creative Source* artists' submissions, designers' suggestions (word of mouth).

The maple leaf before a listing indicates that the market is Canadian.

NEW SOCIETY PUBLISHERS, 4527 Springfield Ave., Philadelphia PA 19143. (215)382-6543. Contact: Production Manager. Estab. 1980. Publishes trade paperback originals and reprints. Specializes in nonfiction books promoting fundamental social change through nonviolent action. Focus is on feminism, environmentalism, multiculturalism, nonviolence. Publishes 12-14 titles/year. Recent titles include *Whole Life Economics*, by Barbara Brandt; and *Challenge of Shalom*, edited by Murray Polner and Naomi Goodman. Book catalog free by request.

Needs: Works with 5 freelance cover designers/year. Prefers freelancers with experience in book publishing, who are able to work for less than the market rate. Uses freelancers mainly for designing covers, rarely for text illustration. Works on assignment only.

First Contact & Terms: Send ("only once a year") query letter with tearsheets, photographs, photocopies or appropriate samples of book covers. "Include rough schedule of availability, rates and turnaround time." Reports back to the artist only if interested. No portfolio reviews. Sometimes requests work on spec before a assigning job. Interested in buying second rights (reprint rights) to previously published work.

Jackets/Covers: Assigns 8 freelance cover design jobs/year. Pays by the project, $275-500.

Tips: Finds artists through "other publisher's recommendations and contacting designers whose work we like."

NORTHLAND PUBLISHING, 2900 N. Fort Valley Rd., Flagstaff AZ 86001. (602)774-5251. Fax: (602)774-0592. Art Director: Trina Stahl. Estab. 1958. Company publishes hardcover and trade paperback originals. Types of books include western, juvenile, natural history, Native American art and cookbooks. Specializes in Native America, Western Americana. Publishes 25 titles/year. Recent titles include *Sunpainters*, by Baje Whitethorne; and *The Tortoise & the Jack Rabbit*, by Susan Lowell. 50% require freelance illustration; 25% require freelance design. Book catalog free for 9 × 12 SASE ($2.13 postage).

Needs: Approached by 40-50 freelancers/year. Works with 5-10 freelance illustrators and 4-6 designers/year. Buys 140 freelance illustrations/year. Prefers freelancers with experience in illustrating children's titles. Uses freelancers mainly for children's books. Also for jacket/cover design and illustration, text illustration and book design. Needs computer-literate freelancers for design and production. 100% of freelance work demands knowledge of Adobe Illustrator, QuarkXPress, Adobe Photoshop or Aldus FreeHand. Works on assignment only.

First Contact & Terms: Send query letter with résumé, SASE, tearsheets, slides and transparencies. Samples are filed or are returned by SASE if requested by artist. Reports back only if interested. Art Director will contact artist for portfolio review if interested. Portfolio should include color tearsheets and transparencies. Rights purchased vary according to project. Originals are returned at job's completion.

Book Design: Assigns 4-6 freelance design jobs/year. Pays by the project, $500-4,500.

Jackets/Covers: Assigns 4-6 freelance design and 5-10 illustration jobs/year. "We prefer realistic, more representational styles in any medium. We have not used collage styles thus far."

Text Illustration: Assigns 5-10 freelance illustration jobs/year. Pays by the project, $1,000-6,000. Royalties are preferred—gives cash advances against royalties. "We prefer more realistic, representational styles in any medium. We prefer artwork to be bendable so we can scan from original art—page dimensions no larger than 19 × 26."

Tips: Finds artists mostly through artists' submissions. "Creative presentation and promotional pieces really make me remember an illustrator."

OCTAMERON PRESS, 1900 Mount Vernon Ave., Alexandria VA 22301. Editorial Director: Karen Stokstod. Estab. 1976. Specializes in paperbacks—college financial and college admission guides. Publishes 10-15 titles/year. Titles include *College Match* and *The Winning Edge*.

Needs: Approached by 25 freelancers/year. Works with 1-2 freelancers/year. Local freelancers only. Works on assignment only.

First Contact & Terms: Send query letter with brochure showing art style or résumé and photocopies. Samples not filed are returned. Reports within 2 weeks if SASE included. Considers complexity of project and project's budget when establishing payment. Rights purchased vary according to project.

Jackets/Covers: Works with 1-2 designers and illustators/year on 15 different projects. Pays by the project, $300-700.

Text Illustration: Works with variable number of artists/year. Pays by the project, $35-75. Prefers line drawings to photographs.

Tips: "The look of the books we publish is friendly! We prefer humorous illustrations."

‡ORCHARD BOOKS, 95 Madison Ave., Room 701, New York NY 10016. Book publisher. Division of Franklin Watts. Art Director: Jean Krulis. Estab. 1987. Publishes hardcover children's books only. Specializes in picture books and novels for children and young adults. Also publishes nonfiction for young children. Publishes 60 titles/year. Recent titles include *Mouse TV*, by Matt Novak; and *The Ear, the Eye and the Arm*, by Nancy Farmer. 100% require freelance illustration; 25% freelance design. Book catalog free for SAE with 2 first-class stamps.

Needs: Works with 50 illustrators/year. Works on assignment only.

First Contact & Terms: Send query letter with brochure, tearsheets slides and transparencies. Samples are filed or are returned by SASE only if requested. Reports back about queries/submissions only if interested. Originals returned to artist at job's completion. Call or write for appointment to show portfolio or mail appropriate materials. Portfolio should include thumbnails, tearsheets, final reproduction/product, slides and dummies or whatever artist prefers. Considers complexity of project, skill and experience of artist and project's budget when establishing payment. Buys all rights.

Book Design: Assigns 15 freelance design jobs/year. Pays by the project, $650 minimum.

Jackets/Covers: Assigns 40 freelance design jobs/year. Pays by the project, $650 minimum.

Text Illustration: Assigns 20 freelance jobs/year. Pays by the project, minimum $2,000 advance against royalties.

Tips: "Send a great portfolio."

‡RICHARD C. OWEN PUBLICATIONS INC., P.O. Box 585, Katonah NY 10536. (914)241-2997. Fax: (914)241-2873. Art Director: Janice Boland. Estab. 1986. Company publishes children's books. Types of books include juvenile fiction and nonfiction. Specializes in autobiographies of authors. Publishes 3-10 titles/year. Recent titles include *Meet the Author* collection. 100% require freelance illustration. Book catalog not available.

Needs: Approached by 200 freelancers/year. Works with 3-10 freelance illustrators/year. Prefers freelancers with experience in children's books. Uses freelancers for jacket/cover and text illustration. Works on assignment only.

First Contact & Terms: Send samples of work (brochure, tearsheets and photocopies). Samples are filed. Art Director will contact artist for portfolio review if interested. Portfolio should include final art, photographs, photostats and tearsheets. Buys all rights. Original illustrations are returned at job's completion.

Text Illustration: Assigns 3-10 freelance illustration jobs/year. Pays by the project.

PAPIER-MACHE PRESS, 135 Aviation Way, #14, Watsonville CA 95076. (408)763-1420. Fax: (408)763-1421. Acquisitions Editor: Shirley Coe. Estab. 1984. Publishes hardcover and trade paperback originals. Types of books include contemporary fiction, poetry, creative nonfiction and anthologies. Specializes in women's issues and the art of growing older for both men and women. Publishes 6-8 titles/year. Recent titles include *I Am Becoming the Woman I've Wanted*, by Sandra Haldeman Martz; and *Late Summer Break*, by Ann B. Knox. Books have fine art on the covers, attractive and accessible designs inside and out. Book catalog and submission guidelines available for SASE with first-class postage.

Needs: Approached by 40-50 freelancers/year. Works with 6-8 freelance illustrators and 1-2 designers/year. Books have fine art on the covers, attractive and accessible designs inside and out. Uses freelancers mainly for covers.

First Contact & Terms: Send query letter with brochure, color photocopies or slides. Samples are filed or are returned by SASE. Art Director will contact artist for portfolio review if interested. Portfolio should include slides, tearsheets, photographs. Buys first rights. Considers buying second rights (reprint rights) to previously published work. "We usually work from transparencies."

Jackets/Covers: Selects 6-8 pieces of art/year. Pays by the project, $350-600. "We are most interested in fine art for reproduction on jacket covers, generally of people."

Tips: Finds artists through artists' submissions, author references and local gallery listings. "After looking at our catalog to see the type of cover art we use, artists should send color photocopies of representative pieces for our file. In addition we will put their names on our mailing list for information about future projects."

PARADIGM PUBLISHING INC., 280 Case Ave., St Paul MN 55101. (612)771-1555. Production Director: Joan Silver. Estab. 1989. Book publisher. Publishes textbooks. Types of books include business and office, communications, software-specific manuals. Specializes in basic computer skills. Publishes 40 titles/year. Recent titles include *Key to Success*, JoAnn Sheeron; and *Word Perfect 6.0*, by Nita Rutkosky. 100% require freelance illustration and design. Books have very modern high tech design, mostly computer-generated. Book catalog free by request.

Needs: Approached by 50-75 freelancers/year. Works with 14 freelance illustrators and 20 designers/year. Uses freelance artists mainly for covers. Works on assignment only.

First Contact & Terms: Send brochure and slides. Samples are filed. Slides are returned. Art Director will contact artist for portfolio review if interested. Portfolio should include b&w and color transparencies. Rights purchased vary according to project. Interested in buying second rights (reprint rights) to previously published work.

Book Design: Assigns 10 freelance design jobs and 30 illustration jobs/year. Pays by the project, $500-1,500.

Jackets/Covers: Assigns 20 freelance design jobs and 20 illustration jobs/year. Pays by the project, $400-1,500.

Text Illustration: Pays $25-100/illustration.
Tips: Finds artists through artists' submission, agents and recommendations. "All work is being generated by the computer. I don't use any art that is done by hand, however, I am not interested in computer techies who think they are now designers"

‡PARAGON HOUSE, Dept. AGDM, 370 Lexington, New York NY 10017. (212)953-5950. Art Director: Marybeth Tregarthen. Estab. 1982. Publishes trade hardcover and softcover originals, textbooks and reprints. Types of books include religion, philosophy, history, New Age and reference. Publishes approximately 50 titles/year.
Needs: Uses illustrators mainly for jacket design and maps. Works on assignment only.
First Contact & Terms: Send query letter with tearsheets, slides, photographs, brochure or color photocopies. Samples are filed. Reports back only if interested. Originals are returned to artist at job's completion. Call or write for appointment to show portfolio of photostats, tearsheets, final reproduction/product, photographs or transparencies. Buys first or one-time rights.
Book Design: 50% of design and 10% of illustration is done by freelancers. Pays by the project, $400-600.
Jacket/Covers: 50% of design and 25% of illustration is done by freelancers. Pays by the project, $800-1,500.
Text Illustration: Pays by the project, approximately $100-300.

PAULINE BOOKS & MEDIA, (formerly St. Paul Books and Media), 50 St. Paul's Ave., Boston MA 02130. (617)522-8911. Fax: (617)541-9805. Contact: Graphic Design Dept. Estab. 1932. Book publisher. "We also publish 2 magazines and produce audio and video cassettes." Publishes hardcover and trade paperback originals and reprints and textbooks. Types of books include contemporary and historical fiction, instructional, biography, preschool, juvenile, young adult, reference, history, self help, prayer and religious. Specializes in religious topics. Publishes 20 titles/year. Art guidelines available. Sample copies for SASE with first-class postage.
Needs: Approached by 50 freelancers/year. Works with 10-20 freelance illustrators/year.
First Contact & Terms: Send query letter with brochure, résumé, SASE, tearsheets, photographs, photocopies, photostats, slides and transparencies. Samples are filed or are returned by SASE. Reports back within 1-3 months only if interested. Rights purchased vary according to project. Originals are returned at job's completion.
Jackets/Covers: Assigns 1-2 freelance illustration jobs/year. Pays by the project.
Text Illustration: Assigns 3-10 freelance illustration jobs/year. Pays by the project.

‡PAULIST PRESS, 997 Macarthur Blvd., Mahwah NJ 07430. (201)825-7300. Fax: (201)825-8345. Managing Editor: Don Brophy. Estab. 1869. Company publishes hardcover and trade paperback originals and textbooks. Types of books include biography, juvenile and religious. Specializes in academic and pastoral theology. Publishes 95 titles/year. 5% require freelance illustration; 5% require freelance design.
Needs: Works with 6-8 freelance illustrators and 15-20 designers/year. Prefers local freelancers only. Uses freelancers for juvenile titles, jacket/cover and text illustration. Needs computer-literate freelancers for design. 10% of freelance work demands knowledge of QuarkXPress. Works on assignment only.
First Contact & Terms: Send query letter with brochure, résumé and tearsheets. Samples are filed. Reports back only if interested. Portfolio review not required. Negotiates rights purchased. Originals are returned at job's completion if requested.
Book Design: Assigns 10-12 freelance design jobs/year.
Jackets/Covers: Assigns 90 freelance design jobs/year. Pays by the project, $400-800.
Text Illustration: Assigns 3-4 freelance illustration jobs/year. Pays by the project.

PELICAN PUBLISHING CO., 1101 Monroe St., Box 3110, Gretna LA 70054. (504)368-1175. Fax: (504)368-1195. Production Manager: Dana Bilbray. Publishes hardcover and paperback originals and reprints. Publishes 60-70 titles/year. Types of books include travel guides, cookbooks and children's books. Books have a "high-quality, conservative and detail-oriented" look.
Needs: Approached by 200 freelancers/year. Works with 20 freelance illustrators/year. Works on assignment only. Needs computer-literate freelancers for illustration. 10% of freelance work demands knowledge of Adobe Illustrator, Aldus FreeHand and Corel Draw.
First Contact & Terms: Send query letter, 3-4 samples and SASE. Samples are not returned. Reports back on future assignment possibilities. Buys all rights. Originals are not returned.
Book Design: Pays by the project, $500 minimum.
Jackets/Covers: Pays by the project, $150-500.
Text Illustration: Pays by the project, $50-250.
Tips: Wants to see "realistic detail, more color samples and knowledge of book design."

‡PETER PAUPER PRESS, INC., 202 Mamaroneck Ave., White Plains NY 10601. (914)681-0144. Fax: (914)681-0389. Contact: Creative Director. Estab. 1928. Company publishes hardcover originals. Types of books include small format illustrated gift books. Specializes in friendship, love, self-help, celebrations,

holidays, topics of interest to women. Publishes 40 titles/year. Recent titles include *Angels Are Forever, The Language of Flowers*, and *You're the Best*. 85% require freelance illustration; 40% require freelance design.
Needs: Approached by 25-30 freelancers/year. Works with 12-15 freelance illustrators and 3-5 designers/year. Uses freelancers for jacket/cover and text illustration. Needs computer-literate freelancers for design and illustration. 40% of freelance work demands knowledge of QuarkXPress. Works on assignment only.
First Contact & Terms: Send query letter with brochure, résumé, SASE, photographs and photocopies. Samples are not filed and are returned by SASE. Reports back within 1 month with SASE. Art Director will contact artist for portfolio review if interested. Portfolio should include book dummy, final art photographs and photostats. Rights purchased vary according to project. Originals are returned at job's completion.
Book Design: Assigns 20-25 freelance design jobs/year. Pays by the project, $100-3,000.
Jackets/Covers: Assigns 15-20 freelance design and 25-30 illustration jobs/year. Pays by the project, $500-1,250.
Text Illustration: Assigns 35-40 freelance illustration jobs/year. Pays by the project, $50-600.
Tips: Finds artists through artists' submissions, gift and card shows. "We particularly like to work with artists who have greeting card lines that they market through gift or stationery stores."

‡PICCADILLY BOOKS, Box 25203, Colorado Springs CO 80936. (719)548-1844. Publisher: Bruce Fife. Estab. 1985. Publishes hardcover and trade paperback originals. Types of books include instruction and humor. Specializes in humor, recreation and performing arts. Publishes 3-8 titles/year. Titles include *Writing Effective New Releases*. 80% require freelance illustration and design. Book catalog for SASE with 2 first-class stamps.
Needs: Uses freelancers mainly for cover design and text illustration. Works on assignment only.
First Contact & Terms: Send query letter with brochure and photocopies. Samples are filed. Reports back to the artist only if interested. To show portfolio, mail appropriate materials.
Book Design: Pays by the project.
Jackets/Covers: Assigns 6 freelance design jobs/year.
Text Illustration: Assigns 6 freelance jobs/year. Pays by the project.

THE PILGRIM PRESS/UNITED CHURCH PRESS, 700 Prospect Ave. E., Cleveland OH 44115-1100. (216)736-3726. Art Director: Martha Clark. Estab. 1957. Company publishes hardcover originals and trade paperback originals and reprints. Types of books environmental ethics, human sexuality, devotion, women's studies, justice, African-American studies, world religions, Christian education, curriculum, reference and social and ethical philosophical issues. Specializes in religion. Publishes 30 titles/year. Recent titles include *Gifts of Many Cultures: Worship Resources for the Global Community, In Good Company: A Woman's Journal for Spiritual Reflection*. 50% require freelance illustration; 50% require freelance design. Books are progressive, classic, exciting, sophisticated—conceptually looking for "high design." Book catalog free by request.
Needs: Approached by 50 freelancers/year. Works with 20 freelance illustrators and 20-25 designers/year. Buys 100-125 illustrations/year. Prefers freelancers with experience in book publishing. Uses freelancers mainly for covers, catalogs and illustration. Also for book design. Works on assignment only.
First Contact & Terms: Send query letter with résumé, tearsheets and photocopies. Samples are filed or are returned by SASE if requested by artist. Art Director will contact artist for portfolio review if interested. Artist should follow up with letter after initial query. Portfolio should include thumbnails, roughs and color tearsheets and photographs. Negotiates rights purchased. Interested in buying second rights (reprint rights) to previously published work based on need, style and concept/subject of art and cost. "I like to see samples." Originals are returned at job's completion.
Book Design: Assigns 6-20 freelance design and 50 illustration jobs/year. Pays by the project, $300-500.
Jackets/Covers: Assigns 6-20 freelance design and 6-20 illustration jobs/year. Prefers contemporary styles. Pays by the project, $400-650.
Text Illustration: Assigns 15-20 design and 15-20 illustration jobs/year. Pays by the project, $100 minimum; negotiable, based on artist estimate of job, number of pieces and style.
Tips: Finds artists through agents. "I also network with other art directors/designers for their qualified suppliers/freelancers. If interested in curriculum illustration, show familiarity with illustrating historical and biblical art and diverse races and ages."

PLAYERS PRESS, Box 1132, Studio City CA 91614. Associate Editor: Marjorie Clapper. Specializes in plays and performing arts books. Recent titles include *Men's Garments 1830-1900*, by R.I. Davis; and *Tangled Garden*, by David Crawford.
Needs: Works with 3-15 freelance illustrators and 1-3 designers/year. Uses freelancers mainly for play covers. Also for text illustration. Works on assignment only.
First Contact & Terms: Send query letter with brochure showing art style or résumé and samples. Samples are filed or are returned by SASE. Request portfolio review in original query. Art Director will contact artist for portfolio review if interested. Portfolio should include thumbnails, final reproduction/product, tearsheets, photographs and as much information as possible. Sometimes requests work on spec before assigning a job.

Buys all rights. Considers buying second rights (reprint rights) to previously published work, depending on usage. "For costume books this is possible."
Book Design: Pays by the project, varies.
Jackets/Covers: Pays by the project, varies.
Text Illustration: Pays by the project, varies.
Tips: "Supply what is asked for in the listing and don't waste our time with calls and unnecessary cards. We usually select from those who submit samples of their work which we keep on file. Keep a permanent address so you can be reached."

PRAKKEN PUBLICATIONS, INC., 275 Metty Dr., Box 8623, Suite 1, Ann Arbor MI 48107. (313)769-1211. Fax: (313)769-8383. Production and Design Manager: Sharon Miller. Estab. 1934. Imprints include The Education Digest, Tech Directions. Company publishes textbooks, educator magazines and reference books. Types of books include reference, texts, especially vocational and technical educational. Specializes in vocational, technical education, general education reference. Publishes 2 magazines and 3 new book titles/year. Titles include *High School-to-Employment Transition*, *Vocational Education in the '90s*, and *Managing The Occupational Education Lab*. Book catalog free by request.
Needs: Rarely uses freelancers. Needs computer-literate freelancers for design and production. 50% of freelance work demands knowledge of Aldus PageMaker. Works on assignment only.
First Contact & Terms: Send samples. Samples are filed or are returned by SASE if requested by asrtist. Reports back only if interested. Art Director will contact artist for portfolio review if interested. Portfolio should include b&w and color final art, photostats and tearsheets.

‡PRENTICE HALL, Simon & Schuster Education Group, School Division Art Dept., One Lake St., Room 1K24, Upper Saddle River NJ 07458. Imprint publishes textbooks. "Will be getting into consumer market." Specializes in history, science, language arts, multimedia. 50% require freelance illustration; 75% require design.
Needs: Buys 15 covers and hundreds of interior illustrations/year. Uses freelancers for jacket/cover design and illustration, text illustration and book design. Needs computer-literate freelancers for design, illustration, production and presentation. Freelancers should be familiar with Adobe Illustrator, QuarkXPress and Adobe Photoshop. Works on assignment only.
First Contact & Terms: Send postcard sample of work or send query letter with samples. Samples are filed. Art Director will contact artist for portfolio review if interested. Portfolio should include book dummy, final art, photographs and tearsheets. Buys all rights. Originals are not returned.
Tips: Finds artists through agents, sourcebooks, word of mouth, artist's submissions, attending art exhibitions.

PRENTICE HALL COLLEGE DIVISION, (formerly Macmillan Publishing College Division), 445 Hutchinson Ave., Columbus OH 43235. (614)841-3700. Fax: (614)841-3645. Production Services Manager: Connie Geldis. Imprint of Simon & Schuster. Specializes in college textbooks in eduction, career and technology. Publishes 300 titles/year. Recent titles include *Exceptional Children*, by Heward; and *Electronics Fundamentals*, by Floyd.
Needs: Approached by 25-40 freelancers/year. Works with 30 freelance illustrators/year. Uses freelancers mainly for book cover illustrations in all types of media. Also for jacket/cover design. Needs computer-literate freelancers for design and illustration. 70% of freelance work demands knowledge of QuarkXPress, Aldus FreeHand, Adobe Illustrator or Photoshop.
First Contact & Terms: Send query letter with tearsheets, slides or transparencies. Samples are filed and portfolios are returned. Reports back within 3 days. To show portfolio, mail tearsheets and transparencies. Rights purchased vary according to project. Originals are returned at job's completion.
Book Design: Pays by the project, $200-1,500.
Jackets/Covers: Assigns 200 illustration jobs/year.
Tips: "Send a style that works well with our particular disciplines. All covers are produced with a computer, but the images from freelancers can come in whatever technique they prefer. We are looking for new art produced on the computer."

PRICE STERN SLOAN, 11835 Olympic Blvd., Suite 500, Los Angeles CA 90064. (310)477-6100. Fax: (310)445-3933. Art Director: Sheena Needham. Estab. 1971. Book publisher. Publishes hardcover, trade paperback and mass market paperback originals and reprints. Types of books include instructional, preschool, juvenile, young adult, calendars, games, crafts, novelty and pop-up books. Publishes 80 titles/year. Recent titles include *Optricks*, by Larry Evans; and *Lunch Box Books*, by Charles Reasoner. 75% require freelance illustration; 10% require freelance design. Books vary from cute to quirky to illustrative.
 • Price Stern Sloan is a division of the Putnam Berkley Group which is owned by MCA/Universal Studios. It does quite a few license tie-in books with the film and TV industries.
Needs: Approached by 300 freelancers/year. Works with 20-30 freelance illustrators and 10-20 designers/year. Prefers freelancers with experience in book or advertising art. Uses freelancers mainly for illustration. Also for jacket/cover and book design. Needs computer-literate freelancers for production.

First Contact & Terms: Send query letter with brochure, résumé and photocopies. Samples are filed or are returned by SASE if requested by artist. Art Director will contact artist for portfolio review if interested. "Please don't call." Portfolios may be dropped off every Thursday. Portfolio should include b&w and color tearsheets. Rights purchased vary according to project.

Book Design: Assigns 5-10 freelance design jobs and 20-30 illustration jobs/year. Pays by the project.

Jackets/Covers: Assigns 5-10 freelance design jobs and 10-20 illustration jobs/year. Pays by the project, varies.

Text Illustration: Pays by the project and occasionally by participation.

Tips: Finds artists through word of mouth, magazines, artists' submissions/self-promotions, sourcebooks and agents. "Do not send original art. Become familiar with the types of books we publish. We are always looking for excellent book submissions. We are extremely selective when it comes to children's books, so please send only your best work. Any book submission that does not include art samples should be sent to our editorial department. Book design is branching out into new markets—CD-ROM, computers, audio, video."

‡**PSYCHOLOGICAL ASSESSMENT RESOURCES, INC.**, 16204 N. Florida Ave., Lutz FL 33549. (813)963-3003. Production Coordinator: Sandy Schneider. Estab. 1980. Company publishes hardcover and trade paperback originals, textbooks, test materials and software manuals. Types of books include instructional and textbooks. Specializes in career assessment, psychology. Publishes 12 titles/year. 5% require freelance illustration; 20% require freelance design. Book catalog free by request.

Needs: Approached by 3 freelancers/year. Works with 1 freelance illustrator and 2 designers/year. Prefers freelancers with experience in professional manuals/publications. Uses freelancers mainly for typesetting, logo design and covers. Also for direct mail design. Needs computer-literate freelancers for design and production. 100% of freelance work demands knowledge of Adobe Illustrator, QuarkXPress and Adobe Photoshop. Works on assignment only.

First Contact & Terms: Send query letter with tearsheets and photocopies. Samples are filed. Art Director will contact artist for portfolio review if interested. Portfolio should include book dummy and final art. Buys all rights.

Book Design: Assigns 6 freelance design jobs/year. Pays by the project.

Jackets/Covers: Assigns 6 freelance design and 2 illustration jobs/year. Pays by the hour.

PULSE-FINGER PRESS, Box 488, Yellow Springs OH 45387. Contact: Orion Roche or Raphaello Farnese. Publishes hardbound and paperback fiction, poetry and drama. Publishes 5-10 titles/year.

Needs: Prefers local freelancers. Works on assignment only. Uses freelancers for advertising design and illustration. Pays $25 minimum for direct mail promos.

First Contact & Terms: Send query letter. "We can't use unsolicited material. Inquiries without SASE will not be acknowledged." Reports back in 6 weeks; reports on future assignment possibilities. Samples returned by SASE. Send résumé to be kept on file. Artist supplies overlays for all color artwork. Buys first serial and reprint rights. Originals are returned at job's completion.

Jackets/Covers: "Must be suitable to the book involved; artist must familiarize himself with text. We tend to use modernist/abstract designs. Try to keep it simple, emphasizing the thematic material of the book." **Pays on acceptance**; $25-100 for b&w jackets.

G.P. PUTNAM'S SONS, (Philomel Books), 200 Madison Ave., New York NY 10016. (212)951-8700. Art Director, Children's Books: Cecilia Yung. Assistant to Art Director: Michelle Regan. Publishes hardcover and paperback juvenile books. Publishes 100 titles/year. Free catalog available.

Needs: Works on assignment only.

First Contact & Terms: Provide flier, tearsheet, brochure and photocopy or stat to be kept on file for possible future assignments. Samples are returned by SASE. "We take drop-offs on Tuesday mornings. Please call in advance with the date you want to drop of your portfolio."

Jackets/Covers: "Uses full-color paintings, painterly style."

Text Illustration: "Uses a wide cross section of styles for story and picture books."

‡**PYX PRESS**, P.O. Box 922648, Sylmar CA 91392-2648. Editor: C. Darren Butler. Estab. 1990. Company publishes experimental fiction, fantasy, horror, humor, juvenile, nonfiction and reference. Specializes in magic realism, folklore, literary fantasy. Publishes 2-10 titles/year. Recent titles include *One Thick Black Cord*, by Brian Everson; *Back at the Civsa Shore*, by Batya Weinbaum. 50% require freelance illustration. Book catalog free for #10 SASE with 1 first-class stamp.

● Pyx Press publishes several serials including *Avatar*, *North-American Magic Realism* and *Strike Through the Mask* which are also in need of artwork. The publications pay in copies or up to $200 for illustrations. Contact the press for more information.

Needs: Approached by 75 freelancers/year. Works with 3-10 freelance illustrators/year. Uses freelancers mainly for covers and spot illustrations. Also for text illustration.

First Contact & Terms: Send postcard sample of work or send query letter with SASE. Samples are filed or returned by SASE if requested by artist. Reports back in 1 month on query; 2-6 months on submissions.

Request portfolio review in original query (reviews photocopies by mail). Buys first or one-time rights. Originals are returned at job's completion.
Jackets/Covers: Assigns 2-4 freelance illustration jobs/year. Pays by the project, $5-100.

‡❦R.T.A.J. FRY PRESS/A.I.C., Box 1223 Edmonton Main Post Office, Edmonton, Alberta T5J 2M4 Canada. Contact: Artist's Editor. Estab. 1989. Publishes hardcover and trade paperback originals and reprints. Types of books include experimental fiction, adventure, biography, reference, history and travel. Specializes in historical reference. Publishes 6 titles/year. Titles include *Alberta Ethnic Mormon Politicians*. 100% require freelance illustration and design. Book catalog available for $5.
Needs: Approached by 20 freelancers/year. Works with 10 freelance illustrators and 10 designers/year. Uses freelancers mainly for design and book design. Works on assignment only.
First Contact & Terms: Send query letter with brochure, résumé, SASE (IRCs), photocopies, photostats. Do not send originals. Samples are filed. Reports back within 3 months with SASE. To show portfolio, mail roughs and original/final art and b&w or color photographs. Buys all rights. Rights purchased vary according to project. Originals are returned at job's completion.
Book Design: Assigns 10 freelance design and 10 illustration jobs/year. Pays by the project, $50-200.
Jackets/Covers: Assigns 10 freelance design and 10 illustration jobs/year. Pays by the project, $50-200.
Text Illustration: Pays by the project, $50-300.

‡RAGNAROK PRESS, Box 140333, Austin TX 78714. Fax: (512)472-6220. E-mail: ragnarokgc@aol.com. Editor: David F. Nall.
● Ragnarok Press is primarily a book publisher, but also publishes *Abyss Magazine*. See listing for *Abyss* in Magazines section for more information. According to Editor David Nall, Ragnarok Press is buying more art than *Abyss* and has different needs. *Abyss* is more open to new artists; Ragnarok is higher paying.

RAINBOW BOOKS, INC., P.O. Box 430, Highland City FL 33846-0430. (813)648-4420. Fax: (813)648-4420. E-mail: naip@aol.com. Media Buyer: Betsy A. Lampe. Estab. 1979. Company publishes hardcover and trade paperback originals. Types of books include instruction, adventure, biography, travel, self help, religious, reference, history and cookbooks. Specializes in nonfiction, self help and how-to. Publishes 20 titles/year. Recent titles include *An Ounce of Preservation*, by Craig A. Tuttle; and *Seafood is Supreme*, by Michael H. Sherwood (cookbook). 10% require freelance illustration. Book catalog available for 9½×6½ SAE with $1.0. postage.
Needs: Approached by "fewer than three" freelance artists/year. Works with 1-2 freelance illustrators/year. Prefers freelancers with experience in book cover design and line illustration. Uses freelancers for jacket/cover illustration and design and text illustration. Needs computer-literate freelancers for design, illustration and production. 90% of freelance work demands knowledge of Aldus PageMaker, Aldus FreeHand or Corel-Draw. Works on assignment only.
First Contact & Terms: Send query letter with SASE, tearsheets, photographs and book covers or jackets. Samples are returned by SASE. Reports back within 2 weeks. Art Director will contact artist for portfolio review if interested. Portfolio should include b&w and color tearsheets, photographs and book covers or jackets. Rights purchased vary according to project. Originals are returned at job's completion.
Jackets/Covers: Assigns 3-6 freelance illustration jobs/year. Pays by the project, $250 minimum. Prefers electronic illustration.
Text Illustration: Pays by the project. Prefers pen & ink or electronic illustration.
Tips: First-time assignments are usually interior illustration, cover art; complete cover design/illustration are given to "proven" freelancers. Finds artists through word of mouth.

RANDOM HOUSE, INC., (Juvenile), 201 E. 50th St., New York NY 10022. (212)940-7670. Vice President/ Executive Art Director: Cathy Goldsmith. Specializes in hardcover and paperback originals and reprints. Publishes 200 titles/year. 100% require freelance illustration.
Needs: Works with 100-150 freelancers/year. Works on assignment only.
First Contact & Terms: Send query letter with résumé, tearsheets and photostats; no originals. Samples are filed or are returned. "No appointment necessary for portfolios. Come in on Wednesdays only, before noon." Considers complexity of project, skill and experience of artist, budget, turnaround time and rights purchased when establishing payment. Negotiates rights purchased.
Book Design: Assigns 5 freelance design jobs/year. Pays by the project.
Text Illustration: Assigns 150 illustration jobs/year. Pays by the project.

‡RANDOM HOUSE VALUE PUBLISHING, 40 Engelhard Ave., Avenel NJ 07001. (908)827-2672. Fax: (908)827-2694. Art Director: Gus Papadopoulos. Creative Director: Don Bender. Imprint of Random House, Inc. Other imprints include Wings, Gramercy, Crescent, Jellybean. Imprint publishes hardcover, trade paperback and mass market paperback reprints and trade paperback originals. Types of books include adventure, coffee table books, cookbooks, fantasy, historical fiction, history, horror, humor, instructional, juvenile, mainstream fiction, New Age, nonfiction, reference, religious, romance, science fiction, self help, travel, western

and young adult. Specializes in contemporary authors' work. Recently published titles by John Saul, Mary Higgins Clark, Tom Wolfe, Dave Barry and Michael Chrichton (all omnibuses). 80% require freelance illustration; 50% require freelance design. Book catalog free by request.

Needs: Approached by 70 freelancers/year. Works with 60-70 freelance illustrators and 20-25 designers/year. Uses freelancers mainly for jacket/cover illustration and design for fiction and romance titles. Needs computer-literate freelancers for design and illustration. 60% of freelance work demands knowledge of Adobe Illustrator, QuarkXPress, Adobe Photoshop and Aldus FreeHand. Works on assignment only.

First Contact & Terms: Send postcard sample of work. Send query letter with tearsheets, photographs, photocopies and transparencies. Samples are filed. Reports back within 2 weeks. Request portfolio review in original query. Art Director will contact artist for portfolio review if interested. Portfolio should include tearsheets. Buys first rights. Originals are returned at job's completion.

Book Design: Pays by the project.

Jackets/Covers: Assigns 30-40 freelance design and 75 illustration jobs/year. Pays by the project, $500-2,500.

Tips: Finds artists through *American Showcase*, *Workbook*, *The Creative Illustration Book*, artist's reps.

READ'N RUN BOOKS, Box 294, Rhododendron OR 97049. (503)622-4798. Publisher: Michael P. Jones. Estab. 1985. Specializes in fiction, history, environment and wildlife books for children through adults. "Books for people who do not have time to read lengthy books." Publishes 2-6 titles/year. Recent titles include *The Moonlit Road*, by Ambrose Bierce; and *The Rose Garden*, by M.R. James. "Our books, printed in b&w or sepia, are both hardbound and softbound, and are not slick looking. They are home-grown-looking books that people love." Accepts previously published material. Art guidelines for #10 SASE.

Needs: Works with 25-50 freelance illustrators and 10 designers/year. Prefers pen & ink, airbrush, charcoal/pencil, markers, calligraphy and computer illustration. Uses freelancers mainly for illustrating books. Also for jacket/cover, direct mail, book and catalog design.

First Contact & Terms: Send query letter with brochure or résumé, tearsheets, photostats, photocopies, slides and photographs. Samples not filed are returned by SASE. Request portfolio review in original query. Art Director will contact artist for portfolio review if interested. Artist should follow up after initial query. Portfolio should include thumbnails, roughs, final reproduction/product, color and b&w tearsheets, photostats and photographs. Buys one-time rights. Interested in buying second rights (reprint rights) to previously published work. Originals are returned at job's completion. Pays in copies, on publication.

Tips: "Generally, the artists find us by submitting samples—lots of them, I hope. Artists may call us, but we will not return calls. We will be publishing short-length cookbooks. I want to see a lot of illustrations showing a variety of styles. There is little that I actually don't want to see. We have a tremendous need for illustrations on the Oregon Trail (i.e., oxen-drawn covered wagons, pioneers, mountain men, fur trappers, etc.) and illustrations depicting the traditional way of life of Plains Indians and those of the North Pacific Coast and Columbia River with emphasis on mythology and legends. Pen & ink is coming back stronger than ever! Don't overlook this. Be versatile with your work."

RIO GRANDE PRESS, P.O. Box 71745, Las Vegas NV 89170-1745. Editor/Publisher: Rosalie Avara. Estab. 1989. Small press. Publishes trade paperback originals. Types of books include poetry journal and anthologies. Publishes 7 titles/year. Recent titles include *Summer's Treasures III* and *Story Shop II*. 95% require freelance illustration; 90% require freelance design. Book catalog for SASE with first-class postage. Artist guidelines available.

Needs: Approached by 30 freelancers. Works with 5-6 freelance illustrators and 1 designer/year. Prefers freelancers with experience in spot illustrations for poetry and b&w cartoons about poets, writers, etc. "I have only one cover designer at present." Uses freelancers for jacket/cover illustration and design and text illustration.

First Contact & Terms: Send query letter with résumé, SASE, tearsheets, photocopies and cartoons. Samples are filed. Reports back within 1 month. To show portfolio, mail roughs, finished art samples and b&w tearsheets. Buys first rights or one-time rights. Originals are not returned.

Book Design: Assigns 2-3 freelance illustration jobs/year. Pays by the project; $4 or copy.

Jackets/Covers: Pays by the project, $4; or copy.

Text Illustration: Assigns 4 freelance illustration jobs/year. Prefers small b&w line drawings to illustrate poems. Pays by the project; $4 or copy.

Tips: "We have been using portraits of famous poets/writers along with a series of cover articles to go with each issue (of *Se La Vie Writer's Journal*)."

ST. MARTIN'S PRESS, INC., 175 Fifth Ave., New York NY 10010. Does not need freelancers at this time.

‡SAUNDERS COLLEGE PUBLISHING, Public Ledger Bldg., Suite 1250, 150 S. Independence Hall, Philadelphia PA 19106. (215)238-5500. Manager of Art & Design: Carol Bleistine. Imprint of Harcourt Brace College Publishers. Company publishes textbooks. Specializes in sciences. Publishes 30-45 titles/year. 100% require freelance illustration; 100% require freelance design. Book catalog not available.

Needs: Approached by 10-20 freelancers/year. Works with 10-20 freelance illustrators and 10-20 designers/year. Prefers local freelancers with experience in hard sciences (biology, chemistry, physics, math, etc.). Uses freelancers mainly for design of text interiors, covers, artwork, page layout. Also for jack/cover and text illustration, jacket/cover and book design. Needs computer-literate freelancers for design and illustration. 95% of freelance work demands knowledge of Aldus PageMaker, Adobe Illustrator, QuarkXPress, Adobe Photoshop and Aldus FreeHand. Works on assignment only.

First Contact & Terms: Send query letter with brochure, résumé, tearsheets, photographs, photocopies, slides and transparencies. Samples are filed or returned by SASE if requested by artist. Request portfolio review in original query. Art Director will contact artist for portfolio review if interested. Portfolio should include book dummy, final art, photographs, roughs, slides, tearsheets and transparencies. Buys all rights.

Books Design: Assigns 30-45 freelance design jobs/year. Pays by the project.

Jackets/Covers: Assigns 30-45 freelance design and 1-2 illustration jobs/year. Pays by the project.

Text Illustration: Assigns 30-45 freelance illustration jobs/year. Pays by the project or per figure. Prefers airbrush reflective; electronic art, styled per book requirements—varies.

Tips: Finds artists through sourcebooks, word of mouth and artists' submissions.

SCHOLASTIC INC., 555 Broadway, New York NY 10012. Executive Art Director: David Tommasino. Specializes in hardcover and paperback originals and reprints of young adult, biography, classics, historical romance and contemporary teen romance. Publishes 250 titles/year. Titles include *Goosebumps*, *Clue* and *Nightmare Hall*. 80% require freelance illustration. Books have "a mass-market look for kids."

Needs: Approached by 100 freelancers/year. Works with 75 freelance illustrators and 2 designers/year. Prefers local freelancers with experience. Uses freelancers mainly for mechanicals. Also for jacket/cover illustration and design and book design.

First Contact & Terms: Send query letter with brochure showing art style or tearsheets. Samples are filed or are returned only if requested. Art Director will contact artist for portfolio review if interested. Considers complexity of project and skill and experience of artist when establishing payment. Buys first rights. Originals are returned at job's completion.

Book Design: Pays by the project, $1,000-3,000.

Jackets/Covers: Assigns 200 freelance illustration jobs/year. Pays by the project, $1,800-3,500.

Text Illustration: Pays by the project, $500-1,500.

Tips: Finds artists through word of mouth, *American Showcase*, *RSVP* and Society of Illustrators. "In your portfolio, show tearsheets or proofs only of printed covers. I want to see oil, acrylic tightly rendered; illustrators should research the publisher. Go into a bookstore and look at the books. Gear what you send according to what you see is being used."

SIMON & SCHUSTER, 1230 Avenue of the Americas, New York NY 10020. (212)698-7556. Fax: (212)698-7455. Art Director: Gina Bonanno. Imprints include Pocket Books, Minstrel and Archway. Company publishes hardcover, trade paperback and mass market paperback originals and reprints and textbooks. Types of books include juvenile, pre-school, romance, self help, young adult and many others. Specializes in young adult, romance and self help. 95% require freelance illustration; 80% require freelance design. Book catalog not available.

Needs: Works with 50 freelance illustrators and 5 designers/year. Prefers freelancers with experience working with models and taking direction well. Uses freelancers for hand lettering, jacket/cover illustration and design and book design. Needs computer-literate freelancers for design and illustration. 80% of freelance work demands knowledge of Adobe Illustrator, QuarkXPress and Adobe Photoshop. Works on assignment only.

First Contact & Terms: Send query letter with tearsheets. Samples are filed and are not returned. Reports back only if interested. Portfolios may be dropped off every Monday and Wednesday and should include tearsheets. Buys all rights. Originals are returned at job's completion.

Text Illustration: Assigns 50 freelance illustration jobs/year.

‡SIMON & SCHUSTER BOOKS FOR YOUNG READERS, 866 Third Ave., 25th Floor, New York NY 10022. (908)702-2019. Art Director: Lucille Chomowicz. Imprint of Simon & Schuster. Other imprints include Atheneum, Macmillan and McElderry. Imprint publishes hardcover originals and reprints. Types of books include picture books, nonfiction and young adult. Publishes 86 titles/year. Recent titles include *Harriet & Promised Land*, *My Rotten Red Headed Brother*, *The Hole Story*, *Zin Zin A Violin*, *The Faithful Friend* and *Uncle Jed's Barbershop*. 100% require freelance illustration; 1% require freelance design. Book catalog not available.

Needs: Approached by 200 freelancers/year. Works with 40 freelance illustrators and 2-4 designers/year. Uses freelancers mainly for jackets and picture books ("all illustration work is freelance"). Needs computer-literate freelancers for design and illustration. 100% of design work demands knowledge of Adobe Illustrator, QuarkXPress and Adobe Photoshop. Works on assignment only.

First Contact & Terms: Send postcard sample of work. Send query letter with non-returnable tearsheets and photocopies. Art Director will contact artist for portfolio review if interested. Portfolio should include original art, photographs and transparencies. Originals are returned at job's completion.

Book Design: Assigns 6 freelance design jobs/year. Pays by the project.
Jackets/Covers: Assigns 15 freelance illustration jobs/year. Pays by the project, $800-2,000. "We use full range of media: collage, photo, oil, watercolor, etc."
Text Illustration: Assigns 30 freelance illustration jobs/year. Pays by the project.
Tips: Finds artists through submissions, agents, scouting in nontraditional juvenile areas such as painters, editorial artists.

‡**SMITH AND KRAUS, INC.**, P.O. Box 127, Lyme NH 03768. (603)795-4340. Fax: (603)795-4427. Production Manager: Julia Hill. Company publishes hardcover and trade paperback originals. Types of books include young adult, drama and acting. Specializes in books for actors. Publishes 20 titles/year. Recent titles include *The Best Men's/Women's Monologues of 1994*, *The Sanford Meisner Approach*, and *The Best Women Playwrights of 1994*. 20% require freelance illustration. Book catalog free for SASE with 3 first-class stamps.
Needs: Approached by 2 freelancers/year. Works with 2-3 freelance illustrators/year. Uses freelancers mainly for cover art, inside illustration. Also for text illustration. Needs computer-literate freelancers for illustration. 10% of freelance work demands knowledge of Adobe Illustrator, QuarkXPress and Adobe Photoshop. Works on assignment only.
First Contact & Terms: Send postcard sample of work or send query letter with brochure, résumé and SASE. Samples are filed or returned by SASE if requested by artst. Art Director will contact artist for portfolio review if interested. Portfolio should include book dummy and roughs. Buys one-time and reprint rights. Originals are returned at job's completion.
Text Illustration: Assigns 1-3 freelance illustration jobs/year. Pays by the project. Prefers pen & ink.
Tips: Finds artists through word of mouth.

SMITHSONIAN INSTITUTION PRESS, 470 L'Enfant Plaza, Room 7100, Washington DC 20560. Does not need freelancers at this time.

SOUNDPRINTS, P.O. Box 679, 165 Water St., Norwalk CT 06856. (203)838-6009. Fax: (203)866-9944. Assistant Editor: Dana Rau. Estab. 1989. Company publishes hardcover originals. Types of books include juvenile. Specializes in wildlife. Publishes 12 titles/year. Recent titles include *Dolphin's First Day* and *Fawn at Woodland Way*, both by Kathleen Weidner Zoehfeld. 100% require freelance illustration. Book catalog free for 9×12 SAE with 2 first-class stamps.
Needs: Approached by 15 freelancers/year. Works with 9 freelance illustrators/year. Prefers freelancers with experience in realistic wildlife illustration and children's books. Uses freelancers for illustrating children's books (cover and interior).
First Contact & Terms: Send query letter with tearsheets, résumé, slides and SASE. Samples are filed or returned by SASE if requested by artist. Reports back within 1 month. Art Director will contact artist for portfolio review if interested. Portfolio should include color final art and tearsheets. Rights purchased vary according to project. Originals are returned at job's completion.
Text Illustration: Assigns 12 freelance illustration jobs/year. Prefers watercolor, colored pencil.
Tips: Finds artists through agents, sourcebooks, references, unsolicited submissions. Wants realism. "We are not looking for cartoons."

‡**SOURCEBOOKS, INC.**, 121 N. Washington, Suite 2, Naperville IL 60540. (708)961-3900. Fax: (708)961-2168. Estab. 1987. Company publishes hardcover and trade paperback originals and ancillary items. Types of books include New Age, nonfiction, pre-school, reference, self help and gift books. Specializes in business books and gift books. Publishes 50 titles/year. Recent titles include *Finding Peace: Letting Go & Liking It*, *Making It In Hollywood* and *365 Days of Creative Play*. Book catalog free for SASE with 4 first-class stamps.
Needs: Uses freelancers mainly for ancillary items, journals, jacket/cover design and illustration, text illustration, direct mail, book and catalog design. Needs computer-literate freelancers for design, illustration, production and presentation. Freelancers should be familiar with QuarkXPress and Adobe Photoshop. Works on assignment only.
First Contact & Terms: Send query letter with "any art material that we can keep on file." Reports back only if interested. Request portfolio review in original query. Negotiates rights purchased.
Book Design: Pays by the project.
Jackets/Covers: Pays by the project.
Text Illustration: Pays by the project.
Tips: "We have expanded our list tremendously and are, thus, looking for a lot more artwork. We have terrific distribution in retail outlets and are looking to provide more great looking material."

THE SPEECH BIN, INC., 1965 25th Ave., Vero Beach FL 32960. (407)770-0007. Fax: (407)770-0006. Senior Editor: Jan Binney. Estab. 1984. Publishes textbooks and educational games and workbooks for children and adults. Specializes in tests and materials for treatment of individuals with all communication disorders. Publishes 20-25 titles/year. Recent titles include *Funology Fables*, by R. Sunderbruch; and *Techniques for Aphasia Rehabilitation*, by M.J. Santo Pietro and R. Goldfarb. 75% require freelance illustration; 50% require freelance design. Book catalog available for 8½×11 SAE with $1.48 postage.

Needs: Works with 8-10 freelance illustrators and 2-4 designers/year. Buys 1,000 illustrations/year. Work must be suitable for handicapped children and adults. Uses freelancers mainly for instructional materials, cover designs, gameboards, stickers. Also for jacket/cover and text illustration. Occasionally uses freelancers for catalog design projects. Works on assignment only.

First Contact & Terms: Send query letter with brochure, SASE, tearsheets and photocopies. Samples are filed or are returned by SASE if requested by artist. Reports back to the artist only if interested. Do not send portfolio; query only. Usually buys all rights. Considers buying second rights (reprint rights) to previously published work.

Book Design: Pays by the project.

Jackets/Covers: Assigns 10-12 freelance design jobs and 10-12 illustration jobs/year. Pays by the project.

Text Illustration: Assigns 6-10 freelance illustration jobs/year. Prefers b&w line drawings. Pays by the project.

Tips: Finds artists through "word of mouth, through our authors and submissions by artists."

SPINSTERS INK, 32 E. First St., #330, Duluth MN 55802. (218)727-3222. Fax: (218)727-3119. Production Manager: Liz Tufte. Estab. 1978. Company publishes trade paperback originals and reprints. Types of books include contemporary fiction, mystery, biography, young women, reference, history of women, humor and feminist. Specializes in "fiction and nonfiction that deals with significant issues in women's lives from a feminist perspective." Publishes 6 titles/year. Recent titles include *Fat Girl Dances with Rocks*, by Susan Stinson (novel); and *Mother Journeys*, edited by Reddy, Roth and Sheldon (anthology). 50% require freelance illustration; 100% require freelance design. Book catalog free by request.

Needs: Approached by 24 freelancers/year. Works with 2-3 freelance illustrators and 2-3 freelance designers/ year. Buys 2-6 freelance illustrations/year. Prefers artists with experience in "portraying positive images of women's diversity." Uses freelance artists for jacket/cover illustration and design, book and catalog design. Needs computer-literate freelancers for design, illustration, production and presentation. 100% of freelance work demands knowledge of Adobe Illustrator, Adobe Photoshop, QuarkXPress or Macintosh FrameMaker. Works on assignment only.

First Contact & Terms: Send query letter with SASE, 3-5 slides or color copies, preferably 8×10 or smaller. Samples are filed or are returned by SASE if requested by artist. Reports back within 1 month. Art Director will contact artist for portfolio review if interested. Portfolio should include b&w and color thumbnails, final art and photographs. Buys first rights. Originals are returned at job's completion.

Jackets/Covers: Assigns 6 freelance design and 2-6 freelance illustration jobs/year. Pays by the project, $500-1,000. Prefers "original art with appropriate type treatment, b&w to 4-color. Often the entire cover is computer-generated, with scanned image. Our production department produces the entire book, including cover, electronically."

Text Illustration: Assigns 0-6 freelance illustrations/year. Pays by the project, $75-150. Prefers "b&w line drawings or type treatment that can be converted electronically. We create the interior of books completely using desktop publishing technology on the Macintosh."

Tips: Finds artists through word of mouth and artists' submissions. "We're always looking for freelancers who have experience portraying celebrating images of diverse women, with current technological experience on the computer."

STAR PUBLISHING, Box 68, Belmont CA 94002. Managing Editor: Stuart Hoffman. Specializes in original paperbacks and textbooks on science, art, business. Publishes 12 titles/year. 33% require freelance illustration. Titles includes *Microbiology Techniques*.

First Contact & Terms: Works with 8-10 freelance illustrators and 3-4 designers/year. Send query letter with résumé, tearsheets and photocopies. Samples not filed are returned only by SASE. Reports back only if interested. Rights purchased vary according to project. Originals are not returned.

Book Design: Assigns 5 freelance jobs/year. Pays by the project.

Jackets/Covers: Assigns 12 freelance design jobs/year. Pays by the project.

Text Illustration: Assigns 6 freelance jobs/year. Pays by the project.

Tips: Freelance artists need to be aware of "increased use of graphic elements, striking color combinations, more use of color illustration."

STARBURST PUBLISHERS, P.O. Box 4123, Lancaster PA 17604. (717)293-0939. Editorial Director: Ellen Hake. Estab. 1982. Publishes hardcover originals and trade paperback originals and reprints. Types of books include contemporary and historical fiction, celebrity biography, self help, cookbooks and other nonfiction. Specializes in inspirational and general nonfiction. Publishes 15-20 titles/year. Recent titles include *Nightmare in Dallas*, by Beverly Oliver; and *Angels, Angels, Angels*, by Phil Phillips. 50% require freelance design; 50% require freelance illustration. Books contain strong, vibrant graphics or artwork. Book catalog available for SAE with 4 first-class stamps.

Needs: Works with 5 freelance illustrators and designers/year. Buys 10 illustrations/year. Prefers artists with experience in publishing and knowledge of mechanical layout. Uses freelancers mainly for jacket/cover design and illustration. Works on assignment only.

First Contact & Terms: Send query letter with brochure, tearsheets, photostats, résumé and SASE. Samples are filed or are returned by SASE. Art Director will contact artist for portfolio review if interested. Sometimes requests work on spec before assigning a job. Buys all rights. Considers buying second rights (reprint rights) to previously published artwork. Originals are not returned.

Book Design: Assigns 5-7 freelance design and 5-7 illustration jobs/year. Pays by the project, $200 minimum.

Jackets/Cover: Assigns 10-15 freelance jobs/year. Pays by the project, $200 minimum.

Text Illustration: Assigns 2-5 freelance design and 2-5 illustration jobs/year. Pays by the project, $200 minimum.

Tips: "Understand what makes a good competitive book cover and/or an enhancing text illustration."

‡STEMMER HOUSE PUBLISHERS, INC., 2627 Caves Rd., Owings Mills MD 21117. (301)363-3690. President: Barbara Holdridge. Specializes in hardcover and paperback fiction, nonfiction, art books, juvenile and design resource originals. Publishes 10 titles/year. Recent titles include *The Magic Storysinger*, Mea McNeil; and *How Pleasant to Know Mr. Lear*, by Edward Lear. Books are "well illustrated." 10% require freelance design; 75% require freelance illustration.

Needs: Approached by more than 50 freelancers/year. Works with 4 freelance illustrators and 1 designer/year. Works on assignment only.

First Contact & Terms: Send brochure/flyer, tearsheets, photocopies or color slides to be kept on file; submission must include SASE. Do not send original work. Material not filed is returned by SASE. Call or write for appointment to show portfolio. Reports in 6 weeks. Works on assignment only. Originals are returned to artist at job's completion on request. Negotiates rights purchased.

Book Design: Assigns 1 freelance design and 4 illustration jobs/year. Pays by the project, $300-2,000.

Jackets/Covers: Assigns 4 freelance design jobs/year. Prefers paintings. Pays by the project, $300-1,000.

Text Illustration: Assigns 8 freelance jobs/year. Prefers full-color artwork for text illustrations. Pays by the project on a royalty basis.

Tips: Looks for "draftmanship, flexibility, realism, understanding of the printing process." Books are "rich in design quality and color, stylized while retaining realism; not airbrushed. 1) Review our books. 2) Propose a strong picture-book manuscript with your illustrations."

‡JEREMY P. TARCHER, INC., 11835 Olympic Blvd., 5th Floor, Los Angeles CA 90064. (310)477-3500. Fax: (310)477-9410. Art Director: Susan Shankin. Estab. 1970s. Imprint of G.P. Putnam Co. Imprint publishes hardcover and trade paperback originals and trade paperback reprints. Types of books include instructional, New Age and self help. Publishes 25-30 titles/year. Recent titles include *The End of Work*, *The Artist's Way* and *The Temple in the House*. 30% require freelance illustration; 30% require freelance design.

Needs: Approached by 10 freelancers/year. Works with 10-12 freelance illustrators and 4-5 designers/year. Works only with artist reps. Uses jacket/cover illustration. 50% of freelance work demands knowledge of QuarkXPress. Works on assignment only.

First Contact & Terms: Send postcard sample of work or send query letter with brochure, tearsheets and photocopies. Samples are filed. Art Director will contact artist for portfolio review if interested. Portfolio should include book dummy, final art, photographs, roughs, tearsheets and transparencies. Buys first rights or one-time rights. Originals are returned at job's completion.

Book Design: Assigns 4-5 freelance design jobs/year. Pays by the project, $800-1,000.

Jackets/Covers: Assigns 4-5 freelance design and 10-12 freelance illustration jobs/year. Pays by the project, $950-1,100.

Text Illustration: Assigns 1 freelance illustration job/year. Pays by the project, $100-500.

Tips: Finds artists through sourcebooks, *Communication Arts*, word of mouth, artists' submissions.

‡TEHABI BOOKS, INC., (formerly Tom Lewis, Inc.), 13070 Via Grimaldi, Del Mar CA 92014. (619)481-7600. Fax: (619)481-3247. E-mail: nancy@tehabi.com. Managing Editor: Nancy Cash. Estab. 1992. Specializes in design and production of large-format, visual books. Works hand-in-hand with publishers, corporations, institutions and nonprofit organizations to identify, develop, produce and market high-quality visual books for the international market place. Produces lifestyle/gift books; institutional books; children's books; corporate-sponsored books and CD-ROM publishing.

Needs: Approached by 50 freelancers/year. Works with 75-100 freelance illustrators and 3 designers/year. Needs computer-literate freelancers for illustration. Freelancers should be familiar with Aldus PageMaker, Adobe Illustrator, QuarkXPress, Adobe Photoshop, Aldus FreeHand and 3-D programs. Works on assignment only.

First Contact & Terms: Send query letter with samples. Rights purchased vary according to project.

Text Illustration: Pays by the project, $100-10,000.

Tips: Finds artists through sourcebooks, publications and submissions.

♣THISTLEDOWN PRESS LTD., 633 Main St., Saskatoon, Saskatchewan S7H 0J8 Canada. (306)244-1722. Fax: (306)244-1762. Director, Production: Allan Forrie. Estab. 1975. Publishes trade and mass market paperback originals. Types of books include contemporary and experimental fiction, juvenile, young adult and

poetry. Specializes in poetry creative and young adult fiction. Publishes 10-12 titles/year. Titles include *The Blue Jean Collection*; *The Big Burn*, by Lesley Choyce; and *The Blue Camaro*, by R.P. MacIntyre. 50% require freelance illustration. Book catalog for SASE.

Needs: Approached by 25 freelancers/year. Works with 8-10 freelance illustrators/year. Prefers local Canadian freelancers. Uses freelancers for jacket/cover illustration. Uses only Canadian artists and illustrators for its title covers. Works on assignment only.

First Contact & Terms: Send query letter with résumé, SASE, slides and transparencies. Samples are filed or are returned by SASE. Reports back to the artist only if interested. Call for appointment to show portfolio of original/final art, tearsheets, photographs, slides and transparencies. Buys one-time rights.

Jackets/Covers: Assigns 10-12 illustration jobs/year. Prefers painting or drawing, "but we have used tapestry—abstract or expressionist to representational." Also uses 10% computer illustration. Pays by the project, $250-600.

Tips: "Look at our books and send appropriate material. More young adult and adolescent titles are being published, requiring original cover illustration and cover design. New technology (Adobe Illustrator, Photoshop) has slightly altered our cover design concepts."

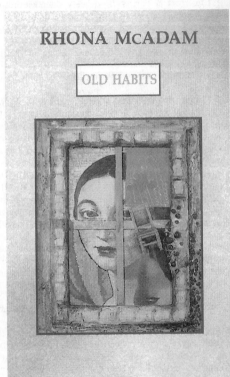

Colleen Phillippi's mixed media collage incorporating found objects appears on the cover of Old Habits, a collection of poetry by Rhona McAdam published by Thistledown Press. "The work was chosen because it reflects the mood of the poetry," says Thistledown's Jackie Forrie. "It deals with everyday subjects in an evocative way."

Cover artwork for *Old Habits* by Rhona McAdam, Thistledown Press, 1993. Reprinted with permission.

‡**THOMASSON-GRANT, INC.**, 1 Morton Dr., Charlottesville VA 22901. (804)977-1780. Fax: (804)977-1696. Creative Director: Lisa Lytton-Smith. Estab. 1980. Book publisher. Publishes hardcover and trade paperback originals. Types of books include photography, juvenile and cookbooks. Specializes in nature, aviation and children's themes. Publishes 20 titles/year. Recent titles include *The Ledgerbook of Thomas Blue Eagle*, by Jewel Grutman and Gay Matthaei; and *Native American Rock Art*, by Yvette La Pierre. 30% require freelance illustration; 10% require freelance design. Book catalog for SASE with first-class postage.

Needs: Approached by 10-15 freelancers/year. Works with 1-3 freelance illustrators and 1-3 freelance designers/year. Prefers freelancers with experience in children's book publishing. Uses freelancers mainly for children's book illustration. Also for jacket/cover and text illustration. Works on assignment only.

First Contact & Terms: Send query letter with résumé, SASE, photographs and transparencies. Samples are filed or are returned by SASE. Reports back within 3 weeks. Write for appointment to show portfolio or mail original/final art, dummies and transparencies. Rights purchased vary according to project. Originals are returned at job's completion.

Book Design: Assigns 1-3 freelance illustration jobs/year. Pays by the project, $200-500.

Jackets/Covers: Assigns 1-2 freelance design and 1-3 illustration jobs/year. Pays by the hour, $12-20; by the project, $300-750.

Text Illustration: Assigns 2-3 freelance design and 2-3 illustration jobs/year. Pays by the project, $250-1,500.

‡THOMPSON WORKS, INC., (formerly Thompson & Company, Inc.), 4600 Longfellow Ave., Minneapolis MN 55407-3638. President: Brad Thompson. Book publisher and independent book producer/packager. Estab. 1980. Publishes trade paperback originals and textbooks. Publishes nonfiction. Types of books include instructional self help, software, technical and business. Specializes in business and computer. Publishes 10 titles/year. 100% require freelance illustration. Book catalog not available.

• According to its president, Thompson Works is starting an extensive commitment to children's books this year. They're interested in new and proven talents to produce books with 16-32 pieces of art, plus covers.

Needs: Works with 20 freelance illustrators and 7 designers/year. Uses illustrators mainly for textbook graphics and cartoons. Also for book design and jacket/cover design. Needs computer-literate freelancers for design. 50% of freelance work demands knowledge of Aldus PageMaker, QuarkXPress and Ventura. Works on assignment only.

First Contact & Terms: Send query letter with résumé and photostats. Samples are filed. Reports back about queries/submissions only if interested. To show portfolio mail photostats. "We will request what we need based on photostats." Considers complexity of project and budget when establishing payment. Negotiates rights purchased. Originals not returned.

Book Design: Assigns 15 freelance design and 20 freelance illustration jobs/year. Pays by the hour, $25 minimum.

Jackets/Covers: Assigns 10 freelance design and 10 freelance illustration jobs/year. Pays by the project, $400-1,200.

Text Illustration: Assigns several large freelance jobs/year. Prefers technical (maps, complex tints, obviously beyond computer graphic capabilities). Pays by the hour, $25 minimum.

Tips: "Make sure we have a good representation of the kind of work you want to get. Then be patient. We do not begin shopping for art until the project is underway to avoid wasting time and false starts. We are not shy about using people across the country as long as they take deadline commitments seriously."

TIMES MIRROR HIGHER EDUCATION GROUP, (formerly William C. Brown Communications, Inc.), 2460 Kerper Blvd., Dubuque IA 52001. (319)588-1451. Design Manager: Jac Tilton. Art Manager: Faye M. Schilling. Estab. 1944. Publishes hardbound and paperback college textbooks. Produces more than 200 titles/year. 10% require freelance design; 50% require freelance illustration.

Needs: Works with 15-25 freelance illustrators and 30-50 designers/year. Uses freelancers for advertising. Needs computer-literate freelancers for design, illustration and production. 90% of freelance work demands knowledge of Aldus PageMaker, Adobe Illustrator, QuarkXPress, Photoshop or Aldus FreeHand. Works on assignment only.

First Contact & Terms: Prefers color 35mm slides and color or b&w photocopies. Send cover letter with emphasis on good portfolio samples. "Do not send samples that are not a true representation of your work quality." Reports back in 1 month. Samples returned by SASE if requested. Reports back on future assignment possibilities. Buys all rights. Pays $35-350 for b&w and color promotional artwork. Pays half contract for unused assigned work.

Book Design: Assigns 50-70 freelance design jobs/year. Uses artists for all phases of process. Pays by the project. Payment varies widely according to complexity.

Jackets/Covers: Assigns 70-80 freelance design jobs and 20-30 illustration jobs/year. Pays $350 average and negotiates pay for special projects.

Text Illustration: Assigns 75-100 freelance jobs/year. Considers b&w and color work. Prefers computer-generated, continuous tone, some mechanical line drawings; ink preferred for b&w. Pays $30-500.

Tips: "In the field, there is more use of color. There is need for sophisticated color skills—the artist must be knowlegeable about the way color reproduces in the printing process. Be prepared to contribute to content as well as style. Tighter production schedules demand an awareness of overall schedules. *Must* be dependable."

TRANSPORTATION TRAILS, National Bus Trader, Inc., 9698 W. Judson Rd., Polo IL 61064. (815)946-2341. Fax: (815)946-2347. Editor: Larry Plachno. Production Manager: Joseph Plachno. Estab. 1977. Imprints include National Bus Trader, Transportation Trails Books; also publishes *Bus Tours Magazine*. Company publishes hardcover and mass market paperback originals and magazines. Types of books include "primarily transportation history but some instruction and reference." Publishes 5-7 titles/year. Titles include *Breezers—A Lighthearted History of The Open Trolley Car in America* and *The Steam Locomotive Directory of North America*. Book catalog free by request.

Needs: Approached by 1 freelancer/year. Works with 3 freelance illustrators/year. Prefers local freelancers if possible with experience in transportation and rail subjects. Uses freelancers mainly for covers and chapter logo lines. Also for text illustration, maps, occasional magazine illustrations, Christmas magazine covers. Works on assignment only.

First Contact & Terms: Send query letter with "any reasonable sample." Samples are returned by SASE if requested by artist. Artist should follow up with letter after initial query. Buys all rights. Originals are not returned.
Jackets/Covers: Assigns 3-6 freelance illustration jobs/year. Pays by the project, $150-700. Prefers b&w pen & ink line drawing of subject with rubylith/amberlith overlays for color.
Text Illustration: Assigns 3-6 freelance illustration jobs/year. Pays by the project, $50-200. Prefers silhouette b&w line drawing approximately 42×6 picas.
Tips: First-time assignments are usually silhouette text illustrations; book jackets and magazine covers are given to "proven" freelancers.

TREEHAUS COMMUNICATIONS, INC., 906 W. Loveland Ave., P.O. Box 249, Loveland OH 45140. (513)683-5716. Fax: (513)683-2882. President: Gerard Pottebaum. Estab. 1973. Publisher. Specializes in books, periodicals, texts, TV productions. Product specialties are social studies and religious education.
Needs: Approached by 12-24 freelancers/year. Works with 12 freelance illustrators/year. Prefers freelancers with experience in illustrations for children. Works on assignment only. Uses freelancers for all work. Also for illustrations and designs for books and periodicals. 5% of work is with print ads. Needs computer-literate freelancers for illustration.
First Contact & Terms: Send query letter with résumé, transparencies, photocopies and SASE. Samples sometimes filed or are returned by SASE if requested by artist. Reports back within 1 month. Art Director will contact artist for portfolio review if interested. Portfolio should include final art, tearsheets, slides, photostats and transparencies. Pays for design and illustration by the project. Rights purchased vary according to project.
Tips: Finds artists through word of mouth, submissions and other publisher's materials.

‡TROLL ASSOCIATES, Book Division, 100 Corporate Dr., Mahwah NJ 07430. Vice President: Marian Frances. Specializes in hardcovers and paperbacks for juveniles (3- to 15-year-olds). Publishes more than 100 titles/year. 30% require freelance design and illustrations.
Needs: Works with 30 freelancers/year. Prefers freelancers with 2-3 years of experience. Works on assignment only.
First Contact & Terms: Send query letter with brochure/flier, résumé and tearsheets or photostats. Samples returned by SASE only if requested. Reports in 1 month. Write for appointment to show portfolio. Considers complexity of project, skill and experience of artist, budget and rights purchased when establishing payment. Buys all rights or negotiates rights purchased. Originals usually not returned at job's completion.

THE TRUMPET CLUB/MARKETING SERVICES/BANTAM DOUBLEDAY DELL PUBLISHING GROUP, 1540 Broadway, New York NY 10036. Art Director: Deborah Thoden. Estab. 1985. Mail-order school book club specializing in paperbacks and related promotional material. Publishes juvenile fiction and nonfiction and original classroom products. Does not publish any original books written outside.
Needs: Works with 5-10 freelance illustrators and 2-3 designers/year. Prefers local computer and non-computer designers and illustrators with children's illustration experience; but out-of-towners okay. Uses freelancers for direct mail and catalog design; poster, sticker, book mark and bookplate illustration; and other original classroom products. Needs computer-literate freelancers for design, illustration and production. 50% of freelance work demands knowledge of Adobe Illustrator, QuarkXPress, Photoshop or Aldus FreeHand.
First Contact & Terms: Send query letter, résumé and tearsheets. Reports back only if interested. Portfolio should include photostats, final reproduction/product. "No slides please." Considers complexity of project and project's budget when establishing payment. Originals are returned at job's completion.
Illustration: Pays by the project, based on complexity.
Tips: "We are looking for freelance Macintosh designers and illustrators familiar with QuarkXPress, Adobe Illustrator and Photoshop. Non-computer illustrators are considered as well. We prefer designers who can carry a job through to production."

‡TSR, INC., 201 Sheridan Springs Rd., Lake Geneva WI 53147. (414)248-3625. Contact: Art Department. Estab. 1975. Company publishes hardcover and trade paperback originals. Types of books include fantasy, young adult and fantasy horror. Specializes in game-related fantasy. Publishes 50-60 titles/year. Recent titles include *Siege of Darkness*, by R.A. Salvatore; *Dragons of Krynn*, by Weis and Hickman; and *Crown of Fire*, by Ed Greenwood. 40% of covers and 95% of interior art require freelance illustration. Book catalog not available.
Needs: Approached by 500 freelancers/year. Works with 30 freelance illustrators/year. Uses freelancers mainly for interior illustrations. Also for jacket/cover illustration. Works on assignment only.
First Contact & Terms: Send query letter with SASE, tearsheets, photographs, photocopies. "No slides or transparencies please." Samples are filed or returned by SASE. Reports back only if interested. Portfolio review not required. Buys all rights. Originals are returned at job's completion.
Jackets/Covers: Assigns 15-20 freelance illustration jobs/year. Pays by the project, $2,000. Prefers sharp focus "realism," usually oils or acrylics.

Text Illustration: Assigns 10-15 freelance illustration jobs/year. Pays by the project, $50 minimum. Prefers b&w line art.
Tips: Finds artists through artists' submissions or on reference from other artists.

TWIN PEAKS PRESS, P.O. Box 129, Vancouver WA 98666. Fax: (360)696-3210. Design Department: Victoria Nova. Estab. 1982. Company publishes hardcover, trade and mass market paperback reprints, trade paperback and mass market paperback originals. Types of books include instruction, travel, self help, reference, humor and cookbooks. Specializes in how-to. Publishes 6 titles/year. Book catalog available for $4.
First Contact & Terms: Send query letter with SASE. Samples are not filed and are not returned. Portfolio review not required.

UAHC PRESS, 838 Fifth Ave., New York NY 10021. (212)249-0100. Director of Publications: Stuart L. Benick. Produces books and magazines for Jewish school children and adult education. Recent titles include *The Bird of Paradise & Other Sabbath Stories*, by Steven Rosman; and *America: The Jewish Experience*, by Sondra Leiman. Books have "clean" look. Book catalog free on request.
Needs: Approached by 20 freelancers/year.
First Contact & Terms: Send samples or write for interview. Include SASE. Reports within 3 weeks.
Jackets/Covers: Pays by the project, $250-600.
Text Illustration: Pays by the project, $150-200.
Tips: Seeking "clean and catchy" design and illustration.

UNIVELT INC., Box 28130, San Diego CA 92198. (619)746-4005. Fax: (619)746-3139. Manager: R.H. Jacobs. Publishes hardcover and paperback originals on astronautics and related fields; occasionally publishes veterinary first-aid manuals. Specializes in space. Publishes 10 titles/year; all have illustrations. Recent titles include *Spaceflight Mechanics 1994, Guidance and Control 1994 Space Programs and Fiscal Reality*. Books have "glossy covers with illustrations." Book catalog free by request.
Needs: Works with 1-2 freelance illustrators/year. Prefers local freelancers. Uses freelancers for covers, title sheets, dividers, occasionally a few illustrations.
First Contact & Terms: Send query letter with résumé, business card and/or flier to be kept on file. Samples not filed are returned by SASE. Reports in 1 month on unsolicited submissions. Buys one-time rights. Originals are returned at job's completion.
Jackets/Covers: Assigns 10 freelance design and 10 illustration jobs/year. Pays $50-100 for front cover illustration or frontispiece.
Text Illustration: Pays by the project, $50-100.
Tips: "Books usually include a front cover illustration and frontispiece. Illustrations have to be space-related. We obtain most of our illustrations from authors and from NASA."

THE UNIVERSITY OF ALABAMA PRESS, Box 870380, Tuscaloosa AL 35487-0380. (205)348-5180. Fax: (205)348-9201. Production Manager: Rick Cook. Specializes in hardcover and paperback originals and reprints of academic titles. Publishes 40 titles/year. Recent titles include *Tail of the Storm*, by Alan Cockrell; and *Forth to the Mighty Conflict*, by Allen Cronenberg. 5% require freelance design.
Needs: Works with 1-2 freelancers/year. Requires book design experience, preferably with university press work. Works on assignment only.
First Contact & Terms: Send query letter with résumé, tearsheets and slides. Samples not filed are returned only if requested. Reports back within a few days. To show portfolio, mail tearsheets, final reproduction/product and slides. Considers project's budget when establishing payment. Buys all rights. Originals are not returned.
Book Design: Assigns several freelance jobs/year. Pays by the project, $250 minimum.
Jackets/Covers: Assigns 1-2 freelance design jobs/year. Pays by the project, $250 minimum.
Tips: Has a limited freelance budget.

‡THE UNIVERSITY OF NEBRASKA PRESS, 312 N. 14th, Lincoln NE 68588-0484. (402)472-3581. Fax: (402)472-0308. Production Manager: Debra K. Turner. Estab. 1941. Publishes hardcover originals and trade paperback originals and reprints. Types of books include history. Specializes in Western history, American Indian ethnohistory, nature, Civil War, women's studies. Publishes 111 titles/year. Titles include *Custer's Last Campaign, Billy the Kid* and *Jubal's Raid*. 5-10% require freelance illustration; 20% require freelance design. Book catalog free by request.
Needs: Approached by 5 freelancers/year. Works with 3 freelance illustrators and 5 designers/year. "We must use Native American artists for books on that subject." Uses freelancers for jacket/cover illustration. Works on assignment only.
First Contact & Terms: Send query letter with appropriate samples. Samples are filed. Reports back to the artist only if interested. Call for appointment to show portfolio of color tearsheets and 4×5 transparencies. Negotiates rights purchased. Originals are returned at job's completion.
Book Design: Assigns 10 freelance design and varying number of freelance illustration jobs/year. Pays by the project, $500 minimum.

Jackets/Covers: Usually prefers realistic, western, action styles. Pays by the project, $300-500.

‡UNIVERSITY OF OKLAHOMA PRESS, 1005 Asp Ave. Norman OK 73019. (405)325-5111. Fax: (405)325-4000. Production Manager: Patsy Willcox. Estab. 1927. Company publishes hardcover and trade paperback originals and reprints and textbooks. Types of books include biography, coffee table books, history, nonfiction, reference, textbooks, western. Specializes in Western/Indian nonfiction. Publishes 80 titles/year. 75% require freelance illustration (for jacket/cover). 5% require freelance design. Book catalog free by request.
Needs: Approached by 15-20 freelancers/year. Works with 40-50 freelance illustrators and 4-5 designers/year. "We cannot commission work, must find existing art." Uses freelancers mainly for jacket/cover illustrations. Also for jacket/cover and book design. Needs computer-literate freelancers for design. 25% of freelance work demands knowledge of Aldus PageMaker, Adobe Illustrator, QuarkXPress, Adobe Photoshop, Aldus FreeHand, Corel Draw and Ventura.
First Contact & Terms: Send query letter with brochure, résumé and photocopies. Samples are filed. Does not report back. Artist should contact us 1 month after submission. Art Director will contact artist for portfolio review if interested. Portfolio should include book dummy and photostats. Buys reprint rights. Originals are returned at job's completion.
Book Design: Assigns 4-5 freelance design jobs/year. Pays by the project.
Jackets/Covers: Assigns 4-5 freelance design jobs/year. Pays by the project.
Tips: Finds artists through submissions, attending exhibits, art shows and word of mouth.

‡J. WESTON WALCH PUBLISHING, 321 Valley St., Portland ME 04102. (207)772-2846. Fax: (207)774-7167. Art Director: Kiyo Tabery. Estab. 1927. Company publishes supplementary educational books and other material (video, software, audio, posters, cards, games, etc.). Types of books include instructional and young adult. Specializes in all middle and high school subject areas. Publishes 100 titles/year. Recent titles include *Teaching from a Positive Perspective*, *Glorious Glue*, *Cultural Conflicts* and *Microsoft Works in Your Classroom*. 15-25% require freelance illustration. Book catalog free by request.
Needs: Approached by 70-100 freelancers/year. Works with 10-20 freelance illustrators and 5-10 designers/year. Prefers local freelancers only. Uses freelancers mainly for text and/or cover illustrations. Also for jacket/cover design. Accepts work in Photoshop, FreeHand, Painter, Ray Dream Designer. "Use of computer is up to the artist, we take in either form."
First Contact & Terms: Send query letter with brochure, tearsheets, résumé, photocopies. Samples are filed. Art Director will contact artist for portfolio review if interested. Portfolio should include final art, roughs and tearsheets. Buys one-time rights. Originals are returned at job's completion.
Jackets/Covers: Assigns 10-15 freelance design and 10-20 illustration jobs/year. Pays by the project, $300-600.
Text & Poster Illustration: Pays by the project, $500-4,000.
Tips: Finds artists through artists' submissions, reviewing with other art directors in the local area.

WARNER BOOKS INC., 1271 Sixth Ave., New York NY 10020. (212)522-7200. Vice President and Creative Director: Jackie Meyer. Publishes mass market paperbacks and adult trade hardcovers and paperbacks. Publishes 350 titles/year. Recent titles include *Spencerville* and *The Bridges of Madison County*. 20% require freelance design; 80% require freelance illustration.
 • Others in the department are Diane Luger, Don Puckey, Julia Kushnirsky, Rachel McClain and Lisa McGarry. Send them mailers for their files as well.
Needs: Approached by 500 freelancers/year. Works with 150 freelance illustrators and 30 designers/year. Uses freelancers mainly for illustration and handlettering. Works on assignment only.
First Contact & Terms: Do not call for appointment or portfolio review. Mail samples only. Send brochure or tearsheets and photocopies. Samples are filed or are returned by SASE. Art Director will contact artist for portfolio review if interested. Negotiates rights purchased. Considers buying second rights (reprint rights) to previously published work. Originals are returned at job's completion (artist must pick up). "Check for most recent titles in bookstores."
Jackets/Covers: Pays for design and illustration by the project; $1,000-1,500. Uses realistic jacket illustrations.
Tips: Finds artists through books, mailers, parties, lectures, judging and colleagues. Industry trends include "more graphics and stylized art." Looks for "photorealistic style with imaginative and original design and use of eye-catching color variations. Artists shouldn't talk too much. Good design and art should speak for themselves."

WEBB RESEARCH GROUP, Box 314, Medford OR 97501. (503)664-4442. Owner: Bert Webber. Estab. 1979. Publishes hardcover and trade paperback originals. Types of books include biography, reference, history and travel. Specializes in the history and development of the Pacific Northwest and the Oregon Trail. Recent titles include *Dredging for Gold*, by Bert Webber; and *Top Secret*, by James Martin Davis and Bert Webber. 5% require freelance illustration. Book catalog for SAE with 2 first-class stamps.

Needs: Approached by more than 30 freelancers/year, "but most do not read what subject areas we will look at." Uses freelancers for localizing travel maps and doing sketches of Oregon Trail scenes. Also for jacket/cover and text illustration. Works on assignment only.

First Contact & Terms: Send query letter with SASE and photocopied samples of the artists' Oregon Trail subjects. "We will look only at subjects in which we are interested—Oregon history, development and Oregon Trail." Samples are not filed and are only returned by SASE if requested by artist. Reports back to the artist only if interested and SASE is received. Portfolios are not reviewed. Rights purchased vary according to project. Originals often returned at job's completion.

Jackets/Covers: Assigns more than 15 freelance design jobs/year.

Text Illustration: Assigns 6 freelance illustration jobs/year. Payment negotiated.

Tips: "Freelancers negatively impress us because they do not review our specifications and send samples unrelated to what we do . We do not want to see 'concept' examples of what some freelancer thinks is 'great stuff.' If the subject is not in our required subject areas, do not waste samples or postage or our time with unwanted heavy mailings. We, by policy do not, will not, will never, respond to postal card inquiries. Most fail to send SASE thus submissions go into the ashcan, never looked at, for the first thing we consider with unsolicited material is if there is SASE. Time is valuable for artists and for us. Let's not waste it."

‡♥WEIGL EDUCATIONAL PUBLISHERS LTD., 1902 11th St. SE, Calgary, Alberta T2G 3G2 Canada. (403)233-7747. Fax: (403)233-7769. Contact: Senior Editor. Estab. 1979. Textbook publisher catering to juvenile and young adult audience. Specializes in social studies, science-environmental, life skills, multicultural and Canadian focus. Publishes 10 titles/year. Titles include *The Living Soil, Alberta Our Province* and *Career and Life Management Student Journal*. 20-40% require freelance illustration. Book catalog free by request.

Needs: Approached by 50-60 freelancers/year. Works with 2-3 illustrators/year. Prefers freelancers with experience in children's text illustration in line art/watercolor. Uses freelancers mainly for text illustration. Also for direct mail design. Freelancers should be familiar with PageMaker 5.0, Illustrator and Photoshop 3.0.

First Contact & Terms: Send query letter with brochure, résumé, SASE, tearsheets, photographs, photocopies ("representative samples of quality work"). Samples are returned by SASE if requested by artist. Reports back to the artist only if interested. Write for appointment to show portfolio of original/final art (small), b&w photostats, tearsheets and photographs. Rights purchased vary according to project.

Text Illustration: Assigns 5-10 freelance illustration jobs/year. Pays by the hour, $20-60. Prefers line art and watercolor appropriate for elementary and secondary school students.

WESTERN PUBLISHING CO., INC., 850 Third Ave., New York NY 10022. (212)753-8500. Fax: (212)371-1091. Art Directors: Georg Brewer and Remo Cosentino. Contact: Candice Smilow. Printing company and publisher. Imprint is Golden Books. Publishes pre-school, juvenile, trade books and young adult and adult nature guides. Specializes in picture books themed for infant to 8-year-olds. Publishes 300 titles/year. Titles include *I Love Christmas, Pierrot's ABC Garden, Walt Disney's Aladdin*. 100% require freelance illustration. Book catalog free by request.

Needs: Approached by several hundred artists/year. Works with approximately 100 illustrators/year. Very little freelance design work. Most design is done in-house or by packagers. Buys enough illustration for 250 plus new titles, the majority being licensed character books. Artists must have picture book experience; illustrations are generally full color. Uses freelancers primarily for picture books for young children, and secondarily for natural science guides, pre-teen covers and interiors. Needs computer-literate freelancers for production and paste-up. 35% (more if we could find qualified people) of freelance work demands knowledge of Adobe Illustrator, QuarkXPress, Photoshop. "Quark is necessity."

First Contact & Terms: Send query letter with SASE and tearsheets. Samples are filed or are returned by SASE if requested by artist. Portfolio drop-off on Thursdays. Will look at original artwork and/or color representations in portfolios, but please do not send original art through the mail. Royalties or work for hire according to project.

Jackets/Covers: All design done in-house or by packagers. Makes outright purchase of cover illustrations.

Text Illustration: Assigns approximately 250 freelance illustration jobs/year. Payment varies.

Tips: "We are open to a much wider variety of styles than in previous years. However, illustrations that have trade and mass market appeal, featuring appealing multicultural children in the vein of Eloise Wilkins will get strongest consideration."

‡ALBERT WHITMAN & COMPANY, 6340 Oakton, Morton Grove IL 60053-2723. Editor: Kathleen Tucker. Art Director: Karen Campbell. Specializes in hardcover original juvenile fiction and nonfiction—many picture books for young children. Publishes 25 titles/year. Recent titles include *Two of Everything*, by Lily Toy Hong; and *Do Pirates Take Baths*, by Kathy Tucker. 100% require freelance illustration. Books need "a young look—we market to preschoolers mostly."

Needs: Works with 30 illustrators and 3 designers/year. Prefers working with artists who have experience illustrating juvenile trade books. Needs computer-literate freelancers for design and production. Freelancers should be familiar with QuarkXPress or Adobe Photoshop. Works on assignment only.

First Contact & Terms: Send brochure/flier or résumé and "a few slides and photocopies of original art and/or tearsheets that we can keep in our files. "One sample is not enough. We need at least three. Do *not* send original art through the mail." Samples are not returned. Reports back "if we have a project that seems right for the artist. We like to see evidence that an artist can show the same children and adults in a variety of moods, poses and environments." Rights purchased vary. Original work returned at job's completion "if artist holds the copyright."

Cover/Text Illustration: Cover assignment is usually part of text illustration assignment. Assigns 30 freelance jobs/year. Prefers realistic and semi-realistic art. Pays by flat fee or royalties.

Tips: Especially looks for "an artist's ability to draw people, especially children and the ability to set an appropriate mood for the story."

‡WILD HONEY, An Ottenheimer Publishers Company, 10 Church Lane, Baltimore MD 21208. (410)484-2100. Contact: Art Director. Estab. 1994. Specializing in literature, picture books, and trade novelty books for children. Some adult titles, also art and literature oriented. Produces 4-6 titles/year. Titles include *Gutenberg's Gift*, by Nancy Willard, illustrated by Bryan Leister; and *The Pond Song*, by Debbie Leland, illustrated by Barry Moser.

Needs: Hires up to 6 illustrators/year; also hires calligraphy/lettering artists regularly.

First Contact & Terms: Send query letter with résumé, slides, photostats, photographs, photocopies or tearsheets to be kept on file. Samples not filed are returned by SASE. Reports back only if interested.

Book Design: Assigns up to 2 freelance design jobs/year. Pays by the project, $800-4,000.

Jackets/Covers: Assigns 2 freelance design and 8 illustration jobs/year. Pays by the project, $800-10,000 depending upon project, time spent and any changes.

Text Illustration: Assigns up to 6 freelance illustration jobs/year.

WILSHIRE BOOK CO., 12015 Sherman Rd., North Hollywood CA 91605. (818)765-8579. President: Melvin Powers. Company publishes trade paperback originals and reprints. Types of books include biography, humor, instructional, New Age, psychology, self help, inspirational and other types of nonfiction. Publishes 25 titles/year. Recent titles include *Think Like a Winner!*, *The Princess Who Believed in Fairy Tales*, and *The Knight in Rusty Armor*. 100% require freelance design. Catalog for SASE with first-class stamps.

Needs: Uses freelancers mainly for book covers, to design cover plus type. Also for direct mail design. "We need graphic design ready to give to printer. Computer cover designs are fine."

First Contact & Terms: Send query letter with fee schedule, tearsheets, photostats, photocopies (copies of previous book covers). Portfolio may be dropped off every Monday-Friday. Portfolio should include book dummy, slides, tearsheets, transparencies. Buys first, reprint or one-time rights. Interested in buying second rights (reprint rights) to previously published work. Negotiates payment.

Book Design: Assigns 25 freelance design jobs/year.

Jackets/Covers: Assigns 25 cover jobs/year.

‡WOODSONG GRAPHICS INC., Box 304, Lahaska PA 18931-0304. (215)794-8321. President: Ellen Bordner. Specializes in paperback originals covering a wide variety of subjects, "but no textbooks or technical material so far." Publishes 3-6 titles/year. Titles include *Snowflake Come Home*, by John Giegling. Books are "usually 5½×8½ format, simple text style with 4-color laminated covers and good halftone illustrations accompanying text where appropriate."

Needs: Approached by several hundred freelancers/year. Works with 1-5 freelance illustrators/year depending on projects and schedules; works with "only a couple of designers, but we expect to expand in this area very soon." Works on assignment only.

First Contact & Terms: Send query letter with brochure and samples to be kept on file. Any format is acceptable for samples, except originals. Samples not filed are returned by SASE. Reports only if interested. Originals are returned to artist at job's completion. Considers complexity of assignment, skill and experience of artist, project's budget and turnaround time when establishing payment. Rights purchased vary according to project.

Book Design: Assigns 2-3 freelance jobs/year. Pays by the project, $400 minimum.

Jackets/Covers: Assigns 3-6 freelance illustration jobs/year. Pays by the project, $150 minimum.

Text Illustration: Assigns 2-3 freelance illustration jobs/year. Medium and style vary according to job. Pays by the project, $250 minimum.

Tips: "As small publishers, we are not necessarily on the 'cutting edge' regarding new trends. We still want art that is beautiful or exciting, and conveys the style and quality of the publication. We are also considering a line of cards and stationery at this time, as well as some traditional 'gallery' art—portraits, serious landscapes, wildlife art, etc."

‡WORD PUBLISHING, 1501 LBJ Freeway, Suite 650, Dallas TX 75234. (214)488-9673. Fax: (214)488-1311. Senior Art Director: Tom Williams. Estab. 1951. Imprints include Word Bibles and Word Kids. Company publishes hardcover, trade paperback and mass market paperback originals and reprints; audio; and video. Types of books include adventure (children's), biography, historical fiction, juvenile, nonfiction, preschool, religious, self help, western, young adult and sports biography. "All books have a strong Christian

content—including fiction." Publishes 120 titles/year. Recent titles include *Storm Warning*, by Billy Graham; *The Body*, by Charles Colson; and *Miracle Man*, by Nolan Ryan. 30-35% require freelance illustration; 100% require freelance design. Book catalog not available.

Needs: Approached by 1,500 freelancers/year. Works with 20 freelance illustrators and 30 designers/year. Buys 35-50 freelance illustrations/year. Uses freelancers mainly for book cover and packaging design. Also for jacket/cover illustration and design and text illustration. Needs computer-literate freelancers for design and production. 75% of freelance work demands knowledge of Adobe Illustrator, QuarkXPress, Adobe Photoshop and Aldus Freehand. Works on assignment only.

First Contact & Terms: Send query letter with SASE, tearsheets, photographs, photocopies, photostats, "whatever shows artist's work best." Samples are filed or are returned by SASE if requested by artist. Art Director will contact artist for portfolio review if interested. Portfolio should include tearsheets and transparencies. Rights purchased vary according to project; usually first rights. Originals are returned at job's completion.

Jacket/Covers: Assigns 120 freelance design and 35-50 freelance illustration jobs/year. Pays by the project $1,200-5,000. Considers all media—oil, acrylic, pastel, watercolor, mixed.

Text Illustration: Assigns 10 freelance illustration jobs/year. Pays by the project $75-250. Prefers line art.

Tips: Finds artists through agents, *Creative Black Book, American Showcase*, word of mouth and artists' submissions. "Please do not phone."

‡✸ZAPP STUDIO INC., 338 St. Antoine St. E., #300, Montreal, Quebec H2Y 1A3 Canada. (514)871-4707. Fax: (514)871-4803. Art Director: Hélène Cousineau. Estab. 1986. Company publishes hardcover originals and reprints. Types of books include cookbooks, instructional, juvenile, pre-school and textbooks. Specializes in kid's books. Publishes 40 titles/year. Recent titles include *Disney's Giant Game Board Book*. 50% require freelance illustration; 30% require freelance design.

Needs: Approached by 30 freelancers/year. Works with 15 freelance illustrators and 7 designers/year. Prefers freelancers with experience in children's illustration. Uses freelancers for jacket/cover illustration and design and book design. Needs computer-literate freelancers for design and illustration. 25% of freelance work demands knowledge of Adobe Illustrator, QuarkXPress and Adobe Photoshop. Works on assignment only.

First Contact & Terms: Send postcard sample of work or send query letter with brochure and photocopies. Samples are filed and are not returned. Reports back within 1 month. Art Director will contact artist for portfolio review if interested. Portfolio should include book dummy, final art and transparencies. Buys first rights. Originals are not returned.

Book Design: Assigns 15 freelance design jobs/year. Pays by the project, $500-2,000.

Jackets/Covers: Assigns 15 freelance design and 30 illustration jobs/year. Pays by the project.

Text Illustration: Assigns 30 freelance illustration jobs/year. Pays by the project.

Tips: Finds artists through sourcebooks, word of mouth, artists' submissions and attending art exhibitions.

ZOLAND BOOKS, INC., 384 Huron Ave., Cambridge MA 02138. (617)864-6252. Design Director: Lori Pease. Estab. 1987. Publishes hardcover and trade paperback originals and reprints. Types of books include literary mainstream fiction, biography, juvenile, travel, poetry, fine art and photography. Specializes in literature. Publishes 6-10 titles/year. Recent titles include *The Circles I Move In*, by Diane Lefer; *Phillip Guston's Late Work*, by Wm. Corbett. Books are of "quality manufacturing with full attention to design and production, classic with a contemporary element." 10% require freelance illustration; 100% require freelance design. Book catalog with SASE.

Needs: Works with 2 freelance illustrators and 6 freelance designers/year. Buys 3 illustrations/year. Uses freelancers mainly for book and jacket design. Also for jacket/cover illustration and catalog design. Needs computer-literate freelancers for design and production. 100% of design work demands knowledge of Aldus PageMaker. Works on assignment only.

First Contact & Terms: Send query letter with brochure, résumé, tearsheets, photocopies and photostats. Samples are filed or are returned by SASE if requested by artist. Design Director will contact artist for portfolio review if interested. Portfolio should include roughs and tearsheets. Rights purchased vary according to project. Originals are returned at job's completion.

Book Design: Assigns 6-10 jobs/year. Pays by the project, $400 minimum.

Jacket/Covers: Assigns 6-10 design and 1-3 freelance illustration jobs/year. Pays by the project, $500 minimum.

Tips: Finds artists through word of mouth, artists' submissions/self promotions. "We love to see all styles appropriate for a literary publisher."

 The double dagger before a listing indicates that the listing is new in this edition. New markets are often more receptive to freelance submissions.

Book Publishers/'95-'96 changes

The following publishers were listed in the 1995 edition but do not have listings in this edition. The majority did not respond to our request to update their listings. If a reason was given for exclusion, it appears in parentheses after the publisher's name.

Alaska Pacific University Press
American Biographical Institute
American Eagle Publications, Inc.
Applezaba Press
ARCsoft Publishers
The Associated Publishers, Inc.
Astara Inc.
Avanyu Publishing Inc.
Beacon Press
Beaver Pond Publishing
Bedford Books of St. Martin's Press
The Benjamin/Cummings Publishing Co.
Blue Dolphin Publishing, Inc.
Brooks/Cole Publishing Company
Canterbury Designs, Inc.
Aristide D. Caratzas, Publisher
Chariot Family Publishing
Charlesbridge Publishing
Chiron Publications (per request)
Cliffs Notes Inc.
CRC Press, Inc.

Custom Comic Services
Delmar Publishers Inc.
Doubleday (does not use freelancers)
Editorial Caribe, Inc,
Educational Impressions
Falcon Press Publishing Co. Inc.
Franklin Watts
Gallopade Publishing Group
Graywolf Press
T. Emmett Henderson, Publisher
Carl Hungness Publishing
Alfred A. Knopf, Inc.
Libraries Unlimited
Lodestar Books
Metamorphous Press
Milkweed Editions
Modern Curriculum Press
Mountain Press Publishing Co.
The New England Press
Northwoods Press
O Pinyon Press
Oregon Historical Society Press
Ottenheimer Publishers, Inc.

Oxford University Press
Peachpit Press, Inc.
Peanut Butter Publishing
Penguin Books
Pippin Press
Princeton Book Publishers, Dance Horizons (does not need freelancers)
Prolingua Associates
Ross Books
Routledge
Sierra Club Books
Silver Burdett & Ginn
Tambourine Books
Tyndale House Publishers, Inc.
Unlimited Editions International
Valley of the Sun Publishing
Webb Research Group
Samuel Weiser Inc.
Dan Weiss Associates Inc.
Whalesback Books
Writer's Publishing Service Co.
WRS Group, Inc.

Design Firms

There are thousands of design firms across the country which regularly hire freelance illustrators and designers. If you have something to offer these firms, they just might offer you a steady stream of freelance projects.

If you are new to the market, you may wonder what design firms do. Design firms, also called design or art studios, offer a range of services to their clients, including conceptualization and design, illustration and layouts. Corporations, small businesses and advertising agencies hire them to develop print ads, annual reports, corporate identity programs, brochures, packaging, signage and other projects.

Design firms and art studios vary greatly in size. A studio could be one person who turns to freelance help when the workload becomes too heavy or it could be a larger operation looking for a fresh approach or for basic mechanical skills. Design firms work with freelance talent in much the same way advertising agencies and PR firms do. (See Advertising section introduction.) They hire both freelance illustrators and graphic artists. A typical assignment for an illustrator might be to create an illustration for a poster, brochure, shopping bag or a product's label. A freelance designer or production artist, on the other hand, might be hired to design the layout of a brochure, or to help the in-house staff meet deadlines. Computer skills continue to be greatly in demand by design firms, and many have work stations equipped especially for freelancers.

Find your best markets

Responding to requests from readers, we've reorganized this section, listing markets by state. Despite fax machines and modems, most design firms still prefer to work with local freelancers because of the need to meet tight deadlines and to make last-minute changes. So first look for a firm close to your city. In addition to reading the listings in *Artist's & Graphic Designer's Market*, consult your Yellow Pages and Business-to-Business directory to locate studios.

When researching the listings in this section, knowing what information to look for will help you get assignments. Be sure to notice what type of work the firm specializes in and who their clients are. If you think your illustrations would look great on cereal boxes, find a firm that specializes in package design and look at their client list. If one of their client's products is breakfast cereal, you'll have a better chance of getting an assignment than if their clients manufacture computer chips. Similarly, if you specialize in medical illustration, look for a firm whose clients include pharmaceutical companies.

Give them what they need

Once you know the type of work a firm does and who their clients are, tailor your portfolio to their needs. When showing your work to a studio specializing in collateral material, present brochures instead of packaging design. Show designs for stationery and logos to firms specializing in corporate identity programs.

Since your initial contact will most likely be the sample you mail and perhaps a cover letter, design your sample as carefully as you would design a client's project (see What Should I Submit?, page 14). Your sample need not be expensive, but it must be professional looking and must convey the type of work you do. If you send a cover letter, send it to the contact person's name in the listing. Keep it simple and to the

point. Write one or two paragraphs stating you are available for freelance work, briefly describing your experience and skills.

Be sure your letter is on excellent quality paper, your letterhead includes your name, address and phone number, and there are no typos! It's even better (but not necessary) to include a line or two to demonstrate you have seen and admire the firm's work, such as "I admired the poster your firm designed for the folk festival. It would be great to be part of your team."

Network, network, network

Consider joining the local branch of one of the national professional organizations, such as The Graphic Artists Guild (GAG), The American Institute of Graphic Arts (AIGA), The Society of Illustrators, The Society of Publication Designers, or the Art Directors Club. Not only will you meet fellow designers and illustrators, but you will meet art directors from design firms. Become an active member and attend the organization's regular meetings, happy hours and lectures.

Members of the design community love to talk about their work and the work of other designers and illustrators. Read current issues of design publications such as *HOW*, *Communication Arts*, *Print* and *Step-by-Step Graphics*. You'll find out what makes this group of people tick, and you'll have plenty to talk about with fellow designers and illustrators at your organization's next event.

Arizona

‡**CRICKET CONTRAST GRAPHIC DESIGN**, 2301 N. 16th St., Phoenix AZ 85006. (602)258-6149. Fax: (602)258-0113. Art Director: Scott Bowers. Estab. 1982. Number of employees: 4. Specializes in annual reports, corporate identity, package and publication design. Clients: corporations. Professional affiliations: AIGA and Phoenix Society of Communicating Arts.
Needs: Approached by 25-50 freelancers/year. Works with 5 freelance illustrators and 5 designers/year. Prefers local artists only. Uses illustrators mainly for lettering. Uses designers mainly for ad design and logos. Also uses freelancers for ad illustration, brochure design and illustration, lettering and logos. Needs computer-literate freelancers for design and production. 90% of freelance work demands knowledge of in Adobe illustrator, Adobe Photoshop and QuarkXPress.
First Contact & Terms: Send photocopies, photographs and résumé. Art Director will contact artist for portfolio review if interested. Portfolio should include b&w photocopies. Pays for design and illustration by the project. Negotiates rights purchased.
Tips: Finds artists through self-promotions and sourcebooks. Impressed by attention-grabbing promotional material and professional attitude.

‡**DESIGNARTS, INC.**, 2343 W. Estrella Dr., Chandler AZ 85224. (602)786-9411. Contact: Kent Loott. Estab. 1990. Number of employees: 2. Specializes in brand and corporate identity; display, direct mail and package design. Clients: ad agencies and corporations.
Needs: Approached by 10-20 freelancers/year. Works with 3-5 freelance illustrators and 3-5 designers/year. Prefers local artists with experience in all media. Uses freelancers for ad, brochure and poster illustration; and charts/graphs. Needs computer-literate freelancers for design, illustration and production. 50% of freelance work demands knowledge of Adobe Illustrator and CorelDraw.
First Contact & Terms: Send query letter with photocopies. Samples are filed and are not returned. Art Director will contact artist for portfolio review if interested. Pays for design and illustration by the project, $100-1,500.
Tips: Finds artists through sourcebooks (i.e. *Arizona Portfolio*) and submissions. "Keep mailers short and sweet—three pages maximum."

DAVE FRENCH DESIGN STUDIOS, 1521 E. Broadway Blvd., Tucson AZ 85719. (520)721-8074. Fax: (520)327-8180. Art Director: Dave French. Estab. 1979. Number of Employees: 3. Approximate annual billing: $165,000. Specializes in corporate identity, direct mail and publication design, signage, cartoon illustration, interior and exterior wall graphics systems and newspaper and magazine ads. "We specialize in offering our services to businesses that are just starting up or are interested in re-doing their image. We deal primarily with all types of businesses on a direct basis. Deal with everything from automobile agencies and restaurants to furniture stores and hospitals. We cover just about any industry or business who needs our services." Client list available upon request.

Needs: Approached by 75-125 freelancers/year. Works with 6-10 freelance illustrators and 6-10 designers/year. Prefers freelancers with experience in editorial and technical illustration, cartooning and caricature. Works on assignment only. Uses illustrators mainly for product and fashion promotion. Uses designers mainly for paste up, layout and mechanicals. Also uses freelancers for brochure and ad design and illustration; newspaper design; catalog, P-O-P and poster illustration; mechanicals; airbrushing; audiovisual materials; lettering; logos; and charts/graphs. Needs computer-literate freelancers for design, illustration, production and presentation. 35% of freelance work demands knowledge of Aldus PageMaker, Aldus FreeHand or Adobe Illustrator.

First Contact & Terms: Send query letter with brochure, résumé, SASE and transparencies. Samples are filed or are returned by SASE if requested by artist. Art Director will contact artist for portfolio review if interested. Portfolio should include finished art, color tearsheets, photographs and transparencies (35mm or 4×4). Sometimes requests work on spec before assigning a job. Pays for design by the hour, $8.50-15. Pays for illustration by the hour, $20-45. Rights purchased vary according to project. Considers buying second rights (reprint rights) to previously published work.

Tips: Finds artists strictly through word of mouth and telephone solicitation by the artists. "Keep in touch with us on a regular basis and send updated design materials. This will always put you ahead of those who don't. The more complete portfolio samples are—the better. Sending just one or two samples doesn't always give us the best ideas of style(s). More and more clients are requesting computer-aided artwork and the one quality that clients are hungry for is personalized one-on-one service."

GODAT/JONCZYK DESIGN CONSULTANTS, 807 S. Fourth Ave., Tucson AZ 85701-2701. (520)620-6337. Partners: Ken Godat and Jeff Jonczyk. Estab. 1983. Number of employees: 2. Specializes in annual reports, marketing communications, publication design and signage. Clients: corporate, retail, institutional, public service. Current clients include Weiser Lock, Rain Bird, IBM and University of Arizona. Professional affiliations: AIGA, ACD.

Needs: Approached by 75 freelancers/year. Works with 6-10 freelance illustrators and 2-3 designers/year. Freelancers should be familiar with Aldus PageMaker, Aldus FreeHand, Photoshop or Adobe Illustrator. Needs editorial and technical illustration.

First Contact & Terms: Send query letter with samples. Samples are filed. Request portfolio review in original query. Art Director will contact artist for portfolio review if interested. Pays for design by the hour, $15-40 or by the project. Pays for illustration by the project.

Tips: Finds artists through sourcebooks.

‡THE M. GROUP GRAPHIC DESIGN, 2512 E. Thomas Rd., Suite #7, Phoenix AZ 85016. (602)957-7557. Fax: (602)957-7876. President: Gary Miller. Estab. 1987. Number of employees: 6. Approximate annual billing: $900,000. Specializes in annual reports; corporate identity; direct mail and package design; and advertising. Clients: corporations and small business. Current clients include Arizona Public Service, Comtrade, Sager, Dole Foods, Giant Industries, Microchip, Phx Manufacturing, ProStar, Teksoft and CYMA.

Needs: Approached by 50 freelancers/year. Works with 3-5 freelance illustrators/year. Uses freelancers for ad, brochure, poster and P-O-P illustration. Needs computer-literate freelancers for design and production. 95% of freelance work demands knowledge of Adobe Illustrator, Adobe Photoshop and QuarkXPress.

First Contact & Terms: Send postcard sample of work or query letter with samples. Samples are filed or returned by SASE if requested by artist. Reports back to the artist only if interested. Request portfolio review in original query. Artist should follow-up. Portfolio should include b&w and color final art, photographs and transparencies. Rights purchased vary according to project.

Tips: Finds artists through publications (trade) and reps. Impressed by "good work, persistence, professionalism."

‡RAINWATER COMMUNICATIONS, INC., 7350 E. Evans, B-103, Scottsdale AZ 85260. (602)948-0770. Fax: (602)948-0683. President/Creative Director: Bob Rainwater. Estab. 1980. Number of employees: 5. Approximate annual billing: $980,000. Specializes in magazine ads, corporate brochures and annual reports. Current clients include AT&T, Axxess Technologies, W.L. Gore. Client list available upon request. Professional affiliations: AIGA, GAG and IAGD.

Needs: Approached by 10 freelancers/year. Works with 6 freelance illustrators and 2 designers/year. Prefers artists with experience in consumer and corporate communications—must be Macintosh literate. Uses illustrators mainly for concept executions. Also for annual reports, billboards, brochure and catalog design and illustration, lettering, logos, mechanicals, posters, retouching, signage and TV/film graphics. 80% of freelance work demands knowledge of Adobe Photoshop, QuarkXPress, Adobe Illustrator and Dimensions.

First Contact & Terms: Send query letter with photocopies, résumé and SASE (slides, tearsheets and transparencies also okay). Samples are sometimes filed or returned by SASE if requested by artist. Art Director will contact artist for portfolio review if interested. Portfolio should include samples of work used in printed pieces. Pays for design and illustration by the project. Rights purchased vary according to project.

Tips: Finds artists through agents, sourcebooks, magazines, word of mouth and artists' submissions.

California

ADVERTISING DESIGNERS, INC., 7087 Snyder Ridge Rd., Mariposa CA 95338-9642. (209)742-6704. Fax: (209)742-6314. President: Tom Ohmer. Estab. 1947. Number of employees: 2. Approximate annual billing: $50,000. Specializes in annual reports, corporate identity, ad campaigns, package and publication design and signage. Clients: corporations. Professional affiliations: LAADC.
Needs: Approached by 50 freelancers/year. Works with 4 freelance illustrators and 5 designers/year. Works on assignment only. Uses freelancers mainly for editorial and annual reports. Also for brochure design and illustration, mechanicals, retouching, airbrushing, lettering, logos and ad design. Needs computer-literate freelancers for design and illustration. 75% of freelance work demands knowledge of Aldus PageMaker, Quark XPress, Aldus FreeHand or Adobe Illustrator.
First Contact & Terms: Send query letter with résumé and photocopies. Samples are filed. Does not report back, in which case the artist should call. Write for appointment to show portfolio. Pays for design by the hour $35 minimum; by the project, $500-7,500. Pays for illustration by the project, $500-5,000. Rights purchased vary according to project.

BASIC/BEDELL ADVERTISING & PUBLISHING, 600 Ward Dr., Suite H, Box 30571, Santa Barbara CA 93130. President: C. Barrie Bedell. Specializes in advertisements, direct mail and how-to manuals. Clients: national and international newspapers, publishers, direct response marketers, retail stores, hard lines manufacturers, software developers, trade associations, plus extensive self-promotion of proprietary advertising how-to manuals.
 • This company's president is seeing "a glut of 'graphic designers,' and an acute shortage of 'direct response' designers."
Needs: Uses artists for publication and direct mail design, book covers and dust jackets and camera-ready computer desktop production. Also interested in hearing from professionals experienced in converting printed training materials to CD-ROM.
First Contact & Terms: Especially wants to hear from publishing and "direct response" pros. Portfolio review not required. Pays for design by the project, $100-2,500. Pays for illustration by the project, $50 minimum. Considers client's budget, and skill and experience of artist when establishing payment.
Tips: "There has been a substantial increase in use of freelance talent and increasing need for true professionals with exceptional skills and responsible performance (delivery as promised and 'on target'). It is very difficult to locate freelance talent with expertise in design of advertising and direct mail with heavy use of type. If work is truly professional and freelancer is business-like, contact with personal letter and photocopy of one or more samples of work that needn't be returned."

BERSON, DEAN, STEVENS, 65 Twining Lane, Wood Ranch CA 93065. (818)713-0134. Fax: (818)713-0417. Owner: Lori Berson. Estab. 1981. Specializes in annual reports, brand and corporate identity and display, direct mail, package and publication design. Clients: manufacturers, ad agencies, corporations and movie studios. Professional affiliation: LA Ad Club.
Needs: Approached by 50 freelancers/year. Works with 10-20 illustrators and 5 designers/year. Works on assignment only. Uses illustrators mainly for brochures, packaging and comps. Also for catalog, P-O-P, ad and poster illustration; mechanicals retouching; airbrushing; lettering; logos; and model making. Needs computer-literate freelancers for illustration and production. 50% of freelance work demands knowledge of Aldus PageMaker, Adobe Illustrator, QuarkXpress, Photoshop and Aldus FreeHand.
First Contact & Terms: Send query letter with tearsheets and photocopies. Samples are filed. Art Director will contact artist for portfolio review if interested. Pays for design and illustration by the project. Rights purchased vary according to project. Considers buying second rights (reprint rights) to previously published work.
Tips: Finds artists through word of mouth, submissions/self-promotions, sourcebooks and agents.

BRAINWORKS DESIGN GROUP, INC., 2 Harris Court, #A7, Monterey CA 93940. (408)657-0650. Fax: (408)657-0750. Art Director: Al Kahn. Vice President Marketing: Michele Strub. Estab. 1970. Number of employees: 4. Specializes in ERC (Emotional Response Communications), graphic design, corporate identity, direct mail and publication. Clients: colleges, universities, nonprofit organizations, medical and high tech; majority are colleges and universities. Current clients include Marymount College, Iowa Wesleyan, Union University and California Baptist College. Client list available upon request.

How to Use Your **Artist's & Graphic Designer's Market** *offers suggestions for understanding and using the information in these listings. Read this and other articles in the front of this book for important business tips.*

Needs: Approached by 100 freelancers/year. Works with 4 freelance illustrators and 20 designers/year. Prefers freelancers with experience in type, layout, grids, mechanicals, comps and creative visual thinking. Works on assignment only. Uses freelancers mainly for mechanicals and calligraphy. Also for brochure, direct mail and poster design; mechanicals; lettering; and logos. Needs computer-literate freelancers for production. 60% of freelance work demands knowledge of Aldus PageMaker, QuarkXPress, Aldus Freehand and Photoshop.

First Contact & Terms: Send brochure/flyer or résumé, slides, b&w photos and color washes. Samples are filed. Artist should follow up with call and/or letter after initial query. Art Director will contact artist for portfolio review if interested. Portfolio should include thumbnails, roughs, final reproduction/product and b&w and color tearsheets, photostats, photographs and transparencies. Pays for design by the project, $200-2,000. Considers complexity of project and client's budget when establishing payment. Rights purchased vary according to project.

Tips: Finds artists through sourcebooks and self-promotions. "Creative thinking and a positive attitude are a plus." The most common mistake freelancers make in presenting samples or portfolios is that the "work does not match up to the samples they show." Would like to see more roughs and thumbnails.

CAREW DESIGN, 200 Gate 5 Rd., Sausalito CA 94965. (415)331-8222. Fax: (415)331-7351. President: Jim Carew. Estab. 1975. Number of employees: 3. Approximate annual billing: $250,000. Specializes in corporate identity, direct mail and package design.

Needs: Approached by 60 freelancers/year. Works with 12 freelance illustrators and 4 designers/year. Prefers local artists only. Works on assignment only. Uses freelancers for brochure and catalog design and illustration, mechanicals, retouching, airbrushing, direct mail design, lettering, logos and ad illustration. Needs computer-literate freelancers for design, illustration and production. 75% of freelance work demands knowledge of QuarkXPress, Aldus FreeHand, Adobe Illustrator or Photoshop. Needs editorial and technical illustration.

First Contact & Terms: Send query letter with brochure, résumé and tearsheets. Samples are filed or are returned only if requested by artist. Reports back only if interested. Call for appointment to show portfolio of roughs and original/final art. Pays for production by the hour, $18-30. Pays for design by the hour, $20-25 or by the project. Pays for illustration by the project, $100-1,500. Buys all rights.

CLIFF AND ASSOCIATES, 715 Fremont Ave., South Pasadena CA 91030. (818)799-5906. Fax: (818)799-9809. Owner: Greg Cliff. Estab. 1984. Number of employees: 5. Approximate annual billing: $1 million. Specializes in annual reports, corporate identity, direct mail and publication design and signage. Clients: Fortune 500 corporations and performing arts companies. Current clients include Arco, Nissan, Southern California Gas Co. and Doubletree Hotels.

Needs: Approached by 50 freelancers/year. Works with 10 freelance illustrators and 10 designers/year. Prefers local freelancers and Art Center graduates. Uses freelancers mainly for brochures. Also for technical, "fresh" editorial and medical illustration; mechanicals; lettering; logos; catalog, book and magazine design; P-O-P and poster design and illustration; and model making. Needs computer-literate freelancers for design and production. 90% of freelance work demands knowledge of QuarkXPress, Aldus FreeHand or Adobe Illustrator.

First Contact & Terms: Send query letter with résumé and sample of work. Samples are filed. Art director will contact artist for portfolio review if interested. Portfolio should include thumbnails and b&w photostats and printed samples. Pays for design by the hour, $15-25. Pays for illustration by the project, $50-3,000. Buys one-time rights.

Tips: Finds artists through sourcebooks. "Make your résumé and samples look like a client presentation. We now have much more computer-generated work—especially benefits packages. We continue to use freelance artists, but not as many as before."

EL CRANMER DESIGN ASSOC., 22301 Kirkwood, Lake Forest CA 92630. Owner: El Cranmer. Estab. 1970. Specializes in items related to corporate image and product sales. Clients: small companies and corporations; mostly industrial. Current clients include Reliance Metals, Tube Service, Metal Center and Gemini Productions. Client list available upon request.

Needs: Approached by 3-6 freelancers/year. Works with 1 freelance illustrator and 1 designer/year. Prefers local artists with experience in industrial work. Works on assignment only. Uses illustrators mainly for airbrush illustration. Uses designers mainly for creative design/layout. Also uses freelancers for brochure, catalog and P-O-P design and illustration; direct mail and ad design; mechanicals; retouching; lettering; logos; and charts/graphs. Needs computer-literate freelancers for design, illustration and production. 50% of freelance work demands knowledge of Aldus PageMaker, Adobe Illustrator, QuarkXPress and Photoshop.

First Contact & Terms: Send query letter with brochure and résumé. Samples are filed. Reports back within 1 week. Call for appointment to show portfolio of thumbnails, roughs, tearsheets, photographs and transparencies. Pays for design and illustration by the hour, $30-50; by the project, $300 minimum; by the day, $300-700. Buys all rights.

DESIGN AXIOM, (formerly R. Thomas Schorer & Assoc. Inc.), 710 Silver Spur Rd., Palos Verdes CA 90274. (213)377-0207. President: Thomas Schorer. Estab. 1993. Specializes in graphic, environmental and

architectural design; product development; and signage. Client list available upon request.

Needs: Approached by 100 freelancers/year. Works with 5 freelance illustrators and 10 designers/year. Works on assignment only. Uses designers for all types of design. Uses illustrators for editorial and technical illustration. 50% of freelance work demands knowledge of Aldus PageMaker or QuarkXPress.

First Contact & Terms: Send query letter with all appropriate samples. Samples are not filed and are returned. Art Director will contact artist for portfolio review if interested. Portfolio should include all appropriate samples. Pays for design and illustration by the project. Buys all rights.

Tips: Finds artists through word of mouth, self-promotions, sourcebooks and agents.

ERVIN ADVERTISING AND DESIGN, 829 Ocean Ave., Seal Beach CA 90740. (310)598-3345. Fax: (310)430-3993. Estab. 1981. Specializes in annual reports, corporate identity and retail, direct mail, package and publication design. Clients: corporations, malls, financial firms, industrial firms and software publishers. Current clients include First American Financial, Interplay, South Towne Center and Time Warner Interactive. Client list available upon request.

Needs: Approached by 100 freelancers/year. Works with 10 freelance illustrators and 6 designers/year. Works on assignment only. Uses illustrators mainly for package designs, annual reports. Uses designers, mainly for annual reports, special projects. Also uses freelancers for brochure design and illustration, P-O-P and ad illustration, mechanicals, audiovisual materials, lettering and charts/graphs. Needs computer-literate freelancers for production. 100% of freelance work demands knowledge of QuarkXPress or Adobe Photoshop.

First Contact & Terms: Send résumé and photocopies. Samples are filed and are not returned. Reports back to the artist only if interested. Request portfolio review in original query. Portfolio should include color roughs, tearsheets and transparencies. Pays for design by the hour, $15-30; by the project (rate varies); by the day, $120-240. Pays for illustration by the project (rate varies). Buys all rights.

Tips: Finds artists through sourcebooks, submitted résumés, mailings.

GRAPHIC DATA, 5111 Mission Blvd., P.O. Box 99991, San Diego CA 92169. Phone/fax: (619)274-4511 (call first before faxing). President: Carl Gerle. Estab. 1971. Number of employees: 3. Specializes in industrial design. Clients: industrial and publishing companies. Client list available upon request. Professional affiliations: IEEE, AGM, NCGA.

Needs: Works with 6 sculptors, 3 freelance illustrators and 3 designers/year. Needs sculptors and designers for miniature figurines. 60% of freelance work demands computer skills.

First Contact & Terms: Send query letter with brochure, résumé or photostats. Samples are returned if SASE included. Sometimes requests work on spec before assigning a job. Pays for design and sculpture by the project, $100-1,000 plus royalties. Rights purchased vary according to project.

Tips: "Know the fundamentals behind your craft. Be passionate about your work; care how it is used. Be professional and business-like."

GRAPHIC DESIGN CONCEPTS, 4123 Wade St., Los Angeles CA 90066. (310)306-8143. President: C. Weinstein. Estab. 1980. Specializes in package, publication and industrial design; annual reports; corporate identity; displays; and direct mail. "Our clients include public and private corporations, government agencies, international trading companies, ad agencies and PR firms." Current projects include new product development for electronic, hardware, cosmetic, toy and novelty companies.

Needs: Works with 15 illustrators and 25 designers/year. "Looking for highly creative idea people, all levels of experience." All styles considered. Uses illustrators mainly for commercial illustration. Uses designers mainly for product and graphic design. Also uses freelancers for brochure, P-O-P, poster and catalog design and illustration; book, magazine, direct mail and newspaper design; mechanicals; retouching; airbrushing; model making; charts/graphs; lettering; logos. Needs computer-literate freelancers for design, illustration, production and presentation. 25% of freelance work demands knowledge of Aldus PageMaker, Adobe Illustrator, QuarkXPress, Photoshop or Aldus FreeHand.

First Contact & Terms: Send query letter with brochure, résumé, tearsheets, photostats, photocopies, slides, photographs and/or transparencies. Samples are filed or are returned if accompanied by SASE. Reports back within 10 days with SASE. Portfolio should include thumbnails, roughs, original/final art, final reproduction/product, tearsheets, transparencies and references from employers. Pays for design by the hour, $15 minimum. Pays for illustration by the hour, $50 minimum. Considers complexity of project, client's budget, skill and experience of artist, how work will be used, turnaround time and rights purchased when establishing payment.

Tips: "Send a résumé if available. Send samples of recent work or *high quality* copies. Everything sent to us should have a professional look. After all, it is the first impression we will have of you. Selling artwork is a business. Conduct yourself in a business-like manner."

BARRY HOWARD LIMITED, 29350 Pacific Coast Hwy., Malibu CA 90265. (310)457-1516. Fax: (310)457-6903. Project Manager: Lynn Paris. Estab. 1985. Number of employees: 10. Approximate annual billing: $1 million. Specializes in exhibition design. Clients: museums, visitor centers, attractions, expo pavilions. Current clients include Hollywood Entertainment Museum, Steamtown National Historic Site, Samsung Automobile Museum. Professional affiliations: TEA, IAAPA.

Needs: Approached by 10 freelancers/year. Works with 3 freelance illustrators and 3 designers/year. Prefers freelancers with experience in 3-D display/exhibit design. Uses illustrators for storyboards. Uses designers for all facets. Also uses freelancers for mechanicals, model making, audiovisual materials and logos. Needs computer-literate freelancers design, production and presentation. 50% of freelance work demands knowledge of Aldus PageMaker, QuarkXPress, Aldus FreeHand, Adobe Illustrator or Adobe Photoshop.

First Contact & Terms: Send query letter with brochure and résumé. Samples are filed or returned if requested. Reports back within 30 days. Artist should follow up with letter after initial query. Portfolio should include "whatever is appropriate." Pays for design and illustration by the hour, $15-35. Rights purchased vary according to project.

Tips: Finds artists "usually through word-of-mouth, through some 'technical aid' firms, through artists' submissions."

HOWRY DESIGN ASSOCIATES, (formerly Russell Howry & Associates), 354 Pine St., San Francisco CA 94104. (415)433-2035. Fax: (415)433-0816. President: Jill Howry. Estab. 1988. Number of employees: 5. Specializes in annual reports and corporate identity. Clients: corporations. Current clients include Tandem, Intel, Cygnus, SciClone Pharmaceuticals, RasterOps, Solectron. Client list available on request. Professional affiliations: AIGA, San Francisco Creative Alliance.

Needs: Approached by 30 freelancers/year. Works with 20 freelance illustrators and 10 designers/year. Works on assignment only. Uses illustrators for "everything and anything that applies." Uses designers mainly for newsletters, brochures, corporate identity. Also uses freelancers for mechanicals, retouching, airbrushing, poster illustration, lettering, logos and charts/graphs. Needs computer-literate freelancers for design, illustration and production. 100% of design work, 10% of illustration work demands knowledge of QuarkXPress, Adobe Illustrator or Adobe Photoshop.

First Contact & Terms: Samples are filed. Reports back to the artist only if interested. Portfolios may be dropped off every Thursday. Pays for design by the hour, $20-50. Pays for illustration on a per-job basis. Rights purchased vary according to project.

Tips: Finds artists through sourcebooks, samples, representatives.

ELLIOT HUTKIN, 2253 Linnington Ave., Los Angeles CA 90064. (310)475-3224. Fax: (310)446-4855. Art Director: Elliot Hutkin. Estab. 1982. Number of employees: 1. Specializes in publication design. Clients: corporations and publishers. Current projects include: corporate and travel magazines, miscellaneous corporate publications. Current clients include Xerox Corporation and International Destinations, Inc.

Needs: Approached by 100 freelancers/year. Works with 10 freelance illustrators and 2-3 designers/year. Works on assignment only. Uses freelancers mainly for editorial illustration. Also for retouching, airbrushing, charts/graphs, lettering and logos. Style is eclectic. Needs computer-literate freelancers for illustration and production. 50% of freelance work demands computer skills. "We can work with any program, any system."

First Contact & Terms: Send non-returnable 8½ × 11 or 9 × 12 samples—tearsheets, photocopies or photographs with name, phone and fax number on sheet. "I do not like to get postcards or brochures because I file samples in a binder." Samples are filed or are returned by SASE. Art Director will contact artist for portfolio review if interested. Pays for design by the project, $100 minimum. Pays for illustration by the project, $50-5,000. Fee is for first use and retention of art and reprint usage with credit. Additional fee paid for other use. Interested in buying second rights (reprint rights) to single panel cartoons.

Tips: Finds artists through sourcebooks, "cold-call" mailings, published work. "Send samples including *all* styles and b&w." Provide fax number if available. "We are now 100% digital and all design must be on Mac platform. Illustration and photography are acceptable in any medium."

BRENT A. JONES DESIGN, 328 Hayes St., San Francisco CA 94102. (415)626-8337. Principal: Brent Jones. Estab. 1983. Specializes in corporate identity, brochure and advertising design. Clients: corporations, museums, book publishers, retail establishments. Client list available upon request.

Needs: Approached by 1-3 freelancers/year. Works with 2 freelance illustrators and 1 designer/year. Prefers local freelancers only. Works on assignment only. Uses illustrators mainly for renderings. Uses designers mainly for production. Also uses freelancers for brochure and ad design and illustration, mechanicals, catalog illustration and charts/graphs. "Computer literacy a must." Needs computer-literate freelancers for production. 95% of freelance work demands knowledge of Aldus PageMaker, Quark XPress, Adobe Illustrator and Photoshop.

First Contact & Terms: Send query letter with brochure and tearsheets. Samples are filed and are not returned. Reports back within 2 weeks only if interested. Write for appointment to show portfolio of slides, tearsheets and transparencies. Pays for design by the hour, $15-25; or by the project. Pays for illustration by the project. Rights purchased vary according to project.

JACK LUCEY/ART & DESIGN, 84 Crestwood Dr., San Rafael CA 94901. (415)453-3172. Contact: Jack Lucey. Estab. 1960. Art agency. Specializes in annual reports, brand and corporate identity, publications, signage, technical illustration and illustrations/cover designs. Clients: businesses, ad agencies and book publishers. Current clients include U.S. Air Force, TWA Airlines, California Museum of Art & Industry, Lee

Books, High Noon Books. Client list available upon request. Professional affiliations: Art Directors Club, Academy of Art Alumni.
Needs: Approached by 20 freelancers/year. Works with 2-3 freelance illustrators and 2-3 designers/year. Uses mostly local freelancers. Uses freelancers mainly for type and airbrush. Also for lettering for newspaper work.
First Contact & Terms: Query. Prefers photostats and published work as samples. Provide brochures, business card and résumé to be kept on file. Portfolio review not required. Originals are not returned to artist at job's completion. Requests work on spec before assigning a job. Pays for design by the project.
Tips: "Show variety in your work. Many samples I see are too specialized in one subject, one technique, one style (such as air brush only, pen & ink only, etc.). Subjects are often all similar too."

‡MOLLY DESIGNS, 711 W. 17th St., Suite F-5, Costa Mesa CA 92627. (714)631-8276. Fax: (714)631-8259. Owner: Molly. Estab. 1972. Number of employees: 3. Approximate annual billing: $200,000. Specializes in corporate identity, signage and automotive graphics. Clients: corporations, ad agencies, PR firms, small companies. Current clients include Toyota Motor Sales, Buick and Chevy.
Needs: Approached by 6-8 freelancers/year. Works with 3-4 freelance illustrators and 3-4 designers/year. Prefers freelancers with experience in the automotive field. Works on assignment only. Uses freelance illustrators mainly for presentations. Uses freelance designers mainly for graphic design. Also uses freelancers for brochure design, mechanicals, lettering, logos, P-O-P design and illustration and direct mail design. Needs computer-literate freelancers for illustration and presentation. 60% of freelance work demands knowledge of Adobe Illustrator and QuarkXPress.
First Contact & Terms: Send query letter with photographs. Samples are filed. Reports back within 2 weeks. Call for appointment to show portfolio of thumbnails, roughs, original/final art and photographs. Pays for design and illustration by the project, $100 minimum. Rights purchased vary according to project.

ROY RITOLA, INC., 431 Jackson St., San Francisco CA 94111. (415)788-7010. President: Roy Ritola. Specializes in brand and corporate identity, displays, direct mail, packaging, signage. Clients: manufacturers.
Needs: Works with 6-10 freelancers/year. Uses freelancers for design, illustration, airbrushing, model making, lettering and logos.
First Contact & Terms: Send query letter with brochure showing art style or résumé, tearsheets, slides and photographs. Samples not filed are returned only if requested. Reports back only if interested. To show portfolio, mail final reproduction/product. Pays for design by the hour, $25-100. Considers complexity of project, client's budget, skill and experience of artist, turnaround time and rights purchased when establishing payment.

DEBORAH RODNEY CREATIVE SERVICES, 1020 Pico Blvd., Suite B, Santa Monica CA 90405. (310)450-9650. Fax: (310)450-9793. Owner: Deborah Rodney. Estab. 1975. Number of employees: 1. Specializes in advertising design and collateral. Clients: ad agencies and direct clients. Current clients include Paul Singer Floor Coverings, Century City Hospital and California Casualty Co.
Needs: Approached by 3 freelancers/year. Works with 4-5 freelance illustrators and 2 designers/year. Prefers local freelancers. Uses illustrators mainly for finished art and lettering. Uses designers mainly for logo design. Also uses freelancers for mechanicals, charts/graphs, ad design and illustration. Especially needs "people who do good marker comps, and work on Macintosh." Needs computer-literate freelancers for production and presentation. 100% of freelance work demands knowledge of QuarkXPress, Adobe Illustrator 5.0 or Photoshop. Needs advertising illustration.
First Contact & Terms: Send query letter with brochure, résumé, tearsheets and photocopies. Request portfolio review in original query. Portfolio should include final reproduction/product and tearsheets or "whatever best shows work." Pays for design by the hour, $30-50; by the project; by the day, $100 minimum. Pays for illustration by the project, $100 minimum. Negotiates rights purchased. Considers buying second rights (reprint rights) to previously published work.
Tips: Finds artists through sourcebooks and referrals. "I do more concept and design work inhouse and hire out production and comps because it is faster, cheaper that way."

CLIFFORD SELBERT DESIGN COLLABORATIVE, 2016 Broadway, Santa Monica CA 90404. (310)453-1093. Fax: (310)453-9491.
● See Clifford Selbert listing in Massachusetts for information on the firm's freelance needs.

The double dagger before a listing indicates that the listing is new in this edition. New markets are often more receptive to freelance submissions.

SPLANE DESIGN ASSOCIATES, 10850 White Oak Ave., Granada Hills CA 91344. (818)366-2069. Fax: (818)831-0114. President: Robson Splane. Specializes in display and package design renderings, model making and phototyping. Clients: small, medium and large companies. Current clients include Teledyne Laars, Baton Labs, MGB Clareblend, Ediflex, Superspine, Likay International, Telaire Systems, Teleflora, 3D Systems and Hanson Research. Client list available upon request.
Needs: Approached by 25-30 freelancers/year. Works with 1-2 freelance illustrators and 0-4 designers/year. Works in assignment only. Uses illustrators mainly for logos, mailings to clients, renderings. Uses designers mainly for sourcing, drawings, prototyping, modeling. Also uses freelancers for brochure design and illustration, ad design, mechanicals, retouching, airbrushing, model making, lettering and logos. Needs computer-literate freelancers for design and illustration. 20-50% of freelance work demands knowledge of Aldus FreeHand, Ashlar Vellum and Excel.
First Contact & Terms: Send query letter with résumé and photocopies. Samples are filed or are returned. Reports back to the artist only if interested. Art Director will contact artist for portfolio review if interested. Portfolio should include color roughs, final art, photostats, slides and photographs. Pays for design and illustration by the hour, $7-25. Rights purchased vary according to project.
Tips: Finds artists through submissions and contacts.

STUDIO WILKS, 8800 Venice, Los Angeles CA 90034. (310)204-2919. Fax: (310)204-2918. Estab. 1990. Specializes in print, collateral, packaging, editorial and environmental work. Clients: ad agencies, architects, corporations and small business owners. Current clients include Gemological Institute of America, Upper-Deck Authenticated and Microgames of America.
Needs: Works with 2-3 freelance illustrators/year. Uses illustrators mainly for editorial illustration. Also for brochures, print ads, packaging, collateral, direct mail and promotions.
First Contact & Terms: Send query letter with tearsheets. Samples are returned by SASE if requested by artist. Art Director will contact artist for portfolio review if interested. Pays for design by the project. Buys all rights. Considers buying second rights (reprint rights) to previously published work.
Tips: Finds artists through *The Workbook* and word of mouth.

JULIA TAM DESIGN, 2216 Via La Brea, Palos Verdes CA 90274. (310)378-7583. Fax: (310)378-4589. Contact: Julia Tam. Estab. 1986. Specializes in annual reports, corporate identity, brochures, promotional material, packaging and design. Clients: corporations. Current clients include Southern California Gas Co., *Los Angeles Times*, UCLA. Client list available upon request. Professional affiliations: AIGA.
Needs: Approached by 20 freelancers/year. Works with 6-12 freelance illustrators 2 designers/year. "We look for special styles." Works on assignment only. Uses illustrators mainly for brochures. Also uses freelancers for brochure design and illustration; catalog and ad illustration; retouching; and lettering. Needs computer-literate freelancers for production. 50-100% of freelance work demands knowledge of QuarkXPress, Adobe Illustrator or Adobe Photoshop.
First Contact & Terms: Send query letter with brochure, tearsheets and résumé. Samples are filed. Reports back to the artist only if interested. Artist should follow up. Portfolio should include b&w and color final art, tearsheets and transparencies. Pays for design by the hour, $10-20. Pays for illustration by the project. Negotiates rights purchased.
Tips: Finds artists through *LA Workbook*.

THARP DID IT, 50 University Ave., Suite 21, Los Gatos CA 95030. (Also an office in Portland OR—Tharp (and Drummond) Did It). Art Director/Designer: Rick Tharp. Estab. 1975. Specializes in brand identity; corporate, non-corporate and retail visual identity; packaging; and signage. Clients: direct and through agencies. Current clients include BRIO Scanditoy (Sweden), Sebastiani Vineyards, Harmony Foods, Mirassou Vineyards, LeBoulanger Bakeries, Gallo Winery and Hewlett-Packard. Professional affiliations: Society for Environmental Graphic Design (SEGD), Western Art Directors Club (WADC), American Institute of Graphic Arts (AIGA).
Needs: Approached by 250-350 freelancers/year. Works with 5-10 freelance illustrators and 2 designers/year. Needs advertising/product, food and people illustration. Prefers local designers with experience. Works on assignment only. Needs computer-literate freelance designers for production. 20% of freelance work demands computer skills.
First Contact & Terms: Send query letter with brochure or printed promotional material. Samples are filed or are returned by SASE. Art Director will contact artist for portfolio review if interested. "No phone calls please. We'll call you." Pays for design by the project. Pays for illustration by the project, $100-10,000. Considers client's budget and how work will be used when establishing payment. Rights purchased vary according to project.
Tips: Finds artists through awards annuals and artists' submissions/self-promotions. Rick Tharp predicts "corporate globalization will turn all flavors of design into vanilla, but globalization is inevitable. Today, whether you go to Mall of America in Minnesota or to the Gamla Stan (Old Town) in Stockholm, you find the same stores with the same interiors and the same products in the same packages. The cultural differences are fading quickly. Environmental and communication graphics are losing their individuality. Eventually

we'll have to go to Mars to find anything unique or stimulating. But, as long as the dictum of business is 'grow, grow, grow' there will always be a place for the designer."

This pen & ink illustration by Ward Schumaker depicts graphic designer Rick Tharp, of Tharp Did It, digging through other designers' garbage looking for ideas. The illustration was originally used in an article Tharp wrote for How *magazine about where ideas come from, and was also used on a brochure Tharp published and sent to friends and associates. "I found this artist's work while looking through the garbage behind a design studio in San Francisco," says Tharp. "They had thrown out some sketches for a project they were working on." Tharp noticed Schumaker's signature on the drawings and found his phone number in the AIGA directory.*

© 1994 Schumaker Did Tharp.

TRIBOTTI DESIGNS, 22907 Bluebird Dr., Calabasas CA 91302-1832. (818)591-7720. Fax: (818)591-7910. E-mail: bob4149@aol.com. Contact: Robert Tribotti. Estab. 1970. Number of employees: 2. Approximate annual billing: $100,000. Specializes in graphic design, annual reports, corporate identity, packaging, publications and signage. Clients: PR firms, ad agencies, educational institutions and corporations. Current clients include Southwestern University, *LA Daily News*, Northrup Corporation and Knitking.
Needs: Approached by 8-10 freelancers/year. Works with 2-3 freelance illustrators and 1-2 designers/year. Prefers local freelancers only. Works on assignment only. Uses freelancers mainly for brochure illustration. Also for catalogs, mechanicals, retouching, airbrushing, charts/graphs, lettering and ads. Prefers marker, pen & ink, airbrush, pencil, colored pencil and computer illustration. Needs computer-literate freelancers for illustration and production. 50% of freelance work demands knowledge of Aldus PageMaker, Adobe Illustrator, QuarkXPress, Photoshop, Aldus FreeHand or Delta Graph. Needs editorial and technical illustration and illustration for annual reports/brochures.
First Contact & Terms: Send query letter with brochure. Art Director will contact artist for portfolio review if interested. Portfolio should include thumbnails, roughs, original/final art, final reproduction/product and b&w and color tearsheets, photostats and photographs. Pays for design by the hour, $35-85. Pays for illustration by the project, $100-1,000. Rights purchased vary according to project.
Tips: Finds artists through word of mouth and self-promotion mailings. "We will consider experienced artists only. Must be able to meet deadline. Send printed samples and follow up with a phone call."

WESCO GRAPHICS, INC., 2034 Research Dr., Livermore CA 94550. (510)443-2400. Fax: (510)443-0452. Art Director: Dawn Hill. Estab. 1977. Number of employees: 20. Service-related firm. Specializes in design, layout, typesetting, paste-up, ads and brochures. Clients: retailers. Current clients include Albertsons, Burlingame Stationers, Fleming Foods, Longs Drugs.
Needs: Approached by 10 freelancers/year. Works with 2 freelance illustrators and 2 designers/year. Prefers local freelancers with experience in paste-up and color. Works on assignment only. Uses freelancers mainly for overload. Also for ad and brochure layout. Needs computer-literate freelancers for production. 90% of freelance work demands knowledge of Adobe Illustrator, QuarkXPress, Photoshop and Multi Ad Creator.
First Contact & Terms: Send query letter with résumé. Samples are filed. Art Director will contact artist for portfolio review if interested. Artist should follow up with call. Portfolio should include b&w thumbnails, roughs, photostats and tearsheets. Sometimes requests work on spec before assigning a job. Pays for design and illustration by the hour, $10-15. Buys all rights.
Tips: Finds artists through word of mouth. Combine computer knowledge with traditional graphic skills.

YAMAGUMA & ASSOCIATES, 255 N. Market St., #120, San Jose CA 95110-2409. (408)279-0500. Fax: (408)293-7819. E-mail: sayd2m@aol.com. Estab. 1980. Specializes in corporate identity, displays, direct mail, publication design, signage and marketing. Clients: high technology, government and business-to-business. Current clients include Hewlet Packard, Metra Corp and 50/50 Micro Electronics. Client list available upon request.

Needs: Approached by 6 freelancers/year. Works with 4 freelance illustrators and 4 designers/year. Works on assignment only. Uses illustrators mainly for 4-color, airbrush and technical work. Uses designers mainly for logos, layout and production. Also uses freelancers for brochure, catalog, ad, P-O-P and poster design and illustration; mechanicals; retouching; lettering; book, magazine, model making; direct mail design; charts/graphs; and AV materials. Needs editorial and technical illustration. Needs computer-literate freelancers for design, illustration and production. 85% of freelance work demands knowledge of Aldus PageMaker, QuarkXPress, Aldus FreeHand, Adobe Illustrator, Model Shop or Photoshop.

First Contact & Terms: Send query letter with brochure and other samples. Samples are filed. Art Director will contact artist for portfolio review if interested. Portfolio should include thumbnails, roughs, b&w and color photostats, tearsheets, photographs, slides and transparencies. Sometimes requests work on spec before assigning a job. Pays for design by the hour, $15-50. Pays for illustration by the project, $300-3,000. Rights purchased vary according to project.

Tips: Finds artists through self-promotions. Would like to see more Macintosh-created illustrations.

Colorado

‡TARA BAZATA DESIGN, 9947 Monroe Dr., Thornton CO 80229. Phone/fax: (303)252-7712. Owner/Designer: Tara L. Bazata. Estab. 1991. Number of employees: 1. Approximate annual billing: $20,000. Specializes in publication design. Clients: publishers (primarily textbook), service bureaus. Current clients include Brown & Benchmark, Lachina Publishing and York Production Services. Client list available upon request.

Needs: Approached by 5 freelancers/year. Works with 5 freelance illustrators and 1 designer/year. Prefers artists with experience in textbook illustration. Uses illustrators and designers mainly for college textbook covers. Also for book design, lettering and logos. Needs computer-literate freelancers for illustration. 10% of freelance work demands knowledge of Adobe Photoshop, Aldus FreeHand and QuarkXPress.

First Contact & Terms: Send postcard sample of work or send tearsheets with SASE (if you want them returned). Art Director will contact artist for portfolio review if interested. Portfolio should include b&w and color photographs. Pays for design and illustration by the project, or artist is paid by publisher directly. Rights purchased vary according to project.

Tips: Finds artists through sourcebooks and sample postcards.

‡C GRAPHICS, 2284 S. Kingston Court, Aurora CO 80014. (303)337-7974. Fax: (303)337-7340. President: Cynthia Rudy. Estab. 1982. Number of employees: 1. Approximate annual billing: $50,000. Specializes in direct mail design. Clients: ad agencies, corporations and museums. Current clients include US West, GTE, NCAR and United Artists. Client list available upon request.

Needs: Approached by 30 freelancers/year. Works with 12 freelance illustrators and 12 designers/year. Prefers artists with experience in computer graphics. Uses illustrators mainly for logos and scanning. Uses designers for help on multimedia production. Also for ad, brochure and catalog design and illustration; audiovisual materials; charts/graphs; direct mail, magazine and newspaper design; and logos. Needs computer-literate freelancers for design, illustration, production and presentation. 100% of freelance work demands knowledge of Adobe Illustrator, Adobe Photoshop, Aldus FreeHand, Macromedia Director and QuarkXPress.

First Contact & Terms: Send query letter with brochure, photocopies and résumé. Samples are filed. Reports back to the artist only if interested. Pays for design and illustration by the hour, $6-30.

Tips: Impressed by "good computer skills and willingness to multitask and work varied hours on deadlines."

JO CULBERTSON DESIGN, INC., 222 Milwaukee St., Denver CO 80206. (303)355-8818. President: Jo Culbertson. Estab. 1976. Number of employees: 2. Approximate annual billing: $200,000. Specializes in direct mail, packaging, publication and marketing design; annual reports; corporate identity; design; and signage. Clients: corporations, not-for-profit organizations. Current clients include Baxa Corporation, Newman & Associates, American Cancer Society, Great-West Life. Client list available upon request.

Needs: Approached by 15 freelancers/year. Works with 3 freelance illustrators and 2 designers/year. Prefers local freelancers only. Works on assignment only. Uses illustrators mainly for corporate collateral pieces. Also uses freelancers for brochure design and illustration, book and direct mail design, lettering and ad illustration. Needs computer-literate freelancers for design, illustration and production. 50% of freelance work demands knowledge of QuarkXPress, Photoshop, Corel Draw.

First Contact & Terms: Send query letter with résumé, tearsheets and photocopies. Samples are filed. Reports back to the artist only if interested. Artist should follow up with call. Portfolio should include b&w and color thumbnails, roughs and final art. Pays for design by the hour, $15-25; by the project, $250

minimum. Pays for illustration by the hour, $15-25; by the project, $100 minimum.
Tips: Finds artists through file of résumés, samples, interviews.

UNIT ONE, INC., 950 S. Cherry St., Suite G-16, Denver CO 80222. (303)757-5690. Fax: (303)757-6801. President: Chuck Danford. Estab. 1968. Specializes in annual reports, corporate identity, direct mail, publication design, corporate collateral and signage. Clients: industrial, financial, nonprofit and construction/architecture. Examples of recent projects include Bonfils Blood Center corporate identity, Western Mobile plant signage.
Needs: Approached by 15-30 freelancers/year. Works with 1 or 2 illustrators and 3-5 designers/year. Uses freelancers mainly for computer design and production; brochure and ad design and illustration; direct mail, poster and newspaper design; mechanicals; retouching; airbrushing; audiovisual materials; lettering; logos; charts/graphs; and signage. Needs computer-literate freelancers for design and production. 100% of freelance work demands knowledge of Aldus PageMaker, Adobe Photoshop, MS Word/Works, QuarkXPress or Aldus FreeHand. Needs editorial and general print illustration.
First Contact & Terms: Send query letter with brochure, tearsheets, photographs, photocopies and résumé. Samples are filed and are returned by SASE if requested. Reports back only if interested. Art Director will contact artist for portfolio review if interested. Portfolio should include thumbnails, photographs, slides and transparencies. Pays for design by the hour, $6-25; by the project, $50 minimum; by the day, $48-200. Pays for illustration by the project, $100 minimum. Considers skill and experience of artist when establishing payment. Rights purchased vary according to project.
Tips: "Show printed pieces whenever possible; don't include fine art. Explain samples, outlining problem and solution. If you are new to the business develop printed pieces as quickly as possible to illustrate practical experience."

Connecticut

ATO STUDIOS, 41 Pepper Ridge Rd., Stamford CT 06905. (203)322-9422. Estab. 1961. Number of employees: 13. Specializes in annual reports; brand and corporate identitiy; display, direct mail, package and publication design; technical illustration; and signage. Client list not available.
• ATO hires freelancers based on skills needed for current project. One project might require foreign language skill, while the next could require knowledge of engineering.
Needs: Approached by 12-30 freelancers/year. Works with 3-6 freelance illustrators and 2-8 designers/year. Prefers freelancers with experience in high end IBM work stations (not Mac). Programming Visual C++ and Turbo Pascal a plus. Uses freelancers for ad, brochure and P-O-P design and illustration; airbrushing; audiovisual materials; book, catalog and direct mail design; and model making. Needs computer-literate freelancers for design; illustration; presentation; and 3D design, CAD and animation. 90% of freelance work demands knowledge of IBM; 3-D Design; CAD.
First Contact & Terms: Send postcard sample of work or send query letter with brochure, photocopies, photographs, photostats, résumé and slides. Samples are filed or stored on disk or CD-ROM. Reports back to the artist only if interested. Art Director will contact artist for portfolio review if interested. Portfolio should include b&w and color final art, photocopies, photographs, roughs and thumbnails. Pays for design by the hour or by the project. Pays for illustration by the project. Rights purchased vary according to project.

‡**DeCESARE DESIGN ASSOCIATES**, 381 Post Rd., Darien CT 06820. (203)655-6057. Fax: (203)656-1983. President: John de Cesare. Estab. 1978. Number of employees 2. Specializes in annual reports and publication design. Clients: corportions and publishers. Current clients include American Medical Association, Mead Corp., Chalk & Vermillion. Professional affiliations: Connecticut ADC.
Needs: Approached by 3 dozen freelancers/year. Works with 6-12 freelance illustrators and 2-3 designers/year. Uses illustrators and designers mainly for magazines, corporate literature. Also uses freelancers for book and magazine design, brochure and poster design and illustration, charts/graphs, logos and mechanicals. Needs computer-literate freelancers for design and production. 100% of freelance design work demands knowledge of Adobe Illustrator, Adobe Photoshop and QuarkXPress 3.3.
First Contact & Terms: Send postcard sample of work or send brochure and résumé. Samples are filed and not returned. Art Director will contact artist for portfolio review if interested. Pays for design by the hour, $10-30; by the project, $500-5,000. Pays for illustration by the project; $300-5,000. Rights purchased vary according to project.
Tips: Finds artists through sourcebooks and referrals. "Be creative; be business-like."

‡**FORDESIGN GROUP**, 14 Wakefield Rd., Wilton CT 06897. (203)761-1053. Fax: (203)761-0558. E-mail: psteve@aeo.com. Principal: Steve Ford. Estab. 1990. Specializes in brand and corporate identity, package and publication design and signage. Clients: corporations. Current clinets include Black & Decker, Cadbury Beverage, Carrs, Master Card. Professional affiliations: AIGA, PDC.
Needs: Approached by 100 freelancers/year. Works with 4-6 freelance illustrators and 4-6 designers/year. Uses illustrators mainly for brochure, ads. Uses designers mainly for corporate identity, packaging, collateral.

Also uses freelancers for ad and brochure design and illustration, logos. Needs computer-literate freelancers for design, illustration and production. 90% of freelance work demands knowledge of Adobe Illustrator, Adobe Photoshop, Aldus FreeHand and QuarkXPress.

First Contact & Terms: Send postcard sample of work or send photostats, slides and transparencies. Samples are filed or returned by SASE if requested by artist. Art Director will contact artist for portfolio review if interested. Portfolio should include b&w and color samples.

Tips: "We are sent all *Showcase*, *Workbook*, etc." Impressed by "great work, simply presented."

FREELANCE EXCHANGE, INC., P.O. Box 1165, Glastonbury CT 06033-6165. (203)677-5700. Fax: (203)677-8342. President: Stella Neves. Estab. 1983. Number of employees: 3. Approximate annual billing: $600,000. Specializes in annual reports; brand and corporate identity; animation; display, direct mail, package and publication design; illustration (cartoon, realistic, technical, editorial, product and computer). Clients: corporations, nonprofit organizations, state and federal government agencies and ad agencies. Current clients include Lego Systems, Milton Bradley Co., Hartford Courant, Abrams Publishing Co., Otis Elevator, Phoenix Home Life Insurance Co., *National Golfer Magazine*, Heublein, Black & Decker, Weekly Reader Corp. Client list available upon request. Professional affiliations: GAIG, Connecticut Art Directors Club.

Needs: Approached by 350 freelancers. Works with 30-50 freelance illustrators and 25-40 designers/year. Prefers freelancers with experience in publications, direct mail, consumer products and desktop publishing. "Computer graphics and illustration are becoming more important and requested by clients." Works on assignment only. Uses illustrators mainly for editorial and computer illustration and cartooning. Design projects vary. Also uses freelancers for brochure, catalog, poster and P-O-P design and illustration; newspaper design; mechanicals; audiovisual materials; lettering; logos; and charts/graphs. Needs computer-literate freelancers for design, illustration, production, presentation and animation. 90% of freelance work demands knowledge of Aldus PageMaker, QuarkXPress, Aldus FreeHand, Adobe Illustrator, Photoshop, Persuasion, Powerpoint and animation programs.

First Contact & Terms: Send query letter with résumé, SASE, tearsheets and photocopies. Samples are filed and are returned by SASE. Reports back within 2 weeks. Call or write for appointment to show portfolio of thumbnails, roughs, final art (if appropriate) and b&w and color photostats, slides, tearsheets, photographs. "We prefer slides." Pays for design by the hour, $30 minimum or by the project, $500 minimum. Pays for illustration by the project, $300 minimum. Rights purchased vary according to project.

Tips: "Send us one sample of your best work that is unique and special. All styles and media are OK, but we're really interested in computer-generated illustration. We want to find new talent with a new fresh look. Don't repeat the same themes that everyone else has—we're looking for different and unique styles."

‡KERRY GAVIN STUDIOS, 154 E. Canaan Rd., East Canaan CT 06024. (203)824-4839. Fax: (203)824-9868. Specializes in publication design. Clients: corporations, companies. Current clients include Aetna, Skip Barber Racing Schools.

Needs: Approached by 6-10 freelancers/year. Works with 6-8 freelance illustrators and 1-2 designers/year. Uses illustrators mainly for magazine covers. Uses designers mainly for production. Also uses freelancers for magazine design. Freelancers should be familiar with Quark, Adobe Illustrator 5.5 and Painter 3.0.

First Contact & Terms: Send postcard sample of work or photocopies and tearsheets. Samples are filed or returned. Reports back to the artist only if interested. Portfolio review not required. Pays for design by the hour, $15-25. Pays for illustration by the project, $450 minimum. Buys one-time rights.

Tips: Finds artists through sourcebooks, direct mailing, word of mouth and annuals. Impressed by "prompt response to query calls, good selection of samples, timely delivery."

IDC, Box 312, Farmington CT 06034. (203)678-1111. Fax: (203)793-0293. President: Dick Russell. Estab. 1960. Number of employees: 6-8. Specializes in industrial design. Clients: corporations. Client list not available.

Needs: Approached by 50 freelance industrial designers/year. Works with 1-2 freelance illustrators and 10-15 designers/year. Prefers local freelancers. Uses designers mainly for product design. Also uses freelancers for model making and industrial design. Needs computer-literate freelancers for design. 50% of freelance work demands knowledge of CADKey or AutoCAD.

First Contact & Terms: Send résumé. Reports back to the artist only if interested. Artist should follow up with call after initial query. Art Director will contact artist for portfolio review if interested. Portfolio should include thumbnails and roughs. Pays for design by the hour.

Washington D.C.

‡LOMANGINO STUDIO INC., 3209 M St. NW, Washington DC 20007. (202)338-4110. Fax: (202)625-0848. President: Donna Lomangino. Estab. 1987. Number of employees: 4. Specializes in annual reports, corporate identity and publication design. Clients: corporations, nonprofit organizations. Current clients include Disclosure Inc., The Brookings Institution, Comsat World Systems, World Resources Institute. Client list available upon request. Professional affiliations: President, AIGA Washington DC.
Needs: Approached by 25-50 freelancers/year. Works with 2-6 freelance illustrators/year. Uses illustrators and designers mainly for publication. Needs computer-literate freelancers for production. 90% of freelance work demands knowledge of Adobe Illustrator, Adobe Photoshop, Aldus FreeHand and QuarkXPress.
First Contact & Terms: Send postcard sample of work or brochure, photocopies and tearsheets. Samples are filed. Art Director will contact artist for portfolio review if interested. Pays for design and illustration by the project.
Tips: Finds artists through sourcebooks, word of mouth and studio files.

VISUAL CONCEPTS, 5410 Connecticut Ave., Washington DC 20015. (202)362-1521. Owner: John Jacobin. Estab. 1984. Service-related firm. Specializes in visual presentation, mostly for retail stores. Clients: retail stores, residential and commercial spaces. Current clients include Cafe Paradiso, Urban Outfitters, Steve Madden Shoes, Guess Jean/neckwear.
Needs: Approached by 15 freelancers/year. Works with 2 freelance illustrators and 6 designers/year. Assigns 10-20 projects/year. Prefers local artists with experience in visual merchandising and 3-D exhibit building. Works on assignment only. Uses freelancers mainly for design and installation. Prefers contemporary, vintage or any classic styles. Also uses freelancers for editorial, brochure and catalog illustration; advertising design and layout; illustration; signage; and P-O-P displays.
First Contact & Terms: Contact through artist rep or send query letter with brochure showing art style or résumé and samples. Samples are filed. Reports back in 2 weeks. Call for appointment to show portfolio of thumbnails, roughs and color photographs or slides. Pays for design and illustration by the hour, $6.50-30. Rights purchased vary according to project.

Florida

‡AURELIO & FRIENDS, INC., 14971 SW 43 Terrace, Miami FL 33185. (305)225-2434. Fax: (305)225-2121. President: Aurelio Sica. Vice President: Nancy Sica. Estab. 1973. Number of employees: 3. Specializes in corporate advertising and graphic design. Clients: corporations, retailers, large companies.
Needs: Approached by 4-5 freelancers/year. Works with 1-2 freelance illustrators and 3-5 designers/year. Also uses freelancers for ad design and illustration; brochure, catalog and direct mail design; and mechanicals. Needs computer-literate freelancers for design. 50% of freelance work demands knowledge of Adobe Ilustrator, Adobe Photoshop and QuarkXPress.
First Contact & Terms: Send brochure and tearsheets. Samples are filed. Art Director will contact artist for portfolio review if interested. Portfolio should include b&w and color final art, photographs, roughs and transparencies. Pays for design and illustration by the project. Buys all rights.

BUGDAL GROUP INC., 7308 S.W. 48 St., Miami FL 33155. (305)665-6686. Fax: (305)663-1387. Vice President: Margarita Spencer. Estab. 1971. Specializes in annual reports, brand and corporate identity, displays/signage design. Clients: corporations, public agencies. Current clients include Spillis Candella & Partners, Ampco Products, Odell Associates, Leesfield Leighton Rubio & Hillencamp and Stephen Samson, DDS. Client list available upon request.
Needs: Approached by 50 freelancers/year. Works with 1 freelance illustrator/year. Prefers local freelancers with experience in signage and corporate. Works on assignment only. Uses illustrators mainly for print and signage. Also for brochure, catalog and ad illustration; mechanicals; retouching; airbrushing; and charts/graphs. Needs computer-literate freelancers for illustration and production. 100% of freelance work demands knowledge of Aldus PageMaker, Aldus FreeHand, Adobe Illustrator or Adobe Photoshop.
First Contact & Terms: Send query letter with brochure, résumé, photographs and transparencies. Samples are filed. Reports back to the artist only if interested. Request portfolio review in original query. Portfolio should include roughs, tearsheets and slides. "Pay depends on the job."

‡CALLYGRAPHICS, 15453 Plantations Oaks Dr., Suite 10, Tampa FL 33647. (813)977-8483. Fax: (813)972-5752. Estab. 1991. Number of employees: 2. Approximate annual billing: $1.5 million. Specializes in direct mail and package design and technical illustration. Clients: corporations. Current clients include Tech Data Corporation. Professional affiliations: AIGA, Creative Club of Tampa Bay.
Needs: Approached by 10 freelancers/year. Works with 10-15 freelance illustrators and 10-15 designers/year. Works only with artist reps. Uses illustrators for "everything that can be printed." Uses designers mainly for layout. Also uses freelancers for ad illustration, brochure design and illustration, direct mail design, lettering and logos. Needs computer-literate freelancers for design, illustration and production. 100%

of freelance work demands knowledge of Adobe Illustrator, Aldus FreeHand and Aldus PageMaker.
First Contact & Terms: Contact only through artist rep. Send tearsheets. Samples are filed. Art Director will contact artist for portfolio review if interested. Portfolio should include printed samples or color copies/transparencies of illustrations. Pays for design and illustration by the project, $300-20,000. Rights purchased vary according to project.
Tips: Likes freelancers who "Listen to direction, are dependable and reliable, and are open to fair negotiation."

CREATIVE WORKS, 1201 US Hwy. One, Suite 200, North Palm Beach FL 33408. (407)775-3800. Owner: Jan Allen. Number of employees: 6. Specializes in design, corporate identity, collateral, copywriting, photography, illustration, product and package design and signage.
Needs: Approached by 60 freelancers/year. Works with 3 freelance illustrators and 8 designers/year. Uses local freelancers to work in-house. 75% of freelance work demands knowledge of QuarkXPress, Photoshop, Illustrator or Freehand.
First Contact & Terms: Send query letter with résumé to be kept on file. Art Director will contact artist for portfolio review if interested. Sometimes requests work on spec before assigning a job. Pays by the project for drafting and mechanicals. Pays for design and illustration by the hour, $12.50 minimum; by the project, $100 minimum.
Tips: Don't make the mistake of "showing samples that don't accurately represent your capabilities. Send only a distinctive graphic or artistic résumé that is memorable and request an appointment. Artists usually send résumés with words and no pictures."

D.A. DESIGN, INC., 8206 NW 105th Ave., Tamarac FL 33321. (305)726-4453. Fax: (305)726-1229. Contact: Albert Barry. Estab. 1984. Specializes in package design and graphic design for toy industry. Clients: toy and novelty manufacturers. Client list not available.
 • Albert Barry has a special need for cartoons and humorous illustrations for toy package design. He will work with out-of-town artists.
Needs: Approached by 150 freelancers/year. Works with 10 freelance illustrators and 15 designers/year. Prefers freelancers with experience in packaging, cartoon and basic illustration. Works on assignment only. Uses freelance illustrators mainly for packaging and headers. Also uses freelancers for brochure and P-O-P design, mechanicals and airbrushing. Needs computer-literate freelancers for presentation. 25% of freelance work demands knowledge of QuarkXPress.
First Contact & Terms: Call for appointment to show portfolio. Samples are filed. Art Director will contact artist for portfolio review if interested. Portfolio should include original/final art, tearsheets and comps. Pays for design and illustration by the hour, $10-15. Buys all rights.
Tips: Finds artists through art schools and artists' submissions. Will have more need for computer-generated art in the future.

‡LUIS FITCH DIEÑO, 1940 Bay Dr., #19, Miami Beach FL 33141. (305)861-9759. Fax: (305)861-9759. Creative Director: Luis Fitch. Estab. 1990. Number of employees: 6. Approximate annual billing: $890,000. Specializes in brand and corporate identity; display, package and retail design; and signage. Clients: Latin American corporations, retail. Current clients include MTV Latino, FEDCO, CIFRA Mexico. Client list available upon request. Professional affiliations: AIGA, GAG.
Needs: Approached by 33 freelancers/year. Works with 8 freelance illustrators and 20 designers/year. Works only with artists reps. Prefers local artists with experience in retail design, graphics. Uses illustrators mainly for packging. Uses designers mainly for retail graphics. Also uses freelancers for ad and book design; brochure, catalog and P-O-P design and illustration; audiovisual materials; logos and model making. Needs computer-literate freelancers for design and production. 60% of freelance work demands computer skills in Adobe Illustrator, Adobe Photoshop, Aldus FreeHand, Aldus PageMaker and QuarkXPress.
First Contact & Terms: Contact only through artist rep. Samples are filed. Art Director will contact artist for portfolio review if interested. Portfolio should include color final art, photographs and slides. Pays for design by the project, $500-6,000. Pays for illustration by the project, $200-20,000. Rights purchased vary according to project.
Tips: Finds artists through artist reps, *Creative Black Book* and *Workbook*.

PRODUCTION INK, 2826 NE 19th Dr., Gainesville FL 32609. (904)377-8973. Fax: (904)373-1175. President: Terry VanNortwick. Estab. 1979. Number of employees: 2. Specializes in publications, marketing, healthcare, engineering, development and ads. Professional affiliations: Public Relations Society of America, Society of Professional Journalists, International Society of Professional Journalists, Gainesville Advertising Federation.
Needs: Works with 6-10 freelancers/year. Works on assignment only. Uses freelancers for brochure illustration, airbrushing and lettering. Needs computer-literate freelancers for illustration. 80% of freelance work demands knowledge of Aldus PageMaker, Adobe Illustrator, QuarkXPress, Photoshop or Aldus FreeHand. Needs editorial, medical and technical illustration.

First Contact & Terms: Send résumé, samples, tearsheets, photostats, photocopies, slides and photography. Samples are filed or are returned if accompanied by SASE. Reports back only if interested. Call or write for appointment to show portfolio of original/final art. Pays for design and illustration by the project, $50-500. Rights purchased vary according to project.
Tips: "Check back with us regularly."

URBAN TAYLOR & ASSOCIATES, 12250 SW 131 Ave., Miami FL 33186. (305)255-7888. Fax: (305)256-7080. E-mail: urbantay@aol.com. Estab. 1976. Specializes in annual reports, corporate identity and communications and publication design. Current clients include IBM, American Express, Polaroid and Office Depot, Inc. Client list available upon request. Professional affiliation: AIGA.
Needs: Approached by 30 freelancers/year. Works with 5 freelance illustrators and 5 designers/year. Works with artist reps and local freelancers. Looking for a variety of editorial, technical and corporate communications illustration styles and freelancers with Mac experience. Works on assignment only. Uses illustrators mainly for brochures and publications. Also uses freelancers for catalog and P-O-P illustration, retouching, airbrushing, lettering and charts/graphs. Needs computer-literate freelancers for design, illustration and production. 90% of freelance work demands knowledge of Aldus PageMaker, QuarkXPress, Aldus FreeHand, Adobe Illustrator, Adobe Photoshop or MicroSoft Word.
First Contact & Terms: Send query letter with SASE and appropriate samples. Samples are filed. Request portfolio review in original query. Art Director will contact artist for portfolio review if interested. Pays for design by the hour $15-25; or by the day, $120-200. Pays for illustration by the project, $250-2,500. "Payment depends on project and quantity printed." Rights purchased vary according to project. Interested in buying second rights (reprint rights) to previously published artwork.
Tips: Finds artists through sourcebooks, direct mail pieces, referral from collegues, clients and reps. "The field is completely technical—provide all illustrations on Mac compatible disk or CD-ROM.'"

MICHAEL WOLK DESIGN ASSOCIATES, 2318 NE Second Court, Miami FL 33137. (305)576-2898. President: Michael Wolk. Estab. 1985. Specializes in corporate identity, displays, interior design and signage. Clients: corporate and private. Client list available upon request.
Needs: Approached by 10 freelancers/year. Works with 5 illustrators and 5 freelance designers/year. Prefers local artists only. Works on assignment only. Needs editorial and technical illustration mainly for brochures. Uses designers mainly for interiors and graphics. Also for brochure design, mechanicals, logos and catalog illustration. Needs "progressive" illustration. Needs computer-literate freelancers for design, production and presentation. 75% of freelance work demands knowledge of Aldus PageMaker, QuarkXPress, Aldus Free-Hand, Adobe Illustrator or other software.
First Contact & Terms: Send query letter with slides. Samples are not filed and are returned by SASE. Reports back to the artist only if interested. To show a portfolio, mail slides. Pays for design by the hour, $10-20. Rights purchased vary according to project.

Georgia

‡DAUER ASSOCIATES, 1134 Warren Hall Lane, Atlanta GA 30319. (404)252-0248. Fax: (404)252-1018. President/CEO: Thomas G. Dauer. Estab. 1978. Number of employees: 1. Specializes in annual reports, brand and corporate identity; display, direct mail, fashion, package and publication design; technical illustration and signage.
Needs: Approached by hundreds of freelancers/year. Uses freelancers for ad, brochure, catalog, poster and P-O-P design and illustration; airbrushing; audiovisual materials; charts/graphs; direct mail and magazine design; lettering; logos; mechanicals; and model making. Needs computer-literate freelancers for design, illustration, production and presentation. Freelancers should be familiar with Adobe Illustrator, Adobe Photoshop, Aldus FreeHand, Aldus PageMaker and QuarkXPress.
First Contact & Terms: Send postcard sample of work or send brochure, photocopies, résumé, slides, tearsheets and transparencies. Samples are filed and are not returned. Request portfolio review in original query. Artist should follow-up with call. Art Director will contact artist for portfolio review if interested. Portfolio should include "work produced on a professional basis." Pays for design and illustration by the project. Rights purchased vary according to project.
Tips: "Be professional; be dedicated; be flexible. Learn how to make every art buyer who uses you once want to work with you again and again."

‡GROOVER DESIGN INC., 1576A W. Sussex Rd., Atlanta GA 30306. (404)875-5295. Fax: (404)875-8990. Estab. 1982. Number of employees: 2. Approximate annual billing: $250,000. Specializes in annual reports, corporate identity and direct mail design. Clients: corporations. Professional affiliations: AIGA.
Needs: Approached by 50 freelancers/year. Works with 5 freelance illustrators and 1 designer/year. Uses freelancers for ad and catalog illustration, airbrushing, lettering, mechanicals and retouching. Needs computer-literate freelancers for design, illustration, production and presentation. 85% of freelance work demands knowledge of Adobe Illustrator, Adobe Photoshop, Aldus FreeHand and QuarkXPress.

First Contact & Terms: Send postcard sample of work. Samples are filed. Art Director will contact artist for portfolio review if interested. Pays for design by the hour and by the project. Pays for illustration by the project. Rights purchased vary according to project.
Tips: Finds artists through sourcebooks.

‡**LEVY DESIGN INC.**, 1465 Northside Dr., Suite 213, Atlanta GA 30318. (404)355-3292. Fax: (404)355-3621. Contact: Art Director. Estab. 1989. Number of employees: 3. Specializes in annual reports; corporate identity; direct mail, package and publication design. Clients: Fortune 100-500 corporations. Current clients include Georgia-Pacific, Equitable Real Estate Investment Management Inc., Nationsbank. Professional affiliations: AIGA, IABC.
Needs: Approached by 100 freelancers/year. Works with 8 freelance illustrators and 3 designers/year. Prefers artists with experience in Macintosh programs. Uses illustrators mainly for corporate illustrations. Uses designers mainly for production. Also uses freelancers for ad, brochure and poster illustration; charts/graphs; and mechanicals. Needs computer-literate freelancers for illustration and production. 75% of freelance work demands knowledge of in Adobe Illustrator, Adobe Photoshop and QuarkXPress.
First Contact & Terms: Send query letter with résumé and samples. Samples are filed. Art Director will contact artist for portfolio review if interested. Portfolio should include b&w and color photographs, photostats, roughs, slides, thumbnails and transparencies. Pays for design by the hour, $20-35. Pays for illustration by the project. Rights purchased vary according to project.
Tips: Finds artists through samples sent by mail. "Send interesting samples in a unique package—do not call—we call if interested."

LORENC DESIGN, INC., 724 Longleaf Dr. NE, Atlanta GA 30342-4307. (404)266-2711. President: Mr. Jan Lorenc. Specializes in display; packaging; publication; architectural signage design; environmental, exhibit and industrial design. Clients: corporate developers, product manufacturers, architects, real estate and institutions. Current clients include Gerald D. Hines Interests, MCI, Georgia-Pacific, IBM, Homart Development, HOH Associates. Client list available upon request.
Needs: Approached by 25 freelancers/year. Works with 5 illustrators and 10 designers/year. Local senior designers only. Uses freelancers for design, illustration, brochures, catalogs, books, P-O-P displays, mechanicals, retouching, airbrushing, posters, direct mail packages, model making, charts/graphs, AV materials, lettering and logos. Needs editorial and technical illustration. Especially needs architectural signage designers. Needs computer-literate freelancers for design, illustration, production and presentation. 95% of freelance work demands knowledge of QuarkXPress, Illustrator or Aldus FreeHand.
First Contact & Terms: Send brochure, résumé and samples to be kept on file. Prefers slides as samples. Samples are filed or are returned. Call or write for appointment to show portfolio of thumbnails, roughs, original/final art, final reproduction/product and color photostats and photographs. Pays for design by the hour, $10-50; by the project, $100-10,000; by the day, $80-400. Pays for illustration by the hour, $10-50; by the project, $100-2,000; by the day, $80-400. Considers complexity of project, client's budget, and skill and experience of artist when establishing payment.
Tips: "Sometimes it's more cost-effective to use freelancers in this economy, so we have scaled down permanent staff."

‡**MURRELL DESIGN GROUP**, 40 Inwood Circle, Atlanta GA 30309. (404)892-5494. Fax: (404)874-6894. President: James Murrell. Estab. 1992. Number of employees: 5. Approximate annual billing: $400,000. Specializes in annual reports, brand and corporate identity, package and publication design and signage. Clients: ad agencies and corporations. Current clients include: ACOG, Coca-Cola, Delta. Professional affiliations: AIGA.
Needs: Approached by 100 freelancers/year. Works with 10 freelance illustrators and 50 designers/year. Uses illustrators mainly for high tech work. Uses designers mainly for package design. Needs computer-literate freelancers for design, illustration, and production and presentation. 100% of freelance work demands knowledge of Adobe Illustrator, Adobe Photoshop and QuarkXPress.
First Contact & Terms: Send postcard sample of work or send photographs and résumé. Samples are filed. Request portfolio review in original query. Art Director will contact artist for portfolio review if interested. Portfolio should include b&w and color photocopies and photographs. Pays by the project, $25 minimum. Pays for illustration by the hour, $15-40. Rights purchased vary according to project.
Tips: Finds artists through sourcebooks, agents and submissions.

‡**ROKFALUSI DESIGN**, 2953 Crosswycke Forest Circle, Atlanta GA 30319. (404)262-2561. Designer/Owner: J. Mark Rokfalusi. Estab. 1982. Number of employees: 1. Approximate annual billing: $100,000.

Always enclose a self-addressed, stamped envelope (SASE) with queries and sample packages.

Specializes in annual reports; display, direct mail, package and publication design; and technical illustration. Clients: ad agencies, direct clients, studios, reps. Current clients include Atlanta Market Center, Hewitt Associates, Stouffer Pine Isle Resort. Professional affiliations: AIGA.

Needs: Approached by 10-20 freelancers/year. Works with 1-5 freelance illustrators/year. Uses illustrators for almost all projects. Also uses freelancers for airbrushing, audiovisual materials, catalog illustration, charts/graphs, model making and retouching. Needs computer-literate freelancers for production and presentation. 50% of freelance work demands knowledge of Adobe Illustrator, Adobe Photoshop, Aldus FreeHand, Aldus PageMaker and QuarkXPress. Send brochure, résumé and tearsheets Samples are filed. Reports back to the artist only if interested. Request portfolio review in original query. Portfolio should include b&w and color final art, photographs, roughs, slides and transparencies. Pays for design and illustration by the project. Rights purchased vary according to project.

Tips: Finds artists through sourcebooks, other publications, agents, artists' submissions. Impressed by "quality work, professional attitude. Do not call every week to see if there is anything coming up. I have a good memory and remember the right talent for the right project."

‡T-D DESIGN INC., 7007 Eagle Watch Court, Stone Mountain GA 30087. (404)413-8276. Fax: (404)413-9856. Creative Director: Charlie Palmer. Estab. 1991. Number of employees: 3. Approximate annual billing: $350,000. Specializes in brand identity, display, package and publication design. Clients: corporations. Current clients include Coca-Cola, Haynes, MLB.

Needs: Approached by 4 freelancers/year. Works with 2 freelance illustrators and 2 designers/year. Prefers local artists with in Mac systems traditional background. Uses illustrators and designers mainly for comps and illustration on Mac. Also uses freelancers for ad, brochure, poster and P-O-P design and illustration; book design; charts/graphs; lettering; logos; mechanicals (important); and newspaper design. Needs computer-literate freelancers for design, illustration, production and presentation. 70% of freelance work demands knowledge of Adobe Illustrator, Adobe Photoshop, Aldus FreeHand and QuarkXPress.

First Contact & Terms: Send postcard sample of work or send brochure, photocopies, photostats, résumé, tearsheets and computer file of samples. Samples are filed. Art Director will contact artist for portfolio review if interested. Portfolio should include b&w and color final art, roughs (important) and thumbnails (important). Pays for design and illustration by the project. Rights purchased vary according to project.

Tips: Finds artists through artists' submissions and word of mouth. "Be original, be creative and have a positive attitude."

Idaho

HENRY SCHMIDT DESIGN, 3141 Hillway Dr., Boise ID 83702. (208)385-0262. President: Henry Schmidt. Estab. 1976. Specializes in brand and corporate identity; package, brochure and catalog design. Clients: corporations. Current clients include Marinco-AFI, Colorado Leisure Sports, Global Theraputics and Swallowtail Corp. Client list available upon request.

Needs: Approached by 25 freelancers/year. Works with 1-5 freelance illustrators and 1-3 designers/year. Uses illustrators mainly for product illustration, board games. Uses designers mainly for overload. Also uses freelancers for brochure and catalog illustration. Needs computer-literate freelancers for design. 100% of freelance work demands knowledge of Aldus PageMaker, QuarkXPress, Adobe Illustrator and/or Adobe Photoshop.

First Contact & Terms: Send query letter with brochure, résumé, tearsheets, photostats, photographs, slides and photocopies. Samples are filed. Reports back to the artist only if interested. Request portfolio review in original query. Artist should follow up. Portfolio should include b&w and color final art, tearsheets, photographs and transparencies. Pays for design by the hour, $20-40; by the project, $100-1,000. Pays for illustration by the project, $100-1,500. Rights purchased vary according to project.

Illinois

‡AMBROSI & ASSOCIATES, 1100 W. Washington, Chicago IL 60607. (312)666-9200. Fax: (312)666-9247. Art Director: Dave Wiggins. Estab. 1970. Number of employees: 300. Full service art studio and multimedia firm. Clients: direct mail, catalog, retail, growing in multimedia. Client list available upon request.

Needs: Approached by 20 freelancers/year. Works with 15 freelance illustrators/year. Uses freelancers mainly for 4-color product illustration or promo material. Also for brochure and catalog illustration, lettering and retouching. 20% of freelance work demands knowledge of Adobe Photoshop, QuarkXPress and Adobe Illustrator.

First Contact & Terms: Send query letter with photocopies and tearsheets. Samples not filed and are returned by SASE if requested by artist. Art Director will contact artist for portfolio review if interested. Portfolio should include color final art, roughs and transparencies. Pays for design by the hour, $20-30. Pays for illustration by the project, $50-3,000. Negotiates rights purchased.

Tips: Finds artists through word of mouth, *Chicago Sourcebook* ("because, usually, I prefer going with local talent.") Impressed by freelancers who "get pencil roughs on time; have prompt turn-around for any revisions; are able to see my goals and, if well thought out, offer creative input. We can offer seamless production at fair prices, attract large clients because of our size, technological diversity and also compete for smaller 'niche' jobs based on our expertise."

‡BENTKOVER'S DESIGN & MORE, 1222 Cavell, Suite 3C, Highland Park IL 60035. (708)831-4437. Fax: (708)831-4462. Creative Director: Burt Bentkover. Estab. 1989. Number of employees: 2. Approximate annual billing: $100,000. Specializes in annual reports; corporate, package and publication design. Clients: advertising, business-to-business, food, retail promo. Client list not available.
Needs: Works with 3 freelance illustrators/year. Works with artist reps. Prefers local artists only. Uses freelancers for ad and brochure illustration, airbrushing, lettering, mechanicals, retouching and desk top mechanicals. Needs computer-literate freelancers for production and presentation. 50% of freelance work demands computer skills.
First Contact & Terms: Send brochure, photocopies and tearsheets. No original art—only disposable copies. Samples are filed. Reports back in 1 week if interested. Request portfolio review in original query. Art Director will contact artist for portfolio review if interested. Portfolio should include b&w and color photocopies. "No final art or photographs." Pays for design and illustration by the project. Rights purchased vary according to project.
Tips: Finds artists through sourcebooks and agents.

‡THE CHESTNUT HOUSE GROUP INC., 540 N. Lakeshore Dr., Chicago IL 60611. (312)222-9090. Fax: (312)222-0358. Art Manager: Janet Sullentrup. Clients: major educational publishers.
Needs: Illustration, layout and assembly. Needs computer-literate freelancers for production. Freelancers should be familiar with QuarkXPress and various drawing and painting programs for illustrators. Pays for production by the hour. Pays for illustration by the project.
First Contact & Terms: "Illustrators submit samples or arrange interview."

‡CHICAGO COMPUTER AND LIGHT, INC., 5001 N. Lowell Ave., Chicago IL 60630-2610. (312)283-2749. President: Larry Feit. Estab. 1976. Creator of souvenir vending machines and unique gift items.
Needs: Works with freelancers for odd jobs throughout the year including ad design and layout, logo and letterhead designs, signage, P.O.P. package design, brochures and periodic illustrations.
First Contact & Terms: Send résumé and samples of work for file. "Looking for fast turnaround time. Must be willing to bid and negotiate based on specific job."

‡COMUNIGRAFIX INC., 5550 W. Armstrong Ave., Chicago IL 60646. (312)774-3012. Fax: (312)774-4219. Production Manager: Bob Niimi. Estab. 1953. Number of employees: 20. Approximate annual billing: $1.5 million. Specializes in brand and corporate identity, direct mail and package design. Clients: agencies and corporations. Current clients include Empire, Davidson Marketing. Client list available upon request.
Needs: Approached by 50 freelancers/year. Works with 2 freelance illustrators and 5 designers/year. Prefers local artists only. Uses illustrators mainly for illustrations for designs. Uses designers mainly for Macintosh. Also uses freelancers for ad illustration, brochure design and illustration, airbrushing and magazine design. Needs computer-literate freelancers for production. 50% of freelance work demands knowledge of Adobe Illustrator, Adobe Photoshop and QuarkXPress.
First Contact & Terms: Send postcard sample of work and résumé. Samples are filed. Art Director will contact artist for portfolio review if interested. Portfolio should include color final art and photographs. Pays for design by the hour, $10-25. Pays for illustration by the hour, $10-50. Rights purchased vary according to project.

‡DESIGN ASSOCIATES, 6117 N. Winthrop Ave., Chicago IL 60660. (312)338-4196. Fax: (312)338-4197. Contact: Paul Uhl. Estab. 1986. Number of employees: 2. Specializes in annual reports, corporate identity, package and publication design. Clients: corporations, publishers and museums. Client list available upon request.
Needs: Approached by 5-10 freelancers/year. Works with 100 freelance illustrators and 5 designers/year. Uses freelancers for book design; brochure, catalog and poster design and illustration; charts/graphs; lettering; logos; and retouching. Needs computer-literate freelancers for design, illustration and production. 100% of freelance demands knowledge of Adobe Illustrator 5.5, Adobe Photoshop 3.0 and QuarkXPress 3.31.
First Contact & Terms: Send query letter with samples that best represent work. Samples are filed. Art Director will contact artist for portfolio review if interested. Portfolio should include b&w and color samples. Pays for design by the hour and by the project. Pays for illustration by the project. Buys all rights.
Tips: Finds artists through sourcebooks, reps and word of mouth.

DESIGN MOVES, LTD., 1073 Gage St., #3, Chicago IL 60093. (708)441-6996. Fax: (708)441-6998. Principal: Laurie Medeiros. Estab. 1988. Number of employees: 2. Specializes in publication, brochure and logo design; annual reports; and direct mail. Clients: corporations, financial institutions, marketing agencies,

hospitals and associations. Current clients include Allstate Insurance, Humana Healthcare, Microsoft Corp. and the American Fund for Dental Health. Client list not available. Professional affiliations: AIGA, GAG, WID, ACD, NAWBO.

Needs: Approached by 5-10 freelancers/year. Works with 3-5 freelance illustrators and 1-3 designers/year. Works on assignment only. Uses freelance designers mainly for brochures and comping existing designs. Also uses freelancers for lettering, poster illustration and design, direct mail design and charts/graphs. Needs computer-literate freelancers for design and production. 100% of freelance work demands knowledge of Adobe Illustrator, QuarkXPress and Photoshop. Needs editorial and medical illustration.

First Contact & Terms: Send query letter with brochure, résumé and tearsheets. Samples are filed or are returned by SASE if requested. Request portfolio review in original query. Reports back to the artist only if interested. Portfolio should include thumbnails, tearsheets, photographs and transparencies. Pays for design by the hour, $10-20. Pays for illustration by the project, $50-500. Rights purchased vary according to project.

‡DESIGN RESOURCE CENTER, 1979 N. Mill, Suite 208, Naperville IL 60565. (708)357-6008. Fax: (708)357-6040. President: John Norman. Estab. 1990. Number of employees: 5. Approximate annual billing: $400,000. Specializes in annual reports, brand and corporate identity, display and package design. Clients: corporations, manufacturers, private label.

Needs: Approached by 5-10 freelancers/year. Works with 3-5 freelance illustrators and 3-5 designers/year. Uses illustrators mainly for illustrating artwork for scanning. Uses designers mainly for Macintosh or concepts. Also uses freelancers for airbrushing; brochure, poster and P-O-P design and illustration; lettering; logos; and package design. Needs computer-literate freelancers for design, illustration and production. 100% of freelance work demands knowledge of Adobe Illustrator 5.0, Aldus FreeHand 4.0 and QuarkXPress.

First Contact & Terms: Send query letter with brochure, photocopies, photographs and résumé. Samples are filed. Does not report back. Artist should follow up. Portfolio review sometimes required. Portfolio should include b&w and color final art, photocopies, photographs, photostats, roughs and thumbnails. Pays for design by the hour, $10-30. Pays for illustration by the project. Buys all rights.

Tips: Finds artists through word of mouth, referrals.

DAVID HIRSCH DESIGN GROUP, INC., 205 W. Wacker Dr., Suite 622, Chicago IL 60606. (312)329-1500. President: David Hirsch. Number of employees: 11. Specializes in annual reports, corporate identity, publications and promotional literature. Clients: manufacturing, PR, real estate, financial and industrial firms. Professional affiliations: American Center for Design, AIGA and IABC.

Needs: Approached by more than 100 freelancers/year. Works with 6-10 freelance illustrators and 4-8 designers/year. Uses freelancers for design, illustration, brochures, retouching, airbrushing, AV materials, lettering, logos and photography. Needs computer, technical, editorial and spot illustration. Freelancers should be familiar with Photoshop and Illustrator.

First Contact & Terms: Send query letter with promotional materials showing art style or samples. Samples not filed are returned by SASE. Reports back only if interested. Call for appointment to show portfolio of roughs, final reproduction/product, tearsheets and photographs. Pays for design and illustration by the project. Considers complexity of project, client's budget and how work will be used when establishing payment. Interested in buying second rights (reprint rights) to previously published work.

Tips: Finds artists primarily through source books and self-promotions. "We're always looking for talent at fair prices."

‡HUGHES & CO., 920 N. Franklin, Suite 401, Chicago IL 60610. (312)664-4700. Fax: (312)944-3595. Art Director: Sally Hughes. Estab. 1978. Number of employees: 10. Approximate annual billing: $400,000. Specializes in annual reports, corporate identity and publication design. Current clients include Surrey Books, Sew/Fit Co., Illinois Int. Port and Garborside G.C.

Needs: Approached by 15 freelancers/year. Works with 5 freelance illustrators/year. Uses illustrators mainly for bookcovers and interiors. Also uses freelancers for ad, brochure and catalog illustration; airbrushing; and book design. 20% of freelance work demands computer skills.

First Contact & Terms: Send postcard sample of work or send brochure, photocopies and photographs. Samples are filed. Art Director will contact artist for portfolio review if interested. Pays for illustration by the project. Rights purchased vary according to project.

‡HUTCHINSON ASSOCIATES, INC., 1147 W. Ohio, Suite 305, Chicago IL 60622. (312)455-9191. Fax: (312)455-9190. Contact: Jerry Hutchinson. Estab. 1988. Number of employees: 3. Specializes in annual reports, corporate identity, multimedia, direct mail and publication design. Clients: corporations, associations and PR firms. Professional affiliations: AIGA, ACD.

Needs: Approached by 5-10 freelancers/year. Works with 3-10 freelance illustrators and 6-10 designers/year. Uses freelancers mainly for brochure design and illustration and annual reports. Also uses freelancers for ad and direct mail design, catalog illustration, charts/graphs, logos and mechanicals. Needs computer-literate freelancers for design, illustration, production and presentation. 90% of freelance work demands knowledge of Adobe Illustrator 5.5, Adobe Photoshop 3.0, Aldus PageMaker and QuarkXPress 3.3.

First Contact & Terms: Send postcard sample of work or send query letter with résumé. Samples are filed. Request portfolio review in original query. Artist should folow-up with call. Art Director will contact artist for portfolio review if interested. Portfolio should include transparencies and printed pieces. Pays by the project, $100-10,000. Rights purchased vary according to project.

Tips: Finds artists through *Creative Illustration, Workbook,* Chicago sourcebooks, Illinois reps, submissions. "Persistence pays off."

IDENTITY CENTER, 1340 Remington Rd, Suite S, Schaumburg IL 60173. President: Wayne Kosterman. Number of employees: 2. Approximate annual billing: $250,000. Specializes in brand and corporate identity, print communications and signage. Clients: corporations, hospitals, manufacturers and banks. Professional affiliations: AIGA, American Center for Design, SEGD.

Needs: Approached by 40-50 freelancers/year. Works with 4 freelance illustrators and 4 designers/year. Prefers 3-5 years of experience minimum. Uses freelancers for editorial and technical illustration, mechanicals, retouching and lettering. Needs computer-literate freelancers for design, illustration and production. 50% of freelance work demands knowledge of QuarkXPress and Adobe Illustrator.

First Contact & Terms: Send résumé and photocopies. Samples are filed or are returned. Reports back within 1 week. To show a portfolio, mail photostats and photographs. Pays for design by the hour, $12-35. Pays for illustration by the project, $200-5,000. Considers client's budget, skill and experience of artist and how work will be used when establishing payment. Rights purchased vary according to project.

Tips: "Not interested in amateurs or 'part-timers.'"

MG DESIGN ASSOCIATES INC., 824 W. Superior, Chicago IL 60622. (312)243-3661. Contact: Michael Grivas or design director. Number of employees: 30. Specializes in trade show exhibits, museum exhibits, expositions and commercial interiors. Clients: industrial manufacturers, consumer-oriented product manufacturers, pharmaceutical firms, state and federal government, automotive parts manufacturers, etc. Professional affiliations: EDPA, IEA.

Needs: Approached by 30 freelancers/year. Works with 5 freelance illustrators and 15 designers/year. Freelancers must be local exhibit designers with minimum of 5 years of experience. Works on assignment only. Uses freelancers for design, illustration, detail drawings and model making, graphic design and CAD.

First Contact & Terms: Send résumé, slides and photocopies to be evaluated. Samples not kept on file are returned only if requested. Write for appointment to show portfolio. Considers complexity of project, client's budget, and skill and experience of artist when establishing payment.

QUALLY & COMPANY INC., 2238 Central St., Suite 3, Evanston IL 60201-1457. (708)864-6316. Creative Director: Robert Qually. Specializes in integrated marketing/communication and new product development. Clients: major corporations.

Needs: Works with 20-25 freelancers/year. "Freelancers must be good and have the right attitude." Works on assignment only. Uses freelancers for design, illustration, mechanicals, retouching, lettering and computer graphics.

First Contact & Terms: Send query letter with brochure, résumé, business card and samples. Samples not filed are returned by SASE. Reports back within several days. Call or write for appointment to show portfolio.

Tips: Looking for "talent, point of view, style, craftsmanship, depth and innovation" in portfolio or samples. Sees "too many look-alikes, very little innovation."

THE QUARASAN GROUP, INC., 214 W. Huron St., Chicago IL 60610-3613. (312)787-0750. President: Randi S. Brill. Project Managers: Renee Calabrese, Nialle Hoffman, Kathy Kasper, Jean LoGrasso and Steve Straus. Specializes in educational products. Clients: educational publishers. Client list not available.

Needs: Approached by 400 freelancers/year. Works with 700-900 illustrators/year. Freelancers with publishing experience preferred. Uses freelancers for illustration, books, mechanicals, charts/graphs, lettering and production. Needs computer-literate freelancers for illustration. 30% of freelance illustration work demands knowledge of Adobe Illustrator, QuarkXPress, Photoshop or Aldus FreeHand. Needs editorial, technical, medical and scientific illustration.

First Contact & Terms: Send query letter with brochure or résumé and samples addressed to ASD to be circulated and to be kept on file. Prefers "anything that we can retain for our files: photostats, photocopies, tearsheets or dupe slides that do not have to be returned" as samples. Reports only if interested. Pays for illustration by the piece/project, $40-2,000 average. Considers complexity of project, client's budget, how

For a list of markets interested in humorous illustration, cartooning and caricatures, refer to the Humor Index at the back of this book.

work will be used and turnaround time when establishing payment. "For illustration, size and complexity are the key factors."

Tips: "Our publishers continue to require us to use only those artists willing to work on a work-for-hire basis. This may change in time, but at present, this is a requirement."

‡JOHN STRIBIAK & ASSOCIATES, INC., 11160 SW Hwy., Palos Hills, IL 60465. (708)430-3380. Fax: (708)974-4975. President: John Stribiak. Estab. 1981. Number of employees: 2. Approximate annual billing: $300,000. Specializes in corporate identity and package design. Clients: corporations. Professional affiliations: IOPP, PDC.

Needs: Approached by 75-100 freelancers/year. Works with 20 freelance illustrators and 2 designers/year. Prefers artists with experience in illustration, design, retouching and packaging. Uses illustrators mainly for packaging and brochures. Uses designers mainly for new products. Also uses freelancers for ad and catalog illustration, airbrushing, brochure design and illustration, lettering, model making and retouching. Needs computer-literate freelancers for production. 70% of freelance work demands knowledge of Adobe Illustrator, Adobe Photoshop and QuarkXPress.

First Contact & Terms: Send postcard sample of work. Samples are filed. Art Director will contact artist for portfolio review if interested. Portfolio should include b&w and color roughs and transparencies. Pays for design and illustration by the project. Rights purchased vary according to project.

Tips: Finds artists through sourcebooks.

TESSING DESIGN, INC., 3822 N. Seeley Ave., Chicago IL 60618. (312)525-7704. Fax: (312)525-7756. Principals: Arvid V. Tessing and Louise S. Tessing. Estab. 1975. Number of employees: 2. Specializes in corporate identity, marketing promotions and publications. Clients: publishers, educational institutions and nonprofit groups. Majority of clients are publishers. Professional affiliation: Women in Design.

Needs: Approached by 30-80 freelancers/year. Works with 8-10 freelance illustrators and 2-3 designers/year. Works on assignment only. Uses freelancers mainly for publications. Also for book and magazine design and illustration, mechanicals, retouching, airbrushing, charts/graphs and lettering. Needs computer-literate freelancers for design, illustration and production. 75% of freelance work demands knowledge of QuarkXPress, Photoshop or Adobe Illustrator. Needs textbook, editorial and technical illustration.

First Contact & Terms: Send query letter with brochure. Samples are filed or are not returned. Request portfolio review in original query. Artist should follow up with letter after initial query. Art Director will contact artist for portfolio review if interested. Portfolio should include original/final art, final reproduction/product and photographs. Pays for design by the hour, $40-60. Pays for illustration by the project, $100 minimum. Rights purchased vary according to project.

Tips: Finds artists through word of mouth, artists' submissions/self-promotions and sourcebooks. "We prefer to see original work or slides as samples. Work sent should always relate to the need expressed. Our advice for artists to break into the field is as always—call prospective clients, show work and follow up."

‡ZÜNDESIGN INCORPORATED, 520 N. Michigan Ave., #424, Chicago IL 60611. (312)494-7788. Fax: (312)494-9988. E-mail: zun@interaccess.com. Partners: William Ferdinand and David Philmee. Estab. 1991. Number of employees: 5. Specializes in annual reports, brand and corporate identity, capability brochures, package and publication design, electronic and interactive. Clients: from Fortune 500 to new upstart companies. Current clients include Ameritech, Arthur Andersen, Harris Bank, Motorola, Sara Lee and Sears. Client list available upon request. Professional affiliations: AIGA, ACD.

Needs: Approached by 24 freelancers/year. Works with 5-10 freelance illustrators and 8-16 designers/year. Prefers local artists. Looks for strong personal style (local and national). Uses illustrators mainly for editorial. Uses designers mainly for design and layout. Also uses freelancers for ad, brochure and poster design and illustration; audiovisual materials; direct mail, magazine and P-O-P design; lettering; logos; and retouching. Needs computer-literate freelancers for design, illustration, production and presentation. 90% of freelance work demands knowledge of Adobe Illustrator, Adobe Photoshop, QuarkXPress, Director and Apple Mediator.

First Contact & Terms: Send postcard sample of work or send query letter with brochure and résumé. Samples are filed. Reports back to the artist only if interested. Portfolios may be dropped off every Friday. Artist should follow-up. Portfolio should include b&w and color samples. Pays for design by the hour and by the project. Pays for illustration by the project. Rights purchased vary according to project.

Tips: Finds artists through reference books and submissions. Impressed by "to the point portfolios. Show me what you like to do, and what you brought to the projects you worked on. Don't fill a book with extra items (samples) for sake of showing quantity."

Indiana

HEIDEMAN DESIGN, 9301 Brunson Run, Indianapolis IN 46256. (317)845-4064. Contact: Mark Heideman. Estab. 1985. Specializes in display, direct mail, package and publication design; annual reports; brand and corporate identity; signage; technical illustration; and vehicle graphics. Clients: technical and industrial.

Needs: Works with 3 freelance illustrators and 2 designers/year. Works on assignment only. Uses freelancers for marker comps, brochure, catalog, P-O-P, and poster illustration. Needs computer-literate freelancers for design, illustration, production and presentation. 95% of freelance work demands knowledge of Adobe Illustrator, Adobe Dimensions, QuarkXPress or Photoshop. Needs editorial and technical illustration.
First Contact & Terms: Send query letter. Samples are filed. Art Director will contact artist for portfolio review if interested. Portfolio should include thumbnails, roughs and tearsheets. Pays for design by the project, $100 minimum. Pays for illustration by the project, $100-2,000. Considers client's budget, skill and experience of artist and turnaround time when establishing payment. rights purchased vary according to project.

‡**JMH CORPORATION,** 921 E. 66th St., Indianapolis IN 46220. (317)255-3400. President: J. Michael Hayes. Number of employees: 3. Specializes in corporate identity, advertising, collateral, packaging and publications. Clients: publishers, consumer product manufacturers, corporations and institutions. Professional affiliations: AIGA.
Needs: Approached by 30-40 freelancers/year. Works with 5 freelance illustrators and 2 designers/year. Prefers experienced, talented and responsible artists only. Works on assignment only. Uses artists for advertising, brochure and catalog design and illustration; P-O-P displays; mechanicals; retouching; charts/graphs and lettering. Needs editorial and medical illustration. Needs computer-literate freelancers for design, illustration, production and presentation. 80% of freelance work demands knowledge of QuarkXPress, Adobe Illustrator or Photoshop (latest versions).
First Contact & Terms: Send query letter with brochure/flyer, résumé and slides. Samples returned by SASE, "but we prefer to keep them." Reporting time "depends entirely on our needs." Write for appointment to show portfolio. Pays for design by the hour, $15-40. Pays for illustration by the project, $300-2,000.
Tips: "Prepare an outstanding mailing piece and 'leave-behind' that allows work to remain on file. Our need for freelance artists has diminished."

‡**JUNGCLAUS & KREFFEL DESIGN STUDIO,** 145 E. 14th St., Indianapolis IN 46202. (317)636-4891. Owners: Fred Jungclaus and Mike Kreffel. Number of employees: 2. Approximate annual billing: $150,000. Specializes in architectural renderings, illustration, graphic design, cartoons and display models. Clients: ad agencies, architects and publishing companies. Current clients include Indianapolis Motor Speedway, Schwitzer Inc. and Kiwanis International. Client list not available. Professional affiliation: GAG.
Needs: Approached by 5-10 freelancers/year. Works with 3-5 freelance illustrators/year. Works on assignment only. Uses freelancers for editorial illustration and airbrushing. Seeks freelancers capable of illustrating Indy-type race cars or antique cars.
First Contact & Terms: Send samples to be kept on file. Prefers color prints or tearsheets as samples. No slides. Samples not filed are not returned. Call for appointment to show portfolio. Pays for illustration by the project, $250-1,800. Considers skill and experience of artist and turnaround time when establishing payment.

Kentucky

DESIGN ELEMENTS, INC., 201 W. Short, Suite 702, Lexington KY 40508. (606)252-4468. President: C. Conde. Estab. 1979. Specializes in corporate identity, package and publication design. "Work directly with end user (commercial accounts)." Client list not available.
Needs: Approached by 6-8 freelancers/year. Works with 2-3 freelance illustrators and designers/year. Works on assignment only. Uses freelancers for brochure and P-O-P design and illustration, mechanicals, airbrushing, poster design, lettering and logos.
First Contact & Terms: Send query letter with brochure, résumé, tearsheets and slides. Samples are filed or are returned if requested by artist. Reports back only if interested. Call or write for appointment to show portfolio. Pays by the hour, $25 minimum. Considers complexity of project, client's budget and skill and experience of artist when establishing payment. Buys all rights.
Tips: "Freelancers need to be more selective about portfolio samples—show items actually done by person presenting, or explain why not. Send résumé and samples of work first."

HAMMOND DESIGN ASSOCIATES, INC., 206 W. Main, Lexington KY 40507. (606)259-3639. Fax: (606)259-3697. Vice-President: Mrs. Kelly Johns. Estab. 1986. Specializes in direct mail, package and publication design and annual reports, brand and corporate identity, display and signage. Clients: corporations, universities and medical facilities. Client list not available.
Needs: Approached by 35-50 freelance/year. Works with 7 illustrators/year. Works on assignment only. Uses freelancers mainly for brochures and ads. Also for editorial, technical and medical illustration; airbrushing; lettering; P-O-P and poster illustration; and charts/graphs.
First Contact & Terms: Send query letter with brochure or résumé. "Sample in query letter a must." Samples are filed or returned by SASE if requested by artist. Reports back only if interested. Art Director

will contact artist for portfolio review if interested. Sometimes requests work on spec before assigning job. Pays by the project, $100-10,000. Rights negotiable.

Louisiana

ANTHONY DI MARCO, 2948½ Grand Route St. John, New Orleans LA 70119. (504)948-3128. Creative Director: Anthony Di Marco. Estab. 1972. Number of employees: 1. Specializes in illustration, sculpture, costume design and art photo restoration and retouching. Current clients include Audubon Institute, Louisiana Nature and Science Center, City of New Orleans, churches, agencies. Client list available upon request. Professional affiliations: Art Directors, Designers Association; Energy Arts Council; Louisiana Crafts Council; Louisiana Association for Conservation of Arts.
Needs: Approached by 50 or more freelancers/year. Works with 5-10 freelance illustrators and 5-10 designers/year. Seeks "local freelancers with ambition. Freelancers should have substantial portfolios and an understanding of business requirements." Uses freelancers mainly for fill-in and finish: design, illustration, mechanicals, retouching, airbrushing, posters, model making, charts/graphs. Prefers highly polished, finished art in pen & ink, airbrush, charcoal/pencil, colored pencil, watercolor, acrylic, oil, pastel, collage and marker. 25% of freelance work demands computer skills.
First Contact & Terms: Send query letter with résumé, business card, slides and tearsheets to be kept on file. Samples not filed are returned by SASE. Reports back within 1 week if interested. Call or write for appointment to show portfolio. Pays for illustration by the hour; by the project, $100 minimum.
Tips: "Keep professionalism in mind at all times. Put forth your best effort. Apologizing for imperfect work is a common mistake freelancers make when presenting a portfolio. Include prices for completed works (avoid overpricing). 3-dimensional works comprise more of our total commissions than before."

‡FOCUS COMMUNICATIONS, INC., 712 Milan, #102, Shreveport LA 71101. (318)221-3808. President: Jim Huckabay. Estab. 1976. Number of employees: 3. Approximate annual billing: $1 million. Specializes in corporate identity, direct mail design and full service advertising. Clients: medical, financial and automotive. Professional affiliations: AAF.
Needs: Approached by 5 freelancers/year. Works with 2 freelance illustrators and designers/year. Prefers local artists with experience in illustration, computer (Mac) design and composition. Uses illustrators mainly for custom projects; print ads. Uses designers mainly for custom projects; direct mail, logos. Also uses freelancers for ad and brochure design and illustration, audiovisual materials, charts/graphs, logos, mechanicals and retouching. Needs computer-literate freelancers for design, illustration and production. 85% of freelance work demands knowledge of Adobe Photoshop, Aldus FreeHand and QuarkXPress.
First Contact & Terms: Send postcard sample of work or send query letter with brochure, photocopies, photostats, slides, tearsheets and transparencies. Samples are filed. Art Director will contact artist for portfolio review if interested. Portfolio should include b&w and color final art and slides. Pays for design by the hour, $40-75; by the project. Pays for illustration by the project, $100-1,000. Negotiates rights purchased.
Tips: Impressed by "turnkey capabilities in Macintosh design and finished film/proof composition."

Maryland

‡ANDERSON DESIGN, INC., 18952 Bonanza Way, Gaithersburg MD 20879. (301)948-0007. Fax: (301)670-6728. Principal: Christopher Anderson. Estab. 1987. Number of employees: 2. Specializes in corporate identity; display, publication and lighting design; and signage. Clients: corporations, medical institutions, research firms and architectural firms.
Needs: Uses illustrators mainly for architectural renderings, medical illustrations. Uses designers mainly for computer-aided design for publications. Also uses freelancers for ad and brochure design and illustration; book, magazine and newspaper design; lettering; and mechanicals. Needs computer-literate freelancers for design, production and multimedia. 75% of freelance work demands knowledge of Adobe Illustrator 5.5, Adobe Photoshop 2.0, Aldus FreeHand 3.0 and QuarkXPress 3.3.
First Contact & Terms: Send postcard sample of work or send query letter, brochure, résumé and tearsheets. Samples are filed and are not returned. Reports back within 2 months. Art Director will contact artist for portfolio review if interested. Portfolio should include "media presentation that best represents the artist's style." Payment for design and illustration "depends on the situation and the artist expensive." Rights purchased vary according to project.
Tips: Finds artists through interviewing, samples send by mail and referrals. Impressed by "a clear, easy-to-interpret résumé, and a portfolio which reflects the creative idealogy of the artist or designer."

‡AVRUM I. ASHERY—GRAPHIC DESIGNER, 5901 Montrose Rd., #S-1101, Rockville MD 20852. (301)984-0142. Estab. 1968. Number of employees: 2 (parttime). Specializes in brand identity, corporate identity (logo), exhibit, publication design and signage. "Specialty is Judaic design for synagogues, Jewish organizations/institutions." Current clients include U.S. Committee for Sports in Israel, Temple Emanuel

Hebrew Day Institute, Jewish federations (many cities), Washington Hebrew Confederation, Masorti (conservative movement in Israel), Embassy of Israel, B'nai B'rith International. Professional affiliations: Federal Design Council.

Needs: Approached by 2-3 freelancers/year. Works with 2-3 freelance illustrators and 2-3 designers/year. Prefers artists with experience in "all around illustration." Uses designers mainly for work overload (logos). Also uses freelancers for brochure design, logos and model making. Needs computer-literate freelancers for production. 20% of freelance work demands knowledge of Adobe Illustrator, Adobe Photoshop and Aldus PageMaker.

First Contact & Terms: Send postcard sample of work or send tearsheets. Samples are filed. Art Director will contact artist for portfolio review if interested. Portfolio should include b&w and color final art and thumbnails. Pays for design and illustration by the hour, $10-15; by the project, $150-500. Rights purchased vary according to project.

Tips: Finds artists through word of mouth. Does not want a "trendy designer/illustrator. Have a specialty or developing interest in Judaic themes for design."

‡**DEVER DESIGNS, INC.,** 9101 Cherry Lane, Suite 102, Laurel MD 20708. (301)776-2812. Fax: (301)953-1196. President: Jeffrey Dever. Estab. 1985. Number of employees: 5. Approximate annual billing: $300,000. Specializes in annual reports, brand and corporate identity, package and publication design. Clients: corporations, museums, government agencies, associations, nonprofit organizations. Current clients include Population Reference Bureau, The Futures Group, The National Museum of Women in the Arts, Washington Post. Client list available upon request.

Needs: Approached by 5-10 freelancers/year. Works with 2-3 freelance illustrators and 1-2 designers/year. Prefers artists with experience in editorial illustration. Uses illustrators mainly for publications. Uses designers mainly for on-site help when there is a heavy workload. Also uses freelancers for brochure illustration, charts/graphs and in-house production. Needs computer-literate freelancers for production. 80% of freelance work demands knowledge of Adobe Illustrator and QuarkXPress.

First Contact & Terms: Send brochure, photocopies, résumé and tearsheets. Samples are filed. Art Director will contact artist for portfolio review if interested. Portfolio should include b&w and color photocopies for files. Pays for design and illustration by the project. Rights purchased vary according to project.

Tips: Finds artists through word of mouth. Impressed by "uniqueness and tenacity."

‡**GEREW GRAPHIC DESIGN,** 2623 N. Charles St., Baltimore MD 21218. (410)366-5424. Fax: (410)366-6123. Owner: Cynthia Gerew. Estab. 1988. Number of employees 3. Specializes in direct mail design. Clients: financial and insurance corporations.

Needs: Approached by 4-5 freelancers/year. Works with 4 freelance illustrators and 4 designers/year. Prefers artists with experience in drawing realistic people. Uses illustrators mainly for brochure illustration. Uses designers mainly for direct mail. Also uses freelancers for ad illustration, brochure design and illustration, charts/graphs, direct mail design, lettering, logos and mechanicals. Needs computer-literate freelancers for design, illustration and production. 90% of freelance work demands knowledge of Adobe Illustrator, Adobe Photoshop and QuarkXPress.

First Contact & Terms: Send postcard sample of work or send query letter. Art Director will contact artist for portfolio review if interested. Portfolio should include color final art, photocopies, photographs, photostats and transparencies. Pays for design by the hour, $15-25. Pays for illustration by the project. Negotiates rights purchased.

Tips: Finds artists through sourcebooks and local referrals. Impressed by freelancers "who are not only talented, but also dependable."

‡**SPIRIT CREATIVE SERVICES INC.,** 412 Halsey Rd., Annapolis MD 21401. (410)974-9377. Fax: (410)974-8290. President: Alice Yeager. Estab. 1992. Number of employees: 1. Approximate annual billing: $90,000. Specializes in annual reports; brand and corporate identity; display, direct mail, package and publication design; technical and general illustration; signage. Clients: government associations, corporations. Client list available upon request.

Needs: Approached by 5-10 freelancers/year. Works with 3-4 freelance illustrators and 4-5 designers/year. Prefers local designers. Uses freelancers for ad, brochure, catalog, poster and P-O-P design and illustration; book direct mail and magazine design; audiovisual materials; crafts/graphs; lettering; logos; mechanicals. Needs computer-literate freelancers for design, illustration, production and presentation. 80% of freelance design work demands knowledge of Adobe Illustrator, Adobe Photoshop, Aldus FreeHand, Aldus PageMaker and QuarkXPress.

First Contact & Terms: Send postcard sample of work or send query letter with brochure, photocopies, résumé, SASE and tearsheets. Samples are filed. Reports back within 1-2 weeks if interested. Request portfolio review in original query. Artist should follow-up with call and/or letter after initial query. Portfolio should include b&w and color final art, tearsheets, sample of comping ability. Pays for design and illustration by the project. Rights purchased vary according to project.

Massachusetts

‡RICHARD BERTUCCI/GRAPHIC COMMUNICATIONS, 3 Juniper Lane, Dover MA 02030-2146. Phone/fax: (508)785-1301. Owner: Richard Bertucci. Estab. 1970. Number of employees: 2. Approximate annual billing: $1 million. Specializes in annual reports; corporate identity; display, direct mail, package and publication design. Clients: companies and corporations. Professional affiliations: AIGA.
Needs: Approached by 12-24 freelancers/year. Works with 6 freelance illustrators and 3 designers/year. Prefers local artists with experience in business-to-business advertising. Uses illustrators mainly for feature products. Uses designers mainly for fill-in projects, new promotions. Also uses freelancers for ad, brochure and catalog design and illustration; airbrushing; direct mail, magazine and newpaper design; logos; and mechanicals. Needs computer-literate freelancers for design, production and presentation. 50% of freelance work demands knowledge of Aldus FreeHand and QuarkXPress.
First Contact & Terms: Send postcard sample of work or send query letter with brochure and résumé. Samples are filed. Art Director will contact artist for portfolio review if interested. Portfolio should include b&w and color roughs. Pays for design by the project, $500-5,000. Pays for illustration by the project, $250-2,500. Rights purchased vary according to project.

‡BODZIOCH DESIGN, 30 Robbins Farm Rd., Dunstable MA 01827. (508)649-2949. Estab. 1986. Number of employees: 1. Specializes in annual reports, corporate identity and direct mail design. Clients: corporations. Current clients include Quadtech Inc., GenRad Inc., New England Business Service and Delta Education. Client list available upon request.
Needs: Works with freelance illustrators and designers. Prefers local artists with experience in direct mail and corporate work. Uses illustrators mainly for charts, graphs and spot illustration. Uses designers mainly for concept, ad and logo design. Also uses freelancers for airbrushing, brochure and direct mail design, retouching. Needs computer-literate freelancers for design, illustration, production and presentation. 90% of freelance work demands knowledge of Adobe Illustrator, Adobe Photoshop, Aldus FreeHand and QuarkXPress.
First Contact & Terms: Send postcard sample of work. Samples are filed. Art Director will contact artist for portfolio review if interested. Portfolio should include b&w and color final art and roughs. Pays for design by the hour, $45-60. Pays for illustration by the hour, $40-50; by the project (supply quote). Rights purchased as dictated by client (usually all rights).
Tips: Finds artists through *American Showcase, Communication Arts, Workbook* and mailing from reps.

‡DeFRANCIS STUDIO, INC., 222 Newbury St., Boston MA 02116. (617)536-0036. Fax: (617)536-5733. Estab. 1984. Number of employees: 4. Specializes in annual reports; corporate identity; display, package and publication design; collateral. Clients: corporations and nonprofit organizations. Current clients include Resource Net International, Dartmouth College, Aetna Insurance, Bridgestone Cycles. Professional affiliations: AIGA.
Needs: Approached by 50 freelancers/year. Works with 15 freelance illustrators and 2-3 designers/year. Uses illustrators mainly for brochures, corporate communications. Uses designers mainly for in-house freelance work. Needs computer-literate freelancers for design, illustration and production. 90% of freelance work demands knowledge of Adobe Photoshop, Aldus FreeHand, Aldus PageMaker and QuarkXPress.
First Contact & Terms: Send query letter with résumé. Samples are filed or returned by SASE if requested by artist. Reports back to the artist only if interested. Portfolio should include b&w samples. Negotiates rights purchased.

FLAGLER ADVERTISING/GRAPHIC DESIGN, Box 1317, Brookline MA 02146. (617)566-6971. Fax: (617)566-0073. President/Creative Director: Sheri Flagler. Specializes in corporate identity, brochure design, ad campaigns and technical illustration. Clients: cable television, finance, real estate, tech and direct mail agencies, infant/toddler manufacturers.
Needs: Works with 10-20 freelancers/year. Works on assignment only. Uses freelancers for illustration, mechanicals, retouching, airbrushing, charts/graphs and lettering.
First Contact & Terms: Send résumé, business card, brochures, photocopies or tearsheets to be kept on file. Call or write for appointment to show portfolio. Samples not filed are not returned. Reports back only if interested. Pays for design and illustration by the project, $150-2,500. Considers complexity of project, client's budget and turnaround time when establishing payment.
Tips: "Send a range and variety of styles showing clean, crisp and professional work."

‡ICONS, 76 Elm St., Suite 313, Boston MA 02130. Phone/fax: (617)522-0165. E-mail: 75573.3077@compuserve. Principal: Glenn Johnson. Estab. 1985. Number of employees: 1. Approximate annual billing: $100,000. Specializes in annual reports, brand and corporate identity, direct mail and package design. Clients: high tech and retail restaurants. Current clients include Lotus Corp., Vicki Boyajain. Client list available upon request.
Needs: Approached by 20 freelancers/year. Works with 10 freelance illustrators and 10 designers/year. Uses illustrators mainly for brochures. Uses designers mainly for concept and mechanical. Also uses freelancers

for ad design and illustration, brochure design, lettering and logos. Needs computer-literate freelancers for design, illustration and production. 90% of freelance work demands knowledge of Adobe Illustrator, Adobe Photoshop, Aldus FreeHand and QuarkXPress.

First Contact & Terms: Send query letter with brochure, photographs, slides and tearsheets. Samples are filed or returned by SASE if requested by artist. Art Director will contact artist for portfolio review if interested. Pays for design and illustration by the project, $150 minimum. Negotiates rights purchased.

Tips: Finds artists through sourcebooks and direct mail samples. "Don't skimp on your mail presentations."

‡**IMAGIGRAPHICS**, 9 Grant St., W. Newton MA 02165. (617)965-7788. Owner: Lisa Miksis. Estab. 1975. Number of employees: 1. Approximate annual billing: $30,000. Specializes in corporate identity. Clients: corporate, government. Current clients include Nynex, Com. of Massachusetts.

Needs: Approached by 12 freelancers/year. Works with 2 freelance illustrators and 1 designer/year. Prefers artists with experience in type. Uses illustrators and designers mainly for technical work. Also uses freelancers for airbrushing, logos and retouching. Needs computer-literate freelancers for design, illustration and production. 50% of freelance work demands knowledge of Adobe Illustrator, Adobe Photoshop and QuarkXPress.

First Contact & Terms: Send brochure or printed sample (advertising work). Samples are filed and are not returned. Art Director will contact artist for portfolio review if interested. Portfolio should include b&w and color printed samples. Pays for design by the hour, $15-100; by the day, $50-200. Pays for illustration by the hour, $15-100; by the day, $50-200. Rights purchased vary according to project.

Tips: Finds artists through artists' submissions.

‡**McGRATHICS**, 24 Abbot St., Marblehead MA 01945. (617)631-7510. Art Director: Vaughn McGrath. Estab. 1978. Number of employees: 4. Specializes in annual reports, corporate identity, package and publication design. Clients: corporations and universities. Professional affiliations: AIGA, VUGB.

Needs: Approached by 30 freelancers/year. Works with 5 freelance illustrators/year. Uses illustrators mainly for advertising, corporate identity (both conventional and computer). Also for ad, brochure, catalog, poster and P-O-P illustration; charts/graphs. Needs computer-literate freelancers for illustration. 25% of freelance work demands knowledge of Adobe Illustrator and Adobe Photoshop.

First Contact & Terms: Send postcard sample of work or send brochure, photocopies, photographs, résumé, slides and transparencies. Samples are filed. Reports back to the artist only if interested. Portfolio review not required. Pays for illustration by the hour or by the project. Rights purchased vary according to project.

Tips: Finds artists through sourcebooks and mailings. "Annually mail us an update for our review."

STEWART MONDERER DESIGN, INC., 10 Thacher St., Suite 112, Boston MA 02113. (617)720-5555. Senior Designer: Robert Davison. Estab. 1982. Specializes in annual reports, corporate identity, package and publication design, employee benefit programs, corporate cabability brochures. Clients: corporations (hi-tech, industry, institutions, health care, utility, consulting, service). Current clients include Aspen Technology, Vivo Software, Voicetek Corporation, Fidelity and Lesley College. Client list not available.

Needs: Approached by 200 freelancers/year. Works with 5-10 freelance illustrators and 1-5 designers/year. Works on assignment only. Uses illustrators mainly for corporate communications. Uses designers for design and production assistance. Also uses freelancers for mechanicals and illustration. Needs computer-literate freelancers for design, illustration and production. 50% of freelance work demands knowledge of Aldus PageMaker, Adobe Illustrator, QuarkXPress, Photoshop or Aldus FreeHand. Needs editorial and corporate illustration.

First Contact & Terms: Send query letter with brochure, tearsheets, photographs and photocopies. Samples are filed. Art Director will contact artist for portfolio review if interested. Portfolio should include b&w and color finished art samples. Sometimes requests work on spec before assigning a job. Pays for design by the hour, $10-25; by the project. Pays for illustration by the project, $250 minimum. Negotiates rights purchased.

Tips: Finds artists through submissions/self-promotions and sourcebooks.

‡**RICHLAND DESIGN ASSOCIATES**, 247 Harvard St., Cambridge MA 02138. (617)547-6545. Fax: (617)868-1384. E-mail: richland@village.com. President: Judy Richland. Estab. 1981. Number of employees: 3. Approximate annual billing: $500,000. Specializes in annual reports, corporate identity, direct mail and package design. Clients: corporations, museums, schools, state agencies. Current clients include Nynex Properties, Apple Computer, Integrate Computer Solutions. Client list available upon request. Professional affiliations: AIGA.

Needs: Approached by 10 freelancers/year. Works with 5 freelance illustrators and 10 designers/year. Prefers local artists only. Uses illustrators mainly for annual reports. Also uses freelancers for ad, catalog and direct mail design. Freelancers should be familiar with Aldus PageMaker 5.0.

First Contact & Terms: Send query letter with brochure, photographs, résumé and tearsheets. Samples are filed. Art Director will contact artist for portfolio review if interested. Portfolio should include b&w and color photographs, slides and thumbnails. Pays for design and illustration by the project. Rights purchased vary according to project.

RUBY SHOES STUDIO, INC., 12A Mica Lane, Wellesley MA 02181-1702. (617)431-8686. Creative Director: Susan Tyrrell Donelan. Estab. 1984. Number of employees: 7. Specializes in corporate identity, direct mail, package and publication design. Client list available upon request.

Needs: Approached by 150-300 freelancers/year. Works with 10-20 freelance illustrators and 10-20 designers/year. Uses freelance illustrators mainly for brochure illustration. Uses freelance designers mainly for ad design and mechanicals. Also uses freelancers for brochure and P-O-P design and illustration, 3-D design, mechanicals, airbrushing, lettering, logos, poster and direct mail design and graphs. Freelancers should be familiar with Adobe Illustrator, Photoshop, QuarkXPress, and/or 3-D Design.

First Contact & Terms: Send query letter with nonreturnable samples, such as tearsheets and résumé. Samples are filed or are returned by SASE. Reports back to the artist only if interested. To show a portfolio, mail roughs, original/final art, b&w and color tearsheets and slides. Pays for design by the hour, $20-30; by the project, $150-1,500. Pays for illustration by the project. Buys first or one-time rights.

‡CLIFFORD SELBERT DESIGN COLLABORATIVE, 2067 Massachusetts Ave., Cambridge MA 02140. (617)497-6605. Fax: (617)661-5772. Estab. 1982. Number of employees: 34. Specializes in annual reports, corporate identity, displays, landscape design, direct mail and package design, exhibits and environmental graphics. Clients: colleges, radio stations, corporations, hospitals, computer companies and retailers. Professional affiliations: AIGA, SEGD.

• This company has added a new office in the Los Angeles area.

Needs: Approached by "hundreds" of freelancers/year. Works with 10-15 freelance illustrators and 20 designers/year. Prefers artists with "experience in all types of design and computer experience." Uses freelance artists for brochures, mechanicals, logos, P-O-P, poster and direct mail.

First Contact & Terms: Send query letter with brochure, résumé, tearsheets, photographs, photocopies, slides and transparencies. Samples are filed. Reports back only if interested. Portfolios may be dropped off every Monday-Friday. Artist should follow up with call and/or letter after initial query. Art Director will contact artist for portfolio review if interested. Pays for design by the hour, $15-35; by the project. Pays for illustration by the project. Rights purchased vary according to project.

Tips: Finds artists through word of mouth, magazines, artists' submissions/self-promotions, sourcebooks and agents.

‡TRIAD DESIGNS, INC., 18 Water St., Holliston MA 01746. (508)429-2498. Fax: (508)429-3042. Design Director: Alan King. Estab. 1981. Number of employees: 3. Approximate annual billing: $350,000. Specializes in brand and corporte identity, display and package design, technical illustration and signage. Clients: ad agencies, corporations. Current clients include Sony, Pennzoil, Lotus and GTE.

Needs: Approached by 3-4 freelancers/year. Works with 2-3 freelance designers/year. Prefers local artists with experience in silkscreen printing prep. Uses designers mainly for exhibit and T-shirt graphics. Also uses freelancers for lettering, mechanicals and retouching. 50% of freelance work demands knowledge of Adobe Illustrator, Adobe Photoshop and Aldus FreeHand.

First Contact & Terms: Send postcard sample of work or résumé and tearsheets. Samples are filed. Reports back to the artist only if interested. Art Director will contact artist for portfolio review if interested. Portfolio should include color final art, roughs and thumbnails. Pays for design by quotation. Rights purchased vary according to project.

Tips: Finds artists through sourcebooks and word of mouth recommendations.

‡WATZMAN INFORMATION DESIGN, 1770 Massachusetts Ave., Cambridge MA 02140. (617)776-0099. President: Suzanne Watzman. Estab. 1980. Number of employees: 5. Specializes in corporate communications, publication design, user interface design (a.k.a. multimedia design or interaction design) and information design. Clients: corporations, organizations, nonprofits, financial. Current clients include ProCD, Corex Technology, Foxboro, Symetrix, T-Rowe Price. Professional affiliations: ACM, SIGCHI, Massachusetts Computer Software Council, Boston Computer Society.

Needs: Approached by 20 freelancers/year. Works with 5-20 freelance illustrators and 5 designers/year. Prefers artists with experience in technology, software programing. Uses designers and illustrators for user interface product support; reengineering design; book, brochure, catalog and poster design; information graphics and visualization; icons; and logos. Needs computer-literate freelancers for design, illustration, production and presentation. 95% of freelance work demands knowledge of Adobe Illustrator, Adobe Photoshop and QuarkXPress.

First Contact & Terms: Send postcard sample of work or query letter with brochure, photocopies, photographs and résumé. Samples are filed. Artist should follow-up with letter after initial query. Art Director will contact artist for portfolio review if interested. Pays for design and illustration "based on circumstances." Rights purchased vary according to project.

Tips: Finds artists through referrals.

WEYMOUTH DESIGN, INC., 332 Congress St., Boston MA 02210-1217. (617)542-2647. Fax: (617)451-6233. Office Manager: Judith Hildebrandt. Estab. 1973. Number of employees: 10. Specializes in annual

reports and corporate collateral. Clients: corporations and small businesses. Client list not available. Professional affiliation: AIGA.

Needs: Approached by "tons" of freelancers/year. Works with 1-2 freelance illustrators and 1 designer/year. Prefers freelancers with experience in corporate annual report illustration. Works on assignment only. Needs editorial, medical and technical illustration mainly for annual reports. Also uses freelancers for brochure and poster illustration.

First Contact & Terms: Send query letter with résumé or illustration samples. Samples are filed or are returned by SASE if requested by artist. Art Director will contact artist for portfolio review if interested. Pays for design by the hour, $20. Pays for illustration by the project; "artists usually set their own fee to which we do or don't agree." Rights purchased vary according to project.

Tips: Finds artists through magazines and agents. "Because our staff is now computer literate as are our clients, and mechanicals are on disk, we no longer need freelance designers during the busy season."

Michigan

‡**HEART GRAPHIC DESIGN**, 501 George St., Midland MI 48640. (517)832-9710. Fax: (517)832-9420. Owner: Clark Most. Estab. 1982. Number of employees: 3. Approximate annual billing: $200,000. Specializes in corporate identity and publication design. Clients: corporations. Current clients include Tannoy North America (Canadian Company), Snow Makers, Lyle Industries, Mullinex Packaging.

Needs: Approached by 6 freelancers/year. Works with 2-4 freelance illustrators and 5-8 designers/year. Uses illustrators mainly for computer illustration. Uses designers mainly for brochure design. Also uses freelancers for ad design, brochure illustration, charts/graphs, logos, mechanicals and retouching. Needs computer-literate freelancers for design and production. 80% of freelance work demands knowledge of Adobe Illustrator, Adobe Photoshop, Aldus FreeHand, Aldus PageMaker and QuarkXPress.

First Contact & Terms: Send query letter with brochure, photocopies and tearsheets. Samples are filed (if interested) or returned if requested. Reports back only if interested. Artist should follow-up with call and/or letter after initial query. Portfolio should include b&w and color final art, photographs, roughs and transparencies. Pays for design and illustration by the project. Negotiates rights purchased.

Tips: Finds artists through word of mouth, sourcebooks and design books. "Present yourself as diligent, punctual and pliable. Let your portfolio speak for itself (it should)."

VARON & ASSOCIATES, INC., 31333 Southfield, Beverly Hills MI 48025. (810)645-9730. Fax: (810)642-1303. President: Shaaron Varon. Estab. 1963. Specializes in annual reports; brand and corporate identity; display, direct mail and package design; and technical illustration. Clients: corporations (industrial and consumer). Current clients include Dallas Industries Corp., Enprotech Corp., FEC Corp., Johnstone Pump Corp., Microphoto Corp., PW & Associates. Client list available upon request.

Needs: Approached by 20 freelancers/year. Works with 7 illustrators and 7 designers/year. Prefers local freelancers only. Works on assignment only. Uses freelancers mainly for brochure, catalog, P-O-P and ad design and illustration; direct mail design; mechanicals; retouching; airbrushing; audiovisual materials; and charts/graphs. Needs computer-literate freelancers for design, illustration and presentation. 70% of freelance work demands knowledge of Aldus PageMaker, QuarkXPress, Aldus FreeHand or Adobe Illustrator.

First Contact & Terms: Send brochure, samples, slides and transparencies. Samples are filed. Reports back to the artist only if interested. Portfolios may be dropped off every Monday-Friday. Portfolio should include color thumbnails, roughs, final art and tearsheets. Buys all rights.

Tips: Finds artists through submissions.

Minnesota

PATRICK REDMOND DESIGN, P.O. Box 75430, St. Paul MN 55175-0430. (612)646-4254. Designer/Owner/President: Patrick M. Redmond, M.A. Estab. 1966. Number of employees: 1. Specializes in book and/or book cover design; logo and trademark design; package, publication and direct mail design; brand and corporate identity; design consulting and education; and posters. Has provided design services for more than 100 clients in the following categories: publishing, advertising, marketing, retail, financial, food, arts, education, computer, manufacturing, small business, health care, government and professions. Current clients

A bullet introduces comments by the editor of **Artist's & Graphic Designer's Market** *indicating special information about the listing.*

include: Dos Tejedoras Fiber Arts Publications, Mid-List Press, Hauser Artists and others.
Needs: Approached by 150 freelancers/year. Works with 2-4 freelance illustrators and 2-4 designers/year. Uses freelancers mainly for editorial and technical illustration, publications, books, brochures and newsletters. Needs computer-proficient freelancers for design, illustration, production and presentation. 70% of anticipated freelance work demands knowledge of Macintosh, QuarkXPress, Photoshop, Illustrator, FreeHand (latest versions).
First Contact & Terms: Send query letter with brochure, résumé, photocopies and SASE. Also "sends us quarterly mailings/updates; a list of three to four references; a rate sheet/fee schedule." Samples not filed are thrown away. No samples returned. Reports back only if interested. "Artist will be contacted for portfolio review if work seems appropriate for client needs. Patrick Redmond Design will not be responsible for acceptance of delivery or return of portfolios not specifically requested from artist or rep. Samples must be presented in person unless other arrangements are made. Unless specifically agreed to in writing in advance, portfolios should not be sent unsolicited." Pays for design and illustration by the project. Rights purchased vary according to project. Considers buying second rights (reprint rights) to previously published work.
Tips: Finds artists through word of mouth, magazines, artists' submissions/self-promotions, exhibitions, competitions, CD-ROM, sourcebooks and agents. "I see trends toward more conservative, traditional approaches to images, subject matter and techniques."

‡**RJB STUDIO, INC.**, 210 N. Second St., Suite 101, Minneapolis MN 55401. (612)339-5758. Fax: (612)339-0811. President: Robert Bussey. Estab. 1983. Number of employees: 3. Approximate annual billing: $300,000. Specializes in display and package design. Clients: manufacturers/distributors of product.
Needs: Approached by 50 freelancers/year. Works with 10 freelance illustrators/year. Uses illustrators mainly for packaging. Also uses freelancers for P-O-P design. Needs computer-literate freelancers for illustration. 100% of freelance work demands knowledge of Adobe Illustrator and Adobe Photoshop.
First Contact & Terms: Send postcard sample of work. Samples are filed or returned by SASE if requested by artist. Art Director will contact artist for portfolio review if interested. Portfolio should include color final art. Pays for illustration by the project. Buys all rights.
Tips: Finds artists through creative sourcebooks.

Missouri

SIGNATURE DESIGN, 2101 Locust, St. Louis MO 63103. (314)621-6333. Fax: (314)621-0179. Owners: Therese McKee and Sally Nikolajevich. Estab. 1988. Specializes in corporate identity and display and exhibit design. Clients: museums, nonprofit institutions, corporations, government agencies, botanical gardens. Current clients include Missouri Botanical Garden, Huntsville Botanical Garden, U.S. Army Corps of Engineers, American Classic Voyages. Client list available upon request.
Needs: Approached by 15 freelancers/year. Works with 1-2 illustrators and 1-2 designers/year. Prefers local freelancers only. Works on assignment only. Needs computer-literate freelancers for production. 50% of freelance work demands knowledge of Aldus PageMaker, QuarkXPress, Adobe Illustrator or Adobe Photoshop.
First Contact & Terms: Send query letter with résumé, tearsheets and photocopies. Samples are filed. Reports back to the artist only if interested. Artist should follow up with letter after initial query. Portfolio should include "whatever best represents your work." Pays for design by the hour. Pays for illustration by the project.

Montana

‡**AYERS/JOHANEK PUBLICATION DESIGN, INC.**, 4750 Rolling Hills Dr., Bozeman MT 59715. (406)585-8826. Fax: (406)585-8837. Partner: John Johanek. Estab. 1987. Number of employees: 5. Specializes in publication design. Clients: magazines. Current clients include: US News & World Report, Rodale Express, CMP Publications, Hearst.
Needs: Approached by 100 freelancers/year. Works with dozens of freelance illustrators/year. Uses illustrators mainly for editorial illustration. Also uses freelancers for magazine illustration. Needs computer-literate freelancers for illustration. 10-15% of freelance work demands knowledge of Adobe Illustrator, Adobe Photoshop, Aldus FreeHand and QuarkXPress.
First Contact & Terms: Send postcard sample of work or send brochure, photocopies, résumé and any non-returnable samples. Samples are filed. Does not report back. "Extensive files are kept and updated annually. Every project sends us to the files to match artist with project." Art Director will contact artist for portfolio review if interested. Portfolio should include color samples and originals. Pays for illustration by the project, $250-2,500. Rights purchased vary according to project.
Tips: Finds artists through sourcebooks, word of mouth, references from clients, peers, examples seen in print.

Make Vendors Your Design Partners

Ann Willoughby

At some point in your career you will work with vendors—whether printers, paper companies or separators. Thinking of them as "partners" and learning to communicate with them will keep projects running smoothly and help you avoid headaches says Ann Willoughby.

Willoughby is the founder and president of WRK Design, a full-service design shop based in Kansas City. Her firm covers many areas of design including product development, packaging and merchandising for such clients as Lee Apparel, Max Factor, Hallmark and Black & Decker. Willoughby has had lots of experience dealing with vendors; happily, most of it has been positive.

"The most important thing is relaying the correct information," says Willoughby. "You have to make sure everyone is talking about the same thing. One of the pitfalls is that either the vendor or the designer isn't communicating properly. If you bring them in early enough in the process, they can save you time and money by uncovering limitations related to equipment and technology."

Make sure your document's format is set according to your printer's specifications. If not, problems can (and will) occur. Also, don't assume printers have all fonts. Check their list of fonts before you choose the typography for your design. It may be necessary to send them the fonts you specify.

Consult with vendors about costs before making design decisions. You'll find out, for example, designs requiring bleeds cost more to print. A quirky size or fold adds huge amounts to your bill because presses and bindery equipment aren't set up for irregular sizes. Checking with printers or paper sales staff before you spec paper could prevent you from choosing a shiny-coated stock which makes type hard to read.

Most problems will hopefully be uncovered during the bidding process. To give an accurate bid, vendors ask for the specifics of jobs up front. With correct information, they can assess if their capabilities match the job. The more accurately you spec the job, the more likely you'll be satisfied with the end result.

The best way to check out vendors is to visit their facilities. "You can learn a lot about them that way. You can see how they operate, if they are organized, and how professional and knowledgeable they are." Ask to see work samples, then call the vendor's clients for a quick reference. Make sure the individual handling your account has experience in the kind of project you're working on.

"We try to stick with the same vendors as long as they treat us well. But

weigh your options, because today there are so many ways to prepare material for printing or production. For example, because of all the new color separation programs, many designers handle color separations in-house."

Not all designers and illustrators are familiar with different production techniques. "I find it interesting that in New York, a lot of designers don't buy their own separations—it's a completely different process in other parts of the country. Here at WRK, we follow our work all the way through. I think it helps the designer understand the limitations of the medium."

Whether you choose local vendors depends on what's available in your area. "I like to keep our work local. Kansas City has good vendors because there are large companies here." For special capabilities or if a client prefers a certain printer, Willoughby will work with vendors outside the area.

Make sure vendors get paid on time. You can ask them to bill your client directly, or cover costs yourself and include them on your client's bill. If you choose the latter option, be sure to add a 17.5% mark-up to the cost of materials and outside services onto your client's invoice. The mark-up covers handling and processing and is standard in the industry. To have the cash flow to pay vendors, Willoughby recommends billing clients monthly rather than in standard thirds or waiting until the end of a project.

Building honest relationships with vendors is the route to take. If everyone is up front and lines of communication are clear, you will avoid many disasters down the road—and you'll save your clients time and money.

—Neil Burns

Reprinted with permission of WRK Design.

Willoughby Design Group created corporate identity for Bagel & Bagel products including this packaging for the company's line of preserves and coffee.

GOTTLIEB COMMUNICATIONS, 25 S. Ewing St., Suite 505, Helena MT 59601. Phone/fax: (406)449-4127. President: Michael Gottlieb. Estab. 1979. Specializes in annual reports; corporate identity and collateral; corporate communication programs; strategic planning, marketing, graphics and posters for the sport of Lacrosse. Clients: corporations. Current clients include Sierra Ventures Management Company, D.W. Beary & Associates, Inc., Helena Chamber of Commerce, Valley Bank. Client list available upon request. Relocated to Montana after 12 years in San Francisco.
Needs: Approached by 12 freelancers/year. Works with 2 illustrators and 3 designers/year. Prefers local freelancers only. Works on assignment only. Uses freelancers mainly for spot illustrations. Also for brochure design and illustration, mechanicals, airbrushing, logos and computer design. Needs computer-literate freelancers for design and production. 75% of freelance work demands knowledge of Aldus PageMaker or Adobe Illustrator. Needs editorial illustration.
First Contact & Terms: Send query letter with brochure and résumé. Samples are filed. Reports back to the artist only if interested. Call for appointment to show portfolio of thumbnails, roughs, color original/final art. Pays for design by the hour, $15-35. Pays for illustration by the hour, $15-35; by the project, $200-1,000. Buys one-time rights. Negotiates rights purchased.

Nebraska

MICHAEL EDHOLM DESIGN, 4201 Teri Lane, Lincoln NE 68502. (402)489-4314. Fax: (402)489-4300. E-mail: edholmdes@aol.com. President: Michael Edholm. Estab. 1989. Number of employees: 1. Approximate annual billing: $100,000. Specializes in annual reports; corporate identity; direct mail, package and publication design. Clients: ad agencies, insurance companies, universities and colleges, publishers, broadcasting. Professional affiliations: AIGA.
Needs: Approached by 6 freelancers/year. Also uses freelancers for ad, catalog and poster illustration; brochure design and illustration; direct mail design; logos; and model making. Needs computer-literate freelancers for design, illustration and production. 20% of freelance work demands knowledge of Adobe Illustrator, Adobe Photoshop, Aldus FreeHand, Aldus PageMaker and QuarkXPress.
First Contact & Terms: Contact through e-mail. Send postcard sample of work or send brochure, photocopies, SASE and tearsheets. Samples are filed. Art Director will contact artist for portfolio review if interested. Portfolio should include b&w and color final art, photographs and slides. Pays for design and illustration by the project. Rights purchased vary according to project.
Tips: Finds artists through *Workbook*, direct mail pieces.

‡STUDIO GRAPHICS, 7337 Douglas St., Omaha NE 68114. (402)397-0390. Fax: (402)558-3717. Owner: Leslie Hanson. Number of employees: 1. Approximate annual billing: $85,000. Specializes in corporate identity, displays, direct mail, packaging, publications and signage. Clients: agencies, corporations, direct with print advertisers, marketing organizations and restaurant chains.
Needs: Approached by 20 freelancers/year. Works with 2 freelance illustrators and 2 designers/year. Works on assignment only. Uses freelancers for illustration, retouching, airbrushing and AV materials. Needs computer-literate freelancers for production. 25% of freelance work demands computer skills.
First Contact & Terms: Send query letter with résumé and samples "as available." Samples are filed or are returned by SASE if requested. Reports back only if interested. Write for an appointment to show portfolio. Pays for design and illustration by the project, $100 minimum. Considers complexity of project and client's budget when establishing payment. Negotiates rights purchased.

Nevada

VISUAL IDENTITY, 6250 Mountain Vista, L-5, Henderson NV 89014. (702)454-7773. Fax: (702)454-6293. Creative Designer: William Garbacz. Estab. 1987. Number of employees: 6. Approximate annual billing: $500,000. Specializes in annual reports; brand and corporate identity; display, direct mail, package and publication design; signage and gaming brochures. Clients: ad agencies and corporations. Current clients include Sam's Town, Green Valley Athletic Club and Westward-Ho.
Needs: Approached by 50 freelancers/year. Works with 3 freelancers and 3 designers/year. Prefers local artists with experience in gaming. Uses illustrators and designers mainly for brochures and billboards. Also uses freelancers for ad, P-O-P and poster design and illustration; direct mail, magazine and newspaper design; lettering; and logos. Needs computer-literate freelancers for design, illustration, production, presentation and 3D. 99% of freelance work demands knowledge of Adobe Illustrator, Adobe Photoshop, Aldus FreeHand, QuarkXPress, Painter, Ray Dream.
First Contact & Terms: Send résumé and tearsheets. Samples are filed. Art Director will contact artist for portfolio review if interested. Portfolio should include photocopies and roughs. Pays for design and illustration by the project, $100-1,000. Rights purchased varied according to project.
Tips: Finds artists through "any and every source available."

New Hampshire

PATTERN PEOPLE, INC., 10 Floyd Rd., Derry NH 03038. (603)432-7180. Vice President: Michael S. Copeland. Estab. 1988. Design studio servicing various manufacturers of consumer products. Designs wall-coverings and textiles with "classical elegance and exciting new color themes for all ages."
Needs: Approached by 5-8 freelancers/year. Works with 5-8 freelance designers/year. Prefers freelancers with professional experience in various media. Uses freelancers mainly for original finished artwork. Also for textile and wallcovering design. "We use all styles but they must be professional." Special needs are "floral (both traditional and contemporary), textural (faux finishes, new woven looks, etc.) and geometric (mainly new wave contemporary)."
First Contact & Terms: Send query letter with photocopies, slides and photographs. Samples are filed. Art Director will contact artist for portfolio review if interested. Portfolio should include original/final art and color samples. Sometimes requests work on spec before assigning a job. Pays for design by the project, $100-1,000. Buys all rights.
Tips: Finds artists through sourcebooks and other artists.

YASVIN DESIGNERS, Box 33, Mill Alley, Harrisville NH 03450. (603)827-3107. Fax: (603)827-3139. Contact: Creative Director. Estab. 1990. Number of employees: 4. Specializes in annual reports, brand and corporate identity, package design and advertising. Clients: corporations, colleges and institutions. Current clients include Antioch University, Blizzard North America, Bagel Works Restaurants, Dynafit Ski, University Medical Group, CIM Industries.
Needs: Approached by 6-10 freelancers/year. Works with 10 freelance illustrators and 2 designers/year. Uses illustrators mainly for annual report and advertising illustration. Uses designers mainly for production, logo design. Also uses freelancers for brochure illustration and charts/graphs. Needs computer-literate freelancers for design and production. 50% of freelance work demands knowledge of Adobe Illustrator, Adobe Photoshop, Aldus FreeHand and QuarkXPress.
First Contact & Terms: Send postcard sample of work or send query letter with photocopies, SASE and tearsheets. Samples are filed. Reports back only if interested. Request portfolio review in original query. Portfolio should include b&w and color photocopies, roughs and tearsheets. Pays for design by the project and by the day. Pays for illustration by the project. Rights purchased vary according to project.
Tips: Finds artists through sourcebooks and artists' submissions. "Show us rough sketches that describe the creative process."

New Jersey

‡CALIBRE FIVE INC., 3117 Route 10 E., Denville NJ 07834. (201)989-9220. Fax: (201)366-6815. Art Director: Bruce Spicer. Estab. 1986. Number of employees: 2. Approximate annual billing: $250,000. Specializes in annual reports, brand and corporate identity, publication design. Clients: corporations. Current clients include Swedish Beauty, Fran's Wicker & Rattan, Princeton Bank. Professional affiliations: AIGA.
Needs: Approached by 40-50 freelancers/year. Works with 3-4 freelance illustrators and 1-2 designers/year. Prefers local artists with experience in illustration in pen & ink. Uses illustrators mainly for publications. Uses designers mainly for presentation work. Also uses freelancers for ad and brochure design and illustration, mechanicals. Needs computer-literate freelancers for production. 30% of freelance work demands knowledge of Adobe Photoshop, Aldus FreeHand, QuarkXPress and Corel 5.0.
First Contact & Terms: Send photocopies and résumé. Samples are filed and are not returned. Art Director will contact artist for portfolio review if interested. Portfolio should include photocopies and roughs. Pays for design and illustration by the project, $100-2,500. Negotiates rights purchased.
Tips: Finds artists through sourcebooks and samples. Impressed by "clean work (samples), professionalism, knowledge of industry and media."

‡CUTRO ASSOCIATES, INC., 47 Jewett Ave., Tenafly NJ 07670. (201)569-5548. Fax: (201)569-8987. Manager: Ronald Cutro. Estab. 1961. Number of employees: 2. Specializes in annual reports; corporate identity; direct mail, fashion, package and publication design; technical illustration; and signage. Clients: corporations, business-to-business, consumer.
Needs: Approached by 5-10 freelancers/year. Works with 2-3 freelance illustrators and 2-3 designers/year. Prefers local artists only. Uses illustrators mainly for wash drawings, fashion, specialty art. Uses designers for comp layout. Also uses freelancers for ad and brochure design and illustration, airbrushing, catalog and P-O-P illustration, direct mail design, lettering, mechanicals and retouching. Needs computer-literate freelancers for design, illustration and production. 98% of freelance work demands knowledge of Adobe Illustrator and QuarkXPress.
First Contact & Terms: Send postcard sample of work. Samples are filed. Art Director will contact artist for portfolio review if interested. Portfolio should include final art and photocopies. Pays for design and illustration by the project. Buys all rights.

© Curtis Parker.

Curtis Parker "really hit the target for an extremely challenging project," says Krista Yasvin of Yasvin Design. "This piece needed to convey a symbolic, spiritual message." His illustration appeared on the cover of an annual report for Antioch College, depicting "the growth and emergence of the graduate student into the world," says the artist, who worked in acrylic on linen. Yasvin found Parker's work in an ad placed by his rep, Scott Hull Associates, in American Showcase. *He was paid $1,200 for the piece.*

‡**THE FORMAN GROUP**, P.O. Box 3174, Princeton NJ 08543. Phone/fax: (609)275-6077. Creative Director: Thomas Forman. Estab. 1990. Number of employees: 8. Specializes in brand identity and fashion design. Clients: corporations, clothing manufacturing. Client list available upon request. Professional affiliations: GAG.
Needs: Approached by 10-20 freelancers/year. Works with 3 freelance illustrators and 2 designers/year. Prefers artists with experience in graphics for fashion industry. Uses illustrators mainly for art for screen printing. Also uses freelancers for ad illustration and mechanicals. Needs computer-literte freelancers for design and illustration. 40% of freelance work demands knowledge Adobe Illustrator and QuarkXPress.
First Contact & Terms: Send brochure and tearsheets. Samples are filed and are not returned. Art Director will contact artist for portfolio review if interested. Negotiates rights purchased.
Tips: Finds artists through *Workbook, Black Book, American Showcase, Creative Illustration* and submissions.

‡**IRVING FREEMAN DESIGN CO.**, 10 Jay St., #2, Tenafly NJ 07670. (201)569-4949. Fax: (201)569-4979. President: Irving Freeman. Estab. 1972. Approximate annual billing: $100,000. Specializes in book cover and interior design. Clients: corporations and publishers. Current clients include HarperCollins, Simon & Schuster and Warner Books. Client list available upon request. Professional affiliations: GAG.
Needs: Approached by 10 freelancers/year. Works with 2 freelance illustrators and 2 designers/year. Prefers local artists only. Uses illustrators mainly for book covers. Uses designers mainly for book interiors. Also

uses freelancers for airbrushing, book design and lettering. Needs computer-literate freelancers for design, illustration, production and presentation. 100% of freelance work demands knowlege of Adobe Illustrator, Adobe Photoshop and QuarkXPress.

First Contact & Terms: Send postcard sample of work or send brochure, photocopies, photographs and tearsheets. Samples are filed. Reports back within 1 month. Art Director will contact artist for portfolio review if interested. Portfolio should include final art. Pays for design by the hour, by the project and by the day. Pays for illustration by the project. Rights purchased vary according to project.

Tips: Finds artists through sourcebooks.

‡**THE HARRINGTON GROUP**, 31 DeHart St., Morristown NJ 07960. (201)326-8877. Fax: (201)326-8824. Art Director: Rachel Avenia. Estab. 1985. Number of employees: 6. Approximate annual billing: $1.4 million. Specializes in corporate identity, direct mail and publication design, corporate marketing. Clients: pharmaceutical and medical. Current clients include Ethicon, Schering Plough, Merck. Professional affiliations: AIGA, IABC.

Needs: Approached by 20 freelancers/year. Works with 50 freelance illustrators and 5 designers/year. Prefers local artists with experience in Mac publishing (freelancers work on site). Uses illustrators mainly for publications. Uses designers mainly for layout. Also uses freelancers for ad and brochure design and illustration; catalog, direct mail, magazine and poster design; charts/graphs; lettering; logos; mechanicals; and display graphics. Needs computer-literate freelancers for design, illustration and production. 100% of freelance work demands knowledge of Adobe Illustrator, Adobe Photoshop, QuarkXPress and Microsoft Word.

First Contact & Terms: Send query letter with photocopies and résumé. Samples are filed. Art Director will contact artist for portfolio review if interested. Portfolio should include b&w and color final art. Pays for design by the hour and by the project. Pays for illustration by the project. Negotiates rights purchased.

Tips: "Show us 10 best pieces, not 100."

‡**HOWARD DESIGN GROUP**, 20 Nassau St., Suite 115, Princeton NJ 08542. (609)924-1106. Fax: (609)924-1165. Partner: Diane Savoy. Estab. 1980. Number of employees: 4. Specializes in annual reports, corporate identity, direct mail and publication design. Clients: corporations, schools and colleges.

Needs: Approached by 20 freelancers/year. Works with 10 freelance illustrators and 5 designers/year. Uses illustrators mainly for publication design. Also uses freelancers for brochure design and illustration; catalog, direct mail, magazine and poster design; logos. Needs computer-literate freelancers for design and production. 98% of freelance work demands knowlege of Adobe Illustrator, Adobe Photoshop, Aldus FreeHand and Aldus PageMaker.

First Contact & Terms: Send résumé. Samples are filed. Art Director will contact artist for portfolio review if interested. Portfolio should include color final art, roughs and thumbnails. Pays for design and illustration by the project. Buys one-time rights.

Tips: Finds artists through *Showcase*. Impressed by "great design samples."

‡**HOWARD LEVY DESIGN**, 40 Cindy Lane, Ocean NJ 07712. (908)493-4888. Art Director: Howard Levy. Estab. 1991. Number of employees: 2. Specializes in corporate marketing and communication design: identities, brochures, annual reports, direct mail, advertising and promotion. Professional affiliations: AIGA and JSPRAA.

Needs: Approached by 10 freelancers/year. Works with 20 freelance illustrators and 20 designers/year. Prefers artists with experience in QuarkXPress, Adobe Illustrator and Photoshop. Uses designers and illustrators mainly for annual reports, brochure and catalog design and illustration, lettering, logos, mechanicals, posters, retouching, signage and TV/film graphics. 80% of freelance work demands knowledge of Adobe Photoshop, QuarkXPress and Adobe Illustrator.

First Contact & Terms: Send query letter with brochure, photocopies, photographs, photostats, résumé, SASE, slides, tearsheets and transparencies. Samples are filed. Reports back to the artist only if interested. Artist should follow-up with call. Pays for design and illustration by the project.

Tips: Finds artists through creative sourcebooks and artists' submissions. "Demonstrate an understanding of the client's marketing objectives and present ideas that meet those objectives and can be produced. We like to see printed samples as well as comps."

‡**LOGO STUDIOS**, One Milton Ave., South River NJ 08882. (908)238-8438. Fax: (908)238-0599. Designer: Barbara Gold. Estab. 1986. Number of employees: 3. Approximate annual billing: $120,000. Specializes in corporate identity; direct mail, package and publication design. Clients: corporations and architects. Current clients include New Jersey Transit, Whitney Corr Pak and William Morrow Publishing.

Needs: Approached by 10 freelancers/year. Works with 1-3 freelance illustrators and 1-3 designers/year. Prefers artists with experience in QuarkXPress, Photoshop and traditional skills. Uses designers and illustrators for ad, book, brochure, catalog, magazine and poster design; lettering; logos; mechanicals; and retouching. Needs computer-literate freelancers for design and illustration. 75% of freelance work demands knowledge of Adobe illustrator, Adobe Photoshop and QuarkXPress.

First Contact & Terms: Send query letter with résumé. Samples are filed or returned. Request portfolio review in original query. Portfolio should include final art and thumbnails. Pays for design by the hour, $10-

20. Pays for illustration by the project. Rights purchased vary according to project.

‡PAOS NEW YORK, P.O. Box 432, West Orange NJ 07052-0432. President: Joshua Marcus. Estab. 1978. Specializes in brand and corporate identity, package and publication design and signage. Clients: corporations, museums. Current clients include Bridgestone Corp., Kenwood Corp., Kirin Beer, Itochu Corp. Client list available upon request.
Needs: Approached by 10 freelancers/year. Works with 1 freelance illustrator and 5 designers/year. Works on assignment only. Uses illustrators mainly for ads and promotional work. Uses designers mainly for identity work and brochure design. Also uses freelancers for catalog design and illustration, book and ad design, brochure and P-O-P illustration and logos. Needs computer-literate freelancers for design, illustration and production. 75% of freelance work demands knowledge of Aldus PageMaker, QuarkXPress, Aldus FreeHand, Adobe Illustrator, Photoshop.
First Contact & Terms: Send query letter with brochure and résumé. Samples are not filed and are not returned. Reports back to artist only if interested. To show portfolio, mail finished art samples, tearsheets and photographs. Pays for design and illustration by the project. Rights purchased vary according to project.
Tips: "Show us samples of final work and explain what you did to make it happen."

‡RICHARD PUDER DESIGN, 2 W. Blackwell St., P.O. Box 1520, Dover NJ 07802-1520. (201)361-1310. Fax: (201)361-1663. Project Manager: Lee Grabarczyk. Estab. 1985. Number of employees: 2. Approximate annual billing: $200,000. Specializes in annual reports, direct mail and publication design, technical illustra- tion. Current clients include AT&T, Warner Lambert, Scholastic, Simon & Schuster Client list not available. Professional affiliation: Type Directors Club.
Needs: Approached by 60 freelancers/year. Works with 10 freelance illustrators and 5 designers/year. Prefers artists with experience in anatomy, color, perspective—many illustrative styles; prefers artists without reps. Uses illustrators mainly for publishing clients. Uses designers mainly for corporate, publishing clients. Also uses freelancers or ad and brochure design and illustration; book, direct mail, magazine and poster design; charts/graphs; lettering; logos; mechanicals; and retouching. Needs computer-literate freelancers for design, illustration and production. 80% of freelance work demands knowledge of Adobe Illustrator 5.5, Adobe Photoshop 3.0, Aldus FreeHand 4.0 and QuarkXPress 3.3.
First Contact & Terms: Send postcard sample of work or send résumé and tearsheets. Samples are filed. Art Director will contact artist for portfolio review if interested. Portfolio should include b&w and color photocopes, photographs, roughs and thumbnails. Pays for design by the hour, $15-35. Pays for illustration by the hour, $20-40. Buys first rights or rights purchsed vary according to project.
Tips: Finds artists through sourcebooks (e.g. *American Showcase*) and by client referral. Impressed by "listening, speed, technical competency and creativity."

‡R.H.GRAPHICS, INC., 179 Mohawk Dr., River Edge NJ 07661. (201)489-5325. President: Roy Horton. Vice President: Irving J. Mittleman. Number of employees: 1. Approximate annual billing: $150,000. Special- izes in brand identity, corporate identity, display, direct mail and packaging. Client list not available.
Needs: Approached by 25 freelancers/year. Works with 2 freelance illustrators/year. Freelancers must have ten years of experience. Especially needs mechanicals and ruling. Uses freelancers for P-O-P displays, mechanicals, retouching, airbrushing and lettering.
First Contact & Terms: Send query letter with brochure showing art style or résumé and tearsheets. Reports only if interested. Write to show a portfolio, which should include roughs and original/final art. Pays for design by the hour, $25. Pays for illustration by the project, $50-250. Considers client's budget, and skill and experience of artist when establishing payment.
Tips: Wants to see "actual art and variety."

RITTA & ASSOCIATES, 568 Grand Ave., Englewood NJ 07631. (201)567-4400. Fax: (201)567-7330. Art Director: Steven Scheiner. Estab. 1976. Specializes in annual reports, corporate identity and communications, and publication design. Clients: corporations. Current clients include Accudart, AT&T, Bellcore, Hoffman LaRoche, Kulite Tungsten Corp., Warner Lambert, Valley National Bancorp. Client list available upon re- quest.
Needs: Approached by 50-100 freelancers/year. Works with 20 freelance illustrators/year. Uses illustrators mainly for corporate publications. Needs computer-literate freelancers for illustration and production. 90% of freelance work demands knowledge of QuarkXPress, Adobe Illustrator or Adobe Photoshop.
First Contact & Terms: Send query letter with résumé, tearsheets and printed samples. Samples are filed or are returned by SASE if requested by artist. Reports back to the artist only if interested. Art Director will contact artist for portfolio review if interested. Pays for illustration by the project. Rights purchased vary according to project.
Tips: Finds artists through sourcebooks, publications, agents and artists' submissions.

SMITH DESIGN ASSSOCIATES, 205 Thomas St., Box 190, Glen Ridge NJ 07028. (201)429-2177. Fax: (201)429-7119. Vice President: Larraine Blauvelt. Clients: cosmetics firms, toy manufacturers, life insurance

companies, office consultants. Current clients: Popsicle, Good Humor, Breyer's and Schering Plough. Client list available upon request.

Needs: Approached by more than 100 freelancers/year. Works with 10-20 freelance illustrators and 2-3 designers/year. Requires quality and dependability. Uses freelancers for advertising and brochure design, illustration and layout; interior design; P-O-P; and design consulting. Needs computer-literate freelancers for design, illustration and production. 90% of freelance work demands knowledge of Adobe Illustrator, QuarkXPress or Photoshop. Needs children's, packaging and product illustration.

First Contact & Terms: Send query letter with brochure showing art style or résumé, tearsheets and photostats. Samples are filed or are returned only if requested by artist. Reports back within 1 week. Call for appointment to show portfolio of color roughs, original/final art and final reproduction. Pays for design by the hour, $25-100; by the project, $175-5,000. Pays for illustration by the project, $175-5,000. Considers complexity of project and client's budget when establishing payment. Buys all rights. Also buys rights for use of existing non-commissioned art.

Tips: Finds artists through word of mouth, self-promotions/sourcebooks and agents. "Know who you're presenting to, the type of work we do and the quality we expect. We use more freelance artists not so much because of the economy but more for diverse styles."

‡**STAADA & KOOREY**, 490 Schooley's Mountain Rd., Hackettstown NJ 07840. (908)852-4949. Fax: (908)852-9803. Estab. 1985. Number of employees: 6. Specializes in marketing communication, P-O-P/displays and package design. Clients: corporations. Current clients include M&M Mars, Nabisco, AT&T, Hewlett Packard and NJ Devils. Client list available upon request. Professional affiliations: AIGA, PDC, POPAI, AMA.

Needs: Approached by 50 freelancers/year. Works with 10 freelance illustrators and 6 designers/year. Prefers freelancers with experience in design, comps, mechanical and Mac (Quark, FreeHand). Uses freelance illustrators mainly for brochures, packaging and P-O-P material. Use freelance designers for brochures, sell sheets, FSI's, P-O-P material and packaging. Also uses freelancers for mechanicals, lettering, logos and ad and poster design.

First Contact & Terms: Send query letter with résumé. Samples are filed or are returned by SASE if requested by artist. Reports back to the artist only if interested. Call for appointment to show portfolio of original/final art and color tearsheets. Pays for design by the hour, $12-25. Pays for illustration by the project, $100-10,000. Buys all rights.

New Mexico

BEAR CANYON CREATIVE, 6753 Academy Rd. NE, Albuquerque NM 87109. (505)823-9150. Fax: (505)823-9291. Senior Designer: Melanie Wegner. Design Director: Raymond Peñala. Estab. 1985. Specializes in graphic and package design. Clients: audio publishers and corporations.

Needs: Approached by 25 freelancers/year. Works with 20 illustrators/year. Prefers freelancers with extensive experience in full color illustration; some children's illustration. Works on assignment only. Uses freelancers mainly for illustration for audio packaging covers.

First Contact & Terms: Send query letter with résumé, tearsheets, photographs, photocopies, photostats, slides or transparencies. Samples are filed or are returned by SASE if requested by artist. Reports back only if interested. Call or write for appointment to show portfolio, or mail appropriate materials. Portfolio should include finished art samples, slides, color tearsheets, transparencies and photographs. Pays by the project, $300-700. Buys only all rights.

Tips: Finds artists mainly through sourcebooks, occasionally through word of mouth and artists' submissions. "Work within our budget. Be highly professional. Be versatile (handle variety of styles). The design field is more competitive—very crowded with new names, new styles."

BOOKMAKERS LTD., P.O. Box 1086, Taos NM 87571. (505)776-5435. Fax: (505)776-2762. President: Gayle Crump McNeil. "We provide service in illustration and design to educational and trade publishers, as well as to the advertising market."

Needs: Approached by 100 freelancers/year. Works with 20-30 freelance illustrators/year. "We are agents and designers. We represent artists for juvenile through adult markets."

First Contact & Terms: Send query letter with samples showing style (tearsheets, photostats, printed pieces or slides). Samples not filed are returned. Reports within 2 weeks. Considers skill and experience of artist when establishing payment.

Tips: The most common mistake freelancers make in presenting samples or portfolios is "too much variety—not enough focus. Be clear about what you are looking for and what you can do in relation to the real markets available."

New York

‡**AVANCÉ DESIGNS, INC.**, 648 Broadway, Suite 201, New York NY 10012-2314. (212)420-1255. Fax: (212)473-3309. President/Creative Director: Thuy Vuong. Estab. 1987. Number of employees: 5. Approximate annual billing: $1 million. Specializes in brand positioning; ad, promotion, package and publications design. Clients: major corporations. Client list available upon request. Professional affiliations: AIGA, Art Directors Club of New York, The Fashion Group.
Needs: Approached by 75-100 freelancers/year. Prefers local artists only. Uses illustrators, designers, 3-dimensional comp artists and computer artists familiar with Adobe Illustrator, Adobe Photoshop and QuarkXPress.
First Contact & Terms: Send query letter. Samples of interest are filed and are not returned. Reports back to the artist only if interested. Portfolios may be dropped off every Monday-Friday. Portfolio should include thumbnails, samples of best work. Pays for design by the hour. Pays for illustrtion by the project. Rights purchased vary according to project.

‡**BARRY DAVID BERGER & ASSOCIATES, INC.**, 54 King St., New York NY 10014. (212)255-4100. Senior Industrial Designer: Jeff Leonard. Senior Graphic Designer: Heidi S. Broecking. Number of employees: 5. Approximate annual billing: $500,000. Specializes in brand and corporate identity, P-O-P displays, product and interior design, exhibits and shows, corporate capability brochures, advertising graphics, packaging, publications and signage. Clients: manufacturers and distributors of consumer products, office/stationery products, art materials, chemicals, health care, pharmaceuticals and cosmetics. Current clients include Dennison, Timex, Sheaffer, Bausch & Lomb and Kodak. Professional affiliations IDSA, AIGA, APDF.
Needs: Approached by 12 freelancers/year. Works with 5 freelance illustrators and 7 designers/year. Uses artists for advertising, editorial, medical, technical and fashion illustration; mechanicals; retouching; direct mail and package design; model making; charts/graphs; photography; AV presentations; and lettering. Needs computer-literate freelancers for illustration and production. 10% of freelance work demands computer skills.
First Contact & Terms: Send query letter, then call for appointment. Works on assignment only. Send "whatever samples are necessary to demonstrate competence" including multiple roughs for a few projects. Samples are filed or returned. Reports immediately. Provide brochure/flyer, résumé, business card, tearsheets and samples to be kept on file for possible future assignments. Pays for design by the project, $1,000-10,000. Pays for illustration by the project.

‡**GLORIA BUCÉ ASSOC. INC.**, 250 Fifth Ave., New York NY 10001. (212)532-1444. President: Gloria Bucé. Estab. 1960. Specializes in original designs for the home furnishing market. Clients are convertors of fabrics, printers of wallcoverings. Current clients include Springs Mills, Covington Fabrics and Culp. Client list not available.
Needs: Approached by more than 100 freelancers/year. Works with varying number of freelance illustrators and 6-10 designers/year. Prefers local freelancers with experience in any home furnishing products for prints; must be able to render animals, florals, scenics. Looks for ability to use varied techniques in renderings. Uses freelance illustrators mainly for reproduction on fabric and wallcoverings. Uses freelance designers mainly for reproduction on fabric and wallcoverings and graphic package design for fragrances.
First Contact & Terms: Call. Samples are not filed and are returned. Reports back to the artist only if interested. Call for an appointment to show portfolio of original/final art that shows "comprehensive group of artist's ability, good drawing and design sense." Pays by the project. Buys all rights.

BYRNE DESIGN, 27 W. 24th St., New York NY 10010. (212)807-6671. Fax: (212)627-8299. Estab. 1976. Specializes in annual reports and collateral material. Clients: financial, telecommunications and industrial. Current clients include Paine Webber, Alliance Capital, Citibank and Dean Witter. Client list available upon request.
Needs: Approached by 100 freelancers/year. Works with 5-10 freelance illustrators and designers/year. Uses illustrators, photographers and designers mainly for promotional brochures and editorial illustration. Also for mechanicals, lettering, logos and charts/graphs. Needs computer-literate freelancers for design, illustration, production and presentation. 90% of freelance work demands knowledge of Aldus PageMaker, Adobe Illustrator, Photoshop, QuarkXPress or Aldus FreeHand.
First Contact & Terms: Send query letter with brochure and résumé. Samples are filed. Reports back only if interested. Portfolio may be dropped off every Wednesday. Pays for design by the hour, $30-60. Pays for illustration by the project, $750-7,500. Rights purchased vary according to project.
Tips: Finds artists through sourcebooks.

‡**COUSINS DESIGN**, 599 Broadway, New York NY 10012. (212)431-8222. President: Michael Cousins. Number of employees: 4. Specializes in packaging and product design. Clients: manufacturing companies. Professional affiliation: IDSA.
Needs: Approached by 12 freelancers/year. Works with 3 freelance designers/year. Prefers local artists. Works on assignment only. Uses artists for design, illustration, mechanicals, retouching, airbrushing, model making, lettering and logos.

First Contact & Terms: Send query letter with brochure or résumé, tearsheets and photocopies. Samples are filed and are returned only if requested. Reports back within 2 weeks only if interested. Write for appointment to show portfolio of roughs, final reproduction/product and photostats. Pays for design by the hour, $20-40. Pays for illustration by the hour, $20 minimum; or pays flat fee. Considers skill and experience of artist when establishing payment. Buys all rights.

‡**CSOKA/BENATO/FLEURANT, INC.**, 134 W. 26th St., New York NY 10001. (212)242-6777. (212)675-2078. President: Robert Fleurant. Estab. 1969. Specializes in brand and corporate identity; display, direct mail, package and publication design. Clients: corporations and foundations. Current clients include Metropolitan Life Insurance and RCA/BMG Special Products.
Needs: Approached by approximately 120 freelancers/year by mail. Works with 3-4 freelance illustrators/year. Prefers local freelancers with experience in print, full color, mixed media. Seeks freelancers "with professionalism and portfolio who can meet deadlines, work from layouts and follow instructions." Works on assignment only. Uses illustrators mainly for album covers, publications and promotions. Also for brochure, catalog and P-O-P illustration; mechanicals; retouching; airbrushing; and lettering. Needs computer-literate freelancers for design, illustration and production. 90% of freelance work demands knowledge of Aldus PageMaker, QuarkXPress, Aldus FreeHand, Adobe Illustrator, Photoshop, Adobe Streamline, Omni-Page and Microsoft Word 5.1.
First Contact & Terms: Send query letter with tearsheets and résumé. Samples are filed. Reports back only if interested. Write for appointment to show portfolio of thumbnails, roughs, final art and b&w and color tearsheets. Pays for design by the hour, $20-35. Pays for illustration by the project (estimated as per requirements). Buys all rights.

D&B GROUP, 386 Park Ave. S., New York NY 10016. (212)532-3884. Fax: (212)532-3921. Contact: Steve Sherman. Estab. 1956. Number of employees: 3. Approximate annual billing: $500,000. Advertising art studio. Specializes in direct mail response advertising, annual reports, brand and corporate identity and publications. Clients: ad agencies, PR firms, direct response advertisers and publishers.
Needs: Approached by 30-40 freelancers/year. Works with 8-10 freelance illustrators and 2 designers/year. Prefers local freelancers only. Uses freelancers mainly for video wraps and promotion. Also for consumer magazines, direct mail, brochures/flyers, newspapers, layout, technical art, type spec, paste-up, lettering and retouching. Needs technical and product illustration. Prefers pen & ink, airbrush, watercolor and oil. Needs computer-literate freelancers for production. 60% of freelance work demands knowledge of Adobe Illustrator, Photoshop or QuarkXPress.
First Contact & Terms: Call for interview or send brochure showing art style, fliers, business card, résumé and tearsheets to be kept on file. Originals are not returned. Call for appointment to show portfolio of thumbnails, roughs, 8 × 10 chromes, original/final art and final reproduction/product. Pays for design by the hour, $25-50; by the project, $200-1,500. Pays for illustration by the project, $75-800. Considers complexity of project and client's budget when establishing payment.
Tips: "We foresee a need for direct response art directors and the mushrooming of computer graphics. Clients are much more careful as to price and quality of work."

EHN GRAPHICS, INC., 244 E. 46th St., New York NY 10017. (212)661-5947. President: Jack Ehn. Specializes in promotion, annual reports, book design, corporate identity, direct mail, publications and signage. Current clients include Macmillan and McGraw-Hill. Client list available upon request.
Needs: Approached by 20 freelancers/year. Works with 10-12 freelancers/year. Uses freelancers for editorial illustration, books, mechanicals, retouching and direct mail packages.
First Contact & Terms: Send query letter with samples. Samples not filed are returned only if requested. Art Director will contact artist for portfolio review if interested. Portfolio should include original/final art and final reproduction/product. Pays for design and illustration by the project. Considers complexity of project, client's budget, and skill and experience of artist when establishing payment.

‡**EMDASH, INC.**, 584 Broadway, Suite 610, New York NY 10012. (212)343-1451. Fax: (212)274-0545. Managing Director: Nancy B. Davidson. Creative Director: Andrea Meyer. Estab. 1992. Number of employees: 4. Approximate annual billing $500,000. Specializes in annual reports; corporate identity; display, direct mail, package and publication design. Clients: Corporations. Current clients ilcude Republic National Bank, GAT, Routledge Publishing, Chapman & Hall.
Needs: Approached by 50 freelancers/year. Works with 1 freelance illustrator and 17 designers/year. Prefers local freelancers only. Uses illustrators mainly for advertising. Uses designers mainly for promotional material. Also uses freelancers for ad, brochure, catalog, poster and P-O-P design and illustration; direct mail design, logos, mechanicals. Needs computer-literate freelancers for design, illustration and production. 95% of freelance work demands knowledge of Adobe Illustrator 5.5, Adobe Photoshop 3.0, Aldus FreeHand 4.0 and QuarkXPress 3.3.
First Contact & Terms: Send query letter with brochure, photographs and résumé. Samples are filed. Art Director will contact artist for portfolio review if interested. Portfolio should include b&w and color final art. Pays for design by the project, $100-1,700. Rights purchased vary according to project.

FREELANCE EXPRESS, INC., 111 E. 85th St., New York NY 10028. (212)427-0331. Multi-service company. Estab. 1988.
Needs: Uses freelancers for cartoons, charts, graphs, illustration, layout, lettering, logo design and mechanicals.
First Contact & Terms: Mail résumé and photocopied nonreturnable samples. "Say you saw the listing in *Artist's & Graphic Designer's Market.*" Provide materials to be kept on file. Originals are not returned.

GRAPHIC ART RESOURCE ASSOCIATES, 257 W. Tenth St., New York NY 10014-2508. (212)929-0017. Fax: (212)929-0017. Owner: Robert Lassen. Estab. 1980. Approximate annual billing: $75,000-100,000. "Provides full range of graphic communications services, including design, editorial, photographic, pre-press and print production, advertising agency and overall graphic communications support." Clients: academia, corporations, institutions and organizations. Current clients include Lopat Enterprises, Disability Income Services, Brooklyn Law School and New York University. Client list "is always in flux."
Needs: Approached by "at least" 60 freelancers/year.
First Contact & Terms: Call first. "Usually work within already established relationships. Rarely, if ever, work with artists more than 50 miles from New York for quality control reasons, although exceptions are made in the case of photographers. Do not send samples unless asked to do so." Art Director will contact artist for portfolio review if interested. "Usually, appointments are available if we are interested." Pays for design and illustration by the project, $150 minimum. All fees are negotiated. "We do not deal with reps." Considers buying second rights (reprint rights) to previously published artwork.
Tips: Uses freelancers mostly for production and paste-up.

JEWELITE SIGNS, LETTERS & DISPLAYS, INC., 106 Reade St., New York NY 10013. (212)233-1900. Fax: (212)233-1998. Vice President: Bobby Bank. Produces signs, letters, silk screening, murals, handlettering, displays and graphics. Current clients include Transamerica, Duggal Labs, Steve Horn and MCI.
Needs: Approached by 15 freelancers/year. Works with 12 freelancers/year. Works on assignment only. Uses freelancers for handlettering, walls, murals, signs, interior design, architectural renderings, design consulting and model making. 80% of freelance work demands computer skills. Prefers airbrush, lettering and painting.
First Contact & Terms: Call or send query letter. Call for appointment to show portfolio of photographs. Pays for design and illustration by the project, $75 and up. Considers complexity of project and skill and experience of artist when establishing payment.

LEO ART STUDIO, INC., 276 Fifth Ave., Suite 610, New York NY 10001. (212)685-3174. Fax: (212)685-3170. Studio Manager: Lynn Johnson. Art Director: Robert Schein. Number of employees: 12. Approximate annual billing: $1 million. Specializes in textile design for home furnishings. Clients: wallpaper manufacturers/stylists, glassware companies, furniture and upholstery manufacturers. Current clients include Burlington House, Blumenthal Printworks, Columbus Coated, Eisenhart Wallcoverings, Victoria's Secret, Town and Country, Fieldcrest-Cannon and Western Textile. Client list available upon request.
Needs: Approached by 25-30 freelancers/year. Works with 3-4 freelance illustrators and 20-25 textile designers/year. Prefers freelancers trained in textile field, not fine arts. Must have a portfolio of original art designs. Should be able to be in NYC on a fairly regular basis. Works both on assignment and speculation. Prefers realistic and traditional styles. Uses freelancers for design, airbrushing, coloring and repeats. "We are always looking to add fulltime artists to our inhouse staff (currently at 12). We will also look at any freelance portfolio to add to our variety of hands. Our recent conversion to CAD system may require future freelance assistance. Knowledge of Coreldraw is a plus."
First Contact & Terms: Send query letter with résumé. Do not send slides. Request portfolio review in original query. "We prefer to see portfolio in person. Contact via phone is OK—we can set up appointments with a day or two's notice." Samples are not filed and are returned. Reports back within 5 days. Portfolio should include original/final art. Sometimes requests work on spec before assigning job. Pays for design by the project, $500-1,500. "Payment is generally a 60/40 split of what design sells for—slightly less if reference material, art material, or studio space is requested." Considers complexity of project, skill and experience of artist and how work will be used when establishing payment. Buys all rights.
Tips: "Stick to the field we are in (home furnishing textiles, upholstery, fabrics, wallcoverings). Understand manufacture and print methods. Walk the market; show that you are aware of current trends. Go to design shows before showing portfolio. We advise all potential textile designers and students to see the annual design show—Surtex—at the Jacob Javitz Center in New York, usually in spring. Also attend High Point Design Show in North Carolina and Heimtex America in Florida."

‡LEONE DESIGN GROUP INC., 7 Woodland Ave., Larchmont NY 10538. President: Lucian J. Leone. Specializes in corporate identity, publications, signage and exhibition design. Clients: nonprofit organizations, museums, corporations, government agencies. Client list not available. Professional affiliations: AAM, SEGD, MAAM, AASLH, NAME.
Needs: Approached by 30-40 freelancers/year. Works with 10-15 freelance designers/year. Uses freelancers for exhibition design, brochures, catalogs, mechanicals, model making, charts/graphs and AV materials.

Needs computer-literate freelancers for design and presentation. 100% of freelance work demands knowledge of QuarkXPress or Aldus FreeHand.
First Contact & Terms: Send query letter with résumé, samples and photographs. Samples are filed unless otherwise stated. Samples not filed are returned only if requested. Reports back within 2 weeks. Write for appointment to show portfolio of thumbnails, b&w and color original/final art, final reproduction/product and photographs. Pays for design by the hour, $15-40 or on a project basis. Considers client's budget and skill and experience of artist when establishing payment.

LESLEY-HILLE, INC., 136 E. 57th St., New York NY 10022. (212)759-9755. President: Valrie Lesley. Specializes in annual reports, corporate identity, publications, advertising and sales promotion. Clients: nonprofit organizations, hotels, restaurants, investment, oil and real estate, financial and fashion firms.
Needs: Seeks "experienced and competent" freelancers. Uses freelancers for illustration, mechanicals, airbrushing, model making, charts/graphs, AV materials and lettering.
First Contact & Terms: Send query letter with résumé, business card and samples to be kept on file. Accepts "whatever best shows work capability" as samples. Samples not filed are returned by SASE. Reports only if interested. Call or write for an appointment to show portfolio. Payment varies according to project.
Tips: "Designers and artists must be *able to do* what they say they can and agree to do . . . professionally and on time!"

LIEBER BREWSTER CORPORATE DESIGN, 324 W. 87 St., New York NY 10024. (212)874-2874. Principal: Anna Lieber. Estab. 1988. Specializes in annual reports, corporate identity, direct mail and package design, publications, exhibits, advertising and signage. Clients: publishing, nonprofits, corporate, financial, foodservice and retail. Client list available upon request. Professional affiliations: NYMUG, NAFF, NAWBO
Needs: Approached by more than 100 freelancers/year. Works with 10 freelance illustrators and 10 designers/year. Works on assignment only. Uses freelancers for mechanicals, retouching, airbrushing, lettering, logos, direct mail design, charts/graphs, audiovisual materials. Needs computer-literate freelancers for design, illustration, production and presentation. 90% of freelance work demands knowledge of Adobe Illustrator, QuarkXPress, Photoshop or Aldus FreeHand. Needs editorial, technical, medical and creative color illustration.
First Contact & Terms: Send query letter with résumé, tearsheets and photocopies. Samples are filed. Art Director will contact artist for portfolio review if interested. Portfolio should include b&w and color work. Pays for design by the hour. Pays for illustration by the project. Rights purchased vary according to project.
Tips: Finds artists through promotional mailings.

‡LUBELL BRODSKY INC., 21 E. 40th St., Suite 1806, New York NY 10016. (212)684-2600. Art Directors: Ed Brodsky and Ruth Lubell. Number of employees: 5. Specializes in corporate identity, direct mail, promotion and packaging. Clients: ad agencies and corporations. Professional affiliations: ADC, TDC.
Needs: Approached by 100 freelancers/year. Works with 10 freelance illustrators and 1-2 designers/year. Works on assignment only. Uses freelancers for illustration, mechanicals, retouching, airbrushing, charts/graphs, AV materials and lettering.
First Contact & Terms: Send business card and tearsheets to be kept on file. Reports back only if interested.

MIRANDA DESIGNS INC., 745 President St., Brooklyn NY 11215. (718)857-9839. President: Mike Miranda. Estab. 1970. Number of employees: 3. Approximate annual billing: $250,000. Specializes in "giving new life to old products, creating new markets for existing products, and creating new products to fit existing manufacturing/distribution facilities." Deals in solving marketing problems, annual reports, corporate identity, direct mail, fashion, packaging, publications and signage. Clients: agencies, manufacturers, PR firms, corporate and retail companies. Current clients include Kings Plaza, Albee Square Mall, Greater New York Savings Bank, Little Things. Client list not available. Professional affiliation: Art Directors Club.
Needs: Approached by 80 freelancers/year. Works with 3 freelance illustrators and 5 designers/year; at all levels, from juniors to seniors, in all areas of specialization. Works on assignment only. Uses freelancers mainly for editorial, food, fashion and product illustration and design; and mechanicals. Also for catalog design and illustration; brochure, ad, magazine and newspaper design; mechanicals; model making; direct mail packages; and charts/graphs. Needs computer-literate freelancers for design, illustration, production and presentation. 60% of freelance work demands knowledge of Aldus PageMaker, QuarkXPress, Photoshop or Adobe Illustrator.
First Contact & Terms: Send query letter with résumé and photocopies. Samples are filed or are not returned. Art Director will contact artist for portfolio review if interested. Portfolio should include thumbnails, roughs, original/final art and final reproduction/product. Pays for design and illustration by the project, whatever the budget permits." Considers complexity of project, client's budget and skill and experience of artist when establishing payment. Rights purchased vary according to project. Considers buying second rights (reprint rights) to previously published work; depends on clients' needs.
Tips: Finds artists through artists' submissions/self-promotions, sourcebooks and agents. "Be professional. Show a variety of subject material and media."

MITCHELL STUDIOS DESIGN CONSULTANTS, 1111 Fordham Lane, Woodmere NY 11598. (516)374-5620. Fax: (516)374-6915. Principals: Steven E. Mitchell and E.M. Mitchell. Estab. 1922. Specializes in

brand and corporate identity, displays, direct mail and packaging. Clients: major corporations.
Needs: Works with 20-25 freelancers/year. "Most work is started in our studio." Uses freelancers for design, illustration, mechanicals, retouching, airbrushing, model making, lettering and logos. Needs computer-literate freelancers for design, illustration and production. 100% of freelance work demands computer skills. Needs technical illustration and illustration of food, people.
First Contact & Terms: Send query letter with brochure, résumé, business card, photostats, photographs and slides to be kept on file. Reports only if interested. Call or write for appointment to show portfolio of roughs, original/final art, final reproduction/product and color photostats and photographs. Pays for design by the hour, $25 minimum; by the project, $250 minimum. Pays for illustration by the project, $250 minimum.
Tips: "Call first. Show actual samples, not only printed samples. Don't show student work. Our need has increased—we are very busy."

MIZEREK DESIGN INC., 318 Lexington Ave., New York NY 10016. (212)689-4885. President: Leonard Mizerek. Estab. 1975. Specializes in catalogs, direct mail, jewelry, fashion and technical illustration. Clients: corporations—various product and service-oriented clientele. Current clients include: Rolex, Leslies Jewelry, World Wildlife, The Baby Catalog and Time Life.
Needs: Approached by 20-30 freelancers/year. Works with 10 freelance designers/year. Works on assignment only. Uses freelancers for design, technical illustration, brochures, retouching and logos. Needs computer-literate freelancers for illustration. 45-65% of freelance work demands knowledge of Macintosh.
First Contact & Terms: Send query letter with tearsheets and photostats. Art Director will contact artist for portfolio review if interested. Portfolio should include original/final art and tearsheets. Pays for design by the project, $500-5,000. Pays for illustration by the project, $500-3,500. Considers client's budget and turnaround time when establishing payment. Interested in buying second rights (reprint rights) to previously published work.
Tips: Finds artists through sourcebooks and self-promotions. "Let the work speak for itself. Be creative. Show commercial product work, not only magazine editorial. Keep me on your mailing list!"

LOUIS NELSON ASSOCIATES INC., 80 University Place, New York NY 10003. (212)620-9191. Fax: (212)620-9194. President: Louis Nelson. Estab. 1980. Number of employees: 6. Approximate annual billing: $750,000. Specializes in environmental, interior and product design and brand and corporate identity, displays, packaging, publications, signage, exhibitions and marketing. Clients: nonprofit organizations, corporations, associations and governments. Current clients include Korean War Veterans Memorial, Port Authority of New York & New Jersey, Richter + Ratner Contracting Corporation, Central Park Conservancy, Steuben, MTA and NYC Transit. Professional affiliations: IDSA, AIGA, SEGD, APDF.
Needs: Approached by 30-40 freelancers/year. Works with 0-1 freelance illustrator and 5-10 designers/year. Works on assignment only. Uses freelancers mainly for specialty graphics and three-dimensional design. Also for design, mechanicals, model making and charts/graphs. Needs computer-literate freelancers for design, production and presentation. 90% of freelance work demands knowledge of Aldus PageMaker, QuarkXPress, Photoshop or Adobe Illustrator. Needs editorial illustration.
First Contact & Terms: Send query letter with brochure showing art style or tearsheets, slides and photographs. Samples are returned only if requested. Reports within 2 weeks. Write for appointment to show portfolio of roughs, color final reproduction/product and photographs. Pays for design by the hour, $10-40; by the project, negotiable.
Tips: "I want to see how the artist responded to the specific design problem and to see documentation of the process—the stages of development. The artist must be versatile and able to communicate a wide range of ideas. Mostly, I want to see the artist's integrity reflected in his/her work."

TOM NICHOLSON ASSOCIATES, INC., 295 Lafayette St., Suite 805, New York NY 10012. (212)274-0470. Fax: (212)274-0380. President: Tom Nicholson. Contact: Wells Packard. Estab. 1987. Specializes in design of interactive computer programs. Clients: corporations, museums, government agencies and multimedia publishers. Client list available upon request.
Needs: Works with 6-10 freelance illustrators and 6 designers/year. Prefers local freelancers. Uses illustrators mainly for computer illustration and animation. Uses designers mainly for computer screen design and concept development. Also for mechanicals, charts/graphs and AV materials. Needs editorial and technical illustration. Especially needs designers with interest (not necessarily experience) in computer screen design plus a strong interest in information design. 80% of freelance work demands computer skills.
First Contact & Terms: Send query letter with résumé; include tearsheets and slides if possible. Samples are filed or are returned if requested. Art Director will contact artist for portfolio review if interested. Portfolio should include thumbnails, original/final art and tearsheets. Considers complexity of project, client's budget and skill and experience of artist when establishing payment. Rights purchased vary according to project. Interested in buying second rights (reprint rights) to previously published work.
Tips: Finds artists through submissions/self-promotions and sourcebooks. "I see tremendous demand for original content in electronic publishing."

‡**NOTOVITZ DESIGN ASSOCIATES, INC.**, 47 E. 19th St., New York NY 10003. (212)677-9700. Fax: (212)677-9704. E-mail: ndi@eworld.com. President: Joseph Notovitz. Number of employees: 5. Approximate annual billing: $800,000. Specializes in corporate design (annual reports, literature, publications), corporate identity and signage. Clients: finance, medicine and industry. Professional affiliation: APDF.

Needs: Approached by 100 freelancers/year. Works with 10 freelance illustrators and 10 designers/year. Uses freelancers for brochure, poster, direct mail and booklet illustration; mechanicals; charts/graphs; and logo design. Needs computer-literate freelancers for design, illustration and production. 90% of freelance work demands knowledge of Aldus PageMaker, QuarkXPress, Adobe Illustrator or Photoshop. Needs editorial, medical and technical illustrations.

First Contact & Terms: Send résumé, slides, printed pieces and tearsheets to be kept on file. Samples not filed are returned by SASE. Reports back in 1 week. Call for appointment to show portfolio of roughs, original/final art and final reproduction/product. Pays for design by the hour, $15-50; by the project, $200-1,500. Pays for illustration by the project, $200-5,000; also negotiates.

Tips: "Do a bit of research in the firm you are contacting. Send pieces which reflect our firm's style and needs. If we never produce book covers, book cover art does not interest us. Know the computer software used by the industry and know it thoroughly."

‡**NOVUS VISUAL COMMUNICATIONS, INC.**, 18 W. 27th St., New York NY 10001. (212)689-2424. Fax: (212)696-9676. President: Robert Antonik. Estab. 1984. Specializes in annual reports, brand and corporate identity; display, direct mail, fashion, package and publication design; technical illustration; and signage. Clients: ad agencies and corporations. Client list available upon request.

Needs: Approached by 12 freelancers/year. Works with 2-4 freelance illustrators and 2-6 designers/year. Works with artist reps. Prefers local artists only. Uses freelancers for ad, brochure, catalog, poster and P-O-P design and illustration; airbrushing; audiovisual materials; book, direct mail, magazine and newpaper design; charts/graphs; lettering; logos; mechanicals; and retouching. Needs computer-literate freelancers for design, illustration, production and presentation. 75% of freelance work demands knowledge of Adobe Illustrator, Adobe Photoshop, Aldus FreeHand, Aldus PageMaker and QuarkXPress.

First Contact & Terms: Contact only through artist rep. Send postcard sample of work. Samples are filed. Reports back ASAP. Follow-up with call. Pays for design and illustration by the project. Rights purchased vary according to project.

Tips: Finds artists through *Creative Illustration, Workbook*, agents and artists' submissions. "First impressions are important, a portfolio should represent the best, whether it's 4 samples or 12."

‡**THE PHOTO LIBRARY INC.**, P.O. Box 606, Chappaqua NY 10514. (914)238-1076. Fax: (914)238-3177. Vice President Marketing: M. Berger. Estab. 1978. Number of employees: 3. Specializes in brand identity, package and publication design, photography and product design. Clients: corporations, design offices. Professional ISDA.

Needs: Approached by 6-12 freelancers/year. Works with 6-9 freelance illustrators and 3-6 designers/year. Uses designers mainly for product design. Also uses freelancers for magazine and poster design, mechanicals and model making. Needs computer-literate freelancers for design, presentation and mechanicals. 50% of freelance work demands knowledge of Adobe Illustrator 5.5, Adobe Photoshop 3.0, Aldus FreeHand, Aldus PageMaker and Form 2 Strata.

First Contact & Terms: Send brochure, photographs and résumé. Samples are not filed and are returned. Art Director will contact artist for portfolio review if interested. Portfolio should include photographs and slides. Pays for design and illustration by the hour and by the project. Buys all rights.

Tips: Finds artists through sourcebooks, other publications, agents and artists' submissions.

‡**QUADRANT COMMUNICATIONS CO., INC.**, 595 Madison Ave., Suite 1602, New York NY 10022. (212)421-0544. Fax: (212)421-0483. E-mail: beichinger@attmail.com. President: Robert Eichinger. Number of employees: 4. Approximate annual billing: $650,000. Estab. 1973. Specializes in annual reports, corporate identity, direct mail, publication design and technical illustration. Clients: corporations. Current clients include AT&T, Citibank, Dean Witter Reynolds, Chase Manhattan Bank, Federal Reserve Bank and Polo/Ralph Lauren. Client list available upon request.

Needs: Approached by 100 freelancers/year. Works with 6 freelance illustrators and 4 designers/year. Prefers freelancers with experience in publication production. Works on assignment only. Uses freelancers mainly for publications, trade show collateral and direct mail design. Also for brochure, magazine and catalog design; mechanicals; retouching; and charts/graphs. Needs computer-literate freelancers for design and production. 80% of freelance work demands knowledge of Aldus PageMaker, QuarkXPress, Aldus FreeHand or Adobe Illustrator.

First Contact & Terms: Send query letter with résumé. Samples are filed. Reports back only if interested. Call for appointment to show portfolio of tearsheets and photographs. Pays for design by the hour, $25-35. Pays for illustration by the project, $400-1,200. Rights purchased vary according to project.

Tips: "We need skilled people. There's no time for training."

MIKE QUON DESIGN OFFICE, INC., 568 Broadway, New York NY 10012. (212)226-6024. Fax: (212)219-0331. President: Mike Quon. Contact: Katherine Lumb. Specializes in corporate identity, displays, direct mail, packaging, publications and technical illustrations. Clients: corporations (fashion, beauty, financial) and ad agencies. Current clients include American Express, HBO, Amtrak, Revlon, Nynex and AT&T. Client list available upon request.
Needs: Approached more than 125 freelancers/year. Works with 6 freelance illustrators and 8 designers/year. Prefers "good/great people; locale doesn't matter." Works by assignment only. Prefers graphic style. Uses artists for design, brochures, P-O-P displays, logos, mechanicals, model making, charts/graphs and lettering. Especially needs computer artists with knowledge of QuarkXPress, Adobe Illustrator and Photoshop.
First Contact & Terms: Send query letter with résumé, tearsheets and photocopies. Samples are filed or are returned if accompanied by SASE. Reports back only if interested. Write for appointment to show portfolio or mail thumbnails, roughs and tearsheets. Pays for design by the hour, $20-45. Pays for illustration by the hour, $20-50; or by the project, $150-500 and up. Rights purchased vary according to project.
Tips: "The introduction of the computer has given us much more control and flexibility in our design and production. It has also allowed us to work much quicker; but on the downside, the clients also want work quicker. The economy has made available a larger pool of talent to make our choice from, and has enabled us to recruit more experienced designers and illustrators on a more competitive price scale. This is not only beneficial to us but to our clients."

GERALD & CULLEN RAPP, INC., 108 E. 35th St., New York NY 10016. (212)889-3337. Fax: (212)889-3341. E-mail: 71612.3674@compuserve.com. Number of employees: 9. Approximate annual billing: $3 million. Associate: John Knepper. Estab. 1944. Clients: ad agencies, coporations and magazines. Client list not available. Professional affiliations: GAG, SPAR, S.I.
Needs: Approached by 250 freelance artists/year. Works with 40 freelance illustrators and 10 designers/year. Works on assignment only. Uses freelance illustrators for editorial advertising and corporate illustration. Uses freelance designers mainly for direct mail pieces. Also uses freelancers for brochure and poster design and illustration, ad and direct mail design, mechanicals, retouching, airbrushing, lettering, and P-O-P illustration.
First Contact & Terms: Send query letter with tearsheets and SASE. Samples are filed or returned by SASE if requested by artist. Reports back within 2 weeks. Call or write for appointment to show portfolio or mail appropriate materials. Pays for design by the project, $500-10,000. Pays for illustration by the project, $500-40,000. Negotiates rights purchased.

RITTER & RITTER, INC., 45 W. Tenth St., New York NY 10011. (212)505-0241. Fax: (212)533-0743. Creative Director: Valerie Ritter Paley. Estab. 1968. Number of employees: 2. Approximate annual billing: $250,000. Specializes in annual reports, corporate identity, book covers, brochures, catalogs and promotion. Clients: publishers, corporations, nonprofit organizations and hospitals. Client list available upon request. Professional affiliations: ADC, AIGA, Society of Illustrators.
Needs: Approached by 500 freelancers/year. Works with 5 freelance illustrators and 5 designers/year according to firm's needs. Does not always work on assignment; "sometimes we need a freelance on a day-to-day basis." Uses freelancers mainly for catalogs and brochures. Uses illustrators for covers; graphic designers for brochure design, mechanicals and desktop publishing. Prefers "elegant, understated, sensitive design without self-conscious trendiness." Needs computer-literate freelancers for design. 65% of freelance work demands knowledge of Aldus PageMaker or QuarkXPress. Needs editorial and technical illustration.
First Contact & Terms: Prefers experienced artists, although "talented 'self-starters' with design expertise/education are also considered." Send query letter with brochure, résumé and samples to be kept on file. "Follow up within a week of the query letter about the possibility of arranging an appointment for a portfolio review." Prefers printed pieces as samples. Samples not filed are returned by SASE. Pays for mechanicals and desktop publishing by the hour, $10-25. Pays for design by the hour, $15-25; by the project. Pays for illustration by the project, $50-1,000.
Tips: Finds artists through submissions/self-promotions. "I think the level of design will continue to deteriorate because of the increasing number of people who are not grounded or trained in design but, with the use of computers function as designers, thus lowering the standard of good design."

‡TONI SCHOWALTER DESIGN, 1133 Broadway, Suite 1610, New York NY 10010. (212)727-0072. Fax: (212)727-0071. Office Manager: Sue Hoffman. Estab. 1986. Number of employees: 4. Approximate annual billing: $500,000. Specializes in corporate identity, publication design and sales promotion brochures. Clients: corporations and small companies. Current clients include CBS, J&J, White & Case, RFI, Archetects. Client list available upon request. Professional affiliations: AIGA, SMPS.
Needs: Approached by 25 freelancers/year. Works with 25 freelance illustrators and 10 designers/year. Prefers artists with experience in illustration and photography. Uses illustrators and designers mainly for publications. Also uses freelancers for brochure design and illustration, charts/graphs, lettering, logos and poster illustration. Needs computer-literate freelancers for design and production. 100% of freelance design work demands knowledge of Adobe Illustrator, Adobe Photoshop and QuarkXPress.

First Contact & Terms: Send postcard sample of work or send query letter with brochure, résumé and tearsheets. Samples are filed. Does not report back. Request portfolio review in original query. Artist should follow-up with call. Portfolio should include b&w and color final art. Pays for design by the hour, $15-30; by the project, $200 minimum. Pays for illustration by the project, $200 minimum. Negotiates rights purchased.
Tips: Finds artists through sourcebooks and awards books.

SCHROEDER BURCHETT DESIGN CONCEPTS, 104 Main St., RR 1 Box 5A, Unadilla NY 13849-9703. (607)369-4709. Designer & Owner: Carla Schroeder Burchett. Estab. 1972. Specializes in packaging, drafting and marketing. Clients: manufacturers.
Needs: Works on assignment only. Uses freelancers for design, mechanicals, lettering and logos. 20% of freelance work demands knowledge of Aldus PageMaker or Adobe Illustrator. Needs technical and medical illustration.
First Contact & Terms: Send résumé. "If interested, we will contact artist or craftsperson and will negotiate." Write for appointment to show portfolio of thumbnails, final reproduction/product and photographs. Pays for illustration by the project. Pays for design by the hour, $10 minimum. "If it is excellent work the person will receive what he asks for!" Considers skill and experience of artist when establishing payment.
Tips: "Creativity depends on each individual. Artists should have a sense of purpose and dependability and must work for long and short range plans."

North Carolina

BOB BOEBERITZ DESIGN, 247 Charlotte St., Asheville NC 28801. (704)258-0316. Owner: Bob Boeberitz. Estab. 1984. Number of employees: 1. Approximate annual billing: $80,000. Specializes in graphic design, corporate identity and package design. Clients: retail outlets, hotels and restaurants, textile manufacturers, record companies, professional services, realtor/developers. Majority of clients are manufacturers—business-to-business. Current clients include GrooVee Appalachian Hardwoods, Blue Duck Music, Transylvania Partnership Inc. and High Windy Audio. Client list not available. Professional affiliations: AAF, ACAD.
 ● Owner Bob Boeberitz predicts "everything in art design will be done on computer; more electronic clip art; photo image editing and conversions will be used; there will be less commissioned artwork."
Needs: Approached by 50 freelancers/year. Works with 5 freelance illustrators/year. Works on assignment only. Uses freelancers primarily for technical illustration and comps. Prefers pen & ink, airbrush and acrylic. Needs computer-literate freelancers for illustration. 50% of freelance work demands knowledge of Aldus PageMaker, Adobe Illustrator, Adobe Photoshop or Corel Draw.
First Contact & Terms: Send query letter with brochure, SASE, photocopies, slides and tearsheets. "Anything too large to fit in file" is discarded. Samples are returned by SASE if requested. Reports only if interested. Art Director will contact artist for portfolio review if interested. Portfolio should include thumbnails, roughs, final art, b&w and color slides and photographs. Sometimes requests work on spec before assigning a job. Pays for design and illustration, by the project, $50 minimum. Rights purchased vary according to project. Will consider buying second rights to previously published artwork.
Tips: Finds artists through word of mouth, artists' submissions/self-promotions, sourcebooks, agents. "Show sketches—sketches help indicate how an artist thinks. The most common mistake freelancers make in presenting samples or portfolios is not showing how the concept was developed, what their role was in it. I always see the final solution, but never what went into it. In illustration, show both the art and how it was used. Portfolios should be neat, clean and flattering to your work. Show only the most memorable work, what you do best. Always have other stuff, but don't show everything. Be brief. Don't just toss a portfolio on my desk; guide me through it. A 'leave-behind' is helpful, along with a distinctive-looking résumé."

Ohio

WATT, ROOP & CO., 1100 Superior, Cleveland OH 44114. (216)566-7019. (216)566-0857. VP, Design Operations: Tom Federico. Estab. 1981. Specializes in annual reports, corporate identity, direct mail and publication design and capability pieces. Clients: corporate and business-to-business. Current clients include TRW, NCR and AT&T. Client list not available.
Needs: Approached by 60 freelancers/year. Works with 12 freelance illustrators and 10 designers/year. Prefers local freelancers. Works on assignment only. Uses illustrators mainly for editorial and newsletter spot illustrations. "Uses designers mainly for completing our designs (follow through)." Also uses freelancers for brochure design and illustration, magazine and direct mail design, mechanicals, retouching and airbrushing. Needs computer-literate freelancers for production. 50% of freelance work demands knowledge of Aldus PageMaker, QuarkXPress or Adobe Illustrator.
First Contact & Terms: Send query letter with brochure and résumé. Samples are filed. Does not report back. Artist should follow up with call. Sometimes requests work on spec before assigning a job. Pays for design by the project, $500 minimum. Pays for illustration by the project, $50 minimum. Rights purchased

vary according to project. Interested in buying second rights (reprint rights) to previously published artwork.
Tips: "Send samples of work. Usually we are looking for a specific style. Freelancers should know that budgets are generally lower now, due to computers (clients have become somewhat spoiled)."

WILDER•FEARN & ASSOC., INC., 644 Linn St., Suite 416, Cincinnati OH 45203. (513)621-5237. Fax: (513)621-4880. President: Gary Fearn. Estab. 1946. Number of employees: 7. Specializes in annual reports; brand and corporate identity; and display, package and publication design. Clients: ad agencies, corporations, packaging. Current clients include Jergens Co., Kenner Toys, Kroger and Kraft. Client list available upon request. Professional affiliation: Art Directors Club of Cincinnati.
Needs: Approached by 20-25 freelancers/year. Works with 5-10 freelance illustrators and 2-5 designers/year. Prefers freelancers with experience in packaging and illustration comps. Uses freelance illustrators mainly for comps and finished art on various projects. Needs editorial illustration. Uses freelance designers mainly for packaging and brochures. Freelancers should be familiar with QuarkXPress, Illustrator, FreeHand, Photoshop, Adobe Streamline and O-Photo-Scan.
First Contact & Terms: Send query letter with brochure, résumé and slides. Samples are filed or are returned by SASE if requested by artist. Reports back to the artist only if interested. Call for appointment to show portfolio of roughs, original/final art and color tearsheets and slides. Payment for design and illustration is based upon talent, client and project. Rights purchased vary according to project.

Oregon

‡OAKLEY DESIGN STUDIOS. 6663 SW Bvrtn-Hillsdale, Suite 318, Portland OR 97225. (503)579-3027. Fax: (503)579-2927. Creative Director: Tim Oakley. Estab. 1992. Number of employees: 2. Specializes in brand and corporate identity; display, package and publication design; and advertising. Clients: ad agencies, record companies, surf apparel manufacturers, mid-size businesses. Current clients include Safari Motorcoaches, Dutch Hill Corp., C2F, Bratwear, Judan Records, Amigo Records, Triad Pools. Professional affiliations, OMPA, AIGA and PDXAD.
Needs: Approached by 5-10 freelancers/year. Works with 2-3 freelance illustrators and 1-2 designers/year. Prefers local artists with experience in technical illustration, airbrush. Uses illustrators mainly for advertising. Uses designers mainly for logos. Also uses freelancers for ad and P-O-P illustration, airbrushing, catalog illustration, lettering and retouching. Needs computer-literate freelancers for design, illustration and production. 40% of freelance work demands knowledge of Adobe Illustrator 5.5, Adobe Photoshop 3.0 and QuarkXPress 3.11.
First Contact & Terms: Contact through artist rep or send query letter with brochure, photocopies, photographs, photostats résumé, slides and tearsheets. Samples are filed or returned by SASE if requested by artist. Reports back within 4-6 weeks. Request portfolio review in original query. Art Director will contact artist for portfolio review if interested. Portfolio should include b&w and color final art, photocopies, photostats, roughs and slides. Pays for design and illustration by the project. Rights purchased vary according to project.
Tips: Finds artists through design workbooks.

WISNER ASSOCIATES, Advertising, Marketing & Design, 2237 NE Wasco, Portland OR 97232. (503)228-6234. Creative Director: Linda Wisner. Estab. 1979. Number of employees: 1. Specializes in brand and corporate identity, book design, direct mail, packaging and publications. Clients: small businesses, manufacturers, restaurants, service businesses and book publishers. Client list not available.
Needs: Approached by 2-3 freelancers/year. Works with 2-5 freelance illustrators/year. Prefers experienced freelancers and "fast, clean work." Works on assignment only. Uses freelancers for technical and fashion illustration, books, mechanicals, airbrushing and lettering. Needs computer-literate freelancers for illustration and production. 70% of freelance work demands knowledge of Quark, CorelDraw, Photoshop and other IBM-compatible software.
First Contact & Terms: Send query letter with résumé, photostats, photocopies, slides and photographs. Prefers "examples of completed pieces which show the fullest abilities of the artist." Samples not kept on file are returned by SASE only if requested. Art Director will contact artist for portfolio review if interested. Portfolio should include thumbnails, roughs and final reproduction/product. Pays for illustration by the hour, $20-45 average; by the project by bid. Pays for paste-up/production by the hour, $15-25.
Tips: "Bring a complete portfolio with up-to-date pieces."

Pennsylvania

BAILEY DESIGN GROUP, INC., (formerly Bailey Spiker, Inc.), 805 E. Germantown Ave., Norristown PA 19401. (610)275-4353. Owners/Partners: Christopher Bailey, Russ Napolitano, Ken Cahill or Dave Fiedler. Estab. 1985. Number of employees: 18. Specializes in package design, brand and corporate identity, sales promotion materials, corporate communications and signage systems. Clients: corporations (food, drug, health and beauty aids). Current clients include Johnson & Johnson Consumer Products, Kiwi Brands, Freshword

Farms, McNeil Consumer Products Company, Alpo Pet Foods, Binney & Smith, Luby's Cafeterias, Welch's, ARAMark and Sunshine Biscuits, Inc. Professional affiliations: AIGA, PDC, APP, AMA, ADC.
Needs: Approached by 10 freelancers/year. Works with 3-6 freelance illustrators and 3-6 designers/year. Uses illustrators mainly for editorial, technical and medical illustration and final art, charts and airbrushing. Uses designers mainly for freelance production (*not* design), or computer only. Also uses freelancers for mechanicals, brochure and catalog design and illustration, P-O-P illustration and model-making.
First Contact & Terms: Send query letter with brochure, résumé, tearsheets and photographs. Samples are filed. Reports back to the artist only if interested. Art Director will contact for portfolio review if interested. Portfolio should include finished art samples, color tearsheets, transparencies and artist's choice of other materials. May pay for illustration by the hour, inhouse $10-15; by the project, $300-3,000. Rights purchased vary according to project.
Tips: Finds artists through word of mouth, self-promotions and sourcebooks.

‡BJORNSON DESIGN ASSOCIATES, INC., 217 Church St., Suite A, Philadelphia PA 19106. (215)928-9000. Fax: (215)928-9019. Principal: Jon A. Bjornson. Estab. 1989. Number of employees: 3. Approximate annual billing: $500,000. Specializes in annual reports, brand and corporate identity and publication design. Clients: corporations. Current clients include Wharton School, Friends Hospital, Charming Shoppes. Professional Affiliations: AIGA.
Needs: Approached by 12 freelancers/year. Works with 1-2 freelance illustrators and 6-10 designers/year. Prefers local artists only. Uses designers mainly for identities. Also uses freelancers for ad and brochure design, logos and mechanicals. Needs computer-literate freelancers for design, illustration and production. 100% of freelance work demands knowledge of in Adobe Illustrator, Adobe Photoshop, Aldus FreeHand and Aldus PageMaker.
First Contact & Terms: Send query letter. Art Director will contact artist for portfolio review if interested. Portfolio should include b&w and color final art, photocopies, photographs, photostats and roughs. Pays for design and illustration by the project. Rights purchased vary according to project.

DESIGN & MARKET RESEARCH LABORATORY, 1035 Longford Rd., Oaks PA 19456. (215)935-4038. Fax: (215)935-4100. Director: M. Ryan. Estab. 1945. Number of employees: 19. Approximate annual billing: $3 million. Specializes in package design. Clients: corporations. Client list available upon request. Professional affiliations: AIGA, IOPP, Art Directors Club.
Needs: Approached by 40 freelancers/year. Works with 10 freelance illustrators and 20 designers/year. Prefers local freelancers only. Uses freelancers mainly for packaging. Also for brochure and P-O-P illustration and design, mechanicals, retouching, airbrushing, lettering and logos. Needs computer-literate freelancers for design and production. 60% of freelance work demands knowledge of QuarkXPress (mostly), Adobe Illustrator or Adobe Photoshop.
First Contact & Terms: Send query letter with brochure and résumé. Samples are filed. Reports back to the artist only if interested. Request portfolio review in original query. Portfolio should include b&w and color thumbnails, final art and slides. Pays for design by the hour, rate negotiable. Pays for illustration by the project. Buys all rights.

‡FULLMOON CREATIONS INC., 81 S. Main St., Doylestown PA 18901. (215)345-1233. Fax: (215)348-5378. Contact: Art Director. Estab. 1986. Number of employees: 5. Approximate annual billing: $300,000. Specializes in brand and corporate identity; direct mail, fashion, publications, newsletter, food and toy packaging design. Clients: Fortune 500 corporations. Current clients include Tyco Toys, Campbell, Bic, Hershey Chocolate USA, Binney & Smith Crayola.
Needs: Approached by 100-120 freelancers/year. Works with 5-15 freelance illustrators and 10-20 designers/year. Uses freelancers for ad, brochure and catalog design and illustration; airbrushing; audiovisual materials; book, direct mail and magazine design; logos; mechanicals; poster and P-O-P illustration. Needs computer-literate freelancers for design, illustration and production. 50% of freelance work demands knowledge of Adobe Illustrator, Adobe Photoshop 2.51 or 3.0, Aldus FreeHand 4.0 and QuarkXPress 3.31.
First Contact & Terms: Send postcard sample of work, photocopies, résumé and 1.44MB diskette/floppies. Samples are filed. Reports back within 1 month with SASE. Art Director will contact artist for portfolio review if interested. Portfolio should include b&w and color roughs, thumbnails and transparencies. Pays for design by the hour and by the project. Pays for illustration by the project. Rights purchased vary according to project.
Tips: Finds artists through sourcebooks, submissions and art schools. "Send samples every three months."

‡MINKUS & ASSOCIATES, 100 Chetwynd Dr., Suite 200, Rosemont PA 19010. (610)525-6769. Fax: (610)525-6829. Creative Director: Nickolas Pfendner. Estab. 1985. Number of employees: 5. Specializes in package design, brand and corporate identity, annual reports, display design and signage. Clients: corporations. Current clients include Borden, Inc., AT&T, Confab Companies and Boiron International. Client list available upon request. Professional affiliations: AIGA, International Trademark Center and Package Design Council.

Needs: Approached by 50-100 freelancers/year. Works with 5-10 freelance illustrators and 10-15 designers/year. Uses designers mainly for computer rendering and mechanicals; some traditional design. Also uses freelancers for airbrushing, brochure design and illustration, logos and mechanicals (computer). Needs computer-literate freelancers for design, illustration, production and presentation. 98% of freelance work demands knowledge of Adobe Illustrator 5.5, Adobe Photoshop 3.0 and QuarkXPress 3.31. "Must be very familiar—no time to train."

First Contact & Terms: Send query letter with brochure and résumé. Samples are filed "if liked." Reports back to the artist only if interested. Artist should follow-up with call. Pays for design by the hour, $15 minimum. Pays for illustration depending on project budget.

Tips: Finds designers through portfolio reviews at local schools and résumés received. Finds illustrators through sourcebooks and artist reps we have on file. Impressed by "clever and unusual solutions to problems; clean and clear idea presentation."

WILLIAM SKLAROFF DESIGN ASSOCIATES, 124 Sibley Ave., Ardmore PA 19003. (610)649-6035. Fax: (610)649-6063. Design Director: William Sklaroff. Estab. 1956. Specializes in display, interior, package and publication design and corporate identity and signage. Clients: contract furniture, manufacturers, health care corporations. Current clients include: Kaufman, Halcon Corporation, L.U.I. Corporation, McDonald Products, Baker Furniture, Novikoff and Metrologic Instruments. Client list available upon request.

Needs: Approached by 2-3 freelancers/year. Works with 2-3 freelance illustrators and 2-3 designers/year. Works on assignment only. Uses freelancers mainly for assistance on graphic projects. Also for brochure design and illustration, catalog and ad design, mechanicals and logos.

First Contact & Terms: Send query letter with brochure, résumé and slides to Lori L. Minassian, PR Coordinator. Samples are returned. Reports back within 3 weeks. To show portfolio, mail thumbnails, roughs, finished art samples and color slides and transparencies. Pays for design by the hour. Rights purchased vary according to project.

Tips: Finds artists through word of mouth and artists' submissions.

‡SPENCER ZAHN & ASSOCIATES, 2015 Sansom St., Philadelphia PA 19103. (215)564-5979. Fax: (215)564-6285. Business Manager: Brian Zahn. Estab. 1970. Number of employees: 9. Specializes in brand and corporate identity, direct mail design, marketing and retail advertising. Clients: corporations.

Needs: Approached by 100 freelancers/year. Works with freelance illustrators and designers. Prefers artists with experience in Macintosh computers. Uses freelancers for ad, brochure and poster design and illustration; direct mail design; lettering; and mechanicals. Needs computer-literate freelancers for design, illustration and production. 80% of freelance work demands knowledge of Adobe Illustrator, Adobe Photoshop, Aldus FreeHand and QuarkXPress.

First Contact & Terms: Send query letter with samples. Samples are not filed and are returned by SASE if requested by artist. Reports back to the artist only if interested. Artist should follow-up with call. Portfolio should include final art and printed samples. Buys all rights.

‡WARKULWIZ DESIGN ASSOCIATES INC., 2218 Race St., Philadelphia PA 19103. (215)988-1777. Fax: (215)988-1780. President: Bob Warkulwiz. Estab. 1985. Number of employees: 3. Approximate annual billing: $1 million. Specializes in annual reports, publication design and corporate communications. Clients: corporations and universities. Current clients include Citibank, Bell Atlantic and Wharton School. Client list available upon request. Professional affiliations: AIGA.

Needs: Approached by 100 freelancers/year. Works with 10 freelance illustrators and 5-10 designers/year. Works on assignment only. Uses freelance illustrators mainly for editorial and corporate work. Also uses freelance artists for brochure and poster illustration and mechanicals. Freelancers should be familiar with most recent versions of QuarkXPress, Illustrator, Photoshop, FreeHand and Director.

First Contact & Terms: Send query letter with tearsheets and photostats. Samples are filed. Reports back to the artist only if interested. Call for appointment to show portfolio of "best edited work—published or unpublished." Pays for illustration by the project, "depends upon usage and complexity." Rights purchased vary according to project.

Tips: "Be creative and professional."

Rhode Island

‡SILVER FOX ADVERTISING, 11 George St., Pawtucket RI 02860. (401)725-2161. Fax: (401)726-8270. President: Fred Marzocchi, Jr. Estab. 1979. Number of employees: 6. Approximate annual billing: $1 million. Specializes in annual reports; brand and corporate identity; display, package and publication design; and technical illustration. Clients: corporations. Client list available upon request.

Needs: Approached by 16 freelancers/year. Works with 6 freelance illustrators and 12 designers/year. Works only with artist reps. Prefers local artists only. Uses illustrators mainly for cover designs. 50% of freelance work demands knowledge of Adobe Illustrator, Adobe Photoshop, Aldus PageMaker and QuarkXPress.

First Contact & Terms: Samples are filed. Does not report back. Artist should follow-up with call and/or letter after initial query. Portfolio should include final art, photographs, photostats, roughs and slides.

HARRY SPRUYT DESIGN, Box 555, Block Island RI 02807. Specializes in design/invention of product, package and device; design counseling service shows "in-depth concern for environments and human factors with the use of materials, energy and time." Clients: product manufacturers, design firms, consultants, ad agencies, other professionals and individuals. Client list available.
Needs: Works on assignment only. Uses freelancers/designers for accurate perspective drawings of products, devices (from concepts and sketches), design and material research and model making. "Illustrations are an essential and cost effective step of evaluation between our concept sketches and model making." Uses freelancers for product, editorial, medical and technical illustrations. Looks for "descriptive line and shade drawings, realistic color illustrations that show how product/object looks and works in simple techniques." Prefers pencil, watercolor and tempera or other "timeless media." 10% of freelance work demands computer skills.
First Contact & Terms: Art Director will contact artist for portfolio review if interested. "Portfolio may include thumbnails and rough sketches, original/final art, final reproduction/product and color photographs/slides of models. I want to see work samples showing the process leading up to these examples, including models or photos, if appropriate, as well as time estimates. After working relationship is established, we can develop projects by fax, phone and mail." Pays for design and illustration by the hour, $10-40; by the day, $60-200; or royalty plus fee.
Tips: Finds artists through word of mouth, self-promotions and agents. "We want to use our time together effectively by finding out each other's needs quickly and communicating efficiently and caringly. We look for the ability to understand the functioning of three-dimensional object/device/product from perspective sketches and descriptive notes so artist/designer can illustrate accurately and clearly."

Tennessee

‡AB STUDIOS INC., 807 Third Ave. S., Nashville TN 37210. (615)256-3393. Fax: (615)256-3464. President: Rick Arnemann. Estab. 1988. Number of employees: 20. Approximate annual billing: $2.5 million. Specializes in brand identity, display and direct mail design and signage. Clients: ad agencies, corporations, mid-size businesses. Current clients include Best Products, Service Merchandise, WalMart, Hartmann Luggage. Client list available upon request. Professional affiliations: Creative Forum.
Needs: Approached by 20 freelancers/year. Works with 4-5 freelance illustrators and 2-3 designers/year. Uses illustrators mainly for P-O-P. Uses designers mainly for fliers and catalogs. Also uses freelancers for ad, brochure, catalog, poster and P-O-P design and illustration; logos; magazine design; mechanicals; and retouching. Needs computer-literate freelancers for design and illustration. 85% of freelance work demands knowledge of Adobe Illustrator 5.5, Adobe Photoshop 3.0 and QuarkXPress 3.31.
First Contact & Terms: Send photographs, résumé, slides and transparencies. Samples are filed. Art Director will contact artist for portfolio review if intereted. Portfolio should include color final art, roughs, slides and thumbnails. Pays for design and illustration by the project. Rights purchased vary according to project.
Tips: Finds artists through sourcebooks and portfolio reviews.

ANDERSON STUDIO, INC., 2609 Grissom Dr., Nashville TN 37204. (615)255-4807. Fax: (615)255-4812. Contact: Andy Anderson. Estab. 1976. Number of employees: 13. Approximate annual billing: $1.6 million. Specializes in T-shirts (designing and printing of art on T-shirts for retail/wholesale market). Clients: business and retail.
Needs: Approached by 20 freelancers/year. Works with 2 freelance illustrators and 2 designers/year. "We use freelancers with realistic (photorealistic) style or approach to various subjects, animals and humor. Also contemporary design and loose film styles accepted." Works on assignment only. Needs freelancers for retail niche markets, resorts, theme ideas, animals, zoos, educational, science and humor-related themes.
First Contact & Terms: Send query letter with color copies. Samples are filed and are returned by SASE if requested by artist. Portfolio should include slides, color tearsheets, transparencies and color copies. Sometimes requests work on spec before assigning a job. Pays for design and illustration by the project, $300-1,000 or in royalties per piece of printed art. Negotiates rights purchased. Considers buying second rights (reprint rights) to previously published work.
Tips: "We're looking for fresh ideas and solutions for art featuring animals, zoos, science, humor and education. We need work that is marketable for specific tourist areas—state parks, beaches, islands; also for women's markets."

‡McCLEAREN DESIGN, 3901 Brush Hill Rd., Nashville TN 37216. (615)859-4550. Fax: (615)859-3988. Owner: Brenda McClearen. Estab. 1987. Number of employees: 2. Specializes in display, music, package and publication design.
Needs: Approached by 5-10 freelancers/year. Works with 2-5 freelance illustrators and designers/year. Prefers local artists only. Uses freelancers for ad design and illustration, model making and poster design. Needs

computer-literate freelancers for design and illustration. 50% of freelance work demands knowledge of QuarkXPress and Macintosh.

First Contact & Terms: Samples are filed. Art Director will contact artist for portfolio review if interested. Portfolio should include b&w and color final art, photographs and roughs.

Texas

‡EGAN DESIGN ASSOCIATES, 6600 LBJ Freeway, Suite 184, Dallas TX 75240. (214)385-2294. Art Director: Abby Egan. Estab. 1980. Number of employees: 6. Specializes in brand and corporate identity; display, direct mail and package design; and signage. Clients: corporations and manufacturers. Current clients include Frito Lay, Atmos Energy, T.C.B.Y., Winn-Dixie. Client list available upon request.

Needs: Approached by 50 freelancers/year. Works with 20 freelance illustrators and 10 designers/year. "Experience in food illustration is helpful." Uses illustrators mainly for package design and brochures. Uses designers mainly for computer production. Also uses freelancers for brochure and catalog design and illustration, lettering, logos, mechanicals and poster and P-O-P illustration. Needs computer-literate freelancers for illustration and production. 10% of freelance work demands knowledge of Adobe Illustrator, Adobe Photoshop, Aldus FreeHand, Aldus Pagemaker and QuarkXPress.

First Contact & Terms: Send postcard sample of work, brochure, photocopies, photographs, photostats, résumé and tearsheets. Samples are filed. Art Director will contact artist for portfolio review if interested. Rights purchased vary according to project.

‡STEVEN SESSIONS INC., 5177 Richmond, Suite 500, Houston TX 77056. (713)850-8450. Fax: (713)850-9324. Contact: Steven Sessions. Estab. 1981. Number of employees: 7. Approximate annual billing: $2.5 million. Specializes in annual reports; brand and corporate identity; fashion, package and publication design. Clients: corporations and ad agencies. Current clients include Compaq Computer, Kellogg Foods, Stroh Foods, Texas Instruments, Schlumberger, Johnson & Higgins. Client list available upon request. Professional affiliations: AIGA, Art Directors Club.

Needs: Approached by 75 freelancers/year. Works with 10 illustrators and 2 designers/year. Uses freelancers for brochure, catalog and ad design and illustration; poster illustration; lettering; and logos. Needs computer-literate freelancers for design, illustration, production and presentation. 50% of freelance work demands knowledge of Adobe Illustrator, QuarkXPress, Photoshop or Aldus FreeHand. Needs editorial, technical and medical illustration.

First Contact & Terms: Send query letter with brochure, tearsheets, slides and SASE. Samples are filed. Reports back within 10 days. To show portfolio, mail slides. Payment depends on project, ranging from $1,000-10,000/illustration. Rights purchased vary according to project.

Virginia

‡EDDINS MADISON & SPITZ, 225 Reinekers Lane, #510, Alexandria VA 22314. (703)683-7016. Fax: (703)683-7021. Production Manager: Amanda Cameron. Estab. 1983. Number of employees: 11. Specializes in brand and corporate identity and publication design. Clients: corporations, associations and nonprofit organizations. Current clients include MCI, Faith Mountain Company, Prodigy, National Fire Protection Assoc. Client list available upon request.

Needs: Approached by 20-25 freelancers/year. Works with 8-10 freelance illustrators and 8-10 designers/year. Uses only artists with experience in Macintosh. Uses illustrators mainly for publications and brochures. Uses designers mainly for simple design and Mac production. Also uses freelancers for airbrushing, brochure and poster design and illustration, catalog design, charts/graphs. Needs computer-literate freelancers for design, production and presentation. 100% of freelance work demands knowledge of Adobe Illustrator, Adobe Photoshop, Aldus FreeHand and QuarkXPress.

First Contact & Terms: Send postcard sample of work or send query letter with photocopies and résumé. Samples are filed. Art Director will contact artist for portfolio review if interested. Rights purchased vary according to project.

Tips: Finds artists through sourcebooks, design/illustration annuals and referrals. Impressed by "great technical skills, nice cover letter, good/clean résumé and good work samples."

‡JOHNSON DESIGN GROUP, INC., 200 Little Falls St., Suite 410, Falls Church VA 22046-4302. (703)533-0550. Art Director: Leonard A. Johnson. Specializes in publications. Clients: corporations, associations and PR firms. Client list not available.

Needs: Approached by 15 freelancers/year. Works with 15 freelance illustrators and 5 designers/year. Works on assignment only. Uses freelancers for brochure and book illustration, mechanicals, retouching and lettering. Especially needs editorial line illustration and a realistic handling of human figure in real-life situations. Needs computer-literate freelancers for design. 90% of freelance work demands knowledge of QuarkXPress, Aldus FreeHand or Adobe Illustrator.

First Contact & Terms: Send query letter with brochure/flyer and nonreturnable samples (photocopies OK) to be kept on file. Pays for design by the hour, $10-15. Pays for illustration by the project.

Tips: The most common mistakes freelancers make in presenting samples or portfolios are "poor quality or non-relevant subject matter." Artists should "have a printed 'leave behind' sheet or photocopied samples that can be left in the art director's files."

Washington

BELYEA DESIGN ALLIANCE, 1809 Seventh Ave., Suite 1007, Seattle WA 98101. (206)682-4895. Fax: (206)623-8912. Estab. 1980. Specializes in annual reports; brand and corporate identity; marketing materials; in-store P-O-P; direct mail, package and publication design. Clients: corporate, manufacturers, retail. Current clients include Weyerhaeuser and Princess Tours. Client list available upon request.

Needs: Approached by 20-30 freelancers/year. Works with 20 freelance illustrators and 3-5 designers/year. Prefers local freelancers only. Works on assignment only. Uses illustrators for "any type of project." Uses designers mainly for overflow. Also uses freelancers for brochure, catalog, poster and ad illustration; and lettering. Needs computer-literate freelancers for design. 100% of freelance work demands knowledge of QuarkXPress, Aldus FreeHand or Adobe Photoshop.

First Contact & Terms: Send query letter. Samples are filed. Reports back to the artist only if interested. Pays for design by the hour, $25-40. Pays for illustration by the project, $125-1,000. Rights purchased vary according to project.

Tips: Finds artists through submissions by mail and referral by other professionals. "Designers must be computer-skilled. Illustrators must develop some styles that make them unique in the marketplace."

‡DITTMANN DESIGN, P.O. Box 31387, Seattle WA 98103-1387. (206)523-4778. E-mail: danditt@aol.com. Owner/Designer: Martha Dittmann. Estab. 1981. Number of employees: 2. Specializes in brand and corporate identity, display and package design and signage. Clients: corporations. Client list available upon request. Professional affiliations: AIGA.

Needs: Approached by 50 freelancers/year. Works with 5 freelance illustrators and 2 designers/year. Uses illustrators mainly for corporate collateral and packaging. Uses designers mainly for color brochure layout and production. Also uses freelancers for brochure and P-O-P illustration, charts/graphs and lettering. Needs computer-literate freelancers for design, illustration, production and presentation. 75% of freelance work demands knowledge of Adobe Illustrator, Adobe Photoshop, Aldus FreeHand, Aldus PageMaker, Aldus Persuasion and Painter.

First Contact & Terms: Send postcard sample of work or brochure and photocopies. Samples are filed. Art Director will contact artist for portfolio review if interested. Portfolio should include final art, roughs and thumbnails. Pays for design by the hour, $35-100. Pays for illustration by the project, $250-5,000. Rights purchased vary according to project.

Tips: Finds artists through sourcebooks, agents and submissions.

‡FARIN DESIGN GROUP, 2326 N. Pacific St., Seattle WA 98103. (206)633-3900. Owner: Lisa Farin. Estab. 1984. Number of employees: 1. Specializes in annual reports; corporate identity; direct mail, package and publication design. Clients: corpoations. Client list available upon request. Professional affiliations: AIGA.

Needs: Approached by 20 freelancers/year. Works with 3 freelance illustrators and 2 designers/year. Works with illustrators mainly for corporate publications. Also uses freelancers for ad illustration, brochure design and illustration and mechanicals. Needs computer-literate freelancers for design, illustration and production. Freelancers should be familiar with Adobe Photoshop, Aldus FreeHand and Aldus PageMaker.

First Contact & Terms: Send postcard sample of work. Samples are filed or returned by SASE if requested by artist. Art Director will contact artist for portfolio review if interested. Portfolio should include b&w and color final art. Pays for design and illustration by the project. Rights purchased vary according to project.

‡TMA, 2562 Dexter Ave. N., Seattle WA 98109. (206)270-9360. Creative Head: Ted Mader. Number of employees: 6. Specializes in corporate and brand identity, displays, direct mail, fashion, packaging, publications, signage, book covers, interactive media and CD-ROM. Client list available upon request.

Needs: Approached by 150 freelancers/year. Works with 0-10 freelancer illustrators and 0-5 designers/year. Uses freelancers for illustration, retouching, electronic media, production and lettering. Needs computer-literate freelancers for design, illustration and production. 90% of freelance work demands knowledge of QuarkXPress or Aldus FreeHand.

First Contact & Terms: Send résumé and samples. Samples are filed. Write or call for an appointment to show portfolio. Pays by the project. Considers skill and experience of freelancer and project budget when establishing payment. Rights purchased vary according to project.

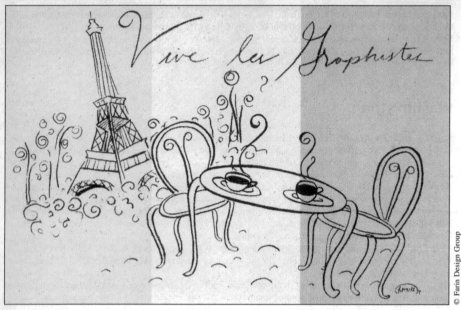

© Farin Design Group

"Springtime in Paris" was the mood Doreen Smith sought to create on the cover of this invitation designed by Farin Design Group for a Seattle AIGA event. "The cafe culture has long been associated with the glamorous artist's lifestyle. I wanted the invitation to convey French culture in a definitive and recognizable way." Smith, who received no payment for the graphite and charcoal illustration, "jumped at the chance" to have it appear on an invitation which many designers in the city received.

Wisconsin

‡HANSON/DODGE DESIGN, 301 N. Water St., Milwaukee WI 53202. (414)347-1266. Fax: (414)347-0493. CEO: Ken Hanson. Estab. 1980. Number of employees: 32. Approximate annual billing: $3.5 million. Specializes in annual reports; brand and corporate identity; display, direct mail and package design; signage. Clients: corporations, agencies, small businesses. Current clients include Miller Genuine Draft, Trek Bicycle, Timex. Client list available upon request. Professional affiliations: AIGA, SEGD.
Needs: Approached by 30 freelancers/year. Works with 5 freelance illustrators and 4-5 designers/year. Also uses freelancers for ad, brochure, catalog, poster and P-O-P design and illustration; charts/graphs; lettering; logos; retouching. Needs computer-literate freelancers for design, illustration and production. 90% of freelance work demands knowledge of Adobe Illustrator, Adobe Photoshop, Aldus FreeHand and QuarkXPress.
First Contact & Terms: Send postcard sample of work or send brochure, photocopies, photographs, photostats, résumé, tearsheets and transparencies. Samples are filed. Reports back within 2 weeks. Artist should follow-up with call. Portfolio should include b&w and color final art, photocopies, photographs, photostats, slides and transparencies. Pays for design and illustration by the hour.
Tips: Finds artists through word of mouth, submissions.

‡HARE STRIGENZ, INC., 306 N. Milwaukee St., Milwaukee WI 53202. (414)272-0072. Fax: (414)291-7990. Owner/Creative Director: Paula Hare. Estab. 1986. Number of employees: 9. Specializes in packaging, annual reports, collateral, corporate communications. Clients: manufacturers, retail, agricultural, electronics industries. Client list available upon request.
Needs: Approached by 12-18 freelancers/year. Works with 10-12 freelance illustrators and 12-15 designers/year. Prefers local illustrators but uses national designers. Uses freelancers for annual reports, catalog design and logos. Needs computer-literate freelancers for design, illustration, production and presentation. 100% of freelance work demands knowledge of Adobe Photoshop, QuarkXPress and Adobe Illustrator.
First Contact & Terms: Send query letter with brochure and tearsheets. Samples are filed. Reports back to the artist only if interested. Portfolios may be dropped off every Monday. Artist should follow-up with letter after initial query. Portfolio should include thumbnails. Buys all rights.
Tips: "Be truly interested in working with our company. Get to know us first—then we'll check you out! We briefly look at portfolios and hire people based on personality fit mostly."

UNICOM, 9470 N. Broadmoor Rd., Bayside WI 53217. (414)352-5070. Fax: (414)352-4755. Senior Partner:

Ken Eichenbaum. Estab. 1974. Specializes in annual reports; brand and corporate identity; display, direct, package and publication design; and signage. Clients: corporations, business-to-business communications, and consumer goods. Client list available upon request.

Needs: Approached by 15-20 freelancers/year. Works with 1-2 freelance illustrators/year. Works on assignment only. Uses freelancers for brochure, book and poster illustration.

First Contact & Terms: Send query letter with brochure. Samples not filed or returned. Does not report back; send nonreturnable samples. Write for appointment to show portfolio of thumbnails, photostats, slides and tearsheets. Pays by the project, $200-6,000. Rights purchased vary according to project.

Canada

✦**2 DIMENSIONS INC.**, 260 Sorauren Ave., Toronto, Ontario M6R 2G4 Canada. (416)539-0766. Fax: (416)539-0746. Estab. 1989. Number of employees: 14. Specializes in annual reports; brand and corporate identity; direct mail, package and publication design. Clients: Fortune 500 corporations (IBM, etc.), major distributors and manufacturers (Letraset), most government ministries (Canadian), television (Fox TV, CBC). Partial client list available (does not include confidential clients). Professional affiliations: GAG, GDAC.

Needs: Approached by 200 freelancers/year. Works with 35 freelancers illustrators and 3 designers/year. Looks for unique and diverse signature styles. Designers must be local, but not illustrators. Works on assignment only (illustrators mostly). Uses illustrators mainly for advertising, collateral. Uses designers mainly for special projects and overflow work. Designers must work under creative director. Also uses freelancers for brochure design and illustration; magazine design; catalog, P-O-P, poster and ad illustration; and charts/graphs. 100% of freelance design work demands knowledge of QuarkXPress, Aldus FreeHand, Photoshop, Microsoft Word or Suitcase. Illustration work does not require computer skills.

First Contact & Terms: Send query letter with brochure or tearsheets, résumé, SASE. Samples are filed or are returned by SASE if requested by artist. Reports back within 2 weeks. Write for appointment to show portfolio. "Don't send portfolio unless we phone. Send tearsheets that we can file." Pays for design by the project, $300-10,000. Pays for illustration by the project, $300-8,000. Negotiates rights purchased.

Tips: "We look for diverse styles of illustration for specific projects. Send tearsheets for our files. Our creative director refers to these files and calls with assignment offer. We don't normally have time to view portfolios except relative to a specific job. Strong defined styles are what we notice. The economy has reduced some client budgets and increased demand for speculative work. Since we are emphatically opposed to spec work, we do not work this way. Generalist artists who adapt to different styles are not in demand. Unique illustrative styles are easier to sell."

Design Firms/'95-'96 changes

The following firms were listed in the 1995 edition but do not have listings in this edition. The majority did not respond to our request to update their listings.

Albee Sign Co.
Alpert & Alpert, Inc.
Alpha Enterprises
Alternative Design & Associates &Co.
The Art Works
Assistants in Design Services
Augustus Barnett Advertising/ Design
Barnstorm Design/Creative
The Bookmakers, Incorporated
The Brubaker Group
Burchette & Company
Carnase, Inc.
Carson & Company
CAS Associates
CN Communications
Critt Graham & Assoc.
Joseph B. Del Valle
Denton Design Associates
Design and Production, Inc.
Design Concepts
The Design Office of Steve Neumann & Friends
Diamond Art Studio Ltd
Dimensions & Directions, Ltd.
Dockx Design

Ray Engle & Associates
Evenson Design Group
Freeman Design Group
Steve Galit Associates, Inc.
Gluckman Design Office, Inc.
April Greiman, Inc.
Harrison Design Group
Hartung & Associates
Thomas Hillman Design
Hjermstad and Associates
The Hoyt Group, Inc.
Hulsey Graphics
Innovative Design & Graphics
Intelplex
Peter James Design Studio
Jensen Communications Group
Larry Kerbs Studios
Leimer Cross Design
Lesiak/Crampton Design Inc.
Lister Butler Inc.
Jodi Luby & Company, Inc.
Sudi McCollum Design
McGuire Associates
Macey Noyes Associates, Inc.
Marketing by Design
Donya Melanson Associates
Menon Associates

Oden & Associates
Oden & Associates
Yashi Okita Design
Sam Payne & Associates
Penultima Inc.
The Red Flannel Design Group
Richard Seiden Interiors
Gad Shaanan Design Inc.
Deborah Shapiro Designs
Smith & Dress
Spectramedia, Inc.
Spectrum Boston Consulting, Inc.
Stephan Design
Studio 38 Design Center
Sylvor Co., Inc.
Renee Tafoya Design
Timmerman Design
Tokyo Design Center
Tollner Design Group
Unit One, Inc.
The Van Noy Group
Wallace Church Associates, Inc.
Wave Design Works
Williams McBride Design Inc.
WYD Design
Clarence Zierhut, Inc.

Galleries

Most artists dream of seeing their work in a gallery. It's the equivalent of "making it" in the art world. That dream can be closer than you realize. The majority of galleries are actually quite approachable and open to new artists. Though there will always be a few austere establishments manned by snooty clerks, most are friendly places where people come to browse and chat with the gallery staff.

So don't let galleries intimidate you. If you approach them in the right way, they'll be happy to take a look at your slides. If they feel your artwork doesn't fit their gallery, most will gently let you know, often steering you toward a more appropriate one. Whenever you meet rejection (and you will), tell yourself it's all part of being an artist. And that's what you want to be isn't it?

It may take months, maybe years, for you to find a commercial gallery to represent you. As you submit your work to galleries and get feedback you might find out your style hasn't developed enough to grab a gallery's interest. But don't worry, there are plenty of other venues for you to show in until you are accepted in a commercial gallery. If you get involved with your local art community, attend openings, read the arts section of your local paper, you'll see there are hundreds of opportunities right in your city.

Enter group shows every chance you get. Go to the art department of your local library and check out the bulletin board, then ask the librarian to steer you to regional arts magazines which list "calls to artists" and other opportunities to exhibit your work. Join a co-op gallery and show your work in a space run by artists for artists. Is there a restaurant in your town that shows the work of local artists? Ask the manager how you can show your work. Become an active member in an arts group. They often mount exhibitions of their members' work. Show your work whenever and wherever you can until you find the right commercial gallery for you.

Gallery do's and don'ts

The first thing you should know about galleries is that they probably won't come knocking at your door asking to see your artwork. You will have to make the effort to approach them. Gallery owners are people who love the arts and enjoy their involvement with artists, but they are also business people. The artists they choose to represent must not only be talented, but experienced and highly professional as well.

No matter how talented you are, do not walk into a gallery with your paintings. When we ask gallery directors for pet peeves they always discuss the talented newcomers walking into the gallery with paintings in hand. Send a polished package of about 8 to 12 neatly labeled, mounted slides of your work submitted in plastic slide sheet format (refer to the listings for more specific information on each gallery's preferred submission method).

Don't think you have to move to New York City to find a gallery. Whether you live in a small town or a big city, the easiest galleries to try first are the ones closest to you. It's much easier to begin developing a reputation within a defined region. New artists rarely burst onto the scene on a national level.

Before you decide whether or not to submit your slides to a particular gallery, try to make a visit to the gallery. Browse for a while and see what type of work they sell. Do you like the work? Is it similar to yours in quality and style? What about the staff?

Are they friendly and professional? Do they seem to know about the artists the gallery handles? Do they have convenient hours? Sign the register book to get on their mailing list. That's one good way to make sure the gallery sends out professional mailings to prospective collectors.

Don't visit just one gallery. Check out all the galleries in your area before making a decision. If a gallery is listed in this book, read the listing for more information about how the gallery works and how they prefer being approached.

Types of galleries

As you search for the perfect gallery, it's important to understand the different types of spaces and how they operate. There are advantages and disadvantages to each type of space. The route you choose depends on your needs, the type of work you do, your long term goals, and the audience you're trying to reach.

● **Retail or commercial galleries.** The goal of the retail gallery is to sell and promote artists while turning a profit. Work in retail galleries is handled by a professional sales staff, because selling the work is the gallery's major concern. Retail galleries take a commission of 40 to 50 percent of all sales.

● **Co-op galleries.** Like retail galleries, co-ops exist to sell and promote artists' work, but they are run by artists, and have no professional sales staff. Members of co-ops exhibit their own work in exchange for a fee, which covers the gallery's overhead. Some co-ops also take a small commission of 20 to 30 percent on work sold to cover expenses. This type of arrangement also requires a time commitment. Members share the responsibilities of gallery-sitting, housekeeping and maintenance.

● **Rental galleries.** In this type of arrangement, the artist rents space from an organization or individual in which to display work. The gallery makes its profit primarily through rent and consequently may not take a commission on sales (or will take only a very small commission). Some rental spaces provide publicity for artists, while others do not.

● **Nonprofit galleries.** The mission of the nonprofit gallery is often to provide a forum for public discussion through art. Many nonprofits exist solely for the benefit of the public: to make art and culture accessible to all people. A show in this type of space will provide the artist an opportunity to sell work and gain publicity, but the nonprofit will not market the work aggressively, as its goals are not necessarily sales-oriented. Nonprofits normally take a small commission of 20 to 30 percent.

● **Museums.** It is not appropriate to submit to most museums unless they publicize a special competition or arts event. The work in museums is by established artists and is usually donated by collectors or purchased through art dealers.

● **Art consultancies.** Generally, art consultants act as liasions between fine artists and buyers. Most represent artists and take a commission on sales (as would a gallery). Some even maintain small gallery spaces and show work to clients by appointment. Corporate consultants, however, are sometimes paid by the corporations they serve and consequently do not take a cut of the artist's sale. (See Artists' Reps section, page 644.)

Broadening your scope

Once you have achieved representation on a local level, you are ready to broaden your scope by querying galleries in other cities. Many artists have had success showing in multiple galleries. When submitting to galleries outside your city, if you can't manage a personal visit before you submit, read the listing carefully to make sure you understand what type of work is shown in that gallery and get a feel for what the space is like. Ask yourself if the type of work you do would be appropriate for the scope of the gallery.

To develop a sense of various galleries, look to the myriad of art publications which contain reviews and advertising (the pictures that accompany a gallery's ad can be very illuminating). A few such publications are *ARTnews*, *Art in America*, *The New Art Examiner* and regional publications such as *ARTweek* (West Coast), *Southwest Art*, *Dialogue* and *Art New England*. Lists of galleries can be found in *Art in America's Guide to Galleries, Museums and Artists* and *Art Now, U.S.A.'s National Art Museum and Gallery Guide*.

After you have identified galleries that interest you, check their listings to find out exactly how they prefer to be approached. For a first contact, most galleries prefer a cover letter, slides, résumé and SASE.

If an out-of-town gallery shows interest in your work, make a special trip to inspect the gallery and meet the staff before you make a commitment. If that's not possible, ask a friend or relative who lives near the city to check it out for you.

Pricing your work

A common question of beginning artists is "What do I charge for my paintings?" There are no hard and fast rules. The better known you become, the more people will pay for your work. Though you should never underprice your work, you must take into consideration what people are willing to pay. (See Negotiating the Best Deal page 6.)

Alabama

CORPORATE ART SOURCE, 2960-F Zelda Rd., Montgomery AL 36106. (334)271-3772. Owner: Jean Belt. Art consultancy. Estab. 1983. Interested in emerging, mid-career and established artists. "I don't represent artists, but keep a slide bank to draw from as resources." Curates several exhibits/year. Open Monday-Friday, 10-5. Clientele: corporate upscale, local. 10% private collectors, 90% corporate collectors. Overall price range: $100-12,000. Most work sold at $600-3,000.
Media: Considers all media. Most frequently exhibits oil/acrylic paintings on canvas, fine crafts and watercolor. Also interested in sculpture.
Style: Exhibits all styles. Genres include landscapes and figurative work. Prefers contemporary landscapes, impressionism, dimensional abstracts and mixed media pieces (collages).
Terms: Artwork is accepted on consignment (50% commission). Retail price set by artist. Gallery provides contract, shipping costs from gallery. Prefers artwork unframed.
Submissions: Send query letter with résumé, slides, bio, photographs and SASE. Call for appointment to show portfolio of slides and photographs. Replies in 3 months.

‡FAYETTE ART MUSEUM, 530 N. Temple Ave., Fayette AL 35555. (205)932-8727. Director: Jack Black. Museum. Estab. 1969. Exhibits the work of emerging, mid-career and established artists. Sponsors 6 shows/year. Average display time is 6 weeks. Open all year. Located downtown Fayette Civic Center; 16,500 sq. ft. 20% of space for special exhibitions.
Media: Considers all media and all types of prints. Most frequently exhibits oil, watercolor and mixed media.
Style: Exhibits expressionism, primitivism, painterly abstraction, minimalism, postmodern works, impressionism, realism and hard-edge geometric abstraction. Genres include landscapes, florals, Americana, wildlife, portraits and figurative work.
Terms: Shipping costs negotiable. Prefers artwork framed.
Submissions: Send query letter with résumé, brochure and photographs. Write for appointment to show portfolio of photographs. Files possible exhibit material.
Tips: "Do not send expensive mailings (slides, etc.) before calling to find out if we are interested. We want to expand collection. Top priority is folk art from established artists. Appreciable percentage of space is devoted to folk art."

MOBILE MUSEUM OF ART, (formerly Fine Arts Museum of the South), P.O. Box 8426, Mobile AL 36689. (334)343-2667. Director: Joe Schenk. Clientele: tourists and general public. Sponsors 6 solo and 12 group shows/year. Average display time 6-8 weeks. Interested in emerging, mid-career and established artists. Overall price range: $100-5,000; most artwork sold at $100-500.
Media: Considers all media and all types of visual art.
Style: Exhibits all styles and genres. "We are a general fine arts museum seeking a variety of style, media and time periods." Looking for "historical significance."

Terms: Accepts work on consignment (20% commission). Retail price set by artist. Exclusive area representation not required. Gallery provides insurance, promotion, contract; shipping costs are shared. Prefers framed artwork.

Submissions: Send query letter with résumé, brochure, business card, slides, photographs, bio and SASE. Write to schedule an appointment to show a portfolio, which should include slides, transparencies and photographs. Replies only if interested within 3 months. Files résumés and slides. All material is returned with SASE if not accepted or under consideration.

Tips: A common mistake artists make in presenting their work is "overestimating the amount of space available." Recent gallery developments are the "prohibitive costs of exhibition—insurance, space, transportation, labor, etc. Our city budget has not kept pace with increased costs."

Alaska

STONINGTON GALLERY, 415 F St., Old City Hall, Anchorage AK 99501. (907)272-1489. Fax: (907)272-5395. Manager: Julie Decker. Retail gallery. Estab. 1983. Interested in emerging, mid-career and established artists. Represents 50 artists. Sponsors 15 solo and group shows/year. Average display time 3 weeks. Clientele: 90% private collectors, 10% corporate clients. Overall price range: $100-5,000; most work sold at $500-1,000.

Media: Considers oil, acrylic, watercolor, pastel, mixed media, collage, works on paper, sculpture, ceramic, craft, fiber, glass and all original handpulled prints. Most frequently exhibits oil, mixed media and all types of craft.

Style: Exhibits all styles. "We have no pre-conceived notions as to what an artist should produce." Specializes in original works by artists from Alaska and the Pacific Northwest. "We are the only source of high-quality crafts in the state of Alaska. We continue to generate a high percentage of our sales from jewelry and ceramics, small wood boxes and bowls and paper/fiber pieces. We push the edge to avante garde."

Terms: Accepts work on consignment (40% commission). Retail price set by artist. Exclusive area representation required. Gallery provides insurance, promotion.

Submissions: Send letter of introduction with résumé, slides, bio and SASE.

Tips: Impressed by "high quality ideas/craftsmanship—good slides."

Arizona

‡COCONINO CENTER FOR THE ARTS, 2300 N. Fort Valley Rd., Flagstaff AZ 86001. (602)779-6921. Fax: (602)779-2984. Director: Keye McCulloch. Nonprofit retail gallery. Estab. 1981. Represents/exhibits emerging, mid-career and established artists. Sponsors 7 shows/year. Average display time 6 weeks. Open all year; Tuesday-Saturday, 10-5 (winter), Tuesday-Sunday 10-5, (summer). Located US Highway 180 N., 1.3 miles north of Flagstaff. 4,000 sq. ft. Clientele: tourists, local community and students.

Media: Considers all media and all types of prints. Most frequently exhibits visual, 3-D and installation.

Style: Exhibits all styles and genres.

Terms: Retail price set by the artist. Gallery provides insurance and promotion. Artist pays for shipping costs. Prefers artwork framed.

Submissions: Send query letter with slides and bio. Call or write for appointment to show portfolio.

Tips: Finds artists through word or mouth, referrals by other artists and artists' submissions.

‡THE CULTURAL EXCHANGE, 7054 E. Indian School, Scottsdale AZ 85251. (602)947-2066. Fax: (602)947-0636. Retail gallery and art consultancy. Exhibits the work of 100s of mid-career and established artists/year. Exhibited artists include Fritz Scholder and Dale Chihuly. Average display time 6 weeks. Open all year; Tuesday-Saturday, 10-5; Thursday evenings, 7-9; Sunday, 12-4. Located downtown—corner of Marshall Way and Indian School; 1,000 sq. ft. "Have vast array of artwork from the 1800s to contemporary." Clientele: upscale, local and tourists. 75% private collectors, 25% corporate collectors. Overall price range: $100-150,000; most work sold at $1,000-5,000.

Media: Considers all media except weavings and tapestry. Considers all types of prints except posters. Most frequently exhibits oils/acrylics, bronze and pastels/lithos.

How to Use Your **Artist's & Graphic Designer's Market** *offers suggestions for understanding and using the information in these listings. Read this and other articles in the front of this book for important business tips.*

Style: Exhibits expressionism, neo-expressionism, painterly abstraction, conceptualism, minimalism, color field, postmodern works, photorealism, hard-edge geometric abstraction, realism and imagism. Exhibits all genres.

Terms: Artwork is accepted on consignment and there is a 30% commission (from clients not artists). Retail price set by the gallery. Gallery provides insurance, promotion and contract; shipping costs are shared.

Submissions: Accepts consignments. "We do not represent artists."

‡**EL PRADO GALLERIES, INC.**, Tlaquepaque Village, Box 1849, Sedona AZ 86336. (602)282-7390. President: Don H. Pierson. Two retail galleries. Estab. 1976. Represents 110 emerging, mid-career and established artists. Exhibited artists include Guy Manning and Jerome Grimmer. Sponsors 3-4 shows/year. Average display time 1 week. Open all year. One gallery located in Santa Fe, NM; 1 gallery in Sedona's Tlaquepaque Village: 5,000 sq. ft. "Each gallery is different in lighting, grouping of art and variety." 95% private collectors, 5% corporate collectors. Accepts artists from all regions. Overall price range: $75-125,000.

Media: Considers oil, acrylic, watercolor, pastel, mixed media, collage, works on paper, sculpture, ceramic, craft, fiber and glass. Considers woodcuts, engravings, lithographs, wood engravings, mezzotints, serigraphs, linocuts and etchings. Most frequently exhibits oil, acrylic, watercolor and sculpture.

Style: Exhibits all styles and genres. Prefers landscapes, Southwestern and Western styles. Does not want to see avant-garde.

Terms: Accepts work on consignment (50% commission). Retail price set by the gallery and the artist. Gallery provides insurance and promotion; shipping costs are shared. Prefers unframed work.

Submissions: Send query letter with photographs. Call or write to schedule an appointment to show a portfolio which should include photographs. "A common mistake artists make is presenting work not up to our standards of quality." Replies in 3 weeks. Files material only if interested.

Tips: "The artist's work must be original, not from copyrighted photos, and must include SASE. Our clients today are better art educated than before."

‡**EL PRESIDIO GALLERY**, 120 N. Main Ave., Tucson AZ 85701. (602)884-7379. Director: Henry Rentschler. Retail gallery. Estab. 1981. Represents 30 artists; emerging, mid-career and established. Sponsors 4 group shows/year. Average display time 2 months. "Located in historic adobe building with 14' ceilings next to the Tucson Museum of Art." Represents 20 artists. Accepts mostly artists from the West and Southwest. Clientele: locals and tourists. 70% private collectors, 30% corporate clients. Overall price range: $500-20,000; most artwork sold at $1,000-5,000.

Media: Considers oil, acrylic, watercolor, mixed media, works on paper, sculpture, ceramic, glass, egg tempera and original handpulled prints. Most frequently exhibits oil, watercolor and acrylic.

Style: Exhibits impressionism, expressionism, realism, photorealism and painterly abstraction. Genres include landscapes, Southwestern, Western, wildlife and figurative work. Prefers realism, representational works and representational abstraction.

Terms: Accepts work on consignment (50% commission). Retail price set by the gallery and the artist. Exclusive area representation required. Gallery provides insurance, promotion and contract; artist pays for shipping. Prefers framed artwork.

Submissions: Send query letter with résumé, brochure, slides, photographs with sizes and retail prices, bio and SASE. Call or write to schedule an appointment to show a portfolio, which should include originals, slides, transparencies and photographs. A common mistake is artists overpricing their work. Replies in 2 weeks.

Tips: "Work hard. Have a professional attitude. Be willing to spend money on good frames."

ELEVEN EAST ASHLAND INDEPENDENT ART SPACE, 11 E. Ashland, Phoenix AZ 85004. (602)257-8543. Director: David Cook. Estab. 1986. Represents emerging, mid-career and established artists. Exhibited artists include Keith Bennett, Stuart Harwood and Margrett Stone. Sponsors 1 juried, 1 invitational and 13 solo and mixed group shows/year. Average display time 3 weeks. Located in "two-story old farm house in central Phoenix, off Central Ave." Overall price range: $100-5,000; most artwork sold at $100-800.

• An anniversary exhibition is held every year in April and is open to national artists. Work must be submitted by March 1. Work will be for sale, and considered for permanent collection and traveling exhibition.

Media: Considers all media. Most frequently exhibits photography, painting, mixed media and sculpture.

Style: Exhibits all styles, preferably contemporary. "This is a non-traditional proposal exhibition space open to all artists excluding Western and Southwest styles (unless contemporary style)."

Terms: Accepts work on consignment (25% commission); rental fee for space covers 1 month. Retail price set by artist. Artist pays for shipping.

Submissions: Accepts proposal in person or by mail to schedule shows 6 months in advance. Send query letter with résumé, brochure, business card, slides, photographs, bio and SASE. Call or write for appointment to show portfolio of slides and photographs. Be sure to follow through with proposal format. Replies only if interested within 1 month. Samples are filed or returned if not accepted or under consideration.

Tips: "Be yourself, avoid hype and commercial glitz. Be sincere and have a positive attitude."

GALERIA MESA, 155 N. Center, Box 1466, Mesa AZ 85211-1466. (602)644-2056. Fax: (602)644-2901. Owned and operated by the City of Mesa. Estab. 1981. Exhibits the work of emerging, mid-career and established artists. "We only do national juried shows and curated invitationals. We are an exhibition gallery, NOT a commercial sales gallery." Sponsors 9 shows/year. Average display time 4-6 weeks. Closed August. Located downtown; 3,600 sq. ft., "wood floors, 14′ ceilings and monitored security." 100% of space for special exhibitions. Clientele: "cross section of Phoenix metropolitan area." 95% private collectors, 5% gallery owners. "Artists selected only through national juried exhibitions." Overall price range: $100-10,000; most artwork sold at $200-400.

Media: Considers all media and original handpulled prints, woodcuts, engravings, lithographs, wood engravings, mezzotints, monotypes, serigraphs, linocuts and etchings.

Style: Exhibits all styles and genres. Interested in seeing contemporary work.

Terms: Charges 25% commission. Retail price set by artist. Gallery provides insurance, promotion and contract; pays for shipping costs from gallery. Requires framed artwork.

Submissions: Send a query letter or postcard with a request for a prospectus. "We do not offer portfolio review. Artwork is selected through national juried exhibitions." Files slides and résumés.

Tips: Finds artists through gallery's placement of classified ads in various art publications, mailing news releases and word of mouth. "Have professional quality slides."

THE GALLOPING GOOSE, 162 S. Montezuma, Prescott AZ 86303. (602)778-7600. Owners: Richard Birtz and Mary Birtz. Retail gallery. Estab. 1987. Represents 200 emerging, mid-career and established artists. Exhibited artists include Bev Doolittle and Maija. Average display time 2 weeks. Open all year. Located in the "SW corner of historic Whiskey Row across from the courthouse in downtown Prescott; newly remodeled with an additional 2,000 sq. ft. of gallery space." 10% of space for special exhibitions. Clients: established art collectors and tourists. 95% private collectors, 5% corporate collectors. Overall price range: $20-5,000; most work sold at $150-1,000.

Media: Considers oil, pen & ink, fiber, acrylic, drawing, sculpture, watercolor, mixed media, ceramic, pastel, original handpulled prints, reliefs, lithographs, offset reproductions and posters. Most frequently exhibits pastel, oil, tempera and watercolor.

Style: Exhibits surrealism, imagism and realism. Genres accepted include landscapes, Americana, Southwestern, Western, wildlife and Indian themes only. Prefers wildlife, Southwestern cowboy art and landscapes.

Terms: Buys outright for 50% of the retail price; net 30 days. Customer discounts and payment by installment are available. Retail price set by the gallery and the artist. Gallery pays for shipping costs to gallery. Prefers artwork unframed.

Submissions: Send query letter with bio, brochure, photographs and business card. To show a portfolio, call for appointment. Gallery prefers written correspondence. Files photographs, brochures and biographies.

Tips: Finds artists through visiting exhibitions, word of mouth and various art publications. "Stop by to see our gallery, determine if artwork would be appropriate for our clientele and meet the owner to see if an arrangement is possible."

‡TRAILSIDE AMERICANA FINE ART GALLERIES, 7330 Scottsdale Mall, Scottsdale AZ 85251. (602)945-7751. Fax: (602)946-9025. Contact: Joan M. Griffith. Retail gallery. Estab. 1963. Represents/exhibits approximately 75 emerging, mid-career and established artists/year. Exhibited artists include G. Harvey and Clyde Aspevig. Sponsors 10-12 shows/year. Average display time 2 weeks. Open all year; Monday-Saturday, 10:00-5:30. Located in downtown Scottsdale Old Town; approximately 5,500 sq. ft. 100% of space for gallery artists. Clientele: tourists, upscale, local community and international. 75% private collectors, 25% corporate collectors. Overall price range: $5,000-100,000; most work sold at $5,000-50,000.

Media: Considers oil, pen & ink, acrylic, drawing, sculpture, watercolor, mixed media and pastel. Does not consider prints. Most frequently exhibits oils, bronzes and watercolors.

Style: Exhibits realism and impressionism. Genres include florals, Western, wildlife, Southwestern, landscapes, Americana and figurative work. Prefers Western art, landscapes and impressionism.

Terms: Artwork is accepted on consignment and there is a 33⅓% commission. Retail price set by gallery and artist. Gallery provides insurance, promotion and contract; shipping costs are shared.

Submissions: Send query letter with résumé, slides and bio. Call for appointment to show portfolio of photographs, slides and transparencies. Usually replies only if interested within 2 weeks. Files brochures.

Tips: Finds artists through referrals, word of mouth and artists' submissions.

‡WILDE-MEYER GALLERY, 4142 North Marshall Way, Scottsdale AZ 85251. (602)945-2323. Fax: (602)941-0362. Owner: Betty Wilde. Retail/wholesale gallery and art consultancy. Estab. 1983. Represents/exhibits 40 emerging, mid-career and established artists/year. Exhibited artists include Linda Carter-Holman and Jacqueline Rochester. Sponsors 5-6 shows/year. Average display time 1-12 months rotating. Open all year; Monday-Saturday, 9-6; Sunday, 12-4. Located in downtown Scottsdale in the heart of Art Walk; 2,600 sq. ft.; 20% of space for special exhibitions; 80% of space for gallery artists. Clientele: upscale tourists: local community. 50% private collectors, 50% corporate collectors. Overall price range: $1,000-10,000; most work sold at $1,500-5,000.

Media: Considers all media and all types of prints. Most frequently exhibits original oil/canvas, mixed media and originals on paper.
Style: Exhibits primitivism, painterly abstraction, figurative, landscapes, all styles. All genres. Prefers contemporary artwork.
Terms: Artwork is accepted on consignment and there is a 50% commission. Retail price set by gallery and artist. Insurance and promotion shared 50/50 by artist and gallery. Artist pays for shipping costs.
Submissions: Send query letter with résumé, slides, bio, photographs, SASE, business card, reviews and prices. Write for appointment to show portfolio of photographs, slides, bio and prices. Replies only if interested within 4-6 weeks. Files all material if interested.
Tips: Finds artists through word of mouth, referrals by artists and artists' submissions. "Just do it."

Arkansas

AMERICAN ART GALLERY, 724 Central Ave., Hot Springs National Park AR 71901. (501)624-0550. Retail gallery. Estab. 1990. Represents 22 emerging, mid-career and established artists. Exhibited artists include Jimmie Tucek and Jimmie Leach. Sponsors 12 shows/year. Average display time 1 month. Open all year. Located downtown; 4,000 sq. ft.; 40% of space for special exhibitions. Clientele: private, corporate and the general public. 85% private collectors, 15% corporate collectors. Overall price range: $50-12,000; most work sold at $250-500.
Media: Considers oil, acrylic, watercolor, pastel, pen & ink, sculpture, ceramic, photography, original hand-pulled prints, woodcuts, wood engravings, lithographs and offset reproductions. Most frequently exhibits oil, wood sculpture and watercolor.
Style: Exhibits all styles and genres. Prefers realistic, abstract and impressionistic styles; wildlife, landscapes and floral subjects.
Terms: Accepts work on consignment (35% commission). Retail price set by gallery and the artist. Gallery provides promotion and contract; artist pays for shipping. Offers customer discounts and payment by installments. Prefers artwork framed.
Submissions: Prefers Arkansas artists, but shows 5-6 others yearly. Send query letter with résumé, slides, bio and SASE. Call or write for appointment to show portfolio of originals and slides. Reports in 6 weeks. Files copy of résumé and bio.
Tips: Finds artists through agents, by visiting exhibitions, word of mouth, various art publications and sourcebooks, artists' submissions/self promotions and art collectors' referrals. "We have doubled our floor space and have two floors which allows us to separate the feature artist from the regular artist. We have also upscaled in the quality of art work exhibited. Our new gallery is located between two other galleries."

‡THE ARKANSAS ARTS CENTER, P.O. Box 2137, Little Rock AR 72203. (501)372-4000. Fax: (501)375-8053. Curator of Art: Ruth Pasquine. Curator of Decorative Arts: Allan DuBois. Museum and rental gallery. Estab. 1930s. Exhibits the work of emerging, mid-career and established artists. Sponsors 25 shows/year. Average display time 6 weeks. Open all year. Located downtown; 10,000 sq. ft.; 60% of space for special exhibitions.
Media: Most frequently exhibits drawings and crafts.
Style: Exhibits all styles and all genres.
Terms: Retail price set by the artist. "Work in the competitive exhibitions is for sale; we usually take 10%."
Submissions: "Artists in our rental gallery usually have exhibited in our competitive exhibitions."
Tips: Write for information about exhibitions for emerging and regional artists, and various themed exhibitions.

‡ARKANSAS STATE UNIVERSITY FINE ARTS CENTER GALLERY, P.O. Drawer 1920, State University AR 72467. (501)972-3050. Chair, Gallery Committee: Curtis Steele. University—Art Department Gallery. Estab. 1968. Represents/exhibits 3-4 emerging, mid-career and established artists/year. Sponsors 3-4 shows/year. Average display time 1 month. Open fall, winter and spring; Monday-Friday, 10-4. Located on university campus; 160 sq. ft.; 60% of time devoted to special exhibitions; 40% to faculty and student work. Clientele: students/community.
Media: Considers all media. Considers all types of prints. Most frequently exhibits painting, sculpture and photography.

 The double dagger before a listing indicates that the listing is new in this edition. New markets are often more receptive to freelance submissions.

Style: Exhibits conceptualism, photorealism, neo-expressionism, minimalism, hard-edge geometric abstraction, painterly abstraction, postmodern works, realism, impressionism and pop. "No preference except quality and creativity."
Terms: Exhibition space only; artist responsible for sales. Retail price set by the artist. Gallery provides insurance, promotion and contract; shipping costs are shared. Prefers artwork framed.
Submissions: Send query letter with résumé, slides and SASE. Portfolio should include photographs, transparencies and slides. Replies only if interested within 2 months. Files résumé.
Tips: Finds artists through call for artists published in regional and national art journals.

CANTRELL GALLERY, 8206 Cantrell Rd., Little Rock AR 72207. (501)224-1335. E-mail: ralph227@aol.com. President: Helen Scott; Director: Cindy Huisman. Wholesale/retail gallery. Estab. 1970. Represents/exhibits 75 emerging, mid-career and established artists/year. Exhibited artists include G.H. Rothe and Robin Morris. Sponsors 8-10 shows/year. Average display time 1 month. Open all year; Monday-Saturday, 10-5. Located in the strip center; 3,500 sq. ft.; "we have several rooms and different exhibits going at one time." Clientele: collectors, retail, decorators. Overall price range: $100-10,000; most work sold at $250-3,000.
Media: Considers oil, acrylic, watercolor, pastel, pen & ink, drawing, mixed media, collage, paper, sculpture, woodcut, engraving, lithograph, wood engraving, mezzotint, serigraphs, linocut, etching. Most frequently exhibits etchings, watercolor, mixed media, oils and acrylics.
Style: Exhibits eclectic, all genres.
Terms: Gallery provides insurance and promotion; shipping costs are shared. Prefers artwork unframed.
Submissions: Send query letter with résumé, slides and bio. Write for appointment to show portfolio of originals. Replies in 2 months. Files all material.
Tips: Finds artists through agents, by visiting exhibitions, word of mouth, art publications and sourcebooks, artists' submissions. "Be professional. Be honest."

HERR-CHAMBLISS FINE ARTS, 718 Central Ave., Hot Springs National Park AR 71901-5333. (501)624-7188. Director: Malinda Herr-Chambliss. Retail gallery. Estab. 1988. Represents emerging, mid-career and established artists. Sponsors 12 shows/year. Average display time 1 month. Open all year. Located downtown; 3 floors, 5,000-5,500 sq. ft.; "turn-of-the-century building with art-deco remodeling done in 1950." Overall price range: $50-24,000.
Media: Considers oil, acrylic, watercolor, pastel, pen & ink, drawings, mixed media, sculpture, fiber, glass, etchings, charcoal and large scale work.
Style: Exhibits all styles, specializing in Italian contemporary art.
Terms: "Negotiation is part of acceptance of work, generally commission is 40%." Gallery provides insurance, promotion and contract (depends on negotiations); artist pays for shipping to and from gallery. Prefers artwork framed.
Submissions: Prefers painting and sculpture of regional, national and international artists. Send query letter with résumé, slides, bio, brochure, photographs, SASE, business card and reviews. Do not send any materials that are irreplaceable. Write for appointment to show portfolio of originals, slides, photographs and transparencies. Replies in 4-6 weeks.
Tips: "Slides should include the date, title, medium, size, and directional information. Also, résumé should be succinct and show the number of one-person shows, educational background, group shows, list of articles (as well as enclosure of articles). The neater the presentation, the greater chance the dealer can glean important information quickly. Put yourself behind the dealer's desk, and include what you would like to have for review."

INDIAN PAINTBRUSH GALLERY, INC., Highway 412 W., Siloam Springs AR 72761. (501)524-6920. Owner: Nancy Van Poucke. Retail gallery. Estab. 1979. Represents over 50 emerging, mid-career and established artists. Interested in seeing the work of emerging artists. Exhibited artists include Troy Anderson and Merlin Little Thunder. Sponsors 2-3 shows/year. Average display time 2 weeks. Open all year. Located on bypass; 1,800 sq. ft.; 66% of space for special exhibitions. Clientele: Indian art lovers. 80% private collectors, 20% corporate collectors. Overall price range: $5-5,000; most work sold at $5-2,000.
Media: Considers oil, acrylic, watercolor, pastel, pen & ink, drawings, mixed media, works on paper, sculpture, ceramic, woodcuts, lithographs, etchings, posters, serigraphs and offset reproductions. Most frequently exhibits paintings, sculpture, knives, baskets, pottery.
Style: Exhibits Native American. Genres include Americana, Southwestern, Western.
Terms: Accepts work on consignment (60-70% commission). Buys outright for 50% of retail price. Retail price set by gallery. Offers payment by installments. Gallery provides insurance and promotion; artist pays for shipping. Prefers unframed artwork.
Submissions: Send personal information. Call for appointment to show portfolio of "prints, etc." Replies in 2 weeks.
Tips: Finds artists through visiting exhibitions and word of mouth.

‡TAYLOR'S CONTEMPORANEA FINE ARTS, 516 Central Ave., Hot Springs AR 71901. (501)624-0516. Owner/Director: Carolyn Taylor. Retail gallery. Estab. 1981. Represents emerging, mid-career and established

artists/year. Exhibited artists include Warren Criswell, William Dunlap, Billy De Williams, Robert Evans and David Hostetler. Sponsors 12 shows/year. Average display time 1 month. Open all year, 11-6 daily (closed Monday). Located downtown Central Ave.; 3,000 sq. ft.; 18 ft. ceiling. Outdoor sculpture garden, restored building (circa 1890). 50% of space for special exhibitions; 50-75% of space for gallery artists. Clientele: upscale, local, various. 90% private collectors, 10% corporate collectors. Overall price range $500-50,000; most work sold at $900-5,000.

Media: Considers all media. Considers monoprint and serigraphs. Most frequently exhibits oil, bronze and clay.

Style: Exhibits contemporary work of all genres. Prefers surrealism, primitivism and impressionism.

Terms: Artwork is accepted on consignment and there is a 40% commission. Retail price set by gallery and artist. Gallery provides insurance, promotion and contract. Artist pays for shipping costs. Prefers artwork framed.

Submissions: Send query letter with résumé, slides and SASE. Write for appointment to show portfolio of slides. Replies in 3 months. Files work of artists currently exhibited and future exhibitors.

‡**THEARTFOUNDATION**, 520 Central Ave., Hot Springs AR 71901. (501)623-9847. Fax: (501)623-9847. Retail gallery. Estab. 1988. Represents/exhibits 15 established artists/year. May be interested in seeing the work of emerging artists in the future. Exhibited artists include Benini, Galardini. Sponsors 12 shows/year. Average display time 1 month. Open during monthly Hot Springs Gallery Walks, weekends and by appointment. Located on historic Central Avenue; 5,000 sq. ft.; housed in 1886 brick structure restored in 1988 according to National Historic Preservation Guidelines. Clientele: tourists, upscale, community and students. 90% private collectors, 10% corporate collectors.

Media: Considers all media except prints. Most frequently exhibits painting, sculpture, drawing/photography.

Style: Exhibits contemporary Italian masters.

California

‡**THE ART COLLECTOR**, 4151 Taylor St., San Diego CA 92110. (619)299-3232. Fax: (619)299-8709. Contact: Janet Disraeli. Retail gallery and art consultancy. Estab. 1972. Represents emerging, mid-career and established artists. Exhibited artists include Dan Sayles and Reed Cardwell. Sponsors 2 shows/year. Average display time 1 month. Open all year; Monday-Friday. 1,000 sq. ft.; 100% of space for gallery artists. Clientele: upscale, business, decorators. 50% private collectors, 50% corporate collectors. Overall price range: $175-10,000; most work sold at $450-1,000.

Media: Considers all media and all types of prints. Most frequently exhibits paintings, sculpture, monoprints.

Style: Exhibits all styles. Genres include all genres, especially florals, landscapes and figurative work. Prefers abstract, semi-realistic and realistic.

Terms: Artwork is accepted on consignment and there is a 50% commission. Retail price set by the artist. Gallery provides insurance. Gallery pays for shipping from gallery. Artist pays for shipping to gallery. Prefers artwork framed.

Submissions: Accepts artists from United States only. Send query letter with résumé and slides. Call for appointment to show portfolio of slides. Replies in 2 weeks. Files slides, biographies, information about artist's work.

Tips: Finds artists through artist's submissions and referrals.

‡**ATHENAEUM MUSIC AND ARTS LIBRARY**, 1008 Wall St., La Jolla CA 92037-4419. (619)454-5872. Nonprofit gallery. Estab. 1899. Represents/exhibits emerging, mid-career and established artists. Exhibited artists include Ming Mur-Ray, Italo Scanga and Mauro Staccioli. Sponsors 8 exhibitions/year. Average display time 2 months. Open all year; Tuesday-Saturday, 10:00-5:30; Wednesday 10:00-8:30. Located downtown La Jolla. An original 1921 building designed by architect William Templeton Johnson: 12-foot high wood beam ceilings, casement windows, Spanish-Italianate architecture. 100% of space for special exhibitions. Clientele: tourists, upscale, local community, students and Athenaeum members. 100% private collectors. Overall price range: $100-1,000; most work sold at $100-500.

Media: Considers all media. Considers all types of prints. Most frequently exhibits painting, multi-media and book art.

Style: Exhibits all styles. Genres include florals, portraits, landscapes and figurative work.

Terms: Artwork is accepted on consignment and there is a 15% commission. Retail price set by the artist. Gallery provides insurance and promotion; shipping costs are shared. Prefers artwork framed.

Submissions: Artists must be considered and accepted by the art committee. Send query letter with slides, bio, SASE and reviews. Write for appointment to show portfolio of photographs, slides and transparencies. Replies in 2 months. Files slide and bio only if there is initial interest in artist's work.

Tips: Finds artists through word of mouth and referrals.

BARLETT FINE ARTS GALLERY, 77 West Angela St., Pleasanton CA 94566. (510)846-4322. Owner: Dorothea Barlett. Retail gallery. Estab. 1981. Represents/exhibits 35-50 emerging, mid-career and established artists/year. Sponsors 6-8 shows/year. Average display time 1 month. Open all year Tuesday-Saturday. Located in downtown Pleasanton; 1,800 sq. ft.; excellent lighting from natural room. 70% of space for special exhibitions; 70% of space for gallery artists. Clientele: "wonderful, return customers." 99% private collectors, 1% corporate collectors. Overall price range: $500-3,500; most work sold at under $2,000.
Media: Considers oil, acrylic, watercolor, pastel, drawing, mixed media, collage, paper, sculpture, ceramics, craft, glass, photography, woodcut, engraving, lithograph, wood engraving, mezzotint, serigraphs, linocut and etching. Most frequently exhibits oil, acrylic, etching.
Style: Exhibits painterly abstraction and impressionism. Genres include landscapes, florals and figurative work. Prefers landscapes, figurative and abstract.
Terms: Accepts work on consignment. Retail price set by the gallery. Gallery provides promotion and contract; artist pays shipping costs to and from gallery.
Submissions: Prefers artists from the Bay Area. Send query letter with slides, bio and SASE. Write for appointment to show portfolio of originals, slides and transparencies. Replies only if interested within 1 month. Files only accepted artists' slides and résumés (others returned).
Tips: Finds artists through word of mouth and "my own canvassing. I accept artists with large portfolios/ works or a body of work (at least 20-30 works) to represent the style or objective the artist is currently producing. Slides must include work currently for sale!"

CATHY BAUM & ASSOCIATES, 384 Stevick Dr., Atherton CA 94027. (415)854-5668. Fax: (415)854-8522. Principal: Cathy Baum. Art advisor. Estab. 1976. Keeps files on several hundred artists. Open all year. Clientele: developers, architects, corporations, small businesses and private collectors. 10% private collectors, 90% corporate collectors. Prices are determined by clients' budget requirements.
Media: Considers all media and all types of prints.
Style: Considers all styles and genres.
Terms: Accepts work on consignment (50% commission). Retail price set by artist. Shipping costs are shared. Prefers artwork unframed.
Submissions: Send query letter with résumé, slides, reviews, bio, SASE, retail and wholesale prices. Write for appointment to show portfolio, which should include slides. Replies in 2-3 weeks. Files all accepted material.

‡BOEHM GALLERY, Palomar College, 1140 W. Mission Rd., San Marcos CA 92069-1487. (619)744-1150 ext. 2304. Fax: (619)744-8123. Gallery Director: Louise Kirtland Boehm. Nonprofit gallery. Estab. 1966. Represents/exhibits mid-career artists. May be interested in seeing the work of emerging artists in the future. Generally exhibits 8 artist/year in solo exhibitions, supplemented with faculty, student work. Exhibited artists include David Avalos and Taller de Arte Fronterizo/Border Art Workshop. Sponsors 6 shows/year. Average display time 5 weeks. Open fall and spring semester; Tuesday 10-4; Wednesday-Thursday 10-7; Friday-Saturday 10-2; closed Sunday, Monday and school holidays. Located on the Palomar College campus in San Marcos; 2,000 sq. ft.; 100% of space for special exhibitions. Clientele: local community and students. "Prices range dramatically depending on exhibition type and artist . . . $25 for student works to $10,000 oils and installational sculptural works."
Media: Considers all media. Considers all types of prints. Most frequently exhibits installation art, oils and metal sculpture.
Style: Exhibits all styles. Styles vary.
Terms: If artwork is sold, gallery retains 10% gallery "donation." Gallery provides insurance, promotion and shipping costs.
Submissions: Accepts primarily artists from San Diego area. Send query letter with résumé, slides, reviews and bio. Call or write for appointment to show portfolio of photographs and slides. Replies in 2-3 months. Files artist bio and résumé.
Tips: Finds artists through "word of mouth, or university visits or following local exhibitions. Much referral." Advises artists to show "Clear focus for a solo exhibition and good slides. Lucid, direct artist statement."

‡BORITZER/GRAY GALLERY, 1001-B Colorado Ave., Santa Monica CA 90401. (310)394-6652. Fax: (310)394-2604. Owner: Jim Gray. Retail gallery. Estab. 1989. Represents 12 emerging, mid-career and established artists/year. Exhibited artists include Soonja O. Kim, Eric Johnson. Sponsors 8 shows/year. Average display time 4-5 weeks. Open all year; Tuesday-Saturday, 11-6; by appointment. Located Westside; 2,000

Always enclose a self-addressed, stamped envelope (SASE) with queries and sample packages.

sq. ft.; features industrial/end of 20th century art, sculpture. 100% of space for special exhibitions; 100% of space for gallery artists. Clientele: private collectors, consultants, designers, museums, foundations. 70% private collectors, 30% corporate collectors. Overall price range: $200-500,000; most work sold at $3,000.
Media: Considers oil, acrylic, watercolor, pen & ink, drawing, mixed media, paper, sculpture, photography. Most frequently exhibits sculpture, painting, photography.
Style: Exhibits conceptualism, minimalism, color field, postmodern works, hard-edge geometric abstraction. Prefers sculpture.
Terms: Accepts work on consignment; commission varies. Retail price set by the gallery. Gallery provides insurance, promotion and contract; artist pays shipping costs to and from gallery.
Submissions: Send query letter with résumé, slides, bio, brochure, photographs, SASE and reviews. "We will contact if appropriate." Portfolio should include slides. Replies in 2 weeks. Files material relevant to future interest.
Tips: Finds artists through referrals.

CENTRAL CALIFORNIA ART LEAGUE ART CENTER & GALLERY, 1402 I St., Modesto CA 95354. (209)529-3369. Gallery Director: Fred Gaebe. Cooperative, nonprofit sales and rental gallery. Estab. 1951. Represents 66 emerging, mid-career and established artists. Exhibited artists include Dolores Longbotham, Barbara Brown and Milda Laukkanen. Sponsors 2 shows/year. Average rental and sales display time 3 months. Open all year. Located downtown; 2,500 sq. ft.; in "a historic building, a former county library, consisting of 2 large gallery rooms, entry, large hallway and two classrooms. (Auditorium shared with historical museum upstairs.)" 10% of space for special exhibitions, 90% for gallery artists. Clientele: 75% private collectors, 25% corporate clients. Overall price range: $50-1,300; most artwork sold at $300-800.
Media: Considers oil, pen & ink, works on paper, fiber, acrylic, drawing, sculpture, watercolor, mixed media, ceramic, pastel, collage, photography and original handpulled prints. Most frequently exhibits watercolor, oil and acrylic.
Style: Exhibits mostly impressionism, realism. Will consider all styles and genres. Prefers realism, impressionism and photorealism.
Terms: Artwork is accepted on consignment (30% commission), a Co-op membership fee plus a donation of time and a rental fee for space, which covers 3 months. Retail and rental price set by artist. Customer discounts and payment by installment are available. Gallery provides insurance. Prefers framed artwork.
Submissions: Call for information—we are a co-op gallery with all works subject to jury process."Submit 5 works, ready for hanging, by 4:00 p.m. any Tuesday. Judging is done each Wednesday with results by Thursday afternoon." Portfolio review not accepted.
Tips: Finds artists through referrals from other artists.

‡COAST GALLERIES, Big Sur, Pebble Beach, CA; Wailea, Hana, HI. Mailing address: P.O. Box 223519, Carmel CA 93922. (408)625-4145. Fax: (408)625-3575. Owner: Gary Koeppel. Retail gallery. Estab. 1958. Represents 60 emerging, mid-career and established artists. Sponsors 3-4 shows/year. Open all year. Located in both rural and resort hotel locations; 4 separate galleries—square footage varies, from 900-3,000 sq. ft. "The Hawaii galleries feature Hawaiiana; our Big Sur gallery is constructed of redwood water tanks and features Central California Coast artists and imagery." 100% of space for special exhibitions. Clientele: 90% private collectors, 10% corporate collectors. Overall price range: $25-60,000; most work sold at $400-4,000.
 ● Recently enlarged their Big Sur Coast Gallery.
Media: Considers all media; engravings, lithographs, posters, etchings, wood engravings and serigraphs. Most frequently exhibits bronze sculpture, limited edition prints and watercolor.
Style: Exhibits impressionism and realism. Genres include landscapes, marine and wildlife.
Terms: Accepts work on consignment (50% commission), or buys outright for 40% of retail price (net 30 days.) Retail price set by gallery. Gallery provides insurance, promotion and contract; artist pays for shipping. Prefers artwork framed.
Submissions: Accepts only artists from Hawaii for Maui galleries; coastal and wildlife imagery for California galleries; interested in Central California Coast imagery for Pebble Beach gallery. Send query letter with résumé, slides, bio, brochure, photographs, SASE, business card and reviews. Write for appointment to show portfolio of photographs, slides and transparencies. Replies in 2 weeks.

‡COLLECTOR'S CHOICE, 20352 Laguna Canyon Rd., Laguna Beach CA 92651-1164. Fax: (714)494-8215. Director: Beverly Inskeep. Art consultancy. Estab. 1976. Represents 15 emerging and established artists. Accepts only artists from southern California. Interested in emerging and established artists. Clientele: 78% collectors and tourists, 15% corporate clients. Most artwork sold at $1,000. Offers unusual art & crafts at realistic prices.
Media: Considers all media. Most frequently exhibits portraiture, photography and crafts: chairs and furnishings, toys and whirligigs and garden art.
Style: Exhibits color field, painterly abstraction, minimalism, conceptual, post-modernism, surrealism, impressionism, photorealism, expressionism, neo-expressionism, realism and magic realism. Genres include landscapes, florals, portraits and figurative work. Portraiture and folk art only.

Terms: Accepts work on consignment (40% commission). Retail price set by gallery and artist. Exclusive area representation not required.
Submissions: Send query letter with résumé, brochure, slides and SASE. Write for appointment to show portfolio of originals, slides and transparencies. Material is filed for corporate clients.
Tips: "I look for exceptional point of view rendered in photography or folk art ... could be political, humanistic, humorous or surreal."

CONTEMPORARY CENTER, 2630 W. Sepulveda Blvd., Torrance CA 90505. (310)539-1933. Director: Sharon Fowler. Retail gallery. Estab. 1953. Represents 150 emerging, mid-career and established artists. Exhibited artists include Terry Erickson Brown, Laura Ross. Open all year; Tuesday-Saturday, 10-6; Sunday 12-5; closed Monday. Space is 5,000 sq. ft. "We sell contemporary American crafts along with contemporary production and handmade furniture." Clientele: private collectors, gift seekers, many repeat customers. Overall price range: $20-800; most work sold at $20-200.
Media: Considers paper, sculpture, ceramics, fiber and glass.
Terms: Retail price set by the gallery and the artist.
Submissions: Send query letter with brochure, slides and photographs. Call for appointment to show portfolio of photographs and slides. Replies in 2 weeks.
Tips: Finds artists through word of mouth and attending craft shows. "Be organized with price, product and realistic ship dates."

CREATIVE GROWTH ART CENTER GALLERY, 355 24th St., Oakland CA 94612. (510)836-2340. Fax: (510)836-2349. Executive Director: Irene Ward Brydon. Nonprofit gallery. Estab. 1978. Represents 100 emerging and established artists; 100 adults with disabilities work in an adjacent studio. Exhibited artists include Dwight Mackintosh, Nelson Tygart. Sponsors 10 shows/year. Average display time 5 weeks. Open all year; Monday-Friday, 10-4. Located downtown; 1,200 sq. ft.; classic large white room with movable walls, track lights; visible from the street. 25% of space for special exhibitions; 75% of space for gallery artists. Clientele: private and corporate collectors. 90% private collectors, 10% corporate collectors. Overall price range: $50-4,000; most work sold at $100-250.
● This gallery concentrates mainly on the artists who work in an adjacent studio, but work from other regional or national artists may be considered for group shows. Only outsider and brut art are shown. Brut art is like Brut champagne—raw and undistilled. Most of the artists have not formally studied art, but have a raw talent that is honest and real with a strong narrative quality.
Media: Considers oil, acrylic, watercolor, pastel, pen & ink, drawing, mixed media, collage, paper, sculpture, ceramics, fiber, woodcut, engraving, lithograph, wood engraving, mezzotint, serigraphs, linocut and etching. Most frequently exhibits (2-D) drawing and painting, (3-D) sculpture, hooked rug/tapestries.
Style: Exhibits expressionism, primitivism, color field, naive, folk art, brut. Genres include landscapes, florals and figurative work. Prefers brut/outsider, contemporary, expressionistic.
Terms: Accepts work on consignment (40% commission). Retail price set by the gallery. Gallery provides insurance, promotion and contract; artist pays shipping costs to and from gallery. Prefers artwork framed.
Submissions: Prefers only brut, naive, outsider; works by adult artists with disabilities. Send query letter with résumé, slides, bio. Write for appointment to show portfolio of photographs and slides. Replies only if interested. Files slides and printed material.
Tips: Finds artists through agents, by visiting exhibitions, word of mouth, various art publications and sourcebooks, artists' submissions and networking. "Peruse publications that feature brut and expressionistic art (example: *Raw Vision*)."

CUESTA COLLEGE ART GALLERY, P.O. Box 8106, San Luis Obispo CA 93403-8106. (805)546-3202. Fax: (805)546-3904. E-mail: efournie@bass.cuesta.cc.ca.us. Director: Marta Peluso. Nonprofit gallery. Estab. 1965. Exhibits the work of emerging, mid-career and established artists. Exhibited artists include William T. Wiley and Catherine Wagner. Sponsors 5 shows/year. Average display time 4½ weeks. Open all year. Space is 750 sq. ft.; 100% of space for special exhibitions. Overall price range: $250-5,000; most work sold at $400-1,200.
Media: Considers all media and all types of prints. Most frequently exhibits painting, sculpture and photography.
Style: Exhibits all styles, mostly contemporary.
Terms: Accepts work on consignment (20% commission). Retail price set by artist. Customer discounts and payment by installment are available. Gallery provides insurance, promotion and contract; shipping costs are shared. Prefers artwork framed.
Submissions: Send query letter with résumé, slides, bio, brochure, SASE and reviews. Call for appointment to show portfolio. Replies in 6 months.
Tips: Finds artists mostly by reputation and referrals, sometimes through slides. "Only submit quality fine art. We have a medium budget, thus cannot pay for extensive installations or shipping. Present your work legibly and simply. Include reviews and/or a coherent statement about the work. Don't be too slick or too sloppy."

‡**RITA DEAN GALLERY,** 548 Fifth Ave., San Diego CA 92101. (619)338-8153. Fax: (619)338-0003. Director: J.D. Healy. Retail gallery. Estab. 1988. Represents/exhibits 50 emerging, mid-career and established artists. Exhibited artists include Charles Manson and R. Steven Connett. Sponsors 12 shows/year. Average display time 3 weeks. Open all year; Tuesday-Saturday 12-11; Sunday 12-5; closed Mondays. Located in Gaslamp Quarter downtown; 1,000 sq. ft.; 17 ft. high ceilings, located on heavy tourist traffic street. Originally built for a mortuary. 75% of space for special exhibitions; 25% of space for gallery artists. 100% private collectors. Overall price range: $25-15,000; most work sold at $200-500.
Media: Considers all media except craft and ceramics. Most frequently exhibits photography, oil and installation.
Style: Exhibits conceptualism, primitivism and outsider. Genres include erotic, outsider and provocative. Prefers outsider, erotic and conceptualism.
Terms: Artwork is accepted on consignment and there is a 50% commission. Retail price set by both gallery and artist. Gallery provides promotion; shipping costs are shared. Prefers artwork framed.
Submissions: Call for appointment to show portfolio of photographs, slides and photocopies. Replies in 6 weeks if SASE is included.

‡**DELPHINE GALLERY,** 1324 State St., Santa Barbara CA 93101. Director: Michael Lepere. Retail gallery and custom frame shop. Estab. 1979. Represents/exhibits 10 mid-career artists/year. Exhibited artists include Jim Leonard and Steve Vessels. Sponsors 8 shows/year. Average display time 4-6 weeks. Open all year; Tuesday-Friday, 10-5; Saturday, 10-3. Located downtown Santa Barbara; 300 sq. ft.; natural light (4th wall is glass). 33% of space for special exhibitions. Clientele: upscale, local community. 40% private collectors, 20% corporate collectors. Overall price range: $1,000-4,500; most work sold at $1,000-2,000.
Media: Considers all media except photography, installation and craft. Considers serigraphs. Most frequently exhibits oil on canvas, acrylic on paper and pastel.
Style: Exhibits conceptualism and painterly abstraction. Includes all genres and landscapes.
Terms: Artwork is accepted on consignment and there is a 50% commission. Retail price set by the gallery. Gallery provides insurance and promotion; shipping costs are shared. Prefers artwork unframed.
Submissions: Prefers artists from Santa Barbara/Northern California. Send query letter with résumé, slides and SASE. Write for appointment to show portfolio of slides. Replies in 1 month.
Tips: "Keep your day job, it's tough."

DOWNEY MUSEUM OF ART, 10419 Rives, Downey CA 90241. (310)861-0419. Executive Director: Scott Ward. Museum. Estab. 1957. Interested in emerging and mid-career artists. Sponsors 10 shows/year. Average display time: 6 weeks. Open all year. Located in a suburban park: 3,000 sq. ft. Clientele: locals and regional art audience. 60% private collectors, 40% corporate collectors. Overall price range: $100-10,000; most work sold at $400-3,000.
Media: Considers oil, acrylic, watercolor, pastel, pen & ink, drawings, mixed media, collage, works on paper, sculpture, ceramic, craft, fiber, glass, installation, photography, egg tempera, original handpulled prints, woodcuts, wood engravings, linocuts, engravings, mezzotints, etchings, lithographs, pochoir, serigraphs and computer art.
Style: Exhibits all styles and genres. Prefers California-made art in a wide range of styles.
Terms: Accepts work on consignment (30% commission). Retail price set by artist. Sometimes offers customer discounts and payment by installment. Gallery provides insurance and promotion. Artist pays for shipping. Prefers artwork framed.
Submissions: Send query letter with résumé, slides and SASE. Portfolio review requested if interested in artist's work. Files résumé and slides.
Tips: Finds artists through visiting exhibitions and artists' submissions. "Take care not to underestimate your competition. Submit a complete and professional package."

‡**SOLOMON DUBNICK GALLERY,** 2131 Northrop Ave., Sacramento CA 95825. (916)920-4547. Fax: (916)923-6356. Director: Shirley Dubnick. Retail gallery and art consultancy. Estab. 1981. Represents/exhibits 20 emerging, mid-career and established artists/year. "Must have strong emerging record of exhibits." Exhibited artists include Jerald Silva and Gary Pruner. Sponsors 11-12 shows/year. Average display time 1 month. Open all year; Tuesday-Saturday, 11-6 or by appointment. Located in suburban area on north side of Sacramento; 7,000 sq. ft.; large space with outside sculpture space for large scale, continued exhibition space for our stable of artists, besides exhibition space on 1st floor. Movable walls for unique artist presentations.

Market conditions are constantly changing! If you're still using this book and it is 1997 or later, buy the newest edition of Artist's & Graphic Designer's Market at your favorite bookstore or order directly from Writer's Digest Books.

75% of space for special exhibitions; 25% of space for gallery artists. Clientele: upscale, local, students, national and international clients due to wide advertising of gallery. 80% private collectors, 20% corporate collectors. Overall price range: $500-50,000; most work sold at $2,000-10,000.

Media: Considers oil, pen & ink, paper, acrylic, drawing, sculpture, watercolor, mixed media, ceramics, pastel and photography. Considers original prints produced only by artists already represented by gallery. Most frequently exhibits painting, sculpture and functional sculpture.

Style: Exhibits all styles (exhibits very little abtract paintings unless used in landscape). Genres include landscapes, figurative and contemporary still life. Prefers figurative, realism and color field.

Terms: Artwork is accepted on consignment and there is a 50% commission. Retail price set by the gallery with artist concerns. Gallery provides insurance, promotion and contract; shipping costs are shared (large scale delivery to and from gallery is paid for by artist). Prefers artwork framed.

Submissions: Accepts only artists from California with invited artists outside state. Send query letter with résumé, slides, photographs, reviews, bio and SASE. Call for appointment to show portfolio of photographs, transparencies and slides. Replies only if interested within 3-4 weeks. Files all pertinent materials.

Tips: Finds artists through word of mouth, referrals by other artists, art fairs, advertising in major art magazines and artists' submissions. "Be professional. Do not bring work into gallery without appointment with Director or Assistant Director. Do not approach staff with photographs of work. Be patient."

EUREKA ART CENTER LTD., (DBA: The Art Center), 211 G. St., Eureka CA 95501. (707)443-7017. Gallery Director: Mary Ann Testagrossa. Retail gallery. Estab. 1972. Represents emerging and established artists; 12-15 ceramic artists; 12-15 artists. Exhibited artists include Peggy Loudon—ceramics; Carrie Grant—photography. Sponsors 9 shows/year. Average display time 1 month. Open all year; Monday-Friday, 9-6; Saturday: 9:30-5:30; Sunday noon-4. Located in Old Town, Eureka; 1,700 sq. ft. 66% of space for special exhibitions; 33% of space for gallery artists. Clientele: local partrons, tourists. 90-100% private collectors. Overall price range: $6-1,000; most work sold at $6-600. "The lower range items are ceramic and glass generally."

Media: Considers oil, acrylic, watercolor, pastel, drawing, mixed media, collage, paper, sculpture, ceramics, craft, fiber, glass, photography, woodcut, engraving, lithograph, serigraphs, linocut and etching. Most frequently exhibits watercolors, ceramics, photography.

Style: Exhibits painterly abstraction, impressionism, photorealism, realism and imagism. Genres include landscapes, florals and figurative work. Prefers landscapes (local), florals (figurative), abstract.

Terms: Accepts work on consignment (40% commission). Retail price set by the artist. Gallery provides insurance and promotion; artist pays shipping to and from gallery. Prefers artwork framed.

Submissions: "Most of the work exhibited is by local artists, with some exceptions." Send query letter with résumé, slides, bio, brochure and photographs. Call for appointment to show portfolio of originals, photographs and slides. Replies in 2 weeks. Files résumé, bio sheets.

Tips: Finds artists through visiting exhibitions and artists' submissions. "The more professional the query package is, the better. Call first for an appointment instead of just dropping by."

GALLERY EIGHT, 7464 Girard Ave., La Jolla CA 92037. (619)454-9781. Director: Ruth Newmark. Retail gallery with focus on craft. Estab. 1978. Represents 100 emerging and mid-career artists. Interested in seeing the work of emerging artists. Exhibited artists include Leni Hoch, Thomas Mann. Sponsors 6 shows/year. Average display time 6-8 weeks. Open all year; Monday-Saturday, 10-5. Located downtown; 1,200 sq. ft.; slightly post-modern. 25% of space for special exhibitions; 100% of space for gallery artists. Clientele: upper middle class, mostly 35-60 in age. Overall price range: $5-5,000; most work sold at $25-150.

Media: Considers ceramics, metal, wood, craft, fiber and glass. Most frequently exhibits ceramics, jewelry, other crafts.

Terms: Accepts work on consignment (50% commission) or buys outright for 50% of retail price (net 30 days). Retail price set by the gallery and the artist. Gallery provides insurance, promotion and shipping costs from gallery; artist pays shipping costs to gallery.

Submissions: Send query letter with résumé, slides, photographs, reviews and SASE. Call or write for appointment to show portfolio of photographs and slides. Replies in 1-3 weeks. Files "generally only material relating to work by artists shown at gallery."

Tips: Finds artists by visiting exhibitions, word of mouth, various art publications and sourcebooks, artists' submissions, through agents, and juried fairs. "Make appointments. Do not just walk in and expect us to drop what we are doing to see work."

GALLERY 57, 204 N. Harbor Blvd., Fullerton CA 92632. (714)870-9194. Director of Membership: John Hertzberg. Nonprofit and cooperative gallery. Estab. 1984. Represents 15-20 emerging artists. Sponsors 11 shows/year. Average display time 1 month. Open all year. Located downtown; 1,000 sq. ft., part of "gallery row" in historic downtown area. 100% of space for special exhibitions; 100% for gallery artists. Clientele: wide variety.

Media: Considers, oil, acrylic, watercolor, pastel, drawings, mixed media, collage, works on paper, sculpture, installation, photography, neon and original handpulled prints. Most frequently exhibits mixed media, painting and sculpture.

Style: Considers all styles. Prefers contemporary works.
Terms: There is a co-op membership fee plus a donation of time. Retail price set by the artist. Gallery provides promotion. Artist pays for shipping.
Submissions: Send query letter with résumé, or bio and slides. Call or write to schedule an appointment to show a portfolio, which should include slides and 1-2 originals. Replies in 1 month. Does not file material.
Tips: "Slides are reviewed by the membership on the basis of content, focus and professionalism. The gallery requires a commitment toward a supportive cooperative experience in terms of networking and support."

‡**L. RON HUBBARD GALLERY**, 7051 Hollywood Blvd., Suite 400, Hollywood CA 90028. (213)466-3310. Fax: (213)466-6474. Contact: Joni Labaqui. Retail gallery. Estab. 1987. Represents 14 established artists. Interested in seeing the work of emerging artists in the future. Exhibited artists include Frank Frazetta and Jim Warren. Average display time is 4 months. Open all year. Located downtown; 6,000 sq. ft.; "marble floors, brass ceilings, lots of glass, state-of-the-art lighting." Clientele: "business-oriented people." 90% private collectors, 10% corporate collectors. Overall price range: $200-15,000; most work sold at $4,000-6,000.
Media: Considers oil and acrylic. "Continuous tone offset lithography is all we exhibit."
Style: Exhibits surrealism and realism. Prefers science fiction, fantasy and Western.
Terms: Artwork is bought outright. Retail price set by the gallery.
Submissions: Send query letter with résumé, slides and photographs. Write or call to schedule an appointment to show a portfolio. Replies in 1 week. Files all material, unless return requested.

INTERNATIONAL GALLERY, 643 G St., San Diego CA 92101. (619)235-8255. Director: Stephen Ross. Retail gallery. Estab. 1980. Represents over 50 emerging, mid-career and established artists. Sponsors 6 solo and 6 group shows/year. Average display time is 2 months. Clientele: 99% private collectors. Overall price range: $15-10,000; most artwork sold at $25-500.
Media: Considers sculpture, ceramic, craft, fiber, glass and jewelry.
Style: "Gallery specializes in contemporary crafts (traditional and current), folk and primitive art, as well as naif art."
Terms: Accepts work on consignment. Retail price set by gallery and artist. Exclusive area representation not required. Gallery provides insurance, promotion and contract; shipping costs are shared.
Submissions: Send query letter, résumé, slides and SASE. Call or write for appointment to show portfolio of slides and transparencies. Résumés, work description and sometimes slides are filed. Common mistakes artists make are using poor quality, unlabeled slides or photography and not making an appointment.

JUDY'S FINE ART CONNECTION, 2880-A Grand Ave., Los Olivos CA 93441-0884. (805)688-1222. Owner: Judy Hale. Retail gallery. Estab. 1987. Represents 30 mid-career and established artists. Exhibited artists include Nancy Phelps, Lori Quarton, Herb Ficher, Angie Whitson, Alice Nathan, Dillie Thomas and Janice Alvarez. Sponsors 4 shows/year. Average display time 6 months. Open all year. Located downtown; 1700 sq. ft.; "the gallery is light and airy, with a woman's touch." 20% of space for special exhibitions which are regularly rotated and rehung. Clientele: homeowners, decorators, collectors. Overall price range: $100-5,000; most work sold at $500-2,000.
Media: Considers oil, acrylic, watercolor, pastel, sculpture, ceramic, fiber, original handpulled prints, offset reproductions, lithographs and etching. Most frequently exhibits watercolor, oil and acrylic.
Style: Exhibits impressionism and realism. Genres include landscapes, florals, Southwestern, portraits and figurative work. Prefers figurative work, florals, landscapes, structure.
Terms: Accepts work on consignment (40% commission). Retail price set by artist. Offers payment by installments. Gallery provides insurance and promotion; artist pays for shipping. Prefers artwork framed.
Submissions: Send query letter with bio, brochure, photographs, business card and reviews. Call for appointment to show portfolio of photographs. Replies in 2 weeks. Files bio, brochure and business card.
Tips: "I like 'genuine' people who present quality with fair pricing. They need to be sure to rotate artwork in a reasonable time, if unsold. Also bring in their best work, not the 'seconds' after the show circuit."

‡**JEANNE McDONALD FINE ART**, 505 S. Beverly Dr., Suite 224, Beverly Hills CA 90212. (310)271-7858. Fax: (310)271-7858. Contact: Jeanne McDonald. Private dealer. Estab. 1989. Represents/exhibits established artists. May be interested in seeing the work of emerging artists in the future. Average display time 6 months. Open all year. Open by appointment. Clientele: upscale. 100% private collectors.
Media: Considers all media. Considers all types of prints.
Style: Exhibits all styles. All genres. Prefers contemporary sculpture, painting and prints.
Terms: Artwork is accepted on consignment. Retail price set by gallery. Gallery provides insurance, promotion and contract. Artist pays for shipping costs.
Submissions: Prefers only established artists. Send query letter for appointment to show portfolio of photographs and slides. Replies in 2 months. Unsolicited art materials may not be returned.
Tips: Finds artists through art fairs and referrals.

‡OLIVER ART CENTER—CALIFORNIA COLLEGE OF ARTS & CRAFTS, 5212 Broadway, Oakland CA 94618. (415)653-8118, ext. 198. Fax: (415)655-3541. Director: Dyana Curreri. Nonprofit gallery. Estab. 1989. Exhibits the work of emerging, mid-career and established artists. Sponsors 5-8 shows/year. Average display time 6-8 weeks. Located on the campus of the California College of Arts & Crafts; 3,500 sq. ft. of space for special exhibitions.
Media: Considers all media.
Style: Exhibits contemporary works of various genres and styles. Interested in seeing "works that relate to a cross-cultural audience."
Terms: Gallery provides insurance and promotion, pays for incoming shipping costs to gallery. Prefers artwork framed.
Submissions: Send query letter with résumé, professional quality slides, statement of intent related to slides sent, brochure, photographs, SASE, business card and reviews. Replies in 3 weeks. Files résumé, bio, reviews, 1 slide per artist for slide registry.
Tips: "Proposals for collaborative works or special installations/projects should be accompanied by a complete write-up, including descriptions, costs, rationale, and drawings/slides as available." A frequent mistake artists make is continuing to call even after material has been reviewed and turned down.

ORLANDO GALLERY, 14553 Ventura Blvd., Sherman Oaks CA 91403. Co-Directors: Robert Gino and Don Grant. Retail gallery. Estab. 1958. Represents 30 emerging, mid-career artists and established. Sponsors 22 solo shows/year. Average display time is 1 month. Accepts only California artists. Overall price range: up to $35,000; most artwork sold at $2,500.
Media: Considers oil, acrylic, watercolor, pastel, pen & ink, drawings, mixed media, collage, works on paper, sculpture, ceramic and photography. Most frequently exhibits oil, watercolor and acrylic.
Style: Exhibits painterly abstraction, conceptualism, primitivism, impressionism, photorealism, expressionism, neo-expressionism, realism and surrealism. Genres include landscapes, florals, Americana, figurative work and fantasy illustration. Prefers impressionism, surrealism and realism. Interested in seeing work that is contemporary. Does not want to see decorative art.
Terms: Accepts work on consignment. Retail price set by artist. Offers customer discounts and payment by installments. Exclusive area representation required. Gallery provides insurance and promotion; artist pays for shipping.
Submissions: Send query letter, résumé and slides. Portfolio should include slides and transparencies.
Tips: Finds artists through artists' submissions. "Be creative and be yourself."

‡PALO ALTO CULTURAL CENTER, 1313 Newell Rd., Palo Alto CA 94303. (415)329-2366. Director: Linda Craighead. Nonprofit gallery. Estab. 1971. Exhibits the work of regional and nationally known artists in group and solo exhibitions. Interested in established artists or emerging/mid-career artists who have worked for at least 3 years in their medium. Overall price range: $150-20,000; most artwork sold at $200-3,000.
Media: Considers oil, acrylic, watercolor, pastel, pen & ink, drawings, sculpture, ceramic, fiber, photography, mixed media, collage, glass, installation, decorative art (i.e., furniture, hand-crafted textiles, etc.) and original handpulled prints. "All works on paper must be suitably framed and behind plexiglass." Most frequently exhibits ceramics, painting, photography and fine arts and crafts.
Style: "Our gallery specializes in contemporary and historic art."
Terms: Accepts work on consignment (10-30% commission). Retail price is set by the gallery and the artist. Exclusive area representation not required. Gallery provides insurance, promotion and contract; artist pays for shipping.
Submissions: Send query letter, résumé, slides, business card and SASE.

‡PEPPERS ART GALLERY, 1200 E. Colton, P.O. Box 3080, Redlands CA 92373-0999. (909)793-2121 ext. 3669. Director: Barbara A. Thomason. Nonprofit university gallery. Estab. 1960s. Represents/exhibits 4-6 mid-career and established artists/year. Work not for sale. Open fall and spring; Tuesday-Saturday, 12-4; Sunday, 2-5. Closed January and September. Located in the city of Redlands; 980 sq. ft.; 12' high walls. 100% of space for special exhibitions. Clientele: local community, students. Overall price range: $1,500-10,000.
Media: Considers all media, all types of prints except posters. Most frequently exhibits sculpture, painting and ceramics.
Style: Exhibits expressionism, neo-expressionism, primitivism, painterly abstraction, postmodern works, realism and imagism.
Terms: Gallery provides insurance and promotion; shipping costs are sometimes shared. Prefers artwork framed.
Submissions: Accepts only artists from Southwest. "No earth, conceptual theory based or pattern." Replies in 6-8 months. Files résumés only.
Tips: Finds artists through visiting gallerys and referrals. "Don't follow trends—be true to yourself."

‡POGAN GALLERY, 255 North Lake Blvd., Tahoe City CA 96145. (916)583-0553. Owner/Director: Patti Pogan. Retail gallery. Estab. 1992. Represents/exhibits 25 emerging, mid-career and established artists. Exhib-

ited artists include T.M. Nicholas and Doug Oliver. Sponsors 5 shows/year. Average display time 3 months. Open all year; 7 days a week, 10-5. Located downtown Tahoe City overlooking Lake Tahoe; 1,500 sq. ft.; 100% of space for gallery artists. Clientele: tourist, upscale, 2nd home owners. 95% private collectors, 5% corporate collectors. Overall price range: $250-12,000; most work sold at $750-3,000.

Media: Considers oil, pen & ink, acrylic, drawing, sculpture, glass, watercolor, mixed media, ceramics and pastel. Most frequently exhibits oil, watercolor and sculpture.

Style: Exhibits impressionism and realism. Genres include florals, landscapes, Americana and figurative work. Prefers landscapes, florals and Americana.

Terms: Artwork is accepted on consignment and there is a 50% commission. Retail price set by the artist. Gallery provides insurance, promotion and contract; shipping costs are shared. Prefers artwork framed.

Submissions: Send query letter with résumé, slides, photographs and bio. Replies in 3 weeks. Write for appointment to show portfolio of photographs and slides.

Tips: "Several artists were contacted by us from feature articles in art magazines. We have one artist we do very well with from an art fair, the rest are from artists' submissions. Visit the gallery first and make a realistic evaluation of the work displayed in comparison to your work. If you feel your work is of the same caliber then submit a portfolio; otherwise continue looking for a gallery that is more suitable."

In Granite Range, a watercolor work shown at Pogan Gallery, Dale Laitinen captures "the feel of a sweeping panorama of the wilderness." Owner Patricia Pogan, who discovered Laitinen's work at an art festival, was struck by "the boldness and strength" of his paintings. The piece, which sold for $1,380, is now in the collection of Golden's Company.

© Dalel Laitinen in collection of Golden's Company.

POSNER FINE ART, 1119 Montana Ave., Santa Monica CA 90403. (310)260-8858. Fax: (310)260-8860. Director: Judith Posner. Retail gallery and art publisher. Estab. 1994. Represents 200 emerging, mid-career and established artists. Sponsors 5 shows/year. Average display time 6 weeks. Open all year, Tuesday-Saturday, 10-6; Sunday, 12-5. Located in shopping district; 1,000 sq. ft.; 80% of space for special exhibitions; 20% of space for gallery artists. Clientele: upscale and collectors. 50% private collectors, 50% corporate collectors. Overall price range: $25-50,000; most work sold at $500-10,000.

Media: Considers oil, acrylic, watercolor, pastel, mixed media, collage, works on paper, sculpture, ceramics, original handpulled prints, engravings, etchings, lithographs, posters and serigraphs. Most frequently exhibits paintings, sculpture and original prints.

Style: Exhibits painterly abstraction, minimalism, impressionism, realism, photorealism, pattern painting and hard-edge geometric abstraction. Genres include florals and landscapes. Prefers abstract, trompe l'oeil, realistic.

Terms: Accepts work on consignment (50% commission). Retail price set by the gallery. Customer discount and payment by installments. Gallery provides insurance and promotion; shipping costs are shared. Prefers artwork unframed.

Submissions: Send query letter with résumé, slides and SASE. Portfolio should include slides. Replies only if interested in 2 weeks.
Tips: Finds artists through artists' submissions and art collectors' referrals. "We are looking for images for our new venture which is poster publishing. We will do a catalog. We pay a royalty on posters created."

‡ROCKRIDGE CAFÉ, 5492 College Ave., Oakland CA 94618. (510)653-1567. Manager: Bill Chung. Café gallery. Estab. 1973. Exhibits emerging artists. Membership varies. Exhibited artists include Jerry Doty and Sandy Diamond. Sponsors 20 shows/year. Average display time 2 months. Open all year. Located in a commercial/residential area. "We have space for 2 shows (group or one-person) per 8-week span of time; large, airy dining room with natural light. We provide an enjoyable environment for our patrons to dine and what can be better than viewing art work?" Clientele: urban professionals, 500-1,000 people daily. 100% private collectors. Overall price range: $50-1,000; most artwork sold at $100-300.
Media: Considers oil, acrylic, watercolor, pastel, pen & ink, drawings, mixed media, collage, works on paper, ceramic (flat), craft (flat), fiber, glass (flat), photography. "Will consider any 2-D media." Considers all types of prints. Most frequently exhibits photography, paintings of all types and mixed media. Does not consider sculpture.
Style: Exhibits all styles and genres. "We'll consider any genre or subject matter that would be appropriate to the dining room clientele, by which we mean that we cannot consider subject matter that would be very disturbing or offensive to someone who is eating."
Terms: Artwork is accepted on consignment (no commission). Artist sets retail price. Gallery provides basic promotion. Artist pays for shipping and is responsible for hanging work. Prefers framed artwork.
Submissions: Send query letter with résumé, slides or photographs and SASE or call for information. Call to schedule an appointment to show a portfolio, which should include slides or photographs. Replies in 3 weeks.
Tips: "Samples should include work you would like to have shown, not a representative sampling. Show us 8-15 pieces. Remember to include SASE with written queries."

SAMIMI ART GALLERY, P.O. Box 200, Orinda CA 94563. or 6 Sunrise Hill Rd., Orinda CA 94563. Phone/fax: (510)254-3994. Director: Ellie Samimi. Retail gallery and art consultancy. Estab. 1991. Represents 10 mid-career and established artists/year. May be interested in seeing the work of emerging artists in the future. Exhibited artists include Mehrdad Samimi, Pam Glover. Sponsors 4-5 shows/year. Average display time 1 month. Open all year; Tuesday-Friday, 11:30-5; Saturday, 11-4; by appointment. Located in Orinda Village across from golf course; 400 sq. ft.; interior decor. warm and cozy. 90% of space for special exhibitions; 90% of space for gallery artists. Clientele: collectors/private collectors. 70% private collectors, 30% corporate collectors. Overall price range: $1,000-15,000; most work sold at $3,000.
• This gallery also accepts commissioned artwork and portraits.
Media: Considers oil, acrylic, watercolor, sculpture and engraving. Most frequently exhibits oil, acrylic and sculpture (bronze).
Style: Exhibits impressionism and realism. Genres include landscapes, florals, portraits and figurative work. Prefers impressionism, realism, representational (also sculptures). Accepts work on consignment (40-50% commission). Retail price set by the gallery and the artist. Gallery provides insurance, promotion, contract and shipping costs from gallery; artist pays shipping costs to gallery. Prefers artwork framed.
Submissions: Prefers only oil. Send query letter with résumé, brochure, slides and photographs. Call for appointment to show portfolio of originals, photographs and slides. Replies only if interested within 2 weeks. Files photos, résumé.
Tips: Finds artists through visiting exhibitions, word of mouth.

‡STANFORD UNIVERSITY MUSEUM OF ART, Lomita Dr. at Museum Way, Stanford University, Stanford CA 94305-5060. (415)723-4177. E-mail: hf.hdf@forsythe. stanford.edu. Curator of Modern & Contemporary Art: Hilarie Faberman. Museum. Estab. 1894. Exhibits emerging, mid-career and established artists. Nonprofit organization with 1,500 members. "We do not represent artists, but have shown the work of a wide range of Bay Area, national and international artists." Sponsors 8-10 shows/year. Average display time 10-12 weeks. Open all year; Tuesday-Friday, 10-5; Saturday-Sunday, 1-5. Located on university campus, on highly populated Bay Area peninsula; 3,000 sq. ft.; old building with renovated skylite interior. 99% of space for special exhibitions.
Media: Considers all media, woodcut, wood engraving, engraving, mezzotint, lithograph and serigraph prints. Most frequently exhibits print, photography and painting/sculpture.
Style: Exhibits all styles. Includes all genres. Gallery provides insurance, promotion and shipping costs. Prefers artwork framed.
Submissions: Send query letter with résumé, slides, bio and SASE. Write for appointment to show portfolio of photographs, transparencies and slides. Replies in 1-2 months. Files résumés/slides of artists of interest for future exhibitions.

‡JUNE STEINGART GALLERY, Laney College, Tower Bldg., 900 Fallon St., Oakland CA 94607. (510)464-3586. Director: Ana Montano. University art gallery. Estab. 1993. Represents/exhibits 12-20 emerging and

mid-career artists/year. Interested in seeing the work of emerging artists. Exhibited artists include Jose R. Lerma. Sponsors 8-10 shows/year. Average display time 5 weeks. Open all year; closed school holidays; Monday-Wednesday, 11-5; Tuesday-Thursday, 11-7; downtown. 10% of space for special exhibitions; 90% of space for gallery artists. Clientele: local community, students, faculty. Overall price range: $150-1,000; most work sold at $150-500.

Media: Considers all media and prints. Most frequently exhibits acrylics, pastel and mixed media.

Terms: Artwork is accepted on consignment and there is a 50% commission. Retail price set by gallery. Gallery provides insurance, promotion, contract and pays shipping costs. Prefers artwork framed.

Submissions: Send query letter with slides, reviews and bio. Call or write for appointment to show photographs and slides. Files résumé/bio and slides or photos of work.

Tips: Finds artists through gallery and studio visits, artists' submissions and recommendations.

SUSAN STREET FINE ART GALLERY, 444 S. Cedros Ave., Studio 100, Solana Beach CA 92075. (619)793-4442. Fax: (619)793-4491. Gallery Director: Jennifer Faist. Retail and wholesale gallery, art consultancy. Estab. 1984. Represents emerging, mid-career and established artists. Exhibited artists include Joseph Maruska, Marcia Burtt. Sponsors 3-4 shows/year. Average display time 1-2 months. Open all year; Monday-Friday, 9:30-5; Saturday, 12-4 and by appointment. Located in North San Diego County coastal; 2,000 sq. ft.; 16 foot ceiling lobby, unique artist-designed counter, custom framing design area. 50% of space for special exhibitions; 50% of space for gallery artists. Clientele: corporate, residential, designers. 30% private collectors, 70% corporate collectors. Overall price range: $125-15,000; most work sold at $400-2,000.

Media: Considers oil, acrylic, watercolor, pastel, pen & ink, mixed media, collage, sculpture, ceramics, glass and photography. Considers all types of prints. Most frequently exhibits painting (oil/acrylic/mixed media), sculpture, ceramics.

Style: Exhibits all styles, all genres. Prefers impressionism, abstract expressionism and minimalism.

Terms: Accepts work on consignment (50% commission). Retail price set by the artist. Gallery provides insurance, promotion; shipping costs are shared. Prefers artwork unframed.

Submissions: Send query letter with résumé, slides, bio, business card, reviews, price list and SASE. Call for appointment to show portfolio of slides. Replies in 1 month.

Tips: Finds artists through referrals, scouting fairs and exhibitions, slide submissions.

‡SWEET ART, 204 Fox St., Ojai CA 93023. (805)646-5252. Fax: (805)640-1213. Owner: Deborist sans Burke. Alternative space. Estab. 1989. Represents/exhibits 50-100 emerging and mid-career artists/year. Exhibited artists include Diane Fabiano and Brian Morgen. Average display time 1 month. Open all year by appointment only due to flooding; downtown; less than 1,600 sq. ft. "My gallery is primarily for the 'art education' of children. Sweet Art also sponsors a traveling exhibit called "The Galloping Gallery" that accesses private and public schools, presenting a 45 minute program to K-8 classrooms of local, living artists." 70% of space for special exhibitions; 30% of space for gallery artists. Overall price range: $50-1,200.

Media: Considers all media except photography or erotica. Considers all types of prints. Most frequently exhibits watercolor, oil-pastel and sculpture.

Style: Exhibits all styles. Includes all genres but erotica. Prefers realism, abstract and primitivism.

Terms: Artwork is accepted on consignment and there is a 50% commission or is bought outright for 50% of the retail price; net 30 days. Retail price set by the gallery and the artist. Gallery provides promotion; shipping costs are shared. Prefers artwork framed.

Submissions: Only exhibits art that is suitable for a child's eye. Send query letter with résumé, slides, bio and SASE. Write for appointment to show portfolio of photographs. Replies in 1 month. Files everything sent.

Tips: Finds artists through word of mouth, referrals by other artists, *Art Business, Art in America*; trips to Los Angeles and Santa Monica. "I have no advice but Mr. Campbell's: 'Do what you love . . . the money will follow.' "

TARBOX GALLERY, 1202 Kettner Blvd., San Diego CA 92101. (619)234-5020. Owner-Director: Ruth R. Tarbox. Retail gallery. Estab. 1969. Represents 75 emerging, mid-career and established artists. Sponsors 5 or 6 solo and group shows alternately/year. Average display time is 1 month. "Located in a building with a center built as an open atrium (glass enclosed) beside two award-winning restaurants. Our walls are moveable; acquisition of a second gallery brings total area to 4,000 sq. ft." Clientele: "In addition to tourists who frequently like local landscapes, the majority of our customers are diners at the top restaurant in the building, "Rainwaters," where the power lunch crowd eat. So, we try to offer a wide variety of art and subject matter." 60% collectors, 40% corporate clients. Overall price range: $35 poster to $6,000 originals; average sale $1,000.

Media: Considers oil, acrylic, watercolor, pastel, mixed media, collage and sculpture in all media.

Style: Exhibits painterly abstraction, primitivism, impressionism and realism. Genres include landscapes, florals, Southwestern, and figurative work. Prefers landscapes. "Our gallery already has some excellent watercolorists, and we would like to augment these with artists in oil working in contemporary themes."

Terms: Accepts work on consignment (50% commission). Retail price set by gallery and artist. Offers customer discounts and payment by installments. Exclusive area representation required within 10-mile radius. Gallery provides insurance, promotion and contract; shipping costs are shared.
Submissions: Send query letter first, with résumé, slides (signed, sized and described) and SASE. From these the gallery can determine if this work will find a ready market in this area. Indicate pricing and medium. Call or write for appointment to show portfolio of originals (at least 1) and slides. Resumes of promising artists are filed. "Slides are returned, but please include SASE."
Tips: Finds artists through word of mouth and "personal discovery on trips. There is interest in landscapes, pleasing colors and effects. This gallery is always interested in new artists but we are not taking new ones unless we feel they offer something different or the market seems to be improving."

THIRD FLOOR GALLERY, California State University, Chico-Bell Memorial Union, Chico CA 95929-0750. (916)898-5079. Fax: (916)898-4717. E-mail: jslaughter@oavax.csuchico.edu. Gallery Coordinator: Marlys Williams. Owned and operated by Associated Students. Represents emerging, mid-career and established artists. Sponsors 7 shows/year. Average display time 1 month. Open all year; Monday-Thursday, 7am-midnight; Friday, 7-5; Saturday, 11-5, Sunday, 12-12. Call for summer hours. Located on downtown campus. 100% of space for special exhibitions.
Media: Considers oil, acrylic, watercolor, pastel, pen & ink, drawing, mixed media, collage, paper, wall sculpture, ceramics, craft, fiber, glass, photography, woodcut, engraving, lithograph, wood engraving, mezzotint, serigraphs, linocut, etching and posters. Most frequently exhibits oil, acrylic, watercolor, ceramics.
Style: Exhibits all styles, all genres.
Terms: Accepts work on consignment (20% commission). Retail price set by the artist. Gallery provides reception, insurance, promotion, contract, artist pays shipping costs. Prefers artwork framed, ready to hang.
Submissions: Send query letter with résumé, slides, brochure, photographs and SASE. Write for appointment to show portfolio of slides. Replies in "spring months only."
Tips: Finds artists through visiting exhibitions, word of mouth, artists' submissions. "Call first."

‡RICHARD BARCLAY TULLIS II—TULLIS FINE ART, 1 N. Salsipuedes, #9, Santa Barbara CA 93103. (805)965-1091. Fax: (805)965-1093. E-mail: rbt9@aol.com. Director: Richard Tullis II. Wholesale gallery. Specializes in collaborations between artists and master printer. Exploration of material and image making on handmade paper and wood. Estab. 1992. Represents/exhibits 40 emerging, mid-career and established artists. Interested in seeing the work of artists. Exhibited artists include Charles Arnoldi, Per Kirkeby. Sponsors 4 shows/year. Average display time 1 month. Hours are flexible (by appointment) around projects. Located in industrial area; 6,500 sq. ft.; sky lights in saw tooth roof; 27' ceiling. 65% of space for special exhibitions. Clientele: wholesale and special collectors. 20% private collectors. Overall price range: $1,000-30,000; most work sold at $2,000-6,000.
Media: Considers oil, paper, mixed media and pastel. Most frequently exhibits unique works on paper and photography.
Style: Exhibits conceptualism, minimalism, pattern painting, hard-edge geometric abstraction, painterly abstraction and realism. Genres include landscapes and figurative work. Prefers geometric abstraction, abstraction and figurative/landscape.
Terms: Retail price set by gallery and artist.
Submissions: Send query letter with photographs and reviews. Write for appointment to show portfolio of transparencies. Replies only if interested. Files bio and slides.
Tips: Finds artists through referrals by artists, visiting exhibitions.

‡WEIR GALLERY, 1605 Solano Ave., Berkeley CA 94707. (510)524-8821. E-mail: weir@well.s.f. Director: Roberta Weir. Retail gallery. Estab. 1987. Represents 12-15 emerging, mid-career and established artists. Exhibited artists include Jerry Garcia, Tony Speirs and Harriet Moore. Sponsors 6-8 shows/year. Average display time 6 weeks. Open all year. Located in North Berkeley; 1,000 sq. ft. 70% of space for special exhibitions. 100% private collectors. Overall price range: $500-25,000; most work sold at $1,000-5,000.
Media: Considers oil, acrylic, watercolor, pastel, pen & ink, drawings, mixed media, collage, sculpture, ceramic, photography, original handpulled prints, woodcuts, wood engravings, linocuts, engravings, mezzotints, etchings, lithographs and serigraphs. Most frequently exhibits sculpture, etching, oil and watercolor painting.
Style: Exhibits expressionism, neo-expressionism and realism. Genres include landscapes and figurative work. Prefers realism, expressionism and surrealism.
Terms: Accepts artwork on consignment (50% commission); buys outright for 50-80% of the retail price (net 30 days). Retail price set by the artist. Shipping costs are shared. Prefers artwork framed.
Submissions: Send query letter with résumé, slides and SASE. Call to schedule an appointment to show a portfolio, which should include photographs and slides. Replies only if interested in 6 weeks. Files artwork as slides for future reference.
Tips: "Stop by if possible to acquaint yourself with our esthetic."

THE WING GALLERY, 13520 Ventura Blvd., Sherman Oaks CA 91423. (818)981-WING and (800)422-WING. Fax: (818)981-ARTS. Director: Robin Wing. Retail gallery. Estab. 1974. Represents 100+ emerging, mid-career and established artists. Exhibited artists include Doolittle and Wysocki. Sponsors 6 shows/year. Average display time 2 weeks-3 months. Open all year. Located on a main boulvard in a charming freestanding building, separate rooms, hardwood floors/carpet, skylights; separate frame design area. 80% of space for special exhibitions. Clientele: 90% private collectors, 10% corporate collectors. Overall price range: $50-50,000; most work sold at $150-5,000.
Media: Considers oil, acrylic, watercolor, pen & ink, drawings, sculpture, ceramic, craft, glass, original handpulled prints, offset reproductions, engravings, lithographs, monoprints and serigraphs. Most frequently exhibits offset reproductions, watercolor and sculpture.
Style: Exhibits primitivism, impressionism, realism and photorealism. Genres include landscapes, Americana, Southwestern, Western, wildlife and fantasy.
Terms: Accepts work on consignment (40-50% commission). Retail price set by gallery and artist. Sometimes offers customer discounts and payment by installments. Gallery provides insurance, promotion and contract; shipping costs are shared. Prefers unframed artwork.
Submissions: Send query letter with résumé, slides, bio, brochure, photographs, SASE, reviews and price list. "Send complete information with your work regarding price, size, medium, etc., and make an appointment before dropping by." Portfolio reviews requested if interested in artist's work. Replies in 1-2 months. Files current information and slides.
Tips: Finds artists through agents, by visiting exhibitions, word of mouth, various publications, artists' submissions, and referrals.

ZANTMAN ART GALLERIES LTD., P.O. Box 5818, 6th & Mission, Carmel CA 93921. (408)624-8314. Fax: (408)626-8408. President: Steven A. Huish. Retail gallery with 4 locations in California. Estab. 1959. Represents 50-60 emerging, mid-career and established artists. Exhibited artists include Duane Alt, Luccio Sollazzi. Sponsors 12 shows/year. Average display time 3 weeks. Open all year; daily, 10-5:30. 2 locations in Carmel-By-The-Sea, 1 location in Palm Desert, 1 location in San Francisco; 4,000, 2,500, 3,900, 2,900 sq. ft. respectively. 25% of space for special exhibitions; 75% of space for gallery artists. Clientele: international. 95% private collectors, 5% corporate collectors. Overall price range: $50-100,000 "sometimes higher;" most work sold at $1,500-3,500.
Media: Considers oil, acrylic, watercolor, pastel, pen & ink, mixed media, paper, sculpture, ceramics, craft, fiber, glass, lithograph, mezzotint, serigraphs, etching and posters. Most frequently exhibits oil, acrylic, watercolor.
Style: Exhibits expressionism, neo-expressionism, primitivism, painterly abstraction, surrealism, impressionism, photorealism, hard-edge geometric abstraction and realism. Genres include landscapes, florals, Americana, Southwestern, Western, wildlife, portraits, figurative work, all genres. Prefers landscapes, figurative paintings and sculpture, still life.
Terms: Accepts work on consignment (50% commission). Retail price set by the gallery and the artist. Gallery provides insurance, promotion and shipping costs from gallery; artist pays shipping costs to gallery. Prefers artwork framed.
Submissions: Send query letter with résumé, slides, bio, brochure, photographs, reviews and SASE. Write for appointment to show portfolio of photographs, slides and transparencies. Replies in 3 weeks.
Tips: Finds artists through artists' submissions, travel exhibitions, publications, referrals.

Los Angeles

COUNTY OF LOS ANGELES CENTURY GALLERY, 13000 Sayre St., Sylmar CA 91342. (818)362-3220, Director: Lee Musgrave. Municipal gallery. Estab. 1977. Exhibits emerging and mid-career artists. Presents 7 group "theme" exhibits/year. Average display time 1 month. Open all year; Monday-Friday, 10-5. Located in the northeast end of San Fernando Valley; 2,800 sq. ft.
Media: Considers all media and all types of prints.
Style: Exhibits all styles, all genres.
Terms: Accepts work on consignment (20% commission). Retail price set by the gallery and the artist. Gallery provides insurance, promotion and contract; artist pays shipping costs to and from gallery. Prefers artwork framed.
Submissions: Prefers only artists from California. Send query letter with résumé, slides, reviews and SASE. Call for appointment. Replies in 1 month.
Tips: Finds artists through visiting exhibitions, art publications and artists' submissions.

SHERRY FRUMKIN GALLERY, 2525 Michigan Ave., #T-1, Santa Monica CA 90404-4011. (310)453-1850. Fax: (310)453-8370. Retail gallery. Estab. 1990. Represents 20 emerging, mid-career and established artists. Interested in seeing the work of emerging artists. Exhibited artists include Ron Pippin, David Gilhooly and James Strombotne. Sponsors 11 shows/year. Average display time 1 month. Open all year; Tuesday-Saturday, 10:30-5:30. Located in the Bergamot Station Arts Center; 3,000 sq. ft. in converted warehouse with 16 ft.

ceilings, skylights. 25% of space for special exhibitions; 75% of space for gallery artists. Clientele: upscale, creative arts, i.e. directors, actors, producers. 80% private collectors, 20% corporate collectors. Overall price range: $1,000-25,000; most work sold at $2,000-5,000.
Media: Considers oil, acrylic, mixed media, collage, pen & ink, sculpture, ceramic and installation. Considers wood engraving, linocut, mezzotint and etching. Most frequently exhibits assemblage sculpture, paintings and photography.
Style: Exhibits expressionism, neo-expressionism, conceptualism, painterly abstraction and postmodern works. Prefers expressionism, painterly abstraction and postmodern.
Terms: Accepts work on consignment (50% commission). Retail price set by gallery and artist. Offers payment by installments. Gallery provides insurance and promotion; shipping costs are shared. Prefers artwork framed.
Submissions: Send query letter with résumé, slides, reviews and SASE. Portfolio review requested if interested in artist's work. Portfolio should include slides and transparencies. Replies in 1 month. Files résumé and slides.
Tips: "Present a coherent body of work, neatly and professionally presented. Follow up, but do not become a nuisance."

‡**GALLERY WEST**, 107 S. Robertson Blvd., Los Angeles CA 90048. (310)271-1145. Director: Roberta Feuerstein. Retail gallery. Estab. 1971. Represents/exhibits 30 emerging, mid-career and established artists/year. Exhibited artists include Tom Gathman and Dorothy Gillespie. Sponsors 7 show/year. Average display time 5 weeks. Open all year; Tuesday-Saturday, 10:30-5. Located in West Hollywood; 1,720 sq. ft.; 70% of space for special exhibitions; 30% of space for gallery artists. Clientele: tourists, upscale, local community, students, corporate. 85% private collectors, 15% corporate collectors.
Overall price range: $250-75,000; most work sold at $1,500-6,000.
Media: Considers all media except photography. Considers serigraphs. Most frequently exhibits paintings, wall constructions and sculpture.
Style: Exhibits photorealism, pattern painting, color field, hard-edge geometric abstraction, painterly abstraction and realism.
Terms: Artwork is accepted on consignment and there is a 50% commission. Retail price set by gallery and artist. Gallery provides insurance and promotion; shipping costs are shared. Prefers artwork framed.
Submissions: Accepts only artists from USA. Send query letter with slides and bio. Call for appointment to show portfolio of slides. Replies in 2 weeks. Files slides and bio.
Tips: Finds artists through word of mouth, referrals by other artists, art fairs, artist submissions. "Send in a clearly labeled sheet of slides and concise bio for review."

LA LUZ DE JESUS GALLERY, Upstairs, 7400 Melrose Ave., Los Angeles CA 90046. (213)651-4875. Fax: (213)651-0917. Gallery Director: Alix Sloan. Retail gallery, retail store attached with ethnic/religious merchandise. "We provide a Space for low brow/cutting edge and alternative artists to show their work." Estab. 1976. Represents emerging, mid-career and established artists. Exhibited artists include Joe Coleman, S. Clay Wilson. Sponsors 12 shows/year; "each show ranges from 1 person to large group (as many as 50)" Average display time 3½ weeks. Open all year; Sunday-Thursday, 12-7; Friday-Saturday, 12-11. Located on Melrose Ave. between Fairfax and LaBrea; 4,800 sq. ft.; interesting and colorful shop attached, french windows, light and airy. 100% of space for special exhibitions; 100% of space for gallery artists. Clientele: "mostly young entertainment biz types, celebrities, studio and record company types, other artists, business people, tourists." 95% private collectors, 5% corporate collectors. Overall price range: $100-10,000; most work sold at $200-2,500.
Media: Considers all media. Considers all types of prints, which are usually shown with paintings and drawings by the same artist. Most frequently exhibits acrylic or oil, pen & ink.
Style: Exhibits alternative, underground, comix-inspired. Prefers alternative/underground/cutting-edge, conix-inspired.
Terms: Accepts work on consignment (50% commission). Retail price set by the gallery and the artist."We ask for an idea of what artist thinks and discuss it." Gallery provides insurance, promotion, contract. Gallery pays shipping costs from gallery, artist pays shipping costs to gallery, buyer pays for shipping if piece goes out of town. Prefers artwork framed.
Submissions: Send query letter with résumé, slides, bio, photographs, SASE, reviews and an idea price range for artist's work. Replies in 2 months.
Tips: Finds artists through word of mouth (particularly from other artists), artists' submissions, visiting exhibitions. "Visit the space before contacting us. If you are out of town ask a friend to visit and give you an idea. We are a very different gallery."

LIZARDI/HARP GALLERY, 8678 Melrose Ave., Los Angeles CA 90069. (310)358-5680. Fax: (310)358-5683. Director: Grady Harp. Retail gallery and art consultancy. Estab. 1981. Represents 15 emerging, mid-career and established artists/year. Exhibited artists include Jim Morphesis, Brad Durham, Christopher James, Walter Askin, Christopher Piazza, Yoshikawa, Stephen Freedman, Kirk Pedersen and Robin Palanker. Sponsors 9 shows/year. Average display time 1 month. Open all year; Monday-Saturday. 80% private collectors,

20% corporate collectors. Overall price range: $900-40,000; most work sold at $2,000-8,000.
Media: Considers oil, acrylic, watercolor, pastel, pen & ink, drawing, mixed media, sculpture, installation, photography, woodcut, lithograph, serigraphs and etchings. Most frequently exhibits works on paper and canvas, sculpture, photography.
Style: Exhibits expressionism, abstraction, postmodern works, photorealism and realism. Genres include landscapes, figurative work, all genres. Prefers figurative, landscapes and experimental.
Terms: Accepts work on consignment (50% commission). Retail price set by the gallery and the artist. Gallery provides insurance, promotion, contract and shipping costs from gallery; artist pays shipping costs to gallery.
Submissions: Send query letter with résumé, slides, bio, photographs, SASE and reviews. Write for appointment to show portfolio of photographs, slides and transparencies. Replies in 3-4 weeks. Files "all interesting applications."
Tips: Finds artists through studio visits, group shows, artists' submissions. "Timelessness of message is a plus (rather than trendy)."

LOS ANGELES MUNICIPAL ART GALLERY, Barnsdall Art Park, 4804 Hollywood Blvd., Los Angeles CA 90027. (213)485-4581. Curator: Noel Korten. Nonprofit gallery. Estab. 1971. Interested in emerging, mid-career and established artists. Sponsors 5 solo and group shows/year. Average display time 2 months. 10,000 sq. ft. Accepts primarily Los Angeles artists.
● LAMAG is funded by the Dept. of Cultural Affairs of the City of Los Angeles. Although mainly interested in Southern California and L.A. artists, a public works program is open to national artists.
Media: Considers oil, acrylic, watercolor, pastel, pen & ink, drawings, contemporary sculpture, ceramic, fiber, photography, craft, mixed media, performance art, collage, glass, installation and original handpulled prints.
Style: Exhibits contemporary works only. "We organize and present exhibitions which primarily illustrate the significant developments and achievements of living Southern California artists. The gallery strives to present works of the highest quality in a broad range of media and styles. Programs reflect the diversity of cultural activities in the visual arts in Los Angeles."
Terms: Gallery provides insurance, promotion and contract. This is a curated exhibition space, not a sales gallery.
Submissions: Send query letter, résumé, brochure, slides and photographs. Slides and résumés are filed. Submit slides to Susan Johannsen, Cultural Affairs Dept., Slide Registry, %the gallery at the above address.
Tips: Finds artists through submissions to slide registry. "No limits—contemporary only."

‡OTIS GALLERY, 2401 Wilshire Blvd., Los Angeles CA 90057. (213)251-0555. Fax: (213)480-0059. Director: Dr. Anne Ayres. Nonprofit college gallery. Represents/exhibits 10-50 emerging and mid-career artists/year. Exhibited artists include Meg Cranston and Nancy Evans. Sponsors 4 shows/year. Average display time 2 months. Open fall, winter, spring—sometimes summer; Tuesday-Saturday, 10-5. Located just west of downtown Los Angeles; 3,000 sq. ft.; 14' ceiling. 100% of space devoted to special exhibitions by gallery artists. Clientele: all types. Work is exhibited, not sold.
Media: Considers all media and all types of prints. Most frequently exhibits painting, sculpture and media.
Style: Exhibits conceptualism all styles. Prefers contemporary.
Terms: Gallery provides insurance, promotion, contract and shipping costs.
Submissions: Send query letter with résumé and 33mm slides.
Tips: Finds artists through word of mouth, studio visits and attending other exhibitions.

VICTOR SALMONES SCULPTURE GARDEN, (formerly Victor Salmones Gallery, Beverly Hills, Inc.), 433 N. Camden Dr., Suite 1200, Beverly Hills CA 90210. (310)271-1297. Fax: (310)205-2088. Vice President: Travis Hansson. Retail and wholesale gallery. Estab. 1962. Represents 4 established artists/year. Interested in seeing the work of emerging artists. Exhibited artists include Victor Salmones, Robert Toll. Sponsors 3 shows/year. Average display time 3 months. Open all year; Monday-Saturday, 10-5. Space is 20,000 sq. ft.; very architectural—showing mainly large sculpture. 100% of space for gallery artists. Clientele: corporate and private. 90% private collectors, 10% corporate collectors. Overall price range: $15,000-250,000; most work sold at $15,000-50,000.
Media: Considers sculpture only. Most frequently exhibits bronze, stones, steel.
Style: Exhibits all styles, all genres; prefers figurative work and cubism.
Terms: Retail price set by the gallery. Gallery provides insurance, promotion and contract. Shipping costs are shared.
Submissions: Send query letter with bio and photographs. Write for appointment to show portfolio of photographs. Replies only if interested within 1 week. Files only photos.
Tips: Finds artists through agents, by visiting exhibitions, word of mouth, various art publications and sourcebooks, artists' submissions.

SYLVIA WHITE CONTEMPORARY ARTISTS' SERVICES, 2022 B Broadway, Santa Monica CA 90404. (310)828-6200. Owner: Sylvia White. Retail gallery, art consultancy and artist's career development services.

Estab. 1979. Represents 20 emerging, mid-career and established artists. Interested in seeing work of emerging artists. Exhibited artists include Martin Mull, John White. Sponsors 12 shows/year. Average display time 1 month. Open all year; Tuesday-Saturday, 11-6. Located in downtown Santa Monica; 2,000 sq. ft.; 100% of space for special exhibitions. Clientele: upscale. 50% private collectors, 50% corporate collectors. Overall price range: $1,000-10,000; most work sold at $3,000.

• Sylvia White also has a location in Soho in New York City, see listing in New York section.

Media: Considers all media, engraving, mezzotint, lithograph and serigraphs. Most frequently exhibits painting and sculpture.

Style: Exhibits all styles, including painterly abstraction and conceptualism.

Terms: Retail price set by gallery and artist. Gallery provides insurance, promotion and contract. Artist pays for shipping costs.

Submissions: Send query letter with résumé, slides, bio and SASE. Portfolio should include slides.

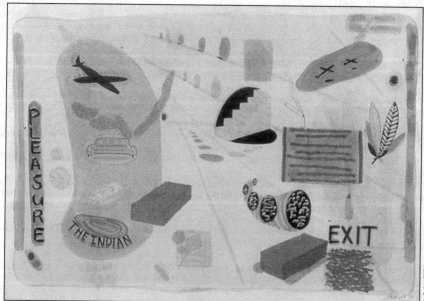

© John White.

John White's abstract piece Travelogue #2 *is a landscape based on images from various trips taken by the artist. The work in ink, paint and pencil on paper was part of a series completed during the artist's Djerassi Foundation Fellowship residency. White's work is handled by Sylvia White's Contemporary Artist's Services, a management consulting firm specializing in career development of visual artists.*

San Francisco

‡A.R.T.S. RESOURCE, 545 Sutter St., #305, San Francisco CA 94102. (415)775-0709. Director: Will Stone. Art consultancy and artist's management agency. Estab. 1972. Represents 6-10 emerging, mid-career and established artists/year. Exhibited artists include Arthur Bell and Lee Madison. Sponsors 4-6 shows/year. Average display time 4-6 weeks. Open September-June by appointment. Located downtown—Union Square; 600 sq. ft.; 80% private collectors, 20% corporate collectors. Overall price range: $500-10,000; most work sold at $1,200-3,000.

Media: Considers all media and all types of prints. Most frequently exhibits painting, sculpture and photography.

Style: Exhibits all styles and all genres. Prefers surrealism, expressionism and photorealism.

Terms: Artwork is accepted on consignment and there is a 50% commission. Retail price set by gallery and artist. Gallery provides contract. Artist pays for shipping costs. Prefers artwork unframed.

Submissions: Send query letter with résumé slides, bio, SASE and evaluation fee. Portfolio should include slides and artist's statement. Replies in 3-6 weeks. Files all material.

Tips: "Persevere. Form good business practices—get an agent."

‡AUROBORA PRESS, 147 Natoma St., San Francisco CA. (415)546-7880. Fax: (415)546-7881. Directors: Michael Dunev and Michael Liener. Retail gallery and fine arts press. Invitational Press dedicated to the monoprint and monotype medium. Estab. 1991. Represents/exhibits emerging, mid-career and established artists. Exhibited artists include William Y. Wiley and Charles Arnoldi. Sponsors 10 shows/year. Average display time 4-6 weeks. Open all year; Monday-Saturday, 11-5. Located south of Market—Yerba Buena; 1,000 sq. ft.; turn of the century firehouse—converted into gallery and press area. Clientele: collectors, tourists and consultants. Overall price range: $1,200-6,000; most work sold at $1,500-4,000.
 • Aurobora Press invites artists each year to spend a period of time in residency working with Master Printers.
Media: Considers and prefers monotypes.
Terms: Retail price set by gallery and artist. Gallery provides promotion.
Submissions: By invitation only.

‡J.J. BROOKINGS GALLERY, 669 Mission St., San Francisco CA 94025. (415)546-1000. Director: Timothy Duran. Retail gallery. Estab. 1970. Of artists represented 15% are emerging, 25% are mid-career and 60% are established. Exhibited artists include Ansel Adams, Robert Motherwell, Ben Schemzeit, Donald Sultan, Richard Diebenkorn, Sandy Skoglund and James Crable. Sponsors 10-12 shows/year. Average display time 1 month in rotation. Open all year; Tuesday-Sunday, 10-5:30. Located next to San Francisco MOMA and Moscone Center; 7,500 sq. ft.; 60% of space for special exhibitions. Clientele: collectors and private art consultants. 60% private collectors, 10% corporate collectors, 30% private art consultants. Overall price range: $500-40,000; most work sold at $2,000-8,000.
Media: Considers oil, acrylic, sculpture, watercolor, mixed media, pastel, collage, photography, original handpulled prints, woodcuts, wood engravings, linocuts, engravings, mezzotints, etchings, lithographs and serigraphs. Most frequently exhibits high quality paintings, prints and photography.
Style: Exhibits expressionism, conceptualism, photorealism, minimalism, painterly abstraction, realism and surrealism. Genres include landscapes, florals, figurative work and city scapes.
Terms: Retail price set by gallery and artist. Gallery provides insurance, promotion, contract and shipping costs from gallery; artist pays for shipping costs to gallery.
Submissions: Prefers "intellectually mature artists who know quality and who are professional in their creative and business dealings. Artists can no longer be temperamental." Send query letter with résumé, slides, bio, brochure, photographs, SASE, business card and reviews. Replies if interested within 2-3 months; if not interested, replies in a few days.
Tips: "Have a well thought-out presentation that shows consistent work and/or consistent development over a period of time. Must have a minimum of 20 slides and perferably 20 current slides."

JOSEPH CHOWNING GALLERY, 1717 17th St., San Francisco CA 94103. (415)626-7496. Fax: (415)863-5471. Director: Joseph Chowning. Retail gallery. Estab. 1972. Represents 19 mid-career and established artists. Exhibited artists include Eduardo Carrillo and Bill Martin. Sponsors 10 shows/year. Average display time 1 month. Open all year; Tuesday-Friday 10:30-5:30, Saturday 12-4. Located south of downtown; 3,600 sq. ft. 50% of space for special exhibitions; 100% of space for gallery artists. Clientele: 80% private collectors, 20% corporate collectors. Overall price range: $100-750,000; most work sold at $100-5,000.
Media: Considers oil, pen & ink, acrylic, sculpture, watercolor, mixed media, ceramic, pastel and original handpulled prints. Most frequently exhibits painting, sculpture, works on paper.
Style: Exhibits synchromy, California contemporary (Bay Area). All genres. Prefers contemporary Bay Area sculpture and painting, contemporary ceramics.
Terms: Accepts work on consignment (50% commission). Retail price set by gallery. Gallery provides insurance and promotion; shipping costs are shared. Prefers artwork framed.
Submissions: Send slides, bio, SASE and cover letter detailing career/objective. Write for appointment to show portfolio of originals and "whatever is on hand, easiest to transport." Replies in 1-2 weeks. Files cover letters and résumés.

‡MICHAEL DUNEV GALLERY, 660 Mission St,. #230, San Francisco CA 94105. (415)398-7300. Fax: (415)331-1240. Director: Michael Dunev. Retail gallery by appointment. Estab. 1984. Represents/exhibits 15 emerging, mid-career and established artists/year. May be interested in seeing the work of emerging artists in the future. Exhibited artists include Gustavo Ramos Rivera and Hans Sieverding. Sponsors 2 shows/year. Average display time 6 weeks. Open all year by appointment only. Located downtown, near new art center; 1,000 sq. ft. Clientele: local collectors, corporate clients and tourists. 70% private collectors, 30% corporate collectors. Overall price range: $750-40,000; most work sold at $2,500-10,000.
Media: Considers all media except performance and installation, woodcut, engraving, lithograph, wood engraving, mezzotint, linocut, etching and monotypes. Most frequently exhibits oils on canvas, works on paper and sculpture.
Style: Exhibits expressionism, neo-expressionism, primitivism and painterly abstraction.
Terms: Artwork is accepted on consignment and there is a 50% commission. Retail price set by the gallery and the artist. Gallery provides insurance, promotion, contract; shipping costs are shared. Prefers artwork framed.

Submissions: Send query letter with résumé, slides, reviews, bio and SASE. Write for appointment to show portfolio of photographs, slides or transparencies. Replies in 2-3 weeks.

Tips: Finds artists through word of mouth, referrals by other artists, visiting art fairs and exhibitions and artists' submissions. "If you submit material by mail, ensure that your photography is good. Galleries are often pressed, and your work must be seen in its best light within the first 3-5 seconds!"

EBERT GALLERY, 49 Geart St., San Francisco CA 94108. (415)296-8405. Owner: Dick Ebert. Retail gallery. Estab. 1989. Represents 24 established artists "from this area." Interested in seeing the work of emerging artists. Exhibited artists include Jerrold Ballaine, Boyd Allen. Sponsors 11-12 shows/year. Average display time 1 month. Open all year; Tuesday-Friday, 10:30-5:30; Saturday, 11-5. Located downtown near bay area; 1,200 sq. ft.; one large room which can be divided for group shows. 85% of space for special exhibitions; 15% of space for gallery artists. Clientele: collectors, tourists, art students. 80% private collectors. Overall price range: $500-20,000; most work sold at $500-8,000.

Media: Considers oil, acrylic, watercolor, pastel, pen & ink, drawing, mixed media, collage, paper, sculpture, glass, photography, woodcut, engraving, mezzotint, etching and encostic. Most frequently exhibits acrylic, oils and pastels.

Style: Exhibits expressionism, painterly abstraction, impressionism and realism. Genres include landscapes, figurative work, all genres. Prefers landscapes, abstract, realism.

Terms: Accepts work on consignment (50% commission). Retail price set by the artist. Gallery provides promotion. Shipping costs are shared. Prefers artwork framed.

Submissions: San Francisco Bay Area artists only. Send query letter with résumé and slides. "We call the artist after slide and résumé review." Portfolio should include originals and slides. Replies in a few weeks.

Tips: Finds artists through referral by professors or stable artists.

INTERSECTION FOR THE ARTS, 446 Valencia, San Francisco CA 94103. (415)626-2787. Gallery Director: Linda Wilson. Alternative space and nonprofit gallery. Estab. 1980. Exhibits the work of 10 emerging and mid-career artists/year. Sponsors 10 shows/year. Average display time 6 weeks. Open all year. Located in the Mission District of San Francisco; 840 sq. ft.; gallery has windows at one end and cement pillars betwen exhibition panels. 100% of space for special exhibitions. Clientele: 100% private collectors.

• This gallery supports emerging and mid-career artists who explore experimental ideas and processes. Interdisciplinary, new genre, video performance and installation is encouraged.

Media: Considers oil, pen & ink, acrylic, drawings, watercolor, mixed media, installation, collage, photography, site-specific installation, video installation, original handpulled prints, woodcuts, lithographs, posters, wood engravings, mezzotints, linocuts and etchings.

Style: Exhibits all styles and genres.

Terms: Retail price set by artist. Customer discounts and payment by installment are available. Gallery provides promotion; shipping costs are shared. Prefers artwork unframed.

Submissions: Send query letter with résumé, 20 slides, reviews, bio, clippings and SASE. Portfolio review not required. Replies within 6 months only if interested and SASE has been included. Files slides.

Tips: "Create proposals which consider the unique circumstances of this location, utilizing the availability of the theater and literary program/resources/audience."

‡THE LAB, 1807 Divisadero St., San Francisco CA 94115. (415)346-4063. Fax: (415)346-4567. Assistant Program Director: Michelle Rollman. Nonprofit gallery and alternative space. Estab. 1983. Represents/exhibits 13 emerging, mid-career artists/year. Interested in seeing the work of emerging artists. Sponsors 7 shows/year. Average display time 1 month. Open all year; Wednesday-Saturday, 12-5. 50×25'; 13' height; 950 sq. ft.; white walls painted wood floor. Doubles as a performance and gallery space. Clientele: artists and Bay Area communities.

Media: Considers all media with emphasis on interdisciplinary and experimental art. Most frequently exhibits installation art, interdisciplinary art and media art.

Terms: Work is not for sale, artists receive honorarium from the art space.

Submissions: Send query letter with slides and SASE. Replies only if interested within 1 month.

Tips: Finds artists through word of mouth, artists' submissions, calls for proposals.

‡MUSEUM WEST FINE ARTS & FRAMING, INC., 170 Minna, San Francisco CA 94105. (415)546-1113. Retail gallery. Represents/exhibits 14 emerging artists/year. Sponsors 8-11 shows/year. Average display time 3 weeks. Open all year; Monday-Saturday. Located downtown next to San Francisco Museum of Modern Art; 3,500 sq. ft.; 30% of space for special exhibitions. Clientele: upscale tourists, art consultants, sophisticated corporate buyers, collectors. Overall price range: $150-1,200; most work sold at $400-1,000.

Media: Considers all media except very large works under 4 ft.×4 ft. Considers oil, acrylic, watercolor, mixed media, pastel, collage, photography, original hand-pulled prints, woodcuts, wood engravings, linocuts, engravings, mezzotints, etchings, lithographs and serigraphs. Considers all types of prints. Most frequently exhibits hand-colored prints—small editions, photography, paintings and collage.

Style: Exhibits expressionism, painterly abstraction, impressionism, photorealism, pattern painting and realism. Genres include florals, landscapes, figurative work and cityscapes. Prefers colorful still lifes, San Francisco Bay imagery and landscapes.

Terms: Artwork is accepted on consignment and there is a 50% commission. Retail price set by the gallery and artist. Gallery provides insurance, promotion and contract; shipping costs are shared or negotiated.

Submissions: No sexually explicit or politically oriented art. Send query letter with résumé, slides, bio, brochure, photographs, SASE, business card and and reviews. Write for appointment to show portfolio of photographs, slides and transparencies. Replies in 2-3 weeks. Files all material if interested.

Tips: Finds artists through open studios, mailings, referrals by other artists and collectors.

‡SAN FRANCISCO ART COMMISSION GALLERY & SLIDE REGISTRY, 155 Grove St., Civic Center, San Francisco CA 94102. (415)252-2569. Fax: (415)252-2595. Director: Jason Tannen. Nonprofit municipal gallery; alternative space. Estab. 1983. Exhibits work of approximately 150 emerging and mid-career artists/year; 400-500 in slide registry. Sponsors 7 indoor group shows/year; 3 outdoor site installations/year. Average display time 5 weeks (indoor); 3 months (outdoor installations) Open all year. Located at the Civic Center; 400 sq. ft. (indoor), 4,500 sq. ft. (outdoor); city site lot across the street from City Hall and in the heart of the city's performing arts complex. 100% of space for special exhibitions. Clientele: cross section of San Francisco/Bay area including tourists, upscale, local and students. Sales are minimal.

● Although seismatic (earthquake) conditions resulted in closing the gallery to the public, the program continues with window installations, site specific projects, the Artists' Slide Registry, artists' talks and special projects.

Media: Considers all media and all types of prints. Most frequently exhibits installation, mixed media and sculpture/3-D.

Style: Exhibits all styles. Prefers cutting-edge, contemporary works.

Terms: Accepts artwork on consignment (20% commission). Retail price set by artist. Gallery provides insurance, promotion and contract; artist pays for shipping.

Submissions: Accepts only artists residing in one of nine Bay Area counties. Write for guidelines to join the slide registry to automatically receive calls for proposals and other exhibition information. Do not send unsolicited slides.

Tips: "The Art Commission Gallery serves as a forum for exhibitions which reflect the aesthetic and cultural diversity of contemporary art in the Bay Area. Temporary installations in the outdoor lot adjacent to the gallery explore alternatives to traditional modes of public art. Gallery does not promote sale of art, as such, but will handle sale of available work if a visitor wishes to purchase it. Exhibit themes, artists, and selected works are recommended by the Gallery Director to the San Francisco Art Commission for approval. Gallery operates for the benefit of the public as well as the artists. It is not a commercial venue for art."

SAN FRANCISCO CRAFT & FOLK ART MUSEUM, Fort Mason Center, Bldg. A, San Francisco CA 94123. (415)775-0990. Curator: Carole Austin. Estab. 1983. Represents emerging and established artists. Average display time 2 months. Open all year. Located in a cultural center in a national park; 1,500 sq. ft.; "amidst 4 other museums and many theaters and nonprofits." 100% of space for special exhibitions and museum shop. Clientele: 100% private collectors. Overall price range: $100-3,000. "We are a museum and sell only occasionally, so we do not keep statistics on prices."

Media: Considers mixed media, collage, works on paper, metal, ceramic, craft, fiber, glass, jewelry. Most frequently exhibits textile, ceramics, glass and metal.

Style: Exhibits primitivism, folk art, contemporary fine art, tribal and traditional art.

Submissions: Send query letter with résumé, slides, bio, brochure, photographs and SASE. Portfolio review not required. Replies in 2 months if SASE included. Does not file material.

Tips: Finds artists through periodicals (craft), announcements, submitted slides, studio visits, word of mouth, galleries.

‡TC ART, 1351 Taraval St., 2, San Francisco CA 94116. (415)759-7070. Fax: (415)759-5163. Owner: Toby Arian. Retail and wholesale gallery and art consultancy. Estab. 1981. Represents/exhibits 4 emerging, mid-career and established artists. Interested in seeing the work of emerging artists. Exhibited artists include Leo Poscillico and Michel Delacroix. Sponsors 10 shows/year. Average display time 1 week. Open all year; Monday-Friday, 10-6. Located SW corner, residential/commercial; 925 sq. ft.; 100% of space for special exhibitions; 50% of space for gallery artists. Clientele: trade buyers. 10% private collectors, 10% corporate collectors. Overall price range: $250-4,500; most work sold at $900.

A bullet introduces comments by the editor of Artist's *& Graphic Designer's Market* indicating special information about the listing.

Media: Considers all media and all types of prints. Most frequently exhibits paintings, limited edition prints and open edition prints.
Style: Exhibits realism, surrealism, impressionism and fantasy. Genres include florals, Western, wildlife, landscapes, Americana and figurative work. Prefers impressionism, surrealism and realism.
Terms: Artwork is accepted on consignment or is bought outright. "We also purchase reproduction rights." Retail price set by the gallery. Gallery provides insurance, promotion and contract; shipping costs are shared. Prefers artwork unframed.
Submissions: Send query letter with résumé, brochure, photographs, reviews, bio and SASE. Call for appointment to show portfolio of photographs and bio. Files photos and bio.
Tips: Finds artists through word of mouth, referrals by other artists, visiting art fairs and exhibitions and artists' submissions. "Learn how to compose a business letter."

Colorado

‡CITY ART WORKS, 17 E. Bijou St., Colorado Springs CO 80903. (719)473-7418. Fax: (719)527-0810. Director: Margareta A. Geary. Retail gallery. Estab. 1994. Represents/exhibits 7 emerging, mid-career and established artists/year. Exhibited artists include Eva Englund and Brit Johansson. Sponsors 6 shows/year. Average display time 1 month. Open all year; Tuesday-Saturday, 10-5:30. Located downtown; 700 sq. ft.; wide open space with high ceiling. 80% of space for special exhibitions; 20% of space for gallery artists. 50% private collectors.
Media: Considers oil, pen & ink, paper, acrylic, drawing, sculpture, watercolor, mixed media, ceramics, pastel, all types of prints. Most frequently exhibits glass, ceramics, sculpture—mixed, wood.
Style: Exhibits conceptualism, minimalism and color field.
Terms: Accepts work on consignment and there is a 50% commission. Retail price set by gallery and the artist. Gallery provides insurance, promotion, contract; shipping costs are shared. Prefers artwork framed.
Submissions: Send query letter with résumé, business card and slides. Call for appointment to show portfolio of photographs and slides. Replies in 2 weeks. Files material from accepted artists.
Tips: Finds artists through word of mouth, referrals by other artists, visiting art fairs, exhibitions and artist's submissions. Sponsors development of art clubs in businesses to develop new talent.

COGSWELL GALLERY, 223 Gore Creek Dr., Vail CO 81657. (303)476-1769. President/Director: John Cogswell. Retail gallery. Estab. 1980. Represents 40 emerging, mid-career and established artists. Exhibited artists include Steve Devenyns, Frances Donald and Jean Richardson. Sponsors 8-10 shows/year. Average display time 3 weeks. Open all year. Located in Creekside Building in Vail; 3,000 sq. ft. 50% of space for special exhibitions. Clientele: American and international, young and active. 80% private collectors, 20% corporate collectors. Overall price range: $100-50,000; most work sold at $1,000-5,000.
• Cogswell Gallery has recently doubled its size.
Media: Considers oil, acrylic, sculpture, watercolor, ceramic, photography and bronze; lithographs and serigraphs. Most frequently exhibits bronze, oil and watercolor.
Style: Exhibits painterly abstraction, impressionism and realism. Genres include landscapes, Southwestern and Western.
Terms: Accepts work on consignment (50% commission). Retail price set by the artist. Offers customer discounts and payment by installments. Gallery provides insurance and promotion; shipping costs from gallery. Prefers artwork framed.
Submissions: Send query letter with résumé, slides and bio. Call for appointment to show portfolio of slides. Replies only if interested within 1 month.

CORE NEW ART SPACE, 1412 Wazee St., Denver CO 80202. (303)571-4831. Coordinators: Tracy Weil and Kim Allison. Cooperative, alternative and nonprofit gallery. Estab. 1981. Exhibits 30 emerging and mid-career artists. Sponsors 30 solo and 6-10 group shows/year. Average display time: 2 weeks. Open Thursday-Sunday. Open all year. Located "in lower downtown, former warehouse area; 3,400 sq. ft.; large windows, hardwood floor, and high ceilings." Accepts mostly artists from front range Colorado. Clientele: 97% private collectors; 3% corporate clients. Overall price range: $75-3,000; most work sold at $100-600.
Media: Considers all media. Specializes in cutting edge work. Prefers quality rather than marketability.
Style: Exhibits expressionism, neo-expressionism, painterly abstraction, conceptualism; considers all styles and genres, but especially contemporary and alternative (non-traditional media and approach).
Terms: Co-op membership fee plus donation of time. Retail price set by artist. Exclusive area representation not required.
Submissions: Send query letter with SASE. Quarterly auditions to show portfolio of originals, slides and photographs. Request membership or associate membership application. "Our gallery gives an opportunity for emerging artists in the metro-Denver area to show their work. We run four to six open juried shows a year. There is an entry fee charged, but no commission is taken on any work sold. The member artists exhibit in a one-person show once a year. Member artists generally work in more avant-garde formats, and the gallery encourages experimentation. Members are chosen by slide review and personal interviews. Due

to time commitments we require that they live and work in the area. There is a yearly Associate Members Show."

Tips: Finds artists through invitations, word of mouth, art publications. "We want to see challenging art. If your intention is to manufacture coffee-table and over-the-couch art for suburbia, we are not a good place to start."

E.S. LAWRENCE GALLERY, 516 E. Hyman Ave., Aspen CO 81611. (303)920-2922. Fax: (303)920-4072. Director: Ben Vaughn. Retail gallery. Estab. 1988. Represents emerging, mid-career and established artists. Exhibited artists include Zvonimir Mihanovic, Graciela Rodo Boulanger. Sponsors 2 shows/year. Average display time 3 months. Open all year; daily 10-10. Located downtown; 2,500 sq. ft. 100% of space for gallery artists. 95% private collectors, 5% corporate collectors.
Media: Considers oil, acrylic, watercolor, pastel, mixed media, sculpture, glass, lithograph and serigraphs. Most frequently exhibits oil, acrylic, watercolor.
Style: Exhibits expressionism, impressionism, photorealism and realism. Genres include landscapes, florals, Americana, Western, wildlife, figurative work. Prefers photorealism, impressionism, expressionism.
Terms: Accepts artwork on consignment (50% commission). Retail price set by the gallery and the artist. Gallery provides insurance, promotion and contract; artist pays shipping costs to and from gallery "if not sold." Prefers artwork framed.
Submissions: Send query letter with résumé, slides and photographs. Write for appointment to show portfolio of photographs, slides and reviews. Replies in 1 month.
Tips: Finds artists through agents, visiting exhibitions, word of mouth, art publications and artists' submissions.

MAGIDSON FINE ART, 525 E. Cooper Ave., Aspen CO 81617. (303)920-1001. Fax: (303)925-6181. Owner: Jay Magidson. Retail gallery. Estab. 1990. Represents 50 emerging, mid-career and established artists. Exhibited artists include Annie Leibovitz, Andy Warhol. Sponsors 5 shows/year. Average display time 3 months. Open all year; December 15-April 15, 10-9 daily; rest of the year, Tuesday-Sunday, 10-6. Located in central Aspen; 1,500 sq. ft.; exceptional window exposure; free hanging walls; 9½ ft. ceilings. 50% of space for special exhibitions; 50% of space for gallery artists. Clientele: emerging and established collectors. 95% private collectors, 5% corporate collectors. Overall price range: $1,200-75,000; most work sold at $2,500-7,500.
Media: Considers oil, acrylic, watercolor, pastel, pen & ink, drawing, mixed media, collage, paper, sculpture, ceramics, fiber, photography, woodcut, engraving, lithograph, wood engraving, serigraphs, linocut and etching. Most frequently exhibits oil/acrylic on canvas, photography and sculpture.
Style: Exhibits painterly abstraction, surrealism, color field, photorealism, hard-edge geometric abstraction and realism; all genres. Prefers pop, realism and unique figurative (colorful and imaginative).
Terms: Accepts work on consignment (40-60% commission). Retail price set by the gallery. Gallery provides insurance, promotion and shipping costs from gallery; artist pays shipping costs to gallery. Prefers artwork framed.
Submissions: Send query letter with slides, bio, photographs and SASE. Call for appointment to show portfolio of photographs, slides, "never originals!" Replies only if interested in 1 month. Files slides, "bios on artists we represent."
Tips: Finds artists through recommendations from other artists, reviews in art magazines, museum shows, gallery shows. "I prefer photographs over slides. No elaborate artist statements or massive résumés necessary."

‡PANACHE CRAFT GALLERY, 315 Columbine St., Denver CO 80206. (303)321-8069. Fax: (303)436-9123. Owner: Judy Kerr. Retail gallery. Estab. 1978. Represents 350 emerging, mid-career, established artists. Exhibited artists include Steve Schrepferman and Cindy Lee Lord. Sponsors 7 shows/year. Average display time 2 months. Open all year; Monday-Saturday, 10:30-5:30; Sunday, 12-4. Located near downtown—in Cherry Creek North Shopping Center; 1,400 sq. ft.; free standing turn-of-the-century brick building with front yard. 20% of space for special exhibitions; 80% of space for gallery artists. Clientele: private collectors, tourists, people looking for gifts. 10% private collectors; 10% corporate collectors. Overall price range: $20-1,000; most work sold at $30-50.
Media: Considers paper, fiber, sculpture, glass, ceramics and serigraphs. Most frequently exhibits ceramics, jewelry, fiber.
Style: Exhibits contemporary craft.
Terms: Accepts work on consignment (50% commission). Retail price set by artist. Gallery provides insurance, promotion, contract; shipping costs are shared. Prefers artwork framed.
Submissions: Send query letter with slides, bio, photographs, SASE. Call for appointment to show portfolio. Replies only if interested within 1 month.
Tips: "Get an idea of what the gallery is showing. Good artists will know if their work is appropriate."

PINE CREEK ART GALLERY, 2419 W. Colorado Ave., Colorado Springs CO 80904. (719)633-6767. Owners: Liz and Nancy Anderson. Retail gallery. Estab. 1991. Represents 10+ emerging, mid-career and established

artists. Exhibited artists include Kirby Sattler, Chuck Mardosz and Don Grzybowski. Sponsors 4 shows/year. Average display time 1 month. Open all year. 2,200 sq. ft.; in a National Historic District. 30% of space for special exhibitions. Clientele: middle to upper income. Overall price range: $30-5,000; most work sold at $100-500.

Media: Considers most media, including bronze, pottery and all types of prints.

Style: Exhibits all styles and genres.

Terms: Accepts artwork on consignment (40% commission). Retail price set by gallery and artist. Gallery provides insurance, promotion and shipping costs from gallery. Prefers artwork "with quality frame only."

Submissions: No fantasy or abstract art. Prefer experienced artists only—no beginners. Send query letter with slides and photographs. Call or write for appointment to show portfolio or originals, photographs, slides and tearsheets. Replies in 2 weeks.

Tips: "We like to include a good variety of work, so show us more than one or two pieces."

SANGRE DE CRISTO ARTS AND CONFERENCE CENTER, 210 N. Santa Fe Ave., Pueblo CO 81003. (719)543-0130. Curator of Visual Arts: Jennifer Cook. Nonprofit gallery and museum. Estab. 1972. Exhibits emerging, mid-career and established artists. Sponsors 25-30 shows/year. Average display time 6 weeks. Open all year. Located "downtown, right off Interstate I-25"; 7,500 sq. ft.; four galleries, one showing a permanent collection of Western art; changing exhibits in the other three. Also a children's museum with changing, interactive exhibits. Clientele: "We serve a 19-county region and attract 200,000 visitors yearly. Most art exhibits are not for sale; however, when they are for sale, anyone can buy." Overall price range: $50-100,000; most work sold at $50-13,000.

Media: Considers all media.

Style: Exhibits all styles. Genres include Southwestern.

Terms: Accepts work on consignment (30% commission). Retail price set by artist. Gallery provides insurance, promotion, contract and shipping costs. Prefers artwork framed.

Submissions: "There are no restrictions, but our exhibits are booked into 1996 right now." Send query letter with slides. Write or call for appointment to show portfolio of slides. Replies in 2 months.

PHILIP J. STEELE GALLERY AT ROCKY MOUNTAIN COLLEGE OF ART & DESIGN, 6875 E. Evans Ave., Denver CO 80224. (303)753-6046. Fax: (303)759-4970. Gallery Director: Deborah Horner. Nonprofit college gallery. Estab. 1962. Represents emerging, mid-career and established artists. Exhibited artists include Christo, Jenny Holzer. Sponsors 9 shows/year. Average display time 3 weeks. Open all year; Monday-Friday, 8-6; Saturday, 9-4. Located in southeast Denver; 600 sq. ft.; in very prominent location (art college with 350 students enrolled).

Media: Considers all media and all types of prints.

Style: Exhibits all styles.

Terms: Artists sell directly to buyer; gallery takes no commission. Retail price set by the artist. Gallery provides insurance and promotion; artist pays shipping costs to and from gallery.

Submissions: Send query letter with résumé, slides, bio, SASE and reviews. Write for appointment to show portfolio of originals, photographs and slides. Replies only if interested within 1 month.

Tips: Impressed by "professional presentation of materials, good quality slides or catalog."

Connecticut

‡ARTWORKS FINE ART ADVISORS, 15 Potter Dr., Old Greenwich CT 06870. (203)637-5562. Fax: (203)637-0417. Director: Wendy Kelley. Art consultancy and exhibition curator. Estab. 1986. Represents/exhibits mid-career artists. Sponsors 12-15 shows/year. Average display time 6 weeks. Open all year; by appointment Monday-Friday, 9-6. Located 40 minutes from New York City. "We curate exhibits for corporate spaces/galleries." 60% private collectors, 40% corporate collectors. Overall price range: $50-50,000; most work sold at $1,500-10,000.

Media: Considers all media and all types of prints. Most frequently exhibits painting, etching/litho/silkscreen and photography.

Style: Exhibits all styles. Genres include landscapes, florals and figurative work. Prefers landscape, prints/abstract and realistic, photography.

Terms: Artwork is accepted on consignment and there is a 50% commission. Retail price set by gallery and the artist. Gallery provides promotion; shipping costs are shared.

Submissions: Send query letter with résumé, slides, bio and SASE. Replies only if interested within 3 weeks. Files slides and bio.

Tips: Finds artists through referrals by other artists, art fairs and galleries.

ARTWORKS GALLERY, 233 Pearl St., Hartford CT 06103. (203)247-3522. Executive Director: Judith Green. Cooperative nonprofit gallery. Estab. 1976. Exhibits 200 emerging, mid-career and established artists. Interested in seeing the work of emerging artists. 50 members. Sponsors 13 shows/year. Average display time 1 month. Open Wednesday-Friday, 11-5; Saturday, 12-3. Closed in August. Located in downtown

Hartford; 1,300 sq. ft.; large, first floor, store front space. 20% of space for special exhibitions; 80% of space for gallery artists. Clientele: 80% private collectors, 20% corporate collectors. Overall price range: $200-5,000; most work sold at $200-1,000.

Media: Considers all media and all types of prints. Most frequently exhibits oil on canvas, photography and sculpture. No crafts or jewelry.

Style: Exhibits all styles and genres, especially contemporary.

Terms: Co-op membership fee plus a donation of time. There is a 30% commission. Retail price set by artist. Offers customer discounts and payment by installments. Gallery provides insurance, promotion and contract. Artist pays for shipping costs. Prefers artwork framed. Accepts only artists from Connecticut for membership. Accepts artists from New England and New York for juried shows.

Submissions: Send query letter with résumé, slides, bio and $10 application fee. Call for appointment to show portfolio of slides. Replies in 1 week.

Tips: Finds artists through visiting exhibitions, various art publications and sourcebooks, artists' submissions, art collectors' referrals, but mostly through word of mouth and juried shows.

B.E.L. GALLERY, 42 Owenoke Park, Westport CT 06880. (203)227-9215. Director: Barbara E. Lans. Retail gallery. Estab. 1971. Represents 3 or 4 mid-career and established artists/year. May be interested in seeing the work of emerging artists in the future. Sponsors 3 or 4 shows/year. Average display time 1 month. Clientele: regional/local. 100% private collectors. Overall price range: $100-400.

Media: Considers oil, acrylic, watercolor, pastel, pen & ink, mixed media, collage, paper, photography.

Style: Exhibits all styles. Genres include landscapes, florals, Americana and abstract.

Terms: Accepts on consignment (40% commission). Retail price set by the gallery and the artist.

Submissions: Accepts only local artists. Send query letter with résumé, slides, bio, photographs and SASE. Call or write for appointment to show portfolio of originals, slides and transparencies. Replies in 1 month.

Tips: Finds artists through visiting exhibitions, artists' submissions.

MONA BERMAN FINE ARTS, 78 Lyon St., New Haven CT 06511. (203)562-4720. Fax: (203)787-6855. Director: Mona Berman. Art consultancy. Estab. 1979. Represents 50 emerging and mid-career artists. Exhibited artists include Tom Hricko and Juliet Holland. Sponsors 1 show/year. Open all year. Located near downtown; 1,000 sq. ft. Clientele: 5% private collectors, 95% coporate collectors. Overall price range: $200-20,000; most artwork sold at $500-5,000.

Media: Considers all media except installation. Considers all limited edition prints except posters and photolithography. Most frequently exhibits works on paper, painting, relief and ethnographic arts.

Style: Exhibits most styles. Prefers abstract, landscape and transitional. No figurative, little still life.

Terms: Accepts work on consignment (50% commission) (net 30 days). Retail price is set by gallery and artist. Customer discounts and payment by installment are available. Gallery provides insurance; artist pays for shipping. Prefers artwork unframed.

Submissions: Send query letter, résumé, "plenty of slides," bio, SASE, reviews and "price list—retail only at stated commission." Portfolios are reviewed only after slide submission. Replies in 1 month. Slides and reply returned only if SASE is included.

Tips: Finds artists through word of mouth, art publications and sourcebooks, artists' submissions and self-promotions and other professionals' recommendations. "Please understand that we are not a gallery, although we do a few exhibits. We are primarily art consultants. We continue to be busy selling high quality art and related services."

MARTIN CHASIN FINE ARTS, 1125 Church Hill Rd., Fairfield CT 06432. (203)374-5987. Fax: (203)372-3419. Owner: Martin Chasin. Retail gallery. Estab. 1985. Represents 40 mid-career and established artists. Interested in seeing the work of emerging artists. Exhibited artists include Katherine Ace and David Rickert. Sponsors 8 shows/year. Average display time 3 weeks. Open all year. Located downtown; 1,000-1,500 sq. ft. 50% of space for special exhibitions. Clientele: "sophisticated." 40% private collectors; 30% corporate collectors. Overall price range: $1,500-10,000; most work sold at $3,000-5,000.

Media: Considers oil, acrylic, watercolor, pastel, pen & ink, drawings, paper, woodcuts, wood engravings, linocuts, engravings, mezzotints, etchings, lithographs, pochoir and serigraphs. "No sculpture." Most frequently exhibits oil on canvas, etchings/engravings and pastel.

Style: Exhibits expressionism, neo-expressionism, color field, postmodern works, impressionism and realism. Genres include landscapes, Americana, portraits, Southwestern and figurative work. Prefers landscapes, seascapes and ships/boating scenes. Particularly interested in realistic art.

Terms: Accepts work on consignment (30-50% commission). Retail price set by artist. Offers payment by installments. Gallery provides insurance, promotion and shipping costs from gallery. Prefers artwork unframed.

Submissions: Send query letter with résumé, slides, bio, price list and SASE. Call or write for appointment to show portfolio of slides and photographs. Replies in 3 weeks. Files future sales material.

Tips: Finds artists through exhibitions, "by artists who write to me and send good slides or transparencies. Send at least 10-15 slides showing all genres of art you produce. Omit publicity sheets and sending too much

material. The art scene is less far-out, fewer avant-garde works are being sold. Clients want artists with a solid reputation."

CHESHIRE FINE ART, INC., 265 Sorghum Mill Dr., Cheshire CT 06410. (203)272-0114. Fax: (203)272-0114. President: Linda Ladden. Retail/wholesale gallery. Estab. 1983. Represents 20 mid-career and established artists/year. Exhibited artists include Emile Gruppe and Bernard Corey. Sponsors 3 shows/year. Average display time 3-6 months. Open all year; daily, by appointment. Located 5 minutes from Town Center; 1,500 sq. ft.; one-to-one personal contact with patrons. 40% of space for special exhibitions; 100% of space for gallery artists. Clientele: collectors looking to assemble related collections. 90% private collectors, 10% corporate collectors. Overall price range: $450-70,000; most work sold at $850-25,000.
Media: Considers oil, watercolor, pastel and gouache. Most frequently exhibits oil, watercolor and pastel.
Style: Exhibits post-impressionism. Prefers landscapes (harbors), genre scenes and floral.
Terms: Accepts work on consignment (negotiable commission). Retail price set by the gallery and the artist. Gallery provides insurance, promotion and shipping costs from gallery; artist pays shipping costs to gallery. Prefers artwork framed.
Submissions: Accepts only artists from New England, or artists who have ties to or paint New England subjects. Send query letter with bio and photographs. Call or write for appointment to show portfolio of photographs. Replies ASAP. Files bio and photos.
Tips: Finds artists through word of mouth and artists' submissions. Impressed by well-presented biographical and exhibition information. "Interested in 'plein-air' painting in the tradition of Anthony Thieme, Jane Peterson, Frank Duveneck and Twachtman."

CONTRACT ART, INC., P.O. Box 520, Essex CT 06426. (203)767-0113. Fax: (203)767-7247. Senior Project Manager: Victoria Taylor. "We contract artwork for blue-chip businesses, including Disney, Royal Caribbean Cruise Lines and Raddison." Represents emerging, mid-career and established artists. Approached by hundreds of artists/year. Assigns work to freelance artists based on client needs and preferences. Showroom is open all year to corporate art directors and designers. 1,600 sq. ft.; Clientele: 98% commercial. Overall price range: $500-15,000.
Media: Considers all media and all types of prints. Frequently contracts murals.
Style: Uses artists for brochure design, illustration and layout, model making and posters. Exhibits all styles and genres.
Terms: Pays for design by the project, negotiable; 50% up front. Prefers artwork unframed. Rights purchased vary according to project.
Submissions: Send query letter with résumé, slides, bio, brochure, photographs and SASE. If local, write for appointment to show portfolio; otherwise, mail appropriate materials, which should include slides and photographs. "Show us a good range of what you can do. Also, keep us updated if you've changed styles or media." Replies in 1 week. Files all samples and information in registry.
Tips: "We exist mainly to solicit commissioned artwork for specific projects."

‡JOHN SLADE ELY HOUSE, 51 Trumbull St., New Haven CT 06510. (203)624-8055. Curators: Raymond Smith and Carla Bengston. Nonprofit gallery. Estab. 1959. Exhibits the work of emerging, mid-career and established artists. Sponsors 10 shows/year. Average display time 3-4 weeks. Closed July and August. Located downtown, off exit 3 from I-91; 1,200 sq. ft.; "in a turn-of-the-century arts and crafts-style brick residence." 100% of space for special exhibitions. Clientele: community and state residents. Overall price range: $200-3,000; most work sold at $300-500.
Media: Considers all media, including prints, performance, architecture and graphic design. Most frequently exhibits painting, sculpture and photography/prints.
Style: Exhibits "quality work, regardless of style or genre."
Terms: "Artists for special shows are selected by curators. No commission is required, but the gallery suggests a 10% donation from a sale. Retail price is set by the artist. Gallery provides promotion; work is brought to the gallery by the artist (not shipped). Artist hangs own work. Prefers artwork framed.
Submissions: Accepts only artists from Connecticut. Send query letter with résumé, slides or photographs, bio, SASE and an artist's statement on current work. Does not review portfolios. Replies in 2-3 months. Files résumé and artist's letter.
Tips: "Do not submit work with expectation of selling—we are a nonprofit gallery and encourage artists to stretch without regard to sales."

‡FARMINGTON VALLEY ARTS CENTER'S FISHER GALLERY, 25 Arts Center Lane, Avon CT 06001. (203)678-1867. Manager: Sally Bloomberg. Nonprofit gallery. Estab. 1972. Exhibits the work of 300 emerging, mid-career and established artists. Exhibited artists include Kerr Grabowski and Randall Darwall. Sponsors 5 shows/year. Average display time 2-3 months. Open all year; Wednesday-Saturday, 11-5; Sunday, 12-4; extended hours November-December. Located in Avon Park North just off Route 44; 600 sq. ft.; "in 19th-century brownstone factory building once used for manufacturing." 25% of space for special exhibitions. Clientele: upscale contemporary craft buyers. Overall price range: $100-1,000; most work sold at $100-300.

Media: Considers "primarily crafts," also considers some mixed media, works on paper, ceramic, fiber, glass and small size prints. Most frequently exhibits jewelry, ceramics and fiber.
Style: Exhibits all styles, including craft.
Terms: Accepts artwork on consignment (40% commission). Retail price set by the artist. Gallery provides promotion and contract; shipping costs are shared. Prefers artwork framed.
Submissions: Send query letter with résumé, slides, brochure, photographs, SASE and reviews. Write for appointment to show a portfolio of slides and transparencies. Replies only if interested within 2 months. Files a slide or photo, résumé and brochure.

BILL GOFF, INC., Box 977, Kent CT 06757-0977. (203)927-1411. Fax: (203)927-1987. President: Bill Goff. Estab. 1977. Exhibits, publishes and markets baseball art. 95% private collectors, 5% corporate collectors.
Needs: Baseball subjects for prints. Realism and photorealism. Represents 10 artists; emerging, mid-career and established. Exhibited artists include Andy Jurinko and William Feldman, Bill Purdom, Bill Williams.
First Contact & Terms: Send query letter with bio and photographs. Write to schedule an appointment to show a portfolio, which should include photographs. Replies only if interested within 2 months. Files photos and bios. Accepts work on consignment (50% commission) or buys outright for 50% of retail price. Overall price range: $95-30,000; most work sold at $125-220. Retail price set by the gallery. Gallery provides insurance and promotion; shipping costs are shared. Prefers artwork unframed.
Tips: "Do not waste our time or your own by sending non-baseball items."

‡PATRICIA SHIPPEE FINE ART, Mile Creek Rd., P.O. Box 747, Old Lyme CT 06371. (203)434-5108. Fax: (203)434-0366. Owner: Patricia Shippee. Retail gallery, art consultancy. Estab. 1980. Represents/exhibits 5-6 emerging, mid-career and established artists/year. Interested in seeing the work of emerging artists. Exhibited artists include Roger W. Dennis and James M. Tripp. Open all year by appointment. Located in rural setting; 500 sq. ft.; 200 year old saltbox/barn. Clientele: local community and corporate. 80% private collectors, 20% corporate collectors. Overall price range: $800-15,000; most work sold at $2,000-10,000.
Media: Considers all media and all types of prints. Most frequently exhibits oil painting and sculpture.
Style: Exhibits color field, abstraction, realism, surrealism and impressionism. Genres include landscapes and figurative work. Prefers landscapes, still life and classical bronze sculpture related to nature.
Terms: Artwork is accepted on consignment (50% commission). Retail price set by the gallery and the artist. Gallery provides insurance, limited promotion and contract; shipping costs are shared. Prefers artwork framed.
Submissions: Send query letter with bio and SASE. Write for appointment to show portfolio of slides. Replies in 1 month.

‡SMALL SPACE GALLERY, Arts Council of Greater New Haven, 70 Audobon St., New Haven CT 06511. (203)772-2788. Fax: (203)495-7111. Director: Helen Herzig. Alternative space. Estab. 1985. Interested in emerging artists. Sponsors 10 solo and group shows/year. Average display time: 4 weeks. Prefers area artists/ Arts Council Members (Greater New Haven). Overall price range: $35-3,000.
Media: Considers all media.
Style: Exhibits all styles and genres. "The Small Space Gallery was established to provide our artist members with an opportunity to show their work. Particularly those who were just starting their careers. We're not a traditional gallery, but an alternative art space.
Terms: AAS Council requests 10% donation on sale of each piece. Retail price set by artist. Exclusive area representation not required. Gallery provides insurance (up to $10,000) and promotion.
Submissions: Send query letter with résumé, brochure, slides, photographs and bio. Call or write for appointment to show portfolio of originals, slides, transparencies and photographs. Replies only if interested. Files publicity, price lists and bio.

Delaware

‡DELAWARE ART MUSEUM ART SALES & RENTAL GALLERY, 2301 Kentmere Parkway, Wilmington DE 19806. (302)571-9590. Fax: (302)571-0220. Director, Art Sales & Rental: Alice B. Hupfel. Nonprofit retail gallery, art consultancy and rental gallery. Estab. 1975. Represents 50-100 emerging artists. Exhibited artists include Elsie Manville and Mary Page Evans. Open all year; Tuesday-Saturday, 10-5. Located seven minutes from the center of Wilmington; 1,200 sq. ft.; "state-of-the-art gallery and sliding racks." Clientele: 30% private collectors; 70% corporate collectors. Overall price range: $500-8,000; most work sold at $1,500-2,500.
Media: Considers all media and all types of prints except posters and reproductions. Most frequently exhibits oil, watercolor and acrylic.
Style: Exhibits all styles. Genres include landscapes, florals, portraits and figurative work. Prefers landscapes, still lifes and abstract works.
Terms: Accepts artwork on consignment (20% commission). Rental fee for artwork covers 2 months. Retail price set by artist and consigning gallery. Gallery provides insurance and contract. Artist pays shipping costs. Artwork must be framed.

Submissions: "Send query letter with slides. Include price and medium.

DELAWARE CENTER FOR THE CONTEMPORARY ARTS, Dept. AGDM, 103 E. 16th St., Wilmington DE 19801. (302)656-6466. Director: Steve Lanier. Nonprofit gallery. Estab. 1979. Exhibits the work of emerging, mid-career and established artists. Sponsors 30 solo/group shows/year of both national and regional artists. Average display time is 1 month. 2,000 sq. ft.; 19 ft. ceilings. Overall price range: $50-10,000; most artwork sold at $500-1,000.
Media: Considers all media, including contemporary crafts.
Style: Exhibits contemporary, abstracts, impressionism, figurative, landscape, non-representational, photorealism, realism and neo-expressionism. Contemporary crafts.
Terms: Accepts work on consignment (35% commission). Retail price is set by the gallery and the artist. Exclusive area representation not required. Gallery provides insurance and promotion; shipping costs are shared.
Submissions: Send query letter, résumé, slides and photographs. Write for appointment to show portfolio. Seeking consistency within work as well as in presentation. Slides are filed.
Tips: Submit up to 20 slides with a corresponding slide sheet describing the work (i.e. media, height by width by depth), artist's name and address on top of sheet and title of each piece in the order in which you would like them reviewed.

District of Columbia

‡ANTON GALLERY, 2108 R St. NW, Washington DC 20008. (202)328-0828. Director: John Figura. Retail gallery. Estab. 1981. Represents/exhibits 24 emerging, mid-career and established artists/year. Exhibited artists include Tom NaKashima and Raimundo Rubio. Sponsors 7 shows/year. Average display time 5 weeks. Open all year; Wednesday-Sunday, 1-5. Located downtown—DuPont Circle; converted townhouse. 85% of space for gallery artists. Clientele: upscale. 75% private collectors, 25% corporate collectors. Overall price range: $2,000-40,000; most work sold at $6,000-10,000.
Media: Considers all media except watercolor, pastel, paints and collage. Most frequently exhibits oil, ceramics and sculpture.
Style: Exhibits expressionism, neo-expressionism, minimalism, pattern painting, hard-edge geometric abstraction, painterly abstraction, realism, surrealism and imagisn. Genres include landscapes and figurative work. Prefers neo-expressionism, painterly abstraction and minimalism.
Terms: Artwork is accepted on consignment (50% commission). Retail price set by the gallery. Gallery provides insurance, promotion and contract. Artist pays for shipping costs. Prefers artwork framed.
Submissions: Accepts only artists from Northeast coast. Prefers only established/mid-career artists. Call for appointment to show portfolio of slides, résumé and SASE. Replies only if interested within 3 months. Files résumé, slides.
Tips: Finds artists through referrals, visiting exhibitions, submissions. "Keep trying."

ATLANTIC GALLERY OF GEORGETOWN, 1055 Thomas Jefferson St. NW, Washington DC 20007. (202)337-2299. Fax: (202)944-5471. Director: Virginia Smith. Retail gallery. Estab. 1976. Represents 10 mid-career and established artists. Exhibited artists include John Stobart, Tim Thompson, John Gable and Frits Goosen. Sponsors 5 solo shows/year. Average display time is 2 weeks. Open all year. Located downtown; 700 sq. ft. Clientele: 70% private collectors, 30% corporate clients. Overall price range: $100-20,000; most artwork sold at $300-5,000.
Media: Considers oil, watercolor and limited edition prints.
Style: Exhibits realism and impressionism. Prefers realistic marine art, florals, landscapes and historic narrative leads.
Terms: Accepts work on consignment (40% commission). Retail price set by gallery and artist. Exclusive area representation required. Gallery provides insurance, promotion and contract; artist pays for shipping.
Submissions: Send query letter, résumé and slides. Portfolio should include originals and slides.

‡DE ANDINO FINE ARTS, 2450 Virginia Ave. NW, Washington DC 20037. (202)861-0638. Fax: (202)659-1899. Director: Jean-Pierre de Andino. Retail gallery and art consultancy. Estab. 1988. Represents/exhibits 4 mid-career and established artists/year. May be interested in seeing the work of emerging artists in the future. Exhibited artists include Sam Gilliam and Rainer Fetting. Sponsors 2 shows/year. Open all year by appointment only. Located downtown; 1,800 sq. ft.; discreet, private gallery in established upscale downtown neighborhood. Clientele: upscale. 60% private collectors, 20% corporate collectors. Overall price range: $1,000-100,000; most work sold at $15,000-50,000.
Media: Considers all media and types of prints. Most frequently exhibits painting, sculpture and conceptual work.
Style: Exhibits conceptualism, neo-expressionism, minimalism, color field, hard-edge geometric abstraction and surrealism. All genres. Prefers minimal, conceptual and color field.

Terms: Artwork is accepted on consignment and there is a 50% commission or is bought outright for a percentage of the retail price; net 60 days. Retail price set by the gallery. Gallery provides promotion. Artist pays for shipping costs. Prefers artwork framed.
Submissions: Send query letter with résumé, slides, bio and SASE. Write for appointment to show portfolio of slides and transparencies. Replies in 1-2 months.
Tips: Finds artists through referrals. "Work is a constant, do not stop."

DISTRICT OF COLUMBIA ARTS CENTER (DCAC), 2438 18th St. NW, Washington DC 20009. (202)462-7833. Fax: (202)328-7099. Executive Director: B. Stanley. Nonprofit gallery and performance space. Estab. 1989. Exhibits emerging and mid-career artists. Sponsors 7-8 shows/year. Average display time 4-6 weeks. Open Wednesday-Thursday, 2-6; Friday-Sunday, 2-10; and by appointment. Closed August. Located "in Adams Morgan, a downtown neighborhood; 132 running exhibition feet in exhibition space and a 52-seat theater." Clientele: all types. Overall price range: $200-10,000; most work sold at $600-1,400.
Media: Considers all media including fine and plastic art. "No crafts." Most frequently exhibits painting, sculpture and photography.
Style: Exhibits all styles. Prefers "innovative, mature and challenging styles."
Terms: Accepts artwork on consignment (30% commission). Artwork only represented while on exhibit. Retail price set by the gallery and artist. Offers payment by installments. Gallery provides promotion and contract; artist pays for shipping. Prefers artwork framed.
Submissions: Send query letter with résumé, slides, bio and SASE. Portfolio review not required. Replies in 2 months.
Tips: "We strongly suggest the artist be familiar with the gallery's exhibitions, and the kind of work we show: strong, challenging pieces that demonstrate technical expertise and exceptional vision. Include SASE if requesting reply and return of slides!"

FINE ART AND ARTISTS, INC., 1710 Connecticut Ave. NW, 4th Floor, Washington DC 20009. (202)462-2787. Fax: (202)462-3128. President: Judith du Berrier. Retail gallery and art consultancy. Estab. 1990. Represents 50 established artists/year. May be interested in seeing the work of emerging artists in the future. Exhibited artists include Warhol, Lichtenstein, Stella. Sponsors 2 shows/year. Average display time 2 months. Open all year; Monday-Saturday, 12-6. Located in Dupont Circle; 1,700 sq. ft.; skylights, brick walls, Victorian renovated building. 75% of space for special exhibitions; 25% of space for gallery artists. Clientele: corporate, doctors, lawyers, other professionals. 60% private collectors, 40% corporate collectors. Overall price range: $1,500-25,000; most work sold at $3,000-5,000.
Media: Considers oil, acrylic, watercolor, pastel, pen & ink, drawing, mixed media, sculpture, woodcut, engraving, lithograph, wood engraving, serigraphs and linocut. Most frequently exhibits lithograph, serigraph, oil.
Style: Exhibits expressionism, pop, neo-pop.
Terms: Accepts work on consignment (50% commission). Retail price set by the gallery and/or the artist. Gallery provides insurance, promotion, contract and shipping costs from gallery; artist pays shipping costs to gallery. Prefers artwork framed.
Submissions: Prefers only pop; abstract expressionists. Send query letter with photographs and SASE. Write for appointment to show portfolio of photographs. Replies only if interested within 1 month. Files bio, duplicate photos or slides.
Tips: "Do not call. Do not send unsolicited photos, etc. Do not 'drop by' without appointment. Write a concise letter stating style, medium, price structure. Enclose photocopy or other non-returnable example of work."

FOXHALL GALLERY, 3301 New Mexico Ave. NW, Washington DC 20016. (202)966-7144. Director: Jerry Eisley. Retail gallery. Represents emerging and established artists. Sponsors 6 solo and 6 group shows/year. Average display time 3 months. Overall price range: $500-20,000; most artwork sold at $1,500-6,000.
Media: Considers oil, acrylic, watercolor, pastel, sculpture, mixed media, collage and original handpulled prints (small editions).
Style: Exhibits contemporary, abstract, impressionistic, figurative, photorealistic and realistic works and landscapes.
Terms: Accepts work on consignment (50% commission). Retail price set by gallery and artist. Customer discounts and payment by installment are available. Exclusive area representation required. Gallery provides insurance.
Submissions: Send résumé, brochure, slides, photographs and SASE. Call or write for appointment to show portfolio.
Tips: Finds artists through agents, by visiting exhibitions, word of mouth, various art publications and sourcebooks, artists' submissions, self promotions and art collectors' referrals.

‡GALERIE LAREUSE, 2820 Pennsylvania Ave. NW, Washington DC 20007. (202)333-5704. Fax: (202)333-2789. Owner: Jean-Michel Lareuse. Retail gallery. Estab. 1982. Represents/exhibits 3 established artists/year. Exhibited artists include Beth Turk and Norma Cawthon. Sponsors 3 shows/year. Average display time

3 weeks. Open all year; Tuesday-Saturday, 10-6; Sunday, 12-6. Located in Georgetown; 800 sq. ft.; old townhouse in an historic area. 20% of space for special exhibitions; 80% of space for gallery artists. Clientele: foreign visitors. 100% private collectors. Overall price range: $650-70,000; most work sold at $1,500-3,000.
Media: Considers all media and all types of prints.
Style: Exhibits expressionism, surrealism and impressionism. Genres include figurative work. Prefers impressionism, abstraction and decorative.
Terms: Artwork is accepted on consignment and there is a commission. Retail price set by the artist. Artist pays for shipping cost. Prefers artwork unframed.
Submissions: Send query letter with résumé, slides, photographs and SASE. Write for appointment to show portfolio of photographs, slides and transparencies. Replies in 2 weeks.
Tips: Finds artists through word of mouth and referrals by other artists.

GALLERY K, 2010 R St. NW, Washington DC 20009. (202)234-0339. Fax: (202)334-0605. Director: Komei Wachi. Retail gallery. Estab. 1976. Represents 47 emerging, mid-career and established artists. Interested in seeing the work of emerging artists. Exhibited artists include Jody Mussoff and Y. David Chung. Sponsors 10 shows/year. Average display time 1 month. Closed mid July-mid September; Tuesday-Saturday 11-6. Located in DuPont Circle area; 2,500 sq. ft. Clientele: local. 80% private collectors, 10% corporate collectors; 10% other galleries. Overall price range: $100-250,000; most work sold at $200-2,000.
Media: Considers oil, pen & ink, paper, acrylic, drawing, sculpture, watercolor, mixed media, ceramic, pastel, collage, photography, woodcuts, wood engravings, linocuts, engravings, mezzotints, etchings, lithographs and serigraphs. Most frequently exhibits oil, acrylic, drawing.
Style: Exhibits realism and surrealism. Genres include landscapes and figurative work. Prefers surrealism, realism and postmodernism.
Terms: Accepts work on consignment (20-50% commission). Retail price set by gallery and artist. Gallery provides insurance, promotion and contract; artist pays for shipping costs. Prefers artwork framed.
Submissions: Accepts artists mainly from DC area. Send query letter with résumé, slides and SASE. Replies in 4-6 weeks only if SASE enclosed.

GATEHOUSE GALLERY, Mount Vernon College, 2100 Foxhall Rd. NW, Washington DC 20007. (202)625-4640. Associate Professor and Gatehouse Gallery/Director: James Burford. Nonprofit gallery. Estab. 1978. Exhibits the work of emerging, mid-career and established artists. Sponsors 7 solo and 2-3 group shows/year. Average display time: 3 weeks. Clientele: college students and professors.
Media: Considers all media. Most frequently exhibits photography, drawings, prints and paintings.
Style: Exhibits all styles and genres. "The exhibitions are organized to the particular type of art classes being offered and are local."
Terms: Accepts work on consignment (20% commission). Retail price set by artist. Exclusive area representation not required. Gallery provides promotion and contract; artist pays for shipping.
Submissions: Send query letter with résumé, brochure, slides or photographs. All material is returned if not accepted or under consideration.

MAHLER GALLERY, 406 7th St. NW, 2nd Floor, Washington DC 20004. (202)393-5180. Retail gallery and art consultancy. Estab. 1990. Represents contemporary artists from the Mid-Atlantic region of the US, with a concentration on Washington DC. Exhibited artists include Virginia Daley, Ron Banks, Tom Zetterstrom, Jane Johnson and Joan Earnhart. Sponsors 10 shows/year. Open September-July; Wednesday-Friday, 11-5; Saturday, 12-5; by appointment. Located downtown on Gallery Row adjacent to Smithsonian Mall and other National Museums; 2,500 sq. ft. Clientele: private and corporate. 75% private collectors, 25% corporate collectors. Overall price range: $750-10,000; most work sold at $1,000-2,000.
Media: Considers oil, acrylic and collage. Most frequently exhibits paintings on canvas and mixed media on paper and limited-edition landscape prints.
Style: "Very small, selective stable, of artists with strong focus on landscapes, abstract work on paper and assemblage."
Terms: Accepts work on consignment (50% commission). Retail price set by the gallery and the artist. Gallery provides insurance, promotion and contract; artist pays shipping costs to and from gallery.
Submissions: Send query letter with résumé, slides, SASE, price list and description of media. Portfolio should include slides and SASE.
Tips: "We're a small-staff gallery with a very small stable of artists. Therefore, please be sure your mailed material is succinct and efficient and easy for us to re-package and return in your SASE."

SPECTRUM GALLERY, 1132 29th St. NW, Washington DC 20007. (202)333-0954. Director: Anna G. Proctor. Retail/cooperative gallery. Estab. 1966. Exhibits the work of 29 mid-career artists. Sponsors 10 solo and 3 group shows/year. Average display time 1 month. Accepts only artists from Washington area. Open year round. Located in Georgetown. Clientele: 80% private collectors, 20% corporate clients. Overall price range: $50-5,000; most artwork sold at $450-900.

Media: Considers oil, acrylic, watercolor, pastel, pen & ink, drawings, mixed media, collage, works on paper, sculpture, ceramic, fiber, woodcuts, mezzotints, etchings, lithographs and serigraphs. Most frequently exhibits acrylic, watercolor and oil.

Style: Exhibits impressionism, realism, minimalism, painterly abstraction, pattern painting and hard-edge geometric abstraction. Genres include landscapes, florals, Americana, portraits and figurative work.

Terms: Co-op membership fee plus donation of time; 35% commission. Retail price set by artist. Sometimes offers payment by installment. Exclusive area representation not required. Gallery provides promotion and contract.

Submissions: Artists must live in the Washington area because of the cooperative aspect of the gallery. Bring actual painting at jurying; application forms needed to apply.

Tips: "A common mistake artists make is not knowing we are a cooperative gallery. We were one of the first cooperatives in the Washington area and were established to offer local artists an alternative to the restrictive representation many galleries were then providing. Each artist is actively involved in the shaping of policy as well as maintenance and operation. The traditional, the abstract, the representational and the experimental can all be found here. Shows change every month and each artist is represented at all times."

STUDIO GALLERY, 2108 R Street NW, Washington DC 20008. (202)232-8734. Director: June Linowitz. Cooperative and nonprofit gallery. Estab. 1964. Exhibits the work of 30 emerging, mid-career and established artists. Sponsors 11 shows/year. Average display time 1 month. Guest artists in August. Located downtown in the Dupont Circle area; 550 sq. ft.; "gallery backs onto a courtyard, which is a good display space for exterior sculpture and gives the gallery an open feeling." 5% of space for special exhibitions. Clientele: private collectors, art consultants and corporations. 85% private collectors; 8% corporate collectors. Overall price range: $300-10,000; most work sold at $500-3,000.

Media: Considers oil, acrylic, watercolor, pastel, pen & ink, drawings, mixed media, collage, works on paper, sculpture, ceramic, fiber, installation, photography, original handpulled prints, woodcuts, engravings, lithographs, wood engravings, mezzotints, monoprints and monotypes, serigraphs, linocuts and etchings. Most frequently exhibits painting, sculpture and prints.

Style: All genres. "Work is exhibited if it is high quality—the particular style varies."

Terms: Co-op membership fee plus a donation of time (30% commission). Gallery provides promotion; artist pays for shipping to gallery; purchaser of work pays for shipping from gallery.

Submissions: Send query letter with SASE. "Artists must be local—or willing to drive to Washington for monthly meetings and receptions. Artist is informed as to when there is a membership opening and a selection review." Files artist's name, address, telephone.

Tips: "This is a cooperative gallery. Membership is decided by the gallery membership. This is peer review. The director does not determine membership. Ask when the next review for membership is scheduled. Do not send slides. Feel free to ask the director questions about gallery operations. Dupont Circle is seeing more and more galleries locating here. It is growing into an exciting gallery row and is drawing more public interest. We are making more of an effort to reach local corporations. We have an outreach program to see to the local businesses and high tech industries."

‡WASHINGTON PRINTMAKERS GALLERY, 2106-b R St. NW, Washington DC 20008. (202)332-7757. Director: Sally Babylon. Cooperative gallery. "We trade shows internationally." Estab. 1985. Exhibits 3 emerging and mid-career artists/year. Exhibited artists include George Chung and Beth MacDonald. Sponsors 12 exhibitions/year. Average display time 1 month. Open all year; Wednesday-Saturday, 11-5 and Sunday, 12-5. Located downtown in Dupont Circle area. 100% of space for gallery artists. Clientele: varied. 90% private collectors, 10% corporate collectors. Overall price range: $50-900; most work sold at $200-400.

Media: Considers only all types of original prints, hand pulled by artist. Most frequently exhibits etchings, lithographs, serigraphs.

Style: Considers all styles and genres. Prefers expressionism, abstract, realism.

Terms: Co-op membership fee plus donation of time (35% commission). Retail price set by artist. Gallery provides promotion; artist pays shipping costs.

Submissions: Prefers only regional printmakers. Send query letter. Call for appointment to show portfolio of original prints and slides. Replies in 1 month.

Tips: "There is a yearly jury in April for prospective new members. We are especially interested in artists who exhibit a strong propensity for not only the traditional conservative approaches to printmaking, but also the looser, more daring and innovative experimentation in technique."

Florida

ALBERTSON-PETERSON GALLERY, 329 S. Park Ave., Winter Park FL 32789. (407)628-1258. Fax: (407)647-6928. Owner: Judy Albertson. Retail gallery. Estab. 1984. Represents 10-25 emerging, mid-career and established artists/year. Exhibited artists include Carol Bechtel and Frank Faulkner. Sponsors 6 shows/year. Average display time 3 weeks. Open all year; Tuesday-Friday, 10-5:30; Saturday, 11:00-5:30. Located

George Chung's **Gwynn's Island** *is a three-plate etching and aquatint, his main medium. Chung, an artist of Chinese descent born in Panama, studied at the Chicago Art Institute and settled in the Washington DC area. The influence of several cultures can be seen in his work, which has been in the collection at Washington Printmaker's Gallery almost since the gallery's inception. Gallery spokesperson Pam Hoyle describes Chung's work as "aggressively playful, yet laid back."*

© George Chung.

downtown; 3,000 sq. ft.; great visability, lots of glass. 45% of space for special exhibitions (during exhibitions); 95% of space for gallery artists (generally). Clientele: 50% local, 50% tourist. 15-20% private collectors, 40-50% corporate collectors. Overall price range: $200-15,000; most work sold at $500-3,000.
Media: Considers oil, acrylic, watercolor, pastel, mixed media, collage, paper, sculpture, ceramics, craft, fiber, glass, installation, photography, woodcut, engraving, lithograph, wood engraving, mezzotint, serigraphs, linocut and etching. Most frequently exhibits paintings, ceramic, sculpture.
Style: Exhibits all styles. Prefers abstract, contemporary landscape and nonfunctional ceramics.
Terms: Accepts work on consignment (varying commission). Retail price set by the gallery and the artist. Gallery provides insurance, promotion, contract and shipping costs from gallery; artist pays shipping costs to gallery. Prefers artwork unframed.
Submissions: Accepts only artists "exclusive to our area." Send query letter with résumé, slides, bio, photographs, SASE and reviews. Call or write for appointment to show portfolio of photographs, slides and transparencies. Replies within a month.
Tips: Finds artists through exhibitions, art publications and artists' submissions.

‡APROPOS ART GALLERY, INC., 1016 E. Las Olas Blvd., Ft. Lauderdale FL 33301. (305)524-2100. Fax: (305)524-1817. Director: Laurie Lee Clark. Retail and wholesale gallery. Estab. 1988. Represents/exhibits 25 mid-career and established artists/year. Interested in seeing the work of emerging artists. Sponsors 4 shows/year. Average display time 3 months. Open all year; Monday-Sunday, 10-7. Located downtown, Main Blvd.; 4,000 sq. ft.; newly remodeled, wood floors, high ceiling. 90% of space for space for gallery artists. Clientele: tourists, upscale, local community. 100% private collectors. Overall price range: $1,000-30,000.
Media: Considers all media except pastel and wood. Considers woodcut, engraving, lithograph, wood engraving, mezzotint, serigraphs, linocut and etching. Most frequently exhibits oil and acrylic painting.
Style: Exhibits expressionism, conceptualism, photorealism, neo-expressionism, painterly abstract, realism, surrealism and imagism. Genres include figurative work. Prefers figurative, surrealism and expressionism.
Terms: Artwork is accepted on consignment and there is a 50% commission. Retail price set by the gallery and the artist. Gallery provides insurance, promotion and contract; shipping costs are shared. Prefers artwork framed.
Submissions: Send query letter with résumé, slides, reviews, bio, SASE and detail/wholesale price list. Gallery will contact artist if interested. Portfolio should include photographs and slides. Replies in 1-2 months.
Tips: Finds artists through word of mouth, referrals by other artists, visiting art fairs and exhibitions and artists' submissions. "Keep your portfolio updated and complete."

ATLANTIC CENTER FOR THE ARTS, INC., 1414 Arts Center Ave., New Smyrna Beach FL 32168. (904)427-6975. Contact: Program Director. Nonprofit interdisciplinary artists-in-residence program. Estab. 1979. Represents established artists. Interested in seeing the work of emerging artists. Exhibited artists include Alex Katz, Wm. Wegman, Janet Fish, Mel Chin. Sponsors 5-6 shows/year. Located on secluded bayfront— 3½ miles from downtown; 100 sq. ft.; building made of cedar wood, 30 ft. ceiling, skylights. Clientele: local

community, art patrons. "Most work is not sold—interested parties are told to contact appropriate galleries."
Media: Most frequently exhibits paintings/drawings/prints, video installations, sculpture, photographs.
Style: Contemporary.
Terms: "Provides insurance, shipping costs, etc. for exhibiting Master Artists' work.
Submissions: Exhibits only Master Artists in residence. Call for more information.

BAKEHOUSE ART COMPLEX, 561 N.W. 32 St., Miami FL 33127. (305)576-2828. Contact: D. Sperow.
Alternative space and nonprofit gallery. Estab. 1986. Represents 150 emerging and mid-career artists. 150
members. Sponsors 11 shows/year. Average display time 3 weeks. Open all year; Tuesday-Friday, 10-4.
Located in Design District; 3,200 sq. ft.; retro fitted bakery preparation area, 17' ceilings, tile floors. Clientele:
80% private collectors, 20% corporate collectors. Overall price range: $500-5,000.
Media: Considers all media and all types of prints.
Style: Exhibits all styles, all genres.
Terms: Co-op membership fee plus donation of time (30% commission). Rental fee for space; covers 1
month. Retail price set by the artist.
Submissions: Accepts only artists from juried membership. Send query letter with résumé, slides, bio,
reviews. Write for appointment to show portfolio of slides. Files all accepted members' slides and résumés.
Tips: "Visit facility on open house days (second Sunday of each month) or during openings."

ALEXANDER BREST MUSEUM/GALLERY, 2800 University Blvd., Jacksonville University, Jacksonville
FL 32211. (904)744-3950 ext. 7371. Fax: (904)744-0101. Director: David Lauderdale. Museum. Estab. 1970.
Represents 4-6 emerging, mid-career and established artists/year. Sponsors 4-6 shows/year. Average display
time 6 weeks. Open all year; Monday-Friday, 9-4:30; Saturday, 2-5. "We close 2 weeks at Christmas and
University holidays." Located in Jacksonville University, near downtown; 800 sq. ft.; 11½ foot ceilings.
20% of space for special exhibitions. "As an educational museum we have few if any sales. We do not
purchase work—our collection is through donations."
Media: "We rotate style and media to reflect the curriculum offered at the institution. We only exhibit media
that reflect and enhance our teaching curriculum. (As an example we do not teach bronze casting, so we do
not seek such artists.)."
Style: Exhibits expressionism, neo-expressionism, primitivism, painterly abstraction, surrealism, all styles,
primarily contemporary.
Terms: Retail price set by the artist. Gallery provides insurance and promotion; artist pays shipping costs
to and from gallery. "The art work needs to be ready for exhibition in a professional manner."
Submissions: Send query letter with résumé, slides, brochure, business card and reviews. Write for appoint-
ment to show portfolio of slides. "Replies fast when not interested. Yes takes longer."
Tips: Finds artists through visiting exhibitions and artists' submissions. "Being professional impresses us.
But circumstances also prevent us from exhibiting all artists we are impressed with."

CENTER FOR THE FINE ARTS, 101 W. Flagler St., Miami FL 33130. (305)375-3000. Fax: (305)375-1725.
Associate Curator of Exhibitions: Kate Rawlinson. Museum. Estab. 1984. Represents 12-14 emerging, mid-
career and established artists/year. Average display time 2 months. Open all year; Tuesday-Saturday, 10-5;
Thursday 10-9; Sunday, noon-5 pm. Located downtown; 16,000 sq. ft.; cultural complex designed by Philip
Johnson. 60% of space for special exhibitions.
Media: Considers oil, acrylic, watercolor, drawing, mixed media, sculpture, installation, photography, wood-
cut, engraving, lithograph, wood engraving, mezzotint, serigraphs, linocut and etching. Most frequently
exhibits paintings, installation and photography.
Style: Exhibits art since 1945, large scale traveling exhibitions, retrospective of internationally known artists.
Terms: Prefers artwork framed.
Submissions: Accepts only artists nationally and internationally recognized. Send query letter with résumé,
slides, bio, brochure, photographs, SASE and reviews. Write for appointment to show portfolio of slides.
Replies in 2-3 months.
Tips: Finds artists through visiting exhibitions, word of mouth, art publications and artists' submissions.

CLAYTON GALLERIES, INC., 4105 S. MacDill Ave., Tampa FL 33611. (813)831-3753. Fax: (813)837-
8750. Director: Cathleen Clayton. Retail gallery. Estab. 1986. Represent 28 emerging and mid-career artists.
Exhibited artists include Bruce Marsh and Craig Rubadoux. Sponsors 7 shows/year. Average display time
5-6 weeks. Open all year. Located in the southside of Tampa 1 block from the Bay; 1,400 sq. ft.; "post-
modern interior with glass bricked windows, movable walls, center tiled platform." 30% of space for special
exhibitions. Clientele: 40% private collectors, 60% corporate collectors. Overall price range: $100-15,000;
most artwork sold at $500-2,000.
Media: Considers oil, pen & ink, works on paper, fiber, acrylic, sculpture, glass, watercolor, mixed media,
ceramic, pastel, craft, photography, original handpulled prints, woodcuts, wood engravings, engravings, mez-
zotints, etchings, lithographs, collagraphs and serigraphs. Prefers oil, metal sculpture and mixed media.

Style: Considers neo-expressionism, painterly abstraction, post-modern works, realism and hard-edge geometric abstraction. Genres include landscapes and figurative work. Prefers figurative, abstraction and realism—"realistic, dealing with Florida, in some way figurative."
Terms: Accepts work on consignment (50% commission). Retail price set by gallery and the artist. Gallery provides insurance, promotion and contract; artist pays for shipping. Prefers unframed artwork.
Submissions: Prefers Florida or Southeast artists with M.F.A.s. Send résumé, slides, bio, SASE and reviews. Write to schedule an appointment to show a portfolio, which should include photographs and slides. Replies in 6 months. Files slides and bio, if interested.
Tips: Looking for artist with "professional background i.e., B.A. or M.F.A. in art, awards, media coverage, reviews, collections, etc." A mistake artists make in presenting their work is being "not professional, i.e., no letter of introduction; poor or unlabeled slides; missing or incomplete résumé."

‡JEANINE COX ● FINE ART, 1029 Lincoln Rd., Miami Beach FL 33139. (305)534-9003. Fax: (305)539-6203. Director: Jeanine Cox. Retail gallery. Estab. 1990. Represents/exhibits 20 emerging, mid-career and established artists. May be interested in seeing the work of emerging artists in the future. Exhibited artists include T.A. Zive and Lamar Briggs. Sponsors 10 shows/year. Average display time 3 weeks. Open in winter; Monday-Thursday, 10-10; Friday-Saturday, 10-9; Sunday, 12-6. Located in Miami Beach; 3,000 sq. ft.; Clientele: collectors. 80% private collectors, 20% corporate collectors. Overall price range: $200-175,000; most work sold at $5,000-10,000.
Media: Considers all media and all types of prints. Most frequently exhibits glass, paintings and prints.
Style: Exhibits photorealism, neo-expressionism, minimalism, painterly abstraction, realism and imagism. All genres. Prefers expressionism, abstraction and realism.
Terms: Retail price set by gallery and artist. Gallery provides insurance, promotion.
Submissions: Send query letter with résumé, slides, SASE. Write for appointment to show portfolio of slides. Replies only if interested within 6 months. Files interesting work.
Tips: "Concentrate on quality of work. Galleries find desirable artists!"

THE DELAND MUSEUM OF ART INC., 600 N. Woodland Blvd., De Land FL 32720-3447. (904)734-4371. Executive Director: Harry Messersmith. Museum. Exhibits the work of established artists. Sponsors 8-10 shows/year. Open all year. Located near downtown; 5,300 sq. ft.; in The Cultural Arts Center; 18′ carpeted walls, two gallery areas, including a modern space. Clientele: 85% private collectors, 15% corporate collectors. Overall price range: $100-30,000; most work sold at $300-5,000.
Media: Considers oil, acrylic, watercolor, pastel, works on paper, sculpture, ceramic, woodcuts, wood engravings, engravings and lithographs. Most frequently exhibits painting, sculpture, photographs and prints.
Style: Exhibits expressionism, surrealism, imagism, impressionism, realism and photorealism; all genres. Interested in seeing work that is finely crafted and expertly composed, with innovative concepts and professional execution and presentation. Looks for "quality, content, concept at the foundation—any style or content meeting these requirements considered."
Terms: Accepts work on consignment (30% donation requested from artist) for exhibition period only. Retail price set by artist. Gallery provides insurance, promotion and contract; shipping costs may be shared.
Submissions: Send résumé, slides, bio, brochure, SASE and reviews. Write for appointment to show portfolio of slides. Replies in 1 month. Files slides and résumé.
Tips: "Artists should have a developed body of artwork and an exhibition history that reflects the artist's commitment to the fine arts. Museum contracts 2-3 years in advance. Label each slide with name, medium, size and date of execution."

‡FLORIDA ART CENTER & GALLERY, 208 First St., NW, Havana FL 32333. (904)539-1770. President: Lee Mainella. Retail gallery, studio and art school. Estab. 1993. Represents 30 emerging, mid-career and established artists. Interested in seeing the work of emerging artists. Open all year. Located in small, but growing town in north Florida; 2,100 st. ft.; housed in a large renovated 50-year-old building, 2 blocks long, exposed rafters and beams. Clientele: private collectors. 100% private collectors.
Media: Considers all media and original handpulled prints (a few).
Style: Exhibits all styles, tend toward traditional styles. Genres include landscapes and portraits.
Terms: Accepts work on consignment (40% commission). Retail price set by gallery and artist. Gallery provides insurance, promotion and contract.
Submissions: Send query letter with slides. Call or write for appointment.
Tips: "Prepare a professional presentation for review, (i.e. quality work, good slides, clear, concise and informative backup materials). Size, medium, price and framed condition of painting should be included."

FRIZZELL CULTURAL CENTRE GALLERY, 10091 McGregor Blvd., Ft. Myers FL 33919. (813)939-2787. Fax: (813)939-0794. Contact: Exhibition committee. Nonprofit gallery. Estab. 1979. Represents emerging, mid-career and established artists. 460 members. Exhibited artists include Jack Dowd and Jay Leviton. Sponsors 16 shows/year. Average display time 1 month. Open all year; Monday-Saturday, 10-4; Sunday, 1-4. Located in Central Lee County—near downtown; 1,400 sq. ft.; high ceiling, open ductwork—ultra modern

and airy. Clientele: local to national. 90% private collectors, 10% corporate collectors. Overall price range: $200-100,000; most work sold at $500-2,500.
Media: Considers all media and all types of print. Most frequently exhibits oil, sculpture and watercolor.
Style: Exhibits all styles, all genres.
Terms: Retail price set by the artist. Prefers artwork framed.
Submissions: Send query letter with slides, bio and SASE. Write for appointment to show portfolio of photographs and slides. Replies in 3 months. Files "all material unless artist requests slides returned."
Tips: Finds artists through visiting exhibitions, word of mouth and artists' submissions.

‡GALA ART GALLERY, 6 Via Sunset, Palm Beach FL 33480. (407)835-4763. Owner: Nicholas Galatis. Retail gallery. Estab. 1982. Represents/exhibits 20-30 established artists/year. May be interested in seeing the work of emerging artists in the future. Exhibited artists include Al Hirschfed and H. Claude Pissarro. Sponsors 2-3 shows/year. Average display time 2 months. Open October-June; Monday-Saturday 11-5. 1,400 sq. ft.; 50% of space for special exhibitions; 50% of space for gallery artists. Clientele: upscale. 70% private collectors, 30% corporate collectors. Overall price range: $800-10,000.
Media: Considers all media, woodcut, engraving, lithograph, mezzotint and serigraphs. Most frequently exhibits oil, acrylic, sculpture and bronze.
Style: Exhibits expressionism, minimalism, color field, realism and impressionism. Genres include landscapes, florals and figurative work.
Terms: Artwork is accepted on consignment and there is a 20% commission, or is bought outright for 50% of the retail price; net 30 days. Retail price set by gallery. Gallery provides promotion and contract. Artists pays for shipping. Prefers artwork framed.
Submissions: Send query letter with résumé, brochure, slides and reviews. Write for appointment to show portfolio of photographs, slides and transparencies. Replies in 3 weeks.
Tips: Finds artists through word of mouth and art publications. Advice to artists: "Keep producing."

‡GALLERY CONTEMPORANEA, 526 Lancaster, Jacksonville FL 32204. Director: Sally Ann Freeman. Retail gallery and art consultancy. Estab. 1974. Represents/exhibits 120 mid-career and established artists. Exhibited artists include Allison Watson and Gretchen Ebersol. Sponsors 3-4 shows/year. Average display time 2 months. Open all year; Thursday-Saturday, 10-2 or by appointment. Located near downtown—historic neighborhood; 1,100 sq. ft.; "corporate consulting is 50-60% of sales." 65% of space for special exhibitions. Clientele: local area. 40-50% private collectors, 50-60% corporate collectors. Overall price range: $15-12,000; most work sold at $600-12,000.
Media: Considers all media and all types of prints. Most frequently exhibits paintings, original prints, sculpture, clay, fiber and photos.
Style: Exhibits expressionism, painterly abstraction, realism and impressionism. Genres include landscapes and florals. Prefers realism, impressionism and abstraction.
Terms: Artwork is accepted on consignment and there is a 50% commission. Retail price set by gallery. Gallery provides insurance, promotion and contract; shipping costs are shared.
Submissions: Accepts only artists from the Southwest. Send query letter with résumé, slides, reviews, bio and SASE. Write for appointment to show portfolio of slides. Replies in 2-3 weeks. Files reviews, bio and slides.
Tips: Finds artists through word of mouth, referrals by other artists and artist's submissions. "Be professional and flexible."

GALLERY V, (formerly Galerie Martin, Inc.), 5250 Boca Center Circle, Suite 213, Boca Raton FL 33432. Director: Edith Mallinger. Retail gallery. Estab. 1970. Represents 10 established artists. Interested in seeing the work of emerging artists. Exhibited artists include Leonardo Nierman and Bruno Perino. Sponsors 6 shows/year. Average display time 2 weeks. Open all year. Located in Boca Center; 2,300 sq. ft.; 50% of space for special exhibitions. Clientele: 75% private collectors; 25% corporate collectors. Overall price range: $100-20,000.
Media: Considers oil, acrylic, mixed media, sculpture, original handpulled prints, lithographs, posters and serigraphs. Most frequently exhibits oil, acrylic and serigraphs.
Style: Exhibits expressionism, neo-expressionism, primitivism, painterly abstraction, impressionism, naive art and realism. Genres include landscapes and figurative work. Prefers impressionism, expressionism and abstraction.
Terms: Accepts artwork on consignment (50% commission). Retail price set by gallery. Gallery provides insurance and promotion; shipping costs are shared.
Submissions: Send query letter with brochure and photographs. Write for appointment to show portfolio of originals. Replies in 2 weeks.

THE HANG-UP, INC., 45 S. Palm Ave., Sarasota FL 34236. (813)953-5757. President: F. Troncale. Retail gallery. Estab. 1971. Represents 25 emerging and mid-career artists. Sponsors 6 shows/year. Average display time 1 month. Open all year. Located in arts and theater district downtown; 1,700 sq. ft.; "high tech, 10 ft. ceilings with street exposure in restored hotel." 50% of space for special exhibitions. Clientele: 75% private

collectors, 25% corporate collectors. Overall price range: $500-5,000; most artwork sold at $500-1,000.
Media: Considers oil, acrylic, watercolor, mixed media, collage, works on paper, sculpture, original hand-pulled prints, lithographs, etchings, serigraphs and posters. Most frequently exhibits painting, graphics and sculpture.
Style: Exhibits expressionism, painterly abstraction, surrealism, impressionism, realism and hard-edge geometric abstraction. All genres. Prefers abstraction, impressionism, surrealism.
Terms: Accepts artwork on consignment (50% commission). Retail price set by artist. Sometimes offers customer discounts and payment by installment. Gallery provides insurance, promotion and contract; shipping costs are shared. Prefers unframed work. Exhibition costs shared 50/50.
Submissions: Send résumé, brochure, slides, bio and SASE. Write for appointment to show portfolio of originals and photographs. "Be organized and professional. Come in with more than slides; bring P.R. materials, too!" Replies in 1 week.

‡HARMON-MEEK GALLERY, 386 Broad Ave. S., Naples FL 33940. (813)261-2637. Fax: (813)261-3804. Director/Owner: William Meek. Retail gallery. Dedicated to helping older established artists to survive as each new fad comes and goes." Estab. 1964. Represents/exhibits 38 established artists/year. Exhibited artists include Richard Segalman and Robert Vickrey. Sponsors 15 shows/year. Average display time 1 week. Open October 15-May 1; Monday-Saturday, 10-5. Located in Olde Naples; 1,500 sq. ft. plus 1,500 sq. ft. storage; carpeted walls. 100% of space for gallery artists. Clientele: upscale. 90% private collectors, 10% corporate collectors. Overall price range: $300-300,000; most work sold at $1,500-9,500.
Media: Considers all media except photography installation, fiber, glass, craft, ceramics and paper. Most frequently exhibits egg tempera, pastel and oil.
Style: Exhibits hard-edge geometric abstraction, painterly abstraction, realism and surrealism. Genres include landscapes, Americana and figurative work. Prefers figurative, landscape, non-objective and objective abstraction.
Terms: Artwork is accepted on consignment and there is a 50% commission. Gallery provides insurance; shipping costs are shared. Prefers artwork framed.
Submissions: Send query letter with résumé, slides, bio and SASE. Does not reply. Artist should include SASE.
Tips: Finds artists through visiting museum juried exhibitions and art fairs. "Marry someone with a steady job."

HEIM/AMERICA AT FISHER ISLAND GALLERY. 42102 Fisher Island Dr., Fisher Island FL 33109. (305)673-6809. Fax: (305)532-2789. Director: J.H. Stoneberger. Retail gallery. Estab. 1990. Represents emerging and established artists. Sponsors 4-5 shows/year. Average display time 1 month. Open September 1-July 1; Tuesday-Saturday 11-6. Located in a private community; 1,000 sq. ft. 65% of space for special exhibitions; 65% of space for gallery artists. 50% private collectors, 50% corporate collectors. Overall price range: $800-200,000; most work sold at $10-15,000.
Media: Considers oil, watercolor, pastel, pen & ink, drawing, mixed media, paper and sculpture. Most frequently exhibits oil on canvas, watercolor and drawings.
Style: Exhibits expressionism, painterly abstraction, minimalism, color field, impressionism and realism. Genres include landscapes, florals, portraits, figurative work, all genres. Prefers landscape (realism and post impressionism), abstraction and color field.
Terms: Accepts work on consignment. Retail price set by the gallery and the artist. Gallery provides insurance, promotion and contract. Artwork framed appropriately.
Submissions: Send query letter with résumé, slides and bio. Write for appointment to show portfolio of photographs. Replies only if interested within 2 months. Will return photos.
Tips: Finds artists through visiting exhibitions and artists' submissions. Impressed by "a good exhibition record."

KENDALL CAMPUS ART GALLERY, MIAMI-DADE COMMUNITY COLLEGE, 11011 SW 104 St., Miami FL 33176-3393. (305)237-2322. Fax: (305)237-2901. Director: Robert J. Sindelir. College gallery. Estab. 1970. Represents emerging, mid-career and established artists. Exhibited artists include Komar and Melamid. Sponsors 10 shows/year. Average display time 3 weeks. Open all year except for 2 weeks at Christmas and 3 weeks in August. Located in suburban area, southwest of Miami; 3,000 sq. ft.; "space is totally adaptable to any exhibition." 100% of space for special exhibitions. Clientele: students, faculty, community and tourists. "Gallery is not primarily for sales, but sales have frequently resulted."
Media: Considers all media, all types of original prints. "No preferred style or media. Selections are made on merit only."
Style: Exhibits all styles and genres.
Terms: "Purchases are made for permanent collection; buyers are directed to artist." Retail price set by artist. Gallery provides insurance and promotion; arrangements for shipping costs vary. Prefers artwork framed.

Submissions: Send query letter with résumé, slides, bio, brochure, SASE, and reviews. Write for appointment to show portfolio of slides. "Artists commonly make the mistake of ignoring this procedure." Replies in 2 weeks. Files résumés and slides (if required for future review).
Tips: "Present good quality slides of works which are representative of what will be available for exhibition."

‡KOUCKY GALLERY, 1246 Third St. S., Naples FL 33940. (813)261-8988. Fax: (813)261-8576. Owners: Chuck and Nancy. Retail gallery. Focus is on contemporary American artists and craftsmen. Estab. 1986. Represents/exhibits 175 emerging, mid-career and established. Exhibited artists include Todd Warner and Jack Dowd. Sponsors 6 shows/year. Open all year; Monday-Saturday. Located downtown; 1,500 sq. ft. Clientele: upscale international, resort. 98% private collectors, 2% corporate collectors. Overall price range: $140-35,000; most work sold at $85-900.
 ● Koucky Gallery also has a location in Charlevoix, Michigan.
Media: Considers all media. Most frequently exhibits sculpture, painting, jewelry and designer crafts.
Style: Exhibits expressionism, painterly abstraction, impressionism, contemporary works and imagism.
Terms: Artwork is accepted on consignment. Retail price set by the artist. Gallery provides insurance. Artist pays for shipping costs. Prefers artwork framed.
Submissions: Accepts only US artists. Send query letter with slides, photographs, bio and SASE. Call for appointment to show portfolio of photographs. "Replies slowly."
Tips: Finds artists through word of mouth.

J. LAWRENCE GALLERY, 1435 Highland Ave., Melbourne FL 32935. (407)259-1492. Fax: (407)259-1494. Director/Owner: Joseph L. Conneen. Retail gallery. Estab. 1980. Represents 65 mid-career and established artists. Exhibited artists include Kiraly and Mari Conneen. Sponsors 10 shows/year. Average display time 3 weeks. Open all year. "Centrally located downtown in a turn-of-the-century bank building in the antique and business district; 2,000 sq. ft.; five individual gallery rooms." 50% of space for special exhibitions. Clientele: 80% private collectors, 20% corporate collectors. Overall price range: $2,000-150,000; most work sold at $2,000-15,000.
Media: Considers oil, acrylic, watercolor, pastel, sculpture, ceramic, glass, original handpulled prints, mezzotints, lithographs and serigraphs. Most frequently exhibits oil, watercolor and silkscreen.
Style: Exhibits expressionism, painterly abstraction, impressionism, realism, photorealism and hard-edge geometric abstraction; all genres. Prefers realism, abstraction and hard-edge works.
Terms: Accepts work on consignment (50% commission). Retail price set by gallery. Customer discounts and payment by installment are available. Gallery provides insurance and promotion; artist pays for shipping.
Submissions: Prefers résumés from established artists. Send résumé, slides and SASE. Write for appointment to show portfolio of originals and slides.
Tips: "The most common mistake artists make is "not making appointments and not looking at the gallery first to see if their work would fit in. The gallery scene is getting better. The last three years have been terrible."

NORTON MUSEUM OF ART, 1451 S. Olive Ave., West Palm Beach FL 33401. (407)832-5196. Fax: (407)659-4689. Senior Curator: David Setford. Museum. Estab. 1941. Represents mid-career and established artists. May be interested in seeing the work of emerging artists in the future. Holds 10 temporary exhibitions per year and several permanent exhibitions. Exhibited artists include Howard Ben tré and Jonathan Green. Sponsors 10 shows/year. Average display time 7 weeks. Open all year; Tuesday-Saturday, 10-5; Sunday, 1-5. Located downtown; 8,111 sq. ft.; architecture is by Marion Syms Wyeth. 40% of space for special exhibitions; 60% of space for permanent collection.
Media: Considers oil, watercolor, pastel, drawing, sculpture, glass, photography, serigraphs and etching. Most frequently exhibits oil, watercolor and photography.
Style: Exhibits all styles, all genres.
Terms: Gallery provides contract. Prefers artwork framed.
Submissions: Send query letter with résumé, slides, bio, brochure and reviews. Write for appointment to show portfolio of slides and transparencies. "We reply in a timely manner."
Tips: Finds artists through visiting exhibitions, publications, sourcebooks and other curators.

‡ORMOND MEMORIAL ART MUSEUM & GARDENS, 78 E. Granada Blvd., Ormond Beach FL 32176. (904)676-3347. Curator: Leslie Scheiblberg. Nonprofit museum. Estab. 1946. Exhibits emerging and established artists. Charming 1946-era building with wood floors and casement windows in the front; French-style doors overlooking a terraced garden with a wooden deck off the two rear galleries."
Media: Considers all media except performance art. Most frequently exhibits mixed media, ceramic, watercolor and oil.
Style: Considers all styles.
Submissions: Send query letter with 10 slides of most recent work. All material filed, "but return slides after exhibit."
Tips: "We have been exhibiting more contemporary art. We look for unusual combinations of media, unique applications, a mixture of the old with the new, innovative ideas. We exhibit a lot of mixed media work and

we love sculpture of any kind. We have been known to exhibit non-mainstream art but mix it in with traditional work, both abstract and representational. We are a museum, not a gallery. We occasionally sell artwork through our exhibits, but that is not our reason for existence."

‡THE RADO GALLERY, 800 West Ave. (inside South Bay Club), Miami Beach FL 33139. Director: Ava L. Rado. Retail/wholesale gallery and art consultancy. Estab. 1991. Represents/exhibits emerging, mid-career and established artist. Exhibited artists include Rafael Mendez and Frederick Soler. Sponsors 6 shows/year. Average display time 1 month. Open all year; Wednesday-Saturday, 1-5 or by appointment only. Located inside a luxury condominimu on lobby level; 600 sq. ft. 90% of space for special exhibitions. Clientele: local community. 90% private collectors, 10% corporate collectors. Overall price range: $300-40,000; most work sold at $600-3,000.
Media: Considers all media and all types of prints. Most frequently exhibits acrylic on canvas, oil on canvas, abstract expressionism and ceramics.
Style: Exhibits all styles. Prefers abstract, landscape and minimalism.
Terms: Artwork is accepted on consignment and there is a commission. Retail price set by gallery. Gallery provides promotion and contract. Artist pays for insurance and shipping costs. Prefers artwork framed.
Submissions: Send query letter with résumé, brochure, slides, photographs, reviews, bio, SASE and video. Write for appointment to show portfolio of pertinent material. Replies only if interested within 1 month.
Tips: Finds artists through word of mouth, submissions and referrals. "Have persistence."

‡RENNER STUDIOS, INC., 4056 S.W. Moores St., Palm City FL 34990, (407)287-1855. Fax: (407)287-0398. Gallery Director/Owner: Ron Renner. Retail gallery. Estab. 1989. Represents 6 emerging and established artists/year. Exhibited artists include Simbari and Ron Renner. Sponsors 4 shows/year. Average display time 1 month. Open all year; Monday-Saturday, 10-6. Located in rural area, barn studios and showroom; 1,200 sq. ft.; 50% of space for special exhibitions; 50% of space for gallery artists. Clientele: upscale. 90% private collectors, 10% corporate collectors. Overall price range: $750-250,000; most work sold at $7,500-10,000.
Media: Considers oil, pen & ink, acrylic, drawing, watercolor, mixed media, pastel, collage, photography, engraving, etching, lithograph and serigraphs. Most frequently exhibits oil on canvas/linen, acrylic on canvas, serigraphs.
Style: Exhibits expressionism, impressionism, action painting. Genres include Mediterranean seascapes. Prefers abstract expressionism, impressionism and drawings.
Terms: Artwork is accepted on consignment and there is a 50% commission. Retail price set by the gallery. Gallery provides insurance, promotion, contract; shipping costs are shared. Prefers artwork framed.
Submissions: Send query letter with résumé, slides, bio and SASE. Write for appointment to show portfolio of slides. Replies only if interested within 3 weeks. Files bio, résumé, photos and slides.
Tips: Finds artists through submissions and visits to exhibits. "Keep producing, develop your style, take good pictures for slides of your work."

‡SANTE FE TRAILS GALLERY, 1429 Main St., Sarasota FL 34236. (813)954-1972. Owner: Beth Segreti. Retail gallery. Emphasis is on Native American and contemporary Southwestern art. Estab. 1990. Represents/exhibits 25 emerging, mid-career and established artists/year. May be interested in seeing the work of emerging artists in the future. Exhibited artists include Amado Peña and R.C. Gorman. Sponsors 5-6 shows/year. Average display time 1 month. Open all year; Tuesday-Saturday, 10-5. Located downtown; 1,000 sq. ft.; 100% of space for special exhibitions featuring gallery artists. Clientele: tourists, upscale and local community. 100% private collectors. Overall range: $35-12,000; most work sold at $500-1,500.
Media: Considers all media, etching, lithograph, serigraphs and posters. Most frequently exhibits lithograph, mixed media and watercolor.
Style: Prefers Southwestern.
Terms: Artwork is accepted on consignment (50% commission), or is bought outright for 50% of the retail price. Retail price set by the gallery and the artist. Gallery provides promotion. Shipping costs are shared. Prefers artwork unframed.
Submissions: Send query letter with résumé, slides or photographs, bio and SASE. Write for appointment to show portfolio of photographs, slides and transparencies. Replies only if interested within 2 weeks.
Tips: Finds artists through word of mouth, referrals by other artists and artists' submissions. "Make an appointment. No walk-ins!!"

STATE STREET GALLERY, 1517 State St., Sarasota FL 33577. Phone/fax: (813)951-0978.
 ● This gallery was opened by the owners of Grove St. Gallery in Illinois. See Grove St. listing for information on needs and submission policies.

‡THE SUWANNEE TRIANGLE G, #5 On The Dock, P.O. Box 127, Cedar Key FL 32625. (904)543-5744. Retail gallery. Estab. 1983. Represents 100 emerging and mid-career artists. Full-time exhibited artists include Connie Nelson and Kevin Hipe. Open all year. Located in the historic district; 1,000 sq. ft.; "directly on the Gulf of Mexico." Overall price range: $50-3,500; most artwork sold at $150-1,200.

Media: Considers oil, watercolor, pastel, ceramic, contemporary craft and jewelry, glass, offset reproductions, T-shirts, posters, serigraphs and etchings. Most frequently exhibits watercolor, oil and craft.
Style: Exhibits painterly abstraction and surrealism.
Terms: Artwork is bought outright (net 30 days). Some consignment. Retail price set by the gallery. Gallery provides promotion.
Submissions: Send query letter with résumé, slides, bio, SASE and reviews. Call for appointment to show a portfolio. Files material of future interest.
Tips: "Send me slides or photos of some incredibly original, incredibly good work at an affordable price."

UNIVERSITY GALLERY, UNIVERSITY OF FLORIDA, 102 Fine Arts, Bldg. B, Gainesville FL 32611-5803. (904)392-0201. Fax: (904)846-0266. Director: Karen Valdés. Nonprofit gallery. Estab. 1965. Represents 45 emerging, mid-career and established artists/year. Exhibited artists include Kruger, Balderssari and Calvo. Sponsors 8 shows/year. Average display time 4-6 weeks. Open all year; Tuesday, 10-8; Wednesday-Friday, 10-5; Saturday and Sunday, 1-5. Located on University campus; 3,000 sq. ft.; 16-foot ceiling with light grey walls. 100% of space for special exhibitions. Clientele: students, community.
Media: Considers all media and all types of prints. Most frequently exhibits painting, sculpture and photography.
Style: Exhibits all styles, contemporary only.
Terms: Gallery provides insurance and promotion; shipping costs are shared. Prefers artwork framed.
Submissions: Send query letter with résumé, slides and photographs. Write for appointment. Replies in 3 weeks. Files slides and résumés.
Tips: Finds artists through recommendations from other artists.

VALENCIA COMMUNITY COLLEGE EAST CAMPUS GALLERIES, 701 N. Econlockhatchee Trail, Orlando FL 32825. (305)299-5000 ext. 2298. Fax: (407)299-5000, ext. 2270. Gallery Curator: Robin Ambrose. Nonprofit gallery. Estab. 1982. Interested in emerging, mid-career and established artists. Sponsors 1 solo and 5 group shows/year. "Would also consider installation proposal by groups." Average display time is 6-8 weeks.
Media: Considers all media and all types of prints except posters. Most frequently exhibits mixed media, paintings and ceramics. Open Monday-Friday, 12:30-4:30; closed August. Located in East Orlando; 160 sq. ft.. Clientele: community and students. Overall price range: $50-5,000; most work sold at: $150-300.
Style: Considers all styles. Genres include landscapes and figurative work. Prefers figurative, nonfunctional and functional crafts.
Terms: Accepts work on consignment (no commission). Retail price set by artist. Exclusive area representation not required. Gallery provides insurance and promotion; shipping costs are shared.
Submissions: Send query letter with résumé, slides, photographs and SASE. Write for an appointment to show portfolio of slides and transparencies. Resumes and other biographical material are filed.
Tips: "I like to visit artists' studios personally. I need to see the work 'in the flesh,' so to speak. Mostly I learn about new artists by visiting other galleries and museums and through recommendations by other artists. We are not a sales gallery. Exhibitions are planned with educational purposes in mind."

‡WATERMARK GALLERIES, 1090 Michigan Ave., Palm Harbor FL 34683. (813)787-2990. Fax: (813)787-2990. E-mail: judith@intnet.net. Owner: Judith Waterman. Retail gallery. Estab. 1994. Represents/exhibits 40 emerging and established Florida artists/year. Exhibited artists include Brooke Allison and Bill Renc. Sponsors 12 shows/year. Average display time 3 months. Open all year; Tuesday-Saturday, 10-4. Located 2 blocks south of historic district; 970 sq. st.; restored 1942 house in Florida style. 100% of space for gallery artists. Clientele: local, winter visitors, upscale. 100% private collectors. Overall price range: $200-5,000; most work sold at $200-650.
Media: Considers all media. Most frequently exhibits 3-dimensional works and works on paper.
Style: Exhibits all styles and all genres.
Terms: Artwork is accepted on consignment (40% commission). Retail price set by the gallery. Exclusive area representation desired. Gallery provides insurance, security and promotion. Artist pays shipping costs. Prefers artwork framed.
Submissions: Accepts only artists from Florida. Send query letter with slides labeled appropriately. Call for appointment to show portfolio of slides. Replies in 2 weeks. Files material from accepted artists only.
Tips: Finds artists through attending art shows in person throughout state.

‡WINDSORS GALLERY, 1855 Griffin Rd., Dania FL 33004. (305)923-9100. Fax: (305)923-9292. President: Robert Windsor. Retail/wholesale gallery. Estab. 1975. Represents/exhibits 65 emerging and mid-career artists/year. Average display time 8 months. Open all year; Monday-Friday, 9-5. Located in Design Center of Avenue Building; 2,800 sq. ft. "Interior designer and architects' gallery—repeat business." 100% of space for gallery artists. Clientele: upscale, South Americans, hotels. Overall price range: $25-15,000; most work sold at $3,000-4,000.
Media: Considers all media except watercolor and photography. Most frequently exhibits paintings, prints and sculpture.

Style: Exhibits expressionism, conceptualism, photorealism, pattern painting, color field, hard-edge geometric abstraction, painterly abstraction, postmodern works, realism, impressionism and imagism. Genres include florals and figurative work. Prefers traditional, abstract and impressionism.
Terms: Artwork is accepted on consignment. Commission is discussed with artist. Retail price set by the gallery. Gallery provides insurance, promotion and contract; shipping costs are shared.
Submissions: No Florida artists. Send query letter with résumé, brochure, business card, slides, photographs, reviews, bio and SASE. Call for appointment to show portfolio of photographs, slides and transparencies. Replies only if interested within 2 weeks.
Tips: Finds artists through word of mouth, referrals by other artists, visiting art fairs and exhibitions and artists' submissions.

Georgia

‡**ABSTEIN GALLERY**, 558 14th St. NW, Atlanta GA 30318. (404)872-8020. Fax: (404)872-2518. Gallery Director: Bobbe Gillis. Retail gallery. Estab. 1973. Represents/exhibits 40 emerging, mid-career and established artists/year. Exhibited artists include Carolyn Goldsmith and Elsie Dresch. Sponsors 3 shows/year. Average display time 1-2 months. Open all year; Monday-Friday, 8:30-5:30; Saturday, 10-4. Located midtown; 5,000 sq. ft.; 2 story glass block window and interior glass wall. 100% of space for gallery artists. Clientele: interior designer, Atlanta and surrounding city homeowners. 50% private collectors, 50% corporate collectors. Overall price range: $100-12,000; most work sold at $1,000-5,000.
Media: Considers all media and all types of prints. Most frequently exhibits oil on canvas, pastel and watercolor.
Style: Exhibits expressionism, conceptualism, photorealism, minimalism, color field, hard-edge geometric abstraction, painterly abstraction, postmodern works, realism, surrealism, impressionism and imagism. All genres. Prefers abstract figurative, landscapes and abstraction.
Terms: Artwork is accepted on consignment and there is a 50% commission. Retail price set by the artist. Gallery provides insurance, promotion and contract. Artist pays for shipping costs. Prefers artwork unframed.
Submissions: Send query letter with résumé, slides, photographs, bio and SASE. "We will contact them once we see slides." Replies in 1 month. Files artist bio.
Tips: "Try to visit galleries where you wish to submit to see if the work would be suitable."

ARIEL GALLERY AT TULA, 75 Bennett St., NW, Atlanta GA 30309. (404)352-5753. Contact: Director. Cooperative gallery. Estab. 1984. Represents 20 emerging, mid-career and established artists/year. 15 members. Exhibited artists include Debra Lynn Gold and Alan Vaughan. Sponsors 8 shows/year. Average display time 6 weeks. Open all year; Tuesday-Saturday, 11-5. Located downtown; 914 sq. ft. Clientele: upscale, urban. 80% private collectors, 20% corporate collectors. Overall price range: $25-6,000; most work sold at $250-1,500.
Media: Considers all media, all types of prints. Most frequently exhibits paintings, sculpture and fine crafts.
Style: Exhibits primitivism, painterly abstraction and pattern painting. Prefers semi-abstract or abstract.
Terms: Accepts work on consignment (40% commission) or Co-op membership fee plus a donation of time (5% commission). Retail price set by the artist. Gallery provides promotion and contract. "Prefers hand delivery."
Submissions: Accepts only member artists from Atlanta area. "Some work taken on consignment. Artist must live outside 50-mile radius of Atlanta." Send query letter with résumé, slides or photographs, and bio. "Applicants for membership are considered at meeting on first Monday of each month." Portfolio should include originals (if possible), photographs or slides. Replies in 2 months.
Tips: Finds artists through visiting exhibitions, word of mouth, artists' submissions, local advertising in arts publications. "Talk with membership chairman or exhibition director and get details. We're approachable and less formal than most."

‡**BRENAU UNIVERSITY GALLERIES**, One Centennial Circle, Gainesville GA 30501. (404)534-6263. Fax: (404)534-6114. Gallery Director: Jean Westmacott. Nonprofit gallery. Estab. 1980s. Represents/exhibits emerging, mid-career and established artists. Sponsors 9 shows/year. Average display time 6 weeks. Open all year; Monday-Friday, 10-4; Sunday, 2-5 during exhibit dates. Summer hours are Monday-Friday, 1-4 only. Located near downtown; 3,958 sq. ft., two galleries—the main one in a renovated 1914 neoclassic building, the other in an adjacent renovated Victorian building dating from the 1890s. 100% of space for special exhibitions. Clientele: tourists, upscale, local community, students. "Although sales do occur as a result of our exhibits, we do not currently take any percentage except in our National Invitational Exhibitions. Our purpose is primarily educational."
Media: Considers all media and all types of prints except posters.
Style: Exhibits all styles and all genres. "We intentionally try to plan a balanced variety of media and styles."

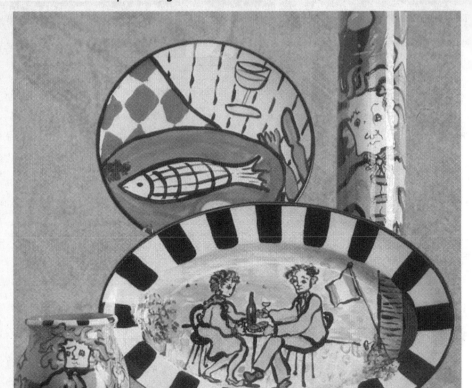

© Blair Mann

These ceramic pieces, the work of Blair Mann, were part of the hundreds in Abstein Gallery's "In a More Perfect World," the gallery's 22nd annual fall exhibit. The show featured works in ceramics, oils, acrylics, pastels, fused glass, antique engravings and more.

Terms: Retail price set by the artist. Gallery provides insurance and promotion; shipping costs are shared, depending on funding for exhibits. Prefers artwork framed. "Artwork must be framed or otherwise ready to exhibit."

Submissions: Send query letter with résumé, slides, photographs and bio. Write for appointment to show portfolio of slides and transparencies. Replies within months if possible. Artist should call to follow up. Files one or two slides or photos with a short résumé or bio if interested. Remaining material returned.

Tips: Finds artists through referrals, direct viewing of work and inquiries. "Be persistent, keep working, be organized and patient. Take good slides and develop a body of work. Galleries are limited by a variety of constraints—time, budgets, location, taste and rejection does not mean your work may not be good; it may not 'fit' for other reasons at the time of your inquiry."

ANN JACOB GALLERY, 3500 Peachtree Rd. NE, Atlanta GA 30326. (404)262-3399. Director: Yvonne J. Spiotta. Retail gallery. Estab. 1968. Represents 35 emerging, mid-career and established artists/year. Sponsors 4 shows/year. Open all year; Monday-Saturday 10-9; Sunday 12-5:30. Located midtown; 1,600 sq. ft. 100% of space for special exhibitions; 100% of space for gallery artists. Clientele: private and corporate. 80% private collectors, 20% corporate collectors.

Media: Considers oil, acrylic, watercolor, sculpture, ceramics, craft and glass. Most frequently exhibits paintings, sculpture and glass.

Style: Exhibits all styles, all genres.

Terms: Accepts work on consignment (50% commission). Retail price set by the gallery and the artist. Gallery provides promotion; artist pays shipping costs.

Submissions: Send query letter with résumé, slides, bio, brochure, photographs and SASE. Write for appointment. Replies in 2 weeks.

‡**KIANG GALLERY**, 75 Bennett St., N-2, Atlanta GA 30309. (404)351-5477. Fax: (404)951-8707. Owner: Marilyn Kiang. Retail gallery. Exhibits the work of non-traditional contemporary artists—with a special emphasis on Asian artists and biculturally influenced art. Estab. 1992. Represents/exhibits 15 emerging and mid-career artists/year. Exhibited artists include Chen Ping and Su Xin Ping. Sponsors 10 shows/year. Average display time 1 month. Open all year; Tuesday-Friday, 11-5; Saturday, 12-5. Located in Buckhead; 2,500 sq. ft.; clean, minimal, authoritative, "white walls-grey floor." 70% of space for special exhibitions; 30% of space for gallery artists. Clientele: upscale. 60% private collectors, 40% corporate collectors. Overall price range: $1,000-5,000; most work sold at $3,000-4,000.
Media: Considers all media, lithograph, small edition of signed original prints.
Style: Exhibits conceptualism, minimalism, realism and surrealism.
Terms: Artwork is accepted on consignment and there is a 50% commission. Retail price set by the gallery and the artist. Gallery provides insurance, promotion and contract; shipping costs are shared. Prefers artwork framed.
Submissions: Prefers serious works. Send query letter with résumé, slides and reviews. Call for appointment to show portfolio of slides.
Tips: Finds artists through referrals by other artists.

‡**LOWE GALLERY**, 75 Bennett St., Suite A-2, Atlanta GA 30309. (404)352-8114. Fax: (404)352-0564. Director: Robert Sherer. Retail gallery. Estab. 1989. Represents/exhibits 45 emerging and mid-career artists/year. Interested in seeing the work of emerging artists. Exhibited artists include Todd Murphy, Gail Foster. Sponsors 10 exhibitions/year. Average display time 1 month. Open all year; Tuesday-Friday, 10:30-5:30; Saturday, 12-5; Sunday and Monday by appointment. Located uptown (Buckhead); 6,000 sq. ft.; dramatic split-level Grand Salon with 30 ft. high ceiling and 18 ft. high exhibition walls. 100% of space for gallery artists. 90% private collectors, 10% corporate collectors. Overall price range: $600-40,000; most work sold at $2,500-10,000.
Media: Considers oil, pen & ink, acrylic, drawing, sculpture, watercolor, mixed media and pastel. Most frequently exhibits oils, drawing and sculpture.
Style: Exhibits neo-expressionism, painterly abstraction, postmodern works, realism, surrealism, postmodern works, realism and imagism. Genres include figurative work. Prefers postmodern works, realism and neo-expressionism.
Terms: Artwork is accepted on consignment and there is a 50% commission. Retail price set by the gallery. Gallery provides promotion and contract; shipping costs are shared. Prefers artwork framed.
Submissions: Send query letter with résumé, slides and SASE. Write for appointment to show portfolio of slides. Replies only if interested within 6 weeks.
Tips: Finds artists through artists' submissions. "Familiarize yourself with the aesthetic sensibilities of a gallery before sending your submission."

NŌVUS, INC., 495 Woodward Way NW, Atlanta GA 30305. (404)355-4974. Fax: (404)355-2250. Vice President: Pamela Marshall. Art dealer. Estab. 1980. Represents 200 emerging, mid-career and established artists. Open all year; daily, 9-5. Located in Buckhead, GA. 50% of space for gallery artists. Clientele: corporate, hospitality, healthcare. 5% private collectors, 95% corporate collectors. Overall price range: $500-20,000; most work sold at $800-5,000.
Media: Considers oil, acrylic, watercolor, pastel, mixed media, collage, paper, sculpture, ceramics, craft, fiber, glass, photography, and all types of prints. Most frequently exhibits mixed/paper and oil/acrylic.
Style: Exhibits all styles. Genres include landscapes, florals and figurative work. Prefers landscapes, abstract and figurative.
Terms: Accepts work on consignment (50% commission). Retail price set by the artist. Gallery provides promotion and contract; shipping costs are shared. Prefers artwork unframed.
Submissions: Artists must have no other representation in our area. Send query letter with résumé, slides, brochure and reviews. Write for appointment to show portfolio of originals, photographs and slides. Replies only if interested within 1 month. Files slides and bio.
Tips: Finds artists through agents, visiting exhibitions, word of mouth, art publications and sourcebooks, artists' submissions. "Send complete information and pricing. Do not expect slides and information back. Keep the dealer updated with current work and materials."

‡**TRINITY ARTS GROUPS**, 315 E. Pages Ferry Rd., Atlanta GA 30305. (404)237-0370. Fax: (404)240-0092. President: Larry Karth. Retail gallery and corporate sales consultants. Estab. 1987. Represents/exhibits 67 mid-career and established artists and old masters/year. Exhibited artists include Frederick Hart and David Fraley. Sponsors 6 shows/year. Average display time 1 month. Open all year; Tuesday-Thursday, 10-6; Friday-Saturday, 10-9 and by appointment. Located mid-city; 6,700 sq. ft.; 25 year old converted restaurant. 50-60% of space for special exhibitions; 40-50% of space for gallery artists. Clientele: upscale, local, regional, national and international. 70% private collectors, 30% corporate collectors. Overall price range: $100-100,000; most work sold at $1,500-5,000.
Media: Considers all media except photography and all types of prints. Most frequently exhibits painting, sculpture and work on paper.

Style: Exhibits expressionism, conceptualism, color field, painterly abstraction, postmodern works, realism, impressionism and imagism. Genres include landscapes, Americana and figurative work. Prefers realism, abstract and figurative.

Terms: Artwork is accepted on consignment and there is a negotiable commission, or it is bought outright for a negotiable price. Retail price set by gallery. Gallery pays promotion and contract. Shipping costs are shared. Prefers artwork framed.

Submissions: Send query letter with résumé, slides, bio and SASE. Call for appointment to show portfolio of photographs, slides, résumé and biography. Replies in 2-3 weeks.

Tips: Finds artists through word of mouth, referrals by other artists and artists' submissions. "Be as complete and professional as possible in presentation."

Hawaii

THE ART CENTRE AT MAUNA LANI, P.O. Box 6303, 2 Mauna Lani Dr., Kohala Coast HI 96743-6303. (808)885-7779. Fax: (808)885-0025. Director: Julie Bancroft. Retail gallery run by nonprofit organization to fund their activities. Estab. 1988. Represents 25 emerging, mid-career and established artists. Sponsors 6 shows/year. Average display time 2 months. Open all year. Located in the Mauna Lani Resort, Big Island of Hawaii; 2,500 sq. ft. 40% of space for special exhibitions. Clientele: tourists and local residents. 90% private collectors, 10% corporate collectors. Overall price range: $50-30,000.

Media: Considers all media and original handpulled prints, engravings, lithographs, mezzotints and serigraphs. Prefers oil, acrylic and watercolor.

Style: Exhibits all styles and genres, including Oriental art. Prefers photorealism, impressionism and expressionism. "Oriental art and antiques make our gallery unique."

Terms: Accepts artwork on consignment (50% commission). Requires exclusive area representation. Retail price set by gallery and artist. Sometimes offers customer discounts and payment by installment. Gallery provides insurance, promotion and contract; artist pays for shipping. Prefers artwork "properly framed."

Submissions: Send query letter with bio, brochure, photographs and SASE. Portfolio review requested if interested in artist's work.

Tips: "Label all works with size, title, medium and retail price (or range)."

COAST GALLERIES, Located in Wailea and Hana HI. Mailing address: P.O. Box 223519, Carmel CA 93922. (408)625-4145. Fax: (408)625-3575. Owner: Gary Koeppel.
• Coast Galleries are located in both Hawaii and California. See listing in San Francisco section for information on the galleries' needs and submission policies.

MAYOR'S OFFICE OF CULTURE AND THE ARTS, 530 S. King, #404, Honolulu HI 96813. (808)523-4674. Fax: (808)527-5445. Director: Peter Apo. Local government/city hall exhibition areas. Estab. 1965. Exhibits group shows coordinated by local residents. Sponsors 50 shows/year. Average display time 3 weeks. Open all year; Monday-Friday, 7:45-4:30. Located at the civic center in downtown Honolulu; 3 galleries—courtyard (3,850 sq. ft.), lane gallery (873 sq. ft.), 3rd floor (536 sq. ft.); Mediterranean-style building, open interior courtyard. "City does not participate in sales. Artists make arrangements directly with purchaser."

Media: Considers all media and all types of prints. Most frequently exhibits oil/acrylic, photo/print and clay.

Terms: Gallery provides promotion; local artists deliver work to site. Prefers artwork framed.

Submissions: "Local artists are given preference." Send query letter with résumé, slides and bio. Write for appointment to show portfolio of slides. "We maintain an artists registry for acquisition review for the art in City Buildings Program."

Tips: "Selections of exhibitions are made through an annual application process. Have a theme or vision for exhibit. Plan show at least one year in advance."

QUEEN EMMA GALLERY, 1301 Punchbowl St., Honolulu HI 96813. (808)547-4397. Fax: (808)547-4646. Director: Masa Morioka Taira. Nonprofit gallery. Estab. 1977. Exhibits the work of emerging, mid-career and established artists. Average display time is 5½ weeks. Located in the main lobby of The Queen's Medical Center; "recently renovated, intimate ambiance allows close inspection." Clientele: M.D.s, staff personnel, hospital visitors, community-at-large. 90% private collectors. Overall price range: $50-5,000.

Media: Considers all media. "Open to innovation and experimental work appropriate to healing environment."

Style: Exhibits contemporary, abstract, impressionism, figurative, primitive, non-representational, photorealism, realism and neo-expressionism. Specializes in humanities-oriented interpretive, literary, cross-cultural and cross-disciplinary works. Interested in folk art, miniature works and ethnic works. "Our goal is to offer a variety of visual expressions by regional artists. Subject matter and aesthetics appropriate for audience in a healthcare facility is acceptable." Interested in seeing "progressive, honest, experimental works with artist's personal interpretation."

Terms: Accepts work on consignment (30% commission). Retail price set by artist. Offers payment by installments. Exclusive area representation not required. Gallery provides promotion and contract.
Submissions: Send query letter with résumé, brochure, business card, slides, photographs and SASE. Wishes to see a portfolio of slides, blown-up full color reproduction is also acceptable. "Prefer brief proposal or statement or proposed body of works." Preference given to local artists. "Include prices, title and medium information."
Tips: Finds artists through direct inquiries, referral by art professionals, news media publicity. "The best introduction to us is to submit your proposal with a dozen slides of works created with intent to show. Show professionalism, integrity, preparation, new direction and readiness to show."

‡**WAILOA CENTER**, 200 Piopio St., Hilo HI 96720. (808)933-4360. Director: Mrs. Pudding Lassiter. Non-profit gallery and museum. Focus is on propigation of Hawaiian culture. Estab. 1968. Represents/exhibits 300 emerging, mid-career and established artists. Interested in seeing work of emerging artists. Sponsors 60 shows/year. Average display time 1 month. Open all year; Monday-Friday, 8-4:30. Located downtown; 10,000 sq. ft.; 3 exhibition areas: main gallery and two local airports. Clientele: tourists, upscale, local community and students. Overall price range: $25-25,000; most work sold at $1,500.
Media: Considers all media and all types of prints. Most frequently exhibits mixed media.
Style: Exhibits all styles. "We cannot sell, but will refer buyer to seller." Gallery provides promotion. Artist pays for shipping costs. Prefers artwork framed.
Submissions: Send query letter with résumé, slides, photographs and reviews. Call for appointment to show portfolio of photographs and slides. Replies in 3 weeks.
Tips: Finds artists through word of mouth, referrals by other artists, visiting art fairs and exhibitions, artists' submissions.

Idaho

BROWN'S GALLERIES, 1022 Main St., Boise ID 83702. (208)342-6661. Fax: (208)342-6677. Director: Randall Brown. Retail gallery featuring appraisal and restoration services. Estab. 1968. Represents 35 emerging, mid-career and established artists. Exhibited artists include Gerald Merfield and John Horéjs. Sponsors 12 shows/year. Average display time 1 month. Open all year. Located downtown; 2,500 sq. ft. Up to 50% of space for special exhibitions. Clientele: mid-to above average income, some tourists. 50% private collectors, 50% corporate collectors. Overall price range: $10-65,000; most work sold at $1,000-5,000.
Media: Considers oil, acrylic, watercolor, pastel, pen & ink, drawings, mixed media, collage, works on paper, sculpture, ceramic, fiber, glass, original handpulled prints, woodcuts, engravings, lithographs, pochoir, wood engravings, mezzotints, serigraphs, linocuts and etchings. Most frequently exhibits painting, sculpture and glass.
Style: Exhibits all styles, including expressionism, neo-expressionism, painterly abstraction, imagism, conceptualism, color field, postmodern works, impressionism, realism, photorealism, pattern painting and hard-edge geometric abstraction. All genres. Prefers impressionism, realism and abstraction.
Terms: Accepts artwork on consignment (50% commission). Retail price set by artist. "We also do some 'wholesale' purchasing." Sometimes offers customer discounts and payment by installment. Gallery provides insurance, promotion and contract; artist pays for shipping. Prefers artwork framed.
Submissions: Send query letter with all available information. Portfolio review requested if interested in artist's work. Files all materials.
Tips: "We deal only with professionals. Amateurs frequently don't focus enough on the finish, framing, display, presentation or marketability of their work. We have a second gallery, Brown's Gallery McCall, located in the heart of a popular summer and winter resort town. We carry an electic group of work focusing slightly more on tourists than our first location."

ANNE REED GALLERY, P.O. Box 597, Ketchum ID 83340. (208)726-3036. Fax: (208)726-9630. Director: Jennifer Gately. Retail Gallery. Estab. 1980. Represents mid-career and established artists. Exhibited artists include Russell Chatham. Sponsors 8 exhibitions/year. Average display time 1 month. Open all year. Located in the Walnut Avenue Mall. 10% of space for special exhibitions; 90% of space for gallery artists. Clientele: 80% private collectors, 20% corporate collectors.
Media: Most frequently exhibits sculpture, wall art and photography.
Style: Exhibits expressionism, abstraction, conceptualism, impressionism, photorealism, realism. Prefers contemporary and landscapes.
Terms: Accepts work on consignment (50% commission). Retail price set by gallery and artist. Sometimes offers customer discounts and payment by installment. Gallery provides insurance, promotion, contract and shipping costs from gallery. Prefers artwork framed.
Submissions: Send query letter with résumé, slides, bio and SASE. Call or write for appointment to show portfolio of originals (if possible), slides and transparencies. Replies in 2 months.
Tips: Finds artists through word of mouth, exhibitions, publications, artists' submissions and collector's referrals.

THE ROLAND GALLERY, 601 Sun Valley Rd., P.O. Box 221, Ketchum ID 83340. (208)726-2333. Fax: (208)726-6266. Owner: Roger Roland. Retail gallery. Estab. 1990. Represents 100 emerging, mid-career and established artists. Sponsors 8 shows/year. Average display time 1 month. Open all year; daily 11-5. 800 sq. ft. 50% of space for special exhibitions; 50% of space for gallery artists. Clientele: 75% private collectors, 25% corporate collectors. Overall price range: $10-10,000; most work sold at $500-1,500.
Media: Considers oil, pen & ink, paper, fiber, acrylic, sculpture, glass, watercolor, mixed media, ceramic, installation, pastel, collage, craft and photography, engravings, mezzotints, etchings, lithographs. Most frequently exhibits glass, paintings and jewelry.
Style: Considers all styles and genres.
Terms: Accepts work on consignment (50% commission) or buys outright for 50% of the retail price (net 30 days). Retail price set by artist. Gallery provides insurance, promotion, shipping costs from gallery. Prefers artwork framed.
Submissions: Send query letter with résumé, slides, bio, brochure, photographs, SASE, business card and reviews. Write for appointment to show portfolio of photographs, slides and transparencies. Replies only if interested within 2 weeks.

Illinois

‡ALTER ASSOCIATES INC., 122 Cary, Highland Park IL 60035. (708)433-1229. Fax: (708)433-2220. President: Chickie Alter. Art consultancy. Estab. 1972. Represents 200 emerging, mid-career and established artistsr through slides. Open all year; Monday-Sunday. Located in suburbs. Clientele: upscale, residential and corporate. 60% private collectors, 40% corporate collectors. Overall price range: $500-10,000; most work sold at $1,000-4,000.
Media: Considers all media except conceptual. Most frequently sells acrylic, oil, mixed media and 3 dimensional work.
Style: Exhibits expressionism, photorealism, neo-expressionism, pattern painting, color field, hard-edge geometric abstraction, painterly abstraction, realism and imagism.
Terms: Artwork is accepted on consignment and there is a 40% commission. Retail price set by the artist. Shipping costs are usually shared. Prefers artwork unframed.
Submissions: Accepts only artists from US. Send query letter with résumé, slides, bio and SASE. Portfolio should include slides and SASE. Reports in 2 weeks.
Tips: Submit clear, well-marked slides and SASE.

‡ARTHURIAN GALLERY, 4646 Oakton, Skokie IL 60076. Owner: A. Sahagian. Retail/wholesale gallery and art consultancy. Estab. 1987. Represents/exhibits 60-80 emerging, mid-career and established artists/year. Interested in seeing the work of emerging artists. Exhibited artists include Christana-Fortunato. Sponsors 3-4 shows/year. Average display time 4-6 weeks. Open all year; Monday-Sunday, 10-4. Located on main street of Skokie; 1,600 sq. ft. 80-100% of space for gallery artists. 5-10% private collectors, 5-10% corporate collectors. Overall price range: $50-3,000; most work sold at: $200-2,000.
Media: Considers all media and all types of prints. Most frequently exhibits oil, water color, acrylic and pastel.
Style: Exhibits expressionism, painterly abstraction, surrealism, all styles. All genres. Prefers impressionism, abstraction and realism.
Terms: Artwork is accepted on consignment and there is a 35% commission. Retail price set by the gallery and the artist. Gallery provides insurance and promotion. Artist pays for shipping costs. Prefers artwork framed.
Submissions: Send query letter with résumé, slides and SASE. Include price and size of artwork. Call or write for appointment to show portfolio of photographs, slides and transparencies. Replies in 2 weeks.
Tips: Finds artists through word of mouth, referrals by other artists, visiting art fairs and exhibitions, artists' submissions. "Be persistent."

‡FREEPORT ART MUSEUM AND CULTURAL CENTER, 121 N. Harlem Ave., Freeport IL 61032. (815)235-9755. Director: Becky Connors. Estab. 1975. Interested in emerging, mid-career and established artists. Sponsors 9 solo and group shows/year. Clientele: 30% tourists; 60% local; 10% students. Average display time 6 weeks.
Media: Considers all media and prints.
Style: Exhibits all styles and genres. "We are a regional museum serving Northwest Illinois, Southern Wisconsin and Eastern Iowa. We have extensive permanent collections and 8-9 special exhibits per year representing the broadest possible range of regional and national artistic trends. Some past exhibitions include. 'Inuit Images of Man & Animals,' 'Gifts for the Table,' 'Picture This: Contemporary Children's Book Illustrations,' 'Chicago: Soliloquy in Five Voices,' 'Between Black and White.' "
Terms: Gallery provides insurance and promotion; shipping costs are shared. Prefers artwork framed.
Submissions: Accepts mainly Illinois artists. Send query letter with résumé, slides, SASE, brochure, photographs and bio. Write for appointment to show portfolio of originals, slides and photographs. Replies in 3-4 months. Files résumés.

Tips: "Send information in December or January. The committee reviews slides in February."

‡**GALESBURG CIVIC ART CENTER**, 114 E. Main St., Galesburg IL 61401. (309)342-7415. Contact: Director. Nonprofit gallery. Estab. 1965. Exhibits emerging, mid-career and established artists. 375 members. Exhibited artists include Mark Barone and Harold Gregor. Sponsors 10 shows/year. Average display time 1 month. Closed August. Located downtown; 1,400 sq. ft. "We have 3 gallery spaces: 1 exhibition gallery, 1 consignment gallery and 1 permanent collection." Overall price range: $100-10,000; most artwork sold at $100-300.
Media: Considers oil, acrylic, watercolor, pastel, mixed media, works on paper, sculpture, ceramic, fiber, glass, photography, original handpulled prints. Most frequently exhibits painting, prints and ceramic.
Style: Exhibits expressionism, painterly abstraction, color field, postmodern works, realism, all styles. Genres include landscapes, florals and figurative work. Prefers realism and painterly abstraction. Interested in seeing "fine crafts and quality 2- and 3-D work."
Terms: Accepts work on consignment (40% commission). Retail price set by artist. Gallery provides insurance and promotion; artist pays for shipping. Framed artwork only.
Submissions: Accepts primarily artists from Midwest. Send query letter with résumé, slides and bio. Call for appointment to show portfolio, which should include slides. "No unsolicited samples, please." Replies in 3 months.

GALLERY TEN, 514 E. State St., Rockford IL 61104. (815)964-1743. Contact: Charlene Berg. Retail gallery. Estab. 1986. "We are a downtown gallery representing visual artists in all media." Represents emerging, mid-career and established artists. Average display time 6 weeks. Clientele: 50% private collectors, 50% corporate clients. Overall price range: $4-10,000; most artwork sold at $50-300.
Media: Considers all media.
Style: Exhibits fine arts and fine crafts; considers all styles and media. Sponsors national and regional juried exhibits and one-person and group shows. "Part of the gallery is reserved for the sales gallery featuring works by numerous artists and craftspeople and incorporates exhibition space for small shows. All work must be for sale and ready to hang or install."
Terms: Retail price set by artist (40% commission). Offers payment by installments. Exclusive area representation not required. Gallery provides promotion. Prefers artwork framed.
Submissions: Send query letter with slides, photographs and SASE. Portfolio review requested if interested in artist's work. All material is returned by SASE if not accepted or under consideration.
Tips: Finds artists through agents, by visiting exhibitions, word of mouth, various art publications and sourcebooks, artists' submissions/self-promotions, art collectors' referrals; "also through our juried exhibits." Looks for "creative viewpoint—professional presentation and craftsmanship. Common mistakes artists make in their submissions include sloppy presentation, poor quality slides, paper and/or photocopying and errors in spelling and grammar. Quality of work is paramount. We like to try a couple of pieces from an artist in our sales gallery before committing to a larger exhibit."

‡**GROVE ST. GALLERY**, 919 Grove St., Evanston IL 60201. (708)866-7341. Gallery Director: Chris or George. Retail gallery. Estab. 1889. Represents 15 emerging and established artists. Sponsors 6 solo and 5 group shows/year. Average display time 1 month. Clientele: 60% private collectors, 40% corporate clients. Overall price range: $500-25,000; most work sold at $2,500-10,000.
• Gallery has two new locations: State Street Gallery in Sarasota, FL and Lerner Gallery in Encinitas, LA.
Media: Considers oil, acrylic, watercolor, pastel, glass and serigraphs. Most frequently exhibits oil.
Style: Exhibits impressionism. Genres include landscapes, florals, Southwestern and Western themes and figurative work. Prefers Mediterranean landscapes, florals and Southwestern/Western works.
Terms: Accepts work on consignment. Retail price set by artist. Exclusive area representation required. Gallery provides partial insurance and promotion; shipping costs are shared. Prefers artwork framed.
Submissions: Send query letter with résumé, slides, brochure, photographs and bio. Call or write for appointment to show portfolio of originals, slides, transparencies and photographs. Replies in 3 weeks. Files photographs or slides. All material is returned if not accepted or under consideration.

‡**MINDSCAPE GALLERY**, 1506 Sherman, Evanston IL 60201. (708)864-2660. Contact: Jury Review Panel. Retail gallery and art consultancy. Estab. 1973. Represents 600 emerging, mid-career and established artists. Exhibited artists include Shane Fero and Heinz Brummel. Sponsors 6 shows/year. Average display time 3-4 months. "Hours vary seasonally." Open all year. Located in downtown Evanston, 20 minutes north of downtown Chicago; 10,000 sq. ft.; "large open space with 12' ceiling heights and carpeted walls." 30% of space for special exhibitions. Clientele: 80% private collectors, 10% corporate collectors. Overall price range: $20-15,000; most work sold at $50-300.
Media: Considers mixed media, paper, sculpture, fiber, glass, ceramic, fine contemporary designer crafts, functional and non-functional. Most frequently exhibits glass, fine jewelry and wearable art.

Style: Exhibits all styles, especially contemporary and all genres.

Terms: Accepts artwork on consignment (50% commission). Retail prices set by gallery and artist. Gallery provides insurance, promotion and contract; artist pays for shipping. Prefers artwork unframed.

Submissions: Accepts only American contemporary fine craft and sculpture. "One of a kind and limited edition only." Send query letter with request for jury application. Write for appointment and request jury application. To show portfolio, include slides, photographs, transparencies, promo information and résumé. Replies in 1 month after jury review. Files general artist information.

Tips: "Stop by the gallery to see if you think your work would fit in. Be professional in presentation and understanding the nature of marketing art in the 90s."

THE PEORIA ART GUILD, 1831 N. Knoxville Ave., Peoria IL 61603. (309)685-7522. Fax: (309)685-7446. Director: Ann Conver. Retail gallery for a nonprofit organization. Also has rental program. Estab. 1888. Represents 450 emerging, mid-career and established artists. Sponsored 7 solo and 3 group shows/year. Average display time 6 weeks. Clientele: 50% private collectors, 50% corporate clients. Overall price range: $25-3,000; most work sold at $125-500.

Media: Considers oil, acrylic, watercolor, pastel, mixed media, collage, works on paper, sculpture, ceramic, jewelry, fiber, glass, photography, woodcuts, wood engravings, linocuts, engravings, mezzotints, etchings, lithographs and serigraphs. Most frequently exhibits acrylic/oil, watercolor and etchings/lithographs.

Style: Exhibits all styles. Genres include landscapes, florals and figurative work. Prefers contemporary work, landscapes, realism and painterly abstraction. "Our main gallery supplies all the two-dimensional work to our extensive art rental program. Realistic watercolors, acrylics and oils work into this program easily with painterly abstractions and color field work always a possibility. The main gallery primarily exhibits newly emerging and established Midwestern artists with no restriction to style."

Terms: Accepts work on consignment (40% commission). Retail price set by artist. Offers customer discounts and payment by installments. Gallery provides insurance, promotion and contract. Prefers artwork framed.

Submissions: Send query letter with résumé, slides and SASE. "It's important to include a résumé or an artist's statement." Call for appointment to show portfolio of originals. Replies in 2 months. Files résumé, slides and statement. All material is returned if not accepted or under consideration.

Tips: Finds artists by visiting exhibitions, word of mouth, artists' submissions/self-promotions and referrals. "Present your work in a professional manner with excellent slides and well-done supporting materials."

PRESTIGE ART GALLERIES, 3909 W. Howard, Skokie IL 60076. (708)679-2555. President: Louis Schutz. Retail gallery. Estab. 1960. Exhibits 100 mid-career and established artists/year. Interested in seeing the work of emerging artists. Exhibited artists include Jean Paul Avisse. Sponsors 4 shows/year. Average display time 4 months. Open all year; Saturday and Sunday, 11-5; Monday-Wednesday, 10-5. Located in a suburb of Chicago; 3,000 sq. ft. 20% of space for special exhibitions; 50% of space for gallery artists. Clientele: professionals. 20% private collectors, 10% corporate collectors. Overall price range: $100-100,000; most work sold at $1,500-2,000.

Media: Considers oil, acrylic, mixed media, paper, sculpture, ceramics, craft, fiber, glass, lithograph and serigraphs. Most frequently exhibits paintings, glass and fiber.

Style: Exhibits surrealism, impressionism, photorealism and realism. Genres include landscapes, florals, portraits and figurative work. Prefers landscapes, figurative-romantic and floral.

Terms: Accepts work on consignment (50% commission). Retail price set by the gallery and the artist. Gallery provides insurance, promotion and contract; shipping costs are shared. Prefers artwork framed.

Submissions: Send query letter with résumé, slides, bio, SASE and prices/sizes. Call for appointment to show portfolio of photographs. Replies in 2 weeks. "Returns all material if SASE is included."

LAURA A. SPRAGUE ART GALLERY, Joliet Junior College, 1216 Houbolt Ave., Joliet IL 60436. (815)729-9020. Gallery Director: Joe B. Milosevich. Nonprofit gallery. Estab. 1978. Interested in emerging and established artists. Sponsors 6-8 solo and group shows/year. Average display time is 3-4 weeks.

Media: Considers all media except performance. Most frequently exhibits painting, drawing and sculpture (all media).

Style: Considers all styles.

Terms: Gallery provides insurance and promotion.

Submissions: Send query letter with résumé, brochure, slides, photographs and SASE. Call or write for appointment to show portfolio of originals and slides. Query letters and résumés are filed.

Chicago

A.R.C. GALLERY, 1040 W. Huron, 2nd Floor, Chicago, IL 60622. (312)733-2787. E-mail: jmorrisroe@aol.com. President: Jane Morrisroe. Nonprofit gallery. Estab. 1973. Exhibits emerging, mid-career and established artists. Interested in seeing the work of emerging artists. 17 members. Exhibited artists include Miriam Schapiro. Average display time 1 month. Closed August. Located in the River West area; 3,500 sq. ft.

Clientele: 80% private collectors, 20% corporate collectors. Overall price range $50-40,000; most work sold at $200-4,000.

Media: Considers oil, acrylic, drawings, mixed media, paper, sculpture, ceramic, installation, photography and original handpulled prints. Most frequently exhibits painting, sculpture (installation) and photography.

Style: Exhibits all styles and genres. Prefers post modern and contemporary work.

Terms: Rental fee for space. Rental fee covers 1 month. Gallery provides promotion; artist pays shipping costs. Prefers work framed.

Submissions: Send query letter with résumé, slides, bio and SASE. Call for deadlines for review. Portfolio should include slides.

JEAN ALBANO GALLERY, 211 W. Superior St., Chicago IL 60610. (312)440-0770. Director: Jean Albano Broday. Retail gallery. Estab. 1985. Represents 14 mid-career artists. Somewhat interested in seeing the work of emerging artists. Exhibited artists include Martin Facey and Jim Waid. Average display time 5 weeks. Open all year. Located downtown in River North gallery district; 1,600 sq. ft. 60% of space for special exhibitions; 40% of space for gallery artists. Clientele: 80% private collectors, 20% corporate collectors. Overall price range: $1,000-20,000; most work sold at $2,500-6,000.

Media: Considers oil, acrylic, sculpture and mixed media. Most frequently exhibits mixed media, oil and acrylic. Prefers non-representational, non-figurative and abstract styles.

Terms: Accepts artwork on consignment (50% commission). Retail price set by gallery and artist; shipping costs are shared.

Submissions: Send query letter with résumé, bio, SASE and well-labeled slides: "size, name, title, medium, top, etc." Write for appointment to show portfolio. Replies in 4-6 weeks. "If interested, gallery will file bio/ résumé and selected slides."

Tips: "We look for artists whose work has a special dimension in whatever medium. We are interested in unusual materials and unique techniques."

BEACON STREET GALLERY & THEATRE, 4520 N. Beacon, Chicago IL 60640. (708)232-2728. Contact: Pat Murphy. Nonprofit gallery/alternative space. Estab. 1983. Exhibits 30 emerging artists. Interested in seeing the work of emerging artists. Exhibited artists include Patricia Murphy and Eugene Pine. Sponsors 18 shows/year. Average display time 6 weeks. Open in fall and spring. 1,100 and 1,000 sq. ft. 50% of space for special exhibitions; 25% of space for gallery artists. Clientele: 20% private collectors, 20% corporate collectors. Overall price range $100-5,000.

● Gallery also has a space at 129½ W. State St., Geneva, IL 60134 for exhibitions and performances.

Media: Considers oil, acrylic, watercolor, pastel, drawings, paper, installation, photography, woodcuts and engravings. Most frequently exhibits oil, installation and crafts.

Style: Exhibits primitivism, painterly abstraction, conceptualism, minimalism and imagism. Prefers abstract and folk ethnic.

Terms: Accepts work on consignment (40% commission). Gallery provides insurance promotion and contract; artist pays for shipping or costs are shared. Prefers artwork framed.

Submissions: Send query letter with résumé, slides and bio. Write for appointment to show portfolio of slides. Replies only if interested once a year. Files résumé and slides.

MARY BELL GALLERIES, 740 N. Franklin, Chicago IL 60610. (312)642-0202. Fax: (312)642-6672. President: Mary Bell. Retail gallery. Estab. 1975. Represents mid-career artists. Interested in seeing the work of emerging artists. Exhibited artists include Mark Dickson. Sponsors 4 shows/year. Average display time 6 weeks. Open all year. Located downtown in gallery district; 5,000 sq. ft. 25% of space for special exhibitions. Clientele: corporations, designers and individuals. 20% private collectors, 80% corporate collectors. Overall price range: $500-8,000; most work sold at $1,000-3,000.

Media: Considers oil, acrylic, watercolor, pastel, mixed media, collage, paper, sculpture, ceramic, fiber, glass, original handpulled prints, offset reproductions, woodcuts, engravings, lithographs, pochoir, posters, wood engravings, mezzotints, serigraphs, linocuts and etchings. Most frequently exhibits canvas, unique paper and sculpture.

Style: Exhibits expressionism, painterly abstraction, impressionism, realism and photorealism. Genres include landscapes and florals. Prefers abstract, realistic and impressionistic styles. Does not want to see "figurative or bizarre work."

Terms: Accepts artwork on consignment (50% commission). Retail price set by gallery and artist. Offers customer discounts and payment by installments. Gallery provides insurance and contract; shipping costs are shared. Prefers artwork unframed.

Submissions: Send query letter with slides and SASE. Portfolio review requested if interested in artist's work. Portfolio should include slides.

Tips: "Today less expensive works are selling, pieces between $2,000-3,000."

CAIN GALLERY, 111 N. Marion St., Oak Park IL 60301. (708)383-9393. Owners: Priscilla and John Cain. Retail gallery. Estab. 1973. Represents 75 emerging, mid-career and established artists. "Although we occasionally introduce unknown artists, because of high overhead and space limitations, we usually accept only

artists who are somewhat established, professional and consistently productive." Sponsors 6 solo shows/ year. Average display time 6 months. Open all year. Recent move triples space, features an on-site interior design consultant. Clientele: 80% private collectors, 20% corporate clients. Overall price range: $100-6,000; most artwork sold at $500-1,000.

Media: Considers oil, acrylic, watercolor, mixed media, collage, sculpture, crafts, ceramic, woodcuts, engravings, mezzotints, etchings, lithographs and serigraphs. Most frequently exhibits acrylic, watercolor and serigraphs.

Style: Exhibits impressionism, realism, surrealism, painterly abstraction, imagism and all styles. Genres include landscapes, florals, figurative work. Prefers impressionism, abstraction and realism. "Our gallery is a showcase for living American artists—mostly from the Midwest, but we do not rule out artists from other parts of the country who attract our interest. We have a second gallery in Saugatuck, Michigan, which is open during the summer season. The Saugatuck gallery attracts buyers from all over the country."

Terms: Accepts artwork on consignment. Retail price set by artist. Sometimes offers customer payment by installment. Exclusive area representation required. Gallery provides insurance, promotion, contract and shipping costs from gallery. Prefers artwork framed.

Submissions: Send query letter with résumé and slides. Portfolio review requested if interested in artist's work. Portfolio should include originals and slides.

Tips: Finds artists through visiting exhibitions, word of mouth, artists' submissions/self-promotions and art collectors' referrals. "We are now showing more fine crafts, especially art glass and sculptural ceramics. The most common mistake artists make is amateurish matting and framing."

CHIAROSCURO, 700 N. Michigan Ave., Chicago IL 60611. (312)988-9253. Proprietors: Ronna Isaacs and Peggy Wolf. Contemporary retail gallery. Estab. 1987. Represents over 200 emerging artists. Average display time 3 months. Located on Chicago's "Magnificent Mile"; 2,500 sq. ft. on Chicago's main shopping boulevard, Michigan Ave. "Space was designed by award winning architects Himmel●Bonner to show art and contemporary crafts in an innovative way." Overall price range: $30-2,000; most work sold at $50-1,000.

Media: All 2-dimensional work—mixed media, oil, acrylic; ceramics (both functional and decorative works); sculpture, art furniture, jewelry. "We moved out of Chicago's gallery district to a more 'retail' environment a year and a half ago because many galleries were closing. Paintings seemed to stop selling, even at the $500-1,000 range, where functional pieces (i.e. furniture) would sell at that price."

Style: "Generally we exhibit bright contemporary works. Paintings are usually figurative works either traditional oil on canvas or to the very non-traditional layers of mixed-media built on wood frames. Other works are representative of works being done by today's leading contemporary craft artists. We specialize in affordable art for the beginning collector, and are focusing on 'functional works' currently."

Terms: Accepts work on consignment (50% commission). Retail price set by gallery and artist. Customer discounts and payment by installment are available. Gallery provides insurance.

Submissions: Send query letter (Attn: Peggy Wolf) with résumé, slides, photographs, price list, bio and SASE. Portfolio review requested if interested in artist's work. All material is returned if not accepted or under consideration.

Tips: Finds artists through agents, by visiting exhibitions and national craft and gift shows, word of mouth, various art publications and sourcebooks, artists' submissions/self-promotions and art collectors' referrals. "Don't be afraid to send photos of anything you're working on. I'm happy to work with the artist, suggest what's selling (at what prices). If it's not right for this gallery, I'll let them know why."

COLUMBIA COLLEGE ART GALLERY, 72 E. 11th St., Chicago IL 60605. (312)663-1600, ext. 110 or ext. 104. Fax: (312)360-1656. Director: Denise Miller-Clark. Assistant Director: Ellen Ushioka. Nonprofit gallery. Estab. 1984. Exhibits emerging, mid-career and established artists in the Chicago area. Sponsors 3 shows/ year. Average display time 2 months. Open September-April. Located downtown in the 11th St. campus of Columbia College, Chicago; 1645 sq. ft. 100% of space for special exhibitions.

Media: Considers oil, acrylic, watercolor, pastel, pen & ink, drawing, mixed media, collage, paper, sculpture, ceramic, craft, fiber, glass and installation.

Style: Exhibits all styles and genres.

Terms: Accepts artwork on consignment (25-30% commission). Retail price set by artist. Shipping costs are shared.

Submissions: Send query letter with résumé, slides, bio, SASE and reviews, if any. "Portfolios are reviewed Friday mornings between 9 a.m. and 1 p.m. The Art Gallery staff offices are located at The Museum of Contemporary Photography of Columbia College Chicago in the main campus building at 600 S. Michigan Ave. Chicago-area residents are asked to deliver portfolios, which may include finished artworks or slide reproductions, to the Museum address by 5 p.m. on the proceding Thursday. Portfolios will be available for pick-up by 1 p.m. on Friday. We suggest you telephone the Museum office to let us know when you will be dropping off a portfolio for review, since we are occasionally out of town, or otherwise unavailable. Visitors to Chicago who will not be in town on a Friday may call Ellen Ushioka at (312)663-5554 to make arrangements for their portfolios to be reviewed on another day." Replies in 1 month. Files slides and bio for future reference, if interested.

Tips: "Portfolio should be of professional quality and show a coherent body of work."

COLUMBIA COLLEGE CHICAGO CENTER FOR BOOK AND PAPER ARTS, (formerly Paper Press), 218 S. Wabash, 7th Floor, Chicago IL 60604. Assistant Director: Marilyn Sward. (312)431-8612. Fax: (312)986-8237. Nonprofit gallery. Estab. 1994. Exhibits artists' books, paper art, fine binding and paper sculpture. Sponsors 8 shows/year. Average display time 6 weeks. Open Monday-Friday, 9-5; some weekends; closed August. Located in downtown Chicago, 1 block from the Art Institute; 900 sq. ft.; natural light; track lighting; grey carpet; white walls. 100% of space for special exhibitions. Clientele: local community, students. 90% private collectors, 10% corporate collectors. Overall price range: $100-10,000.
 • Two organizations, Paper Press and Artists Book Works, merged to form this center.
Media: Considers drawing, mixed media, collage, paper, sculpture, craft, fiber, installation and photography. "Everything we show relates to books and/or paper." Most frequently exhibits book arts/paper, installation, typography, design and calligraphy.
Style: Exhibits all styles and genres.
Terms: Accepts work on consignment (40% commission). Retail price set by the artist. "Some artists donate work." Gallery provides insurance; shipping costs are shared.
Submissions: Send query letter with résumé, bio and slides. Write for appointment to show portfolio of slides. Replies only if interested within 2 weeks. Files slides and résumés. "We have a slide registry. There is a $10 fee. We find new artists through the slide registry, recommendations from other artists and our annual national open call for entries."

CONTEMPORARY ART WORKSHOP, 542 W. Grant Place, Chicago IL 60614. (312)472-4004. Director: Lynn Kearney. Nonprofit gallery. Estab. 1949. Interested in emerging and mid-career artists. Average display time is 4½ weeks "if it's a show, otherwise we can show the work for an indefinite period of time." Clientele: art-conscious public. 75% private collectors, 25% corporate clients. Overall price range: $300-5,000; most artwork sold at $1,000 "or less."
Media: Considers oil, acrylic, watercolor, mixed media, works on paper, sculpture, installations and original handpulled prints. Most frequently exhibits paintings, sculpture and works on paper.
Style: "Any high-quality work" is considered.
Terms: Accepts work on consignment (33% commission). Retail price set by gallery or artist. "Discounts and payment by installments are seldom and only if approved by the artist in advance." Exclusive area representation not required. Gallery provides insurance and promotion.
Submissions: Send query letter with résumé, slides and SASE. Slides and résumé are filed. "First we review slides and then send invitations to bring in a portfolio based on the slides."
Tips: Finds artists through call for entries in arts papers; visiting local BFA, MFA exhibits; referrals from other artists, collectors. "Looks for a professional approach and a fine art school degree (or higher). Artists a long distance from Chicago will probably not be considered."

‡CORPORATE ART SOURCE INC., Dept. AM, Suite 200, 900 N. Franklin St., Chicago IL 60610. (312)751-1300. Fax: (312)751-1331. Owner: Kathleen Bernhardt. Retail gallery. Estab. 1975. Located in River North gallery area. Represents 200 emerging and established artists. Exhibited artists include Virginio Ferrari and Marlene Bauer. Sponsors 4 group shows/year. Average display time 1 month. Located in the River North neighborhood; 4,000 sq. ft. Clientele: 10% private collectors; 90% corporate clients. Overall price range: $200-100,000; most work sold at $500-5,000.
Media: Considers oil, acrylic, watercolor, pastel, pen & ink, drawings, mixed media, collage, works on paper, sculpture, ceramic, fiber, glass, egg tempera, woodcuts, wood engravings, linocuts, engravings, mezzotints, etchings, lithographs, pochoir and serigraphs. Most frequently exhibits works on paper, paintings on canvas and sculpture.
Style: Exhibits expressionism, realism, surrealism, color field, painterly abstraction and imagism. Considers all genres. Prefers realism, painterly abstraction and color field. Specializes in meeting the needs of architects, designers and corporate clientele.
Terms: Accepts artwork on consignment (50% commission) or buys outright (40% retail price; net 30 days). Retail price set by gallery and artist. Gallery provides insurance and contract; artist pays for shipping.
Submissions: Send query letter with résumé, slides and bio. Portfolio should include originals and slides. Replies in 1 month.

DEBOUVER FINE ARTS, Suite 15-109 Merchandise Mart, Chicago IL 60654. (312)527-0021. President: Ronald V. DeBouver. Wholesale gallery and art consultancy. Estab. 1981. Clientele: interior designers and wholesale trade only. Represents 200 emerging, mid-career and established artists. Overall price range: $50-8,000; most artwork sold at $500.
Media: Considers oils, acrylics, watercolor, drawings, mixed media, collage, paper and posters. Most frequently exhibits oils, watercolors, graphics.
Style: Exhibits abstraction, color field, painterly abstraction, impressionistic, photorealistic and realism. Genres include landscapes, florals, Americana, English and French school and figurative work. Most frequently exhibits impressionistic, landscapes and floral. Currently seeking impressionistic, realism and abstract work.

Terms: Accepts work on consignment (33-50% commission). Retail price is set by gallery or artist. Offers customer discounts and payment by installments. Exclusive area representation not required.
Submissions: Send résumé, slides, photographs, prices and sizes. Indicate net prices. Portfolio review requested if interested in artist's work. Portfolio should include originals, slides and transparencies. Resume and photos are filed.
Tips: Finds artists through Chicago and New York art expos, art exhibits, word of mouth, artists' submissions and collectors' referrals. "When submitting pictures please list all information, such as media, size and prices that we would pay the artist. Also, would prefer receiving a phone call before mailing any information or photographs."

ROBERT GALITZ FINE ART, 166 Hilltop Court, Sleepy Hollow IL 60118. (708)426-8842. Fax: (708)426-8846. Owner: Robert Galitz. Wholesale representation to the trade. Makes portfolio presentations to corporations. Estab. 1986. Represents 40 emerging, mid-career and established artists. Exhibited artists include Marko Spalatin and Jack Willis. Open by appointment. Located in far west suburban Chicago.
Media: Considers oil, acrylic, watercolor, mixed media, collage, ceramic, fiber, original handpulled prints, engravings, lithographs, pochoir, wood engravings, mezzotints, serigraphs and etchings. "Interested in original works on paper."
Style: Exhibits expressionism, painterly abstraction, surrealism, minimalism, impressionism and hard-edge geometric abstraction. Interested in all genres. Prefers landscapes and abstracts.
Terms: Accepts artwork on consignment (variable commission) or artwork is bought outright (25% of retail price; net 30 days). Retail price set by artist. Customer discounts and payment by installment are available. Gallery provides promotion and shipping costs from gallery. Prefers artwork unframed only.
Submissions: Send query letter with SASE and submission of art. Portfolio review requested if interested in artist's work. Files bio, address and phone.
Tips: "Do your thing and seek representation—Don't drop the ball!—Keep going— Don't give up!"

‡GALLERY 1633, 1633 N. Damen Ave., Chicago IL 60647. (312)384-4441. Director: Montana Morrison. Consortium of 16 contributing artists. Estab. 1986. Represents/exhibits 16 regular plus a number of emerging, mid-career and established guest artists. Interested in seeing the work of emerging artists. Exhibited artists include William Marshall and M. Morrison. Sponsors 11 shows/year. Average display time 1 month. Open all year; Friday, 12-9:30; Saturday and Sunday, 12-5. Located in Bucktown; 900 sq. ft.; original tin ceiling, storefront charm. 35% of space for special exhibitions; 65% of space for gallery artists. Clientele: tourists, local community, local artists, "suburban visitors to popular neighborhood." 100% private collectors. Overall price range: $50-5,000; most work sold at $250-500.
Media: Considera all media and types of prints. Most frequently exhibits painting and drawing; ceramics and sculpture.
Style: Exhibits all styles including usable crafts (i.e. tableware). All genres. Prefers neo-expressionism, activated minimalism and post modern works.
Terms: Artwork is accepted on consignment and there is a 25% commission. There is a rental fee for space: The rental fee covers 6 months or one year. Available memberships include "gallery artists" who may show work every month for 1 year; associate gallery artists who show work for 6 months; and guest artists, who show for one month. Retail price set by the artist. Gallery provides promotion and contract. Artist pays for shipping costs. Call for appointment to show portfolio. Does not reply. Artist should call and visit gallery.
Tips: "If you want to be somewhat independent and handle your own work under an 'umbrella' system where 15 artists work together, in whatever way fits each individual—join us."

GWENDA JAY GALLERY, 301 W. Superior, 2nd Floor, Chicago IL 60610. (312)664-3406. Director: Gwenda Jay. Retail gallery. Estab. 1988. Represents mainly mid-career artists, but emerging and established, too. Exhibited artists include Remi Bourquin and Ruth Weisberg. Sponsors 11 shows/year. Average display time 1 month. Open all year. Located in River North area; 2,000 sq. ft.; 60% of space for 1-2 person and group exhibitions. Clientele: "all types—budding collectors to corporate art collections." Overall price range: $500-12,000; most artwork sold at $1,000-6,000.
 • The gallery has a small exhibition space but bigger back room, emphasizing more personal contact with collectors and features one-person and group shows.
Media: Considers paintings.
Style: Exhibits various styles and a "personal vision." Genres include landscapes and figurative or representational imagery. Styles are contemporary with traditional elements or classical themes.
Terms: Accepts work on consignment (50% commission). Retail price set by the gallery. Offers customer discounts and payment by installments. Gallery provides insurance, promotion and contract; shipping costs are shared.
Submissions: Send query letter with résumé, slides, bio and SASE. No unsolicited appointments. Replies in 2-4 weeks.
Tips: Finds artists through visiting exhibitions and artists' submissions. "Please send slides with résumé and SASE first. We will reply and schedule an appointment once slides have been reviewed if we wish to see more. Please be familiar with the gallery's style—for example, we don't typically carry abstract art." Looking

for "consistent style and dedication to career. There is no need to have work framed excessively. The work should stand well on its own, initially."

‡CARL HAMMER GALLERY, 200 W. Superior, Chicago IL 60610. (312)266-8512. Fax: (312)266-8510. Director/Owner: Carl Hammer. Estab. 1979. Represents/exhibits emerging, mid-career and established artists. Exhibited artists include Hollis Sigler and Lee Godie. Sponsors 8 shows/year. Average display time 4-6 weeks. Open all year. Located at River North, downtown; 1,500 sq. ft. Clientele: local, upscale, tourists and students. Overall price range: $600-10,000; most work sold at $3,000-4,000.
Media: Considers all media, woodcut, lithography, wood engraving, serigraphy and etching. Most frequently exhibits works on canvas, sculpture and works on paper.
Style: Prefers self-taught and outsider artists and contemporary figurative art.
Terms: Artwork is accepted on consignment and there is a commission. Artwork is bought outright for a percentage of the retail price. Retail price set by the gallery. Gallery provides insurance, promotion and contract; shipping costs are shared.
Submissions: Send query letter with résumé, slides, bio and SASE. Replies in 1 month. Files slides if interested.
Tips: Finds artists through word of mouth, self discovery and referrals.

HYDE PARK ART CENTER, 5307 S. Hyde Park Blvd., Chicago IL 60615. (312)324-5520. Executive Director: Eileen M. Murray. Nonprofit gallery. Estab. 1939. Exhibits emerging artists. Sponsors 9 group shows/ year. Average display time is 4-6 weeks. Located in the historic Del Prado building, in a former ballroom. "Primary focus on Chicago area artists not currently affiliated with a retail gallery." Clientele: general public. Overall price range: $100-10,000.
Media: Considers all media. Interested in seeing "innovative, 'cutting edge' work by young artists; also interested in proposals from curators, groups of artists."
Terms: Accepts work "for exhibition only." Retail price set by artist. Sometimes offers payment by installment. Exclusive area representation not required. Gallery provides insurance and contract.
Submissions: Send query letter with résumé, no more than 6 slides and SASE. Will not consider poor slides. "A coherent artist's statement is helpful." Portfolio review not required. Replies in 3-6 weeks.
Tips: Finds artists through open calls for slides, curators, visiting exhibitions (especially MFA programs) and artists' submissions. Prefers not to receive phone calls. "Do not bring work in person."

ILLINOIS ART GALLERY, (formerly State of Illinois Art Gallery), Suite 2-100, 100 W. Randolph, Chicago IL 60601. (312)814-5322. Fax: (312)814-3891. Assistant Administrator: Jane Stevens. Museum. Estab. 1985. Exhibits emerging, mid-career and established artists. Sponsors 6-7 shows/year. Average display time 7-8 weeks. Open all year. Located "in the Chicago loop, in the State of Illinois Center designed by Helmut Jahn." 100% of space for special exhibitions.
Media: All media considered, including installations.
Style: Exhibits all styles and genres, including contemporary and historical work.
Terms: "We exhibit work, do not handle sales." Gallery provides insurance and promotion; artist pays for shipping. Prefers artwork framed.
Submissions: Accepts only artists from Illinois. Send résumé, high quality slides, bio and SASE. Write for appointment to show portfolio of slides.

ILLINOIS ARTISANS PROGRAM, James R. Thompson Center, 100 W. Randolph St., Chicago IL 60601. (312)814-5321. Fax: (312)814-3891. Director: Ellen Gantner. Three retail shops operated by the nonprofit Illinois State Museum Society. Estab. 1985. Represents over 1,000 artists; emerging, mid-career and established. Average display time 6 months. "Accepts only juried artists living in Illinois." Clientele: tourists, conventioneers, business people, Chicagoans. Overall price range: $10-5,000; most artwork sold at $25-100.
Media: Considers all media. "The finest examples in all media by Illinois artists."
Style: Exhibits all styles. "Seeks contemporary, traditional, folk and ethnic arts from all regions of Illinois."
Terms: Accepts work on consignment (50% commission). Retail price set by gallery and artist. Sometimes offers customer discounts. Exclusive area representation not required. Gallery provides promotion and contract.
Submissions: Send résumé and slides. Accepted work is selected by a jury. Résumé and slides are filed. "The finest work can be rejected if slides are not good enough to assess." Portfolio review not required.
Tips: Finds artists through word of mouth, requests by artists to be represented and by twice yearly mailings to network of Illinois crafters announcing upcoming jury dates.

MARS GALLERY, 1139 W. Fulton Market, Chicago IL 60607. (312)226-7808. Owner: Barbara Bancroft. Retail gallery. Estab. 1987. Represents 10-15 emerging, mid-career and established artists. Exhibited artists include Peter Mars and Craig Kersten. Sponsors 7 shows/year. Average display time 3-4 weeks. Open all year by appointment only. Located downtown; 2,000 sq. ft. 50% of space for special exhibitions; 50% of space for gallery artists. Clientele: young professionals. 80% private collectors, 20% corporate collectors. Overall price range: $250-5,000; most work sold at $500-1,000.

Media: Considers oil, acrylic, watercolor, pastel, mixed media, collage and original handpulled prints. Most frequently exhibits acrylic, collage and mixed media.

Style: Exhibits pop and outsider art. All genres—especially humorous. Prefers pop outsider and painterly abstraction.

Terms: Accepts work on consignment (50% commission). Retail price set by gallery and artist. Sometimes offers payment by installment. Gallery provides promotion; artist pays shipping costs. Prefers artwork framed only.

Submissions: Send query letter with résumé, brochure, photographs and SASE. Portfolio review requested if interested in artist's work. Portfolio should include originals, photographs and transparencies. Replies in 1 month. Files résumé.

Tips: Finds artists through art collectors' referrals.

PETER MILLER GALLERY, 401 W. Superior St., Chicago IL 60610. (312)951-0252. Co-Director: Natalie R. Domchenko. Retail gallery. Estab. 1979. Represents 15 emerging, mid-career and established artists. Sponsors 9 solo and 3 group shows/year. Average display time is 1 month. Clientele: 80% private collectors, 20% corporate clients. Overall price range: $500-20,000; most artwork sold at $5,000 and up.

Media: Considers oil, acrylic, mixed media, collage, sculpture, installations and photography. Most frequently exhibits oil and acrylic on canvas and mixed media.

Style: Exhibits abstraction, conceptual, post-modern, and realism.

Terms: Accepts work on consignment (50% commission). Retail price set by gallery and artist. Exclusive area representation required. Insurance, promotion and contract negotiable.

Submissions: Send slides and SASE. Slides, show card are filed.

Tips: Looks for "classical skills underlying whatever personal vision artists express. Send a sheet of 20 slides of work done in the past 18 months with a SASE."

PORTIA GALLERY, 1702 N. Damen, Chicago IL 60647. (312)862-1700. Director: Elysabeth Alfano. Retail gallery. Estab. 1993. Represents 30 emerging, mid-career and established glass artists/year. Average display time 3 months. Open all year; Tuesday-Friday, 12-7; Saturday and Sunday, 12-5. Located in Chicago's Soho; 180 sq. ft.; glass sculpture, interior decor, high quality paperweights. 100% of space for gallery artists. Clientele: designers, collectors. Overall price range: $50-15,000; most work sold at $300-1,500.

Media: Considers glass only.

Terms: Accepts work on consignment (50% commission). Retail price set by the artist. Gallery provides insurance, promotion, contract and shipping costs from gallery; artist pays shipping costs to gallery.

Submissions: Send query letter with résumé, slides, SASE and reviews (if possible). Replies in 1 month. Files résumé, artist statement, slides—only if accepted.

Tips: "We are very approachable."

RANDOLPH STREET GALLERY, Dept. AGDM, 756 N. Milwaukee, Chicago IL 60622. (312)666-7737. Fax: (312)666-8986. E-mail: randolph@merle.acns.nwu.edu. Contact: Exhibition Committee or Time Arts Committee. Nonprofit artist-run gallery. Estab. 1979. Sponsors 10 group shows/year. Average display time is 1 month. Interested in emerging, mid-career and established artists.

Media: Considers all media. Most frequently exhibits mixed media and performance.

Style: Exhibits hard-edge geometric abstraction, painterly abstraction, minimalism, conceptualism, post-modern, feminist/political, primitivism, photorealism, expressionism and neo-expressionism. "We curate exhibitions which include work of diverse styles, concepts and issues, with an emphasis on works relating to social and critical concerns."

Terms: Retail price is set by artist. Exclusive area representation not required. Gallery provides shipping costs, promotion, contract and honorarium.

Submissions: Send résumé, brochure, slides, photographs and SASE. "Live events and exhibitions are curated by a committee which meets monthly." Résumés, slides and other supplementary material are filed.

Tips: "Some of the most common mistakes artists make in presenting their work are not sending slides, not clearly labeling slides and not sending enough written description of work that is difficult to grasp in slide form."

VALE CRAFT GALLERY, 207 W. Superior St., Chicago IL 60610. (312)337-3525. Fax: (312)337-3530. Owner: Peter Vale. Retail gallery. Estab. 1992. Represents 50 emerging, mid-career artists/year. Exhibited artists include Tina Fung Holder and Chet Geiselman. Sponsors 7 shows/year. Average display time 2 months. Open all year; Tuesday-Friday, 10-5; Saturday, 11-5. Located in River North gallery district near downtown; 900 sq. ft.; first floor of Victorian brick building; windows provide natural light and break up wall space. 60% of space for special exhibitions; 40% of space for gallery artists. Clientele: private collectors, tourists, people looking for gifts, people furnishing and decorating their homes. 50% private collectors, 5% corporate collectors. Overall price range; $25-2,500; most work sold at $50-300.

Media: Considers paper, sculpture, ceramics, craft, fiber, glass, metal, wood and jewelry. Most frequently exhibits fiber wall pieces, jewelry and ceramic sculpture and vessels.

Style: Exhibits contemporary craft. Prefers decorative, colorful and natural or organic.
Terms: Accepts work on consignment (50% commission). Retail price set by the artist. Gallery provides insurance, promotion, contract and shipping costs from gallery; artist pays shipping costs to gallery.
Submissions: Accepts only artists from US. Only craft media. Send query letter with résumé, slides, bio or artist's statement, photographs, record of previous sales, SASE and reviews if available. Call for appointment to show portfolio of originals and photographs. Replies in 1 month. Files résumé (if interested).
Tips: Finds artists through artists' submissions, art and craft fairs, publishing a call for entries, artists' slide registry and word of mouth.

‡MARIO VILLA GALLERY, 500 N. Wells St., Chicago IL 60610. (312)923-0993. Fax: (312)923-0977. Retail gallery. Estab. 1989. Represents 30 emerging and mid-career artists. Interested in seeing the work of emerging artists. Exhibited artists include Mario Villa and Winifred Ross. Sponsors 8 shows/year. Average display time 5 weeks. Open all year; Monday-Friday 11-6 and Saturday 11-5. Located in River North (Chicago's Art District); 2,400 sq. ft. 50% of space for special exhibitions; 50% of space for gallery artists. Clientele: 90% private collectors, 10% corporate collectors. Overall price range: $400-18,000; most work sold at $500-5,000.
Media: Considers oil, pen & ink, paper, acrylic, drawing, sculpture, glass, watercolor, mixed media, ceramic, pastel, collage, craft, photography, furniture, reliefs and intaglios. Most frequently exhibits art furniture, paintings and photography.
Style: Exhibits all styles.
Terms: Accepts work on consignment (50% commission). Retail price set by artist. Gallery provides insurance, promotion; shipping costs are shared. Prefers artwork framed.
Submissions: Send query letter with résumé, slides, bio and SASE. Call or write for appointment to show portfolio. Replies in 1 month.

SONIA ZAKS GALLERY, 311 W. Superior St., Suite 207, Chicago IL 60610. (312)943-8440. Director: Sonia Zaks. Retail gallery. Represents 25 emerging, mid-career and established artists/year. Sponsors 10 solo shows/year. Average display time is 1 month. Overall price range: $500-15,000.
Media: Considers oil, acrylic, watercolor, drawings, sculpture.
Style: Specializes in contemporary paintings, works on paper and sculpture. Interested in narrative work.
Terms: Accepts work on consignment. Retail price is set by gallery and artist. Exclusive area representation required. Gallery provides insurance and contract.
Submissions: Send query letter with résumé, slides.
Tips: "A common mistake some artists make is presenting badly-taken and unmarked slides. Artists should write to the gallery and enclose a résumé and about one dozen slides."

Indiana

ARTLINK, 437 E. Berry St., Suite 202, Fort Wayne IN 46802-2801. (219)424-7195. Artistic Director: Betty Fishman. Nonprofit gallery. Estab. 1979. Exhibits emerging and mid-career artists. 500 members. Sponsors 8 shows/year. Average display time 5-6 weeks. Open all year. Located 4 blocks from central downtown, 2 blocks from Art Museum and Theater for Performing Arts; in same building as a cinema theater, dance group and historical preservation group; 1,600 sq. ft. 100% of space for special exhibitions. Clientele: "upper middle class." Overall price range: $100-500; most artwork sold at $200.
• Publishes a newsletter, *Genre*, which is distributed to members. Includes features about upcoming shows, profiles of members and other news. Some artwork shown at gallery is reproduced in b&w in newsletter. Send SASE for sample and membership information.
Media: Considers all media, including prints. Prefers work for annual print show and annual photo show, sculpture and painting.
Style: Exhibits expressionism, neo-expressionism, painterly abstraction, conceptualism, color field, postmodern works, photorealism, hard-edge geometric abstraction; all styles and genres. Prefers imagism, abstraction and realism. "Interested in a merging of craft/fine arts resulting in art as fantasy in the form of bas relief, photo/books, all experimental media in non-traditional form."
Terms: Accepts work on consignment only for exhibitions (35% commission). Retail price set by artist. Gallery provides insurance, promotion and contract; shipping costs are shared. Prefers framed artwork.
Submissions: Send query letter with résumé, 6 slides and SASE. Reviewed by 14-member panel. Replies in 2-4 weeks. "Jurying takes place 3 times per year unless it is for a specific call for entry. A telephone call will give the artist the next jurying date."
Tips: Common mistakes artists make in presenting work are "bad slides and sending more than requested—large packages of printed material. Printed catalogues of artist's work without slides are useless." Sees trend of community-wide cooperation by organizations to present art to the community.

ECHO PRESS, 1901 E. Tenth St., Bloomington IN 47408. (812)855-0476. Fax: (812)855-0477. Curator: Pegram Harrison. Retail gallery and contemporary print publishers. Estab. 1979. Represents 37 emerging,

mid-career and established artists. Exhibited artists include Steven Sorman, Valerie Jaudon and Sam Gilliam. Average display time 2 months. Open all year. 3,000 sq. ft. 33% of space for special exhibitions. "We are a print workshop with gallery space: ⅔ workshop, ⅓ gallery." Clientele: 40% private collectors, 60% corporate collectors. Overall price range: $200-10,000; most work sold at $1,000-3,000.
Media: Considers original handpulled prints: lithographs, etchings, collagraphs, woodcuts, linocuts and engravings.
Style: Exhibits neo-expressionism, painterly abstraction and postmodern works.
Terms: "We show our own publications." Retail price set by gallery. Gallery provides insurance and promotion; shipping costs are shared.
Submissions: Send résumé, slides, bio and reviews. Files bio, reproduction and review.

EDITIONS LIMITED GALLERY, 2727 E. 86th St., Indianapolis IN 46240. (317)253-7800. Owner: John Mallon. Director: Marta Blades. Retail gallery. Represents emerging, mid-career and established artists. Sponsors 4 shows/year. Average display time 1 month. Open all year. Located "north side of Indianapolis; track lighting, exposed ceiling, white walls." Clientele: 60% private collectors, 40% corporate collectors. Overall price range: $100-8,500; most artwork sold at $200-1,200.
Media: Considers oil, acrylic, watercolor, pastel, pen & ink, drawings, mixed media, collage, works on paper, sculpture, ceramic, craft, fiber, glass, photography, original handpulled prints, woodcuts, engravings, mezzotints, etchings, lithographs, pochoir and serigraphs. Most frequently exhibits mixed media, acrylic and pastel.
Style: Exhibits all styles and genres. Prefers abstract, landscapes and still lifes.
Terms: Accepts work on consignment (50% commission). Retail price set by gallery. "I do discuss the prices with artist before I set a retail price." Sometimes offers customer discounts and payment by installment. Gallery provides insurance, promotion and contract; shipping costs are shared. Prefers artwork framed.
Submissions: Send query letter with slides, SASE and bio. Portfolio review requested if interested in artist's work. Portfolio should include originals, slides, résumé and bio. Files bios, reviews, slides and photos.
Tips: Does not want to see "hobby art." Please send "a large enough body of work."

‡GALLERY 614, 0350 C.R., N. Coronna IN 46730. (219)281-2752. Vice President: Mary Green. Retail gallery. Estab. 1973. Represents 4 artists; emerging and mid-career. Exhibited artists include R. Green and M. Viles. Sponsors 2 shows/year. Average display time 6 months. Open by appointment all year. Located in a rural area; 1,600 sq. ft.; "with track lighting, wooden and slate floors—plush." 50% of space for special exhibitions. Clientele: doctors, lawyers and businesspeople. 100% private collectors. Overall price range: $750-3,000; most artwork sold at $750-1,000.
Media: Exhibits carbro and carbon prints only.
Style: Exhibits painterly abstraction and impressionism. Genres include landscapes, florals, portraits and figurative work. Prefers portraits, landscapes and still lifes.
Terms: Accepts work on consignment (30% commission). Retail price set by the gallery and the artist. Gallery provides insurance and promotion; shipping costs are shared. Prefers framed artwork.
Submissions: Send query letter with résumé, slides and bio. Call for appointment to show portfolio or originals, photographs and slides. Replies only if interested within 2 weeks. Files all inquiries.

‡GREATER LAFAYETTE MUSEUM OF ART, 101 South Ninth St., Lafayette IN 47901. (317)742-1128. Director: John Z. Lofgren Ph.D. Curator: Ellen E. Fischer. Museum. Estab. 1909. Exhibits 100 emerging, mid-career and established artists from Indiana and the midwest. 1,340 members. Sponsors 14 shows/year. Average display time 10 weeks. Closed August. Located 6 blocks from city center; 3,318 sq. ft.; 4 galleries. 100% of space for special exhibitions. Clientele: audience includes Purdue University faculty, students and residents of Lafayette/West Lafayette and nine-county area. Clientele: 50% private collectors, 50% corporate collectors. Most work sold at $500-1,000.
Media: Considers all media. Most frequently exhibits paintings, prints and sculpture.
Style: Exhibits all styles. Genres include landscapes, still life, portraits, abstracts, non-objective and figurative work.
Terms: Accepts work on consignment (35% commission). Retail price set by artist. Gallery provides insurance, promotion and contract; artist pays for shipping. Prefers artwork framed.
Submissions: Send query letter with résumé, slides, artists statement and letter of intent. Write for appointment to show portfolio of slides. "Send good-quality, clearly labeled slides, and include artist's statement, please!" Replies in 1 month. Files artist's statement, résumé. Slides are returned to artists.

INDIAN IMAGE GALLERY, Dept. AGDM, 100 NW Second St., Suite 108, Evansville IN 47708. (812)464-5703. President: Stephen Falls. Retail gallery. Estab. 1972. Represents 40 emerging, mid-career and established artists. Exhibited artists include Donald Vann and Paladine Roye. Sponsors 3 shows/year. Average display time 3 weeks. Open all year. Located downtown; 1,200 sq. ft.; historic building. 20% of space for special exhibitions. Clientele: business/professional. 95% private collectors, 5% corporate collectors. Overall price range: $30-10,000; most work sold at $100-600.

Media: Considers all media, including original handpulled prints, engravings, lithographs, etchings, serigraphs, offset reproductions and posters. Most frequently exhibits painting, sculpture and jewelry.
Style: Exhibits realism. Genres include Southwestern and Western.
Terms: Accepts artwork on consignment (40% commission) or artwork is bought outright for 50% of the retail price. Retail price set by the gallery and the artist. Gallery provides promotion and contract; shipping costs are shared. Prefers artwork unframed.
Submissions: Accepts mainly Native American artists. Send query letter with slides and bio. Call for appointment to show portfolio, which should include slides and photographs. Replies in 2 weeks.

INDIANAPOLIS ART CENTER, 820 E. 67th St., Indianapolis IN 46220. (317)255-2464. Fax: (317)254-0486. Exhibitions Curator: Julia Moore. Nonprofit art center. Estab. 1934. Prefers emerging artists. Exhibits approximately 100 artists/year. 1,800 members. Sponsors 15-20 shows/year. Average display time 5 weeks. Open Monday-Friday, 9-10; Saturday, 9-3; Sunday, 12-3. Located in urban residential area; 2,560 sq. ft. in 3 galleries; "Progressive and challenging work is the norm!" 100% of space for special exhibitions. Clientele: mostly private. 90% private collectors, 10% corporate collectors. Overall price range: $50-15,000; most work sold at $100-1,000.
Media: Considers all media and all types of prints. Most frequently exhibits painting, sculpture installations and fine crafts.
Style: All styles. Interested in figurative work. "In general, we do not exhibit genre works. We do maintain a referral list, though." Prefers postmodern works, installation works, conceptualism.
Terms: Accepts work on consignment (35% commission). Commission is in effect for 3 months after close of exhibition. Retail price set by artist. Gallery provides insurance, promotion, contract; artist pays for shipping. Prefers artwork framed.
Submissions: "Special consideration for IN, OH, MI, IL, KY artists." Send query letter with résumé, slides, SASE, reviews and artist's statement. Replies in 5-6 weeks. Season assembled in January.
Tips: "Have slides done by a professional if possible. Stick with one style—no scattershot approaches, please. Have a concrete proposal with installation sketches (if it's never been built). We book two years in advance—plan accordingly. Do not call. Put me on your mailing list one year before sending application so I can be familiar with your work and record—ask to be put on my mailing list so you know the gallery's general approach. It works!"

‡**L B W GALLERY**, 1724 E. 86th St., Indianapolis IN 46240. (317)848-ARTS. Director: Linda Walsh. Retail gallery. Estab. 1993. Represents/exhibits 25 mid-career and established aritsts/year. Interested in seeing the work of emerging artists. Sponsors 10 shows/year. Average display time 1 month. Open all year; Monday-Saturday, 10-5. Located on north side of Indianapolis (in a mall); features unique interior decor. 75% of space for special exhibitions, 25% of space for gallery artists. Clientele: tourists, local community. 50% private collectors.
Media: Considers all media and all types of prints. Most frequently exhibits acrylic, crafts and mixed media.
Style: Exhibits realism. Genres include landscapes and Americana. Prefers landscapes, Americana and florals.
Terms: Artwork is accepted on consignment (commission). Gallery provides promotion; shipping costs are shared. Prefers artwork framed.
Submissions: Send query letter with résumé, slides and bio. Call or write for appointment to show portfolio of photographs and slides. Replies in 2 weeks. Files information; slides are returned if SASE is sent.
Tips: Finds artists through art fairs, exhibitions, word or mouth, referral by other artists. "Be realistic about price."

‡**MIDWEST GALLERIES INC.**, 6056 E. St. Rd. 46, Bloomington IN 47401. (812)331-0900. Manager: Tim Finley. Retail gallery. Estab. 1985. Represents/exhibits 30 established artists/year. May be interested in seeing the work of emerging artists in the future. Exhibited artists include T.C. Steele and Glen Cooper Henshaw. Sponsors 5 shows/year. Average display time 6 weeks. Open all year; Tuesday-Saturday, 10-5 by appointment. Located between Bloomington and Nashville, IN; 1,600 sq. ft. Clientele: collectors. 90% private collectors, 10% corporate collectors. Overall price range: $200-20,000.
Media: Considers all media, woodcut, lithograph and serigraphs. Most frequently exhibits oil, watercolor and pastel.
Style: Exhibits expressionism and painterly abstraction. Genres include landscapes. Prefers landscapes, character portraits and bat scenes.
Terms: Artwork is accepted on consignment (20-30% commission). Retail price set by the gallery and the artist. Gallery provides insurance and promotion. Artist pays for shipping costs. Prefers artwork framed.
Submissions: Prefers only Indiana artists. Send query letter with photographs. Write for appointment to show portfolio of photographs. Replies only if interested within 2 weeks.
Tips: Finds artists through referrals. "Be persistent with showing your work."

MIDWEST MUSEUM OF AMERICAN ART, 429 S. Main St., Elkhart IN 46516. (219)262-3603. Director: Jane Burns. Curator: Brian D. Byrn. Museum. Estab. 1978. Represents mid-career and established artists.

May be interested in seeing the work of emerging artists in the future. Sponsors 10-12 shows/year. Average display time 5-6 weeks. Open all year; Tuesday-Friday 11 to 5; Saturday and Sunday 1-4. Located downtown; 1,000 sq. ft. temporary exhibits; 10,000 sq. ft. total; housed in a renovated neoclassical style bank building; vault gallery. 10% for special exhibitions. Clientele: general public.

Media: Considers all media and all types of prints.

Style: Exhibits all styles, all genres.

Terms: Acquired through donations. Retail price set by the artist "in those cases when art is offered for sale." Gallery provides insurance, promotion and contract; artist pays shipping costs to and from gallery. Prefers artwork framed.

Submissions: Accepts only art of the Americas, professional artists 18 years or older. Send query letter with résumé, slides, bio, reviews and SASE. Write for appointment to show portfolio of slides. Replies in 6 months. Files résumé, bio, statement.

Tips: Finds artists through visiting exhibitions, art submissions, art publications. "Keep portfolio updated."

Iowa

ARTS FOR LIVING CENTER, P.O. Box 5, Burlington IA 52601-0005. Located at Seventh & Washington. (319)754-8069. Executive Director: Lois Rigdon. Nonprofit gallery. Estab. 1974. Exhibits the work of mid-career and established artists. May consider emerging artists. 425 members. Sponsors 10 shows/year. Average display time 3 weeks. Open all year. Located in Heritage Hill Historic District, near downtown; 2,500 sq. ft.; "former sanctuary of 1868 German Methodist church with barrel ceiling, track lights." 35% of space for special exhibitions. Clientele: 80% private collectors, 20% corporate collectors. Overall price range: $25-1,000; most work sold at $75-500.

Media: Considers all media and all types of prints. Most frequently exhibits watercolor, intaglio and sculpture.

Style: Exhibits all styles. Prefers landscapes, portraits and abstracts.

Terms: Accepts work on consignment (25% commission). Retail price set by artist. Gallery provides insurance, promotion and contract; artist pays for shipping. Prefers artwork framed.

Submissions: Send query letter with résumé, slides, bio, brochure, photographs, SASE and reviews. Call or write for appointment to show portfolio of slides and gallery experience verification. Replies in 1 month. Files résumé and photo for reference if interested.

CORNERHOUSE GALLERY, 2753 First Ave. SE, Cedar Rapids IA 52402. (319)365-4348. Fax: (319)365-1707. Director: Janelle McClain. Retail gallery. Estab. 1976. Represents 125 emerging, mid-career and established artists. Exhibited artists include John Preston, Grant Wood and Stephen Metcalf. Sponsors 2 shows/year. Average display time 6 months. Open all year. 3,000 sq. ft.; "converted 1907 house with 3,000 sq. ft. matching addition devoted to framing, gold leafing and gallery." 15% of space for special exhibitions. Clientele: "residential/commercial, growing collectors." 60% private collectors. Overall price range: $20-75,000; most artwork sold at $400-2,000.

Media: Considers oil, acrylic, watercolor, pastel, drawings, mixed media, collage, works on paper, sculpture, ceramic, fiber, glass, original handpulled prints, woodcuts, wood engravings, linocuts, engravings, mezzotints, jewelry, etchings, lithographs and serigraphs. Most frequently exhibits oil, acrylic, original prints and ceramic works.

Style: Exhibits painterly abstraction, conceptualism, color field, postmodern works and impressionism. All genres. Prefers abstraction, impressionism and postmodern.

Terms: Accepts work on consignment (45% commission). Retail price set by artist and gallery. Offers payment by installments. Gallery provides insurance, promotion and shipping costs from gallery. Prefers artwork unframed.

Submissions: Send résumé, brochure, photographs and bio. Portfolio review requested if interested in artist's work. Replies in 1 month. Files bio and samples.

Tips: Finds artists through word of mouth, art publications, sourcebooks, artists' submissions/self-promotions, art collectors' referrals and other artists. Do not stop in unannounced. "Today's buyer is more concerned with 'budget,' still has money to spend but seems more discriminating."

PERCIVAL GALLERIES, INC., 528 Walnut, Firstar Bank Building, Des Moines IA 50309-4106. (515)243-4893. Fax: (515)243-9716. Director: Bonnie Percival. Retail gallery. Estab. 1969. Represents 100 emerging, mid-career and established artists. Exhibited artists include Mauricio Lasansky and Karen Strohbeen. Sponsors 8 shows/year. Average display time is 3 weeks. Open all year. Located in downtown Des Moines; 3,000 sq. ft. 50-75% of space for special exhibitions.

Terms: Accepts work on consignment (50% commission). Retail price set by gallery. Gallery provides insurance and promotion.

Submissions: Send query letter with résumé, slides, photographs, bio and SASE. Call or write for appointment to show portfolio of originals, photographs and slides. Replies in 1 month. Files only items of future interest.

Kansas

PHOENIX GALLERY TOPEKA, 2900-F Oakley Dr., Topeka KS 66614. (913)272-3999. Owner: Kyle Garia. Retail gallery. Estab. 1990. Represents 60 emerging, mid-career and established artists/year. Exhibited artists include Dave Archer, Louis Copt, Nagel, Phil Starke and Ernst Ulmer. Sponsors 6 shows/year. Average display time 6 weeks-3 months. Open all year, 7 days/week. Located downtown; 2,000 sq. ft. 100% of space for special exhibitions; 100% of space for gallery artists. Clientele: upscale. 75% private collectors, 25% corporate collectors. Overall price range: $500-20,000.
Media: Considers all media and engraving, lithograph, woodcut mezzotint, serigraphs, linocut, etching and collage. Most frequently exhibits oil, watercolor, ceramic and artglass.
Style: Exhibits expressionism and impressionism, all genres. Prefers regional, abstract and 3-D type ceramic; national glass artists.
Terms: Terms negotiable. Retail price set by the gallery and the artist. Prefers artwork framed.
Submissions: Call for appointment to show portfolio of originals, photographs and slides.
Tips: "We are scouting [for artists] constantly."

THE SAGEBRUSH GALLERY OF WESTERN ART, 115 E. Kansas, P.O. Box 128, Medicine Lodge KS 67104. (316)886-5163. Fax: (316)886-5104. Co-Owners: Earl and Kaye Kuhn. Retail gallery. Estab. 1979. Represents up to 20 emerging, mid-career and established artists. Exhibited artists include Garnet Buster, Lee Cable, H.T. Holden, Earl Kuhn, Gary Morton and David Vollbracht. Sponsors 4 shows/year. Average display time 3-6 months. Open all year. Located ½ block off Main St.; 1,000 sq. ft. 100% of space for special exhibitions. Clientele: 80% private collectors, 20% corporate collectors. Overall price range: $100-7,000; most work sold at $500-4,000.
Media: Considers oil, acrylic, watercolor, pastel, pen & ink, drawings, mixed media, sculpture, original handpulled prints, lithographs and posters. Most frequently exhibits watercolors, acrylics and bronze sculpture.
Style: Exhibits realism. Genres include landscapes, Southwestern, Western and wildlife. Prefers representational works of contemporary and historical Western.
Terms: Accepts artwork on consignment (25% commission). Retail price set by artist. Offers payment by installments. Gallery provides promotion; artist pays for shipping.
Submissions: Send query letter with résumé, slides, brochure, photographs and SASE. Portfolio review requested if interested in artist's work. Files résumés, bio info and photos.
Tips: Finds artists by any source but the artist's work must speak for itself in quality. "Looks for professional presentation of portfolios. Neatness counts a great deal! and of course—quality! We are careful to screen wildlife and Western livestock to be anatomically correct. Ask about the annual Indian Summer Days Western and Wildlife Art Show Sale."

STRECKER GALLERY, 332 Poyntz, Manhattan KS 66502. (913)539-2139. President: Julie Strecker. Retail gallery. Estab. 1979. Represents 20 emerging and mid-career artists. Exhibited artists include Dean Mitchell and Judy Love. Sponsors 4 shows/year. Average display time 6 weeks. Open all year; Tuesday-Saturday, 10-5. Located downtown; 3,000 sq. ft.; upstairs in historic building. 50% of space for special exhibitions; 50% of space for gallery artists. Clientele: university and business. 95% private collectors, 5% corporate collectors. Overall price range: $300-5,000; most work sold at $300-500.
Media: Considers all media and all types of prints (no offset reproductions). Most frequently exhibits watercolor, intaglio, lithograph.
Style: All styles. Genres include landscapes, florals, portraits, Southwestern, figurative work. Prefers landscapes, figurative and floral.
Terms: Accepts work on consignment (50% commission). Retail price set by artist. Sometimes offers payment by installment. Gallery provides promotion; artist pays for shipping costs. Prefers artwork framed.
Submissions: Send query letter with résumé, slides, reviews, bio and SASE. Write for appointment to show portfolio of slides. Replies in 1-2 weeks.
Tips: "I look for uniqueness of vision, quality of craftsmanship and realistic pricing."

TOPEKA & SHAWNEE COUNTY PUBLIC LIBRARY GALLERY, 1515 W. Tenth, Topeka KS 66604-1374. (913)233-2040. Fax: (913)233-2055. Gallery Director: Larry Peters. Nonprofit gallery. Estab. 1976. Exhibits emerging, mid-career and established artists. Sponsors 8-9 shows/year. Average display time 1 month. Open Memorial Day to Labor Day: Monday-Saturday, 9-6; Sunday, 2-6. Located 1 mile west of downtown; 1,200 sq. ft.; security, track lighting, plex top cases; recently added two moveable walls. 100% of space for special exhibitions. Overall price range: $150-5,000.
Media: Considers oil, fiber, acrylic, sculpture, glass, watercolor, mixed media, ceramic, pastel, collage, metal work, woodcuts, wood engravings, linocuts, engravings, mezzotints, etchings, lithographs. Most frequently exhibits ceramic, oil and watercolor.
Style: Exhibits neo-expressionism, painterly abstraction, postmodern works and realism. Prefers painterly abstraction, realism and neo-expressionism.

Terms: Artwork accepted or not accepted after presentation of portfolio/résumé. Retail price set by artist. Gallery provides insurance; artist pays for shipping costs. Prefers artwork framed.
Submissions: Usually accepts only artists from KS, MO, NE, IA, CO, OK. Send query letter with résumé and slides. Call or write for appointment to show portfolio of slides. Replies in 1-2 months. Files résumé.
Tips: Finds artists through visiting exhibitions, word of mouth and artists' submissions. "Have good quality slides—if slides are bad they probably will not be looked at. Have a dozen or more to show continuity within a body of work. Competition gets heavier each year."

‡**WICHITA ART MUSEUM STORE SALES GALLERY & REGISTRY,** (formerly Wichita Art Museum Sales/ Rental Gallery), 619 Stackman Dr., Wichita KS 67203. (316)268-4975. Fax: (316)268-4980. Manager/Buyer: Barbara Rensner. Nonprofit retail and consignment gallery. Estab. 1963. Exhibits 150 emerging and established artists. Sponsors 4 group shows/year. Average display time is 6 months. 1,228 sq. ft. Accepts only artists from expanded regional areas. Clientele: tourists, residents of city, students. 75% private collectors, 25% corporate clients. Overall price range: $25-2,500; most work sold at $25-800.
Media: Considers oil, acrylic, watercolor, pastel, mixed media, collage, works on paper, sculpture, ceramic, fiber, glass and original handpulled prints.
Style: Exhibits organic/abstraction, impressionism, expressionism and realism. Genres include landscapes, florals, portraits and figurative work. Most frequently exhibits realism and impressionism.
Terms: Accepts work on consignment (40% commission). Retail price set by artist. Exclusive area representation not required. Gallery provides insurance and contract.
Submissions: Send query letter with résumé. Resumes and brochures are filed.
Tips: "Framing and proper matting very important. Realism and impressionism are best sellers. Landscapes and florals most popular. We are constantly looking for and exhibiting new artists. We have a few artists who have been with us for many years but our goal is to exhibit the emerging artist."

Kentucky

BROWNSBORO GALLERY, 4806 Brownsboro Center, Louisville KY 40207. (502)893-5209. Owner: Leslie Spetz; Curator: Rebekah Hines. Retail gallery. Estab. 1990. Represents 20-25 emerging, mid-career and established artists. Exhibited artists include Karen and Charlie Berger and Michaele Ann Harper. Sponsors 9-10 shows/year. Average display time 5 weeks. Open all year; Tuesday-Friday, 10-6; Saturday, 10-3; closed Sunday and Monday. Located on the east end (right off I-71 at I-264); 1,300 sq. ft.; 2 separate galleries for artist to display in give totally different feelings to the art; one is a skylight room. 85% of space for gallery artists. Clientele: upper income. 90% private collectors, 10% corporate collectors. Overall price range: $100-2,500; most work sold at $800-1,000.
Media: Considers oil, acrylic, watercolor, pastel, pen & ink, drawing, mixed media, collage, paper, sculpture, ceramics, fiber, glass, installation, photography, woodcut, engraving and etching. Most frequently exhibits oil, mixed (oil or watercolor pastel) and watercolor.
Style: Exhibits painterly abstraction, all styles, color field, postmodern works, impressionism, photorealism and realism. Genres include landscapes, Americana and figurative work. Prefers landscape, abstract and collage/contemporary.
Term: Accepts work on consignment (40% commission). Retail price set by the gallery and the artist. Gallery provides insurance, promotion, contract and shipping costs from gallery; artist pays shipping costs to gallery. Prefers artwork framed.
Submissions: Send query letter with résumé, slides, bio, price list and SASE. Call for appointment to show portfolio of photographs and slides. Replies only if interested within 3-4 weeks.
Tips: Finds artists through word of mouth and artists' submissions, "sometimes by visiting exhibitions."

EAGLE GALLERY, Murray State University, P.O. Box 9, Murray KY 42071-0009. (502)762-6734. Fax: (502)762-6335. Director: Albert Sperath. University gallery. Estab. 1971. Represents emerging, mid-career and established artists. Sponsors 8 shows/year. Average display time 6 weeks. Open Monday, Wednesday, Friday, 8-6; Tuesday, Thursday, 8-7:30; Saturday, 10-4; Sunday, 1-4; closed during university holidays. Located on campus, small town; 4,000 sq. ft.; modern multi-level dramatic space. 100% of space for special exhibitions. Clientele: "10,000 visitors per year."
Media: Considers all media and all types of prints.
Style: Exhibits all styles.
Terms: "We supply the patron's name to the artist for direct sales. We take no commission." Retail price set by the artist. Gallery provides insurance, promotion and shipping costs from gallery. Prefers artwork framed.
Submissions: Send query letter with résumé and slides. Replies in 1 month.
Tips: "Do good work that *expresses* something."

THE GALLERY AT CENTRAL BANK, Kincaid Towers, 300 Vine St., Lexington KY 40507. (800)637-6884 US, (800)432-0721 KY. Fax: (606)253-6244. Curator: John Irvin. Gallery. Estab. 1988. Exhibits emerging,

mid-career and established artists. Sponsors 11-12 shows/year. "We have an annual show for University of Kentucky art students that is usually wild!" Average display time 3 weeks. Open all year. Located downtown; 2,000 sq. ft. Overall price range: $75-5,000; most work sold below $1,000.

Media: Considers all media. Most frequently exhibits watercolor, oil and fiber.

Style: Exhibits all styles and genres.

Terms: Artist receives 100% of the sale price. Retail price set by artist. Sometimes offers payment by installment. Gallery provides insurance, promotion, reception and cost of hanging; artist pays for shipping. Prefers artwork framed.

Submissions: Accepts only artists from Kentucky. No nudes. Call for appointment to show portfolio of originals. Replies immediately. Files names, addresses and phone numbers.

Tips: Finds artists through word of mouth; University of Kentucky Art Department and art museum. "Don't be shy, call me. We pay 100% of the costs involved once the work is delivered."

‡LIBERTY GALLERY, 416 W. Jefferson, Louisville KY 40207. (502)566-2081. Fax: (502)566-1800. Director: Jacque Parsley. Nonprofit gallery. Estab. 1976. Represent/exhibits 50 emerging, mid-career and established artists/year. Exhibited artists include Arturo Alonzo Sandoral and Dan Dry. Sponsors 6 shows/year. Average display time 2 months. Open all year; Monday-Thursday, 9-4; Friday, 9-5. Located downtown in Liberty National Bank. 100% of space for special exhibitions. Clientele: tourists, local community and students. 20% private collectors, 15% corporate collectors. Overall price range: $200-2,000; most work sold at $300.

Media: Considers all media, etching. Most frequently exhibits crafts—ceramics, oil paintings and watercolors.

Style: Exhibits expressionism, painterly abstraction and pattern painting. Genres include florals, portraits and landscapes. Prefers abstract, landscapes and folk art.

Terms: Artwork is accepted on consignment and there is no commission. Retail price set by the artist. Gallery provides insurance, promotion and contract. Artist pays for shipping costs. Prefers artwork framed.

Submissions: Accepts only regional artists from Louisville. Send query letter with résumé, slides, bio and SASE. Write for appointment to show portfolio of slides. Replies in 2 months. Files announcements.

Tips: Finds artists through referrals by other artists and artists' submissions. "Submit professional slides."

LOUISVILLE VISUAL ART ASSOCIATION, 3005 Upper River Rd., Louisville KY 40207. (502)896-2146. Fax: (502)896-2148. Gallery Manager: Janice Emery. Nonprofit sales and rental gallery. Estab. 1989. Represents 70 emerging, mid-career and established regional artists. Average display time 3 months. Open all year; Monday-Friday, 11:30-3:30 and by appointment. Located downtown; 1,500 sq. ft. 10% of space for special exhibitions; 90% of space for gallery artists. Clientele: all ages and backgrounds. 50% private collectors, 50% corporate collectors. Overall price range: $300-4,000; most work sold at $300-1,000.

- Headquarters for LVAA are at 3005 Upper River Rd.; LVAA Sales and Rental Gallery is at #275 Louisville Galleria (Fourth and Liberty).

Media: Considers oil, acrylic, watercolor, pastel, pen & ink, drawing, mixed media, collage, paper, sculpture, ceramics, craft (on a limited basis), fiber, glass, photography, woodcut, engraving, lithograph, wood engraving, mezzotint, serigraphs, linocut, etching and some posters. Most frequently exhibits oil, acrylic, watercolor, sculpture and glass.

Style: Exhibits contemporary, local and regional visual art, all genres.

Terms: Accepts work on consignment (40% commission). Membership is suggested. Retail price set by the artist. Gallery provides insurance, promotion and contract (nonexclusive gallery relationship). Artist pays shipping costs to and from gallery. Accepts framed or unframed artwork. Framing is offered. Artists should provide necessary special displays. (Ready-to-hang is advised with or without frames.)

Submissions: Accepts only artists from within a 400-mile radius, or former residents or those trained in KY-(university credentials). Send query letter with résumé, slides, bio and reviews. Write for appointment to show portfolio of slides. Replies only if interested within 4-6 weeks. Files up to 20 slides (in slide registry), bio, résumé, brief artist's statement, reviews, show announcement.

Tips: Finds artists through visiting exhibitions, word of mouth, art publications and artists' submissions. "Novices and experienced regional artists are welcome to submit slides and résumés."

MAIN AND THIRD FLOOR GALLERIES, Northern Kentucky University, Nunn Dr., Highland Heights KY 41099. (606)572-5148. Fax: (606)572-5566. Gallery Director: David Knight. University galleries. Program established 1975; new main gallery in fall of 1992; renovated third floor gallery fall of 1993. Represents emerging, mid-career and established artists. Sponsors 10 shows/year. Average display time 1 month. Open Monday-Friday, 9-9; Saturday, Sunday, 1-5; closed major holidays and between Christmas and New Years. Located in Highland Heights, KY 8 miles from downtown Cincinnati; 3,000 sq. ft.; two galleries—one small and one large space with movable walls. 100% of space for special exhibitions. 90% private collectors, 10% corporate collectors. Overall price range; $25-50,000; most work sold at $25-2,000.

Media: Considers all media and all types of prints. Most frequently exhibits painting, printmaking and photography.

Style: Exhibits all styles, all genres.
Terms: Proposals are accepted for exhibition. Retail price set by the artist. Gallery provides insurance, promotion and contract; shipping costs are shared. Prefers artwork framed "but we are flexible."
Submissions: Send query letter with résumé, slides, bio, photographs, SASE and reviews. Write for appointment to show portfolio of originals, photographs and slides. Submissions are accepted in December for following academic school year. Files résumés and bios.
Tips: Finds artists through agents, visiting exhibitions, word of mouth, art publications and sourcebooks and artists' submissions.

‡YEISER ART CENTER INC., 200 Broadway, Paducah KY 42001. (502)442-2453. Executive Director: Dan Carver. Nonprofit gallery. Estab. 1957. Exhibits emerging, mid-career and established artists. 450 members. Sponsors 8 shows/year. Average display time 6-8 weeks. Open all year. Located downtown; 1,800 sq. ft.; "in historic building that was farmer's market." 90% of space for special exhibitions. Clientele: professionals and collectors. 90% private collectors. Overall price range: $200-8,000; most artwork sold at $200-1,000.
Media: Considers all media except installation. Prints considered include original handpulled prints, woodcuts, wood engravings, linocuts, mezzotints, etchings, lithographs and serigraphs. Most frequently exhibits oil, acrylic and mixed media.
Style: Exhibits all styles. Genres include landscapes, florals, Americana and figurative work. Prefers realism, impressionism and abstraction.
Terms: Accepts work on consignment (35% commission). Retail price set by artist. Gallery provides insurance and promotion; shipping costs are shared. Prefers artwork framed.
Submissions: Send résumé, slides, bio, SASE and reviews. Replies in 1 month.
Tips: "Do not call. Send complete submissions that include size information and artist's background. Must have large body of work. Presentation of material is important."

‡ZEPHYR GALLERY, W. Main St., Louisville KY 40202. (502)585-5646. Directors: Patrick Donley, Dudley Zopp. Cooperative gallery and art consultancy with regional expertise. Estab. 1988. Exhibits 18 emerging and mid-career artists. Exhibited artists include Chris Radtke, Dudley Zopp, Kerry Malloy, Kocka, Robert Stagg, Jenni Deame. Sponsors 9 shows/year. Average display time 5 weeks. Open all year. Located downtown; approximately 3,000 sq. ft. Clientele: 25% private collectors, 75% corporate collectors. Most work sold at $200-7,000.
Media: Considers all media. Considers only small edition print work by the artist. Most frequently exhibits painting, photography and sculpture.
Style: Exhibits individual styles.
Terms: Co-op membership fee plus donation of time (25% commission); outside the Louisville metropolitan area, 50% consignment. Retail price set by artist. Gallery provides insurance, promotion and contract; artist pays for shipping. Prefers artwork framed.
Submissions: No functional art (jewelry, etc.). Send query letter with résumé and slides. Call for appointment to show portfolio of slides; may request original after slide viewing. Replies in 6 weeks. Files slides, résumés and reviews (if accepted).
Tips: "Submit well-organized slides with slide list. Include professional résumé with notable exhibitions."

Louisiana

‡CASELL GALLERY, 818 Royal St., New Orleans LA 70116. (800)548-5473. Title/Owner-Directors: Joachim Casell. Retail gallery. Estab. 1970. Represents 20 mid-career artists/year. Exhibited artists include J. Casell and Don Picou. Sponsors 2 shows/year. Average display time 10 weeks. Open all year; 10-6. Located in French Quarters; 800 sq. ft. 25% of space for special exhibitions. Clientele: tourists and local community. 20-40% private collectors, 10% corporate collectors. Overall price range: $100-1,200; most work sold at $300-600.
Media: Considers all media, wood engraving, etching, lithograph, serigraphs and posters. Most frequently exhibits pastel and pen & ink drawings..
Style: Exhibits impressionism. All genres including landscapes. Prefers pastels.
Terms: Artwork is accepted on consignment and there is a 50% commission. Retail price set by the artist. Gallery provides promotion and pays for shipping costs. Prefers artwork unframed.
Submissions: Accepts only local area and Southern artists. Replies only if interested within 1 week.

GALLERY OF THE MESAS, 2010-12 Rapides Ave., Alexandria LA 71301. (318)442-6372. Artist/Owner: C.H. Jeffress. Retail and wholesale gallery and artist studio. Focus is on Southwest and native American art. Estab. 1975. Represents 6 established artists. Exhibited artists include Charles H. Jeffress, Peña, Gorman, Atkinson, Doug West and Mark Snowden. Open all year. Located on the north edge of town; 2,500 sq. ft. Features new canvas awnings, large gold letters on brick side of buildings and new mini-gallery in home setting next door. Clientele: 95% private collectors, 5% corporate collectors. Overall price range: $165-3,800.

Media: Considers original handpulled prints, intaglio, lithographs, serigraphs, Indian jewelry, sculpture, ceramics and drums. Also exhibits Hopi carved Katchina dolls. Most frequently exhibits serigraphs, inkless intaglio, collage and lithographs.
Style: Exhibits realism. Genres include landscapes, Southwestern and figurative work.
Submissions: Handles only work of well-known artists in Southwest field. Owner contacts artists he wants to represent.

HALL-BARNETT GALLERY, 320 Exchange Alley, New Orleans LA 70130. (504)525-5656. Fax: (504)525-4434. Director: Sjason Prohaska. Retail gallery. Estab. 1989. Represents 45 emerging, mid-career and established artists/year. Exhibited artists include J.L.Steg, Hunt Stonem, Ray Donley, B.F. Jones and Melissa Smith. Sponsors 6-8 shows/year. Average display time 2 months. Open all year; Monday-Saturday, 10-5. Located in the French Quarter between Bienville and Chartres; 5,000 sq. ft. on bottom floor ("recently purchased the building where we are located with 4 floors—each floor containing 2,500 sq. ft."). 80% of space for special exhibitions; 90% of space for gallery artists. Clientele: private collectors, special interest, local collectors. 70% private collectors, 20% corporate collectors. Overall price range: $100-10,000; most work sold at $100-3,500.
 • This gallery is housed in a building erected in 1830 which was the former residence of Degas.
Media: Considers oil, acrylic, watercolor, pastel, pen & ink, mixed media, collage, sculpture, glass, woodcut, engraving and etching. Most frequently exhibits oil painting (landscapes and figure), acrylic (figure and stills) and watercolor (figure and landscape).
Style: Genres include landscapes, figure/stills and abstracts. "We like to think we exhibit poetry rather than prose—no political art."
Terms: Accepts work on consignment (50% commission). Retail price set by the artist. Gallery provides insurance, contract and shipping costs from gallery; artist pays shipping costs to gallery. Prefers artwork framed.
Submissions: Send query letter with résumé, slides, bio, SASE, business card, reviews and artist statement. Call for appointment to show portfolio of originals. Replies in 2 weeks-1 month. "If we are interested we call—we never file without advising the artist first."
Tips: Finds artists through private travel, word of mouth, some publications. "When submitting slides—include statement reflecting your opinion of your own work."

‡HILDERBRAND GALLERY, 4524 Magazine St., New Orleans LA 70115. (504)895-3312. Fax: (504)899-9574. Director: Holly Hilderbrand. Retail gallery and art consultancy. Estab. 1991. Represents/exhibits 22 emerging, mid-career and established artists/year. Exhibited artists include Walter Rutkowski and Massimo Boccuni. Average display time 1 month. Open September-June; Tuesday-Saturday, 10-5. Located uptown; 2,300 sq. ft.; 12′ walls; pitch open ceiling with exposed steel beams/skylites. 90% of space for special exhibitions; 10% of space for gallery artists. Clientele: collectors, museum and corporate. 70% private collectors, 30% corporate collectors. Overall price range: $500-40,000; most work sold at $500-3,500.
Media: Considers all media, woodcut, linocut, engraving, mezzotint and etching. Most frequently exhibits oil, glass/steel and photography.
Style: Considers all styles. Genres include landscapes, Americana and figurative work. Prefers nontraditional landscapes, conceptualist and abstract figurative.
Terms: Artwork is accepted on consignment (50% commission). Retail price set by the gallery. Gallery provides insurance, limited promotion and contract. Artist pays for shipping costs. Prefers artwork framed.
Submissions: Send query letter with résumé, brochure, slides, reviews, bio and SASE. Replies in 1 month.
Tips: Finds artists through submissions, studio visits and exhibitions.

LERNER GALLERY, 1038 N. Highway 101, Encinitas LA 92024. Phone/fax: (619)753-0705.
 • This gallery was opened by the owners of Grove St. Gallery in Illinois. See Grove St. listing for information on needs and submission policies.

‡RICHARD RUSSELL GALLERY, 639 Royal St., New Orleans LA 70130. (504)523-0533. Owner: Richard Russell. Retail gallery. Estab. 1989. Represents/exhibits 10 emerging, mid-career and established artists/year. Exhibited artists include Barrett DeBusk and Jim Tweedy. Open all year. Located in the French Quarters; 800 sq. ft. 100% of space for gallery artists. Clientele: tourists, upscale. 95% private collectors. Overall price range: $200-2,000; most work sold at $800-1,200.
Media: Considers fiber, sculpture, ceramics, and serigraphs. Most frequently exhibits sculpture of metal, mixed media and clay.
Style: Whimsical and representational work.
Terms: Artwork is accepted on consignment and there is a 50% commission, or artwork is bought outright for 50% of the retail price. Retail price set by the gallery and the artist. Gallery provides insurance and promotion. Artist pays for shipping costs. Prefers artwork framed.
Submissions: Send query letter with résumé, brochure, business card, slides, photographs, bio and SASE. Call for appointment to show portfolio of photographs, slides and transparencies. Replies in 2-4 weeks. Does not reply. Artist should send SASE. Files material.

Tips: Finds artists through word of mouth, referrals by by other artists, visiting art fairs and exhibitions and artists' submissions. "Don't give up."

STILL-ZINSEL, 328 Julia, New Orleans LA 70130. (504)588-9999. Fax: (504)588-1111. E-mail: ufax@aol. com. Contact: Suzanne Zinsel. Retail gallery. Estab. 1982. Represents 25 emerging, mid-career and established artists. Sponsors 12 shows/year. Average display time 3 weeks. Open all year. Located in the warehouse district; 4,200 sq. ft.; unique architecture. 40% of space for special exhibitions. Clientele: collectors, museums and businesses.
Media: Considers oil, acrylic, watercolor, pastel, pen & ink, drawings, mixed media, paper, sculpture, glass, installation, photography, original handpulled prints, woodcuts, engravings, wood engravings, mezzotints, linocuts and etchings.
Style: Exhibits neo-expressionism, painterly abstraction, conceptualism, minimalism, color field, postmodern works, impressionism, realism, photorealism and hard-edge geometric abstraction. All genres.
Terms: Accepts work on consignment (50% commission). Retail price set by gallery and artist. Offers customer discounts and payment by installments. Gallery provides promotion and contract; artist pays for shipping.
Submissions: Send query letter with résumé, slides, SASE and reviews. Portfolio review requested if interested in artist's work.
Tips: "Please send clearly labeled slides."

‡STONE AND PRESS GALLERIES, 238 Chartres St., New Orleans LA 70130. (504)561-8555. Fax: (504)561-5814. Owner: Earl Retif. Retail gallery. Estab. 1988. Represents/exhibits 20 mid-career and established artists/year. Interested in seeing the work of emerging artists. Exhibited artists include Carol Wax and Benton Spruance. Sponsors 9 shows/year. Average display time 1 month. Open all year; Monday-Saturday, 10:30-5:30. Located in historic French Quarter; 1,200 sq. ft.; in historic buildings. 50% of space for special exhibitions; 50% of space for gallery artists. Clientele: collectors nationwide also tourists. 90% private collectors, 10% corporate collectors. Overall price range: $50-10,000; most work sold at $400-900.
• This gallery has a second location at 608 Julia St., also in New Orleans.
Media: Considers all drawing, pastel and all types of prints. Most frequently exhibits mezzotint, etchings and lithograph.
Style: Exhibits realism. Genres include Americana, portraits and figurative work. Prefers American scene of '30s and '40s and contemporary mezzotint.
Terms: Artwork is accepted on consignment (40% commission) or bought outright for 50% of the retail price; net 30 days. Retail price set by the gallery and the artist. Gallery provides insurance, promotion and contract; shipping costs are shared. Prefers artwork unframed.
Submissions: Send query letter with résumé, slides and SASE. Write for appointment to show portfolio of photographs. Replies in 2 weeks.
Tips: Finds artists through word of mouth and referrals of other artists.

Maine

THE ART GALLERY AT SIX DEERING STREET, 6 Deering St., Portland ME 04101. (207)772-9605. Director/Owner: Elwyn Dearborn. Retail gallery. Estab. 1987. Represents 10-12 emerging, mid-career and established artists/year, none exclusively. Exhibited artists include Betty Lou Schlemm, Edward Minchin, Jonathan Hotz, Ken Pratson, Carl Schmalz, Eliot O'Hara and T.M. Nicholas. Sponsors 8 shows/year. Average display time 3 weeks. Open March through June; September through December. Located downtown, on a residential, historic street; restored Victorian townhouse, gallery decorated and furnished in period (circa 1868-90). 66% of space for special exhibition. Clientele: local (*not* tourist). 95% private collectors, 5% corporate collectors. Overall price range: $500-1,000; most work sold at $500.
Media: Considers oil, acrylic, watercolor and pastel. Does not consider prints, drawings, sculpture or photographs.
Style: Exhibits expressionism and realism. Genres include landscapes and florals. Prefers "any subject as long as it is basically realism."
Terms: Accepts work on consignment (40% commission). Retail price set by gallery and artist. Gallery provides promotion; artist pays for shipping. Prefers artwork framed.
Submissions: Accepts only artists from the US. Send query letter with résumé, slides, bio, brochure, photographs, SASE and reviews. Write for appointment to show portfolio of originals or photographs, and slides or transparencies. Replies within weeks. Files résumé, brochure and bio.
Tips: "Artists must have been trained at a recognized art institution and preferably have a successful track record."

‡GREENHUT GALLERIES, 146 Middle St., Portland ME 04101. (207)772-2693. President: Peggy Greenhut Golden. Retail gallery. Estab. 1990. Represents/exhibits 20 emerging and mid-career artists/year. Sponsors 6 shows/year. Exhibited artists include Alison Goodwin and Connie Hayes. Average display time 3 weeks.

Open all year; Monday-Friday, 10-5:30; Saturday, 10-5. Located in downtown-Old Port; 3,000 sq. ft. with neon accents in interior space. 60% of space for special exhibitions. Clientele: tourists and upscale. 55% private collectors, 10% corporate collectors. Overall price range: $400-5,000; most work sold at $600-1,000.
Media: Considers all media, mezzotint, etching, lithograph, serigraphs and posters. Most frequently exhibits oil paintings, acrylic paintings and mixed media.
Style: Exhibits contemporary realism. Prefers landscape, seascape and abstract.
Terms: Artwork is accepted on consignment and there is a 50% commission. Retail price set by the gallery. Gallery provides insurance and promotion. Artists pays for shipping costs. Prefers artwork unframed.
Submissions: Accepts only artists from Maine or New England area with Maine connection. Send query letter with slides, reviews, bios and SASE. Call for appointment to show portfolio of slides. Replies in 1 month.
Tips: Finds artists through word of mouth, referrals by other artists, visiting art fairs and exhibitions and artists' submissions. "Visit the gallery and see if you feel you would fit in."

PINE TREE SHOP AND BAYVIEW GALLERY, 33 Bayview St., Camden ME 04843. (207)236-4534. Owner: Betsy Rector. Retail gallery. Estab. 1977. Represents 50 emerging, mid-career and established artists. Exhibited artists include Carol Sebold and Brian Kliewer. Sponsors 12 shows/year. Average display time 1 month. Open all year. Located in downtown; 1,500 sq. ft. 50% of space for special exhibitions. Clientele: 60% private collectors; 40% corporate collectors. Overall price range: $50-5,000; most work sold at $50-500.
Media: Considers oil, acrylic, watercolor, pastel, sculpture, original handpulled prints and offset reproductions. Most frequently exhibits oil, watercolor, pastels and sculpture.
Style: Exhibits primitivism, impressionism and realism. Genres include landscapes, florals, and figurative work. Prefers realism, impressionism and primitivism.
Terms: Accepts work on consignment (45% commission). Retail price set by gallery. Customer discounts and payment by installment are available. Gallery provides insurance, promotion and contract; artist pays for shipping. Prefers artwork framed.
Submissions: Send query letter with résumé, slides, bio, SASE and reviews. Portfolio review not required.
Tips: "Primarily new artists are acquired from their own submissions. We occasionally pursue artists whose work we are custom framing when its quality and nature would be desirable and marketable additions to the gallery. Make sure work is appropriate for gallery. We are showing a slightly broader range of styles, but we need to show a greater percentage of in-state artists to meet the expectations of our market and to maximize press releases. Most of our artists have survived the economy, although we've had to revise our territorial policy in order to allow artists to show elsewhere within our market territory. 90% of our clientele was hit by the economy, forcing us to consider more emerging artists and more modestly priced artwork. Also, as corporate sales are increasing, choices are made more with their trends in mind. Strong, professional work that is evocative of life and landscape of Maine tends to sell best."

ROUND TOP CENTER FOR THE ARTS GALLERY, Business Rt. 1, P.O. Box 1316, Damariscotta ME 04543. (207)563-1507. Artistic Director: Nancy Freeman. Nonprofit gallery. Estab. 1988. Represents emerging, mid-career and established artists. 1,200 members (not all artists). Exhibited artists include Lois Dodd and Marlene Gerberick. Sponsors 12-14 shows/year. Average display time 1 month. Open all year; Monday-Saturday, 11-4; Sunday, 1-4. Located on a former dairy farm with beautiful buildings and views of salt water tidal river. Exhibition space is on 2 floors 30×60, several smaller gallery areas, and a huge barn. 50% of space for special exhibitions; 25% of space for gallery artists. "Sophisticated year-round community and larger summer population." 25% private collectors. Overall price range: $75-10,000; most work sold at $300-1,000.
Media: Considers all media and all types of prints. Most frequently exhibits watercolor, fiber arts (quilts) and mixed media.
Style: Exhibits all styles. Genres include landscapes, florals, Americana and figurative work. Prefers landscape and historic.
Terms: Accepts work on consignment (25% commission). Retail price set by the artist. Gallery provides insurance, promotion and contract; shipping costs are shared. Prefers artwork simply framed.
Submissions: Send query letter with résumé, slides or photographs, bio and reviews. Write for appointment to show portfolio. Replies only if interested within 2 months. Files everything but slides, which are returned.
Tips: Finds artists through visiting exhibitions, word of mouth and artists' submissions.

Maryland

ARTEMIS, INC., 4715 Crescent St., Bethesda MD 20816. (301)229-2058. Fax: (301)229-2186. Owner: Sandra Tropper. Retail and wholesale dealership, art consultancy and art appraisals. Represents more than 100 emerging and mid-career artists. Does not sponsor specific shows. Clientele: 40% private collectors, 60% corporate clients. Overall price range: $100-10,000; most work sold at $500-1,500.
Media: Considers oil, acrylic, watercolor, mixed media, collage, works on paper, sculpture, ceramic, craft, fiber, glass, installations, woodcuts, engravings, mezzotints, etchings, lithographs, pochoir, serigraphs and offset reproductions.

Style: Carries impressionism, expressionism, realism, minimalism, color field, painterly abstraction, conceptualism and imagism. Genres include landscapes, florals and figurative work. "My goal is to bring together clients (buyers) with artwork they appreciate and can afford. For this reason I am interested in working with many, many artists." Interested in seeing works with a "finished" quality.

Terms: Accepts work on consignment (50% commission). Retail price set by dealer and artist. Exclusive area representation not required. Dealer provides insurance and contract; shipping costs are shared. Prefers artwork unframed.

Submissions: Send query letter with résumé, slides, photographs and SASE. Write for appointment to show portfolio of originals, slides, transparencies and photographs. Indicate net and retail prices. Files slides, photos, résumés and promo material. All material is returned if not accepted or under consideration.

Tips: "Many artists have overestimated the value of their work. Look at your competition's prices."

THE GLASS GALLERY, 4720 Hampden Lane, Bethesda MD 20814. (301)657-3478. Owner: Sally Hansen. Retail gallery. Estab. 1981. Represents 30 emerging, mid-career and established artists. Sponsors 10 shows/year. Average display time 5 weeks. Open all year; Tuesday-Saturday 11-5. Located metropolitan Washington DC (Bethesda urban district); 1,400 sq. ft. 50% of space for special exhibitions; 50% of space for gallery artists. Clientele: collectors.

Media: Considers sculpture in glass and monoprints (only if they are by glass sculptors who are represented by The Glass Gallery). Also interested in sculpture in glass incorporated with additional materials (bronze, steel etc.). "Focus is on creativity as well as on ability to handle the material well. The individuality of the artist must be evident."

Terms: Accepts work on consignment. Retail price set by artist. Sometimes offers customer discounts and payment by installment. Gallery provides insurance (while work is in gallery), promotion, contract and shipping costs from gallery.

Submissions: Send query letter with résumé, slides, photographs, reviews, bio and SASE. Portfolio review requested if interested in artist's work.

Tips: Finds artists through visits to exhibitions and professional glass conferences, plus artists' submissions and keeping up-to-date with promotion of other galleries (show announcements and advertising). "Send good slides with SASE and clear, concise cover letter and/or description of process. Familiarize yourself with the work of gallery displays to evaluate whether the quality of your work meets the standard."

‡GOMEZ GALLERY, 836 Leadenhall St., Baltimore MD 21217. (410)752-2080. Fax: (410)752-2082. Director: Diane DiSalvo. Retail gallery. Estab. 1988. Represents/exhibits emerging, mid-career and established artists. Interested in seeing the work of emerging artists. Sponsors 12 exhibitions/year. Average display time 5 weeks. Open all year; Tuesday-Saturday, 9-5. Located in Federal Hill, (downtown) Baltimore; 2,400 sq. ft.; converted warehouse space. Clientele: art collectors and a varietry of patrons.

Media: Considers all media. Most frequently exhibits painting, photography and sculpture.

Style: "Good work usually possessing an experimental element."

Terms: Artwork is accepted on consignment and there is a commission. Retail price set by the gallery and the artist. Gallery provides insurance, promotion and contract.

‡LOBBY FOR THE ARTS GALLERY, Cumberland Theatre, 101 Johnson St., Cumberland MD 21502. (301)759-3606. Exhibitions Director: Frank S. deCosta. Alternative space. Estab. 1989. Sponsors 6 shows/year. Average display time 1 month. Open April-October; Monday-Friday, 1-7 during performances in artists Equity Theatre. Located in downtown area; 600 sq. ft.; museum standard lighting. 100% of space for special exhibitions. 95% private collectors, 5% corporate collectors. Overall $100-2,000; most work sold at $1,000.

Media: Considers all media, woodcut, wood engraving, linocut, engraving, mezzotint and etching. Most frequently exhibits expressionism, neo-expressionism, realism, surrealism, impressionism and imagism. All genres. Prefers expressionism, figurative work, realism and surrealism.

Terms: Artwork is accepted on consignment and there is a 25% commission. Retail price set by the artist. Gallery provides promotion and contract. Prefers artwork framed.

Submissions: Accepts only artists who are able to have work hand delivered and hand picked up. Send query letter with résumé, brochure, slides and bio. Replies only if interested. "All replies made once a year in February submission deadline is December 15th."

Tips: Finds artists through artist's submissions. "Five slides minimum, ten maximum. Slides must be of the highest quality. Always by very polite and do not ask for exemptions from patterns of operation set down by galleries."

‡MARIN-PRICE GALLERIES, 7022 Wisconsin Ave., Chevy Chase MD 20815. (301)718-0622. President: F.J. Marin-Price. Retail/wholesale gallery. Estab. 1992. Represents/exhibits 25 established painters and 10 sculptors/year. Exhibited artists include Joseph Sheppard. Sponsors 24 shows/year. Average display time 3 weeks. Open Monday-Sunday, 11-8. 4,000 sq. ft. 50% of space for special exhibitions; 50% of space for gallery artists. Clientele: upscale. 90% private collectors, 10% corporate collectors. Overall price range: $3,000-25,000; most work sold at 5,000-8,000.

• This gallery has three locations, one in downtown Washington DC; one in Georgetown and one in the suburb of Chevy Chase.

Media: Considers oil, drawing, watercolor and pastel. Most frequently exhibits oil, watercolor and pastels.

Style: Exhibits expressionism, photorealism, neo-expressionism, primitivism, realism and impressionism. Genres include landscapes, florals, Americana and figurative work.

Terms: Retail price set by the gallery and the artist. Gallery provides insurance, promotion and contract. Artist pays for shipping costs. Prefers artwork framed.

Submissions: Prefers only oils. Send query letter with résumé, slides, bio and SASE. Replies in 3-6 weeks.

Tips: Finds artists through research, from clients visiting studios. "We do well with established artists and totally unknown artists, better than mid-career. If you are just starting out, keep your prices as low as you can tolerate them."

MARLBORO GALLERY, 301 Largo Rd., Largo MD 20772. (301)322-0965-7. Coordinator: John Krumrein. Nonprofit gallery. Estab. 1976. Interested in emerging, mid-career and established artists. Sponsors 4 solo and 4 group shows/year. Average display time 3 weeks. Seasons for exhibition: September-May. 2,100 sq. ft. with 10 ft. ceilings and 25 ft. clear story over 50% of space—track lighting (incandescent) and day light. Clientele: 100% private collectors. Overall price range: $200-16,000; most work sold at $500-700.

Media: Considers all media. Most frequently exhibits acrylics, oils, photographs, watercolors and sculpture.

Style: Exhibits expressionism, neo-expressionism, realism, photorealism, minimalism, primitivism, painterly abstraction, conceptualism and imagism. Exhibits all genres. "We are open to all serious artists and all media. We will consider all proposals without prejudice."

Terms: Accepts artwork on consignment. Retail price set by artist. Exclusive area representation not required. Gallery provides insurance. Artist pays for shipping. Prefers artwork ready for display.

Submissions: Send query letter with résumé, slides, SASE, photographs, artist's statement and bio. Portfolio review requested if interested in artist's work. Portfolio should include slides and photographs. Replies every 6 months. Files résumé, bio and slides.

Tips: Impressed by originality. Finds artists through word of mouth, visiting exhibitions and artists' submissions. "Indicate if you prefer solo shows or will accept inclusion in group show chosen by gallery."

MONTPELIER CULTURAL ARTS CENTER, 12826 Laurel-Bowie Rd., Laurel MD 20708. (301)953-1993. Fax: (301)206-9682. Director: Richard Zandler. Alternative space, nonprofit gallery, public arts center. Estab. 1979. Exhibits 1,000 emerging, mid-career, established artists/year. Sponsors 24 shows/year. Average display time 1 month. Open all year; 7 days/week, 10-5. Located midway between Baltimore and Washington on 80 acre estate; 2,500 sq. ft. (3 galleries): cathedral ceilings up to 32′. 85% of space for special exhibitions; 15% of space for gallery artists. Clientele: diverse, general public. Overall price range: $50-50,000; most work sold at $200-300.

Media: Considers oil, pen & ink, paper, fiber, acrylic, drawing, sculpture, glass, watercolor, mixed media, ceramic, installation, pastel, collage, craft, photography, media arts, performance and mail art. Also considers all types of prints.

Style: Exhibits all styles and genres.

Terms: Special exhibitions only. 25% commission on sales during show. Retail price set by artist. Offers customer discount (seniors and members). Gallery provides insurance, promotion, contract and shipping costs from gallery. Prefers artwork framed.

Submissions: "Different shows target different media, theme and region. Call first to understand programs." Send résumé, slides and SASE. Replies only if interested within 8 months. Files résumés and cover letters. Slides are returned.

Tips: Finds artists through visiting exhibitions and artists' submissions.

‡MUSE GALLERY AND STUDIOS OF FINE ARTS, 2032 York Rd., Timonium MD 21093. (410)561-8283. President: Elizabeth B. Muse. Retail gallery. Estab. 1990. Represents/exhibits 40 established artists/year. Exhibited artists include John Sills and Frederic Schuler Briggs. Sponsors 6 shows/year. Average display time 6 weeks. Open all years; Tuesday-Friday, 10-4. Located on York Rd., Corridor-town; 2,000 sq. ft.; beautiful skylights, parking. 50% of space for special exhibitions; 50% of space for gallery artists. Clientele: established, averaging in age from mid forties. 10% private collectors and 5% corporate collectors. Overall price range: $500-16,000; most worl sold at $2,000.

Media: Considers oil, pen & ink, paper, sculpture, watercolor, mixed media, pastel and collage, woodcut, engraving, etching and lithograph. Most frequently exhibits oils, watercolors, drawings and pastels.

Style: Exhibits impressionism. Genres include landscapes, florals, wildlife, Americana, portraits and figurative work. Prefers landscapes, still life and florals.

Terms: Artwork is accepted on consignment (40% commission). Retail price set by the gallery and the artist. Gallery provides insurance, promotion and contract. Shipping costs are shared. Prefers artwork framed. Generally accepts only artists from the Eastern Seaborad. Prefers only established or exceptional mid-level. Work should be well framed. Send query letter with brochure, business card, slides and reviews. Call or write for appointment to show portfolio of originals and slides. Replies in 1 month. Files slides, résumé and reviews.

Tips: Finds artists by visiting exhibitions, word of mouth, artist organizations, submissions and publications. The gallery is interested in Old Master styles especially.

PYRAMID ATLANTIC, 6001 66th Ave., Suite 103, Riverdale MD 20737. (301)459-7154, (301)577-3424. Artistic Director: Helen Frederick. Nonprofit gallery/library. Estab. 1981. Represents emerging, mid-career and established artists. Sponsors 6 shows/year. Average display time 2 months. Open all year; 10-6. 15% of space for special exhibitions; 10% of space for gallery artists. Also features research library. Clientele: print and book collectors, general audiences. Overall price range: $1,000-10,000; most work sold at $800-2,500.
Media: Considers watercolor, pastel, pen & ink, drawing, mixed media, collage, paper, sculpture, craft, installation, photography, artists' books and all types of prints. Most frequently exhibits works in and on paper, prints and artists' books and mixed media by faculty who teach at the facility and members of related programs.
Style: Exhibits all styles and genres.
Terms: Accepts work on consignment (50-60% commission). Print subscription series produced by Pyramid; offers 50% to artists. Retail prices set by gallery and artist. Gallery provides insurance, promotion and contract; shipping costs are shared.
Submissions: Send query letter with résumé, slides, bio, brochure, SASE and reviews. Call or write for an appointment to show portfolio, which should include originals and slides. Replies in 1 month. Files résumés.

RESURGAM GALLERY, 910 S. Charles St., Baltimore MD 21230. (410)962-0513. Office Manager: P. Randall Whitlock. Cooperative gallery. Estab. 1990. Represents 34 emerging, mid-career and established artists/year. 34 members. Exhibited artists include Ruth Pettus and Beth Wittenberg. Sponsors 14 shows/year. Average display time 3 weeks. Open all year; Wednesday-Saturday, noon-6; closed in August. Located downtown; 600 sq. ft.; in Baltimore's historic Federal Hill district. 100% of space for gallery artists. Clientele: urban professionals. 100% private collectors. Overall price range: $100-1,800; most work sold at $200-800.
Media: Considers oil, acrylic, watercolor, pastel, pen & ink, drawing, mixed media, collage, paper, sculpture, ceramics, craft, fiber, glass, photography and all types of prints. Most frequently exhibits painting, sculpture (mid-sized) and fine crafts.
Style: Exhibits all styles, all genres.
Terms: Co-op membership fee plus donation of time. Retail prices set by the artist. Gallery provides insurance. "Artists are responsible for their own promotion." Artist pays shipping costs to and from gallery. Prefers artwork framed.
Submissions: "Artists must be available to sit in gallery—or pay a sitter—five days each year." Memberships for calendar year decided in June. Rolling-basis jurying throughout the year. Send query letter with SASE to receive application form. Portfolio should include slides.

TOWN CENTER GALLERY, INC., Airrights Center, 7315 Wisconsin Ave., Bethesda MD 20814. (301)652-0226. Manager: Connie Woolard. Cooperative gallery. Estab. 1972. Represents 22 emerging, mid-career and established artists. "Gallery offers space to nonmembers. Gallery members' feature show hangs for 1 month, 12 times/year, if no special shows are scheduled." 1,500 sq. ft. with direct access from metro stop, "bright, well-lighted, in large office building with first level shops and restaurants." Clientele: 90% private collectors; 10% corporate clients. Overall price range: $50-2,500; most artwork sold at $50-500.
Media: Considers oil, acrylic, watercolor, pastel, pen & ink, drawings, mixed media, collage, works on paper, sculpture, ceramic, egg tempera, woodcuts, wood engravings, linocuts, engravings, mezzotints, etchings, lithographs, serigraphs and offset reproductions by artist members. Most frequently exhibits watercolors or acrylics, oils and prints.
Style: Exhibits impressionism, expressionism and realism. Genres include landscapes, florals, Americana, wildlife and figurative work. Prefers landscapes, florals and still lifes."Customers are seeking realism."
Terms: Co-op donation of time; 35% commission. Initial membership fee, rental fee for space; rental fee for nonmembers covers 1 month. Retail price set by artist. Customer discounts and payment by installments are available. Exclusive area representation not required. Prefers framed artwork.
Submissions: Send query letter with résumé, business card, slides, bio and SASE. Call or write to schedule an appointment to show a portfolio, which should include originals, slides, transparencies and photographs. Prefers to see 4 original works, suitably framed, for jurying. Replies in 3 weeks.
Tips: "Nine months a year there are group shows with one large wall featuring a member each month. A *special* nonmember show (three times a year) might be best consideration for anyone living outside the immediate area, as members are required to give working time, etc., since we are a cooperative gallery. Presentation for jurying should be professional, with well-framed pieces—screw eyes and wire and always clear glass and mats where necessary."

Massachusetts

‡ALON GALLERY/ART SERVICES, 1665A Beacon St., Brookline MA 02146. (617)232-3388. Fax: (617)232-9480. Director: Moshe Alon. Retail gallery. Estab. 1976. Represents 20 emerging mid-career and

established artists. Exhibited artists include Jason Berger and Amos Yaskil. Sponsors 6-10 shows/year. Average display time 1 month. Open all year; Tuesday-Saturday, 10-6. Located on a main street, in small town next to Boston; 1,500 sq. ft.; 2 levels; window on street. 100% of space for special exhibitions. Clientele: 80% private collectors, 10% corporate collectors and 10% dealers. Overall price range: $200-10,000; most work sold at $400-2,000.

Media: Considers all media and all types of limited edition prints. Most frequently exhibits oil, graphics and watercolor.

Style: Exhibits expressionism, painterly abstraction and realism. Prefers figurative works, landscapes and expressionism.

Terms: Accepts work on consignment (50% commission). Retail price set by gallery and artist. Gallery provides promotion; artist pays for shipping. Prefers artwork framed.

Submissions: Send query letter with résumé, slides, bio and SASE. "Always label slides with size and title." Write for appointment to show portfolio of photographs and slides. Replies in 1 week. Files all material if interested.

Tips: "We suggest the artist be familiar with our gallery."

‡BOSTON CORPORATE ART, 470 Atlantic Ave., Boston MA 02210. (617)426-8880. Fax: (617)426-5551. Principal: Woody Rollins. Retail gallery and art consultancy. Estab. 1987. Represents several hundred emerging and mid-career artists. Exhibited artists include John Stockwell and Peter Kitchell. Average display time 6-8 weeks. Open all year; Monday-Friday 8:30-5:30. Located downtown, waterfront, near financial district; 4,500 sq. ft. "We use our gallery space in conjunction with our offices—for art consulting. Our gallery is more of a display area than a traditional gallery." Clientele: large corporations and small businesses. Overall price range: $300-5,000; most work sold at $600-1,500.

Media: Considers all media. Most frequently exhibits oil/acrylic on canvas, watercolor, pastel. Most frequently sells works on paper.

Style: Exhibits all styles and genres. Prefers impressionism, realism, painterly abstraction.

Terms: Accepts work on consignment (50% commission). Retail price set by artist. Gallery provides insurance and shipping costs from gallery; artist pays for shipping costs to gallery. Prefers artwork unframed.

Submissions: Send query letter with résumé, slides, bio, SASE, price list and reviews. Write for appointment to show portfolio of slides. Replies in 6 weeks. Files slides, bio, résumé, price list.

Tips: "Please fill out a price list that includes price per piece on slides. Mark all slides with name, title, medium, size."

BROMFIELD GALLERY, 107 South St., Boston MA 02111. (617)451-3605. Director: Christina Lanzl. Cooperative gallery. Estab. 1974. Represents 20 emerging and mid-career artists. Exhibited artists include Barbara Andrus, Erica Licea-Kane, Martin Mugar and Tim Nichols. Sponsors 25 shows/year. Average display time 1 month. Open all year; Tuesday-Friday 12-5; Saturday 11-5. Located downtown; 2,500 sq. ft.; sequence of 3 large gallery spaces. 30% of space for special exhibitions; 70% of space for gallery artists. Clientele: 70% private collectors, 30% corporate collectors. Overall price range: $300-6,000; most work sold at $300-2,000.

Media: Considers all media and original handpulled prints. Most frequently exhibits paintings, prints, sculpture.

Style: Exhibits all styles and genres.

Terms: Co-op membership fee plus donation of time (35% commission). For invitational exhibitions, there is a rental fee for space which covers 12 months. Retail price set by artist. Offers customer discounts and payment by installments. Gallery provides promotion and contract; artist pays for shipping costs.

Submissions: Accepts only artists from New England. Send query letter with résumé, slides and SASE. Write for appointment to show portfolio of originals. Replies in 1 month. Files all info on members and visiting artists.

Tips: Finds artists through word of mouth, various art publications and sourcebooks, artists' submissions/self-promotions and referrals.

CLARK WHITNEY GALLERY, 25 Church St., Lenox MA 01240. (413)637-2126. Director: Ruth Kochta. Retail gallery. Estab. 1983. Represents 25 emerging, mid-career and established artists/year. Exhibited artists include Ross Barbera, Suzanne Howes-Stevens and Stanley Marcus. Sponsors 5 shows/year. Average display time 1 month. Open Thursday-Monday, 11-5; closed January and February. Located downtown; 800 sq. ft. "My gallery is in historic Lenox Village in the Berkshire Mountains. It is located in an area very rich in culture, i.e., classical music, dance, opera, Shakespeare, etc." 60% of space for special exhibitions; 100% of space for gallery artists. 90% private collectors, 10% corporate collectors. Overall price range: $200-8,000; most work sold at $200-5,000.

Media: Considers oil, acrylic, mixed media, sculpture, glass and conceptual assemblage. Most frequently exhibits oils, sculpture (bronze, steel, stone) and acrylics.

Style: Exhibits expressionism, neo-expressionism, surrealism, postmodern works, impressionism, realism and imagism. Genres include landscapes, florals and figurative work. Prefers realistic figures in an environment, large scale landscapes and semi-abstracts.

Terms: Accepts work on consignment (40% commission). Retail price set by the artist. Gallery provides insurance. "We do not get involved in shipping." Prefers artwork framed.
Submissions: Accepts only artists who live within 3 hours driving time from Lenox. Send query letter with slides, bio, SASE and price range. Call for appointment to show portfolio of photographs or slides. Replies in 2 weeks. Files bio and copies of slides.
Tips: "I search for uniqueness of concept combined with technical competence."

DE HAVILLAND FINE ART, 39 Newbury St., Boston MA 02116. (617)859-3880. Fax: (617)859-3973. Contact: Gallery Manager. Retail gallery. Estab. 1989. Represents 40 emerging New England artists. Sponsors 10-12 shows/year. Average display time 1 month. Open all year. Located downtown ½ block from the Ritz Hotel; 1,200 sq. ft. 75% of space for special exhibitions. Clientele: 80% private collectors, 20% corporate collectors. Overall price range: $200-7,000.
Media: Considers oil, acrylic, watercolor, pastel, pen & ink, drawing, mixed media and sculpture. Most frequently exhibits oil/acrylic, watercolor/pastel and mixed media. Also special interest in fine art crafts.
Style: Exhibits expressionism, neo-expressionism, primitivism, painterly abstraction, surrealism, postmodern works, impressionism and realism. Genres include landscapes, florals and Americana. Prefers realism, painterly abstraction and impressionism.
Terms: Accepts artwork on consignment (50% commission). Retail price set by the gallery and artist. Sometimes offers customer discounts. Gallery provides promotion and contract; artist pays for shipping. Prefers artwork framed.
Submissions: Send query letter with résumé, slides, and SASE. "We support emerging artists who reside in New England." Replies in 1 month. Files résumé.

‡FLETCHER/PRIEST GALLERY, 5 Pratt St., Worcester MA 01609-1721. (508)791-5929. Director: Terri Priest. Retail gallery and art consultancy. Estab. 1990. Represents/exhibits emerging, mid-career and established artists. Interested in seeing work of emerging artists. Exhibited artists include Christopher Brown and Cynthia Nartonis. Sponsors 6 shows/year. Average display time 4-5 weeks. Open September-June; Wednesday-Friday, 12-6; Saturday, 10-3 and by appointment. 300 running feet; located in private home renovated as gallery in small shopping area. 70% of space for special exhibitions of gallery artists. Clientele: upscale and local. 60% private collectors, 40% corporate collectors. Overall price range: $190-5,000; most work sold at $1,200-3,000.
Media: Considers primarily high quality prints and photographs. Most frequently exhibits lithographs, mixed print media and etchings.
Style: Exhibits all styles. "No preference in style. We are looking for strong images."
Terms: Artwork is accepted on consignment and there is a 40% commission. Retail price set by the artist. Gallery provides insurance and promotion. Shipping costs are shared. Prefers artwork unframed.
Submissions: "No decorative or large editions." Send query letter with résumé, slides, reviews and SASE. Call for appointment to review portfolio of slides, transparencies and photographs. Replies only if interested within 2-3 weeks. Slides and résumé by subject and/or style.
Tips: "If you cannot send a 'minimum' of 20 related images in a single medium we would not be interested."

‡THE FREYDA GALLERY, 28 Main St., Rockport MA 01966. (508)546-9828. Owner: Freyda M. Craw. Retail gallery. Represents/exhibits 8 mid-career and established artists/year. Exhibited artists include David L. Millard and Lou Bonamarte. Sponsors on-going group show and 2-3 special shows/year. Average display time 9 months. Open March through December; Monday-Saturday, 9-5; Sunday, 1-5 (summer); 1-5 (fall and summer). Located downtown. Clientele: tourist, beginning and experienced collectors. 50% private collectors. Overall price range: $200-8,000; most work sold at $200-4,000.
Media: Considers oil, acrylic, watercolor and pastel. Most frequently exhibits oil, watercolor and acrylic.
Style: Exhibits expressionism and impressionism. Genres include landscapes, florals, Americana, figurative work and seascapes. Prefers impressionism, realism and expressionism.
Terms: Artwork is accepted on consignment and there is a 40% commission. Retail price set by the gallery and the artist. Gallery provides promotion and contract. Shipping costs are shared. Prefers artwork framed.
Submissions: Regional gallery exclusivity required. Send query letter with résumé, slides, reviews, bio and SASE. Write for appointment to show portfolio of slides. Replies only if interested within 1 month. Files artist's résumé and bio if future interest.
Tips: Finds artists through referrals by other artists, exhibitions and artists' submissions.

GALLERY NAGA, 67 Newbury St., Boston MA 02116. (617)267-9060. Director: Arthur Dion. Retail gallery. Estab. 1977. Represents 24 emerging, mid-career and established artists. Exhibited artists include Henry Schwartz and Judy Kensley McKie. Sponsors 10 shows/year. Average display time 1 month. Closed August. Located on "the primary street for Boston galleries; 1,500 sq. ft.; housed in an historic neo-gothic church." Clientele: 90% private collectors, 10% corporate collectors. Overall price range: $500-40,000; most work sold at $2,000-10,000.
Media: Considers oil, acrylic, mixed media, sculpture, photography, studio furniture and monotypes. Most frequently exhibits painting and furniture.

Style: Exhibits expressionism, painterly abstraction, postmodern works and realism. Genres include landscapes, portraits and figurative work. Prefers expressionism, painterly abstraction and realism.
Terms: Accepts work on consignment (50% commission). Retail price set by gallery and artist. Gallery provides insurance and promotion; artist pays for shipping. Prefers artwork framed.
Submissions: "Not seeking submissions of new work at this time."
Tips: "We focus on Boston and New England artists. We exhibit the most significant studio furniture makers in the country. Become familiar with a gallery to see if your work is appropriate before you make contact."

KAJI ASO STUDIO/GALLERY NATURE AND TEMPTATION, 40 St. Stephen St., Boston MA 02115. (617)247-1719. Fax: (617)247-7564. Administrator: Kate Finnegan. Nonprofit gallery. Estab. 1975. Represents 40-50 emerging, mid-career and established artists. 35-45 members. Exhibited artists include Kaji Aso and Katie Sloss. Sponsors 10 shows/year. Average display time 3 weeks. Open all year; Tuesday, 1-8; Wednesday-Saturday, 1-5; and by appointment. Located in city's cultural area (near Symphony Hall and Museum of Fine Arts); "intimate and friendly." 30% of space for special exhibitions; 70% of space for gallery artists. Clientele: urban professionals and fellow artists. 80% private collectors, 20% corporate collectors. Overall price range: $150-8,000; most work sold at $150-1,000.
Media: Considers oil, acrylic, watercolor, pastel, pen & ink, drawing, ceramics and etching. Most frequently exhibits watercolor, oil or acrylic and ceramics.
Style: Exhibits painterly abstraction, impressionism and realism.
Terms: Co-op membership fee plus donation of time (35% commission). Retail price set by the artist. Gallery provides promotion; artist pays shipping costs to and from gallery. Prefers artwork framed.
Submissions: Send query letter with résumé, slides, bio, photographs and SASE. Write for appointment to show portfolio of originals, photographs, slides or transparencies. Does not reply; artist should contact. Files résumé.
Tips: Finds artists through advertisements in art publications, word of mouth, artists' submissions.

KINGSTON GALLERY, 129 Kingston St., Boston MA 02111. (617)423-4113. Director: Steve Novick. Cooperative gallery. Estab. 1982. Exhibits the work of 11 emerging, mid-career and established artists. Sponsors 11 shows/year. Average display time 1 month. Closed August. Located "in downtown Boston (financial district/Chinatown); 1,300 sq. ft.; large, open room with 12′ ceiling and smaller front room—can accomodate large installation." Overall price range: $100-7,000; most work sold at $600-1,000.
Media: Considers all media but craft. 10% of space for special exhibitions.
Style: Exhibits all styles.
Terms: Co-op membership requires dues plus donation of time. 25% commission charged on sales by members. Retail price set by the artist. Sometimes offers payment by installments. Gallery provides insurance, some promotion and contract. Rental of front gallery by arrangement.
Submissions: Accepts only artists from New England for membership. Artist must fulfill monthly co-op responsibilities. Send query letter with résumé, slides, SASE and "any pertinent information. Slides are reviewed once a month. Gallery will contact artist within 1 month." Does not file material but may ask artist to re-apply in future.
Tips: "Please include thorough, specific information on slides: size, price, etc."

‡LE PETIT MUSÉE, 137 Front St., Housatonic MA 01236. (413)274-3838. Owner: Sherry Steiner. Retail gallery. Estab. 1991. Represents/exhibits 26 emerging, mid-career and established artists/year. Interested in see the work of emerging artists. Exhibited artists include Roy Interstate and Felicia Zumakoo. Average display time 1-3 months. Open all year; Friday-Sunday, opens at noon or by appointment. Located in village of Housatonic "Soho of the Berkshires"; 144 sq. ft.; storefront in an arts community. 95% of space for gallery artists. Clientele: tourists, upscale local. 70% private, 30% corporate collectors. Overall price range: $100-10,000; most work sold at $100-10,000.
Media: Considers all media except craft. Considers woodcut, wood engraving, engraving, mezzotint, lithographs and serigraphs. Most frequently exhibits paintings, drawings and photographs.
Style: Exhibits all styles. Prefers post modern works, realism and imagism.
Terms: Artwork is accepted on consignment and there is a 50% commission. Retail price set by the gallery. Gallery provides promotion. Artist pays for shipping costs. Prefers artwork framed.
Submissions: Send slides, photographs, reviews, bio and SASE. Call for appointment to show photographs and slides. Replies in 1 week.
Tips: Finds artists through word of mouth, referrals and artists' submissions. Advises artists to "submit adequate information on work."

‡LICHTENSTEIN CENTER FOR THE ARTS/BERKSHIRE ARTISANS GALLERY, 28 Renne Ave., Pittsfield MA 01201. (413)499-9348. Artistic Director: Daniel M. O'Connell. Nonprofit retail and rental gallery, alternative space and art consultancy exhibiting juried shows. Estab. 1976. Represents/exhibits 60 emerging, mid-career and established artists/year. Exhibited artists include Thomas Patti and Rapheal Soyer. Sponsors 13-15 shows/year. Average display time 4-6 weeks. Open Tuesday-Friday, 11-5; Saturday, 12-4. Located in downtown Pittsfield, 2,400 sq. ft.; historic brownstone, high oak ceilings, north light, wood floors. 100% of

space for special exhibitions of gallery artists. 35% private collectors, 10% corporate collectors. Overall price range: $150-20,000; most work sold at $150-20,000.

Media: Considers all media and all types of prints. Most frequently exhibits painting, drawing/prints, sculpture/glass.

Style: Exhibits all styles. All genres.

Terms: "We exhibit juried works at 20% commission." Retail price set by the artist. Gallery provides insurance, promotion and contract. Artist pays for shipping costs.

Submissions: Send query letter with résumé, slides, photographs, reviews, bio and SASE. Does not reply. Artist should send 20 slides with résumé and SASE only. No entry fee.

Tips: "We are usually booked solid for exhibitions 3-5 years ahead of schedule." Advises artists to "develop professional, leather bound portfolio in duplicate with up to 20 slides, résumé, exhibit listings and SASE. Submit to specialized galleries and museums."

R. MICHELSON GALLERIES, 132 Main St., Northampton MA 01060. (413)586-3964. Also 25 S. Pleasant St., Amherst MA 01002. (413)253-2500. Owner: R. Michelson. Retail gallery. Estab. 1976. Represents 30 emerging, mid-career and established artists/year. Exhibited artists include Barry Moser and Leonard Baskin. Sponsors 6 shows/year. Average display time 1 month. Open all year; Monday-Saturday, 10-6; Sunday, 12-5. Located downtown; Northampton gallery has 1,500 sq. ft.; Amherst gallery has 1,800 sq. ft. 50% of space for special exhibitions. Clientele: 80% private collectors, 20% corporate collectors. Overall price range: $10-75,000; most artwork sold at $1,000-25,000.

Media: Considers all media and all types of prints. Most frequently exhibits oil, egg tempera, watercolor and lithography.

Style: Exhibits impressionism, realism and photorealism. Genres include florals, portraits, wildlife, landscapes, Americana and figurative work.

Terms: Accepts work on consignment (50% commission). Retail price set by gallery and artist. Customer discounts and payment by installment are available. Gallery provides promotion; shipping costs are shared.

Submissions: Prefer local, Pioneer Valley artists. Send query letter with résumé, slides, bio, brochure and SASE. Write for appointment to show portfolio. Replies in 3 weeks. Files slides.

PEPPER GALLERY, 38 Newbury St., Boston MA 02116. (617)236-4497. Fax: (617)236-4497. Director: Audrey Pepper. Retail gallery. Estab. 1993. Represents 20 emerging, mid-career and established artists/year. Exhibited artists include Roy DeCarava, Edith Vonnegut, Robert Bauer, Nicholas Kahn, Kathryn Freeman and Nancy Friese. Sponsors 9 shows/year. Average display time 6 weeks. Open all year; Tuesday-Saturday, 10-5. Located downtown, Back Bay; 500 sq. ft. 90% of space for special exhibitions; 90% of space for gallery artists. Clientele: private collectors, museums, corporate. 70% private collectors, 15% corporate collectors, 15% museum collectors. Overall price range: $275-15,000; most work sold at $800-4,000.

Media: Considers oil, acrylic, watercolor, pastel, handmade furniture, drawing, mixed media, glass, woodcut, engraving, lithograph, mezzotint, etching and photogravures. Most frequently exhibits oil on canvas, lithos/etchings and photogravures.

Style: Exhibits contemporary representational paintings, prints, drawings and photographs.

Terms: Accepts work on consignment (50% commission). Retail price set by the gallery and the artist. Gallery provides insurance, promotion and contract.

Submissions: Send query letter with résumé, slides, bio, SASE and reviews. Call for appointment to show portfolio of originals, photographs, slides and transparencies. Replies in 2 months.

Tips: Finds artists through exhibitions, word of mouth, open studios and artists' submissions.

PIERCE GALLERIES, INC., 721 Main St., Rt. 228, Hingham MA 02043. (617)749-6023. Fax: (617)749-6685. President: Patricia Jobe Pierce. Retail and wholesale gallery, art historians, appraisers and consultancy. Estab. 1968. Represents 8 established artists. May consider emerging artists in the future. Exhibited artists include Eric Midttun, Joseph Fontaine, Geeteshi De Cünto and Kahlil Gibran. Sponsors 8 shows/year. Average display time 1 month. Open all year. Hours by appointment only. Located "in historic district on major road; 3,800 sq. ft.; historic building with high ceilings and an elegant ambiance." 100% of space for special exhibits. Overall price range: $1,500-400,000; most work sold at $1,500-100,000.

Media: Considers oil, acrylic, watercolor, pastel, pen & ink, drawings and sculpture. Does not consider prints. Most frequently exhibits oil, acrylic and watercolor.

Style: Exhibits expressionism, neo-expressionism, painterly abstraction, surrealism, impressionism, realism, photorealism and social realism. All genres and subjects, including landscapes, florals, Americana, Western, wildlife and figurative work. Prefers impressionism, expressionism and super realism.

Terms: Often buys artwork outright for 50% of retail price; sometimes accepts on consignment (20-33% commission). Retail price set by artist, generally. Sometimes offers customer discounts and payment by installment. Gallery provides insurance and promotion; contract and shipping costs may be negotiated.

Submissions: Send query letter with résumé, slide sheets and SASE. Gallery will contact if interested for portfolio review. Portfolio should include photos or slides of originals. Replies in 48 hours. Files material of future interest.

Tips: Finds artists through referrals, portfolios/slides "sent to me or I see the work in a show or magazine. I want to see consistent, top quality work and techniques—not a little of this, a little of that. Please supply three prices per work: price to dealer buying outright, price to dealer for consigned work and a retail price. The biggest mistake artists make is that they sell their own work (secretly under the table) and then expect dealers to promote them! If a client can buy art directly from an artist, dealers don't want to handle the work."

‡JUDI ROTENBERG GALLERY, 130 Newbury St., Boston MA 02116. (617)437-1518. Retail gallery. Estab. 1964. Represents 14 emerging, mid-career and established artists. Average display time 3 weeks. Open all year. Located in the Back Bay; 1,400 sq. ft. 100% of space for special exhibitions. Overall price range: $800-19,000; most work sold at $1,200-7,000.
Media: Considers all media. Most frequently exhibits oil, watercolor and acrylic.
Style: Exhibits expressionism, painterly abstraction and postmodern works. Genres include landscapes, florals, portraits and figurative work. Prefers expressionism and post-modernism.
Terms: Accepts artwork on consignment (50% commission). Retail price set by the artist. Gallery provides insurance, promotion and contract; artist pays shipping costs. Prefers artwork framed.
Submissions: Send query letter with résumé, slides, bio and photographs, reviews and SASE. Write for appointment to show portfolio of photographs. Replies only if interested.

THE SOCIETY OF ARTS AND CRAFTS, 175 Newbury St., Boston MA 02116. (617)266-1810. Also, second location at 101 Arch St., Boston MA 02110. (617)345-0033. Executive Director: Beth Ann Gerstein. Gallery Manager: Ms. Randi Lathrop. Retail gallery with for-sale exhibit space. Estab. 1897. Represents 450 emerging, mid-career and established artists. 900 members. Exhibited artists include Grechten Ewert, Clay. Sponsors 6-10 shows/year (in the 2 gallery spaces). Average display time 6-8 weeks. Open all year; main: Monday-Saturday, 10-6; Sunday 12-5; second: Monday-Friday, 11-7. Located in the Copley Square Area; 2nd floor of a brownstone. "The Society is the oldest nonprofit craft gallery in America." 50% of space for special exhibitions; 50% of space for gallery artists. Clientele: corporate, collectors, students, interior designers. 85% private collectors, 15% corporate collectors. Overall price range: $2.50-6,000; most work sold at $100-300.
Media: Considers mixed media, collage, paper, sculpture, ceramics, craft, fiber and glass. Most frequently exhibits wood, clay and metal.
Style: Exhibits contemporary crafts in all mediums, all genres.
Terms: Accepts work on consignment (50% commission). "Exhibiting/gallery artists can become members of the Society for $25 membership fee, annual." Retail price set by the artist; "if assistance is needed, the gallery will suggest." Gallery provides insurance, promotion and contract. Prefers artwork framed.
Submissions: Accepts only artists residing in the US. Send q;uery letter with résumé, slides, bio, brochure, SASE, business card and reviews. Portfolio should include slides or photos (if slides not available). Replies in 6 weeks. Files résumés (given out to purchaser), reviews, visuals.
Tips: Finds artists through networking with artists and other craft organizations, trade shows (ACC Philadelphia, Springfield, Rosen Baltimore), publications (*Niche, American Craft*) and various specialty publications (*Metalsmith, Sculpture, American Woodworking*, etc.), collectors, other galleries, general submissions.

THRONJA ORIGINAL ART, 260 Worthington St., Springfield MA 01103. (413)732-0260. Director/Owner: Janice S. Throne. Retail gallery and art consultancy. Estab. 1967. Represents 75 emerging, mid-career and established artists. Exhibited artists include Harold Altman, Philip Hichen, Asa Cheffetz, Teri Mabo, Teri Priest and Robert Sweeney. Sponsors 4-5 shows/year. Open all year; Monday-Friday, 9:30-4:45; Saturday and evenings, by appointment; special holiday hours. Located in downtown Springfield; 1,000 sq. ft.; 2nd floor location overlooking park. 75% of space for special exhibitions; 75% of space for gallery artists. Clientele: corporate, professional, private. 30% private collectors, 70% corporate collectors. Overall price range: $100-15,000; most work sold at $150-1,500.
Media: Considers oil, acrylic, pastel, pen & ink, drawing, mixed media, collage, paper, sculpture, ceramics, fiber, glass, photography and all types of prints. Most frequently exhibits oils, watercolors and prints.
Style: Exhibits expressionism, painterly abstraction, conceptualism, impressionism, photorealism, realism and imagism, all genres. Prefers impressionism, realism and expressionism.
Terms: Accepts work on consignment (50% commission) or buys outright for 50% of retail price (net 30 days).
Retail price set by the gallery and the artist. Gallery provides promotion and contract, "sometimes." Artist pays shipping to and from gallery.
Submissions: Send query letter with résumé, slides, bio, photographs, SASE and reviews. Call or write for appointment to show portfolio of photographs, slides and transparencies. Replies in 1 month. "Follow up with a postcard if you don't hear from us."
Tips: Finds artists through visiting exhibitions at colleges, museums; artists' submissions (a great number); recommendations from museum professionals and art traders; reading art publications. "Send in your best works; slides, b&w glossies for publicity purposes, a complete bio and a separate list of titles and retail prices. Prices should be reasonable! Market is difficult and new artists with us should price to *sell*."

WENNIGER GALLERY, 19 Mount Pleasant St., Rockport MA 01966. (508)546-8116. Directors/Owners: Mary Ann and Mace Wenniger. Retail gallery and art consultancy. Estab. 1971. Represents 100 emerging, mid-career and established artists. Exhibited artists include Yuji Hiratsuka and Helen Frank. Sponsors 10 shows/year. Average display time 3 weeks. Open all year; Monday-Saturday, 11-5. Located downtown; 1,000 sq. ft.; on the harbor, attractive cheery building. 50% of space for special exhibitions, 50% of space for gallery artists. Clientele: young professionals. 75% private collectors, 25% corporate collectors. Overall price range: $50-1,000.
Media: Considers woodcut, engraving, lithograph, wood engraving, mezzotint, serigraph, etching and collagraph. Most frequently exhibits collagraph, mezzotint and wood engraving.
Style: Exhibits expressionism, color field and realism. Genres include figurative work.
Terms: Accepts work on consignment (50% commission). Retail prices set by the artist. Gallery provides insurance and shipping costs from gallery; artist pays shipping costs to gallery. Prefers artwork unframed.
Submissions: Send query letter with résumé and slides. Write for appointment to show portfolio of slides and color photographs. Replies only if interested within 2 months.
Tips: Finds artists through visiting exhibitions.

‡WORCESTER CENTER FOR CRAFTS GALLERIES, 25 Sagamore Rd., Worcester MA 01605. (508)753-8183. Fax: (508)797-5626. Executive Director: M. Attwood. Nonprofit rental gallery. Dedicated to promoting artisans and American crafts. Estab. 1856. Represents/exhibits 750 emerging, mid-career and established artists/year. May be interested in seeing the work of emerging artists in the future. Exhibited artists include Simon Pearce (glass) and Russell Spellman (ceramics). Sponsors 26 shows/year. Open all year; Tuesday-Thursday, 9-5 and Saturday, 10-4. Located at edge of downtown; 2,205 sq. ft. (main gallery); 630 sq. ft. (atrium gallery); track lighting, security. Overall price range: $5-400; most work sold at $30-60.
Media: Considers all media except paintings and drawings. Most frequently exhibits wood, metal, fiber and ceramics.
Style: Exhibits all styles.
Terms: Artwork is accepted on consignment (40% commission). Retail price set by the artist. Gallery provides insurance, promotion and contract. Shipping costs are shared.
Submissions: Call for appointment to show portfolio of photographs and slides. Replies in 1 month.

Michigan

THE ART CENTER, 125 Macomb Place, Mount Clemens MI 48043. (810)469-8666. Fax: (810)469-4529. Executive Director: Jo-Anne Wilkie. Nonprofit gallery. Estab. 1969. Represents emerging, mid-career and established artists. 500 members. Sponsors 9 shows/year. Average display time 1 month. Open all year except July and August; Tuesday-Friday, 11-5; Saturday, 9-2. Located in downtown Mount Clemens; 1,300 sq. ft. The Art Center is housed in the historic Carnegie Library Building, listed in the State of Michigan Historical Register. 100% of space for special exhibitions; 50% of space for gallery artists. Clientele: all types. 100% private collectors. Overall price range: $5-500; most work sold at $50-500.
Media: Considers oil, acrylic, watercolor, pastel, pen & ink, drawing, mixed media, collage, paper, sculpture, ceramics, photography, jewelry, metals, craft, fiber, glass, all types of prints. Most frequently exhibits oils/acrylics, watercolor and ceramics.
Style: Exhibits all styles, all genres.
Terms: The Art Center receives a 30% commission on sales.
Submissions: Send query letter with reviews good, professional slides and a professional artist biography. Call for appointment to show portfolio of photographs, slides and résumé. Files résumé, b&w photos.
Tips: Finds artists through artists' submissions, queries, exhibit announcements, word of mouth and membership. "Join The Art Center as a member, call for placement on our mailing list, enter the Michigan Annual Exhibition."

‡ARTS EXTENDED GALLERY, INC., 1553 Woodward, 212, Detroit Michigan 48226. Director: Dr. C.C. Taylor. Retail, nonprofit gallery, educational 501C3 space and art consultancy. Estab. 1959. Represents/exhibits many emerging, mid-career and established artists. Exhibited artists include Michael Kelly Williams and Samuel Hodge. Sponsors 10 shows/year. Average display time 3-4 weeks. Open all year; Wednesday-Saturday, 12-5. Located downtown; 1,000 sq. ft.; three small comfortable spaces inside the historic David Whitney Bldg. 75% of space for special exhibitions. Clientele: tourists, upscale, local community. 80% private collectors, 20% corporate collectors. Overall price range: $150-1,200 up; most work sold at $200-300 (for paintings—craft items are considerably less).
Media: Considers all media, woodcut, engraving, linocut, etching and monoprints. Most frequently exhibits painting, fibers and photographs.
Style: "The work which comes out of the community we serve is varied but rooted in realism, ethnic symbols and traditional designs/patterns with many exceptions."

Terms: Artwork is accepted on consignment and there is a 33⅓% commission or artwork is bought outright for 50% of the retail price. Retail price set by the gallery and the artist. Gallery provides insurance, promotion and contract; shipping costs are shared. Prefers artwork framed.
Submissions: Send query letter with résumé, slides, photographs and reviews. Call for appointment to show a portfolio of photographs, slides and bio. Replies in 2-3 weeks. Files biographical materials sent with announcements, catalogs, résumés, visual materials to add to knowledge of local artists, letters, etc.
Tips: "Our work of recruiting local artists is known and consequently artists beginning to exhibit or seeking to expand are sent to us. Many are sent by relatives and friends who believe that ours would be a logical place to inquire. Study sound technique—there is no easy way or scheme to be successful. Work up to a standard of good craftsmanship and honest vision."

ARTS MIDLAND: GALLERIES & SCHOOL, (formerly Midland Art Council Galleries of the Midland Center for the Arts), 1801 W. St. Andrews, Midland MI 48640. (517)631-3250. Director: Maria Ciski. Nonprofit visual art gallery and school. Estab. 1956. Exhibits emerging, mid-career and established artists. Sponsors 20 shows/year. Average display time 2 months. Open all year, seven days a week, 10-6. Located in a cultural center; "an Alden B. Dow design." 100% of space for special exhibitions.
Media: Considers all media and all types of prints.
Style: Exhibits all styles and genres.
Terms: "Exhibited art may be for sale" (30% commission). Retail price set by the artist. Gallery provides insurance, promotion and contract; shipping costs are shared. Artwork must be exhibition ready.
Submissions: Send query letter with résumé, slides, bio, SASE and proposal. Write to schedule an appointment to show a portfolio, which should include slides, photographs and transparencies. Replies only if interested as appropriate. Files résumé, bio and proposal.

JESSE BESSER MUSEUM, 491 Johnson St., Alpena MI 49707. (517)356-2202. Director: Dennis R. Bodem. Chief of Resources: Robert E. Haltiner. Nonprofit gallery. Estab. 1962. Interested in emerging and established artists. Sponsors 5 solo and 16 group shows/year. Average display time 1 month. Prefers but not limited to northern Michigan artists. Clientele: 80% private collectors, 20% corporate clients. Overall price range: $10-2,000; most artwork sold at $50-250.
Media: Considers oil, acrylic, watercolor, pastel, pen & ink, drawings, mixed media, collage, works on paper, sculpture, ceramic, craft, fiber, glass, installation, photography, original handpulled prints and posters. Most frequently exhibits prints, watercolor and acrylic.
Style: Exhibits hard-edge geometric abstraction, color field, painterly abstraction, pattern painting, primitivism, impressionism, photorealism, expressionism, neo-expressionism, realism and surrealism. Genres include landscapes, florals, Americana, portraits, figurative work and fantasy illustration.
Terms: Accepts work on consignment (25% commission). Retail price set by gallery and artist. Sometimes offers customer discounts and payment by installment. Exclusive area representation not required. Gallery provides insurance, promotion and contract.
Submissions: Send query letter, résumé, brochure, slides and photographs to Robert E. Haltiner. Write for appointment to show portfolio of slides. Letter of inquiry and brochure are filed.
Tips: Finds artists through word of mouth, art publications and sourcebooks, artists' submissions, self-promotions, art collectors' referrals and through visits to art fairs and festivals. "Make sure you submit good quality slides with necessary information on them—title, media, artist, size."

‡DE GRAAF FORSYTHE GALLERIES, INC., Park Place No. 4, 403 Water St. on Main, Saugatuck MI 49453. (616)857-1882. Fax: (616)857-3514. Director: Tad De Graaf. Retail gallery and art consultancy. Estab. 1950. Represents/exhibits 18 established artists/year. May be interested in seeing emerging artists in the future. Exhibited artists include Stefan Davidek and C. Jagdish. Average display time 3-4 weeks. Open May-December; Monday-Saturday, 11-5; Sunday, 1-5. Located in center of town, 1,171 sq. ft.; adjacent to two city parks. 60% of space for gallery artists. Clientele: upscale. 50% private collectors; 10% corporate collectors. Overall price range: $500-50,000; most work sold at $2,000-5,000.
Media: Considers all media except photography and crafts. Most frequently exhibits sculpture, paintings and tapestry.
Style: Exhibits all styles.
Terms: Artwork is accepted on consignment and there is a 50% commission. Retail price set by the gallery and the artist. Gallery provides promotion. Shipping costs are shared.
Submissions: Accepts only artists with endorsements from another gallery or museum. Send query letter with résumé, brochure, slides, photographs, reviews, bio and SASE. Write for appointment to show portfolio. Replies in 2 months, or if interested 3 weeks. Files résumé if possible future interest.

‡DETROIT ARTISTS MARKET, 300 River Place, Suite 1650, Detroit MI 48207. (313)393-1770. Executive Director: Ms. Gerry Craig. Nonprofit gallery. Estab. 1932. Exhibits the work of 600 emerging, mid-career and established artists/year; 1,100 members. Sponsors 12-14 shows/year. Average display time 1 month. Open Tuesday-Saturday, 11-5; Friday until 8. Closed August. Located in downtown Detroit; 3,500 sq. ft.

95% of space for special exhibitions. Clientele: "extremely diverse client base—varies from individuals to the Detroit Institute of Arts." 95% private collectors; 5% corporate collectors. Overall price range: $200-15,000; most work sold at $100-500.

Media: Considers all media. No posters. Most frequently exhibits painting, sculpture and craft.

Style: All contemporary styles and genres.

Terms: Accepts artwork on consignment (40% commission). Retail price set by the artist. Gallery provides insurance; artist pays for shipping. Prefers artwork framed.

Submissions: Accepts only artists from Michigan. Send query letter with résumé, slides and SASE. "No portfolio reviews." Replies only if interested.

Tips: "The Detroit Artists Market is a nonprofit contemporary art gallery that exhibits the work of Michigan artists and educates the public of southeastern Michigan about contemporary art and artists. It is the oldest continuously operating gallery in Detroit."

‡DETROIT FOCUS GALLERY, 33 E. Grand River, Detroit MI 48232. (313)965-3245. Director: Kay Young. Nonprofit gallery. Estab. 1978. Exhibits the work of 500 emerging and mid-career artists. Sponsors 10 shows/year. Average display time 6 weeks. Open Sept.-June. Located in downtown Detroit; 2,000 sq. ft.; 95% of space for special exhibitions. Overall price range $50-3,000; most work sold at $350-1,000.

Media: Most frequently exhibits sculpture, painting, installation and photography.

Style: Exhibits expressionism, neo-expressionism, primitivism, painterly abstraction, surrealism, imagism, conceptualism, minimalism, color field, postmodern works, impressionism, realism and all styles and genres.

Terms: Accepts artwork on consignment (40% commission). Retail price set by the artist. Gallery provides insurance and promotion. Artists pays for shipping.

Submissions: Send query letter with résumé, slides, SASE, proposal and comprehensive artist's statement to the attention of the Exhibition Committee. Call for appointment to show portfolio of slides and résumé. Replies in 1 month. Files résumé.

Tips: Wants to see "mature artists whose works are well documented with slides."

DETROIT REPERTORY THEATRE LOBBY GALLERY, 13103 Woodrow Wilson, Detroit MI 48238. (313)868-1347. Fax: (313)868-1705. Gallery Director: Gilda Snowden. Alternative space, nonprofit gallery, theater gallery. Estab. 1965. Represents emerging, mid-career and established artists. Exhibited artists include Sabrina Nelson, Renee Dooley and Shirley Woodson. Sponsors 4 shows/year. Average display time 6-10 weeks. Exhibits November and June; Thursday-Friday, 8:30-11:30 pm; Saturday-Sunday, 7:30-10:30. Located in midtown Detroit; 750 sq. ft.; features lobby with a wet bar and kitchen; theatre. 100% of space for special exhibitions. Clientele: theatre patrons. 100% private collectors. Overall price range: $50-500; most work sold at $125-300.

Media: Considers oil, acrylic, watercolor, pastel, pen & ink, drawing, mixed media, collage and paper. "Must be two-dimensional; no facilities for sculpture." Most frequently exhibits painting, photography and drawing.

Style: Exhibits all styles, all genres. Prefers figurative painting, figurative photography and collage.

Terms: "No commission taken by gallery; artist keeps all revenues from sales." Retail price set by the artist. Gallery provides insurance and promotion (catalog, champagne reception); artist pays shipping costs to and from gallery. Prefers artwork framed.

Submissions: Accepts only artists from Metropolitan Detroit area. Prefers only two dimensional wall work. Artists install their own works. Send query letter with résumé, slides, bio and SASE. Write for appointment to show portfolio of slides, résumé and bio. Replies in 3 months.

Tips: Finds artists through word of mouth and visiting exhibitions.

RUSSELL KLATT GALLERY, 1467 S. Woodward, Birmingham MI 48009. (810)647-6655. Fax: (810)644-5541. Director: Sharon Crane. Retail gallery. Estab. 1987. Represents 100 established artists/year. Interested in seeing the work of emerging artists. Exhibited artists include Henri Plisson, Mary Mark, Roy Fairchild, Eng Tay and Aleah Koury. Open all year; Monday-Friday, 10-6; Saturday, 10-5. Located on Woodward, 4 blocks north of 14 mile on the east side; 800 sq. ft. 100% private collectors. Overall price range: $800-1,500; most work sold at $1,000.

Media: Considers oil, acrylic, watercolor, pastel, ceramics, lithograph, mezzotint, serigraphs, etching and posters. Most frequently exhibits serigraphs, acrylics and oil pastels.

Style: Exhibits painterly abstraction, impressionism and realism. Genres include landscapes, florals and figurative work. Prefers landscape-impressionism, painterly abstraction and florals.

Terms: Accepts work on consignment (60% commission) or buys outright for 50% of retail price (net 30-60 days). Retail price set by the gallery and the artist. Gallery provides insurance and shipping to gallery; artist pays shipping costs from gallery. Prefers artwork unframed.

Submissions: Send query letter with brochure and photographs. Write for appointment to show portfolio of photographs.

Tips: Finds artists through visiting exhibitions.

‡KOUCKY, 319 Bridge St., Charlevoix MI 49720. (616)547-2228. Fax: (616)547-2455. Owners: Chuck and Nancy. Retail gallery.
• This gallery has two locations (Michigan and Naples, Florida). See their listing in the Florida section for information about the galleries' submissions policies as well as media and style needs.

KRASL ART CENTER, 707 Lake Blvd., St. Joseph MI 49085. (616)983-0271. Fax: (616)983-0275. Director: Dar Davis. Retail gallery of a nonprofit arts center. Estab. 1980. Clientele: community residents and summer tourists. Sponsors 30 solo and group shows/year. Average display time is 1 month. Interested in emerging and established artists. Most artwork sold at $100-500.
Media: Considers oils, acrylics, watercolor, pastels, pen & ink, drawings, mixed media, collage, paper, sculpture, ceramics, crafts, fibers, glass, installations, photography and performance.
Style: Exhibits all styles. "The works we select for exhibitions reflect what's happening in the art world. We display works of local artists as well as major traveling shows from SITES. We sponsor all annual Michigan competitions and construct significant holiday shows each December."
Terms: Accepts work on consignment (25% commission or 50% markup). Retail price is set by artist. Sometimes offers customer discounts. Exclusive area representation required. Gallery provides insurance, promotion, shipping and contract.
Submissions: Send query letter, résumé, slides, and SASE. Call for appointment to show a portfolio of originals.

‡MICHIGAN GUILD GALLERY, 118 N. 4th Ave., Ann Arbor MI 48104-1402. (313)662-ARTS. MGAA Executive Director: Mary Strope. Nonprofit gallery. Estab. 1986. Represents emerging, mid-career and established artists. 2000 national members. Average display time 3-4 weeks. Open all year. Located downtown; 1,000 sq. ft.; "unique interior design and use of space." 100% of space for special exhibitions.
Media: Considers oil, acrylic, watercolor, pastel, pen & ink, drawing, mixed media, collage, paper, sculpture, ceramic, craft, fiber, glass, installation, photography and jewelry. Also, original handpulled prints; woodcut, wood engraving, linocut, engraving, mezzotint, etching and lithograph.
Style: Exhibits all styles and genres.
Terms: Gallery provides insurance. Artists must install work.
Submissions: Artists must be members of the Michigan Guild of Artists and Artisans. "Send a written proposal describing the show and a fact sheet about each participating artist. Each artist must be a Guild member. Include SASE with 10 slides that represent the style and quality of the work to be exhibited. The Gallery Committee may ask to see samples of your work." Reports within 2 months. "Sales are not permitted on the premises. All work is for exhibition only. No commissions are collected or paid."

REFLECTIONS OF COLOR GALLERY, 18951 Livernois Ave., Detroit MI 48221. (313)342-7595. Owners: Carl and Marla Wellborn. Retail gallery. Estab. 1988. Represents 30 emerging, mid-career and established artists. Exhibited artists include Kathleen Wilson and Carl Owens. Average display time 6 weeks. Open all year; Monday-Saturday, 11-6; Friday-Saturday, 11-7. 30% of space for special exhibitions; 100% of space for gallery artists. Clientele: middle to upper income (professional). 90% private collectors, 10% corporate collectors. Overall price range: $100-3,000; most work sold at $250-400.
Media: Considers oil, acrylic, watercolor, pastel, pen & ink, drawing, mixed media, collage, paper, sculpture, ceramic, fiber, glass, photography, woodcuts, etchings, lithographs, serigraphs and posters. Most frequently exhibits pastel sculpture, mixed media and collages.
Style: Exhibits conceptualism, photorealism, hard-edge geometric abstraction, realism and surrealism. All genres. Prefers realism, conceptualism and photorealism.
Terms: Accepts work on consignment (40-50% commission). Offers payment by installments. Gallery provides promotion, contract; shipping costs are shared. Prefers artwork framed.
Submissions: "Minority artists only—African-American, Hispanic, African, Native American, East Indian, etc." Send query letter with slides, brochure and photographs. Call or write for appointment to show portfolio of originals, photographs and slides. Replies only if interested within 1 month. Files photos and brochures.

SAPER GALLERIES, 433 Albert Ave., East Lansing MI 48823. (517)351-0815. Fax: (517)351-0815. Director: Roy C. Saper. Retail gallery. Estab. in 1978 as 20th Century Fine Arts; in 1986 designed and built new location and name. Displays the work of 60 artists; mostly mid-career. Exhibited artists include H. Altman and J. Isaac. Sponsors 2-3 shows/year. Average display time 6 weeks. Open all year. Located downtown; 3,700 sq. ft.; "We were awarded *Decor* magazine's Award of Excellence for gallery design." 30% of space for special exhibitions. Clientele: students, professionals, experienced and new collectors. 80% private collectors, 20% corporate collectors. Overall price range: $30-140,000; most work sold at $400-4,000.
Media: Considers oil, acrylic, watercolor, pastel, drawings, mixed media, collage, paper, sculpture, ceramic, craft, glass and original handpulled prints. Considers all types of prints except offset reproductions. Most frequently exhibits intaglio, serigraphy and sculpture. "Must be of highest quality."
Style: Exhibits expressionism, painterly abstraction, surrealism, postmodern works, impressionism, realism, photorealism and hard-edge geometric abstraction. Genres include landscapes, florals, Southwestern and

figurative work. Prefers abstract, landscapes and figurative. Seeking artists who will continue to produce excellent work.

Terms: Accepts work on consignment (negotiable commission); or buys outright for negotiated percentage of retail price. Retail price set by gallery and artist. Offers payment by installments. Gallery provides insurance, promotion and contract; shipping costs are shared. Prefers artwork unframed (gallery frames).

Submissions: Send query letter with bio or résumé, brochure and slides or photographs and SASE. Call for appointment to show portfolio of originals or photos of any type. Replies in 1 week. Files any material the artist does not need returned.

Tips: Finds artists through mostly through NY Art Expo."Artists must know the nature of works displayed already. Have phenomenal quality and technical skill. 'Junque' doesn't make it. Be sure to include prices and SASE."

‡STUDIO 508, 206 E. Grand River, #508, Detroit MI 48226. (313)961-1934. Fax: (313)259-8242. Contact: Gilda Snowden. Alternative space and archive of local African-American art and artists. Estab. 1994. Represents/exhibits emerging and mid-career artists. May be interested in seeing emerging artists in the future. Exhibited artists include Ruth Lampkus and Gilda Snowden. Sponsors 2 shows/year. Average display time 2 months. Open spring, fall and winter by appointment. Located downtown; 1,300 sq. ft.; "plain old office building in downtown Detroit." Clientele: local community. 100% private collectors. Overall price range: $150-12,000; most work sold at $150-500.

Media: Considers all media and all types of prints. Most frequently exhibits pastel drawings, oil paintings, assemblage and constructions.

Style: Exhibits all styles, especially expressionism and painterly abstraction. Prefers abstraction, expressionistic realism and assemblabe sculpture.

Terms: There is a Co-op membership fee plus a donation of time. There is a 40% commission. Retail price set by the artist. Gallery provides promotion. Artist pays for shipping costs.

Submissions: Accepts only artists from metro Detroit area. Send query letter with résumé, business card, slides, reviews, bio and SASE. Write for appointment to show portfolio of slides. Replies only if interested within 4 months; will send package back if it was SASE. Files archival information on African American artists, and other artists of color.

Tips: Finds artists mainly through word of mouth, local community students. "Stick in there! Be strong!"

URBAN PARK–DETROIT ART CENTER, 508 Monroe, Detroit MI 48226. (313)963-5445. Fax: (313)963-2333. Director: Dave Roberts. Retail cooperative gallery. Estab. 1991. Represents 100 emerging and mid-career artists/year. Exhibited artists include Walter Warren and Diana Gamerman. Sponsors 60 shows/year. Average display time 1 month. Open all year; Monday-Thursday, 10-9; Friday-Saturday, 10-11; Sunday 12-7. Located downtown inside Trappers Alley, Greektown; 3,316 sq. ft.; 10 individual exhibit spaces in historic building. 90% of space for special exhibitions; 10% of space for gallery artists. Clientele: mostly beginning collectors, tourists. 90% private collectors, 10% corporate collectors. Overall price range: $50-2,000; most work sold at $50-600.

Media: Considers all media. Most frequently exhibits paintings, sculpture and photography.

Style: Exhibits all styles.

Terms: Co-op membership fee plus donation of time (40% commission). Rental fee for space; covers 1 month. Retail price set by the artist. Gallery provides promotion; shipping costs are shared. Prefers artwork framed.

Submissions: Send query letter with résumé, slides, bio and SASE. Call for appointment to show portfolio of originals, slides and transparencies. Replies in 3 weeks. Files résumé, bio.

Tips: Finds artists through artists' submissions. "Request gallery brochure for specific information."

Minnesota

GLASSPECTACLE ART GALLERY, 402 N. Main St., Stillwater MN 55082. (612)439-0757. Manager: Brenda Hanson. Retail gallery. Estab. 1984. Represents 65 emerging, mid-career and established artists/year. Exhibited artists include John Simpson and Steve Maslach. Sponsors 3 shows/year. Average display time 2 months. Open all year; Monday-Saturday, 10-5; Sunday 11-5. Located downtown; 650 sq. ft.; features hand blown art glass, stain and fused only. 30% of space for special exhibitions; 70% of space for gallery artists. Clientele: mid-upper income. 100% private collectors. Overall price range; $10-2,000; most work sold at $80-250.

Media: Considers glass.

Style: Exhibits all styles.

Terms: Accepts work on consignment (60% commission) or buys outright for 50% of retail price (net 30 days). Retail price set by the artist. Gallery pays for shipping costs from gallery; artist pays for shipping costs to gallery.

Submissions: Prefers only glass. Send query letter with slides, photographs and SASE. Call for appointment to show portfolio. Replies in 3 weeks. Files photos, slides and résumé.

Tips: Finds artists through *American Craft.*

M.C. GALLERY, 400 First Ave., #336, Minneapolis MN 55401. (612)339-1480. Fax: (612)339-1480-04. Gallery Director: M.C. Anderson. Retail gallery. Estab. 1984. Represents 30 emerging, mid-career and established artists/year. Exhibited artists include Terri Hallman and Tom Grade. Sponsors 8 shows/year. Average display time 5 weeks. Open all year; Tuesday-Saturday, 12-4. Located downtown; 3,500 sq. ft.; in a warehouse with 8 other galleries. 5% of space for special exhibitions; 45% of space for gallery artists. 50% private collectors; 50% corporate collectors. Overall price range: $800-12,000; most work sold at $1,500-3,500.
Media: Considers oil, acrylic, pastel, drawing, mixed media, collage, paper, sculpture, ceramics, fiber, glass, photography and multi media prints. Most frequently exhibits paintings, glass and ceramics.
Style: Exhibits painterly abstraction. Prefers glass and ceramic.
Terms: Accepts work on consignment (50% commission). Retail price set by the artist. Gallery provides promotion and shipping costs from gallery; artist pays shipping costs to gallery. Prefers artwork framed.
Submissions: Send query letter with résumé, slides and bio. Call or write for appointment to show portfolio of slides. Replies if interested "right away."
Tips: Finds artists through agents, visiting exhibitions, word of mouth, art publications and sourcebooks and artists' submissions. "Be organized, submit good slides and updated résumé." Looks for art "from the higher self from the heart and soul of the person."

THE CATHERINE G. MURPHY GALLERY, The College of St. Catherine, 2004 Randolph Ave., St. Paul MN 55105. (612)690-6637. Fax: (612)690-6024. Curator: Kathleen M. Daniels. Nonprofit gallery. Estab. 1973. Represents emerging, mid-career and nationally and regionally established artists. "We have a mailing list of 1,000." Sponsors 6 shows/year. Average display time 5-6 weeks. Open September-June Monday-Friday, 8-8; Saturday, 12-5; Sunday, 12-8. Located on the college campus of the College of St. Catherines; 1,480 sq. ft.
● This gallery also exhibits art historical and didactic shows of visual significance. Gallery shows 75% women's art since it is an all women's undergraduate program.
Media: Considers all media and all types of prints.
Style: Exhibits all styles.
Terms: Artwork is loaned for the period of the exhibition. Gallery provides insurance. Shipping costs are shared. Prefers artwork framed.
Submissions: Send query letter with résumé, slides, bio and SASE. Write for appointment to show portfolio. Replies in 4-6 weeks. Files résumé and cover letters.

JEAN STEPHEN GALLERIES, 924 Nicollet Mall, Minneapolis MN 55402. (612)338-4333. Directors: Steve or Jean Danke. Retail gallery. Estab. 1987. Represents 12 established artists. Interested in seeing the work of emerging artists. Exhibited artists include Jiang, Hart and Max. Sponsors 2 shows/year. Average display time 4 months. Open all year; Monday-Saturday, 10-6. Located downtown; 2,300 sq. ft. 15% of space for special exhibitions; 85% of space for gallery artists. Clientele: upper income. 90% private collectors, 10% corporate collectors. Overall price range: $600-12,000; most work sold at $1,200-2,000.
Media: Considers oil, acrylic, pastel, pen & ink, drawing, mixed media, collage, paper, sculpture, ceramics, woodcut, engraving, lithograph, wood engraving, mezzotint, serigraphs, linocut and etching. Most frequently exhibits serigraphs, stone lithographs and sculpture.
Style: Exhibits expressionism, neo-expressionism, surrealism, minimalism, color field, postmodern works and impressionism. Genres include landscapes, Southwestern, portraits and figurative work. Prefers Chinese contemporary, abstract and impressionism.
Terms: Accepts work on consignment (50% commission). Retail price set by the gallery. Gallery provides insurance and contract; artist pays shipping costs to and from gallery.
Submissions: Send query letter with résumé, slides and bio. Call for appointment to show portfolio of originals, photographs and slides. Replies in 1-2 months.
Tips: Finds artists through art shows and visits.

THE FREDERICK R. WEISMAN ART MUSEUM, 333 East River Rd., Minneapolis MN 55455. (612)625-9494. Fax: (612)625-9630. E-mail: bitza001@maroon.tc.vmn.edu. Public Relations Director: Robert B. Bitzan. Museum. Frederick R. Weisman Art Museum opened in November 1993; University of Minnesota Art Museum established in 1934. Represents 13,000 works in permanent collection. Represents established artists. 1,000 members. Sponsors 4-5 shows/year. Average display time 10 weeks. Open all year; Monday-Friday, 10-6; Saturday, Sunday, 12-5. Located at the University of Minnesota, Minneapolis; 11,000 sq. ft.; designed by Frank O. Gehry. 40% of space for special exhibitions.
Media: Considers all media and all types of prints. Most frequently exhibits oil, acrylic and watercolor.
Style: Exhibits all styles, all genres.
Terms: Gallery provides insurance. Prefers artwork framed.
Submissions: "Generally we do not exhibit one-person shows. We prefer thematic exhibitions with a variety of artists. However, we welcome exhibition proposals. Formulate exhibition proposal with a scholarly base. Exhibitions which are multi-disciplinary are preferred."

Mississippi

MERIDIAN MUSEUM OF ART, 628 25th Ave., P.O. Box 5773, Meridian MS 39302. (601)693-1501. Acting Director: Terence Heder. Museum. Estab. 1970. Represents emerging, mid-career and established artists. Interested in seeing the work of emerging artists. Exhibited artists include Terry Cherry, Bruce Brady, Jere Allen, Susan Ford and Hugh Williams. Sponsors 15 shows/year. Average display time 5 weeks. Open all year; Tuesday-Sunday, 1-5. Located downtown; 1,750 sq. ft.; housed in renovated Carnegie Library building, originally constructed 1912-13. 50% of space for special exhibitions. Clientele: general public. Overall price range: $75-1,000; most work sold at $300-500.
 • Sponsors annual Bi-State Art Competition for Mississippi and Alabama artists.
Media: Considers all media, woodcut, engraving,lithograph, wood engraving, mezzotint, serigraphs, linocut and etching. Most frequently exhibits oils, watercolors and sculpture.
Style: Exhibits all styles, all genres.
Terms: Work available for sale during exhibitions (25% commission). Retail price set by the artist. Gallery provides insurance and promotion; shipping costs are shared. Prefers artwork framed.
Submissions: Prefers artists from Mississippi, Alabama and the Southeast. Send query letter with résumé, slides, bio and SASE. Replies in 3 months.
Tips: Finds artists through artists' submissions, referrals, work included in competitions and visiting exhibitions.

MISSISSIPPI CRAFTS CENTER, Box 69, Ridgeland MS 39158. (601)856-7546. Director: Martha Garrott. Retail and nonprofit gallery. Estab. 1975. Represents 70 emerging, mid-career and established guild members. 200 members. Exhibited artists include Susan Denson and Wortman Pottery. Open all year. Located in a national park near the state capitol of Jackson; 1200 sq. ft.; a traditional dogtrot log cabin. Clientele: travelers and local patrons. 99% private collectors. Overall price range: $2-900; most work sold at $10-60.
Media: Considers paper, sculpture, ceramic, craft, fiber and glass. Most frequently exhibits clay, basketry and metals.
Style: Exhibits all styles. Crafts media only. Interested in seeing a "full range of craftwork—Native American, folk art, naive art, production crafts, crafts as art, traditional and contemporary. Work must be small enough to fit our limited space."
Terms: Accepts work on consignment (40% commission), first order; buys outright for 50% of retail price (net 30 days), subsequent orders. Retail price set by the gallery and the artist. Gallery provides promotion and shipping costs to gallery.
Submissions: Accepts only artists from the Southeast. Artists must be juried members of the Craftsmen's Guild of Mississippi. Ask for standards review application form. Call or write for appointment to show portfolio of slides. Replies in 1 week.
Tips: "All emerging craftsmen should read *Crafts Report* regularly and know basic business procedures. We will probably need more low-end work this year."

MISSISSIPPI MUSEUM OF ART CORPORATE ART PROGRAM, 201 East Pascagoula St., Jackson MS 39201. (601)960-1515. Fax: (601)960-1505. Director/Associate Curator: Sabrina Comola. Estab. 1986. Represents hundreds of emerging, mid-career and established artists/year. Artists include George Ohr, Karl Wolfe, Marie Hull and Sam Gilliam. Open all year; Monday-Friday, 9-5. Located in the downtown Arts Center; represents Mississippi artists exclusively. 85% of space for gallery artists. 100% corporate collectors. Overall price range: $100-20,000; most work sold at $500-5,000.
Media: Considers oil, acrylic, watercolor, pastel, pen & ink, mixed media, collage, paper, sculpture, ceramics, craft, fiber, glass, installation, photography, woodcut, engraving, lithograph, wood engraving, mezzotint, serigraphs, linocut and etching.
Style: Exhibits all styles, all genres. Prefers realism, impressionism and primitivism.
Terms: Accepts work on consignment (35% commission). Retail price set by the gallery and the artist. Gallery provides insurance and promotion; shipping costs are shared.
Submissions: Accepts only artists Mississippi born or residing. Send query letter with slides, bio, business card and reviews. Call for appointment to show. Replies in 1 week.

Missouri

‡AUSTRAL GALLERY, 2115 Park Ave., St. Louis MO 63104. (314)776-0300. Fax: (314)664-1030. E-mail: australart@aol.com. Director: Ms. Mary Reid Brunstrom. Retail gallery. The gallery brings to the United States exhibitions of contemporary art from Australia, including Aboriginal painting and other media. Estab. 1988. Represents/exhibits 12 emerging and mid-career Australian fine artists and several Aboriginal artists. Sponsors 4 shows/year. Average display time 6 weeks. Open all year; Wednesday-Saturday, 1-5 and by appointment. Located in Lafayette Square downtown; 2,500 sq. ft.; in a 3 story historic house built in 1860s. 50% of space for special exhibitions; 50% of space for gallery artists. Clientele: local community and out

of state. 60% private collectors, 40% corporate collectors. Overall price range: $100-25,000; most work sold at $100-5,000.

Media: Considers all media and all types of prints. Most frequently exhibits acrylic and oil painting, limited edition prints and mixed media.

Style: Exhibits expressionism, conceptualism, minimalism, pattern painting, primitivism, hard-edge geometric abstraction and painterly abstraction. All genres. Prefers landscape, figurative and abstract.

Terms: Artwork is accepted on consignment and there is a 50% commission. Retail price set by the gallery. Gallery provides insurance, promotion and contract. Shipping costs are shared.

Submissions: Accepts only artists from Australia. Send query letter with résumé, business card, slides, photographs, reviews and bio. Call for appointment to show portfolio of photographs. Replies only if interested within 2 months. Files all material if it is an artist of interest.

BARUCCI'S ORIGINAL GALLERIES, 8101 Maryland Ave., St Louis MO 63105. (314)727-2020. President: Shirley Taxman Schwartz. Retail gallery and art consultancy. Estab. 1977. Represents 40 artists. Interested in emerging and established artists. Sponsors 3-4 solo and 4 group shows/year. Average display time is 2 months. Located in "affluent county, a charming area. Clientele: affluent young area. 70% private collectors, 30% corporate clients. Overall price range: $500-5,000.

• This gallery has moved into a corner location featuring three large display windows.

Media: Considers oil, acrylic, watercolor, pastel, collage and works on paper. Most frequently exhibits watercolor, oil, acrylic and hand blown glass.

Style: Exhibits painterly abstraction, primitivism and impressionism. Genres include landscapes and florals. Currently seeking contemporary works: abstracts in acrylic and fiber, watercolors and some limited edition serigraphs.

Terms: Accepts work on consignment (50% commission). Retail price set by gallery or artist. Sometimes offers payment by installment. Gallery provides contract.

Submissions: Send query letter with résumé, slides and SASE. Portfolio review requested if interested in artist's work. Slides, bios and brochures are filed.

Tips: "More clients are requesting discounts or longer pay periods."

‡FINE ARTS RESOURCES, 11469 Olive St., #266, St. Louis MO 63141. Phone/fax: (314)432-5824. President: R. Michael Bush. Art consultancy, broker. Estab. 1986. Represents/exhibits 50 emerging, mid-career and established artists/year. Interested in seeing the work of emerging artists. Open all year; by appointment only. Located in suburb. Clientele: commercial/residential. 25% private collectors, 75% corporate collectors. Overall price range: $150-10,000; most work sold at $1,000-3,000.

Media: Considers oil, pen & ink, paper, acrylic, drawing, sculpture, glass, watercolor, pastel and all types of prints. Most frequently exhibits oil, acrylic and sculpture.

Style: Exhibits impressionism.

Terms: Artwork is accepted on consignment (40% commission). Retail price set by the gallery and the artist. Shipping costs are shared. Prefers artwork framed.

Submissions: Send query letter with résumé, slides and bio. Write for appointment to show portfolio of slides. Replies only if interested within 2 weeks.

‡FORUM FOR CONTEMPORARY ART, 3540 Washington Ave., St. Louis MO 63103. (314)535-4660. Fax: (314)535-1226. Executive Director/Curator: Elizabeth Wright Millard. Nonprofit gallery, museum. Estab. 1980. Represents/exhibits emerging, mid-career and established artists. Interested in seeing the work of emerging artists. Sponsors 5-8 shows/year. Average display time 2 months. Open all year; Tuesday-Saturday 10-5. Located mid-town, Grand Center; 4,000 sq. ft.; urban, spare space. 95% of space for special exhibitions. Clientele: local community, students.

Media: Considers all media. Most frequently exhibits installation, multi-media, performance, time arts and photography.

Style: Exhibits all styles. Genres include cutting edge, contemporary.

Terms: Gallery provides insurance, promotion and shipping costs.

Submissions: Only interested in contemporary work. Send query letter with résumé, slides and SASE. Write for appointment to show portfolio of slides. Replies in 6 months.

Tips: Finds artists through referrals from other artists and galleries or museums. "Do not submit unless your work fits the 'alternative' contemporary criteria of the museum."

GALERIE BONHEUR, 9243 Clayton Rd., St. Louis MO 63124. (314)993-9851. Fax: (314)993-4790. E-mail: varley1@ix.netcom.com. Owner: Laurie Carmody. Private retail and wholesale gallery. Focus is on international folk art. Estab. 1980. Represents 60 emerging, mid-career and established artists/year. Exhibited artists include Woodie Long and Justin McCarthy. Sponsors 6 shows/year. Average display time 1 year. Open all year; by appointment. Located in Ladue (a suburb of St. Louis); 1,500 sq. ft.; art is all displayed all over very large private home. 75% of sales to private collectors. Overall price range: $25-25,000; most work sold at $50-1,000.

Media: Considers oil, acrylic, watercolor, pastel, pen & ink, drawing, mixed media, collage, paper, sculpture, ceramics and craft. Most frequently exhibits oil, acrylic and metal sculpture.

Style: Exhibits expressionism, primitivism, impressionism, folk art, self-taught, outsider art. Genres include landscapes, florals, Americana and figurative work. Prefers genre scenes and figurative.

Terms: Accepts work on consignment (50% commission) or buys outright for 50% of retail price. Retail price set by the gallery and the artist. Gallery provides promotion; artist pays shipping costs to and from gallery. Prefers artwork framed.

Submissions: Prefers only self-taught artists. Send query letter with bio, photographs and business card. Write for appointment to show portfolio of photographs. Replies only if interested within 6 weeks.

Tips: Finds artists through agents, visiting exhibitions, word of mouth, art publications and sourcebooks, artists' submissions. "Be true to your inspirations. Create from the heart and soul."

GOMES GALLERY OF SOUTHWESTERN ART, 7513 Forsyth, Clayton MO 63105. (314)725-1808. President: Larry Gomes. Retail gallery. Estab. 1985. Represents 80 emerging, mid-career and established artists. Exhibited artists include R.C. Gorman and Frank Howell. Sponsors 5 shows/year. Average display time 4 months. Open all year; Monday-Thursday, 10-6; Friday and Saturday, 10-8; Sunday, 11-4. Located "downtown, across from the Ritz Carlton; 3,600 sq. ft.; total Southwestern theme, free covered parking." 35% of space for special exhibition during shows. Free standing display wall on wheels. Clientele: tourists, local community. 96% private collectors, 4% corporate collection. Overall price range: $100-15,000; most work sold at $1,200-2,000.

• This gallery reports that business is up 10%.

Media: Considers all media and all types of prints. Most frequently exhibits stone lithos, originals and serigraphs.

Style: Exhibits all styles. Genres include landscapes, Western, wildlife and Southwestern. Prefers Western/Southwestern themes and landscapes.

Terms: Accepts artwork on consignment (50% commission); or buys outright for 40-50% of retail price (net 10-30 days). Retail price set by gallery and artist. Customer discounts and payment by installment are available. Gallery provides insurance, promotion and contract; shipping costs are shared.

Submissions: Prefer, but not limited to Native American artists. Send query letter with slides, bio, medium, price list, brochure and photographs. Portfolio review requested if interested in artist's work. Portfolio should include originals, slides, photographs, transparencies and brochure. Replies in 2-3 weeks; or does not reply, in which case the artist should "call and remind." Files bio.

Tips: "Send complete package the first time you submit. Include medium, size and cost or retail. Submit until you get 8-10 galleries, then do serigraphs and stone lithos. Promote co-op advertising with your galleries."

‡THE JAYNE GALLERY, 108 W. 47th St., Kansas City MO 64112. (816)561-5333. Fax: (816)561-8402. E-mail: cjnkc@aol.com. Owners: Ann Marie Jayne and Clint Jayne. Retail gallery. Represents/exhibits 30 emerging, mid-career and established artists/year. Exhibited artists include Jody dePew McLeane and Jim Rabby. Sponsors 4-6 shows/year. Average display time 3 weeks. Open all year; Monday-Saturday, 10-7; Thursday, 10-6; Sunday, 12-5. 2,000 sq. ft. in outdoor gallery located in The Plaza, a historic shopping district featuring Spanish architecture such as stucco buildings with red tile roofs, ornate towers and beautiful courtyards. 100% of space is devoted to the work of gallery artists. 40% out-of-town clients; 60% Kansas City metro and surrounding communities. Overall price range: $500-5,000; most work sold at $1,500-3,700.

Media: Considers all media and all types of prints by artists whose original work is handled by gallery. Most frequently exhibits paintings—all media, ceramics, glass and other fine crafts.

Style: Exhibits all styles. Genres include landscapes and figurative work. Prefers impressionism, expressionism and abstraction.

Terms: Artwork is accepted on consignment and there is a 50% commission. Retail price set by the artist. Gallery provides insurance, promotion and contract; shipping costs are shared. Prefers artwork framed.

Submissions: Accepts only artists from US. Send query letter with résumé, brochure, business card, slides, photographs, reviews, bio, SASE and price list. Write for appointment to show portfolio of photographs, transparencies, slides of available work. Replies in 6-8 weeks; if interested within 2 weeks. Files résumé, any visuals that need not be returned.

Tips: Finds artists through referrals, travel, art fairs and exhibitions. "Visit galleries to see if your work 'fits' with gallery's look, vision, philosophy."

LEEDY-VOULKOS GALLERY, 2012 Baltimore Ave., Kansas City MO 64108. (816)474-1919. Director: Sherry Leedy. Retail gallery. Estab. 1985. Represents 50 mid-career and established artists. May be interested in seeing the work of emerging artist in the future. Exhibited artists include Dale Chihuly, Theodore Waddell. Sponsors 20 shows/year. Average display time 6 weeks. 10,000 sq. ft. of exhibit area in 3 galleries. Clientele: established and beginning collectors. 80% private collectors, 20% corporate clients. Price range: $50-100,000; most work sold at $3,500-35,000.

Media: Considers all media and one of a kind or limited edition prints; no posters. Most frequently exhibits painting, ceramic sculpture and glass.

© C.P. Bennett.

Philomene Bennett's **After Midnight** *was used as the invitation image for the artist's one-person show "Settings: Inside & Out" at the Jayne Gallery. "The image was characteristic of the overall show," says owner Ann Marie Jayne. "It incorporated the classic Bennett landscape with whimsical still life table settings." The audience reacted very positively to the piece, painted in oil on canvas. Bennett also works in acrylic on canvas and mixed media on handmade paper.*

Style: Exhibits all style.
Terms: Accepts work on consignment (50% commission). Retail price set by gallery. Sometimes offers customer discounts and payment by installment. Exclusive area representation required. Gallery provides insurance, promotion; shipping costs are shared. Prefers artwork framed.
Submissions: Send query letter, résumé, good slides, prices and SASE. Write for appointment to show portfolio of originals, slides and transparencies. Bio, vita, slides, articles, etc. are filed if they are of potential interest.
Tips: "We pursue artists that are of interest to us—usually recommended by other artists, galleries and museums. We also find out about artists through their direct inquiries to us—they are usually directed to us by other atists, collectors, museums, etc. Allow three months for gallery to review slides."

‡LYSOGRAPHICS FINE ART, 722 S. Meramec, St. Louis MO 63105. (314)726-6140. Owner: Esther Lyss. Retail and wholesale gallery. Estab. 1971. Represents emerging, mid-career and established artists. Open all year by appointment. Located mid-town. Clientele: corporate and upper end.
Media: Considers all media and all types of prints.
Style: Exhibits all styles and genres.
Terms: Retail price set by gallery and/or artist. Prefers artwork unframed.
Submissions: Send query letter with résumé, slides, brochure, photographs, business card, reviews, bio and SASE. Call or write for appointment to show portfolio. Replies in 2-3 weeks. Files all material sent with query.
Tips: "I am always happy to speak with artists. I am a private dealer and specialize in helping my clients select works for their home or office."

‡**WILLIAM SHEARBURN FINE ART**, 4740-A McPherson, St. Louis MO 63108. (314)367-8020. Owner/Director: William Shearburn. Retail gallery. Estab. 1990. Represents/exhibits 40 mid-career and established artists/year. Exhibited artists include James McGarrel and Michael Eastman. Sponsors 5 shows/year. Average display time 6 weeks. Open all year; Tuesday-Saturday, 1-5. Located midtown; 1,200 sq. ft. "Has feel of a 2nd floor New York space." 60% of space for special exhibitions; 40% of space for gallery artists. Clientele: local and corporate collectors. 70% private collectors, 30% corporate collectors. Overall price range: $500-50,000; most work sold at $2,500-3,500.
Media: Considers all media and all types of prints. Most frequently exhibits paintings, prints and photography.
Style: Exhibits expressionism, minimalism, painterly abstraction and realism. Prefers abstraction, figurative and minimalism.
Terms: Artwork is accepted on consignment (50% commission). Retail price set by the gallery. Gallery provides promotion and contract; shipping costs are shared. Prefers artwork framed.
Submissions: Prefers established artists only. Send query letter with résumé, slides, reviews and SASE. Call for appointment to show portfolio of photographs or transparencies. Replies in 2 weeks.
Tips: Finds artists through art fairs. "You are your best salesperson."

‡**THE SOURCE FINE ARTS**, 4137 Pennsylvania, Kansas City MO 64111. (816)931-8282. Fax: (816)913-8283. Owner: Denyse Ryan Johnson. Retail gallery. Estab. 1985. Represents/exhibits 50 mid-career artists/year. Exhibited artists include Jack Roberts and John Gary Brown. Sponsors 6 shows/year. Open all year; Monday-Friday, 9-5; Saturday, 11-4. Located in midtown—Westport Shopping District; 1,200 sq. ft. 50% of space for special exhibitions. Clientele: tourists, upscale. 40% private collectors, 60% corporate collectors. Overall price range: $200-5,000; most work sold at $1,000-4,500.
Media: Considers all media except photography and all types of prints. Most frequently exhibits oil, acrylic, mixed media, ceramics and glass.
Style: Exhibits expressionism, minimalism, color field, hard-edge geometric abstraction, painterly abstraction and impressionism. Genres include landscapes and figurative work. Prefers non-objective, abstraction and impressionism.
Terms: Artwork is accepted on consignment and there is a 50% commission. Retail price set by the gallery. Gallery provides insurance, promotion and contract; shipping costs are shared.
Submissions: Prefers Midwest artists with exhibit, sales/gallery record. Send query letter with résumé, brochure, business card, slides, photographs, reviews and SASE. Call for appointment to show portfolio of photographs, slides and transparencies. Replies in 1 month. Files slides and résumé.
Tips: Finds artists through word of mouth, referrals by other artists, visiting art fairs and exhibitions and artist's submissions. "Present professional materials with follow-up call."

Montana

CUSTER COUNTY ART CENTER, Box 1284, Water Plant Rd., Miles City MT 59301. (406)232-0635. Executive Director: Suzanne M. Warner. Nonprofit gallery. Estab. 1977. Interested in emerging and established artists. Clientele: 90% private collectors, 10% corporate clients. Sponsors 8 group shows/year. Average display time is 6 weeks. Overall price range: $200-10,000; most artwork sold at $300-500.
• The galleries are located in the former water-holding tanks of the Miles City WaterWorks. The underground, poured concrete structure is listed on the National Register of Historic Places. It was constructed in 1910 and 1924 and converted to its current use in 1976-77.
Media: Considers all media and original handpulled prints. Does not consider crafts. Most frequently exhibits painting, sculpture and photography.
Style: Exhibits painterly abstraction, conceptualism, primitivism, impressionism, expressionism, neo-expressionism and realism. Genres include landscapes, Western, portraits and figurative work. "Our gallery is seeking artists working with traditional and non-traditional Western subjects in new, contemporary ways." Specializes in Western, contemporary and traditional painting and sculpture.
Terms: Accepts work on consignment (30% commission). Retail price is set by gallery and artist. Exclusive area representation not required. Gallery provides insurance, promotion and contract; shipping expenses are shared.
Submissions: Send query letter, résumé, brochure, slides, photographs and SASE. Write for appointment to show portfolio of originals, "a statement of why the artist does what he/she does" and slides. Slides and résumés are filed.

HARRIETTE'S GALLERY OF ART, 510 1st Ave. N., Great Falls MT 59405. (406)761-0881. Owner: Harriette Stewart. Retail gallery. Estab. 1970. Represents 20 artists. Exhibited artists include Frank Miller, Arthur Kober, Richard Luce, Lane Kendrick, Susan Guy and Lee Cable. Sponsors 1 show/year. Average display time 6 months. Open all year. Located downtown; 1,000 sq. ft. 100% of space for special exhibitions. Clientele: 90% private collectors, 10% corporate collectors. Overall price range: $100-10,000; most artwork sold at $200-750.

Media: Considers oil, acrylic, watercolor, pastel, pencils, pen & ink, mixed media, sculpture, original hand-pulled prints, lithographs and etchings. Most frequently exhibits watercolor, oil and pastel.
Style: Exhibits expressionism. Genres include wildlife, landscape, floral and Western.
Terms: Accepts work on consignment (33⅓% commission); or outright for 50% of retail price. Retail price set by gallery and artist. Sometimes offers customer discounts and payment by installment. Gallery provides promotion; "buyer pays for shipping costs." Prefers artwork framed.
Submissions: Send query letter with résumé, slides, brochure and photographs. Portfolio review requested if interested in artist's work. "Have Montana Room in largest Western Auction in US—The "Charles Russell Auction," in March every year—looking for new artists to display."
Tips: "Proper framing is important."

HOCKADAY CENTER FOR THE ARTS, P.O. Box 83, Kalispell MT 59903. (406)755-5268. Director: Magee Nelson. Museum. Estab. 1968. Exhibits emerging, mid-career and established artists. Interested in seeing the work of emerging artists. 500 members. Exhibited artists include Theodore Waddell and David Shaner. Sponsors approximately 20 shows/year. Average display time 6 weeks. Open year round. Located 2 blocks from downtown retail area; 2,650 sq. ft.; historic 1906 Carnegie Library Building with new (1989) addition; wheelchair access to all of building. 50% of space for special exhibitions. Overall price range $500-35,000.
Media: Considers all media, plus woodcuts, wood engravings, linocuts, engravings, mezzotings, etchings, lithographs and serigraphs. Most frequently exhibits painting (all media), sculpture/installations (all media), photography and original prints.
Style: Exhibits all styles and genres. Prefers contemporary art (all media and styles), historical art and photographs and traveling exhibits. "We are not interested in wildlife art and photography, mass-produced prints or art from kits."
Terms: Accepts work on consignment (30% commission). Also houses permanent collection: Montana and regional artists acquired through donations. Sometimes offers customer discounts and payment by installment to museum members. Gallery provides insurance, promotion and contract; shipping costs are shared. Prefers artwork framed.
Submissions: Send query letter with résumé, slides, bio, reviews and SASE. Portfolio should include b&w photographs and slides (20 maximum). "We review *all* submitted portfolios once a year, in spring."
Tips: Finds artists through artists' submissions and self-promotions.

LEWISTOWN ART CENTER, 801 W. Broadway, Lewistown MT 59457. (406)538-8278. Executive Director: Ellen Gerharz. Nonprofit gallery and gift shop. Estab. 1971. Represents emerging, mid-career and established artists. Sponsors 12 shows/year. Average display time 1 month. Open all year. Located in historic Courthouse Square; 1,075 sq. ft. (3 separate galleries: 400 sq. ft in one, 425 sq. ft. in another, approximately 250 sq. ft. in the last); historical stone bunk house—1897 and historical carriage house same era. Clientele: business/professional to agriculture. 75% private collectors, 25% corporate collectors. Overall price range: $45-1,200; most work sold at $200-400.
 • Though the Lewistown Art Center is in Montana, its interests in art are much broader than might be expected.
Media: Considers oil, acrylic, watercolor, pastel, pen & ink, drawings, mixed media, sculpture, ceramic, fiber and glass; all types of prints on consignment only.
Style: Exhibits expressionism, primitivism, conceptualism, postmodern works, impressionism and realism. All genres.
Terms: Accepts work on consignment (30% commission). Retail price set by gallery and artist. Sometimes offers customer discounts and payment by installment. Gallery provides insurance, promotion and contract; artist pays for shipping. Prefers artwork framed.
Submissions: First send query letter with slides and bio. Then later send brochure and reviews. Replies in 2 weeks.
Tips: Finds artists through word of mouth, artists' submissions, traveling shows and visiting and chatting with artists. "Located in the center of Montana, between Great Falls and Billings, the LAC serves Montanans within a 100-mile radius."

Nebraska

GALLERY 72, 2709 Leavenworth, Omaha NE 68105-2399. (402)345-3347. Director: Robert D. Rogers. Retail gallery and art consultancy. Estab. 1972. Interested in emerging, mid-career and established artists. Represents 10 artists. Sponsors 4 solo and 4 group shows/year. Average display time is 3 weeks. Clientele: individuals, museums and corporations. 75% private collectors, 25% corporate clients. Overall price range: $750 and up.
Media: Considers oil, acrylic, watercolor, pastel, pen & ink, drawings, mixed media, collage, sculpture, ceramic, installation, photography, original handpulled prints and posters. Most frequently exhibits paintings, prints and sculpture.

Style: Exhibits hard-edge geometric abstraction, color field, minimalism, impressionism and realism. Genres include landscapes and figurative work. Most frequently exhibits color field/geometric, impressionism and realism.

Terms: Accepts work on consignment (commission varies), or buys outright. Retail price is set by gallery or artist. Gallery provides insurance and promotion; shipping costs are shared.

Submissions: Send query letter with résumé, slides and photographs. Call to schedule an appointment to show a portfolio, which should include originals, slides and transparencies. Vitae and slides are filed.

GERI'S ART AND SCULPTURE GALLERY, 7101 Cass St., Omaha NE 68132. (402)558-3030. President: Geri. Retail gallery and art consultancy featuring restrike etchings and tapestry. Estab. 1975. Exhibited artists include Agam, Hivar, Ting and Calder. Open all year. Located in midtown Omaha. Clientele: collectors, designers, residential and corporate. 50% private collectors, 50% corporate collectors. Overall price range: $35-10,000; most work sold at $500-1,000.

Media: Considers watercolor, mixed media, collage, paper, sculpture, ceramic and tapestry. Considers all types of prints, especially lithographs, serigraphs and monoprints.

Style: Considers all styles and genres. "We carry mostly original limited editions."

Terms: Artwork is bought outright or leased. Sometimes offers discounts to gallery customers.

Submissions: Portfolio review not required.

Tips: Finds artists through agents, visiting exhibitions, word of mouth, art publications and sourcebooks, artists' submissions, self-promotions and art collectors' referrals.

HAYDON GALLERY, 335 N. Eighth St., Suite A, Lincoln NE 68508. (402)475-5421. Fax: (402)472-9185. Director: Anne Pagel. Nonprofit sales and rental gallery in support of Sheldon Memorial Art Gallery. Estab. 1984. Exhibits 100 mid-career and established artists. Exhibited artists include Karen Kunc, Stephen Dinsmore, Kirk Pedersen and Neil Christensen. Sponsors 12 shows/year. Average display time 1 month. Open all year; Monday-Saturday, 10-5. Located in Historic Haymarket District (downtown); 1,100 sq. ft. 85% of space for special exhibitions; 10% of space for gallery artists. Clientele: collectors, corporate, residential, architects, interior designers. 75% private collectors, 25% corporate collectors. Overall price range: $75-20,000; most work sold at $500-3,000.

Media: Considers all media and all types of original prints. Most frequently exhibits paintings, mixed media and prints.

Style: Exhibits all styles. Genres include landscapes, abstracts, still lifes and figurative work. Prefers contemporary realism, nonrepresentational work in all styles.

Terms: Accepts work on consignment (45% commission). Retail price set by gallery and artist. Offers customer discounts and payment by installments. Gallery provides insurance, promotion, contract; artist pays for shipping.

Submission: Accepts primarily Midwest artists. Send query letter with résumé, slides, reviews and SASE. Portfolio review requested if interested in artist's work. Portfolio should include originals, photographs or slides. Replies only if interested within 1 month (will return slides if SASE enclosed). Files slides and other support information.

Tips: Finds artists through submissions, regional educational programs, visiting openings and exhibitions and news media.

Nevada

‡ARTIST'S CO-OP OF RENO, 627 Mill St., Reno NV 89502. (702)322-8896. Cooperative nonprofit gallery. Estab. 1966. 20 emerging, mid-career and established artists/year. Sponsors 6 shows/year. Average display time 6 months. Open all year; Monday-Sunday, 11-4. Located in fringes of downtown; 1,000 sq. ft. in historic, turn of century "French laundry" building. 10% of space for special exhibitions; 90% of space for gallery artists. Clientele: tourists, upscale, local community. 90% private collectors, 10% corporate collectors. Overall price range: $50-400; $50-200.

Media: Considers all media. Does not sell prints. Most frequently exhibits watercolor, oil and mixed media.

Style: Exhibits conceptualism, photorealism, color field, realism and imagism. Genres include Western, landscapes, florals, wildlife, Americana, portraits, Southwestern and figurative work. Prefers florals, landscapes and Americana.

The double dagger before a listing indicates that the listing is new in this edition. New markets are often more receptive to freelance submissions.

Terms: There is Co-op membership fee plus a donation of time. There is a 15% commission. Retail price set by the artist. Gallery provides promotion. Artist pays for shipping costs from gallery. Prefers art framed.
Submissions: Accepts only artists from Reno, Nevada. Send query letter with résumé, slides, photographs, reviews and bio. Call for appointment to show portfolio.
Tips: Finds artists through word of mouth and artists' visits. "We are very small and keep our gallery at 20 local artists."

NEVADA MUSEUM OF ART, E.L. Wiegand Gallery, 160 W. Liberty St., Reno NV 89501. (702)329-3333. Fax: (702)329-1541. Curator: Howard Spencer. Museum. Estab. 1931. Shows the work of emerging, mid-career and established artists. Sponsors 12 solo shows/year. Average display time: 6-8 weeks. Open all year. Located downtown in business district; 5,000 sq. ft.; "the only art museum in the state of Nevada." 80% of space for special exhibitions. Overall price range, $1,000-100,000. "Sales are minimal." "NMA is a nonprofit private art museum. The E.L. Wiegand Gallery is a new contemporary museum with 8,000+ square feet for all media and format. Museum curates individual and group exhibitions and has active acquisition policy for West/Great Basin artists."
Media: Considers all media and all types of original prints. Most frequently exhibits painting, sculpture, prints and photography.
Style: Exhibits all styles and all genres. Focus is on American art, with special emphasis on Great Basin and West Coast art.
Terms: Acquires art through donation or occasional special purchase. Retail price set by the artist. Gallery provides insurance, promotion and shipping costs to and from gallery. Prefers artwork framed.
Submissions: Send query letter with nonreturnable samples. Include SASE for return of work. Write to schedule an appointment to show a portfolio, which should include originals, photographs, slides, transparencies and "whatever gives a fair impression of your art."
Tips: "We are a nonprofit art museum, not a commercial gallery. We have no stable of artists, and are booked years in advance. Nevada artists are eligible to enter and win prizes in the Nevada Biennial Juried competition."

‡RED MOUNTAIN GALLERY (Truckee Meadows Community College), 7000 Dandini Blvd., Reno NV 89512. (702)673-7084. Gallery Director: Erik Lauritzen. Nonprofit and college gallery. Estab. 1991. Represents emerging and mid-career artists. Sponsors 10 shows/year. Average display time 1 month. Open all year. Located north of downtown Reno; 1,200 sq. ft.; "maximum access to entire college community—centrally located." 100% of space for special exhibitions. Clientele: corporate art community and students/faculty. 95% private collectors, 5% corporate collectors. Overall price range: $150-1,500; most work sold at $300-500.
Media: Considers oil, acrylic, watercolor, pastel, pen & ink, drawings, mixed media, collage, paper, sculpture, ceramic, fiber and photography. "Video is a new addition." Considers original handpulled prints, woodcuts, engravings, lithographs, wood engravings, mezzotints, serigraphs, linocuts and etchings. Most frequently exhibits painting, photography and sculpture.
Style: Exhibits all styles and genres. Prefers primitivism, impressionism and socio-political works. Looks for "more contemporary concerns—less traditional/classical approaches. Subject matter is not the basis of the work—innovation and aesthetic exploration are primary."
Terms: Accepts work on consignment (20% commission). Retail price set by gallery and artist. Gallery provides insurance, promotion, contract and shipping from gallery. Prefers artwork unframed.
Submissions: Accepts only artists from WA, OR, CA, ID, UT, AZ and NV. Send query letter with résumé, slides, SASE, reviews and artist's statement. Deadline for submissions: April 15 of each year. Replies in 2 months. Files résumé.

New Hampshire

KILLIAN GALLERY AT SHARON ARTS CENTER, RFD 2, Box 361, Rt 123, Sharon NH 03458. (603)924-7256. Gallery Director: Randall Hoel. Nonprofit gallery. Estab. 1967. Exhibits, emerging, mid-career and established artists. Exhibits 120 juried and 15 invited artists/year. 250 artists; 600 members. Sponsors 9 shows/year. Open all year; Monday-Saturday 10-5 and Sunday 12-5. Located in rural woodland setting; 1,100 sq. ft. Features Killian Gallery for large exhibits, foyer space for solo shows, Laws House Gallery for member artist exhibits. 40% of space for special exhibitions; 60% of space for gallery artists. Clientele: retail. 15% private collectors, 5% corporate collectors. Overall price range: $200-6,000; most work sold at $200-500.
Media: Considers oil, pen & ink, paper, fiber, acrylic, drawing, sculpture, watercolor, mixed media, ceramic, pastel, collage, photography, woodcuts, wood engravings, linocuts, engravings, mezzotints, etchings, lithographs, collagraphs and serigraphs. Most frequently exhibits paintings, prints (most types including photography) and sculptures.

Style: Exhibits all styles and genres. Prefers realism, postmodernism and abstraction.
Terms: Accepts work on consignment (40% commission). Retail price set by artist. Customer discounts and payment by installment are available for center members. Gallery provides insurance, promotion and contract; artist pays for shipping costs. Prefers artwork framed.
Submissions: Send query letter with résumé, slides, bio and SASE. Call for appointment to show portfolio of originals, photographs and slides. Replies in 2 months. Files résumé, bio, slides and photographs.
Tips: "We plan one to one and a half years in advance. Expect a long wait." Finds new artists through visiting exhibitions, word of mouth, art publications, sourcebooks and artists' submissions.

PERFECTION FRAMING, 213 Rockingham Rd., Londonderry NH 03053. Phone/fax: (603)434-7939. Owner: Valerie Little. Retail gallery. Estab. 1986. Represents "3 or 4 local/regional," emerging, mid-career and established artists/year. Interested in seeing the work of emerging artists. Exhibited artists include Bateman, Kuck. Sponsors 2-3 shows/year. Average display time 2 months. Open all year; Tuesday-Saturday, 10-6. Located on Route 28; 1,100 sq. ft. 25% of space for special exhibitions; 60% of space for gallery artists. Clientele: residential and corporate. 90% private collectors, 10% corporate collectors. Overall price range: $200-400; most work sold at $300.
Media: Considers all media and all types of prints. Most frequently exhibits limited edition prints, originals and etchings.
Style: Exhibits impressionism and realism. Genres include landscapes, florals, Americana and wildlife. Prefers wildlife, landscapes and Americana.
Terms: Accepts work on consignment (25% commission). Retail price set by the artist. Gallery provides promotion and contract; artist pays shipping costs. Prefers artwork unframed.
Submissions: Accepts only artists from New Hampshire. Send query letter with bio and photographs. Write for appointment to show portfolio of originals and photographs.
Tips: Finds artists through word of mouth.

New Jersey

ARC-EN-CIEL, 64 Naughright Rd., Long Valley NJ 07853. (908)832-6605. Fax: (908)832-6509. E-mail: arreed@aol.com, areed@escape.cnct.com. Owner: Ruth Reed. Retail gallery and art consultancy. Estab. 1980. Represents 35 mid-career and established artists/year. Exhibited artists include Andre Pierre, Petian Savain. Sponsors 1 or 2 corporate shows/year. Clientele: 50% private collectors, 50% corporate clients. Average display time is 6 weeks-3 months. Open by appointment only. Represents emerging, mid-career and established artists. Overall price range: $150-158,000; most artwork sold at $250-2,000.
Media: Considers oil, acrylic, wood carvings, sculpture. Most frequently exhibits acrylic, painted iron, oil.
Style: Exhibits surrealism, minimalism, primitivism and impressionism. "I exhibit country-style paintings, naif art from around the world. The art can be on wood, iron or canvas."
Terms: Accepts work on consignment (50% commission). Retail price is set by gallery and artist. Customer discounts and payment by installment are available. Exclusive area representation required. Gallery provides promotion; shipping costs are shared.
Submissions: Send query letter, photographs and SASE. Portfolio review requested if interested in artist's work. Photographs are filed.
Tips: Finds artists through word of mouth and art collectors' referrals.

ART FORMS, 16 Monmouth St., Red Bank NJ 07701. (201)530-4330. Fax: (201)530-9791. Director: Charlotte T. Scherer. Retail gallery. Estab. 1984. Represents 12 emerging, mid-career and established artists. Exhibited artists include Paul Bennett Hirsch and Sica. Sponsors 7 exhibitions/year. Average display time 1 month. Open all year. Located in downtown area; 1,200 sq. ft.; "Art Deco entranceway, tin ceiling, Soho appeal." 50% of space for special exhibitions. Clientele: 60% private collectors, 40% corporate collectors. Overall price range: $250-70,000; most work sold at $1,200-4,500.
Media: Considers all media, including wearable art. Considers original handpulled prints, woodcuts, wood engravings, linocuts, engravings, mezzotints, etchings, lithographs, pochoir and serigraphs. Most frequently exhibits mixed media, oil and lithographs.
Style: Exhibits neo-expressionism, expressionism and painterly abstraction. Interested in seeing contemporary representationalism.
Terms: Accepts work on consignment (50% commission). Retail price set by artist. Gallery provides insurance, promotion, contract and shipping costs from gallery. Prefers artwork unframed.
Submissions: Send query letter with résumé, slides, bio and SASE. Write for appointment to show portfolio of originals and slides. Replies in 1 month. Files résumé and slides.

‡THE ARTFUL DEPOSIT GALLERY, 46 S. Main St., P.O. Box 203, Allentown NJ 08501. (609)259-3234. Owner: C.L. Mugarero. Retail gallery. Represents/exhibits 30 emerging, mid-career and established artists/year. May be interested in seeing work of emerging artists. Exhibited artists include Joseph Dawley and Afi Toro. Average display time 2-3 months. Open all year; Tuesday-Saturday, 11-5; Sunday, 12-5 and by evening

appointment. Located by the "Olde Mill" on S. Main St., in business district; 900 sq. ft.; modern interior space in building attached to 200-year-old mill. 100% of space for gallery artists. Clientele: tourist, upscale. 95% private collectors, 5% corporate collectors. Overall price range: $95-40,000; most work sold at $750-5,000.

Media: Considers all media, woodcut, wood engraving, engraving, mezzotint and lithograph. Most frequently exhibits oil, collage and watercolors.

Styles: Exhibits all styles. All genres. Prefers impressionism, expressionism and abstraction.

Terms: Artwork is accepted on consignment (40% commission). Retail price set by the gallery. Gallery provides insurance, promotion and contract; shipping costs are shared. Prefers artwork framed.

Submissions: Prefers to represent artists residing in New York and New Jersey. Send query letter with résumé, business card, slides, photographs, bio and SASE. Call for appointment to show portfolio of photographs, slides and transparencies. Files résumés with my notes. Slides or transparencies are returned to artist ASAP.

Tips: "Approach all gallery opportunities with professionalism. Make an appointment! Do not walk in and expect immediate review of work."

‡BARRON ARTS CENTER, 582 Rahway Ave., Woodbridge NJ 07095. (201)634-0413. Director: Stephen J. Kager. Nonprofit gallery. Estab. 1977. Interested in emerging, mid-career and established artists. Sponsors several solo and group shows/year. Average display time is 1 month. Clientele: culturally minded individuals mainly from the central New Jersey region. 80% private collectors, 20% corporate clients. Overall price range: $200-5,000.

Media: Considers oil, acrylic, watercolor, pastel, pen & ink, drawings, mixed media, collage, works on paper, sculpture, ceramic, craft, fiber, glass, installation, photography, performance and original handpulled prints. Most frequently exhibits acrylic, photography and mixed media.

Style: Exhibits painterly abstraction, impressionism, photorealism, realism and surrealism. Genres include landscapes and figurative work. Prefers painterly abstraction, photorealism and realism.

Terms: Accepts work on consignment. Retail price set by artist. Exclusive area representation not required. Gallery provides insurance, promotion and contract; artist pays for shipping.

Submissions: Send query letter, résumé and slides. Call for appointment to show portfolio. Résumés and slides are filed.

Tips: Most common mistakes artists make in presenting their work are "improper matting and framing and poor quality slides. There's a trend toward exhibition of more affordable pieces—pieces in the lower end of price range."

BERGEN MUSEUM OF ART & SCIENCE, 327 E. Ridgewood, Paramus NJ 07652. (201)265-1248. Director: David Messer. Museum. Estab. 1956. Represents emerging, mid-career and established artists. Exhibited artists include Norman Lundine and Beverly Hallam. Sponsors 10 shows/year. Average display time 2 months. Open all year. Located across from Bergen Pines Hospital in Paramus; 8,000 sq. ft. 65% of space for special exhibitions.

Terms: Payment/consignment terms arranged by case. Retail price set by the artist. Gallery provides promotion; artist pays for shipping. Prefers artwork framed.

Submissions: Send query letter with résumé, bio and photographs. Write for appointment to show portfolio of originals, photographs and transparencies. Replies only if interested within 4 weeks.

Tips: Finds artists through word of mouth, artists' submissions and self-promotions. Prefers "upbeat art of quality."

BLACKWELL ST. CENTER FOR THE ARTS, 32-34 W. Blackwell St., Dover NJ 07801. (201)328-9628. Director: Annette Hanna. Nonprofit gallery. Estab. 1987. Exhibits the work of 28 emerging and established artists. Sponsors nine 1-3 person shows and 2-3 group shows/year. Average display time 1 month. Overall price range $100-5,000; most work sold at $150-350.

Media: Considers oil, acrylic, watercolor, pastel, pen & ink, drawings, mixed media, collage, paper, sculpture, ceramics, photography, egg tempera, woodcuts, wood engravings, linocuts, engravings, mezzotints, etchings, lithographs and serigraphs. Most frequently exhibits oil, photography and pastel.

Style: Exhibits all styles and genres. Prefers painterly abstraction, realism and photorealism.

Terms: Membership fee plus donation of time; 25% commission. Retail price set by artist. Sometimes offers payment by installments. Exclusive area representation not required. Artist pays for shipping. Prefers artwork framed.

Submissions: Send query letter with résumé, brochure, slides photographs, bio and SASE. Call or write for appointment to show portfolio of originals and slides. Replies in 1 month. Files slides of accepted artists. All material returned if not accepted or under consideration.

Tips: "The gallery functions as a cultural center and exhibition space for member artists and others. We have three categories of artist members. Each pays a fee and participates in the administration of the center. Artists applying for membership are juried. We are seeking visual artists of all types and endeavor to provide the area with exhibitions of high quality art."

‡**MABEL SMITH DOUGLASS LIBRARY**, Douglass College, New Brunswick NJ 08901. (908)932-9411. Fax: (908)932-6667. Curator: Ferris Olin. Alternative exhibition space for exhibitions of works by women artists. Estab. 1971. Represents/exhibits 5-7 emerging, mid-career and established artists/year. Interested in seeing the work of emerging artists. Sponsors 5-7 shows/year. Average display time 5-6 weeks. Open September-June; Monday-Sunday approximately 12 hours a day. Located on college campus in urban area; lobby-area of library. Clientele: students, faculty, community. Overall price range: $3,000-10,000.
Media: Considers all media. Most frequently exhibits painting, prints, photographs and sculpture.
Style: Exhibits all styles. All genres.
Terms: Retail price by the artist. Gallery provides insurance, promotion and arranges transportation. Prefers artwork framed.
Submissions: Exhibitions are curated by invitation. Portfolio should include slides.
Tips: Finds artists through referrals.

ESSEX FINE ARTS GALLERY, 13 S. Fullerton Ave., Montclair NJ 07042. (201)783-8666. Fax: (201)783-8613. President/Owner: Diane E. Israel. Retail gallery. Estab. 1987. Represents 35 established artists. May be interested in seeing the work of emerging artists in the future. Exhibited artists include Frank Zuccarelli, Diane Barton. Sponsors 2 shows/year. Average display time 6 months. Open all year; Tuesday-Friday, 10-5:30; Saturday, 10-4:30; Sunday-Monday closed. Located in downtown business district; 600 sq. ft.; old building—"lovely exhibit space." 100% of space for special exhibitions; 100% of space for gallery artists. Clientele: upper class. 90% private collectors, 10% corporate collectors. Overall price range: $50-12,000; most work sold at $200-500.
Media: Considers oil, acrylic, watercolor, pastel, pen & ink, drawing, photography, "all must be representational." Also woodcut, engraving, lithograph, wood engraving, mezzotint, etching "older prints only—1500-1900." Most frequently exhibits watercolor, oil and photography.
Style: Exhibits impressionism, photorealism and realism. Genres include landscapes, florals, wildlife, portraits and figurative work.
Terms: Accepts work on consignment (40% commission). Retail price set by the gallery. Gallery provides promotion; shipping costs are shared. Prefers artwork "gallery matted and framed (acid-free mats only)."
Submissions: Prefers only realistic artworks-no abstracts. Send query letter with photographs, SASE and business card. Write for appointment to show portfolio of photographs. Replies only if interested in 1 month. No material filed.
Tips: Finds artists through visiting local exhibitions. "Be professional, know your work and how it relates to the contemporary art scene and be neat and clean in your appearance."

DAVID GARY LTD. FINE ART, 391 Millburn Ave., Millburn NJ 07041. (201)467-9240. Fax: (201)467-2435. Director: Steve Suskauer. Retail and wholesale gallery. Estab. 1971. Represents 17-20 mid-career and established artists. Exhibited artists include John Talbot and Marlene Lenker. Sponsors 3 shows/year. Average display time 3 weeks. Open all year. Located in the suburbs; 2,500 sq. ft.; high ceilings with sky lights and balcony. Clientele: "upper income." 70% private collectors, 30% corporate collectors. Overall price range: $250-25,000; most work sold at $1,000-15,000.
Media: Considers oil, acrylic, watercolor, drawings, sculpture, pastel, woodcuts, engravings, lithographs, wood engravings, mezzotints, linocuts, etchings and serigraphs. Most frequently exhibits oil, original graphics and sculpture.
Style: Exhibits primitivism, painterly abstraction, surrealism, impressionism, realism and collage. All genres. Prefers impressionism, painterly abstraction and realism.
Terms: Accepts artwork on consignment (50% commission). Retail price set by gallery and artist. Gallery services vary; artist pays for shipping. Prefers artwork unframed.
Submissions: Send query letter with résumé, photographs and reviews. Call for appointment to show portfolio of originals, photographs and transparencies. Replies in 1-2 weeks. Files "what is interesting to gallery."
Tips: "Have a basic knowledge of how a gallery works, and understand that the gallery is a business."

‡**LANDSMAN'S GALLERY & PICTURE FRAMING**, 401 S. Rt. 30, Magnolia NJ 08049. (609) Fine Art. Fax: (609)784-0334. Owner: Howard Landsman. Retail gallery and art consultancy. Estab. 1965. Represents/exhibits 25 emerging, mid-career and established artists/year. Interested in seeing the work of emerging artists. Open all year; Tuesday-Saturday, 9-5. Located in suburban service-oriented area; 2,000 sq. ft. "A refuge in an urban suburban maze." Clientele: upscale, local, established. 50% private collectors, 50% corporate collectors. Overall price range: $100-10,000; most work sold at $300-1,000.
Media: Considers all media and all types of prints. Most frequently exhibits serigraphs, oils and sculpture.
Style: Exhibits all styles. All genres. Gallery provides insurance, promotion and contract. Artist pays for shipping costs. Prefers artwork framed.
Terms: Artwork is accepted on consignment (50% commission). Retail price set by artist. Gallery provides insurance, promotion, contract. Artist pays shipping costs. Prefers artwork framed.
Submissions: Send query letter with slides, photographs and reviews. Write for appointment to show portfolio of photographs and slides. Files slides, bios and résumé.

Tips: Finds artists through word of mouth, referrals by other artists, visiting art fairs and exhibitions, artists' submissions. "Hang tough."

THE NOYES MUSEUM, Lily Lake Rd., Oceanville NJ 08231. (609)652-8848. Fax: (609)652-6166. Curator of Collections and Exhibitions: Stacy Smith. Museum. Estab. 1982. Exhibits emerging, mid-career and established artists. Sponsors 15 shows/year. Average display time 6 weeks to 3 months. Open all year; Wednesday-Sunday, 11-4. 9,000 sq. ft.; "modern, window-filled building successfully integrating art and nature; terraced interior central space with glass wall at bottom overlooking Lily Lake." 75% of space for special exhibitions. Clientele: rural, suburban, urban mix; high percentage of out-of-state vacationers during summer months. 100% private collectors. "Price is not a factor in selecting works to exhibit."
Media: All types of fine art, craft and folk art.
Style: Exhibits all styles and genres.
Terms: Accepts work on consignment (10% commission). "Artwork not accepted solely for the purpose of selling; we are a nonprofit art museum." Retail price set by artist. Gallery provides insurance. Prefers artwork framed.
Submissions: Send query letter with résumé, slides, photographs and SASE. "Letter of inquiry must be sent; then museum will set up portfolio review if interested." Portfolio should include originals, photographs and slides. Replies in 1 month. "Materials only kept on premises if artist is from New Jersey and wishes to be included in New Jersey Artists Resource File or if artist is selected for inclusion in future exhibitions."

PELICAN ART GALLERIES & FRAMERS, 1 Nasturtium Ave., Glenwood NJ 07418. (914)986-8113 or (201)764-7149. Fax: (201)764-9745. Owner: Thomas F. Prendergast. Art Director: Sean Prendergast. Art consultancy. "Brokers prints at various locations—restaurants, automobile dealers, galleries, dental offices, frame shops and banks." Estab. 1986. Represents emerging, mid-career and established artists. Exhibited artists include Doolittle and Bateman. Sponsors 2 shows/year. Average display time 2 months. Open all year. Clientele: 50% private collectors, 40% other galleries, 10% corporate clients. Overall price range: $150-1,500; most artwork sold at $350-500.
Media: Considers watercolor, pen & ink, woodcuts, lithographs, serigraphs and etchings. Most frequently exhibits original prints and serigraphs. Interested in "portrait art—mostly of famous people."
Style: Exhibits imagism and realism. Genres include landscapes, Americana, Southwestern, Western, marine, aviation and wildlife. Prefers wildlife, Western and Americana. "Interested in seeing good, close-up animal paintings."
Terms: Accepts work on consignment (30% commission). Retail price set by artist. Customer discounts and payment by installment are available. Gallery provides promotion; artist pays for shipping. Prefers artwork framed. "Must be framed with acid-free matting and no cuts or digs on mats. Must be in top shape."
Submissions: Send query letter with résumé and brochure. Call for appointment to show portfolio of originals. Replies in 1 week.
Tips: "Large part of business is sport art prints—baseball, football, hockey, boxing, skiing—signed by artist and autographed by player."

QUIETUDE GARDEN GALLERY, 24 Fern Rd., East Brunswick NJ 08816. (908)257-4340. Fax: (908)257-1378. Owner: Sheila Thau. Retail/wholesale gallery and art consultancy. Estab. 1988. Represents 60 emerging, mid-career and established artists/year. Exhibited artists include Tom Doyle, Han Van de Boven Kamp. Sponsors 5 shows/year. Average display time 6 weeks. Open April 24-November 1; by appointment. Located in a suburb; 4 acres; unique work exhibited in natural and landscaped, wooded property—each work in its own environment. 25% of space for special exhibitions; 75% of space for gallery artists. Clientele: upper middle class, private home owners and collectors, small corporations. 75% private collectors, 25% corporate collectors. Overall price range: $2,000-50,000; most work sold at $10,000-20,000.
Media: Considers "only sculpture suitable for outdoor (year round) display and sale." Most frequently exhibits metal (bronze, steel), ceramic and wood.
Style: Exhibits all styles.
Terms: Accepts work on consignment. Retail price set by the artist. Gallery provides insurance, promotion and contract; artist pays shipping costs to and from gallery.
Submissions: Send query letter with résumé, slides, bios, photographs, SASE and reviews. Write for appointment to show portfolio of photographs, slides and bio. Replies in 2 weeks. Files "slides, bios of artists who we would like to represent or who we do represent."
Tips: Finds artists through word of mouth, publicity on current shows and ads in art magazines.

Always enclose a self-addressed, stamped envelope (SASE) with queries and sample packages.

‡**SCHERER GALLERY**, 93 School Rd. W., Marlboro NJ 07746. (908)536-9465. Fax: (908)536-8475. Owner: Tess Scherer. Retail gallery. Estab. 1968. Represents over 30 mid-career and established artists. May be interested in seeing the work of emerging artists in the future. Exhibited artists include Tamayo and Hundertwasser. Sponsors 4 solo and 3 group shows/year. Average display time 2 months. Open Wednesday-Sunday, 10-5; closed mid-July to early September. Located in "New York" suburb; 2,000 sq. ft.; 25% of space for special exhibitions; 75% for gallery artists. Clientele: upscale, local community and international collectors. 90% private collectors, 10% corporate clients. Overall price range: $1,000-20,000; most artwork sold at $5,000-10,000.
Media: Considers all media except craft; considers all types of original handpulled prints (no posters or offsets). Most frequently exhibits paintings, original graphics and sculpture.
Style: Exhibits color field, minimalism, surrealism, expressionism, modern and post modern works. Looking for artists "who employ creative handling of a given medium(s) in a contemporary manner." Specializes in handpulled graphics (lithographs, serigraphs, monotypes, woodcuts, etc.). "Would like to be more involved with original oils and acrylic paintings."
Terms: Accepts work on consignment (50% commission). Retail price set by artist. Exclusive area representation required. Gallery provides insurance, promotion and contract; shipping costs are shared.
Submissions: Send query letter, résumé, bio, photographs and SASE. Follow up with a call for appointment to show portfolio. Replies in 2-4 weeks.
Tips: Considers "originality and quality of handling the medium."

BEN SHAHN GALLERIES, William Paterson College, 300 Pompton Rd, Wayne NJ 07470. (201)595-2654. Director: Nancy Eireinhofer. Nonprofit gallery. Estab. 1968. Interested in emerging and established artists. Sponsors 5 solo and 10 group shows/year. Average display time is 6 weeks. Clientele: college, local and New Jersey metropolitan-area community.
• The gallery specializes in contemporary art and encourages site-specific installations. They also have a significant public sculpture collection and welcome proposals.
Media: Considers all media.
Style: Specializes in contemporary and historic styles, but will consider all styles.
Terms: Accepts work for exhibition only. Gallery provides insurance, promotion and contract; shipping costs are shared.
Submissions: Send query letter with résumé, brochure, slides, photographs and SASE. Write for appointment to show portfolio.
Tips: Finds artists through artists' submissions, referrals and exhibits.

WYCKOFF GALLERY, 648 Wyckoff Ave., Wyckoff NJ 07481. (201)891-7436. Director: Sherry Cosloy. Retail gallery. Estab. 1980. Interested in emerging, mid-career and established artists. Sponsors 1-2 solo and 4-6 group shows/year. Average display time 1 month. Clientele: collectors, art lovers, interior decorators and businesses. 75% private collectors, 25% corporate clients. Overall price range: $250-10,000; most artwork sold at $500-3,000.
Media: Considers oil, acrylic, watercolor, pastel, pen & ink, pencil, mixed media, sculpture, ceramic, collage and limited edition prints. Most frequently exhibits oil, watercolor and pastel.
Style: Exhibits contemporary, abstract, traditional, impressionistic, figurative, landscape, floral, realistic and neo-expressionistic works.
Terms: Accepts work on consignment. Retail price set by gallery or artist. Gallery provides insurance and promotion.
Submissions: Send query letter with résumé, slides and SASE. Résumé and biography are filed.
Tips: Sees trend toward "renewed interest in traditionalism and realism."

New Mexico

A.O.I. GALLERY (ART OBJECTS INTERNATIONAL), 634 Canyon Rd., Santa Fe NM 87501. (505)982-3456. Fax: (505)982-2040. Director: Frank. Retail gallery. Estab. 1993. Represents 24 emerging and mid-career artists/year. Exhibited artists include Carl Goldhagen, Gary Dodson, Kimiko Fujimura, Michael Kenna, Ernst Haas, Maxine Fine. Sponsors 5 shows/year. Average display time 4-6 weeks. Open daily; 10-6 (summer), 11-5 (winter, closed on Tuesdays). 1,000 sq. ft.; beautiful adobe house, over 100 years old. 100% of space for special exhibitions; 100% of space for gallery artists. Clientele: "Highly sophisticated collectors who are interested in contemporary arts." 50% private collectors. Overall price range: $500-15,000; most work sold at $1,000-3,000.
Media: Considers all types. Most frequently exhibits photography and multi-media work, drawing and painting.
Style: Exhibits all styles. Prefers contemporary art.
Terms: Accepts work on consignment (50% commission). Retail price set by both the gallery and the artist. Gallery provides insurance; shipping costs are shared. Prefers artwork unframed.

Submissions: Must call first for appointment to show portfolio.
Tips: Impressed by "professional artists who can accept rejection with grace and who are extremely polite and well mannered."

THE ALBUQUERQUE MUSEUM, 2000 Mountain Rd. NW, Albuquerque NM 87104. (505)243-7255. Curator of Art: Ellen Landis. Nonprofit museum. Estab. 1967. Interested in emerging, mid-career and established artists. Sponsors mostly group shows. Average display time is 3-6 months. Located in Old Town (near downtown).
Media: Considers all media.
Style: Exhibits all styles. Genres include landscapes, florals, Americana, Western, portraits, figurative and nonobjective work. "Our shows are from our permanent collection or are special traveling exhibitions originated by our staff. We also host special traveling exhibitions originated by other museums or exhibition services."
Submissions: Send query letter, résumé, slides, photographs and SASE. Call or write for appointment to show portfolio.
Tips: "Artists should leave slides and biographical information in order to give us a reference point for future work or to allow future consideration."

PHILIP BAREISS CONTEMPORARY EXHIBITIONS, 15 Taos Ski Valley, Box 2739, Taos NM 87571. (505)776-2284. Associate Director: Susan Strong. Retail gallery and 3-acre sculpture park. Estab. 1989 at current location "but in business over 10 years in Taos." Represents 21 mid-career and established artists. Exhibited artists include Jim Wagner and Patricia Sanford. Sponsors 8 shows/year. Average display time 2 months. Open all year. "Located in the countryside, close to town next to Taos Pueblo reservation under stunning aspect of Taos Mountain.; 4,000 sq. ft.; gallery is unique metal building with sculptural qualities, walls 10-20 ft. high." Clientele: 99% private collectors, 1% corporate collectors. Overall price range: $250-65,000.
Media: Most frequently exhibits outdoor sculpture, paintings and monotypes.
Styles: Exhibits all styles and genres, including abstract. Interested in seeing original contemporary art, especially outdoor sculpture by artists who are committed to being represented in Taos.
Terms: Accepts work on consignment (varying commission). Gallery provides contract; artist pays for shipping.
Submissions: Currently interested in outdoor sculpture. Send query letter with photographs. Write for appointment to show portfolio of photographs. Replies only if interested. Files résumés and photos only if interested.
Tips: "Do not send material unless your query results in a request for submission. The amount of material a gallery receives from artists can be overwhelming. New artists have to devote more effort to the business side of their careers."

‡BENT GALLERY AND MUSEUM, 117 Bent St., Box 153, Taos NM 87571. (505)758-2376. Owner: Otto Noeding. Retail gallery and museum. Estab. 1961. Represents 15 emerging, mid-career and established artists. Exhibited artists include Tom Waugh, Robert Dennis, Victor Czerkas, Endre Szabo, Cheryl Price, Deborah Lynn and James Beman. Open all year. Located 1 block off of the Plaza; "in the home of Charles Bent, the first territorial governor of New Mexico." Clientele: 95% private collectors, 5% corporate collectors. Overall price range: $100-10,000; most work sold at $500-1,000.
Media: Considers oil, acrylic, watercolor, pastel, pen & ink, drawings, sculpture, original handpulled prints, woodcuts, engravings and lithographs.
Style: Exhibits impressionism and realism. Genres include traditional, landscapes, florals, Southwestern and Western. Prefers impressionism, landscapes and Western works. "We continue to be interested in collectors' art: deceased Taos artists and founders works."
Terms: Accepts work on consignment (33⅓-50% commission). Retail price set by gallery and artist. Artist pays for shipping. Prefers artwork framed.
Submissions: Send query letter with brochure and photographs. Write for appointment to show portfolio of originals and photographs. Replies if applicable.
Tips: "It is best if the artist comes in person with examples of his or her work."

‡CLAY & FIBER, 126 W. Plaza, Taos NM 82571. Owner: Sue Westbrook. Retail gallery. Estab. 1974. Represents/exhibits 50 emerging, mid-career and established artists/year. Interested in emerging artists. Exhibited artists include Hilary Walker and Bob Smith. Sponsors 4 shows/year. Average display time 1 month. Open all year; Monday-Saturday, 10-5; Sunday, 11-4. Located ½ block off Plaza; 2,000 sq. ft.; historical adobe with handcarved corbels. 75% of space for gallery artists. Clientele: tourist, local- long-time clients. Overall price range: $50-2,500; most work sold at $75-500.
Media: Considers paper, fiber, sculpture, glass, ceramics and craft. Most frequently exhibits clay-decorative and functional; fiber-wearable and wall; jewelry.

Style: Exhibits minimalism, pattern painting, painterly abstraction and realism.

Terms: Artwork is accepted on consignment (50% commission). Retail price set by the artist. Gallery provides insurance, promotion and contract; shipping costs are shared.

Submissions: Send query letter with slides and bio. Call or write for appointment to show portfolio of photographs and slides. Replies in 1 month.

Tips: Finds artists through word of mouth, referrals by other artists, visiting art fairs and exhibitions, artists' submissions.

COPELAND RUTHERFORD FINE ARTS LTD., 403 Canyon Rd., Santa Fe NM 87501. (505)983-1588. Fax: (505)982-1654. Assistant Director: Samantha P. Furgason. Retail gallery. Estab. 1991. Represents 10 mid-career and established artists. May be interested in seeing the work of emerging artists in the future. Exhibited artists include Doug Coffin, Colette Hosmer. Sponsors 9 shows/year. Average display time 1 month. Open all year; Tuesday-Saturday, 10-5. Located downtown 2 blocks off the plaza; 1,200 sq. ft.; wood floors, 13-foot ceilings; ½ acre outdoor sculpture garden. 95% of space for special exhibitions; 40% of space for gallery artists during exhibitions. Clientele: mid to high end. 95% private collectors, 5% corporate collectors. Overall price range: $500-20,000.

Media: Considers oil, acrylic, watercolor, pastel, pen & ink, drawing, mixed media, collage, paper, sculpture, fiber, glass, installation, photography, mixed media, all types of prints. Most frequently exhibits sculpture, original 2-dimensional, photos, mixed media.

Media: Exhibits painterly abstraction, conceptualism and realism. Genres including cutting edge. Prefers cutting edge contemporary and modern.

Terms: Accepts work on consignment (50% commission). "We do offer space rental for events." Retail price set by the gallery. Gallery provides insurance and promotion; artist usually pays shipping costs to and from gallery. Prefers artwork framed. ''We do not accept non-hangable work.''

Submissions: Accepts only artists from New Mexico. Send query letter with résumé, slides, bio, brochure, photographs, business card, reviews and SASE. Call or write for appointment to show portfolio of photographs or slides and transparencies. Replies in 2 weeks. Files inexpensive visuals and résumé.

Tips: Finds artists through visiting exhibitions, word of mouth and artists' submissions. "Try to stay in 'cutting edge' focus. Have a nicely compiled portfolio—self contained. I had someone dump a pillow case full of photos on my desk once, bad approach . . . Don't be too pushy."

‡DARTMOUTH STREET GALLERY, 3011 Monte Vista Ave., Albuquerque NM 87106. (505)266-7751. Fax: (505)266-0005. E-mail: jcdsq@aol.com. Owner: John Cacciatore. Retail gallery. Estab. 1992. Represents/exhibits 25 mid-career and established artists/year. Exhibited artists include Angus Macpherson and Nancy Kuzikowski. Sponsors 6 shows/year. Average display time 2 months. Open all year; Monday-Sunday, 1-5. Located near University of New Mexico; 2,000 sq. ft. 80% of space for special exhibitions; 20% of space for gallery artists. Clientele: tourists, upscale, local community and corporate. 80% private collectors, 20% corporate collectors. Overall price range $35-50,000; most work sold at $3,000-10,000.

Media: Considers all media except ceramic. Also considers tapestry. Most frequently exhibits acrylic or oil on canvas, works on paper.

Style: Exhibits hard-edge geometric abstraction, painterly abstraction, postmodern works, realism and impressionism. Genres include landscapes, Southwestern and figurative work. Prefers landscapes, abstracts and figures.

Terms: Artwork is accepted on consignment (50% commission). Retail price set by the artist. Gallery provides insurance, promotion and contract; shipping costs are shared.

Submissions: Accept only artists for New Mexico. Prefers only paintings. Send query letter with résumé, brochure, slides, photographs, bio and SASE. Portfolio should include slides. Replies in 1 month.

Tips: "Have persistence."

‡EL TALLER DE TAOS GALLERY, 119 A. Kit Carson Rd., Taos NM 87571. (505)758-4887. Fax: (505)758-4888. Executive Director: Judith Gesell-Jones. Retail gallery. Estab. 1983. Represents/exhibits 20 emerging, mid-career and established artists/year. Exhibited artists include Amado M Peña, Jim Prindiville and Malcolm Furlow. Sponsors 4 shows/year. Average display time 2-4 weeks. Open all year; Monday-Saturday, 10-5; Sunday, 12-4. Located in historic town; 3,000 sq. ft. 100% of space for gallery artists. Clientele: tourists, upscale, local community, students. 99% private collectors, 1% corporate collectors. Overall price range: $10-25,000; most work sold at $350-4,000.

Media: Considers all media and all types of prints. Most frequently exhibits mixed media, pastels and serigraphs.

Style: Exhibits expressionism, color field, painterly abstraction and impressionism. Genres include landscapes, Southwestern and figurative work.

Terms: Artwork is accepted on consignment (50% commission). Retail price set by the artist. Gallery provides insurance, promotion and contract; shipping costs are shared. Prefers artwork framed.

Submissions: Send query letter with résumé, slides and photographs. Write for appointment to show portfolio of photographs and slides. Replies in 3-4 weeks.

FENIX GALLERY, 228-B N. Pueblo Rd., Taos NM 87571. Phone/Fax: (505)758-9120. E-mail: judith@lapla zataos.nm.us. Director/Owner: Judith B. Kendall. Retail gallery. Estab. 1989. Represents 14 emerging, mid-career and established artists/year. Exhibited artists include Alyce Frank, Earl Stroh. Sponsors 4 shows/year. Average display time 4-6 weeks. Open all year; daily, 10-5; Sunday, 12-5; closed Wednesday during winter months. Located on the main road through Taos; 1,000 sq. ft.; minimal hangings; clean, open space. 100% of space for special exhibitions during one-person shows; 100% of space for gallery artists during group exhibitions. Clientele: experienced and new collectors. 90% privatecollectors, 10% corporate collectors. Overall price range: $400-10,000; most work sold at $1,000-2,500.
Media: Considers all media; primarily non-representational, all types of prints except posters. Most frequently exhibits oil, sculpture and paper work/ceramics.
Style: Exhibits expressionism, painterly abstraction, conceptualism, minimalism and postmodern works. Prefers conceptualism, expressionism and abstraction.
Terms: Accepts work on consignment (50% commission). Retail price set by the artist or a collaboration. Gallery provides insurance, promotion and contract; artist pays shipping costs to and from gallery. Prefers artwork framed.
Submissions: Prefers artists from area; "we do very little shipping of artist works." Send query letter with résumé, slides, bio, brochure, photographs, SASE, business card and reviews. Call for appointment to show portfolio of photographs. Replies in 3 weeks. Files "material I may wish to consider later—otherwise it is returned."
Tips: Finds artists through personal contacts, exhibitions, studio visits, reputation regionally or nationally.

FULLER LODGE ART CENTER, Box 790, 1715 Iris, Los Alamos NM 87544. (505)662-9331. Director: Gloria Gilmore House. Retail gallery/nonprofit gallery and rental shop for members. Estab. 1977. Represents over 50 emerging, mid-career and established artists. 388 members. Sponsors 11 shows/year. Average display time 1 month. Open all year. Located downtown; 1,300 sq. ft.; temporarily housed in storefront. 98% of space for special exhibitions. Clientele: local, regional and international visitors. 99% private collectors, 1% corporate collectors. Overall price range: $50-1,200; most artwork sold at $30-300.
Media: Considers all media, including original handpulled prints, woodcuts, engravings, lithographs, wood engravings, mezzotints, serigraphs, linocuts and etchings.
Style: Exhibits all styles and genres.
Terms: Accepts work on consignment (30% commission). Retail price set by the artist. Gallery provides insurance and promotion; artist pays for shipping. "Work should be in exhibition form (ready to hang)."
Submissions: "Prefer the unique." Send query letter with résumé, slides, bio, brochure, photographs, SASE and reviews. Call for appointment to show portfolio of originals, photographs (if a photographer) and slides. Replies in 2 weeks. Files "résumés, etc.; slides returned only by SASE."
Tips: "No one-person shows—artists will be used as they fit in to scheduled shows." Should show "impeccable craftsmanship."

THE GALLERY LA LUZ, P.O. Box 158, La Luz NM 88337. (505)437-3342. Manager: Jacque Day. Cooperative gallery. Exhibits the work of 25 established artists. Interested in seeing the work of emerging artists. Exhibited artists include Ernie Lee Miller, Myrna Lea Landrie, Cherry Carroll and Randy Clements. Open all year. 1,950 sq. ft.; "adobe walls; all rustic wood." Clientele: local residents and tourists. Overall price range: $25-1,200; most work sold at $50-150.
Media: Considers handcrafted furniture, recirculating fountains, baskets, pottery, steel and copper sculpture, rugs, jewelry and mixed media.
Style: Prefers Southwestern.
Terms: Accepts artwork on consignment (25% commission). Co-op membership fee plus donation of time (20% commission). Retail price set by artist. Offers payment by installments. Artist pays for shipping. Prefers artwork framed.
Submissions: Send query letter with résumé, photographs and SASE. Replies in 2 weeks.
Tips: "Write or apply in person for a new member prospectus."

‡IAC CONTEMPORARY ART, P.O. Box 11222, Albuquerque NM 87192-0222. (505)292-3675. Broker/Agent: Michael F. Herrmann. Art consultancy. Estab. 1992. Represents/exhibits 12 emerging, mid-career and established artists. Exhibited artists include Russel Ball and Michelle Cook. Sponsors 12 shows/year. Average display time 6 weeks. Open all year; Monday-Saturday, 7-6. "We exhibit at various locations. Presently working with two galleries for 90-day and 30-day shows respectively. Galleries have 1,000 sq. ft. each." One gallery located across from University of New Mexico. Other is located in Old Town (tourist center). 100% of space for gallery artists. 80% private collectors, 10% corporate collectors, 10% museums. Overall price range: $250-20,000; most work sold at $250-7,000.
Media: Considers all media except glass, ceramics or craft. Most frequently exhibits acrylics on canvas, serigraphs and waterless lithographs.
Style: Exhibits primitivism, painterly abstraction, postmodern works and surrealism. Genres include figurative work.

Terms: Artwork is accepted on consignment (50% commission). "We locate alternative venues, coordinate exhibits and collaborate with galleries. Fees vary depending on event, market, duration." Retail price set by collaborative agreement with artist. Gallery provides promotion and contract. Artist pays for shipping costs. Prefers artwork framed.
Submissions: Send query letter with résumé, brochure, business card, slides, photographs, reviews, bio and SASE. Call or write for appointment to show portfolio of photographs and slides. Replies in 3 months.
Tips: "We look for work that is outside the McMainstream."

JORDAN'S MAGIC MOUNTAIN GALLERY, T.A.O.S., 107 A North Plaza, Taos NM 87571. (505)758-9604. Owner: Marilyn Jordan. Retail gallery. Estab. 1980. Represents 25 mid-career and established artists. Exhibited artists include Jerry Jordan, Philip Moulthrop and James Roybal. Sponsors 1 show/year. Average display time 1 month. Open all year. Located in adobe building in historic Taos Plaza; 1,200 sq. ft. 50% of space for special exhibitions. Clientele: 90% private collectors, 10% corporate collectors. Overall price range: up to $16,000; most work sold at $1,000-5,000.
Media: Considers oil, sculpture, ceramic and jewelry. Most frequently exhibits sculpture, oil, ceramic (clay art) and jewelry.
Style: Exhibits expressionism, color field and impressionism. Genres include landscapes and Southwestern (Northern New Mexico subject matter).
Terms: Accepts work on consignment (50% commission). Retail price set by artist. Customer discounts and payment by installments are available. Gallery provides insurance, promotion and contract; shipping costs are shared. Prefers artwork framed.
Submissions: Send query letter with résumé, slides, bio, and photographs. Portfolio review requested if interestedin artist's work. Files bio and photos.
Tips: Finds artists through word of mouth and artists' submissions.

MICHAEL McCORMICK GALLERY, 121 B. N. Plaza, Taos NM 87571. (505)758-1372. E-mail: sheilam@l aplaza.taos.nm.us. Assistant Director: Sheila Macdonald. Retail gallery. Estab. 1983. Represents 35 emerging and established artists. Provides 3 solo and 1 group show/year. Average display time 2-3 weeks. "Located in old county courthouse where movie 'Easy Rider' was filmed." Clientele: 90% private collectors, 10% corporate clients. Overall price range: $1,500-85,000; most work sold at $3,500-10,000.
Media: Considers oil, acrylic, watercolor, pastel, pen & ink, drawings, mixed media, collage, works on paper, sculpture, ceramic, craft, photography, woodcuts, wood engravings, linocuts, engravings, mezzotints, etchings, lithographs, pochoir, serigraphs and posters. Most frequently exhibits oil, pottery and sculpture/ stone.
Style: Exhibits impressionism, neo-expressionism, surrealism, primitivism, painterly abstraction, conceptualism and postmodern works. Genres include landscapes and figurative work. Interested in work that is "classically, romantically, poetically, musically modern." Prefers figurative work, lyrical impressionism and abstraction.
Terms: Accepts work on adjusted consignment (approximately 50% commission). Retail price set by gallery and artist. Customer discounts and payment by installment are available. Exclusive area representation required. Gallery provides promotion and contract; artist pays for shipping. Prefers artwork framed.
Submissions: Send query letter with résumé, brochure, slides, photographs, bio and SASE. Portfolio review requested if interested in artist's work. Replies in 4-7 weeks.
Tips: Finds artists usually through word of mouth and artists traveling through town. "Send a brief, concise introduction with several color photos. During this last year there seems to be more art and more artists but fewer sales. The quality is declining based on mad, frantic scramble to find something that will sell."

MAYANS GALLERIES, LTD., 601 Canyon Rd., Santa Fe NM 87501; also at Box 1884, Santa Fe NM 87504. (505)983-8068. Fax: (505)982-1999. Contact: Erica Terman. Retail gallery and art consultancy. Estab. 1977. Represents 10 emerging, mid-career and established artists. Sponsors 2 solo and 2 group shows/year. Average display time 1 month. Clientele: 70% private collectors, 30% corporate clients. Overall price range: $1,000 and up; most work sold at $3,000-10,000.
Media: Considers oil, acrylic, watercolor, pastel, pen & ink, drawings, mixed media, sculpture, photography and original handpulled prints. Most frequently exhibits oil, photography, and lithographs.
Style: Exhibits 20th century American and Latin American art. Genres include landscapes and figurative work. Interested in work "that takes risks and is from the soul."
Terms: Accepts work on consignment. Retail price set by gallery and artist. Exclusive area representation required. Shipping costs are shared.
Submissions: Send query letter, résumé, business card and SASE. Discourages the use of slides. Prefers 2 or 3 snapshots or color photocopies which are representative of body of work. Files résumé and business card.
Tips: "Currently seeking contemporary figurative work and still life with strong color and superb technique. Gallery space cannot accomodate very large work comfortably."

‡**NEW DIRECTIONS GALLERY**, 107-B N. Plaza, Taos NM 87571. Phone/fax: (505)758-2771. Director: Cecelia Torres or Assistant Director: Ann Emory. Retail gallery. Estab. 1988. Represents/exhibits 12 emerging, mid-career and established artists. Interested in seeing work of emerging artists. Exhibited artists include Maye Torres and Larry Bell. Sponsors 1-3 shows/year. Average display time 1 month. Open all year; Monday-Sunday, 10-5. Located in North Plaza; 1,100 sq. ft.. 25-33⅓% of space for special exhibitions; 66-75% of space for gallery artists. 100% private collectors. overall price range: $150-32,000. most work sold at $900-12,000.

Media: Considers all media except craft. Considers woodcut, etching, lithograph, serigraphs and posters. Most frequently exhibits mixed media/collage, acrylic or oil on canvas, sculpture-bronze.

Style: Exhibits expressionism, conceptualism, minimalism, hard-edge geometric abstraction, painterly abstraction and postmodern works. Prefers non-objective, highly stylized and expressive.

Terms: Artwork is accepted on consignment (40% commission). Retail price set by the artist. Gallery provides promotion. Prefers artwork framed.

Submissions: Accepts only artists from Taos. Call or come in to gallery for appointment to show portfolio of photographs. Replies in weeks. Files only "material I'm seriously considering."

Tips: "I'm always looking."

‡**NEW MILLENNIUM FINE ART**, (formerly 21st Century Fox), 217 W. Water, Santa Fe NM 87501. (505)983-2002. Owner: S.W. Fox. Retail gallery. Estab. 1980. Represents 12 mid-career artists. Exhibited artists include R.C. Gorman and T.C. Cannon. Sponsors 4 shows/year. Average display time 1 month. Open all year. Located 3 blocks from plaza; 3,000 sq. ft.; "one large room with 19′ ceilings." 20% of space for special exhibitions. Clientele: "urban collectors interested in Indian art." 90% private collectors; 10% corporate collectors.

Media: Considers oil, acrylic, watercolor, pastel, mixed media, sculpture, original handpulled prints, offset reproductions, woodcuts, lithographs, serigraphs and posters. Most frequently exhibits acrylic, woodblock prints and posters.

Style: Exhibits expressionism and impressionism. Genres include Southwestern.

Terms: Accepts artwork on consignment (40% commission). Retail price set by the gallery. Gallery provides insurance and promotion. Shipping costs are shared. Prefers artwork framed.

Submissions: Accepts only Native American artists from the Southwest. Send query letter with résumé, brochure, photographs and reviews. Write for appointment to show portfolio photographs. Replies in 2 weeks.

Tips: "We are only interested in art by American Indians; occasionally we take on a new landscapist."

ROSWELL MUSEUM AND ART CENTER, 100 W. 11th St., Roswell NM 88201. (505)624-6744. Fax: (505)624-6765. Director: William D. Ebie. Museum. Estab. 1937. Represents emerging, mid-career and established artists. Sponsors 12-14 shows/year. Average display time 2 months. Open all year; Monday-Saturday, 9-5; Sunday and holidays, 1-5. Closed Thanksgiving, Christmas and New Years Day. Located downtown; 25,000 sq. ft.; specializes in Southwest. 50% of space for special exhibitions; 50% of space for gallery artists.

Media: Considers all media and all types of prints but posters. Most frequently exhibits painting, prints and sculpture.

Style: Exhibits all styles. Prefers Southwestern but some non-SW for context.

Terms: Accepts work on consignment (20% commission). Retail price set by the artist. Gallery provides insurance, promotion and shipping costs to and from gallery. Prefers artwork framed.

Submissions: Accepts only artists from Southwest or SW genre. Send query letter with résumé, slides, bio, brochure, photographs, SASE and reviews. Write for appointment to show portfolio of photographs, slides and transparencies. Replies in 1 week. Files "all material not required to return."

Tips: Looks for "Southwest artists or artists consistently working in Southwest genre." Advice to artists: "Make an appointment well in advance. Be on time. Be prepared. Don't bring a truckload of paintings or sculpture. Have copies of résumé and transparencies for filing. Be patient. We're presently scheduling shows two years in advance."

‡**SHIDONI GALLERIES**, P.O. Box 250, Tesuque NM 87574. (505)988-8008. Fax: (505)984-8115. Owner: T. Kern Hicks. Retail galleries, art consultancy and sculpture garden. Estab. 1971. Clientele: 80% private collectors, 20% corporate clients. Represents 60-80 emerging, mid-career and established artists. Exhibited artists include Bill Weaver and Frank Morbillo. Sponsors 8 group shows/year. Average display time is 5 weeks. "Located 5 mi. north of Santa Fe; 5,000 sq. ft.; sculpture gardens are 8½ acres."Open all year; Monday-Saturday, 9-5 (winter); and Monday-Sunday (summer). Overall price range: $400-150,000; most artwork sold at $1,800-15,000.

Media: Considers all media primarily indoor and outdoor sculpture. Most frequently exhibits cast bronze, fabricated sculpture, oil paintings and prints.

Style: Exhibits all styles. Genres include wildlife and figurative work. "The ideal artwork is new, exciting, original, unpretentious and honest. We seek artists who are totally devoted to art, who display a deep passion for the process of making art and who are driven by a personal and spiritual need to satisfy an inventive

mind." Interested in seeing a full range of artworks. Sculpture: varies from classical-traditional to figurative and contemporary. 2-dimensional work: contemporary only.

Terms: Accepts work on consignment (50% commission on 2-dimensional work; 45% on 3-dimensional work). Retail price is set by artist. Exclusive area representation required. Gallery provides insurance, promotion and contract; artist pays for shipping. Prefers artwork framed.

Submissions: Prefers sculptors. Send query letter, résumé, slides, bio, photographs and SASE. Call to schedule an appointment to show a portfolio, which should include slides and transparencies, résumé, catalogs, clippings, dimensions and prices. Slides and résumés are filed in registry. "Please indicate your interest in leaving your slides and résumé in the registry." The most common mistakes artists make in presenting their work is failing to show up for an appointment, having inadequate or poor slides and apologizing for their work. Replies only if interested in 6 weeks.

Tips: Looks for "continuity, focus for subject matter."

New York

‡ALBANY CENTER GALLERIES, 23 Monroe St., Albany NY 12210. (518)462-4775. Fax: (518)426-0759. Director/Curator: Leslie Urbach. Nonprofit gallery. Estab. 1977. Represents/exhibits emerging, mid-career and established artists. May be interested in seeing work of emerging artists in the future. Presents 12 exhibitions of 6 weeks each year. Exhibited artists include Jeanette Fintz and Yokimo Shido. Selects 12 shows/year. Average display time 6 weeks. Located downtown; 9,000 sq. ft.; "excellent well lit space." 100% of space for gallery artists. Clientele: tourists, upscale, local community, students. 2% private collectors. Overall price range: $250-5,000; most work sold at $800-1,200.

Media: Considers all media and all types of prints except posters. Most frequently exhibits oil, sculpture and photography.

Style: Exhibits all styles. All genres. Prefers painterly abstraction, representational, sculpture and ceramics.

Terms: Artwork is accepted on consignment (30% commission). Retail price set by the artist. Gallery provides insurance, promotion, contract, reception and sales. Artist pays for shipping costs. Prefers artwork framed.

Submissions: Accepts only artists from within a 75 mile radius of Albany (the Mohawk-Hudson area). Send query letter with résumé, slides, reviews, bio and SASE. Call for appointment to show portfolio of photographs, slides and transparencies. Replies only if interested within 1 week. Files slides, résumés, etc.

Tips: Finds artists through visiting exhibitions, artists' submissions. "We're currently booked through 1996." Advice to artists: "Try."

AMERICA HOUSE, 466 Piermont Ave., Piermont NY 10968. (914)359-0106. President: Susanne Casal. Retail craft gallery. Estab. 1974. Represents 200 emerging, mid-career and established artists. Sponsors 4 shows/year. Average display time 3 months. Open all year; Tuesday-Saturday, 10:30-5:30; Sunday, 12:30-5:30. Located downtown; 1,100 sq. ft.; 1st floor of renovated house. 50% of space for special exhibitions; 50% of space for gallery artists.

Media: Considers mixed media, ceramics, fiber and glass. Most frequently displays jewelry, ceramics and glass.

Terms: Accepts work on consignment (50% commission) or buys outright for 50% of retail price (net 30 days). Retail price set by the artist. Gallery provides insurance, promotion and shipping costs from gallery; artist pays shipping costs to gallery. Prefers artwork framed.

Tips: Finds artists through visiting exhibitions, word of mouth, art publications and sourcebooks.

ANDERSON GALLERY, Martha Jackson Place, Buffalo NY 14214. (716)834-2579. Fax: (716)834-7789. Retail gallery. Estab. 1952. Exhibits emerging, mid-career and established artists. Exhibited artists include Antoni Tapies, Karel Appel. Presents 8-10 shows/year. Average display time 6 weeks. Open September-July; Thursday-Saturday, 10:30-5:30. Located University Heights; 65,000 sq. ft.; two floors, sculpture atrium; award-winning building. 100% of space for special exhibitions. 75% private collectors, 10% corporate collectors, 5% museums. Overall price range: $100-2,000,000.

Media: Considers oil, acrylic, watercolor, pastel, pen & ink, drawing, mixed media, collage, paper, sculpture, ceramics, installation, all types of prints but posters.

Style: Exhibits neo-expressionism, painterly abstraction, surrealism, conceptualism, minimalism, color field, postmodern works, photorealism, pattern painting, hard-edge geometric abstraction, realism and imagism.

Terms: Accepts work on consignment (commission varies). Retail price set by the gallery. Gallery provides insurance, some promotion and simple contract.

Submissions: Send September-February query letter with résumé, slides and SASE. Replies in 3 months.

‡BURCHFIELD-PENNEY ART CENTER, Buffalo State College, 1300 Elmwood Ave., Buffalo NY 14222. (716)878-6012. Director: Anthony Bannon. Nonprofit gallery. Estab. 1966. Interested in emerging, mid-career and established artists who have lived in western New York state. Sponsors solo and group shows.

Average display time 6-8 weeks. Clientele: urban and suburban adults, college students, corporate clients, all ages in touring groups.

Media: Considers all media, folk, craft and performance art, architecture and design.

Style: Exhibits contemporary, abstract, impressionism, primitivism, non-representational, photorealism, realism, neo-expressionism and post-pop works. Genres include figurative, landscape, floral. "We show both contemporary and historical work by western New York artists, Charles Burchfield and his contemporaries. The museum is not oriented toward sales."

Terms: Accepts work on craft consignment for gallery shop (50% commission). Retail price set by gallery and artist. Exclusive area representation not required. Gallery provides insurance, promotion and contract; shipping costs are shared.

Submissions: Send query letter, résumé, slides and photographs. Files biographical materials about artist, work, slides and photos, etc.

CENTRAL GALLERIES/J.B. FINE ARTS, INC., 420 Central Ave., Cedarhurst NY 11516. (516)569-5686. Fax: (516)569-7114. President: Jeff Beja. Retail gallery. Estab. 1985. Represents 25 emerging, mid-career and established artists. Exhibited artists include Robin Morris and Howard Behrens. Sponsors 2 shows/year. Average display time 1 month. Open all year. Located in Long Island, 5 minutes from JFK airport; 1,800 sq. ft. Clientele: 90% private collectors, 10% corporate collectors. Overall price range: $100-50,000; most work sold at $500-5,000.

Media: Considers oil, acrylic, watercolor, pastel, mixed media, sculpture, original handpulled prints, lithographs, wood engravings, serigraphs and etchings. Most frequently exhibits painting, sculpture and serigraphs.

Style: Exhibits all styles and genres.

Terms: Accepts work on consignment (50% commission). Exclusive area representation required. Retail price set by artist and gallery. Gallery provides insurance and promotion; artist pays for shipping. Prefers artwork framed.

Submissions: Send query letter with résumé, bio, brochure, photographs and SASE. Write for appointment to show portfolio of originals, photographs and transparencies. Replies in 2 weeks.

CEPA (CENTER FOR EXPLORATORY AND PERCEPTUAL ART), 4th Floor, 700 Main St., Buffalo NY 14202. Fax: (716)856-2720. E-mail: cepa@aol.com. Director/Curator: Robert Hirsch. Alternative space and nonprofit gallery. Interested in emerging, mid-career and established artists. Sponsors 5 solo and 1 group show/year. Average display time 4-6 weeks. Open fall, winter and spring. Clientele: artists, students, photographers and filmmakers. Prefers photographically related work.

Media: Installation, photography, film, mixed media, computer imaging and digital photography.

Style: Contemporary photography. "CEPA provides a context for understanding the aesthetic, cultural and political intersections of photo-related art as it is produced in our diverse society." Interested in seeing "conceptual, installation, documentary and abstract work."

Terms: Accepts work on consignment (25% commission).

Submissions: Call first regarding suitability for this gallery. Send query letter with résumé, slides, SASE, brochure, photographs, bio and artist statement. Call or write for appointment to show portfolio of slides and photographs. Replies in 6 weeks.

Tips: "It is a policy to keep slides and information in our file for indefinite periods. Grant writing procedures require us to project one and two years into the future. Provide a concise and clear statement to give staff an overview of your work."

CHAPMAN ART CENTER GALLERY, Cazenovia College, Cazenovia NY 13035. (315)655-9446. Fax: (315)655-2190. Director: John Aistars. Nonprofit gallery. Estab. 1978. Interested in emerging, mid-career and established artists. Sponsors 8-9 shows/year. Average display time is 3 weeks. Clientele: the greater Syracuse community. Overall price range: $50-3,000; most artwork sold at $100-200.

Media: Considers oil, acrylic, watercolor, pastel, pen & ink, drawings, sculpture, ceramic, fiber, photography, craft, mixed media, collage, glass and prints.

Style: Exhibits all styles. "Exhibitions are scheduled for a whole academic year at once. The selection of artists is made by a committee of the art faculty in early spring. The criteria in the selection process is to schedule a variety of exhibitions every year to represent different media and different stylistic approaches; other than that, our primary concern is quality. Artists are to submit to the committee by March 1 a set of slides or photographs and a résumé listing exhibitions and other professional activity."

Terms: Retail price set by artist. Exclusive area representation not required. Gallery provides insurance and promotion; works are usually not shipped.

Submissions: Send query letter, résumé, 10-12 slides or photographs.

Tips: A common mistake artists make in presenting their work is that the "overall quality is diluted by showing too many pieces. Call or write and we will mail you a statement of our gallery profiles."

JAMES COX GALLERY AT WOODSTOCK, 26 Elwyn Lane, Woodstock NY 12498. (914)679-7608. Fax: (914)679-7627. Retail gallery. Estab. 1990. Represents 60 mid-career and established artists. Exhibited artists include Richard Segalman, Mary Anna Goetz. Represents estates of 7 Woodstock artists including James

Chapin, Margery Ryerson and Winold Reiss. Sponsors 10 shows/year. Average display time 1 month. Open all year; Wednesday-Sunday, 11-6. 6,000 sq. ft.; elegantly restored Dutch barn (200 years-old). 50% of space for special exhibitions; 50% of space for gallery artists. Clientele: New York City and tourists, residents of 50 mile radius. 95% private collectors. Overall price range: $500-50,000; most work sold at $3,000-10,000.
Media: Considers oil, watercolor, pastel, drawing and sculpture. Considers "historic Woodstock, fine prints." Most frequently exhibits oil paintings, water colors, sculpture.
Style: Exhibits impressionism, realism and imagism. Genres include landscapes and figurative work. Prefers expressive or evocative realism, painterly landscapes and stylized figurative sculpture.
Terms: Accepts work on consignment (40% commission). Retail price set by the artist. Gallery provides promotion; artist pays shipping costs to and from gallery. Prefers artwork framed.
Submissions: Prefers only artists from New York region. Send query letter with résumé, slides, bio, brochure, photographs, SASE and business card. Replies in 3 months. Files material on artists for special, theme or group shows.
Tips: "Be sure to enclose SASE—be patient for response. Include information on present pricing structure."

DARUMA GALLERIES, 554 Central Ave., Cedarhurst NY 11516. (516)569-5221. Owner: Linda Tsuruoka. Retail gallery. Estab. 1980. Represents about 25-30 emerging and mid-career artists. Exhibited artists include Christine Amarger, Eng Tay, Dorothy Rice, Joseph Dawley, Seymour Rosenthal, Kamil Kubick and Nitza Flantz. Sponsors 2-3 shows/year. Average display time 1 month. Open all year. Located on the main street; 1,000 sq. ft. 100% private collectors. Overall price range: $150-5,000; most work sold at $250-1,000.
Media: Considers watercolor, pastel, pen & ink, drawings, mixed media, collage, woodcuts, linocuts, engravings, mezzotints, etchings, lithographs and serigraphs. Most frequently exhibits etchings, lithographs and woodcuts.
Style: Exhibits all styles and genres. Prefers scenic (not necessarily landscapes), figurative and Japanese woodblock prints. "I'm looking for beach, land and sea scapes; sailing; pleasure boats."
Terms: 33⅓% commission for originals; 50% for paper editions. Retail price set by the gallery (with input from the artist). Sometimes offers customer discounts and payment by installments. Artist pays for shipping to and from gallery. Prefers unframed artwork.
Submissions: Send query letter with résumé, bio and photographs. Call for appointment to show portfolio of originals and photographs. Replies "quickly." Files bios and photo examples.
Tips: Finds artists through agents, visiting exhibitions, word of mouth, various art publications and sourcebooks, artists' submissions/self-promotions and art collectors' referrals. "Bring good samples of your work and be prepared to be flexible with the time needed to develop new talent. Have a competent bio, presented in a professional way. Use good materials. Often artists have nice images but they put them on cheap, low quality paper which creases and soils easily. Also, I'd rather see work matted in acid free mats alone, rather than cheaply framed in old and broken frames."

THE FORUM GALLERY, 525 Falconer St., Jamestown NY 14701. (716)665-9107. Fax: (716)665-9110. E-mail: talleydr@jcc22.cc.sunyjcc.edu. Nonprofit college gallery. Estab. 1979. Represents 50 emerging, mid-career and established artists/year. Sponsors 5 shows/year. Average display time 6 weeks. Open during academic year; Tuesday-Saturday, 11-5; Thursday, 11-8. Located on campus of Jamestown Community College; 1,000 sq. ft.; white cube—good lighting. 100% of space for special exhibitions. Clientele: students, community members.
Media: Considers mixed media, sculpture, installation, photography. "Primarily interested in nontraditional ideas and approaches." Considers all types of prints. Most frequently exhibits photo-based works, installation oriented works and book works.
Style: Exhibits conceptualism, minimalism and postmodern works.
Terms: "We are not sales oriented, however, if someone is interested in purchasing a piece, we notify the artist and let the artist deal directly with the collector." Retail price set by the artist. Gallery provides insurance and promotion. "We do catalogs for most exhibitions." Gallery pays shipping costs from gallery; artist pays shipping costs to gallery.
Submissions: Send query letter with résumé, slides and SASE. Replies in 3-4 weeks. Files "anything the artist wishes us to retain."
Tips: Finds artists through visiting exhibitions, word of mouth. "We respond primarily to work that explores new directions in form and content."

How to Use Your **Artist's & Graphic Designer's Market** *offers suggestions for understanding and using the information in these listings. Read this and other articles in the front of this book for important business tips.*

‡**RENÉE FOTOUHI FINE ART**, 1612 Newtown Lane, East Hampton NY 11937. (516)324-8939. Fax: (516)324-8508. Director: Renée Fotouhi. Retail gallery. Estab. 1990. Represents/exhibits emerging, mid-career and established artists. Interested in seeing the work of emerging artists. Exhibited artists include Marc Wilson and Ellen Frank. Sponsors 6 shows/year. Average display time 6-8 weeks. Open April-January; Friday-Monday, 10-6. 3,000 sq. ft.; outdoor sculpture garden. 85% of space for special exhibitions; 20% of space for gallery artists.
Media: Considers all media and all types of prints. Most frequently exhibits oil, paper and sculpture.
Style: Exhibits all styles. Prefers landscapes.
Terms: Artwork is accepted on consignment and there is a commission. Retail price set by the gallery. Gallery provides insurance; shipping costs are shared.
Submissions: Send query letter with résumé, brochure, business card, slides, photographs, reviews, bio and SASE. Call for appointment to show portfolio of photographs, slides and transparencies. Replies in 1 month. Files all material unless return is requested.

‡**THE GALLERY AT HUNTER MOUNTAIN**, Rt. 23A, Ski Bowl Base Lodge, Hunter NY 12442. (518)263-4365. Fax: (518)263-3704. Gallery Manager: Peter James. Retail gallery and art consultancy. Estab. 1990. Represents/exhibits 275 emerging artists/year. Interested in seeing the work of emerging artists. Exhibited artists include Janusz Obst and Thomas Locker. Sponsors 12 shows/year. Average display time 1 month. Open all year; Wednesday-Monday, 9-4:30. Located at Base Lodge of Hunter Mountain Ski Bowl; 800 sq. ft. "We are the only art gallery in the world located at a ski resort and open year round." 40% of space for special exhibitions; 60% of space for gallery artists. Clientele: tourists, second home res. 90% private collectors, 10% corporate collectors. Overall price range: $100-7,000; most work sold at $100-500.
Media: Considera all media and all types of prints. Most frequently exhibits oil on canvas, pastel and acrylic on canvas/board.
Style: Exhibits expressionism, photorealism, realism and impressionism. Genres include landscapes, florals, wildlife, Americana, portraits and figurative work. Prefers landscape, figurative and wildlife.
Terms: Artwork is accepted on consignment and there is a 25% commission. Retail price set by the artist. Gallery provides promotion and shipping costs.
Submissions: Accepts only artists from Catskills and Mid-Hudson (Hudson Valley) Region. Send query letter with résumé and SASE. Call for appointment to show portfolio of photographs and slides. Replies in 6 weeks. Files résumé.
Tips: Finds artists through artists' submissions, referrals by other artists. "Please stop in to the gallery to see if our space and location meets the artist's needs before sending in a portfolio. Artist should live within a reasonable distance from gallery so that we may change work frequently."

‡**GALLERY EAST**, 257 Pantigo Rd., East Hampton NY 11937. (516)324-9393. Partner: Rosemary Terrible. Retail gallery. Emphasis is on realism—from photo realism to impressionism. Estab. 1975. Represents/exhibits emerging, mid-career and established artists. Represents 45 artists; exhibits 18 on-artist shows each year. Open Thursday-Monday, 12-6; Closed December 1-May 1. Located on main road; 1,600 sq. ft.; in an old home. 60% of space for special exhibitions; 40% of space for gallery artists. Clientele: upscale. 100% private collectors. Overall price range: $300-15,000; most work sold at $1,000.
Media: Considers fiber, glass, ceramics, installation, craft and photography. Does not consider prints. Most frequently exhibits oil, watercolor and pastel.
Style: Exhibits photorealism, primitivism, realism and impressionism. Genres include landscapes, Americana and architectural works. Prefers realism, photorealism and impressionism.
Terms: Artwork is accepted on consignment (40% commission). Retail price set by the artist. Gallery provides insurance and promotion. Artist pays for shipping costs. Prefers artwork framed.
Submissions: Send query letter with résumé, slides and bio. Call for appointment to show portfolio of actual work. Replies in weeks. Files bio.
Tips: Finds artists through referrals by other artists. "If possible visit the gallery."

GALLERY NORTH, 90 N. Country Rd., Setauket NY 11733. (516)751-2676. Director: Louise Kalin. Non-profit gallery. Estab. 1965. Exhibits the work of emerging, mid-career and established artists mainly from Long Island and New York City. 200 members. Sponsors 9 shows/year. Average display time 4-5 weeks. Open all year. Located in the suburbs, near the State University at Stony Brook; approximately 1,200 sq. ft.; "in a renovated Victorian house." 85% of space for special exhibitions. Clientele: university faculty and staff, Long Island collectors and tourists. Overall price range: $100-50,000; most work sold at $15-3,000.
Media: Considers all media and original handpulled prints, woodcuts, wood engravings, linocuts, engravings, mezzotints, etchings, lithographs and serigraphs. Does not consider installation. Most frequently exhibits paintings, prints and crafts, especially jewelry and ceramics.
Style: Exhibits all styles. Prefers realism, abstraction and expressionism and reasonable prices.
Terms: Accepts work on consignment (40% commission). Retail price set by gallery and artist. Sometimes offers customer discounts and payment by installment. Gallery provides insurance, promotion and contract; shipping costs are shared. Prefers well-framed artwork.

Submissions: Send query letter with résumé, slides, bio, SASE and reviews. Portfolio review requested if interested in artist's work. Portfolio should include originals, slides or photographs. Replies in 2-4 weeks. Files slides and résumés when considering work for exhibition.

Tips: Finds artists from other exhibitions, slides and referrals. "If possible the artist should visit to determine whether he would feel comfortable exhibiting here. A common mistake artists make is that slides are not fully labeled as to size medium, which end is up."

GREENHUT GALLERIES, Stuyvesant Plaza, Albany NY 12208. (518)482-1984. Fax: (518)482-0685. President: John Greenhut. Retail gallery and art consultancy. Estab. 1977. Represents 10-20 emerging, mid-career and established artists. Exhibited artists include Frederick Mershimer and John Stockwell. Sponsors 4 shows/year. Average display time 3 weeks. Open all year. Located "near uptown state university campus at beginning of Adirondack Northway"; 2,000-2,500 sq. ft. 25% of space for special exhibitions. Clientele: in banking, industry and health care. 2% private collectors, 50% corporate collectors. Overall price range: $60-20,000; most work sold at $400-2,000.

Media: Considers oil, acrylic, watercolor, pastel, mixed media, collage, paper, sculpture, ceramic, fiber, glass, original handpulled prints, woodcuts, engravings, lithographs, pochoir, wood engravings, mezzotints, linocuts, etchings, serigraphs and posters. Most frequently exhibits graphics, painting and sculpture. Edition sizes of multiples not to exceed 250.

Style: Exhibits expressionism, painterly abstraction, minimalism, color field, postmodern works, impressionism, realism, photorealism and all genres. Prefers landscapes, abstractions and florals.

Terms: Accepts artwork on consignment (50% commission); or buys outright for 50% of retail price (net 30 days). Retail price set by gallery. Gallery provides insurance and promotion; shipping costs are shared. Prefers artwork unframed.

Submissions: Send query letter with résumé, slides, photographs and bio. Call or write for appointment to show portfolio of originals and photographs. Replies in 1-3 months. Files materials of artists represented or previously sold.

Tips: "Try to visit the gallery first to see if we are compatible with you and your work."

GUILD HALL MUSEUM, 158 Main St., East Hampton NY 11937. (516)324-0806. Fax: (516)324-2722. Curator: Christina Mossaides Strassfield. Museum. Estab. 1931. Represents emerging, mid-career and established artists. Sponsors 6-10 shows/year. Average display time 6-8 weeks. Open all year; Wednesday-Sunday, 11-5. 500 running feet; features artists who live and work on Eastern Long Island. 85% of space for special exhibitions.

Media: Considers all media and all types of prints. Most frequently exhibits painting, prints and sculpture.

Style: Exhibits all styles, all genres.

Terms: Artwork is donated or purchased. Gallery provides insurance and promotion. Prefers artwork framed.

Submissions: Accepts only artists from Eastern Long Island. Send query letter with résumé, slides, bio, brochure, SASE and reviews. Write for appointment to show portfolio of originals and slides. Replies in 2 months.

HALLWALLS CONTEMPORARY ARTS CENTER, 2495 Main St., Suite 425, Buffalo NY 14214-2103. (716)835-7362. E-mail: hallwall@tmn.com. Alternative space. Estab. 1974. Exhibits the work of emerging artists. 600 members. Past exhibited artists include Heidi Kumao, Judith Jackson and Tom Huff. Sponsors 10 shows/year. Average display time 6 weeks. Open all year. Located in north Buffalo; "3 galleries, very flexible space." 100% of space for special exhibitions.

 • Hallwalls supports the creation and presentation of new work in the visual, media, performing and literary arts. The gallery looks for work which "challenges and extends the boundaries of various art forms."

Media: Considers all media.

Style: Exhibits all styles and genres. "Contemporary cutting edge work which challenges traditional cultural and aesthetic boundaries."

Terms: Retail price set by artist. Hallwalls takes a voluntary 15% commission on sales. Gallery provides insurance.

Submissions: Send query letter with résumé, slides, bio, brochure, photographs, SASE and reviews. Write for appointment to show portfolio of slides. Replies only if interested. Files slides, résumé, statement and proposals.

Tips: "Slides are constantly reviewed for consideration in group shows and solo installations by the staff curators and guest curators. It is recommended that artists leave slides on file for at least a year. We are showing more work by artists based in areas other than NYC and Buffalo."

LEATHERSTOCKING GALLERY, Pioneer Alley, P.O. Box 446, Cooperstown NY 13326. (607)547-5942. (Gallery) (607)547-8044 (Publicity). Publicity: Dorothy V. Smith. Retail nonprofit cooperative gallery. Estab. 1968. Represents emerging, mid-career and established artists. 55 members. Sponsors 1 show/year. Average display time 3 months. Open in the summer (mid-June to Labor Day); daily 11-5. Located downtown Coopers-

town; 300-400 sq. ft. 100% of space for gallery artists. Clientele: varied locals and tourists. 100% private collectors. Overall price range: $25-500; most work sold at $25-100.

Media: Considers oil, acrylic, watercolor, pastel, pen & ink, drawing, mixed media, collage, paper, sculpture, ceramics, craft, photography, handmade jewelry, woodcut, engraving, lithograph, wood engraving, mezzotint, serigraphs, linocut and etching. Most frequently exhibits watercolor, oil and crafts.

Style: Exhibits impressionism and realism, all genres. Prefers landscapes, florals and American decorative.

Terms: Co-op membership fee plus a donation of time (10% commission). Retail price set by the artist. Gallery provides insurance, promotion and contract; artist pays shipping costs from gallery if sent to buyer. Prefers artwork framed.

Submissions: Accepts only artists from Otsego County; over 18 years of age; member of Leatherstocking Brush & Palette Club. Replies in 2 weeks.

Tips: Finds artists through word of mouth locally; articles in local newspaper. "We are basicaly non-judgemental (unjuried). You just have to live in the area!"

OXFORD GALLERY, 267 Oxford St., Rochester NY 14607. (716)271-5885. Fax: (716)271-2570. Director: Judy Putman. Retail gallery. Estab. 1961. Represents 50 emerging, mid-career and established artists. Sponsors 10 shows/year. Average display time 1 month. Open all year. Located "on the edge of downtown; 1,000 sq. ft.; large gallery in a beautiful 1910 building." 50% of space for special exhibitions. Overall price range: $100-30,000; most work sold at $1,000-2,000.

Media: Considers oil, acrylic, watercolor, pastel, pen & ink, drawings, mixed media, collage, paper, sculpture, ceramic, fiber, installation, original handpulled prints, woodcuts, engravings, lithographs, wood engravings, mezzotints, serigraphs, linocuts and etchings.

Styles: All styles.

Terms: Accepts artwork on consignment (50% commission). Retail price set by gallery and artist. Gallery provides insurance, promotion and contract.

Submissions: Send query letter with résumé, slides, bio and SASE. Call for appointment to show portfolio of originals. Replies in 2-3 months. Files résumés, bios and brochures.

Tips: "Have professional slides done of your artwork."

PRINT CLUB OF ALBANY, 140 N. Pearl St., P.O. Box 6578, Albany NY 12206. (518)432-9514. President: Dr. Charles Semowich. Nonprofit gallery and museum. Estab. 1933. Exhibits the work of 70 emerging, mid-career and established artists. Sponsors 1 show/year. Average display time 6 weeks. Located in downtown arts district. "We currently have a small space and hold exhibitions in other locations." Clientele: varies. 90% private collectors, 10% corporate collectors.

Media: Considers original handpulled prints.

Style: Exhibits all styles and genres. "No reproductions."

Terms: Accepts work on consignment from members. Membership is open internationally. "We welcome donations (of artists' works) to the permanent collection." Retail price set by artist. Customer discounts and payment by installment are available. Gallery provides promotion. Artist pays for shipping. Prefers artwork framed.

Submissions: Prefers only prints. Send query letter. Write for appointment to show portfolio of slides. Replies in 1 week.

Tips: "We are a nonprofit organization of artists, collectors and others. Artist members exhibit without jury. We hold member shows and the Triannual National Open Competitive Exhibitions. We commission an artist for an annual print each year. Our shows are held in various locations. We are planning a museum (The Museum of Prints and Printmaking) and building. We also collect artists' papers, etc. for our library."

PYRAMID ARTS CENTER, 274 N. Goodman St., Rochester NY 14607. (716)461-2222. Fax: (716)461-2223. Director: Beth Bohling. Nonprofit gallery. Estab. 1977. Represents 475 emerging, mid-career and established artists/year. 500 members. Sponsors 50 shows/year. Average display time 2-6 weeks. Open 10 months. Business hours Tuesday-Friday, 12-5; gallery hours, Thursday-Saturday, 12-5; closed during July. Located in museum district of Rochester; 17,000 sq. ft.; features 5 gallery spaces, 1 shop, and 2 theater/performance spaces. 80% of space for special exhibitions. Clientele: artists, curators, collectors, dealers. 90% private collectors, 10% corporate collectors. Overall price range: $25-15,000; most work sold at $40-500.

● Gallery strives to create a forum for challenging, innovative ideas and works.

Media: Considers all media, video, film, dance, music, performance art, computer media; all types of prints including computer, photo lithography.

Style: Exhibits all styles, all genres.

Terms: During exhibition a 25% commission is taken on sold works; gallery shop sales are 40% for non-members and 25% for members. Retail price set by the artist. Gallery provides insurance, promotion and contract; shipping costs are shared, "depending upon exhibition, funding and contract." Prefers artwork framed.

Submissions: Includes regional national artists and alike in thematic solo/duo exhibitions. Send query letter with résumé and slides. Call for appointment to show portfolio of originals and slides. Replies only if

interested within 1 month. "We have a permanent artist archive for slides, bios, résumés and will keep slides in file if artist requests."

Tips: Finds artists through national and local calls for work, portfolio reviews and studio visits. "Present slides that clearly and accurately reflect your work. Label slides with name, title, medium and dimensions. Be sure to clarify intent and artistic endeavor. Proposals should simply state the artist's work. Documentation should be accompanied by clear, concise script."

RAVENSONG, 2132 Seneca St., Lawtons NY 14091. (716)337-3946. Owners: Judi and Ken Young. Retail gallery. Focus is on Native American artists of the Northeastern tribes. Estab. 1990. Represents 25-30 emerging, mid-career and established artists/year. Exhibited artists include Peter Jones, Ben Buffalo. Sponsors 10 shows/year. Average display time 1-5 months. Open all year; Wednesday-Sunday, noon-6; Monday-Tuesday, by appointment. Located 30 miles south of Buffalo, next to the Cattaraugus Indian Reservation; 1,000 sq. ft.; gallery is housed in the former Lawtons Railroad Hotel. 33% of space for special exhibitions; 33% of space for gallery artists. Clientele: collectors, tourists, galleries, local residents. 30% private collectors, 5% corporate collectors. Overall price range: $100-7,500; most work sold at $100-500.

Media: Considers all media including bone and antler carving, leather, silver, beadwork, all types of prints. Most frequently exhibits stone and ceramic sculpture, oil/acrylic paintings, pencil drawings, antler and bone carvings, mixed media.

Style: Exhibits all styles, all genres. Prefers traditional woodland Indian images, contemporary/statement pieces and traditional woodland crafts.

Terms: Accepts work on consignment (30% commission) or buys outright for 50% of retail price (net 30 days). Retail price set by the artist. Gallery provides promotion; shipping costs are shared. Prefers artwork framed.

Submissions: Accepts only artists with Native American tribal membership. Send query letter with résumé, bio, photographs, reviews, tribal affiliation and copy of certification. Call for appointment to show portfolio of photographs or slides. Replies in 2-4 weeks. Files résumé, bio, reviews, tribal certification copy.

Tips: Finds artists through shows, word of mouth, submissions.

‡RCCA: THE ARTS CENTER, 189 Second St., Troy NY 12180. (518)273-0552. Fax: (518)273-4591. Gallery Director: Tara Fracalossi. Nonprofit arts center. Estab. 1969. Represents/exhibits 12-15 emerging artists/year. Interested in seeing the work of emerging artists. Exhibited artists include Robin Tewes and Thomas Lail. Sponsors 6-8 shows/year. Average display time 4-6 weeks. Open all year; Monday-Sunday, 9-5. Located in historic district; 1,200 sq. ft.; moving to 40,000 sq. ft. renovated arts center in spring 1966. 100% of space for special exhibitions. Clientele: upscale, students, artists. 90% private collectors, 10% corporate collectors. Overall price range: $50-5,000; most work sold at $400-500.

Media: Considers all media, woodcut, wood engraving, linocut, engraving, mezzotint, etching and lithograph. Most frequently exhibits painting, sculpture and photography/installation.

Style: Exhibits neo-expressionism, painterly abstraction, all styles. Prefers contemporary images, conceptual work and post modern.

Terms: Artwork is accepted on consignment (25% commission). Retail price set by the gallery and the artist. Gallery provides insurance and promotion. Artist pays for shipping costs.

Submissions: Send query letter with SASE to receive information about annual call for slides. Submit work to call for slides. Portfolio should include slides. Replies in 1 month. Files slides and résumés in curated slide registry.

ROCKLAND CENTER FOR THE ARTS, 27 S. Greenbush Rd., West Nyack NY 10994. (914)358-0877. Executive Director: Julianne Ramos. Nonprofit gallery. Estab. 1972. Exhibits emerging, mid-career and established artists. 1,500 members. Sponsors 6 shows/year. Average display time 5 weeks. Open September-May. Located in suburban area; 2,000 sq. ft.; "contemporary space." 100% of space for special exhibitions. Clientele: 100% private collectors. Overall price range: $500-50,000; most artwork sold at $1,000-5,000.

Media: Considers oil, acrylic, watercolor, pastel, pen & ink, mixed media, sculpture, ceramic, fiber, glass and installation. Most frequently exhibits painting, sculpture and craft.

Style: Exhibits all styles and genres.

Terms: Accepts work on consignment (33% commission). Retail price set by artist. Gallery provides insurance, promotion and shipping costs to and from gallery. Prefers artwork framed.

Submissions: "Proposals accepted from curators only. No one-person shows. Artists should not apply directly." Replies in 2 weeks.

 A bullet introduces comments by the editor of Artist's & Graphic Designer's Market indicating special information about the listing.

Tips: "Artist may propose a curated show of three or more artists: curator may not exhibit. Request curatorial guidelines. Unfortunately for artists, the trend is toward very high commissions in commercial galleries. Nonprofits like us will continue to hold the line."

THE SCHOOLHOUSE GALLERIES, Owens Rd., Croton Falls NY 10519. (914)277-3461. Fax: (914)277-2269. Director: Lee Pope. Retail gallery. Estab. 1979. Represents 30 emerging and mid-career artists/year. Exhibited artists include Joseph Keiffer and Michelle Harvey. Average display time 1 month. Open all year; Tuesday-Sunday, 1-5. Located in a suburban community of New York City; 1,200 sq. ft.; 70% of space for special exhibitions; 30% of space for gallery artists. Clientele: residential, corporate, consultants. 50% private collectors, 50% corporate collectors. Overall price range: $75-6,000; most work sold at $350-2,000.
Media: Considers oil, acrylic, watercolor, pastel, pen & ink, drawing, mixed media, collage, paper, sculpture, ceramics, fiber and photography, all types of prints. Most frequently exhibits paintings, prints and sculpture.
Style: Exhibits expressionism, painterly abstraction, impressionism and realism. Genres include landscapes. Prefers impressionism and painterly abstraction.
Terms: Accepts work on consignment (40% commission). Retail price set by the artist. Gallery provides insurance and promotion; shipping costs are shared. Prefers artwork on paper, unframed.
Submissions: Send query letter with slides, photographs and SASE. Call for appointment to show portfolio of photographs and slides. Replies in 1 month. Files slides, bios if interested.
Tips: Finds artists through visiting exhibitions and referrals.

SCHWEINFURTH MEMORIAL ART CENTER, 205 Genesee St., Auburn NY 13021. (315)255-1553. Director: Susan Marteney. Museum. Estab. 1981. Represents emerging, mid-career and established artists. Sponsors 15 shows/year. Average display time 2 months. Open Tuesday-Friday, 12-5; Saturday, 10-5; Sunday, 1-5. Closed in January. Located on the outskirts of downtown; 7,000 sq. ft.; large open space with natural and artificial light.
Media: Considers all media, all types of prints.
Style: Exhibits all styles, all genres.
Terms: Retail price set by the artist. Gallery provides insurance and promotion; artist pays for shipping costs. Artwork must be framed and ready to hang.
Submissions: Accepts artists from central New York and across the nation. Send query letter with résumé, slides and SASE.

‡BJ SPOKE GALLERY, (formerly Northport/BJ Spoke Gallery), 299 Main St., Huntington NY 11743. (516)549-5106. President: Constance Wain-Schwartz. Membership Director: Phyllis Baron. Cooperative and nonprofit gallery. Estab. 1978. Exhibits the work of 24 emerging, mid-career and established artists. Exhibited artists include Betty Cranendonk and Irwin Traugot. Sponsors 2-3 invitationals and juried shows/year. Average display time 1 month. Open all year. "Located in center of town; 1,400 sq. ft.; flexible use of space— 3 separate gallery spaces." Generally, 66% of space for special exhibitions. Overall price range: $300-2,500; most work sold at $900-1,600. Artist is eligible for a 2-person show every 18 months. Entire membership has ability to exhibit work 11 months of the year.
 • Sponsors annual national juried show. Deadline December. Send SASE for prospectives.
Media: Considers all media except crafts, all types of printmaking. Most frequently exhibits paintings, prints and sculpture.
Style: Exhibits all styles and genres. Prefers painterly abstraction, realism and expressionism.
Terms: Co-op membership fee plus donation of time (25% commission). Monthly fee covers rent, other gallery expenses. Retail price set by artist. Payment by installment is available. Gallery provides promotion and publicity; artists pay for shipping. Prefers artwork framed; large format artwork can be tacked.
Submissions: For membership, send query letter with résumé, high-quality slides, bio, SASE and reviews. For national juried show send SASE for prospectus and deadline. Call or write for appointment to show portfolio of originals and slides. Files résumés; may retain slides for awhile if needed for upcoming exhibition.
Tips: "Send slides that represent depth and breadth in the exploration of a theme, subject or concept. They should represent a cohesive body of work."

‡HELENE TROSKY GALLERY, 26 Yarmouth Rd., Purchase NY 10577. (914)946-2464. Contact: Helene Trosky. Retail gallery, art consultancy, conservation, restoration and appraisal service. Estab. 1970. Represents/exhibits many emerging, mid-career and established artists. Exhibited artists include Sam Francis and Robert Arneson. Open spring, summer and fall by appointment. Located in suburbs. Clientele: upscale, local community. 80% private collectors, 20% corporate collectors. Overall price range: $300-30,000; most work sold at $5,000-10,000.
Media: Considers all media and all types of prints. Most frequently exhibits paintings, prints and sculpture.
Style: Exhibits all styles.
Terms: Retail price set by the gallery.

‡VISUAL STUDIES WORKSHOP GALLERY, 31 Prince St., Rochester NY 14607. (716)442-8676. Fax: (716)442-1992. Curator: James Wyman. Retail, rental and nonprofit gallery, museum and alternative space.

Estab. 1968. Represents 150 emerging, mid-career and established artists. Sponsors 15 shows/year. Average display time 10 weeks. Open all year. "Centrally located downtown; 4,000 sq. ft.; cathedral ceilings." 90% of space for special exhibitions. Overall price range: $350-5,000; most work sold at $500-1,000.
Media: Considers mixed media, collage, paper, installation, photography, video, bookmaking, original hand-pulled prints, litohographs and offset reproductions. Most frequently exhibits photography, video and "book arts."
Style: Exhibits all styles and genres.
Terms: Accepts artwork on consignment. Retail price set by the gallery and the artist. Gallery provides insurance, promotion and contract.
Submissions: Contact in person. Call or write for appointment to show portfolio. Files résumés.
Tips: "Be familiar with the overall programs of our workshop prior to submitting."

New York City

‡A.F.T.U./BILL HODGES GALLERY, 24 W. 57th St., 606, New York NY 10019. (212)333-2640. Fax: (212)333-2644. Owner/Director: Bill Hodges. Retail gallery. Estab. 1979. Represents/exhibits 10 emerging, mid-career and established artists/year. Exhibited artists include Romare Bearden and Norman Lewis. Sponsors 8 shows/year. Average display time 6 weeks. Open all year; Tuesday-Friday, 10-6; Saturday, 12-6. 1,000 sq. ft., 80% of space for gallery artists. Clientele: upscale. 60% private collectors, 20% corporate collectors. Overall price range: $2,000-90,000; most work sold at $5,000-40,000.
Media: Considers all media and all types of prints except posters. Most frequently exhibits works on canvas, sculpture and limited edition graphics.
Style: Exhibits color field, hard-edge geometric abstraction and painterly abstraction. Genres include landscapes, Americana and figurative work. Abstract abstract paintings on canvas, figurative work and landscape.
Terms: Artwork is accepted on consignment (50% commission), or artwork is bought outright for 30% of the retail price; net 30 days. Retail price set by the artist. Gallery provides insurance, promotion and contract; shipping costs are shared.
Submissions: Send query letter with slides and photographs. Write for appointment to show portfolio of photographs and slides. Replies in 3 weeks. Files material under consideration.
Tips: Finds artists through word of mouth and referrals by other artists. "Keep working."

‡A.I.R. GALLERY, 40 Wooster St., Floor 2, New York NY 10013-2229. (212)966-0799. Director: Alissa Schoenfeld. Cooperative nonprofit gallery, alternative space. To advance the status of women artists and provide a sense of community. Estab. 1972. Represents/exhibits emerging, mid-career and established women artists. 20 New York City members; 15 National Affiliates. Sponsors 15 shows/year. Average display time 3 weeks. Open all year except late summer; Tuesday-Saturday, 11-6. Located in SoHo; 1,600 sq. ft., 11'8" ceiling; the end of the gallery which faces theh street is entirely windows. 20% of space for special exhibitions; 80% of space for gallery artists. Clientele: art world professionals, students, local community, tourists. Overall price: $500-15,000; most work sold at $2,000-5,000.
Media: Considers all media and all types of prints.
Style: Exhibits all styles. All genres.
Terms: There is a co-op membership fee plus a donation of time. There is a 15% commission. Retail price set by the artist. Gallery provides limited promotion (i.e., Gallery Guide listing) and contract. Artist pays for shipping costs. Prefers artwork framed.
Submissions: Membership and exhibitions are open to women artists. Send query letter with résumé, slides and SASE. Replies in 2 months. Files no material unless an artist is put on the waiting list for membership.
Tips: Finds artists through word of mouth, referrals by other artists, suggestions by past and current members. "A.I.R. has both New York City members and members across the United States. We also show emerging artists in our Gallery II program which is open to all artists interested in a one-time exhibition. Please specify whether you are applying for membership, Gallery II or both."

‡AGORA GALLERY, 560 Broadway, New York NY 10012. (212)226-4151. Fax: (212)966-4380. Director: Grace Gabriel. Retail/wholesale gallery, artist agent. Estab. 1985. Represents 100 emerging and mid-career artists/year. Exhibited artists include Heydiri and Idzelis. Sponsors 12 artists/year. Average display time 1 month. Open all year; Tuesday-Saturday, 12-6. Located in Soho; 1,600 sq. ft. 100% of space for gallery artists. Clientele: corporations, private collectors. 50% private collectors, 50% corporate collectors. Overall price range: $200-10,000; most work sold at $500-4,000.
Media: Considers all media and all types of prints. Most frequently exhibits paintings, sculpture and prints.
Style: Exhibits all styles. Prefers abstract, figurative and landscapes.
Terms: Artwork is accepted on consignment (40% commission). There is representation fee for new artists or artists whose work has not sold in previous year. Retail price set by the gallery and the artist. Gallery provides insurance, promotion and contract. Artist pays shipping costs.
Submissions: Send query letter with résumé, slides, photographs, bio and SASE. Portfolio should include photographs or slides, résumé and SASE. Replies in 3 weeks. Files everything.

Tips: Finds artists through word of mouth, referrals by other artists, visiting art fairs and exhibitions, artists' submissions, ads in magazines.

‡**ALLEGED GALLERY**, 172 Ludlow St., New York NY 10002. (212)533-9322. Director: A. Rose. Retail gallery, alternative space. Estab. 1992. Represents/exhibits 6 stable/20-30 transient emerging artists/year Exhibited artists include Mark Gonzales and Thomas Campbell. Sponsors 12-15 shows/year. Average display time 3 weeks. Closed 2 months in summer; Wednesday-Friday, 6-midnight; Saturday, 3-midnight; Sunday, 2-8. 400 sq. ft.; storefront, large window exposure, "hip street." 25% of space for special exhibitions; 25% of space for gallery artists. Clientele: local community, students, music industry. 100% private collectors. Overall price range: $10-3,000; most work sold at $10-1,000.
Media: Considers all media and all types of prints. Most frequently exhibits painting (oil, latex, acrylic), photography and mixed media.
Style: Genres include portraits and figurative work. Prefers drawings, figurative and portrait photography.
Terms: Artwork is accepted on consignment (50% commission). Retail price set by the gallery and the artist. Gallery provides promotion and contract. Artist pays for shipping costs. Prefers artwork framed.
Submissions: Must be in 20s age group except for special cases. Send query letter with résumé, business card, photographs, reviews, bio and SASE. Write for appointment to show portfolio of photographs and transparencies. Replies only if interested within 1 month. If no reply, artist should call, but if SASE is enclosed the materials will be returned. Files slides, business card, only if interested.
Tips: "We have cultivated a strong network of artists nationwide and most of the artists shown at Alleged are chosen from this pool. I do show unsolicited work, but only about 5% of what I see—maybe less. We are very contemporary in our thinking and promotional techniques, and expect our artists to be the same— if you are stuck in the 1980s you need not apply." Advice to artists: "Do it yourself, organize your own shows in different locales and venues than galleries. A gallery of stature is much more likely to show you if you prove you are serious, and don't need a gallery to promote yourself."

‡**ART DIRECTORS CLUB GALLERY**, 250 Park Ave. S., New York NY 10003-1402. (212)674-0500. Fax: (212)460-8506. Executive Director: Myrna Davis. Nonprofit gallery. Exhibits groups in the field of visual communications (advertising, graphic design, publications, art schools). Estab. 1986. Exhibits emerging and professional work; 10-12 shows/year. Average display time 1-4 weeks. Closed August; Monday-Friday, 10-6. Located in Flatiron district; 3,500 sq. ft.; two galleries street level and lower level. 100% of space for special exhibitions. Clientele: professionals, students.
Media: Considers all media and all types of prints. Most frequently exhibits posters, printed matter, photos, paintings and 3-D objects.
Style: Genres include graphic design, publication and advertising design and illustration.
Terms: There is a rental fee for space or gallery invites groups to show.
Submissions: Submissions are through professional groups. Group rep should send reviews and printed work. Replies within a few months.

‡**ARTISTS SPACE**, 38 Greene St., 3rd Floor, New York NY 10013. (212)226-3970. Fax: (212)966-1434. Curator: Denise Fasanello. Nonprofit gallery, alternative space. Estab. 1973. Represents/exhibits emerging artists. Sponsors 4-5 shows/year. Average display time 6-8 weeks. Open Tuesday-Saturday, 10-6. Located in Soho; 5,000 sq. ft. 100% of space for special exhibitions.
Media: Considers all media.
Terms: "All curated shows selected by invitation." Gallery provides insurance and promotion.
Submissions: Send query letter with slides and SASE and application. Portfolio should include slides.

BILL BACE GALLERY, 39 Wooster St., New York NY 10013. (212)219-0959. Retail gallery. Estab. 1989. Represents 15 emerging, mid-career and established artists/year. Exhibited artists include Tom Doyle, Michael A. Smith. Sponsors 10 shows/year. Average display time 5 weeks. Open Tuesday-Saturday, 11-5. Closed in summer. Located in Soho; 2,500 sq. ft. 100% of space for special exhibitions. Clientele: private and corporate collectors. 50% private collectors, 50% corporate collectors. Overall price range: $500-50,000; most work sold at $1,000-5,000.
Media: Considers oil, sculpture, ceramics and photography. Most frequently exhibits sculpture and painting.
Style: Exhibits all styles, all genres.
Terms: Accepts work on consignment (50% commission). Retail price set by the gallery and the artist. Gallery provides promotion and contract; artist pays shipping costs to and from gallery. Prefers artwork framed.
Submissions: The gallery does not review unsolicited material.
Tips: "The gallery does not review unsolicited slides. The gallery works closely with the artists it represents and develops these relationships over a long period of time. Artists are invited to participate in the gallery by attending exhibitions, discussing same with gallery and after some time a working relationship may develop."

BLUE MOUNTAIN GALLERY, 121 Wooster St., New York NY 10012. (212)226-9402. Co-Directors: Helene Manzo and Marcia Clark. Artist-run cooperative gallery. Estab. 1980. Exhibits 27 mid-career artists. Sponsors 13 solo and 1 group shows/year. Display time is 3 weeks. "We are located on the second floor of a loft building in Soho. We share our floor with two other well-established cooperative galleries. Each space has white partitioning walls and an individual floor-plan." Clientele: art lovers, collectors and artists. 90% private collectors, 10% corporate clients. Overall price range: $100-8,000; most work sold at $100-4,000.
Media: Considers oil, acrylic, watercolor, pastel, pen & ink, drawings, mixed media, collage, paper, sculpture, installations, photography and original handpulled prints. Most frequently exhibits oil and watercolor.
Style: Exhibits feminist/political, impressionism, expressionism, neo-expressionism and realism. Genres include landscapes, figurative work and fantasy. "We like bold statements in imagery."
Terms: Co-op membership fee plus donation of time. Retail price set by artist. Exclusive area representation not required. Gallery provides insurance, some promotion and contract; artist pays for shipping.
Submissions: Send name and address with intent of interest. "We cannot be responsible for material return without SASE."
Tips: Finds artists through artists' submissions and referrals. "Qualities we look for are integrity and stability. The most common mistakes artists make in presenting their work are sending poor quality slides, not including a SASE, submitting too diverse a body of work, and not submitting recent work."

BRIDGEWATER/LUSTBERG GALLERY, 529 Broadway, New York NY 10012. (212)941-6355. Fax: (212)674-3650. Directors: Jamie Lustberg and Paul Bridgewater. Retail gallery. Estab. 1985. Represents 18 emerging and mid-career artists. Exhibited artists include Sean Earley and Steven Skollar. Sponsors 10 shows/year. Average display time 5 weeks. Closed August. Located in Soho; 1,200 sq. ft. 33% of space for special exhibitions. Clientele: international. 90% private collectors, 10% corporate collectors. Overall price range: $250-7,000; most work sold at $1,500-5,000.
Media: Considers oil, acrylic, watercolor, pen & ink, sculpture, photography, original handpulled prints, engravings, lithographs and etchings. Most frequently exhibits oil on canvas, sculpture and photography.
Style: Prefers figurative and narrative styles and landscapes.
Terms: Accepts artwork on consignment (50% commission). Retail price set by gallery and artist. Sometimes offers customer discounts and payment by installment. Gallery provides insurance and promotion; artist pays for shipping. Prefers artwork framed.
Submissions: Send query letter with SASE. Looks at slides 2-3 times a year. Call for dates. Files information applicable to future shows.
Tips: The most common mistake artists make in presenting their work is showing work "too diverse in style, often looking as if it is the work of two or three people."

BROOKLYN BOTANIC GARDEN—STEINHARDT CONSERVATORY GALLERY, 1000 Washington Ave., Brooklyn NY 11225. (718)622-4433, ext. 215. Fax: (718)622-7839. Director of Public Programs: Joanne Woodfin. Nonprofit botanic garden gallery. Estab. 1988. Represents emerging, mid-career and established artists. 20,000 members. Sponsors 8-10 shows/year. Average display time 4-6 weeks. Open all year; Tuesday-Sunday, 10-4. Located near Prospect Park and Brooklyn Museum; 1,200 sq. ft.; part of a botanic garden, gallery adjacent to the tropical, desert and temperate houses. Clientele: BBG members, tourists, collectors. 100% private collectors. Overall price range: $75-7,500; most work sold at $75-500.
Media: Considers all media and all types of prints. Most frequently exhibits watercolor and oil.
Style: Exhibits all styles. Genres include landscapes, florals and wildlife. Prefers florals.
Terms: Accepts work on consignment (20% commission). Retail price set by the artist. Gallery provides insurance, promotion and contract; artist pays shipping costs to and from gallery. Prefers artwork framed.
Submissions: Work must have botanical, horticultural or environmental theme. Send query letter with résumé, slides, bio, brochure, photographs, SASE, business card and reviews. Write for appointment to show portfolio of slides. Replies in 2 weeks. Files résumé.
Tips: "Artists' groups contact me by submitting résumé and slides of artists in their group. BBG has had only group shows in the last two years, because of city budget cuts in the exhibit department. Groups such as Flatbush Artists Association, Guild of National Science Illustrators, Women in the Arts, Penumbra, Brooklyn Watercolor Society contact us for group shows."

CERES, 584 Broadway, Room 306, New York NY 10012. (212)226-4725. Administrator: Tamara Damon. Women's cooperative and nonprofit, alternative gallery. Estab. 1984. Exhibits the work of emerging, mid-career and established artists. 45 members. Sponsors 11-14 shows/year. Average display time 1 month. Open all year; Tuesday-Saturday, 11-6. Located in Soho, between Houston and Prince Streets; 2,000 sq. ft. 30% of space for special exhibitions; 70% of space for gallery artists. Clientele: artists, collectors, tourists. 85% private collectors, 15% corporate collectors. Overall price range, $300-10,000; most work sold at $350-1,200.
Media: All media considered.
Style: All genres. "Work concerning politics of women and women's issues; although *all* work will be considered, still strictly women's co-op."

Terms: Co-op membership fee plus donation of time. Retail price set by artist. Gallery provides insurance; artists pays for shipping.
Submissions: Prefers women from tri-state area; "men may show in group/curated shows." Write with SASE for application. Replies in 1-3 weeks.

EUGENIA CUCALON GALLERY, 145 E. 72nd St., New York NY 10021 Phone/fax: (212)472-8741. Gallery Director: Eugenia Cucalon. Retail/wholesale gallery. Estab. 1977. Represents 4 emerging, mid-career and established artists/year. Exhibited artists include Waldo Balart, Bill Beckley, Joselyn Carvalho. Sponsors 5-6 shows/year. Average display time 4-6 weeks. Open all year; Tuesday-Saturday, 12-6; closed during August and holidays. Located uptown East Side; 1,000 sq. ft.
Media: Considers oil, acrylic, watercolor, pastel, pen & ink, drawing, mixed media, collage, paper, sculpture, ceramics, installation, photography, woodcut, lithograph, wood engraving, mezzotint, serigraphs, etching and posters. Most frequently exhibits oil on canvas and works on paper.
Style: Exhibits painterly abstraction, surrealism, conceptualism, minimalism, color field, postmodern works, hard-edge geometric abstraction, realism and imagism. Prefers modern, abstraction and semi-figurative.
Terms: Accepts work on consignment (50% commission) or buys outright for 50% of retail price. Retail price set by the gallery and the artist. Gallery provides insurance, promotion and contract; shipping costs are shared. Prefers artwork framed.
Submissions: Send query letter with résumé, slides and business card. Write for appointment to show portfolio of slides. Replies only if interested. Files slides and résumés.
Tips: Finds artists through word of mouth, publications and sourcebooks, artists' submissions.

‡THE ARTHUR DANZIGER GALLERY, 96 Spring St., 5th Floor, New York NY 10012. (212)941-7383. Fax: (212)941-7328. Director: Arthur Danziger. Retail gallery. Estab. 1993. Represents/exhibits 6 emerging and mid-career artists/year. Exhibited artists include William Scarborough. Sponsors 8 shows/year. Average display time 1 month. Open all year; Monday-Saturday, 10-6. Located in Soho; 6,000 sq. ft.
Media: Considers all media and all types of prints. Most frequently exhibits sculpture, painting and drawings.
Style: Exhibits all styles. All genres.
Terms: Artwork is accepted on consignment and there is a 50% commission. Retail price set by the gallery. Gallery provides insurance, promotion and contract. Shipping costs are shared. Prefers artwork framed.
Submissions: Send query letter with résumé and slides. Write for appointment to show portfolio of photographs and slides. Replies only if interested within 1 month. Files slides.
Tips: Finds artists through referrals and artists' submissions.

‡AMOS ENO GALLERY, 594 Broadway, Suite 404, New York NY 10012. (212)226-5342. Director: Anne Yearsley. Nonprofit and cooperative gallery. Estab. 1973. Exhibits the work of 34 mid-career artists. Sponsors 16 shows/year. Average display time 3 weeks. Open all year. Located in Soho; about 1,000 sq. ft.; "excellent location."
Media: Considers oil, acrylic, watercolor, pastel, pen & ink, drawings, mixed media, collage, works on paper, sculpture, fiber, glass, installation and photography.
Style: Exhibits a range of styles. Not interested in genre art.
Terms: Co-op membership fee (20% commission). Retail price set by the gallery and the artist. Artist pays for shipping.
Submissions: Send query letter with SASE for membership information.

STEPHEN E. FEINMAN FINE ARTS LTD., 448 Broome St., New York NY 10012. (212)925-1313. Contact: S.E. Feinman. Retail/wholesale gallery. Estab. 1972. Represents 20 emerging, mid-career and established artists/year. Exhibited artists include Mikio Watanabe, Johnny Friedlaender, Andre Masson. Sponsors 4 shows/year. Average display time 10 days. Open all year; Monday-Sunday, 12-6. Located in Soho; 1,000 sq. ft. 100% of space for gallery artists. Clientele: prosperous middle-aged professionals. 90% private collectors, 10% corporate collectors. Overall price range, $300-20,000; most work sold at $1,000-2,500.
Media: Considers oil, acrylic, watercolor, pastel, pen & ink, drawing, mixed media, sculpture, woodcut, engraving, lithograph, mezzotint, serigraphs, linocut and etching. Most frequently exhibits mezzotints, aquatints and oils. Looking for artists that tend toward abstract-expressionists, (watercolor/oil or acrylic) in varying sizes.
Style: Exhibits painterly abstraction and surrealism, all genres. Prefers abstract, figurative and surrealist.
Terms: Buys outright for % of retail price (net 90-120 days). Retail price set by the gallery. Gallery provides insurance, promotion, contract and shipping costs from gallery; artist pays shipping costs to gallery. Prefers artwork unframed.
Submissions: Send query letter with résumé, slides and photographs. Replies in 2-3 weeks.
Tips: Currently seeking artists of quality who (1) see a humorous bent in their works (sardonic, ironic), (2) are not pretensious. "Artists who show a confusing presentation drive me wild. Artists should remember that dealers and galleries are not critics. They are merchants who try to seduce their clients with aesthetics. Artists who have a chip on their shoulder or an 'attitude' are self-defeating. A sense of humor helps!!"

FIRST PEOPLES GALLERY, 114 Spring St., New York NY 10012. (212)343-0166. Fax: (212)343-0167. E-mail: indianart@mcimail.com. Director: Victoria Torrez. Retail gallery. Estab. 1992. Represents 60 mid-career and established artists/year. Interested in seeing the work of emerging artists. Exhibited artists include Ray Tracey, Dan Lomahaftewa, Mirac Creeping Bear and Raymond Nordwall. Sponsors 5 shows/year. Average display time 6 weeks. Open all year; Tuesday-Sunday, 11-6. Located in the Soho area of New York City; 2,500 sq. ft. upstairs, 2,000 sq. ft. downstairs; the gallery is in historical area of New York City, turn of century loft, brick building. 60% of space for special exhibitions; 40% of space for gallery artists. Clientele: collectors, walk-in traffic, tourists. 30% private collectors, 10% corporate collectors. Overall price range: $100-1,000 (40%), $1,000-15,000 (10%); most work sold at $3,000 (50%).
Media: Considers oil, acrylic, watercolor, pastel, pen & ink, mixed media, sculpture, pottery (coiled, traditional style only), lithograph, serigraphs and posters. Most frequently exhibits oil and acrylic, Northwest woodcarvings, pottery.
Style: Exhibits expressionism, painterly abstraction and realism. Genres includes Southwestern, portraits and figurative work. Prefers expressionism, painterly abstraction and realism.
Terms: Accepts work on consignment (40-50% commission) or buys outright for 50% of retail price (net 30 days). Retail price set by the gallery and the artist. Gallery provides insurance, promotion and contract; artist pays shipping costs to gallery. Prefers artwork framed in wood.
Submissions: Accepts only artists native to North America. Send query letter with résumé, slides, bio, brochure, price list, list of exhibitions, business card and reviews. Call for appointment to show portfolio. Replies in 3-4 weeks. Replies if interested within 1 week. Files entire portfolio.
Tips: Finds artists through exhibits, submissions, publications and Indian markets.

FOCAL POINT GALLERY, 321 City Island, Bronx NY 10464. (718)885-1403. Artist/Director: Ron Terner. Retail gallery and alternative space. Estab. 1974. Interested in emerging and mid-career artists. Sponsors 2 solo and 6 group shows/year. Average display time 3-4 weeks. Clientele: locals and tourists. Overall price range: $175-750; most work sold at $300-500.
Media: Most frequently exhibits photography. Will exhibit painting and etching and other material by local artists only.
Style: Exhibits all styles and genres. Prefers figurative work, landscapes, portraits and abstracts. Open to any use of photography.
Terms: Accepts work on consignment (30% commission). Exclusive area representation required. Customer discounts and payment by installment are available. Gallery provides promotion. Prefers artwork framed.
Submissions: "Please call for submission information."
Tips: "Do not include résumés. The work should stand by itself. Slides should be of high quality."

GALLERY HENOCH, 80 Wooster, New York NY 10012. (212)966-6360. Director: George Henoch Shechtman. Retail gallery. Estab. 1983. Represents 40 emerging and mid-career artists. Exhibited artists include Daniel Greene and Max Ferguson. Sponsors 10 shows/year. Average display time 3 weeks. Closed August. Located in Soho; 4,000 sq. ft. 50% of space for special exhibitions. Clientele: 90% private collectors, 10% corporate clients. Overall price range: $3,000-40,000; most work sold at $10,000-20,000.
Media: Considers oil, acrylic, watercolor, pastel, pen & ink, drawings, and sculpture. Most frequently exhibits painting, sculpture, drawings and watercolor.
Style: Exhibits photorealism and realism. Genres include landscapes and figurative work. Prefers landscapes, cityscapes and still lifes.
Terms: Accepts work on consignment (50% commission). Retail price set by gallery. Gallery provides insurance and promotion; shipping costs are shared. Prefers artwork framed.
Submissions: Send query letter with slides, bio and SASE. Portfolio should include slides and transparencies. Replies in 3 weeks.
Tips: "We suggest artists be familiar with the kind of work we show and be sure their work fits in with our styles."

GALLERY JUNO, 568 Broadway, Suite 604B, New York NY 10012. (212)431-1515. Fax: (212)431-1583. Gallery Manager: Gary Timmons. Retail gallery, art consultancy. Estab. 1992. Represents 18 emerging artists/year. Exhibited artists include Pierre Jacquemon, Kenneth McIndoe and Otto Mjaanes. Sponsors 12 shows/year. Average display time 6 weeks. Open all year; Monday-Friday, 10-6; Saturday, 11-6. Located in Soho; 1,000 sq. ft.; small, intimate space. 50% of space for special exhibitions; 50% of space for gallery artists. Clientele: corporations, private, design. 20% private collectors, 80% corporate collectors. Overall price range: $600-5,000; most work sold at $2,000-5,000.
Media: Considers oil, acrylic, watercolor, pastel, pen & ink, drawing, sculpture, ceramics, glass, mixed media and photography. Most frequently exhibits painting, sculpture and prints.
Style: Exhibits expressionism, neo-expressionism, painterly abstraction, conceptualism, minimalism, color field, pattern painting and hard-edge geometric abstraction. Genres include landscapes. Prefers contemporary modernism, abstraction and color field.
Terms: Accepts work on consignment (50% commission). Retail price set by the gallery and the artist. Gallery provides insurance and promotion; artist pays shipping costs. Prefers artwork framed.

Submissions: Send query letter with résumé, slides, bio, photographs, SASE, business card and reviews. Write for appointment to show portfolio of originals, photographs and slides. Replies in 3 weeks. Files slides, bio, photos, résumé.
Tips: Finds artists through visiting exhibitions, word of mouth and submissions.

GALLERY 10, 7 Greenwich Ave., New York NY 10014. (212)206-1058. Director: Marcia Lee Smith. Retail gallery. Estab. 1972. Open all year. Represents approximately 150 emerging and established artists. Clientele: 100% private collectors. Overall price range: $24-1,000; most work sold at $50-300.
Media: Considers ceramic, craft, glass, wood, metal and jewelry.
Style: "The gallery specializes in contemporary American crafts."
Terms: Accepts work on consignment (50% commission); or buys outright for 50% of retail price (net 30 days). Retail price set by gallery and artist.
Submissions: Call or write for appointment to show portfolio of originals, slides, transparencies or photographs.

O.K. HARRIS WORKS OF ART, 383 W. Broadway, New York NY 10012. Director: Ivan C. Karp. Commercial exhibition gallery. Estab. 1969. Represents 55 emerging, mid-career and established artists. Sponsors 50 solo shows/year. Average display time 3 weeks. Open fall, winter, spring and early summer. "Four separate galleries for 4 separate one-person exhibitions. The back room features selected gallery artists which also change each month." Clientele: 90% private collectors, 10% corporate clients. Overall price range: $50-250,000; most work sold at $12,500-100,000.
Media: Considers all media. Most frequently exhibits painting, sculpture and photography.
Style: Exhibits realism, photorealism, minimalism, abstraction, conceptualism, photography and collectibles. Genres include landscapes, Americana but little figurative work. "The gallery's main concern is to show the most significant artwork of our time. In its choice of works to exhibit, it demonstrates no prejudice as to style or materials employed. Its criteria demands originality of concept and maturity of technique. It believes that its exhibitions over the years have proven the soundness of its judgment in identifying important artists and its pertinent contribution to the visual arts culture."
Terms: Accepts work on consignment (50% commission). Retail price set by gallery. Customer discounts and payment by installment are available. Exclusive area representation required. Gallery provides insurance and limited promotion. Prefers artwork ready to exhibit.
Submissions: Send query letter with slides "labeled with size, medium, top, etc." and SASE. Replies in 1 week.
Tips: "We strongly suggest the artist be familiar with the gallery's exhibitions, and the kind of work we prefer to show. Always include SASE." Common mistakes artists make in presenting their work are "poor, unmarked photos (size, material, etc.), submissions without return envelope, utterly inappropriate work. We affiliate about one out of 10,000 applicants."

PAT HEARN GALLERY, 530 W. 22nd St., New York NY 10011. (212)727-7366. Fax: (212)727-7467. Retail gallery. Estab. 1983. Represents 8-10 emerging, mid-career and established artists/year. Exhibited artists include Mary Hellman, Renée Green. Sponsors 7 shows/year. Average display time 5-6 weeks. Open all year; Wednesday-Sunday, 11-6. Located Chelsea; 2,500 sq. ft.; natural light, clean uninterrupted space. Generally 100% of space for gallery artists. Clientele: all types. 95% private collectors, 5% corporate collectors. Overall price range: $1,000-40,000; most work sold at $6,000-18,000.
Media: Considers all media including video and all types of prints.
Style: Exhibits expressionism, conceptualism, minimalism, color field, postmodern works and video, text, all genres.
Terms: Accepts work on consignment (50% commission). Retail price set by the gallery and the artist. Gallery provides promotion; shipping costs are shared ("this varies").
Submissions: Send query letter with slides and SASE. Portfolio should include slides. Replies in 1-2 months. Files bio only if interested.
Tips: Finds artists through visiting exhibitions, word of mouth.

‡HELLER GALLERY, 71 Greene St., New York NY 10012. (212)966-5948. Fax: (212)966-5956. Director: Douglas Heller. Retail gallery. Estab. 1973. Represents/exhibits emerging, mid-career and established artists. Exhibited artists include Bertil Vallien and Robin Grebe. Sponsors 11 shows/year. Average display time 3 weeks. Open all year; Tuesday-Saturday, 11-6; Sunday, 12-5. Located in Soho; 4,000 sq. ft.; classic Soho Cast Iron landmark building. 65% of space for special exhibitions; 35% of space for gallery artists. Clientele: serious private collectors and museums. 80% private collectors, 10% corporate collectors and 10% museum collectors. Overall price range: $1,000-35,000; most work sold at $3,000-10,000.
Media: Considers glass sculpture. Most frequently exhibits glass, glass and mixed media.
Style: Prefers geometric abstraction and figurative.
Terms: Artwork is accepted on consignment (50% commission). Retail price set by the artist. Gallery provides insurance and limited promotion; shipping costs are shared.

Submission: Send query letter with résumé, slides, photographs, reviews, bio and SASE. Call or write for appointment to show portfolio of photographs, slides and résumé. Replies in 2-4 weeks. Files information on artists represented by the gallery.

Tips: Finds artists through word of mouth, referrals by other artists, visiting art fairs and exhibitions, artists' submissions.

‡JEANETTE HENDLER, 55 E. 87th St., Suite 15E, New York NY 10128. (212)860-2555. Fax: (212)360-6492. Art consultancy. Represents/exhibits mid-career and established artists. Exhibited artists include Warhol, Dubuffet, Haring. Open all year by appointment. Located uptown. 50% private collectors, 50% corporate collectors.

Media: Considers oil and acrylic. Most frequently exhibits oils, acrylics and mixed media.

Style: Exhibits all styles. Genres include landscapes, florals, figurative and Latin. Prefers realism, classical, neo classical, pre Raphaelite, still lifes and florals.

Terms: Artwork is accpeted on consignment and there is a commission. Retail price set by the gallery and the artist. Gallery provides insurance, promotion and contract.

Submissions: Send query letter with résumé and slides. Portfolio should include photographs, slides, transparencies or photocopies.

Tips: Finds artists through word of mouth, referrals by other artists, visiting art fairs and exhibitions, artists' submissions.

IMAGES, 580 Broadway, New York NY 10012. (212)219-8484. Fax: (212)219-9144. Contact: Gallery Director. Retail gallery, art consultancy. Estab. 1980. Represents 10 mid-career and established artists/year. Exhibited artists include George Anthonisen, Yale Epstein, Susan Klebanoff, Alan Spanier and Jolyon Hofsted. Sponsors 8 shows/year. Average display time 6 weeks. Open all year; Tuesday-Saturday, 12-5. Located in Soho, gallery district; 1,200 sq. ft.; in historic landmark building. 70% of space for special exhibitions; 30% of space for gallery artists. Clientele: corporate, institutional, retail. 25% private collectors, 75% corporate collectors. Overall price range: $2,000-20,000.

Media: Considers all media except installation and photography, all types of prints. Most frequently exhibits oil painting, lithograph/serigraph, sculpture/tapestry.

Style: Exhibits painterly abstraction, impressionism, photorealism and realism. Genres include landscapes, florals, Americana and figurative work. Prefers color realism, expressionist landscape and figurative sculpture.

Terms: Accepts work on consignment (50% commission). Retail price set by the artist. Gallery provides insurance, promotion and contract; artist pays shipping costs to and from gallery. Prefers artwork framed.

Submissions: Send query letter with résumé, slides ("2-3 slides for our permanent file, not to be returned"), brochure and business card. Replies only if interested within 2 months. Files slides, résumés.

‡MICHAEL INGBAR GALLERY OF ARCHITECTURAL ART, 568 Broadway, New York NY 10012. (212)334-1100. Curator: Millicent Hathaway. Retail gallery. Estab. 1977. Represents 45 emerging, mid-career and established artists. Exhibited artists include Richard Haas and Judith Turner. Sponsors 5 shows/year. Average display time 2 months. Open all year; Tuesday-Saturday, 12-6. Located in Soho; 1,000 sq. ft. 60% private collectors, 40% corporate clients. Overall price range: $500-10,000; most work sold at $3,000.

Media: Considers all media and all types of prints. Most frequently exhibits paintings, works on paper and sculpture.

Style: Exhibits photorealism, realism and impressionism. Prefers New York City buildings, New York City structures (bridges, etc.) and New York City cityscapes.

Terms: Artwork accepted on consignment (50% commission). Artists pays shipping costs.

Submissions: Accepts artists preferably from New York City Metro area. Send query letter with SASE. Call for appointment to show portfolio of slides. Replies in 1-2 weeks.

Tips: The most common mistakes artists make in presenting their work are "coming in person, constantly calling, poor slide quality (or unmarked slides)."

‡THE JEWISH MUSEUM, 1109 Fifth Ave., New York NY 10128. (212)423-3200. Fax: (212)423-3232. Curator of Collections: Norman Kleeblatt. Museum. Estab. 1904. Represents/exhibits emerging, mid-career and established artists. Sponsors 4 songs. Average display time 4 months. Open all year; Sunday-Thursday, 11-5:45; Tuesday, 11-8; Friday, 11-3; closed Friday and Saturday. Located in Manhattan; 20,000 sq. ft. 50% of space for special exhibitions.

Media: Considers all media and all types of prints.

Submissions: Send query letter with résumé, slides, photographs, reviews and bio. Write for appointment.

STUART LEVY FINE ARTS, 588 Broadway, Suite 303, New York NY 10012. (212)941-0009. Fax: (212)941-7987. Retail gallery. Represents emerging, mid-career and established artists. Exhibited artists include Osmo Rauhula, Miro Svolik. Sponsors 6-8 shows/year. Average display time 2 months. Open all year; 10-6 daily. Located downtown; 3,000 sq. ft.

Media: Considers all media including photography.
Style: Exhibits neo-expressionism, primitivism, surrealism and conceptualism. Genres include landscapes.
Terms: Accepts work on consignment (50% commission). Retail price set by the gallery and the artist. Gallery provides insurance and promotion.
Submissions: Send query letter with résumé, slides, bio, reviews and SASE. Write for appointment to show portfolio of photographs, slides, transparencies, bio, press clippings. Replies in 2 weeks.
Tips: Finds artists through recommendations, artists' submissions, etc.

‡BRUCE R. LEWIN GALLERY, 136 Prince St., New York NY 10012. (212)431-4750. Fax: (212)431-5012. Director: Bruce R. Lewin. Retail gallery. Estab. 1992. Represents/exhibits 30 emerging, mid-career and established artists/year. Exhibited artists include Linda Bacon and Hal Brooks. Sponsors 20 shows/year. Average display time 3-4 weeks. Open all year; Tuesday-Saturday, 10-6. Located in Soho; 7,500 sq. ft.; high ceilings; 40 ft. walls; dramatic architecture. 100% of space for gallery artists. Clientele: upscale. 80% private collectors, 20% corporate collectors. Overall price range: $500-500,000; most work sold at $5,000-100,000.
Media: Considers all media. Most frequently exhibits paintings, watercolors and sculpture.
Style: Exhibits photorealism, color field and realism. Genres include figurative work.
Terms: Artwork is accepted on consignment (50% commission). Retail price set by the gallery. Gallery provides insurance and promotion; shipping costs are shared. Prefers artwork framed.
Submissions: Send query letter with slides. Portfolio should include slides or transparencies. Replies only if interested within 1 week.
Tips: Finds artists through word of mouth and submission of slides.

THE JOE & EMILY LOWE ART GALLERY AT HUDSON GUILD, (formerly Hudson Guild Art Gallery), 441 W. 26th St., New York NY 10001. (212)760-9812. Director: Jim Furlong. Nonprofit gallery. Estab. 1948. Represents emerging, mid-career and established artists. Sponsors 8 shows/year. Average display time 1 month. Open all year. Located in West Chelsea; 1,200 sq. ft.; a community center gallery in a New York City neighborhood. 100% of space for special exhibitions. Clientele: 100% private collectors.
Media: Considers oil, acrylic, watercolor, pastel, pen & ink, drawings, mixed media, collage, paper, sculpture, original handpulled prints, woodcuts, wood engravings, linocuts, engravings, mezzotints, etchings, lithographs, pochoir and serigraphs. Most frequently exhibits paintings, sculpture and graphics. Looking for artist to do an environmental "installation."
Style: Exhibits all styles and genres.
Terms: Accepts work on consignment (20% commission). Retail price set by artist. Sometimes offers payment by installments. Gallery provides insurance; artist pays for shipping. Prefers artwork framed.
Submissions: Send query letter, résumé, slides, bio and SASE. Portfolio should include photographs and slides. Replies in 1 month.
Tips: Finds artists through visiting exhibitions, word of mouth, various art publications and sourcebooks, artists' submissions/self-promotions, art collectors' referrals.

MALLET FINE ART LTD., 141 Prince St., New York NY 10012. (212)477-8291. Fax: (212)673-1051. President: Jacques Mallet. Retail gallery, art consultancy. Estab. 1982. Represents 3 emerging and established artists/year. Exhibited artists include Sonntag, Ouattara. Sponsors 1 show/year. Average display time 3 months. Open fall and spring; Tuesday-Saturday, 11-6. Located in Soho; 2,000 sq. ft. 50% of space for special exhibitions; 50% of space for gallery artists. Clientele: private and art dealers, museums. 80% private collectors. Overall price range: $2,000-5,000,000; most work sold at $40,000-400,000.
Media: Considers oil, acrylic, watercolor, pastel, pen & ink, drawing, mixed media, collage, paper, sculpture, engraving, lithograph and etching. Most frequently exhibits oil, works on paper and sculpture.
Style: Exhibits expressionism, surrealism, all styles and impressionism.
Terms: Accepts work on consignment (20% commission) or buys outright for 50% of retail price (net 30 days). Retail price set by the gallery. Gallery provides insurance and contract; shipping costs are shared. Prefers artwork framed.
Submissions: Accepts only artists from America and Europe. Send query letter with résumé, slides, bio, photographs and SASE. Write for appointment to show portfolio of transparencies. Replies in 3 weeks.
Tips: Finds artists through word of mouth.

‡THE MARBELLA GALLERY INC., 28 E. 72nd St., New York NY 10021. (212)288-7809. President: Mildred Thaler Cohen. Retail gallery. Estab. 1971. Represents/Exhibits established artists. Exhibited artists include Pre Ten and The Eight. Sponsors 1 show/year. Average display time 6 weeks. Open all year; Tuesday-Saturday, 11-5:30. Located uptown; 750 sq. ft. 100% of space for special exhibitions. Clientele: tourists, upscale. 50% private collectors, 10% corporate collectors, 40% dealers. Overall price range: $1,000-60,000; most work sold at $2,000-4,000.
Style: Exhibits expressionism, realism and impressionism. Genres include landscapes, florals, Americana and figurative work. Prefers Hudson River, "The Eight" and genre.
Terms: Artwork is bought outright for a percentage of the retail price. Retail price set by the gallery. Gallery provides insurance.

‡**MARKEL/SEARS FINE ARTS**, 560 Broadway, New York NY 10012. (212)966-7469. President: Kathryn Markel. Private art consultancy. Estab. 1985. Represents 40 emerging, mid-career and established artists/year. Exhibited artists include Steve Aimone and Madge Willner. Sponsors no exhibitions. Open all year by appointment. Clientele: 80% corporate clients. Overall price range: $700-5,000.
Media: Considers all original work, unique works on paper. Most frequently sells pastel, watercolor and collage.
Style: Exhibits all styles.
Terms: Accepts work on consignment (50% commission). Retail price set by gallery and artist. Gallery provides insurance; artist pays for shipping. Prefers artwork unframed.
Submissions: Send query letter with slides and SASE. Portfolio should include slides. Replies in 2 weeks.
Tips: "Send 10-15 slides of recent work with SASE."

JAIN MARUNOUCHT GALLERY, 560 Broadway, New York NY 10012. (212)274-8087. Fax: (212)274-8284. President: Ashok Jain. Retail gallery. Estab. 1991. Represents 30 emerging artists. Exhibited artists include Fernando Pamalaza and Pauline Gagnon. Sponsors 10 shows/year. Average display time 3 weeks. Open all year; Tuesday-Saturday 11-6. Located in downtown Soho across from new Guggenheim; 3,200 sq. ft. 80% of space for special exhibitions; 20% of space for gallery artists. Clientele: corporate and designer. 50% private collectors, 50% corporate collectors. Overall price range: $1,000-20,000; most work sold at $5,000-10,000.
Media: Considers oil, acrylic and mixed media. Most frequently exhibits oil, acrylic and collage.
Style: Exhibits painterly abstraction. Prefers abstract only.
Terms: Accepts work on consignment (50% commission). Retail price set by artist. Offers customer discount. Gallery provides contract; artist pays for shipping costs. Prefers artwork framed.
Submissions: Send query letter with résumé, brochure, slides, reviews and SASE. Portfolio review requested if interested in artist's work. Portfolio should include originals, photographs, slides, transparencies and reviews. Replies in 1 week.
Tips: Finds artists through referrals and promotions.

‡**PEDER BONNIER INC.**, 420 W. Broadway, New York NY 10012. (212)431-1939. Fax: (212)431-1662. Retail gallery. Estab. 1983. Represents/exhibits 12 established artists/year. May be interested in seeing work of emerging artists in the future. Exhibited artists include Judd and Helander. Sponsors 8 shows/year. Average display time 5 weeks. Open September-June; 10-6. Located in Soho; 1,600 sq. ft. 80% of space for special exhibitions; 20% of space for gallery artists. 50% private collectors; 50% corporate collectors. Overall price range: $2,500-250,000.
Media: Considers all media. Most frequently exhibits painting and sculpture.
Style: Exhibits minimalism and postmodern works.
Terms: Artwork is accepted on consignment (50% commission). Retail price set by the gallery and the artist. Gallery provides insurance. Artist pays for shipping costs to and from gallery. Prefers artwork framed.
Submissions: Write for appointment to show portfolio. Does not reply. Artist should call.
Tips: Keep on working.

FRIEDRICH PETZEL GALLERY, 26 Wooster St., New York NY 10013. (212)334-9466. Fax: (212)431-6638. Contact: Petzel. Retail gallery and office for organization of art events. Estab. 1993. Represents 7 emerging artists/year. Exhibited artists include Paul Myoda, Keith Edmier, Jorge Pardo. Sponsors 9-10 shows/year. Average display time 1 month. Open September-July; Tuesday-Saturday, 11-6. Located in Soho; 800 sq. ft. 100% of space for gallery artists. 80% private collectors, 20% corporate collectors. Overall price range: $1,000-8,000; most work sold at $4,000.
Media: Considers all media. Most frequently exhibits mixed media.
Terms: Accepts work on assignment (50% commission). Retail price set by the gallery and the artist. Gallery provides promotion, contract and shipping costs to and from gallery. Prefers artwork framed.
Submissions: Send query letter with résumé, slides, bio and reviews. Call for appointment to show portfolio of photographs, slides and transparencies. Replies in 2-3 weeks. Files "only material we are interested in."
Tips: Finds artists through various art publications, word of mouth and studio visits.

THE PHOENIX GALLERY, 568 Broadway, Suite 607, New York NY 10012. (212)226-8711. Director: Linda Handler. Nonprofit gallery. Estab. 1958. Exhibits the work of 32 emerging, mid-career and established artists. 32 members. Exhibited artists include Barbara Londin and Betty Mcgeehan Sponsors 10-12 shows/year. Average display time 1 month. Open fall, winter and spring. Located in Soho; 180 linear ft.; "We are in a landmark building in Soho, the oldest co-op in New York. We have a movable wall which can divide the gallery into two large spaces." 100% of space for special exhibitions. Clientele: 75% private collectors, 25% corporate clients, also art consultants. Overall price range: $50-20,000; most work sold at $300-10,000.
Media: Considers oil, acrylic, watercolor, pastel, pen & ink, drawings, mixed media, collage, works on paper, sculpture, ceramic, photography, original handpulled prints, woodcuts, engravings, wood engravings, linocuts and etchings. Most frequently exhibits oil, acrylic and watercolor.

Style: Exhibits painterly abstraction, minimalism, realism, photorealism, hard-edge geometric abstraction and all styles. Prefers painterly abstraction, hard-edge geometric abstraction and sculpture.

Terms: Co-op membership fee plus donation of time (25% commission). Retail price set by gallery. Offers customer discounts and payment by installment. Gallery provides insurance, promotion and contract; artist pays for shipping. Prefers artwork framed.

Submissions: Send query letter with résumé, slides and SASE. Call for appointment to show portfolio of slides. Replies in 1 month. Only files material of accepted artists. The most common mistakes artists make in presenting their work are "incomplete résumés, unlabeled slides and an application that is not filled out properly."

Tips: "We find new artists by advertising in art magazines and art newspapers, word of mouth, and inviting artists from our juried competition to be reviewed for membership. Come and see the gallery—meet the director. The New York gallery scene is changing. Many galleries in the Soho area have once again moved to less expensive space further downtown."

‡QUEENS COLLEGE ART CENTER, Benjamin S. Rosenthal Library, Queens College/CUNY, Flushing NY 11367. (718)997-3770. Fax: (718)997-3753. E-mail: sbsqc@cunyvm.cuny.edu. Director: Suzanna Simor. Curator: Alexandra de Luise. Nonprofit university gallery. Estab. 1955. Exhibits work of emerging, mid-career and established artists. Sponsors 10 shows/year. Average display time 1 month. Open all year; Monday-Thursday, 9-7; Friday, 9-5. Located in borough of Queens; 1,000 sq. ft. The gallery is wrapped "Guggenheim Museum" style under a circular skylight in the library's atrium. 100% of space for special exhibitions. Clientele: "college and community, some commuters." 100% private collectors. Overall price range: up to $10,000; most work sold at $300.

Media: Considers all media and all types of prints. Most frequently exhibits paintings, prints, drawings and photographs.

Style: Exhibits all styles.

Terms: Accepts work on consignment (40% commission). Retail price set by the artist. Gallery provides promotion. Artist pays for shipping costs. Prefers artwork framed.

Submissions: Cannot exhibit large 3-D objects. Send query letter with résumé, brochure, slides, photographs, reviews, bio and SASE. Write for appointment to show portfolio of photographs, slides, photographs or transparencies, originals if presented in person. Replies in 3 weeks. Files all documentation.

THE REECE GALLERIES, INC., 24 W. 57th St., New York NY 10019. (212)333-5830. Fax: (212)333-7366. President: Shirley Reece. Retail and wholesale gallery and art consultancy. Estab. 1974. Represents 40 emerging and mid-career artists. Exhibited artists include Tsugio Hattori and Sica. Sponsors 5-6 shows/year. Average display time 1 month. Open all year. Located in midtown; 1,500 sq. ft.; gallery is broken up into 3 show areas. 90% of space for special exhibitions. Clientele: corporate, private, architects and consultants. 50% private collectors, 50% corporate collectors. Overall price range: $300-30,000; most work sold at $1,000-15,000.

Media: Considers oil, acrylic, watercolor, pastel, mixed media, collage, paper, original handpulled prints, engravings, mezzotints, etchings, lithographs, pochoir and serigraphs.

Style: Exhibits expressionism, painterly abstraction, color field and impressionism.

Terms: Accepts work on consignment (50% commission). Retail price set by gallery and artist. Gallery provides insurance; artist pays for shipping. Prefers artwork unframed.

Submissions: Prefers only work on canvas and prints. Send query letter with résumé, slides, bio, SASE and prices. Call or write for appointment to show portfolio of slides and photographs with sizes and prices. Replies in 2 weeks.

Tips: "A visit to the gallery (when possible) to view what we show would be helpful for you in presenting your work—to make sure the work is compatible with our aesthetics."

ST. LIFER ART EXCHANGE, INC., 3 Hanover Square, #21E, New York NY 10004. (212)825-2059. Fax: (212)825-2582. Director: Jane St. Lifer. Art consultancy and fine art brokers and appraisers. Estab. 1988. Represents established artists. May be interested in seeing the work of emerging artists in the future. Exhibited artists include Miro, Picasso. Open all year by appointment. Located in the Wall Street area. Clientele: national and international contacts. 50% private collectors, 50% corporate collectors. Overall price range: $300-3,000.

Media: Considers oil, acrylic, watercolor, pastel, pen & ink, drawing, woodcut, engraving, lithograph, wood engraving, mezzotint, serigraphs, linocut, etching, posters (original).

Style: Exhibits postmodern works, impressionism and realism. Considers all genres.

Terms: Accepts work on consignment or buys outright. Retail price set by the gallery. Gallery pays shipping costs from gallery; artist pays shipping costs to gallery. Prefers artwork framed.

Submissions: Send query letter with résumé, bio, photographs, SASE and business card. Portfolio should include photographs. Replies in 3-4 weeks. Files résumé, bio.

SCULPTURE CENTER GALLERY, 167 E. 69th St., New York NY 10021. (212)879-3500. Fax: (212)879-7155. Gallery Director: Marian Griffiths. Alternative space, nonprofit gallery. Estab. 1928. Exhibits emerging

and mid-career artists. Sponsors 8-10 shows/year. Average display time 3-4 weeks. Open September-June; Tuesday-Saturday, 11-5. Located upper East side, Manhattan; main gallery, 1,100 sq. ft.; gallery 2, 104 sq. ft.; old carriage house with 14 ft. ceilings; 6×3×3 ft. alcove for installations devoted to AIDS. 85% of space for gallery artists. 90% private collectors, 10% corporate collectors. Overall price range: $100-100,000; most work sold at $200-3,000.

Media: Considers drawing, mixed media, sculpture and installation. Most frequently exhibits sculpture, installations and video installations.

Terms: Accepts work on consignment (25% commission). Retail price set by the gallery and the artist. Gallery provides promotion; artist pays shipping costs.

Submissions: Send query letter with résumé, slides, bio and SASE. Call for appointment to show portfolio of photographs, slides and transparencies. Replies in 2 months. Files bios, slides.

Tips: Finds artists through artists' and curators' submissions (mostly) and word of mouth.

NATHAN SILBERBERG FINE ARTS, 301 E. 63rd St., Suite 7-G, New York NY 10021. (212)752-6160. Owner: N. Silberberg. Retail and wholesale gallery. Estab. 1973. Represents 10 emerging and established artists. Exhibited artists include Joan Miro, Henry Moore and Nadezda Vitorovic. Sponsors 4 shows/year. Average display time 1 month. Open March-July. 2,000 sq. ft. 75% of space for special exhibitions. Overall price range: up to $50,000; most work sold at $4,000.

Media: Considers oil, acrylic, watercolor, original handpulled prints, lithographs, pochoir, serigraphs and etchings.

Style: Exhibits surrealism and conceptualism. Interested in seeing abstract work.

Terms: Accepts work on consignment (40-60% commission). Retail price set by gallery. Sometimes offers customer discounts. Gallery provides insurance and promotion; shipping costs are shared. Prefers framed artwork.

Submissions: Send query letter with résumé, slides and SASE. Write for appointment to show portfolio of originals, slides and transparencies. Replies in 1 month.

Tips: Finds artists through visiting art schools and studios. "First see my gallery and the artwork we show."

‡SOHO 20 GALLERY, 469 Broome St., New York NY 10013. (212)226-4167. Contact: Gallery Director. Nonprofit cooperative gallery and alternative space. Estab. 1973. Represents/exhibits 55 emerging, mid-career and established artists/year. Sponsors approximately 50 shows/year. Average display time 3½-4 weeks. Open all year; Tuesday-Saturday, 12-6. Located in Soho; 1,700 sq. ft.; ground floor space in historical building; 12 ft. ceilings; "Greene St. Window." 25-35% of space for special exhibitions; 75% of space for gallery artists. Clientele: wide range: private, corporate. 75% private collectors, 25% corporate collectors. Overall price range: $100-20,000; most work sold at $500-7,500.

Media: Considers all media and all types of prints except posters. Most frequently exhibits painting, sculpture, mixed media and installations.

Style: Exhibits all styles. Most genres.

Terms: There is a co-op membership fee plus a donation of time. There is a 20% commission. There is a rental fee for space. The rental fee covers exhibition dates. Retail price set by the artist. Gallery provides promotion. Artists usually pays for shipping costs. Prefers artwork framed "ready to exhibit. Artists generally install their own exhibits."

Submissions: "Soho 20 is a feminist cooperative gallery. The gallery exhibits work by women artists." Send résumé, brochures, slides, reviews SASE and letter stating which exhibit opportunities they are interested in (call gallery first). Call for appointment to show portfolio of slides and résumé. Replies in 1 month.

Tips: Finds artists through word of mouth, referrals by other artists, visiting art fairs and exhibitions, artist's submissions and advertising. "We have several categories of exhibition opportunities. Call first in order to decide which category best meets the artist's and gallery's needs/intent. Clearly state exhibition category that you are applying for. Send all materials SASE."

JOHN SZOKE GRAPHICS, INC., 164 Mercer St., New York NY 10012. (212)219-8300. Fax: (212)966-3064. President: John Szoke. Director: Susan Jaffe. Retail gallery and art publisher. Estab. 1974. Represents 30 mid-career artists. Exhibited artists include Janet Fish and Peter Milton. Open all year. Located downtown in Soho; 1,500 sq. ft.; "gallery has a skylight." 50% of space for special exhibitions. Clientele: other dealers and collectors. 20% private collectors, 20% corporate collectors. Overall price range: $1,000-22,000.

● Gallery has recently increased exhibition space by 40%.

Media: Considers works on paper, multiples in relief and intaglio and sculpture. Most frequently exhibits prints and other multiples.

Style: Exhibits surrealism, minimalism and realism. All genres.

Terms: Buys artwork outright. Retail price set by gallery. Gallery provides insurance and promotion; artist pays for shipping. Prefers unframed artwork.

Submissions: Send query letter with slides and SASE. Write for appointment to show portfolio of slides. The most common mistake artists make in presenting their work is "sending material without explanation, instructions or reference to our needs." Replies in 1 week. Files all correspondence and slides unless SASE is enclosed.

Tips: Finds artists through word of mouth.

TATYANA GALLERY, 145 E. 27th St., 6th Floor, New York NY 10016. (212)683-2387. Fax: (212)683-9147. Contact: Director. Retail gallery. Estab. 1980. Represents and exhibits work of established artists. Sponsors 2 solo and 2 group shows/year. Open all year. Clientele: 50% private collectors. Overall price range: $200-150,000; most artwork sold at $400-16,000.
Media: Considers oil, watercolor, pastel, pen & ink, drawings, mixed media and works on paper. Most frequently exhibits oil, watercolor and drawings.
Style: Exhibits impressionism and realism. Prefers landscapes, figurative work and portraits. "Our gallery specializes in Russian and Soviet realist art and impressionism."
Tips: Looking for "the best Russian realist paintings I can find in the USA."

TIBOR DE NAGY GALLERY, 41 W. 57th St., New York NY 10019. (212)421-3780. Fax: (212)421-3731. Directors: Andrew H. Arnst and Eric Brown. Retail gallery. Estab. 1950. Represents 18 emerging and mid-career artists. Exhibited artists include Robert Berlind, Gretna Campbell. Sponsors 12 shows/year. Average display time 1 month. Closed August. Located midtown; 3,500 sq. ft. 100% of space for work of gallery artists. 60% private collectors, 40% corporate collectors. Overall price range: $1,000-100,000; most work sold at $5,000-20,000.
● The gallery focus is on representative painting within the New York school traditions. They do not generally consider abstract painting.
Media: Considers oil, pen & ink, paper, acrylic, drawings, sculpture, watercolor, mixed media, pastel, collage, etchings, and lithographs. Most frequently exhibits oil/acrylic, watercolor and sculpture.
Style: Exhibits representation work as well as abstrct painting and sculpture. Genres include landscapes and figurative work. Prefers abstract, painterly realism and realism.
Terms: Accepts work on consignment (50% commission). Retail price set by gallery and artist. Gallery provides insurance, promotion and contract; artist pays for shipping. Prefers artwork framed.
Submissions: Send query letter with résumé, slides, bio, brochure, photographs, SASE and reviews. Call for an appointment to show portfolio of photographs and slides. Replies in 2 weeks. Files résumé and bio.

TRIBECA 148 GALLERY, 148b Duane St., New York NY 10013. (212)406-4073. Assistant Director: Rene Escala. Alternative space. Estab. 1992. Represents emerging and mid-career artists. Exhibited 1,600 artists in 2 years. 1,200 members. Sponsors 24 shows/year. Average display time 1 month. Open in summer; Tuesday-Saturday, 12-6. Located downtown Tribeca; 1,700 sq. ft. (plus other renegade and donated spaces); long loft space, and ground floor, high ceilings, interesting vault sub-exhibition space. 90% of space for special exhibitions; 10% of space for gallery artists. Clientele: "The arts community."
Media: Considers oil, acrylic, watercolor, pastel, pen & ink, drawing, mixed media, collage, paper, sculpture, installation and photography. Most frequently exhibits painting, sculpture and photography.
Style: Exhibits all styles, all genres.
Terms: "Work is received for exhibitions; sales are encouraged, but are not our main focus—20% commission."
Submissions: Accepts only professional artists. Send query letter with request for membership information ($30 a year). Portfolio should include slides. "We only receive slides for our slide file as part of the membership service." Files 20 slides, résumé, 3 slides for carousels.
Tips: "We show mostly NYC artists—but do accept artists from out-of-town."

‡ALTHEA VIAFORA, 203 E. 72nd St., New York NY 10021. (212)628-2402. Contact: Althea Viafora. Alternative space and art consultancy. Estab. 1981. Represents/exhibits 10 emerging, mid-career and established artists/year. Exhibited artists include Matthew Barney and Emil Lukas. Sponsors 2 shows/year. Average display time 1 month. Open by appointment. 100% of space for special exhibitions. Clientele: upscale. 100% private collectors. Overall price range: $500-300,000; most work sold at $20,000-40,000.
Media: Considers oil, pen & ink, paper, acrylic, drawing, sculpture, watercolor, mixed media, installation, collage, photography, woodcut, wood engraving, linocut, engraving, mezzotint, etching, lithograph and serigraphs. Most frequently exhibits installation, mixed media and oil paintings.
Style: Exhibits conceptualism and minimalism. Genres include action works. Prefers action works.
Terms: Artwork is accepted on consignment and there is a 50% commission. Retail price set by the gallery. Gallery provides insurance and promotion. Gallery pays for shipping costs. Prefers artwork framed.
Submissions: "Artists must have shown in alternative space." Send query letter with slides, reviews, bio and SASE. Contact through the mail. Replies in 1 month. Files bio.
Tips: Finds artists through alternative spaces, art magazines, graduate schools, word of mouth. "Go to galleries and museums to view your peers' work. Know the history of the dealer, curator, critic you are contacting."

VIRIDIAN GALLERY, 24 W. 57 St., New York NY 10019. (212)245-2882. Director: Joan Krauczyk. Cooperative gallery. Estab. 1970. Exhibits the work of 34 emerging, mid-career and established artists. Sponsors 13 solo and 2 group shows/year. Average display time is 3 weeks. Clientele: consultants, corporations, private

collectors. 50% private collectors, 50% corporate clients. Overall price range: $500-20,000; most work sold at $1,000-8,000.

Media: Considers oil, acrylic, watercolor, pastel, pen & ink, drawings, mixed media, collage, works on paper, sculpture, installation, photography and limited edition prints. Most frequently exhibits works on canvas, sculpture, mixed media and works on paper.

Style: Exhibits hard-edge geometric abstraction, color field, painterly abstraction, conceptualism, postmodern works, primitivism, photorealism, abstract, expressionism, and realism. "Eclecticism is Viridian's policy. The only unifying factor is quality. Work must be of the highest technical and aesthetic standards."

Terms: Accepts work on consignment (30% commission). Retail price set by gallery and artist. Sometimes offers customer discounts and payment by installment. Exclusive area representation not required. Gallery provides promotion, contract and representation.

Submissions: Send query letter and SASE or call ahead for information on procedure. Portfolio review requested if interested in artist's work.

Tips: "Artists often don't realize that they are presenting their work to an artist-owned gallery where they must pay each month to maintain their represenation. We feel a need to demand more of artists who submit work. Because of the number of artists who submit work our critieria for approval has increased as we receive stronger work than in past years as commercial galleries are closing."

‡**SYLVIA WHITE CONTEMPORARY ARTISTS' SERVICES**, 560 Broadway, #206, New York NY 10012. (212)966-3564. Contact: Jennifer Dakoske. Retail gallery, art consultancy, artist's career development services.

 • This gallery has two locations (New York and Santa Monica, California). See their California listing for information about the galleries' submission policies as well as media and style needs.

‡**PHILIP WILLIAMS POSTERS**, 60 Grand St., New York NY 10013. (212)226-7830. Fax: (212)226-0712. Contact: Philip Williams. Retail and wholesale gallery. Represents/exhibits 40 emerging, mid-career and established artists. Open all year; Monday-Sunday, 11-7. Located in downtown Soho; 2,500 sq. ft.

Terms: Shipping costs are shared. Prefers artwork unframed.

Submissions: Prefers only vintage posters and outsider artist. Send query letter with photographs. Call for appointment to show portfolio of photographs.

YESHIVA UNIVERSITY MUSEUM, 2520 Amsterdam Ave., New York NY 10033. (212)960-5390. Director: Sylvia A. Herskowitz. Nonprofit museum. Estab. 1973. Interested in emerging, mid-career and established artists. Clientele: New Yorkers and tourists. Sponsors 5-7 solo shows/year. Average display time is 3 months. "4 modern galleries; track lighting; some brick walls." Museum works can be sold through museum shop.

Media: Considers all media and original handpulled prints.

Style: Exhibits post-modernism, surrealism, photorealism and realism with Jewish themes or subject matter. Genres include landscapes, florals, Americana, portraits and figurative work. "We mainly exhibit works of Jewish theme or subject matter or that reflect Jewish consciousness but are somewhat willing to consider other styles or mediums."

Terms: Accepts work for exhibition purposes only, no fee. Pieces should be framed. Retail price is set by gallery and artist. Gallery provides insurance, promotion and contract; artist pays for shipping and framing.

Submissions: Send query letter, résumé, brochure, good-quality slides, photographs and statement about your art. Prefers not to receive phone calls/visits. "Once we see the slides, we may request a personal visit." Resumes, slides or photographs are filed if work is of interest.

Tips: Mistakes artists make are sending "slides that are not identified, nor in a slide sheet." Notices "more interest in mixed media and more crafts on display."

North Carolina

‡**ALBAN EILER CONTEMPORARY ART**, 560 N. Trade St., Winston-Salem NC 27101. Director: T.M. Hughes. Retail and exhibition gallery. Estab. 1994. Represents/exhibits 6 emerging, mid-career and established artists/year. Exhibited artists include T.M. Lucas Hughes. Sponsors 10-12 shows/year. Open all year; Monday-Friday, 10-6 and by appointment. Located in Winston-Salem 6th and Trade Art district, downtown; 1,100 sq. ft. 40% of space for special exhibitions; 60% of space for gallery artists. Clientele: local community, private clients. 90% private collectors, 5% corporate collectors. Overall price range: $150-4,500; most work sold at $600-1,200.

Media: Considers all media and all types of prints. Most frequently exhibits mixed media (oil, paper, wood, found object), photography, graphite drawing.

Style: Exhibits all styles. Genres include landscapes, portraits and figurative work (primarily children). Prefers contemporary expressionism and minimalism.

Terms: Artwork is accepted on consignment (30% commission). Artwork is bought outright for 50% of the retail price. Retail price set by the artist. Gallery provides contract. Promotion and shipping costs are shared. Prefers artwork framed.

Submissions: Send query letter with slides, bio and SASE. Write for appointment to show portfolio of photographs and slides. Replies only if interested within 2 weeks.
Tips: Finds artists through referrals and artists' submissions. Looks for "soul inspired, meaningful work. Commercial or over-educated work not accepted. Interested in the use of the child in contemporary art.

‡ART GALLERY, (formerly Case Art Gallery), Barton College, College Station Wilson NC 27893. (919)399-6477. Director of Exhibitions: J. Chris Wilson. Nonprofit gallery. Estab. 1965. Represents mid-career and established artists. Sponsors both solo and group shows during academic year. Most artwork sold at $350.
Media: Considers all media and original handpulled prints. Most frequently exhibits fiber, pottery and painting. Interested in seeing "all types of visual arts—glass, sculpture, drawings, etc."
Style: Considers all styles.
Terms: Retail price set by artist. Gallery provides standard insurance coverage and promotion locally through the media and mailings; shipping expenses are negotiated.
Submissions: Contact the Director of Exhibitions for additional information.

ASSOCIATED ARTISTS OF WINSTON-SALEM, 226 N. Marshall St., Winston-Salem NC 27101. (910)722-0340. Executive Director: Rosemary H. Martin. Nonprofit gallery. Gallery estab. 1982; organization estab. 1956. Represents 500 emerging, mid-career and established artists/year. 375 members. Sponsors 12 shows/year. Average display time 1 month. Open all year; office hours: Monday-Friday, 9-5; gallery hours: Monday-Friday, 9-9; Saturday, 9-6. Located in the historic Sawtooth Building downtown. "Our gallery is 1,000 sq. ft., but we often have the use of 2 other galleries with a total of 3,500 sq. ft. The gallery is housed in a renovated textile mill (circa 1911) with a unique 'sawtooth' roof. 30% of space for special exhibitions; 70% of space for gallery artists. Clientele: "generally walk-in traffic—this is a multi-purpose public space, used for meetings, receptions, classes, etc." 85% private collectors, 15% corporate collectors. Overall price range: $50-3,000; most work sold at $100-500.
Media: Considers oil, acrylic, watercolor, pastel, pen & ink, drawing, mixed media, collage, paper, sculpture, photography, woodcut, engraving, lithograph, wood engraving, mezzotint, serigraphs, linocut and etching (no photo-reproduction prints.). Most frequently exhibits watercolor, oil and photography.
Style: Exhibits all styles, all genres.
Terms: "Artist pays entry fee for each show; if work is sold, we charge 30% commission. If work is unsold at close of show, it is returned to the artist." Retail price set by the artist; artist pays shipping costs to and from gallery. Artwork must be framed.
Submissions: Request membership information and/or prospectus for a particular show. Replies in 1 week to membership/prospectus requests. Files "slides and résumés of our exhibiting members only."
Tips: "We don't seek out artists per se—membership and competitions are generally open to all. We advertise call for entries for our major shows in national art magazines and newsletters. Artists can impress us by following instructions in our show prospecti and by submitting professional-looking slides where appropriate. Because of our non-elitist attitude, we strive to be open to all artists—from novice to professional, so first-time artists can exhibit with us."

BLUE SPIRAL 1, 38 Biltmore Ave., Asheville NC 28801. (704)251-0202. Fax: (704)251-0884. Director: John Cram. Retail gallery. Estab. 1991. Represents emerging, mid-career and established artists living in the Southeast. Exhibited artists include Shane Fero, Jill Carnes, Steve Forbes de Soule, Gary Chapman and Kathy Triplett. Sponsors 10 shows/year. Average display time 6-8 weeks. Open all year; Monday-Saturday, 10-5. Located downtown; 11,000 sq. ft.; historic building, performance/alternative space, sculpture garden (indoor). 85% of space for special exhibitions; 15% of space for gallery artists. Clientele: "across the range." 90% private collectors, 10% corporate collectors. Overall price range: less than $100-50,000; most work sold at $100-2,500.
Media: Considers all media including outsider and contemporary folk art. Most frequently exhibits painting, clay, sculpture and glass.
Style: Exhibits all styles, all genres.
Terms: Accepts work on consignment (50% commission). Retail price set by the artist. Gallery provides insurance, promotion and contract; artist pays shipping costs to and from gallery. Prefers artwork framed.
Submissions: Accepts only artists from Southeast. Send query letter with résumé, slides, prices, statement and SASE. Replies in 3 months. Files slides, name and address.
Tips: Finds artists through word of mouth, referrals, travel.

BROADHURST GALLERY, 800 Midland Rd., Pinehurst NC 28374. (910)295-4817. Owner: Judy Broadhurst. Retail gallery. Estab. 1990. Represents/exhibits 50 emerging, mid-career and established artists/year. Sponsors about 4 large shows and many smaller shows/year. Average display time 1-3 months. Open all year; Tuesday-Friday, 11-5; Saturday, 1-4; and by appointment. Located on the main road between Pinehurst and Southern Pines; 3,000 sq. ft.; lots of space, lots of light, lots of parking spaces. 50% of space for special exhibitions; 50% of space for gallery artists. Clientele: people building homes and remodeling, also collectors. 80% private collectors, 20% corporate collectors. Overall price range: $500-10,000; most work sold at $1,000-2,400.

Media: Considers oil, acrylic, watercolor, pastel, mixed media, collage, sculpture, craft and glass. Most frequently exhibits oil, acrylic, sculpture (stone and bronze), watercolor, glass.
Style: Exhibits all styles, all genres.
Terms: Retail price set by the artist. Gallery provides insurance, promotion and contract; shipping costs are shared. Prefers artwork framed.
Submissions: Send query letter with résumé, slides and/or photographs, and bio. Write for appointment to show portfolio of originals and slides. Replies only if interested within 2-3 weeks. Files résumé, bio, slides and/or photographs.
Tips: Finds artists through agents, by visiting exhibitions, word of mouth, various art publications and sourcebooks, artists' submissions. "Talent is always the most important factor but professionalism is very helpful."

‡**BROADWAY ARTS, home of the green door**, 49 Broadway St., Asheville NC 28801. (704)258-9206. Owner/Director: Bonnie Hobbs, David Hobbs. Center for visual and performance arts. Estab. 1987. Represents/exhibits emerging, mid-career and established artists. Exhibited artists include Brian Rutenberg and Aimee Oliver. Open all year; hours change with each exhibit. Located in historic downtown Asheville, north end; 15,000 sq. ft.; 3 galleries—(1) the greendoor—intimate alternative space, natural stone walls, exposed wood ceiling, beer, wines, coffee, soft drinks. (2) The Gallery—wood floors, 15′ ceiling. (3) Fridholm Fine Arts open by appointment only. Overall price range: $100-5,000; most work sold at under $1,000.
Media: Considers all media. "Prefers interdisciplinary."
Style: Exhibits all styles as they relate to performance art being presented.
Terms: Artwork is accepted on consignment (50% commission). Retail price set by the gallery and the artist. Gallery provides promotion. Artist pays for shipping costs.
Submissions: Send query letter with résumé, slides, bio and SASE. Call or write for appointment. Replies in 1 month.
Tips: Finds artists through word of mouth, referrals by other artists, visiting art fairs and exhibitions, artists' submissions.

‡**THE DAVIDSON COUNTY MUSEUM OF ART**, (formerly The Davidson County Art Guild), 224 S. Main St., Lexington NC 27292. (704)249-2472. Curator: Mark Alley. Nonprofit gallery. Estab. 1968. Exhibits 30 emerging, mid-career and established artists. Interested in seeing the work of emerging artists. 400 members. Exhibited artists include Bob Timberlake and Zoltan Szabo. Disney Animation Archives (1993), Ansel Adams (1994), P. Bukeley Moss (1996). Sponsors 11 shows/year. Average display time 1 month. Open all year. 6,000 sq. ft; historic building, good location, marble foyer. 80% of space for special exhibitions; 10% of space for gallery artists. Clientele: 98% private collectors, 2% corporate collectors. Overall price range: $50-20,000; most work sold at $50-4,000.
Media: Considers all media and all types of prints. "Originals only for exhibition. Most frequently exhibits painting, photography and mixed media. "We try to provide diversity."
Style: Exhibits expressionism, painterly abstraction, postmodern works, expressionism, photorealism and realism. Genres include landscapes and Southern artists.
Terms: Accepts work on consignment (30% commission). Members can exhibit art for 2 months maximum per piece in our members gallery. 30% commission goes to Guild. Retail price set by gallery and artist. Gallery provides insurance, promotion and contract; artist pays for shipping. Prefers artwork framed for exhibition and unframed for sales of reproductions.
Submissions: Send query letter with résumé, slides, bio, brochure, photographs, business card, reviews and SASE. Write for appointment to show portfolio of originals, photographs and slides. Entries reviewed every May for following exhibition year.

‡**DURHAM ART GUILD, INC.**, 120 Morris St., Durham NC 27701. (919)560-2713. Gallery Director: Susan Hickman. Nonprofit gallery. Estab. 1948. Represents/exhibits 400 emerging, mid-career and established artists/year. Sponsors 9 shows/year. Average display time 4½ weeks. Open all year; Monday-Saturday, 9-9; Sunday, 1-6. Located in center of downtown Durham in the Arts Council Building; 3,600 sq. ft.; large, open, movable walls. 100% of space for special exhibitions. Clientele: general public. 80% private collectors, 20% corporate collectors. Overall price range: $100-14,000; most work sold at $200-1,200.
Media: Considers all media. Most frequently exhibits painting, sculpture and photography.
Style: Exhibits all styles, all genres.
Terms: Artwork is accepted on consignment (25-35% commission). Retail price set by the artist. Gallery provides insurance and promotion. Artist pays for shipping costs. Prefers artwork framed.
Submissions: Artists 18 years or older. Send query letter with résumé, slides and SASE. We accept slides for review by January 31 for consideration of a solo exhibit. Does not reply. Artist should include SASE.
Tips: Finds artists through word of mouth, referral by other artists, call for slides.

‡**GALLERY C**, 3532 Wade Ave., Ridgewood Shopping Center, Raleigh NC 27607. (919)828-3165. Fax: (919)828-7795. Director: Charlene Newsom. Retail gallery and art consultancy. Estab. 1985. Represents/exhibits 40 emerging, mid-career, established artists/year. Exhibited artists include Joseph Cave and Louis

St. Lewis. Sponsors 9 shows/year. Average display time 5 weeks. Open all year; Tuesday-Thursday, 10-6; Friday, 10-9; Saturday, 10-5; Sunday, 1-5; closed Monday. Located in shopping center; 3,500 sq. ft.; neo-classical architecture. 33% of space for special exhibitions; 66% of space for gallery aritsts. Clientele: upscale residential. 80% private collectors; 20% corporate collectors. Overall price range: $100-20,000; most work sold at $500-1,500.

Media: Considers all media and all types of prints except posters. Most frequently exhibits paintings on canvas, works on paper and sculpture.

Style: Exhibits all styles. All genres. Prefers landscapes, realism and painterly abstraction.

Terms: Artwork is accepted on consignment (50% commission). Retail price set by the gallery. Gallery provides insurance, promotion and contract. Artist pays for shipping costs. Prefers artwork framed.

Submissions: Accepts only artists from Southeastern region. Send query letter with résumé, slide, bio, SASE. Write for appointment to show portfolio of slides and transparencies. Slides are reviewed and juried 3 times a year. Files material from artists we have contacted.

Tips: Finds artists through word of mouth, referrals by artists, visiting art fairs and exhibitions, artists' submissions.

‡JERALD MELBERG GALLERY INC., 3900 Colony Rd., Charlotte NC 28211. (704)365-3000. Fax: (704)365-3016. President: Jerald L. Melberg. Retail gallery. Estab. 1983. Represents 24 emerging, mid-career and established artists/year. Exhibited artists include Arless Day and Wolf Kahn. Sponsors 8-10 shows/year. Average display time 6 weeks. Open all year; Monday-Saturday, 10-6. Located in suburbs; 2,000 sq. ft.; clear space—gray carpet—white walls— high ceilings. 50% of space for special exhibitions. Clientele: 80% private collectors, 20% corporate collectors. Overall price range: $600-60,000; most work sold at $1,200-8,000.

Media: Considers all media except photos and crafts. Most frequently exhibits pastel, oils/acrylics and collages.

Style: Genres include landscapes and florals. Prefers landscapes and abstractions.

Terms: Artwork is accepted on consignment (50% commission). Retail price set by the gallery and the artist. Gallery provides insurance, promotion. "I believe in hand shakes not contracts." Shipping costs are shared. Prefers artwork unframed.

Submissions: Accepts only artists from USA. Send query letter with résumé, brochure, slides, reviews, bio and SASE. Replies in 3-4 weeks. Files résumé and slides.

Tips: Finds artists through art fairs, dealer referrals and other artists.

RALEIGH CONTEMPORARY GALLERIES, 323 Blake St., Raleigh NC 27601. (919)828-6500. Director: Rory Parnell. Retail gallery. Estab. 1984. Represents 20-25 emerging and mid-career artists/year. Exhibited artists include Walter Piepke, Nancy Baker. Sponsors 6 shows/year. Average display time 2-3 months. Open all year; Tuesday-Friday, 11-4. Located downtown; 1,300 sq. ft.; architect-designed; located in historic property in a revitalized downtown area. 70% of space for special exhibitions; 30% of space for gallery artists. Clientele: corporate and private. 35% private collectors, 65% corporate collectors. Overall price range: $500-5,000; most work sold at $1,200-2,500.

Media: Considers oil, acrylic, watercolor, pastel, pen & ink, drawing, woodcut, engraving and lithograph. Most frequently exhibits oil/acrylic paintings, drawings and lithograph.

Style: Exhibits all styles. Genres include landscapes and florals. Prefers landscapes, realistic and impressionistic; abstracts.

Terms: Accepts work on consignment (50% commission). Retail price set by the gallery and the artist. Gallery provides insurance, promotion and contract; shipping costs are shared.

Submissions: Send query letter with résumé, slides, bio, SASE and reviews. Call or write for appointment to show portfolio of slides. Replies in 1 month.

Tips: Finds artists through exhibitions, word of mouth, referrals.

‡SOMERHILL GALLERY, 3 Eastgate E. Franklin St., Chapel Hill NC 27514. (919)968-8868. Fax: (919)967-1879. Director: Joseph Rowand. Retail gallery. Estab. 1972. Represents emerging, mid-career and established artists. Sponsors 10 major shows/year, plus a varied number of smaller shows. Open all year. 10,000 sq. ft.; gallery features "architecturally significant spaces, pine floor, 18′ ceiling, 6 separate gallery areas, stable, photo, glass." 50% of space for special exhibitions.

Media: Considers all media, woodcuts, wood engravings, linocuts, engravings, mezzotints, etchings, lithographs and serigraphs. Does not consider installation. Most frequently exhibits painting, sculpture and glass.

Style: Exhibits all styles and genres.

Submissions: Focus is on Southeastern contemporary of the United States; however artists from all over the world are exhibited. Send query letter with résumé, slides, bio, SASE and any relevant materials. Replies in 6-8 weeks. Files slides and biographical information of artists.

SPIRIT SQUARE CENTER FOR ARTS AND EDUCATION, 345 N. College St., Charlotte NC 28202. (704)372-9664. Fax: (704)377-9808. Director of Visual Arts: Donna Devereaux. 6 nonprofit galleries. Estab.

1983. Exhibits emerging, mid-career and established artists. Sponsors 45-50 shows/year. Average display time 2 months. Overall price range: $3,500-60,000.
Tips: Looks for qualities "dealing with issues important to the development of contemporary art. Temporary exhibitions only."
Media: Considers all media.
Terms: Sometimes offers customer discounts if they are members and purchase in excess of $1,000.
Submissions: Send query letter with artist's statement, artist's process, résumé, full sheet of slides ("in focus!") and SASE. Call for an appointment to show portfolio.
Tips: Finds artists through visiting exhibitions, word of mouth, artists' submissions, and research into particular topics or themes.

North Dakota

‡**THE ARTS CENTER**, Dept. AGDM, 115 Second St. SW, Box 363, Jamestown ND 58402. (701)251-2496. Director: Mark Zimmerman. Nonprofit gallery. Estab. 1981. Sponsors 8 solo and 4 group shows/year. Average display time 6 weeks. Interested in emerging artists. Overall price range: $50-600; most work sold at $50-350.
Style: Exhibits contemporary, abstraction, impressionism, primitivism, photorealism and realism. Genres include Americana, figurative and 3-dimensional work.
Terms: 40% commission on sales from regularly scheduled exhibitions. Retail price set by artist. Gallery provides insurance, promotion and contract; shipping costs are shared.
Submissions: Send query letter, résumé, brochure, slides, photograph and SASE. Write for appointment to show portfolio. Invitation to have an exhibition is extended by Arts Center curator.
Tips: Interested in variety.

GANNON & ELSA FORDE GALLERIES, 1500 Edwards Ave., Bismarck ND 58501. (701)224-5520. Fax: (701)224-5550. Gallery Director: Michelle Lindblom. College gallery. Represents 12 emerging, mid-career and established artists per school year. Sponsors 6 shows/year. Average display time 6 weeks. Open all year; Monday-Thursday, 9-9; Friday, 9-4; Saturday, 1-5; Sunday, 6-9. Summer exhibit is college student work (May-August). Located Bismarck State College Campus; high traffic areas on campus. Clientele: all. 80% private collectors, 20% corporate collectors. Overall price range: $50-10,000; most work sold at $50-3,000.
Media: Considers oil, acrylic, watercolor, pastel, drawing, mixed media, collage, paper, sculpture, ceramics, fiber, photography, woodcut, engraving, lithograph, wood engraving, mezzotint, serigraphs, linocut and etching. Most frequently exhibits painting media (all), mixed media and sculpture.
Style: Exhibits expressionism, neo-expressionism, painterly abstraction, surrealism, impressionism, photorealism, hard-edge geometric abstraction and realism, all genres. Prefers figurative, landscapes and abstract.
Terms: Accepts work on consignment (20% commission). Retail price set by the artist. Gallery provides insurance on premises, promotion, contract and shipping costs from gallery; artist pays shipping costs to gallery. Prefers artwork framed.
Submissions: Send query letter with résumé, slides, bio and SASE. Call or write for appointment to show portfolio of photographs and slides. Replies in 2 months. Files résumé, bio, photos if sent.
Tips: Finds artists through word of mouth, art publications, artists' submissions, visiting exhibitions. "Because our gallery is a University gallery, the main focus is not just selling work but exposing the public to art of all genres. However, we do sell work, occasionally."

HUGHES FINE ART CENTER ART GALLERY, Department of Visual Arts, University of North Dakota, Grand Forks ND 58202-7099. (701)777-2257. Director: Brian Paulsen. Nonprofit gallery. Estab. 1979. Exhibits emerging, mid-career and established artists. Sponsors 5 shows/year. Average display time 3 weeks. Open all year. Located on campus; 96 running ft. 100% of space for special exhibitions.
 • Director states gallery is interested in "well-crafted, clever, sincere, fresh, inventive, meaningful, unique, well-designed compositions—surprising, a bit shocking, etc."
Media: Considers all media. Most frequently exhibits painting, photographs and jewelry/metal work.
Style: Exhibits all styles and genres.
Terms: Retail price set by artist. Gallery provides "space to exhibit work and some limited contact with the public and the local newspaper." Gallery pays for shipping costs. Prefers artwork framed.
Submissions: Send query letter with slides and résumé. Portfolio review not required. Replies in 1 week. Files "duplicate slides, résumés."
Tips: Finds artists from submissions through *Artist's & Graphic Designer's Market* listing, *Art in America* listing in their yearly museum compilation; as an art department listed in various sources as a school to inquire about; the gallery's own poster/ads. "We have a video we send out by request. Send slides and approximate shipping costs."

MINOT ART GALLERY, Box 325, Minot ND 58702. (701)838-4445. Executive Director: Judith Allen. Nonprofit gallery. Estab. 1970. Represents emerging, mid-career and established artists. Sponsors 9 shows/

year. Average display time 1-2 months. Open all year. Located at North Dakota state fairgrounds; 1,600 sq. ft.; "2-story turn-of-the-century house." 100% of space for special exhibitions. Clientele: 100% private collectors. Overall price range: $50-2,000; most work sold at $100-400.

Media: Considers oil, acrylic, watercolor, pastel, pen & ink, drawings, mixed media, collage, works on paper, sculpture, ceramic, fiber, glass, photograph, woodcuts, engravings, lithographs, serigraphs, linocuts and etchings. Most frequently exhibits watercolor, acrylic and mixed media.

Style: Exhibits all styles and genres. Prefers figurative, Americana and landscapes. No "commercial style work." Interested in all media (minimal photography).

Terms: Accepts work on consignment (30% commission). Retail price set by artist. Offers discounts to gallery members and sometimes payment by installments. Gallery provides insurance, promotion and contract; pays shipping costs from gallery or shipping costs are shared. Requires artwork framed.

Submissions: Send query letter with résumé and slides. Write for appointment to show portfolio of good quality photographs and slides. "Show variety in your work." Replies in 1 month. Files material interested in.

Tips: Finds artists through visiting exhibitions, word of mouth, artists' submissions of slides and members' referrals. "Do not call for appointment. We are seeing many more photographers wanting to exhibit."

NORTHWEST ART CENTER, Minot State University, 500 University Ave. W., Minot ND 58707. (701)857-3264 or 3836. Fax: (701)839-6933. E-mail: olsonl@warp6.cs.misu.nodak.edu. Director: Linda Olson. Nonprofit gallery. Estab. 1970. Represents emerging, mid-career and established artists. Sponsors 15-25 shows/year. Average display time 4-6 weeks. Open all year. Two galleries: Hartnett Hall Galleries; Monday-Friday, 8-5; The Library Gallery; Monday-Friday, 8-10. Located on University campus; 1,000 sq. ft. 100% of space for special exhibitions. 100% private collectors. Overall price range: $100-40,000; most work sold at $100-4,000.

Media: Considers all media and all types of prints except posters.

Style: Exhibits all styles, all genres.

Terms: Retail price set by the artist. Gallery provides insurance, promotion and contract; shipping costs are shared. Prefers artwork framed.

Submissions: Send query letter with résumé, slides, bio, SASE and artist's statement. Call for appointment to show portfolio of originals, photographs, slides and transparencies. Replies in 1-2 months. Files all material.

Tips: Finds artists through artists' submissions, visiting exhibitions, word of mouth. "Develop a professional presentation. Use excellent visuals—slides, etc."

Ohio

ACME ART COMPANY, 737 N. High St., Columbus OH 43215. (614)299-4003. Art Director: Lori McCargish. Nonprofit gallery. Estab. 1986. Represents 300 emerging and mid-career artists/year. 250 members. Exhibited artists include Rick Borg, Eric Lubkeman. Sponsors 12 shows/year. Average display time 1 month. Open all year; Wednesday-Saturday, 1:00-7:00. Located in Short North District; 1,200 sq. ft.; 3 gallery areas. 70% of space for special exhibitions; 70% of space for gallery artists. Clientele: avant-garde collectors, private and professional. 85% private collectors, 15% corporate collectors. Overall price range: $30-5,000; most work sold at $50-1,000.

Media: Considers all media and all types of prints except posters. Most frequently exhibits painting, installations and sculpture.

Style: Exhibits all styles, prefers avante-garde and cutting edge. Genres include all types of experimental and emerging art forms. Prefers experimental, socio/political and avante-garde.

Terms: Accepts work on consignment (30% commission). Retail price set by the gallery and the artist. Gallery provides promotion and contract; shipping costs are shared. Prefers artwork framed.

Submissions: Prefers only "artists who push the envelope, who explore new vision and materials of presentation." Send query letter with résumé, slides, bio, SASE and reviews. Write for appointment to show portfolio of originals if possible, slides or transparencies. Call for following fiscal year line-up ("we work 1 year in advance"). Files bio, slides, résumé and other support materials sent by artists.

Tips: Finds artists through art publications, slides from call-for-entries, minority organizations, universities and word of mouth.

‡ALAN GALLERY, 36 Park St., Berea OH 44017. (216)243-7794. Fax: (216)243-7772. President: Alan Boesger. Retail gallery and arts consultancy. Estab. 1983. Represents 25-30 emerging, mid-career and established artists. Sponsors 4 solo shows/year. Average display time 6-8 weeks. Clientele: 20% private collectors, 80% corporate clients. Overall price range: $700-6,000; most work sold at $1,500-2,000.

Media: Considers all media and limited edition prints. Most frequently exhibits watercolor, works on paper and mixed media.

Style: Exhibits color field, painterly abstraction and surrealism. Genres include landscapes, florals, Western and figurative work.

Terms: Accepts work on consignment (40% commission). Retail price set by gallery and artist. Exclusive area representation not required. Gallery provides insurance, promotion and contract; shipping costs are shared.

Submissions: Send résumé, slides and SASE. Call or write for appointment to show portfolio of originals and slides. All material is filed.

‡ALLEZ LES FILLES, 761 N. High St., Columbus OH 43215. (614)291-2555. Fax: (614)291-2715. Contact: Rebecca Ibel or Iana Simeonov. Retail gallery and art consultancy. Estab. 1993. Represents/exhibits 20-25 emerging, mid-career and established artists/year. Sponsors 9 shows/year. Average display time 6 weeks. Open all year; Tuesday-Saturday, 12-6. Located in Short North (gallery district) near downtown; 1,800 sq. ft.; double storefront, white walls, high ceilings. 85% of space for special exhibitions. 100% private collectors. Overall price range: $100-50,000; most work sold at $800-6,000.

Media: Considers all media except crafts and all types of prints. Most frequently exhibits painting, works on paper and sculpture.

Style: Exhibits expressionism, conceptualism, neo-expressionism, minimalism, color field, painterly abstraction, postmodern works and realism. All genres.

Terms: Artwork is accepted on consignment (50% commission). Retail price set by the gallery and artist. Gallery provides insurance, promotion, contract; shipping costs are shared. Prefers artwork unframed.

Submissions: Send query letter with slides, reviews, bio and SASE. Call for appointment to show portfolio of slides. Replies in 2 weeks.

Tips: Finds artists through referrals, art fairs and artists' submissions. "Clearly label all slides including name, title, year, full description, size and price. Do not include an artist statement."

ART SALES AND RENTAL SERVICE OF CLEVELAND CENTER FOR CONTEMPORARY ART, 8501 Carnegie Ave., Cleveland OH 44106. (216)421-8671. Fax: (216)421-0737. Museum rental shop. Estab. 1986. Represents 100 emerging, mid-career and established artists/year. Interested in seeing the work of emerging local artists. Exhibited artists include John Pearson, La Wilson. Sponsors 6 shows/year. Average display time 7 weeks. Open all year: Tuesday-Wednesday, 11-6; Thursday-Friday, 11-8:30; Saturday, 12-5; Sunday, 1-4. Located in University Circle, Cleveland, Ohio. 50% of space for special exhibitions; 50% of space for gallery artists. Clientele: gallery visitors and members, corporate. 70% private collectors, 30% corporate collectors. Overall price range: $300-100,000; most work sold at $600-2,000.

Media: Considers oil, acrylic, watercolor, pastel, pen & ink, drawing, mixed media, collage, paper, sculpture, ceramics, glass, photography, woodcut, engraving, lithograph, wood engraving, mezzotint, serigraphs, linocut and etching. Most frequently exhibits prints, paintings, works on paper.

Style: Exhibits all styles (contemporary). Genres include abract, minimalist.

Terms: Accepts work on consignment. Retail price set by the artist. Gallery provides insurance and promotion; artist pays shipping costs to and from gallery. Prefers artwork framed.

Submissions: Send query letter with résumé, slides and SASE. Call for appointment to show portfolio of slides. Replies in 2 months. Files slides of interest.

Tips: Finds artists through studio and gallery visits, referrals from artists, slides.

C.A.G.E., 1416 Main St., Cincinnati OH 45210. (513)381-2437. Contact: Alan Bratton. Nonprofit gallery. Estab. 1978. Represents emerging, mid-career and established artists. Sponsors 10-15 solo/group shows/year. Average display time 5 weeks. North gallery 18×20 w/12' ceiling; main gallery 18×50 w/12' ceiling; window space 4×8 with 16' ceiling. Clientele: 99.9% private collectors, .1% corporate clients. Overall price range: $100-5,000; most work sold at $100-500.

● The art shown at C.A.G.E. tends to be on the cutting edge, often controversial and politically left of center.

Media: Considers all media. Most frequently exhibits paintings, mixed media and installation/video/performance.

Style: Considers all styles; "experimental, conceptual, political, media/time art, public art and artists' projects encouraged. Proposals from artists are accepted and reviewed in the fall (deadline September 15) for exhibition 9-20 months from deadline. A panel of peer artists and curators selects the exhibitions."

Terms: Retail price set by artist. Exclusive area representation not required. Gallery provides insurance, promotion and contract.

Submissions: Send query letter with SASE for prospectus. Portfolio review not required.

Tips: Finds artists through various art publications and sourcebooks, artists' submissions and self-promotions. "Some of the most common mistakes artists make are presenting badly or incorrectly labeled slides and unclear proposals. Proposals should be concise, intelligent and well-written and should include artist's statement."

‡CHELSEA GALLERIES, 23225 Mercantile Rd., Beachwood OH 44122. (216)591-1066. Fax: (216)591-1068. Director: Jill T. Wieder. Retail gallery. Estab. 1975. Represents/exhibits 400 emerging and mid-career artists/year. Exhibited artists include Jamie Morse and Edit Hepp. Sponsors 5 shows/year. Average display time 6 months. Open all year; Monday-Friday, 9-5; Saturday, 12-4. Located in suburban design and architec-

tural resource area; 3,500 sq. ft.; open, adjustable showroom; easy access, free parking, halogen lighting. 40% of space for special exhibitions; 100% of space for gallery artists. Clientele: upscale. 85% private collectors, 15% corporate collectors. Overall price range: $50-10,000; most work sold at $500-2,000.
Media: Considers all media and all types of prints. Most frequently exhibits painting, glass and ceramics.
Style: Exhibits all styles. All genres. Prefers impressionism, realism and abstraction.
Terms: Artwork is accepted on consignment (50% commission). Retail price set by the gallery and the artist. Gallery provides insurance, promotion and contract; shipping costs are shared. Prefers artwork framed.
Submissions: Send query letter with résumé and slides. Call for appointment to show portfolio of photographs and slides. Replies in 6 weeks. Files résumé and slides.
Tips: "Be realistic in pricing—know your market."

CLEVELAND STATE UNIVERSITY ART GALLERY, 2307 Chester Ave., Cleveland OH 44114. (216)687-2103. Fax: (216)687-9366. Director: Robert Thurmer. University gallery. Exhibits 50 emerging, mid-career and established artists. Exhibited artists include Ellen Phelan and Kay Walkingstick. Sponsors 6 shows/year. Average display time 1 month. Open Monday-Friday 10-4. Closed Saturday, Sunday and holidays. Located downtown: 4,500 sq. ft. (250 running ft. of wall space). 100% of space for special exhibitions. Clientele: students, faculty, general public. 85% private collectors, 15% corporate collectors. Overall price range: $250-50,000; most work sold at $300-1,000.
Media: Considers all media and all types of prints. Prefers painting, sculpture and new genres work.
Style: Exhibits all styles and genres. Prefers contemporary, modern and postmodern. Looks for challenging work.
Terms: 25% suggested donation to gallery. Sales are a service to artists and buyers. Gallery provides insurance, promotion, shipping costs to and from gallery; artists handle crating. Prefers artwork framed.
Submissions: Send query letter with résumé and slides. Portfolio review requested if interested in artist's work. Files résumé and slides.
Tips: Finds artists through visiting exhibitions, artists' submissions, publications and word of mouth. Submission guidelines available for SASE. "No oversized or bulky materials please! 'Just the facts ma'am.' "

THE A.B. CLOSSON JR. CO., 401 Race St., Cincinnati OH 45202. (513)762-5510. Fax: (513)762-5515. Director: Phyllis Weston. Retail gallery. Estab. 1866. Represents emerging, mid-career and established artists. Average display time 3 weeks. Clientele: general. Overall price range: $600-75,000.
Media: Considers oil, watercolor, pastel, mixed media, sculpture, original handpulled prints and limited offset reproductions.
Style: Exhibits all styles and genres.
Terms: Accepts work on consignment or buys outright. Retail price set by gallery and artist. Customer discounts and payment by installment are available. Exclusive area representation required. Gallery provides insurance and promotion; shipping costs are shared.
Submissions: Send photos, slides and résumé. Call or write for appointment. Portfolio review requested if interested in artist's work. Portfolio should include originals.
Tips: Finds artists through agents, visiting exhibitions, word of mouth, various art publications, sourcebooks, artists' submissions/self-promotions and art collectors' referrals.

SPANGLER CUMMINGS, 641 N. High St., Suite 106, Columbus OH 43215. (614)224-4484. Fax: (614)224-4483. Owner: Spangler Cummings. Retail gallery. Estab. 1987, reopened 1993. Represents 12 emerging, mid-career and established artists. Sponsors 5 shows/year. Average display time 2 months. Open all year; Tuesday-Saturday, 11-5. Located arts district north of downtown; 800 sq. ft.; "Duchamps meets Gehry" office and storage. 100% of space for gallery artists. Clientele: corporate and private. 75% private collectors, 25% corporate collectors. Overall price range: $250-15,000; most work sold at $250-3,500.
Media: Considers oil, acrylic on canvas or board, drawing, sculpture. Most frequently exhibits paintings, sculpture and drawings.
Style: Exhibits expressionism, neo-expressionism, painterly abstraction, minimalism, color field, impressionism and photorealism. Prefers color field, expressionism and painterly abstraction, all contemporary.
Terms: Accepts work on consignment (negotiated commission). Retail price set by the artist. Gallery provides insurance, promotion and contract; artist pays shipping costs to and from gallery.
Submissions: Send query letter with résumé, slides, bio, SASE and reviews. Replies in 1 month.
Tips: "Files only material from artists we may be interested in in the future." Finds artists through visiting exhibits, various art publications, other galleries, art league and community art shows and international art fairs.

EMILY DAVIS GALLERY, School of Art, University of Akron, Akron OH 44325. (216)972-5950. Director: Rod Bengston. Nonprofit gallery. Estab. 1974. Clientele: persons interested in contemporary/avant-garde art. 12 shows/year. Average display time is 3½ weeks. Interested in emerging and established artists. Overall price range: $100-65,000; "no substantial sales."

Create a Demand for Your Work

John Stobart

John Stobart, America's premier marine painter, is one of the busiest artists around. He runs six art galleries, owns an art publishing company, authored *The Pleasures of Painting Outdoors* (North Light Books), established a foundation to help art students, and traveled the world painting for the PBS "WorldScape" series. The secret to his energy, says Stobart, is he's doing what he loves.

Stobart encourages all artists to pursue their life's work. "The world is at the feet of the aspiring artist today," says Stobart, from his studio in Martha's Vineyard, as if he's glad to have the chance to say it. "But you've got to understand what galleries and collectors need.

"You must develop your 'signature'—characteristics that reveal your own individual personality in whatever ideology you choose to embrace."

Stobart began developing his own unique style while he was a paint-stained art student at the Royal Academy in London. Realizing he couldn't make a living selling the lessons he sketched in class, he began painting small oils from nature.

It wasn't until a gentleman in a Homburg hat asked the price of a painting that the young artist realized his work's value. When Stobart told him the small oil of tugboats was earmarked for a school competition and was not for sale, the man smiled and asked "What *would* you have charged if you *had* wanted to sell it?" With nothing to lose, Stobart stammered what seemed an impossibly high price—between five and ten pounds. The gentleman reached for his wallet and started counting out crisp bills. "The sight of those fresh bills threw me for a loop. From that moment I knew I could make a living as a painter."

His friends at school weren't so impressed. When word of the sale got out, Stobart overheard classmates grumble "Stobart has prostituted his art!" and recalls fellow students crossing the street to avoid him.

The artist laughs at the memory, but adds "In a way they were right. It's the artist's dilemma. As soon as a customer likes your work and you go and paint something similar, you can become trapped by what you've done before."

If art is to be your livelihood you'll need to narrow your subject matter. Since Stobart is fascinated by ships, he chose them as his emphasis. "It's somewhat like being a physician. Artists will reach greater heights if they specialize." Galleries and collectors value artists with a consistency in subject and approach.

Secondly, your work must stand out from everybody else's. "Just as every person has a recognizable face, your primary purpose should be to ensure your

work has characteristics that are different from any other and recognizably so." The work you submit to a gallery must all look as though it's been done by you. The subject matter and style shouldn't jump all over the place.

One element does not make a style. A Stobart painting, for example, is recognizable for several qualities. The subject is usually historic ships, ports and harbors. The skies are dramatic and take up more than half the canvas. Scenes are often depicted in moonlight, with light reflecting on water. "I liked the idea of having this cool painting with a little hot spot in it." Stobart employs a second style in smaller canvases. Though his brush strokes are looser, more spontaneous in these plein air works, they are recognizable as "Stobarts" because of the spacious skies and his facility for painting light and reflection.

How do you develop your own "signature?" Consider what you like doing best, what you are most comfortable with and what your friends and associates seem to be attracted by. What subject matter gives you your biggest kick? The choices are endless. Only you know what you are happiest about, says Stobart.

Don't think, "I've finished this painting, now I can relax." Work with consistency and regularity. "The greatest masterpiece won't come by design, but by accident, through working every day." The majority of artists don't have the staying power or motivation to become prolific, and galleries love prolific artists.

Don't knock out potboilers, thinking "I guess I'll make the geese fly off to the left this time." Work on composition so your paintings look interesting from 25 feet away. "Your work has to beckon the viewer to walk over and take a look," says Stobart. When it's that good, it will be in demand.

—*Mary Cox*

Delicate water reflection and a predominant sky are characteristic of maritime artist John Stobart's work such as **Shrimp Boats at Skull Creek.** *This 20 × 32 piece, printed in an edition of 850, is one in Stobart's line of seascapes available from the artist's Maritime Heritage Prints.*

Media: Considers all media.

Style: Exhibits contemporary, abstract, figurative, non-representational, photorealistic, realistic, avant-garde and neo-expressionistic works.

Terms: Retail price is set by artist. Exclusive area representation not required. Gallery provides insurance, shipping costs, promotion and contract.

Submissions: Send query letter with one page résumé, brochure, slides, photographs and SASE. Write for an appointment to show a portfolio. Résumés are filed.

Tips: Finds artists through visiting exhibitions, word of mouth, various art publications, sourcebooks and artists' submissions/self-promotions. "The gallery is a learning laboratory for our students—to that end— we exhibit contemporary—avant-garde artists drawn from national level."

EAST/WEST ALTERNATIVE GALLERY, 2025 Murray Hill Rd., Cleveland OH 44106. (216)231-6141. Contact: Director. Cooperative/consignment gallery. Estab. 1990. Interested in seeing the work of all artists. Sponsors 8 shows/year. Average display time 6 weeks. Open all year. Located in historic Little Italy. 40% of space for special exhibitions. Clientele: 90% private collectors, 10% corporate collectors. Overall price range: $30-3,000; most work sold at $30-750.

Media: Considers all media and all types of prints except posters and offset reproductions. Most frequently exhibits paintings, sculpture and ceramics.

Style: Exhibits all styles and genres.

Terms: Co-op membership fee plus donation of time (80% commission). Retail price set by artist. Sometimes offers customer discounts and payment by installment. Gallery provides promotion. Prefers artwork framed.

Submissions: Send query letter with résumé and bio. Write for appointment to show portfolio of slides. Replies in 1 month. Files résumé and letter of acceptance or rejection.

Tips: Looking for "financial ability to split rent, time to gallery sit and most importantly, quality artwork and commitment."

‡FIRELANDS ASSOCIATION FOR VISUAL ARTS, 80 S. Main St., Oberlin OH 44074. Phone/fax: (216)774-7158. Gallery Director: Susan Jones. Nonprofit gallery. Estab. 1979. Represents/exhibits 15 emerging, mid-career and established artists/year. Exhibited artists include Lawrence Krause. Sponsors 6-7 shows/ year. Average display time 1 month. Open all year except August; Tuesday-Saturday, 12-5; Sunday, 2-4. Located downtown Oberlin; 1,050 sq. ft.; 2 galleries; wood floor, white walls. 100% of space for special exhibitions. Clientele: national audience for national quilt show. 85% private collectors, 15% corporate collectors. Overall price range: $100-4,000; most work sold at $100-500.

Media: Considers all media and all types of prints except posters.

Style: Exhibits all styles. Not interested in genre work.

Terms: "We select artists once a year based on slide application. Artists are not represented after show ends." 30% commission on sales during show. Retail price set by the artist. Gallery provides insurance, promotion and contract. Artist pays for shipping cost. Prefers artwork framed.

Submissions: Accepts only artists from Ohio. Send query letter with résumé, slides, reviews and SASE.

THE MIDDLETOWN FINE ARTS CENTER, 130 N. Verity Pkwy., P.O. Box 441, Middletown OH 45042. (513)424-2416. Contact: Peggy Davish. Nonprofit gallery. Estab. 1957. Represents emerging, mid-career and established artists. Sponsors 5 solo and/or group shows/year. Average display time 3 weeks. Clientele: tourists, students, community. 95% private collectors, 5% corporate clients. Overall price range: $100-1,000; most work sold at $150-500.

Media: Considers all media except prints. Most frequently exhibits watercolor, oil, acrylic and drawings.

Style: Exhibits all styles and genres. Prefers realism, impressionism and photorealism. "Our gallery does not specialize in any one style or genre. We offer an opportunity for artists to exhibit and hopefully sell their work. This also is an important educational experience for the community. Selections are chosen 2 years in advance by a committee."

Terms: Accepts work on consignment (30% commission). Retail price set by artist. Sometimes offers customer discounts and payment by installment. Exclusive area representation not required. Gallery provides insurance and promotion; artist pays for shipping. Artwork must be framed and wired.

Submissions: Send query letter with résumé, brochure, slides, photographs and bio. Write for an appointment to show portfolio, which should include originals, slides or photographs. Replies in 3 weeks-3 months (depends when exhibit committee meets.). Files résumé or other printed material. All material is returned if not accepted or under consideration.

Tips: Finds artists through word of mouth, artists' submissions and self-promotions. "Decisions are made by a committee of volunteers, and time may not permit an on-the-spot interview with the director."

MILLER GALLERY, 2715 Erie Ave., Cincinnati OH 45208. (513)871-4420. Fax: (513)871-4429. Co-Directors: Barbara and Norman Miller. Retail gallery. Estab. 1960. Interested in emerging, mid-career and established artists. Represents about 50 artists. Sponsors 5 solo and 4 group shows/year with display time 1 month. Located in affluent suburb. Clientele: private collectors. Overall price range: $100-35,000; most artwork sold at $300-12,000.

Media: Considers, oil, acrylic, mixed media, collage, works on paper, ceramic, fiber, bronze, stone, glass and original handpulled prints. Most frequently exhibits oil or acrylic, glass and sculpture.

Style: Exhibits impressionism, realism and painterly abstraction. Genres include landscapes, interior scenes and still lifes. "Everything from fine realism (painterly, impressionist, pointilist, etc.) to beautiful and colorful abstractions (no hard-edge) and everything in between. Also handmade paper, collage, fiber and mixed mediums."

Terms: Accepts artwork on consignment (50% commission). Retail price set by artist and gallery. Sometimes offers payment by installment. Exclusive area representation is required. Gallery provides insurance, promotion and contract; shipping and show costs are shared.

Submissions: Send query letter with résumé, brochure, slides or photographs with sizes, wholesale (artist) and selling price and SASE. "Material of interest is filed or is returned by SASE."

Tips: Finds artists through agents, visiting exhibitions, word of mouth, various art publications and sourcebooks, artists' submissions/self-promotions, art collectors' referrals, and *Artist's and Graphic Designer's Market.* "Artists often either completely omit pricing info or mention a price without identifying as artist's or selling price. Submissions without SASE will receive reply, but no return of materials submitted. Make appointment—don't walk in without one. Quality, beauty, originality are primary. 'Commercial,' conceptual, political works not exhibited."

RUTLEDGE GALLERY, 1964 N. Main St., Dayton OH 45405. (513)278-4900. Director: Jeff Rutledge. Retail gallery, art consultancy. Focus is on artists from the Midwest. Estab. 1991. Represents 80 emerging and mid-career artists/year. Exhibited artists include Pat Antonic, Chris Shatzby and M. Todd Muskopf. Sponsors 12 shows/year. Average display time 2 months. Open all year; Tuesday-Saturday, 11-6. Located 1 mile north of downtown in Dayton's business district; 2800 sq. ft. "We specialize in sculpture and regional artists. We also offer commissioned work and custom framing." 70% of space for special exhibitions; 70% of space for gallery artists. Clientele: residential, corporate, private collectors, institutions. 65% private collectors, 35% corporate collectors.

Media: Considers oil, acrylic, watercolor, pastel, pen & ink, drawing, mixed media, paper, sculpture, ceramic, craft, glass, jewelry, woodcuts, engraving, lithographs, linocuts, etchings and posters. most frequently exhibits paintings, drawings, prints and sculpture.

Style: Exhibits expressionism, painterly abstraction, surrealism, color filed, impressionism and realism. Considers all genres. Prefers contemporary (modern), geometric and abstract.

Terms: Accepts work on consignment (40% commission). Retail price set by gallery. Gallery provides insurance, promotion and contract; artists pays shipping costs. Prefers artwork framed.

Submissions: Accepts mainly Midwest artists. Send query letter with résumé, brochure, 20 slides and 10 photographs. Call for appointment to show portfolio of originals, photographs, slides and transparencies. Replies only if interested within 1 month. Files "only material on artists we represent; others returned if SASE is sent or thrown away."

Tips: "Be well prepared, be professional, be flexible on price and listen."

SPACES, 2220 Superior Viaduct, Cleveland OH 44113. (216)621-2314. Alternative space. Estab. 1978. Represents emerging artists. Has 300 members. Sponsors 10 shows/year. Average display time 1 month. Open all year. Located downtown Cleveland; 6,000 sq. ft.; "loft space with row of columns." 100% private collectors.

Media: Considers all media. Most frequently exhibits installation, painting and sculpture.

Style: Exhibits all styles. Prefers challenging new ideas.

Terms: 20% commission. Retail price set by the artist. Sometimes offers payment by installment. Gallery provides insurance, promotion and contract.

Submissions: Send query letter with résumé, slides and SASE. Annual deadline in spring for submissions.

THE ZANESVILLE ART CENTER, 620 Military Rd., Zanesville OH 43701. (614)452-0741. Fax: (614)452-0741. Director: Charles Dietz Ph.D. Nonprofit gallery, museum. Estab. 1936. Represents emerging, mid-career and established artists. "We usually hold 3 exhibitions per month." Sponsors 25-30 shows/year. Average display time 1 month. Open all year; daily 1-5; closed Mondays and major holidays. Located edge of town; 1,152 sq. ft. 50% of space for special exhibitions; 50% of space for gallery artists. Clientele: artists of distinguished talent. 25% private collectors, 25% corporate collectors. Overall price range: $25-5,000; most work sold at $300-600.

Media: Considers all media and all types of prints including mono prints. Most frequently exhibits watermedia, oil, collage, ceramics, sculpture and children's art.

Style: Exhibits expressionism, neo-expressionism, painterly abstraction, all styles, impressionism, photorealism, realism. Genres include landscapes, florals, Americana, figurative non-objective work, all genres.

Terms: Accepts work on consignment (15% commission on sales). Retail price set by the artist. Gallery provides insurance and promotion; artist responsible for shipping costs to and from gallery. Prefers artwork framed.

Submissions: Send query letter with résumé, slides, bio, brochure, photographs and reviews. Call or write for appointment to show portfolio of originals, photographs, slides, bio or résumé. Replies in 2 weeks. Artist should follow up after query letter or appointment. Files bio or résumé.

Tips: Finds artists through visiting exhibitions, word of mouth, various art publications, artists' submissions.

Oklahoma

‡CITY ARTS CENTER, 3000 Pershing Blvd., Oklahoma City OK 73107. (405)948-6400. Fax: (405)948-6404. Nonprofit gallery. Estab. 1988. Exhibits 12 emerging, mid-career and established artists. 200 patron members. Exhibited artists include Michi Susan and Gloria Duncan. Sponsors 11 shows/year. Open all year; Monday-Thursday 9-10, Friday and Saturday 9-5, Sunday 1-5. Located on the State Fairgrounds. 5,000 sq. ft. "Main Gallery is large and spacious and newly renovated; Circle Gallery is old Planetarium space." 60% of space for special exhibitions; 40% of space for gallery artists. Clientele: art patrons from Oklahoma City metro area. 70% private collectors, 30% corporate collectors. Overall price range: $12-3,000; most work sold at $500-3,000.

Media: Considers oil, pen & ink, paper, fiber, acrylic, drawings, sculpture, glass, watercolor, mixed media, ceramic, installation, pastel, collage, craft, photography, relief, intaglio, lithographs and serigraphs. Prefers mixed media, photography and ceramic.

Style: Exhibits expressionism, neo-expressionism, primitivism, painterly abstraction and realism. All genres. Prefers abstraction, conceptualism and postmodern works.

Terms: Accepts work on consignment (70% commission). Retail price set by artist. Gallery provides promotion and contract (when required); artist pays for shipping costs. Prefers artwork framed.

Submissions: Cannot exhibit works of a graphic sexual nature. Send query letter with résumé, brochure, business card, slides, bio and SASE. Call or write for appointment to show portfolio of slides and transparencies. Replies in 2 months. Files résumé, bio, slides (unless artist wants returned).

Tips: "Professional quality slides are a must."

FIREHOUSE ART CENTER, 444 S. Flood, Norman OK 73069. (405)329-4523. Contact: Gallery Committee. Nonprofit gallery. Estab. 1971. Exhibits emerging, mid-career and established artists. 400 members. Sponsors 10-12 group and solo shows/year. Average display time 3-4 weeks. Open all year. Located in former fire station; 629.2 sq. ft. in gallery; consignment sales gallery has additional 120 sq. ft. display area; handicapped accessible community art center offering fully equipped ceramics, painting, sculpture, jewelry and fiber studios plus b&w photography lab. Classes and workshops for children and adults are offered quarterly. Clientele: 99% private collectors, 1% corporate collectors.

Media: Most frequently exhibits functional and decorative ceramics and sculpture, jewelry, paintings and wood.

Style: All styles and fine crafts. All genres. Prefers realism and impressionism.

Terms: Accepts work on consignment (35% commission). Offers discounts to gallery members. Gallery provides insurance and promotion for gallery exhibits and consignment sales; artist pays for shipping. Prefers artwork framed.

Submissions: Accepts only artists from south central US. Send query letter with résumé, bio, artist's statement, 20 slides of current work and SASE. Portfolio review required. Replies in 4 months.

Tips: Finds artists through word of mouth, art publications, and art collectors' referrals. "Develop a well-written statement and résumé."

GUSTAFSON GALLERY, 9606 N. May, Oklahoma City OK 73120. (405)751-8466. President: Diane. Retail gallery. Estab. 1973. Represents 15 mid-career artists. Exhibited artists include D. Norris Moses and Downey Burns. Sponsors 1 show/year. Average display time 2 months. Open all year. Located in a suburban mall; 1,800 sq. ft. 100% of space for special exhibitions. Clientele: upper and middle income. 60% private collectors, 40% corporate collectors. Overall price range: $4,000 maximum.

Media: Considers oil, acrylic, pastel, mixed media, collage, works on paper, sculpture, ceramic, fiber, offset reproductions, lithographs, posters and serigraphs. Most frequently exhibits acrylic, pastel and serigraphs.

Style: Exhibits primitivism and painterly abstraction. Genres include landscapes, Southwestern and Western. Prefers contemporary Southwestern art.

Terms: Artwork is accepted on consignment (40% commission); or buys outright for 50% of the retail price; net 30 days. Retail price set by the the artist. Gallery provides promotion; Shipping costs are shared.

Submissions: Send query letter with résumé, brochure, photographs, business card and reviews. Call for appointment to show portfolio of originals and photographs. Replies in 1 month.

LACHENMEYER ARTS CENTER, 700 S. Little, P.O. Box 586, Cushing OK 74023. (918)225-7525. Director: Rob Smith. Nonprofit gallery. Estab. 1984. Represents 35 emerging and mid-career artists/year. Exhibited artists include Dale Martin. Sponsors 4 shows/year. Average display time 2 weeks. Open in August, September, December; Monday, Wednesday, Friday, 9-5; Tuesday, Thursday, 5-9; Saturday, 9-12. Located inside

the Cushing Youth and Community Center; 550 sq. ft. 80% of space for special exhibitions; 80% of space for gallery artists. 100% private collectors.

Media: Considers oil, acrylic, watercolor, pastel, pen & ink, drawing, mixed media, collage, paper, sculpture, ceramics, fiber, photography, woodcut, engraving, lithograph, wood engraving, mezzotint, serigraphs, linocut and etching. Most frequently exhibits oil, acrylic and works on paper.

Style: Exhibits all styles. Prefers landscapes, portraits and Americana.

Terms: Accepts work on consignment (0% commission). Retail price set by the artist. Gallery provides promotion; shipping costs are shared. Prefers artwork framed.

Submissions: Send query letter with résumé, professional quality slides, SASE and reviews. Call or write for appointment to show portfolio of originals. Replies in 1 month. Files résumés.

Tips: Finds artists through visiting exhibits, word of mouth, other art organizations. "We are booked 1-2 years in advance."

NO MAN'S LAND MUSEUM, P.O. Box 278, Goodwell OK 73939-0278. (405)349-2670. Fax: (405)349-2302. Director: Kenneth R. Turner. Museum. Estab. 1934. Represents emerging, mid-career and established artists. Sponsors 12 shows/year. Average display time 1 month. Open all year; Tuesday-Saturday, 9-12 and 1-5. Located adjacent to university campus. 10% of space for special exhibitions. Clientele: general, tourist. 100% private collectors. Overall price range: $20-1,500; most work sold at $20-500.

Media: Considers all media and all types of prints. Most frequently exhibits oils, watercolors and pastels.

Style: Exhibits primitivism, impressionism, photorealism and realism. Genres include landscapes, florals, Americana, Southwestern, Western and wildlife. Prefers realist, primitive and impressionist.

Terms: "Sales are between artist and buyer; museum does not act as middleman." Retail price set by the artist. Gallery provides promotion and shipping costs to and from gallery. Prefers artwork framed.

Submissions: Send query letter with résumé, brochure, photographs and reviews. Call or write for appointment to show portfolio of photographs. Replies only if interested within 3 weeks. Files all material.

Tips: Finds artists through art publications, exhibitions, news items, word of mouth.

‡SHORNEY GALLERY OF FINE ART, 6616 N. Olie, Oklahoma City OK 73116-7318. Owner/director: Margo Shorney. Retail gallery. "Some private lessons and critiques given." Estab. 1976. Represents 40 emerging, mid-career and established artists. Exhibited artists include Rita Busch and Bill Thompson. Sponsors 2 major shows/year, and several Artist of the Month shows. Average display time 1 month. Open all year. Located in NW Oklahoma City; "gallery on one acre of land with landscaping, fish ponds and outdoor and indoor entertaining spaces." 1,800 sq. ft; 66% of space for special exhibitions. Clientele: experienced as well as beginning collectors. 80% private collectors, 20% corporate collectors. Overall price range: $60-6,000; most work sold at $500-3,500.

Media: Considers oil, acrylic, watercolor, pastel, pen & ink, mixed media, sculpture, fiber, raku pottery, stoneware, original handpulled prints, woodcuts, engravings, lithographs, etchings and serigraphs. Most frequently exhibits bronze, oil and watercolor.

Style: Exhibits painterly abstraction, surrealism, imagism, conceptualism, color field, impressionism and realism. Genres include landscapes, florals, Southwestern, Western, wildlife, portraits and figurative work. Prefers painterly realism, impressionism and representational bronze sculpture.

Terms: Accepts artwork on consignment (40% commission); or buys outright for 50% of retail price. Retail price set by gallery and artist. Gallery provides 50% of promotion and contract; artist pays for shipping. Prefers artwork framed.

Submission: Send query letter with résumé, bio, brochure and SASE. Write for appointment to show portfolio of originals, photographs and slides. Replies only if interested within 3 months. Files bio, résumé and brochure.

Tips: "Artist should have exposure through juried shows, other galleries, education or workshops in their expertise. Looking for serious, committed professionals, not 'Sunday' artists. We are adding artists only as a niche develops or when a certain style is in demand. The clientele has become very discerning and requires a greater degree of professionalism in all areas, the work itself and the presentation. We ship to out-of-state buyers more often. They are looking for quality at reasonable prices, which has been good for emerging and lesser-known artists."

THE WINDMILL GALLERY, 3750 W. Robinson, Suite 103, Norman OK 73072. (405)321-7900. Director: Andy Denton. Retail gallery. Estab. 1987. Focus is on Oklahoma American Indian art. Represents 20 emerging, mid-career and established artists. Exhibited artists include Rance Hood and Doc Tate Neuaquaya. Sponsors 4 shows/year. Average display time 1 month. Open all year. Located in northwest Norman (Brookhaven area); 900 sq. ft.; interior decorated Santa Fe style: striped aspen, adobe brick, etc. 30% of space for special exhibitions. Clientele: "middle-class to upper middle-class professionals/housewives." 100% private collectors. Overall price range $50-15,000; most artwork sold at $100-2,000.

Media: Considers oil, acrylic, watercolor, pastel, pen & ink, drawings, mixed media, works on paper, sculpture, craft, original handpulled prints, offset reproductions, lithographs, posters, cast-paper and serigraphs. Most frequently exhibits watercolor, tempera and acrylic.

Style: Exhibits primitivism and realism. Genres include landscapes, Southwestern, Western, wildlife and portraits. Prefers Native American scenes (done by Native Americans), portraits and Western-Southwestern and desert subjects.

Terms: Artwork is accepted on consignment (40% commission). Retail price set by the artist. Customer discounts and payment by installments available. Gallery provides insurance and promotion. Shipping costs are shared. Prefers framed artwork.

Submissions: Send query letter with slides, bio, brochure, photographs, SASE, business card and reviews. Replies only if interested within 1 month. Portfolio review not required. Files brochures, slides, photos, etc.

Tips: Finds artists through agents, visiting exhibitions, word of mouth, art publications and sourcebooks, artists' submissions/self-promotions and art collectors' referrals. Accepts artists from Oklahoma area; Indian art done by Indians only. Director is impressed by artists who conduct business in a very professional manner, have written biographies, certificates of limited editions for prints, and who have honesty and integrity. "Call, tell me about yourself, try to set up appointment to view works or to hang your works as featured artist. Fairly casual—but must have bios and photos of works or works themselves! Please, no drop-ins!"

Oregon

‡BUCKLEY CENTER GALLERY, UNIVERSITY OF PORTLAND, 5000 N. Willamette Blvd., Portland OR 97203. (503)283-7258. E-mail: soissen@uofport.edu. Gallery Director: Michael Miller. University gallery. Exhibits emerging, mid-career and established artists. Exhibited artists include Don Gray and Melinda Thorsnes. Sponsors 7 shows/year. Average display time 3-4 weeks. Open September-May; Monday-Friday; 8:30-8:00 and Saturday, 8:30-4:00. Located 5 miles from downtown Portland; 525 sq. ft.; 2 walls of floor to ceiling windows (natural light). Clientele: students, faculty staff and locals. 100% private collectors. Overall price range: $300-3,000; most work sold at $400-700.

Media: Considers all media and all types of prints. Prefers oil/acrylic, photography, watercolor and mixed media.

Style: Exhibits all styles and genres. Prefers neo-expressionism, realism and primitivism.

Terms: Accepts work on consignment (10% commission). Retail price set by artist. Gallery provides insurance and promotion; artist pays shipping costs. Prefers artwork framed.

Submissions: Accepts only artists from Portland metropolitan area. No shipping, artist must deliver and pick-up. Send query letter with résumé, professional slides, bio and SASE. Replies in 3 weeks. Files résumés.

BUSH BARN ART CENTER, 600 Mission St. SE, Salem OR 97302. (503)581-2228. Fax: (503)581-2228. Gallery Director: Saralyn Hilde. Nonprofit gallery. Represents 125 emerging, mid-career and established artists/year. Sponsors 18 shows/year. Average display time 5 weeks. Open all year; Tuesday-Friday, 10-5; Saturday-Sunday, 1-5. Located near downtown in an historic park near Mission and High Streets in a renovated historic barn—the interior is very modern. 50% of space for special exhibitions; 50% of space for gallery artists. Overall price range: $10-2,500.

Media: Considers oil, acrylic, watercolor, pastel, pen & ink, drawing, mixed media, collage, paper, sculpture, ceramics, fiber, glass, installation, photography, all types of prints.

Style: Exhibits all styles.

Terms: Accepts work on consignment (40% commission). Gallery provides contract. Prefers artwork framed.

Submissions: Send query letter with résumé, slides and bio. Write for appointment.

‡FRAME DESIGN & SUNBIRD GALLERY, 916 Wall St., Bend OR 97701. (503)389-9196. Fax: (503)389-8831. Gallery Director: Sandra Miller. Retail gallery. Estab. 1980. Represents/exhibits 25-50 emerging, mid-career and established artists/year. Exhibited artists include Dittebrandt and Rie Muñoz. Sponsors 3 shows/year. Average display time 1 month. Open all year; Monday-Saturday, 9:30-5:30. Located downtown; 3,000 sq. ft. "We feature large outdoor sculpture in an indoor setting." 60% of space for special exhibitions; 40% of space for gallery artists. Clientele: tourists, upscale, local community. 90% private collectors, 2% corporate collectors. Overall price range: $100-15,000; most work sold at $200-2,500.

Media: Considers all media and all types of prints. Most frequently exhibits acrylic, sculpture and mixed media.

Style: Exhibits all styles. All genres. Prefers contemporary Native American and landscape (all media).

Terms: Artwork is accepted on consignment (50% commission). Artwork is bought outright for 50% of the retail price. Retail price set by the gallery and the artist. Gallery provides promotion and contract; shipping costs are shared.

Submissions: Send query letter with résumé, brochure, business card, slides, photographs, reviews, bio and SASE. Call or write for appointment to show portfolio of photographs, slides and transparencies. Replies in 2-4 weeks. Files material on possible future shows.

Tips: Finds artists through word of mouth, referrals by other artists, visiting art fairs and exhibitions and artists' submissions. "Know the kind of artwork we display before approaching us."

THE MAUDE KERNS ART CENTER, 1910 E. 15th Ave., Eugene OR 97403. (503)345-1571. Executive Director: Nancy Frey. Nonprofit gallery. Estab. 1963. Exhibits hundreds of emerging, mid-career and estab-

lished artists. Interested in seeing the work of emerging artists. 650 members. Sponsors 8-10 shows/year. Average display time 6 weeks. Open all year. Located in church bulding on Historic Register. 4 renovated galleries with over 2,500 sq. ft. of modern exhibit space. 100% of space for special exhibitions. Clientele: 50% private collectors, 50% corporate collectors. Overall price range: $200-20,000; most work sold at $200-500.

Media: Considers all media and original handpulled prints. Most frequently exhibits oil/acrylic, mixed media and sculpture.

Style: Contemporary artwork.

Terms: Accepts work on consignment (40% commission). Retail price set by artist. Offers customer discounts and payment by installments. Gallery provides insurance and contract; artist pays for shipping. Prefers artwork framed.

Submissions: Send query letter with résumé, slides, bio and SASE. Call for appointment to show portfolio of photographs, slides and transparencies. Files slide bank, résumé and statement.

Tips: Finds artists through "Calls to Artists," word of mouth, and local arts council publications. "Call first! Come visit to see exhibits and think about whether the gallery suits you."

LANE COMMUNITY COLLEGE ART GALLERY, 4000 E. 30th Ave., Eugene OR 97405. (503)747-4501. Gallery Director: Harold Hoy. Nonprofit gallery. Estab. 1970. Exhibits the work of emerging, mid-career and established artists. Sponsors 7 solo and 2 group shows/year. Average display time 3 weeks. Most work sold at $100-2,000.

Media: Considers all media.

Style: Exhibits contemporary works. Interested in seeing "contemporary, explorative work of quality. Open in terms of subject matter."

Terms: Retail price set by artist. Sometimes offers customer discounts. Exclusive area representation not required. Gallery provides insurance, promotion and contract; shipping costs are shared. "We retain 25% of the retail price on works sold."

Submissions: Send query letter, résumé and slides with SASE. Portfolio review required. Résumés are filed.

LAWRENCE GALLERY, Box 187, Sheridan OR 97378. (503)843-3633. Director: Gary Lawrence. Retail gallery and art consultancy. Estab. 1977. Represents 150 mid-career and established artists. Sponsors 10 two-person and 1 group shows/year. "The gallery is surrounded by several acres of landscaping in which we feature sculpture, fountains and other outdoor art." Clientele: tourists, Portland and Salem residents. 80% private collectors, 20% corporate clients. Overall price range: $10-50,000; most work sold at $1,000-5,000.

Media: Considers oil, acrylic, watercolor, pastel, pen & ink, drawings, mixed media, collage, sculpture, ceramic, fiber, glass, jewelry and original handpulled prints. Most frequently exhibits oil, watercolor, metal sculpture and ceramic.

Style: Exhibits painterly abstraction, impressionism, photorealism and realism. Genres include landscapes and florals. "Our gallery features beautiful art-pieces that celebrate life."

Terms: Accepts work on consignment (50% commission). Retail price set by artist. Offers payment by installments. Exclusive area representation required. Gallery provides insurance, promotion and contract; artist pays for shipping.

Submissions: Send query letter, résumé, brochure, slides and photographs. Portfolio review required if interested in artists' work. Files résumés, photos of work, newspaper articles, other informative pieces and artist's statement.

Tips: Find artists through agents, visiting exhibitions, word of mouth, art publications and sourcebooks, artists' submissions/self-promotions, art collectors' referrals. "Do not bring work without an appointment."

‡LITTMAN GALLERY, Box 751, Portland OR 97207-0751. (503)725-4452. Contact: Gallery Director. Nonprofit gallery. Estab. 1968. Represents emerging, mid-career and established artists. Sponsors 11-12 shows/year. Average display time 1 month. Open all year. Located downtown; 1,500 sq. ft.; wood floors, 18 ft. 11 in. running window space. 100% of space for special exhibitions. Overall price range: $300-15,000; most work sold at $300-600.

Media: Considers all media and performance art; all types of prints. Most frequently exhibits mixed media, oil and sculpture.

Style: Exhibits all styles and genres.

Terms: Retail price set by the artist. Gallery provides insurance and promotion; shipping costs are shared. Prefers artwork framed.

Submissions: Send query letter, résumé, slides and bio. "A common mistake of artists is not sending enough slides." Replies in 2 months. Files all information.

Tips: "We are a nonprofit university gallery which looks specifically for educational and innovative work."

MINDPOWER GALLERY, 417 Fir Ave., Reedsport OR 97467. (503)271-2485. 1-800-644-2485. Manager: Tamara Szalewski. Retail gallery. Estab. 1989. Represents 50 mid-career and established artists/year. Exhibited artists include Rose Szalewski, John Stewart and Jean McKendree. Sponsors 6 shows/year. Average

display time 2 months to continuous. Open all year; Tuesday-Saturday, 10-5, November 1-May 29; open Tuesday-Sunday (same hours) Memorial Day to Halloween. Located in "Oldtown" area—front street is Hwy. 38; 5,000 sq. ft.; 8 rooms with 500' of wall space. 20% of space for "Infinity" gift store (hand-crafted items up to $100 retail, New Age music, books); 10% for special exhibitions; 70% of space for gallery artists. Clientele: ⅔ from state, ⅓ travelers. 90 private collectors, 10% small business collectors. Overall price range: $100-20,000; most work sold at $500.
Media: Considers oil, acrylic, watercolor, pastel, mixed media, paper, batik, computer, sculpture: wood, metal, clay, glass; all types of prints. Most frequently exhibits, sculpture, acrylic/oil, watercolor, pastel.
Style: Exhibits all styles, all genres. "We have a visual computer catalog accessible to customers, showing work not currently at gallery."
Terms: Accepts work on consignment (40% commission). Retail price set by the artist. Gallery provides promotion, contract and insurance; artist pays shipping costs to and from gallery. Prefers artwork framed.
Submissions: Send query letter with typewritten résumé, slides, photographs and SASE. Replies within 1 month. Files résumés.
Tips: Finds artists through artists' submissions, visiting exhibitions, word of mouth. Please call between 9-9:30 and 5-5:30 to verify your submission was received.

RICKERT ART CENTER AND GALLERY, 620 N. Hwy. 101, Lincoln City OR 97367. (503)994-0430. Fax: (503)1-800-732-8842. Manager/Director: Lee Lindberg. Retail gallery. Represents more than 20 emerging, mid-career and established artists/year. Exhibited artists include Sharon Rickert, Nikki Lindner. Sponsors 3 shows/year. Open all year; daily, 9:30-5:30. Located south end of town on main street; 2,300 sq. ft.; 50-year-old building. 20% of space for special exhibitions; 60% of space for gallery artists. Overall price range: $200-6,000; most work sold at $800-3,000.
Media: Considers oil, acrylic, watercolor, pastel, pen & ink, mixed media, sculpture, lithograph, serigraphs and posters. Most frequently exhibits oil, acrylic, watercolor and pastel.
Style: Exhibits all styles. Genres include landscapes, florals, Southwestern, Western, wildlife, portraits, figurative work, seascapes. Prefers seascapes, florals, landscapes.
Terms: Accepts work on consignment (50% commission). Retail price set by the gallery and the artist. Gallery provides promotion; artist pays shipping costs to and from gallery. Prefers artwork framed.
Submissions: Send query letter with résumé and photographs. Call or write for appointment to show portfolio of originals. Artist should follow up with call.
Tips: Looking for landscapes and still lifes in oil.

Pennsylvania

ALBER GALLERIES, 3300 Darby Rd., Suite 5111, Haverford PA 19041. (610)896-9297. Owners: Howard and Elaine Alber. Wholesale gallery/art consultancy. Represents emerging, mid-career and established artists. Clientele: 20% private collectors, 80% corporate clients, cooperating with affiliated galleries. Overall price range: $25-10,000; most work sold at $150-800.
Media: Considers oil, acrylic, watercolor, mixed media, collage, works on paper, sculpture, photography, woodcuts, linocuts, lithographs and serigraphs.
Style: Exhibits impressionism, realism, painterly abstraction, conceptualism. Considers all styles. Genres include landscapes and figurative work. "We're a contributor to the sales and rental gallery of the Philadelphia Museum of Art."
Terms: Accepts work on consignment (40% commission). Retail price set by gallery and artist. Exclusive area representation not required.
Submissions: Presently, only accepting work requested by clients (search material).
Tips: Advises artists to "stop being loners. Join Artists Equity Association (local and national chapters) to get better laws for the art world."

THE ART BANK, 3028 N. Whitehall Rd., Norristown PA 19403-4403. Phone/fax: (610)539-2265. Director: Phyllis Sunberg. Retail gallery, art consultancy, corporate art planning. Estab. 1985. Represents 40-50 emerging, mid-career and established artists/year. Exhibited artists include Lisa Fedon, Bob Koffler. Average display time 3-6 months. Open all year; by appointment only. Located in a Philadelphia suburb; 1,000 sq. ft.; Clientele: corporate executives and their corporations. 20% private collectors, 80% corporate collectors. Overall price range: $300-35,000; most work sold at $500-1,000.
Media: Considers oil, acrylic, watercolor, pastel, pen & ink, mixed media, collage, sculpture, glass, installation, holography, exotic material, lithography, serigraphs. Most frequently exhibits acrylics, serigraphs and sculpture.
Style: Exhibits expressionism, painterly abstraction, color field and hard-edge geometric abstraction. Genres include landscapes. Prefers color field, hard edge abstract and impressionism.
Terms: Accepts work on consignment (40% commission). Shipping costs are shared. Prefers artwork unframed.

Submissions: Prefers artists from the region (PA, NJ, NY, DE). Send query letter with résumé, slides, brochure, SASE and prices. Write for appointment to show portfolio of originals (if appropriate), photographs and corporate installation photos. Replies only if interested within 2 weeks. Files "what I think I'll use—after talking to artist and seeing visuals."
Tips: Finds artists through agents, by visiting exhibitions, word of mouth, art publications and sourcebooks, artists' submissions.

‡**THE ART INSTITUTE OF PHILADELPHIA**, 1622 Chestnut St., 1st Floor, Philadelphia PA 19103. (215)567-7080. Fax: (215)246-3339. Gallery Coordinator: Gregory Walker. Estab. 1971. Represents/exhibits emerging, mid-career and established artists. Interested in seeing the work of emerging artists. Sponsors 12 shows/year. Average display time 1 month. Open all year; Monday-Friday, 9-6; Saturday, 9-3. Located in Center City Philadelphia. Clientele: local community and students. Overall price range: $150-2,000; most work sold at $400-500.
Media: Considers oil, pen & ink, paper, acrylic, drawing, watercolor, mixed media, pastel, photography and all types of prints. Most frequently exhibits photography, graphic design, illustration and painting (all media).
Style: Exhibits all styles. All genres.
Terms: No rental fee. Artist retains 100% of sales. Retail price set by the artist. Gallery provides insurance, promotion. "Invitation payment must be worked out with gallery." Artists pays for shipping costs. Prefers artwork framed.
Submissions: Send query letter with résumé, slides, bio and SASE. Write for appointment to show portfolio of slides. Replies in 3 months.
Tips: Finds artists through word of mouth and referrals.

CAT'S PAW GALLERY, 31 Race St., Jim Thorpe PA 18229. (717)325-4041. Director/Owner: John and Louise Herbster. Retail gallery. Represents 100 emerging, mid-career and established artists/year. Exhibited artists include Shelley Buonaiuto, Nancy Giusti. Sponsors 1 or 2 shows/year. Average display time 1 month. Open all year; April-December, Wednesday-Sunday, 11-5; January-March, by chance or appointment. Located in historic downtown district; 400 sq. ft.; in one of 16 "Stone Row" 1848 houses built into mountainside. 40% of space for special exhibitions; 60% of space for gallery artists. Clientele: collectors, tourists, corporate. 50% private collectors. 5% corporate. Overall price range: $2-2,000; most work sold at $20-200.
Media: Considers oil, acrylic, watercolor, pastel, pen & ink, drawing, mixed media, collage, paper, sculpture, ceramics, craft, fiber, glass, original hand-pulled prints. Most frequently exhibits ceramics, sculpture and jewelry.
Style: Exhibits all styles. Only domestic feline subjects.
Terms: Accepts work on consignment (40% commission) or buys outright for 50% of retail price (net 30 days). "We usually purchase, except for major exhibits." Retail price set by the artist. Gallery provides insurance, promotion and contract; shipping costs are shared. Prefers artwork framed.
Submissions: Accepts artists from all regions of the US. Send query letter with résumé, slides or photographs, bio, brochure and reviews. Call or write for appointment to show portfolio of photographs. Replies only if interested within 1 week. Files all material of interest.
Tips: Finds artists through visiting exhibitions and trade shows, word of mouth, artists' submissions, collectors, art publications. "Submit only studio work depicting the domestic feline. We strive to treat cat art in a serious manner. Cat art should be accorded the same dignity as equestrian art. We are not interested in cutsey items aimed at the mass market. We will review paintings and graphics, but are not currently seeking them."

CENTER GALLERY OF BUCKNELL UNIVERSITY, Elaine Langone Center, Lewisburg PA 17837. (717)524-3792. Fax: (717)524-3760. E-mail: peltier@bucknell.edu. Assistant Director: Cynthia Peltier. Nonprofit gallery. Estab. 1983. Represents emerging, mid-career and established artists. Sponsors 6 shows/year. Average display time 6 weeks. Open all year; Monday-Friday, 11-6; Saturday-Sunday, 1-4. Located on campus; 3,000 sq. ft. plus 40 movable walls.
Media: Considers all media, all types of prints. Most frequently exhibits painting, prints and photographs.
Style: Exhibits all styles, all genres.
Terms: Retail price set by the artist. Gallery provides insurance, promotion (local) and contract; artist pays shipping costs to and from gallery. Prefers artwork framed.
Submissions: Send query letter with résumé, slides and bio. Write for appointment to show portfolio of originals. Replies in 2 weeks. Files bio, résumé, slides.
Tips: Finds artists through occasional artist invitationals/competitions.

THE COMMUNITY GALLERY OF LANCASTER COUNTY, 135 N. Lime St., Lancaster PA 17602. (717)394-3497. Executive Director: Ellen Rosenholtz. Assistant Director: Carol Foley. Nonprofit gallery. Estab. 1965. Represents 12 emerging, mid-career and established artists/year. 500 members. Exhibited artists include Margrit Schmidtke, Tom Lacagnini. Sponsors 12 shows/year. Average display time 1 month. Open all year; Monday-Saturday, 10-4; Sunday, 12-4. Located downtown Lancaster; 4,000 sq. ft.; neoclassical architecture. 100% of space for special exhibitions. 100% of space for gallery artists. Overall price range: $100-5,000; most work sold at $100-800.

Media: Considers all media.
Terms: Accepts work on consignment (30% commission). Retail price set by the artist. Gallery provides insurance; shipping costs are shared. Prefers artwork framed.
Submissions: Send query letter with résumé, slides and photographs. Files slides, résumé, artist's statement.
Tips: Finds artists through word of mouth, other galleries and "many times the artist will contact me first." Advises artists to submit quality slides and well presented proposal. "No phone calls."

‡DOLAN/MAXWELL, 2046 Rittenhouse Square, Philadelphia PA 19103. (215)732-7787. Fax: (215)790-1866. Director: Ronald Rumford. Retail gallery. Estab. 1984. Represents/exhibits 25 emerging, mid-career and established artists/year. Exhibited artists include N. Ackroyd and D. Shapiro. Sponsors 6 shows/year. Open all year by appointment only. Located in Center City. Clientele: knowledgeable collectors. 80% private collectors, 20% corporate collectors. Overall price range: $1,000-10,000; most work sold at $1,000-4,000.
Media: Considers drawing, watercolor, mixed media, collage and all types of prints. Most frequently exhibits prints and works on paper.
Style: Exhibits minimalism, painterly abstraction, postmodern works and realism. All genres.
Terms: Artwork is accepted on consignment (50% commission). Retail price set by the gallery. Gallery provides insurance and promotion; shipping costs are shared. Prefers artwork unframed.
Submissions: Send query letter with résumé, slides and SASE. Write for appointment to show portfolio of slides and transparencies. Replies in 1 month.
Tips: Finds artists through referrals, art fairs and exhibitions.

EVERHART MUSEUM, Nay Aug Park, Scranton PA 18510. Phone/fax: (717)346-8370. Curator: Barbara Rothermel. Museum. Estab. 1908. Represents mid-career and established artists. Interested in seeing the work of emerging artists. 1,500 members. Sponsors 6 shows/year. Average display time 2-3 months. Open all year; Tuesday-Friday, 10-5; Saturday-Sunday, 12-5; closed Monday. Located in urban park; 300 linear feet. 20% of space for special exhibitions.
Media: Considers all media.
Style: Exhibits all styles, all genres. Prefers regional, Pennsylvania artists.
Terms: Gallery provides insurance, promotion and shipping costs. Prefers artwork framed.
Submissions: Send query letter with résumé, slides, bio, brochure and reviews. Write for appointment. Replies in 1-2 months. Files letter of query, selected slides or brochures, other information as warranted.
Tips: Finds artists through agents, by visiting exhibitions, word of mouth, art publications and sourcebooks, artists' submissions. Sponsors regional juried exhibition in the fall. "Write for prospectus."

‡JANET FLEISHER GALLERY, 211 S. 17th St., Philadelphia PA 19103. (215)545-7562. Fax: (215)545-6140. Director: John Ollman. Retail gallery. Estab. 1952. Represents 12 emerging and established artists. Exhibited artists include Tony Fitzpatrick and Bill Traylor. Sponsors 10 shows/year. Average display time 5 weeks. Closed August. Located downtown; 3,000 sq. ft. 75% of space for special exhibitions. Clientele: primarily art collectors. 90% private collectors; 10% corporate collectors. Overall price range: $2,500-100,000; most work sold at $2,500-30,000.
Media: Considers oil, acrylic, watercolor, pastel, pen & ink, drawing, mixed media and collage. Most frequently exhibits drawing, painting and sculpture.
Style: Exhibits self-taught and contemporary works.
Terms: Accepts artwork on consignment (commission) or buys outright. Retail price set by the gallery. Gallery provides insurance and promotion; shipping costs are shared. Prefers artwork framed.
Submissions: Send query letter with résumé, slides, bio and SASE; gallery will call if interested within 1 month.
Tips: "Be familiar with our exhibitions and the artists we exhibit."

‡GALLERY ENTERPRISES, 310 Bethlehem Plaza Mall, Bethlehem PA 18018. (610)868-1139. Fax: (610)868-9482. Owner: David Michael Donnangelo. Wholesale gallery. Estab. 1981. Represents/exhibits 10 established artists/year. May be interested in seeing the work of emerging artists in the future. Exhibited artists include K. Haring and Andy Warhol. Sponsors 1 show/year. Average display time 3 weeks. Open all year; 12:30-5:30. Located in mall, 700 sq. ft.; good light and space. 100% of space for special exhibitions. Clientele: upscale. 50% private collectors; 10% corporate collectors. Overall price range: $350-5,000; most work sold at $1,200-2,500.
Media: Considers all media, etching, lithograph, serigraphs and posters. Most frequently exhibits serigraphs, lithography and posters.
Style: Exhibits neo-expressionism, realism, surrealism and environmental. Genres include landscapes and wildlife. Prefers pop art, kenetic art, environmental and surrealism.
Terms: Artwork is accepted on consignment. Retail price set by the gallery. Prefers artwork unframed.
Submissions: Well established artist only. Send query letter with slides and photographs. Call for appointment to show portfolio of photographs and slides. "If slides or photos are sent they will be kept on file but not returned. We reply only if we are interested."

‡GALLERY JOE, 304 Arch St., Philadelphia PA 19106. (215)592-7752. Fax: (215)297-5165. Director: Becky Kerlin. Retail and commercial exhibition gallery. Estab. 1993. Represents/exhibits 15-20 emerging, mid-career and established artists. Exhibited artists include Turner Brooks (architect) and Harry Roseman. Sponsors 6 shows/year. Average display time 6 weeks. Open all year; Tuesday, Friday-Sunday. Located in Old City; 350 sq. ft. 100% of space for gallery artists. 80% private collectors, 20% corporate collectors. Overall price range: $500-20,000; most work sold at $1,000-5,000.
Media: Considers sculpture, architectural drawings/models. Only exhibits sculpture and architectural drawings/models.
Style: Exhibits representational/realism. Genres include landscapes, portraits and figurative work.
Terms: Artwork is accepted on consignment (50% commission). Retail price set by the gallery and the artist. Gallery provides insurance and promotion. Artist pays for shipping costs. Prefers artwork framed.
Submissions: Send query letter with résumé, slides, reviews and SASE. Replies in 6 weeks.
Tips: Finds artists mostly by visiting galleries and through artist referrals.

‡INTERNATIONAL IMAGES, LTD., The Flatiron Building, 514 Beaver St., Sewickley PA 15143. (412)741-3036. Fax: (412)741-8606. Director of Exhibitions: Charles M. Wiebe. Retail gallery. Estab. 1978. Represents 100 emerging, mid-career and established artists; primarily Russian, Estonian, Latvian, Lithuanian, Georgian, Bulgarian, African and Cuban. Sponsors 8 solo shows/year. Average display time: 4-6 weeks. Clientele: 90% private collectors; 10% corporate clients. Overall price range: $150-150,000; most work sold at $10,000-65,000.
Media: Considers oils, watercolors, pastels, pen & ink, drawings and original handpulled prints, small to medium sculptures, leather work from Africa and contemporary jewelry. Most frequently exhibits oils, watercolors and works on paper.
Style: Exhibits all styles. Genres include landscapes, florals and portraits. Prefers abstraction, realism and figurative works.
Terms: Accepts work on consignment. Retail price set by gallery. Exclusive area representation required. Shipping costs are shared.
Submissions: Send query letter with résumé and slides. Portfolio should include slides. "Include titles, medium, size and price with slide submissions." Replies in 1 month. All material is returned if not accepted or under consideration.
Tips: "Founded by Elena Kornetchuk, it was the first gallery to import Soviet Art, with an exclusive contract with the USSR. In 1986, we began to import Bulgarian art as well and have expanded to handle several countries in Europe and South America as well as the basic emphasis on Eastern bloc countries. We sponsor numerous shows each year throughout the country in galleries, museums, universities and conferences, as well as featuring our own shows every four to six weeks. Looks for Eastern European, Bulgarian and International art styles." The most common mistakes artists make in presenting their work are "neglecting to include pertinent information with slides/photographs, such as size, medium, date, and cost and failing to send biographical information with presentations."

‡MANGEL GALLERY, 1714 Rittenhouse Sq., Philadelphia PA 19103. (215)545-4343. Director: Tara F. Goings. Retail gallery. Estab. 1970. Represents 30 emerging, mid-career and established artists. Exhibited artists include Alex Katz, Jane Piper, Harry Bertoia, Marko Spalatin and Francis McCarthy. Sponsors 9 shows/year. Average display time 3 weeks. Open all year; Tuesday-Friday, 11-6; Saturday, 11-5. Located in the center of the city; 2,000 sq. ft.; "building is 160 years old, former residence of the famous conductor Lepold Stokoski." 75% of space for special exhibitions. 95% private collectors; 5% corporate collectors. Overall price range: $500-125,000; most work sold at $3,000-5,000.
Media: Considers all media except photography. Considers all types of prints. Most frequently exhibits paintings, sculpture and prints.
Style: Exhibits neo-expressionism, color field, painter abstraction, realism and all genres.
Terms: Accepts artwork on consignment. Retail price set by the artist. Gallery provides insurance and promotion; artist pays for shipping costs. Prefers artwork framed.
Submissions: Send query letter with résumé, slides, bio, photographs, reviews and SASE. Write for appointment to show portfolio of slides and transparencies. Replies only if interested within 2 months.

‡THE MORE GALLERY, 1630 Walnut St., Philadelphia PA 19103. (215)735-1827. President: Charles N. More. Retail gallery. Estab. 1980. Represents 20 artists; emerging, mid-career and established. Exhibited artists include Sidney Goodman and Paul George. Sponsors 8 shows/year. Average display time 1 month. Open all year. Located in center of the city; 1,800 sq. ft. 80% of space for special exhibitions. 60% private collectors, 40% corporate collectors. Overall price range: $1,000-20,000; most work sold at $5-10,000.
Media: Considers oil, pen & ink, acrylic, drawing, sculpture, watercolor, mixed media, installation, pastel, collage and photography; woodcuts, wood engravings, linocuts, engravings, mezzotints, etchings, lithographs, pochoir and serigraphs. Most frequently exhibits oil and sculpture.
Style: Exhibits expressionism, neo-expressionism and painterly abstraction. Interested in all genres. Prefers figurative work.

Terms: Accepts work on consignment (50% commission). Retail price set by the gallery and the artist. Gallery provides insurance and promotion; shipping costs are shared. Prefers artwork framed.
Submissions: Send query letter with résumé, slides, bio, photographs and SASE. Write to schedule an appointment to show a portfolio, which should include slides and transparencies. Replies only if interested within 1 month.
Tips: "Visit first."

NEWMAN GALLERIES, 1625 Walnut St., Philadelphia PA 19103. (215)563-1779. Fax: (215)563-1614. Manager: Terrence C. Newman. Retail gallery. Estab. 1865. Represents 40-50 emerging, mid-career and established artists/year. Exhibited artists include Tim Barr and Philip Jamison. Sponsors 2-4 shows/year. Average display time 1 month. Open all year; Monday-Friday, 9-5:30; Saturday, 10-4:30. Located in Center City Philadelphia. 4,000 sq. ft. "We are the largest and oldest gallery in Philadelphia." 50% of space for special exhibitions; 100% of space for gallery artists. Clientele: traditional. 50% private collectors, 50% corporate collectors. Overall price range: $1,000-100,000; most work sold at $2,000-20,000.
Media: Considers oil, acrylic, watercolor, pastel, mixed media, sculpture, woodcut, wood engraving, linocut, engraving, mezzotint, etching, lithograph, serigraphs and posters. Most frequently exhibits watercolor, oil/acrylic, and pastel.
Style: Exhibits expressionism, impressionism, photorealism and realism. Genres include landscapes, florals, Americana, wildlife, portraits and figurative work. Prefers landscapes, Americana and figurative work.
Terms: Accepts work on consignment (45% commission). Retail price set by gallery and artist. Gallery provides insurance and promotion; shipping costs are shared. Prefers oils framed; prints, pastels and watercolors unframed but matted.
Submissions: Send query letter with résumé, slides, bio and SASE. Call for appointment to show portfolio of originals, photographs and transparencies. Replies in 2-4 weeks. Files "things we may be able to handle but not at the present time."
Tips: Finds artists through agents, visiting exhibitions, word of mouth, art publications, sourcebooks and artists' submissions.

‡NEXUS FOUNDATION FOR TODAY'S ART, 137 N. Second St., Philadelphia PA 19106. (215)629-1103. Gallery Director: Anne Raman. Nonprofit artist-run alternative space. Estab. 1975. Represents/exhibits 50 emerging, mid-career and established artists/year. Sponsors 18 shows/year. Average display time 3½ weeks. Open Tuesday-Friday, 12-6; Saturday-Sunday, 12-5; closed August. Located in Old City Gallery District in downtown Philadelphia; 1,700 sq. ft.; contemporary space with hardwood floors, 11½' ceilings.
Style: Exhibits experimental and innovative work in all media.
Terms: "Nexus takes no commission and is concerned with exhibition rather than sales. Prices are made available to the public as a courtesy to the artist."
Submissions: Send query letter with SASE. Request exhibition application forms.

OLIN FINE ARTS GALLERY, Washington and Jefferson College, Washington PA 15301. (412)223-6110. Gallery Chairman: P. Edwards. Nonprofit gallery. Estab. 1982. Exhibits emerging, mid-career and established artists. Exhibited artists include Mary Hamilton and Jack Cayton. Sponsors 9 shows/year. Average display time 3 weeks. Open all year. Located near downtown (on campus); 1,925 sq. ft.; modern, air-conditioned, flexible walls, secure. 100% of space for special exhibitions. Clientele: mostly area collectors and students. 95% private collectors, 5% corporate collectors. Most work sold at $300-500.
 • This gallery describes its aesthetic and subject matter as "democratic."
Media: Considers all media, except installation, offset reproductions and pochoir. Most frequently exhibits oil, acrylic and watercolor.
Style: Exhibits all styles and genres. Prefers realism/figure, landscapes and abstract.
Terms: Accepts work on consignment (20% commission). Retail price set by artist. Sometimes offers customer discounts. Gallery provides insurance and promotion; artist pays for shipping. Prefers artwork framed.
Submissions: Send query letter with résumé, slides, bio and SASE. Portfolio review not required. "A common mistake artists make is sending unprofessional material." Replies in 2-4 weeks.
Tips: Finds artists through word of mouth, artists' submissions and self-promotions. Values "timely follow-through!".

ROSENFELD GALLERY, 113 Arch St., Philadelphia PA 19106. (215)922-1376. Owner: Richard Rosenfeld. Retail gallery. Estab. 1976. Represents 35 emerging and mid-career artists/year. Sponsors 18 shows/year. Average display time 3 weeks. Open all year; Wednesday-Saturday, 10-5; Sunday, noon-5. Located downtown, "Old City"; 2,200 sq. ft.; ground floor loft space. 85% of space for gallery artists. 80% private collectors, 20% corporate collectors. Overall price range: $200-6,000; most work sold at $1,500-2,000.
Media: Considers oil, acrylic, watercolor, pastel, drawing, mixed media, paper, sculpture, ceramics, craft, fiber, glass, woodcut, engraving, lithograph, monoprints, wood engraving and etching. Most frequently exhibits works on paper, sculpture and crafts.

Style: Exhibits all styles. Prefers painterly abstraction and realism.

Terms: Accepts work on consignment (50% commission). Retail price set by the gallery. Gallery provides insurance and promotion; shipping costs are shared. Prefers artwork framed.

Submissions: Send query letter with slides and SASE. Call or write for appointment to show portfolio of photographs and slides. Replies in 2 weeks.

Tips: Finds artists through visiting exhibitions, word of mouth, various art publications and artists' submissions.

SAINT JOSEPH'S UNIVERSITY GALLERY, 5600 City Line Ave., Philadelphia PA 19131. Assistant Gallery Director: Timothy W. Shea. Nonprofit gallery. Represents emerging, mid-career and established artists. Sponsors 5 solo and 1 group shows/year. Average display time 1 month.

Media: Considers all media.

Style: Exhibits all styles and genres.

Terms: Accepts work on consignment (15% commission). Retail price set by artist. Gallery provides insurance and promotion; artist pays for shipping. Artwork must be framed.

Submissions: Send query letter with résumé, slides, bio and SASE. Write for appointment to show portfolio. Replies in 4 months. All material returned if not accepted or under consideration.

Tips: "Slides should be neat, clearly labeled and arranged in order, with red dot in upper right corner."

THE STATE MUSEUM OF PENNSYLVANIA, Third and North St., Box 1026, Harrisburg PA 17108-1026. (717)787-4980. Contact: Senior Curator, Art Collections. The State Museum of Pennsylvania is the official museum of the Commonwealth, which collects, preserves and exhibits Pennsylvania history, culture and natural heritage. The Museum maintains a collection of fine arts, dating from 1645 to present. Current collecting and exhibitions focus on works of art by contemporary Pennsylvania artists. The Archives of Pennsylvania Art includes records on Pennsylvania artists and continues to document artistic activity in the state by maintaining records for each exhibit space/gallery in the state. Estab. 1905. Sponsors 9 shows/year. Accepts only artists who are Pennsylvania natives or past or current residents. Interested in emerging and mid-career artists.

Media: Considers all media including oil, works on paper, photography, sculpture, installation and crafts.

Style: Exhibits all styles and genres.

Submissions: Send query letter with résumé, slides, SASE and bio. Replies in 1-3 months. Retains résumé and bio for archives of Pennsylvania Art. Photos returned if requested.

Tips: Finds artists through professional literature, word of mouth, Gallery Guide, exhibits, all media and unsolicited material. "Have the best visuals possible. Make appointments. Remember most curators are also overworked, underpaid and on tight schedules."

‡TANGERINE FINE ARTS, 310 N. Second St., Harrisburg PA 17101. (717)236-8180. Associate Director: Thomas Giannelli. Retail, rental gallery; alternative space, art consultancy. Estab. 1971. Represents/exhibits emerging and mid-career artists. Interested in seeing work from emerging artists. Exhibited artists include Michael Kessler and Robert Patierno. Sponsors 4-5 shows/year. Average display time 4-6 weeks. Open all year; Monday-Saturday 10:30-6. Located downtown; 1,500 sq. ft. Clientele: variety and upscale. 70% private collectors, 30% corporate collectors. Overall price range: $25-10,000; most work sold at $100-450.

Media: Considers all media and all types of prints. Most frequently exhibits paintings, prints and sculpture.

Style: Exhibits all styles. All genres. Prefers postmodern, impressionism and abstraction.

Terms: Artwork is accepted on consignment (50% commission). Artwork is bought outright for 50% of the retail price; net 90 days. Retail price set by the gallery. Gallery provides promotion and contract; shipping costs are shared. Prefers artwork framed.

Submissions: Send query letter with résumé, slides and bio. Call or write for appointment to show portfolio of slides. Replies in 3 weeks.

Tips: Finds artists through art fairs, word of mouth and artists' submissions.

SANDE WEBSTER GALLERY, 2018 Locust St., Philadelphia PA 19102. (215)732-8850. Fax: (215)732-7850. Director: Gerard Brown. Retail gallery. Estab. 1969. Represents emerging, mid-career and established artists. "We exhibit from a pool of 40 and consign work from 200 artists." Exhibited artists include Charles Searles, Moe-Brooker. Sponsors 12-14 shows/year. Average display time 1 month. Open all year; Monday-Friday, 10-6; Saturday, 11-4. Located downtown; 2,000 sq. ft.; "We have been in business in the same location for 25 year." 50% of space for special exhibitions; 50% of space for gallery artists. Clientele: art consultants, commercial and residential clients. 30% private collectors, 70% corporate collectors. Overall price range: $25-25,000; most work sold at $1,000-2,000.

Media: Considers oil, acrylic, watercolor, drawing, mixed media, collage, sculpture, fiber, photography, woodcut, engraving, lithograph, wood engraving, mezzotint, serigraphs, linocut and etching.

Style: Exhibits work in all styles, all genre. Prefers non-objective painting and sculpture and abstract painting.

Terms: Accepts work on consignment (50% commission). Retail price set by agreement. Gallery provides insurance, promotion, contract and shipping costs from gallery; artist pays shipping costs to gallery. "We also own and operate a custom frame gallery."

Submissions: Send query letter with résumé, slides, bio, SASE and retail PR. Call for appointment to show portfolio of slides. "All submissions reviewed from slides with no exceptions." Replies within 2 months. Files "slides, résumés of persons in whom we are interested."
Tips: Finds artists through referrals from artists, seeing work in outside shows, and unsolicited submissions.

ZOLLER GALLERY, Penn State University, 102 Visual Arts Building, University Park PA 16802. (814)863-3352. Contact: Exhibition Committee. Nonprofit gallery. Estab. 1971. Exhibits 250 emerging, mid-career and established artists. Interested in seeing the work of emerging artists. Sponsors 8 shows/year. Average display time 4-6 weeks. Closed in May. Located on Penn State University campus; 2,200 sq. ft. 100% of space for special exhibitions. Overall price range: $50-10,000; most work sold at $300-500.
 • This campus gallery features artists' lectures, installation art, visual artists' residencies and interdisciplinary events.
Media: Considers all media, styles and genres.
Terms: "We charge no commission." Retail price set by artist. Gallery provides insurance and promotion; shipping costs are shared. Prefers artwork framed.
Submissions: "We accept proposals once a year. Deadline is February 1." Send query letter with résumé, slides, reviews and SASE. Replies by April 1. Files résumés.

Rhode Island

BANNISTER GALLERY/RHODE ISLAND COLLEGE ART CENTER, 600 Mt. Pleasant Ave., Providence RI 02908. (401)456-9765 or 8054. Gallery Director: Dennis O'Malley. Nonprofit gallery. Estab. 1978. Represents emerging, mid-career and established artists. Sponsors 9 shows/year. Average display time 3 weeks. Open September- May. Located on college campus; 1,600 sq. ft.; features spacious, well-lit gallery space with off-white walls, gloss black tile floor; two sections with 9 foot and 12 foot ceilings. 100% of space for special exhibitions. Clientele: students and public.
Media: Considers all media and all types of original prints. Most frequently exhibitis painting, photography and sculpture.
Style: Exhibits all styles.
Terms: Artwork is exhibited for educational purposes—gallery takes no commission. Retail price set by artist. Gallery provides insurance, promotion and limited shipping costs from gallery. Prefers artwork framed.
Submissions: Send query letter with résumé, slides, bio, brochure, SASE and reviews. Files addresses, catalogs and résumés.

HERA EDUCATIONAL FOUNDATION, HERA GALLERY, 327 Main St., P.O. Box 336, Wakefield RI 02880. (401)789-1488. Director: Alexandra Broches. Nonprofit gallery. Estab. 1974. Located in downtown Wakefield, a rural resort Northeast area (near Newport beaches). Exhibits the work of emerging and mid-career artists. 15 members. Exhibited artists include Grace Bentley-Sheck. Sponsors 16 shows/year. Average display time 3 weeks. Open all year. Located downtown; 1,200 sq. ft. 40% of space for special exhibitions.
Media: Considers all media and original handpulled prints.
Style: Exhibits expressionism, neo-expressionism, painterly abstraction, surrealism, conceptualism, post-modern works, realism and photorealism. "We are interested in innovative, conceptually strong, contemporary works that employ a wide range of styles, materials and techniques." Prefers "a culturally diverse range of subject matter which explores contemporary social and artistic issues important to us all."
Terms: Co-op membership fee plus donation of time. Retail price set by artist. Sometimes offers customer discount and payment by installments. Gallery provides promotion; artist pays for shipping, or sometimes shipping costs are shared.
Submissions: Send query letter with résumé, slides and SASE. Portfolio required for membership; slides for invitational/juried exhibits. Deadlines June 30 and December 31. Files résumé.
Tips: Finds artists through word of mouth, advertising in art publications, and referrals from members. "Be sensitive to the cooperative nature of our gallery. Everyone donates time and energy to assist in installing exhibits and running the gallery. Please write for membership guidelines and send SASE."

WHEELER GALLERY, 228 Angell St., Providence RI 02906. (401)421-9230. Director: Sue L. Carroll. Nonprofit gallery. Presents emerging, mid-career and established artists. We have an open jury each year to select the 5 exhibitions for the next year." Sponsors 5 shows/year. Average display time 3 weeks. Open fall, winter, spring; Tuesday-Saturday, 12-5; Sunday, 3-5. Located in a university and residential area; 1,250 sq. ft.; award-winning architectural design. 100% of space for special exhibitions. 50% private collectors, 50% corporate collectors. Overall price range: $100-25,000.
Media: Considers all media, all types of prints except posters. Most frequently exhibits oil and acrylic painting, sculpture and glass.
Style: Exhibits all styles, all genres.
Terms: Accepts work on consignment (33% commission). Retail price set by the artist. Gallery provides insurance, promotion and contract; artist pays shipping costs to and from gallery.

Submissions: Prefers artists from New England area. Send query letter with SASE. Write for appointment to show portfolio of slides. Replies in 1 month.
Tips: Finds artists through word of mouth, various art publications and artists' submissions. "We also mail out a 'call for slides' notice in late fall."

South Carolina

CECELIA COKER BELL GALLERY, Coker College, 300 E. College Ave., Hartsville, SC 29550. (803)383-8152. Director: Larry Merriman. "A campus-located teaching gallery which exhibits a great diversity of media and style to expose students and the community to the breadth of possibility for expression in art. Exhibits include regional, national and international artists with an emphasis on quality. Features international shows of emerging artists and sponsors competitions." Estab. 1984. Interested in emerging and mid-career artitsts. Sponsors 5 solo shows/year. Average display time 1 month. "Gallery is 30×40, located in art department; grey carpeted walls, track lighting."
Media: Considers oil, acrylic, drawings, mixed media, collage, works on paper, sculpture, installation, photography, performance art, graphic design and printmaking. Most frequently exhibits painting, sculpture/installation and mixed media.
Style: Considers all styles. Not interested in conservative/commercial art.
Terms: Retail price set by artist (sales are not common). Exclusive area representation not required. Gallery provides insurance, promotion and contract; shipping costs are shared.
Submissions: Send résumé, good-quality slides and SASE by November 1. Write for appointment to show portfolio of slides.

PICKENS COUNTY MUSEUM, 307 Johnson St., Pickens SC 29671. (803)898-7818. Director: Olivia G. Fowler. Nonprofit museum located in old county jail. Estab. 1976. Interested in emerging, mid-career and established artists. Sponsors 5 art exhibits/year. Average display time is 3 months. Clientele: artists and public. Overall price range: $200-700; most artwork sold at $200.
Media: Considers oil, acrylic, watercolor, pastel, pen & ink, drawings, sculpture, ceramics, fiber, photography, crafts, mixed media, collage and glass.
Style: Exhibits contemporary, abstract, landscape, floral, primitive, non-representational, photo-realistic and realism.
Terms: Accepts work on consignment (20% commission). Retail price is set by artist. Sometimes offers customer discounts. Exclusive area representation not required. Gallery provides insurance, promotion and contract.
Submissions: Send query letter with résumé, photographs (5) and SASE. Portfolio review required. Call or write, "no drop-ins."
Tips: Find artists by visiting exhibitions, reviewing submissions, slide registries and word of mouth. "We are interested in work produced by artists who have worked seriously enough to develop a signature style." Advises artists to "keep appointments, answer correspondence, honor deadlines."

PORTFOLIO ART GALLERY, 2007 Devine St., Columbia SC 29205. (803)256-2434. Owner: Judith Roberts. Retail gallery and art consultancy. Estab. 1980. Represents 40-50 emerging, mid-career and established artists. Exhibited artists include Sigmund Abeles and Joan Ward Elliott. Sponsors 4-6 shows/year. Average display time 3 months. Open all year. Located in a 1930s shopping village, 1 mile from downtown; 500 sq. ft. plus 1,100 sq. ft.; features 12 foot ceilings. 100% of space for work of gallery artists. "We have added exhibition space by opening second location (716 Saludo Ave.) around the corner from our 15-year location. The new space has excellent visibility and accomodates large pieces. A unique feature is glass shelves where matted and medium to small pieces can be displayed without hanging on the wall." Clientele: professionals, corporations and collectors. 40% private collectors, 40% corporate collectors. Overall price range: $150-12,500; most work sold at $300-3,000.
Media: Considers oil, acrylic, watercolor, pastel, mixed media, collage, works on paper, sculpture, ceramic, glass, original handpulled prints, woodcuts, wood engravings, linocuts, engravings, mezzotints, etchings, lithographs and serigraphs. Most frequently exhibits watercolor, oil and original prints.

Style: Exhibits neo-expressionism, painterly abstraction, imagism, minimalism, color field, impressionism, realism, photorealism and pattern painting. Genres include landscapes and figurative work. Prefers landscapes/seascapes, painterly abstraction and figurative work. "I especially like mixed media pieces, original prints and oil paintings. Pastel medium and watercolors are also favorites. Kinetic sculpture and whimsical clay pieces."

Terms: Accepts work on consignment (40% commission). Retail price set by gallery and artist. Offers payment by installments. Gallery provides insurance, promotion and contract; artist pays for shipping. Artwork may be framed or unframed.

Submissions: Send query letter with slides, bio, brochure, photographs, SASE and reviews. Write for appointment to show portfolio of originals, slides, photographs and transparencies. Replies only if interested within 1 month. Files tearsheets, brochures and slides.

Tips: Finds artists through visiting exhibitions and referrals. "The most common mistake beginning artists make is showing all the work they have ever done. I want to see only examples of recent best work—unframed, originals (no copies)—at portfolio reviews."

South Dakota

THE HERITAGE CENTER, INC., Red Cloud Indian School, Pine Ridge SD 57770. (605)867-5491. Fax: (605)867-1291. Director: Brother Simon. Nonprofit gallery. Estab. 1984. Represents emerging, mid-career and established artists. Sponsors 6 group shows/year. Accepts only Native Americans. Average display time 10 weeks. Clientele: 80% private collectors. Overall price range: $50-1,500; most work sold at $100-400.

Media: Considers oil, acrylic, watercolor, pastel, pen & ink, drawings, sculpture and original handpulled prints.

Style: Exhibits contemporary, impressionism, primitivism, Western and realism. Genres include Western. Specializes in contemporary Native American art (works by Native Americans). Interested in seeing pictographic art in contemporary style. Likes clean, uncluttered work.

Terms: Accepts work on consignment (20% commission). Retail price set by artist. Customer discounts and payment by installments are available. Exclusive area representation not required. Gallery provides insurance and promotion; artist pays for shipping.

Submissions: Send query letter, résumé, brochure and photographs Wants to see "fresh work and new concepts, quality work done in a professional manner." Portfolio review requested if interested in artist's work.

Tips: Finds artists through word of mouth, publicity in Native American newspapers. "Show art properly matted or framed. Good work priced right always sells. We still need new Native American artists if their prices are not above $300. Write for information about annual Red Cloud Indian Art Show."

Tennessee

BENNETT GALLERIES, Dept. AGDM, 4515 Kingston Pike, Knoxville TN 37919. (615)584-6791. Director: Marga Hayes Ingram. Owner: Rick Bennett. Retail gallery. Represents established artists. Exhibited artists include Richard Jolley, Carl Sublett, Scott Duce, Sarah Frederick, Lanie Oxman, Tommie Rush and Philip Livingston. Sponsors 10 shows/year. Average display time 1 month. Open all year. Located in West Knoxville. Clientele: 70% private collectors; 30% corporate collectors. Overall price range: $200-20,000; most work sold at $2,000-4,000.

Media: Considers oil, acrylic, watercolor, pastel, drawing, mixed media, works on paper, sculpture, ceramic, craft, glass, original handpulled prints. Most frequently exhibits painting, ceramic/clay, wood, glass and sculpture.

Style: Exhibits primitivism, abstraction, figurative, non-objective, impressionism and realism. Genres include landscapes, still life and interiors. Prefers realism and contemporary styles.

Terms: Accepts artwork on consignment (50% commission). Retail price set by the gallery and the artist. Sometimes offers customer discounts and payment by installments. Gallery provides insurance, promotion, contract from gallery. "We are less willing to pay shipping costs for unproven artists." Prefers artwork framed.

Submissions: Send query letter with résumé, slides, bio, photographs, SASE and reviews. Portfolio review requested if interested in artist's work. Portfolio should include originals, slides, photographs and transparencies. Replies in 6 weeks. Files samples and résumé.

Tips: Finds artists through agents, visiting exhibitions, word of mouth, various art publications, sourcebooks, artists' submissions/self-promotions and art collectors' referrals.

‡COOPER ST. GALLERY, 964 S. Cooper St., Memphis TN 38104. (901)272-7053. Owner: Jay S. Etkin. Retail gallery. Estab. 1989. Represents/exhibits 20 emerging, mid-career and established artists/year. Exhibited artists include Rob vander Schoor and James Starks. Sponsors 10 shows/year. Average display time 1 month. Open all year; Wednesday, Friday and Saturday, 11-5 or by appointment. Located in midtown Mem-

phis; 1,200 sq. ft.; gallery features public viewing of works in progress. 33⅓ of space for special exhibitions; 75% of space for gallery artists. Clientele: young upscale, corporate. 80% private collectors, 20% corporate collectors. Overall price range $200-12,000; most work sold at $500-2,000.

Media: Considers all media except craft, papermaking. Also considers kinetic sculpture and conceptual work. "We do very little with print work." Most frequently exhibits oil on paper canvas, mixed media and sculpture.

Style: Exhibits expressionism, conceptualism, neo-expressionism, painterly abstraction, postmodern works, realism, surrealism. Genres include landscapes and figurative work. Prefers figurative expressionism, abstraction, landscape.

Terms: Artwork is accepted on consignment (40% commission). Retail price set by the gallery and the artist. Gallery provides promotion. Artist pays for shipping or costs are shared at times.

Submissions: Accepts artists generally from mid-south. Prefers only original works. Looking for long-term committed artists. Send query letter with photographs, bio and SASE. Write for appointment to show portfolio of photographs, slides and cibachromes. Replies only if interested within 1 month. Files bio/slides if interesting work.

Tips: Finds artists through referrals, visiting area art schools and studios, occasional drop-ins. "Be patient. The market in Memphis for quality contemporary art is only starting to develop."

CUMBERLAND GALLERY, 4107 Hillsboro Circle, Nashville TN 37215. (615)297-0296. Director: Carol Stein. Retail gallery. Estab. 1980. Represents 35 emerging, mid-career and established artists. Sponsors 6 solo and 2 group shows/year. Average display time 5 weeks. Clientele: 60% private collectors, 40% corporate clients. Overall price range: $450-35,000; most work sold at $1,000-5,000.

Media: Considers oil, acrylic, watercolor, pastel, mixed media, collage, works on paper, sculpture, photography, woodcuts, wood engravings, linocuts, engravings, mezzotints and etchings. Most frequently exhibits painting, drawings and sculpture.

Style: Exhibits realism, photorealism, minimalism, painterly abstraction, postmodernism and hard-edge geometric abstraction. Prefers landscapes, abstraction, realism and minimalism. "We have always focused on contemporary art forms including paintings, works on paper, sculpture and multiples. Approximately half of the artists have national reputations and half are strongly emerging artists. These individuals are geographically dispersed." Interested in seeing "work that is technically accomplished, with a somewhat different approach, not derivative."

Tips: "I would hope that an artist would visit the gallery and participate on the mailing list so that he/she has a sense of what we are doing. It would be helpful for the artist to request information with regard to how we prefer work to be considered for inclusion. I suggest slides, résumé, prices, recent articles and a SASE for return of slides. We are currently not actively looking for new work but always like to review work that may be appropriate for our needs."

PAUL EDELSTEIN GALLERY, 519 N. Highland St., Memphis TN 38122-4521. (901)454-7105. E-mail: pre2@aol. Owner/Director: Paul Edelstein. Retail gallery. Estab. 1985. Represents 30 emerging, mid-career and established artists. Exhibited artists include Nancy Cheairs, Marjorie Liebman and Carroll Cloar. Sponsors 1-2 shows/year. Average display time 12 weeks. Open all year; by appointment only. Located in East Memphis; 1,000 sq. ft.; 80% of space for special exhibitions. Clientele: upscale. 95% private collectors, 5% corporate collectors. Overall price range: $100-800; most work sold at $200-400.

Media: Considers all media and all types of prints. Most frequently exhibits oil, watercolor and prints.

Style: Genres include florals, landscapes, Americana and figurative. Prefers impressionism, abstraction and contemporary figurative work.

Terms: Accepts work on consignment (40% commission). Retail price set by gallery. Offers customer discounts and payment by installments. Gallery provides insurance and contract; artist pays for shipping. Prefers artwork framed.

Submissions: Send query letter with résumé, slides, bio, brochure, photographs, SASE and business card. Portfolio review not required. Replies in 2 months. Files all material.

Tips: Finds artists mostly through word of mouth, *Art in America*, and also through publications like *Artist's & Graphic Designer's Market*.

‡HAMILTON HILLS ART GALLERY, Hamilton Hills Shopping Center, Highway 45 Bypass at Old Hickory, Jackson TN 38305. (901)668-7285. Director: Naida Jones. Retail gallery. Estab. 1994. Represents/exhibits 12 emerging, mid-career and established artists/year. Exhibited artists include Shirley Flemming and Duke Eastin. Average display time 2-3 months. Open all year; Tuesday-Saturday, 11-4. Located on Highway 45 Bypass at Carriage House Dr., Gallery has "great window space—most paintings are visable from windows." 25% of space for special exhibitions; 75% of space for gallery artists. Clientele: local students and tourists. 80% private collectors, 20% corporate collectors. Overall price range: $100-5,000; most work sold at $300.

Media: Considers all media and all types of prints except that "too large or heavy to manage." Most frequently exhibits oil, watercolor and pastel.

Style: Exhibits painterly abstraction, realism, impressionism. All genres. Prefers impressionism, realism and portraits.

Terms: Artwork is accepted on consignment (40% commission). Retail price set by the gallery and the artist. Gallery provides insurance (in gallery) and promotion. Artist pays for shipping costs. Prefers framed and unframed work.

Submissions: Call or write for appointment to show portfolio of photographs. Replies only if interested within 2 weeks. Files photos and résumé.

Tips: "We are very small and in our first year, so we're open to ideas."

‡KURTS BINGHAM GALLERY, INC., 766 S. White Station Rd., Memphis TN 38117. (901)683-6200. Fax: (901)683-6265. Director: Lisa Kurts. Retail gallery. Estab. 1979. Represents/exhibits 50 mid-career and established artists/year. Exhibited artists include Mary Sims and Maria Myers. Sponsors 20 shows/year. Average display time 1 month. Open all year; Monday-Friday, 10-5:30; Saturday, 11-4. Located in east Memphis; 2,800 sq. ft. 80% of space for special exhibitions; 20% of space for gallery artists. Clientele: architects, art consultants, collectors, museums, designers and major corporations. 80% private collectors; 10% corporate collectors; 10% designers, art consultants, architects. Overall price range: $1,500-200,000; most work sold at $5,000-20,000.

Media: Considers all media; emphasis on painting. Most frequently exhibits paintings, sculpture and museum level craft.

Style: Exhibits color field, painterly abstract, realism and imagism. All genres. Prefers contemporary painterly abstraction, realism and fine craft.

Terms: Artwork is accepted on consignment "for artists in our gallery's stable" (50% commission). Retail price set by the gallery. Gallery provides insurance, promotion and contract; shipping costs are shared. Prefers artwork framed only to preapproved gallery specified (with only acid-free matting).

Submissions: Prefers only mid-career or full-time younger artists. Send query letter with résumé, slides, review, bio, SASE artist statement. Write for appointment to show portfolio of slides and transparencies. Replies in 8-10 weeks. Artist should not call. Files slides, bio and résumé.

Tips: Finds artists by going to museums, exhibitions, art fairs, and on rare occasions from slide submissions. "Be professional and polite, never drop in without appointments or pressure dealers, always document work, catalog and always take slides. Be patient."

Texas

THE ART STUDIO, INC., 720 Franklin St., Beaumont TX 77701. (409)838-5393. Executive Director: Greg Busceme. Assistant Director: Terri Fox. Cooperative, nonprofit gallery "in the process of expanding into multicultural arts organization." Estab. 1983. Exhibits 20 emerging, mid-career and established artists. Sponsors 10 shows/year. Average display time 1 month. No shows July through August. Artist space open and sales gallery open. Located in the downtown industrial district; 14,000 sq. ft.; 1946 brick 2-story warehouse with glass brick accents. Overall price range: $25-500; most work sold at $50-250.

- Gallery publishes an arts review tabloid called "*Issue*," which is open for submissions of poetry, essays, opinions from public. The publication welcomes alternative views and controversial subjects.

Media: Considers all media and all types of prints. Most frequently exhibits painting, ceramics and collage.

Style: Exhibits all styles. Prefers contemporary, painterly abstraction and photorealism.

Terms: Co-op membership fee plus donation of time (25% commission). Retail price set by artist. Gallery provides contract; artist pays for shipping. Prefers artwork framed.

Submissions: Send query letter with résumé and slides. Write for appointment to show portfolio of slides. Replies only if interested within 2 months. Files résumé and slides.

Tips: "Send résumé stating style and reason for choosing the Art Studio."

‡ARTENERGIES GALLERY, INC., 6333 Camp Bowie, Ft. Worth TX 76116. (817)737-9910. Fax: (817)737-9911. Director: Donna Craft. Retail gallery. Estab. 1989. Represents/exhibits 21 emerging, mid-career and established artists/year. Exhibited artists include Wayne McKinzie and Michael Bane. Sponsors 6 show/year. Average display time 3-4 weeks. Open all year; Monday-Saturday, 10-5:30. Located in West Fort Worth; 800 sq. ft.; 1,200 sq. ft. 90% of space for gallery artists. Clientele: upscale, local community. 90% private collectors, 10% corporate collectors. Overall price range: $100-10,000.

Media: Considers all media, woodcut, mezzotint and etching. Most frequently exhibits oil, acrylic and glass.

Style: Exhibits expressionism, photorealism, primitivism, painterly abstraction and realism. Genres include landscapes, florals and figurative work. Prefers figurative, abstract and landscape.

Terms: Artwork is accepted on consignment (50% commission). Retail price set by the gallery and the artist. Gallery provides insurance, promotion and contract; shipping costs are shared. Prefers artwork framed.

Submissions: Send query letter with résumé, brochure, business card, slides, photographs, reviews, bio and SASE. Call for appointment to show portfolio of photographs, slides and transparencies. Replies in 2 weeks.

Tips: Finds artists through referrals, artists' submissions.

ARTHAUS GALERIE, 4319 Oak Lawn Ave., Suite F, Dallas TX 75219. (214)522-2721. Fax: (214)324-3416. Director: C. Ann Sousa. Associate Director: Tim O'Neill. Retail gallery, art consultancy. Estab. 1991.

Represents 10 emerging, mid-career and established artists/year. Exhibited artists include Michael Cross, Joerg Fercher. Sponsors 9 shows/year. Average display time 3 weeks. Open all year; Tuesday-Saturday, 12-4 and by appointment. Located in Highland Park/Oak Lawn area of Dallas; 500 sq. ft. of exhibition space and 1,000 sq. ft. of storage for inventory. 40% of space for special exhibitions; 60% of space for gallery artists. Clientele: international collectors of contemporary art. 60% private collectors, 40% corporate collectors. Overall price range: $800-22,000; most work sold at $900-12,000.

Media: Considers oil, acrylic, mixed media, sculpture, installation, woodcut and linocut. Most frequently exhibits mixed media, acrylic and oil.

Style: Exhibits painterly abstraction, minimalism and postmodern works. Genres include landscapes and figurative work. Prefers painterly abstraction, minimalism and figurative work.

Terms: Accepts work on consignment (40% commission; variable commission with promotion fee for new artists). Retail price set by the gallery. Gallery provides promotion and contract; shipping costs are shared.

Submissions: Send query letter with résumé, slides, bio and photographs. Call or write for appointment to show portfolio of photographs, slides and works from the past 2-3 years. Replies in 1 month. Files bio and slides.

Tips: Finds artists through artists' submissions. "It is not the artist's role to impress galleries. Artists who concentrate on their own vision and artistic process produce work that is impressive."

CONTEMPORARY GALLERY, 4152 Shady Bend Dr., Dallas TX 75244. (214)247-5246. Director: Patsy C. Kahn. Private dealer. Estab. 1964. Interested in emerging and established artists. Clientele: collectors and retail.

Media: Considers oil, acrylic, drawings, sculpture, mixed media and original handpulled prints.

Style: Contemporary, 20th-century art—paintings, graphics and sculpture.

Terms: Accepts work on consignment or buys outright. Retail price set by gallery and artist; shipping costs are shared.

Submissions: Send query letter, résumé, slides and photographs. Write for appointment to show portfolio.

‡CREATIONS, 2613 Potomac, Houston TX 77057. (713)789-1233. Fax: (713)974-6213. Owner: Barbara Carpenter. Retail gallery. Estab. 1993. Represents/exhibits 25 emerging, mid-career and established artists/year. Exhibited artists include Karen Vernon, Jerry Seagle and Ken Muenzenmayer. Sponsors 3 shows/year. Average display time 6-8 weeks. Open all year; Tuesday-Saturday, 10-5:30. Located near Galleria (major mall); 1,200 sq. ft.; located in high-end neighborhood in a charming old house, white elegant interior. 50% of space for special exhibitions. Clientele: upscale. 80% private collectors, 20% corporate collectors. Overall price range: $600-8,000; most work sold at $1,000-2,000.

Media: Considers all media except prints and photography. Most frequently exhibits oil on canvas and acrylic, watercolor, glass and ceramic.

Style: Exhibits painterly abstraction, realism and impressionism. Genres include landscapes, florals, wildlife, Southwestern and figuratiave work. Prefers landscapes, abstract and figurative.

Terms: Artwork is accepted on consignment (40-50% commission). Gallery provides insurance and promotion; shipping costs are shared. Prefers artwork framed.

Submissions: Send query letter with résumé, slides and bio. Call for appointment to show portfolio. Replies in 2 weeks.

Tips: Finds artists through references by other artists, art fairs and exhibits. "Continually work at your art and education; everyday if possible."

DALLAS VISUAL ART CENTER, (formerly D-Art Visual Art Center), 2917 Swiss Ave., Dallas TX 75204. (214)821-2522. Fax: (214)821-9103. Director: Katherine Wagner. Nonprofit gallery. Estab. 1981. Represents emerging, mid-career and established artists. Sponsors 20 shows/year. Average display time 3-6 weeks. Open all year. Located "downtown; 24,000 sq. ft.; renovated warehouse." Provides information about opportunities for local artists, including resource center.

Media: Considers all media.

Style: Exhibits all styles and genres.

Terms: Invitational, juried and rental shows available. Rental fee for space. Retail price set by artist. Gallery provides promotion; artist pays for shipping. Requires artwork framed.

Submissions: Supports Texas-area artists. Send query letter with résumé, slides, bio and SASE.

Tips: "We offer a lot of information on grants, commissions and exhibitions available to Texas artists. We are gaining members as a result of our inhouse resource center and non-lending library. Our Business of Art seminar series provides information on marketing artwork, presentation, museum collection, tax/legal issues and other related business issues."

DEBUSK GALLERY, 3813 N. Commerce, Ft. Worth TX 76106. (817)625-8476. Owner: Barrett DeBusk. Retail/wholesale gallery, alternative space. Estab. 1987. Represents 5 emerging artists/year. Exhibited artists include Barrett DeBusk, Sue Davis. Sponsors 4 shows/year. Average display time 6 weeks. Open all year; hours vary. Located industrial area; 1,000 sq. ft.; in DeBusk' avant-garde studio. Clientele: mostly wholesale.

90% private collectors, 10% corporate collectors. Overall price range: $20-10,000; most work sold at $500-1,000.

Media: Considers oil, acrylic, sculpture, photography, woodcut, engraving, lithograph and serigraphs. Most frequently exhibits sculpture, painting and performance.

Style: Exhibits expressionism, primitivism, conceptualism and impressionism. Prefers figurative sculpture, expressionist painting and performance.

Terms: Accepts work on consignment (50% commission). Retail price set by the gallery and the artist. Shipping costs are shared.

Submissions: Send query letter with résumé and slides. Write for appointment to show portfolio of photographs and slides.

Tips: Finds artists through word of mouth, exhibitions.

EL TALLER GALLERY, 8015 Shoal Creek Blvd., Suite 109, Austin TX 78757-805. (512)302-0100 or (800)234-7362. Fax: (512)302-4895. Owner: Olga Piña. Retail gallery. Estab. 1980. Represents 10 emerging, mid-career and established artists. Exhibited artists include Amado Peña, Jr., Michael Atkinson, R.C. Gorman and Frank Howell. Sponsors 6 shows/year. Average display time 3 months. Open all year; Tuesday-Thursday, 10-6; Friday-Saturday, 10-8; Sunday, 1-5. 2,200 sq. ft.; Southwestern architecture. Clientele: 90% private collectors, 5% corporate collectors. Overall price range: $450-30,000; most work sold at $500.

Media: Considers all media. Considers lithographs, wood engravings, mezzotints, serigraphs, linocuts, etchings, offset reproductions and posters. Most frequently exhibits acrylic, graphics and watercolors.

Style: Genres include landscapes, Western, Southwestern, pottery and contemporary, bronzes and figurative work. Prefers Southwestern.

Terms: Accepts artwork on consignment (50% commission). Retail price set by the gallery. Sometimes offers customer discounts and payment by installment. Gallery provides promotion; artist pays for shipping.

Submissions: Send query letter with slides, bio, brochure and photographs and business card. Replies only if interested within 3 weeks. Write for appointment to show portfolio of photographs, slides and business card.

Tips: Finds artists through agents, by visiting exhibitions, word of mouth, various art publications, sourcebooks, artists' submissions/self-promotions and art collectors' referrals. "We will not see walk-ins."

500 X GALLERY, 500 Exposition, Dallas TX 75226. (214)828-1111. President: Tom Sime. Cooperative gallery. Estab. 1978. Represents emerging artists. 11 regular, 8 associate board members. Exhibited artists include Robert McAn, Robert Moore. Sponsors 16 shows/year. Average display time 1 month. Open all year except August; Saturday and Sunday, 12-5. Located downtown (Deep Ellum); "very large"; studio lofts surround gallery which is an old warehouse of bricks and wood beams by train tracks. 50% of space for special exhibitions; 50% of space for gallery artists. Clientele: established and first time collectors. 75% private collectors, 25% corporate collectors. Overall price range: $50-3,500; most work sold at $250-500.

Media: Considers all media but crafts, all types of prints but posters. Most frequently exhibits oil paintings, sculpture/assemblage and photography.

Style: Exhibits painterly abstraction, conceptualism, photography, minimalism and postmodern works. Prefers post modern, minimalism and conceptualism.

Terms: Co-op membership fee plus a donation of time (30% commission). Rental fee for upstairs space; covers 1 month. Retail price set by the artist. Gallery provides promotion; artist pays shipping costs to and from gallery.

Submissions: Prefers only artists from north Texas. Send query letter with résumé, slides, bio, SASE, reviews and artist's statement. Write for appointment to show portfolio of slides. Replies in 1-2 weeks. Files slides, résumé, artist's statement.

Tips: Finds artists through agents, visiting exhibitions, word of mouth, art publications and sourcebooks, artists' submissions, friends of members. Looks for artists who "take themselves seriously, price their work modestly and use good slides."

FLORENCE ART GALLERY, 2500 Cedar Springs at Fairmount, Dallas TX 75201. (214)754-7070. Director: Estelle Shwiff. Contact: Kim Radtke. Retail gallery. Estab. 1975. Represents 10-15 emerging and established artists. Exhibited artists include Simbari, H. Claude Pissarro, private collection of Vladan Stiha, Peter Max and Marc Chagall. Sponsors 2 shows/year. Average display time 2 months. Open all year; Monday-Friday, 10-5; Saturday, 11-4. Located 5 minutes from downtown/arts and antique district. 20% of space for special exhibitions. Clientele: international, US, local. 90% private collectors, 10% corporate collectors.

Media: Considers oil, acrylic, watercolor, pastel, pen & ink, mixed media, collage, paper, sculpture, bronze, original handpulled prints, woodcuts, etchings, lithographs, serigraphs. Most frequently exhibits oils, bronzes and graphics.

Style: Exhibits all styles and genres. Prefers figurative, landscapes and abstract. Interested in seeing contemporary, impressionist, figurative oils.

Terms: Accepts work on consignment. Retail price set by gallery and artist. Sometimes offers payment by installment. Gallery provides insurance, promotion and contract; shipping costs are shared. Prefers artwork framed.

Submissions: Send query letter with photographs and bio. Does not want to see slides. Call for appointment to show portfolio of photographs. Replies in 2 weeks. Files artists accepted in gallery.

Tips: "Usually we are contacted by new and upcoming artists who have heard of the gallery through word of mouth or in various art publications. Local artists are recommended to come into the gallery with their original works. If they are not available, they may bring in photos. Slides are not acceptable. For out-of-town artists, send query letter with photos and biography. Please call for appointments. Have a complete body of representative work. We always need to see new artists."

‡THE GALLERY GOLDSMITHS, 5175 Westheimer, #2350 Galleria III, Houston TX 77056. (713)961-3552. Fax: (713)626-9608. Owner: Michael Zibman. Retail gallery. Estab. 1977. Represents/exhibits 100 emerging, mid-career and established artists/year. Exhibited artists include Loren Gideon and Jim Grahl. Open all year; Monday-Friday, 10-9; Saturday, 10-7; Sunday, 12-6. Located in The Galleria (mall with hotels, offices, ice rink, etc.); 450 sq. ft.; simple all white decor. 100% of space for gallery artists. Clientele: 85% local middle income to high income mostly professionals. Overall price range: $20-50,000; most work sold at $200-1,500.

Media: Considers only jewelry: precious metals and gemstones.

Style: Exhibits all styles.

Terms: Artist sets wholesale price and gallery prices at retail based on internal criteria. Most artists start on consignment. Retail price set by the gallery. Gallery provides insurance and promotion. Gallery pays for shipping costs.

Submissions: Accepts only artists work in the US. Prefers only jewelry. Send query letter with résumé, brochure, slides and photographs. Include phone number. Call or write for appointment tho show portfolio of photographs and slides. Replies in 1 week. Files all promotional information, slides, photos, etc.

Tips: Finds artists through referrals by artists, customers, trade magazines and trade shows. Be persistent, learn a little about the business end of the business.

GALLERY 1114, 1114 N. Big Spring, Midland TX 79701. (915)685-9944. President: Pat Cowan Harris. Cooperative gallery and alternative space. Estab. 1983. Represents 12-15 emerging, mid-career and established artists. 11 members. Sponsors 8 shows/year. Average display time 6 weeks. Closed during August. Located at edge of downtown; 900-950 sq. ft.; special features include one large space for featured shows, smaller galleries for members and consignment—"simple, elegant exhibit space, wood floors, and white walls." 60% of space for special exhibitions. Clientele: "younger." Almost 100% private collectors. Overall price range: $10-8,000; most work sold at $50-350.

Media: Considers all media. Interested in all original print media. Most frequently exhibits painting, ceramics and drawing.

Style: Exhibits all styles and all genres—"in a contemporary sense, but we are not interested in genre work in the promotion sense."

Terms: Accepts work on consignment (40% commission). Retail price set by gallery. Customer discounts and payment by installment are available. Gallery provides promotion and shipping costs from gallery. Prefers artwork framed.

Submissions: Send query letter, résumé, slides, bio, reviews and SASE. Call or write for appointment to show portfolio of slides. Replies in 3-6 weeks. Files all material of interest. "We schedule up to 2-3 years in advance. It helps us to keep material. We do not file promotional material."

Tips: "Make a neat, sincere, consistent presentation with labeled slides and SASE. We are interested in serious work, not promotion. We are an alternative space primarily for central U.S. We are here to give shows to artists working in a true contemporary or modernist context: artists with a strong concern for formal strength and originality and an awareness of process and statement."

GREMILLION & CO. FINE ART, INC., 2501 Sunset Blvd., Houston TX 77005. (713)522-2701. Fax: (713)522-3712. Director: Christopher Skidmore. Retail gallery. Estab. 1981. Represents 25 mid-career and established artists. May be interested in seeing the work of emerging artists in the future. Exhibited artists include John Pavlicek and Knox Martin. Sponsors 8-10 shows/year. Average display time 4-6 weeks. Open all year. Located "West University" area; 4,000 sq. ft. 50% of space for special exhibitions. 60% private collectors; 40% corporate collectors. Overall price range: $500-300,000; most work sold at $3,000-10,000.

Media: Considers oil, acrylic, watercolor, pastel, pen & ink, drawing, mixed media, collage, works on paper, sculpture, original handpulled prints, woodcuts, engravings, lithographs, wood engravings, mezzotints, linocuts, etchings and serigraphs. Most frequently exhibits oil, acrylic and collage.

Style: Exhibits painterly abstraction, minimalism, color field and realism. Genres include landscapes and figurative work. Prefers abstraction, realism and color field.

Terms: Accepts artwork on consignment (varying commission). Retail price set by the gallery and artist. Gallery provides insurance and promotion; shipping costs are shared. Prefers artwork unframed.

Submissions: Call for appointment to show portfolio of photographs and transparencies. Replies only if interested within 1-3 weeks. Files slides and bios.

Tips: Finds artists through submissions and word of mouth.

LONGVIEW ART MUSEUM, 102 W. College St., Longview TX 75601. (903)753-8103. Director: Shannon Gilliland. Museum. Estab. 1967. Represents 80 emerging, mid-career and established artists/year. 600 members. Exhibited artists include Jan Stratman. Sponsors 6-9 shows/year. Average display time 6 weeks. Open all year; Tuesday-Saturday, 10-4. Located near downtown; interesting old building. 75% of space for special exhibitions. Clientele: members, visitors (local and out-of-town) and private collectors. Overall price range: $200-2,000; most work sold at $200-800.
Media: Considers all media, all types of prints. Most frequently exhibits oil, acrylic and photography.
Style: Exhibits all styles and genres. Prefers contemporary and realistic American art and photography.
Terms: Accepts work on consignment (30% commission). Retail price set by the artist. Offers customer discounts to museum members. Gallery provides insurance and promotion. Prefers artwork framed.
Submissions: Send query letter with résumé and slides. Portfolio review not required. Replies in 1 month. Files slides and résumés.
Tips: Finds artists through art publications and shows in other areas.

‡MODERN REALISM, 1903 McMillan Ave., Room #1, Dallas TX 75206. (214)827-1625. Director: John Held, Jr. Retail gallery. Estab. 1982. Represents/exhibits 10 emerging, mid-career and established artists/year. Exhibited artists include Davi Det Hompson and Picasso Gaglione. Sponsors 6 shows/year. Average display time 6 weeks. Open all year; Tuesday-Friday, 10-2 by appointment. Located in Lower Greenville area, near East Dallas. Clientele: students, art historians, collectors of contemporary art. Overall price range: $5-500.
Media: Considers all media and all types of prints. Most frequently exhibits works on paper, rubber stamps and artist postage stamps.
Style: Exhibits conceptualism, mail art and fluxism. Prefers mail art, fluxism and networking art.
Terms: Artwork is accepted on consignment (35% commission). Retail price set by the artist. Gallery provides promotion; shipping costs are shared. Prefers artwork framed.
Submissions: Accepts only participants in mail art and alternative art networks. Send query letter with résumé, bio and SASE. Call for appointment to show portfolio of photographs and slides. Replies only if interested within 2 weeks. Files all material sent.
Tips: Gallery director is a participant in mail art and other alternative art networks (zines, performance, e-mail, fax). Gallery artists are usually selected from repeated contacts in these areas.

SELECT ART, 10315 Gooding Dr., Dallas TX 75229. (214)353-0011. Fax: (214)350-0027. Owner: Paul Adelson. Private art gallery. Estab. 1986. Represents 25 emerging, mid-career and established artists. Exhibited artists include Barbara Elam and Larry Oliverson. Open all year; Monday-Saturday, 9-5 by appointment only. Located in North Dallas; 2,500 sq. ft. "Mostly I do corporate art placement." Clientele: 15% private collectors, 85% corporate collectors. Overall price range: $200-7,500; most work sold at $500-1,500.
Media: Considers oil, fiber, acrylic, sculpture, glass, watercolor, mixed media, ceramic, pastel, collage, photography, woodcuts, linocuts, engravings, etchings and lithographs. Prefers monoprints, paintings on paper and photography.
Style: Exhibits photorealism, minimalism, painterly abstraction, realism and impressionism. Genres include landscapes. Prefers abstraction, minimalism and impressionism.
Terms: Accepts work on consignment (50% commission). Retail price set by consultant and artist. Sometimes offers customer discounts. Provides contract (if the artist requests one). Consultant pays shipping costs from gallery; artist pays shipping to gallery. Prefers artwork unframed.
Submissions: "No florals or wildlife." Send query letter with résumé, slides, bio and SASE. Call for appointment to show portfolio of slides. Replies only if interested within 1 month. Files slides, bio, price list.
Tips: Finds artists through word of mouth and referrals from other artists. "Be timely when you say you are going to send slides, artwork, etc., and neatly label slides."

‡EVELYN SIEGEL GALLERY, 3700 W. Seventh, Fort Worth TX 76107. (817)731-6412. Fax: (817)731-6413. Owner: E. Siegel. Retail gallery and art consultancy. Estab. 1983. Represents about 30 artists; emerging, mid-career and established. Interested in seeing the work of emerging artists. Exhibited artists include Judy Pelt and John Bryant. Sponsors 9 shows/year. Average display time 3 weeks. Open all year; Monday-Friday, 11-5; Saturday, 11-4. Located in museum area; 2500 sq. ft.; Diversity of the material and artist mix. "The gallery is warm and inviting; a reading area is provided with many art books and publications." 66% of space for special exhibitions. Clientele: upscale, community, tourists. 90% private collectors. Overall price range: $30-10,000; most work sold at $1,500.
Media: Considers oil, acrylic, watercolor, pastel, mixed media, collage, sculpture, ceramic; original hand-pulled prints; woodcuts, wood engravings, linocuts, engravings, mezzotints, etchings, lithographs and serigraphs. Most frequently exhibits painting and sculpture.
Style: Exhibits expressionism, neo-expressionism, painterly abstraction, color field, impressionism and realism. Genres include landscapes, florals and figurative work. Prefers landscape, florals, interiors and still life.

Terms: Accepts work on consignment (40% commission), or is sometimes bought outright. Retail price set by gallery and artist. Gallery provides insurance, promotion and contract. Artist pays for shipping. Prefers artwork framed.
Submissions: Send query letter with résumé, slides and bio. Call or write for appointment to show portfolio of two of the following: originals, photographs, slides and transparencies.
Tips: Artists must have an appointment.

SPICEWOOD GALLERY & DESIGN STUDIO, 1206 W. 38th St., Austin TX 78705. (512)458-6575. Fax: (512)458-8102. Owner: Jackie Depew. Retail gallery. Estab. 1978. Represents 100 mid-career and established artists/year. May be interested in seeing the work of emerging artists in the future. Exhibited artists include Ken Muenzenmayer, Bobbie Kilpatrick. Sponsors 10 shows/year. Average display time 1 month. Open all year; Monday-Saturday, 10-6. Located in a retail specialty shopping center; 3,895 sq. ft.; airy, built around large atrium. 25% of space for special exhibitions; 75% of space for gallery artists. Clientele: middle-upper class, professionals, well educated. 95% private collectors, 5% corporate collectors. Overall price range: $300-30,000; most work sold at $750-2,000.
Media: Considers oil, acrylic, watercolor, pastel, drawing, mixed media, collage, paper, sculpture, ceramics, craft and glass. Most frequently exhibits oil, watercolor and mixed media.
Style: Exhibits expressionism, neo-expressionism, painterly abstraction, surrealism and impressionism. Genres include landscapes, florals, Americana, Southwestern and figurative work. Prefers landscapes and floral.
Terms: Accepts work on consignment (50% commission). Retail price set by the artist. Gallery provides promotion and contract; artist pays shipping costs to and from gallery. Prefers artwork framed.
Submissions: Accepts only artists from Southwest. Prefers only oil, watercolor, acrylic, mixed media, pastel. Send query letter with résumé, slides, bio, brochure, photographs and SASE. Call for appointment to show portfolio of originals, photographs and slides. Replies only if interested within 1 month. Files résumé, bio, brochure, photos.
Tips: Finds artists through agents by visiting exhibitions, word of mouth, various art publications and sourcebooks, artists' submissions.

‡**THE UPSTAIRS GALLERY**, 1038 W. Abram, Arlington TX 76013. (817)277-6961. Owner/Manager: Eleanor Martin. Retail gallery. Estab. 1967. Represents 15 mid-career and established artists. Exhibited artists include Al Brovillette and Judi Betts. Average display time 1-3 months. Open all year. Located near downtown; 1,500 sq. ft. "An antique house, vintage 1930." 100% of space for special exhibitions. Clientele: homeowners, businesses/hospitals. 90% private collectors, 10% corporate collectors. Overall price range: $50-5,000; most work sold at $200-600.
Media: Considers oil, acrylic, watercolor, mixed media, ceramic, collage, original handpulled prints, etchings, lithographs and offset reproductions (few). Most frequently exhibits watercolor, oil and acrylic.
Style: Exhibits expressionism, surrealism, conceptualism, impressionism and realism. All genres.
Terms: Accepts work on consignment (40-60% commission). Retail price set by the gallery and the artist. Gallery provides insurance. Artist pays for shipping. Prefers artwork framed.
Submissions: Send query letter with slides, photographs and SASE. Call for appointment to show portfolio of slides or photographs. Replies in 3-4 weeks.

WEST END GALLERY, 5425 Blossom, Houston TX 77007. (713)861-9544. Owner: Kathleen Packlick. Retail gallery. Estab. 1991. Exhibits emerging and mid-career artists. Exhibited artists include Kathleen Packlick and Suzanne Decker. Sponsors 6 shows/year. Average display time 6 weeks. Open all year; Saturday, 12-4. Located 5 mintues from downtown Houston; 800 sq. ft.; "The gallery shares the building (but not the space) with West End Bicycles." 75% of space for special exhibitions; 25% of space for gallery artists. Clientele: 100% private collectors. Overall price range: $30-2,200; most work sold at $300-600.
Media: Considers oil, pen & ink, acrylic, drawings, watercolor, mixed media, pastel, collage, woodcuts, wood engravings, linocuts, engravings, mezzotints, etchings, lithographs and serigraphs. Prefers collage, oil and mixed media.
Style: Exhibits conceptualism, minimalism, primitivism, postmodern works, realism and imagism. Genres include landscapes, florals, wildlife, Americana, portraits and figurative work. Prefers figurative and conceptual.
Terms: Accepts work on consignment (40% commission). Retail price set by artist. Customer discounts and payment by installment are available. Gallery provides promotion; artist pays shipping costs. Prefers artwork framed.
Submissions: Accepts only artists from Houston area. Send query letter with slides and SASE. Portfolio review requested if interested in artist's work.
Tips: "Don't be too impressed with yourself."

‡**JUDY YOUENS GALLERY**, 3115 D'Amico, Houston TX 77091. (713)527-0303. Contact: Director. Retail gallery. Estab. 1981. Clientele 75% private collectors, 25% corporate clients. Represents approximately 30

artists. Sponsors 10 solo and 5 group shows/year. Average display time 5 weeks. Interested in emerging artists. Price range $2,000-20,000; most artwork sold at $2,000-12,000.
Media: Considers oil, acrylic, mixed media, collage, sculpture, glass and installation. Most frequently exhibits paintings and sculpture; predominantly exhibits glass.
Style: Exhibits expressionism, neo-expressionism, realism, surrealism, minimalism and painterly abstraction.
Terms: Accepts work on consignment. Retail price set by gallery and artist. Exclusive area representation generally not required. Gallery provides insurance, promotion and contract. Prefers unframed artwork.
Submissions: Send query letter with slides, photographs and bio. Write for appointment to show portfolio of slides and transparencies. Replies in 3-4 weeks. Files only the work that we accept. All material is returned if not accepted or under consideration.
Tips: "Have good slides that are well marked and presented in an organized manner."

Utah

APPLE YARD ART, 3096 S. Highland Dr., Salt Lake City UT 84106. (801)467-3621. Manager: Sue Valentine. Retail gallery. Estab. 1981. Represents 15 established artists. Interested in seeing the work of emerging, mid-career and established artists. Average display time 3 months. "We have added European pine antiques and home accessories to compliment our art." Clientele: 70% private collectors, 30% corporate clients. Overall price range: $150-2,000; most artwork sold at $450.
Media: Most frequently exhibits watercolor, oil, mixed media, serigraphs and limited edition lithographs.
Style: Exhibits impressionisim. Genres include landscapes and florals. Prefers impressionistic watercolors.
Terms: Accepts work on consignment (40% commission). Retail price set by artist. Gallery provides insurance, promotion and contract; artist pays for shipping.
Submissions: Send query letter, résumé and slides. Write for appointment to show portfolio of well-matted and framed originals.
Tips: Looks for "fresh, spontaneous subjects, no plagiarism." The most common mistakes artists make in presenting their work are "poor framing, no established prices, wanting us to tell them what to sell it for. The artists should establish a retail price that is affordable and competitive. Decide whether you want your work to sell or 'sit.' "

BRAITHWAITE FINE ARTS GALLERY, 351 West Center, Cedar City UT 84720. (801)586-5432. E-mail: mandy@edu-suu-dce.ce.suu.edu. Director: Mandy Brooks. Nonprofit gallery. Estab. 1976. Represents emerging, mid-career and established artists. Has "100 friends (donors)." Exhibited artists include Jim Jones and Milford Zornes. Sponsors 17 shows/year. Average display time 1 month. Open all year. Located on "college campus; 1,500 sq. ft. (275 ft. running wall); historic—but renovated—building." 100% of space for special exhibitions. Clientele: local citizens, visitors for Shakespeare festival during summer. Clientele: 100% private collectors. Overall price range: $100-8,000; most work sold at $100-500.
Media: Considers oil, acrylic, watercolor, pastel, pen & ink, drawings, mixed media, collage, works on paper, sculpture, ceramic, fiber, glass, installation, photography, original handpulled prints, woodcuts, wood engravings, linocuts, engravings, mezzotints, etchings, lithographs, serigraphs. Most frequently exhibits oil, watercolor and ceramic.
Style: Exhibits all styles and genres.
Terms: Accepts work on consignment (25% commission). Retail price set by the artist. Customer discounts and payment by installment are available. Gallery provides insurance, promotion and contract (duration of exhibit only); shipping costs are shared. Ready to hang artwork only.
Submissions: Send query letter with résumé, slides, bio and SASE. Write for appointment to show portfolio of slides and transparencies. Replies in 3-4 weeks. Files bios, slides, résumé (only for 2 years).
Tips: "Know our audience! Generally conservative; during summer (Shakespeare festival) usually loosens up. We look for broad stylistic vision and content. Artists often send no slides, no bio, no artist's statement."

‡EVERGREEN FRAMING CO. & GALLERY, 2019 E. 3300 S., Salt Lake City UT 84109. (801)467-8770. Fax: (801)485-7172. Manager: David Schultz. Retail gallery. Estab. 1985. Represents 6 mid-career artists. Interested in seeing the work of emerging artists. Exhibited artists include Karen Christensen and Ann Argyle. Sponsors 2 show/year. Average display time 2 months. Open all year. Located in Holladay, at the mouth of Parleys Canyon; 1,000 sq. ft. 30% of space for special exhibitions. 65% private collectors, 35% corporate collectors. Overall price range: up to $1,000; most work sold at $300-500.
Media: Considers acrylic, watercolor, pastel and photography. Considers, lithographs, serigraphs and limited editions. Most frequently exhibits watercolor, acrylic and oil.
Style: Exhibits classic and traditional. Genres include landscapes, florals, Americana, Southwestern, Western and wildlife.
Terms: Accepts work on consignment (40% commission) or buys outright for 50% of retail price. Retail price set by the gallery and the artist. Gallery provides promotion. Shipping costs are shared. Prefers artwork unframed.

Submissions: Prefers local area watercolor, oil, acrylic and photography—unframed. Send query letter and make an appointment. Write for appointment to show portfolio of originals, photographs and slides. Replies only if interested within 1 month.

Tips: "We offer unique (original) local art—support local economy. Also want our customers to be able to purchase any medium, style, etc. from our gallery. We have the lazer disc system for viewing. To show artist well we need a minimum of six pieces."

‡KIMBALL ART CENTER, 638 Park Ave., P.O. Box 1478, Park City UT 84060. (801)649-8882. Fax: (801)649-8889. Program Coordinator: Rebecca Samson. Nonprofit gallery. Estab. 1976. Represents/exhibits 24-300 emerging, mid-career and established artists/year. Exhibited artists include Northwest Rendezvous Group, Randi Wagner and Trevor Southey. Sponsors 24 shows/year. Average display time 1 month. Open all year; Monday-Saturday, 10-6; Sunday, 12-6. Located in Old Town District; restored historic building. 50% of space for special exhibitions; 30% of space for gallery artists. Clientele: tourists, upscale, local clientele. 90% private collectors, 10% corporate collectors. Overall price range: $100-30,000; most work sold at $200-5,000.

Media: Considers all media except craft. Most frequently exhibits oil paintings, watercolor and sculpture.

Style: Exhibits realism and impressionism. All genres. Prefers landscapes, western and mixed genres.

Terms: Artwork is accepted on consignment (40% commission). Retail price set by the artist. Gallery provides insurance, promotion and contract; shipping costs are shared. Prefers artwork framed.

Submissions: Prefers Southwest—West Coast artists. Send query letter with résumé, slides, bio and SASE. Portfolio should include slides. Replies in 4 months.

Tips: Finds artists through word of mouth, Park City Art Festival (Kimball Art Center production) and artists' submissions.

MARBLE HOUSE GALLERY, 44 Exchange Place, Salt Lake City UT 84111. (801)532-7332; 7338. Fax: (801)532-7338 (call first to turn on.) Owner: Dolores Kohler. Retail gallery and art consultancy. Estab. 1987. Represents 20 emerging, mid-career and established artists. Sponsors 6 solo or 2-person shows and 2 group shows/year. Average display time 1 month. Located in the historic financial district; modern interior, marble facade, well lit; 6,000 sq. ft. Clientele: 70% private collectors, 30% corporate clients. Overall price range $100-10,000; most work sold at $200-5,000.

• Now carries limited edition prints from Greenwich Workshop and Somerset House Publishing.

Media: Considers oil, acrylic, watercolor, pastel, pen & ink, mixed media, collage, sculpture, ceramic, photography, egg tempera, woodcuts, wood engravings, linocuts, engravings, mezzotints, etchings, lithographs, pochoir and serigraphs. Most frequently exhibits oil, watercolor, sculpture and limited editions.

Style: Exhibits impressionism, expressionism, realism, surrealism, painterly abstraction and postmodern works. Genres include landscapes, florals, Americana, Southwestern, Western, portraits, still lifes and figurative work. Prefers abstraction, landscapes and florals. Looking for "artwork with something extra: landscapes with a center of interest (people or animals, etc.); abstracts that are well designed; still life with a unifying theme; subjects of interest to viewers."

Terms: Accepts work on consignment (50% commission) or buys outright (net 30 days.) Retail price set by gallery and artist. Customer discounts and payment by installment are available. Exclusive area representation required. Gallery provides promotion and contract; shipping costs are shared.

Submissions: Send query letter with résumé, slides, photographs, bio and SASE. Portfolio review requested if interested in artist's work. Portfolio should include originals, slides, transparencies and photographs. Files slides, résumé and price list. All material returned if not accepted or under consideration.

Tips: Finds artists through agents, associations, artists' submissions and referrals. "Use striking colors. No crude, suggestive subjects. We look for professionalism and steady production in artists. We have a Gallery Stroll on the third Friday of each month. About 15 galleries participate."

Vermont

‡CONE EDITIONS, Powder Spring Rd., East Topsham VT 05076. (802)439-5751. Fax: (802)439-6501. E-mail: jcone@aol.com. Owner: Jon Cone. Gallery workshop. Printmakers, publishers and distributors of computer and digitally made works of art. Estab. 1980. Represents/exhibits 12 emerging, mid-career and established artists/year. Exhibited artists include Norman Bluhm and Wolf Kahn. Sponsors 4 shows/year. Average display time 3 months. Open all year; Monday-Friday, 7:30-5. Located downtown; 1,000 sq. ft.; post and beam, high ceilings, natural light. 50% of space for special exhibitions; 50% of space for gallery artists. Clientele: private, corporate. 40% private collectors, 60% corporate collectors. Overall price range: $300-5,000; most work sold at $500-1,500.

Media: Considers computer and digital art and computer prints. Most frequently exhibits iris ink jet print, digitial monoprint and digital gravure.

Style: Exhibits expressionism, minimalism, color field, painterly abstraction and imagism.

Terms: Artwork is accepted on consignment (50% commission). Retail price set by the artist. Gallery provides promotion; shipping costs are shared. Prefers artwork unframed.

Submissions: Prefers computer and digital art. Contact through e-mail. Call for appointment to show portfolio of CD-ROM. Replies in 1-3 weeks. Files slides and CD-ROM.
Tips: "We find most of the artists we represent by referrals of our other artists."

COTTONBROOK GALLERY, 1056-13 Mt. Rd., Stowe VT 05672. (802)253-8121. Owner: Vera Beckerhoff. Retail gallery and custom frame shop. Estab. 1981. Average display time 3 weeks. Clientele: upscale second homeowners. Overall price range: $50-3,000; most work sold at $100-200.
Media: Considers oil, watercolor, drawings, mixed media and sculpture. Most frequently exhibits watercolor and oil.
Style: Exhibits painterly abstraction, primitivism and impressionism. Shows are thematic.
Terms: Work accepted on consignment. Retail price set by gallery or artist. Exclusive area representation required. Shipping costs are shared.
Submissions: Send query letter with résumé, slides and SASE. Write for appointment to show portfolio of originals.
Tips: "Have good slides. Have a consistent body of work. Be business-like—not flashy, but honest and thorough."

Virginia

THE ART LEAGUE, INC., 105 N. Union St., Alexandria VA 22314. (703)683-1780. Executive Director: Cora J. Rupp. Gallery Director: Katy Hunt. Cooperative gallery. Estab. 1953. Interested in emerging, mid-career and established artists. 1,000-1,100 members. Sponsors 10 solo and 16 group shows/year. Average display time 1 month. Located in The Torpedo Factory Art Center. Accepts artists from metropolitan Washington area, northern Virginia and Maryland. Clientele: 75% private collectors, 25% corporate clients. Overall price range: $50-4,000; most work sold at $150-500.
Media: Considers oil, acrylic, watercolor, pastel, pen & ink, drawings, mixed media, collage, works on paper, sculpture, ceramic, fiber, glass, photography and original handpulled prints. Most frequently exhibits watercolor, all printmaking media and oil/acrylic.
Style: Exhibits all styles and genres. Prefers impressionism, painted abstraction and realism. "The Art League is a membership organization open to anyone interested."
Terms: Accepts work on consignment (33⅓% commission) and co-op membership fee plus donation of time. Retail price set by artist. Offers customer discounts (designers only) and payment by installments (if requested on long term). Exclusive area representation not required.
Submissions: Portfolio review requested if interested in artist's work.
Tips: "Artists find us and join/exhibit as they wish within framework of our selections jurying process."

ART MUSEUM OF WESTERN VIRGINIA, 1 Market Square, Roanoke VA 24011. (703)342-5760. Fax: (703)342-5798. E-mail: cesouth@aol.com. Assistant Curator: Carissa South. Museum. Estab. 1951. Represents emerging, mid-career and established artists. 800 members. Sponsors 10 shows/year. Average display time 3 months. Open all year; Tuesday-Saturday, 10-5; Sunday, 1-5. Located downtown; 60,000 sq. ft.; in facility with 4 other cultural organizations. 70% of space for rotating/temporary special exhibitions; 30% of space for permanent collection. Clientele: tourists, educators and classes.
 • AMWV also has a children's art center, Artventure, with its own gallery space for exhibitions of special interest to children.
Media: Considers all media, including photography.
Terms: Gallery provides insurance and promotion; shipping costs are shared. Prefers artwork framed.
Submissions: Prefers only artists from southern and mid-Atlantic regions of US. Send query letter with résumé, slides, bio. Write for appointment to show portfolio of slides and transparencies. Replies in 6-8 weeks. Files 1-2 slides from regional artists, résumé.
Tips: Finds artists through visiting exhibitions, word of mouth and artists' submissions. "Slide submission *strongly* encouraged!"

‡CUDAHY'S GALLERY, 1314 E. Cary St., Richmond VA 23219. (804)782-1776. Director: Helen Levinson. Retail gallery. Estab. 1981. Represents 50 emerging and established artists. Exhibited artists include Eldridge Bagley and Nancy Witt. Sponsors 12 shows/year. Average display time 4-5 weeks. Open all year; Monday-Thursday, 10-6; Friday-Saturday, 10-10; Sunday, 12-5. Located downtown in historic district; 3,600 sq. ft.; "1870s restored warehouse." 33% of space for special exhibits. Clientele: diverse. 70% private collectors, 30% corporate collectors. Overall price range: $100-10,000; most work sold at $400-2,500.
Media: Considers all media except fiber; and all types of prints except posters. Most frequently exhibits oil, watercolor and pastel.
Style: Exhibits impressionism, realism and photorealism. Genres include landscapes, portraits and figurative work. Prefers realism, figurative work and abstraction.
Terms: Accepts work on consignment (45% commission). Retail price set by artist. Gallery provides insurance and promotion; shipping costs are shared. Prefers artwork framed..

Submissions: Prefers artists from Southeast or East Coast. Send query letter with résumé, slides, bio, brochure, business card, reviews, photographs and SASE. Replies in 1 month.

‡EMERSON GALLERY McLEAN PROJECT FOR THE ARTS, 1234 Ingleside Ave., McLean VA 22101. (703)790-0123. Fax: (703)556-0547. Exhibitions Director: Andrea Pollan. Alternative space. Estab. 1962. "Over 400 artists have exhibited at the space." Exhibited artists include Yuriko Yamaguchi and Christopher French. Sponsors 16 shows/year. Average display time 5-6 weeks. Open Tuesday-Friday, 10-5; Saturday, 1-5. 3,000 sq. ft.; large luminous "white cube" type of gallery; moveable walls. 85% of space for special exhibitions. Clientele: local community, students, artists families. 100% private collectors. Overall price range: $200-15,000; most work sold at $800-1,800.
Media: Considers all media except graphic design and traditional crafts; all types of prints except posters. Most frequently exhibits painting, sculpture and installation.
Style: Exhibits all styles, all genres.
Terms: Artwork is accepted on consignment (25% commission). Retail price set by the artist. Gallery provides insurance and promotion. Artist pays for shipping costs. Prefers artwork framed (if works on paper) and unframed (if painting).
Submissions: Accepts only artists from Maryland, DC, Virginia and some regional Mid-Atlantic. Send query letter with résumé, slides, reviews and SASE. Write for appointment to show portfolio of photographs, slides and transparencies. Replies only if interested within 1-2 months. Artists' slides, bios and written material kept on file for 2 years.
Tips: Finds artists through referrals by other artists and curators; by visiting exhibitions and studios.

FINE ARTS CENTER FOR NEW RIVER VALLEY, P.O. Box 309, Pulaski VA 24301. (703)980-7363. Director: Michael Dowell. Nonprofit gallery. Estab. 1978. Represents 75 emerging, mid-career and established artists and craftspeople. Sponsors 10 solo and 2 group shows/year. Average display time is 1 month (gallery); 3-6 months (Art Mart). Clientele: general public, corporate, schools. 80% private collectors, 20% corporate clients. Overall price range: $20-500; most artwork sold at $20-100.
 • Downtown Pulaski is enjoying a new growth in the arts, music and antiques areas thanks to an active and successful main street revitalization program.
Media: Considers all media. Most frequently exhibits oil, watercolor and ceramic.
Style: Exhibits hard-edge/geometric abstraction, painterly abstraction, minimalism, post-modernism, pattern painting, feminist/political works, primitivism, impressionism, photorealism, expressionism, neo-expressionism, realism and surrealism. Genres include landscapes, florals, Americana, Western, portraits and figurative work. Most frequently exhibits landscapes, abstracts, Americana.
Terms: Accepts work on consignment (30% commission). Retail price is set by gallery or artist. Sometimes offers payment by installments. Exclusive area representation not required. Gallery provides insurance (80% of value), promotion and contract.
Submissions: Send query letter with résumé, brochure, clearly labeled slides, photographs and SASE. Slides and résumés are filed. Portfolio review requested if interested in artist's work. "We do not want to see unmatted or unframed paintings and watercolors."
Tips: Finds artists through visiting exhibitions and art collectors' referrals. "In the selection process, preference is often (but not always) given to regional and Southeastern artists. This is in accordance with our size, mission and budget constraints."

GALLERY WEST, LTD., 205 S. Union St., Alexandria VA 22314. (703)549-7359. Director: Craig Snyder. Cooperative gallery and alternative space. Estab. 1979. Exhibits the work of 30 emerging, mid-career and established artists. Sponsors 17 shows/year. Average display time 3 weeks. Open all year. Located in Old Town; 1,000 sq. ft. 60% of space for special exhibitions. Clientele: individual, corporate and decorators. 90% private collectors, 10% corporate collectors. Overall price range: $100-2,000; most work sold at $150-400.
Media: Considers all media.
Style: All styles and genres.
Terms: Co-op membership fee plus a donation of time. (25% commission.) Retail price set by artist. Sometimes offers customer discounts and payment by installments. Gallery assists promotion; artist pays for shipping. Prefers artwork framed.
Submissions: Send query letter with résumé, slides, bio and SASE. Call for appointment to show portfolio of slides. Replies in 3 weeks. Files résumés.

‡HAMPTON UNIVERSITY MUSEUM, Marshall Ave. at Shore Rd., Hampton VA 23668. (804)727-5308. Fax: (804)227-5084. Director: Jeanne Zeidler or Curator of Exhibitions: Jeffrey Bruce. Museum. Estab. 1868. Represents/exhibits established artists. Exhibited artists inclucde Elizabeth Catlett and Jacob Lawrence. Sponsors 4-5 shows/year. Average display time 4-5 weeks. Open all year; Monday-Friday, 8-5; Saturday-Sunday, 12-4; closed on major and campus holidays. Located on the campus of Hampton University.
Media: Considers all media and all types of prints. Most frequently exhibits oil or acrylic paintings, ceramics and mixed media.

Style: Exhibits African-American, African and/or Native American art.
Submissions: Send query letter with résumé and slides. Portfolio should include photographs and slides.

MARSH ART GALLERY, University of Richmond, Richmond VA 23173. (804)289-8276. Fax: (804)287-6006. E-mail: waller@urvax.urich.edu. Director: Richard Waller. Museum. Estab. 1967. Represents emerging, mid-career and established artists. Sponsors 10 shows/year. Average display time 1 month. Open all year; with limited summer hours June-August. Located on University campus; 1,800 sq. ft. 100% of space for special exhibitions.
Media: Considers all media and all types of prints. Most frequently exhibits painting, sculpture, photography and drawing.
Style: Exhibits all styles and genres.
Terms: Work accepted on loan for duration of special exhibition. Retail price set by the artist. Gallery provides insurance, promotion, contract and shipping costs. Prefers artwork framed.
Submissions: Send query letter with résumé, slides, brochure, SASE, reviews and printed material if available. Write for appointment to show portfolio of photographs, slides, transparencies or "whatever is appropriate to understanding the artist's work." Replies in 1 month. Files résumé and other materials the artist does not want returned (printed material, slides, reviews, etc.).

‡PREMIER GALLERY, 814 Caroline St., Fredericksburg VA 22401. (703)899-3100. Owner: Jack Garver. Retail gallery. Estab. 1986. Represents/exhibits 35 mid-career and established/year. Interested in seeing the work of emerging artists. Exhibited artists include Anthony Watkins and Stuart White. Sponsors 4 shows/year. Average display time 1 month. Open all year; Monday, Tuesday, Thursday, Friday, Saturday, 11-5; Sunday, 1-5; closed Wednesday. Located in Old Town in historic district; 2,800 sq. ft.; intimate, elegant setting in historic building. 50% of space for special exhibitions; 50% of space for gallery artists. Clientele: tourists, upscale, local community Washington DC and metropolitan area. 90% private collectors. Overall price range: $100-15,000; most work sold at $600-3,500.
Media: Considers all media except photocopy, etching, lithograph and serigraph. Most frequently exhibits oil, watercolor and sculpture.
Style: Exhibits realism and impressionism. Genres include landscapes, florals, wildlife and figurative work. Prefers realism, impressionism and wildlife.
Terms: Artwork is accepted on consignment (40% commission) or bought outright for 50% of retail price; net 30 days. Retail price set by the gallery and the artist. Gallery provides insurance, promotion and contract; shipping costs are shared. Prefers artwork framed.
Submission: Prefers only established artists with credentials. Send query letter with résumé, slides and reviews. Call or write for appointment to show portfolio of slides. Replies only if interested within 3 weeks.
Tips: Finds artists mostly through artist referrals. "Some surprises have come by unsolicited presentations. Always looking during my travels. Try to determine what area of country might be best suited and send out letters and sampling of slides. Enter as many quality shows as possible for feedback."

‡SECOND STREET GALLERY, 201 Second St. NW, Charlottesville VA 22902. (804)977-7284. Director: Sarah Sargent. Nonprofit gallery. Estab. 1973. Represents/exhibits 12 emerging and established artists/year. Sponsors 9 shows/year. Average display time 1 month. Open all year except August; Tuesday-Saturday, 10-5; Sunday, 1-5. Located downtown; 825 sq. ft.; high ceilings lots of light (uv filtered). 100% of space for gallery artists. Clientele: tourists and locals. 100% private collectors. Overall price range: $300-20,000; most work sold at $500.
Media: Considers all media except computer art. Most frequently exhibits paintings, prints and photographs.
Style: Exhibits conceptualism, primitivism, color field, painterly abstraction and realism. Prefers conceptualism, painterly abstraction and primitivism.
Terms: Artwork is accepted on consignment (25% commission). Retail price set by the artist. Gallery provides insurance, promotion and contract. Artist pays for shipping costs. Prefers artwork framed.
Submissions: Send query letter with résumé, slides, reviews, bio and SASE. Replies in 5 weeks.
Tips: Finds artists through word of mouth, studio visits and calls for art.

Washington

‡THE AMERICAN ART COMPANY, 1126 Broadway Plaza, Tacoma WA 98402. (206)272-4377. Director: Rick Gottas. Retail gallery. Estab. 1978. Represents/exhibits 50 emerging, mid-career and established artists/year. Exhibited artists include Toko Shinoda. Sponsors 10 shows/year. Open all year; Monday-Friday, 10-5; Saturday, 10-5:30. Located downtown; 3,500 sq. ft. 60% of space for special exhibitions; 40% of space for gallery artists. Clientele: local community. 95% private collectors; 5% corporate collectors. Overall price range: $500-15,000; most work sold at $1,800.
Media: Considers oil, fiber, acrylic, sculpture, glass, watercolor, mixed media, pastel, collage; woodcut, wood engraving, linocut, engraving, mezzotint, etching lithograph and serigraphs. Most frequently exhibits works on paper, sculpture and oils.

Style: Exhibits all styles. Genres include landscapes, Chinese and Japanese.

Terms: Artwork is accepted on consignment (50% commission) or bought outright for 50% of retail price; net 30 days. Retail price set by the gallery and the artist. Gallery provides insurance and promotion; shipping costs are shared. Prefers artwork unframed.

Submissions: Send query letter with résumé, slides, bio and SASE. Write for appointment to show portfolio of slides. Replies in 2-3 weeks.

Tips: Finds artists through word of mouth, referrals by other artists, visiting art fairs and exhibitions, artists' submissions.

‡AMY BURNETT FINE ART GALLERY, 412 Pacific Ave., Bremerton WA 98337. (360)373-3187. Owner: Jill Hawes-Wright. Director: Melissa Weatherly. Retail gallery and art consultancy. Estab. 1991. Represents 8 established artists. Exhibited artists include Amy Burnett and Donna Howell Sickles. Sponsors 6 show/year. Average display time 2 months. Open all year. Located "minutes from Seattle by ferry, downtown; almost 14,000 sq. ft.; the most spacious, gallery in the Northwest. The building was designed by the famous architect Harlem Thomas in 1922." 80% of space for special exhibitions. Clientele: "every kind from everywhere." Overall price range: $300-8,000; most work sold at $1,000-3,000.

Media: Considers oil, acrylic, watercolor, ceramic and glass. Does not consider prints. Most frequently exhibits mixed media, acrylic and watercolor. Seeks unusual pottery and blown glass.

Style: Exhibits expressionism, painterly abstraction, conceptualism, impressionism and realism. Genres include Americana, Northwest Coast, Western, portraits and figurative work. Prefers figurative work.

Terms: Accepts work on consignment (50% commission). Retail price set by gallery and artist. Gallery provides insurance, promotion, negotiates a contract and pays for shipping costs from gallery. Prefers artwork framed.

Submissions: Restricted to "already recognized, well-educated professional artists. Send query letter with résumé, photographs and SASE. Gallery will contact artist if interested in a portfolio review. Replies immediately, if possible. Files everything, unless artist requests return.

Tips: "When you come in, leave a résumé and a few photographs. The extremely large gallery space can exhibit large 3-D works: representational, contemporary representational or Northwest Coast theme, monumental totems, ravens, horses or bears will attract gallery's immediate attention."

‡CIRCLE GALLERY, 2001 Western Ave., Seattle WA 98121. (206)443-9242. Fax: (206)443-9243. Contact: Director. Regail gallery. Estab. 1974. Represents/exhibits 25 established artists/year. May be interested in seeing the work of emerging artists in the future. Exhibited artists include Victor Vasarely and Sandro Chia. Sponsors 6 shows/year. Average display time 5 weeks. Open all year; Monday-Saturday, 10-6; Sunday, 12-5. Located downtown near Pike Place Market; 2,000 sq. ft. 60% of space for special exhibitions; 40% of space for gallery artists. Clientele: collectors and tourists. 90% private collectors, 10% corporate collectors. Overall price range: $1,200-2,000; most work sold at $1,500-1,800.

Media: Considers oil, acrylic, sculpture, watercolor, mixed media, collage and photography, mezzotint, lithograph and serigraphs. Most frequently exhibits lithographs, photography and oil/acrylic.

Style: Exhibits photorealism, neo-expressionism, pattern painting and painterly abstraction. All genres except Western and Southwestern. Prefers portraits, abstract and figurative/florals.

Terms: Retail price set by the gallery and the artist. Gallery provides contract; shipping costs are shared. Prefers artwork framed.

Submissions: Send query letter with résumé, brochure, business card, bio and SASE. Write for appointment. Replies only if interested within 4 months.

Tips: Finds artists through word of mouth, referrals by other artists, visiting art fairs and exhibitions. "Visit galleries, get to know them and the work they handle before spending time trying to get the gallery to represent you."

‡DAVIDSON GALLERIES, 313 Occidental Ave. S., Seattle WA 98104. (206)624-7684. Director: Kate Joyce. Retail gallery. Estab. 1973. Represents 150 emerging, mid-career and established artists. Sponsors 36 shows/year. Average display time 3½ weeks. Open all year; Monday-Saturday, 11-5:30 (summer, open 7 days). Located in old, restored part of downtown: 3,200 sq. ft.; "Beautiful antique space with columns and high ceilings in 1890 style." 20% of space for special exhibitions; 80% of space for gallery artists. Clientele: 90% private collectors, 10% corporate collectors. Overall price range: $10-350,000; most work sold at $150-5,000.

Media: Considers oil, pen & ink, paper, acrylic, drawing, sculpture, watercolor, mixed media, pastel, woodcuts, wood engravings, linocuts, engravings, mezzotints, etchings, lithographs, serigraphs, posters (our own).

Style: Exhibits expressionism, neo-expressionism, primitivism, painterly abstraction, postmodern works, realism, surrealism, impressionism.

Terms: Accepts work on consignment (50% commission). Retail price set by gallery and artist. Gallery provides insurance, promotion and contract; shipping costs are shared.

Submissions: Send query letter with résumé, slides, bio and SASE. Replies in 4-6 weeks.

Tips: Impressed by "simple straight-forward presentation of slides, résumé with SASE included."

FOSTER/WHITE GALLERY, 311½ Occidental Ave. S., Seattle WA 98104. (206)622-2833. Fax: (206)622-7606. Owner/Director: Donald Foster. Retail gallery. Estab. 1973. Represents 90 emerging, mid-career and established artists/year. Interested in seeing the work of local emerging artists. Exhibited artists include Chihuly, Tobey, George Tsutakawa. Average display time 1 month. Open all year; Monday-Saturday, 10-5:30; Sunday, 12-5. Located historic Pioneer Square; 5,800 sq. ft. Clientele: private, corporate and public collectors. Overall price range: $300-35,000; most work sold at $2,000-8,000.
- Gallery has additional space at 126 Central Way, Kirkland WA 98033 (206)822-2305. Fax: (206)828-2270.

Media: Considers oil, acrylic, watercolor, pastel, pen & ink, drawing, mixed media, collage, paper, sculpture, ceramics, craft, fiber, glass and installation. Most frequently exhibits glass sculpture, works on paper and canvas and ceramic and metal sculptures.
Style: Contemporary Northwest art. Prefers contemporary Northwest abstract, contemporary glass sculpture.
Terms: Gallery provides insurance, promotion and contract.
Submissions: Accepts only artists from Pacific Northwest. Send query letter with résumé, slides, bio and reviews. Write for appointment to show portfolio of slides. Replies in 3 weeks.

GALLERY ONE, 408½ N. Pearl St., Ellensburg WA 98926. (509)925-2670. Director: Eveleth Green. Non-profit gallery. Estab. 1968. Represents emerging, mid-career and established artists. 400 members. Sponsors 10 shows/year. Average display time 3½ weeks. Open all year; Monday-Saturday, 11-5. Located in the heart of downtown business district; 5,000 sq. ft.; entire upper floor of 1889 building (Stewart Bldg.) listed in National Historical Directory. "In addition to 5 exhibit areas, we have 3 sales rooms. The atrium and 4 rooms have original skylights which result in special lighting for artwork." 75% of space for special exhibitions; 100% of space for gallery artists. Clientele: general public, tourists, foreign visitors. Overall price range: $25-10,000; most work sold at $75-500.
Media: Considers all media including jewelry, woodcut, engraving, lithograph, wood engraving, mezzotint, serigraphs, linocut and etching. Most frequently exhibits oil, watercolor, ceramics and handblown glass.
Style: Exhibits expressionism, primitivism, painterly abstraction, surrealism, conceptualism, minimalism, impressionism, photorealism, hard-edge geometric abstraction and realism, all genres. Sells mainly landscapes, florals and wildlife, but tries "to introduce every style of art to the public."
Terms: Accepts work on consignment (30% commission). Retail price set by the artist. Gallery provides insurance and promotion; shipping costs are shared. Prefers artwork framed.
Submissions: Send query letter with résumé, slides or photographs and bio. Call or write for appointment to show portfolio of originals, photographs or slides. Replies only if interested within 2 weeks. Files "everything, if interested in artist and work."
Tips: Finds artists through visiting exhibitions, art publications, sourcebooks, artists' submissions, references from other artists, referrals and recommendations. "Paintings, prints, etc. should be nicely presented with frames that do not 'overpower' the work."

KIRSTEN GALLERY, INC., 5320 Roosevelt Way NE, Seattle WA 98105. (206)522-2011. Director: R.J. Kirsten. Retail gallery. Estab. 1975. Represents 60 emerging, mid-career and established artists. Exhibited artists include Birdsall and Daiensai. Sponsors 10 shows/year. Average display time 1 month. Open all year. 3,500 sq. ft.; outdoor sculpture garden. 40% of space for special exhibitions; 60% of space for gallery artists. 90% private collectors, 10% corporate collectors. Overall price range: $75-15,000; most work sold at $75-2,000.
Media: Considers oil, acrylic, watercolor, mixed media, sculpture, glass and offset reproductions. Most frequently exhibits oil, watercolor and glass.
Style: Exhibits surrealism, photorealism and realism. Genres include landscapes, florals, Americana. Prefers realism.
Terms: Accepts work on consignment (50% commission). Retail price set by artist. Offers payment by installments. Gallery provides promotion; artist pays shipping costs. "No insurance, artist responsible for own work."
Submissions: Send query letter with résumé, slides and bio. Write for appointment to show portfolio of photographs and/or slides. Replies in 2 weeks. Files bio and résumé.
Tips: Finds artists through visiting exhibitions and word of mouth. "Keep prices down. Be prepared to pay shipping costs both ways. Work is not insured (send at your own risk). Send the best work—not just what you did not sell in your hometown."

MING'S ASIAN GALLERY, 10217 Main St., Old Bellevue WA 98004-6121. (206)462-4008. Fax: (206)453-8067. Director: Nelleen Klein Hendricks. Retail gallery. Estab. 1964. Represents/exhibits 3-8 mid-career and established artists/year. Exhibited artists include Kai Wang and Kaneko Jonkoh. Sponsors 8 shows/year. Average display time 1 month. Open all year; Monday-Saturday, 10-6. Located downtown; 6,000 sq. ft.; exterior is Shanghai architecture circa 1930. 20% of space for special exhibitions. 35% private collectors, 20% corporate collectors. Overall price range: $350-10,000; most work sold at $1,500-3,500.
Media: Considers oil, acrylic, watercolor, sumi paintings, Japanese woodblock. Most frequently exhibits sumi paintings with woodblock and oil.

Style: Exhibits expressionism, primitivism, realism and imagism. Genres include Asian. Prefers antique, sumi, watercolors, temple paintings and folk paintings.
Terms: Artwork is accepted on consignment (50% commission). Retail price set by the gallery and the artist. Gallery provides insurance, promotion and contract; shipping costs are shared. Prefers artwork framed.
Submissions: Send query letter with résumé, brochure, slides, photographs, reviews, bio and SASE. Write for appointment to show portfolio of photographs, slides and transparencies. Replies in 2 weeks.
Tips: Finds artists by traveling to Asia, visiting art fairs, and through artists' submissions.

PAINTERS ART GALLERY, 30517 S.R. 706E, P.O. Box 106, Ashford WA 98304. Owner: Joan Painter. Retail gallery. Estab. 1972. Represents 60 emerging, mid-career and established artists. Exhibited artists include Cameron Blagg, Roger Kamp and David Bartholet. Open all year. Located 5 miles from the entrance to Mt. Rainier National Park; 1,200 sq. ft. 75% of space for work of gallery artists. Clientele: collectors and tourists. Overall price range $10-5,500; most work sold at $300-2,500.
● The gallery has over 100 people on consignment. It is very informal, outdoors atmosphere.
Media: Considers oil, acrylic, watercolor, pastel, pen & ink, drawings, mixed media, sculpture (bronze), photography, stained glass, original handpulled prints, reliefs, offset reproductions, lithographs, serigraphs and etchings. "I am seriously looking for bronzes, totem poles and outdoor carvings." Most frequently exhibits oil, pastel and acrylic.
Style: Exhibits primitivism, surrealism, imagism, impressionism, realism and photorealism. All genres. Prefers Mt. Rainier themes and wildlife. "Indians are a strong sell."
Terms: Accepts artwork on consignment (30% commission on prints and bronzes; 40% on paintings). Retail price set by gallery and artist. Gallery provides promotion; artist pays for shipping. Prefers artwork framed.
Submissions: Send query letter or call. "I can usually tell over the phone if artwork will fit in here." Portfolio review requested if interested in artist's work. Does not file materials.
Tips: "Sell paintings and retail price items for the same price at mall and outdoor shows that you price them in galleries. I have seen artists under price the same paintings/items, etc. when they sell at shows."

PHINNEY CENTER GALLERY, 6532 Phinney Ave. N., Seattle WA 98103. (206)783-2244. Fax: (206)783-2246. Arts Coordinator: Ed Medeiros. Nonprofit gallery. Estab. 1982. Represents 10-12 emerging artists/year. Sponsors 10-12 shows/year. Average display time 1 month. Open all year; Monday-Friday, 10-9; Saturday, 10-1. Located in a residential area; 92 sq. ft.; in 1904 building—hard wood floors, high ceilings. 20% of space for special exhibitions; 80% of space for gallery artists. 50-60% private collectors. Overall price range: $50-4,000; most work sold at $50-200.
Media: Considers oil, acrylic, watercolor, pastel, pen & ink, drawing, mixed media, collage, paper, sculpture, ceramics, installation, photography, all types of prints. Most frequently exhibits painting, sculpture and photography.
Style: Exhibits painterly abstraction, all genres.
Terms: Accepts work on consignment (25% commission). Retail price set by the artist. Gallery provides promotion and contract; artist pays shipping costs to and from gallery. Prefers artwork framed.
Submissions: Send query letter with résumé, bio and SASE. Call or write for appointment to show portfolio of slides. Replies in 2 weeks.
Tips: Finds artists through calls for work in local and national publications.

West Virginia

THE ART STORE, 1013 Bridge Rd., Charleston WV 25314. (304)345-1038. Director: E. Schaul. Retail gallery. Estab. 1980. Represents 16 mid-career and established artists. Sponsors 4 shows/year. Average display time 1 month. Open all year. Located in a suburban shopping center; 2,000 sq. ft. 50% of space for special exhibitions. Clientele: professionals, executives, decorators. 60% private collectors, 40% corporate collectors. Overall price range: $200-8,000; most work sold at $1,800.
Media: Considers oil, acrylic, watercolor, pastel, mixed media, works on paper, ceramic, woodcuts, engravings, linocuts, etchings, and monoprints. Most frequently exhibits oil, pastel, mixed media and watercolor.
Style: Exhibits expressionism, painterly abstraction, color field and impressionism.
Terms: Accepts artwork on consignment (40% commission). Retail price set by gallery and artist. Gallery provides insurance, promotion and shipping costs from gallery. Prefers artwork unframed.
Submissions: Send query letter with résumé, slides, SASE and announcements from other galleries if available. Gallery makes the contact after review of these items; replies in 4-6 weeks.
Tips: "Do not sent slides of old work."

SUNRISE MUSEUM, 746 Myrtle Rd., Charleston WV 25314. (304)344-8035. Fax: (304)344-8038. Deputy Director of Exhibitions: Ric Ambrose. Museum. Estab. 1974. Represents emerging, mid-career and established artists. Sponsors 6 shows/year. Average display time 2-3 months. Open all year. Located in the South Hills, residential area; 2,500 sq. ft.; historical mansion.

Media: Considers oil, acrylic, watercolor, pastel, pen & ink, drawings, mixed media, collage, works on paper, sculpture, installations, photography and prints.
Style: Considers all styles and genres.
Terms: Retail price set by artist. Gallery pays shipping costs. Prefers artwork framed.
Submissions: Send query letter with résumé, slides, brochure, photographs, reviews, bio and SASE. Write for appointment to show portfolio of slides. Replies only if interested within 2 weeks. Files everything or returns in SASE.

Wisconsin

ART INDEPENDENT GALLERY, 623 Main St., Lake Geneva WI 53147. (414)248-3612. Owner: Joan O'Brien. Retail gallery. Estab. 1969. Represents 100 mid-career and established artists/year. May be interested in seeing the work of emerging artists in the future. Exhibited artists include Peg Sindelar, Peg Cullen, Gail Jones, Eric Jensen and Leslie O'Brien. Sponsors 4 shows/year. Average display time 6-8 weeks. Open February-March: Thursday/Friday/Saturday, 10-5; Sundays, 12-5. April-May: daily, 10-5; Sundays, 12-5; closed Tuesday. June-August: daily, 10-5; Sundays, 12-5. September-December: daily, 10-5; Sundays, 12-5; closed Tuesday. Closed month of January. 3,000 sq. ft.; loft-like 1st floor, location in historic building. 25% of space for special exhibitions; 100% of space for gallery artists. Clientele: collectors, tourists, designers. 90% private collectors, 10% corporate collectors. Overall price range: $2-2,400; most work sold at $200-600.
Media: Considers oil, acrylic, watercolor, pastel, pen & ink, mixed media, collage, paper, sculpture, ceramics, fiber, glass, photography, jewelry, woodcut, engraving, serigraphs, linocut and etching. Most frequently exhibits paintings, ceramics and jewelry.
Style: Exhibits expressionism and painterly abstraction. Genres include landscapes, florals, Southwestern, portraits and figurative work. Prefers abstracts, impressionism and imagism.
Terms: Accepts work on consignment (50% commission). Retail prices set by the artist. Gallery provides insurance, promotion, contract and shipping costs from gallery; artist pays shipping costs to gallery. Prefers artwork framed.
Submissions: Send query letter with résumé, slides, bio and SASE. Call or write for application. Portfolio should include slides and transparencies. Replies in 2-4 weeks. Files bios and résumés.
Tips: Finds artists through visiting exhibitions, word of mouth, shows/art fairs.

DAVID BARNETT GALLERY, 1024 E. State St., Milwaukee WI 53202. (414)271-5058. Fax: (414)271-9132. Office Manager: Milena Marich. Retail and rental gallery and art consultancy. Estab. 1966. Represents 300-400 emerging, mid-career and established artists. Exhibited artists include Claude Weisbuch and Carol Summers. Sponsors 12 shows/year. Average display time 1 month. Open all year. Located downtown at the corner of State and Prospect; 6,500 sq. ft.; "Victorian-Italianate mansion built in 1875, three floors of artwork displayed." 25% of space for special exhibitions. Clientele: retail, corporations, interior decorators, private collectors, consultants, museums and architects. 20% private collectors, 10% corporate collectors. Overall price range: $50-375,000; most work sold at $1,000-50,000.
Media: Considers oil, acrylic, watercolor, pastel, pen & ink, drawings, mixed media, collage, sculpture, ceramic, fiber, glass, photography, bronzes, marble, woodcuts, engravings, lithographs, wood engravings, serigraphs, linocuts, etchings and posters. Most frequently exhibits prints, drawings and oils.
Style: Exhibits expressionism, neo-expressionism, primitivism, painterly abstraction, surrealism, imagism, conceptualism, minimalism, postmodern works, impressionism, realism and photorealism. Genres include landscapes, florals, Southwestern, Western, wildlife, portraits and figurative work. Prefers old master graphics, contemporary and impressionistic.
Terms: Accepts artwork on consignment (50% commission). Retail price set by gallery and artist. Sometimes offers customer discounts and payment by installment. Gallery provides insurance and promotion; artist pays for shipping. Prefers artwork framed.
Submissions: Send query letter with slides, bio, brochure and SASE. "We return everything if we decide not to carry the artwork."
Tips: Finds artists through agents, word of mouth, various art publications, sourcebooks, artists' submissions and self-promotions.

‡GRACE CHOSY GALLERY, 218 N. Henry St., Madison WI 53703. (608)255-1211. Fax: (608)255-1211. Director: Grace Chosy. Retail gallery. Estab. 1979. Represents/exhibits 80 emerging, mid-career and established artists/year. Exhibited artists include Wendell Arneson and William Weege. Sponsors 11 shows/year. Average display time 3 weeks. Open all year; Tuesday-Saturday, 11-5. Located downtown; 2,000 sq. ft.; "open uncluttered look." 45% of space for special exhibitions; 55% of space for gallery artists. Clientele: primarily local community. 60% private collectors, 40% corporate collectors. Overall price range: $200-7,000; most work sold at $500-2,000.
Media: Considers all media except photography and fiber; all types of prints except posters. Most frequently exhibits paintings, drawings and sculpture.

Style: Exhibits all styles. Genres include landscapes, florals and figurative work. Prefers landscapes, still life and abstract.
Terms: Artwork is accepted on consignment. Retail price set by the gallery and the artist. Gallery provides insurance, promotion and contract. Artist pays for shipping costs.
Submissions: Send query letter with résumé, bio and SASE. Call or write for appointment to show portfolio. Replies in 3 months.

‡**GALLERIA DEL CONTE**, 1226 N. Astor St., Milwaukee WI 53202. (414)276-7545. Co-Directors: Cece Murphy and Beth Eisendrath. Retail gallery. Estab. 1991. Represents/exhibits 30 emerging, mid-career and established artists/year. Exhibited artists include Joseph Friebert and Angela Colombo. Sponsors 12 shows/year. Average display time 1 month. Open all year; Tuesday-Saturday, 11-4 or by appointment. Located on east side of downtown; 125 year old historic townhouse. 60% of space for special exhibitions. Overall price range: $130-10,000; most work sold at $300-3,000.
Media: Considers oil, pen & ink, acrylic, drawing, watercolor, mixed media, pastel, collage, wall sculpture, woodcut, wood engraving, linocut, engraving, mezzotint, etching, lithograph, serigraph and metal prints. Most frequently exhibits oils, watercolors and prints.
Style: Exhibits painterly abstraction. Genres include landscapes and figurative work. Prefers landscapes and figures.
Terms: Artwork is accepted on consignment (50% commission). Retail price set by the artist. Gallery provides insurance and promotion; shipping costs are shared. Prefers artwork framed.
Submissions: Prefers Wisconsin artists. Must be trained artists (college level). Send query letter with résumé, slides, photographs, bio and SASE. Call for appointment to show portfolio of originals, photographs and slides. Replies in 4-6 weeks. Files some bios for reference.
Tips: Finds artists through visiting exhibitions, word of mouth and artists' submissions. Both directors are active artists quite involved in community on artistic and business level. "Presentation is important. Have professional slides or photos, well ordered résumé. Do not simply show up. Call first for appointment."

THE FANNY GARVER GALLERY, 230 State St., Madison WI 53703. (608)256-6755. Vice President: Jack Garver. Retail Gallery. Estab. 1972. Represents 100 emerging, mid-career and established artists/year. Exhibited artists include Harold Altman and Josh Simpson. Sponsors 11 shows/year. Average display time 1 month. Open all year; Monday-Saturday, 10-5. Located downtown; 3,000 sq. ft.; older refurbished building in unique downtown setting. 33% of space for special exhibitions; 95% of space for gallery artists. Clientele: private collectors, gift-givers, tourists. 40% private collectors, 10% corporate collectors. Overall price range: $10-10,000; most work sold at $30-200.
 ● Gallery has second location at 7432 Mineral Point Rd., Madison, WI 53717 (608)833-8000; 7,000 sq. ft., suburban locale with upscale clientele.
Media: Considers oil, pen & ink, paper, fiber, acrylic, drawing, sculpture, glass, watercolor, mixed media, ceramics, pastel, collage, craft, woodcut, wood engraving, linocuts, engraving, mezzotint, etchings, lithograph and serigraphs. Most frequently exhibits watercolor, oil and glass.
Style: Exhibits all styles. Prefers landscapes, still lifes and abstraction.
Terms: Accepts work on consignment (40% commission) or buys outright for 50% of retail price (net 30 days). Retail price set by gallery. Gallery provides promotion and contract, shipping costs from gallery; artist pays shipping costs. Prefers artwork framed.
Submissions: Send query letter with résumé, slides, bio, brochure, photographs and SASE. Write for appointment to show portfolio, which should include originals, photographs and slides. Replies only if interested within 1 month. Files announcements and brochures.

‡**DEAN JENSEN GALLERY**, 165 N. Broadway, Milwaukee WI 53202. Phone/fax: (414)278-7100. Director: Dean Jensen. Retail gallery. Estab. 1987. Represents/exhibits 20 mid-career and established artists/year. Exhibited artists include Alex Katz and Fred Stonehouse. Sponsors 8 shows/year. Average display time 5-6 weeks. Open all year. Tuesday-Friday, 10-6; Saturday, 10-4. Located downtown; 1,800 sq. ft.; located directly across from New Broadway Theater center in a high-ceiling, former warehouse building. 60% of space for special exhibitions; 30% of space for gallery exhibitions. Clientele: local community, museums, visiting business people. 90% private collectors, 10% corporate collectors. Overall price range: $350-35,000; most work sold at $1,500-6,000.
Media: Considers all media except crafts, fiber, glass; all types of prints except posters. Most frequently exhibits painting, prints and photography.
Style: Exhibits conceptualism, neo-expressionism, minimalism, postmodern works, imagism and outsider art.
Terms: Artwork is accepted on consignment (50% commission). Retail price set by the gallery. Gallery provides insurance and promotion; shipping costs are shared. Prefers artwork framed.
Submissions: Send query letter with résumé, slides, bio and SASE. "We review portfolios only after reviewing slides, catalogs, etc." Replies in 4-6 weeks.
Tips: "Most of the artists we handle are nationally or internationally prominent. Occasionally we will select an artist on the basis of his/her submission, but this is rare. Do not waste your time—and ours—by submitting

your slides to us unless your work has great clarity and originality of ideas, is 'smart,' and is very profession-ally executed."

LATINO ARTS, (formerly Gallery of the Americas), 1028 S. Ninth, Milwaukee WI 53204. (414)384-3100 ext. 61. Fax: (414)649-4411. Visual Artist Specialist: Robert Cisneros. Nonprofit gallery. Represents emerg-ing, mid-career and established artists. Sponsors 4 individual to group exhibitions/year. Average display time 2 months. Open all year; Monday-Friday, 10-4. Located in the near southeast side of Milwaukee; 1,200 sq. ft.; one-time church. 50% of space for special exhibitions; 40% of space for gallery artists. Clientele: the general Hispanic community. Overall price range: $100-2,000.
Media: Considers all media, all types of prints. Most frequently exhibits original 2- and 3-dimensional works and photo exhibitions.
Style: Exhibits all styles, all genres. Prefers artifacts of Hispanic cultural and educational interests.
Terms: "Our function is to promote cultural awareness (not to be a sales gallery)." Retail price set by the artist. Artist is encouraged to donate 15% of sales to help with operating costs. Gallery provides insurance, promotion, contract, shipping costs to gallery; artist pays shipping costs from gallery. Prefers artwork framed.
Submissions: Send query letter with résumé, slides, bio, business card and reviews. Call or write for appointment to show portfolio of photographs and slides. Replies in 2 weeks.
Tips: Finds artists through recruiting, networking, advertising and word of mouth.

‡NEW VISIONS GALLERY, INC., at Marshfield Clinic, 1000 N. Oak Ave., Marshfield WI 54449. Executive Director: Ann Waisbrot. Nonprofit educational gallery. Runs museum and art center program for community. Represents emerging, mid-career and established artists. Organizes a variety of group and thematic shows (10 per year), very few one person shows, sponsors Marshfield Art Fair. "Culture and Agriculture": annual springtime invitational exhibit of art with agricultural themes. Does not represent artists on a continuing basis. Average display time 6 weeks. Open all year. 1,500 sq. ft. Price range varies with exhibit. Small gift shop with original jewelry, notecards and crafts at $10-50. "We do not show 'country crafts.' "
Media: Considers all media.
Style: Exhibits all styles and genres.
Terms: Accepts work on consignment (35% commission). Retail price set by artist. Gallery provides insur-ance and promotion. Prefers artwork framed.
Submissions: Send query letter with résumé, high-quality slides and SASE. Label slides with size, title, media. Replies in 1 month. Files résumé. Will retain some slides if interested, otherwise they are returned.
Tips: "Meet deadlines, read directions, make appointments—in other words respect yourself and your work by behaving as a professional."

‡M.B. PERINE GALLERY, (formerly Valperine Gallery), 1719 Monroe St., Madison WI 53711. (608)256-4040. Director: Perine Rudy. Retail gallery. Estab. 1983. Represents 75 emerging, mid-career and established artists. Exhibited artists include Sarah Aslakson, Evelyn Terry and Adrienne Sager. Sponsors 4 shows/year. Average display time 1 month. Open all year; Monday-Friday, 10-5; Saturday, 10-4. Located in neighborhood shopping area near UW campus; 3,000 sq. ft. gallery is "spacious, with excellent wall space and lighting—built to be a gallery, not remodeled to be one." 50% of space for special exhibitions. Clientele: 25% private collectors, 75% corporate collectors. Overall price range: $150-3,000; most work sold at $150-1,500.
Media: Considers oil, acrylic, watercolor, pastel, mixed media, collage, works on paper, sculpture, ceramic, fiber, glass, original handpulled prints, engravings, lithographs, posters, etchings and serigraphs. Most fre-quently exhibits watercolor, oil, acrylic and pastel.
Style: Exhibits expressionism, painterly abstraction, impressionism, realism and photorealism. Genres in-clude landscapes and florals. Prefers landscapes, florals and abstract.
Terms: Accepts work on consignment (40% commission). Retail price set by artist. Gallery provides insur-ance, promotion and contract; artist pays for shipping. Prefers artwork framed.
Submissions: Send query letter with résumé, slides, bio, brochure, reviews and retail price list. Call or write for appointment to show portfolio of slides and photographs. Replies in 1 month. Files résumé and, if possible, slides and photos of artists of interest to gallery; others are returned.
Tips: "We are primarily a watercolor gallery. We do not sell 'investment art.' Our market would be artwork for homes and corporation by contemporary artists."

SANTA FÉ GALLERY, 2608 Monroe St., Madison WI 53711. (608)233-4223. Fax: (608)276-3171. Owner: John Sveum. Retail gallery. Estab. 1988. Represents 12 emerging, mid-career and established artists. Exhib-ited artists include Francisco Zuniga and Francisco Mora. Sponsors 5 shows/year. Open all year; Tuesday-Saturday, 10-5. 1,200 sq. ft. Clientele: professional. 95% private collectors, 5% corporate collectors. Overall price range: $35-8,000; most work sold at $800-2,000.
Media: Considers oil, acrylic, sculpture, watercolor, mixed media, ceramic, pastel, collage, original hand-pulled prints, etchings, lithographs and serigraphs. Prefers lithograph, serigraph, watercolor and acrylic.
Style: Exhibits all styles. Prefers contemporary, Latin American and Southwestern. Accepts work on consign-ment (50% commission) or buys outright for 50% of retail price. Retail price set by artist. Customer discounts

and payment by installments are available. Gallery provides insurance, promotion, contract and shipping costs to gallery.

Submissions: Send query letter with résumé, slides, photographs and bio. Portfolio review requested if interested in artist's work.

Tips: Finds artists through art expos, visiting other galleries and publications. "Be bold—don't worry about public response."

CHARLES A. WUSTUM MUSEUM OF FINE ARTS, 2519 Northwestern Ave., Racine WI 53404. (414)636-9177. Associate Curator: Caren Heft. Museum. Estab. 1941. Represents about 200 emerging, mid-career and established artists. Sponsors 12-14 shows/year. Average display time 6 weeks. Open all year. Located northwest of downtown Racine; 3,000 sq. ft.; "an 1856 Italianate farmhouse on 13 acres of parks and gardens." 100% of space for special exhibitions. "75% private collectors from a tri-state area between Chicago and Milwaukee, and 25% corporate collectors." Overall price range: $100-10,000; most work sold at $300-1,000.

Media: "We show all media, including video, but specialize in 20th-century works on paper, craft and artists' books." Considers original handpulled prints, woodcuts, wood engravings, linocuts, engravings, mezzotints, etchings, lithographs and pochoir. Most frequently exhibits works on paper, ceramics, fibers.

Style: Exhibits all styles and genres. Most frequently exhibits abstraction, realism and surrealism. "We are interested in good craftsmanship and vision."

Terms: Accepts work on consignment (40% commission). Retail price set by artist. Gallery provides insurance, promotion, contract and shipping costs from gallery (for group); artist pays for shipping (for solo). Prefers artwork framed.

Submissions: Museum reviews artists' requests on an ongoing basis. Must submit 10-20 slides, current résumé and a statement about the work. Must also enclose SASE for return of slides. Files résumés and statements for future reference.

Tips: "I want to see evidence of a consistent body of work. Include a letter telling me why you are sending slides. The most common mistake artists make is sloppy presentation—no slide info sheet, no résumé, no SASE, etc."

Wyoming

CROSS GALLERY, Box 4181, 180 N. Center, Jackson Hole WY 83001. (307)733-2200. Fax: (307)733-1414. Director: Mary Schmidt. Retail gallery. Estab. 1982. Represents 10 emerging and established artists. Exhibited artists include Penni Anne Cross, Kennard Real Bird, Val Lewis, Kevin Smith and Lilly Szell. Sponsors 2 shows/year. Average display time 1 month. Open all year. Located at the corner of Center and Gill; 1,000 sq. ft. 50% of space for special exhibitions. Clientele: retail customers and corporate businesses. Overall price range: $20-35,000.

Media: Considers oil, acrylic, watercolor, pastel, pen & ink, drawings, mixed media, sculpture, original handpulled prints, engravings, lithographs, pochoir, serigraphs and etchings. Most frequently exhibits oil, original graphics, alabaster, bronze, metal and clay.

Style: Exhibits realism and contemporary styles. Genres include Southwestern, Western and portraits. Prefers contemporary Western and realist work.

Terms: Accepts artwork on consignment (33⅓% commission) or buys outright for 50% of retail price. Retail price set by gallery and artist. Offers payment by installments. Gallery provides insurance, promotion and contract; shipping costs are shared. Prefers artwork unframed.

Submissions: Send query letter with résumé, slides and photographs. Portfolio review requested if interested in artist's work. Portfolio should include originals, slides and photographs. Samples not filed are returned by SASE. Reports back within "a reasonable amount of time."

Tips: "We are seeking artwork with creative artistic expression for the serious collector. We look for originality. Presentation is very important."

HALSETH GALLERY—COMMUNITY FINE ARTS CENTER, 400 C, Rock Springs WY 82901. (307)362-6212. Fax: (307)382-6657. Director: Gregory Gaylor. Nonprofit gallery. Estab. 1966. Represents 12 emerging, mid-career and established artists/year. Sponsors 8-10 shows/year. Average display time 1 month. Open all year; Monday, 12-9; Tuesday and Wednesday, 10-9; Thursday, 12-9; Friday, 10-5; Saturday, 12-5. Located downtown—on the Rock Springs Historic Walking Tour route; 2,000 ground sq. ft. and 100 running sq. ft.; recently remodeled to accommodate painting and sculpture. 50% of space for special exhibitions; 50% of space for gallery artists. Clientele: commjunity at large. 100% private collectors. Overall price range: $100-1,000; most work sold at $200-600.

Media: Considers all media, all types of prints. Most frequently exhibits oil/watercolor/acrylics, sculpture/ceramics, and installation.

Style: Exhibits all styles, all genres. Prefers neo-expressionism, realism and primitivism.

Terms: "We require a donation of a work." Retail price set by the artist. Gallery provides promotion; artist pays shipping costs to and from gallery. Prefers artwork framed.

Submissions: Send query letter with résumé, slides, bio, brochure, photographs, SASE, business card, reviews, "whatever available." Call or write for appointment to show portfolio of slides. Replies only if interested within 1 month. Files all material sent.
Tips: Finds artists through artists' submissions.

Puerto Rico

GALERIA BOTELLO INC., 208 Cristo St., Old San Juan Puerto Rico 00901. (809)723-9987. Owner: Juan Botello. Retail gallery. Estab. 1952. Represents 10 emerging and established artists. Sponsors 3 solo and 2 group shows/year. Average display time 3 months. Accepts only artists from Latin America. Clientele: 60% tourist and 40% local. 75% private collectors, 30% corporate clients. Overall price range: $500-30,000; most work sold at $1,000-5,000.
Media: Considers oil, acrylic, watercolor, pastel, drawings, mixed media, collage, sculpture, ceramic, woodcuts, wood engravings, linocuts, engravings, mezzotints, etchings, lithographs and serigraphs. Most frequently exhibits oil on canvas, mixed media and bronze sculpture. "The Botello Gallery exhibits major contemporary Puerto Rican and Latin American artists. We prefer working with original paintings, sculpture and works on paper."
Style: Exhibits expressionism, neo-expressionism and primitivism. Genres include Americana and figurative work. Prefers expressionism and figurative work.
Terms: Accepts work on consignment or buys outright. Retail price set by artist. Exclusive area representation required. Gallery provides insurance and contract; artist pays for shipping. Prefers artwork framed.
Submissions: Send query letter with résumé, brochure, slides and photographs. Call for appointment to show portfolio of originals. Replies in 2 weeks. Files résumés.
Tips: "Artists have to be Latin American or major European artists."

International

***ABEL JOSEPH GALLERY**, 32 Rue Fremicourt, Paris France 75015. 33-1-45671886. Directors: Kevin and Christine Freitas. Retail gallery and alternative space. Estab. 1989. Represents 20 emerging and established national and international artists. Exhibited artists include Bill Boyce, Diane Cole and Régent Pellerin. Sponsors 6-8 shows/year. Average display time 5 weeks. Open all year. Located in Paris. 100% of space for work of gallery artists. Clientele: varies from first time buyers to established collectors. 80% private collectors; 20% corporate collectors. Overall price range: $500-10,000; most work sold at $1,000-5,000.
 • Located in Paris, but had plans to open an exhibition space in an 18th century two-story house in Eymet, France, which is located near Bordeaux. It would provide gallery space on the first floor, open up the second floor to artists in residency program and offer studio and exposition possibilities.
Media: Considers most media except craft. Most frequently exhibits sculpture, painting/drawing and installation (including active-interactive work with audience—poetry, music, etc.).
Style: Exhibits painterly abstraction, conceptualism, minimalism, post-modern works and imagism. "Interested in seeing all styles and genres." Prefers abstract, figurative and mixed-media.
Terms: Accepts artwork on consignment (50% commission). Retail price set by the gallery with input from the artist. Customer discounts and payment by installments are available. Gallery provides insurance, promotion and contract; shipping costs are shared.
Submissions: Send query letter with résumé, slides, bio, SASE and reviews. Portfolio review requested if interested in artist's work. Portfolio should include slides, photographs and transparencies. Replies in 1 month. Files résumé, bio and reviews.
Tips: "Gallery districts are starting to spread out. Artists are opening galleries in their own studios. Galleries have long outlived their status as the center of the art world. Submitting work to a gallery is exactly the same as applying for a job in another field. The first impression counts. If you're prepared, interested, and have any initiative at all, you've got the job."

Galleries/'95-'96 change

The following galleries were listed in the 1995 edition but do not have listings in this edition. The majority did not respond to our request to update their listings.

Aaron Gallery
Actual Art Foundation
Adams Fine Arts Gallery
Adirondack Lakes Center for the Arts
Afro-American Historical and Cultural Museum
Alleghany Highlands Arts and Crafts Center
Alternative Museum
American Indian Contemporary Arts
Anderson & Anderson Gallery
Appleridge Art Gallery and Flores Fiol Studio
Arab American Cultural Foundation—Alif Gallery
Arizona State University Art Museum
Arnold Art
The Art Alliance
Art By Law
Art Center of Battle Creek
Art Gallery—Horace C. Smith Building
Art Insights Gallery
Art League of Houston
Art Tree Gift Shop/Gallery II
The Art Scene
Artco, Incorporated
Artemisia Gallery
Artists in Residence
Artists' Cooperative Gallery
Arts Center—The Arts Partnership
ArtSource Consultants Inc.
Artspace, Inc.
Artworks Gallery
Barnard-Biderman Fine Art
Barnards Mill Art Museum
Baton Rouge Gallery, Inc.
Belian Art Center
Bell-Ross Fine Art Gallery
Beret International Gallery
Toni Birckhead Gallery
Blackfish Gallery
Blanden Memorial Art Museum
Blue Star Art Space
Boca Raton Museum of Art
Boody Fine Arts, Inc.
William Bonifas Fine Arts Center
Boritzer/Gray Gallery
Boulder Art Center
Fred Boyle Fine Arts
Brewster Arts Limited
Bridge Center for Contemporary Art
Bronx River Art Center, Inc.
Brookfield/Sono Craft Gallery
Brookgreen Gardens
Robert Brown Gallery
Suzanne Brown Gallery
Bruskin Gallery
Frank Bustamante Gallery
Cambridge Artists Cooperative
Cape Museum of Fine Art
Carriage House Galleries

Sandy Carson Gallery
Carteret Contemporary Art
Karen Casey Gallery
Castellani Art Museum of Niagara University
Center Street Gallery
Centre Art Gallery
Dolores Chase Fine Art
Chicago Center for the Print
City Without Walls
CityArts, Inc.
C.L. Clark Galleries
Clark Gallery, Inc.
Wilson W. Clark Memorial Library Gallery
Class Canvas Gallery, Inc.
The Clay Place
Cogley Art Center
Eve Cohon Gallery
The Collection Gallery
The Collector's Gallery
Commencement Art Gallery
County of Los Angeles Century Gallery
Craft & Folk Art Museum (CAFAM)
The Craftsman's Gallery Ltd.
Crossman Gallery
Cultural Resource Center Metro-Dade
Daruma Galleries
The Dayton Art Institute
De Leca Fine Art/Miguel Espel Galeria de Arte
Del Mano Gallery
Dephena's Fine Art
Depo Square Gallery
Design Arts Gallery
Olga Dollar Gallery
Donlee Gallery of Fine Art
Dougherty Art Center Gallery
Duncan Gallery of Art
East End Arts Council
Elaine Horwitch Galleries
Electric Ave/Sharon Truax Fine Art
Emmanuel Gallery & Auraria Library Gallery
Etherton/Stern Gallery
Evanston Art Center
The Fabric Workshop and Museum
First Street Gallery
Fitchburg Art Museum
Flanders Contemporary Art
Florida Center for Contemporary Art
Florida State University Gallery & Museum
Foundry Gallery
14th Street Painters
Freedman Gallery, Albright College
Oskar Friedl Gallery
Fresno Art Museum Gift Gallery
The Galbreath Gallery
Galeria Sin Fronteras

Galerie Cujas
Galerie Europa/Flying Colours
Gallery A
Gallery 500
Gallery of Contemporary Art
The Gallery Shop at Abington Art Center
The Gallery Shop/Ann Arbor Art Association Art Center
Gallery Revel
The Gallery (ID)
The Gallery (LA)
Gallery 30
Gallery 306
Gallery XII
Garland Gallery
Len Garon Art Studios
Carol Getz Gallery
Gilpin Gallery, Inc.
Katie Gingrass Gallery
Fay Gold Gallery
Gold/Smith Gallery
The Graphic Eye Gallery
Greene Gallery
Greenleaf Gallery
Greenville Museum of Art
Grohe Glass Gallery
Gruen Gallery
The Hand of Man—A Craft Gallery
Hanson Arts
The Hendrix Collection
Herndon Old Town Gallery
Hillwood Art Museum
Hillyer House Inc.
Michael Himovitz Gallery
Hollis Taggart Galleries, Inc.
Howe Fine and Decorative Art
Hubert Gallery
Hummingbird Originals, Inc.
Images Gallery
Imago Galleries
International Gallery of Contemporary Printmaking
Irving Galleries
Jadite Galleries
Fred Jones Jr. Museum of Art, The University of Oklahoma
Kala Institute
Kalamazoo Institute of Arts
Neel Kanth Galerie
Kentucky Art & Craft Gallery
Patrick King Galleries, Inc.
Klein Art Works
Kneeland Gallery
Kouros
Kussmaul Gallery
L.J. Wender Fine Chinese Paintings
La Mama La Galleria
Lambert Gallery
Lanning/Sapp Gallery
Lawrence Galleries
Lidtke Fine Art
Limestone Press: Greve/Hine
Limner Gallery
Lincoln Arts

Linda Hodges Gallery
Little Art Gallery
Loft 101 Soho International Production Group
Gilbert Luber Gallery
Lyons Matrix Gallery
Mackey Gallery
Judah L. Magnes Museum
Daniel Maher Gallery
Maine Coast Gallery
Malton Gallery
Masten Fine Art Gallery
Masters' Portfolio
Matrix Gallery Ltd.
Morton J. May Foundation Gallery
Metropolitan State College of Denver/Center for the Visual Arts
Michael Galleries
Monterey Peninsula Museum of Art at Civic Center
More By Far
Moreau Galleries
Morphos Gallery
The Museum of Arts and Sciences, Inc.
N.A.M.E.
Phyllis Needlman Gallery
Newspace
Nicolaysen Art Museum
North Country Museum of Arts
Northern Illinois University Gallery in Chicago
Northport/BJ Spoke Gallery
Not Just Art Gallery
Nuance Galleries
NIU Art Museum
Off the Wall Gallery
One West Art Center
Open Space
Orange County Center for Contemporary Art
Owl 57 Galleries
Palmer's Gallery 800

Panoramic Fine Art
Eva J. Pape
Parade Gallery
The Parthenon
PAStA Plus Art
Peltz Gallery
Pensacola Museum of Art
John Pence Gallery
Perception
Anita L. Pickren Gallery
Potlatch Gallery
The Prince Royal Gallery
The Print Gallery, Inc.
Printed Matter Bookstore at Dia
Pro Art of Gig Harbor
Quast Galleries, Taos
Qunicy Art Center
Qunicy University Gray Gallery
Rathbone Gallery
Reinberger Galleries, Cleveland Institute of Art
Reston Art Gallery
The Rittenhouse Galleries
Robinson Galleries
Sidney Rothman—The Gallery
Rouge Gallery
Runnings Gallery
St. Tammany Art Assocation
Martin Schweig Studio & Gallery
Sculptors Guild, Inc.
Carla Stellweg Latin American & Contemporary Art
The Mary Porter Sesnon Gallery
1708 Gallery
Slocumb Galleries
Smith/Cosby Galleries
Vladimir Sokolov Studio Gallery
Sue Spaid Fine Art
Staten Island Institute of Arts and Sciences
The Stein Gallery Contemporary Glass
Stonington Gallery
The Stream of Consciousness Koffiehuis

Struve Gallery
Studio Museum in Harlem
Stux Gallery
Suburban Fine Art Gallery
Sudderth Art International, Inc.
Synchronicity Space
Tamenaga Gallery
The Teahouse Gallery at the New York Open Center
Tenri Gallery
Terraih
M. Thompson Kravetz Gallery
Tivoli Gallery
Todd Galleries
Tomorrow's Treasures
Touchstone Gallery
Tower Gallery
Turman Art Gallery, Indiana State University
Turner Art Gallery
Edwin A. Ulrich Museum of Art
University Gallery
University Memorial Fine Arts Center
Vered Gallery
Viewpoints Art Gallery
The Village Gallery
Volcano Art Center
Walsdorf Gallery
Ward-Nasse Gallery
Waterworks Gallery
Elaine Wechsler P.D.
Wellington Fine Art
Wellspring Gallery
Westchester Gallery
White Horse Gallery
Adam Whitney Gallery
Whitehall
Wichita Falls Museum & Art Center
Wildlife Gallery
The Winters Gallery
Woodstock Gallery of Art
Works in Progress Gallery
Ruth Zafir Sculpture Gallery

Greeting Cards, Gift Items and Paper Products

It's safe to say you'll send at least a few greeting cards this year, and you'll probably receive even more. According to the Greeting Card Association, the average American receives 30 cards a year, eight of which are birthday cards. Though all the figures are not in as we go to press, the greeting card industry is close to its projected goal of $6.3 billion in U.S. sales for 1995. That's a whopping 7.4 billion cards! And, since about 40 percent of all greeting cards require freelance artwork, it's a whopping big market for artists.

In recent years the market has seen tremendous growth in what was once just an offshoot of the greeting card industry. Balloons, giftwrap and ribbons, party favors, paper plates, tablecloths, shopping bags, stationery, diaries, calendars, mugs, journals, even fountain pens and rubber stamps have become big business. Industry insiders, noticing this expansion, coined a term to encompass greeting cards, party supplies and stationery goods. The whole shebang is known as the "social expressions industry."

You'll find all sorts of opportunities in the social expressions industry and other related markets in this section's listings. Look closely and you'll find companies looking for wrapping paper and giftbag designs, firms needing artwork for plates and other collectibles, even a company looking for designs to decorate personal checks.

Study the market

The industry is still dominated by the big three: Hallmark, American Greetings and Gibson. Together, these corporations control 91% of the market share. But in spite of the shadow cast by these giants, there are approximately 1,500 smaller publishers doing quite well in the business too. Large firms have extensive inhouse art staffs but they also work with hundreds of freelance artists each year. Many smaller firms rely solely on freelance artwork.

Read the listings carefully before submitting your work. Each company has carved out its own specific niche in the field. The best way to research card or stationery firms is to visit your local card or gift shop. Grocery stores and pharmacies also devote aisle space to greeting cards. Look at the various cards and try to find those featuring artwork similar to your style. Take a notebook along and jot down the name of the company off of the back of the card. Study the listings in this book carefully to find out what publishers are looking for.

The next step is to send for a catalog or artist's guidelines. Some companies have very specific guidelines for artist submissions, so it's worth it to get the rules ahead of time. Most of the listings in this section indicate whether guidelines are available.

It may also be worth your while to visit a regional or national trade show. This will give you the opportunity to meet art buyers in person and to see what's hot off the press in the industry. *Party and Paper Retailer* magazine features a calendar of events in every issue, highlighting upcoming trade shows and their locations.

What to send

When sending samples to companies, do not send originals. Companies want to see photographs, slides or tearsheets. They don't want the artwork itself until they give you a definite assignment.

When sending to greeting card companies, don't just send copies of existing paintings or assignments from school. Your samples should be appropriate to the market, so adapt one of your designs by making a few adjustments. Render your artwork in watercolor or gouache on illustration board, preferably in the standard industry size, which is 4⅝ × 7½ inches. Leave some space at either the top or bottom of your work, because cards often feature lettering there. Check the cards in stores for an idea of how much space to leave. It isn't necessary to add lettering unless you want to do your own lettering. Card companies usually have staff artists or freelancers who are experts at creating lettering to accompany a card's image.

Artwork should be upbeat, brightly colored, and appropriate for one of the two major divisions in the greeting card market: seasonal or everyday. Seasonal cards express greetings for holidays like Christmas, Easter, Valentine's Day and Mother's Day. Everyday cards are sent to express sympathy, a get well message, birthday greetings or to just say "hi." The market is then further broken down between traditional greetings, humorous or "studio" cards, and "alternative" cards, which feature quirky, sophisticated or offbeat humor. The lines between categories are blurring, but a visit to your nearest card display rack will confirm the divisions still apply.

Once your artwork is complete, have color photographs or slides made. Check the listings to see which types of cards a company needs. Then send three to five appropriate samples of your work to the contact person named in the listing. Make sure each sample is labeled with your name, address and phone number. Include a brief (one to two paragraph) cover letter and enclose a self-addressed stamped envelope (see What Should I Submit? page 14 for more information on submitting your work).

As you're preparing your submissions, think not only in terms of individual card ideas, but also in terms of entire lines and related gift items. Like any other company, a card company wants to create an identity for itself and build brand loyalty among its buyers. Consequently, many companies look for artistic styles that they can build into an entire line of products.

Tracking trends

Spotting trends—who's sending to whom, which colors and patterns (even pets!) are popular—will help you create marketable cards and gift items. If your images feature popular colors and consider the needs of today's consumer, they'll have wider appeal. The most popular card-sending holidays are (in order of popularity) Christmas, Valentine's Day, Easter, Mother's Day and Father's Day so realize card companies need more images appropriate to those cards. Women buy 85-90 percent of all cards, so card companies look for images that appeal to women.

The multicultural movement has fostered greater interest in ethnic art. We're seeing cards celebrating Kwanzaa, an African-American holiday, alongside Christmas and Hanukkah greetings. Current popular images include Americana motifs, like quilts, folkart and Amish-based designs; African-inspired batiks; and florals paired with stripes, paisleys and small prints. Angels, teddy bears, puppies and kittens continue to be popular with card buyers.

The fastest growing trends reflect our changing society. According to American Greetings more than 1,300 new stepfamilies are created each day and 65 percent of all grandparents will be step-grandparents by the year 2000. American Greetings cards responded to those statistics by offering Mother's Day cards for single mothers, stepmothers, and even "to Dad on Mother's Day!" Though past Father's Day cards concentrated on sports, hunting and fishing images, today's cards increasingly show Dads with their children, reflecting increased parental involvement. There are even cards reflecting the sometimes strained relationships between parents and teenagers.

There are more "friend to friend" cards, empathizing with a fellow dieter, encouraging a friend to quit smoking, and even offering sensitive alternatives to "get well" for friends stricken with a chronic or terminal illness. We're seeing more cards expressing support for couples who are splitting up. Yet at the same time, a new breed of romantic greeting card is becoming popular. Written in direct, often humorous prose instead of flowery verse, the new cards help the sender communicate feelings on difficult subjects.

Plates and collectibles

Don't overlook the giant collectible market! Limited edition collectibles—everything from plates to porcelain dolls to English cottages—appeal to a wide audience. Companies like The Hamilton Collection, The Franklin Mint and The Bradford Exchange are the leaders in this multi-million-dollar industry, but there are many more companies producing collectibles these days. If you seek to enter the collectible field, you have to be flexible enough to take suggestions. Companies do heavy market testing to find out which images will sell the best, so they will want to guide you in the creative process. For a collectible plate, for example, your work must fit into a circular format or you'll be asked to extend the painting out to the edge of the plate.

Popular images for collectibles include Native American, wildlife, animals (especially kittens and puppies), children and sports images. You can submit slides to the creative director of companies specializing in collectibles. Several are listed in this book. For special insight into the market consider attending one of the industry's trade shows held yearly in South Bend, Indiana; Secaucus, New Jersey; and Anaheim, California.

The class of 1995 received more than 81 million graduation cards, according to the Greeting Card Association, and 25 percent were humorous cards. Eighty-five percent of graduates receive gifts of money, so card companies are interested in ideas incorporating special flaps for cash and checks. The changing roll of women is reflected in cards which express the trials and joys of juggling career and family. Fifty-one percent of women and 31 percent of men had a birthday party on the job in 1995, so we're seeing an increase in the number of birthday cards from the gang at the office, too.

Pay serious attention to trends—card companies do! Original images and/or words that match trends are not only more saleable, but show your knowledge of the market.

Setting fees

Although payment rates for card design are comparable to those given for magazine and book illustration, price is not normally negotiable in this business. Most card and paper companies have set fees or royalty rates that they pay for design and illustration. What has recently become negotiable, however, is rights. In the past, card companies almost always demanded full rights to work, but now some are willing to negotiate for other arrangements, such as greeting card rights only. Keep in mind, however, that if the company has ancillary plans in mind for your work (for example, calendars, stationery, party supplies or toys) they will probably want to buy all rights. In such cases, you may be able to bargain for higher payment.

Help along the way

To keep current with the greeting card industry, consult *Greetings* magazine and *Party and Paper* (see Publications of Interest, page 679, for addresses). *The Complete Guide to Greeting Card Design & Illustration* by Eva Szela (from North Light Books) features published samples, tips and inside information on creating successful card designs.

If you'd like to try your hand at writing greetings to go with your designs, read *How to Write & Sell Greeting Cards, Bumper Stickers, T-Shirts and Other Fun Stuff* by Molly Wigand (Writer's Digest Books). Marbleizing, paper making and dozens of helpful techniques are described in *Create Your Own Greeting Cards & Gift Wrap with Patricia House* (North Light Books).

For further insight and encouragement, read Jerry King's first-hand account of his entry into the market on page 30, and listen in as Gibson Greetings' Anna Bower offers tips for freelancers on page 446.

ABEL LOVE, INC., Dept. AGDM, 20 Lakeshore Dr., Newport News VA 23602. (804)877-2939. Buyer: Abraham Leiss. Estab. 1985. Distributor of books, gifts, hobby, art and craft supplies and drafting material. Clients: retail stores, libraries and college bookstores. Current clients include Hampton Hobby House, NASA Visitors Center, Temple Gift Shops, Hawks Hobby Shop and Army Transportation Museum.
Needs: Approached by 100 freelancers/year. Works with 10 freelance illustrators and 1 designer/year. Uses freelancers for catalog design, illustration and layout.
First Contact & Terms: Send query letter with slides, photographs and transparencies. Samples are filed. Reports back ASAP. Art director will contact artist for portfolio review if interested. Pays 10% royalties. Rights purchased vary according to project.

ACME GRAPHICS, INC., 201 Third Ave. SW, Box 1348, Cedar Rapids IA 52406. (319)364-0233. Fax: (319)363-6437. President: Stan Richardson. Estab. 1913. Produces printed merchandise used by funeral directors, such as acknowledgments, register books and prayer cards.
Needs: Approached by 30 freelancers/year. Considers pen & ink, watercolor and acrylic. Looking for religious, church window, floral and nature art. Needs computer-literate freelancers for illustration. 10% of freelance work demands knowledge of Aldus PageMaker.
First Contact & Terms: Send brochure. Samples are not filed and are returned by SASE. Reports back within 10 days. Call or write for appointment to show portfolio of roughs. Originals are not returned. Requests work on spec before assigning a job. Pays by the project or flat fee of $50. Payment varies. Buys all rights.
Tips: "Send samples or prints of work from other companies. No modern art or art with figures. Some designs are too expensive to print."

ALASKA MOMMA, INC., 303 Fifth Ave., New York NY 10016. (212)679-4404. Fax: (212)696-1340. President: Shirley Henschel. "We are a licensing company representing artists, illustrators, designers and established characters. We ourselves do not buy artwork. We act as a licensing agent for the artist. We license artwork and design concepts to toy, clothing, giftware, textiles, stationery and housewares manufacturers and publishers."
Needs: Approached by 100 or more freelancers/year. Needs illustrators. "An artist must have a distinctive and unique style that a manufacturer can't get from his own art department. We need art that can be applied to products such as posters, cards, puzzles, albums, etc."
First Contact & Terms: "Artists may submit work in any form as long as it is a fair representation of their style." Prefers to see several multiple color samples in a mailable size. No originals. "We are interested in artists whose work is suitable for a licensing program. We do not want to see b&w art drawings. What we need to see are transparencies or color photographs or color photocopies of finished art. We need to see a consistent style in a fairly extensive package of art. Otherwise, we don't really have a feeling for what the artist can do. The artist should think about products and determine if the submitted material is suitable for licensed product. Please send SASE so the samples can be returned. We work on royalties that run from 5-10% from our licensees. We require an advance against royalties from all customers. Earned royalties depend on whether the products sell."
Tips: "Publishers of greeting cards and paper products have become interested in more traditional and conservative styles. There is less of a market for novelty and cartoon art. We need freelance artists more than ever as we especially need fresh talent in a difficult market."

ALEF JUDAICA, INC., 8440 Warner Dr., Culver City CA 90034. (310)202-0024. Fax: (310)202-0940. President: Guy Orner. Estab. 1979. Manufacturer and distributor of a full line of Judaica, including menorahs, Kiddush cups, greeting cards, giftwrap, tableware, etc.
Needs: Approached by 15 freelancers/year. Works with 10 freelancers/year. Buys 75-100 freelance designs and illustrations/year. Prefers local freelancers with experience. Works on assignment only. Uses freelancers for new designs in Judaica gifts (menorahs, etc.) and ceramic Judaica. Also for calligraphy, pasteup and mechanicals. All designs should be upper scale Judaica.
First Contact & Terms: Mail brochure, photographs of final art samples. Art director will contact artist for portfolio review if interested, or portfolios may be dropped off every Friday. Sometimes requests work on spec before assigning a job. Pays $300 for illustration/design; pays royalties of 10%. Considers buying second rights (reprint rights) to previously published work.

ALL STAR PAPER COMPANY, 1500 Old Deerfield Rd., #19-20, Highland Park IL 60035. (708)831-5811. Fax: (708)831-5812. President/Owner: Fran Greenspon. Produces greeting cards, giftwrap, stationery, T-shirts, books. "All product, currently, geared to the Judaic Market with contemporary designs being most important."
Needs: Works with 12-15 freelancers/year. Buys 125-150 illustrations/year. Prefers freelancers with experience in greeting cards. Works on assignment only. Uses freelancers mainly for cards and giftwrap. Also for calligraphy. Considers any media. Produces material for Rosh Hashanah, Hanukkah, Passover and Bar/Bat Mitzvah. Submit seasonal material 8 months in advance.
First Contact & Terms: Send query letter with brochure, résumé, SASE, tearsheets, photographs and photocopies. Samples are filed or returned by SASE if requested by artist. Reports back to the artist only if interested. Art Director will contact artist for portfolio review if interested. Portfolio should include color final art. Originals are returned at job's completion. Pays $200-250. Rights purchased vary according to project.

AMBERLEY GREETING CARD CO., 11510 Goldcoast Dr., Cincinnati OH 45249-1695. (513)489-2775. Fax: (513)489-2857. Art Director: Dave McPeek. Estab. 1966. Produces greeting cards. "We are a multi-line company directed toward all ages. Our cards are conventional and humorous."
Needs: Approached by 20 freelancers/year. Works with 10 freelancers/year. Buys 250 designs and illustrations/year. Works on assignment only. Considers any media.
First Contact & Terms: Samples are not filed and are returned by SASE if requested by artist. Reports back to artist only if interested. Call for appointment to show portfolio of original/final art. Pays by the project, $75-80. Buys all rights.

AMCAL, 2500 Bisso Lane, Bldg. 500, Concord CA 94520. (510)689-9930. Fax: (510)689-0108. Publishes calendars, notecards, Christmas cards and other book and stationery items. "Markets to better gift, book and department stores throughout US. Some sales to Europe, Canada and Japan. We look for illustration and design that can be used many ways—calendars, note cards, address books and more so we can develop a collection. We buy art that appeals to a widely female audience." No gag humor or cartoons.
Needs: Needs freelancers for design and production. Prefers work in horizontal format. Send photos, samples, slides, color photocopies or published work.
First Contact & Terms: Art director will contact artist for portfolio review if interested. Pay for illustration by the project, advance against royalty.
Tips: Finds artists through word of mouth, magazines, artists' submissions/self-promotions, sourcebooks, visiting artist's exhibitions, art fairs and artists' reps. "Know the market. Go to gift shows and visit lots of stationery stores. Read all the trade magazines. Talk to store owners to find out what's selling and what isn't."

‡AMERICAN GREETINGS CORPORATION, 10500 American Rd., Cleveland OH 44144. (216)252-7300. Director of Creative Resources and Development: Lynne Shlonsky. Estab. 1906. Produces greeting cards, stationery, calendars, paper tableware products, giftwrap and ornaments—"a complete line of social expressions products."
Needs: Prefers local artists with experience in illustration, decorative design and calligraphy.
First Contact & Terms: Send query letter with résumé. "Do not send samples." Pays average flat fee of $350.

‡AMERICAN TRADITIONAL STENCILS, RD 281, Bow St., Northwood NH 03261. (603)942-8100. Fax: (603)942-8919. Owner: Judith Barker. Estab. 1970. Manufacturer of brass and laser cut stencils and 24 karat gold finish charms. Clients: retail craft, art and gift shops. Current clients include Williamsburg Museum, Old Sturbridge and Pfaltzgraph Co., Henry Ford Museum, and some Ben Franklin stores.
Needs: Approached by 1-2 freelancers/year. Works with 1 freelance illustrator/year. Assigns 2 freelance jobs/year. Prefers freelancers with experience in graphics. Works on assignment only. Uses freelancers mainly for stencils. Also for ad illustration and product design. Prefers b&w camera-ready art.

First Contact & Terms: Send query letter with brochure showing art style and photocopies. Samples are filed or are returned. Reports back in 2 weeks. Call for appointment to show portfolio of roughs, original/final art and b&w tearsheets. Pays for design by the hour, $8.50-20, by the project, $15-150. Pays for illustration by the hour, $6-7.50. Rights purchased vary according to project.

‡**AMSCAN INC.**, Box 587, Harrison NY 10528. (914)835-4333. Vice President of Art and Design: Diane A. Spaar. Director of Art and Catalog: Katherine A. Kusnierz. Estab. 1954. Designs and manufactures paper party goods. Extensive line includes paper tableware, invitations and thank you cards, gift wrap and bags, decorations. Complete range of party themes for all ages, all seasons and all holidays.

Needs: "Ever expanding department with incredible appetite for fresh design and illustration. Subject matter varies from baby, juvenile, floral type and graphics. Designing is accomplished both in the traditional way by hand (i.e., painting)) or on the computer using a variety of programs. Always looking for new talent in both product, surface and catalog design. Layout and production artists who are expert in Freehand 4.0 are also needed. Opportunity is endless! Freelancers are welcome. For design submissions please call for requirements."

First Contact & Terms: "Send samples or copies of artwork to show us range of illustration styles. If artwork is appropriate, we will pursue. Competitive pay; excellent benefits."

Tips: Flexo, offset and letterpress printing are involved. Looking for complex illustrations that will be printed using spot colors and complex screen work.

‡**ANGEL GRAPHICS**, 903 W. Broadway, Fairfield IA 52556. (515)472-5481. Fax: (515)472-7353. Project Manager: Lauren Wendroff. Estab. 1981. Produces full line of posters for wall decor market.

Needs: Approached by hundreds of freelancers/year. Works with 5-10 freelancers/year. Buys 50-100 freelance designs and illustrations/year. Uses freelancers mainly for posters. Also for calligraphy. Considers any media. Looking for realistic artwork. Prefers 16×20 proportions. Needs computer-literate freelancers for design and illustration. 10% of work demands knowledge of Adobe Illustrator, Adobe Photoshop and QuarkXPress. Produces material for all holidays and seasons. Submit seasonal material 6 months in advance.

First Contact & Terms: Send query letter with photographs, slides and transparencies. Samples are not filed and are returned by SASE. Company will contact artist for portfolio review if interested. Portfolio should include photographs, slides and transparencies. Negotiates rights purchased. Originals are returned at jobs completion. Pays by the project, $250-400.

Tips: Finds artists through word of mouth.

‡**APC**, 16250 NW 48th Ave., Miami FL 33014. (305)624-2333. Fax: (305)621-4093. Marketing Director: Barry Spatz. Produces P-O-P displays.

Needs: Works with 2-4 freelancers/year. Buys 25-50 freelance designs and illustrations/year. Prefers artists with experience in P-O-P displays. Works on assignment only. Uses freelancers mainly for illustrations.

First Contact & Terms: Send postcard-size sample of work. Samples are not filed and are not returned. Reports back to the artist only if interested. Portfolio review not required. Buys all rights. Originals are not returned. Pays by the project.

‡**APPIAN SOFTWARE INC.**, 1462 Guava Ave., Melbourne FL 32935. (407)255-0066. Fax: (407)255-4735. E-mail: 73672.216@compuserve.com. Art Director: Mary Agrusa. Estab. 1993. Produces software. "We produce a software program called E-mail Impact. This product integates notepads, stationery and greeting cards into e-mail. Our users are people in the workplace. All art must be sensitive to the office environment and be appropriate for this market. No 'off color' humor at all."

Needs: Approached by 100-200 freelancers/year. Works with 20-30 freelancers/year. Buys 400 freelance designs and illustrations/year. Prefers artists with experience in humorous illustrating, cartooning and gag writing and stationery design. "We're not interested in a lot of full color art at this time because of technical considerations." Works on assignment only. "We tend to lean toward humorous illustrations that will convey the tone or theme of an e-mail message. Our art work adds the personal touch that text-only based messaging systems lack. Graphic images can help the sender more accurately convey his message and avoid misunderstandings for the receipient." Needs computer-literate freelancers for illustration. Produces material for Christmas, Hannukkah, New Year, birthdays, everyday, Secretary's Day (office related events). Submit seasonal material 6 months in advance.

How to Use Your Artist's & Graphic Designer's Market *offers suggestions for understanding and using the information in these listings. Read this and other articles in the front of this book for important business tips.*

First Contact & Terms: Send query letter with brochure, tearsheets, photostats, SASE and photocopies. Samples are filed and are returned by SASE if requested by artist. Reports back to the artist only if interested. Portfolio review not required. Rights purchased vary according to project. Pays by the project, $50-300.

Tips: Finds artists through agents, submissions, word of mouth. "I am always looking for an artist whose style fits our product. Keep your presentation neat and professional. Take time to organize your work. Put effort into developing a business-like presentation package. Don't get discouraged if you don't make the cut with your first submissions. E-mail is growing at a staggering rate. This trend will provide traditional and computer artists with increasing opportunities to market their work."

APPLE ORCHARD PRESS, P.O. Box 240, Dept. A, Riddle OR 97469. Art Director: Gordon Lantz. Estab. 1988. Produces greeting cards and book products. "We manufacture our products in our own facility and distribute them nationwide. We make it a point to use the artist's name on our products to help them gain recognition. Our priority is to produce beautiful products of the highest quality."

Needs: Works with 4-8 freelancers/year. Buys 50-75 designs/year. Uses freelancers mainly for note cards and book covers. All designs are in color. Considers all media, but prefers watercolor and colored pencil. Looking for florals, cottages, gardens, gardening themes, recipe book art, Christmas themes and animals. "We usually produce 4 or more images from an artist on the same theme at the same time." Produces material for Christmas, Valentine's Day and everyday. Submit seasonal material 9-12 months in advance, "but will always be considered for the next release of that season's products whenever it's submitted."

First Contact & Terms: Submit photos, slides, brochure or color copies. Must include SASE. "Samples are not filed unless we're interested." Reports back within 1-2 months. Company will contact artist for portfolio review if interested. Portfolio should include slides and/or photographs. Pays one-time flat fee/image. Amount varies. Rights purchased vary according to project.

Tips: "Please do not send pictures of pieces that are not available for reproduction. We must eventually have access to either the original or an excellent quality transparency. If you must send pictures of pieces that are not available in order to show style, be sure to indicate clearly that the piece is not available. We work with pairs of images. Sending quality pictures of your work is a real plus."

‡AR-EN PARTY PRINTERS, INC., 3252 W. Bryn Mawr, Chicago IL 60645. (312)539-0055. Fax: (312)539-0108. Vice President: Gary Morrison. Estab. 1978. Produces stationery and paper tableware products. Makes personalized party accessories for weddings, and all other affairs and special events. Works with 2 freelancers/year. Buys 10 freelance designs and illustrations/year. Works on assignment only. Uses freelancers mainly for new designs. Also for calligraphy. Looking for contemporary and stylish designs. Prefers small (2×2) format.

First Contact & Terms: Send query letter with brochure, résumé and SASE. Samples are filed or returned by SASE if requested by artist. Reports back within 2 weeks. Company will contact artist for portfolio review if interested. Rights purchased vary according to project. Pays by the project, $10-10,000.

THE AVALON HILL GAME CO., 4517 Harford Rd., Baltimore MD 21214. (410)254-9200. Fax: (410)254-0991. E-mail: ahgames@aol.com; avalon.hill2@genie.geis.com; 72662.2443@compuserve.com. Art Director: Jean Baer. Estab. 1958. "Produces strategy, sports, family, role playing and military strategy games (for the computer) for adults."

• This company also publishes the magazine *Girls' Life*.

Needs: Approached by 30 freelancers/year. Works with 10 freelancers/year. Buys less than 30 designs and illustrations from freelancers/year. Prefers freelancers with experience in realistic military and/or fantasy art. Works on assignment only. Uses freelancers mainly for cover and interior art. Considers any media. "The styles we are looking for vary from realistic to photographic to fantasy."

First Contact & Terms: Send query letter with tearsheets, slides, SASE and photocopies. Samples are filed or returned by SASE if requested by artist. Prefers samples that do not have to be returned. Reports back within 2-3 weeks. If Art Director does not report back, the artist should "wait. We will contact the artist if we have an applicable assignment." Art Director will contact artist for portfolio review if interested. Original artwork is not returned. Sometimes requests work on spec before assigning a job. Pays by the project, $500 average for cover art, according to job specs. Buys all rights. Considers buying second rights (reprint rights) to previously published work.

Tips: Finds artists through word of mouth and submissions.

BARTON-COTTON INC., 1405 Parker Rd., Baltimore MD 21227. (301)247-4800. Contact: Art Buyer. Produces religious greeting cards, commercial all occasion, Christmas cards, wildlife designs and spring note cards. Free guidelines and sample cards; specify area of interest (religious, Christmas, spring, etc.).

Needs: Buys 150-200 freelance illustrations/year. Submit seasonal work any time.

First Contact & Terms: Send query letter with résumé, tearsheets or slides. Submit full-color work only (watercolor, gouache, pastel, oil and acrylic). Previously published work and simultaneous submissions accepted. Reports in 1 month. Pays average flat fee of $400-500 for illustration and design. **Pays on acceptance.**

Tips: "Good draftsmanship is a must. Spend some time studying current market trends in the greeting card industry. There is an increased need for creative ways to paint traditional Christmas scenes with up-to-date styles and techniques."

ANITA BECK CARDS, 5555 W. 78th St., Edina MN 55439. President: Nini Sieck. "We manufacture and distribute greeting cards, note cards, Christmas cards and related stationery products through a wholesale and direct mail market."
Needs: Uses freelancers mainly for card designs; photographs are *not* used.
First Contact & Terms: Send query letter with brochure and photographs of artwork. Samples are filed or are returned only if requested by artist. Reports back within 3 months. Call or write for appointment to show portfolio. Pays for design by the project, $50 minimum. Buys all rights.

FREDERICK BECK ORIGINALS, 20644 Superior St., Chatsworth CA 91311. (818)988-0323. Fax: (818)998-5808. Contact: Ron Pardo, Gary Lainer or Richard Aust. Estab. 1953. Produces silk screen printed Christmas cards, traditional to contemporary.
• This company is under the same umbrella as Gene Bliley Stationery (see listing). One submission will be seen by both companies, so there is no need to send two mailings. Frederick Beck designs are a little more high end than Gene Bliley designs. The cards are sold through stationery and party stores, where the customer browses through thick binders to order cards, stationery or invitations imprinted with customer's name. Though many of the same cards are repeated or rotated each year, both companies are always looking for fresh images.
Needs: Approached by 20 freelancers/year. Works with 10 freelancers/year. Buys 25-50 freelance designs and illustrations/year. Prefers freelancers with experience in silk screen printing. Uses freelancers mainly for silk screen Christmas card designs. Looking for "artwork compatible with existing line; shape and color are important design elements." Prefers $5\frac{3}{8} \times 7\frac{7}{8}$. Produces material for Christmas. Submit holiday material 1 year in advance.
First Contact & Terms: Send query letter with simple sketches. Samples are filed. Portfolio review not required. Usually purchases all rights. Original artwork is not generally returned at job's completion "but could be." Sometimes requests work on spec before assigning a job. Pays by the project, average flat fee of $175 for illustration/design.
Tips: Finds artists through word of mouth and artists' submissions/self-promotions.

‡BEDOL INTERNATIONAL GROUP, INC., P.O. Box 2847, Rancho Cucamonga CA 91729. (909)948-0668. President: Mark A. Bedol. Estab. 1982. "We make school supplies for ages 5-15. Also stationery and cards."
Needs: Approached by 100 freelancers/year. Works with 10 freelancers/year. Buys 20 freelance designs and illustrations/year. Uses freelancers mainly for greeting cards and stationery. Also for P-O-P displays, mechanicals and advertising. "We prefer computer production; but we also use non-computer-based illustrations." Needs computer-literate freelancers for design, illustration and production. 50% of freelance work demands knowledge of Adobe Illustrator 5.0, Adobe Photoshop and QuarkXPress. Produces material for all holidays and seasons. Submit seasonal material 2 months in advance.
First Contact & Terms: Send query letter with samples. Samples are filed and are not returned. Company will contact artist for portfolio review if interested. Buys all rights. Originals are not returned.

BEISTLE COMPANY, 1 Beistle Plaza, Box 10, Shippensburg PA 17257. (717)532-2131. Fax: (717)532-7789. Product Manager: C.M. Luhrs-Wiest. Estab. 1900. Manufacturer of paper and plastic decorations, party goods, gift items, tableware and greeting cards. Targets general public, home consumers through P-O-P displays, specialty advertising, school market and other party good suppliers.
• The Beistle Company is expanding and has added gift items, tableware and greeting cards to its line.
Needs: Approached by 15-20 freelancers/year. Prefers artists with experience in designer gouache illustration—fanciful figure work. Looks for full-color, camera-ready artwork for separation and offset reproduction. Works on assignment only. Uses freelance artists mainly for product rendering and brochure design and layout. Prefers designer gouache and airbrush technique for poster style artwork. Needs computer-literate freelancers for design and illustration. Freelancers should be familiar with QuarkXPress, Aldus FreeHand, Adobe Illustrator, Photoshop or Fractal Design PAINTER.
First Contact & Terms: Send query letter with résumé and the following samples: tearsheets, photostats, photocopies, slides, photographs, transparencies. Samples are filed or returned by SASE. Art Director will contact artist for portfolio review if interested. sometimes requests work on spec before assigning a job. Pays average flat fee of $325; or pays by the hour, $25-35; by the project $600-1,200. Considers buying second rights (reprint rights) to previously published work.
Tips: Finds artists through word of mouth, magazines, artists' submissions/self-promotions, sourcebooks, agents, visiting artists' exhibitions, art fairs and artists' reps. "Our primary interest is in illustration; often we receive freelance propositions for graphic design—brochures, logos, catalogs, etc. These are not of interest to us as we are manufacturers of printed decorations. Send color samples rather than b&w. There is a move toward brighter, stronger designs with more vibrant colors and bolder lines. We have utilized more freelancers

in the last few years than previously. We predict continued and increased consumer interest—greater juvenile product demand due to recent baby boom and larger adult market because of baby boom of the '50s."

BERQQUIST IMPORTS, INC., 1412 Hwy. 33 S., Cloquet MN 55720. (218)879-3343. Fax: (218)879-0010. President: Barry Berqquist. Estab. 1948. Produces paper napkins, mugs and tile. Wholesaler of mugs, decorator tile, plates and dinnerware.
Needs: Approached by 5 freelancers/year. Works with 5 freelancers/year. Buys 50 design and illustrations/year. Prefers freelancers with experience in Scandinavian and wildlife designs. Works on assignment only. Uses freelancers for calligraphy. Produces material for Christmas, Valentine's Day and everyday. Submit seasonal material 6-8 months in advance.
First Contact & Terms: Send query letter with brochure, tearsheets and photographs. Samples are not filed and are returned. Reports back within 2 months. Request portfolio review in original query. Artist should follow-up with a letter after initial query. Portfolio should include roughs, color tearsheets and photographs. Rights purchased vary according to project. Originals are returned at job's completion. Requests work on spec before assigning a job. Pays by the project, $50-300; average flat fee of $50 for illustration/design; or royalties of 5%.
Tips: Finds artists through word of mouth, artists' submissions/self-promotions and art fairs.

‡BLACK "INC" GREETINGS, P.O. Box 301248, Houston TX 77230-1248. (713)799-2046. Owner: Frank Williamson. Estab. 1993. Produces greeting cards. Black "Inc" Greetings produces greeting cards that are targeted mainly toward African-Americans and other ethnic groups.
Needs: Approached by 25 freelancers/year. Works with 2-4 freelancers/year. Buys 20 freelance designs and illustrations/year. Prefers local freelancers (but will considers others) with experience in watercolor, gouache, acrylic paints. Works on assignment only. Uses freelancers mainly for illustrations and design. Also for P-O-P displays and mechanicals. Considers all media. Looking for styles that are consistent to the appeal of our main target market. Prefers 5×7. Needs computer-literate freelancers for design, illustration and production. 10% of work demands knowledge of QuarkXPress. Produces material for all holidays and seasons. Submit seasonal material 6 months in advance.
First Contact & Terms: Send query letter with brochure, tearsheets, photostats, résumé and photographs. Samples are not filed and are returned by SASE if requested by artist. Company will contact artist for portfolio review if interested. Portfolio should include thumbnails, roughs, final art, photostats, tearsheets and photographs. Negotiates rights purchased. Originals are not returned. Pays by the project, $540.
Tips: Finds artists through word of mouth, art schools and artists' submissions. "Show your best strength in a particular media."

GENE BLILEY STATIONERY, 20644 Superior St., Chatsworth CA 91311. (818)998-0323. Fax: (818)998-5808. General Manager: Gary Lainer. Sales Manager: Ron Pardo. Estab. 1967. Produces stationery, family-oriented birth announcements and invitations for most events and Christmas cards.
● This company also owns Frederick Beck Originals (see listing). One submission will be seen by both companies.
Needs: Approached by 10-20 freelancers/year. Works with 4-7 freelancers/year. Buys 15-60 designs and illustrations/year. Prefers local freelancers. Uses freelancers mainly for invitation and photo card designs. Also for calligraphy, paste-up and mechanicals. Considers any color media, except photography and oil. Produces material for Christmas, graduation, birthdays, Valentine's Day and Mother's Day. Submit Christmas material 1 year in advance; others reviewed year round.
First Contact & Terms: Send query letter with résumé and color tearsheets, photographs or photocopies. Samples are filed. Portfolio review not required. Original artwork not returned at job's completion. Sometimes requests work on spec before assigning a job. Pays flat fee of $100-150 per design on average. Buys all rights.
Tips: "We are open to new ideas and different approaches within our niche. Our most consistent need is designs for Christmas invitations and photo cards. Familiarize yourself with the marketplace."

BLUE SKY PUBLISHING, 6395 Gunpark Dr., Suite M, Boulder CO 80301. (303)530-4654. Fax: (303)530-4627. Art Director: Theresa Brown. Estab. 1989. Produces greeting cards and stationery. "At Blue Sky Publishing, we are committed to producing contemporary fine art greeting cards that communicate reverence for nature and all creatures of the earth, that share different cultural perspectives and traditions, and that maintain the integrity of our artists' work."

A bullet introduces comments by the editor of Artist's & Graphic Designer's Market indicating special information about the listing.

Needs: Approached by 500 freelancers/year. Works with 30 freelancers/year. Licenses 80 fine art pieces/year. Works with freelancers from all over US. Prefers freelancers with experience in fine art media: oils, oil pastels, watercolor, fine art photography. "We primarily license existing pieces of art or photography. We rarely commission work." Uses freelancers for calligraphy, mechanicals, computer layout/design. Looking for colorful, contemporary images with strong emotional impact. "Computer layout requires knowledge of Pagemaker, Illustrator and QuarkXPress." Produces cards for Christmas, Valentine's Day, birthdays, Thanksgiving, everyday, Mother's Day, New Year, sympathy, congratulations, baby, anniversary, wedding and thank you. Submit seasonal material 1 year in advance.
First Contact & Terms: Send query letter with résumé, SASE, photographs, slides, photocopies or transparencies. Samples are filed. Reports back within 2-3 months if returning artwork. Reports back to the artist only if interested if not returning art. Art Director will contact artist for portfolio review if interested. Portfolio should include color photographs, slides or 4×5 transparencies. Transparencies are returned at job's completion. Pays royalties of 3% with upfront license fee of $250 per image. Buys greeting card rights for 5 years (standard contract; sometimes this is negotiated).
Tips: "We're interested in seeing artwork that touches you deeply. Since we are licensing existing works of art, this is critical for us. Holiday cards are what we produce in biggest volume. We are looking for joyful images, cards dealing with relationships and folk art. Vibrant colors are important."

THE BRADFORD EXCHANGE, 9333 Milwaukee Ave., Niles IL 60714. (708)581-8204. Fax: (708)581-8770. Art Acquisition Manager: Susan Collier. Estab. 1973. Produces and markets collectible plates. "Bradford produces limited edition collectors plates featuring various artists' work which is reproduced on the porcelain surface. Each series of 6-8 plates is centered around a concept, rendered by one artist, and marketed internationally."
Needs: Approached by thousands of freelancers/year. Works with approximately 100 freelancers/year. Prefers artists with experience in rendering painterly, realistic, "finished" scenes; best mediums are oil and acrylic. Uses freelancers for all work including border designs, sculpture. Considers oils, watercolor, acrylic and sculpture. Traditional representational style is best, depicting scenes of children, pets, wildlife, homes, religious subjects, fantasy art, florals or songbirds in idealized settings. Produces material for all holidays and seasons, Halloween, Christmas, Easter, Valentine's Day, Thanksgiving, Mother's Day. Submit seasonal material 6-9 months in advance.
First Contact & Terms: Send query letter with brochure, résumé, tearsheets, photographs, photocopies or slides. Samples are filed and are not returned. Art Director will contact artist only if interested. Originals are returned at job's completion. Pays royalties, upfront fee or a combination of both. Rights purchased vary according to project.

‡BRAZEN IMAGES, INC., 269 Chatterton Pkwy., White Plains NY 10606-2013. (914)949-2605. Fax: (914)683-7927. President/Art Director: Kurt Abraham. Estab. 1981. Produces greeting cards and postcards. "Primarily we produce cards which lean towards the erotic arts; whether that be of a humorous/novelty nature or a serious/fine arts nature. We buy stock only—no assignments."
Needs: Approached by 10-20 freelancers/year. Works with 10 freelancers/year. Buys 10-30 freelance designs and illustrations/year. Uses freelancers mainly for postcards. Considers any media "I don't want to limit the options." Prefers 5×7 (prints); may send slides. Produces material for Christmas, Valentine's Day, Hannukkah, Halloween, birthdays, everyday and weddings.
First Contact & Terms: Send query letter with photographs, slides, SASE and transparencies. Samples are filed or returned by SASE if requested by artist. Reports back ASAP depending on workload. Company will contact artist for portfolio review if interested. Portfolio should include final art, photographs, slides and transparencies. Buys one-time rights. Originals are returned at job's completion. Pays royalties of 2%.
Tips: Finds artists through artists' submissions.

BRILLIANT ENTERPRISES, 117 W. Valerio St., Santa Barbara CA 93101. Art Director: Ashleigh Brilliant. Publishes postcards.
Needs: Buys up to 300 designs/year. Freelancers may submit designs for word-and-picture postcards, illustrated with line drawings.
First Contact & Terms: Submit 5½×3½ horizontal b&w line drawings and SASE. Reports in 2 weeks. Buys all rights. "Since our approach is very offbeat, it is essential that freelancers first study our line. Ashleigh Brilliant's books include *I May Not Be Totally Perfect, But Parts of Me Are Excellent*; *Appreciate Me Now and Avoid the Rush*; and *I Want to Reach Your Mind. Where Is It Currently Located?* We supply a catalog and sample set of cards for $2 plus SASE." Pays $50 minimum, depending on "the going rate" for camera-ready word-and-picture design.
Tips: "Since our product is highly unusual, familiarize yourself with it by sending for our catalog. Otherwise, you will just be wasting our time and yours."

BRISTOL GIFT CO., INC., P.O. Box 425, 6 North St., Washingtonville NY 10992. (914)496-2821. Fax: (914)496-2859. President: Matt Ropiecki. Estab. 1988. Produces posters and framed pictures for inspiration and religious markets.

Needs: Approached by 5-10 freelancers/year. Works with 2 freelancers/year. Buys 15-30 freelance designs and illustrations/year. Works on assignment only. Uses freelancers mainly for design. Also for calligraphy, P-O-P displays and mechanicals. Prefers 16×20 or smaller. Needs computer-literate freelancers for design, illustration and production. 15% of work demands knowledge of Aldus PageMaker or Adobe Illustrator. Produces material for Christmas, Mother's Day, Father's Day and Graduation. Submit seasonal material 6 months in advance.

First Contact & Terms: Send query letter with brochure and résumé. Samples are filed and are returned. Reports back within 2 weeks. Company will contact artist for portfolio review if interested. Portfolio should include roughs. Requests work on spec before assigning a job. Originals are not returned. Pays by the project or royalties of 5-10%. Rights purchased vary according to project. Interested in buying second rights (reprint rights) to previously published artwork.

‡BRUSH DANCE INC., 100 Ebbtide Ave., Sausalito CA 94965. (415)331-9030. Fax: (415)331-9059. Vice President of Marketing: Diana Hill. Estab. 1989. Produces greeting cards, posters, calendars, bookmarks, blank journal books, T-shirts and magnets. "Brush Dance creates products that make 'spiritual' ideas accessible. We do this by combining humor, heartfelt sayings and sacred writings with exceptional art."

Needs: Approached by 60 freelancers/year. Works with 20 freelancers/year. Buys 100 freelance designs and illustrations/year. Uses freelancers mainly for illustration and calligraphy. Looking for non-traditional, spiritual work conveying emotion or message. Prefers 5×7 or 7×5 originals or designs that can easily be reduced or enlarged to these proportions. Produces material for Christmas, Valentine's Day, Hannukkah, New Year, birthdays and everyday. Submit seasonal material by November 15 (for following year's Christmas, Hannukkah) or by June 1 (for following year's Valentine's).

First Contact & Terms: Call or write for artist guidelines before submitting. Samples are filed or returned by SASE. Reports back to the artist only if interested. Buys all rights. Originals are returned at job's completion. Pays royalty of 5-7.5% depending on product.

Tips: Finds artists through word of mouth.

BURGOYNE, INC., 2030 E. Byberry Rd., Philadelphia PA 19116. (215)677-8962. Fax: (215)677-6081. Creative Director: Jeanna Lane. Estab. 1907. Produces greeting cards. Publishes Christmas greeting cards geared towards all age-groups. Style ranges from traditional to contemporary to old masters' religious.

Needs: Approached by 150 freelancers/year. Works with 25 freelancers/year. Buys 50 designs and illustrations/year. Prefers freelancers with experience in all styles and techniques of greeting card design. Uses freelancers mainly for Christmas illustrations. Also for lettering/typestyle work. Considers watercolor and pen & ink. Produces material for Christmas. Accepts work all year round.

First Contact & Terms: Send query letter with slides, transparencies, photocopies and SASE. Samples are filed. Creative Director will contact artist for portfolio review if interested. Payment depends on project. Buys first rights or all rights. Sometimes requests work on spec before assigning a job. Interested in buying second rights (reprint rights) to previously published work.

Tips: "Send us fewer samples. Sometimes packages are too lengthy."

‡CANETTI DESIGN GROUP INC., P.O. Box 57, Pleasantville NY 10570. (914)238-1076. Fax: (914)238-3177. Marketing Vice President: M. Berger. Estab. 1982. Produces greeting cards, stationery, games/toys and product design.

Needs: Approached by 50 freelancers/year. Works with 20 freelancers/year. Works on assignment only. Uses freelancers mainly for illustration/computer. Also for calligraphy and mechanicals. Considers all media. Looking for contemporary style. Needs computer-literate freelancers for illustration and production. 80% of freelance work demands knowledge of Adobe Illustrator, Adobe Photoshop, Aldus FreeHand, Form 2/Strata.

First Contact & Terms: Send postcard-size sample of work and query letter with brochure. Samples are not filed. Portfolio review not required. Buys all rights. Originals are not returned. Pays by the hour.

Tips: Finds artists through agents, sourcebooks, magazines, word of mouth and artists' submissions.

CAPE SHORE, INC., 42 N. Elm St., Yarmouth ME 04096. (207)846-3726. Art Director: Joan Jordan. Estab. 1947. "Cape Shore is concerned with seeking, manufacturing and distributing a quality line of gifts and stationery for the souvenir and gift market."

Needs: Approached by 50-75 freelancers/year. Works with 30-40 freelancers/year. Buys 75-80 freelance designs and illustrations/year. Prefers artists with experience in illustration. Uses freelance artists mainly for illustrations for boxed notes and Christmas card designs. Considers watercolor, gouache, acrylics, tempera, pastel, markers, colored pencil. Looking for traditional subjects rendered in a realistic style with strong attention to detail. Prefers final artwork on flexible stock for reproduction purposes.

First Contact & Terms: Send query letter with photocopies and slides. Samples are filed or are returned by SASE. Art Director will contact artist for portfolio review if interested. Portfolio should include slides, finished samples, printed samples. Pays by the project, $150 minimum. Buys reprint rights or varying rights according to project.

Tips: "Cape Shore is looking for realistic detail, good technique, bright clear colors and fairly tight designs of traditional themes."

CARDMAKERS, (formerly Diebold Designs), Box 236, High Bridge Rd., Lyme NH 03768. Phone/fax: (603)795-4422. Principle: Peter Diebold. Estab. 1978. Produces greeting cards. "We produce special cards for special interests and greeting cards for businesses—primarily Christmas. We have now expanded our Christmas line to include 'photo mount' designs, added designs to our everyday line for stockbrokers and are ready to launch a line for boaters."
Needs: Approached by more than 100 freelancers/year. Works with 5-10 freelancers/year. Buys 10-20 designs and illustrations/year. Prefers professional caliber artists. Works on assignment only. Uses freelancers mainly for greeting card design, calligraphy and mechanicals. Also for paste-up. Considers all media. "We market 5×7 cards designed to appeal to individual's specific interest—golf, tennis, etc." Prefers an upscale look. Submit seasonal ideas 6-9 months in advance.
First Contact & Terms: Send query letter with SASE and brief sample of work. "One good sample of work is enough for us. A return postcard with boxes to check off is wonderful. Phone calls are out; fax is a bad idea." Samples are filed or are returned by SASE. Reports back to artist only if interested. Portfolio review not required. Pays flat fee of $200 minimum. Rights purchased vary according to project. Interested in buying second rights (reprint rights) to previously published work, if not previously used for greeting cards.
Tips: Finds artists through word of mouth, exhibitions and *Artist's & Graphic Designer's Market*. "It's important that you show us samples *before* requesting submission requirements. There's a 'bunker' mentality in business today and suppliers (including freelancers) need to understand the value they add to the finished product in order to be successful. Consumers are getting more for less every day and demanding more all the time. We need to be more precise every day in order to compete."

‡CARDS FOR A CAUSE, 175 Spencer Place, Ridgewood NJ 07450. Creative Director: Carolyn Ferrari. Estab. 1994. Produces greeting cards. "Cards For A Cause produces greeting cards (everyday note cards and holiday cards) to benefit charitable and nonprofit organizations (including Amnesty International USA, National Committee to Prevent Child Abuse, Environmental Defense Fund, American Foundation for AIDS Research and others). A percentage of all sales revenues goes to the beneficiary organizations."
Needs: Approached by 100 freelancers/year. "This will be our first year buying art." Expects to purchase 10-20 freelance designs and illustrations/year. Works on assignment only. Uses freelancers mainly for greeting card art/design. Considers all media (except photography). "We're looking for artwork that depicts the ideals of the beneficiary organizations we represent (i.e., environmental/wildlife art for the Environmental Defense Fund) in any style appropriate for greeting cards." Prefers art proportionate to 5×7-inch card format. Produces material for Christmas, Hannukkah and everyday. Submit seasonal material 1 year in advance.
First Contact & Terms: Send query letter with brochure, SASE, photocopies and color copies. Samples are filed or returned by SASE. Reports back within 2 months. Portfolio should include final art, tearsheets and transparencies. Negotiates rights purchased. Originals are returned at job's completion. Pays by the project, $200-300.
Tips: "We use all sources available to locate talent. We encourage artists' submissions because we like to work with artists interested in causes. We are most impressed when artists have done their homework prior to sending us a submission. Because our needs are very specifically tied to causes, we appreciate seeing appropriately specific submissions. We've had a tremendous response to our card line. People are becoming much more cause-conscious in their purchasing decisions."

‡CASE STATIONERY CO., INC., 179 Saw Mill River Rd., Yonkers NY 10701. (914)965-5100. President: Jerome Sudwow. Vice President: Joyce Blackwood. Estab. 1954. Produces stationery, notes, memo pads and tins for mass merchandisers in stationery and housewares departments.
Needs: Approached by 10 freelancers/year. Buys 50 designs from freelancers/year. Works on assignment only. Buys design and/or illustration mainly for stationery products. Uses freelancers for mechanicals and ideas. Produces materials for Christmas; submit 6 months in advance. Likes to see youthful and traditional styles, as well as English and French country themes.
First Contact & Terms: Send query letter with résumé and tearsheets, photostats, photocopies, slides and photographs. Samples not filed are returned. Reports back. Call or write for appointment to show a portfolio. Original artwork is not returned. Pays by the project. Buys first rights or one-time rights.
Tips: "Find out what we do. Get to know us. We are creative and know how to sell a product."

Always enclose a self-addressed, stamped envelope (SASE) with queries and sample packages.

‡**CAST ART INDUSTRIES, INC.**, 1120 California Ave., Corona CA 91719. (909)371-3025. Fax: (909)371-0674. Art Director: Dana Hoff. Estab. 1991. Produces greeting cards, calendars and giftware (collectible figurines and sculptures).
Needs: Approached by 10 freelancers/year. Works with 5 freelancers/year. Buys 100 freelance designs and illustrations/year. Works on assignment only. Uses freelancers mainly for illustrations. Needs computer-literate freelancers for production. 10% of freelance work demands knowledge of Adobe Illustrator, Adobe Photoshop, QuarkXPress and Aldus FreeHand. Produces material for all holidays and seasons, Christmas, Valentine's Day, Mother's Day, Father's Day, Easter, Hannukkah, Passover, Rosh Hashanah, graduation, Thanksgiving, New Year, Halloween, birthdays, everyday and weddings. Submit seasonal material 6 months in advance.
First Contact & Terms: Send query letter with tearsheets and photocopies (color samples). Samples are filed. Reports back within 2 weeks. Portfolio review not required. Buys all rights. Originals are not returned.
Tips: Finds artists through sourcebooks.

‡**CATCH PUBLISHING, INC.**, 32 S. Lansdowne Ave., Lansdowne PA 19050. (610)626-7770. Fax: (610)626-2778. Contact: Michael Markowicz. Produces greeting cards, stationery and posters.
Needs: Approached by 200 freelancers/year. Works with 5-10 freelancers/year. Buys 25-50 freelance designs and illustrations/year. Works on assignment only. Uses freelancers mainly for design. Considers all media. Produces material for Christmas, New Year and everyday. Submit seasonal material 1 year in advance.
First Contact & Terms: Send query letter with brochure, tearsheets, résumé, slides, SASE and transparencies. Samples are not filed and are returned by SASE if requested by artist. Reports back within 2-6 months. Company will contact artist for portfolio review if interested. Portfolio should include final art, slides and 4×5 and 8×10 transparencies. Rights purchased vary according to project. Originals are returned at job's completion. Pays royalties of 10-12% (may vary according to job).
Tips: Finds artists through submissions, word of mouth and referrals.

CEDCO PUBLISHING CO., 2955 Kerner Blvd., San Raphael CA 94901. Contact: Art Department. Estab. 1982. Produces 155 upscale calendars and books.
Needs: Approached by 500 freelancers/year. Works with 5 freelancers/year. Buys 48 freelance designs and illustrations/year. "We never give assignment work." Uses freelancers mainly for stock material and ideas. "We use either 35mm slides or 4×5s of the work."
First Contact & Terms: "No phone calls accepted." Send query letter with brochure, tearsheets and photostats. Samples are filed. "Send non-returnable samples only." Reports back to the artist only if interested. To show portfolio, mail thumbnails and b&w photostats, tearsheets and photographs. Original artwork is returned at the job's completion. Pays by the project. Buys one-time rights. Interested in buying second rights (reprint rights) to previously published work.
Tips: Finds artists through art fairs and licensing agents. "Full calendar ideas encouraged!"

CENTRIC CORP., 6712 Melrose Ave., Los Angeles CA 90038. (213)936-2100. Fax: (213)936-2101. Vice President: Neddy Okdot. Estab. 1986. Produces fashion watches, clocks, mugs, frames, pens, non-holographic 3-D posters and stand-ups for ages 18-55.
Needs: Approached by 40 freelancers/year. Works with 6-7 freelancers/year. Buys 30-40 designs and illustrations/year. Prefers local freelancers only. Works on assignment only. Uses freelancers mainly for watch and clock dials, posters, mugs and packaging. Also for mechanicals. Considers graphics, computer graphics, cartoons, pen & ink, photography. Needs computer-literate freelancers for design. 70% of freelance work demands knowledge of QuarkXPress, Adobe Illustrator, Photoshop and Adobe Paintbox.
First Contact & Terms: Send query letter with photographs. Samples are filed if interested. Reports back to the artist only if interested. Originals are returned at job's completion. Requests work on spec before assigning a job. Pays by the project. Rights purchased vary according to project.
Tips: Finds artists through artists' submissions/self-promotions, sourcebooks, agents and artists' reps.

CHESAPEAKE CONSUMER PRODUCTS CO., 1200 S. Perkins St., Appleton WI 54912-1039. (414)739-8233. Fax: (414)730-4880. Creative Manager: Beth Dahlke. Produces decorative tableware products. "Chesapeake provides high-quality consumer decorative tableware. With the ability to print 4-6-color flexo napkins, plates and table covers, Chesapeake has become the preferred resource in the mass market industry."
Needs: Approached by 15-20 freelancers/year. Works with 15 freelancers/year. Buys 30 designs and illustrations/year. Prefers freelancers with experience in paper tableware products (but this is not a prerequisite). Uses freelancers for concept and design. "Style and look depend mainly on the market category being filled. This information is available through contact with the creative manager." Prefers 9½″ circle image size. Needs computer-literate freelancers for design and illustration. 50% of freelance work demands knowledge of Aldus PageMaker, QuarkXPress, Aldus FreeHand, Adobe Illustrator, Photoshop. Produces tableware for seasonal and everyday events.
First Contact & Terms: Send query letter with résumé, SASE, tearsheets, photocopies. Samples are filed and are returned by SASE if requested by artist. Creative Manager will contact artist for portfolio review if interested. Portfolio should include thumbnails, roughs, finished art samples and color photostats, tearsheets,

photographs and dummies. Rights purchased vary according to project. Interested in buying second rights (reprint rights) to previously published work. Originals are returned at job's completion. Requests work on spec before assigning a job. Pays by the project, $200-2,000; a royalty arrangement may be negotiated.

Tips: Finds artists through art fairs and artist reps. "We are interested in trend setting, as well as traditional concepts and designs. Contact should be made with the creative manager, via a letter containing a résumé and style samples."

‡CLARKE AMERICAN, P.O. Box 460, San Antonio TX 78292-0460. (210)662-1449. Fax: (210)662-7503. Product Development: Lecy Benke. Estab. 1874. Produces checks and other products and services sold through financial institutions. "We're a national printer seeking original works for check series, consisting of five, three, or one scene. Looking for a variety of themes, media, and subjects for a wide market appeal."

Needs: Uses freelancers mainly for illustration and design of personal checks. Considers all media and a range of styles. Prefers art twice standard check size.

First Contact & Terms: Send postcard-size sample of work. Send query letter with brochure and résumé. "Indicate whether the work is available; do not send original art." Samples are filed and are not returned. Reports back to the artist only if interested. Rights purchased vary according to project. Payment for illustration varies by the project.

Tips: "Keep red and black in the illustration to a minimum for image processing."

CLASSIC OILS, Box 33, Flushing NY 11367. (718)426-4960 or (718)261-5402. Contact: Roy Sicular. Estab. 1978. Produces greeting cards and posters."I publish scenes of New York City—watercolor, collages, b&w."

Needs: Approached by 5 freelancers/year. Works with 0-1 freelancer/year. Buys 0-1 freelance design and illustration/year. Considers all media.

First Contact & Terms: Send query letter with photocopies. Samples are not filed and are returned. Reports back to the artist only if interested. Portfolio review not required. Originals are returned at job's completion. Pays $100-300 for reproduction rights. Buys reprint rights.

‡CLAY ART, 239 Utah Ave. S., San Francisco CA 94080. (415)244-4970. Fax: (415)244-4979. Art Director: Thomas Biela. Estab. 1979. Produces giftware and home accessory products: cookie jars, teapots, salt & peppers, mugs, magnets, pitchers, masks, platters and cannisters.

Needs: Approached by 70 freelancers/year. Works with 10 freelancers/year. Buys 30 designs and illustrations/year. Prefers freelancers with experience in 3-D design of giftware and home accessory itmes. Works on assignment only. Uses freelancers mainly for illustrations, 3-D design and sales promotion. Also for P-O-P displays, paste-up, mechanicals and product design. Seeks humorous, whimisical, innovative work. Needs computer-literate freelancers for design, production, presentation. 60% of freelance work demands knowledge of Aldus PageMaker, Aldus FreeHand, Adobe Illustrator, Photoshop.

First Contact & Terms: Send query letter with brochure, résumé, SASE, tearsheets, photographs, photocopies and photostats. Samples are filed. Reports back to the artist only if interested. Call for appointment to show portfolio of thumbnails, roughs and final art and color photostats, tearsheets, slides and dummies. Negotiates rights purchased. Originals are returned at job's completion. Payment varies.

‡CLEAR CARDS, 11054 Ventura Blvd., #207, Studio City CA 91604. (818)980-4120. Fax: (818)980-0771. Director of Marketing: André Cheeks. Estab. 1989. Produces greeting cards, CD packaging, collectibles, promotional and advertising products. "Clear Cards produces and markets greeting cards using PVC and high-end graphics. The buying group is women 25-55. The unique concept lends itself to promotional and advertising products."

Needs: Approached by 5-10 freelancers/year. Works with 3-4 freelancers/year. Buys 30-50 freelance designs and illustrations/year. Looking for a humorous style (sketch, ideas and image); cartoonists welcome. Prefers 9×12 images with 1″ margins left/right. Needs computer-literate freelancers for design, illustration and presentation. 70% of work demands knowledge of Adobe Illustrator, Adobe Photoshop and QuarkXPress. Produces material for Christmas, Valentine's Day, Mother's Day, New Year, birthdays and everyday. Submit seasonal material 4 months in advance.

First Contact & Terms: Send postcard-size sample of work. Samples are filed. Reports back with 15 working days. Company will contact artist for portfolio review if interested. Portfolio should include final art and photographs. Negotiates rights purchased. Originals are not returned. Pays by the project, $100-500.

Tips: Finds artists through submissions, via referrals and local art schools.

‡CLEO, INC., 4025 Viscount Ave., Memphis TN 38118. (901)369-6661. Fax: (901)369-6376. Director of Graphic Arts: Harriet Byall. Estab. 1953. Produces greeting cards, calendars, giftwrap, gift bags, tags, valentines (kiddie packs). "Cleo is the world's largest Christmas giftwrap manufacturer. Also provides extensive all occasion product line. Cards are boxed only (no counter cards) and only Christmas. Other product categories include seasonal product. Mass market for all age groups."

Needs: Approached by 25 freelancers/year. Works with 40-50 freelancers/year. Buys more than 200 freelance designs and illustrations/year. Uses freelancers mainly for giftwrap and greeting cards (designs). Also for

calligraphy. Considers most any media. Looking for fresh, imaginative as well as classic quality designs for Christmas. Prefers 5×7 for cards; 30" repeat for giftwrap. Produces material for Christmas, Valentine's Day, Halloween, birthdays and everyday. Submit seasonal material at least a year in advance.

First Contact & Terms: Send query letter with résumé, slides, SASE, photocopies, transparencies and speculative art. Samples are filed if interested or returned by SASE if requested by artist. Reports back to the artist only if interested. Rights purchased vary according to project; usually buys all rights. Payment varies by product and complexity of design.

Tips: Finds artists through agents, sourcebooks, magazines, word of mouth and artists' submissions. "Understand the needs of the particular market to which you submit your work."

COMSTOCK CARDS, INC., 600 S. Rock Blvd., Suite 15, Reno NV 89502. (702)856-9400. Fax: (702)856-9406. Production Manager: David Delacroix. Estab. 1987. Produces greeting cards, notepads and invitations. Styles include alternative and adult humor, outrageous, shocking and contemporary themes; specializes in fat, age and funny situations. No animals or landscapes. Target market predominately professional females, ages 25-55.

Needs: Approached by 250-350 freelancers/year. Presently working with 10-12 freelancers/year. "Especially seeking artists able to produce outrageous adult-oriented cartoons." Uses freelancers mainly for cartoon greeting cards. No verse or prose. Gaglines must be brief. Prefers 5×7 final art. Needs computer-literate freelancers for illustration in Aldus PageMaker, QuarkXPress, Photoshop or Adobe Illustrator. Produces material for Christmas, Hanukkah, Easter, birthdays, Valentine's Day, Thanksgiving, Halloween, Mother's Day, Father's Day, anniversaries, as well as everyday. Submit holiday concepts 11 months in advance.

First Contact & Terms: Send query letter with SASE, tearsheets, sample illustrations, slides or transparencies. Samples are not usually filed and are returned by SASE if requested. Reports back only if interested. Portfolio review not required. Originals are not returned. Pays by the project, $50 minimum; may negotiate other arrangements. Buys all rights.

‡CONCORD LITHO COMPANY, INC., 92 Old Turnpike Rd., Concord NH 03301. (603)225-3328. Fax: (603)225-6120. Vice President/Creative Services: Lester Zaiontz. Estab. 1958. Produces greeting cards, stationery, posters, giftwrap, specialty paper products for direct marketing. "We provide a range of print goods for commercial markets but also supply high quality paper products used for fundraising purposes."

Needs: Approached by 50 freelancers/year. Works with 10 freelancers/year. Buys 300 freelance designs and illustrations/year. Works on assignment only. Uses freelancers mainly for greeting cards, wrap and calendars. Also for calligraphy, P-O-P displays and computer-generated art. Considers all media but prefers watercolor. "Our needs range from generic seasonal and holiday greeting cards to religious subjects, florals, nature, scenics, inspirational vignettes. We prefer more traditional designs with occasional contemporary needs." Prefers 10×14. Needs computer-literate freelancers for design, illustration, production and presentation. 15% of freelance work demands knowledge of Adobe Illustrator, Adobe Photoshop, QuarkXPress, Aldus FreeHand and Aldus PageMaker. Produces material for all holidays and seasons, Christmas, Valentine's Day, Mother's Day, Father's Day, Easter, Hannukah, Passover, Rosh Hashanah, Thanksgiving, New Year, birthdays, everyday and other religious dates. Submit seasonal material 6 months in advance.

First Contact & Terms: Send query letter with résumé, photographs, slides, photocopies or transparencies. Samples are filed. Reports back within 3 months. Portfolio review not required. Rights purchased vary according to project. Originals are returned at job's completion. Pays by the project, $200-800. "We will exceed this amount depending on project."

Tips: "Keep sending samples or color photocopies of work to update our reference library. Be patient and follow guidelines or samples provided. More and more work is coming in in a digital format."

CONTENOVA GIFTS, INC., 735 Park N. Blvd., Suite 114, Clarkston GA 30021. (404)292-4676. Fax: (404)292-4684. Contact: Creative Director. Estab. 1965. Produces impulse gift merchandise and ceramic greeting mugs.

Needs: Buys 100 freelance designs/year for mugs and other items. Prefers freelancers with experience in full color work and fax capabilities. Works on assignment only. Looking for humorous cartoon work, cute animals and caricatures. Produces material for Father's Day, Christmas, Easter, birthdays, Valentine's Day, Mother's Day and everyday.

First Contact & Terms: Send query letter with brochure, tearsheets, SASE and photocopies. Samples are not filed and are returned by SASE. Art Director will contact artist for portfolio review if interested. Portfolio

The double dagger before a listing indicates that the listing is new in this edition. New markets are often more receptive to freelance submissions.

should include roughs, photostats, slides, color tearsheets and dummies. Sometimes requests work on spec before assigning a job. Pays by the project, $400-500. Buys all rights.
Tips: Finds artists through submissions/self-promotions and word of mouth. "We see steady growth for the future."

‡COTTAGE ART, P.O. Box 425, Cazenovia NY 13035. Owner: Jeanette Robertson. Estab. 1994. Produces greeting cards and notecards. "All of our designs are one color, silk screened, silhouette designs. Most cards are blank notes. They appeal to all ages and males! They are simple yet bold."
Needs: Uses freelancers mainly for design. Considers flat b&w; ink, marker, paint. Looking for silhouette designs only. Any subjects considered. "Remember they are only one color, solid, no tones." Prefers no larger than 8½×11. Does not need computer-literate freelancers. Produces material for Christmas. Submit seasonal material 1 year in advance.
First Contact & Terms: Send query letter with SASE and photocopies. Samples are returned by SASE. "If no SASE, they are destroyed." Reports back within 2 weeks with SASE. Portfolio review not required. Pays $50 and 25 free cards, $25 and 50 free cards or $1 and 75 free cards.
Tips: Finds artists through artists' submissions. "Being a new company we are interested in artists who are willing to work with us and grow with us. Our company seeks out industry 'holes.' Things that are missing, such as designs that appeal to men."

COURAGE CENTER, 3915 Golden Valley Rd., Golden Valley MN 55422. (612)520-0211. Fax: (612)520-0299. Art & Production Manager: Fran Bloomfield. Greeting cards from original art first produced in 1970. "Courage Center produces holiday notecards and Christmas cards. Cards are reproduced from fine art aquired through nationwide Art Search. Courage Center is a nonprofit rehabilitation and independent living center helping children and adults with physical, communication and sensory disabilities."
Needs: Approached by 300-500 freelancers/year. Works with 5-10 freelancers/year. Buys 0-10 freelance designs and illustrations/year. Prefers artists with experience in holiday/Christmas designs. Considers all media (no 3-D). Produces material for Christmas, birthdays, Thanksgiving, everyday. "We prefer that art arrives as a result of our Art Search announcement. Information is sent in September with mid-January deadline the following year."
First Contact & Terms: Send query letter with SASE. Samples are not filed and are returned by SASE if requested by artist. Acknowledgment of receipt of artwork is sent immediately. Decisions as to use are made 6-8 weeks after deadline date. Portfolio review not required. Originals are returned at job's completion. Pays $350 honorarium.

CREATE-A-CRAFT, Box 330008, Fort Worth TX 76163-0008. (817)292-1855. Contact: Editor. Estab. 1967. Produces greeting cards, giftwrap, games, calendars, posters, stationery and paper tableware products for all ages.
Needs: Approached by 500 freelancers/year. Works with 3 freelancers/year. Buys 3-5 freelance designs and illustrations/year. Prefers freelancers with experience in cartooning. Works on assignment only. Uses freelancers mainly for greetings cards and T-shirts. Also for calligraphy, P-O-P display, paste-up and mechanicals. Considers pen & ink, watercolor, acrylic and colored pencil. Prefers humor and "cartoons that will appeal to families. Must be cute, appealing, etc. No religious, sexual implications or offbeat humor." Produces material for all holidays and seasons; submit seasonal material 6 months before holiday.
First Contact & Terms: Contact only through artist's agent. "No phone calls from freelancers accepted." Samples are filed and are not returned. Reports back only if interested. Write for appointment to show portfolio of original/final art, final reproduction/product and color and b&w slides and tearsheets. Originals are not returned. Pays by the hour, $6-8; or by the project, $100-200. Pays royalties of 3% for exceptional work on one year basis. "Payment depends upon the assignment, amount of work involved, production costs, etc." Buys all rights.
Tips: "Demonstrate an ability to follow directions exactly. Too many submit artwork that has no relationship to what we produce. Sample greeting cards are available for $2.50 and a #10 SASE. Write, do not call. We cannot tell what your artwork looks like from a phone call."

CREATIF LICENSING, 31 Old Town Crossing, Mount Kisco NY 10549. Vice President: Paul Cohen. Licensing Manager. "Creatif is a licensing agency that represents artists and concept people."
Needs: Looking for unique art styles and/or concepts that are applicable to multiple products. "The art can range from fine art to cartooning."
First Contact & Terms: "If you have a style that you feel fits our qualifications please send photocopies or slides of your work with SASE. If we are interested in representing you, we will present your work to the appropriate manufacturers in the clothing, gift, publishing, home furnishings, paper products (cards/giftwrap/party goods, etc.) areas with the intent of procuring a license. We try to obtain advances and/or guarantees against a royalty percentage of the firm's sales. We will negotiate and handle the contracts for these arrangements, show at several trade shows to promote your style and oversee payments to insure that the requirements of our contracts are honored. Artists are responsible for providing us with materials for our meetings and presentations and for copyrights, trademarks and protecting their ownership (which is

The Crystal Tissue Co. used this oil pastel and ink drawing by Tom Post for a children's party gift bag, one of the wide range of styles they produce. "I like Tom's graphic depiction of a child's drawing," says Art Director Mary Jo Recker, "It is fun and whimsical, and also reminiscent of childhood innocence with its simple lines and 'crayon' texture." Crystal Tissue found Post's work through his rep.

discretionary). For our services, as indicated above, we receive 50% of all the deals we negotiate as well as renewals. There are no fees if we are not productive."

Tips: Common mistakes illustrators make in presenting samples or portfolios are "sending oversized samples mounted on heavy board and not sending appropriate material. Color photocopies and photos are best."

THE CROCKETT COLLECTION, Rt. 7A N., Box 1428, Manchester Center VT 05255. (802)362-2913. Fax: (802)362-5590. President: Sharon Scheirer. Estab. 1929. Publishes mostly traditional, some contemporary, humorous and whimsical Christmas and everyday greeting cards, postcards, note cards and bordered stationery on recycled paper. Christmas themes are geared to sophisticated, upper-income individuals. Artist's guidelines available for SASE.

Needs: Approached by 225 freelancers/year. Buys 25 designs/year. Produces products by silk screen method exclusively. Considers gouache, poster paint, cut and pasted paper and acrylic.

First Contact & Terms: Send query letter with SASE. Request guidelines which are mailed out once a year in February, 1 year in advance of printing. Submit unpublished, original designs only. Art should be in finished form. Art not purchased is returned by SASE. Pays flat fee of $90-140 for illustration/design. Buys all rights.

Tips: "Designs must be suitable for silk screen process. Airbrush, watercolor techniques and pen & ink are not amenable to this process. Bold, well-defined designs only. Our look is traditional, mostly realistic and graphic. Request guidelines and submit work according to our instructions."

THE CRYSTAL TISSUE COMPANY, 1201 Enoch Dr., Middletown OH 45042. (513)727-1274. Fax: (513)423-8207. Art Director: Mary Jo Recker. Estab. 1894. Produces giftwrap, gift bags and printed giftwrapping tissues. "Crystal produces a broad range of giftwrapping items for the mass market. We especially emphasize our upscale gift bags with coordinating specialty tissues and gift wrap. Our product line encompasses all age groups in both Christmas and all occasion themes."

Needs: Approached by 20 freelancers/year. Works with 100 freelancers/year. Buys 200 freelance designs and illustrations/year. Prefers freelancers with experience in greeting cards or giftwrap markets. Works on assignment and "we also purchase reproduction rights to existing artwork." Uses freelancers mainly for gift

bag and tissue repeat design. Also for calligraphy, mechanicals (computer only), b&w line illustration and local freelancers for design and production. Needs computer-literate freelancers for design, production and illustration. 20% of freelance work demands knowledge of QuarkXPress, Adobe Illustrator, FreeHand, Page-Maker and Adobe Photoshop. Produces seasonal material for Christmas, Valentine's Day, Easter, Hanukkah, Halloween, birthdays and everyday. "We need a variety of styles from contemporary to traditional—florals, geometric, tropical, whimsical, cartoon, upscale, etc." Submit all samples March 1-April 30.

First Contact & Terms: Send query letter with any samples that best show work. Samples are filed or are returned by SASE if requested by artist. Reports back in 1 month. Company will contact artist for portfolio review if interested. Portfolio should include roughs and final art. Originals returned depending on rights purchased. Pays by the project, $600-1,200. Negotiates rights purchased.

Tips: "Our products continue to trend to a more upscale, sophisticated look within the mass market. Angels and nature are still important subjects. Our product line continues to grow as gift bag packaging increases in popularity. We purchase and commission a lot of our artwork from contacts made through the Surtex and stationery trade shows in New York City. We also use reps and local talent. We have found a few artists through sourcebooks."

DECORAL INC., 165 Marine St., Farmingdale NY 11735. (516)752-0076 or (800)645-9868. Fax: (516)752-1009. President: Walt Harris. Produces decorative, instant stained glass, as well as sports and wildlife decals.

Needs: Buys 50 designs and illustrations from freelancers/year. Uses freelancers mainly for greeting cards and decals; also for P-O-P displays. Prefers watercolor.

First Contact & Terms: Send query letter with brochure showing art style or résumé and samples. Samples not filed are returned. Art Director will contact artist for portfolio review if interested. Portfolio should include final reproduction/product and photostats. Originals are not returned. Sometimes requests work on spec before assigning a job. Pays flat fee of $400 minimum. Buys all rights.

Tips: Finds artists through word of mouth, magazines, artists' submissions/self-promotions, sourcebooks, agents, visiting artists' exhibitions, art fairs and artists' reps. "We predict a steady market for the field."

‡DESIGN DESIGN, INC., P.O. Box 2266, Grand Rapids MI 49501. (616)774-2448. Fax: (616)774-4020. Art Director: Tom Vituj. Estab. 1986. Produces humorous and traditional greeting cards, stationery, journals, address books, calendars and giftwrap for all ages.

Needs: Approached by 50 freelancers/year. Works with 25 freelancers/year. Works on assignment only. Uses freelancers mainly for greeting cards and giftwrap. Considers most media. Produces material for all holidays and seasons. Submit 1 year before holiday.

First Contact & Terms: Send query letter with appropriate samples and SASE. Samples are not filed and are returned by SASE if requested by artist. Reports back within 1 month. To show portfolio, mail thumbnails, roughs, color photostats, photographs and slides. Do not send originals. Pays royalties. Negotiates rights purchased.

‡DIMENSIONS, INC., 641 McKnight St., Reading PA 19601. (610)372-8491. Fax: (610)372-0426. Designer Relations Coordinator: Mary Towner. Produces craft kits and leaflets, including but not limited to needlework, iron-on transfer, printed felt projects. "We are a craft manufacturer with emphasis on sophisticated artwork and talented designers. Products include needlecraft kits and leaflets, wearable art crafts, baby products. Primary market is adult women but children's crafts also included."

Needs: Approached by 50-100 freelancers/year. Works with 200 freelancers/year. Develops more than 400 freelance designs and illustrations/year. Uses freelancers mainly for the original artwork for each product. In-house art staff adapts for needlecraft. Considers all media. Looking for fine art, realistic representation, good composition, more complex designs than some greeting card art; fairly tight illustration with good definition; also whimsical, fun characters. Produces material for Christmas; Valentine's Day; Easter; Halloween; everyday; birth, wedding and anniversary records.

First Contact & Terms: Send cover letter with color brochure, tearsheets, photographs, photocopies or transparencies and SASE. Samples are filed "if artwork has potential for our market." Samples are returned by SASE if requested by artist. Reports back within 1 month. Portfolio review not required. Rights purchased vary according to project. Originals are returned at job's completion. Pays by the project, royalties of 2-5%; sometimes purchases outright.

Tips: Finds artists through magazines, trade shows, word of mouth, licensors/reps. "Current popular subjects in our industry: florals, country/folk art, garden themes, ocean themes, celestial, Southwest/Native American, Victorian, juvenile/baby and whimsical."

‡EARTH CARE, 966 Mazzoni, Ukiah CA 95482. (707)468-9292. Fax: (707)468-0301. E-mail: realgood@ well.sf.ca.us. Art Director: Robert Klayman. Estab. 1983. Produces greeting cards, note cards and stationery; primarily mail order. "All of our products are printed on recycled paper and are targeted toward nature enthusiasts and environmentalists."

Needs: Buys 50-75 freelance illustrations/year. Uses freelancers for greeting cards, giftwrap, note cards, stationery and postcards. Considers all media. Produces Christmas cards; seasonal material should be submitted 18 months before the holiday.

Gwyn Wahlmann created this illustration for Earthnotes, an environmentally-friendly line of note cards from Earthcare. "The design captures the idea of the unity of nature, and nature's special relationship to the divine," says Earthcare's Robert Klayman. The cards, printed on 100% recycled paper with soy inks, come in packages of 12 wrapped in biodegradable cellulose. Klayman says this card has strong retail and wholesale sales. The artist received an advance against royalties for the project.

First Contact & Terms: "For initial contact, artists should submit samples which we can keep on file." Must include SASE for return. Reports back within 1 month. Originals are returned at job's completion. Pays 3-5% royalties plus a cash advance on royalties; or pays flat fee. Buys reprint rights.

Tips: "In the industry, environmentally sound products (our main focus) are becoming more popular. Ethnic art is also popular. We primarily use nature themes. We accept only professional quality work and consider graphic, realistic or abstract designs. We would like to develop a humor line based on environmental and social issues."

ENESCO CORPORATION, 225 Windsor Dr., Itasca IL 60143. (708)875-5748. Fax: (708)875-5349. Manager of New Product Design: Karen F. George. Producer and importer of fine giftware and collectibles, such as ceramic, porcelain bisque and earthenware figurines, plates, hanging ornaments, bells, thimbles, picture frames, decorative housewares, music boxes, dolls, tins, crystal and brass. Clients: gift stores, card shops and department stores.
Needs: Works with 300 freelance artists/year. Assigns 1,000 freelance jobs/year. Prefers artists with experience in gift product and packaging development. Uses freelancers for rendering, illustration and sculpture. Needs computer-literate freelancers for design, illustration, production and presentation. 50% of freelance work demands knowledge of Photoshop, QuarkXPress or Adobe Illustrator.
First Contact & Terms: Send query letter with brochure, résumé, tearsheets, photostats and photographs. Samples are filed or are returned. Reports back within 2 weeks. Pays by the project.
Tips: "Contact by mail only. It is better to send samples and/or photocopies of work instead of original art. All will be reviewed by Senior Creative Director, Executive Vice President and Licensing Director. If your talent is a good match to Enesco's product development, we will contact you to discuss further arrangements. Please do not send slides. Have a well thought-out concept that relates to giftware products before mailing your submissions."

ENVIRONMENTAL PRESERVATION INC. (EPI Marketing), 250 Pequot Ave., Southport CT 06490. (203)255-1112. Fax: (203)255-3313. Vice President Marketing: Merryl Lambert. Estab. 1989. Produces greeting cards, posters, games/toys, books, educational children's gifts.
Needs: Works with "many" freelancers/year. Buys "many" designs and illustrations/year. Prefers freelancers with experience in nature images and sports. Works on assignment only. Uses freelancers for P-O-P displays and mechanicals. Needs computer-literate freelancers for design, production and presentation. Freelancers should be familiar with Aldus PageMaker, QuarkXPress, Adobe Illustrator or Adobe Photoshop.
First Contact & Terms: Send query letter with brochure, tearsheets and slides. Samples are filed and are not returned. Reports back to the artist only if interested. Art Director will contact artist for portfolio review if interested. Originals are returned at job's completion. Negotiates rights purchased.

‡**EP CONCEPTS**, P.O. Box 363, Piermont NY 10968. (914)359-7137. Fax: (914)365-0841. Owner: Steve Epstein. Estab. 1983. Produces greeting cards. "We're looking to expand to graphic designs and cartoons where we could also apply our messages. We now take mostly antique photography and apply funny, romantic and topical messages." Approached by 23-30 freelancers/year. Works with 10-15 freelancers/year. Prefers artists with experience in greeting cards; cartoons and illustrations are preferable. Considers any media. "Any style that interprets the message." Prefers 5×7. Needs computer-literate freelancers for design and illustration. Freelancers should be familiar with Adobe Illustrator, Adobe Photoshop, QuarkXPress, Aldus FreeHand and Aldus PageMaker, "although not absolutely necessary." Produces material for all holidays and seasons, Christmas, Valentine's Day, Mother's Day, Father's Day, Easter, Hannukkah, Passover, Rosh Hashanah, graduation, Thanksgiving, New Year, Halloween, birthdays, everyday, St. Patrick's Day, anniversaries, college humor, adult "light" risque, inspirational (but funny not sappy). Submit seasonal material 2 months in advance.
First Contact & Terms: Send query letter with photocopies or whatever is the least expensive way. Samples are filed or returned by SASE. Reports back within 1 week only with SASE. Company will contact artist for portfolio review if interested. Portfolio should include final art. Buys one-time rights. Originals are returned at job's completion. Pays by the project, $50-75/greeting card idea.
Tips: Finds artists through artists' submissions, word of mouth and advertising in art schools. "It's always good to see political or topical cartoons or illustrations, but they must be light and funny and less satirical."

‡**EQUITY MARKETING, INC.**, 11444 W. Olympic Blvd., Los Angeles CA 90064. (310)231-6000. Fax: (310)231-6025. Director, Creative Services: Katie Cahill. Specializes in design, development and production of promotional, toy and gift items, especially licensed properties from the entertainment industry. Clients include Tyco, Applause, Avanti and Ringling Bros. and worldwide licensing relationships with Disney, Warner Bros., 20th Century Fox and Lucas Film.
Needs: Needs product designers, sculptors, packaging and display designers, graphic designers and illustrators. Prefers whimsical and cartoon styles. Products are typically targeted at children. Works on assignment only.
First Contact & Terms: Send query letter with tearsheets, résumé and slides. Samples are returned by SASE if requested by artist. Reports back within 1 month. To show portfolio, mail thumbnails, roughs, original, final art and samples. Rights purchased vary according to project. Pays for design by the project, $50-1,200. Pays for illustration by the project, $75-3,000.
Tips: Finds artists through word of mouth, network of design community, agents/reps. "Gift items will need to be simply made, priced right and of quality design to compete with low prices at discount houses."

EUROPEAN TOY COLLECTION/CROCODILE CREEK, 6643 Melton Rd., Portage IN 46368. (219)763-3234. Fax: (219)762-1740. President: Mel Brown. Estab. 1984. Produces "high quality, well-designed toys, children's gifts, books and decorative accessories. Works with all major museums, catalogs, department

stores and specialty stores. An innovative, creative company committed to imaginative well-designed children's products. Listed in INC 500 as one of the fastest growing small companies in the US. Winner of several Parents' Choice Awards."

Needs: Approached by 100 freelancers/year. Works with 10 freelancers/year. Buys 10-20 designs and illustrations/year. Prefers freelancers with experience in a variety of media. "Over the next few years we plan on expanding and broadening our product development and creative department significantly." Uses freelancers mainly for product development and P-O-P and show display. "Artists can contact us for a free catalog—to get some ideas of our current products."

First Contact & Terms: Send query letter with photographs. Samples are filed. Reports back only if interested. "We currently will contact artist for portfolio review after they've made initial inquiry." Portfolio should include color tearsheets and photographs. Sometimes requests work on spec before assigning a job. Rights purchased vary according to project. Interested in buying second rights (reprint rights) to previously published work.

Tips: Finds artists through networking, artists' submissions and exhibitions. "There are many opportunities for original, creative work in this field."

THE EVERGREEN PRESS, INC., 3380 Vincent Rd., Pleasant Hill CA 94523. (415)933-9700. Art Director: Malcolm K. Nielsen. Publishes greeting cards, giftwrap, stationery, quality art reproductions, Christmas cards and postcards.

Needs: Approached by 750-1,000 freelancers/year. Buys 200 designs/year from freelancers. Uses freelancers mainly for greeting cards, Christmas cards and giftwrap and product design. Uses only full-color artwork in any media. Seeks unusual designs, sophisticated art and humor or series with a common theme. No super-sentimental Christmas themes, single greeting card designs with no relation to each other, or single-color pen or pencil sketches. Roughs may be in any size to get an idea of work; final art must meet size specifications. Would like to see nostalgia, ecology, sports scenes and fine-arts-oriented themes. Produces seasonal material for Christmas, Easter, Mother's Day and Valentine's Day. "We examine artwork at any time of the year to be published for the next following holiday."

First Contact & Terms: Send query letter with brochure showing art style or slides and actual work; write for art guidelines. Samples returned by SASE. Reports within 2 weeks. Originals are returned at job's completion. Negotiates rights purchased. "We usually make a cash down payment against royalties; royalty to be negotiated." Pays on publication.

Tips: Sees "trend toward using recycled paper for cards and envelopes and subject matter involving endangered species, the environment and ecology. Spend some time in greeting card stores and become familiar with the 'hot' cards of the moment. Try to find some designs that have been published by the company you approach."

‡FERNBROOK LANE STATIONERY, 2533 Fernbrook Lane, Plymouth MN 55447. (612)476-6797. Fax: (612)476-2738. General Manager: Michele Netka. Estab. 1987. Produces stationery, giftwrap, packaged cards and tablets. "We manufacture packaged cards, invitations, thank yous, note cards, for all age groups—bold graphic designs to formal."

Needs: Approached by 6 freelancers/year. Works with 3 freelancers/year. Buys 100 freelance designs and illustrations/year. Prefers artists with experience in card designs and giftwrap. Uses freelancers for all product artwork. Considers watercolor, pencil and computer graphics. Prefers 5×7 minimum. Needs computer-literate freelancers for design. Freelancers should be familiar with Adobe Illustrator and Adobe Photoshop. Produces material for Christmas, graduation, birthdays and everyday. Submit seasonal material 3 months in advance.

First Contact & Terms: Send query letter with résumé, SASE and any samples. Samples are filed or returned by SASE if requested by artist. Reports back within 1 month. Company will contact artist for portfolio review if interested. Rights purchased vary according to project (may buy all rights). Originals are not returned. Pays by the project, $50-150.

Tips: Finds artists through trade shows, artists' submissions and word of mouth. "Show a variety of abilities."

‡FINE ART PRODUCTIONS, 67 Maple St., Newburgh NY 12550-4034. Phone/fax: (914)561-5866. Contact: Richie Suraci. Estab. 1994. Produces greeting cards, stationery, calendars, posters, games/toys, paper tableware products, giftwrap, CD-ROMs, video/film backgrounds, magazine, newspaper print. "Our products are fantasy, New Age, sci-fi, outer space, environmental, adult erotica."

Needs: Prefers freelancers with experience in sci-fi, outer space, adult erotica, environmental, fantasy and mystical themes. Uses freelancers for calligraphy, P-O-P displays, paste-up and mechanicals. Considers all media. Needs computer-literate freelancers for design, illustration, production and presentation. 50% of freelance work demands knowledge of Adobe Illustrator, Adobe Photoshop, QuarkXPress, Aldus FreeHand, Aldus PageMaker, SGI and ImMix. Produces material for all holidays and seasons and Valentine's Day. Submit seasonal material 1 year in advance.

First Contact & Terms: Send query letter with brochure, tearsheets, photostats, résumé, photographs, slides, SASE, photocopies and transparencies. Samples are filed or returned by SASE if requested by artist. Reports back within 3-4 months if interested. Company will contact artist for portfolio review if interested. Portfolio

Presentation Is Key to Greeting Card Success

The nearly $6 billion greeting card industry has invaded drugstores, supermarkets, discount stores, bookstores and other outlets. This creates a burgeoning market for freelancers. Gibson Greetings, Inc., one of "The Big Three" card producers along with Hallmark and American Greetings, often uses nearly 200 freelancers a year, according to Anna Bower, design director for Everyday and Specialty Products.

Anna Bower

"We have a highly-trained inhouse staff," Bower says, "But we have a roster of over 200 freelancers. Among these there's a core group of 85 to 90 who we use often."

Bower, an illustrator for more than five years before joining Gibson, tells how to break into the market. "The best way to start is to go inside for a while; get a job with a card company for a year or two until you understand the product. You don't have to do it this way, but it's the quickest."

Gibson looks for illustrators who can draw well and who have a finely-honed color sense. "Sometimes we see self-made artists with no formal training, but that's the exception," she says. As an exercise, she advises freelancers to practice drawing and painting flowers and people, which she says are difficult to render but are the backbone of the company's stock-in-trade.

Before you can get a freelance assignment from a card company, you must create an artist's equivalent of a résumé: your portfolio. "You need to present your work professionally, not just loose in a folder," says Bower. She likes to see up to 20 samples of original artwork. Work is usually sent for consideration in actual card size, 4⅝ × 7½, but Gibson reproduces even from enormous paintings.

"A beautiful portfolio format using, say, a printed sample on a specialty paper stock to lend unity and cohesiveness, adds to the attractiveness of the presentation and shows your skill, too," Bower says. But she emphasizes that even a less attractively arranged portfolio, if the work is well done, will be considered.

"We like to see both variety (of styles) and a consistent level of execution of finished paintings. Size isn't important. It's OK to send original art, C-prints, digital outputs, transparencies or printed samples. But it's crucial to show color. You can have b&w in there, but there must be color, too. In terms of drawing, it's important to remember that greeting cards are idyllic and pretty and color enhances these qualities. Be sure the color can be reproduced. No fluorescents."

Bower says artists should keep the typical customer in mind. More than 90 percent of card buyers are women. They like cards with cats and dogs, flowers

and what she calls "cutes," endearing human or animal characters. Gibson doesn't like to receive material that's overtly sexual or violent. It shows the artist doesn't understand the market, she says.

Artists who want to design greeting cards also must "be extremely reliable. Get jobs in on time and keep your quality level consistently high. If an art director gets burnt, he or she won't use you again. Show a variety of styles when you submit. We like to be able to assign work and know you'll come through."

Almost all Gibson freelancers work on assignment. Artists whose work meets the company's needs receive an information packet detailing procedures for submissions. Card design begins with what Bower calls the "editorial"—the card's verse or wording. It's up to the artist to catch the spirit of the verbal message and create a marriage between word and illustration. Calligraphy artists are invited to submit lettering samples separately for consideration.

Because greeting card companies like to stay on the cutting edge of trends, Bower advises artists to be informed about design innovations. "Artists can do their own research. I love to consult European magazines—*Marie Claire* and *Maison Jardin*—and, in America, *Elle Decor*, *Veranda* and *House and Garden*," Bower says. She adds that Victorian themes are currently popular. So are sunflowers, angels, natural and recycled looks and technologies such as prismatics and holograms.

What's next in design trends? Bower encourages artists to find their own answers. "Think in new directions and research to see what's new," she says. "The art director does this, but it's important also to have the artist's help. The bottom line is: put your whole heart and soul into your paintings. That's the best formula for success."

—*Mari Messer*

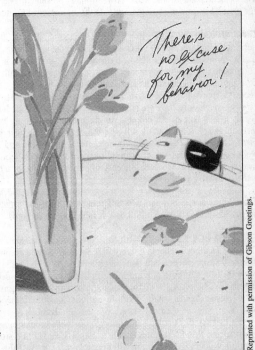

Gibson Greetings' Anna Bower provides both art direction and artwork for the company's extensive and popular card line. The inside copy for this card illustrated by Bower reads ". . . but give me time—I'll try to think of one! Sorry."

should include thumbnails, roughs, final art, photostats, tearsheets, photographs, slides and transparencies. Rights purchased vary according to project. Originals are returned at job's completion. Pays by the hour, by the project or royalties.

Tips: Finds artists through agents, sourcebooks, magazines, word of mouth and artists' submissions. "Send unique material that is colorful."

FRAVESSI GREETINGS, INC., 11 Edison Place, Springfield NJ 07081. (201)564-7700. Fax: (201)376-9371. Art Director: Janet Thomassen. Estab. 1930. Produces greeting cards, packaged goods, notes.

• Fravessi has added some contemporary styles to its usual traditional look. Now considers cartoons.

Needs: Approached by 25 freelancers/year. Works with 12 freelancers/year. Uses freelancers for greeting card design. Considers watercolor, gouache, and pastel. Especially needs seasonal and everyday designs; prefers cute and whimsical imagery. Produces seasonal material for Christmas, Mother's Day, Father's Day, Thanksgiving, Easter, Valentine's Day, St. Patrick's Day, Halloween, graduation, Jewish New Year and Hanukkah. Submit seasonal art 1 year in advance.

First Contact & Terms: Send query letter and samples of work. Include SASE. Reports in 2-3 weeks. Provide samples to be kept on file for possible future assignments. Art Director will contact artist for portfolio review if interested. Originals are not returned. Requests work on spec before assigning a job. Pays flat fee of $125-200/illustration or design. **Pays on acceptance.** Buys all rights.

Tips: Finds artists through word of mouth and artists' submissions. Must now implement "tighter scheduling of seasonal work to adapt to changing tastes. There is an emphasis on lower priced cards. Check the marketplace for type of designs we publish."

‡FREEMAN SPORTS APPAREL CO., 830 Taylor St., Elyria OH 44035. (216)322-5140. Fax: (216)322-6784. Chief Artist: Mark Brabant. Estab. 1989. Produces sports apparel particularly golf and ski wear.

Needs: Approached by 20-30 freelancers/year. Works with 2-3 freelancers/year. Buys 5-10 freelance designs and illustrations/year. Prefers artists with experience in Mac-based programs. Uses freelancers mainly for apparel designs. Considers hard copy and Mac files. Looking for athletic-oriented appeal. Prefers no larger the 8½×11 to start. Needs computer-literate freelancers for design and illustration. 99.9% of freelance work demands knowledge of Adobe Illustrator 5.0, Adobe Photoshop 3.0, Aldus FreeHand 4.0 and Aldus Page-Maker 5.0. Produces material for Christmas, spring and fall. Submit seasonal material 6-8 months in advance.

First Contact & Terms: Send query letter with tearsheets, résumé, photographs, SASE and photocopies. Samples are not filed and returned by SASE if requested by artist. Company will contact artist for portfolio review if interested. Buys all rights. Originals are not returned. Payment negotiated per artist.

Tips: "Send professional work, professionally presented. There are a lot of unqualified candidates who apply for work. The proper presentation cuts through a lot of clutter."

G.A.I. INCORPORATED, Box 30309, Indianapolis IN 46230. (317)257-7100. President: William S. Gardiner. Licensing agents. "We represent artists to the collectibles and gifts industries. Collectibles include high-quality prints, collector's plates, figurines, bells, etc. There is no up-front fee for our services. We receive a commission from any payment the artist receives as a result of our efforts." Clients: Lenox, Enesco, The Bradford Exchange and The Hamilton Group.

Needs: Approached by 100 freelancers/year. Works with 50 freelance illustrators and 5 designers/year. Works on assignment only. "We are not interested in still lifes or modern art. A realistic—almost photographic—style seems to sell best to our clients. We are primarily looking for artwork featuring people or animals. Young animals and children usually sell best. Paintings must be well done and should have broad emotional appeal."

First Contact & Terms: Send query letter with résumé and color photographs; do *not* send original work. Request portfolio review in original query. Samples not kept on file are returned by SASE. Reports in 1-3 months. Payment: "If we are successful in putting together a program for the artist with a manufacturer, the artist is usually paid a royalty on the sale of the product. This varies from 4-10%. Payment is negotiated individually for each project."

Tips: Finds artists through word of mouth, magazines, artists' submissions/self-promotions, sourcebooks, agents, visiting artists' exhibitions, art fairs and artists' reps.

GALISON BOOKS, 36 W. 44th St., New York NY 10036. (212)354-8840. Fax: (212)391-4037. Design Director: Heather Zschock. Estab. 1978. Produces boxed greeting cards, puzzles, address books and specialty journals. Many projects are done in collaboration with museums around the world.

• Galison Books is moving toward more contemporary designs.

Needs: Works with 10-15 freelancers/year. Buys 20 designs and illustrations/year. Works on assignment only. Uses freelancers mainly for illustration. Considers all media. Also produces material for Christmas and New Year. Submit seasonal material 1 year in advance.

First Contact & Terms: Send query letter with brochure, résumé and tearsheets (no unsolicited original artwork) and SASE. Samples are filed. Reports back to the artist only if interested. Request portfolio review in original query. Art Director will contact artist for portfolio review if interested. Portfolio should include color photostats, slides, tearsheets and dummies. Originals are returned at job's completion. Rights purchased vary according to project.

Tips: Finds artists through word of mouth, magazines and artists' reps.

‡GARBORG'S, 2060 W. 98th St., Bloomington MN 55431. (612)888-5727. Fax: (612)888-4775. Product Development: Joanie Garborg. Produces inspirational page-a-day perpetual calendars and some book product, marketed to giftshops and Christian bookstores. Majority of buyers are women of all ages; line includes some masculine and children's products.

Needs: Works with 15 freelancers/year. Buys 30 freelance designs and illustrations/year. Prefers freelancers with experience in paper products. Uses freelancers mainly for color illustration. Also uses freelancers for calligraphy and P-O-P displays. Considers watercolor, gouache, colored pencil, dyes, mixed media, rarely oils. Prefers joyful, warm-hearted, uplifting art. Prefers feminine look: florals, botanicals, soft scenes, still lifes, patterns. Considers some masculine looks: wildlife, graphics, cartoon art. Also needs highly detailed, highly rendered art. Needs computer literate freelancers with experience in Aldus FreeHand and Adobe Illustrator. Produces seasonal material for Christmas, Valentine's Day, Mother's Day, Father's Day, birthdays and everyday.

First Contact & Terms: Send query letter with résumé. Samples are filed or returned by SASE if requested by artist. Reports back in 2 weeks. Company will contact artist for portfolio review if interested. Portfolio should include color photostats, photographs, tearsheets and final art. Negotiates rights purchased. Originals not returned at job's completion. Pays by the project, $350 average.

C.R. GIBSON CO., (formerly Creative Papers by C.R. Gibson), 32 Knight St., Norwalk CT 06856-5220. (203)847-4543. Fax: (203)847-1165. Freelance Coordinator: Harriet Richards. Estab. 1870. Produces greeting cards, stationery, paper tableware products, giftwrap, gift books, baby books, wedding books, photo albums, scrap books, kitchen products (recipe books and coupon files). "The C.R. Gibson Company has a very diversified product line. Generally we sell our products to the better markets including department stores, gift shops and stationery stores. Our primary consumers are women buying for themselves or men. Masculine products and designs make up less than 10% of the lines. Our designs are fashionable without being avant-garde, always in good taste."

Needs: Approached by 250-300 freelancers/year. Works with 60-80 freelancers/year. Buys 200 freelance designs and illustrations/year. Prefers artists with experience in traditional materials; rarely uses computer generated art. Works on assignment 90% of time. Uses freelancers for everything. Considers all traditional media. Looking for conservative, traditional looks—no abstract or regional themes. Most designs subject-oriented—"pretty," fashionable and in good taste. Uses a very small amount of cartoonists. Does not need computer-literate freelancers, although computer skills are helpful. Produces material for Christmas, Hannukkah, New Year, birthdays and everyday. Submit Christmas material 1 year in advance.

First Contact & Terms: Send query letter with tearsheets, photostats, photographs, slides, SASE, photocopies and transparencies. Samples are sometimes filed or returned. Reports back within 1 month. Company will contact artist for portfolio review if interested. Portfolio should include "anything appropriate." Rights purchased vary according to project. Originals are returned at job's completion. Pays by the project, $250-1,500; royalties of 2-5%; negotiable with project.

Tips: Finds artists through word of mouth, submissions and agents. "Try to be aware of current design themes and colors. Regional designs should be avoided. Most of our designs are subject-oriented and not abstract prints or designs. Before we can review any artwork we require artists to sign a submission agreement."

‡GIBSON GREETINGS, INC., 2100 Section Rd., Cincinnati OH 45237. (513)841-6600. Director of Design Development: Wayne Wright. Estab. 1850. Produces greeting cards, giftwrap, stationery, calendars and paper tableware products. "Gibson is a leader in social expression products."

Needs: Approached by 300 freelancers/year. Works with 200 freelancers/year. Buys 3,500 freelance designs and illustrations/year. Prefers freelancers with experience in social expression. Works on assignment only. Uses freelancers mainly for greeting cards. Considers any media and a wide variety of styles. Needs computer-literate freelancers for design and illustration. 40% of freelance work demands knowledge of Adobe Illustrator, Adobe Photoshop and QuarkXPress. Produces material for all holidays and seasons. Submit seasonal material 1 year in advance.

First Contact & Terms: Send query letter with résumé, SASE, tearsheets, photographs, photocopies, photostats, slides, transparencies. Samples are filed if accepted or returned by SASE. Reports back within 1 week. Company will contact artist for portfolio review if interested. Portfolio should include final art, tearsheets,

 A bullet introduces comments by the editor of Artist's & Graphic Designer's Market *indicating special information about the listing.*

photographs, transparencies. "Artwork is bought outright—all rights and art belong to company." Originals are not returned. Pays by the project, $350-1,000.
Tips: "Excellent drawing skills and color abilities are crucial, as well as ability to meet deadlines and carry through on technical aspects of artwork preparation."

‡GK ENTERPRISES, 89 Greene St., 3rd Floor, New York NY 10012. (212)941-1511. Fax: (212)941-7322. Director of Tee-Branch: Digby Carter. Estab. 1994. Produces T-shirts. "GK Enterprises is a distribution company for Art Unlimited (Netherlands); distributes posters, art books, postcards and note cards. Presently GKE is establishing its own retail line in apparel (caps and shirts). Our markets have always been specialty gift, alternative, European, age 25 and up."
Needs: Approached by 20 freelancers/year. Works with 10-15 freelancers/year. Prefers artists with experience in screen printing. For T-shirts, looking for clear, bold designs. "Our T-shirts are design rather than topic—words, when well designed are as important to us as images." Does not need computer-literate freelancers.
First Contact & Terms: Send query letter with photocopies. Samples are filed. Reports back within 3 weeks. Company will contact artist for portfolio review if interested. Portfolio should include roughs, final art (camera ready). Rights purchased vary according to project. Originals are returned at job's completion. Pays 5% royalty.
Tips: Finds artists through word of mouth and artists' submissions. "Be extremely creative, good natured and knowledgeable about how your art will look on the finished product. Our product is very trend-oriented, so we are always looking for artists who are way ahead of their time."

GREAT AMERICAN PUZZLE FACTORY INC., 16 S. Main St., S. Norwalk CT 06854. (203)838-4240. Fax: (203)838-2065. President: Pat Duncan. Estab. 1975. Produces jigsaw puzzles and games for adults and children.
Needs: Approached by 100 freelancers/year. Works with 50 freelancers/year. Buys 60 designs and illustrations/year. Uses freelancers mainly for puzzle material. Looking for "fun, involved and colorful" work. Needs computer-literate freelancers for box design.
First Contact & Terms: Send query letter with brochure and photocopies. Do not send originals or transparencies. Samples are filed or are returned. Art Director will contact artist for portfolio review if interested. Original artwork is returned at job's completion. Pays royalties of 5%. Rights purchased vary according to project. Interested in buying second rights (reprint rights) to previously published work.

GREAT ARROW GRAPHICS, 1685 Elmwood Ave., Buffalo NY 14207. (716)874-5819. Fax: (716)874-2775. Art Director: Alan Friedman. Estab. 1981. Produces greeting cards and stationery. "We produce silkscreened greeting cards—seasonal and everyday—to a high-end design-conscious market."
Needs: Approached by 20 freelancers/year. Works with 3-4 freelancers/year. Buys 30-40 images/year. Prefers freelancers with experience in hard-separated art. Uses freelancers mainly for greeting card design. Considers all 2-dimensional media. Looking for sophisticated, classic or contemporary styles. Needs computer-literate feelancers for design. Freelancers should be familiar with QuarkXPress, Adobe Illustrator or Adobe Photoshop. Produces material for all holidays and seasons. Submit seasonal material 6-8 months in advance; Christmas, 1 year in advance.
First Contact & Terms: Send query letter with brochure, résumé, SASE, photographs, photostats and slides. Samples are filed or returned if requested. Reports back within 1 month. Art Director will contact artist for portfolio review if interested. Portfolio should include color roughs, final art, photographs and transparencies. Originals are returned at job's completion. Pays royalties of 5% of production at wholesale. Rights purchased vary according to project.
Tips: "We are most interested in artists familiar with hand-separated process and with the assets and limitations of screenprinting."

‡*GREETWELL, D-24, M.I.D.C., Satpur, Nasik 422 007 India. Chief Executive: V.H. Sanghavi. Produces greeting cards, calendars and posters.
Needs: Approached by 50-60 freelancers/year. Buys 50 designs/year. Uses freelancers mainly for greeting cards and calendars. Prefers flowers, landscapes, wildlife and general themes.
First Contact & Terms: Send color photos and samples to be kept on file. Samples not filed are returned only if requested. Reports within 1 month. Originals are returned at job's completion. Pays flat fee of $25 for design. Buys reprint rights.
Tips: "Send color photos. No SASE."

‡GROUP PUBLISHING—BOOK & CURRICULUM DIVISION, 2890 N. Monroe, Loveland CO 80538. (303)669-3836. Fax: (303)669-3269. Art Director: Lisa Smith. Produces posters, puzzles, curriculum products for use in Christian education.
 • This company also publishes books and magazines. See listings in those sections for information.

HALLMARK CARDS, INC., P.O. Box 419580, Drop 216, Kansas City MO 64141-6580. Contact: Carol King for submission agreement and guidelines; include SASE, no samples.

Needs: Works on assignment only. Limited needs for general/humor illustration and surface design. Product formats range from paper items such as greeting cards, puzzles and giftwrap to gift items. Buys all rights.
First Contact & Terms: Write for submission guidelines before sending samples. Samples will not be accepted without a submission agreement form.
Tips: "Hallmark has a large and talented creative staff. Freelance designers must show professional experience, exceptional originality and technical skill."

THE HAMILTON COLLECTION, 4810 Executive Park Court, Jacksonville FL 32216-6069. (904)279-1300. Artist Liaison, Product Development: Kathryn McGoldrick. Direct marketing firm for collectibles: limited edition plates, sculpture, dolls, jewelry and general gifts. Clients: general public, specialized lists of collectible buyers and retail market in US, Great Britain, Canada, France and Germany.
Needs: Approached by 100 freelancers/year. Works with 100-200/year. Assigns all jobs (200-400) to freelancers/year. "No restrictions on locality but must have quality work and flexibility regarding changes." Uses freelancers for product design and illustration. Needs fine art for plates.
First Contact & Terms: Send query letter with samples. Samples will be returned if requested (must include a SASE or appropriate package with sufficient postage). "Please do not send original art; preferences are for photographs, slides, transparencies, and/or tearsheets." Reports within 6-12 weeks. Artist should follow-up with letter after initial query. Sometimes requests work on spec before assigning a job. Pays by the project, $100-1,500. Sometimes interested in buying second rights (reprint rights) to previously published work "for product development in regard to collectibles/plates; artwork must be suitable for cropping to a circular format."
Tips: Open to a wide range of styles "We aggressively seek out new talent for our product development projects through every avenue available. Attitude and turnaround time are important. Be prepared to offer sketches on speculation. This is a strong market (collectibles) that has continued its growth over the years, despite economic slumps."

H&L ENTERPRISES, 1844 Friendship Dr., El Cajon CA 92020. (619)448-0883. Fax: (619)448-7935. Operations Vice President: Carol Lorsch. Estab. 1978. Produces posters, novelty, humorous signs and magnets for all ages (6-adult).
Needs: Approached by 25 freelancers/year. Works with 4 freelancers/year. Prefers freelancers with experience in art for silkscreen process. Must have cartoon-like style and imagination in illustrating humorous slogans. Works on assignment only. Uses freelancers mainly for product illustration. Looking for simple, cartoon style.
First Contact & Terms: Send query letter with tearsheets and sketches. "If you want samples back include SASE." Reports back within 15 days. "Be sure to provide phone number." Art Director will contact artist for portfolio review if interested. Artist should follow-up with call after initial query. Requests work on spec before assigning a job. Originals are not returned. Pays flat fee of $25 for quick illustration/design. Considers buying second rights (reprint rights) to previously published work and rights to licensed characters.
Tips: Finds artists through word of mouth and artists' reps. "We're not interested in fine art. Interested in quick-sketch illustrations of humorous sayings. Don't use scanners to copy others' work and plagiarize it."

‡HAPPY TUSH CARD COMPANY INC., 25 Lakeside Dr., Centerport NY 11721. (800)666-TUSH. Fax: (516)754-9107. Vice President: Amy Schneider. Estab. 1993. Produces greeting cards for all ages—"humorous, unique, fun, artistic."
Needs: Approached by 50 freelancers/year. Works with 5 freelancers/year. Buys 50 freelance designs and illustrations/year. Uses freelancers to create artwork to complement our verse. Considers all media. Looking for fun, contemporary, beautiful artwork. Prefers 5×7. Needs computer-literate freelancers for design, illustration, production and presentation. 50% of freelance work demands computer skills. Produces material for Christmas, Valentine's Day, Mother's Day, Father's Day, graduation, Halloween, birthdays and everyday. Submit seasonal material 6-8 months in advance.
First Contact & Terms: Send query letter with quality samples. Samples are not filed and are returned by SASE. Reports back within 1 month. Company will contact artist for portfolio review if requested. Portfolio should include representative samples. Buys all rights. Originals are not returned. Pays $35 and up for each card design purchased, royalty arrangements may be considered.
Tips: Finds artists through word of mouth and artists' submissions.

‡KATE HARPER DESIGNS, P.O. Box 2112, Berkeley CA 94702. E-mail: kate.harper@tigerteam.org. Contact: Art Director. Estab. 1987. Produces greeting cards. "Kate Harper Designs are a line of greeting cards for the '90s: how to cope with family, work, life—with a twist of humor. These cards are calligraphic, with quotations being the design emphasis."
Needs: "I am opening up my line for the first time to hired artists." Prefers freelancers with experience in combining quotations with artwork. Works on assignment only. Uses freelancers mainly for new card designs. Also for calligraphy. Looking for a hand-made element of style. Prefers 4½×6⅛. Needs computer-literate freelancers familiar with communication via modem. Produces material for Valentine's Day, birthdays and everyday. Submit seasonal material at least 6 months in advance.

First Contact & Terms: Send postcard-size sample of work or query letter with SASE and any samples. Samples are filed. Reports back within 3 months. Portfolio review not required. Rights purchased vary according to project. Originals are returned at job's completion. Pays by the project, $25-200.

HIGH RANGE GRAPHICS, 365 N. Glenwood, P.O. Box 3302, Jackson WY 83001. President: Jan Stuessl. Estab. 1989. Produces T-shirts. "We produce screen-printed garments for the resort market. Subject matter includes, but is not limited to, skiing, climbing, hiking, biking, fly fishing, mountains, out-of-doors, nature and rafting. We do designs for kids, college age, and 'youthful at any age' men and women. Some designs incorporate humorous text."
Needs: Approached by 20 freelancers/year. Works with 10 freelancers/year. Buys 10-20 designs and illustration/year. Prefers artists with experience in screen printing. Uses freelancers mainly for T-shirt ideas and artwork and color separations. Prefers artwork 10-12 wide × 12-16 tall. Will accept computer-generated artwork.
First Contact & Terms: Send query letter with résumé, SASE, photocopies and photographs. Samples are filed or are returned by SASE if requested by artist. Reports back within 2 months. Company will contact artist for portfolio review if interested. Portfolio should include b&w thumbnails, roughs and final art. Originals are returned at job's completion. Pays by the project, $300 minimum; royalties of 5%. Buys garment rights.
Tips: "Familiarize yourself with screen printing and T-shirt art that sells. Know how to do color separations that are production friendly. Designs should evoke an emotional connection for retail customers with their vacation experience or activity. Ink colors should work on several shirt colors. We must have creative new ideas for same old subject matter. Be willing to work with us on design changes to get the most marketable product."

‡HIXSON & FIERING, INC., 3734 W. 95th St., Leawood KS 66206. Fax: (913)752-1201. Art Director: Suzy Turner. Estab. 1987. Produces birth announcements and invitations. "We started out as a birth announcement company, branched off into children's party invitations and now do party invitations for adults as well."
Needs: Approached by 30 freelancers/year. Works with 5 freelancers/year. Buys 20-30 freelance designs and illustrations/year. Uses freelancers mainly for card design. Also interested in calligraphy. Buys art outright and by assignment. "If the artist has a style we like and is a good conceptualizer, we will approve a sketch, then he gives us the final product." Considers watercolor, acrylic (soft) and pastels. Also interested in computer generated art using Adobe Illustrator, PhotoShop, QuarkXPress and Fractal Painter. Prefers high quality, whimsical, but not cartoonish artwork for the baby and children's lines. Nothing that could be construed as negative or off color in any way. Prefers work that is soft, happy and colorful. Needs computer-literate freelancers for design. "In the past, 95% of our designs were electronic—but we are moving away from that look." Produces seasonal material for Christmas, New Year, Valentine's Day, Halloween, graduation and birthdays. Submit seasonal material 6 months in advance.
First Contact & Terms: Send query letter with color copies of work. "Please do not call. Will only take mail or fax inquiries." Samples are filed or are returned. Reports back in 1 month. Company will contact artist for portfolio review of final art if interested. Rights purchased vary according to project. Originals are not returned at job's completion. Payment varies according to project.
Tips: "We are starting to work on some lines of elegant, embossed and foil stamped cards for birth, christening and adult invitations. So, we need the soft, warm and cuddly children's things as well as elegant formal designs."

‡THE HUMORSIDE OF IT . . . , 7030 Etiwanda Ave., Resida CA 91335. (818)757-3814. Owner: Lorenzo Griffie. Estab. 1990. Produces greeting cards with personalized printing. Makes "very humorous greeting cards; very colorful, loaded with different fonts; directed to all ages; very modern graphics."
Needs: Approached by 7-10 freelancers/year. Works with 2 freelancers/year. Prefers local artists with experience in humor and graphics cartoons. Works on assignment only. Uses freelancers mainly for cartoons, humor and graphics. Needs computer-literate freelancers for design. 50% of freelance work demands knowledge of Aldus PageMaker and Corel Draw. Produces material for all holidays and seasons, Christmas, Valentine's Day, Mother's Day, Father's Day and everyday. Submit seasonal material 3 months in advance.
First Contact & Terms: Send query letter with brochure and photographs. Samples are filed. Reports back within 2 weeks. Company will contact artist for portfolio review if interested. Portfolio should include photographs. Rights purchased vary according to project. Originals are returned at job's completion. Pays by the project, royalties of 3%.
Tips: Finds artists through artists' submissions.

HURLIMANN ARMSTRONG STUDIOS, Box 1246, Menlo Park CA 94026. (415)325-1177. Fax: (415)324-4329. Managing General Partner: Mary Ann Hurlimann. Estab. 1987. Produces greeting cards and enclosures, fine art folders, stationery, portfolios and pads.
Needs: Approached by 60 freelance artists/year. Works with 6 freelancers/year. Buys 16 designs/year. Considers watercolor, oil and acrylic. No photography. Prefers rich color, clear images, no abstracts. "We have

some cards that use words as the central element of the design." Not interested in computer-generated art. Prefers 10 × 14 final art.

First Contact & Terms: Send query letter with slides. Samples are not filed and are returned by SASE if requested by artist. Art Director will contact artist for portfolio review if interested. Originals are returned at job's completion. Requests work on spec before assigning a job. Pays by the project, $250-300; royalties of 5% or fixed fee. Buys all rights.

Tips: "Send good quality slides and photos of your work."

‡THE IMAGINATION ASSOCIATION, 10477 Pearson Place, Shadow Hills CA 91040. (818)353-0804. Fax: (818)353-8914. Creative Director: E.J. Tobin. Estab. 1992. Produces greeting cards, T-shirts, mugs, aprons and magnets. "We are primarily a freelance design firm that has been quite established with several major greeting card and T-shirt companies who, in fact, produce our work. We have a sub-division that manufactures cutting edge, contemporary aprons and T-shirts for the gourmet food market."

Needs: Works with 12 freelancers/year. Artists must be fax accessible and able to work on fast turnaround. Uses freelancers for everything. Considers all media. "We're open to a variety of styles." Needs computer-literate freelancers for design. 10% of freelance work demands knowledge of Adobe Illustrator, Adobe Photoshop and QuarkXPress. "That is rapidly increasing as many of our publishers are going to disc." Produces material for all holidays and seasons. Submit seasonal material 18 months in advance.

First Contact & Terms: Send query letter with brochure, photographs, SASE and photocopies. Samples are filed or returned by SASE if requested by artist. Company will contact artist for portfolio review if interested. Portfolio should include final art, photographs or any material to give indication of range of artist's style. Negotiates rights purchased. Originals are returned at job's completion. Pays royalties—the amount is variable depending on assignment.

Tips: Finds artists via word of mouth from other freelancers or referrals from publishers. Looking for artist "with a style we feel we can work with and a professional attitude. Understand that sometimes our publishers and manufacturers require several revisions before final art and all under tight deadlines. Shelf space for greeting cards on the retail level is becoming extremely competitive, forcing more publishers to test market products or try to guess what will sell. The bottom line is it's all a crap shoot out there! But it's a good thing because, from a commercial point of view, if there were any sure things, we'd all be forced into following the same trend."

‡IN A BOX, 1635 16th St., Santa Monica CA 90404. (310)399-9175. Fax: (310)399-7095. Art Director: Erik Photenhauer. Estab. 1992. Produces greeting cards, stationery and games/toys. "We produce a very diverse mix of products—mostly decorative boxes—for all ages."

Needs: Approached by 100 freelancers/year. Works with 30 freelancers/year. Buys 60 freelance designs and illustrations/year. Uses freelancers mainly for new designs on boxes. Considers all media. Needs computer-literate freelancers for design, illustration, production and presentation. 80% of freelance work demands knowledge of Adobe Illustrator, Adobe Photoshop, QuarkXPress, Aldus FreeHand and Aldus PageMaker. Produces material for all holidays and seasons, Christmas, Valentine's Day, Mother's Day, Father's Day, Easter, graduation, Halloween, birthdays and everyday. Submit seasonal material 6 months in advance.

First Contact & Terms: Send query letter with tearsheets and photocopies, no originals. Samples are filed or returned by SASE if requested by artist. Company will contact artist for portfolio review if interested. Portfolio should include photostats, tearsheets, photographs and transparencies. Rights purchased vary according to project. Originals are returned at job's completion. Pays by the hour, $20-150; royalties of 1-3%.

Tips: Finds artists through submissoins, books and word of mouth. "Angels are still up; sunflowers are out; neon is in."

‡INCOLAY STUDIOS INCORPORATED, 445 North Fox St., San Fernando CA 91340. Fax: (818)365-9599. Art Director: Shari Bright. Estab. 1966. Manufacturer. "Basically we reproduce antiques in Incolay Stone, all handcrafted here at the studio. There were marvelous sculptors in that era, but we believe we have the talent right here in the USA today and want to reproduce living American artists' work."

Needs: Prefers local artists with experience in carving bas relief. Uses freelance artists mainly for carvings. Also uses artists for product design and model making.

First Contact & Terms: Samples not filed are returned. Reports back within 1 month. Call for appointment to show portfolio. Pays royalties; pays by the project, $100-2,000. Negotiates rights purchased.

‡INKADINKADO, INC., 60 Cummings Park, Woburn MA 01801. (617)938-6100. Fax:(617)938-5585. President: Ron Gelb. Estab. 1978. Produces stationery, games/toys and artistic rubber stamps.

Needs: Approached by 20 freelancers/year. Works with 20 freelancers/year. Buys 100-125 freelance designs and illustrations/year. Works on assignment only. Uses freelancers mainly for design. Also for calligraphy, mechanicals, P-O-P displays and paste-up. Considers pen & ink in various styles, from cartoon to nature. Needs computer-literate freelancers for design, illustration and production. 50% of freelance work demands knowledge of Adobe Illustrator, Adobe Photoshop, QuarkXPress, Aldus FreeHand and Aldus PageMaker (all the latest versions). Produces material for all holidays and seasons. Submit seasonal material 5 months in advance.

Gregg Sokolsky has been collaborating on ideas with The Imagination Association for more than seven years. "I love Gregg's 'gonzo' style and all the bizarre touches he adds to his work," says President E.J. Tobin. "Coffees O' The World" was created in 1992, and has since been licensed to a number of companies—it's appeared on T-shirts for Post Industrial Press and Bad Habits, an apron for The Imagination Association, this greeting card for Marcel Schurman, and may appear on mugs in the near future. Sokolsky collects royalties for the work which was done in cell paint.

First Contact & Terms: Send query letter with brochure, tearsheets, resume, photographs, photocopies. Samples are filed. Reports back within 2 weeks. Artist should follow up with letter after initial query. Portfolio should include thumbnails, roughs and final art. Buys all rights, or rights purchased vary according to project. Originals are not returned. Pays by the project $25-50.

Tips: Finds artists through word of mouth and artists' submissions. Looks for "quality work and originality."

INSPIRATIONART & SCRIPTURE, P.O. Box 5550, Cedar Rapids IA 52406. (319)365-4350. Fax: (319)366-2573. Division Manager: Lisa Edwards. Estab. 1993. Produces greeting cards, framed art prints, posters and calendars. "We create and produce jumbo-sized (24×36) posters targeted at pre-schoolers, pre-teens (10-14), teens (15-18) and young adults (18-30). A Christian message is contained in every poster. Some are fine art and some are very commercial. We prefer very contemporary images."

 • Inspirationart & Scripture has added framed art prints to its line. The prints are more traditional and aimed at an older market (30 and older) than their posters.

Needs: Approached by 350-500 freelance artist/year. Works with 60-80 freelancers/year. Buys 80-100 designs and illustrations/year. Christian art only. Uses freelance artists mainly for posters and greeting cards. Considers all media. Looking for "something contemporary or unusual that appeals to teens or young adults." Produces material for Christmas, Valentine's Day, Mother's Day, Father's Day, Easter, graduation, Thanksgiving, New Year's, birthdays and everyday. Submit seasonal material 9-12 months in advance.

First Contact & Terms: Send query letter with photographs, slides, SASE, photocopies and transparencies. Samples are filed or are returned by SASE. Reports back within 3-4 weeks. Company will contact artist for portfolio review if interested. Portfolio should include color roughs, final art, photographs and transparencies. "We need to see the artist's range. It is acceptable to submit 'secular' work, but we also need to see work that is Christian-inspired." Originals are returned at job's completion. Pays by the project, $50-500. Rights purchased vary according to project.

Tips: "The better the quality of the submission, the better we are able to determine if the work is suitable for our use (slides are best). The more complete the submission (e.g., design, art layout, scripture, copy), the more likely we are to purchase the work. We do accept traditional work, but are looking for work that is more commercial and hip (think MTV with values)."

INTERCONTINENTAL GREETINGS LTD., 176 Madison Ave., New York NY 10016. (212)683-5830. Fax: (212)779-8564. Creative Marketing Director: Robin Lipner. Sells reproduction rights on a per country, per product basis. Licenses and syndicates to 4,500-5,000 publishers and manufacturers in 50 different countries. Products include greeting cards, calendars, prints, posters, stationery, books, textiles, heat transfers, giftware, china, plastics, toys and allied industries, scholastic items and giftwrap.

Needs: Approached by 500-700 freelancers/year. Assigns 400-500 jobs and 1,500 designs and illustrations/year. Buys illustration/design mainly for greeting cards and paper products. Also buys illustration for giftwrap, calendars, giftware and scholastic products. Uses traditional as well as humorous and cartoon-style illustrations. Accepts airbrush, watercolor, colored pencil, acrylic, pastel, marker and computer illustration. Prefers "clean work in series format. All card subjects are considered. 20% of freelance work demands knowledge of Adobe Illustrator, Aldus FreeHand or Photoshop.

First Contact & Terms: Send query letter and/or résumé, tearsheets, slides, photographs and SASE. Request portfolio review in original query. Artist should follow-up after initial query. Portfolio should include color tearsheets and photographs. Pays for original artwork by the project. Pays 20% royalties upon sale of reproduction rights on all selected designs. Contractual agreements made with artists and licensing representatives; will negotiate reasonable terms. Provides worldwide promotion, portfolio samples (upon sale of art) and worldwide trade show display.

Tips: Finds artists through word of mouth, self-promotions, visiting artists' exhibitions and artists' reps. "Perhaps we'll see more traditional/conservative subjects and styles due to a slow economy. More and more of our clients need work submitted in series form, so we have to ask artists for work in a series or possibly reject the odd single designs submitted. Make as neat and concise a presentation as possible with commercial application in mind. Artists often send too few samples, unrelated samples or sloppy, poor quality reproductions. Show us color examples of at least one finished piece as well as roughs."

THE INTERMARKETING GROUP, 29 Holt Rd., Amherst NH 03031. (603)672-0499. President: Linda L. Gerson. Estab. 1985. Licensing agent for greeting cards, stationery, calendars, posters, paper tableware products, tabletop, dinnerware, giftwrap, eurobags, giftware, toys, needle crafts. The Intermarketing Group is a full service merchandise licensing agency representing artists' works for licensing with companies in consumer goods products including the paper product, greeting card, giftware, toy, housewares, needlecraft and apparel industries.

Needs: Approached by 100 freelancers/year. Works with 6 freelancers/year. Licenses works as developed by clients. Prefers freelancers with experience in full-color illustration. Uses freelancers mainly for tabletop, cards, giftware, calendars, paper tableware, toys, bookmarks, needlecraft, apparel, housewares. Will consider all media forms. "My firm generally represents highly illustrated works, characters and humorous illustrations for direct product applications. All works are themed." Prefers 5×7 or 8×10 final art. Produces material for all holidays and seasons and everyday. Submit seasonal material 6 months in advance.

First Contact & Terms: Send query letter with brochure, tearsheets, photostats, résumé, photographs, slides, SASE, photocopies and transparencies. Samples are not filed and are returned by SASE. Reports back within 3 weeks. Artist should follow-up with letter after initial query. Originals are returned at job's completion. Requests work on spec before assigning a job. Pays royalties of 3-10%. Buys all rights. Considers buying second rights (reprint rights) to previously published work.

Tips: Finds new artists "mostly by referrals and via artist submissions. I do review trade magazines, attend art shows and other exhibits to locate suitable clients. Companies today seem to be leaning towards the tried and true traditional art approach. Economic times are tough so companies are selective in their licenses."

KEM PLASTIC PLAYING CARDS, INC., Box 1290, Scranton PA 18501. (717)343-4783. Vice President: Mark D. McAleese. Estab. 1937. Produces plastic playing cards. Manufactures high-quality durable cards and markets them worldwide to people of all ages, ethnic backgrounds, etc. Special interest is young people.

Needs: Buys 1-3 designs/illustrations/year. Prefers "freelancers who know composition and colors." Buys freelance design/illustrations mainly for playing cards. Also uses freelancers for calligraphy. Considers watercolor, oil and acrylics. Seeks "good composition with vivid, bouncing colors and color contrasts, always in good taste." Prefers 5½×7. Produces material for all holidays and seasons.

First Contact & Terms: Send query letter with brochure and slides. Samples are not filed and are returned. Reports back within 1 week. To show portfolio, mail roughs and color final reproduction/product, slides, tearsheets and photostats. Originals are returned at job's completion. Pays $500-1,000/illustration. Buys first or one-time rights; negotiates rights purchased.

Tips: "Call Mark D. McAleese at (800)233-4173."

‡*KINNERET PUBLISHING HOUSE, 22 Derech Hashalon St., Tel Aviv, Israel 67892. (03)5616996. Fax: (03)5615526. Managing Director: Mr. Yoram Ros. Estab. 1979. Produces greeting cards, posters and postcards.

Needs: Approached by 10-20 freelancers/year. Works with 5-10 freelancers/year. Buys 5-10 freelance designs and illustrations/year. Prefers local artists with experience in greeting cards. Works on assignment only. Uses freelancers mainly for greeting card design. Also fo P-O-P displays. Considers professional media. Needs computer-literate freelancers. 30% of freelance work demands knowledge of Aldus PageMaker, Quark-XPress, Aldus FreeHand, Adobe Illustrator and Adobe Photoshop. Produces material for all holidays and seasons, Hannukkah, Passover, Rosh Hashanah, graduation, New Year and birthdays. Submit seasonal material 4 months in advance.

First Contact & Terms: Send query letter with brochure, photostats, résumé, photographs, slides, SASE, photocopies and transparencies. Samples are filed or returned by SASE if requested by artist. Reports back within 3 months. Company will contact artist for portfolio review if interested. Portfolio should include b&w and color thumbnails, roughs, final art, photostats, tearsheets, photographs, slides and transparencies. Buys all rights; rights purchased vary according to project. Originals are returned at job's completion. Payment is negotiable.

‡KIPLING CREATIVE DARE DEVILS, (formerly Kipling Cartoons & Creative Dare Devils), P.O. Box 2546, Vista CA 92085-2546. Creative Director: John Kipling. Estab. 1981.

Needs: Approached by 200-250 freelancers/year. Works with 10 freelancers/year. Interested in seeing and working with more freelancers. Prefers freelancers with experience in cartooning and oil painting. Uses freelancers mainly for introduction of new designs, cartoon characters and licensable ideas. Prefers ink renderings, airbrush and watercolor.

First Contact & Terms: Send photocopies and SASE. Samples are filed. Rights purchased vary according to project. Originals are not returned. Artist will not be given credit—unsigned work only.

Tips: "We need oils of Hawaiian natives, fish, sea, etc."

KOGLE CARDS, INC., 1498 S. Lipan St., Denver CO 80223-3411. President: Patricia Koller. Estab. 1982. Produces greeting cards and postcards for all business situations.

Needs: Approached by 500 freelancers/year. Buys 250 designs and 250 illustrations/year. Works on assignment only. Considers all media for illustration. Prefers 5×7 or 10×14 final art. Produces material for Christmas and all major holidays plus birthdays and all occasion; material accepted year-round. Send Attention: Art Director.

First Contact & Terms: Send slides. Samples not filed are returned only if SASE included. Reports back within 1 month. To show portfolio, mail color and b&w photostats and photographs. Originals are not returned. Pays royalties of 5%. Buys all rights.

Tips: "We look for fun work with a hint of business-oriented edge."

L.B.K. CORP., 7800 Bayberry Rd., Jacksonville FL 32256-6893. (904)737-8500. Fax: (904)737-9526. Art Director: Barbara McDonald. Estab. 1940. "Three companies feed through L.B.K.: NAPCO and INARCO are involved with manufacturing/distributing for the wholesale floral industry; First Coast Design produces fine giftware." Clients: wholesale.

• L.B.K. Corp. has a higher-end look for their floral market products. They are doing very little decal, mostly dimensional pieces.

Needs: Works with 15 freelance illustrators and designers/year. 50% of work done on a freelance basis. Prefers local freelancers for mechanicals for sizing decals; no restrictions on artists for design and concept. Works on assignment only. Uses freelancers mainly for mechanicals and product design. "Background with a seasonal product such as greeting cards is helpful. 75% of our work is very traditional and seasonal. We're also looking for a higher-end product, an elegant sophistication."

First Contact & Terms: Send résumé, tearsheets, slides, photostats, photographs, photocopies and transparencies. Samples are filed or returned by SASE if requested by artist. Reports back in 2 weeks. Artist should follow-up with letter after initial query. Portfolio should include samples which show a full range of illustration style. Sometimes requests work on spec before assigning a job. Pays for design by the project, $25 and up. Pays for illustration by the hour, $15; or by the project, $100-250. Pays for mechanicals by the hour, $15. Buys all rights. Considers buying second rights (reprint rights) to previously published work.

Tips: Finds artists through word of mouth and artists' self-promotions. "We are very selective in choosing new people."

‡**LIFE GREETINGS**, P.O. Box 468, Little Compton RI 02837. (401)635-8535. Editor: Kathy Brennan. Estab. 1973. Produces greeting cards. Religious, inspirational greetings.

Needs: Approached by 25 freelancers/year. Works with 5 freelancers/year. Uses freelancers mainly for greeting card illustration. Also for calligraphy. Considers all media but prefers pen & ink and pencil. Prefers 4½×6¼—no bleeds. Produces material for Christmas, religious/liturgical events, baptism, first communion, confirmation, ordination.

First Contact & Terms: Send query letter with photocopies. Samples are filed or returned by SASE if requested by artist. Reports back to the artist only if interested. Portfolio review not required. Buys all rights. Originals are not returned. Pays by the project, $25-45. **"We pay on acceptance."**

Tips: Finds artists through artists' submissions.

LOVE GREETING CARDS, INC., 1717 Opa Locka Blvd., Opa Locka FL 33054-4221. (305)685-5683. Fax: (305)685-0903. Vice President: Norman Drittel. Estab. 1984. Produces greeting cards, posters and stationery. "We produce cards for the 40- to 60-year-old market, complete lines and photography posters."

• This company has found a niche in targeting middle-aged and older Floridians. Keep this audience in mind when developing card themes for this market. One past project involved a line of cards featuring Florida's endangered wildlife.

Needs: Works with 2 freelancers/year. Buys 20 designs and illustrations/year. Prefers freelancers with experience in greeting cards and posters. Also buys illustrations for high-tech shopping bags. Uses freelancers mainly for greeting cards. Considers pen & ink, watercolor, acrylic, oil and colored pencil. Seeks a contemporary/traditional look. Prefers 5×7 size. Produces material for Hanukkah, Passover, Rosh Hashanah, New Year, birthdays and everyday.

First Contact & Terms: Send query letter, brochure, résumé and slides. Samples are filed or are returned. Reports back within 10 days. Call or write for appointment to show portfolio of roughs and color slides. Originals are not returned. Pays average flat fee of $150/design. Buys all rights.

Tips: "Most of the material we receive from freelancers is of poor quality. We use about 5% of submitted material. We are using a great deal of animal artwork and photographs."

‡**L&H MAHAR PUBLISHERS**, 945 Murray Rd., Middle Grove NY 12850. (518)587-6781. Fax: (518)587-6781. E-mail: 574214.3424@compuserve.com. President: Larry Mahar. Produces greeting cards. "We manufacture and distribute two lines of special cards (in Northeast only): Framables®, 8½×11 verse on parchment; and ProseCards®, postcards with messages instead of pictures. Both are done in calligraphy."

Needs: Approached by 1-5 freelancers/year. Buys 3-4 freelance verses/year. Looking for "calligraphy; verses 100 words or less, social expression, i.e. mother, love, God and friendship themes."

First Contact & Terms: Send postcard-size sample of work and SASE. Samples are filed. Reports back within 1 month. Portfolio review not required. Portfolio should include roughs. Buys reprint rights. Originals are not returned. Pays by the project, $25 minimum.

Tips: "The conversion of market from small retailers to superstores negatively influenced the scope of small and niche-producer market."

‡**MARVART DESIGNS INC.**, 149 Florida St., Farmingdale NY 11735. (516)420-9765. Fax: (516)420-9784. President: Marvin Kramer. Estab. 1972. Produces plates, engravings and pins.

Needs: Approached by 5-10 freelancers/year. Works with 3-4 freelancers/year. Buys 16-20 freelance designs and illustrations/year. Uses freelancers mainly for new hires. Also uses freelance artists for P-O-P displays, paste-up and mechanicals. Considers all media. Produces material for all holidays and seasons. Submit 6 months before holiday.

First Contact & Terms: Send query letter with brochure, résumé, SASE, tearsheets, photographs, photocopies, photostats, slides and transparencies. Samples are filed or are returned by SASE if requested by artist. Reports back within 1 week. Call appointment to show portfolio of appropriate samples. Original artwork is returned at the job's completion. Pays royalties of 5-7%. Rights purchased vary according to project.

‡**MILLROCK INC.**, P.O. Box 974, Sanford ME 04073. (207)324-0041. Fax: (207)324-0134. Creative Director: Kris Acher. Estab. 1979. Produces store fixtures.

● This company is a display manufacturer of "in-stock" items and custom items. They are interested in expanding their P-O-P sales base in the greeting card and gift market, working with artists to create and enhance their material. They also welcome new ideas and merchandising concepts.

Needs: Approached by 10 freelancers/year. Uses freelancers mainly for renderings. Also for P-O-P displays. Considers both electronic and conventional media. Prefers 10×12. Needs computer-literate freelancers for design and presentation. 90% of freelance work demands knowledge of Adobe Illustrator, Adobe Photoshop, QuarkXPress, Aldus FreeHand and Painter. Produces material for all holidays and seasons. Submit seasonal material 3 months in advance.

First Contact & Terms: Send query letter with brochure, tearsheets and résumé. Samples are filed. Company will contact artist for portfolio review if interested. Portfolio should include roughs, tearsheets and photographs. Rights purchased vary according to project. Originals are returned at job's completion. Pays by the project.

Tips: Finds artists through word of mouth. "We are looking for artists who have mechanical drawing skills."

‡**MUG SHANTY**, 1212 Avenida Chelsea, Vista CA 92083. (619)598-0650. Fax: (619)598-0949. President: Bruce Starr. Estab. 1973. Produces ceramic souvenir mugs, milkcaps and containers, ashtrays, steins, etc. "Our company is a leading decorator of souvenir ceramic products usually appealing to over-20 age group."

Needs: Approached by 6 freelancers/year. Works with 4-8 freelancers/year. Buys 36-50 designs and illustrations/year. Prefers freelancers with experience in silkscreen printing. Uses freelancers mainly to create new souvenir designs that will apply to many parts of the country. Also for mechanicals. Considers rough sketches or previously published products/designs. Design must be simple. Especially looking for "great" new designs for mugs. Prefers 5½ high × 6 long. Produces material for Christmas and birthdays. Submit seasonal material 6 months in advance. Freelancers should be familiar with Illustrator, Aldus Freehand and Photoshop.

First Contact & Terms: Send query letter with brochure, tearsheets, photographs and slides. Samples are not filed and are returned by SASE if requested by artist. Reports back within 2 weeks. Call for appointment to show portfolio of color roughs. Negotiates rights purchased. Originals returned only if requested. Pays royalties of 8%, no advance.

Tips: Designs must be general so that any city, town or state can be printed underneath the design. Categories include the following: cityscapes, farmscapes, mountain/lake scapes, ocean/lake scapes, desert scapes, hot air balloons. "We're interested in creating a golfing portfolio of designs. They can be scenic, comic, etc."

‡**J.T. MURPHY CO.**, 200 W. Fisher Ave., Philadelphia PA 19120. (215)329-6655. Fax: (800)457-5838. Contact: Jack Murphy. Estab. 1937. Produces greeting cards and stationery. "We produce a line of packaged invitations, thank you notes and plate cards for retail."

Needs: Approached by 5 freelancers/year. Works with 3 freelancers/year. Buys 8 freelance designs and illustrations/year. Prefers local freelancers only. Uses freelancers mainly for concept, design and finished artwork. Looking for graphic, contemporary or traditional designs. Prefers 4 × 5⅛ but can work double size.

First Contact & Terms: Send query letter with brochure, tearsheets and résumé. Samples are filed and are not returned. Reports back within 1 month. Company will contact artist for portfolio review if interested. Rights purchased vary according to project. Originals are not returned. Payment negotiated.

NALPAC, LTD., 8700 Capital, Oak Park MI 48237. (313)541-1140. Fax: (313)544-9126. President: Ralph Caplan. Estab. 1971. Produces coffee mugs and T-shirts for gift and mass merchandise markets.

Needs: Approached by 10-15 freelancers/year. Works with 2-3 freelancers/year. Buys 70 designs and illustrations/year. Works on assignment only. Considers all media. Needs computer-literate freelancers for design, illustration and production. 60% of freelance work demands computer skills.

First Contact & Terms: Send query letter with brochure, résumé, SASE, photographs, photocopies, slides and transparencies. Samples are filed or are returned by SASE if requested by artist. Reports back within 1 month. Call for appointment to show portfolio. Usually buys all rights, but rights purchased may vary according to project. Pays for design and illustration by the hour $10-25; or by the project $40-500, or offers royalties of 4-10%.

NCE, New Creative Enterprises Inc., 5481 Creek Rd., Cincinnati OH 45242. (513)891-1172. Fax: (513)891-1176. Design & Art Director: Dave J. Griffiths. Estab. 1979. Produces low-medium priced giftware and decorative accessories. "We sell a wide variety of items ranging from magnets to decorative flags. Our typical retail-level buyer is female, age 30-50."

Needs: Approached by 5-10 freelancers/year. Works with 2-5 freelancers/year. Buys 10-50 designs and illustrations/year. Prefers artists with experience in giftware/decorative accessory design, concept development and illustration and concept sketching skills. Most often needs ink or marker illustration. Seeks heart-warming and whimsical designs and illustrations using popular (Santa, Easter Bunny, etc.) or unique characters. Final art must be mailable size. Needs computer-literate freelancers for design, illustration and production. 50% of freelance work demands knowledge of Adobe Illustrator. Produces material for Christmas, Valentine's Day, Easter, Thanksgiving and Halloween. Submit seasonal material 10 months in advance.

First Contact & Terms: Send query letter with tearsheets, photographs, photocopies, photostats, slides and transparencies. Samples are filed and are returned by SASE if requested by artist. Reports back within 3-5 weeks. Call for appointment to show portfolio if local or mail appropriate materials. Portfolio should include thumbnails, roughs, finished art samples, b&w and color tearsheets, photographs, slides and dummies. Originals are returned at job's completion. Pays average flat fee of $75 for illustration/design; or by the hour, $9-15. Rights purchased vary according to project.

Tips: "Familiarity and experience with the industry really helps, but is not imperative. Yard and garden decoration/accessories are very popular right now."

THE NELSON LINE, 102 Commerce Dr., Suite 6, Moorestown NJ 08057. (609)778-4801. Fax: (609)778-4725. Owner: Eli Nelson. Estab. 1987. Produces greeting cards and giftwrap of "art-oriented images and children's sophisticated (not cutesy) designs."

Needs: Approached by 50 freelancers/year. Works with 1-2 freelancers/year. Buys 10-20 designs and illustrations/year. Uses freelancers mainly for greeting cards. Considers any media. Looking for sophisticated Christmas images and animals and bright color in children's images. Prefers 5×7 final art. Produces material for Christmas, Valentine's Day, Mother's Day, Hanukkah, Rosh Hashanah, birthdays and everyday. Submit seasonal material 6 months in advance.

First Contact & Terms: Send query letter with photostats, photographs, SASE and photocopies. Samples are not filed and are returned by SASE if requested by artist. Reports back within 2-3 weeks. Pays average flat fee of $150. Rights purchased vary according to project.

NEW ENGLAND CARD CO., Box 228, Route 41, West Ossipee NH 03890. (603)539-5095. Owner: Harold Cook. Estab. 1980. Produces greeting cards and prints of New England scenes.

Needs: Approached by 75 freelancers/year. Works with 10 freelancers/year. Buys more than 24 designs and illustrations/year. Prefers freelancers with experience in New England art. Considers oil, acrylic and watercolor. Looking for realistic styles. Prefers art proportionate to 5×7. Produces material for all holidays and seasons. "Submit all year."

First Contact & Terms: Send query letter with SASE, photographs, slides and transparencies. Samples are filed or are returned. Reports back within 2 months. Artist should follow-up after initial query. Payment negotiable. Rights purchased vary according to project; but "we prefer to purchase all rights."

Tips: "Once you have shown us samples, follow up with new art."

NEW YORK GRAPHIC SOCIETY, P.O. Box 1469, Greenwich CT 06836. (203)661-2400. Fax: (203)661-2480. Vice President: Owen Hickey. Estab. 1925. Produces posters, reproductions and limited editions.

Needs: Approached by hundreds of freelancers/year. Works with 5-10 freelancers/year. Buys 5-10 freelance designs and illustrations/year. Works on assignment only. Uses freelancers mainly for reproductions. Considers oil, watercolor, acrylic, pastel and photography. Looking for landscapes, florals, abstracts and impressionism. Produces material for Christmas. Submit seasonal material 6 months in advance.

First Contact & Terms: Send query letter with brochure, résumé, SASE, tearsheets and slides. Samples are not filed and are returned by SASE. Art Director will contact artist for portfolio review if interested. Originals are returned at job's completion. Sometimes requests work on spec before assigning a job. Pays royalties. Buys reprint rights.

Tips: Finds artists through word of mouth, magazines, artists' submissions/self-promotions, artists' exhibitions and art fairs.

‡N-M LETTERS, INC., 125 Esten Ave., Pawtucket RI 02860. (401)728-8990. Fax: (401)726-2050. President: Judy Mintzer. Estab. 1982. Produces stationery, birth announcements and party invitations.

Needs: Approached by 2-5 freelancers/year. Works with 2 freelancers/year. Prefers local artists only. Works on assignment only. Produces material for graduation and everyday. Submit seasonal material 5 months in advance.

First Contact & Terms: Send query letter with résumé. Reports back within 1 month only if interested. Call for appointment to show portfolio of b&w roughs. Original artwork is not returned. Pays by the project.

‡NOTES & QUERIES, 9003 L-M Yellow Brick Rd., Baltimore MD 21237. (410)682-6102. Fax: (410)682-5397. General Manage/National Sales Manager: Barney Stacher. Estab. 1981. Produces greeting cards, statio-

nery, calendars, paper tableware products and giftwrap. Products feature contemporary art.

Needs: Approached by 30-50 freelancers/year. Works with 3-10 freelancers/year. Produces material for Christmas, Valentine's Day, Mother's Day, Easter, birthdays and everyday. Submit seasonal material 1 year in advance.

First Contact & Terms: Send query letter with photographs, slides, SASE, photocopies, transparencies, "whatever you prefer." Samples are filed or returned by SASE if requested by artist. Reports back within 1 month. Artist should follow-up with call and/or letter after initial query. Portfolio should include thumbnails, roughs, photostats and 4×6 or 5×7 transparencies. Rights purchased vary according to project.

NOVEL TEE DESIGNS AND GREETINGS, 141 Chinquapin Orchard, Yorktown VA 23693. Contact: Art Director. Estab. 1985. Manufacturer and distributor of imprinted greeting cards, T-shirts, sweatshirts, aprons and nightshirts for retail shops. Also produces tourist-oriented, ski resort, beach/surf, seasonal and cartoon/humorous designs. Clients: Gift shops, surf shops and department stores.

Needs: Approached by 50-100 freelancers/year. Works with 50-100 freelance illustrators and 25 designers/year. Assigns 50 jobs to freelancers/year. Prefers freelancers with experience in silkscreen printing, art and design. Works on assignment only. Uses freelancers mainly for apparel graphic designs. "We are looking for designs that will appeal to women ages 18-40 and men ages 15-40. We also need ethnic designs; greeting card designs featuring blacks, cartoons, humor; detailed and graphic designs." Needs computer-literate freelancers for illustration. 15% of freelance work demands knowledge of Adobe Illustrator, Aldus FreeHand, QuarkXPress or Painter.

First Contact & Terms: Send query letter with brochure showing art style or résumé, tearsheets, SASE and photostats. Samples are filed or are returned only if requested by artist. Art Director will contact artist for portfolio review if interested. Portfolio should include thumbnails, roughs, final reproduction/product and tearsheets. Requests work on spec before assigning a job. Pays for design and illustration by the project, $200 average. Negotiates rights purchased.

Tips: Finds artists through self-promotions and trade shows. "Artists should have past experience in silkscreening art. Understand the type of line work needed for silkscreening and originality. We are looking for artists who can create humorous illustrations for a product line of T-shirts. Fun, whimsical art sells in our market. Graphic designs are also welcome. Have samples of roughs through completion."

OATMEAL STUDIOS, Box 138, Rochester VT 05767. (802)767-3171. Fax: (802)767-9890. Creative Director: Helene Lehrer. Estab. 1979. Publishes humorous greeting cards and notepads, creative ideas for everyday cards and holidays.

Needs: Approached by approximately 300 freelancers/year. Buys 100-150 freelance designs and illustrations/year. Considers all media. Produces seasonal material for Christmas, Mother's Day, Father's Day, Easter, Valentine's Day and Hanukkah. Submit art in May for Christmas and Hanukkah; in January for other holidays.

First Contact & Terms: Send query letter with slides, roughs, printed pieces or brochure/flyer to be kept on file; write for artists' guidelines. "If brochure/flyer is not available, we ask to keep one slide or printed piece; color or b&w photocopies also acceptable for our files." Samples returned by SASE. Reports in 3-6 weeks. No portfolio reviews. Sometimes requests work on spec before assigning a job. Negotiates payment.

Tips: "We're looking for exciting and creative, humorous (not cutesy) illustrations for our everday lines. If you can write copy and have a humorous cartoon style all your own, send us your ideas! We do accept work without copy too. Our seasonal card line includes traditional illustrations, so we do have a need for non-humorous illustrations as well."

‡PANDA INK, P.O. Box 5129, Woodland Hills CA 91308-5129. (818)340-8061. Fax: (818)883-6193. Art Director: Ruth Ann Epstein. Estab. 1982. Produces greeting cards, stationery, calendars and magnets. Products are Judaic, general, every day, anniversay, etc.

Needs: Approached by 8-10 freelancers/year. Works with 1-2 freelancers/year. Buys 3-4 freelance designs and illustrations/year. Uses freelancers mainly for design, card ideas. Considers all media. Looking for bright, colorful artwork, no risque, more ethnic. Prefers 5×7. Does not need computer-literate freelancers. Produces material for all holidays and seasons, Christmas, Valentine's Day, Mother's Day, Father's Day, Easter, Hanukkah, Passover, Rosh Hashanah, graduation, Thanksgiving, New Year, Halloween, birthdays and everyday. Submit seasonal material 6 months in advance.

First Contact & Terms: Send query letter with résumé and photocopies. Samples are filed. Reports back within 1 month. Portfolio review not required. Rights purchased vary according to project. Originals are returned at job's completion. Pays by the project, $50-140; royalties of 2% (negotiable).

Tips: Finds artists through word of mouth and artists' submissions.

‡PANGAEA LTD., 7 Pine Hill Ave., Norwalk CT 06855. (203)855-1295. Fax: (203)852-1114. President: Erica Gjersvik Green. Produces greeting cards, Christmas ornaments and Mexican tin crafts.

Needs: Approached by 1-3 freelancers/year. Works with 1-2 freelancers/year. Buys 30-50 freelance designs and illustrations/year. Prefers freelancers with experience in illustration. Works on assignment only. Uses freelancers mainly for design of new merchandise. Looking for well-defined illustration that translates well

into tin-ware. Produces material for all holidays and seasons. Seasonal material may be submitted at any time.

First Contact & Terms: Send query letter with brochure, tearsheets and photocopies. Samples are filed. Does not report back, in which case the artist should call. To show portfolio, mail b&w samples. Originals are returned at job's completion. Pays by the project. Buys first rights.

STANLEY PAPEL DESIGNS, 17337 Ventura Blvd., #100, Encino CA 91316. (818)789-9119. Fax: (818)789-9171. Director of Product Development: Joy Tangarone. Estab. 1955. Produces stationery, greeting cards, tableware mugs, totebags, keyrings, magnets, ceramic tabletop ensembles and picture frames. "Stanley Papel is a product development agency creating fine illustrated art, social and personal expression graphics and novelty impulse products for major giftware firms. The designs and products are directed to consumers ages 18-70 worldwide."

Needs: Approached by 150 freelancers/year. Works with 50 freelancers/year. Buys 500 freelance designs and illustration/year. Prefers freelancers with experience in giftware, paper and party goods and 3-D molded gifts. Uses freelancers mainly for illustration, graphic designs and 3-D tabletop ensembles. Considers watercolor, gouache, acrylic, computer graphics and pen & ink. Looking for "colorful graphics with outstanding use of typestyles as well as crisp watercolor illustrations, either photorealism or decorative styles." Needs computer-literate freelancers for design. 33% of freelance work demands knowledge of QuarkXPress, Aldus FreeHand, Adobe Illustrator or Adobe Photoshop. Produces material for Christmas, Valentine's Day, Mother's Day, graduation and birthdays. Submit seasonal material 1 year in advance.

First Contact & Terms: Send query letter with tearsheets, résumé, slides and color photocopies. Samples are filed or are returned by SASE if requested by artist. Reports back within 6 weeks. Company will contact artist for portfolio review if interested. Pays by the project, $150-1,000. Rights purchased vary according to project.

Tips: "We review freelancers quarterly. Looking for great color sense; strong skills in either photorealistic illustration or typography and computer graphics. All projects are assigned to freelancers. We prefer to work with freelancers who have some experience in giftware. The final products are given as gifts so artists should keep in mind the 'me-to-you' reason to buy products with their designs."

PAPEL FREELANCE, INC., 2530 US Highway 130, CN 9600, Cranbury NJ 08512. (609)395-0022, ext. 205. Design Manager: Lori Farbanish. Estab. 1955. Produces everyday and seasonal giftware items: mugs, photo frames, magnets, molded figurines, candles and novelty items. Paper items include memo pads, gift bags, journals.

Needs: Approached by about 125 freelancers/year. Buys 250 illustrations/year. Uses freelancers for product design, illustrations on product, calligraphy, paste-up and mechanicals. "Very graphic, easy to interpret, bold, clean colors, both contemporary and traditional looks as well as juvenile and humorous styles." Produces material for Halloween, Christmas, Valentine's Day, Easter, St. Patrick's Day, Mother's Day, Father's Day and everyday lines: graduation, wedding, back to school. Freelancers should be familiar with Adobe Illustrator, Adobe Photoshop and QuarkXPress.

First Contact & Terms: Send query letter with brochure, résumé, photostats, photocopies, slides, photographs and tearsheets to be kept on file. Samples not filed are returned by SASE if requested. Art Director will contact artist for portfolio review if interested. Portfolio should include final reproduction/product and b&w and color tearsheets, photostats and photographs. Originals are not returned. Sometimes requests work on spec before assigning a job. Pays by the project, $125 and up; or royalties of 3%. Buys all rights.

Tips: "I look for an artist with strong basic drawing skills who can adapt to specific product lines with a decorative feeling. It is an advantage to the artist to be versatile and capable of doing several different styles, from contemporary to traditional looks, to juvenile and humorous lines. Send samples of as many different styles as you are capable of doing well. Quality and a strong sense of color and design are the keys to our freelance resource. In addition, clean, accurate inking and mechanical skills are important to specific jobs as well. Update samples over time as new work is developed. New ideas and 'looks' are always welcome."

‡PAPER ANIMATION DESIGN, 33 Richdale Ave., Cambridge MA 02140. (617)441-9600. Fax: (617)646-0657. Art Director: David Whittredge. Estab. 1993. Produces greeting cards and animated tri-dimensional paper products. "We design and produce animated greeting cards and other products for an international market using illustrations and photographs of sophisticated and/or humorous images that move with pull-down tabs."

Needs: Approached by 6-10 freelancers/year. Works with 5 freelancers/year. Buys 50 freelance designs and illustrations/year. Uses freelancers mainly for illustration and design. Aslo for P-O-P displays and mechanicals. Considers any media. Looking for crisp, representative work with a strong color sense. Needs computer-literate freelancers for design, illustration and production. 30% of freelance work demands computer skills. Produces material for Valentines' Day, birthdays and everyday.

First Contact & Terms: Send postcard-size sample of work or send query letter with tearsheets, photographs, slides, SASE, photocopies, transparencies. Samples are filed (if interested) or returned by SASE. Reports back within 6 weeks. Company will contact artist for portfolio review if interested. Portfolio should include

final art, photostats, photographs. Buys all rights. Originals are returned to artist at job's completion. Pays by the project $250-500.

Tips Finds artists through sourcebooks, word of mouth and artists' submissions. "Exhibit a clear understanding of the contemporary world."

PAPERPLAINS, (formerly CPS Corporation), 9901 Princeton Rd., Cincinnati OH 45246. (513)874-6350. Creative Director: Francis Huffman. Manufacturer producing Christmas and all-occasion giftwrap and gift bags.

- • CPS Corporation has merged design studios with their sister company Paperplains and has created a new studio in Cincinnati. All product development for both companies will be done there.

Needs: Approached by 75 freelancers/year. Assigns 75-100 jobs/year. Uses freelancers mainly for giftwrap design. Computer work not necessary but acceptable for design and illustration.

First Contact & Terms: Send query letter with résumé, tearsheets, photostats and slides. Samples are filed or are returned by SASE. Reports back only if interested. Call or write for appointment to show portfolio of roughs, original/final art, final reproduction/product, tearsheets and photostats. Pays average flat fee of $400 for illustration/design; or by the hour, $15 and up. Considers complexity of project and skill and experience of artist when establishing payment. Negotiates rights purchased.

Tips: "Designs should be appropriate for one or more of the following categories: Christmas, wedding, baby shower, birthday, masculine/feminine and abstracts. Understand our market—giftwrap is not nice illustration, but surface texture design with ability to repeat."

✦PAPERPOTAMUS PAPER PRODUCTS INC., Box 310, Delta, British Columbia V4K 3Y3 Canada. (604)270-4580. Fax: (604)270-1580. Director of Marketing: George Jackson. Estab. 1988. Produces greeting cards for women ages 18-60. "We have also added a children's line."

Needs: Works with 8-10 freelancers/year. Buys 75-100 illustrations from freelancers/year. Also uses freelancers for P-O-P displays, paste-up and inside text. Prefers watercolor, but will look at all media that is colored; no b&w except photographic. Seeks detailed humorous cartoons and detailed nature drawings, i.e. flowers, cats. "No studio card type artwork." Prefers 5¼×7¼ finished art work. Produces material for Christmas, Valentine's Day, Easter and Mother's Day; submit 18 months before holiday. Normally works with an artist to produce an entire line of cards but will put selected work into existing or future lines and possibly develop line based on success of the selected pieces.

First Contact & Terms: Send query letter with brochure, résumé, photocopies and SASE. Samples are not filed and are returned by SASE only if requested by artist. Reports back within 2 months. Call or write for appointment to show portfolio, or mail roughs and color photographs. Original artwork is not returned. Pays average flat fee of $100/illustration or royalties of 5%. Prefers to buy all rights, but will negotiate rights purchased. Company has a 20-page catalog you may purchase by sending $4 with request for artist's guidelines. Please do not send IRCs in place of SASE.

Tips: "Know your market! Have a sense of what is selling well in the card market. Learn about why people buy cards and why they buy certain types of cards for certain people. Understand the time frame necessary to produce a good card line."

‡PARAMOUNT CARDS INC., 400 Pine St., Pawtucket RI 02860. (401)726-0800. Fax: (401)727-3890. Art Coordinator: Susan C. Calitri. Estab. 1906. Publishes greeting cards. "We produce an extensive line of seasonal and everyday greeting cards which range from very traditional to whimsical to humorous. Almost all artwork is assigned."

Needs: Works with 50-80 freelancers/year. Uses freelancers mainly for finished art. Also for calligraphy. Considers watercolor, gouache, airbrush and acrylic. Prefers 5½×8⁵⁄₁₆. Produces material for all holidays and seasons. Submit seasonal holiday material 12 months in advance.

First Contact & Terms: Send query letter résumé, SASE (important), photocopies and printed card samples. Samples are filed only if interested, or returned by SASE if requested by artist. Reports back within 1 month if interested. Company will contact artist for portfolio review if interested. Portfolio should include photostats, tearsheets and card samples. Buys all rights. Originals are not returned. Pays by the project, $200-450.

Tips: Finds artists through word of mouth and submissions. "Send a complete, professional package. Only include your best work—you don't want us to remember you from one bad piece. Always include SASE with proper postage and *never* send original art—color photocopies are enough for us to see what you can do."

The double dagger before a listing indicates that the listing is new in this edition. New markets are often more receptive to freelance submissions.

PHILADELPHIA T-SHIRT MUSEUM, 235 N. 12th St., Philadelphia PA 19107. (215)625-9230. Fax: (215)625-0740. President: Marc Polish. Estab. 1972. Produces T-shirts and sweatshirts. "We specialize in printed T-shirts and sweatshirts. Our market is the gift and mail order industry, resort shops and college bookstores."

Needs: Works with 6 freelancers/year. Designs must be convertible to screenprinting. Produces material for Christmas, Valentine's Day, Mother's Day, Father's Day, Hanukkah, graduation, Halloween, birthdays and everyday.

First Contact & Terms: Send query letter with brochure, tearsheets, photographs, photocopies, photostats and slides. Samples are filed and are returned. Reports back within 2 weeks. To show portfolio, mail anything to show concept. Originals returned at job's completion. Pays royalties of 6%. Negotiates rights purchased.

Tips: "We like to laugh. Humor sells. See what is selling in the local mall or department store."

This whimsical surfer design, "On Board," is part of the Primitive Archetypes collection designed by Julie Topolanski and Idelle Levey for the Philadelphia T-Shirt Museum. The collection, which sells well for the company, features two dozen designs such as "Rasta Ladies," "Ethnic Burro," "Katz & Dawgs" and "Condo Condo." Topolanski and Levey found the T-Shirt Museum through Artist's & Graphic Designer's Market.

© Primitive Archetypes

‡PIECES OF THE HEART, P.O. Box 571975, Tarzana CA 91357-1975. (818)774-9000. Fax: (818)774-1591. President: David Wank. Estab. 1989. Produces greeting cards and puzzle cards for all ages.

Needs: Approached by 5 freelancers/year. Works with 2 freelancers/year. Buys 2 freelance designs and illustrations/year. Works on assignment only. Uses freelancers mainly for cards. Also for P-O-P displays. Does not want to see line art. Produces material for all holidays and seasons. Submit seasonal material 9 months in advance.

First Contact & Terms: Send query letter with brochure, photographs and photocopies. Samples are filed. Reports back to the artist only if interested. Call for appointment to show portfolio of color thumbnails. Originals are returned at job's completion. Pays average flat fee of $100-1,000 for illustration/design; by the project, $100-1,000 average. Buys first rights.

Tips: "Remember, art is to be used on puzzles."

PLUM GRAPHICS INC., Box 136, Prince Station, New York NY 10012. (212)966-2573. Contact: Yvette Cohen. Estab. 1983. Produces greeting cards. "They are full-color, illustrated, die-cut; fun images for young and old."

Needs: Buys 12 designs and illustrations/year. Prefers local freelancers only. Works on assignment only. Uses freelancers for greeting cards only. Considers oil, acrylic, airbrush and watercolor (not the loose style). Looking for representational and tight-handling styles.

First Contact & Terms: Send query letter with photocopies or tearsheets. Samples are filed or are returned by SASE if requested by artist. Reports back to the artist only if interested. "We'll call to view a portfolio." Portfolio should include final art and color tearsheets. Originals are returned at job's completion. Sometimes requests work on spec before assigning a job. Pays average flat fee of $300-400 for illustration/design. Pays an additional fee if card is reprinted. Buys all rights. Considers buying second rights (reprint rights) to previously published work; "depends where it was originally published."

Tips: Finds artists through word of mouth, artists' submissions and sourcebooks. "I suggest that artists look for the cards in stores to have a better idea of the style. They are sometimes totally unaware of Plum Graphics and submit work that is inappropriate."

‡PORTERFIELD'S, 5020 Yaple Ave., Santa Barbara CA 93111. (805)964-1824. Fax: (805)964-1862. President: Lance Klass. Estab. 1994. Produces collector plates and other limited editions. "We produce high-quality limited-edition collector plates sold in the US and abroad through direct response, requiring excellent representational art, primarily wonder of early childhood (under age 6); baby wildlife, foreign and domestic (cats/kittens, puppies/dogs), baby and mother exotic animals (Asian, African); cottages and English country scenes. Also looking for artists who can create realistic representational works from references supplied to them."

Needs: Approached by 60 freelancers/year. Buys 12 freelance designs and illustrations/year. Prefers representational artists "who can create beautiful pieces of art that people want to look at and look at and look at." Works on assignment only but will consider existing works. Considers any media—oil, pastel, pencil, acrylics. "We want artists who have exceptional talent and who would like to have their art and their talents introduced to the broad public via the highest quality limited edition collector plates." Does not need computer-literate freelancers. Produces material for Christmas, Valentine's Day and Easter. Submit seasonal material 1 year in advance.

First Contact & Terms: Send postcard-size sample of work or send query letter with brochure, tearsheets, résumé, photographs, slides, SASE, photocopies and transparencies. Samples are filed or returned by SASE if requested by artist. Reports back within 2 weeks. Company will contact artist for portfolio review if interested. Portfolio should include tearsheets, photographs and transparencies. Rights purchased vary according to project. Generally pays an advance against royalties when a work is accepted, and then royalties/sale are paid after product sales have been made.

Tips: "We are impressed first and foremost by level of ability, even if the subject matter is not something that we would use. Thus a demonstration of a competence is the first step; hopefully the second would be that demonstration using subject matter that we feel would be marketable. We work with artists to help them with the composition of their pieces for this particular medium. We treat artists well, give them fair payment for their work, and do what we can to promote them. We also give them something no other collectibles company will give—final approval of the reproduction quality of their work before production gets underway. We want our artists to be completely satisfied that their art is being reproduced in a manner that they like, and would be willing to share professionally and with their friends."

POTPOURRI DESIGNS, 6210 Swiggett Rd., Greensboro NC 27419. Mailing address: Box 19566, Greensboro NC 27410. (910)852-8961. Fax: (910)852-8975. Director of New Product Development: Janet Pantuso. Estab. 1968. Produces paper products including bags, boxes, stationery and tableware; tins; stoneware items; and Christmas and home decor products for gift shops, the gourmet shop trade and department stores. Targets women age 25 and older.

Needs: Buys 10-20 freelance designs and 10-20 illustrations/year. "Our art needs are increasing. We need freelancers who are flexible and able to meet deadlines." Works on assignment only. Uses freelancers for calligraphy, mechanicals and art of all kinds for product reproduction. Prefers watercolor and acrylic. Also needs mechanical work. Seeking traditional, seasonal illustrations for Christmas introductions and feminine florals for everyday. Submit seasonal material 1-2 years in advance.

First Contact & Terms: Send query letter with résumé and tearsheets, slides or photographs. Samples not filed are returned by SASE. Art Director will contact artist for portfolio review if interested. Pays average flat fee of $300; or pays by the project, $1,000-5,000 average. Buys all rights.

Tips: Finds artists through word of mouth, magazines, artists' submissions/self-promotions, sourcebooks, agents, visiting artist's exhibitions, art fairs and artists' reps. "Our audience has remained the same but our products are constantly changing as we continue to look for new products and discontinue old products. I often receive work from artists that is not applicable to our line. I prefer that artists learn more about the company before submitting work."

PRATT & AUSTIN COMPANY, INC., 642 S. Summer St., Holyoke MA 01040. (413)532-1491. Fax: (413)536-2741. President: Bruce Pratt. Art Director: Lorilee Costello. Estab. 1931. Produces envelopes, children's items, stationery and calendars. "Our market is the modern woman at all ages. Design must be bright, cute busy and elicit a positive response." Using more recycled paper products and endangered species designs.

Needs: Approached by 50 freelancers/year. Works with 20 freelancers/year. Buys 100-150 designs and illustrations/year. Uses freelancers mainly for concept and finished art. Also for calligraphy. Produces material for Christmas, birthdays, Mother's Day and everyday. Submit seasonal material 1½ years in advance.

First Contact & Terms: Send query letter with tearsheets, slides and transparencies. Samples are filed or are returned by SASE if requested. Art Director will contact artist for portfolio review if interested. Portfolio should include thumbnails, roughs, color tearsheets and slides. Pays by the hour, $20-30; or by the project, $200-1,000 average; or royalties of 1-5%. Rights purchased vary according to project. Interested in buying second rights (reprint rights) to previously published work.

Tips: Finds artists through artists' submissions and agents. "It is imperative that freelancers submit seasonal/holiday designs 18 months in advance."

THE PRINTERY HOUSE OF CONCEPTION ABBEY, Conception MO 64433. Fax: (816)944-2582. Art Director: Rev. Norbert Schappler. Estab. 1950. Publishes religious greeting cards. Specializes in religious Christmas and all-occasion themes for people interested in religious, yet contemporary, expressions of faith. "Our card designs are meant to touch the heart. They feature strong graphics, calligraphy and other appropriate styles."
Needs: Approached by 75 freelancers/year. Works with 25 freelancers/year. Uses freelancers for product illustration. Prefers acrylic, pastel, cut paper, oil, watercolor, line drawings and classical and contemporary calligraphy. Looking for dignified styles and solid religious themes. Produces seasonal material for Christmas and Easter "as well as the usual birthday, get well, sympathy, thank you, etc. cards of a religious nature. Creative general message cards are also needed." Strongly prefers calligraphy to type style.
First Contact & Terms: Send query with brief résumé and a few samples representative of your art style and skills. Non-returnable samples preferred—or else samples with SASE. Reports back usually within 3 weeks. To show portfolio, mail appropriate materials only after query has been answered. "In general, we continue to work with artists once we have accepted their work." Pays flat fee of $150-300 for illustration/design. Usually buys exclusive reproduction rights for a specified format; occasionally buys complete reproduction rights.
Tips: "Abstract or semi-abstract background designs seem to fit best with religious texts. Color washes and stylized designs are often appropriate. Remember our specific purpose of publishing greeting cards with a definite Christian/religious dimension but not piously religious. It must be good quality artwork. We sell mostly via catalogs so artwork has to reduce well for catalog." Sees trend towards "more personalization and concern for texts."

PRODUCT CENTRE-S.W. INC./THE TEXAS POSTCARD CO., Box 860708, Plano TX 75086. (214)423-0411. Fax: (214)578-0592. Art Director: Susan Grimland. Produces postcards. Themes range from nostalgia to art deco to pop/rock for contemporary buyers.
Needs: Buys 100 designs from freelancers/year. Uses freelancers for P-O-P display, paste-up and mechanicals. Considers any media, but "we do use a lot of acrylic/airbrush designs." Prefers contemporary styles. Final art must not be larger than 8×10. "Certain products require specific measurements. We will provide these when assigned."
First Contact & Terms: Send résumé, business card, slides, photostats, photographs, photocopies and tearsheets to be kept on file. Samples not filed are returned only by request with SASE including return insurance. Reports within 4 months. Originals are not returned. Call or write to show portfolio. Pays by the project, $100-200. Buys all rights.
Tips: "Artist should be able to submit camera-ready work and understand printer's requirements. The majority of our designs are assigned. No crafty items or calligraphy. No computer artwork."

PRODUCT CONCEPT CONSULTING, INC, 3334 Adobe Court, Colorado Springs CO 80907. (719)632-1089. Fax: (719)632-1613. President: Susan Ross. Estab. 1986. New product development agency. "We work with a variety of companies in the gift and greeting card market in providing design, new product development and manufacturing services."
● This company has recently added children's books to its product line.
Needs: Works with 20-25 freelancers/year. Buys 400 designs and illustrations/year. Prefers freelancers with 3-5 years experience in gift and greeting card design. Works on assignment only. Buys freelance designs and illustrations mainly for new product programs. Also for calligraphy, P-O-P display and paste-up. Considers all media. Needs computer-literate freelancers for design and production. 25% of freelance work demands knowledge of Adobe Illustrator, Adobe Streamline, QuarkXPress or Aldus FreeHand. Produces material for all holidays and seasons.
First Contact & Terms: Send query letter with résumé, tearsheets, photostats, photocopies, slides and SASE. Samples are filed or are returned by SASE if requested by artist. Reports back within 1 week. To show portfolio, mail color and b&w roughs, final reproduction/product, slides, tearsheets, photostats and photographs. Originals not returned. Pays average flat fee of $250; or pays by the project, $250-2,000. Buys all rights.
Tips: "Be on time with assignments." Looking for portfolios that show commercial experience.

‡PUNKIN' HEAD PETS, 6909 Custer Rd., #2703, Plano TX 75023. (214)491-2435. Owner: Lyn Skaggs. Estab. 1994. Produces, greeting cards, stationery, posters, paper tableware products and giftwrap. "Punkin Head Pets is a greeting card company geared toward pet owners (mostly dogs and cats) of all ages. We will be expanding into posters, giftwrap, stationery and paper tableware and part products."
Needs: Prefers freelancers with experience in pet drawings. Considers all media. Good color drawings of dogs and cats in "cute" poses and surroundings. Prefers 3×5. Produces material for all holidays and seasons.
First Contact & Terms: Send query letter with tearsheets, résumé, photographs and SASE; color photocopies also accepted for initial review. Samples are filed or returned by SASE if requested by artist. Reports

back within 2 weeks. Portfolio review not required. Negotiates rights purchased. Originals are returned with SASE. Pays by the drawing $50 minimum plus credit.

‡PUZZLING POSTCARD COMPANY, 21432 Vintage Way, Lake Forest CA 92630. (714)951-3784. Fax: (714)458-0150. President: Thomas J. Judge. Estab. 1991. Produces puzzle greeting cards, greeting cards, stationery, games/toys. "We produce jigsaw puzzle greeting cards—the giver writes a message on the back, breaks card apart and sends. Cards are for all age groups; popular to send to children, young teens, the elderly and the ill."
Needs: Approached by 3-5 freelancers/year. Works with 2-3 freelancers/year. Buys 24-36 freelance designs and illustrations/year. Uses freelancers mainly for greeting designs. Also for P-O-P displays and mechanicals. Considers all media. Looking for "a clean non-cluttered look. Cards cannot have too much small detail because the die cut lines will distract from the image making it difficult to see. We would love to introduce a new cartoon character to the industry via the puzzling postcard." Prefers 4×6. Needs computer-literate freelancers for design, illustration and production. 60% of freelance work demands knowledge of Adobe Illustrator, Adobe Photoshop, QuarkXPress, Aldus FreeHand and Aldus PageMaker. Produces material for Christmas, Valentine's Day, New Year, birthdays and everyday. Submit seasonal material 6-9 months in advance.
First Contact & Terms: Send query letter with brochure, tearsheets, photostats, résumé, photographs, slides, photocopies and transparencies. Samples are filed. Company will contact artist for portfolio review if interested. Portfolio should include thumbnails, roughs, final art, photostats, tearsheets, photographs, slides and transparencies. Rights purchased vary according to project. Originals are returned at job's completion. Negotiates price and rights. Outright purchase generally ranges from $100-300. Royalties are negotiable; usually pay an advance against royalty.
Tips: Finds artists through word or mouth and artists' submissions. "Be willing to negotiate price/rights at beginning of relationship. We prefer to produce 'series' of cards of 6-12 designs from a particular artist. Our risk as a manufacturer is high when introducing new designs. There seems to be a definite trend toward lower cost greeting cards. Our specialty is alternative greeting cards with added elements at very reasonable cost!"

QUALITY ARTWORKS, INC., 2262 North Penn Rd., P.O. Box 369, Hatfield PA 19440-0369. Creative Director: Linda Tomezsko Morris. Estab. 1985. Manufacturer/distributor producing bookmarks, blank books, notepads, note cards, stationery and scrolls. Subject matter ranges from classic, traditional to contemporary, fashion-oriented. Clients: bookstores, card and gift shops and specialty stores.
Needs: Works with 20 freelancers/year. Needs 100-200 designs/year. Considers any medium. Freelancers must be able to work within a narrow vertical format (bookmarks). Works on assignment only. Uses freelancers for product illustration.
First Contact & Terms: Send query letter with tearsheets, slides and/or printed pieces. Samples are filed or are returned only if requested by artist with SASE. Creative director will contact artist for portfolio review if interested. Portfolio should include roughs, original/final art, product samples, tearsheets, slides or color prints. Pays for illustration $50-400; or royalties of 6%. Considers skill and experience of artist, how work will be used and rights purchased when establishing payment.
Tips: "We are looking for creative, fresh looks with strong color and design. Study our product and the market. Design with the consumer in mind—for the most part, a high-end female, age late teens-senior years. You must also have an understanding of the 4-color printing process."

RECO INTERNATIONAL CORPORATION, Collector's Division, Box 951, 138-150 Haven Ave., Port Washington NY 11050. (516)767-2400. Manufacturer/distributor of limited editions, collector's plates, lithographs and figurines. Sells through retail stores and direct marketing.
Needs: Works with freelance and contract artists. Uses freelancers under contract for plate and figurine design and limited edition fine art prints. Prefers romantic and realistic styles.
First Contact & Terms: Send query letter and brochure to be filed. Write for appointment to show portfolio. Art Director will contact artist for portfolio review if interested. Negotiates payment. Considers buying second rights (reprint rights) to previously published work.
Tips: "We are very interested in new artists. We go to shows and galleries, and receive recommendation from artists we work with."

RECYCLED PAPER GREETINGS INC., 3636 N. Broadway, Chicago IL 60613. Fax: (312)281-1697. Art Director: Melinda Gordon. Publishes greeting cards, adhesive notes, buttons and mugs.
• This company, which began as a tiny grass-roots organization, has grown to become a leading trendsetter in the industry.
Needs: Buys 1,000-2,000 freelance designs and illustrations. Considers b&w line art and color—"no real restrictions." Looking for "great ideas done in your own style with messages that reflect your own slant on the world." Prefers 5×7 vertical format for cards; 10×14 maximum. "Our primary interest is greeting cards." Produces seasonal material for all major and minor holidays including Jewish holidays. Submit seasonal material 18 months in advance; everyday cards are reviewed throughout the year.

Dick Chodkowski used marker and colored pencil for this "bold, bright, easy to read" card for Recycled Paper Greetings. "Dick is a good example of an artist who had never done cards, decided to try something new, and by focusing his considerable skills as a cartoonist and communicator became successful in the field," says Art Director Melinda Gordon. The inside message delivers a funny surprise plus a nice warm birthday message. It reads "That's my reflection. Actually, you're looking terrific! Happy Birthday." Chodkowski found Recycled Paper Greetings through Artist's & Graphic Designer's Market.

© Recycled Paper Greetings.

First Contact & Terms: Send SASE for artist's guidelines. "I don't want slides or tearsheets—I am only interested in work done for our products." Reports in 2 months. Portfolio review not required. Originals returned at job's completion. Sometimes requests work on spec before assigning a job. Pays average flat fee of $250 for illustration/design with copy. Some royalty contracts. Buys all rights.

Tips: "Remember that a greeting card is primarily a message sent from one person to another. The art must catch the customer's attention, and the words must deliver what the front promises. We are looking for unique points of view and manners of expression. Our artists must be able to work with a minimum of direction and meet deadlines. There is a renewed interest in the use of recycled paper—we have been the industry leader in this for more than two decades."

RED FARM STUDIO, 1135 Roosevelt Ave., Box 347, Pawtucket RI 02861. (401)728-9300. Fax: (401)728-0350. Contact: Creative Director. Estab. 1955. Produces greeting cards, giftwrap and stationery from original watercolor art. Specializes in nautical and traditional themes. Approached by 150 freelance artists/year. Works with 20 freelancers/year. Buys 200 freelance watercolor designs and illustrations/year. Uses freelancers for greeting cards, notes, Christmas cards. Considers watercolor only. Looking for accurate, detailed, realistic work. Produces material for Christmas, Mother's Day, Father's Day, Easter, birthdays and everyday.

First Contact & Terms: First send query letter and #10 SASE to request art guidelines. Submit slides, transparencies, photographs, SASE. "Do not send sketches." Samples not filed are returned by SASE. Art Director will contact artist for portfolio review if interested. Originals are not returned. Pays flat fee of $250-300 for illustration/design; or pays by the project, $200-300. Buys all rights.

Tips: "We are interested in realistic, fine art watercolors of traditional subjects like nautical scenes, flowers, birds, shells and landscapes. No photography."

REEDPRODUCTIONS, 2175 Francisco Blvd., Suite B, San Rafael CA 94901. (415)456-8267. Partner/Art Director: Susie Reed. Estab. 1978. Produces celebrity postcards, key rings, magnets, address books, etc.

Needs: Approached by 20 freelancers/year. Works with few freelancers/year. Prefers local freelancers with experience. Works on assignment only. Artwork used for paper and gift novelty items. Also for paste-up and mechanicals. Prefers color or b&w photorealist illustrations of celebrities.

First Contact & Terms: Send query letter with brochure or résumé, tearsheets, photostats, photocopies or slides and SASE. Samples are filed or are returned by SASE. Art Director will contact artist for portfolio review if interested. Portfolio should include color or b&w final art, final reproduction/product, slides, tearsheets and photographs. Originals are returned at job's completion. Payment negotiated at time of purchase. Considers buying second rights (reprint rights) to previously published work.

Tips: "We specialize in products related to Hollywood memorabilia."

RENAISSANCE GREETING CARDS, Box 845, Springvale ME 04083. (207)324-4153. Fax: (207)324-9564. Art Director: Janice Keefe. Estab. 1977. Publishes greeting cards; "current approaches" to all-occasion cards,

INSIDER REPORT

Start Small and Make It Big

Barbara Dale

Creative vision, a little luck and a sense of humor guided Barbara Dale to success in the greeting card market. Since 1979, the Baltimore artist, together with her husband Jim, has created a successful line of greeting cards that appeals to everyone from new parents to senior citizens. Though Dale Cards sell by the millions, the endeavor started with a few scribbles on a paper cocktail napkin.

During a romantic dinner in the Florida Keys— their first time alone since the birth of their son— the couple talked about their first year as parents, prompting Dale to think of a great idea for a card to send a new mother. Her husband, an ad agency creative director, joined in the fun, reworking the punchline to make it even funnier, and Dale sketched a wiggly cartoon. They spent the rest of their vacation laughing and thinking up ideas for cards.

Back home in Birmingham, Michigan, Dale made copies of the cards to send to friends. On her way back from the print shop, she ran into a local shop owner who spotted the cards and asked for a few to try out in his store. It wasn't long before he ordered more, giving Dale the idea to approach other merchants in the Detroit area. "We had a one-year-old at the time so I delivered the cards in Huggies diaper boxes," recalls Dale. When she expanded the line to include invitations, she used a boil-in-the-bag kitchen device to seal the cards in plastic freezer bags.

The cards sold briskly in the Detroit area. Then, as is the case now, the market was in need of new ideas. Stores were packed with cards featuring "flowery, impersonal, sappy sweet or boorish, conventional humor—not very reflective of the way people were thinking and living," says Dale. Dale Cards, with their simple format and sophisticated humor, introduced an alternative.

A year and a half after after they launched Dale Cards, the couple crammed a small collapsible booth into a suitcase and traveled to the New York Stationery Show. At the show, the cards were discovered by Recycled Paper Greetings. Today, the cards are distributed widely by Recycled Paper Greetings and also marketed by Andrews and McMeel/Oz, the gift industry arm of Universal Press Syndicate. So far, more than 80 million have been sold.

Since the launch of Dale Cards in 1979, the "alternative" greeting card market has seen tremendous growth. Trendy cards with similar designs, ranging from witty to campy, are a common sight, and take up as much shelf space in stores as the more traditional cards. The industry now needs a new alternative, according

to Dale.

If you want to get in on the ground floor of an industry ripe for change, Dale is full of encouragement, shirking the notion that a formal illustration background is a must. In fact, she majored in English and studied ceramics in college. Still you must be skillful in crafting a unique card with both illustrations and words. Always recognize the importance of a card's punchline, Dale emphatically notes. Her rule is "Never hurt the words. Help the words. Always the words come first. There are very few purely visual ideas." If you're unaccustomed to writing crisp copy, admit you don't have the verbal skills and get a partner.

If you think you have what it takes to create a successful card line, find out what the public wants by performing your own market test. "One of the nice things about greeting cards is that they're not terribly expensive to test," says Dale. She estimates that for approximately $500, you can create and print a selection of your cards, then work with store owners (preferably several shops in different parts of town) to sell them. Trouble placing your cards signals a problem right off, she says.

Once your cards are on the shelves, visit the stores every two weeks and find out how they're selling. "Be ruthlessly honest with yourself. Keep in mind that failure is a great piece of information," says Dale. If your ideas don't sell, you're free to choose different venues or alter your ideas.

Just as important as doing your homework and fine-tuning your skills is adopting a positive attitude, says this seasoned greeting card artist. "Most people are so afraid of failure they don't even try." But if you learn from your mistakes and keep at it, success just might be in the cards.

—Jennifer Hogan-Redmond

Barbara Dale's line of funny cards includes several poking fun at getting older. The punchline of this Dale card reads "Does it happen during the day?"

seasonal cards, Christmas cards including nostalgic themes. "Alternative card company with unique variety of cards for all ages, situations and occasions."
Needs: Approached by 500-600 artists/year. Buys 350 illustrations/year. Full-color illustrations only. Produces materials for all holidays and seasons and everyday. Submit art 18 months in advance for fall and Christmas material; approximately 1 year in advance for other holidays.
First Contact & Terms: Request artist's guidelines, include SASE. To show portfolio, mail color copies, tearsheets, slides or transparencies. Packaging with sufficient postage to return materials should be included in the submission. Reports in 2 months. Originals are returned to artist at job's completion. Sometimes requests work on spec before assigning a job. Pays for design by the project, $125-300 advance on royalties or flat fee, negotiable.
Tips: Finds artists mostly through artists' submissions/self-promotions. "Especially interested in humorous concepts and illustration as well as trendy styles. Start by requesting guidelines and then send a small (10-12) sampling of 'best' work, preferably color copies or slides (with SASE for return). Indicate if the work shown is available or only samples. We're doing more designs with special effects like die-cutting and embossing."

THE ROSENTHAL JUDAICA COLLECTION, by Rite Lite, 260 47th St., Brooklyn NY 11220. (718)439-6900. Fax: (718)439-5197. Vice President Product Design: Rochelle Stern. Estab. 1948. Manufacturer and distributor of a full range of Judaica ranging from mass-market commercial goods to exclusive numbered pieces. Clients: department stores, galleries, gift shops, museum shops and jewelry stores.
• Company is looking for children's game ideas.
Needs: Approached by 40 freelancers/year. Works with 4 freelance designers/year. Works on assignment only. Uses freelancers mainly for new designs for Judaic giftware. Prefers ceramic and brass. Also uses artists for brochure and catalog design, illustration and layout and product design. Needs computer-literate freelancers for design. 20% of freelance work demands computer skills.
First Contact & Terms: Send query letter with brochure or résumé, tearsheets and photographs. Do not send originals. Samples are filed. Reports back only if interested. Portfolio review not required. Art Director will contact artist for portfolio review if interested. Portfolio should include original/final art and color tearsheets, photographs and slides. Pays flat fee of up to $500 for illustration/design; or royalties of 5%. Buys all rights. "Works on a royalty basis."
Tips: Finds artists through word of mouth. "Know that there is one retail price, one wholesale price and one distributor price."

‡RUSS BERRIE AND COMPANY, 111 Bauer Dr., Oakland NJ 07436. (800)631-8465. Fax: (201)337-7901. Director Paper Goods: Angelica Urra. Produces greeting cards, bookmarks and calendars. Manufacturer of impulse gifts for all age groups.
Needs: Works with average of 50 freelancers/year. Buys average of 500 freelance designs and illustrations/year. Prefers freelancers with experience in industry or greeting cards. Works on assignment only. Uses freelancers mainly for greeting cards. Also for calligraphy. Produces material for all holidays and seasons.
First Contact & Terms: Send query letter with résumé, SASE and color photocopies. Samples are filed or returned by SASE if requested by artist. Reports back to the artist only if interested. To show portfolio, mail tearsheets and printed samples. Rights purchased vary according to project. Pays flat rate depending on amount of work involved; or royalties of 2%. Do not send b&w samples. Color only.

‡SANGRAY CORPORATION, 2318 Lakeview Ave., Pueblo CO 81004. (719)564-3408. Fax: (719)564-0956. President: James Stuart. Estab. 1971. Produces refrigerator magnets, trivets, wall decor and other decorative accessories—all using full color art.
Needs: Approached by 5-6 freelancers/year. Works indirectly with 6-7 freelancers/year. Buys 25-30 freelance designs and illustrations/year. Prefers florals, scenics, small animals and birds. Uses freelancers mainly for fine art for products. Considers all media. Prefers 7×7. Does not need computer-literate freelancers. Submit seasonal material 10 months in advance.
First Contact & Terms: Send query letter with examples of work in any media. Samples are filed. Reports back within 30 days. Company will contact artist for portfolio review if interested. Buys first rights. Originals are returned at job's completion. Pays by the project, $250-400.
Tips: Finds artists through artists' submissions and design studios.

SARUT INC., 107 Horatio, New York NY 10014. (212)691-9453. Fax: (212)691-1077. Vice President Marketing: Frederic Rambaud. Estab. 1979. Produces museum quality science and nature gifts. "Marketing firm with 6 employees. 36 trade shows a year. No reps. All products are exclusive. Medium- to high-end market."
Needs: Approached by 4-5 freelancers/year. Works with 4 freelancers/year. Uses freelancers mainly for new products. Seeks contemporary designs. Produces material for all holidays and seasons.
First Contact & Terms: Samples are returned. Reports back within 2 weeks. Write for appointment to show portfolio. Rights purchased vary according to project.
Tips: "We are looking for concepts; products not automatically graphics."

SCANDECOR INC., 430 Pike Rd., Southampton PA 18966. (215)355-2410. Creative Director: Lauren H. Karp. Produces posters, calendars, greeting cards and art prints.
- Scandecor is looking for artwork for posters geared to three target markets: mother and child (juvenile style); preteen (faries, dragons); and teens. Art director says there's a greater need for poster art than for greeting cards, but she would like to see art by greeting card artists that could also work for posters.

Needs: Looking for cute and trendy designs mainly for posters for boys, girls and teens. Prefers illustrations and airbrush work. Art prints needs are fine art in floral, traditional and contemporary styles.

First Contact & Terms: Samples not filed are returned by SASE. Artist should follow-up after initial query. Art Director will contact artist for portfolio review if interested. Portfolio should include color slides, photostats and photographs. Originals are sometimes returned at job's completion. Requests work on spec before assigning a job. Negotiates rights purchased.

Tips: Finds artists through magazines, submissions, gift shows and art fairs. Advises artists to attend local gift shows. "Artists can look at products in the market to get a feel for how art can be used. Submissions can then show how the artist's work can be used, and this will help the buyer to visualize the art on his or her product."

SCHMID, 55 Pacella Park Dr., Randolph MA 02368. (617)961-3000. Fax: (617)986-8168. Product Development: Elizabeth Hazelton. Estab. 1930. Manufacturer and distributor producing giftware such as music boxes, figurines and decorative accessories in earthenware, porcelain, paper and resin. Clients: gift shops, department stores, jewelry stores, specialty shops and catalogs.
- Schmid is beginning to focus more on decorative accessories and the utilization of 2D art.

Needs: Assigns 30-60 jobs/year. Prefers freelancers with experience in giftware or greeting card design. Works on assignment only. Uses freelancers mainly for product design. "We assign concept art and freelancer is responsible for pencil roughs and sometimes color once pencil concept is approved."

First Contact & Terms: Send query letter with photocopies and other nonreturnable samples. Samples are filed or are returned by SASE only if requested by artist. Art Director will contact artist for portfolio review if interested. Portfolio should include roughs, final art, color and b&w tearsheets. Pays for design and illustration by the project. Considers complexity of project and how work will be used when establishing payment. Buys all rights.

Tips: Finds artists through artists' submissions/self-promotions, art fairs and word of mouth. "We are interested in computer artists who can crop, manipulate and image images."

SCOTT CARDS INC., Box 906, Newbury Park CA 91319. Estab. 1984. Produces contemporary greeting cards for young-minded adults.

Needs: Accepts 50-75 freelance designs/year. Will select more if submissions warrant. "We are seeking clever, risque designs for our Naughty Card line, but please, NO pornography. Naughty Cards are the kind that 'women love to buy and men love to get.' Messages are not required; risque artwork is more important to us than risque verse."

First Contact & Terms: Send SASE for artist guidelines and sample brochure. Please do not submit artwork until you have reviewed our guidelines. Buys first five designs outright for $50 each; pays 5% royalty on subsequent designs accepted.

Tips: "When creating risque designs keep in mind people who enjoy R-rated movies. The key is cleverness, not obscenity. Work creatied for the X-rated audience won't sell or be appreciated."

‡SEABRIGHT PRESS, P.O. Box 7285, Santa Cruz CA 95061. Phone/fax: (408)457-1568. Editor: Jim Thompson. Estab. 1990. Produces greeting cards and journals. "We publish contemporary notecards and blank journals."

Needs: Approached by 20-30 freelancers/year. Works with 5-10 freelancers/year. Buys 10-20 freelance designs and illustrations/year. Uses freelancers mainly for notecard designs. Considers any media. Produces material for all holidays and seasons. Submit seasonal material 4-6 months in advance.

First Contact & Terms: Send query letter with brochure, tearsheets, photographs, SASE and photocopies. Samples are not filed and are returned by SASE if requested by artist. Reports back within 2 months. Portfolio review not required. Negotiates rights purchased. Originals are returned at job's completion. Pays royalties of 5-7%.

Tips: Finds artists through word of mouth.

***SECOND NATURE, LTD.**, 10 Malton Rd., London, W105UP England. (01)960-0212. Art Director: David Roxburgh. Produces greeting cards and giftwrap. "High-end, higher-priced product mainly for women 15-40 years old."

Needs: Prefers interesting new contemporary but commercial styles. Produces material for Christmas, Valentine's Day, Mother's Day and Father's Day. Submit seasonal material 18 months in advance.

First Contact & Terms: Send query letter with brochure showing art style. Samples not filed are returned only if requested by artist. Reports back within 2 months. Call or write for appointment to show portfolio. Originals are not returned at job's completion. Pays $300 for illustration/design. Negotiates rights purchased.

Tips: "We are interested in all forms of paper engineering."

SHERRY MFG. CO., INC., 3287 NW 65th St., Miami FL 33147. Fax: (305)691-6132. E-mail: nuthouse@aol. com. Art Director: Jeff Seldin. Estab. 1948. Manufacturer of silk-screen T-shirts with beach and mountain souvenir themes. Label: Sherry's Best. Clients: T-shirt retailers. Current clients include Walt Disney Co., Club Med and Kennedy Space Center.
Needs: Approached by 50 freelancers/year. Works with 15 freelance designers and illustrators/year. Assigns 350 jobs/year. Prefers freelancers that know the T-shirt market and understand the technical aspects of T-shirt art. Prefers colorful graphics or highly stippled detail. Needs computer-literate freelancers for design and illustration. 25% of freelance work demands knowledge of Adobe Illustrator, Aldus FreeHand 5.0, Photoshop, Typestyler or Stratavision.
First Contact & Terms: Send query letter with brochure showing art style or résumé, photostats and photocopies. Samples are not filed and are returned only if requested. Art Director will contact artist for portfolio review if interested. Portfolio should include thumbnails, roughs, original/final art, final reproduction/product and color tearsheets, photostats and photographs. Sometimes requests work on spec before assigning a job. Pays average flat fee of $250. Considers complexity of project, skill and experience of artist, and volume of work given to artist when establishing payment. Buys all rights.
Tips: "Know the souvenir T-shirt market and have previous experience in T-shirt art preparation. Some freelancers do not understand what a souvenir T-shirt design should look like. Send sample copies of work with résumé to my attention."

SMART ART, P.O. Box 661, Chatham NJ 07928. (201)635-1690. Fax: (201)635-2011. President: Barb Hauck-Mah. Vice President: Wesley Mah. Estab. 1992. Produces greeting cards, photo frame cards and invitations. "Smart Art creates pen & ink cards with a warm, gentle humor. We contribute a portion of all profits to organizations dedicated to helping our nation's kids."
 ● Smart Art is expanding its photo frame card line, so they are looking for artists who can do great watercolor border designs. The cards are ready-to-use "frames" customers can slip photos into and mail to friends.
Needs: Approached by 40-50 freelancers/year. Works with 6 freelancers/year. Buys 25-30 illustrations/year. Prefers artists with experience in children's book illustration. Works on assignment only. Uses freelancers for card design/illustration. Considers watercolor and pen & ink. Produces material for most holidays and seasons, plus birthdays and everyday. Submit seasonal material 10-12 months in advance.
First Contact & Terms: Send query letter with tearsheets, photocopies, résumé and SASE. Samples are filed or returned by SASE. Reports back within 6-8 weeks. Portfolio review not required. Sometimes requests work on spec before assigning a job. Originals are returned at job's completion. Pays royalties of 4%. Negotiates rights purchased.
Tips: Finds artists through word of mouth and trade shows. "Send us rough color samples of potential greeting cards or border designs you've created."

STUART HALL CO., INC., P.O. Box 200915, Kansas City MO 64120-0915. Director of Advertising and Art: Judy Riedel. Produces stationery, school supplies and office supplies.
Needs: Approached by 30 freelancers/year. Buys 40 freelance designs and illustrations/year. Artist must be experienced—no beginners. Works on assignment only. Uses freelance artists for design, illustration, calligraphy on stationery, notes and tablets, and paste-up and mechanicals. Considers pencil sketches, rough color, layouts, tight comps or finished art; watercolor, gouache, or acrylic paints are preferred for finished art. Avoid fluorescent colors. "All art should be prepared on heavy white paper and lightly attached to illustration board. Allow at least one inch all around the design for notations and crop marks. Avoid bleeding the design. In designing sheet stock, keep the design small enough to allow for letter writing space. If designing for an envelope, first consult us to avoid technical problems."
First Contact & Terms: Send query letter with résumé, tearsheets, photostats, slides and photographs. Samples not filed are returned by SASE. Reports only if interested. Art Director will contact artist for portfolio review if interested. Portfolio should include roughs, original/final art, final reproduction/product, color, tearsheets, photostats and photographs. Originals are not returned. "Stuart Hall may choose to negotiate on price but generally accepts the artist's price." Buys all rights.
Tips: Finds artists primarily through word of mouth.

SUN HILL INDUSTRIES, INC., 48 Union St., Stamford CT 06906. Fax: (203)356-9233. Creative Director: Nancy Mimoun. Estab. 1977. Manufacturer of Easter egg decorating kits, Halloween novelties (the Giant

For a list of markets interested in humorous illustration, cartooning and caricatures, refer to the Humor Index at the back of this book.

Stuff-A-Pumpkin®) and Christmas items. Produces only holiday material. Clients: discount chain and drug stores and mail-order catalog houses. Clients include K-Mart, Walmart, Walgreens and Caldor.

Needs: Approached by 10 freelancers/year. Works with 2-3 freelance illustrators and 1-2 designers/year. Assigns 5-6 freelance jobs/year. Works on assignment only. Uses freelancers for product and package design, rendering of product and model-making. Prefers marker and acrylic. Needs computer-literate freelancers for design and presentation. 70% of freelance work demands knowledge of Aldus PageMaker, QuarkXPress and Adobe Illustrator.

First Contact & Terms: Send query letter with brochure and résumé. Samples are filed or are returned only if requested by artist. Reports back only if interested. Pays by the hour, $25 minimum; or by the project, $250 minimum. Considers complexity of project and turnaround time when establishing payment. Buys all rights.

Tips: "Send all information; don't call. Include package designs; do not send mechanical work."

SUNRISE PUBLICATIONS INC., Box 4699, Bloomington IN 47402. (812)336-9900. Fax: (812)336-8712. E-mail: jjensen@aviion.com. Administrative Assistant, Creative Services Dept.: Julia Jensen. Estab. 1974. Produces greeting cards, posters, writing papers, gift packaging and related products.

Needs: Approached by 300 freelancers/year. Works with 200 freelancers/year. Buys 400 designs and illustrations/year. Uses freelancers mainly for greeting card illustration. Also for calligraphy. Considers any medium. Looking for "highly detailed, highly rendered illustration, but will consider a range of styles." Also looking for photography and surface design. 2% of freelance work demands computer skills. Produces material for all holidays and seasons and everyday. Reviews seasonal material year-round.

First Contact & Terms: Send query letter with SASE, tearsheets, photographs, photocopies, photostats, slides and/or transparencies. Samples are not filed and are returned by SASE. Reports back within 2 weeks for queries regarding status; submissions returned within 3 months. Art Director will contact artist for portfolio review if interested. Portfolio should include color tearsheets, photographs and/or slides (duplicate slides or transparencies, please; *not* originals). Originals are returned at job's completion. Negotiates rights purchased. Considers buying second rights (reprint rights) to previously published work.

CURTIS SWANN, Division of Burgoyne, Inc., 2030 E. Byberry Rd., Philadelphia PA 19116. (215)677-8000. Fax: (215)677-6081. Contact: Creative Director. Produces greeting cards. Publishes everyday greeting cards based on heavily embossed designs. Style is based in florals and "cute" subjects.

Needs: Works with 10 freelancers/year. Buys 20 designs and illustrations. Prefers freelancers with experience in greeting card design. Considers designs and media that work well to enhance embossing. Produces material for everyday designs as well as Christmas, Valentine's, Easter, Mother's and Father's Day. Accepts work all year round.

First Contact & Terms: Send query letter with slides, transparencies, photocopies and SASE. Would like to see a sample card with embossed features. Samples are filed. Creative Director will contact artist for portfolio review if interested. Sometimes requests work on spec before assigning a job. Payment depends on project. Buys first rights or all rights.

A SWITCH IN ART, Gerald F. Prenderville, Inc., P.O. Box 246, Monmouth Beach NJ 07750. (908)389-4912. Fax: (908)389-4913. President: G.F. Prenderville. Estab. 1979. Produces decorative switch plates. "We produce decorative switch plates featuring all types of designs including cats, animals, flowers, kiddies/baby designs, birds, etc. We sell to better gift shops, museums, hospitals, specialty stores with large following in mail order catalogs."

Needs: Approached by 4-5 freelancers/year. Works with 2-3 freelancers/year. Buys 20-30 designs and illustrations/year. Prefers artists with experience in card industry and cat rendering. Seeks cats and wildlife art. Prefers 8×10 or 10×12. Produces material for Christmas and everyday. Submit seasonal material 6 months in advance.

First Contact & Terms: Send query letter with brochure, tearsheets and photostats. Samples are filed and are returned. Reports back within 3-5 weeks. Pays by the project, $75-150. Interested in buying second rights (reprint rights) to previously published artwork.

Tips: Finds artists mostly through word of mouth. "Be willing to accept your work in a different and creative form that has been very successful. We seek to go vertical in our design offering to insure continuity. We are very easy to work with and flexible. Cats have a huge following among consumers but designs must be realistic."

‡SYRACUSE CULTURAL WORKERS, Box 6367, Syracuse NY 13217. (315)474-1132. Art Director: Linda Malik. Estab. 1982. Produces greeting cards, posters and calendars. "SCW is a nonprofit publisher of artwork that inspires and supports social change. Our *Art with Heart* catalog is distributed to individuals, stores, co-ops and groups in North America."

Needs: Approached by 30-50 freelancers/year. Works with 50 freelancers/year. Buys 40-50 freelance designs and illustrations/year. Considers all media (in slide form). Looking for progressive, feminist, liberating, vital, people- and earth-centered themes. Submit holiday material 6 months in advance.

First Contact & Terms: Send query letter with slides. Samples are filed or returned by SASE. Reports back within 1 month. Company will contact artist for portfolio review if interested. Buys one-time rights. Originals are returned at job's completion. Pays by the project, $75-300; royalties of 6%.
Tips: Finds artists through word of mouth, our own artist list.

‡**TALICOR, INC.**, Dept. AGDM, 190 Gentry St., Pomona CA 91767. (709)593-5877. President: Lew Herndon. Estab. 1971. Manufacturer and distributor of educational and entertainment games and toys. Clients: chain toy stores, department stores, specialty stores and Christian bookstores.
Needs: Works with 4-6 freelance illustrators and 4-6 designers/year. Prefers local freelancers. Works on assignment only. Uses freelancers mainly for game design. Also for advertising, brochure and catalog design, illustration and layout; product design; illustration on product; P-O-P displays; posters and magazine design.
First Contact & Terms: Send query letter with brochure. Samples are not filed and are returned only if requested. Reports back only if interested. Call or write for appointment to show portfolio. Pays for design and illustration by the project, $100-5,000. Negotiates rights purchased.

‡**TSR, INC.**, 201 Sheridan Springs Rd., Lake Geneva WI 53147. (414)248-3625. Contact: Art Department. Estab. 1975. Produces games, book and calendars. "We produce the *Dungeons & Dragons®* roleplaying game and the game worlds and fiction books that support it."
Needs: Approached by 500 freelancers/year. Works with 30 freelancers/year. Buys thousands of freelance illustrations/year. Works on assignment only. Uses freelancers for book and game covers and interiors and trading card game art. Considers any media. "Artists interested in cover work should show us tight, action-oriented 'realistic' renderings of fantasy or science fiction subjects in oils or acrylics."
First Contact & Terms: Send query letter with tearsheets, photographs, SASE and photocopies. Samples are filed or returned by SASE. Reports back to the artist only if interested. Buys all rights. Originals are returned at job's completion. Pays by the project, $50-2,000 per illustration depending on the size and type of work.
Tips: Finds artists through submissions, reference from other artists and by viewing art on display at the annual Gencon® Game Fair in Milwaukee, Wisconsin. "Be familiar with the adventure game industry in general and our products in particular."

‡**UMBRELLA PRESS**, P.O. Box 11394, Eugene OR 97440. (503)342-6130. Fax: (503)688-1232. Art Director/Owner: Kassy Daggett. Estab. 1993. Produces greeting cards, stationery, posters and postcards. "Our items feature humor, art, coffee theme and inspirational quotes targeted towards a general audience. We distribute nationally and work with artists to develop their individual line on a royalty basis. We work to create progress on our mission statement, 'changing reality . . . one card at a time!' "
Needs: Approached by 50-100 freelancers/year. Works with 5-10 freelancers/year. Prefers artists with experience in working within specific production requirements. Uses freelancers mainly for developing new card lines. Considers mostly b&w line art with spot color. Prefers 5×7 plus bleed and $4\frac{1}{4} \times 6$ plus bleed. Needs computer-literate freelancers for design, illustration and production. 50% of freelance work demands computer skills. Produces material for Christmas, Valentine's Day, Mother's Day, Father's Day, Hannukkah and birthdays. Submit seasonal material 1 year in advance.
First Contact & Terms: Send query letter with photostats, photographs, slides, SASE, photocopies and transparencies. No originals. Samples are not filed and are returned by SASE. Reports back within 3 months. Portfolio review not required. Originals are returned at job's completion. Pays royalties of 5%.
Tips: Finds artists through word of mouth. "We produce coffee theme images and see that trend continuing."

VAGABOND CREATIONS INC., 2560 Lance Dr., Dayton OH 45409. (513)298-1124. Art Director: George F. Stanley, Jr. Publishes stationery and greeting cards with contemporary humor. 99% of artwork used in the line is provided by staff artists working with the company.
Needs: Works with 4 freelancers/year. Buys 30 finished illustrations/year. Prefers local freelancers. Seeking line drawings, washes and color separations. Material should fit in standard size envelope.
First Contact & Terms: Query. Samples are returned by SASE. Reports in 2 weeks. Submit Christmas, Mother's Day, Father's Day, Valentine's Day, everyday and graduation material at any time. Originals are returned only upon request. Payment negotiated.
Tips: "Important! Important! Currently we are *not* looking for additional freelance artists because we are very satisfied with the work submitted by those individuals working directly with us. We do not in any way wish to offer false hope to anyone, but it would be foolish on our part not to give consideration. Our current artists are very experienced and have been associated with us for in some cases over 30 years."

‡**VINTAGE IMAGES**, Box 228, Lorton VA 22199. (703)550-1881. Fax: (703)550-7992. Art Director: Brian Smolens. Estab. 1987. Produces greeting cards and posters. "We produce social stationery and prints using sophisticated humor." Comic/cartoon line is in development.
Needs: Approached by 10 freelancers/year. Works with 2 freelancers/year. Buys 20-40 freelance designs and illustrations/year. Uses freelancers for whole card lines. Also for calligraphy and P-O-P displays. Considers "any media that can be accurately reproduced." Looking for sophisticated humor, not "computer-look-

ing" designs. "We will also consider a bold, elegant personal style." Needs computer-literate freelancers for design. 15% of freelance work demands knowledge of Aldus PageMaker or Photoshop. Produces material for Christmas, Valentine's Day and everyday.

First Contact & Terms: Send query letter with brochure, SASE and photostats/samples. Samples are filed or are returned by SASE. Portfolio review not required. Negotiates rights purchased. Originals are returned at job's completion. Pays average flat fee of $100; or pays by the hour, $30; or by the project, $500 minimum; or royalties of 6%.

Tips: "Provide samples we can keep on file." Has observed more direct/explicit greeting cards in the last year, as well as a move to computer graphics. Needs cartoonists. "We have new calligraphic and traditional art lines in development. No fancy portfolios needed—we have to file materials."

WARNER PRESS, INC., 1200 E. Fifth St., Anderson IN 46018. (317)644-7721, ext. 217. Creative Manager: Roger Hoffman. Estab. 1884. Produces greeting cards, posters, stationery, calendars, church bulletins and supplies. Warner Press is the publication board of the Church of God. "We produce products for the Christian market including greeting cards, calendars and posters. Our main market is the Christian bookstore, but we are expanding into general market with some items. We provide products for all ages."

Needs: Approached by 50 freelancers/year. Works with 35-40 freelancers/year. Buys 300 freelance designs and illustrations/year. Prefers freelancers with experience in greeting cards, posters, calendars, books and giftware—must adhere to deadline and produce quality work. Works on assignment only. Uses freelancers for all products—cards, coloring books, calendars, stationery, etc. Also for calligraphy. "We use local Macintosh artists with own equipment capable of handling 40 megabyte files in PhotoShop, FreeHand and QuarkXPress." Considers all media and photography. Looking for bright florals, sensitive still lifes, landscapes, wildlife, birds, seascapes; all handled with bright or airy pastel colors. Needs computer-literate freelancers for production. 100% of production work demands knowledge of QuarkXPress, Aldus FreeHand, Adobe Illustrator or Adobe Photoshop. Produces material for Father's Day, Mother's Day, Christmas, Easter, graduation, birthdays, Valentine's Day and everyday. Submit seasonal material 18 months in advance.

First Contact & Terms: Send query letter with brochure, tearsheets and photocopies. Samples are filed and are not returned. Creative manager will contact artist for portfolio review if interested. Portfolio should include b&w and color final art, tearsheets, photographs and transparencies. Originals are not returned. Pay by the project, $250-350. Pays for calligraphy pieces by the project. Buys all rights (occasionally varies).

Tips: "Subject matter must be appropriate for Christian market. We prefer palettes of brights colors as well as clean, pretty pastels for greeting cards and calendars. Dramatic palettes work in our poster line."

WEST GRAPHICS, 385 Oyster Point Blvd., #7, San Francisco CA 94080. (800)648-9378. Contact: Production Department. Estab. 1980. "West Graphics is an alternative greeting card company offering a diversity of humor from 'off the wall' to 'tastefully tasteless.' Our goal is to publish cards that challenge the limits of taste and keep people laughing." Produces greeting cards.

● West Graphics' focus is adult alternative humor.

Needs: Approached by 100 freelancers/year. Works with 40 freelancers/year. Buys 150 designs and illustrations/year. Uses freelancers mainly for illustration. "All other work is done inhouse." Considers all media. Looking for outrageous contemporary illustration and "fresh new images on the cutting edge." Prefers art proportionate to finished vertical size of 5×7, no larger than 10×14. Produces material for all holidays and everyday (birthday, get well, love, divorce, congratulations, etc.) Submit seasonal material 1 year in advance.

First Contact & Terms: Send query letter with SASE, tearsheets, photocopies, photostats, slides or transparencies. Samples should relate to greeting card market. Samples are not filed and will be returned by SASE if requested by artist. Reports back within 6 weeks. Company will contact artist for portfolio review if interested. Portfolio should include thumbnails, roughs, photostats, color tearsheets, photographs, slides, dummies and samples of printed work if available. Rights purchased vary. Pays by the project, $100-350, or offers royalties of 5%.

Tips: "We welcome both experienced artists and those new to the greeting card industry. Develop art and concepts with an occasion in mind such as birthday, etc. Your target should be issues that women care about: men, children, relationships, sex, religion, aging, success, money, crime, health, etc. Increasingly, there is a younger market and more cerebral humor. Greeting cards are becoming a necessary vehicle for humorously communicating genuine sentiment that is uncomfortable to express personally."

‡WHITEGATE FEATURES SYNDICATE, 71 Faunce Dr., Providence RI 02906. (401)274-2149. Contact: Eve Green.

● This syndicate is looking for fine artists and illustrators. See their listing in Syndicates & Clip Art Firms for more information about their needs.

WILLIAMHOUSE-REGENCY, INC., 28 W. 23rd St., New York NY 10010. Senior Art Director: Nancy Boecker Oates. Estab. 1955. Produces wedding invitations and announcements, Christmas cards and stationery.

Needs: Approached by 30 freelancers/year. Works with 10 freelancers/year. Buys 30 freelance designs and illustrations/year. "Prefers freelancers with experience in our products and techniques (including foil and

embossing)." Uses freelancers mainly for design and illustration of wedding invitations. Also for calligraphy. Considers all media. Produces material for personalized Christmas, Rosh Hashanah, New Year, graduation, wedding invitations and birth announcements. Submit seasonal material 1 year in advance.

First Contact & Terms: Send query letter with SASE. Samples are not filed and are returned by SASE. Reports back within 3 weeks. Artist should follow-up with letter after initial query. Pays average flat fee of $150/design; pays more for full color or complicated artwork. Buys reprint rights or all rights. No royalties.

Tips: "Send in any roughs or copies of finished ideas you have, and we'll take a look. Write for specs on size first (with SASE) before submitting any material. In wedding invitations, we seek a non-greeting card look. Have a look at what is out there."

Greeting Cards, Gift Items & Paper Products/'95-'96 changes

The following companies were listed in the 1995 edition but do not have listings in this edition. The majority did not respond to our request to update their listings. If a reason was given for exclusion, it appears in parentheses after the company's name.

Advanced Cellocard Co., Inc.
Patricia Allen & Company
The Ashton-Drake Galleries
Athena International
Balloon Wholesalers International
BePuzzled
J.F. Caroll Publishing
John C.W. Carroll
H. George Caspari, Inc.
Colors By Design
Creegan Co., Inc.
Custom Studios Inc.
Design House Inc. (out of business)
Designers Greetings, Inc.

The Duck Press
E.F. Musical Greetings Cards
Everything Metal Imaginable, Inc.
Fotofolio, Inc.
Goes Lithographing Company Since 1879
Heritage Collection
Home Interiors & Gifts
Hurlimann Armstrong Studios
GPC
Innovative Icons Incorporated
Lang Companies
Lucy & Company
Frances Meyer, Inc.
Mixedblessing

Thomas Nelson, Inc.—Markings
The Paper Company℠
Papillon International Giftware Inc.
Pickard China
The Popcorn Factory
Pretty Paper Company
Punch Enterprises Inc.
Regency & Century Greetings
St. Argos Co., Inc.
Saludos, USA
Spencer Gifts, Inc.
Sunshine Art Studios, Inc.
Super-Calli-Graphics
TLC Greeetings
Carol Wilson Fine Arts, Inc.

Magazines

Magazines are a great market for freelance artists. The best proof of this fact is as close as your nearest newsstand. The colorful publications competing for your attention are chock-full of interesting illustrations, cartoons and caricatures. Since magazines are generally published on a monthly or bimonthly basis, art directors look for dependable artists who can deliver on deadline quality artwork with a particular style and focus.

Art that illustrates a story in a magazine or newspaper is called editorial illustration. You'll notice that term as you browse through the listings. Art directors look for the best visual element to hook the reader into the story. In some cases this is a photograph, but often, especially in stories dealing with abstract ideas or difficult concepts, an illustration makes the story more compelling. A whimsical illustration sets the tone for a humorous article and a caricature might dress up a short feature about a celebrity.

Attractive art won't be enough to grab a magazine assignment. Your work must convey the tone and content of a writer's article. Good illustrators accomplish this whether their style is realistic or they specialize in simple line drawings. Even though you may be versatile, impress art directors with your proficiency in a certain style. It's easier for them to think in terms of "the guy who does the frantic wiggly line drawings," or "the woman who does the realistic portraits," than somebody whose talents are all over the map.

Targeting your approach

The key to success in the magazine arena is matching your style to appropriate publications. Art directors work to achieve a chemistry between artist and magazine, creating a relationship in which the artwork and editorial content complement each other.

Consumer magazines appeal to the public at large, while trade publications focus on an audience involved in a particular profession. Don't overlook publications in your own city (see D.J. Stout's Insider Report on page 582 for the scoop on regional magazines). It's important to study the unique personalities of individual magazines before submitting samples. Art directors expect prospective freelancers to understand their publication's focus and audience, and they expect any samples submitted to reflect this understanding.

Before submitting, research the markets you wish to target. Although many magazines can be found at a newsstand or library, some of your best markets may not be readily available on newsstands. If you can't find a magazine, check the listing in *Artist's & Graphic Designer's Market* to see if sample copies are available. Keep in mind that many magazines also provide artists' guidelines in exchange for a SASE.

Submitting samples

It's fairly standard practice to mail nonreturnable samples: either postcard-size reproductions of your work, photographs, slides or whatever is requested in the listing; along with a brief cover letter of introduction. Some art directors like to see a résumé; some don't. If you are a designer, a well-designed résumé can serve as a testimony to your creative talent. Send a résumé if you think it will build a stronger case for you. Always include a self-addressed, stamped envelope large enough to accommodate your samples,

but indicate that the director is welcome to keep samples on file.

Persistence pays off in this field if your work is good, your attitude professional and your target market appropriate. Don't be afraid to send in new samples as you acquire tearsheets and do new work. This reminds the art director that you're still interested in the publication and are available for assignments. Remember, however, to check the magazine's masthead for staff changes before submitting new material.

Some art directors still conduct portfolio reviews, although this practice has become somewhat antiquated. Check individual listings for information about whether such reviews are conducted. For more information on portfolios and sample packages, turn to page 14.

Fees

Fees vary depending on the assignment, rights purchased, experience of the free-lancer and the magazine's budget. Widely circulated publications often boast large pay scales, while those with smaller circulations—particularly literary or "little" maga-zines—sometimes pay only in copies. Keep in mind that there are advantages to publish-ing in small magazines, despite their low payment. They're often more open to experi-mental work and to new artists. For more information on setting fees, turn to page 6.

Hit the spot

This year, as we compiled information from magazine art directors, we asked them about their use of spot illustration. Spot illustrations, which are a half-page or smaller, are used in magazine layouts as interesting visual cues accompanying shorter articles, or to help break up larger articles into smaller chunks for readers. Because "spots," as they are called by art directors and illustrators, are small in size, they must be all the more compelling. Though spots do not pay as much per illustration as larger assign-ments, they can be lucrative. Often a magazine will use four or five spots by the same illustrator for one issue. So when submitting to magazines, consider including a sample which demonstrates you can create power-packed small pieces as well as large illustra-tions.

Each year the Society of Publication Designers sponsors an annual juried competi-tion called, appropriately enough, SPOTS. The winners of the annual competition are featured in a prestigious yearly exhibition held in New York. The winners of the 1995 competition are featured in a *The Best of Spot Illustrations* published by Rockport Publishers, Inc. If you would like information about the annual SPOTS competition contact the Society of Publication Designers at (212)983-8585.

A note about sourcebooks

If an art director uses creative directories or sourcebooks we have included this information under the Tips subhead. The term "sourcebooks" as used in the listings, refers to the various creative directories published each year which showcase the work of photographers, illustrators and cartoonists. Some of the popular annual talent directo-ries like *The Creative Black Book*, *The American Showcase* and *RSVP* carry paid adver-tisements, costing several thousand dollars per page, bought by illustrators and/or agents. Other annuals, like the *Print Regional Design Annual* and *Communication Art Illustration Annual* feature award winners of various competitions. Art directors fre-quently turn to these publications when looking for artists with interesting styles. In listings where the art director reports use of these publications, be aware that your competition is stiff, but do not let that deter you in your marketing plans. A great submission package will put your work in front of art directors and keep it in their

frequently-referred-to files. For more information on creative directories see What Should I Submit? on page 14.

ABERRATIONS, P.O. Box 460430, San Francisco CA 94146-0430. (415)777-3909. Art Director: Eric Turowski. Estab. 1992. Monthly science fiction/fantasy/horror magazine aimed at an adult readership. Circ. 1,500. Originals returned at job's completion. Sample copies available for $3.50 plus 3 first-class stamps. Art guidelines available for SASE with first-class postage.

Illustrations: Approached by 58 illustrators/year. Buys 9-22 illustrations/issue. Works on assignment only. Prefers science fiction, fantasy, horror story illustrations. Considers pen & ink, watercolor, collage, airbrush, acrylic, marker, colored pencil, oil, charcoal, mixed media, pastel, "just about anything that's *camera-ready*." Send query letter with photocopies. Samples are filed. Reports back to the artist only if interested. "Mail a portfolio of 3-6 photocopies for our files." Pays on publication; $25 for b&w or monochromatic cover; $10 for b&w inside. Buys first rights.

Tips: Finds artists through submissions and queries. "We are mainly interested in pulp-styled b&w illustrations for the interior of the magazine. Covers are done with spot colors (no more than three), so separations are required. We do full color covers on occasion. Please query for information. Mail your samples *flat*. Tell us the kind of work you like to do, and what you don't like to do. We are eager to work with new artists, and we aren't hard to please. Also, we prefer camera-ready art, or as close to it as you are able. I tend to assign the art for several issues at a time, so don't be discouraged if I don't get back to you right away. We would like to work with artists who are interested in working in and around our text as opposed to a plain box format. Our primary interest is in illustration. Show me an interesting piece that will draw in a reader, without giving away the end. No computer art accepted."

‡ABYSS MAGAZINE, RAGNAROK PRESS, Box 140333, Austin TX 78714. Fax: (512)472-6220. E-mail: ragnarokgc@aol.com. Editor: David F. Nalle. Estab. 1979. Black and white quarterly emphasizing fantasy and adventure games for adult game players with sophisticated and varied interests. Circ. 1,800. Does not accept previously published material. Returns original artwork after publication. Sample copy for $5. Art guidelines free for SASE with first-class postage. 25% of freelance work demands computer skills.

● Ragnarok Press is also a book publisher. See its listing in the Book Publishers section.

Illustrations: Approached by 100 illustrators/year. Works with 10-20 illustrators/year. Buys 200-300 illustrations/year. Need editorial, horror, historical and fantasy in tradition of H.J. Ford and John D. Batten. Uses freelancers mainly for covers and spots. Prefers science fiction, fantasy, dark fantasy, horror or mythology themes. Send query letter with samples. Write for appointment to show portfolio. Prefers photocopies or photographs as samples. Samples not filed are returned by SASE. Reports within 1 month. Buys first rights. Pays on publication; $20-40 for b&w, $50-300 for color cover; $3-10 for b&w inside; $10-20 for b&w spots.

Tips: Does not want to see "Dungeons and Dragons-oriented cartoons or crudely created computer art." Notices "more integration of art and text through desktop publishing. We are now using all scanned art in layout either as provided by artists or scanned inhouse. Knowledge of Photoshop helpful."

‡AD ASTRA, 922 Pennsylvania Ave. SE, Washington DC 20003. (202)543-1900. Editor: Pat Dasch. Estab. 1989. Bimonthly feature magazine popularizing and advancing space exploration for the general public interested in all aspects of the space program.

Illustrations: Works with 20 freelancers/year. Uses freelancers for magazine illustration. Buys 50 illustrations/year. "We are looking for original artwork on space themes, either conceptual or representing specific designs, events, etc." Prefers acrylics, then oils and collage. Send query letter with photographs. "Color slides are best." Samples not filed are returned by SASE. Reports back within 6 weeks. Pays $100-300 color, cover; $25-100 color, inside. "We do not generally commission original art." Fees are for one-time reproduction of existing artwork. Considers rights purchased when establishing payment.

Tips: "Show a set of slides showing planetary art, spacecraft and people working in space. I do not want to see 'science-fiction' art. Label each slide with name and phone number."

ADVENTURE CYCLIST, 150 E. Pine, Missoula MT 59802. (406)721-1776. Fax: (406)721-8754. Art Director: Greg Siple. Estab. 1974. Published 9 times a year. A journal of adventure travel by bicycle. Circ. 26,000. Originals returned at job's completion. Sample copies available. Needs computer-literate freelancers for design, illustration and production. 50% of freelance work demands knowledge of QuarkXPress or Aldus FreeHand.

A bullet introduces comments by the editor of Artist's & Graphic Designer's Market *indicating special information about the listing.*

Illustrations: Buys 1 illustration/issue. Works on assignment only. Send query letter with transparencies. Samples are not filed and are returned. Reports back within 1 month. Publication will contact artist for portfolio review if interested. Portfolio should include color photocopies. Pays on publication; $150 for color cover; $50 and up for color inside. Buys one-time rights.

THE ADVOCATE, 301A Rolling Hills Park, Prattsville NY 12468. (518)299-3103. Art Editor: C.J. Karlie. Estab. 1987. Bimonthly b&w literary tabloid. *"The Advocate* provides aspiring artists, writers and photographers the opportunity to see their works published and to receive byline credit toward a professional portfolio so as to promote careers in the arts." Circ. 12,000. "Good quality photocopy or stat of work is acceptable as a submission." Sample copies available for the cost of $4. Art guidelines for SASE with first-class postage.
Cartoons: Open to all formats except color washes. Send query letter with SASE and submissions for publication. Samples are not filed and are returned by SASE. Reports back within 2-6 weeks. Buys first rights. Pays in contributor's copies.
Illustrations: Buys 10-15 illustrations/issue. Considers pen & ink, charcoal, linoleum-cut, woodcut, lithograph, pencil. Also needs editorial and entertainment illustration. Send query letter with SASE and photos of artwork (b&w or color prints only). No simultaneous submissions. Samples are not filed and are returned by SASE. Portfolio review not required. Reports back within 2-6 weeks. Buys first rights. Pays in contributor's copies.
Tips: Finds artists through submissions and from knowing artists and their friends. "Please remember SASE for return of materials. We hope to continue publishing six times per year and will need 10-15 illustrations per issue."

AGING TODAY, 833 Market St., San Francisco CA 94103. (415)974-9619. Fax: (415)974-0300. Editor: Paul Kleyman. Estab. 1979. *"Aging Today* is the bimonthly b&w newspaper of The American Society on Aging. It covers news, public policy issues, applied research and developments/trends in aging." Circ. 15,000. Accepts previously published artwork. Originals returned at job's completion if requested. Sample copies available. Art guidelines not available.
Cartoons: Approached by 50 cartoonists/year. Buys 1-2 cartoons/issue. Prefers political and social satire cartoons; single, double or multiple panel with or without gagline, b&w line drawings. Send query letter with brochure and roughs. Samples returned by SASE if requested by artist. Reports back to the artist only if interested. Buys one-time rights. Pays $15-25 for b&w.
Illustrations: Approached by 50 illustrators/year. Buys 1 illustration/issue. Works on assignment only. Prefers b&w line drawings and some washes. Considers pen & ink. Needs editorial illustration. Send query letter with brochure, SASE and photocopies. Samples are not filed and are returned by SASE if requested by artist. Reports back to the artist only if interested. Artist should follow-up with call and/or letter after initial query. Buys one-time rights. Pays on publication; $25 for b&w cover; $25 for b&w inside.
Tips: "Send brief letter with two or three applicable samples. Don't send hackneyed cartoons that perpetuate ageist stereotypes."

AIM, Box 20554, Chicago IL 60620. (312)874-6184. Editor-in-Chief: Ruth Apilado. Managing Editor: Dr. Myron Apilado. Estab. 1973. 8½×11 b&w quarterly with 2-color cover. Readers are those "wanting to eliminate bigotry and desiring a world without inequalities in education, housing, etc." Circ. 7,000. Sample copy $4; artist's guidelines for SASE. Reports in 3 weeks. Previously published, photocopied and simultaneous submissions OK. Receives 12 cartoons and 4 illustrations/week from freelancers.
Cartoons: Buys 10-15 cartoons/year. Uses 1-2 cartoons/issue. Prefers education, environment, family life, humor in youth, politics and retirement; single panel with gagline. Especially needs "cartoons about the stupidity of racism." Send samples with SASE. Reports in 3 weeks. Buys all rights on a work-for-hire basis. Pays on publication; $5-15 for b&w line drawings.
Illustrations: Uses 4-5 illustrations/issue; half from freelancers. Prefers pen & ink. Prefers current events, education, environment, humor in youth, politics and retirement. Provide brochure to be kept on file for future assignments. Samples not returned. Reports in 1 month. Prefers b&w for cover and inside art. Buys all rights on a work-for-hire basis. Pays on publication; $25 for b&w cover illustrations.
Tips: "We could use more illustrations and cartoons with people from all ethnic and racial backgrounds in them. We also use material of general interest. Artists should show a representative sampling of their work and target the magazine's specific needs. Nothing on religion."

How to Use Your Artist's & Graphic Designer's Market *offers suggestions for understanding and using the information in these listings. Read this and other articles in the front of this book for important business tips.*

‡ALASKA BUSINESS MONTHLY, P.O. Box 241288, Anchorage AK 99524-1288. (907)276-4373. Fax: (907)279-2900. Editor: Cliff Gerhart. Estab. 1985. Monthly business magazine. *"Alaska Business Monthly* magazine is written, edited and published by Alaskans for Alaskans and other U.S. and international audiences interested in business affairs of the 49th state. Its goal is to promote economic growth in the state by providing thorough and objective discussion and analyses of the issues and trends affecting Alaska's business sector and by featuring stories on the individuals, organizations and companies that shape the Alaskan economy." Circ. 10,000. Accepts previously published artwork. Originals returned at job's completion if requested. Sample copies available for SASE with first-class postage. Art guidelines available.
Illustrations: Rights purchased vary according to project. Pays on publication; $500 for color cover; $50-250 for b&w inside and $150-300 for color inside.

‡ALTERNATIVE THERAPIES IN HEALTH AND MEDICINE, 101 Columbia, Aliso Viejo CA 92656. (714)362-2000. Fax: (714)632-2020. Art Director: LeRoy Hinton. Estab. 1995. Bimonthly trade journal. *"Alternative Therapies* is a peer-reviewed medical journal established to promote integration between alternative and cross-cultural medicine with conventional medical traditions." Circ. 20,000. Accepts previously published artwork. Originals returned at job's completion. Sample copies available. Art guidelines not available. Needs computer-literate freelancers for illustration. 50% of freelance work demands knowledge of Adobe Illustrator, QuarkXPress and Adobe Photoshop.
Cartoons: Buys 2 cartoons/issue. Prefers alternative or conventional medicine themes. Prefers single panel, political and humorous, b&w washes and line drawings with gagline. Send query letter with roughs. Samples are filed. Reports back within 10 days. Buys one-time rights. Pays $250 for b&w.
Illustrations: Buys 6 illustrations/year. "We purchase fine art for the covers not graphic art." Send query letter with slides. Samples are filed. Reports back within 10 days. Publication will contact artist for portfolio review if interested. Portfolio should include photographs and slides. Buys one-time and reprint rights. Pays on publication; negotiable.
Tips: Finds artists through agents, sourcebooks and word of mouth.

AMELIA, 329 E St., Bakersfield CA 93304. (805)323-4064. Editor: Frederick A. Raborg, Jr. Estab. 1983. Quarterly magazine. Also publishes 2 supplements—*Cicada* (haiku) and *SPSM&H* (sonnets) and illustrated postcards. Emphasizes fiction and poetry for the general review. Circ. 1,500. Accepts some previously published material from illustrators. Original artwork returned after publication if requested with SASE. Sample copy $8.95; art guidelines for SASE.
Cartoons: Buys 3-5 cartoons/issue for *Amelia*. Prefers sophisticated or witty themes (see Ford Button's, Earl Engleman's and Vahan Shirvanian's work). Prefers single panel b&w line drawings and washes with or without gagline (will consider multipanel on related themes). Send query letter with finished cartoons to be kept on file. Material not filed is returned by SASE. Reports within 1 week. Usually buys first rights. **Pays on acceptance**; $5-25 for b&w. Occasionally uses captionless cartoons on cover; $50 b&w; $100 color.
Illustrations: Buys 80-100 illustrations and spots/year for *Amelia;* 24-30 spots for *Cicada;* 15-20 spots for *SPSM&H* and 50-60 spots for postcards. Considers all themes. "No taboos, except no explicit sex; nude studies in taste are welcomed, however." Prefers pen & ink, pencil, watercolor, acrylic, oil, pastel, mixed media and calligraphy. Send query letter with résumé, photostats and/or photocopies to be kept on file. Unaccepted material returned immediately by SASE. Reports in 1 week. Portfolio should contain "one or two possible cover pieces (either color or b&w), several b&w spots, plus several more fully realized b&w illustrations." Buys first rights or one-time rights (prefers first rights). **Pays on acceptance**; $50 for b&w, $100 for color, cover; $5-25 for b&w, inside. "Spot drawings are paid for on assignment to an issue."
Tips: "In illustrations, it is very difficult to get excellent nude studies. Everyone seems capable of drawing an ugly woman; few capture sensuality, and fewer still draw the nude male tastefully. (See male nudes we've used by Susan Moffett and Miguel Angel Reyes for example.)"

AMERICA WEST AIRLINES MAGAZINE, 4636 E. Elwood St., Suite 5, Phoenix AZ 85040-1963. Art Director: Katharine McGee. Estab. 1986. Monthly inflight magazine for fast-growing national airline; 4-color, "conservative design. Appeals to an upscale audience of travelers reflecting a wide variety of interests and tastes." Circ. 130,000. Accepts previously published artwork. Original artwork is returned after publication. Sample copy $3. Needs computer-literate illustrators familiar with Photoshop, Adobe Illustrator, Quark XPress and Aldus FreeHand.
Illustrations: Approached by 100 illustrators/year. Buys illustrations mainly for spots, columns and feature spreads. Buys 5 illustrations/issue from freelancers. Uses freelancers mainly for features and columns. Works on assignment only. Prefers editorial illustration in airbrush, mixed media, colored pencil, watercolor, acrylic, oil, pastel, collage and calligraphy. Send query letter with color brochure showing art style and tearsheets. Looks for the "ability to intelligently grasp idea behind story and illustrate it. Likes crisp, clean colorful styles." Samples are filed. Does not report back. Publication will contact artist for portfolio review if interested. Sometimes requests work on spec before assigning job. Buys on publication one-time rights. Pays $75-250, b&w; $150-500, color, inside. "Send lots of good-looking color tearsheets that we can keep on hand for reference. If your work interests us we will contact you."

Tips: "In your portfolio show examples of editorial illustration for other magazines, good conceptual illustrations and a variety of subject matter. Often artists don't send enough of a variety of illustrations; it's much easier to determine if an illustrator is right for an assignment if I have a complete grasp of the full range of his abilities. Send high-quality illustrations and show specific interest in our publication." Does not want to see "photocopies—makes artwork and artist look sloppy and unprofessional."

‡THE AMERICAN ATHEIST, Box 140195, Austin TX 78714-0195. (512)458-1244. Editor: R. Murray-O'Hair. Estab. 1958. Monthly for atheists, agnostics, materialists and realists. Circ. 30,000. Simultaneous submissions OK. Sample copy for 9×12 envelope or label.
Cartoons: Buys 5 cartoons/issue. Especially needs 4-seasons art for covers and greeting cards. Send query letter with résumé and samples. Pays $15 each.
Illustrations: Buys 1 illustration/issue. "Send samples to be kept on file. We do commission artwork based on the samples received. All illustrations must have bite from the atheist point of view and hit hard." Prefers pen & ink, then airbrush, charcoal/pencil and calligraphy. To show a portfolio, mail final reproduction/product and b&w photographs. **Pays on acceptance**; $75-100 for cover; $25 for inside.
Tips: "*The American Atheist* looks for clean lines, directness and originality. We are not interested in side-stepping cartoons and esoteric illustrations. Our writing is hard-punching and we want artwork to match. The American Atheist Press (parent company), buys book cover designs and card designs. I would like to see a sample of various styles, but since we can't print in color, I need to know if the artist can design/illustrate for offset printing."

‡AMERICAN BANKERS ASSOCIATION-BANKING JOURNAL, 345 Hudson St., New York NY 10014. (212)620-7256. Art Director: John McLaughlin. Estab. 1908. 4-color; conservative design. Emphasizes banking for middle and upper level-banking executives and managers. Monthly. Circ. 42,000. Accepts previously published material. Returns original artwork after publication.
Illustrations: Buys 4-5 illustrations/issue from freelancers. Themes relate to stories, primarily financial, from the banking industry's point of view; styles vary, realistic, cartoon, surreal. Uses full-color illustrations and occasional b&w spots. Works on assignment only. To send a portfolio, send query letter with brochure and tearsheets, promotional samples or photographs. "Please do not send work to be returned." Negotiates rights purchased. **Pays on acceptance**; $600-800, color, cover; $150-300, b&w or color, inside.

AMERICAN BREWER MAGAZINE, Box 510, Hayward CA 94543-0510. (510)538-9500 (mornings). E-mail: beerthemag@aol.com; 75753.1677@compuserve.com; btm@ambrew.com; http://ambrew.com/btm/. Publisher: Bill Owens. Estab. 1985. Quarterly trade journal in b&w with 4-color cover focusing on the micro-brewing industry. Circ. 10,000. Accepts previously published artwork. Original artwork returned after publication. Sample copies for $5. Phone for art guidelines. Needs computer-literate freelancers for illustration. 80% of freelance work demands knowledge of Aldus PageMaker.
● Also publishes *BEER, The Magazine*.
Cartoons: Approached by 6-8 cartoonists/year. Buys 2 cartoons/issue. Prefers themes related to drinking or brewing handcrafted beer; single panel. Send query letter with roughs. Samples not filed are returned. Reports back within 2 weeks. Buys reprint rights. Pays $25-50 for b&w.
Illustrations: Approached by 6-10 illustrators/year. Buys 2 illustrations/issue. Works on assignment only. Prefers themes relating to beer, brewing or drinking; pen & ink. Send query letter with photocopies. Samples are not filed and are returned. Reports back within 2 weeks. Pays $200 for color cover. Buys reprint rights.
Tips: "I prefer to work with San Francisco Bay area artists."

‡AMERICAN CAREERS, 6701 W. 64th St., Overland Park KS 66202. (913)362-7788 or (800)669-7795. Fax: (913)362-4864. Publisher: Barbara Orwig. Estab. 1990. Quarterly educational magazine for students in middle/high school. Designed to promote vocational technical education, career options, business and industry partnerships. Circ. 500,000. Accepts previously published artwork. Original artwork returned at job's completion on request. Sample copies available. Art guidelines not available. Needs computer-literate freelancers for design and illustration. 90% of freelance work demands knowledge of QuarkXPress, Aldus FreeHand and Photoshop.
Cartoons: Buys 2-3 cartoons/year. Themes and styles must be youth-appropriate and content-specific. Send query letter with brochure and roughs. Samples are filed or are returned by SASE if requested. Reports back only if interested. Negotiates rights purchased. Pays $150 for b&w; $300 for color (negotiable).
Illustrations: Approached by 4-6 illustrators/year. Buys 10 illustrations/year. Works on assignment only. Prefers editorial illustration. Prefers educational-related themes or styles. Send query letter with brochure or résumé and tearsheets or proof of work. Show enough to prove work experience. Samples are filed or are returned by SASE if requested by artist. Reports back only if interested. Negotiates rights purchased. Pays on publication; $100 for b&w, $300 for color, cover; $100 for b&w, $200 for color, inside.

AMERICAN FITNESS, 15250 Ventura Blvd., Suite 200, Sherman Oaks CA 91403. (818)905-0040. Editor-at-Large: Peg Jordan. Managing Editor: Rhonda J. Wilson. Bimonthly magazine emphasizing fitness, health and exercise "for sophisticated, college-educated, active lifestyles." Circ. 30,000. Accepts previously pub-

lished material. Original artwork returned after publication. Sample copy $1.
Cartoons: Approached by 12 cartoonists/month. Buys 1 cartoon/issue. Material not kept on file is returned if requested. Buys one-time rights. Pays $35.
Illustrations: Approached by 12 illustrators/month. Assigns 4-6 illustrations/issue. Works on assignment only. Prefers "very sophisticated" 4-color line drawings. Send query letter with thumbnails, roughs or brochure showing art style. Reports back within 2 months. Acquires one-time rights.
Tips: "Excellent source for never-before-published illustrators who are eager to supply full-page lead artwork."

‡THE AMERICAN LEGION MAGAZINE, Box 1055, Indianapolis IN 46206. Contact: Cartoon Editor. Emphasizes the development of the world at present and milestones of history; 4-color general-interest magazine for veterans and their families. Monthly. Original artwork not returned after publication.
Cartoons: Uses 2-3 freelance cartoons/issue. Receives 100 freelance submissions/month. Especially needs general humor in good taste. "Generally interested in cartoons with broad appeal. Prefers action in the drawing, rather than the illustrated joke-type gag. Those that attract the reader and lead us to read the caption rate the highest attention. No-caption gags purchased only occasionally. Because of tight space, we're not in the market for the spread or multipanel cartoons but use both vertical and horizontal single-panel cartoons. Themes should be home life, business, sports and everyday Americana. Cartoons that pertain only to one branch of the service may be too restricted for this magazine. Service-type gags should be recognized and appreciated by any ex-service man or woman. Cartoons that may offend the reader are not accepted. Liquor, sex, religion and racial differences are taboo. No roughs. Send final product for consideration." Usually reports within 1 month. Buys first rights. **Pays on acceptance**; $150.
Tips: "Artists should submit their work as we are always seeking new slant and more timely humor. Black & white art is primarily what we seek. Note: Cartoons are separate from the art department."

AMERICAN LIBRARIES, 50 E. Huron St., Chicago IL 60611. (312)280-4216. Fax: (312)440-0901. Acting Editor: Leonard Kriffel. Senior Editor of Design: Edie McCormick. Estab. 1907. Monthly professional 4-color journal of the American Library Association for its 55,000 members, providing independent coverage of news and major developments in and related to the library field. Circ. 55,000. Original artwork returned at job's completion. Sample copy $6. Art guidelines available.
Cartoons: Approached by 15 cartoonists/year. Buys no more than 1 cartoon/issue. Prefers themes related to libraries. Send query letter with brochure and finished cartoons. Samples are filed. Does not report on submissions. Buys first rights. Pays $35-50 for b&w.
Illustrations: Approached by 20 illustrators/year. Buys 1-2 illustrations/issue. Works on assignment only. Send query letter with brochure, tearsheets and résumé. Samples are filed. Does not report on submissions. To show a portfolio, mail tearsheets, photostats, photographs and photocopies. Portfolio should include broad sampling of typical work with tearsheets of both b&w and color. Buys first rights. **Pays on acceptance**; $75-150 for b&w and $250-300 for color, cover; $75-150 for b&w and $150-250 for color, inside.
Tips: "I suggest inquirer go to a library and take a look at the magazine first." Sees trend toward "more contemporary look, simpler, more classical, returning to fewer elements."

‡AMERICAN MEDICAL NEWS, 515 N. State, Chicago IL 60610. (312)464-4432. Fax: (312)464-5793. Art Director: Jef Capaldi. Estab. 1958. Weekly trade journal. "We're the nation's most widely circulated publication covering socioeconomic issues in medicine." Circ. 375,000. Originals returned at job's completion. Sample copies available. Needs computer-literate freelancers for illustration. 10% of freelance work demands knowledge of Adobe Photoshop and Aldus FreeHand.
Illustrations: Approached by 100 freelancers/year. Buys 2-3 illustrations/issue. Works on assignment only. Considers mixed media, collage, watercolor, acrylic and oil. Send query letter with tearsheets and photostats. Samples are filed. Publication will contact artist for portfolio review if interested. Buys first rights. **Pays on acceptance**. Pays $275 for b&w, $500-850 for color inside. Pays $150 for spots.
Tips: Finds artists through illustration contest annuals, word of mouth and artists' submissions. "Illustrations need to convey a strong, clever concept."

AMERICAN MOTORCYCLIST, American Motorcyclist Association, Box 6114, Westerville OH 43081-6114. (614)891-2425. Executive Editor: Greg Harrison. Managing Editor: Bill Wood. Circ. 190,000. Monthly 4-color for "enthusiastic motorcyclists investing considerable time and money in the sport." Sample copy $1.50.
Cartoons: Buys 1-2 cartoons/issue. Receives 5-7 submissions/week. Interested in "single panel gags about motorcycling." Prefers to receive finished cartoons. Must include SASE. Reports in 3 weeks. Buys all rights on a work-for-hire basis. Pays on publication; $15 minimum for b&w washes.
Illustrations: Buys 1-2 illustrations/issue, almost all from freelancers. Receives 1-3 submissions/week. Interested in motorcycling themes. Send query letter with résumé and tearsheets to be kept on file. Samples returned by SASE. Reports in 3 weeks. Buys first North American serial rights. Pays on publication; $150 minimum for color cover; $30-100 for b&w and color inside.

The headline "Dying a Natural Death" accompanies this powerful illustration by David Beck in **American Medical News.** *Beck used the image of the grim reaper harvesting a tobacco field for the story on the decline of the tobacco industry, and got a great feedback from readers. "Two oncologists called to have prints made to hang in their offices." Beck, who has worked extensively in the editorial market, then used this single piece in a direct mail promotion to 30 prospective clients. "I had a 25% response," says Beck. "I had to turn down $4,500 worth of work in a three-week period. It's been a very positive experience."*

AMERICAN MUSCLE MAGAZINE, Box 6100, Rosemead CA 91770. Art Director: Michael Harding. Monthly 4-color magazine emphasizing bodybuilding, exercise and professional fitness. Features general interest, historical, how-to, inspirational, interview/profile, personal experience, travel articles and experimental fiction (all sports-related). Circ. 310,331. Accepts previously published material. Original artwork returned after publication.
Illustrations: Buys 5 illustrations/issue. Send query letter with résumé, tearsheets, slides and photographs. Samples are filed or are returned. Reports back within 1 week. Buys first rights, one-time rights, reprint rights or all rights. **Pays on acceptance.**
Tips: "Be consistent in style and quality."

‡**AMERICAN MUSIC TEACHER**, 441 Vine St. Suite 505, Cincinnati OH 45202-2814. Art Director: Stacey Clark. Estab. 1951. Bimonthly 4-color trade journal emphasizing music teaching. Features historical and

how-to articles. "*AMT* promotes excellence in music teaching and keeps music teachers informed. It is the official journal of the Music Teachers National Association, an organization which includes concert artists, independent music teachers and faculty members of educational institutions." Circ. 26,424. Accepts previously published material. Original artwork returned after publication. Sample copies available.

Illustrations: Buys 1 illustration/issue. Uses freelancers mainly for diagrams and illustrations. Prefers musical theme. "No interest in cartoon illustration." Send query letter with brochure or résumé, tearsheets, slides and photographs. Samples are filed or are returned only if requested. Reports back within 3 months. To show a portfolio, mail printed samples, color and b&w tearsheets, photographs and slides. Buys one-time rights. Pays on publication; $50-150 for b&w and color, cover and inside.

AMERICAN WOMAN MOTORSCENE, 1510 11th St., Suite 201-B, Santa Monica CA 90401-2906. (310)260-0192. Fax: (310)260-0175. Editor-in-Chief: Courtney Caldwell. Estab. 1988. Bimonthly automotive and recreational motorsports magazine for today's active women. Feature oriented for women of achievement. Circ. 100,000. Accepts previously published artwork. Originals returned at job's completion only if requested. Sample copies available for 9×12 SASE and 10 first-class stamps. Art guidelines not available. Needs computer-literate freelancers for illustration. 20% of freelance work demands knowledge of QuarkXPress or Aldus PageMaker.

Cartoons: Approached by 3-5 cartoonists/year. Prefers women in automotive—"classy, no bimbo stuff"; single/double panel humorous cartoons with gaglines. Send query letter with roughs and finished cartoons. Samples are filed. Reports back within 1 month with SASE or if interested. Rights purchased vary according to project. Pays $50 for b&w.

Illustrations: Approached by 3-5 illustrators/year. Works on assignment only. Prefers women of achievement. Open/flexible to all media. Send query letter with résumé, SASE, tearsheets and photocopies. Samples are filed or are returned by SASE if requested by artist. Reports back within 1 month with SASE. Publication will contact artist for portfolio review if interested. Portfolio should include b&w tearsheets, roughs, photocopies, final art and photographs. Rights purchased vary according to project. Pays on publication; $50 minimum for b&w inside.

Tips: Finds artists through submissions, *Artist's & Graphic Designer's Market.* "Must have knowledge of cars, trucks, motorcycles, hot rods and how today's women think!"

ANIMALS, 350 S. Huntington Ave., Boston MA 02130. (617)522-7400. Fax: (617)522-4885. Contact: Jim Grisanzio. Estab. 1868. "*Animals* is a national bimonthly 4-color magazine published by the Massachusetts Society for the Prevention of Cruelty to Animals. We publish articles on and photographs of wildlife, domestic animals, conservation, controversies involving animals, animal-welfare issues, pet health and pet care." Circ. 90,000. Original artwork usually returned after publication. Sample copy $2.95.

Illustrations: Approached by 1,000 illustrators/year. Works with 5 illustrators/year. Buys 5 or less illustrations/year from freelancers. Uses artists mainly for spots. Prefers pets or wildlife illustrations relating to a particular article topic. Prefers pen & ink, then airbrush, charcoal/pencil, colored pencil, watercolor, acrylic, oil, pastel and mixed media. Needs editorial and medical illustration. Send query letter with brochure or tearsheets. Samples are filed or are returned by SASE. Reports back within 1 month. Publication will contact artist for portfolio review if interested. Portfolio should include color roughs, original/final art, tearsheets and final reproduction/product. Negotiates rights purchased. **Pays on acceptance**; $300 maximum for color cover; $150 maximum for b&w, $200 for color inside.

Tips: "In your samples, include work showing animals, particularly dogs and cats or humans with cats or dogs. Show a representative sampling."

APPALACHIAN TRAILWAY NEWS, Box 807, Harpers Ferry WV 25425. (304)535-6331. Fax: (304)535-2667. Editor: Judith Jenner. Emphasizes the Appalachian Trail for members of the Appalachian Trail Conference. 5 issues/year; 4 issues b&w, 1 issue color. Circ. 26,000. Sometimes accepts previously published material. Returns original artwork after publication. Sample copy $3 (no SASE); art guidelines for SASE with first-class postage.

Illustrations: Buys 2-5 illustrations/issue. Prefers pen & ink, charcoal/pencil, colored pencil, watercolor, acrylic, oil, pastel and calligraphy. Original artwork must be related to the Appalachian Trail. Send query letter with samples to be kept on file. Prefers photostats, photocopies or tearsheets as samples. Samples not filed are returned by SASE. Reports within 2 months. Negotiates rights purchased. **Pays on acceptance;** $25-200 for b&w, occasional color. Also buys 1-2 cartoons/year; pays $25 and up.

Tips: Finds most artists through references, word of mouth and samples received through the mail.

‡AQUA-FIELD PUBLICATIONS, 66 W. Gilbert, Shrewsbury NJ 07702. (908)842-8300. Fax: (908)842-0281. Art Director: Sharon Kissling. Estab. 1974. Magazines emphasizing outdoor recreation: hunting, fishing, scuba, camping, home improvement and gardening. "Geared to the active, outdoors-oriented adult, mid-to-upper income. There is some family material." Publications are 4-color, 2-color and b&w with conservative/classic design. Publishes annuals. Circ. 200,000. Accepts previously published material. Original artwork is returned to the artist after publication. Art guidelines for SASE with first-class postage.

Illustrations: Approached by 30-40 illustrators/year. Works with 3-4 illustrators/year. Buys 4-8 illustrations/ issue. Uses freelancers mainly for paste-up, covers and spots, and b&w magazine illustration specific to story subject matter. Works on assignment only. Send query letter with photostats and slides of color work and photocopies of b&w art. Samples are filed or returned by SASE. Reports back within 1 month. Call or write for appointment to show portfolio of final art, tearsheets, photographs and slides. Negotiates rights purchased. Pays on publication; $35-75 for b&w spots; $150-300 for color inside. Payment for cover negotiable. Needs technical illustration.

Tips: "Don't send original art. I want to see mostly realistic/painterly work. No totally abstract work or work that doesn't apply to our outdoors theme."

AQUARIUM FISH MAGAZINE, P.O. Box 6050, Mission Viejo CA 92690. (714)855-8822. Fax: (714)855-3045. Editor: Edward Bauman. Estab. 1988. Monthly magazine covering fresh and marine aquariums and garden ponds. Circ. 75,000. Accepts previously published artwork. Originals are returned at job's completion. Sample copies available for $4. Art guidelines for SASE with first-class postage.

Cartoons: Approached by 30 cartoonists/year. Buys 6 cartoons/issue. Themes should relate to aquariums and ponds. Send query letter with finished cartoon samples. Samples are filed. Reports back within 1 month. Buys one-time rights. Pays $35 for b&w, $50 for color.

Illustrations: Considers pen & ink, watercolor, air brush and colored pencil. Send query letter with photocopies. Samples are filed or returned by SASE. Reports back within 1 month. Portfolio review not required. Buys one-time rights. Pays on publication; $50-100 for b&w and $100-200 for color inside.

ARMY MAGAZINE, 2425 Wilson Blvd., Arlington VA 22201. (703)841-4300. Art Director: Patty Zukerowski. Estab. 1950. Monthly trade journal dealing with current and historical military affairs. Also covers military doctrine, theory, technology and current affairs from a military perspective. Circ. 115,000. Originals returned at job's completion. Sample copies available for $2.25. Art guidelines available.

Cartoons: Approached by 5 cartoonists/year. Buys 1 cartoon/issue. Prefers military, political and humorous cartoons; single or double panel, b&w washes and line drawings with gaglines. Send query letter with brochure and finished cartoons. Samples are filed or are returned by SASE if requested by artist. Reports back to the artist only if interested. Buys one-time rights. Pays $50 for b&w.

Illustrations: Approached by 10 illustrators/year. Buys 1-3 illustrations/issue. Works on assignment only. Prefers military, historical or political themes. Considers pen & ink, airbrush, acrylic, marker, charcoal and mixed media. "Can accept artwork done with Illustrator or Photoshop for Macintosh." Send query letter with brochure, résumé, tearsheets, photocopies and photostats. Samples are filed or are returned by SASE if requested by artist. Publication will contact artist for portfolio review if interested. Portfolio should include b&w and color tearsheets, photocopies and photographs. Buys one-time rights. Pays on publication; $300 minimum for b&w, $500 minimum for color cover; $50 for b&w, $75 for color inside; $35-50 for spots.

ART DIRECTION, 10 E. 39th St., 6th Floor, New York NY 10016. (212)889-6500. Fax: (212)889-6504. Editor: Dan Barron. Estab. 1949. Monthly 4-color trade magazine that emphasizes advertising for art directors. Circ. 9,091. Accepts previously published artwork. Original work not returned after publication. Sample copy $4.50. Art guidelines available.

Illustrations: Receives 7 illustrations/week from freelancers. Uses 2-3 illustrations/issue. Works on assignment only. Interested in themes that relate to advertising. Needs editorial illustration. Send query letter with brochure showing art styles. Samples are not filed and are returned only if requested. Reports in 3 weeks. Portfolio of tearsheets may be dropped off every Monday-Friday. Sometimes requests work on spec before assigning job. Negotiates rights purchased. Pays on publication; $350 for color cover.

Tips: "Must be about current advertising."

ARTHRITIS TODAY MAGAZINE, 1314 Spring St. NW, Atlanta GA 30309-2858. (404)872-7100. Fax: (404)872-9559. Art Director: Deb Gaston. Estab. 1987. Bimonthly consumer magazine. "*Arthritis Today* is the official magazine of the Arthritis Foundation. It is an award-winning publication that provides the most comprehensive and reliable source of information about arthritis research, care and treatment. It is written both for people with arthritis and those who care about them." Circ. 500,000. Originals returned at job's completion. Sample copies available. Art guidelines not available. 20% of freelance work demands computer knowledge of Adobe Illustrator, QuarkXPress or Adobe Photoshop.

Market conditions are constantly changing! If you're still using this book and it is 1997 or later, buy the newest edition of Artist's & Graphic Designer's Market *at your favorite bookstore or order directly from Writer's Digest Books.*

Illustrations: Approached by 10-20 illustrators/year. Buys 2-6 illustrations/issue. Works on assignment only. Considers watercolor, collage, airbrush, acrylic, colored pencil, mixed media and pastel. Send query letter with brochure, tearsheets, photostats, slides (optional) and transparencies (optional). Samples are filed. Publication will contact artist for portfolio review if interested. Portfolio should include color tearsheets, photostats, photocopies, final art and photographs. Buys one-time rights. **Pays on acceptance;** $700 for color cover; $75 for b&w, $100 for color inside.
Tips: Finds artists through sourcebooks, other publications, word of mouth, artists' submissions. "No limits on areas of the magazine open to freelancers. two-three departments, each issue use spot illustrations. Submit tearsheets for consideration. No cartoons."

THE ARTIST'S MAGAZINE, 1507 Dana Ave., Cincinnati OH 45207. Editor: Mary Magnus. Monthly 4-color magazine emphasizing the techniques of working artists for the serious beginning, amateur and professional artist. Circ. 275,000. Occasionally accepts previously published material. Returns original artwork after publication. Sample copy $2 with SASE and 3 first-class stamps.
 • Sponsors annual contest. Send SASE for more information. Also publishes a quarterly issue called *Watercolor Magic*.
Cartoons: Contact Ann Abbott, managing editor. Buys 2-3 "top-quality" cartoons/issue. Most cartoons bought are single panel finished cartoons with or without gagline—b&w line drawings and washes. "We're also on the lookout for color, multipanel (4-6 panels) work with a theme to use on our 'P.S.' page. Any medium." All cartoons should be artist-oriented, appeal to the working artist and should not denigrate art or artists. Avoid cliché situations. For single panel cartoon submissions, send cover letter with 4 or more finished cartoons. For "P.S." submissions, query first with roughs and samples. Material not filed is returned only by SASE. Reports within 1 month. Buys first North American serial rights. **Pays on acceptance**; $65 and up for b&w single panels; $200 and up for "P.S." work.
Illustrations: Contact Jeff Borisch, art director. Buys 2-3 illustrations/issue. Works on assignment only. Send query letter with brochure, résumé and samples to be kept on file. Prefers photostats or tearsheets as samples. Samples not filed are returned by SASE. Buys first rights. **Pays on acceptance.** "We're also looking for b&w spots of art-related subjects. We will buy all rights; pay $15-25 per spot."

ARTS INDIANA, 47 S. Pennsylvania, #701, Indianapolis IN 46204-3622. (317)632-7894. Fax: (317)632-7966. Editor: Hank Nuwer. Estab. 1979. Monthly arts magazine. Circ. 10,000. Sample copies available for $4. Art guidelines not available. Needs computer-literate freelancers for presentation. 25% of freelance work demands computer knowledge of Aldus PageMaker.
Cartoons: Approached by 5-10 cartoonists/year. Buys 2 cartoons/issue. Prefers arts-related (all arts) and humorous cartoons; single panel b&w washes and line drawings with or without gaglines. Send query letter with roughs and finished cartoons. Samples are not filed. Reports back within 3 days. Buys one-time rights. Pays $35 for b&w.
Illustrations: Approached by 5-10 illustrators/year. Buys 2 illustrations/issue. Prefers any line drawings for illustrating columns. Considers pen & ink. Send query letter with SASE and photocopies. Reports back within 3 days. Portfolio review not required. Buys one-time rights. Pays on publication; $25-35 per line drawing; $35 for spots.
Tips: "Anticipate lead time better with submissions."

ISAAC ASIMOV'S SCIENCE FICTION MAGAZINE, 1540 Broadway, New York NY 10036. (212)354-6500. Fax: (212)697-1567. Art Director: Terri Czeczko. Estab. 1977. Monthly b&w with 4-color cover magazine of science fiction and fantasy. Circ. 100,000. Accepts previously published artwork. Original artwork returned at job's completion. Sample copies available. Art guidelines for SASE with first-class postage.
Illustrations: Approached by 60 illustrators/year. Buys 10 illustrations/issue. Works on assignment only. Considers pen & ink, airbrush, watercolor, acrylic and oil. Send query letter with tearsheets. Views portfolios on Tuesday of each week. Samples are sometimes filed or are returned by SASE if requested by artist. Reports back only if interested. Rights purchased vary according to project. Pays $1,200 for color cover; $100 for b&w.

ASPCA ANIMAL WATCH, 424 E. 92nd St., New York NY 10128. (212)876-7700, ext. 4441. Art Director: Amber Alliger. Estab. 1960. Quarterly company magazine. Circ. 90,000. Accepts previously published artwork. Original artwork returned at job's completion.
Cartoons: Approached by 20-25 cartoonists/year. Buys 3 cartoons/issue. Prefers animal-related themes or styles. Send brochure, roughs and photocopies. Samples are filed. Rights purchased vary according to project. Pays $75-100.
Illustrations: Approached by 20 illustrators/year. Buys 3 illustrations/issue. Prefers animal-related themes or styles. Considers all media. Send photocopies. Samples are filed. Reports back within 2 weeks. Rights purchased vary according to project. Pays on publication; $150 for color cover; $75 for b&w and $100 for color inside.

ASSOCIATION OF COLLEGE UNIONS-INTERNATIONAL, 400 E. Seventh St., Bloomington IN 47405. (812)332-8017. Fax: (812)333-8050. Assistant Director of Publishing and Marketing: Ann Vest. Estab. 1914. Professional education association journal. "Covers multicultural issues, creating community on campus, union and activities programming, managing staff, union operation, professional development and student development." Needs computer-literate freelancers with knowledge of CorelDraw for illustration.
 • Also publishes hardcover and trade paperback originals. See listing in Book Publishers section for more information.
Illustrations: Works on assignment only. Considers pen & ink, pencil, and computer illustration. Send query letter with tearsheets, photographs, and color transparencies of college student union activities. Samples are filed. Reports back to artist only if interested. Negotiates rights purchased.
Tips: "We are a volunteer-driven association. Most people submit work on that basis."

‡ATHLON SPORTS COMMUNICATIONS, INC., 220 25th Ave., Nashville TN 37203. (615)327-0747. Fax: (615)327-1149. Art Director: Jeff Hansen. Estab. 1967. Consumer magazine; college and pro pre-season football annuals, pro baseball and pro basketball pre-season annuals. Circ. 800,000. Accepts previously published artwork. Original artwork is returned at job's completion. Sample copies and/or art guidelines available.
Illustrations: Approached by 6 illustrators/year. Buys 1 illustration/issue. Works on assignment only. Prefers sports figure illustration. Considers all media. Send query letter with brochure, photographs, photocopies, slides, transparencies, samples and pricing information. Samples are filed. Reports back only if interested within 2-3 weeks. Buys one-time rights. Pays $1,200 for color cover (poster).

ATLANTIC CITY MAGAZINE, Box 2100, Pleasantville NJ 08232-1324. (609)272-7907. Fax: (609)272-7910. Art Director: Michael L.B. Lacy. Estab. 1979. 4-color monthly that emphasizes the growth, people and entertainment of the Atlantic City/South Jersey region for residents and visitors. Circ. 50,000.
Illustrations: Approached by 1,000 illustrators/year. Works with 20 illustrators/year. Buys 36 illustrations/year. Uses artists for spots, department and feature illustration. Uses mainly 4-color and some b&w. Works on assignment only. Send query letter with brochure showing art style, tearsheets, slides and photographs to be kept on file. Call or write for appointment to show portfolio of printed samples, final reproduction/product, color and b&w tearsheets and photographs. Buys first rights. Pays on publication; $250 for b&w and $500 for color cover; $125 for b&w and $225 for color inside.
Tips: "We are looking for intelligent, reliable artists who can work within the confines of our budget and time frame. Deliver good art and receive good tearsheets. We are produced completely electronically and have more flexibility with design. Now illustrators who can work with and provide electronic files are a plus."

‡AUSTRALIAN WOMEN'S WEEKLY, 54 Park St., Sydney, Australia 2000. A.C.P. Art Director: Nikki Byrne. Readers are average to highly sophisticated women. Monthly. Circ. over 1 million. Original artwork not returned after publication. Art guidelines with SASE (nonresidents include IRCs).
Cartoons: Approached by 10 cartoonists/year. Pays $50 (Australian) for b&w.
Illustrations: Uses 2 illustrations/issue; buys all from freelancers. Interested in varied styles, any medium. Works on assignment only. Provide tearsheets to be filed for possible future assignments. Send samples of style. No samples returned. Reports in 2 weeks. Buys all rights. **Pays on acceptance**; $400 (Australian) for color.
Tips: Artists "must be good enough for national publication."

AUTOMOBILE MAGAZINE, Dept. AGDM, 120 E. Liberty, Ann Arbor MI 48104. (313)994-3500. Art Director: Lawrence C. Crane. Estab. 1986. Monthly 4-color "automobile magazine for upscale life-styles." Traditional, "imaginative" design. Circ. 650,000. Original artwork is returned after publication. *Art guidelines specific for each project.*
Illustrations: Buys illustrations mainly for spots and feature spreads. Works with 5-10 illustrators/year. Buys 2-5 illustrations/issue. Works on assignment only. Considers airbrush, mixed media, colored pencil, watercolor, acrylic, oil, pastel and collage. Needs editorial and technical illustrations. Send query letter with brochure showing art style, résumé, tearsheets, slides, photographs or transparencies. Show automobiles in various styles and media. "This is a full-color magazine, illustrations of cars and people must be accurate." Samples are returned only if requested. "I would like to keep something in my file." Reports back about queries/submissions only if interested. Request portfolio review in original query. Portfolio should include final art, color tearsheets, slides and transparencies. Buys first rights and one-time rights. Pays $200 and up for color inside. Pays up to $2,000 depending on size of illustration.
Tips: Finds artists through mailed samples. "Send samples that show cars drawn accurately with a unique style and imaginative use of medium."

AWARE COMMUNICATIONS, INC., 2720 NW Sixth St., Gainesville FL 32609-2992. (904)331-8422. Vice President-Creative: Scott M. Stephens. Estab. 1984. Quarterly, semi-annual, annual 4-color company magazines and posters for Fortune 100 companies. Circ. 500,000 to 6.5 million. Needs computer-literate

freelancers for design and production. 30% of freelance work demands knowledge of CorelDraw and Ventura. Original artwork is not returned.

Cartoons: Approached by 3 comic-book-style cartoonists/year. Prefers Marvel Comic style—sports, health, fitness. Samples are filed and not returned. Reports back to the artist only if interested. Buys all rights. Pays $250 minimum for color.

Illustrations: Approached by 10 illustrators/year. Buys 40 illustrations/year. Works on assignment only. Needs editorial, medical and technical illustration. Prefers comic book and realistic styles; very graphic and educational. Considers airbrush, acrylic, oil and colored pencil. Send query letter with brochure, tearsheets and photostats. Samples are filed or returned by SASE if requested by artist. Publication will contact artist for portfolio review if interested. Portfolio should include printed samples, color tearsheets, photostats, photographs, slides and photocopies. Buys all rights. Sometimes requests work on spec before assigning job. **Pays on acceptance;** $1,500 for color cover; $200 for color inside.

Tips: "Have a universal appealing style. We deal with medical and educational publications, so abstract images and style will not be considered." Must be able to illustrate people and be anatomically accurate.

***AXIOS, The Orthodox Journal**, 30-32 Macaw Ave., Belmopan, Belize. 501-8-23284. E-mail: father.daniel@belize.com.bz. Editor: Daniel Gorham. Monthly 2-color newsletter emphasizing "challenges in ethics and theology, some questions that return to haunt one generation after another, old problems that need to be restated with new urgency. *Axios* tries to present the 'unthinkable' from an Orthodox Catholic viewpoint." Circ. 10,506. Accepts previously published material, simultaneous submissions. Original artwork returned after publication. Sample copy $2. Needs computer-literate freelancers for design, illustration, production and presentation. 25% of freelance work demands knowledge of Ventura and Microsoftword.

Illustrations: Buys 5-10 illustrations/issue from freelancers. Prefers bold line drawings, seeks icons, b&w; "no color *ever*; uses block prints—do not have to be religious, but must be *bold!*" Send query letter with brochure, résumé, business card or samples to be kept on file. Samples not filed are returned by SASE. Publication will contact artist for portfolio review if interested. Portfolio should include final reproduction/product and b&w. Buys one-time rights. **Pays on acceptance**; $50 for b&w, $150 for color, cover; $40 for b&w, $100 for color inside; $10-25 for spots.

Tips: "Realize that the Orthodox are *not* Roman Catholics, nor Protestants. We do not write from those outlooks. Though we do accept some stories about those religions, be sure *you* know what an Orthodox Catholic is. Know the traditional art form—we prefer line work, block prints, linocuts."

❦B.C. OUTDOORS, 202-1132 Hamilton St., Vancouver, British Columbia V6B 2S2 Canada. (604)687-1581. Editor: Karl Bruhn. 4-color magazine, emphasizing fishing, hunting, RV camping, wildlife/conservation. Published 8 times/year. Circ. 40,000. Original artwork returned after publication unless bought outright. Free sample copy. Prefers inquiring freelancers to be familiar with Adobe Illustrator and QuarkXPress.

Cartoons: Approached by more than 10 cartoonists/year. Buys 1-2 cartoons/year. Should pertain to outdoor recreation: fishing, hunting, camping and wildlife in British Columbia. Format: single panel, b&w line drawings with or without gagline. Prefers finished cartoons. Include SAE (nonresidents include IRC). Reports in 2 weeks. Pays $50 for b&w. Buys one-time rights.

Illustrations: Approached by more than 10 illustrators/year. Buys 16-20 illustrations/year. Interested in outdoors, creatures and activities as stories require. Format: b&w line drawings and washes for inside and color washes for inside and cover. Works on assignment only. Samples returned by SAE (nonresidents include IRC). Reports back on future assignment possibilities. Arrange personal appointment to show portfolio or send samples of style. Subject matter and the art's quality must fit with publication. Reports in 2-6 weeks. Buys first North American serial rights or all rights on a work-for-hire basis. **Pays on acceptance**; $40 minimum for spots.

Tips: "Send us material on fishing and hunting. We generally just send back non-related work."

THE BACKSTRETCH, 19899 W. Nine Mile Rd., Southfield MI 48075-3960. (810)354-3232. Fax: (810)354-3157. Editor-in-Chief/Publisher: Harriet H. Dalley. Estab. 1962. Bimonthly trade journal. "Covers topics of importance and interest to thoroughbred trainers and owners, other industry personnel; and racing fans. The editorial focus is on issues and trends in the industry; personality profiles; historical, business and vet topics." Circ. 12,000. Accepts previously published artwork. Originals are not returned. Sample copies and art guidelines available.

Cartoons: Approached by 4-6 cartoonists/year. Send query letter with roughs. Samples are filed. Reports back within 2-3 months. Buys one-time rights. Pays $25 for b&w; $35 for color.

Illustrations: Approached by 4-6 illustrators/year. Buys 2-3 illustrations/year. Works on assignment only. Prefers contemporary, realistic art related to thoroughbred training and racing. Considers pen & ink, water-

The maple leaf before a listing indicates that the market is Canadian.

color, airbrush, acrylic, marker, colored pencil, oil, charcoal and pastel. Send query letter with résumé, tearsheets, photographs, slides, transparencies. Samples are not filed and are returned by SASE if requested by artist. Reports back within 2-3 months. Publication will contact artist for portfolio review if interested. Portfolio should include b&w and color roughs. Buys one-time rights. Pays on publication; $250 for color cover; $25 for b&w, $35 for color inside.

BALLAST QUARTERLY REVIEW, 2022 X Ave., Dysart IA 52224-9767. Contact: Art Director. Estab. 1985. Quarterly literary and graphic design magazine. *"Ballast* is an acronym for Books Art Language Logic Ambiguity Science and Teaching. It is a journal of verbal and visual wit. Audience consists mainly of designers, illustrators, writers and teachers." Circ. 600. Accepts previously published artwork. Originals returned at job's completion. Sample copies available for 2 first-class stamps.

Illustrations: Approached by 50 illustrators/year. Publishes 6 illustrations/issue. Preferred themes are metamorphosis (one thing evolving into another) and visual puns. Seeks b&w line art—no halftones. Send query letter with photocopies. Samples are sometimes filed or returned by SASE if requested by artist. Reports back to the artist only if interested. No portfolio reviews. Payment is 5-10 copies of issue.

Tips: Finds artists through books, magazines, word of mouth, other illustrators.

BALLOON LIFE MAGAZINE, 2145 Dale Ave., Sacramento CA 95815. (916)922-9648. Fax: (916)922-4730. E-mail: 73232.1112@compuserve.com. Editor: Tom Hamilton. Estab. 1985. Monthly 4-color magazine emphasizing the sport of ballooning. "Contains current news, feature articles, a calendar and more. Audience is sport balloon enthusiasts." Circ. 4,000. Accepts previously published material. Original artwork returned after publication. Sample copy for SASE with 8 first-class stamps. Needs computer illustrators familiar with Aldus PageMaker, Adobe Illustrator, Adobe Photoshop, Colorit, Pixol Paint Professional and Aldus FreeHand.

Cartoons: Approached by 20-30 cartoonists/year. Buys 1-2 cartoons/issue. Seeks gag, editorial or political cartoons, caricatures and humorous illustrations. Prefers single panel b&w line drawings with or without gaglines. Send query letter with samples, roughs and finished cartoons. Samples are filed or returned. Reports back within 1 month. Buys all rights. Pays on publication; $25 for b&w and $25-40 for color.

Illustrations: Approached by 10-20 illustrators/year. Buys 1-3 illustrations/year. Send query letter with business card and samples. Samples are filed or returned. Reports back within 1 month. Publication will contact artist for portfolio review if interested. Buys all rights. Pays on publication; $50 for color cover; $25-40 for b&w or color inside.

Tips: "Know what a modern hot air balloon looks like! Too many cartoons reach us that are technically unacceptable."

BALTIMORE MAGAZINE, 16 S. Calvert St., Baltimore MD 21202. (410)752-7375. Fax: (410)625-0280. Art Director: Lisa Chune. Production Manager: John Marsh. Estab. 1908. Monthly city magazine featuring news, profiles and service articles. Circ. 50,000. Originals returned at job's completion. Sample copies available for $2.05/copy. Art guidelines not available. Needs computer-literate freelancers for illustration and production. 10% of freelance work demands knowledge of QuarkXPress, Aldus FreeHand, Adobe Illustrator or Photoshop or any other program that is saved as a TIFF or PICT file.

Illustrations: Approached by 60 illustrators/year. Buys 4 illustrations/issue. Works on assignment only. Considers all media, depending on assignment. Send query letter with brochure. Samples are filed. Publication will contact artist for portfolio review if interested. Buys one-time rights. Pays on publication; 60 days after invoice.

Tips: Finds artists through sourcebooks, publications, word of mouth, artists' submissions. All art is freelance—humorous front pieces, feature illustrations, etc. Does not use cartoons.

BARTENDER MAGAZINE, Box 158, Liberty Corner NJ 07938. (908)766-6006. Fax: (908)766-6607. Editor: Jackie Foley. Estab. 1979. Quarterly 4-color trade journal emphasizing restaurants, taverns, bars, bartenders, bar managers, owners, etc. Circ. 145,000. Needs computer-literate designers familiar with QuarkXPress and Adobe Illustrator.

Cartoons: Approached by 10 cartoonists/year. Buys 3 cartoons/issue. Prefers bar themes; single panel. Send query letter with finished cartoons. Samples are filed. Buys first rights. Pays on publication; $50 for b&w and $100 for color cover; $50 for b&w and $100 for color inside.

Illustrations: Approached by 5 illustrators/year. Buys 1 illustration/issue. Works on assignment only. Prefers bar themes. Considers any media. Send query letter with brochure. Samples are filed. Negotiates rights purchased. Pays on publication; $500 for color cover.

‡BAY AREA PARENT/BAY AREA BABY, 401 Alberto Way, Suite A, Los Gatos CA 95032. (408)356-4801. Fax: (408)356-4903. Editorial Art Director: Sallie. Estab. 1983. Biannual family and parenting resource magazine. Circ. 75,000. Accepts previously published artwork. Originals are returned at job's completion. Sample copies and art guidelines available. Needs computer-literate freelancers for design, illustration and production. 40% of freelance work demands knowledge of Aldus PageMaker and QuarkXPress.

This *"raggedy—yet positive" fellow, created by Eugene Gryniewicz, appeared with several others by the artist in* Black Bear Review. *"I selected this piece because I feel its clarity and strength are indicative of the Black Bear style," says Editor Ave Jeanne. "Gene's potency complements our poetry theme of social awareness." Gryniewicz wished to convey a casual elegance in his character, rendered in pen & ink and marker. Although he received only a contributor copy as payment, "My appearance in* Black Bear *has netted me at least three other illustration opportunities—including a chapbook of poetry."*

© Eugene R. Gryniewicz.

Cartoons: Approached by 5 cartoonists/year. Prefers fun, cute style: single panel. Send query letter with résumé and finished cartoons. Samples are filed. Reports back only if interested. Negotiates rights purchased. Pays $30 for b&w, $40 for color.

Illustrations: Approached by 10 illustrators/year. Buys 2 illustrations/year. Works on assignment only. Prefers cute, fun images of parenting, babies, beautiful families, parent-child, etc. Considers pen & ink, watercolor, acrylic, colored pencil and pastel. Send query letter with brochure, tearsheets, photographs, photocopies, photostats, slides and transparencies. Samples are filed. Reports back only if interested. Write for appointment to show portfolio. Portfolio should include thumbnails, roughs, printed samples, tearsheets and photographs. Negotiates rights purchased. Pays on publication; $100 for b&w, $125 for color cover. $25 for b&w, $35 for color inside.

Tips: "Start out cheap, get us hooked, be reliable, work fast, make sure artwork arrives on time. Keep in mind that the work will be printed on newsprint. This can be very muddy. Artist has to compensate for this."

BAY WINDOWS, 1523 Washington St., Boston MA 02118. (617)266-6670. E-mail: epperly@baywindows. com. Editor: Jeff Epperly. Estab. 1981. A weekly newspaper "targeted to politically-aware lesbians, gay men and other political allies publishing non-erotic news and features"; b&w with 2-color cover. Circ. 46,000. Accepts previously published artwork. Original artwork returned after publication. Sample copies available. Art guidelines not available. Needs computer illustrators familiar with Adobe Illustrator or Aldus FreeHand.

Cartoons: Approached by 25 freelance cartoonists/year. Buys 1-2 freelance cartoons/issue. Buys 50 freelance cartoons/year. Preferred themes include politics and life-styles. Prefers double and multiple panel, political and editorial cartoons with gagline, b&w line drawings. Send query letter with roughs. Samples are returned by SASE if requested by artist. Reports back to the artist within 6 weeks only if interested. Rights purchased vary according to project. Pays on publication; $75-100 for b&w only.

Illustrations: Approached by 60 freelance illustrators/year. Buys 1 freelance illustration/issue. Buys 50 freelance illustrations/year. Artists work on assignment only. Preferred themes include politics—"humor is a plus." Considers pen & ink and marker drawings. Send query letter with photostats and SASE. Samples are filed. Reports back within six weeks only if interested. Portfolio review not required. Rights purchased vary according to project. Pays on publication; $100-125 for cover; $75-100 for b&w inside; $75 for spots.

‡BEER, The Magazine, Box 717, Hayward CA 94543-0717. (510)538-9500. Fax: (510)538-7644. E-mail: beerthemag@aol.com; 757531.1677@compuserve.com; btm@ambrew.cohn; http://ambrew.com/btm/. Publisher: Bill Owens. Estab. 1993. Bimonthly (except January) consumer magazine. "A magazine for beer lovers, aficionados and fanatics!" Circ. 60,000. Accepts previously published artwork. Originals returned at job's completion. Samples copies available for $5. Art guidelines free for SASE with first-class postage.

• Also publishes *American Brewer Magazine*.

Cartoons: Approached by 10 freelancers/year. Buys 2 cartoons/issue. Wants cartoons dealing with drinking beer. Prefers single or multiple panel. Send query letter with roughs. Samples are not filed and are returned by SASE if requested by artist. Reports back within 2 months. Negotiates rights purchased. Pays $50-100 for color.

Illustrations: Approached by 10 illustrators/year. Buys 10 illustrations/issue. Works on assignment only. Prefers any style. Considers pen & ink, airbrush, colored pencil, mixed media, collage, charcoal, watercolor,

acrylic and oil. Send query letter with brochure, tearsheets, photostats, photographs, slides, photocopies and transparencies. Samples are not filed and are returned by SASE if requested by artist. Reports back to the artist only if interested. Artist should follow-up with call or letter after initial query. Portfolio should include roughs. Buys first rights or negotiates rights purchased. **Pays on acceptance**; $300-500 for color cover; $200-300 for color inside. Pays $50 for spots.

THE BERKELEY MONTHLY, 1301 59th St., Emeryville CA 94608. (510)658-9811. Fax: (510)658-9902. Art Director: Andreas Jones. Estab. 1970. Consumer monthly tabloid; b&w with 4-color cover. Editorial features are general interests (art, entertainment, business owner profiles) for an upscale audience. Circ. 75,000. Accepts previously published artwork. Originals returned at job's completion. Sample copies and art guidelines for SASE with first-class postage. No nature or architectural illustrations. Needs computer-literate freelancers for design. 100% of freelance design work demands knowledge of Aldus PageMaker, QuarkXPress or Aldus FreeHand.

Cartoons: Approached by 75-100 cartoonists/year. Buys 3 cartoons/issue. Prefers single panel, b&w line drawings; "any style, extreme humor." Send query letter with finished cartoons. Samples are filed or returned by SASE if requested by artist. Reports back to the artist only if interested. Buys one-time rights. Pays $35 for b&w.

Illustrations: Approached by 150-200 illustrators/year. Buys 2 illustrations/issue. Prefers pen & ink, water-color, acrylic, colored pencil, oil, charcoal, mixed media and pastel. Send query letter with résumé, SASE, tearsheets, photocopies and slides. Samples are filed or returned by SASE if requested by artist. Reports back only if interested. Write for appointment to show portfolio of thumbnails, roughs, b&w tearsheets and slides. Buys one-time rights. Pays $100-200 for b&w inside. Pays 30 days after publication.

BEVERAGE WORLD MAGAZINE, 150 Great Neck Rd., Great Neck NY 11021. (516)829-9210. Desktop Publishing Manager: Paul Leone. Editor: Larry Jabbonsky. Monthly magazine covering beverages (beers, wines, spirits, bottled waters, soft drinks, juices) for soft drink bottlers, breweries, bottled water/juice plants, wineries and distilleries. Circ. 33,000. Accepts simultaneous submissions. Original artwork returned after publication if requested. Sample copy $2.50.

Illustrations: Buys 3-4 illustrations. Works on assignment only. Send query letter with photostats, slides or tearsheets to be kept on file. Write for appointment to show portfolio. Reports only if interested. Negotiates rights purchased. **Pays on acceptance**; $350 for color cover; $50-100 for b&w inside. Uses color illustration for cover, usually b&w for spots inside.

Tips: "We prefer to work with Macintosh graphic and layout artists."

BLACK BEAR PUBLICATIONS, 1916 Lincoln St., Croydon PA 19021-8026. Editor: Ave Jeanne. Associate Editor: Ron Zettlemoyer. Estab. 1984. Publishes semiannual b&w magazine emphasizing social, political, ecological and environmental subjects "for mostly well-educated adults." Circ. 500. Also publishes chap-books. Accepts previously published artwork. Art guidelines for SASE with first-class postage. Current copy $5 postpaid in US.

Illustrations: Works with 20 illustrators/year. Buys 10 illustrations/issue. Prefers collage, woodcut, pen & ink. Send samples with SASE, résumé and photocopies. Samples not filed returned by SASE. Portfolio review not required. Reports within 2 weeks. Acquires one-time rights or reprint rights. Pays in copies, on publication, for the magazine. Pays cash on acceptance for chapbook illustrators. Chapbook illustrators are contacted for assignments. Average pay for chapbook illustrators is $35 for one-time rights.

Tips: Finds artists through word of mouth and artists' submissions. "Read our listing carefully. Be familiar with our needs and our tastes in previously published illustrations. We can't judge you by your résumé— send small samples of b&w artwork. No humor please. If we are interested, we won't let you know without a SASE."

BLACK WARRIOR REVIEW, Box 2936, University of Alabama, Tuscaloosa AL 35486. (205)348-4518. E-mail: warrior@woodsquad.as.ua.edu. Editor: Mark S. Drew. Biannual 4-color literary magazine publishing contemporary poetry, fiction and nonfiction by new and established writers. Circ. 2,000. Accepts previously published artwork. Original artwork is returned at job's completion. Sample copy $6. Art guidelines not available.

Illustrations: Approached by 30 illustrators/year. Buys 2 illustrations/issue. Themes and styles vary. Needs editorial illustration. Considers pen & ink, airbrush, watercolor, acrylic, oil, collage and marker. Send query letter with photocopies. Samples are not filed. Pays on publication; $150 for b&w or color cover; $50 for b&w or color inside.

Tips: "Look at the magazine."

THE B'NAI B'RITH INTERNATIONAL JEWISH MONTHLY, B'nai B'rith, 1640 Rhode Island Ave. NW, Washington DC 20036. (202)857-6645. Editor: Jeff Rubin. Estab. 1886. Specialized magazine published 8 times a year, focusing on issues of interest to the Jewish family. Circ. 200,000. Originals returned at job's completion. Sample copies available for $2. Art guidelines not available.

Illustrations: Approached by 100 illustrators/year. Buys 1-2 illustrations/issue. Works on assignment only. Considers pen & ink, airbrush, colored pencil, mixed media, watercolor, acrylic, oil, pastel, collage, marker, charcoal. Send query letter with brochure and SASE. Samples are filed. Reports back only if interested. Request portfolio review in original query. Portfolio should include final art, color, tearsheets and published work. Buys one-time rights. **Pays on acceptance**; $400 for color cover; $50 for b&w, $100 for color inside.
Tips: Finds artists through word of mouth and artists' submissions. "Have a strong and varied portfolio reflecting a high degree of professionalism. Illustrations should reflect a proficiency in conceptualizing art—not just rendering. Will not be held responsible for unsolicited material."

This B'nai B'rith Jewish Monthly cover, and the three spots that accompanied it, were both the artist's and the magazine's "first foray into fully digital illustration." The piece illustrated "the decidedly unique perspective kids have about Passover," says artist Michael Fleishman, who conveyed a "childlike wackiness" in the work generated on his Macintosh. "While the job was not tremendously lucrative for four full-color pieces of art ($700 for the job), it was an invaluable first step for me as a 'computer artist,' " says Fleishman. "I needed the training, the experience and the samples to validate my new direction. The piece gets good response, worked out well, and was quite fun to do."

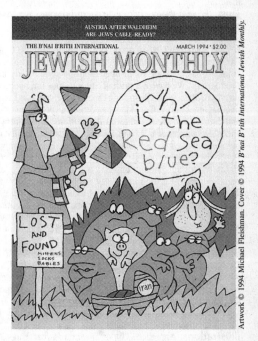

BOSTONIA MAGAZINE, 10 Lenox St., Brookline MA 02146. (617)353-9711. Art Director: Douglas Parker. Estab. 1900. Quarterly 4-color magazine emphasizing "innovative ideas and excellence in writing" for graduates of the university and those interested in quality writing. Circ. 145,000. Original artwork returned to artist after publication. Sample copies $2.50.
Cartoons: "Would be interested in creative ideas appropriate for highly educated audience." Send photocopies of unpublished work regularly. Do not send originals. Samples are filed. Reports back within weeks only if interested. Buys first rights. Pays $200.
Illustrations: Buys 25 illustrations/issue. Works with 150-200 illustrators/year. Works on assignment only. Send résumé, tearsheets, photostats, photocopies, slides and photographs. Samples are filed. Reports back within weeks only if interested. Portfolio should include color and b&w thumbnails, roughs, final art, tearsheets, final reproduction/product, photostats, photographs and slides. Buys first rights. "Payment depends on final use and size." **Pays on acceptance**. "Liberal number of tearsheets available at no cost."
Tips: "Portfolio should include plenty of tearsheets/photocopies as handouts. Don't phone; it disturbs flow of work in office. No sloppy presentations. Show intelligence and uniqueness of style." Prefers original illustrations "meant to inform and elucidate."

‡BOTH SIDES NOW, 10547 State Hwy. 110 N., Tyler TX 75704-9537. (903)592-4263. Contact: Editor. Magazine emphasizing the New Age "for people seeking holistic alternatives in spirituality, life-style, and politics." Irregular, photocopied publication. Circ. 200. Accepts previously published material. Original artwork returned by SASE. Sample copy $1.
Cartoons: Buys various number of cartoons/issue. Prefers fantasy, political satire, religion and exposés of hypocrisy as themes. Prefers single or multi panel b&w line drawings. Send query letter with good photocopies. Samples not filed are returned by SASE. Reports within 3 months. Pays in copies only.
Illustrations: Buys variable amount of illustrations/issue. Prefers fantasy, surrealism, spirituality and realism as themes. B&w only. Send query letter with résumé and photocopies. Samples not filed are returned by SASE. Reports back within 3 months. Pays on publication in copies.
Tips: "Pay close attention to listing. Do not send color."

BOWLING MAGAZINE, 5301 S. 76th St., Greendale WI 53129. (414)423-3232. Fax: (414)421-7977. Editor: Bill Vint. Estab. 1933. Bimonthly 4-color magazine covering the sport of bowling in its many facets. Circ. 140,000. Sample copies for 9×12 SAE with 5 first-class stamps. Art guidelines for SASE with first-class postage.

Illustrations: Approached by 12 illustrators/year. Buys 1-2 illustrations/issue. Works on assignment only. Send query letter with tearsheets, SASE and photocopies. Samples are filed or are returned by SASE if requested by artist. Reports back within 10 days. Rights purchased vary according to project. **Pays on acceptance**; $250-500 for color cover; $75-250 for color inside; $25-75 b&w spots (instructional themed material).

Tips: "Have a thorough knowledge of bowling. We have a specific interest in instructional materials that will clearly illustrate bowling techniques."

BRIDE'S MAGAZINE, Condé-Nast Publications, 140 E. 45th St., New York NY 10017. (212)880-8530. Art Director: Phyllis Cox. Assistant to the Art Director: Mary Catherine McCooey. Estab. 1934. Bimonthly 4-color; "classic, clean, sophisticated design style." Original artwork is returned after publication.

Cartoons: "We have not printed cartoons thus far, but possibly would like to in the future (funny cartoons)."

Illustrations: Buys illustrations mainly for spots and feature spreads. Buys 5-10 illustrations/issue. Works on assignment only. Considers pen & ink, airbrush, mixed media, colored pencil, watercolor, acrylic, collage and calligraphy. Needs editorial illustrations. Send query letter with brochure, tearsheets, photocopies and slides. In samples or portfolio, looks for "graphic quality, conceptual skill, good 'people' style; lively, young, but sophisticated work." Samples are filed. Publication will contact artist for portfolio review if interested. Portfolios may be dropped off every Monday-Thursday and should include color and b&w final art, tearsheets, slides, photostats, photographs and transparencies. Buys one-time rights or negotiates rights purchased. Pays on publication; $250-350 for b&w or color inside; $250 minimum for spots.

Tips: Finds artists through word of mouth, magazines, artists' submissions/self-promotions, sourcebooks, artists' agents and reps, attending art exhibitions. Sections most open to illustrators are "Something New" (a short subject page with 4-color art); also needs illustrations to accompany feature articles such as "Wedding Nightmare" and "Honeymoon Hotline," travel section features (color).

BRIGADE LEADER, Box 150, Wheaton IL 60189. (708)665-0630. Fax: (708)665-0372. Estab. 1960. Art Director: Robert Fine. Quarterly 2-color magazine for Christian men leading boys in Brigade. Circ. 11,000. Accepts previously published artwork. Original artwork returned after publication if requested. Sample copy for 6 first-class stamps and large SASE; artist's guidelines for SASE.

Cartoons: Approached by 30 cartoonists/year. Buys 1-2 cartoons/issue. Interested in sports, nature and youth themes; single panel with gagline. Include SASE. Buys first rights only. Pays on publication $35-50 for b&w cartoons.

Illustrations: Approached by 45 illustrators/year. Buys 2-4 illustrations/issue. Uses freelancers for editorial illustrations. Uses editorial illustration in pen & ink, airbrush, pencil and watercolor. Interested in masculine subjects (sports, camping, out of doors, family). Provide business card and photocopies to be kept on file. Works on assignment only. Pays on publication; $150 and up for b&w cover; $100-250 for inside.

BUCKMASTERS WHITETAIL MAGAZINE, 10350 Hwy. 80 E., Montgomery AL 36117. (205)215-3337. Fax: (334)215-3535. Vice President of Production: Dockery Austin. Estab. 1987. Magazine covering whitetail deer hunting. Seasonal—6 times a year. Circ. 250,000. Accepts previously published artwork. Originals are not returned. Sample copies and art guidelines available. Needs computer-literate freelancers for design and illustration. 80% of freelance work demands knowledge of Adobe Illustrator, QuarkXPress, Photoshop or Aldus FreeHand.

Cartoons: Approached by 5 cartoonists/year. Buys 1 cartoon/issue. Send query letter with brochure and photos of originals. Samples are filed or returned by SASE. Reports back within 3 months. Rights purchased according to project. Pays $25 for b&w.

Illustrations: Approached by 5 illustrators/year. Buys 1 illustration/issue. Works on assignment only. Considers all media. Send query letter with brochure, SASE, tearsheets, photographs and slides. Samples are filed or are returned by SASE if requested. Reports back within 3 months. Call or write for appointment to show portfolio. Portfolio should include final art, slides and photographs. Rights purchased vary according to project. Pays on publication; $500 for color cover; $150 for color inside.

BUILDINGS MAGAZINE, 427 Sixth Ave. SE, Cedar Rapids IA 52406. (319)364-6167. Fax: (319)364-4278. Graphic Designer/Art Director: Elisa Geneser. Estab. 1906. Monthly trade journal; magazine format; "information related to current approaches, technologies and products involved in large commercial facilities." Circ. 43,000. Original artwork not returned at job's completion. Sample copies available. Art guidelines not available.

Illustrations: Works on assignment only. Considers all media, themes and styles. Send query letter with brochure, tearsheets and photocopies. Samples are filed. Publication will contact artist for portfolio review if interested. Portfolio should include thumbnails, b&w/color tearsheets. Rights purchased vary according to project. **Pays on acceptance**; $350 for color cover; $75 for color inside; $30-75 for spots.

Tips: Finds artists through word of mouth and submissions. "Send postcards with samples of your work printed on them. Show us a variety of work (styles), if available."

‡BUSINESS & COMMERCIAL AVIATION, (Division of McGraw-Hill), 4 International Dr., Rye Brook NY 10573. (914)939-0300. E-mail: bcaedit@mcimail.com. Art Director: Mildred Stone. Monthly technical publication for corporate pilots and owners of business aircraft. 4-color; "contemporary design." Circ. 55,000.
Illustrations: Works with 12 illustrators/year. Buys 12 editorial and technical illustrations/year. Uses artists mainly for editorials and some covers. Especially needs full-page and spot art of a business-aviation nature. "We generally only use artists with a fairly realistic style. This is a serious business publication—graphically conservative. Need artists who can work on short deadline time." Needs computer-literate freelancers for illustration, production, presentation and charts. 70% of freelance work demands knowledge of Photoshop, Adobe Illustrator, QuarkXPress and Aldus FreeHand. Query with samples and SASE. Reports in 1 month. Photocopies OK. Buys all rights, but may reassign rights to artist after publication. Negotiates payment. **Pays on acceptance;** $300 for color; $150-200 for spots.
Tips: "I like to buy based more on style than whether an artist has done aircraft drawings before. Send tearsheets of printed art."

BUSINESS NH MAGAZINE, 404 Chestnut St., Suite 201, Manchester NH 03101-1831. (603)626-6354. Fax: (603)626-6359. Art Director: Nikki Bonenfant. Estab. 1982. Monthly magazine with focus on business, politics and people of New Hampshire. Circ. 13,000. Accepts previously published artwork. Originals returned at job's completion. Sample copies free for 9×12 SASE and 5 first-class stamps. Art guidelines not available. Needs computer-literate freelancers for design, illustration and production. 10% of freelance work demands computer knowledge of Adobe Illustrator or QuarkXPress.
Illustrations: Approached by 4 illustrators/year. Buys 1-4 illustrations/year. Works on assignment only. Prefers bold, contemporary graphics. Considers pen & ink, airbrush, colored pencil and computer-generated illustration. Send query letter with résumé and tearsheets. Samples are filed or are returned by SASE if requested by artist. Publication will contact artist for portfolio review if interested. Portfolio should include b&w and color thumbnails, tearsheets, slides and final art. Buys one-time rights and reprint rights. Pays on publication; $50 for b&w, $75 for color inside; $25-50 for spots.
Tips: Art Director hires freelancers mostly to illustrate feature stories and for small icon work for departments. Does not use cartoons.

BUSINESS TRAVEL NEWS, 1515 Broadway., New York NY 10036. (212)626-2531. Fax: (212)944-7144. Art Director: Teresa Carboni. Estab. 1985. Biweekly, 4-color trade journal covering "business (not leisure) travel: airfare wars, negotiations, management." Circ. 52,000. Accepts previously published artwork. Originals are returned at job's completion.
Illustrations: Approached by 150 illustrators/year. Buys 20 illustrations/issue. All styles and themes welcome. Considers pen & ink, watercolor, collage, airbrush, acrylic, marker, colored pencil, oil, mixed media, pastel and computer art. Send query letter with tearsheets, photographs and photocopies. Samples are filed and are not returned. Reports back only if interested. Buys one-time rights. **Pays on acceptance;** $200 for b&w, $700 for color cover; $300 for b&w and color inside.
Tips: "Send me your best samples, be flexible to work with, meet deadlines."

BUTTERICK CO., INC., 161 Avenue of the Americas, New York NY 10013. (212)620-2500. Art Director: Renna Franco. Associate Art Director: Robin Read. Quarterly magazine and monthly catalog. "*Butterick Magazine* is for the home sewer, providing fashion and technical information about our newest sewing patterns through fashion illustration, photography and articles. The Butterick store catalog is a guide to all Butterick patterns, shown by illustration and photography." Magazine circ. 350,000. Catalog readership: 9 million worldwide. Originals are returned at job's completion.
Illustrations: "We have two specific needs: primarily fashion illustration in a contemporary yet realistic style, mostly depicting women and children in full-length poses for our catalog. We are also interested in travel, interior, light concept and decorative illustration for our magazine." Considers watercolor and gouache for catalog art; all other media for magazine. Send query letter with tearsheets and color photocopies and promo cards. Samples are filed or are returned by SASE if requested by artist. Does not report back, in which case the artist should call soon if feedback is desired. Portfolio drop off every Monday or mail appropriate materials. Portfolio should include final art, tearsheets, photostats, photocopies and large format transparencies. Rights purchased vary according to project.
Tips: "Send non-returnable samples several times a year—especially if style changes. We like people to respect our portfolio drop-off policy. Repeated calling and response cards are undesirable. One follow-up call by illustrator for feedback is fine."

‡CALIFORNIA GARDEN, San Diego Floral Association, Casa del Prado, Balboa Park, San Diego CA 92101-1619. (619)232-5762. Editor: J. Coleman. Estab. 1909. Magazine emphasizing horticulture; b&w.

Bimonthly. Circ. 3,000. Accepts previously published material. Original artwork returned after publication. Sample copy $1.50 and 4 first-class stamps.

Illustrations: Uses freelance artists mainly for covers or article illustrations. "Anything pertaining to horticulture." Send query letter with photographs or illustrations. Samples not filed are returned if requested. Reports back within 30 days. SASE. Pays 2 contributor's copies. Negotiates rights acquired.

✦**CANADIAN DIMENSION (CD)**, 707-228 Notre Dame Ave., Winnipeg, Manitoba R3R 1N7 Canada. (204)957-1519. Fax: (204)943-4617. E-mail: info@canadiandimension.mb.ca. Office Manager: Michelle Torres. Estab. 1963. Bimonthly consumer magazine published "by, for and about activists in the struggle for a better world, covering women's issues, aboriginal issues, the enrivonment, labour, etc." Circ. 2,600. Accepts previously published artwork. Originals returned at job's completion. Sample copies available for $2. Art guidelines available for SASE with first-class postage.

Cartoons: Approached by 10 cartoonists/year. Buys 4 cartoons/issue. Prefers political and humorous cartoons. Send query letter with roughs. Samples are filed or returned by SASE if requested by artist. Buys one-time rights. Pays $30 for b&w.

Illustrators: Approached by 5 illustrators/year. Buys 6 illustrations/year. Send query letter with brochure and SASE. Samples are filed or returned by SASE if requested by artist. Publication will contact artist for portfolio review if interested. Buys one-time rights. Pays on publication; $100 for b&w cover; $30 for b&w inside and spots.

Tips: Finds artists through word of mouth and artists' submissions.

‡**CANADIAN PHARMACEUTICAL JOURNAL**, 20 Camelot Dr., Suite 600, Nepean, Ontario K2G 5X8 Canada. (613)727-1364. Fax: (613)727-1714. Graphic Designer: Jacqueline D'Souza. Estab. 1861. Trade journal. Circ. 13,000. Accepts previously published artwork. Originals are returned at job's completion. Sample copies available.

Illustrations: Approached by 20 illustrators/year. Buys 6 illustrations/issue. Works on assignment only. "Stories are relative to the interests of pharmacists—scientific to life-style." Considers all media. Send query letter with photostats and transparencies. Samples are filed. Reports back to the artist only if interested. Call for an appointment to show a portfolio, which should include slides, photostats and photographs. Rights purchased vary according to project. **Pays on acceptance**; $600-2,000 for color cover; $200-1,000 for color inside.

‡**CAREER FOCUS**, 106 W. 11th St., 250 Mark Twain Tower, Kansas City MO 64105-1806. (816)221-4404. Fax: (816)221-1112. Contact: Editorial Department. Estab. 1985. Bimonthly educational, career development magazine. "A motivational periodical designed for Black and Hispanic college graduates who seek career development information." Circ. 250,000. Accepts previously published artwork. Originals are returned at job's completion. Sample copies and art guidelines for SASE with first-class postage.

Illustrations: Buys 1 illustration/issue. Send query letter with SASE, photographs, slides and transparencies. Samples are filed. Reports back to the artist only if interested. Buys one-time rights. Pays on publication; $20 for b&w, $25 for color.

CAREER PILOT MAGAZINE, 4959 Massachusetts Blvd., Atlanta GA 30337. (404)997-8097. Fax: (404)997-8111. E-mail: 76517.54@compuserve.com. Graphic Designer: Kellie Frissell. Estab. 1983. "Monthly aviation information magazine covering beginning pilot to retirement. Articles relate to business, lifestyle, health and finance." Circ. 14,000. Accepts previously published artwork. Originals returned at job's completion. Sample copies available (free postage). Art guidelines available. Interested in both computer-generated and conventional illustrations.

Illustrations: Approached by 30 illustrators/year. Buys 4 illustrations/issue. Main subjects: training/education, health, lifestyle, finance (1 or 2/year with an airplane/subject). Open to various media including photographic illustration, 3-D, paper sculpture, etc. Send query letter with brochure, résumé, tearsheets, photocopies, photostats, slides and transparencies. "No phone calls please." Samples are filed or returned if requested. Reports back to the artist only if interested. Buys one-time rights. Pays net 30 days on receipt of invoice. $200 for b&w, $300 for color, full page; $100 for b&w, $200 for color spots.

Tips: "Please use discretion when choosing samples to send. *Career Pilot* is a fairly conservative, professional publication."

CAREERS AND COLLEGES, 989 Sixth Ave., New York NY 10018. (212)563-4688. Fax: (212)967-2531. Art Director: Michael Hofmann. Estab. 1980. Biannual 4-color educational magazine. "Readers are college-bound high school juniors and seniors. Besides our magazine, we produce educational publications for outside companies." Circ. 500,000. Accepts previously published artwork. Original artwork is returned at job's completion. Sample copy for $2.50 and SASE with first-class postage. Art guidelines not available.

Illustrations: "We're looking for contemporary, upbeat, sophisticated illustration. All techniques are welcome." Send query letter with samples. Portfolio review not required. "Please do not call. Will call artist if interested in style." Buys one-time rights. Pays $950, color, cover; $350, color departments; $400-800, color, inside; $200-250 for color spots within 2 months of delivery of final art.

Stacey Schuett's use of vibrant color and unusual perspective helped portray the rather unsettling idea of a pilot who loves his job, but finds himself trapped in the disease of alcoholism for a two-part story in Career Pilot Magazine *entitled "Alcohol and the Pilot." Designer Kellie Frissell was attracted to Schuett's work by her "spectacular use of color to create a feeling and mood." The illustration accompanying part two of the series is another painting in acrylic and gouache showing a broken bottle with freed wings. The artist discovered* Career Pilot *through* Artist's & Graphic Designer's Market.

© Stacey Schuett for *Career Pilot Magazine.*

CAROLINA QUARTERLY, Greenlaw Hall CB 3520, University of North Carolina, Chapel Hill NC 27599. Editor: Amber Vogel. Triquarterly publishing poetry, fiction and nonfiction. Magazine is "perfect-bound, finely printed, b&w with one-color cover." Circ. 1,500. Send only clear copies of artwork. Sample copy $5 (includes postage and handling). Art guidelines free for SASE with first-class postage.
Illustrations: Uses artists for covers and inside illustrations. Approached by 10 illustrators/year. Buys up to 10 illustrations/issue. Prefers small b&w sketches. Send query letter with samples. Prefers b&w prints. Reports within 2 months. Acquires first rights.
Tips: "Bold, spare images often work best in our format. Look at a recent issue to get a clear idea of content and design."

CAT FANCY, Fancy Publications Inc., Box 6050, Mission Viejo CA 92690. (714)855-8822. Editor: Debbie Phillips-Donaldson. Monthly 4-color magazine for cat owners, breeders and fanciers; contemporary, colorful and conservative. Readers are men and women of all ages interested in all phases of cat ownership. Circ. 303,000. No simultaneous submissions. Sample copy $5.50; artist's guidelines for SASE. Needs computer-literate freelancers for charts and graphs in QuarkXPress or Adobe Illustrator.
Cartoons: Buys 12 cartoons/year. Seeks single, double and multipanel with gagline. Should be simple, upbeat and reflect love for and enjoyment of cats. "Central character should be a cat." Send query letter with photostats or photocopies as samples and SASE. Reports in 2-3 months. Buys first rights. Pays on publication; $35 for b&w line drawings.
Illustrations: Buys 2-5 b&w spot illustrations/issue. Article illustrations assigned. Portfolio review not required. Pays $20 for spots; $50-100 for b&w illustrations; $200-300 for color illustrations; more for packages of multiple illustrations. Needs editorial, medical and technical illustration and images of cats.
Tips: "We need cartoons with an upbeat theme and realistic illustrations of purebred and mixed-breed cats. Please review a sample copy of the magazine before submitting your work to us."

CATHOLIC FORESTER, 355 W. Shuman Blvd., Box 3012, Naperville IL 60566-7012. (708)983-4920. Editor: Dorothy Deer. Estab. 1883. Magazine. "We are a fraternal insurance company but use general-interest articles, art and photos. Audience is middle-class, many small town as well as big-city readers, patriotic, somewhat conservative distributed nationally." Bimonthly 4-color magazine. Circ. 150,000. Accepts previously published material. Original artwork returned after publication if requested. Sample copy for 9 × 12 SASE with 3 first-class stamps.
Cartoons: Buys approximately 20 cartoons/year from freelancers. Considers "anything *funny* but it must be clean." Prefers single panel with gagline or strip; b&w line drawings. Material returned by SASE if requested. Reports within 2 months; "we try to do it sooner." Buys one-time rights or reprint rights. **Pays on acceptance**; $25 for b&w.
Illustrations: Needs editorial illustration. Portfolio review not required. Publication will contact artist for portfolio review if interested. Requests work on spec before assigning job. Pays $50-100 for b&w, $100-300 for color inside.

CATS MAGAZINE, P.O. Box 290037, Port Orange FL 32129. (904)788-2770. Fax: (904)788-2710. E-mail: roycat@aol.com; 74463.2222@compuserve.com. Art Editor: Roy Copeland. Estab. 1945. Monthly 4-color magazine for cat enthusiasts of all types. Circ. 150,000. Sample copies for SASE with $3. Art guidelines available for SASE. Uses freelance artists mainly for inside art. Freelancers should be familiar with Painter, Photoshop, Illustrator or Freehand.
Illustrations: Buys 15-36 illustrations/year. Prefers "cats" themes. Considers pen & ink, watercolor, oil and other media. Send query letter with SASE and samples. All illustration is assigned to reflect feature articles. Sample illustrations that show the behavioral aspects of cats, typical feline personality and motion are desired as opposed to a static portrait. "Non-cat" illustrations are accepted to determine the artist's quality and style; however, include at least 1 small sketch of a cat if possible. Samples are reviewed upon arrival. Samples accepted are kept on file for possible future assignments. Printed samples are preferred. 35mm slides and photos are also accepted. If a SASE or return postage is enclosed, rejected artwork will be returned within 1-2 months. If no SASE is enclosed, rejected samples will be discarded. Accepted artwork will be filed; however, no response will be sent to the artist without a SASE. Pays $100-500 depending on size. Kill fee dependent upon progress of work. Payment upon publication. Buys first serial rights.
Tips: Finds artists through artists' submissions and sourcebooks. Label material clearly with name, address, phone and fax. Do not send over-sized submissions (no bigger than 9¼×11¾). Most frequent reasons for rejection: art is too "wild"; poor depiction of cat; cat is in pain or danger; poor drawing or painting style; uninteresting; style too messy or cluttered; background is ugly or "busy."

‡CD REVIEW, Dept. AGDM, 86 Elm St., Peterborough NH 03458. (603)924-7271. Fax: (603)924-7013. Art Director: Charles Dixon III. *"CD Review* is edited for those who buy or intend to buy compact discs, compact disc players and related audio system components. The editorial content consists of reviews of compact discs, compact disc players and related hardware; the news and developments in the digital audio industry; interviews and articles about the people, events and technology. *CD Review* evaluates performance and sound quality of the CDs." Monthly. Circ. 100,000. Accepts previously published artwork. Originals returned at job's completion. Samples copies available.
Illustrations: Approached by 40-50 illustrators/year. Buys 6-12 illustrations/year. Works on assignment only. Prefers clever, original and conceptual themes in pen & ink, watercolor, collage, colored pencil, oil, mixed media and pastel. Send query letter with tearsheets and slides. Samples are filed or returned by SASE if requested by artist. Reports back to the artist only if interested. Write and send samples for appointment to show portfolio of original/final art, tearsheets and slides. **Pays on acceptance;** $50 for b&w, $500 for color cover; $300 for color inside.
Tips: "Be available to work quickly, meet deadlines and be able to work within a tight budget."

‡CED, 600 S. Cherry St., Suite 400, Denver CO 80222. (303)393-7449. Fax: (303)393-6654. Art Director: Don Ruth. Estab. 1978. Monthly trade journal. "We deal with the engineering aspects of the technology in Cable TV. We try to publish both views on subjects." Circ. 15,000. Accepts previously published work. Original artwork not returned at job's completion. Sample copies and art guidelines available.
Cartoons: Approached by 5-10 freelance illustrators/year. Perfers cable-industry-related themes; single panel, color washes without gagline. Contact only through artist rep. Samples are filed. Rights purchased vary according to project. Pays $200 for b&w; $400 for color.
Illustrations: Buys 1 illustration/issue. Works on assignment only. Prefers cable TV-industry themes. Considers watercolor, airbrush, acrylic, colored pencil, oil, charcoal, mixed media, pastel, computer disk through Photoshop, Adobe Illustrator or FreeHand. Contact only through artist rep. Samples are filed. Call for appointment to show portfolio. Portfolio should include final art, b&w/color tearsheets, photostats, photographs and slides. Rights purchased vary according to project. **Pays on acceptance**; $200 for b&w, $400 for color; cover; $100 for b&w, $200 for color inside.

CHEMICAL ENGINEERING, 1221 Avenue of Americas, New York NY 10020. (212)512-3377. Fax: (212)512-4762. Art Director: M. Gleason. Estab. 1903. Monthly 4-color trade journal featuring chemical process, industry technology, products and professional career tips. Circ. 80,000. Accepts previously published artwork. Original artwork returned at job's completion. Sample copies available. "Illustrators should review any issue for guidelines."
• Now also publishes *Environmental Engineering World* issued six times/year. Needs cover illustrations.
Illustrations: Approached by 1,000 illustrators/year. Buys 200 illustrations/year. Works on assignment only. Prefers technical information graphics in all media, especially computer art. 50% freelance work demands knowledge of QuarkXPress, Aldus Freehand, Adobe Illustrator or Photoshop. Send query letter with samples and SASE. Samples are filed or are returned by SASE if requested by artist. Reports back only if interested. To show a portfolio, mail appropriate representative materials. Buys first rights, one-time rights or reprint rights. Pays on publication; up to $300 for color inside.
Tips: "Have a style and content appropriate to the business of engineering and a fit with our limited budget."

CHEMICAL ENGINEERING PROGRESS, 345 E. 47th St., New York NY 10017. (212)705-7966. Art Director: Paul Scherr. Technical trade magazine published by the American Institute of Chemical Engineering. Needs computer-literate freelancers for design and illustration. 100% of freelance work demands knowledge of Adobe Illustrator, QuarkXPress, Photoshop and Aldus FreeHand.
Illustrations: Approached by 20 illustrators/year. Works on assignment only. Needs technical and editorial illustration. Send query letter with tearsheets. Samples are filed. Publication will contact artist for portfolio review if interested. Artist should follow up with a call or letter after original query. Reports back to the artist only if interested. Buys first or one-time rights. Pays $600 for cover; $300 for b&w, $450 for color inside.

CHESAPEAKE BAY MAGAZINE, 1819 Bay Ridge Ave., Annapolis MD 21403. (410)263-2662. Fax: (410)267-6924. Art Director: Christine Gill. Estab. 1972. Monthly 4-color magazine focusing on the boating environment of the Chesapeake Bay—including its history, people, places and ecology. Circ. 35,000. Original artwork returned after publication. Sample copies free for SASE with first-class postage. Art guidelines available. "Please call."
Cartoons: Approached by 12 cartoonists/year. Prefers single panel, b&w washes and line drawings with gagline. Cartoons are nautical humor or appropriate to the Chesapeake environment. Send query letter with finished cartoons. Samples are filed. Reports back to the artist only if interested. Buys one-time rights. Pays $25-30 for b&w.
Illustrations: Approached by 12 illustrators/year. Buys 2-3 technical and editorial illustrations/issue. Considers pen & ink, watercolor, collage, acrylic, marker, colored pencil, oil, charcoal, mixed media and pastel. Usually prefers watercolor or oil for 4-color editorial illustration. "Style and tone are determined by the artist after he/she reads the story." Send query letter with résumé, tearsheets and photographs. Samples are filed. Reports back only if interested. Publication will contact artist for portfolio review if interested. Portfolio should include "anything you've got." No b&w photocopies. Buys one-time rights. "Price decided when contracted." Pays $50-175 for b&w inside; $75-275 for color inside.
Tips: "Our magazine design is relaxed, fun, oriented toward people having fun on the water. Style seems to be loosening up. Boating interests remain the same. But for the Chesapeake Bay—water quality and the environment are more important to our readers than in the past. Colors brighter. We like to see samples that show the artist can draw boats and understands our market environment. Send tearsheets or call for an interview—we're always looking."

‡CHESS LIFE, 186 Route 9W, New Windsor NY 12553. (914)562-8350. Art Director: Jami Anson. Estab. 1939. Official publication of the United States Chess Federation. Contains news of major chess events with special emphasis on American players, plus columns of instruction, general features, historical articles, personality profiles, cartoons, quizzes, humor and short stories. Monthly b&w with 4-color cover. Design is "text-heavy with chess games." Circ. 60,000. Accepts previously published material and simultaneous submissions. Sample copy for SASE with 6 first-class stamps; art guidelines for SASE with first-class postage.
Cartoons: Approached by 200-250 cartoonists/year. Buys 60-75 cartoons/year. All cartoons must have a chess motif. Prefers single panel with gagline; b&w line drawings. Send query letter with brochure showing art style. Material kept on file or returned by SASE. Reports within 6-8 weeks. Negotiates rights purchased. Pays $25, b&w; $40, color; on publication.
Illustrations: Approached by 100-150 illustrators/year. Works with 4-5 illustrators/year from freelancers. Buys 8-10 illustrations/year. Uses artists mainly for covers and cartoons. All must have a chess motif; uses some humorous and occasionally cartoon-style illustrations. "We use mainly b&w." Works on assignment, but will also consider unsolicited work. Send query letter with photostats or original work for b&w; slides for color, or tearsheets to be kept on file. Reports within 2 months. Call to schedule an appointment to show a portfolio, which should include roughs, original/final art, final reproduction/product and tearsheets. Negotiates rights purchased. Pays $150, b&w; $200, color, cover; $25, b&w; $40, color, inside; on publication.
Tips: "Include a wide range in your portfolio."

CHIC MAGAZINE, 9171 Wilshire Blvd., Suite 300, Beverly Hills CA 90210. (310)858-7100. Art Director: John Berado. Estab. 1976. Monthly magazine "which contains fiction and nonfiction; sometimes serious, often humorous. Sex is the main topic, but any sensational subject is possible." Circ. 50,000. Originals returned at job's completion. Sample copies available for $6. Art guidelines not available.
Illustrations: Approached by 15 illustrators/year. Buys 2 illustrations/issue. Works on assignment only. Prefers themes: sex/eroticism, any and all styles. Considers all media. Send query letter with tearsheets, photographs and photocopies. Samples are filed. Artist should follow up with call and/or letter after initial query. Publication will contact artist for portfolio review if interested. Portfolio should include b&w and color slides and final art. Buys all rights. **Pays on acceptance;** $800 for color inside.
Tips: Finds artists through word of mouth, mailers and submissions. "We use artists from all over the country, with diverse styles, from realistic to abstract. Must be able to deal with adult subject matter and have no reservations concerning explicit sexual images. We want to show these subjects in new and interesting ways."

CHICAGO LIFE MAGAZINE, Box 11311, Chicago IL 60611-0311. Publisher: Pam Berns. Estab. 1984. Bimonthly lifestyle magazine. Circ. 60,000. Accepts previously published artwork. Original artwork returned at job's completion. Sample copy for SASE with $3 postage. Art guidelines not available.
Cartoons: Approached by 25 cartoonists/year. Buys 2 cartoons/issue. Prefers sophisticated humor; b&w line drawings. Send query letter with photocopies of finished cartoons. Samples are filed or are returned by SASE if requested. Reports back only if interested. Buys one-time rights. Pays $20.
Illustrations: Approached by 30 illustrators/year. Buys 3 illustrations/issue. Prefers "sophisticated, avant-garde or fine art. No 'cute' art, please." Considers all media. Send SASE, slides and photocopies. Samples are filed or returned by SASE. Reports back within 3 weeks. Buys one-time rights. **Pays on acceptance**; $30 for b&w and color inside.

‡CHICAGO'S CASINO REVIEW, % Hyde Park Media, 635 Chicago Ave., #250, Evanston IL 60202. (312)274-3337. Contact: Art Editor. Estab. 1994. Bimonthly. Circ. 50,000. Sample copy for $4.
Cartoons: Buys 1 cartoon/issue. Prefers casino and other gambling-related panel cartoons for regular "Casino Capers" slot. Prefers single, double or multiple panel; b&w line drawings with gagline. Send query letter with photocopies. Samples are returned by SASE if requested by artists "usually within 1 month." Negotiates rights purchased.
Illustrations: Buys 6-12 illustrations/issue. Prefers casino gambling themes. Considers b&w or 2-color (usually red and black) illustrations for articles, features and columns. Also considers 4-color cover art, usually detailed line illustrations that have been painted by computer. Also publishes block art prints. Send query letter with 2-3 photocopies. "Write and request a sample copy. After reviewing the publication call and request a specific image you can develop a non-returnable rough for, then submit it." Pays a flat fee; $10-200.
Tips: "Our pre-press operations are completely desk-top. Once we accept an illustration it can be submitted as either camera-ready art, on a Macintosh floppy, a SyQuest cartridge or via modem."

✦CHICKADEE, 179 John St., Suite 500, Toronto, Ontario M5T 3G5 Canada. (416)971-5275. Fax: (416)971-5294. Art Director: Tim Davin. Estab. 1979. 10 issues/year. Children's science and nature magazine. Chickadee is a "hands-on" science and nature publication designed to entertain and educate 3-9 year-olds. Each issue contains photos, illustrations, an easy-to-read animal story, a craft project, puzzles, a science experiment, and a pull-out poster. Circ. 150,000 in North America. Originals returned at job's completion. Sample copies available. Art guidelines not available. Uses all types of conventional methods of illustration. Needs computer-literate freelancers for illustration. Freelancers should be familiar with Adobe Illustrator, CorelDraw or Adobe Photoshop.
Illustrations: Approached by 500-750 illustrators/year. Buys 3-7 illustrations/issue. Works on assignment only. Prefers animals, children, situations and fiction. All styles, loaded with humor but not cartoons. Realistic depictions of animals and nature. Considers all media and computer art. No b&w illustrations. Send query letter with tearsheets. Samples are filed or returned by SASE if requested by artist. Publication will contact artist for portfolio review if interested. Portfolio should include final art, tearsheets and photocopies. Buys all rights. Pays within 30 days of invoice; $450 for color cover; $650 for color/double page spread; $250-300 for spots.
Tips: Finds artists through sourcebooks, word of mouth, artists' submissions as well as looking in other magazines to see who's doing what. "Please become familiar with the magazine before you submit. Ask yourself whether your style is appropriate before spending the money on your mailing." Impress this art director by being "fantastic, enthusiastic and unique."

CHILD LIFE, Children's Better Health Institute, 1100 Waterway Blvd., Box 567, Indianapolis IN 46206. (317)636-8881. Fax: (317)684-8094. Contact: Art Director. Estab. 1921. 4-color magazine for children 9-11. Monthly, except bimonthly January/February, April/May, July/August and October/November. Sample copy $1.25.
 • Also publishes *Children's Digest, Children's Playmate, Humpty Dumpty's Magazine, Jack and Jill* and *Turtle Magazine.*
Illustrations: Approached by 200 illustrators/year. Works with 30 illustrators/year. Buys approximately 50 illustrations/year on assigned themes. Especially needs health-related (exercise, safety, nutrition, etc.) themes, and stylized and realistic styles of children 9-11 years old. Uses freelance art mainly with stories, recipes and poems. Send query letter with brochure showing art style or résumé and tearsheets, photostats, photocopies, slides, photographs and SASE. Especially looks for an artist's ability to draw well consistently. Reports in 2 months. Portfolio review not required. Buys all rights. Pays $275 for color cover. Pays for inside illustrations by the job, $70-155 (4-color), $60-120 (2-color), $35-90 (b&w); $35-70 for spots. Pays within 3 weeks prior to publication date. "All work is considered work for hire."
Tips: Finds artists through artists' submissions, occasionally through a sourcebook. "Artists should obtain copies of current issues to become familiar with our needs. I look for the ability to illustrate children in group situations and interacting with adults and animals, in realistic styles. Also use unique styles for occasional assignments—cut paper, collage or woodcut art. No cartoons, portraits of children or slick airbrushed advertising work."

CHILDREN'S DIGEST, Children's Better Health Institute, 1100 Waterway Blvd., Box 567, Indianapolis IN 46206. (317)636-8881. Fax: (317)684-8094. Contact: Art Director. 4-color magazine with special emphasis on health, nutrition, safety and exercise for preteens. Published 8 times/year. Sample copy $1.25; art guidelines for SASE.
 ● Also publishes *Child Life, Children's Playmate, Humpty Dumpty's Magazine, Jack and Jill* and *Turtle Magazine.*
Illustrations: Approached by 200 illustrators/year. Works with 40 illustrators/year. Buys 15-20 illustrations/issue. Uses freelance art mainly with stories, articles, poems and recipes. Works on assignment only. Send query letter with brochure, résumé, samples and tearsheets to be kept on file. Portfolio review not required. Prefers photostats, slides and good photocopies as samples. Samples returned by SASE if not kept on file. Reports within 2 months. Buys all rights. Pays $275 for color cover; $35-90 for b&w, $60-120 for 2-color, $70-155 for 4-color inside; $35-70 for spots. Pays within 3 weeks prior to publication date. "All artwork is considered work for hire."
Tips: Finds artists through artists' submissions and sourcebooks. Likes to see situation and storytelling illustrations with more than 1 figure. When reviewing samples, especially looks for artist's ability to bring a story to life with illustrations and to draw well consistently. No advertising work, cartoon styles or portraits of children. Needs realistic styles and animals.

CHILDREN'S PLAYMATE, Children's Better Health Institute, 1100 Waterway Blvd., Box 567, Indianapolis IN 46206. (317)636-8881. Art Director: Marty Jones. 4-color magazine for ages 6-8. Special emphasis on entertaining fiction, games, activities, fitness, health, nutrition and sports. Published 8 times/year. Original art becomes property of the magazine and will not be returned. Sample copy $1.25.
 ● Also publishes *Child Life, Children's Digest, Humpty Dumpty's Magazine, Jack and Jill* and *Turtle Magazine.*
Illustrations: Uses 25-30 illustrations/issue; buys 10-20 from freelancers. Interested in editorial, medical, stylized, humorous or realistic themes; also food, nature and health. Considers pen & ink, airbrush, charcoal/pencil, colored pencil, watercolor, acrylic, oil, pastel, collage, multimedia and computer illustration. Works on assignment only. Send sample of style; include illustrations of children, families, animals—targeted to children. Provide brochure, tearsheet, stats or good photocopies of sample art to be kept on file. Samples returned by SASE if not filed. Artist should follow up with call or letter. Also considers b&w camera-ready art for puzzles, such as dot-to-dot, hidden pictures, crosswords, etc. Buys all rights on a work-for-hire basis. Payment varies. Pays $275 for color cover; up to $155 for color and $90 for b&w inside, per page.
Tips: Finds artists through artists' submissions/self-promotions. "Become familiar with our magazine before sending anything. Don't send just two or three samples. I need to see a minimum of eight pieces to determine that the artist fits our needs. Looking for samples displaying the artist's ability to interpret text, especially in fiction for ages 6-8. Illustrators must be able to do their own layout with a minimum of direction."

THE CHRISTIAN CENTURY, 407 S. Dearborn, Chicago IL 60605. (312)427-5380. Fax: (312)427-1302. Production Coordinator: Matthew Giunti. Estab. 1888. Religious magazine; "a weekly ecumenical magazine with a liberal slant on issues of Christianity, culture and politics." Circ. 35,000. Accepts previously published artwork. Original artwork returned at job's completion. Art guidelines for SASE with first-class postage.
Cartoons: Buys 1 cartoon/issue. Prefers religious themes. Line art works best on newsprint stock. Seeks single panel, b&w line drawings and washes. Send query letter with finished cartoons. Samples are filed or are returned by SASE if requested by artist. Reports back within 3 weeks. Buys one-time rights. Pays $25 for b&w; $50 for cover.
Illustrations: Approached by 40 illustrators/year. Buys 30 illustrations/year. Works on assignment only. Needs editorial illustration with "religious, specifically Christian themes and styles that are inclusive, i.e., women and minorities depicted." Considers pen & ink and charcoal. Send query letter with tearsheets. Portfolio review not required. Samples are filed or returned by SASE. Reports back within 1 month. Buys one-time rights. Pays on publication; $100 for b&w cover; $50 for b&w inside; $25-50 for spots.

CHRISTIAN HOME & SCHOOL, 3350 E. Paris Ave. SE, Grand Rapids MI 49512. (616)957-1070. Fax: (616)957-5022. Senior Editor: Roger W. Schmurr. Emphasizes current, crucial issues affecting the Christian home for parents who support Christian education. Half b&w, half 4-color magazine; 4-color cover; published 6 times/year. Circ. 58,000. Original artwork returned after publication. Sample copy for 9 × 12 SASE with 4 first-class stamps; art guidelines for SASE with first-class postage.
Cartoons: Prefers family and school themes. Pays $50 for b&w.
Illustrations: Buys approximately 2 illustrations/issue. Prefers pen & ink, charcoal/pencil, colored pencil, watercolor, collage, marker and mixed media. Prefers family or school life themes. Works on assignment only. Send query letter with résumé, tearsheets, photocopies or photographs. Show a representative sampling of work. Samples returned by SASE if requested, or "send one or two samples art director can keep on file." Publication will contact artist if interested in portfolio review. Buys first rights. Pays on publication; $250 for 4-color full page inside; $75 for b&w spots.
Tips: Finds most artists through references, portfolio reviews, samples received through the mail and artist reps.

THE CHRISTIAN READER, Dept. AGDM, 465 Gundersen Dr., Carol Stream IL 60188. (708)260-6200. Fax: (708)260-0114. Art Director: Jennifer McGuire. Estab. 1963. Bimonthly general interest magazine. "A digest of the best in Christian reading." Circ. 250,000. Accepts previously published artwork. Originals returned at job's completion. Sample copies and art guidelines for SASE with first-class postage.
Cartoons: Buys 3 cartoons/issue. Prefers home, family, church life and general interest. Send query letter with samples of published work. Samples are filed or returned by SASE. Reports back to artist only if interested. Buys one-time rights. Pays $45 for reprint; $75 originals.
Illustrations: Buys 12 illustrations/issue. Works on assignment only. Prefers family, home and church life. Considers all media. Samples are filed or returned by SASE if requested by artist. Reports back only if interested. To show a portfolio, mail appropriate materials. Buys one-time rights. **Pays on acceptance**; $150 for b&w, $250 for color inside.
Tips: "Send samples of your best work, in your best subject and best medium. We're interested in fresh and new approaches to traditional subjects and values."

‡THE CHRONICLE OF THE HORSE, Box 46, Middleburg VA 22117. Editor: John Strassburger. Estab. 1937. Weekly magazine emphasizing horses and English horse sports for dedicated competitors who ride, show and enjoy horses. Circ. 23,500. Sample copy and guidelines available for $2.
Cartoons: Approached by 25 cartoonists/year. Buys 1-2 cartoons/issue. Considers anything about English riding and horses. Prefers single panel b&w line drawings or washes with or without gagline. Send query letter with finished cartoons to be kept on file if accepted for publication. Material not filed is returned. Reports within 4-6 weeks. Buys first rights. Pays on publication $20, b&w.
Illustrations: Approached by 25 illustrators/year. "We use a work of art on our cover every week. The work must feature horses, but the medium is unimportant. We do not pay for this art, but we always publish a short blurb on the artist and his or her equestrian involvement, if any." Send query letter with samples to be kept on file until published. If accepted, insists on high-quality, b&w 8 × 10 photographs of the original artwork. Samples are returned. Reports within 1 month.
Tips: Does not want to see "current horse show champions or current breeding stallions."

THE CHURCHMAN'S HUMAN QUEST, 1074 23rd Ave. N., St. Petersburg FL 33704. (813)894-0097. Editor: Edna Ruth Johnson. Magazine is b&w with 2-color cover, conservative design. Published 6 times/year. Circ. 10,000. Sample copy available.
Cartoons: Buys 2-3 cartoons/issue. Interested in religious, political and social themes. Prefers to see finished cartoons. Include SASE. Reports in 1 week. **Pays on acceptance**; $7.
Tips: "Read current-events news so you can cover it humorously."

CICADA, 329 E St., Bakersfield CA 93304. (805)323-4064. Editor: Frederick Raborg. Estab. 1984. A quarterly literary magazine "aimed at the reader interested in haiku and fiction related to Japan and the Orient. We occasionally include excellent Chinese and other Asian poetry forms and fiction so related." Circ. 600. Accepts previously published artwork. Originals returned at job's completion. Sample copies available for the cost of $4.95. Art guidelines for SASE with first-class postage.
Cartoons: Approached by 50-60 cartoonists/year. Buys 2 cartoons/issue. Prefers the "philosophically or ironically funny. Excellent cartoons without gaglines occasionally used on cover." Prefers single panel b&w washes and line drawings with or without gagline. Send good photocopies of finished cartoons. Samples are filed or returned by SASE. Reports back within 2 months. Buys first rights. **Pays on acceptance**; $10 for b&w; $15 if featured.
Illustrations: Approached by 150-175 illustrators/year. Buys 2 illustrations/issue. Prefers Japanese or Oriental, nature themes in pen & ink. Send query letter with photostats of finished pen & ink work. Samples are filed or returned by SASE. Reports back within 2 months. Portfolio review not required. Buys first rights and one-time rights. Pays $15-20 for b&w cover; $10 for b&w inside. Pays on publication for most illustrations "because they are dictated by editorial copy."
Tips: Finds artists through market listings and artists' submissions.

CINCINNATI MAGAZINE, 409 Broadway, Cincinnati OH 45202. (513)421-4300. Art Director: Tom Hawley. Estab. 1960. Monthly 4-color lifestyle magazine for the city of Cincinnati. Circ. 30,000. Accepts previously published artwork. Original artwork returned at job's completion. Art guidelines not available.
Cartoons: Approached by 20 cartoonists/year. Buys 8 cartoons/issue. "There are no thematic or stylistic restrictions." Prefers single panel b&w line drawings. Send finished cartoons. Samples are filed or returned

The double dagger before a listing indicates that the listing is new in this edition. New markets are often more receptive to freelance submissions.

with SASE. Reports back within 2 months. Buys one-time rights or reprint rights. Pays $25.
Illustrations: Approached by 20 illustrators/year. Buys 6 illustrations/issue from local freelancers. Works on assignment only. Send tearsheets and/or photocopies. Samples are filed or returned by SASE if requested by artist. Reports back only if interested. Buys one-time rights or reprint rights. **Pays on acceptance**; $250 for color cover; $85 for b&w; $135 for color inside; $25 for spots.
Tips: "Let the work speak for itself."

‡**CINEFANTASTIQUE**, Box 270, Oak Park IL 60303. (708)366-5566. Fax: (708)366-1441. Editor-in-Chief: Frederick S. Clarke. Bimonthly magazine emphasizing science fiction, horror and fantasy films for "devotees of 'films of the imagination.' " Circ. 60,000. Original artwork not returned. Sample copy $8.
Illustrations: Uses 1-2 illustrations/issue. Interested in "dynamic, powerful styles, though not limited to a particular look." Works on assignment only. Send query letter with résumé, brochure and samples of style to be kept on file. Samples not returned. Reports in 3-4 weeks. Buys all rights. Pays on publication; $150 maximum for inside b&w line drawings and washes; $300 maximum for cover color washes; $150 maximum for inside color washes.

CIRCLE K MAGAZINE, 3636 Woodview Trace, Indianapolis IN 46268. (317)875-8755. Fax: (317)879-0204. Art Director: Dianne Bartley. Estab. 1968. Kiwanis International's youth magazine for (college age) students emphasizing service, leadership, etc. Published 5 times/year. Circ. 12,000. Originals returned to artist at job's completion.
Illustrations: Approached by more than 30 illustrators/year. Buys 1-2 illustrations/issue. Works on assignment only. Needs editorial illustration. "We look for variety." Send query letter with tearsheets. Samples are filed. Publication will contact artist for portfolio review if interested. Portfolio should include tearsheets and slides. **Pays on acceptance**; $100 for b&w, $250 for color cover; $50 for b&w, $150 for color inside.

CITY LIMITS, 40 Prince St., New York NY 10012. (212)925-9820. Fax: (212)966-3407. Senior Editor: Jill Kirschenbaum. Estab. 1976. Monthly urban affairs magazine covering issues important to New York City's low- and moderate-income neighborhoods, including housing, community development, the urban environment, crime, public health and labor. Circ. 10,000. Originals returned at job's completion. Sample copies free for 9×12 SASE and 4 first-class stamps.
● Plans to publish more cartoons in the future. Would like to see more submissions.
Cartoons: Buys 5 cartoons/year. Prefers N.Y.C. urban affairs—social policy, health care, environment and economic development. Prefers political cartoons; single, double or multiple panel b&w washes and line drawings with or without gaglines. Send query letter with finished cartoons and tearsheets. Samples are filed. Reports back within 1 month. Buys first rights and reprint rights. Pays $35-50 for b&w.
Illustrations: Buys 1-2 illustrations/issue. Must address urban affairs and social policy issues, affecting low and moderate income neighborhoods, primarily in New York City. Considers pen & ink, watercolor, collage, airbrush, charcoal, mixed media and anything that works in b&w. Send query letter with tearsheets. Samples are filed. Reports back within 1 month. Request portfolio review in original query. Buys first rights. Pays on publication; $50-100 for b&w cover; $35-50 for b&w inside. "Our production schedule is tight, so publication is generally within two weeks of acceptance, as is payment."
Tips: Finds artists through other publications, word of mouth and submissions. "Make sure you've seen the magazine before you submit. Our niche is fairly specific."

CLASSIC AUTO RESTORER, P.O. Box 6050, Mission Viejo CA 92690. (714)855-8822. Fax: (714)855-3045. Editor: Brian Mertz. Estab. 1989. Monthly consumer magazine with focus on collecting, restoring and enjoying classic cars. Circ. 100,000. Accepts previously published artwork. Originals returned at job's completion. Sample copies available for $5.50. Art guidelines not available. Needs computer-literate freelancers for illustration. 20% of freelance work demands knowledge of Adobe Illustrator or QuarkXPress.
Illustrations: Approached by 5-10 illustrators/year. Buys 2-3 illustrations/issue. Prefers technical illustrations and cutaways of classic/collectible automobiles through 1972. Considers pen & ink, watercolor, airbrush, acrylic, marker, colored pencil, oil, charcoal, mixed media and pastel. Send query letter with SASE, slides, photographs and photocopies. Samples are filed or returned by SASE if requested by artist. Reports back to the artist only if interested. Buys one-time rights. Pays on publication; $300 for color cover; $35 for b&w, $100 for color inside.
Tips: Finds artists through submissions. Areas most open to freelance work are technical illustrations for feature articles and renderings of classic cars for various sections.

‡**CLASSIC TOY TRAINS**, 2107 Crossroads Circle, Waukesha WI 53187. Fax: (414)796-1383. Art Director: Lawrence Luser. Estab. 1987. Quarterly magazine emphasizing collectible toy trains. Circ. 73,000. Accepts previously published material. Original artwork sometimes returned to artist after publication. Sample copies available.
● Published by Kalmbach Publishing, which also publishes *Finescale Modeler* and several other magazines focusing on hobbies and collectibles.

Illustrations: Send query letter and/or samples, "either postcard, 8 × 10 sheet, color copy or photographs. Currently running Illustrator 5.0. Accepts submissions on disk." Samples are filed or returned only if requested. Reports back only if interested. Negotiates rights purchased.

CLEANING BUSINESS, 1512 Western Ave., Box 1273, Seattle WA 98111. (206)622-4241. Fax: (206)622-6876. Publisher: Bill Griffin. Submissions Editor: Jim Saunders. Quarterly magazine with technical, management and human relations emphasis for self-employed cleaning and maintenance service contractors. Circ. 6,000. Prefers first publication material. Simultaneous submissions OK "if to noncompeting publications." Original artwork returned after publication if requested by SASE. Sample copy $3.
Cartoons: Buys 1-2 cartoons/issue. Must be relevant to magazine's readership. Prefers b&w line drawings.
Illustrations: Buys approximately 12 illustrations/issue including some humorous and cartoon-style illustrations. Send query letter with samples. Samples returned by SASE. Buys first publication rights. Reports only if interested. Pays for design by the hour, $10-15. Pays for illustration by the project, $3-15. Pays on publication.
Tips: "Our budget is extremely limited. Those who require high fees are really wasting their time. We are interested in people with talent and ability who seek exposure and publication. Our readership is people who work for and own businesses in the cleaning industry, such as maid services; janitorial contractors; carpet, upholstery and drapery cleaners; fire, odor and water damage restoration contractors; etc. If you have material relevant to this specific audience, we would definitely be interested in hearing from you."

CLEARWATER NAVIGATOR, 112 Market St., Poughkeepsie NY 12603. (914)454-7673. Fax: (914)454-7952. Graphics Coordinator: Nora Porter. Bimonthly b&w newsletter emphasizing sailing and environmental matters for middle-upper income Easterners with a strong concern for environmental issues. Circ. 10,000. Accepts previously published material. Original artwork returned after publication. Sample copy free with SASE.
Cartoons: Buys 1 cartoon/issue. Prefers editorial lampooning—environmental themes. Prefers single panel b&w line drawings with gaglines. Send query letter with samples of style to be kept on file. Material not filed is returned only if requested. Reports within 1 month. Publication will contact artist for portfolio review if interested. Buys first rights. Pays on publication, negotiable rate, for b&w.
Illustrations: Buys editorial and technical illustration of nature subjects. Pays $100 for b&w, $150 for color cover; $75 for b&w, $100 for color inside.
Tips: Finds artists through word of mouth, artists' submissions and attending art exhibitions. Sees "greater and greater specialization" in the magazine field.

CLEVELAND MAGAZINE, Dept. AGDM, 1422 Euclid Ave., Suite 730, Cleveland OH 44115. (216)771-2833. Fax: (216)781-6318. Contact: Gary Sluzewski. Monthly city magazine, b&w with 4-color cover, emphasizing local news and information. Circ. 45,000. Uses computer-literate freelancers for illustration. 40% of freelance work demands knowledge of QuarkXPress, Aldus FreeHand or Photoshop.
Illustrations: Approached by 100 illustrators/year. Buys 5-6 editorial illustrations/issue on assigned themes. Sometimes uses humorous illustrations. Send query letter with brochure or 2-3 samples showing consistent quality. Call or write for appointment to show portfolio of printed samples, final reproduction/product, color tearsheets and photographs. Pays $300 for b&w, $400 for color cover; $200 for b&w, $250 for color inside; $75 for spots.
Tips: "Artists used on the basis of talent. We use many talented college graduates just starting out in the field. We do not publish gag cartoons but do print editorial illustrations with a humorous twist. Full page editorial illustrations usually deal with local politics, personalities and stories of general interest. Generally, we are seeing more intelligent solutions to illustration problems and better techniques. The economy has drastically affected our budgets; we pick up existing work almost completely as opposed to commissioning illustrations."

COLLISION® MAGAZINE, Box M, Franklin MA 02038. (508)528-6211. Editor: Jay Kruza. Cartoon Editor: Brian Sawyer. Monthly magazine with an audience of new car dealers, auto body repair shops and towing companies. Articles are directed at the managers of these small businesses. Circ. 16,000. Prefers original material but may accept previously published material. Sample copy $4. Art guidelines for SASE with first-class postage.
Cartoons: Buys 3 cartoons/issue. Prefers themes that are positive or corrective in attitude. Prefers single panel b&w line drawings with gagline. Send rough versions or finished cartoons. Reports back in 2 weeks or samples returned by SASE. Buys one-time rights and reprint rights. Pays $10/single panel b&w line cartoon.
Illustrations: Buys about 2 illustrations/issue based upon a 2-year advance editorial schedule. Send query letter which includes phone number and time to call, with brochure, tearsheets, photostats, photocopies, slides and photographs. Samples are returned by SASE. "We prefer clean pen & ink work but will use color." Reports back within 15-30 days. "**Pays on acceptance** for assigned artwork ranging from $25 for spot illustrations up to $200 for full-page material."

‡♥COMMON GROUND, Box 34090, Station D, Vancouver, British Columbia V6J 4M1 Canada. (604)733-2215. Fax: (604)733-4415. Contact: Art Director. Estab. 1982. Bimonthly consumer magazine and holistic personal resource directory. Accepts previously published artwork. Original artwork is returned at job's completion. Sample copies for SASE with first-class postage.
 • Publisher launched a cartoon magazine, *Smile*.
Cartoons: "Lots! We publish monthly cartoon magazine as well." Send query letter with brochure. Samples are filed or are returned by SASE if requested by artist. Reports back only if interested. Rights purchased vary according to project. Payment varies.
Illustrations: Approached by 10-20 freelance illustrators/year. Buys 1-2 freelance illustrations/issue. Prefers all themes and styles. Considers pen & ink, watercolor, collage and marker. Send query letter with brochure, photographs, SASE and photocopies. Samples are filed or are returned by SASE if requested by artist. Reports back to the artist only if interested. Buys one-time rights. Payment varies; on publication.
Tips: "Send photocopies of your top one-three inspiring works in b&w or color. Can have all three on one sheet of 8½ × 11 paper or all in one color copy. I can tell from that if I am interested."

COMMONWEAL, 15 Dutch St., New York NY 10038. (212)732-0800. Contact: Editor. Estab. 1924. Public affairs journal. "Journal of opinion edited by Catholic lay people concerning public affairs, religion, literature and all the arts"; b&w with 2-color cover. Biweekly. Circ. 18,000. Original artwork is returned at the job's completion. Sample copies for SASE with first-class postage. Guidelines for SASE with first-class postage.
Cartoons: Approached by 20-40 cartoonists/year. Buys 3-4 cartoons/issue from freelancers. Prefers simple lines and high-contrast styles. Prefers single panel, with or without gagline; b&w line drawings. Send query letter with finished cartoons. Samples are filed or are returned by SASE if requested by artist. Reports back within 2 weeks. Buys first rights. Pays $8.50 for b&w.
Illustrations: Approached by 20 illustrators/year. Buys 3-4 illustrations/issue, 60/year from freelancers. Prefers high-contrast illustrations that "speak for themselves." Prefers pen & ink and marker. Send query letter with tearsheets, photographs, SASE and photocopies. Samples are filed or returned by SASE if requested by artist. Reports back within 2 weeks. To show a portfolio, mail b&w tearsheets, photographs and photocopies. Buys first rights. Pays $25 for b&w cover; $10 for b&w inside on publication.

‡COMMUNICATION WORLD, One Hallidie Plaza, Suite 600, San Francisco CA 94102. (415)433-3400. Editor: Gloria Gordon. Emphasizes communication, public relations (international) for members of International Association of Business Communicators: corporate and nonprofit businesses, hospitals, government communicators, universities, etc. who produce internal and external publications, press releases, annual reports and customer magazines. Monthly except June/July combined issue. Circ. 14,000. Accepts previously published material. Original artwork returned after publication. Art guidelines available.
Cartoons: Approached by 6-10 cartoonists/year. Buys 6 cartoons/year. Considers public relations, entrepreneurship, teleconference, editing, writing, international communication and publication themes. Prefers single panel with gagline; b&w line drawings or washes. Send query letter with samples of style to be kept on file. Material not filed is returned by SASE only if requested. Reports within 2 months only if interested. To show portfolio, write or call for appointment. Buys first rights, one-time rights or reprint rights; negotiates rights purchased. Pays on publication; $25-50, b&w.
Illustrations: Approached by 20-30 illustrators/year. Buys 6-8 illustrations/issue. Theme and style are compatible to individual article. Send query letter with samples to be kept on file. To show a portfolio, write or call for appointment. Accepts tearsheets, photocopies or photographs as samples. Samples not filed are returned only if requested. Reports back within 1 year only if interested. To show a portfolio, write or call for appointment. Buys first rights, one-time rights or reprint rights; negotiates rights purchased. Pays on publication; $100, b&w, $300, color, cover; $100 maximum, b&w, $275, color, inside.
Tips: Sees trend toward "more sophistication, better quality, less garish, glitzy—subdued, use of subtle humor."

‡COMPUTER CURRENTS, 5720 Hollis St., Emeryville CA 94608. Art Director: Kris Warrenburg. "A newsmagazine which delivers timely and topical information of a national/regional nature to business/professional PC users; cleanly designed 4-column format with news and review emphasis." Published twice a month in San Francisco Bay Area; monthly in Los Angeles, Boston, Atlanta, Houston and Dallas/Ft. Worth. Accepts previously published material. Original artwork is returned to the artist after publication.
Illustrations: Buys 6 cover illustrations/year. Prefers high-tech style and microcomputer themes. Needs computer-literate freelancers for production. Send query letter with brochure showing art style or tearsheets and photocopies. Samples are filed. Reports back only if interested. Call for appointment to show portfolio roughs, original/final art, tear sheets and final reproduction/product. Negotiates rights purchased. Pays $700 maximum for color or b&w cover.
Tips: "Work from manuscript without much direction. Work fast in styles easily reproducible for open web printing."

‡CONCRETE PRODUCTS, 29 N. Wacker Dr., Chicago IL 60606. (312)726-2802. Fax: (312)726-2574. Art Director: Sundée Koffarnus. Estab. 1894. Monthly trade journal. Circ. 28,000. Needs computer-literate

freelancers for illustration. 75% of freelance work demands knowledge of Adobe Illustrator.
Illustrations: Approached by 10 illustrators/year. Buys 2 illustrations/year. Works on assignment only. Looking for realistic, technical style. Send query letter with brochure and samples or slides. Samples are filed or are returned by SASE if requested by artist. Reports back to the artist only if interested. Write for appointment to show portfolio of thumbnails, roughs, final art, b&w and color tearsheets. Rights purchased vary according to project. Pays; $300 for color cover. $100 for b&w, $200 for color inside.
Tips: Prefers local artists. "Get lucky, and approach me at a good time. A follow-up call is fine, but pestering me will get you nowhere. Few people ever call after they send material. This may not be true of most art directors, but I prefer a somewhat casual, friendly approach. Also, being 'established' means nothing. I prefer to use new illustrators as long as they are professional and friendly."

‡CONDÉ NAST TRAVELER, 360 Madison Ave., 10th Floor, New York NY 10017. (212)880-2142. Fax: (212)880-2190. Art Director: Chris Gangi. Estab. 1988. Monthly travel magazine with emphasis on "truth in the travel industry." Geared toward upper income 40-50 year olds with time to spare. Circ. 1 million. Originals are returned at job's completion. Sample copies and art guidelines available. Needs computer-literate freelancers for design and production. Freelance work demands knowledge of QuarkXPress and Photoshop.
Illustrations: Approached by 5 illustrators/week. Buys 2 illustrations/issue. Works on assignment only. Considers pen & ink, collage, oil and mixed media. Send query letter with tearsheets. Samples are filed. Does not report back, in which case the artist should wait for assignment. To show a portfolio, mail b&w and color tearsheets. Buys first rights. Pays on publication; $150-500 inside.

CONFRONTATION: A LITERARY JOURNAL, English Department, C.W. Post, Long Island University, Brookville NY 11548. (516)299-2391. Fax: (516)299-2735. Editor: Martin Tucker. Estab. 1968. Semiannual literary magazine devoted to the short story and poem, for a literate audience open to all forms, new and traditional. Circ. 2,000. Sample copies available for $3. Art guidelines not available. 20% of freelance work demands computer skills.
Illustrations: Approached by 10-15 illustrators/year. Buys 2-3 illustrations/issue. Works on assignment only. Considers pen & ink and collage. Send query letter with SASE and photocopies. Samples are not filed and are returned by SASE. Reports back within 1-2 months only if interested. Portfolio review not required. Rights purchased vary according to project. Pays on publication; $50-100 for b&w, $100-250 for color cover; $25-50 for b&w, $50-75 for color inside; $25-75 for spots.

CONSTRUCTION EQUIPMENT OPERATION AND MAINTENANCE, Construction Publications, Inc., Box 1689, Cedar Rapids IA 52406. (319)366-1597. Editor-in-Chief: C.K. Parks. Estab. 1948. Bimonthly b&w tabloid with 4-color cover. Concerns heavy construction and industrial equipment for contractors, machine operators, mechanics and local government officials involved with construction. Circ. 67,000. Original artwork not returned after publication. Free sample copy.
Cartoons: Buys 8-10 cartoons/issue. Interested in themes "related to heavy construction industry" or "cartoons that make contractors and their employees 'look good' and feel good about themselves"; single panel. Send finished cartoons and SASE. Reports within 2 weeks. Buys all rights, but may reassign rights to artist after publication. Pays $20 for b&w. Reserves right to rewrite captions.

COOK COMMUNICATIONS MINISTRIES, (formerly David C. Cook Publishing Co.), 7125 Disc Dr., Colorado Springs CO 80918. Director of Design Services: Randy R. Maid. Publisher of magazines, teaching booklets, visual aids and filmstrips for Christians, "all age groups."
Cartoons: Approached by 250 cartoonists/year. Pays $50 for b&w; $65 for color.
Illustrations: Buys about 30 full-color illustrations/week. Send tearsheets, slides or photocopies of previously published work; include self-promo pieces. No samples returned unless requested and accompanied by SASE. Works on assignment only. **Pays on acceptance**; $550 for color cover; $350 for color inside. Considers complexity of project, skill and experience of artist and turnaround time when establishing payment. Buys all rights. Originals can be returned in most cases.
Tips: "We do not buy illustrations or cartoons on speculation. We welcome those just beginning their careers, but it helps if the samples are presented in a neat and professional manner. Our deadlines are generous but must be met. We send out checks as soon as final art is approved, usually within two weeks of our receiving the art. We want art radically different from normal Sunday School art. Fresh, dynamic, the highest of quality is our goal; art that appeals to preschoolers to senior citizens; realistic to humorous, all media."

COUNTRY AMERICA, 1716 Locust St., Des Moines IA 50309-3023. (515)284-2135. Fax: (515)284-3035. Art Director: Ray Neubauer. Estab. 1989. Consumer magazine "emphasizing entertainment and lifestyle for people who enjoy country life and country music." Monthly 4-color magazine. Circ. 1,000,000. Art guidelines not available.
Illustrations: Approached by 10-20 illustrators/year. Buys 1-2 illustrations/issue, 10-15 illustrations/year from freelancers on assignment only. Contact through artist rep or send query letter with brochure, tearsheets,

slides and transparencies. Samples are filed. Reports back only if interested. Buys all rights. **Pays on acceptance**.

COUNTRY JOURNAL, 4 High Ridge Park, Stamford CT 06905. Art Director: Robin DeMougeot. Estab. 1974. Consumer magazine that is "the authoritative resource on rural life, providing practical advice for the country dweller. Readership aimed to middle and upper income levels." Bimonthly 4-color magazine. Circ. 200,000. Original artwork is returned after publication. Sample copies available for $4. Art guidelines available for SASE.
Illustrations: Buys illustrations mainly for departments and feature spreads. Buys 8-16 illustrations/issue. Works on assignment only. Considers pen & ink, mixed media, colored pencil, oils, pastels, collage, charcoal pencil, woodcuts and scratchboard. Send query letter with brochure showing art style, tearsheets, photostats, photocopies, photographs and transparencies. Looks for "ability with human form, architectural and technical illustration (but not high-tech styles)." Samples are filed. Samples not filed are returned only if requested and accompanied by SASE. Reports back about queries/submissions only if interested. Write for appointment to show portfolio of original/final art, tearsheets and transparencies. Pays on publication; $500 for color cover; $125 for b&w, $225 for color inside ¼ page.
Tips: The best advice for an illustrator is "to examine the magazine. Present samples appropriate to our style. Artists who exemplify this style include James Needham, Malcolm Wells and Frank Fretz."

THE COVENANT COMPANION, 5101 N. Francisco Ave., Chicago IL 60625. (312)784-3000. Editor: John E. Phelan, Jr. Monthly b&w magazine with 4-color cover emphasizing Christian life and faith. Circ. 23,500. Original artwork returned after publication if requested. Sample copy $2.25. Needs computer-literate freelancers familiar with Aldus PageMaker and CorelDraw.
Cartoons: Needs cartoons with contemporary Christian themes—church life, personal life, theology. Pays $15 for b&w.
Illustrations: Uses b&w drawings or photos about Easter, Advent, Lent and Christmas. Works on submission only. Write or submit art 10 weeks in advance of season. Send SASE. Reports "within a reasonable time." Buys first North American serial rights. Pays 1 month after publication; $20 for b&w, $75 for color cover; $20 for b&w, $50 for color inside. More photos than illustrations.
Tips: "We usually have some rotating file, if we are interested, from which material may be selected."

‡CRICKET, The Magazine for Children, Box 300, Peru IL 61354. Art Director: Ron McCutchan. Estab. 1973. Monthly magazine emphasizes children's literature for children ages 6-14. Design is fairly basic and illustration-driven; full-color with 2 basic text styles. Circ. 110,000. Original artwork returned after publication. Sample copy $2; art guidelines for SASE.
Cartoons: "We rarely run cartoons, but those we have run are 1-2 pages in format (7×9 page dimension); we have more short picture stories rather than traditional cartoons; art styles are more toward children's book illustration."
Illustrations: Approached by 600-700 illustrators/year. Works with 75 illustrators/year. Buys 600 illustrations/year. Needs editorial (children's) illustration in style of Trina Schart Hyman, Charles Mikolaycak, Troy Howell, Janet Stevens and Quentin Blake. Uses artists mainly for cover and interior illustration. Prefers realistic styles (animal or human figure); occasionally accepts caricature. Works on assignment only. Send query letter with brochure and samples to be kept on file, "if I like it." Prefers photostats and tearsheets as samples. Samples not kept on file are returned by SASE if requested. Reports within 6-8 weeks. To show a portfolio, include "several pieces that show an ability to tell a continuing story or narrative." Does not want to see "overly slick, cute commercial art (i.e. licensed characters and overly sentimental greeting cards)." Buys reprint rights. Pays 45 days from receipt of final art; $750 for color cover; $100-250 for color inside.
Tips: Freelancers have "a tendency to throw in the kitchen sink—I notice a lack of editing, which is helpful for me actually, since I can see what they've done that doesn't work. Of course, it's usually to their detriment. Today there is a lack of good realists who know anatomy and how the body works in movement."

‡DAIRY GOAT JOURNAL, W-2997 Markert Rd., Helenville WI 53137. (414)593-8385. Fax: (414)593-8384. Estab. 1923. Monthly trade publication covering dairy goats. Circ. 8,000. Accepts previously published work. Sample copies available.
Cartoons: Approached by 20 cartoonists/year. Buys 2-8 cartoons/issue. Will consider all styles and themes. Prefers single panel. Samples are returned. Reports back in 3 weeks. **Pays on acceptance**; $15-25.

For a list of markets interested in humorous illustration, cartooning and caricatures, refer to the Humor Index at the back of this book.

Illustrations: Approached by 20 illustrators/year. Buys 10-30 illustrations/year. Works on assignment only. Send query letter with appropriate samples. Buys first rights or all rights. Pays $50-150 for color and b&w cover and inside.
Tips: "Please query first. We are eager to help beginners."

‡THE DAIRYMAN, 14970 Chandler St., Box 819, Corona CA 91718. (909)735-2730. Fax: (909)735-2460. Art Director: Maria Bise. Estab. 1922. Monthly trade journal with audience comprised of "Western-based milk producers (dairymen), herd size 100 and larger, all breeds of cows, covering the 13 Western states." Circ. 23,000. Accepts previously published artwork. Samples copies and art guidelines available.
Illustrations: Approached by 5 illustrators/year. Buys 1-4 illustrations/issue. Works on assignment only. Preferred themes "depend on editorial need." Considers pen & ink, airbrush, watercolor, computer, acrylic, collage and pastel. Send query letter with brochure, tearsheets and résumé. Samples are filed or are returned by SASE if requested by artist. Reports back within 2 weeks. Write for appointment to show portfolio of thumbnails, tearsheets and photographs. Buys all rights. Pays on publication; $100 for b&w, $200 for color cover; $50 for b&w, $100 for color inside.
Tips: "We have a small staff. Be patient if we don't get back immediately. A follow-up letter helps. Being familiar with dairies doesn't hurt. Quick turnaround will put you on the 'A' list."

DAKOTA COUNTRY, Box 2714, Bismark ND 58502. (701)255-3031. Publisher: Bill Mitzel. Estab. 1979. *Dakota Country* is a monthly hunting and fishing magazine with readership in North and South Dakota. Features stories on all game animals and fish and outdoors. Basic 3-column format, b&w and 2-color with 4-color cover, feature layout. Circ. 13,200. Accepts previously published artwork. Original artwork is not returned after publication. Sample copies for $2.
Cartoons: Likes to buy cartoons in volume. Prefers outdoor themes, hunting and fishing. Prefers multiple or single cartoon panels with gagline; b&w line drawings. Send query letter with samples of style. Samples not filed are returned by SASE. Reports back regarding queries/submissions within 2 weeks. Negotiates rights purchased. **Pays on acceptance**; $10-20, b&w.
Illustrations: Portfolio review not required. Pays $20-25 for b&w inside.
Tips: "Always need good-quality hunting and fishing line art and cartoons."

DAKOTA OUTDOORS, P.O. Box 669, Pierre SD 57501-0669. (605)224-7301. Fax: (605)224-9210. E-mail: 73613.3456@compuserve.com. Editor: Kevin Hipple. Managing Editor: Rachel Engbrecht. Estab. 1978. Monthly outdoor magazine covering hunting, fishing and outdoor pursuits in the Dakotas. Circ. 7,500. Accepts previously published artwork. Original artwork is returned at job's completion. Sample copies and art guidelines for SASE with first-class postage.
Cartoons: Approached by 10 cartoonists/year. Buys 1-2 cartoons/issue. Prefers outdoor, hunting and fishing themes. Prefers cartoons with gagline. Send query letter with appropriate samples and SASE. Samples are not filed and are returned by SASE. Reports back within 1-2 months. Rights purchased vary according to project. Pays $5 for b&w.
Illustrations: Approached by 2-10 illustrators/year. Buys 1 illustration/issue. Prefers outdoor, hunting/fishing themes, depictions of animals and fish native to the Dakotas. Prefers pen & ink. Can accept computer-generated work on TIFF, EPS and PICT. Also accepts drawings on Macintosh in Illustrator, FreeHand and Photoshop. Send query letter with SASE and copies of line drawings. Reports back within 1-2 months. To show a portfolio, mail "high-quality line art drawings." Rights purchased vary according to project. Pays on publication; $5-25 for b&w.
Tips: "We especially need line-art renderings of fish, such as walleye."

DATAMATION, Dept. AGDM, 275 Washington St., Newton MA 02158. (617)558-4221. Fax: (617)630-3930. Senior Art Director: Chris Lewis. Associate Art Director: Dave Gordon. Bimonthly trade journal; magazine format, "computer journal for corporate computing professionals worldwide." Circ. 200,000. Accepts previously published artwork. Original artwork is returned at job's completion. Sample copies available. Art guidelines not available.
Cartoons: Approached by 60 cartoonists/year. Buys 2 cartoons/issue. Prefers "anything with a computer-oriented theme; people in businesses; style: horizontal cartoons"; single panel, b&w line drawings and washes. Send query letter with finished cartoons. "All cartoons should be sent only to Andrea Ovans, Assistant Managing Editor." Samples are not filed and are returned by SASE. Reports back within 1 month. Buys first rights. Pays $125 for b&w.
Illustrations: Approached by 100-200 illustrators/year. Buys 1-2 illustrations/issue. Works on assignment only. Open to most styles. Considers pen & ink, watercolor, collage, airbrush, acrylic, marker, colored pencil, mixed media and pastel. Send query letter with non-returnable brochure, tearsheets and photocopies. Samples are filed and are not returned. Does not report back. To show a portfolio, mail b&w/color tearsheets, photostats and photocopies. Buys first rights. **Pays on acceptance**; $150 for b&w, $1,000 for color inside.
Tips: "Send non-returnable samples only by mail; do not wish to meet and interview illustrators."

DAUGHTERS OF SARAH, 2121 Sheridan Rd., Evanston IL 60201-3298. (708)866-3882. Editor: Liz Anderson. Estab. 1974. Quarterly magazine with focus on religious/social justice/Christian feminist theology.

Audience is Christian and feminist. Supports ordination of women and inclusive language for God. Circ. 5,000. Accepts previously published artwork. Originals are returned at job's completion. Sample copies available for $5. Art guidelines free for SASE with first-class postage.
Cartoons: Approached by 12 cartoonists/year. Prefers feminist themes. "We have a different theme each issue." Prefers humorous cartoons; single panel b&w line drawings with gagline. Send query letter with brochure. Samples are not filed and are returned by SASE. Reports back within 3 months. Buys one-time rights. Pay is negotiable.
Illustrations: Approached by 10 illustrators/year. Buys 4 illustrations/issue. Works on assignment only. Prefers Christian feminist themes. Considers pen & ink. Send query letter with brochure. Samples are not filed and are returned by SASE. Reports back within 1 month. Portfolio review not required. Buys one-time rights. Pays on publication; $30 for b&w cover and inside.
Tips: Finds artists through artists' submissions, word of mouth. Each quarterly issue has a different theme. Artists should send for list of future themes and guidelines. "Please have some understanding of Christian feminism. Do not send generic religious art—it is usually not relevant to our themes. Please do not send more than one or two samples."

DC COMICS, Dept. AGDM, 1325 Avenue of the Americas, New York NY 10019. (212)636-5400. Group Editor-Creative Services: Lee Nordling. Monthly 4-color comic books for ages 7-25. Circ. 6,000,000. Original artwork is returned after publication.
Illustrations: Buys 22 comic pages/title each month. Works on assignment only. Send query letter with résumé and photocopies. Do not send original artwork. Samples not filed are returned if requested and accompanied by SASE. Reports back within 2 months. Buys all rights. **Pays on acceptance.**
Tips: "Work should show an ability to tell stories with sequential illustrations. Single illustrations are not particularly helpful, since your ability at storytelling is not demonstrated."

DEAD OF NIGHT MAGAZINE, 916 Shaker Rd., Suite 228, Longmeadow MA 01106-2416. E-mail: genie@lstein1. Editor: Lin Stein. Estab. 1989. Quarterly magazine which "offers variety to fans of horror, fantasy, mystery, science fiction and vampire-related fiction." Circ. 3,000. Sample copies available for $5. Art guidelines available for SASE with first-class postage.
Illustrations: Approached by 20 illustrators/year. Buys 5-10 illustrations/year. Considers pen & ink and marker. Send query letter with SASE and dark, unfolded photocopies. Samples are filed. Reports back within 6 weeks. Portfolio review not required. Buys first rights. Pays on publication; $100 for 1-color cover; $25 for b&w cover; $15 for b&w inside; $15 for spots.
Tips: Finds artists through market listings, advertising and flier mailings. "Artist should read a sample to get a feel for the type of fiction we publish. Send a well-written cover letter with your samples. Since we do not usually assign art (except for the occasional cover) but instead, choose story illustrations from available samples, knowing our 'slant' is vital. Study the magazine!"

DEALER BUSINESS, 5743 Corsa Ave., Suite 220, Westlake Village CA 91362. (818)597-1520. Fax: (818)597-1436. Art Director: Rebecca Brackett. Estab. 1966. "*Dealer Business* is a monthly national trade magazine that reaches virtually every new car and truck dealership in the United States, with heavy emphasis on business subjects." Circ. 30,000. Accepts previously published artwork (if stock). Samples copies available. Art guidelines are not available.
Illustrations: Approached by 10-15 illustrators/year. Buys 3-4 illustrations/issue. Accepts realism or abstract—business situations, people/cars. Some stylization depending on concept. Concepts usually involve business problems, themes, etc. Send query letter with brochure, tearsheets, photocopies and photostats. Samples are filed. Reports back to the artist only if interested. To show a portfolio, mail tearsheets, slides, photostats, photocopies and transparencies (4×5 or 8×10). Buys all rights. Pays on publication; fee negotiable. Fees for inside illustration depend on size and b&w or color.

DEC PROFESSIONAL, 1300 Virginia Dr., Suite 400, Fort Washington PA 19034. (215)643-8000. Fax: (215)643-1705. Art Director: Al Feuerstein. Estab. 1982. Monthly 4-color trade journal for users of digital equipment company computers. Circ. 100,000. Sample copies available. Art guidelines not available. Needs computer-literate freelancers for illustration. 10% of freelance work demands knowledge of QuarkXPress, Aldus FreeHand, Adobe Illustrator or Photoshop.
Illustrations: Approached by 15-20 illustrators/year. Buys 1 illustration/issue. Works on assignment only. Prefers computer-related themes and styles. Considers watercolor, collage, airbrush, colored pencil and computer art. Send query letter with tearsheets. Samples are filed. Reports back only if interested. To show a portfolio, write to schedule an appointment. Portfolio should include printed samples, tearsheets and slides. Pays on publication; $800-1,000 for color cover.
Tips: "Being a computer trade magazine—we are constantly changing the way we do things based on the up-to-date hardware/software we receive regularly."

DECORATIVE ARTIST'S WORKBOOK, 1507 Dana Ave., Cincinnati OH 45207. Art Director: Scott Finke. Estab. 1987. "A step-by-step bimonthly decorative painting workbook. The audience is primarily female;

slant is how-to." Circ. 89,000. Does not accept previously published artwork. Original artwork is returned at job's completion. Sample copy available for $4.65. Art guidelines not available.

Cartoons: Approached by 5-10 cartoonists/year. Buys 1-5 cartoons/year. Prefers themes and styles related to the decorative painter; single panel b&w line drawings with and without gagline. Send query letter with finished cartoons. Samples are not filed and are returned by SASE if requested by artist. Reports back within 1 month. Buys first rights. Pays $50 for b&w.

Illustrations: Approached by 100 illustrators/year. Buys occasional illustration; 3-4/year. Works on assignment only. Prefers realistic and humorous themes and styles. Prefers pen & ink, watercolor, airbrush, acrylic, colored pencil, mixed media and pastel. Send query letter with brochure, tearsheets and photocopies. Samples are filed. Reports back to the artist only if interested. Buys first rights or one-time rights. Pays on publication; $100 for b&w, $200-300 for color inside.

DELAWARE TODAY MAGAZINE, 201 N. Walnut St., 3 Christina Centre, Suite 1204, Wilmington DE 19801. Fax: (302)656-5843. Art/Design Director: Ingrid Hansen-Lynch. Monthly 4-color magazine emphasizing regional interest in and around Delaware. Features general interest, historical, humorous, interview/profile, personal experience and travel articles. "The stories we have are about people and happenings in and around Delaware. Our audience is middle-aged (40-45) people with incomes around $79,000, mostly educated. We try to be trendy in a conservative state." Circ. 25,000. Original artwork returned after publication. Sample copy available. Needs computer-literate freelancers for illustration.

Cartoons: Works on assignment only. Do not send gaglines. Send query letter with samples of style. Do not send folders of pre-drawn cartoons. Samples are filed. Reports back only if interested. Buys first rights or one-time rights

Illustrations: Buys approximately 3-4 illustrations/issue. "I'm looking for different styles and techniques of editorial illustration!" Works on assignment only. Open to all styles. "Will accept work compatible with QuarkXPress 7.5/version 3.3. Send EPS files." Send printed color promos. Publication will contact artist for portfolio review if interested. Portfolio should include printed samples and color and b&w tearsheets and final reproduction/product. Pays on publication; $200-400 for color cover; $75-125 for b&w or color inside; $75 for spots.

Tips: Finds artists through artists' submissions and self-promotions.

‡DETROIT FREE PRESS MAGAZINE, Dept. AGDM, 321 W. Lafayette, Detroit MI 48226. (313)222-6737. Fax: (313)222-5992. Art Director: Clare C. Innes. Weekly 4-color Sunday magazine of major metropolitan daily newspaper emphasizing general subjects. "The third largest newspaper magazine in the country." Circ. 1.1 million. Original artwork returned after publication. Sample copy available for SASE. 10% of freelance work demands knowledge of QuarkXPress, Aldus FreeHand or Adobe Illustrator.

Illustrations: Buys 2-3 illustrations/issue. Uses a variety of themes and styles, "but we emphasize fine art over cartoons." Works on assignment only. Send query letter with samples to be kept on file unless not considered for assignment. Send "whatever samples best show artwork and can fit into 8½ × 11 file folder." Samples not filed are not returned. Reports only if interested. Buys first rights. Pays on publication; fees vary, depending on size.

‡DETROIT MONTHLY MAGAZINE, Dept AGDM, 1400 Woodbridge, Detroit MI 48207. (313)446-6000. Editor: Megan Swoyer. Design Director: Marge Kelly. Emphasizes "features on political, economic, style, cultural, lifestyles, culinary subjects, etc., relating to Detroit and region for middle and upper-middle class, urban and suburban, mostly college-educated professionals." Circ. approximately 100,000. "Very rarely" accepts previously published material. Sample copy for SASE.

• Won 1994 Gold Ozzie award for best cover, city or regional.

Cartoons: Approached by 25 cartoonists/year. No editorial cartoons. Pays $150, b&w; $200, color.

Illustrations: Approached by 1,300 illustrators/year. Buys 10/issue. Works on assignment only. Send query letter with samples and tearsheets to be kept on file. Write for appointment to show portfolio. Prefers anything *but* original work as samples. Samples not kept on file are returned by SASE. Reports only if interested. Pays on publication; $1,000 for color cover; $500-600 for color full page, $300-400 for b&w full page, $100 for spot illustrations.

Tips: A common mistake freelancers make in presenting their work is to "send too much material or send badly printed tearsheets." Sees trends toward Russian/European poster style illustrations, postmodern "big type" designs.

‡DISCOVER, 114 Fifth Ave., New York NY 10011. (212)633-4400. Fax: (212)633-4817. Art Director: Richard Boddy. Estab. 1980. Monthly science magazine. Circ. 1 million.

Illustrations: Buys illustrations mainly for covers, spots and feature spreads. Buys 20 illustrations/issue. Prefers watercolor. Considers all media including electronic. Send query letter with brochure showing art style, or nonreturnable tearsheets. Samples are filed or are returned only if requested. Reports back within 1 month. To show a portfolio, mail appropriate materials. Buys first rights. **Pays on acceptance.**

Tips: Would like to see technical, anatomical, science maps, schematic diagrams, astronomical, geological and archeological illustrations.

DISCOVERIES, 6401 The Paseo, Kansas City MO 64131. (816)333-7000. Editor: Rebecca S. Raleigh. Estab. 1974. Weekly 4-color story paper; "for 8-10 year olds of the Church of the Nazarene and other holiness denominations. Material is based on everyday situations with Christian principles applied." Circ. 30,000. Originals are not returned at job's completion. Sample copies for SASE with first-class postage. Art guidelines not available.

Cartoons: Approached by 15 cartoonists/year. Buys 52 cartoons/year. "Cartoons need to be humor for children—not about them." Spot cartoons only. Prefers artwork with children and animals; single panel. Send finished cartoons. Samples not filed are returned by SASE. Reports back in 6-8 weeks. Buys all rights. Pays $15 for b&w.

Illustrations: Approached by 30-40 illustrators/year. Buys 52 illustrations/year. Works on assignment only. Needs cover illustrations. Considers watercolor, acrylic and other mediums on request. Send query letter with brochure and résumé. Samples are filed. Reports back only if interested. Request portfolio review in original query. To show a portfolio, mail tearsheets. Buys all rights. **Pays on acceptance**; $75 for color, $40 for b&w cover.

Tips: Finds artists through artists' submissions/self-promotions and word of mouth. No "fantasy or science fiction situations or children in situations not normally associated with Christian attitudes or actions. Our publications require more full-color artwork than in the past."

DOLPHIN LOG, The Cousteau Society, 870 Greenbrier Circle, Suite 402, Chesapeake VA 23320. (804)523-9335. Editor: Elizabeth Foley. Bimonthly 4-color educational magazine for children ages 7-13 covering "all areas of science, natural history, marine biology, ecology, and the environment as they relate to our global water system." 20-pages, 8×10 trim size. Circ. 80,000. Sample copy for $2.50 and 9×12 SASE with 3 first-class stamps; art guidelines for letter-sized SASE with first-class postage.

Illustrations: Buys approximately 4 illustrations/year. Uses simple, biologically and technically accurate line drawings and scientific illustrations. "*Never* uses art that depicts animals dressed or acting like people. Subjects should be carefully researched." Prefers pen & ink, airbrush and watercolor. Send query letter with tearsheets and photocopies or brochure showing art style. "No portfolios. We review only tearsheets and/or photocopies. No original artwork, please." Samples are returned upon request with SASE. Reports within 3 months. Buys one-time rights and worldwide translation rights for inclusion in other Cousteau Society publications and the right to grant reprints for use in other publications. Pays on publication; $25-200 for color inside.

Tips: "We usually find artists through their submissions/promotional materials and in sourcebooks. Artists should first request a sample copy to familiarize themselves with our style. Send only art that is both water-oriented and suitable for children."

ELECTRICAL APPARATUS, Barks Publications, Inc., 400 N. Michigan Ave., Suite 1016, Chicago IL 60611-4198. (312)321-9440. Fax: (312)321-1288. Contact: Cartoon Editor. Estab. 1948. Monthly 4-color trade journal emphasizing industrial electrical/mechanical maintenance. Circ. 16,000. Original artwork not returned at job's completion. Sample copy $4. Art guidelines not available.

Cartoons: Approached by several cartoonists/year. Buys 3-4 cartoons/issue. Prefers themes relevant to magazine content; with gagline. "Captions are typeset in our style." Send query letter with roughs and finished cartoons. "Anything we don't use is returned." Reports back within 2-3 weeks. Buys all rights. Pays $15-20 for b&w and color.

Illustrations: "We have staff artists so there is little opportunity for freelance illustrators, but we are always glad to hear from anyone who believes he or she has something relevant to contribute."

ELECTRONICS NOW, 500-B Bi-County Blvd., Farmingdale NY 11735. (516)293-3000. Fax: (516)293-3115. Editor: Brian Fenton. Estab. 1939. Monthly b&w magazine with 4-color emphasizing electronic and computer construction projects and tutorial articles; practical electronics for technical people including service technicians, engineers and experimenters in TV, hi-fi, computers, communications and industrial electronics. Circ. 133,000. Previously published work OK. Free sample copy. Needs computer-literate freelancers for illustration.

Cartoons: Approached by 20-25 cartoonists/year. Buys 70-80 cartoons/year on electronics, computers, communications, robots, lasers, stereo, video and service; single panel. Send query letter with finished cartoons. Samples are filed or are returned by SASE. Reports in 1 week. Buys first or all rights. **Pays on acceptance**; $25 minimum for b&w washes.

Always enclose a self-addressed, stamped envelope (SASE) with queries and sample packages.

Illustrations: Approached by 10 illustrators/year. Buys 3 illustrations/year. Works on assignment only. Needs editorial and technical illustration. Preferred themes or styles depend on the story being illustrated. Considers airbrush, watercolor, acrylic and oil. Send query letter with tearsheets and slides. Samples are filed or are returned by SASE. Publication will contact artist for portfolio review if interested. Portfolio should include roughs, tearsheets, photographs and slides. Buys all rights. **Pays on acceptance**; $400 for color cover $100 for b&w inside.

Tips: Finds artists through artists' submissions/self-promotions. "Artists approaching *Electronics Now* should have an innate interest in electronics and technology that shows through in their work."

‡EMERGENCY MEDICINE MAGAZINE, 105 Raider Blvd., Bellemeade NJ 08502. (908)874-8550. Fax: (908)874-6096. Art Director: Robert Hazelrigg. Estab. 1969. Emphasizes emergency medicine for primary care physicians, emergency room personnel, medical students. Bimonthly. Circ. 129,000. Returns original artwork after publication.

Illustrations: Works with 70 illustrators/year. Buys 3-12 illustrations/issue. Prefers all media except marker and computer illustration. Works on assignment only. Send tearsheets, transparencies, original art or photostats to be kept on file. Samples not filed are not returned. To show a portfolio, mail appropriate materials. Reports only if interested. Buys first rights. **Pays on acceptance**; $850, color, cover; $100-500, b&w, $250-600, color, inside.

Tips: "Portfolios may be dropped off Tuesdays only and picked up Thursdays. Do not show marker comps. At least show 4×5 transparencies; 8×10 is much better. In general, slides are too small to see in a review."

ENVIRONMENT, 1319 18th St. NW, Washington DC 20036. (202)296-6267, ext. 236. Fax: (202)296-5149. Graphics/Production Manager: Jennifer Crock. Estab. 1958. Emphasizes national and international environmental and scientific issues. Readers range from "high school students and college undergrads to scientists, business and government leaders and college and university professors." Black & white magazine with 4-color cover; "relatively conservative" design. Published 10 times/year. Circ. 12,500. Original artwork returned after publication. Sample copy $7; cartoonist's guidelines available.

Cartoons: Buys 1-2 cartoons/issue. Receives 5 submissions/week. Interested in single panel line drawings or b&w washes with or without gagline. Send finished cartoons and SASE. Reports in 2 months. Buys first North American serial rights. Pays on publication; $35 for b&w cartoon.

Illustrations: Buys 2-10/year. Uses illustrators mainly for cover design, promotional work, feature illustration and occasional spots. Send query letter, brochure, tearsheets and photocopies. Publication will contact artist for portfolio review if interested. Portfolio should include printed samples. Pays $350 for b&w or color cover; $100 for b&w, $200 for color inside.

Tips: "Regarding cartoons, we prefer witty or wry comments on the impact of humankind upon the environment. Stay away from slapstick humor." For illustrations, "we are looking for an ability to communicate complex environmental issues and ideas in an unbiased way."

‡ESQUIRE, 250 W. 55th St., 8th Floor, New York NY 10019. (212)659-4020. Art Director: Amid Capeci. Contemporary culture magazine for men ages 28-40.

Illustrations: Drop off portfolio on Wednesdays for review.

EVANGELIZING TODAY'S CHILD, Box 348, Warrenton MO 63383-0348. (314)456-4321. Fax: (314)456-2078. Art Director: Kevin Williamson. Estab. 1942. Bimonthly magazine for Sunday school teachers, Christian education leaders and children's workers in every phase of Christian ministry for children 4-11. Circ. 22,000. Accepts previously published artwork "if we are informed." Sample copies available. Art guidelines for SASE with first-class postage.

Illustrations: Approached by 10-15 illustrators/year. Buys 8 illustrations/issue. Works on assignment only. Prefers bright, clean, realistic art with child appeal, sometimes Bible figures or contemporary and historical people. Needs to be clear from distance of 8-15 ft. for teaching purpose. Considers all media. Send query letter with tearsheets, photographs, photocopies, color photostats, slides and transparencies. Samples are filed or returned by SASE if requested by artist. Reports back to the artist only if interested. Portfolio review not required. Buys all rights (negotiable). Pays on publication; $200 for color inside.

Tips: Finds artists through submissions, word of mouth, personal contacts. "Realism, lively color and action are key items we look for. An understanding of Christian themes is very helpful. Computer knowledge helpful, but not essential."

‡✤EVENT, Douglas College, Box 2503, New Westminster, British Columbia V3L 5B2 Canada. (604)527-5293. Editor: David Zieroth. Estab. 1971. For "those interested in literature and writing"; b&w with 4- or 2-color cover. Published 3 times/year. Circ. 1,100. Original artwork returned after publication. Sample copy for $5.

Illustrations: Buys approximately 3 illustrations/year. Uses freelancers mainly for covers. "Interested in drawings and prints, b&w line drawings, photographs and lithographs for cover, and thematic or stylistic series of 12-20 works. Work must reproduce well in one color." SAE (nonresidents include IRCs). Reporting

time varies; at least 4 months. Buys first North American serial rights. Pays on publication; $50 for b&w, $100 for color cover.

EXECUTIVE FEMALE, 30 Irving Place, New York NY 10003. (212)477-2200. Art Director: Adriane Stark. Estab. 1972. Association magazine for National Association for Female Executives, 4-color. "Get ahead guide for women executives, which includes articles on managing employees, personal finance, starting and running a business." Circ. 200,000. Accepts previously published artwork. Original artwork is returned after publication.
Illustrations: Buys illustrations mainly for spots and feature spreads. Buys 7 illustrations/issue. Works on assignment only. Send samples (not returnable). Samples are filed. Responds only if interested. Buys first or reprint rights. Pays on publication; $100-800.

‡**EXECUTIVE REPORT**, 3 Gateway Center, Pittsburgh PA 15222. (412)471-4585. Art/Production Director: Deanna Marra. Estab. 1981. Monthly 4-color trade/consumer magazine; business reporting and analysis for mid- to upper-level managers. Circ. 26,000. Sample copies available. Art guidelines not available. Needs computer-literate freelancers for design and illustration. Freelancers should be familiar with Aldus PageMaker and Adobe Illustrator.
Illustrations: Approached by 15-20 illustrators/year. Buys 0-5 illustrations/issue. Prefers business topics. Considers all media. Send query letter with tearsheets. Samples are filed. Reports back only if interested. Call or write for appointment to show portfolio, or mail thumbnails, printed samples, b&w and color tearsheets. Rights purchased vary according to project. Pays on publication; $500 for color cover; $75 minimum for b&w, $75 and up for color inside.

‡**EXPECTING MAGAZINE**, 685 Third Ave., New York NY 10017. Contact: Art Director. Estab. 1967. Quarterly 4-color; emphasizes pregnancy, birth and care of the newborn for pregnant women and new mothers. Circ. 1.3 million, distributed through obstetrician and gynecologist offices nationwide. Original artwork returned after publication.
Illustrations: Approached by 40-50 illustrators/year. Buys approximately 6 illustrations/issue. Color and b&w. Works on assignment.
Tips: "I need examples of 'people' illustrations. Bright colors. Very stylized work. Almost all of the illustrations I assign are about moms, dads, babies and sometimes I need a still life. Also need expert medical illustration."

‡**THE FAMILY**, 50 St. Paul's Ave., Boston MA 02130. (617)522-8911. Fax: (617)541-9805. Contact: Graphic Design Dept. Estab. 1952. Religious (Catholic) family-oriented magazine. "*The Family* magazine is committed to helping families grow in the awareness of the heritage that is theirs, in reverence for the dignity of persons, in understanding of Catholic teaching, and in holiness of purpose." Monthly; b&w with 4-color cover. Circ. 10,000. Original artwork is returned at the job's completion. Art guidelines available. Sample copies for SASE with first-class postage.
Illustrations: Approached by 50 illustrators/year. Buys 3-4 freelance illustrations/issue; 20/year. Works on assignment only. Prefers realistic style. Considers pen & ink, airbrush, color pencil, mixed media, watercolor, acrylic, oil, pastel, marker, charcoal. Send query letter with brochure, résumé, SASE, tearsheets, photocopies, slides and transparencies. Samples are filed. Reports back within 1-2 months only if interested. Buys one-time rights. Pays on publication; $200, color, cover; $100, b&w, $125, color, inside.

FAMILY CIRCLE, Dept. AGDM, 110 Fifth Ave., New York NY 10011. (212)463-1000. Art Director: Doug Turshen. Circ. 7,000,000. Supermarket-distributed publication for women/homemakers covering areas of food, home, beauty, health, child care and careers. 17 issues/year. Does not accept previously published material. Original artwork returned after publication. Sample copy and art guidelines not available.
Cartoons: No unsolicited cartoon submissions accepted. Reviews in office first Wednesday of each month. Buys 1-2 cartoons/issue. Prefers themes related to women's interests from a feminist viewpoint. Uses limited seasonal material, primarily Christmas. Prefers single panel with gagline, b&w line drawings or washes. Buys all rights. **Pays on acceptance**; $325. Contact Jim Chambers, (212)463-1000, for cartoon query only.
Illustrations: Buys 20 illustrations/issue. Works on assignment only. Provide query letter with samples to be kept on file for future assignments. Prefers slides or tearsheets as samples. Samples returned by SASE. Reports only if interested. Prefers to see finished art in portfolio. Submit portfolio on "portfolio days," every Wednesday. All art is commissioned for specific magazine articles. Buys all rights on a work-for-hire basis. **Pays on acceptance.**

‡**FAMILY TIMES**, 1900 Superfine Lane, Suite 6, Wilmington DE 19802. (302)575-0935. Fax: (302)575-0933. Editor: Alison Garber. Estab. 1990. Monthly parenting tabloid. Circ. 50,000. Accepts previously published artwork. Sample copy free for 3 first-class stamps. Art guidelines free for SASE with first-class postage. Needs computer-literate freelancers for illustration, production and presentation. 75% of freelance work demands knowledge of Aldus PageMaker and Adobe Photoshop.

Cartoons: Approached by 12 cartoonists/year. Buys 1 cartoon/issue. Prefers parenting issues or kids' themes; single panel b&w line drawings. Samples are filed or returned by SASE if requested by artist. Reports back within 3 months. Buys reprint rights. Pays $25 for b&w.

Illustrations: Approached by 50 illustrators/year. Buys 100/year. Prefers parenting issues or kids' themes. Considers pen & ink. Send query letter with tearsheets, SASE and photocopies. Samples are filed or returned by SASE if requested by artist. Reports back within 3 months. Portfolio review not required. Buys reprint rights. Pays on publication. Pays $50 for color cover; $25 for b&w inside.

Tips: Finds artists through artists' submissions.

‡FANTAGRAPHIC BOOKS, 7563 Lake City Way, Seattle WA 98115. (206)524-1967. Fax: (206)524-2104. Contact: Gary Groth or Kim Thompson. Monthly and bimonthly comic books and graphic novels. Titles include *Love and Rockets, Hate, Eightball, Zero Zero, Zippy Quarterly, Prince Valiant* and *Unsupervised Existence*. All genres except superheroes. Circ. 8,000-30,000. Sample copy $2.50.

Cartoons: Approached by 500 cartoonists/year. "Fantagraphic is looking for artists who can create an entire product or who can work as part of an established team." Most of the titles are b&w. Send query letter with photocopies which display storytelling capabilities or submit a complete package. All artwork is creator-owned. Buys one-time rights usually. Payment terms vary. Creator receives an advance upon acceptance and then royalties after publication.

Tips: "We prefer not to see illustration work unless there is some accompanying comics work. We also do not want to see unillustrated scripts. Be sure to include basic information like name, address, phone number, etc. Also include SASE. In comics, I see a trend toward more personal styles. In illustration in general, I see more and more illustrators who got their starts in comics appearing in national magazines."

FASHION ACCESSORIES, 65 W. Main St., Bergenfield NJ 07621. (201)384-3336. Fax: (201)384-6776. Publisher: Sam Mendelson. Estab. 1951. Monthly trade journal; tabloid; emphasizing costume jewelry and accessories. Publishes both 4-color and b&w. Circ. 10,000. Accepts previously published artwork. Original artwork is returned to the artist at the job's completion. Sample copies for $3. Art guidelines not available. Needs computer-literate freelancers for illustration. Freelance work demands knowledge of QuarkXPress.

Cartoons: Pays $75 for b&w cartoons.

Illustrations: Works on assignment only. Needs editorial illustration. Prefers mixed media. Send query letter with brochure and photocopies. Samples are filed. Reports back within 2 weeks. Portfolio review not required. Rights purchased vary according to project. **Pays on acceptance**; $100 for b&w, $150 for color cover; $100 for b&w, $100 for color inside.

‡FICTION INTERNATIONAL, San Diego State University, San Diego CA 92182-8140. (619)594-5469. E-mail: maj@aol.com. Art Editor: Maggie Jaffe. Estab. 1970. Biannual, b&w with 2-color cover, literary magazine with "twin interests: left politics and experimental fiction and art." Accepts previously published artwork. Original artwork is returned to the artist at the job's completion. Sample copies are available. Art guidelines are not available.

Illustrations: Prefers political artwork. Prefers pen & ink and photos. Send query letter with photographs and slides. Reports back within 1 month. To show a portfolio, mail b&w tearsheets, slides and photographs. "We pay in copies."

Tips: "We have published art by Jenny Holzer, Rupert Garcia, Kim Abeles, Peter Kennard, Klaus Staeck, Rolf Staeck, Deborah Small, Christer Themptander, Juan Sanchez, Jonh Fekner, David Avalos, Alison Saar, Emma Amos, Emilya Naymark, Joseph Beuys, Joel Lipman and Norman Conquest."

‡FIELD & STREAM MAGAZINE, Dept. AGDM, 2 Park Ave., New York NY 10016. (212)779-5294. Art Director: Danial McClaim. Monthly magazine emphasizing wildlife hunting and fishing. Circ. 10 million. Original artwork returned after publication. Sample copy and art guidelines for SASE.

Illustrations: Approached by 200-250 illustrators/year. Buys 9-12 illustrations/issue. Works on assignment only. Prefers "good drawing and painting ability, realistic style, some conceptual and humorous styles are also used depending on magazine article." Wants to see "emphasis on strong draftsmanship, the ability to draw wildlife and people equally well. Artists who can't, please do not apply." Send query letter with brochure showing art style or tearsheets and slides. Samples not filed are returned only if requested. Reports only if interested. Call or write for appointment to show portfolio of roughs, final art, final reproduction/product and tear sheets. Buys first rights. **Pays on acceptance**; $75-300 for simple spots; $500-1,000 for single page, $1,000 and up for spreads, $1,500 and up for covers.

Tips: Wants to see "more illustrators who are knowledgeable about hunting and fishing and can handle simple pen & ink and 2-color art besides 4-color illustrations."

‡FINESCALE MODELER, 21027 Crossroads Circle, Waukesha WI 53187. Fax: (414)796-1383. Art Director: Lawrence Luser. Estab. 1972. Magazine emphasizing plastic modeling. Circ. 73,000. Accepts previously published material. Original artwork is returned after publication. Sample copy and art guidelines available.

• Published by Kalmbach Publishing, which also publishes *Classic Toy Trains* and other hobby publications.

Illustrations: Prefers technical illustration "with a flair." Send query letter with "samples, either postcard, 8×10 sheet, color copy or photographs. Currently running Illustrator 5.0. Accepts submissions on disk." Samples are filed or returned only if requested. Reports back only if interested. Write for appointment to show portfolio or mail color and b&w tearsheets, final reproduction/product, photographs and slides. Negotiates rights purchased.

Tips: "Show b&w and color technical illustration. I want to see automotive, aircraft and tank illustrations."

‡FIRST FOR WOMEN, 270 Sylvan Ave., Englewood Cliffs NJ 07632. (201)569-6699. Fax: (201)569-6264. Art Director: Rosemarie Wyer. Estab. 1988. Mass market consumer magazine for the younger woman published every 3 weeks. Circ. 1.4 million. Originals returned at job's completion. Sample copies and art guidelines not available.

Cartoons: Buys 10 cartoons/issue. Prefers women's issues. Prefers humorous cartoons; single panel b&w washes and line drawings. Send query letter with photocopies. Samples are filed. Reports back to the artist only if interested. Buys one-time rights. Pays $150 for b&w.

Illustrations: Approached by 100 illustrators/year. Buys 1 illustration/issue. Works on assignment only. Preferred themes are humorous, sophisticated women's issues. Considers all media. Send query letter with any sample or promo we can keep. Publication will contact artist for portfolio review if interested. Buys one-time rights. **Pays on acceptance**; $200 for b&w, $300 for color inside.

Tips: Finds artists through promo mailers and sourcebooks. Uses humorous or conceptual illustration for articles where photography won't work. "Use the mail—no phone calls please."

FIRST VISIT & BEYOND, EPI, 8003 Old York Rd, Elkins Park PA 19027-1410. (215)635-1700. Fax: (215)635-6455. Project Coordinator: Deana C. Jamroz. Estab. 1990. Triannual/pediatric handbook distributed to parents at first "well-baby visit" by children's pediatrician. Circ. 2,250,000. Accepts previously published artwork. Sample copies and art guidelines free for SASE with first-class postage. Needs computer-literate freelancers for design, illustration and production. 75% of freelance work demands knowledge of Ventura.

● EPI also publishes a Spanish language version of *First Visit*, called *Primera Visita* and *Guide for Expectant Parents.*

Illustrations: Approached by 25-50 freelance illustrators/year. Works on assignment only. Considers pen & ink, collage, airbrush, acrylic and mixed media. Send query letter with SASE. Samples are not filed and are returned by SASE. Reports back within 2 weeks. Call for appointment to show portfolio of thumbnails, roughs, tearsheets, photocopies and photographs. **Pays on acceptance**; $75-125 for b&w, $100-250 for color inside ("also depends on intricacy: we have paid $1,500-2,500 for special air-brushed art").

‡FLORIDA KEYS MAGAZINE, P.O. Box 6524, Key West FL 33040. (305)296-7300. Fax: (305)296-7414. Art Director: Tricia Lay. Estab. 1978. Bimonthly magazine targeted at residents and frequent visitors to the area; covers most subjects of interest to the region. Circ. 10,000. Accepts previously published work. Originals returned at job's completion. Sample copies free for SASE with first-class postage (1st copy only).

Cartoons: Approached by 2 freelance cartoonists/year. Rarely purchases cartoons. Prefers regional issues and style; single panel b&w line drawings with gagline. Send query letter with brochure and published samples. Samples are filed. Reports back within 3 months. Rights purchased vary according to project. Pays $20 for b&w.

Illustrations: Approached by 5 freelance illustrators/year. Number purchased each year varies. Will consider all styles, themes. Interested in tropical living and environmental issues. Accepts any media. Send query letter with résumé and tearsheets. Samples are filed. Reports back within 3 months. Write for appointment to show portfolio of final art, b&w and color tearsheets, photostats, photocopies and photographs. Rights vary according to project. Pays on publication; $20 for b&w, $25 for color.

‡FLOWER & GARDEN, 700 W. 47th St., Suite 310, Kansas City MO 64112. (816)531-5730. Editor: Kay M. Olson. Estab. 1957. "The World's Home Gardening Magazine." Bimonthly 4-color. Circ. 600,000. Sample copy $3.95.

Cartoons: Receives about 10 submissions/week. Seldom buys cartoons. Needs cartoons related to "indoor or outdoor home gardening. Cartoons emphasizing the problems related with gardening are not really appropriate. Our audience is made up of gardening enthusiasts who *love* to garden. Nagging wife cartoons are not appreciated." Format: single panel b&w line drawings or washes with gagline. Prefers to see finished cartoons. Send SASE. Reports in 1-2 months. Buys one-time rights. **Pays on acceptance**; $25 for b&w cartoon.

Tips: "Our readers love gardening. They do not see it as a chore but rather as a pleasurable hobby."

‡FLY FISHERMAN MAGAZINE, 6405 Flank Dr., Harrisburg PA 17112. (717)657-9555. Art Director: David Siegfried. Estab. 1969. Bimonthly magazine covering all aspects of fly fishing including how to, where to, new products, wildlife and habitat conservation, and travel through top-of-the-line photography and artwork; 4-color. In-depth editorial. Readers are upper middle class subscribers. Circ. 130,000. Sample copies for SASE with first-class postage. Art guidelines for SASE with first-class postage.

Cartoons: Buys 1 cartoon/issue, 6-10 cartoons/year from freelancers. Prefers fly fishing related themes only. Prefers single panel with or without gagline; b&w line drawings and washes. Send query letter with samples

of style. Samples are filed or returned by SASE. Reports back regarding queries/submissions within 3 weeks. Buys one-time rights. Pays on publication.

Illustrations: Buys illustrations to illustrate fishing techniques and for spots. Buys 4-10 illustrations/issue, 50 illustrations/year. Prefers pen & ink. Considers airbrush, mixed media, watercolor, acrylic, pastel and charcoal pencil. Needs computer-literate illustrators familiar with QuarkXPress and Aldus FreeHand. Send query letter with brochure showing art style, résumé and appropriate samples, excluding originals. Samples are filed or returned by SASE. Call or write to schedule an appointment to show a portfolio or mail appropriate materials. Buys one-time rights and occasionally all rights. Pays on publication.

Tips: Spot art for front and back of magazine is most open to illustrators.

‡FOLIO: MAGAZINE, COWLES BUSINESS MEDIA, 911 Hope St., Stamford CT 06907-0949. (203)358-9900. Fax: (203)357-9014. Art Director: Cathi Kroha. Trade magazine covering the magazine publishing industry. Sample copies for SASE with first-class postage. Needs computer-literate freelancers for design, illustration and production. 75% of freelance work demands knowledge of Adobe Illustrator, QuarkXPress, and Photoshop.

 • This company publishes a total of 24 magazines. Also uses Mac-literate freelancers for production work on catalogs and direct mail pieces. Send SASE for more information.

Illustrations: Approached by 50 illustrators/year. Buys 150-200 illustrations/year. Works on assignment only. Send query letter with résumé, tearsheets or other samples. No originals. Samples are filed and returned by SASE if requested by artist. Reports back to the artist only if interested. Call for appointment to show portfolio of tearsheets, slides, final art, photographs and transparencies. Buys one-time rights. Pays by the project.

Tips: "Art director likes to see printed 4-color and b&w sample illustrations. Do not send originals unless requested. Computer-generated illustrations are used but not always necessary. Charts and graphs must be Macintosh generated; illustrations are hand-rendered."

FOOD & SERVICE, Box 1429, Austin TX 78767. (512)472-3666. Editor: Julie Sherrier. Art Director: Neil Ferguson. Estab. 1940. Official trade publication of Texas Restaurant Association. Seeks illustrations (but not cartoons) dealing with business problems of restaurant owners and food-service operators, primarily in Texas, and including managers of clubs, bars and hotels. Published 10 times/year. Circ. 6,500. Simultaneous submissions OK. Originals returned after publication. Sample copy for SASE.

Illustrations: Works with 15 illustrators/year. Buys 36-48 illustrations/year. Uses artwork mainly for covers and feature articles. Seeks high-quality b&w or color artwork in variety of styles (airbrush, watercolor, pastel, pen & ink, Adobe Illustrator, Photoshop). Seeks versatile artists who can illustrate articles about food-service industry, particularly business aspects. "Humor is a plus; we seldom use realistic styles." Works on assignment only. Query with résumé, samples and tearsheets. Publication will contact artist for portfolio review if interested. Pays $250-300 for color cover; $150-250 for b&w, $200-275 for color inside. Negotiates rights and payment upon assignment.

Tips: Finds artists through artists' submissions and occasionally other magazines. "In a portfolio, show samples of color work and tearsheets. Common mistakes made in presenting work include sloppy presentation and typos in cover letter or résumé. Request a sample of our magazine (include a 10×13 SASE), then send samples that fit the style or overall mood of our magazine. We do not run illustrations or photos of food, so don't send or create samples specific to a food theme. We are a business issues magazine, not a food publication."

‡FOR SENIORS ONLY, FOR GRADUATES ONLY, 339 N. Main St., New City NY 10956. (914)638-0333. Executive Editor: Jud Oliff. Estab. 1970. Biannual and annual guidance-oriented magazines for high school seniors and college graduates and includes features on travel. Circ. 350,000. Accepts previously published artwork. Originals are not returned. Sample copies and art guidelines free for SASE with first-class postage. Needs computer-literate freelancers for design and production. 75% of freelance work demands knowledge of Aldus PageMaker.

Cartoons: Buys 10 cartoons/issue. Prefers single panel b&w line drawings with gagline. Send brochure, roughs, finished cartoon samples. Samples sometimes filed and are returned by SASE if requested. Reports back if interested. Rights purchased vary according to project. Pays $15 for b&w, $25 for color.

Illustrations: Buys 3 illustrations/issue. Works on assignment only. Considers pen & ink, airbrush, charcoal and mixed media. Send query letter with résumé, SASE and samples. Samples sometimes filed and are returned by SASE if requested. Reports back only if interested. Rights purchased vary according to project. **Pays on acceptance**; $75 for b&w, $125 for color cover; $50 for b&w, $100 for color inside.

FORBES MAGAZINE, 60 Fifth Ave., New York NY 10011. (212)620-2200. Art Director: Everett Halvorsen. Established 1917. Biweekly business magazine. Circ. 765,000. "*Forbes* is a magazine for readers who are interested in business and investing. Most stories use photography but this does not rule out the need for illustrations that are more appropriate to the story. We do not use, nor are we liable for ideas submitted in the hope that they will be published. *Forbes* does not use previously published illustrations nor does it use cartoons."

Illustrations: Contacted by 100 illustrators/year. Buys 5-6 illustrations/issue. "We prefer contemporary illustrations that are lucid and convey an unmistakable idea. Covers are usually illustrated. The medium is optional as long as the artwork is rendered on a material and size that can be separated on a drum scanner." **Pays on acceptance** whether reproduced on not. Pays up to $2,500 for a cover assignment and an average of $450 to $600 for an inside illustration depending on complexity and reproduction size. "Discuss the fee with art director when you are contacted about doing an assignment."
Tips: "Address samples or portfolios to Everett Halvorsen. If you can, drop off your portfolio. Deliver by 11 a.m. Call first. Attach local phone number to outside of portfolio. Besides the art director, *Forbes* has four associate art directors who make assignments. It is helpful if you address by name those you want to contact. Listed on the masthead are the art director and four associate art directors. Send printed or scanned samples or photocopies. Samples are filed if they are interesting and returned only if requested, otherwise they are discarded. Do not mail original artwork. We don't report back unless we have an assignment or wish we had. It's preferable and advantageous to leave your portfolio, to allow those art directors who are available to look at your work. We discourage appointments but if circumstance required a meeting, call Roger Zapke, the Deputy Art Director."

FOREIGN SERVICE JOURNAL, 2101 E St. NW, Washington DC 20037. (202)338-4045. Contact: Managing Editor. Estab. 1924. Monthly magazine emphasizing foreign policy for foreign service employees; 4-color with design in *"Harpers'* style." Circ. 11,000. Returns original artwork after publication.
● *Foreign Service Journal* no longer buys cartoons.
Illustrations: Works with 6-10 illustrators/year. Buys 20 illustrations/year. Needs editorial illustration. Uses artists mainly for covers and article illustration. Works on assignment only. "Mail in samples for our files." Publication will contact artist for portfolio review if interested. Buys first rights. Pays on publication; $500 for color cover; $100 and up for b&w inside.
Tips: Finds artists through sourcebooks.

FUTURIFIC MAGAZINE, Foundation for Optimism, 305 Madison Ave., Concourse 10-B, New York NY 10165. Publisher: B. Szent-Miklosy. Monthly b&w publication emphasizing future-related subjects for highly educated, upper income leaders of the community. Circ. 10,000. Previously published material and simultaneous submissions OK. Original artwork returned after publication. Sample copy for SASE with $5 postage and handling.
Cartoons: Buys 5 cartoons/year. Prefers positive, upbeat, futuristic themes; no "doom and gloom." Prefers single, double or multiple panel with or without gagline, b&w line drawings. Send finished cartoons. Samples returned by SASE. Reports within 1 month. Will negotiate rights and payment. Pays on publication.
Illustrations: Buys 5 illustrations/issue. Prefers positive, upbeat, futuristic themes; no "doom and gloom." Send finished art. Samples returned by SASE. Reports within 1 month. To show a portfolio, walk in. Negotiates rights and payment. Pays on publication.
Tips: "Only optimists need apply. Looking for good, clean art. Interested in future development of current affairs, but not science fiction."

THE FUTURIST, Dept. AGDM, 7910 Woodmont Ave., Suite 450, Bethesda MD 20814. (301)598-6414. Art Director: Mariann Seriff. Managing Editor: Cynthia Wagner. Emphasizes all aspects of the future for a well-educated, general audience. Bimonthly b&w magazine with 4-color cover; "fairly conservative design with lots of text." Circ. 30,000. Accepts simultaneous submissions and previously published work. Return of original artwork following publication depends on individual agreement.
Illustrations: Approached by 50-100 illustrators/year. Buys 3-4 illustrations/issue. Needs editorial illustration. Uses a variety of themes and styles "usually b&w drawings, often whimsical. We like an artist who can read an article and deal with the concepts and ideas." Works on assignment only. Send samples or ctearsheets to be kept on file. Publication will contact artist for portfolio review if interested. Rights purchased negotiable. **Pays on acceptance**; $500-750 for color cover; $75-350 for b&w, $200-400 for color inside; $100 for spots.
Tips: "Send samples that are strong conceptually with skilled execution. When a sample package is poorly organized, poorly presented—it says a lot about how the artists feel about their work." Sees trend of "moving away from realism; highly stylized illustration with more color."

GALLERY MAGAZINE, Dept. AGDM, 401 Park Ave. S., New York NY 10016. (212)779-8900. Creative Director: Jana Khalifa. Emphasizes "sophisticated men's entertainment for the middle-class, collegiate male;

A bullet introduces comments by the editor of Artist's & Graphic Designer's Market ***indicating special information about the listing.***

monthly 4-color with flexible format, conceptual and sophisticated design." Circ. 375,000. Accepts previously published artwork. Interested in buying second rights (reprint rights) to previously published artwork. Needs computer-literate freelancers for production. 100% of freelance work demands knowledge of QuarkXPress and Adobe Illustrator.

Cartoons: Approached by 100 cartoonists/year. Buys 3-8 cartoons/issue. Interested in sexy humor; single, double or multiple panel, color and b&w washes, b&w line drawings with or without gagline. Send finished cartoons. Enclose SASE. Contact: J. Linden. Reports in 1 month. Buys first rights. Pays on publication; $75 for b&w, $100 for color.

Illustrations: Approached by 300 illustrators/year. Buys 60 illustrations/year. Works on assignment only. Needs editorial illustrations. Interested in the "highest creative and technical styles." Especially needs slick, high-quality, 4-color work. Send flier, samples and tearsheets to be kept on file for possible future assignments. Prefers prints over transparencies. Samples returned by SASE. Publication will contact artist for portfolio review if interested. Negotiates rights purchased. Pays on publication; $350 for b&w, $800 for color inside.

Tips: Finds artists through artists' submissions and sourcebooks. A common mistake freelancers make is that "often there are too many samples of literal translations of the subject. There should also be some conceptual pieces."

GAME & FISH PUBLICATIONS, 2250 Newmarket Pkwy., Marietta GA 30067. (404)953-9222. Fax: (404)933-9510. Graphic Artist: Allen Hansen. Estab. 1975. Monthly b&w with 4-color cover. Circ. 500,000 for 30 state-specific magazines. Original artwork is returned after publication. Sample copies available.

Illustrations: Approached by 50 illustrators/year. Buys illustrations mainly for spots and feature spreads. Buys 1-8 illustrations/issue. Considers pen & ink, watercolor, acrylic and oil. Send query letter with photostats and photocopies. "We look for an artist's ability to realistically depict North American game animals and game fish or hunting and fishing scenes." Samples are filed or returned only if requested. Reports back only if interested. Portfolio review not required. Buys first rights. Pays 2½ months prior to publication; $25 and up for b&w, $75-100 for color, inside.

Tips: "We do not publish cartoons, but we do use some cartoon-like illustrations, which we assign to artists to accompany specific humor stories. Send us some samples of your work, showing as broad a range as possible, and let us hold on to them for future reference. Being willing to complete an assigned illustration in a 4-6 week period, and provide what we request, will make you a candidate for working with us."

✦GEORGIA STRAIGHT, 1235 W. Pender St., 2nd Floor, Vancouver, British Columbia V6E 2V6 Canada. (604)681-2000. Fax: (604)681-0272. Managing Editor: Charles Campbell. Estab. 1967. A weekly tabloid; b&w with 4-color cover. An urban news and entertainment paper for educated adults 18-49 years of age. Circ. 100,000. Accepts previously published artwork. Originals are returned at job's completion. Sample copies free for SASE with first-class postage.

Cartoons: Approached by 50 cartoonists/year. Buys 4-5 cartoons/issue. Prefers intelligent satire with cultural/lifestyle bent. Prefers single panel, b&w line drawings and washes, with or without gagline. Send query letter with photocopies of finished cartoons. Samples are filed. Reports back to the artist only if interested. Buys one-time rights. Pays on publication; $35 and up for b&w.

Illustrations: Approached by 20 illustrators/year. Buys 2 illustrations/issue. Works on assignment only. Send query letter with samples. Samples are filed. Reports back only if interested. To show a portfolio, mail photostats. Buys one-time rights. Pays on publication; $200 for b&w cover; $125 and up for b&w inside.

Tips: "Be able to deliver good work on a 7-day turnaround."

GIRLS' LIFE, 4517 Hartford Rd., Baltimore MD 21214-9989. (410)254-9200. Fax: (410)254-0991. Art Director: Chun Kim. Estab. 1994. Bimonthly consumer magazine for 7- to 14-year-old girls. Originals sometimes returned at job's completion. Sample copies available for $5 on back order or on newsstands. Art guidelines not available. Sometimes needs computer literate freelancers for illustration. 20% of freelance work demands computer knowledge of Adobe Illustrator, QuarkXPress or Adobe Photoshop.

Illustrations: Prefers anything pertaining to 7- to 14-year-old girls. Considers pen & ink, watercolor, airbrush, acrylic and mixed media. Send query letter with SASE, tearsheets, photographs, photocopies, photostats, slides and transparencies. Samples are filed or are returned by SASE if requested by artist. Publication will contact artist for portfolio review if interested. Portfolio should include tearsheets, slides, photostats, photocopies, final art and photographs. Buys first rights. Pays on publication.

Tips: Finds artists through artists' submissions. Loves humorous cartoons. "Send work pertaining to our market."

‡GLAMOUR, 350 Madison Ave., New York NY 10017. Art Director: Kati Korpijaakko. Monthly magazine. Covers fashion and issues concerning working women (ages 20-35). Originals returned at job's completion. Sample copies available on request. Art guidelines not available. Needs computer-literate freelancers for illustration. 5% of freelance work demands knowledge of Adobe Illustrator, QuarkXPress, Adobe Photoshop and Aldus FreeHand.

Cartoons: Buys 1 cartoon/issue. Prefers feminist humor. Prefers humorous b&w line drawings with gagline. Send postcard-size sample. Samples are filed and not returned. Reports back to the artist only if interested. Rights purchased vary according to project.

Illustrations: Buys 7 illustrations/issue. Works on assignment only. Considers pen & ink, airbrush, colored pencil, mixed media, collage, charcoal, watercolor, acrylic, oil, pastel and marker. Send postcard-size sample. Samples are filed and not returned. Publication will contact artist for portfolio review if interested. Portfolio should include final art, color photographs, tearsheets, color photocopies and photostats. Rights purchased vary according to project. Pays on publication.

GLASS FACTORY DIRECTORY, Box 2267, Hempstead NY 11557. (516)481-2188. Manager: Liz Scott. Annual listing of glass manufacturers in US, Canada and Mexico.

Cartoons: Receives an average of 1 submisson/week. Buys 5-10 cartoons/issue. Cartoons should pertain to glass manufacturing (flat glass, fiberglass, bottles and containers; no mirrors). Prefers single and multiple panel b&w line drawings with gagline. Prefers roughs or finished cartoons. Send SASE. Reports in 1-3 months. Buys all rights. **Pays on acceptance**; $25.

Tips: "Learn about making glass of all kinds. We rarely buy broken glass jokes. There *are* women working in glass plants. Glassblowing is overdone. What about flat glass, autoglass, bottles?"

GOLD AND TREASURE HUNTER MAGAZINE, 27 Davis Rd., P.O. Box 47, Happy Camp CA 96039. (916)493-2029. Fax: (916)493-2095. Managing Editor: Janice Trombetta. Estab. 1988. Bimonthly magazine featuring "true, fictional and how-to" stories about people worldwide discovering gold, treasure and outdoor adventure. "Provides excellent family recreational opportunities!" Circ. 51,000. Accepts previously published artwork. Published originals and artwork are not returned. Sample copies for #10 SASE with first-class postage. Art guidelines not available.

Cartoons: Approached by 3 cartoonists/year. Buys 1 cartoon/issue. Prefers gold mining, metal detecting, treasure hunting. Prefers humorous cartoons; b&w line drawings with gagline. Send query letter with roughs and finished cartoons. Samples are filed. Reports back within 4-6 weeks. Buys first rights. Pays $10-25 for b&w.

Illustrations: Approached by 3 illustrators/year. Buys 5-7 illustrations/year. Considers pen & ink and charcoal. Send query letter with brochure, résumé, SASE, tearsheets and photocopies. Samples are filed. Reports back within 4-6 weeks. Portfolio review not required. Buys first rights. Pays on publication; $10-25 for b&w inside.

Tips: Finds artists through word of mouth and artists' submissions. Area most open to freelancers is the fiction section.

‡GOLF JOURNAL, Golf House, Far Hills NJ 07931. (908)234-2300. Editor: Brett Avery. Readers are "literate, professional, knowledgeable on the subject of golf." Published 9 times/year. Circ. 500,000. Original artwork not returned after publication. Free sample copy.

Cartoons: Buys 1-2 cartoons/issue. "The subject is golf. Golf must be central to the cartoon. Drawings should be professional and captions sharp, bright and literate, on a par with our generally sophisticated readership." Formats: single or multiple panel, b&w line drawings with gagline. Prefers to see finished cartoons. Send SASE. Reports in 1 month. Buys one-time rights. **Pays on acceptance**; $25-50, for b&w cartoons.

Illustrations: Buys several illustrations/issue. "We maintain a file of samples from illustrators. Our needs for illustrations are based almost solely on assignments, illustrations to accompany specific stories. We need talent with a light artistic touch, and we would assign a job to an illustrator who is able to capture the feel and mood of a story. A sense of humor is a useful quality in the illustrator, but this sense shouldn't lapse into absurdity." Uses color washes. Send samples of style to be kept on file for future assignments. Reports in 1 month. Buys all rights on a work-for-hire basis. Payment varies, "usually $300 for page, $500 for color cover."

Tips: Wants to see "a light touch, identifiable, relevant, rather than nitwit stuff showing golfballs talking to each other." Does not want to see "willy-nilly submissions of everything from caricatures of past presidents to meaningless art. Know your market; we're a golf publication, not an art gazette."

‡GOOD OLD DAYS, 306 E. Parr Rd., Berne IN 46711. (219)589-8741. Fax: (219)589-8093. Editor: Ken Tate. Estab. 1964. Monthly literary magazine covering American oral history 1900-1949; b&w with 4-color cover; conservative design. Circ. 140,000. Accepts previously published artwork. Original artwork is sometimes returned after publication. Sample copies available for $2. Art guidelines not available. Needs computer-literate freelancers for illustration. Freelancers should be familiar with Aldus FreeHand or Adobe Illustrator. "Editor and art director are now highly computerized. The more electronic generation of images the better; will accept disk (3½″ Mac) or modem."

Cartoons: Buys 1 or more cartoons/issue. Prefers nostalgic, "humorous look at any type of 1900-1950 phenomenon." Prefers single or double panel b&w line drawings with or without gagline. Send finished cartoons. Samples are filed. Reports back regarding queries/submissions within 2 weeks. Buys first rights, one-time or all rights. Pays on publication; $15-75 for b&w.

Illustrations: Buys illustrations mainly for covers, spots and feature spreads. Buys 1 illustration/issue. Works on assignment only. Prefers pen & ink. Send query letter with photocopies or photographs. Looks for realism and authenticity in subject matter. Reports back about queries/submissions within 2 weeks. Will negotiate rights purchased. Pays on publication; $500-800 for color cover; $35-75 for b&w inside.
Tips: "Show realistic, historically accurate portrayals. I do not want to see cartoony drawings."

‡GRAND RAPIDS MAGAZINE, Gemini Publications, 549 Ottawa Ave., Grand Rapids MI 49503. (616)459-4545. Editor: Carole Valade Smith. Monthly for greater Grand Rapids residents. Circ. 13,500. Original artwork returned after publication. Local artists only.
Cartoons: Buys 2-3 cartoons/issue. Prefers Michigan, Western Michigan, Lake Michigan, city, issue or consumer/household themes. Send query letter with samples. Samples not filed are returned by SASE. Reports within 1 month. Buys all rights. Pays $25-40 for b&w.
Illustrations: Buys 2-3 illustrations/issue. Prefers Michigan, Western Michigan, Lake Michigan, city, issue or consumer/household themes. Send query letter with samples. Samples not filed are returned by SASE. Reports within 1 month. To show a portfolio, mail printed samples and final reproduction/product or call for an appointment. Buys all rights. Pays on publication; $100-$150 for color cover; $20-40 for b&w and $30-75 for color inside.
Tips: "Approach us only if you have good ideas."

GRAPHIC ARTS MONTHLY, 249 W. 17th St., New York NY 10011. (212)463-6579. Fax: (212)463-6530. Art Director: Rani Levy. Estab. 1930. Monthly 4-color trade magazine for management and production personnel in commercial and specialty printing plants and allied crafts. Design is "direct, crisp and modern." Circ. 95,000. Accepts previously published artwork. Originals returned at job's completion. Sample copy available. Needs computer-literate freelancers for design and illustration. 50% of freelance work demands knowledge of Adobe Illustrator, QuarkXPress, Adobe Photoshop.
Illustrations: Approached by 150 illustrators/year. Buys 6 illustrations/issue. Works on assignment only. Considers all media, including computer. Send postcard-sized sample to be filed. Publication will contact artist for portfolio review if interested. Portfolio should include final art, photographs, tearsheets. Buys one-time and reprint rights. **Pays on acceptance**; $750 for color cover; $350 for color inside; $350 for spots.
Tips: Finds artists through submissions.

GRAY AREAS, P.O. Box 808, Broomall PA 19008-0808. Publisher: Netta Gilboa. Estab. 1991. Quarterly magazine examining gray areas of law and morality in the fields of music, law, technology and popular culture. Accepts previously published artwork. Originals not returned. Sample copies available for $7. Art guidelines not available. Needs computer-literate (IBM-PC) freelancers for design and illustration. 50% of freelance work demands knowledge of Aldus PageMaker 5.0 or CorelDRAW 4.0.
Cartoons: Approached by 5 cartoonists/year. Buys 2-5 cartoons/issue. Prefers "illegal subject matter" humorous cartoons; single, double or multiple panel b&w line drawings. Send query letter with brochure, roughs, photocopies or finished cartoons. Samples are filed. Reports back within 1 week only if SASE provided. Buys one-time rights.
Illustrations: Works on assignment only. "Illegal subject matter like sex, drugs, computer criminals." Considers "any media that can be scanned by a computer." Send query letter with SASE and photocopies. Samples are filed. Reports back within 1 week only if SASE enclosed. Portfolio review not required. Buys one-time rights. Pays on publication; $500 for color cover; negotiable b&w. Pays 5 copies of issue and masthead listing for spots.
Tips: "Most of the artists we use have approached us after seeing the magazine. All sections are open to artists. We are only interested in art which deals with our unique subject matter. Please do not submit without having seen the magazine. We have a strong 1960s style. Our favorite artists include Robert Crumb and Rick Griffin. We accept all points of view in art, but only if it addresses the subject we cover. Don't send us animals, statues or scenery."

‡GREENSPEAK, P.O. Box 34518, Memphis TN 38184-0518. (901)377-1818. Fax: (901)382-6419. Editor: Elizabeth Pease. Estab. 1989. Monthly newsletter for trade association. Publication covers "forest products industry, government affairs and environmental issues. Audience is forest products members, Congress, natural resource users. *GreenSpeak* is pro-resource use, *no preservationist slant* (we fight to be able to use our private property and natural resources)." Accepts previously published artwork. Art guidelines not available.
 • Also publishes *Forest Resource Update*, biweekly newsletter on "current forestry-related issues or legislative action." This publication buys one cartoon/issue at $20 (b&w). Send query letter with finished cartoons (single, double or multi-panel).
Illustrations: Buys 6 illustrations/year. Prefers forestry, environment, legislative, legal themes. Considers pen & ink. Send query letter with résumé, photocopies of pen & ink work. Rights purchased vary according to project. Pays up to $200 for b&w inside.

Tips: "Our publication covers all aspects of the forest industry and we consider ourselves good stewards of the land and manage our forestlands in a responsible, sustainable way—submissions should follow this guideline."

‡GROUP PUBLISHING—MAGAZINE DIVISION, 2890 N. Monroe, Loveland CO 80538. (303)669-3836. Fax: (303)669-3269. Senior Art Director: Joel Armstrong. Publishes *Group Magazine* (6 issues/year; circ. 50,000; 4-color); *Jr. High Ministry Magazine* (5 issues/year b&w with 4-color cover) for adult leaders of Christian youth groups; *Children's Ministry Magazine* (6 issues/year; 4-color) for adult leaders who work with kids from birth to sixth grade. Previously published, photocopied and simultaneous submissions OK. Original artwork returned after publication, if requested. Sample copy $1 with 9×12 SAE. Artist guildelines free with SASE.
 • This company also produces books and clip art. See listings under those sections.
Cartoons: Generally buys one spot cartoon per issue that deals with youth or children ministry. Pays $50 minimum.
Illustrations: Buys 2-10 illustrations/issue. Prefers a loose, contemporary, lighthearted pen & ink and/or color style. Send samples or tearsheets to be kept on file for future assignments. Reports only if interested. To show a portfolio, mail color and b&w photostats and slides. Pays $400 minimum, color cover (negotiable). **Pays on acceptance**; $35-450, from b&w/spot illustrations (line drawings and washes) to full-page color illustrations inside. Buys first publication rights and occasional reprint rights.
Tips: "We prefer contemporary, nontraditional (not churchy), well developed styles that are appropriate for our innovative, youth-oriented publications. We appreciate artists who can conceptualize well and approach difficult and sensitive subjects creatively."

‡GUIDE FOR EXPECTANT PARENTS, EPI, 8003 Old York Rd., Elkins Park PA 19027-1410. (215)635-1700. Fax: (215)635-6455. Project Coordinator: Deana Jamroz. Estab. 1975. Biannual prenatal care publication distributed to couples/pregnant women attending prenatal/birthing classes. Circ. 1.8 million. Accepts previously published artwork. Originals are not returned. Sample copies and art guidelines free for SASE with first-class postage. Needs computer-literate freelancers for design, illustration and production. 75% of freelance work demands knowledge of Ventura.
 • EPI also publishes *First Visit & Beyond*.
Illustrations: Approached by 25-50 illustrators/year. Works on assignment only. Considers pen & ink, collage, airbrush, acrylic and mixed media. Send query letter with SASE and samples. Samples are not filed and are returned by SASE. Reports back within 2 weeks. Call for appointment to show portfolio. Portfolio should include thumbnails, roughs, b&w and color tearsheets, slides, photocopies and photographs. Buys all rights. **Pays on acceptance**; $75-100 for b&w, $100-250 for color inside ("also depends on intricacy of illustration; we have paid $500-2,500 for medical renderings").

GUIDEPOSTS MAGAZINE, 16 E. 34th St., New York NY 10016. (212)251-8127. Fax: (212)684-0679. Art Director: Lawrence A. Laukhuf. Estab. 1945. Monthly nonprofit inspirational, consumer magazine. *Guideposts* is a "practical interfaith guide to successful living. Articles present tested methods for developing courage, strength and positive attitudes through faith in God." Circ. 4 million. Sample copies and guidelines are available.
Illustrations: Buys 3-5 illustrations/issue. Works on assignment only. Prefers realistic, reportorial. Considers watercolor, collage, airbrush, acrylic, colored pencil, oil, mixed media and pastel. Send query letter with SASE, tearsheets, photographs, slides and transparencies. Samples are returned by SASE if requested by artist. To arrange portfolio review artist should follow up with call after initial query. Portfolio should include color transparencies 8×10. Buys one-time rights. **Pays on acceptance**.
Tips: Finds artists through sourcebooks, other publications, word of mouth, artists' submissions and Society of Illustrators' shows. Sections most open to freelancers are illustrations for action/adventure stories. "Do your homework as to our needs. At least see the magazine!"

‡GUITAR PLAYER, 411 Borel Ave., Suite #100, San Mateo CA 94402. (415)358-9500. Fax: (415)358-9527. Art Director: Richard Leeds. Estab. 1975. Monthly 4-color magazine focusing on keyboard and electronic instruments, technique, artist interviews, etc. Circ. 100,000. Original artwork is returned at job's completion. Sample copies and art guidelines not available.
Illustrations: Approached by 15-20 illustrators/year. Buys 3 illustrations/issue. Works on assignment only. Prefers conceptual, "outside, not safe" themes and styles. Considers pen & ink, watercolor, collage, airbrush, computer based, acrylic, mixed media and pastel. Send query letter with brochure, tearsheets, photographs, photocopies, photostats, slides and transparencies. Samples are filed. Reports back only if interested. Publication will contact artist for portfolio review if interested. Portfolio should include printed samples and tearsheets. Buys first rights. Pays on publication; $100-250 for b&w, $100-600 for color inside.

‡HABITAT MAGAZINE, (formerly *New York Habitat Magazine*), 928 Broadway, New York NY 10010. (212)505-2030. Managing Editor: David Karp. Estab. 1982. "We are a how-to magazine for cooperative and condominium boards of directors in New York City and Westchester." Published 8 times a year; b&w with

4-color cover. Circ. 18,000. Original artwork is returned after publication. Sample copy $5. Art guidelines free for SASE with first-class postage.

Cartoons: Cartoons appearing in magazine are "line with some wash highlights." Pays $75-100 for b&w.

Illustrations: Approached by 50 illustrators/year. Buys illustrations mainly for spots and feature spreads. Buys 1-3 illustrations/issue from freelancers. Needs editorial and technical illustration that is "ironic, whimsical, but not silly." Works on assignment only. Prefers pen & ink. Considers marker. Send query letter with brochure showing art style, résumé, tearsheets, photostats, photocopies, slides, photographs and transparencies (fee requirements). Looks for "clarity in form and content." Samples are filed or are returned by SASE. Reports back about queries/submissions only if interested. For a portfolio review, mail original/final art and b&w tearsheets. Pays $75-125, b&w.

Tips: "Read our publication, understand the topic. Look at the 'Habitat Hotline' and 'Case Notes' sections." Does not want to see "tired cartoons about Wall Street board meetings and cute street beggars."

‡HADASSAH MAGAZINE, 50 W. 58th St., New York NY 10019. (212)688-1809. Fax: (212)446-9521. Estab. 1914. Consumer magazine. *Hadassah Magazine* is a monthly magazine chiefly of and for Jewish interests—both here and in Israel. Circ. 340,000.

Cartoons: Buys 1-2 freelance cartoons/issue. Preferred themes include the Middle East/Israel, domestic Jewish themes and issues. Send query letter with finished cartoons. Samples are filed or returned by SASE. Reports back within 3 weeks. Buys first rights. Pays $50, b&w; $100, color.

Illustrations: Approached by 5 freelance illustrators/year. Works on assignment only. Prefers themes of Jewish holidays. Samples are filed or are returned by SASE. Reports back within 3 weeks. Write for an appointment to show portfolio of original/final art, tearsheets and slides. Buys first rights. Pays on publication; $125, b&w, $300, color, cover.

‡HAWAII MAGAZINE, 1400 Kapiolani Blvd., #A25, Honolulu HI 96814. (808)942-2556. Editor: Jim Borg. Estab. 1984. Bimonthly "written for and directed to the frequent visitor and residents who travel frequently among the Hawaiian Islands. We try to encourage people to discover the vast natural beauty of these Islands." Circ. 70,000. Original artwork is returned after publication. Sample copies $3.95. Art guidelines not available.

Illustrations: Buys illustrations mainly for spots and feature spreads. Buys 1-2 illustrations/issue. Works on assignment only. Considers pen & ink, airbrush, watercolor, acrylic, oil, charcoal pencil and calligraphy. Send query letter with photocopies. Samples are not filed and are returned. Reports back about queries/submissions within 1 month. To show a portfolio mail printed samples and tearsheets. Buys first rights. Pays $75 for b&w; $150 for color, inside.

HEART DANCE, 473 Miller Ave., Mill Valley CA 94941-2941. Fax: (415)383-7500. Editor: Randy Peyser. Estab. 1990. Monthly New Age magazine. "The Bay Area's largest events calendar for contemporary human awareness, spirituality and well-being. Features workshops, classes, groups, getaways and special events." Circ. 35,000. Accepts previously published artwork. Original artwork is returned with SASE at job's completion. Sample copies and art guidelines available.

Cartoons: Approached by 15-20 cartoonists/year. Uses 1-4 cartoons/issue. New Age, spiritual and cosmic themes preferred; any format acceptable; must be b&w. Send query letter with finished cartoons. Samples are filed or are returned by SASE if requested by artist. Reports back within 1 month. Buys one-time rights. Pays in copies.

Illustrations: Approached by 40 illustrators/year. Buys 4 illustrations/issue. Prefers New Age, cosmic, positive, light and heartfelt themes and styles. Prefers pen & ink. Send query letter with SASE and photocopies. Samples are filed or are returned by SASE if requested by artist. Reports back within 1 month. Acquires one-time rights. "Not able to pay for cover or inside art but will credit artist in masthead and send copies."

Tips: Looking for positive, beautiful, uplifting b&w art; cartoons with New Age themes.

HEARTLAND BOATING MAGAZINE, P.O. Box 1067, Martin TN 38237-1067. (901)587-6791. Fax: (901)587-6893. Editor: Molly Lightfoot Blom. Estab. 1988. Specialty magazine published 7 times per year devoted to power (cruisers, houseboats) and sail boating enthusiasts throughout middle America. The content is both humorous and informative and reflects "the challenge, joy and excitement of boating on America's inland waterways." Circ. 16,000. Occasionally accepts previously published artwork. Originals are returned at job's completion. Sample copies available for $5. Art guidelines for SASE with first-class postage. Needs

Market conditions are constantly changing! If you're still using this book and it is 1997 or later, buy the newest edition of Artist's & Graphic Designer's Market at your favorite bookstore or order directly from Writer's Digest Books.

computer-literate freelancers for design and illustration. 50% of freelance work demands computer knowledge of Adobe Illustrator, QuarkXPress or Adobe Photoshop.

Cartoons: Approached by 10-12 cartoonists/year. Buys 2-3 cartoons/issue. Prefers boating; single panel without gaglines. Send query letter with roughs. Samples are filed or returned by SASE if requested by artist. Reports back within 2 months. Negotiates rights purchased. Pays $30 for b&w.

Illustrations: Approached by 2-3 illustrators/year. Buys 2-3 illustrations/issue. Works on assignment only. Prefers boating-related. Considers pen & ink. Send query letter with SASE and tearsheets. Samples are filed or returned by SASE if requested by artist. Reports back within 2 months. Portfolio review not required. Negotiates rights purchased. Pays on publication. Pays $30 for b&w inside.

Tips: Finds artists through artists' submissions. "Submit professional cover letters with no typos. Grammar is important too!"

‡HEARTLAND USA, Box 925, Hailey ID 83333-0925. (208)788-4500. Fax: (208)788-5098. Picture Researcher: Michael Cord. Estab. 1990. Quarterly 4-color of US Tobacco. Audience is blue-collar men. Circ. 1 million. Accepts previously published artwork. Originals are returned at job's completion. Sample copies for SASE with first-class postage.

Cartoons: Approached by 60 cartoonists/year. Buys 4 cartoons/issue. Preferred themes are blue-collar life-style, "simple style, light humor, nothing political or controversial"; single panel, b&w line drawings and washes with or without gagline. Send query letter with roughs. Samples are filed. Reports back within 2 weeks. Rights purchased vary according to project. Pays $150, b&w.

Illustrations: Approached by 36 illustrators/year. Buys 2 illustrations/issue. Preferred themes are blue-collar life-style. Prefers flexible board. Send query letter with tearsheets. Samples are filed. Reports back within 2 weeks. Call for appointment to show portfolio of printed samples, tearsheets and slides. Rights purchased vary according to project. Pays on publication; $150 for b&w or color.

‡THE HERB QUARTERLY, P.O. Box 689, San Anselmo CA 94960. (415)455-9540. E-mail: herbquart@aol. com. Editor and Publisher: James Keough. "Quarterly magazine emphasizing horticulture for middle to upper class men and women with an ardent enthusiasm for herbs and all their uses—gardening, culinary, crafts, etc. Most are probably home owners." Unusual design with 2 main text columns flanked by mini-columns. Uses original artwork extensively. Circ. 40,000. Original artwork returned after publication. Sample copy $5.

Illustrations: Accepts pen & ink illustrations, pencil, washes and 4-color watercolors. Needs illustrations of herbs, garden designs, etc. "Artist should be able to create illustrations drawn from themes of manuscripts sent to them." Send query letter with brochure showing art style or résumé, tearsheets, slides and photographs. Samples not filed are returned by SASE only if requested. Reports within weeks. Buys reprint rights. Pays on publication; $200 for full page; $100 for half page; $50 for quarter page and $25 for spots.

‡HERBALGRAM, P.O. Box 201660, Austin TX 78720-1660. (512)331-8868. Fax: (512)331-1924. Art Director: Ginger Hudson-Maffei. Estab 1983. Quarterly journal. "We're a non-commercial education and research journal with a mission to educate the public on the uses of beneficial herbs and plants. Fairly technical. For the general public, pharmacists, educators and medical professions." Circ. 25,000. Accepts previously published artwork. Originals are returned at job's completion. Sample copies and art guidelines available. Needs computer-literate freelancers for illustration and production. 90% of freelance work demands knowledge of Aldus PageMaker 5.0, Adobe Photoshop 3.0 and Aldus Freehand 3.11 and 4.0.

• This publication was redesigned in 1994. Currently at 80 pages, they plan to expand to 96 pages in 1996. Expansion will include adding new departments.

Cartoons: Buys 3-4 cartoons/year. Prefers medical plant, general plant, plant regulation themes; single panel, political, humorous b&w line drawings with gaglines. Send query letter with brochure or roughs. Samples are filed. Buys one-time rights. Pays $50 for b&w.

Illustrations: Approached by 10 illustrators/year. Buys 2 illustrations/year. Works on assignment only. Prefers plant/drug themes. Considers acrylic, mixed media, collage or computer-generated images. Send query letter with photocopies and transparencies. Samples are filed. Publication will contact artist for portfolio review if interested. Portfolio should include final art, tearsheets and photocopies. Buys one-time rights. **Pays on acceptance**; $50-100 for b&w inside; $100 for color inside. Pays $50-100 for spot illustrations.

Tips: Finds artists through submissions, word of mouth and *Austin Creative Directory.*

HIGHLIGHTS FOR CHILDREN, 803 Church St., Honesdale PA 18431. (717)253-1080. Fax: (717)253-0179. Contact: Art Director. Cartoon Editor: Rich Lawlace. Monthly 4-color magazine for ages 2-12. Circ. 3 million.

Cartoons: Receives 20 submissions/week. Buys 2-4 cartoons/issue. Interested in upbeat, positive cartoons involving children, family life or animals; single or multiple panel. Send roughs or finished cartoons and SASE. Reports in 4-6 weeks. Buys all rights. **Pays on acceptance**; $20-40 for line drawings. "One flaw in many submissions is that the concept or vocabulary is too adult, or that the experience necessary for its appreciation is beyond our readers. Frequently, a wordless self-explanatory cartoon is best."

Illustrations: Buys 30 illustrations/issue. Works on assignment only. Prefers "realistic and stylized work; upbeat, fun, more graphic than cartoon." Pen & ink, colored pencil, watercolor, marker, cut paper and mixed media are all acceptable. Discourages work in fluorescent colors. Send samples of style and flier to be kept on file. Send SASE. Request portfolio review in original query. Publication will contact artist for portfolio review if interested. Buys all rights on a work-for-hire basis. **Pays on acceptance**; $1,025 for color front and back covers; $50-500 for color inside. "We are always looking for good hidden pictures. We require a picture that is interesting in itself and has the objects well-hidden. Usually an artist submits pencil sketches. In no case do we pay for any preliminaries to the final hidden pictures." Submit hidden pictures to Jody Taylor.
Tips: "We have a wide variety of needs, so I would prefer to see a representative sample of an illustrator's style or styles."

ALFRED HITCHCOCK MYSTERY MAGAZINE, Dell Magazines Fiction Group, 1540 Broadway, New York NY 10036. (212)354-6500. Art Director: Terri Czeczko. Emphasizes mystery fiction; b&w with 4-color cover.
Illustrations: Works with 25 illustrators/year. Buys 80 illustrations/year. Uses artwork for covers, interiors and spots. Publication will contact artist for portfolio review if interested. Portfolio may be dropped off every Tuesday. Buys first rights. **Pays on acceptance**; $1,200 for cover illustrations; $150 for b&w inside; minimum $150 for line drawings.

‡HOBSON'S CHOICE, Box 98, Ripley OH 45167. Editor: Susannah West. Estab. 1974. Bimonthly b&w newsletter emphasizes science fiction, fantasy and nonfiction of scientific and technological interest. 16-20 pages; two-column format; 8½×11 saddle-stitched. Circ. 2,500. Sample copy $2.50; art guidelines for SASE; tipsheet packet which contains all guidelines $1.50.
Cartoons: Approached by 10-12 cartoonists/year. Buys 17-20 cartoons/year. Interested in science fiction, science and fantasy subjects; single and multi-panel b&w line drawings. Prefers finished cartoons. Include SASE. Reports in 2-3 months. Buys first North American serial rights. Pays on publication; $5.
Illustrations: Approached by 20-30 illustrators/year. Buys 35 illustrations/year. Needs editorial, technical and story illustrations. Illustrators whose work appears in the SF press exemplify the style, tone and content: Brad Foster, Alfred Klosterman, Janet Aulisio. Sometimes uses humorous and cartoon-style illustrations depending on the type of work being published. Works on assignment only. Samples returned by SASE. Reports back on future assignment possibilities. Send résumé or brochure and samples of style to be kept on file. Illustrates stories rather extensively (normally an 8×11 and an interior illustration). Format: b&w line drawings, camera-ready artwork. Send SASE. Reports in 2-3 months. Buys first North American rights. Pays on publication; up to $25 for b&w inside; $5 for spots.
Tips: "We first of all look for work that falls into science fiction genre; if an artist has a feel for and appreciation of science fiction he/she is more likely to be able to meet our needs. We are especially attracted to work that is clean and spare, not cluttered, and that has a finished, not sketchy quality. If an artist also does technical illustrations, we are interested in seeing samples of this style too. Would specifically like to see samples of work that we'd be capable of reproducing and that are compatible with our magazine's subject matter. We prefer to see photocopies rather than slides. We also like to be able to keep samples on file, rather than have to return them. Send us photocopies of your typical work. If you specialize in a specific genre (i.e. traditional fantasy or hard science fiction) make sure your samples emphasize that."

‡HOME & CONDO MAGAZINE, 2975 Horseshoe Dr., Naples FL 33942. (813)643-3933. Fax: (813)643-5017. Art Director: Nicole Coderre. "We are southwest Florida's resource for home and garden ideas." Published 7 times/year, plus special issues. Accepts previously published artwork. Originals returned at job's completion. Sample copies and art guidelines available. 30% of work demands knowledge of Compugraphics.
Illustrations: Approached by 40 illustrators/year. Buys 1-2 illustrations/issue. Works on assignment only. Prefers pen & ink, marker, colored pencil and pastel. Send query letter and price list with brochure, tearsheets and photocopies. "No phone calls please. Welcome illustrations created in Illustrator 5.0. OK to submit on disk." Samples are filed. Reports back only if interested. Buys one time rights. Pays on publication; $500 for color cover; $300 for full page inside; $150 for ¼ page b&w spots; $200 for ¼ page color spots.
Tips: "If an artist will work with us and be sensitive to our constraints, we'll be willing to work with the artist to find a mutually beneficial arrangement. Look through copies of our magazine or call and request a copy before you show your portfolio. Your samples should be geared toward the particular needs and interests of our magazine, and should be in keeping with the unique architecture and environment of southwest Florida."

HOMEPC, 600 Community Dr., Manhasset NY 11030. (516)562-5000. Fax: (516)562-7007. Art Director: David Loewy. Estab. 1994. Monthly consumer magazine. A magazine for home computer users. Easy to read, non-technical; covering software and hardware, entertainment and personal products. Circ. 250,000. Originals are returned at job's completion. Sample copies available. Art guidelines not available. Needs computer-literate freelancers for illustration. 50% of freelance work demands knowledge of Adobe Photoshop.

Illustrations: Approached by 200 illustrators/year. Buys 30 illustrations/issue. Works on assignment only. Considers pen & ink, airbrush, colored pencil, mixed media, collage, acrylic, oil and computer illustration. Send postcard-size sample or query letter with tearsheets. Samples are filed and are not returned. Publication will contact artist for portfolio review if interested. Portfolio should include final art and tearsheets. Buys one-time and reprint rights; rights purchased vary according to project. **Pays on acceptance**; $2,000 for color cover; $1,000 for color inside; $300-500 for spots.
Tips: Finds 75 percent of illustrators through sourcebooks; 25 percent through mailers and chance discovery.

‡HOPSCOTCH, The Magazine for Girls, Box 164, Bluffton OH 45817. (419)358-4610. Contact: Flo Weber. Estab. 1989. A bimonthly magazine for girls between the ages of 6 and 12; 2-color with 4-color cover; 50 pp.; 7×9 saddle-stapled. Circ. 9,000. Original artwork returned at job's completion. Sample copies available for $3. Art guidelines free for SASE with first-class postage. 20% of freelance work demands computer skills.
 ● Also publishes *Boys' Quest*.
Illustrations: Approached by 200-300 illustrators/year. Buys 6-7 freelance illustrations/issue. Artists work mostly on assignment. Needs story illustration. Prefers traditional and humor; pen & ink. Send query letter with photocopies. Samples are filed. Reports back within 2 months. Buys first rights and reprint rights. **Pays on acceptance**; $35 for full-page b&w; $25 for smaller b&w; $150 for color cover.

HORSE ILLUSTRATED, P.O. Box 6050, Mission Viejo CA 92690. (714)855-8822. Managing Editor: Moira C. Harris. Editor: Audrey Pavia. Estab. 1975. Monthly consumer magazine providing "information for responsible horse owners." Circ. 180,000. Originals are returned after job's completion. Sample copies available for $4. Art guidelines for SASE with first-class postage.
Cartoons: Approached by 200 cartoonists/year. Buys 1 or 2 cartoons/issue. Prefers satire on horse ownership ("without the trite clichés"); single panel b&w line drawings with gagline. Send query letter with brochure, roughs and finished cartoons. Samples are not filed and are returned by SASE if requested by artist. Reports back within 6 weeks. Buys first rights and one-time rights. Pays $35 for b&w.
Illustrations: Approached by 60 illustrators/year. Buys 1 illustration/issue. Prefers realistic, mature line art, pen & ink spot illustrations of horses. Considers pen & ink. Send query letter with brochure, SASE, tearsheets, photocopies and photostats. Samples are not filed and are returned by SASE if requested by artist. Reports back within 6 weeks. Portfolio review not required. Buys first rights or one-time rights. Pays on publication; $35 for b&w inside.
Tips: Finds artists through artists' submissions. "We only use spot illustrations for breed directory and classified sections. We do not use much, but if your artwork is within our guidelines, we usually do repeat business."

HORTICULTURE MAGAZINE, 98 N. Washington St., Boston MA 02114. (617)742-5600. Art Director: Pam Conrad. Estab. 1904. Monthly magazine for all levels of gardeners (beginners, intermediate, highly skilled). "*Horticulture* strives to inspire and instruct people who want to garden." Circ. 350,000. Originals are returned at job's completion. Art guidelines are available.
Illustrations: Approached by 75 freelance illustrators/year. Buys 10 illlustrations/issue. Works on assignment only. Prefers tight botanicals; garden scenes with a natural sense to the clustering of plants; people; hands and "how-to" illustrations. Considers all media. Send query letter with brochure, résumé, SASE, tearsheets, slides. Samples are filed or returned by SASE. Publication will contact artist for portfolio review if interested. Buys one-time rights. Pays 1 month after project completed. Payment depends on complexity of piece.
Tips: Finds artists through word of mouth, magazines, artists' submissions/self-promotions, sourcebooks, artists' agents and reps, attending art exhibitions. "I always go through the sourcebook and request portfolio materials if a person's work seems appropriate and is impressive."

‡HOUSE BEAUTIFUL, 1700 Broadway, 29th Floor, New York NY 10019. (212)903-5229. Fax: (212)765-8292. Art Director: Andrzej Janerka. Estab. 1896. Monthly consumer magazine. *House Beautiful* is a magazine about interior decorating—emphasis is on classic and contemporary trends in decorating, architecture and gardening. The magazine is aimed at both the professional and non-professional interior decorator. Circ. 1.3 million. Originals returned at job's completion. Sample copies available. Art guidelines not available.
Illustrations: Approached by 75-100 illustrators/year. Buys 2-3 illustrations/issue. Works on assignment only. Prefers contemporary, conceptual, interesting use of media and styles. Considers pen & ink, mixed media, collage, watercolor, acrylic, oil, pastel, computer generated art and photo-illustration. Send postcard-size sample. Samples are filed only if interested and are not returned. Portfolios may be dropped off every Monday-Friday. Publication will contact artist for portfolio review of final art, photographs, slides, tearsheets and good quality photocopies if interested. Buys one-time rights. Pays on publication; $600-700 for color inside; $600-700 for spots (99% of illustrations are done as spots).
Tips: "We find most of our artists through artist submissions of either portfolios or postcards. Sometimes we will contact an artist whose work we have seen in another publication. Some of our artists are found through artist reps and annuals."

HOW, The Bottomline Design Magazine, 1507 Dana Ave., Cincinnati OH 45207. Associate Art Director: Scott Finke. Estab. 1985. Bimonthly trade journal covering "how-to and business techniques for graphic design professionals." Circ. 35,000. Original artwork returned at job's completion. Sample copy $8.50. Art guidelines not available.
 • Sponsors annual conference for graphic artists. Send SASE for more information.
Illustrations: Approached by 100 illustrators/year. Buys 2 illustrations/issue. Works on assignment only. Considers all media, including photography and computer illustration. Send query letter with brochure, tearsheets, photocopies and transparencies. Samples are filed or are returned by SASE if requested. Reports back only if interested. To show a portfolio, mail slides. Buys first rights or reprint rights. Pays on publication; $500 for color cover; $100 for b&w; $150-400 for color inside.

HSUS NEWS, 700 Professional Dr., Gaithersburg MD 20814. Art Director: Theodora T. Tilton. Estab. 1954. Quarterly 4-color magazine focusing on Humane Society news and animal protection issues. Circ. 450,000. Accepts previously published artwork. Originals are returned at job's completion.
Illustrations: Buys 1-2 illustrations/issue. Works on assignment only. Themes vary. Send query letter with samples. Samples are filed or returned. Reports back within 1 month. To show a portfolio, mail appropriate materials. Portfolio should include printed samples, b&w and color tearsheets and slides. Buys one-time rights and reprint rights. **Pays on acceptance**; $250 for b&w, $400 for color cover; $150 for b&w, $300 for color inside.

HUMPTY DUMPTY'S MAGAZINE, Children's Better Health Institute, 1100 Waterway Blvd., Box 567, Indianapolis IN 46206. (317)636-8881. Art Director: Lawrence Simmons. A health-oriented children's magazine for ages 4-7; 4-color; simple and direct design. Published 8 times a year. Circ. 300,000. Originals are not returned at job's completion. Sample copies available for $1.25 Art guidelines available for SASE.
 • Also publishes *Child Life*, *Children's Digest*, *Children's Playmate*, *Jack and Jill* and *Turtle Magazine*.
Illustrations: Approached by 300-400 illustrators/year. Buys 20 illustrations/issue. Works on assignment only. Preferred styles are mostly cartoon and some realism. Considers any media as long as finish is done on scannable (bendable) surface. Send query letter with slides, photocopies, tearsheets and SASE. Samples are filed or returned by SASE if not kept on file. Reports back only if interested. To show a portfolio, mail color tearsheets, photostats, photographs and photocopies. Buys all rights. Pays on publication; $275 for color cover; $35-90 for b&w and $70-155 for color inside.

IDEALS MAGAZINE, Box 148000, Nashville TN 37214. (615)231-6740. Fax: (615)231-6750. Editor: Lisa Thompson. 4-color magazine, published 8 times/year, emphasizing poetry and light prose. Accepts previously published material. Sample copy $4.
Illustrations: Buys 6-8 illustrations/issue. Uses freelancers mainly for flowers, plant life, wildlife and people illustrations. Prefers seasonal themes rendered in a nostalgic style. Prefers pen & ink, airbrush, colored pencil, oil, watercolor and pastel. "We are interested in seeing examples of what illustrators can do with Fractal Design Painter. Must *look* as hand-drawn as possible." Send query letter with brochure showing art style or tearsheets. Samples not filed are returned by SASE. Do not send originals or slides. Buys artwork outright. Pays on publication.
Tips: "In submissions, target our needs as far as style is concerned, but show representative subject matter. Artists should be familiar with our magazine before submitting samples of work."

ILLINOIS ENTERTAINER, 124 W. Polk, #103, Chicago IL 60605. (312)922-9333. Fax: (312)922-9369. Editor: Michael C. Harris. Estab. 1975. Sleek consumer/trade-oriented monthly entertainment magazine focusing on local and national alternative music. Circ. 80,000. Accepts previously published artwork. Originals are not returned. Sample copies for SASE with first-class postage. Art guidelines not available.
Illustrations: Approached by 1-5 freelance illustrators/year. Works on assignment only. Publication will contact artist for portfolio review if interested. Buys first rights. Pays on publication; $20 for b&w.
Tips: Finds artists through word of mouth and submissions. "Send some clips and be patient."

ILLINOIS MEDICINE, 20 N. Michigan Ave., Suite 700, Chicago IL 60602. (312)782-1654. Fax: (312)782-2023. Production Design Manager: Carla Nolan. Estab. 1989. Biweekly 4-color company tabloid published for the physician members of the Illinois State Medical Society featuring nonclinical socio-economic and legislative news; conservative design. Circ. 20,000. Accepts previously published artwork. Illustrations are returned at job's completion. Sample copies available.
Cartoons: Approached by 20 cartoonists/year. Buys 1 cartoon/issue. Prefers medical themes—geared to physicians; single panel, b&w washes and line drawings with gagline. Send query letter with finished cartoons. Samples are not filed and are returned. Reports back within 2 months. Buys one-time rights. Pays $50 for b&w, $100 for color.
Illustrations: Approached by 30 illustrators/year. Buys 1 illustration/issue. Works on assignment only. Preferred themes are medical or government. Send query letter with brochure, tearsheets, photostats or photographs. Samples are filed. Publication will contact artist for portfolio review if interested. Artist should

follow up with call or letter. Portfolio should include roughs, printed samples, b&w and color tearsheets, photostats and photographs. Buys one-time rights. **Pays on acceptance**; $500 for b&w, $800-1,200 for color.
Tips: Finds artists mostly through artists' self-promotions.

IN TOUCH FOR MEN, 13122 Saticoy St., North Hollywood CA 91605-3402. (818)764-2288. Fax: (818)764-2307. Editor: Darrell Roberts. Estab. 1973. "*In Touch* is a monthly erotic magazine for gay men that explores all aspects of the gay community (sex, art, music, film, etc.)" Circ. 60,000. Accepts previously published work (very seldom). Originals returned after job's completion. Sample copies and art guidelines available. Needs computer-literate freelancers for illustration.
• This magazine is open to working with illustrators who create work on computers and transfer it via modem. Final art must be saved in a Macintosh-readable format.
Cartoons: Approached by 10 cartoonists/year. Buys 1-2 cartoons/issue. Prefers humorous, gay lifestyle related (not necessarily sexually explicit in nature); single and multiple panel b&w washes and line drawings with gagline. Send query letter with finished cartoons. Samples are filed. Reports back within 1 month. Buys one-time rights. Pays $50 for b&w, $100 for color.
Illustrations: Approached by 10 illustrators/year. Buys 3-5 illustrations/issue. Works on assignment only. Prefers open-minded, lighthearted style. Considers all types. Send query letter with résumé, tearsheets, photocopies and slides. Samples are filed. Reports back within 2 weeks. Publication will contact artist for portfolio review if interested. Portfolio should include b&w and color final art. Usually buys one-time rights or vary according to project. **Pays on acceptance**; $50 for b&w inside, $100 for color inside.
Tips: "Most artists in this genre will contact us directly, but we get some through word-of-mouth and occasionally we will look up an artist whose work we've seen and interests us. Areas most open to freelancers are 4-color illustrations for erotic fiction stories, humorous illustrations and stand-alone comic strips/panels depicting segments of gay lifestyle. Understanding of gay community and lifestyle a plus."

INCOME OPPORTUNITIES, 1500 Broadway, New York NY 10036-4015. (212)642-0600. E-mail: incomeed@aol.com. Contact: Andrew Bass. Estab. 1956. Monthly consumer magazine for small business investors. Circ. 400,000. Accepts previously published artwork. Originals returned at job's completion. Sample copies available. Art guidelines available. Needs computer-literate freelancers for illustration. 5% of freelance work demands knowledge of QuarkXPress and Adobe Illustrator 5.0-5.5.
• *Income Opportunities* no longer publishes cartoons.
Illustrations: Approached by 10 illustrators/year. Buys 10 illustrations/issue. Works on assignment only. Prefers money-oriented art. Considers watercolor and airbrush. Send query letter with brochure, tearsheets and photocopies. Samples are filed. Reports back to the artist only if interested. To arrange portfolio review artist should follow up with call and letter after initial query. Portfolio should include tearsheets, final art and photographs. Buys first rights. Pays on publication; $1,500 for color cover; $300 color, $225 b&w inside.
Tips: Finds artists through sourcebooks like *American Showcase*, also through artists' submissions. Mostly hires artists for humorous illustrations for the departments. "Send mailing cards."

‡INCOME PLUS, 73 Spring St., Suite 303, New York NY 10012. (212)925-3180. Fax: (212)925-3612. Art Director: Greg Treadway. Estab. 1989. Monthly trade journal for small business entrepreneurs. Circ. 250,000. Originals are returned at job's completion. Sample copies available. Art guidelines free for SASE with first-class postage. Needs computer-literate freelancers for design "sometimes." Freelancers should be familiar with QuarkXPress, Aldus FreeHand, Adobe Illustrator and Photoshop.
Cartoons: Approached by 20 cartoonists/year. Buys 10 cartoons/issue. Preferred themes are small business situations; single panel without gagline. Send query letter with finished cartoons. Reports back within 1 month. Buys one-time rights. Pays $10 for b&w.
Illustrations: Approached by 50 illustrators/year. Buys 2 illustrations/issue. Works on assignment only. Themes are small business; style is varied between serious and caricature. Prefers pen & ink, watercolor, collage, airbrush, colored pencil and mixed media. Send query letter with tearsheets, SASE and samples. Samples are filed or returned by SASE if requested by artist. Reports back within 1 month. Call or write for appointment to show portfolio of tearsheets and photocopies. Buys one-time rights. Pays on publication; $100 for b&w, $300 for color cover; $100 for b&w, $200 for color inside.
Tips: "Know the publication. Contact the art director by mail only."

‡THE INDEPENDENT WEEKLY, P.O. Box 2690, Durham NC 27715. (919)286-1972. Fax: (919)286-4274. Contact: Jewel Wheeler. Estab. 1982. Weekly b&w with 2-color cover tabloid; general interest alternative. Circ. 50,000. Original artwork is returned if requested. Sample copies for SASE with first-class postage. Art guidelines not available.
Illustrations: Buys 5-8 illustrations/year. Works on assignment only. Prefers political satire, caricatures. Considers pen & ink; b&w only. Samples are filed or are returned by SASE if requested. Reports back only if interested. Call for appointment to show portfolio or mail b&w tearsheets. Pays on publication; $100 for b&w cover; $25-50 for b&w inside and spots.
Tips: "Have a political 'point of view.' Understand the peculiarities of newsprint."

INSIDER REPORT

Enter Your Career on the "Short Line"

Nationally known illustrator C.F. (Chris) Payne has been called "the modern Rockwell." His realistic yet quirky character studies of celebrities, politicians, belligerent baseball umpires and other figures on the American scene regularly show up on the covers of *Time* and enliven the pages of *Rolling Stone*, *Esquire* and *Sports Illustrated*.

C.F. Payne

These days art directors track down the artist at his Cincinnati studio, where he works on his pick of assignments. But it wasn't always that way. Fifteen years ago, Payne launched his career by working on small assignments for regional magazines.

When he first started freelancing, Payne made an important observation. "I noticed there are 'long lines' and 'short lines' for the kinds of illustration jobs that are out there. The long lines are filled with illustrators who want to work for *Time*, *Sports Illustrated* and other national magazines. Everybody wants to do that. But there aren't that many artists lined up to do spot illustrations for Sunday supplements and city magazines. It's a supply and demand type of thing."

Take as many "short line" jobs as you can, advises Payne. Not only are they easier to find, but they offer more creative freedom. "If there's a long line and an art director says 'I want you to do it this way' and you want to try another way, he can always look down the line and find another artist. But if there's a short line and the art director thinks you have some skills and can bring something to the plate, he's more apt to let you develop your ideas because you're willing to do the illustration for $200."

These "short line" editorial jobs gave Payne a chance to gain experience and refine his style. "I wasn't making much money—I had to produce two to three illustrations a week to cover my overhead—but I was learning how to deal with deadlines, how to develop ideas, and experimenting with techniques to work fast enough to meet tight deadlines."

Early in his career, Payne found ways to save money producing impressive samples by cutting deals with vendors. For example in exchange for a cost break, the printer's name appeared on the piece so it could serve as a promotional vehicle for the printer as well. It worked perfectly.

To get his portfolio in order, he would select his 20 best pieces and line them up. "I tried to disassociate the emotions from my work and looked at it from a critical, logical point of view," says Payne. He'd look at the 20 pieces and eliminate six, keeping 14 in his portfolio.

Every eight months or so, he'd update his portfolio by swapping old pieces for newer work. That way when he made repeat calls, his work appeared fresh and delivered the message that he was working. "You want to be seen as productive," says Payne. "You want them to think they're not seeing the same old book."

Portfolios serve two purposes, says Payne: to show you can work to professional standards and to assure the client you have experience meeting deadlines. Art directors hate to take a chance with a new illustrator only to end up being embarrassed by missed deadlines or unacceptable work. They look for evidence in your portfolio that you're up to the assignment. "It doesn't matter how many pieces are in it, but how much time it takes to go through the portfolio that counts. Don't make the art director look at your book for much more than a minute and a half."

Before he signed with a rep, Payne developed a system to make sure his artwork was seen. Every Monday he called art directors and made appointments to show his book. Therefore, no matter what happened that week, he always had five or six appointments.

"I am a firm believer if you can look a potential client in the eye and say 'Look, I would like to have the chance to work with you. Give me the opportunity and I will do the best I can for you,' and can back it up, people will respond to that," says Payne.

When he went on appointments, he had one rule: "You never, ever leave an office without another name." That way he had another connection and could call and make another appointment. At the end of every appointment he handed art directors his "leave behind" sample, so they could keep something on file.

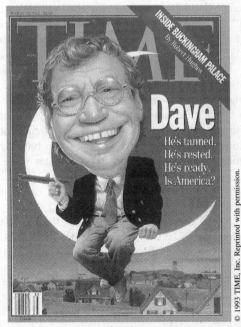

Chris Payne's quirky caricature of David Letterman is one of his many illustrations appearing on the cover of Time magazine. Says Time's Art Director Arthur Hochstein, a fan of Payne's, "Even though most of his work is either kind of funny or ironic, there's an Americana quality to it."

© 1993 TIME, Inc. Reprinted with permission.

Payne made a habit of checking magazine racks to see which publications use artwork, noting the art directors' names to call for appointments. He also talked with other illustrators to find out who was buying. (Even now that he's a success, Payne is an active member of the local Art Directors Club, and meets local illustrators for lunch every Wednesday.)

One strategy in particular helped Payne graduate to the "long line" assignments. He began entering competitions—such as local Art Directors Club shows, the Society of Illustrators show, and the *Communication Arts* competition. "The shows are great, cheap advertising if you get in, and because they are juried, they give your work a certain level of credibility," says Payne. If chosen, your work will be reproduced in lavish color in publications widely read by art directors across the country.

The first Payne illustration accepted in the Society of Illustrators show was a piece he did for the *Dallas Times Herald* Sunday supplement, says Payne. When he entered a $200 spot illustration from the same supplement in the *Communication Arts* competition it was reproduced in *CA's* annual and Payne started getting calls from magazine art directors and New York art reps asking to see more of his work.

Payne says he owes a lot of his success to Fred Woodward, the current art director for *Rolling Stone*. They met when Woodward, then art director for *D*, a city magazine in Dallas, hired him for an assignment. Their working relationship taught Payne a valuable lesson. When Woodward left *D* to become art director of *Texas Monthly* he continued to commission Payne, but only for last-minute assignments. "Woodward had me pigeoned-holed as someone to call in a crunch," says Payne "He told me no matter what the deadline or circumstances I always gave him something he could print.

"At first I thought that was a great compliment. Then I realized he wasn't saying I did great artwork, just that my work wasn't embarrassing. He was giving all the plum assignments to Alexa Grace, Melissa Grimes, Jose Cruz and Brad Holland—all these really talented people whose work I admired. So I thought 'Why am I not getting any of these?' "

Payne hatched a plan to change his image in Woodward's eyes. Without an assignment he took it upon himself to create an elaborate illustration tailored to one of *Texas Monthly*'s regular features and sent it to Woodward.

"When he saw that illustration," says Payne, "his perception of me changed. He saw how serious I was. It's one of those things you have to go out after. If an art director puts you in a slot you have to actively make changes to move yourself out of that slot, or you will stay there."

As Woodward moved on to other publications with huge national reputations, such as *Regardies* and *Rolling Stone*, he continued to use Payne's illustrations and does so to this day.

Payne still does many "short line" jobs and enjoys them. "I have to be careful which ones I take on because of deadlines," says Payne. "The only reason I turn down jobs is deadlines. Unfortunately now I'm often booked for three weeks and to try to slip them in is tough."

That's the kind of problem any illustrator would love to have.

—Neil Burns

INSIDE, 226 S. 16th St., Philadelphia PA 19102. (215)893-5797. Editor: Jane Biberman. Estab. 1979. Quarterly. Circ. 70,000. Accepts previously published artwork. Interested in buying second rights (reprint rights) to previously published work. Original artwork returned after publication.

Illustrations: Buys several illustrations/issue from freelancers. Prefers color and b&w drawings. Works on assignment only. Send samples and tearsheets to be kept on file. Samples not kept on file are not returned. Call for appointment to show portfolio. Reports only if interested. Buys first rights. **Pays on acceptance**; minimum $500 for color cover; minimum $150 for b&w, $200 for color inside. Prefers to see sketches.

Tips: Finds artists through artists' promotional pieces, attending art exhibitions, artists' requests to show portfolio.

INTERRACE, P.O. Box 12048, Atlanta GA 30355-2048. (409)364-9590. Fax: (404)364-9965. Associate Publisher: Gabe Grosz. Estab. 1989. Consumer magazine published 8 times/year. "Magazine of interracial/multiracial/biracial theme for couples and people. Reflects the lives and lifestyles of interracial couples and people." Circ. 25,000. Accepts previously published artwork. Originals are returned at job's completion with SASE if requested. Sample copies available for $2 and 9×12 SASE. Guidelines available for SASE with first-class postage.

• *Interrace* launched *Biracial Child* magazine ("the only one if its kind in the U.S.") in 1994 for parents of mixed-race children, interracial stepfamilies and transracial adoption. This new publication is in need of illustrators. Submit to above address.

Cartoons: Approached by 10 cartoonists/year. Buys 10 cartoons/year. Prefers interracial couple/family, multiracial people themes; any format. Send query letter with roughs or finished cartoons. Samples are filed or are returned by SASE if requested. Reports back if interested within 1 month. Negotiated rights purchased. Pays $10 for b&w, $15 for color.

Illustrations: Approached by 20 illustrators/year. Uses 2-3 illustrations/issue. Prefers interracial couple/family, multiracial people themes. Considers pen & ink, airbrush, colored pencil, mixed media, watercolor, acrylic, pastel, collage, marker and charcoal. Send query letter with résumé and photocopies. Samples are filed or are returned by SASE if requested. Reports back if interested within 1 month. Request portfolio review in original query. Artist should follow-up with letter after initial query. Portfolio should include photocopies and any samples; "it's up to the artist." Negotiates rights purchased. Pays on publication; $75 for b&w or color cover; $15 for b&w, $20 for color inside.

Tips: Finds artists through submissions. "We are looking for artwork for interior or cover that is not only black and white couples/people, but all mixtures of black, white, Asian, Native American, Latino, etc."

IOWA WOMAN, Box 680, Iowa City IA 52244. (319)987-2879. Editor: Marianne Abel. Estab. 1979. Quarterly b&w with 4-color cover literary magazine. "A magazine for every woman who has a mind of her own and wants to keep it that way, with fine literature and visual art by women everywhere." Circ. 2,400. Accepts previously published artwork. Originals are returned at job's completion. Sample copies $6. Art guidelines for SASE with first-class postage. Needs computer-literate freelancers for illustration. Amount of freelance work demanding computer skills varies. Freelancers should be familiar with QuarkXPress.

Cartoons: Approached by 2 cartoonists/year. "Have bought none yet, but we would use 10 cartoons/year." Preferred theme/style is narrative, political and feminist "without male-bashing"; single, double and multiple panel b&w line drawings with or without gagline. Send query letter with roughs, finished cartoons and SASE. Samples are filed or are returned by SASE if requested. Reports back within 1 month. Buys first rights. Pays $15 and 2 copies.

Illustrations: Approached by 30 illustrators/year. Buys 6 illustrations/issue. Prefers incidental sketches and scenes; pen & ink, watercolor, collage, mixed media, b&w photos. Send query letter with tearsheets or slides, letter of introduction, SASE and photocopies. Samples are filed or returned by SASE if requested. Reports back within 1 month. Portfolio review not required. Buys first rights. Pays $15 for b&w inside; $50 for color cover; $15 for spots.

Tips: "We consider Iowa (or former Iowa) women artists only for the cover; women artists from everywhere else for inside art. We prefer to work on assignment, except for cartoons."

JACK AND JILL, Children's Better Health Institute, 1100 Waterway Blvd., Box 567, Indianapolis IN 46206. (317)636-8881. Fax: (317)637-0126. Art Director: Karen Neligh. Emphasizes entertaining articles written with the purpose of developing the reading skills of the reader. For ages 7-10. Monthly except bimonthly January/February, April/May, July/August and October/November. Magazine is 32 pages, 4-color and 16 pages, b&w. The editorial content is 50% artwork. Buys all rights. Original artwork not returned after publication (except in case where artist wishes to exhibit the art; art must be available to us on request). Sample copy $1.25. "Freelancers can work in Aldus FreeHand, PageMaker or Quark programs, and can submit work in disk form."

• Also publishes *Child Life, Children's Digest, Children's Playmate, Humpty Dumpty's Magazine, Turtle* and *U.S. Kids*.

Illustrations: Approached by more than 100 illustrators/year. Buys 25 illustrations/issue. Uses freelance artists mainly for cover art, story illustrations and activity pages. Interested in "stylized, realistic, humorous

illustrations for mystery, adventure, science fiction, historical and also nature and health subjects." Style of Len Ebert, Les Gray, Fred Womack, Phil Smith and Clovis Martin. Prefers editorial illustration in mixed media. Works on assignment only. Send query letter with brochure showing art style and résumé, tearsheets, photostats, photocopies, slides and photographs to be kept on file; include SASE. Publication will contact artist for portfolio review if interested. Portfolio should include printed samples, tearsheets, b&w and 2-color pre-separated art. Pays $275 cover, $155 full page, $100 ½ page, $70 for 4-color spots. For 4-color pre-separation art pays $190 full page, $115 ½ page and $80 for spots. Pays $120 full page, $90 ½ page, $60 for 2-color spots. Pays $90 full page, $60 ½ page, $35 for b&w spots. Buys all rights on a work-for-hire basis. On publication date, each contributor is sent 2 copies of the issue containing his or her work.
Tips: Finds artists through artists' submissions and self-promotion pieces. Portfolio should include "illustrations composed in a situation or storytelling way, to enhance the text matter. I do not want to see samples showing *only* single figures, portraits or landscapes, sea or air. Send samples of published story for which you did illustration work, or samples of puzzles, hidden pictures, mazes, etc."

JACKSONVILLE, 1650 Prudential Dr., Suite 300, Jacksonville FL 32207. (904)396-8666. Creative Director: Carolyn Richardson. Estab. 1983. City/regional lifestyle magazine covering Florida's First Coast. 10 times/yearly. Circ. 25,000. Accepts previously published artwork. Originals returned at job's completion. Sample copies available for $5 (includes postage). Art guidelines for SASE with first-class postage.
Illustrations: Approached by 50 illustrators/year. Buys 4 illustrations/issue. Prefers editorial illustration with topical themes and sophisticated style. Send tearsheets. Will accept computer-generated illustrations compatible with Macintosh programs: Adobe Illustrator and Photoshop. Samples are filed and are returned by SASE if requested. Reports back within 2-4 weeks. Request portfolio review in original query. Publication will contact artist for portfolio review if interested. Portfolio should include b&w and color tearsheets and slides. Buys all rights. Pays on publication; $800 for color cover; $175 for b&w, $225 for color inside; $100-125 for spots.
Tips: Finds artists through illustration annuals. "We are very interested in seeing new talent—people who are part of the breaking trends."

‡JEMS, Journal of Emergency Medical Services, 1947 Camino Vida Roble, Suite 200, Carlsbad CA 92008. (619)431-9797. Director of Design and Production: Harriet Wilcox. Estab. 1980. Monthly trade journal aimed at paramedics/paramedic instructors. Circ. 35,000. Accepts previously published artwork. Originals returned at job's completion. Sample copies available. Art guidelines not available. Needs computer-literate freelancers for design, illustration and production. 75% of freelance work demands knowledge of QuarkXPress, Adobe Illustrator and Adobe Photoshop.
Illustrations: Approached by 20 illustrators/year. Buys 2-6 illustrations/issue. Works on assignment only. Prefers medical as well as general editorial illustration. Considers pen & ink, airbrush, colored pencil, mixed media, collage, watercolor, acrylic, oil and marker. Send postcard-size sample or query letter with brochure, SASE, tearsheets, 4-color photocopies and slides. Samples are filed and are not returned. Portfolio review not required. Publication will contact artist for portfolio review of final art, tearsheets and printed samples if interested. Rights purchased vary according to project. Pays on publication. Pays $350-1,000 for color cover; $150-600 for color; $50-100 for b&w inside; $25-100 for spots.
Tips: Finds artists through illustrators' directories, agents, direct mail campaigns.

JOURNAL OF ACCOUNTANCY, AICPA, Harborside 201 Plaza III, Jersey City NJ 07311. (201)938-3450. Art Director: Jeryl Ann Costello. Monthly 4-color magazine emphasizing accounting for certified public accountants; corporate/business format. Circ. 350,000. Accepts previously published artwork. Original artwork returned after publication. Needs computer-literate freelancers for design and illustration of charts and graphs. 35% of freelance work demands knowledge of Adobe Illustrator, QuarkXPress and Aldus FreeHand.
Illustrations: Approached by 200 illustrators/year. Buys 2-6 illustrations/issue. Prefers business, finance and law themes. Prefers mixed media, then pen & ink, airbrush, colored pencil, watercolor, acrylic, oil and pastel. Works on assignment only. Send query letter with brochure showing art style. Samples not filed are returned with SASE. Portfolio should include printed samples, color and b&w tearsheets. Buys first rights. Pays on publication; $1,200 for color cover; $200-600 for color (depending on size) inside.
Tips: Finds artists through artists' submissions/self-promotions, sourcebooks and magazines. "I look for indications that an artist can turn the ordinary into something extraordinary, whether it be through concept or style. In addition to illustrators, I also hire freelancers to do charts and graphs. In portfolios, I like to see tearsheets showing how the art and editorial worked together."

JOURNAL OF ASIAN MARTIAL ARTS, 821 W. 24th St., Erie PA 16502-2523. (814)455-9517. Fax: (814)838-7811. Publisher: Michael A. DeMarco. Estab. 1991. Quarterly journal covering all historical and cultural aspects of Asian martial arts. Interdisciplinary approach. College-level audience. Circ. 6,000. Accepts previously published artwork. Sample copies available for $10. Art guidelines for SASE with first-class postage. Needs computer-literate freelancers for illustration. Freelancers should be familiar with Aldus PageMaker and QuarkXPress.

Illustrations: Buys 60 illustrations/issue. Prefers b&w wash; brush-like Oriental style; line. Considers pen & ink, watercolor, collage, airbrush, marker and charcoal. Send query letter with brochure, résumé, SASE and photocopies. Samples are filed. Reports back within 4-6 weeks. Publication will contact artist for portfolio review if interested. Portfolio should include b&w roughs, photocopies and final art. Buys first rights and reprint rights. Pays on publication; $100 for b&w cover, $25-100 for b&w inside.

Tips: "Usually artists hear about or see our journal. We can be found in bookstores, libraries, or in listings of publications. Areas most open to freelancers are illustrations of historic warriors, weapons, castles, battles—any subject dealing with the martial arts of Asia. If artists appreciate aspects of Asian martial arts and/or Asian culture, we would appreciate seeing their work and discuss the possibilities of collaboration."

JOURNAL OF HEALTH EDUCATION, 1900 Association Dr., Reston VA 22091. Editor: Patricia Lyle. Estab. 1970. "Bimonthly trade journal for school and community health professionals, keeping them up-to-date on issues, trends, teaching methods, and curriculum developments in health." Conservative; b&w with 4-color cover. Circ. 10,000. Original artwork is returned after publication if requested. Sample copies available. Art guidelines not available. Needs computer-literate freelancers for design, illustration and production. 70% of freelance work demands knowledge of Aldus PageMaker, Adobe Illustrator, QuarkXPress and Aldus FreeHand.

Illustrations: Approached by 50 illustrators/year. Buys 6 illustrations/year. Uses artists mainly for covers. Wants health-related topics, any style; also editorial and technical illustrations. Prefers watercolor, pen & ink, airbrush, acrylic, oil and computer illustration. Works on assignment only. Send query letter with brochure showing art style or photostats, photocopies, slides or photographs. Samples are filed or are returned by SASE. Publication will contact artist for portfolio review if interested. Portfolio should include color and b&w thumbnails, roughs, printed samples, photostats, photographs and slides. Negotiates rights purchased. **Pays on acceptance**; $45 for b&w; $250-500 for color cover.

THE JOURNAL OF LIGHT CONSTRUCTION, RR 2, Box 146, Richmond VT 05477. (802)434-4747. Fax: (802)434-4467. Art Director: Theresa Emerson. Monthly magazine emphasizing residential and light commercial building and remodeling. Focuses on the practical aspects of building technology and small-business management. Circ. 45,000. Accepts previously published material. Original artwork is returned after publication. Sample copy free. Needs computer-literate freelancers for design and production. 80% of freelance work demands knowledge of QuarkXPress and Adobe Photoshop.

Cartoons: Buys cartoons relevent to construction industry, especially business topics.

Illustrations: Buys 10 illustrations/issue. "Lots of how-to technical illustrations are assigned on various construction topics." Send query letter with brochure, résumé, tearsheets, photostats or photocopies. Samples are filed or are returned only if requested by artist. Reports back within 2 weeks. Call or write for appointment to show portfolio of printed samples, final reproduction/product and b&w tearsheets. Buys one-time rights. **Pays on acceptance**; $500 for color cover; $100 for b&w inside.

Tips: "Write for a sample copy. We are unusual in that we have drawings illustrating construction techniques. We prefer artists with construction and/or architectural experience."

JUDICATURE, 25 E. Washington, Suite 1600, Chicago IL 60602. Contact: David Richert. Estab. 1917. Journal of the American Judicature Society. Black & white bimonthly with 2-color cover and conservative design. Circ. 15,000. Accepts previously published material and computer illustration. Original artwork returned after publication. Sample copy for SASE with $1.47 postage. Needs computer-literate freelancers for design and illustration. Work demands knowledge of Aldus PageMaker and FreeHand.

Cartoons: Approached by 10 cartoonists/year. Buys 1-2 cartoons/issue. Interested in "sophisticated humor revealing a familiarity with legal issues, the courts and the administration of justice." Send query letter with samples of style and SASE. Reports in 2 weeks. Buys one-time rights. Pays $35 for unsolicited b&w cartoons.

Illustrations: Approached by 20 illustrators/year. Buys 2-3 illustrations/issue. Works on assignment only. Interested in styles from "realism to light humor." Prefers subjects related to court organization, operations and personnel. Send query letter with brochure showing art style and SASE. Publication will contact artist for portfolio review if interestsed. Portfolio should include roughs and printed samples. Wants to see "b&w and the title and synopsis of editorial material the illustration accompanied." Buys one-time rights. Negotiates payment. Pays $250 for 2- or 3-color cover; $250 for b&w full page, $175 for b&w half page inside.

Tips: "Show a variety of samples, including printed pieces and roughs."

JUGGLER'S WORLD, Box 443, Davidson NC 28036. (704)892-1296. Fax: (704)892-2499. E-mail: bigiduz@davidson.edu. Editor: Bill Giduz. Estab. 1981. Quarterly magazine publishing news, features and how-to information on juggling and jugglers. Circ. 3,500. Accepts previously published artwork. Originals not returned. Sample copies free for 9×12 SASE and 5 first-class stamps. Art guidelines available for SASE with first-class postage.

Cartoons: Approached by 15 cartoonists/year. Buys 2 cartoons/issue. Prefers cartoons about juggling. Prefers humorous cartoons; single panel with gagline. Send query letter with roughs and finished cartoons. Samples are not filed and are not returned. Reports back within 1 week. Buys one-time rights. Pays $15 for b&w.

Illustration: Pays $15 for spots.
Tips: "Send work that demonstrates insight into juggling, rather than simply reflecting popular conception of the art."

KALEIDOSCOPE: International Magazine of Literature, Fine Arts, and Disability, 326 Locust St., Akron OH 44302. (216)762-9755. Editor-in-Chief: Darshan Perusek. Estab. 1979. Black & white with 4-color cover. Semiannual. "Elegant, straightforward design. Unlike medical, rehabilitation, advocacy or independent living journals, explores the experiences of disability through lens of the creative arts. Specifically seeking work by artists with disabilities. Work by artists without disabilities must have a disability focus." Circ. 1,500. Accepts previously published artwork. Sample copy $4. Guidelines with SASE.
Illustrations: Freelance art occasionally used with fiction pieces. More interested in publishing art that stands on its own as the focal point of an article. Approached by 15-20 artists/year. Do not send originals. Prefers high contrast, b&w glossy photos, but will also review color photos or 35mm slides. Include sufficient postage for return of work. Samples are not filed. Publication will contact artist for portfolio review if interested. Acceptance or rejection may take up to a year. Pays $25-100 plus two copies. Rights return to artist upon publication.
Tips: Finds artists through artists' submissions/self-promotions and word of mouth. "Inquire about future themes of upcoming issues. Considers all mediums, from pastels to acrylics to sculpture. Must be high quality art."

‡KANSAS CITY MAGAZINE, 7007 College Blvd., Suite 430, Overland Park KS 66211. (913)338-0900. Fax: (913)338-1148. Director of Design: Kevin Swanson. Estab. 1994. Bimonthly lifestyle-oriented magazine, focusing on people behind events. "We try to look at things from a little different angle (for added interest)." Circ. 33,000. Originals returned at job's completion. Sample copies available. Art guidelines not available. Needs computer-literate freelancers for illustration and production. 20% of freelance work demands knowledge of Adobe Illustrator and Photoshop.
Illustrations: Approached by 52 illustrators/year. Buys 3 illustrations/issue. Works on assignment only. Prefers lifestyle themes. Considers colored pencil, mixed media, collage, watercolor, acrylic, oil and pastel. Send postcard-size sample or query letter with brochure, tearsheets, photographs, photocopies, photostats, slides and transparencies. Samples are filed. Reports back to the artist only if interested. Artist should follow-up with call and/or letter after initial query. Portfolio should include final art, photographs, tearsheets, photocopies and photostats. Buys reprint rights. **Pays on acceptance**; $500-800 for color cover; $50-200 for b&w, $150-300 for color inside. Pays $50-150 for spots.
Tips: Finds artists through sourcebooks, word of mouth, artists' submissions. "Our magazine is new, we have a high quality, clean, cultural, creative format."

✦KEY PACIFIC PUBLISHERS, Dept. AGDM, 1001 Wharf St., 3rd Floor, Victoria, British Columbia V8W 1T6 Canada. (604)388-4324. Fax: (604)388-6166. Art Director: Patricia Wade. Estab. 1977. Annual tourist magazines, travel trade manuals and conference planners featuring general information on shopping and attractions for the tourist market. Accepts previously published artwork. Original artwork returned to artist at the job's completion. Sample copies and art guidelines available.
Illustrations: Approached by 10 illustrators/year. Buys 20 illustrations/year. Prefers life-style and scenic themes and realistic styles; usually used in shopping or dining listings section. Considers watercolor and acrylic. Send query letter with tearsheets, photographs, slides and transparencies. Will accept computer-generated illustrations compatible with Adobe Illustrator 5.5 and Photoshop 3.0. "Please *no* CorelDraw—always horrible problems with this program at output bureaus." Samples are filed. Publication will contact artist for portfolio review if interested. Portfolio should include tearsheets, photographs and slides. Buys first, one-time or reprint rights. Sometimes requests work on spec before assigning job. Payment negotiable on publication.
Tips: Finds artists usually through art exhibitions and word of mouth.

KEYBOARD MAGAZINE, 411 Borel Ave., Suite #100, San Mateo CA 94402. (415)358-9500. Fax: (415)358-9527. Art Director: Paul Martinez. Estab. 1975. Monthly 4-color magazine focusing on keyboard and electronic instruments, technique, artist interviews, etc. Circ. 100,000. Original artwork is returned at job's completion. Sample copies and art guidelines not available.
Illustrations: Approached by 15-20 illustrators/year. Buys 3 illustrations/issue. Works on assignment only. Prefers conceptual, "outside, not safe" themes and styles. Considers pen & ink, watercolor, collage, airbrush, computer-based, acrylic, mixed media and pastel. Send query letter with brochure, tearsheets, photographs, photocopies, photostats, slides and transparencies. Samples are filed. Reports back only if interested. Publication will contact artist for portfolio review if interested. Portfolio should include printed samples and tearsheets. Buys first rights. Pays on publication; $100-250 for b&w, $100-600 for color inside.

‡KEYNOTER, Kiwanis International, 3636 Woodview Trace, Indianapolis IN 46268. (317)875-8755. Executive Editor: Julie Carson. Art Director: Jim Patterson. Official publication of Key Club International, nonprofit high school service organization. 4-color; "contemporary design for mature teenage audience." Published 7

times/year. Circ. 170,000. Previously published, photocopied and simultaneous submissions OK. Original artwork returned after publication. Free sample copy with SASE and 65¢ postage.
Illustrations: Buys 3 editorial illustrations/issue. Works on assignment only. Include SASE. Reports in 2 weeks. "Freelancers should call our Production and Art Department for interview." Buys first rights. **Pays on receipt of invoice**; $500 for b&w, $700 for color, cover; $200 for b&w, $500 for color, inside.

KID CITY MAGAZINE, 1 Lincoln Plaza, New York NY 10023. Art Director: Michele Weisman. For ages 6-10.
Illustrations: Approached by 1,000 illustrators/year. Buys 100 illustrations/year from freelancers. Query with color photocopied samples. Buys one-time rights. **Pays on acceptance**; $300 for b&w full page, $400 for color full page, $600 for color spread.
Tips: A common mistake freelancers make in presenting their work is "sending samples of work too babyish for our acceptance."

KIPLINGER'S PERSONAL FINANCE MAGAZINE, 1729 H St. NW, Washington DC 20006. (202)887-6416. Contact: Jenifer Walter. Estab. 1937. A monthly 4-color magazine covering personal finance issues including investing, saving, housing, cars, health, retirement, taxes and insurance. Circ. 1,300,000. Originals are returned at job's completion. Sample copies available.
Illustrations: Approached by 1,000 illustrators/year. Buys 15 illustrations/issue. Works on assignment only. Looking for original conceptual art. Interested in editorial illustration in new styles, including computer illustration. Send query letter with tearsheets and photocopies. Samples are filed or are returned by SASE if requested by artist. Publication will contact artist for portfolio review if interested. Portfolio should include tearsheets. Buys first rights. **Pays on acceptance**; $250-350 for spots.
Tips: "Send us high-caliber original work that shows creative solutions to common themes."

‡KIWANIS, 3636 Woodview Trace, Indianapolis IN 46268. (317)875-8755. Fax: (317)879-0204. Managing Editor: Chuck Jonak. Art Director: Jim Patterson. Estab. 1918. 4-color magazine emphasizing civic and social betterment, business, education and domestic affairs for business and professional persons. Published 10 times/year. Original artwork returned after publication.
Cartoons: Buys 30 cartoons/year. Interested in "daily life at home or work. Nothing off-color, no silly wife stuff, no blue-collar situations." Prefers finished cartoons. Send query letter with brochure showing art style or tearsheets, slides, photographs and SASE. Reports in 3-4 weeks. **Pays on acceptance**; $50 for b&w.
Illustrations: Works with 20 illustrators/year. Buys 3-6 illustrations/issue. Prefers pen & ink, airbrush, colored pencil, watercolor, acrylic, mixed media, calligraphy and paper sculpture. Interested in themes that correspond to themes of articles. Works on assignment only. Keeps material on file after in-person contact with artist. Include SASE. Reports in 2 weeks. To show a portfolio, mail appropriate materials (out of town/state) or call or write for appointment. Portfolio should include roughs, printed samples, final reproduction/product, color and b&w tearsheets, photostats and photographs. Buys first North American serial rights or negotiates. **Pays on acceptance**; $1,000 for full-color cover; $400-800 for full-color inside; $50-75 for spots.
Tips: Finds artists through talent sourcebooks, references/word-of-mouth and portfolio reviews. "We deal direct—no reps. Have plenty of samples, particularly those that can be left with us. Too many student or unassigned illustrations in many portfolios."

‡L.A. PARENT MAGAZINE, 443 E. Irving Dr., Burbank CA 91504. (818)846-0400. Fax: (818)841-4380. Editor: Jack Bierman. Estab. 1979. Tabloid. A monthly city magazine for parents of young children, b&w with 4-color cover; "bold graphics and lots of photos of kids and families." Circ. 100,000. Accepts previously published artwork. Originals are returned at job's completion. 80% of freelance work demands knowledge of Aldus PageMaker, Adobe Illustrator, Quark XPress, Aldus FreeHand MacPaint or MacDraw.
Cartoons: Uses cartoons relating to parenting issues. Include SASE with first-class postage. Pays $25 for b&w.
Illustrations: Buys 2 freelance illustrations/issue. Works on assignment only. Send query letter with samples. Samples are filed or returned by SASE. Reports back within 2 months. To show a portfolio, mail thumbnails, tearsheets and photostats. Buys one-time rights or reprint rights. **Pays on acceptance**; $300 color cover (may use only 1 color cover/year).
Tips: "Show an understanding of our publication. Since we deal with parent/child relationships, we tend to use fairly straightforward work."

‡LACROSSE MAGAZINE, 113 W. University Pkwy., Baltimore MD 21210-3300. (410)235-6882. Fax: (410)366-6735. Art Director: Jen Parvis. Estab. 1978. "*Lacrosse Magazine* includes opinions, news, features, 'how-to's' for fans, players, coaches, etc. of all ages." Published 8 times/year. Circ. 10,000. Accepts previously published work. Originals returned at job's completion. Sample copies available. Art guidelines not available. Needs computer-literate freelancers for illustration. Freelancers should be familiar with QuarkXPress or Aldus FreeHand.
Cartoons: Prefers ideas and issues related to lacrosse. Prefers single panel, b&w washes or b&w line drawings with gagline. Send query letter with finished cartoon samples. Samples are filed or returned by

SASE if requested. Reports back within 2 weeks. Rights purchased vary according to project. Pays $40 for b&w.

Illustrations: Approached by 1 freelance illustrator/year. Buys 1 illustration/year. Works on assignment only. Prefers ideas and issues related to lacrosse. Considers pen & ink, collage, marker and charcoal. Send query letter with photocopies. Samples are filed. Reports back within 2 weeks. Call for appointment to show portfolio of final art, b&w and color photocopies. Rights purchased vary according to project. Pays on publication; $100 for b&w, $150 for color cover; $75 for b&w, $100 for color inside.

Tips: "Learn/know as much as possible about the sport. Be patient."

LADYBUG, the Magazine for Young Children, Box 300, Peru IL 61354. Associate Art Director: Suzanne Beck. Estab. 1990. Monthly 4-color magazine emphasizing children's literature and activities for children, ages 2-7. Design is "geared toward maximum legibility of text and basically art-driven." Circ. 120,000. Accepts previously published material. Original artwork returned after publication. Sample copy $4; art guidelines for SASE.

Illustrations: Approached by 600-700 illustrators/year. Works with 40 illustrators/year. Buys 200 illustrations/year. Examples of artists used: Marc Brown, Cyndy Szekeres, Rosemary Wells, Tomie de Paola, Diane de Groat. Uses artists mainly for cover and interior illustration. Prefers realistic styles (animal, wildlife or human figure); occasionally accepts caricature. Works on assignment only. Send query letter with brochure, samples and tearsheets to be kept on file, "if I like it." Prefers photostats and tearsheets as samples. Samples are returned by SASE if requested. Publication will contact artist for portfolio review if interested. Portfolio should show a strong personal style and include "several pieces that show an ability to tell a continuing story or narrative." Does not want to see "overly slick, cute commercial art (i.e., licensed characters and overly sentimental greeting cards)." Buys reprint rights. Pays on publication; $750 for color cover; $250 for color full page.

Tips: "Has a need for artists who can accurately and attractively illustrate the movements for finger-rhymes and songs and basic informative features on nature and 'the world around you.' Multi-ethnic portrayal is also a *very* important factor in the art for *Ladybug*."

LAW PRACTICE MANAGEMENT, Box 11418, Columbia SC 29211-1418. (803)754-3563. Managing Editor/Art Director: Delmar L. Roberts. 4-color trade journal for the practicing lawyer. Estab. 1975. Published 8 times/year. Circ. 22,008. Previously published work rarely used. Needs computer-literate freelancers for illustration. 15% of freelance work demands computer skills.

Cartoons: Primarily interested in cartoons "depicting situations inherent in the operation and management of a law office, e.g., operating computers and other office equipment, interviewing, office meetings, lawyer/office staff situations, and client/lawyer situations. We use 2-4 cartoons/issue. Cartoons depicting courtroom situations are not applicable to an office management magazine." Send cartoons for consideration. Reports in 3 months. Usually buys all rights. **Pays on acceptance**; $50 for all rights.

Illustrations: Uses inside illustrations and, rarely, cover designs. Pen & ink, watercolor, acrylic, oil, collage and mixed media used. Currently uses all 4-color artwork. Send query letter with résumé. Reports in 3 months. Usually buys all rights. Pays on publication; $250-300 for color cover; $75-125 for b&w, $150-250 for 4-color inside.

Tips: "There's an increasing need for artwork to illustrate high-tech articles on technology in the law office. (We have two or more such articles each issue.) We're especially interested in computer graphics for such articles."

‡✤LEISURE WORLD, 1253 Ouellette Ave., Windsor, Ontario N8X 1J3 Canada. (519)971-3209. Fax: (519)977-1197. Editor: Douglas O'Neil. Estab. 1988. Bimonthly magazine. Reflects the leisure time activities of members of the Canadian Automobile Association. "Upscale" 4-color with travel spreads; b&w club news is 8-page insert. Circ. 340,000. Accepts previously published artwork. Original artwork returned at the job's completion. Sample copy for SASE with first-class stamp. Art guidelines available.

Illustrations: Needs people, travel illustration. Needs computer-literate freelancers for design and production in PC compatible format. Send query letter with photographs, slides, transparencies or disks. Most samples are filed. Those not filed are returned. Reports back in 1 month. Call or write for appointment to show portfolio or mail thumbnails, roughs, original/final art, b&w or color tearsheets, photostats, photographs, slides and photocopies. Pays $200 for b&w and color cover; $75 for b&w, $100 for color inside; $75 for spots.

LISTEN MAGAZINE, 55 W. Oak Ridge Dr., Hagerstown MD 21740. (301)791-7000. Editor: Lincoln Steed. Monthly magazine for teens with specific aim to educate against alcohol and other drugs and to encourage positive life choices. Circ. 50,000. Accepts previously published artwork. Originals returned at job's completion. Sample copies available. Art guidelines for SASE with first-class postage. Needs computer-literate freelancers for design and illustration. 10% of freelance work demands knowledge of CorelDraw, QuarkXPress and Aldus PageMaker.

Cartoons: Buys 1 cartoon/issue. Prefers single panel b&w washes and line drawings. Send query letter with brochure and roughs. Samples are filed. Reports back to the artist only if interested. Buys reprint rights. Pays $30 for b&w, $150 for color.
Illustrations: Approached by 50 illustrators/year. Buys 6 illustrations/issue. Works on assignment only. Considers all media. Send query letter with brochure, SASE and photostats. Samples are filed or are returned by SASE. Publication will contact artist for portfolio review if interested. Buys reprint rights. **Pays on acceptance**; $200 for b&w, $400 for color cover; $100 for b&w, $200 for color inside.

LOG HOME LIVING, 4451 Brookfield Corporate Dr., Suite 101, Chantilly VA 22021. (800)826-3893 or (703)222-9411. Fax: (703)222-3209. Art Director: Randy Pope. Estab. 1989. Bimonthly 4-color magazine "dealing with the aspects of buying, building and living in a log home. We emphasize upscale living (decorating, furniture, etc.)." Circ. 125,000. Accepts previously published artwork. Sample copies not available. Art guidelines available. Needs computer-literate freelancers for design and production. 20% of freelance work demands knowledge of QuarkXPress, Adobe Illustrator and Photoshop.
Cartoons: Prefers playful ideas about logs and living and wanting a log home.
Illustrations: Buys 2 illustrations/issue. Works on assignment only. Prefers editoral illustration with "a strong style—ability to show creative flair with not-so-creative a subject." Considers watercolor, airbrush, colored pencil and pastel. Send query letter with brochure, if possible, tearsheets and photocopies. Samples are filed. Publication will contact artist for portfolio review if interested. Portfolio should include thumbnails, roughs, printed samples, or color tearsheets. Buys all rights. **Pays on acceptance**; $50 for b&w, $200 for color inside.
Tips: Finds artists through artists' submissions/self-promotions, sourcebooks.

LONG ISLAND UPDATE, 990 Motor Parkway, Central Islip NY 11722. (516)435-8890. Fax: (516)435-8925. Editor: Cheryl A. Meglio. Estab. 1990. Monthly consumer magazine which covers events, entertainment and other consumer issues for general audience, ages 21-40, of Long Island area. Circ. 58,000. Originals returned at job's completion. Sample copies available. Art guidelines not available.
Illustrations: Approached by 25-30 illustrators/year. Buys 1 illustration/issue. Considers watercolor. Send query letter with résumé and tearsheets. Samples filed. Reports back within 7 weeks. Portfolio review not required. Buys first rights. Pays on publication; $25 for color inside.
Tips: Area most open to freelancers is humor page illustrations.

LONGEVITY, 277 Park Ave., New York NY 10172-0003. (212)702-6000. Art Director: Cathryn Mezzo. Estab. 1988. Monthly 4-color lifestyle publication with a practical guide to the art and science of staying young. Reaches women readers ages 25 to 50 years old. "This is not a magazine for the elderly." Accepts previously published artwork. Originals are returned at job's completion. Sample copies and art guidelines not available.
● *Longevity* has a new format and now uses fewer illustrations.
Illustrations: Buys 5-10 illustrations/year. "Artists should come up with good solutions to problems." Needs editorial, technical and medical illustration. Send query letter with tearsheets, photographs, photocopies and slides. Samples are filed and are not returned. Publication will contact artist for portfolio review if interested. Portfolio should include tearsheets, slides, photostats and photographs. Buys first rights. Pays on publication; $1,500 for color cover.

THE LOOKOUT, 8121 Hamilton Ave., Cincinnati OH 45231. (513)931-4050. Art Coordinator: Richard Briggs. Weekly 4-color magazine for conservative Christian adults and young adults. "We work with basic 2- or 3-column grids, but flexible." Circ. 120,000. Original artwork not returned after publication, unless requested. Sample copy and art guidelines available for 50¢. Needs computer-literate freelancers for illustration. Freelancers should be familiar with Adobe Illustrator, QuarkXPress or Aldus FreeHand.
Cartoons: Prefers cartoons on family life and religious/church life; mostly single panel. Pays $35 for b&w.
Illustrations: Buys 1-3 illustrations/issue. Interested in "adults, families, interpersonal relationships; also, graphic treatment of titles." Works on assignment only. Send query letter with brochure, flier or tearsheets to be kept on file. Reporting time varies. Request portfolio review in original query. Buys all rights but will reassign. **Pays on acceptance**; $200 for b&w cover; $150 for b&w, $200 for color inside.
Tips: Finds artists through word of mouth, other magazines and self-promotions. "We use a variety of styles, but mainly realistic and impressionistic. The design of magazine is conservative, in that we are not avant-garde in design—but we're not always locked in a standard grid."

‡LOS ANGELES MAGAZINE, 1888 Century Park E., Los Angeles CA 90067. (310)557-7592. Fax: (310)557-7517. Design Director: Rip Georges. Art Director: Leane Brenes. Monthly 4-color magazine with a contemporary, modern design, emphasizing life-styles, cultural attractions, pleasures, problems and personalities of Los Angeles and the surrounding area. Circ. 170,000. Especially needs very localized contributors—custom projects needing person-to-person concepting and implementation. Previously published work OK. Pays on publication. Sample copy $3. Needs computer-literate freelancers for illustration. 10% of freelance work demands knowledge of QuarkXPress, Adobe Illustrator and Photoshop.

Illustrations: Buys 10 illustrations/issue on assigned themes. Prefers general interest/life-style illustrations with urbane and contemporary tone. To show a portfolio, send or drop off samples showing art style (tearsheets, photostats, photocopies and dupe slides). Pays on publication; $400 for color cover; $150 for b&w and $1,000 for color inside.

Tips: "Show work similar to that used in the magazine—a sophisticated style. Study a particular publication's content, style and format. Then proceed accordingly in submitting sample work. We initiate contact of new people per *Showcase* reference books or promo fliers sent to us. Portfolio viewing is all local."

THE LUTHERAN, 8765 W. Higgins Rd., Chicago IL 60631. (312)380-2540. E-mail: lutheran_maga zine.partl@ecunet.org. Art Director: Jack Lund. Estab. 1988. Monthly general interest magazine of the Evangelical Lutheran Church in America; 4-color, "contemporary" design. Circ. 850,000. Previously published work OK. Original artwork returned after publication on request. Free sample copy for 9×12 SASE and 5 first-class stamps. Cartoon guidelines available. Needs computer-literate freelancers for illustration. Freelancers should be familiar with Adobe Illustrator, QuarkXPress or Adobe Photoshop.

Cartoons: Approached by 100 cartoonists/year. Buys 2 cartoons/issue from freelancers. Interested in humorous or thought-provoking cartoons on religion or about issues of concern to Christians; single panel b&w washes and line drawings with gaglines. Prefers finished cartoons. Send query letter with photocopies or finished cartoons and SASE. Reports usually within 2 weeks. Buys one time rights. Pays on publication; $50-100 for b&w line drawings and washes.

Illustrations: Buys 6 illustrations/year from freelancers. Works on assignment. Does not use spots. Send samples of style to keep on file for future assignments. Buys all rights on a work-for-hire basis. Samples returned by SASE if requested. Portfolio review not required. Pays on publication; $400 for color cover; $150-350 for b&w, $400 for color inside.

Tips: Finds artists mainly through artists' submissions. "Include your phone number with submission. Send samples that can be retained for future reference. We are partial to computer illustrations. Would like to see samples of charts and graphs."

‡MAGICAL BLEND, 133½ Broadway, Chico CA 95928. (916)893-9037. Art Direction: Matthew Courtway and Yuka Hirota. Estab. 1980. Quarterly 4-color magazine emphasizing spiritual exploration, transformation and visionary arts; eclectic design. Circ. 57,000. Original artwork returned after publication. Sample copy $5; art guidelines for SASE.

Illustrations: Works with 20 illustrators/year. Uses 65 illustrations/year. Also publishes 2-3 portfolios on individual artists per issue. "We keep samples on file and work by assignment according to the artists and our time table and workability. We prefer color work. We look for pieces with a positive, inspiring, uplifting feeling." Interested in computer illustrators familiar with Photoshop. Send photographs, slides and SASE. Reports in 1 week to 6 months. Buys first North American serial rights. Pays in copies. Will print contact information with artwork if desired by artist.

Tips: "We want work that is energetic and thoughtful, and that has a hopeful outlook on the future. Our page size is 8½×11. High-quality, camera-ready reproductions are preferable over originals. We like to print quality art by people who have talent, but don't fit into any category and are usually unpublished."

MAINSTREAM, Magazine of the Able-Disabled, 2973 Beech St., San Diego CA 92102. (619)234-3138. E-mail: wstothers@aol.com. Editor: William G. Stothers. Estab. 1975. Black & white consumer magazine with 4-color cover "serving active, upscale men and women with disabilities, with emphasis on disability rights." Published 10 times/year. Circ. 19,400. Originals are returned at job's completion. Sample copy available for $5. Art guidelines not available.

Cartoons: Approached by 20 cartoonists/year. Prefers themes and styles that say "disability *can* be funny to disabled people." Prefers b&w line drawings, single panel. Send query letter with brochure and finished cartoons. Samples are filed or are returned by SASE if requested by artist. Reports back within 2 months only if interested. Negotiates rights purchased. Pays $25 for b&w.

Illustrations: Approached by 20 illustrators/year. Buys few illustrations/year. Works on assignment only. Considers pen & ink, acrylic, colored pencil and oil. Send postcard-size sample. Samples are filed. or are returned by SASE if requested by artist. Reports back within 2 months only if interested. Portfolio review not required. Requests work on spec before assigning a job. Negotiates rights purchased. Pays on publication; $35 for b&w.

MANAGEMENT ACCOUNTING, 10 Paragon Dr., Montvale NJ 07645. (201)573-6269. Assistant Publisher: Robert F. Randall. Estab. 1919. Monthly 4-color with a 3-column design emphasizing management accounting for management accountants, controllers, chief accountants and treasurers. Circ. 85,000. Accepts simultaneous submissions. Originals are returned after publication. Sample copy free for SASE.

Cartoons: Approached by 15 cartoonists/year. Buys 12 cartoons/year. Prefers single panel b&w line drawings with gagline. Topics include office, financial, business-type humor. Send finished cartoons. Material not kept on file is returned by SASE. Reports within 2 weeks. Buys one-time rights. **Pays on acceptance**; $25 for b&w.

Illustrations: Approached by 6 illustrators/year. Buys 1 illustration/issue.
Tips: No sexist cartoons.

‡**MANAGEMENT REVIEW**, 135 W. 50th St., New York NY 10020. (212)903-8058. Fax: (212)903-8083. E-mail: sevp@aol.com. Art & Production Director: Seval Newton. Estab. 1921. Monthly company "business magazine for senior managers. A general, internationally-focused audience." 64-page 4-color publication. Circ. 80,000. Original artwork returned after publication. Tearsheets available.
Cartoons: Approached by 10-20 cartoonists/year. Buys 1-2 cartoons/issue. Prefers "business themes and clean drawings of minority women as well as men." Prefers double panel; washes and line drawings. Send query letter with copies of cartoons. Selected samples are filed. Will call for b&w or 4-color original when placed in an issue. (Do not send originals). Buys first rights. Pays $100 for b&w, $200 for color.
Illustrations: Approached by 50-100 illustrators/year. Buys 10-20 illustrations/issue. Electronic chart and graph artists welcome. Works on assignment only. Prefers business themes and strong colors. Considers airbrush, watercolor, collage, acrylic and oil. Needs computer-literate freelancers for design and illustration. 20% of freelance work demands knowledge of Adobe Illustrator, QuarkXPress, Photoshop or Deltagraph. Send query letter with tearsheets, photographs and slides. Samples are filed. Reports back only if interested. To show a portfolio, mail printed samples and b&w tearsheets, photographs and slides or "drop off portfolio at the above address, 15th floor, Office Services window. Portfolio will be ready to pick up after two days." Buys first rights. **Pays on acceptance**; $800-900 for color cover; $250-300 for b&w, $350-400 for color inside.
Tips: "Send tearsheets; periodically send new printed material. The magazine is set on the Mac. Any computer illustration helps cut down scanning costs."

‡**MAÑANA**, P.O. Box 4590, Austin TX 78765-4590. (512)323-9350. Fax: (512)847-1022. E-mail: sfeher@ mail.utexas.edu. Managing Editor: Sonya Fehér. Estab. 1994. Bimonthly literary magazine. Circ. 1,000. Accepts previously published artwork. Originals returned at job's completion. Sample copies available for $3.50. Art guidelines free for SASE with first-class postage.
Cartoons: Approached by 3 cartoonists/year. Prefers nonviolent, short, satirical, entertaining. Prefers single, double and multiple panel; political, humorous, b&w washes and line drawings; with or without gagline. Send query letter with finished cartoons. Samples are not filed and are returned by SASE. Reports back within 2 months. Acquires one-time rights. Pays 1 copy for b&w.
Illustrations: Buys 2-3 illustrations/issue. Open to all themes and styles. Considers b&w, pen & ink, collage, charcoal, marker and pencil. Send query letter with tearsheets, SASE and photocopies. Samples are not filed and are returned by SASE. Reports back within 2 months. Portfolio review not required. Acquires one-time rights. Pays 1 copy for b&w cover; 1 copy for b&w inside; 1 copy for spots.

‡**MARRIAGE PARTNERSHIP**, Christianity Today, Inc., 465 Gundersen Dr., Carol Stream IL 60188. (708)260-6200. Fax: (708)260-0114. Art Director: Gary Gnidovic. Estab. 1988. Quarterly consumer magazine. "We seek to strengthen and encourage healthy marriages. Read by couples aged 23-55 most of them Christians with kids at home." Circ. 75,000. Accepts previously published artwork. Original artwork is returned after publication. Sample copies available upon assignment. Art guidelines available.
Cartoons: Contact Barbara Calvert, editorial coordinator. Approached by 20 cartoonists/year. Buys 10 freelance cartoons/issue. Preferred themes are marriage, home life, family relationships. Prefers single panel. Send query letter with finished cartoons. Samples are not filed and are returned by SASE. Reports back within 1 month. Buys first rights. Pays $50, b&w.
Illustrations: Approached by 50 illustrators/year. Buys 20 illustrations/issue. Works on assignment only. Themes/styles vary. Accepts any medium. Send query letter with tearsheets and photocopies. Samples are filed. Reports back only if interested. To show a portfolio, mail tearsheets, photocopies and promo pieces. Buys first rights. **Pays on acceptance**; $200-600, color and b&w.

‡**THE MERCEDES-BENZ STAR**, Dept. AGDM, 1235 Pierce St., Lakewood CO 80214. (303)235-0116. Editor: Frank Barrett. Estab. 1956. Bimonthly magazine emphasizing new and old Mercedes-Benz automobiles for members of the Mercedes-Benz Club of America and other automotive enthusiasts. Circ. 25,000. Does not usually accept previously published material. Returns original artwork after publication. Sample copy for SASE with $2 postage.
Illustrations: Works with 3 illustrators/year. Buys 20 illustrations/year. Uses freelancers mainly for technical illustration. Prefers Mercedes-Benz related themes. Looks for authenticity in subject matter. Prefers pen & ink, airbrush and oil. Send query letter with résumé, slides or photographs to be kept on file except for material requested to be returned. Write for appointment to show portfolio. Samples not filed are returned by SASE. Buys first rights. Pays on publication; $100-1,500.
Tips: " In a portfolio, include subject matter similar to ours."

METRO NEWSPAPERS, 550 S. First St., San Jose CA 95113. (408)298-8000. Fax: (408)298-0602. E-mail: darin@livewire.com. Contact: Design Director. Estab. 1985. A general interest urban alternative weekly newspaper covering local politics, entertainment and lifestyle. Circ. 80,000. Accepts previously published

artwork. Original artwork is returned at job's completion. Sample copies for $3. Art guidelines not available.
Cartoons: Approached by dozens of cartoonists/year. Buys less than 10 cartoons/year. Prefers sophisticated humor. Send query letter with finished cartoons. Samples are filed or returned by SASE. Reports back within 2 months. Buys one-time rights. Pays $25 for b&w. Contact: Editor (for cartoons only).
Illustrations: Approached by dozens of illustrators/year. Buys 25 illustrations/year. Works on assignment only. Send query letter with printed, preferably 4-color samples and SASE. Samples are filed or returned by SASE. Reports back within 2 months. To show portfolio, mail appropriate materials, then call. Buys one-time rights. Pays on publication; rates vary.
Tips: Finds artists through word of mouth. "Exhibit versatility, work fast, be flexible. Review publication to see what we've run in the past."

‡**MICHIGAN NATURAL RESOURCES**, 30700 Telegraph Rd., Suite 1401, Bingham Arms MI 48025. (810)642-9580. Fax: (810)642-5290. Creative Director: Kathleen Kolka. Estab. 1930. Bimonthly consumer magazine. "*Michigan Natural Resources* magazine is the official publication of Michigan's Department of Natural Resources. It's Michigan's oldest outdoor publication. Kolka & Robb Inc. have a seven-year contract to publish magazine." Circ. 90,000. Accepts previously published artwork. Originals returned at job's completion. Art guidelines available. Needs computer-literate freelancers for design, illustration and production. 100% of freelance work demands knowledge of Adobe Illustrator, QuarkXPress and Adobe Photoshop.
Cartoons: Approached by 3 cartoonists/year. Buys 2-6 cartoons/year. Prefers double panel, humorous drawings, b&w and color washes. Send query letter with slides or laser copies of finished work. Samples are filed or returned by SASE if requested by artist. Reports back to the artist only if interested. Buys reprint rights or negotiates rights purchased. Pays $50 for b&w, $75 for color.
Illustrations: Approached by 8-12 illustrators/year. Buys 9-16 illustrations/issue. Prefers bright, crisp and loose style—decorative art, wildlife, flowers, natural outdoor scenery. Considers pen & ink, mixed media, watercolor, acrylic, oil and pastel. Send query letter with résumé, slides and photocopies. Samples are filed. Publication will contact artist for portfolio review if interested. Portfolio should include b&w and color tearsheets, slides (duplicates for files) . Rights purchased vary according to project. Pays on publication.
Tips: Finds artists through artists' submissions.

MILITARY LIFE MAGAZINE, (formerly *Military Lifestyle Magazine*), 4800 Montgomery Lane, Suite 710, Bethesda MD 20814. Fax: (301)718-7604. Design Director: Judi Connelly. Estab. 1969. Emphasizes active-duty military life-styles for military families; 4-color; "open, lively, colorful but fairly traditional in design." Published 12 times/year. Circ. 100,000. Original artwork returned after publication. Sample copy for $1.50.
Illustrations: Approached by 30-35 illustrators/year. Buys 2-6 illustrations/issue. Uses artists mainly for features. Theme/style depends on editorial content. Works on assignment only. Send brochure and business card to be kept on file. Accepts photostats, recent tearsheets, photocopies, slides, photographs, etc., as nonreturnable samples. Samples returned only if requested. Reports only if interested. Buys first rights. Pays on publication; $200-600 depending on size published for cover and inside.

MILLER FREEMAN, INC., 600 Harrison St., San Francisco CA 94107. (415)905-2200. Fax: (415)905-2236. E-mail: abrokeri@mfi.com. Graphics Operations Manager: Amy R. Brokering. Publishes over 50 monthly and quarterly 4-color business and special-interest consumer magazines serving the paper, travel, retail, real estate, sports, design, forest products, computer, music, electronics and medical markets. Circ. 20,000-150,000. Returns original artwork after publication. Needs computer-literate freelancers for design and illustration. 50% of freelance work demands knowledge of QuarkXPress, Adobe Illustrator or Photoshop.
Illustrations: Approached by 300 illustrators/year. Uses freelancers mainly for illustration of feature articles. Needs editorial, technical and medical illustration. (No cartoons please.) Buys numerous illustrations/year. Works on assignment only. Send query letter with printed samples to be kept on file. Do not send photocopies or original work. Samples not filed are returned by SASE. Reports back only if interested. "No phone queries, please." Negotiates rights purchased. **Pays on acceptance**.

MODERN MATURITY, Dept. AGDM, 3200 E. Carson, Lakewood CA 90712. (213)496-2277. Art Director: James H. Richardson. Estab. 1956. Bimonthly 4-color magazine emphasizing health, lifestyles, travel, sports, finance and contemporary activities for members 50 years and over. Circ. 21 million. Previously published work OK "in some instances." Originals are returned after publication. Sample copy available for SASE.
Illustrations: Approached by 200 illustrators/year. Buys 8 freelance illustrations/issue. Works on assignment only. Considers watercolor, collage, oil, mixed media and pastel. Samples are filed "if I can use the work. Do not send anything you wish to have returned." Reports back to the artist only if interested. Publication will contact artist for portfolio review if interested. Portfolio should include original/final art, tearsheets, slides and photocopies. Buys first rights. **Pays on acceptance**; $600 for b&w; $2,000 for color cover; $1,200 for color inside, full page.
Tips: "We generally use people with a proven publications track record. I request tearsheets of published work when viewing portfolios."

‡**MODERN PLASTICS**, 1221 Avenue of Americas, New York NY 10020. (212)512-3491. Art Director: Bob Barravecchia. Monthly trade journal emphasizing technical articles for manufacturers of plastic parts and

machinery; 4-color with contemporary design. Circ. 60,000. Needs computer-literate freelancers for design and illustration. 20% of freelance work demands knowledge of Adobe Illustrator, Quark XPress or Aldus FreeHand.
Illustrations: Works with 4 illustrators/year. Buys 4 illustrations/year. Prefers airbrush and conceptual art. Works on assignment only. Send brochure. Samples are filed. Does not report back. Call for appointment to show portfolio of tearsheets, photographs, slides, color and b&w. Buys all rights. **Pays on acceptance**; $800-1,000 for color cover; $150 for color inside.

‡**MOMENT**, 4710 41st St. NW, Washington DC 20016. (202)364-3300. Fax: (202)364-2636. Managing Editor: Suzanne Singer. Contact: Andres Silow-Carroll, senior editor. Estab. 1973. Bimonthly Jewish magazine, featuring articles on religion, politics, culture and Israel. Circ. 45,000. Accepts previously published artwork. Originals returned at job's completion. Sample copies available for $4.50.
Cartoons: Uses reprints and originals. Prefers political themes relating to Middle East, Israel and contemporary Jewish life. Samples are filed. Reports back only if interested. Rights purchased vary according to project. Pays minimum of $30 for ¼ page, b&w and color.
Illustrations: Buys 5-10 illustrations/year. Works on assignment only. Send query letter. Samples are filed. Reports back only if interested. Rights purchased vary according to project. Pays $30 for b&w, $225 for color cover; $30 for color inside (¼ page or less).
Tips: "We look for specific work or style to illustrate themes in our articles. Please know the magazine—read back issues!"

‡**THE MORGAN HORSE**, Box 960, Shelburne VT 05482. (802)985-4944. Art Director: Rob Minero. Emphasizes all aspects of Morgan horse breed including educating Morgan owners, trainers and enthusiasts on breeding and training programs; the true type of the Morgan breed, techniques on promoting the breed, howto articles, as well as preserving the history of the breed. Monthly. Circ. 10,000. Accepts previously published material, simultaneous submissions. Original artwork returned after publication. Sample copy $4.
Illustrations: Approached by 10 illustrators/year. Buys 2-5 illustrations/year. Uses artists mainly for editorial illustration and mechanical production. "Line drawings are most useful for magazine work. We also purchase art for promotional projects dealing with the Morgan horse—horses must look like *Morgans*." Send query letter with samples and tearsheets. Accepts "anything that clearly shows the artist's style and craftsmanship" as samples. Samples are returned by SASE. Reports within 6-8 weeks. Call or write for appointment to show portfolio. Buys all rights or negotiates rights purchased. **Pays on acceptance**; $25-100 for b&w; $100-300 for color inside.
Tips: As trend sees "more of an effort on the part of art directors to use a broader style. Magazines seem to be moving toward more interesting graphic design. Our magazine design is a sophisticated blend of conservative and tasteful contemporary design. While style varies, the horses in our illustrations must be unmistakably Morgans."

‡**MOTHER JONES**, 731 Market St., San Francisco CA 94103. (415)665-6637. Fax: (415)665-6696. Creative Director: Kerry Tremain. Estab. 1976. Bimonthly magazine. Focuses on progressive politics and exposés. Circ. 120,000. Accepts previously published artwork. Originals returned at job's completion. Sample copies available. Needs computer-literate freelancers for illustration. Freelancer should be familiar with QuarkXPress and Adobe Photoshop.
Cartoons: Approached by 25 cartoonists/year. Buys 1 cartoon/issue. Prefers single panel, political b&w line drawings. Send query letter with postcard-size sample or finished cartoons. Samples are filed or returned by SASE if requested by artist. Reports back to the artist only if interested. Buys first rights.
Illustrations: Approached by hundreds of illustrators/year. Works on assignment only. Considers pen & ink, colored pencil, mixed media, watercolor, acrylic and oil. Send postcard-size sample or query letter with any samples. Samples are filed or returned by SASE if requested by artist. Reports back to the artist only if interested. Portfolio should include photographs, slides and tearsheets. Buys first rights. Pays on publication; payment varies widely.
Tips: Finds artists through illustration books; other magazines; "word of mouth is always key."

‡**MOTOR MAGAZINE**, Dept. AGDM, 645 Stewart Ave., Garden City NY 11530. (516)227-1309. Art Director: Don Wilbur. Estab. 1903. Emphasizes automotive technology, repair and maintenance for auto mechanics and technicians. Monthly. Circ. 140,000. Accepts previously published material. Original artwork returned after publication if requested. Never send unsolicited original art.
Illustrations: Buys 5-15 illustrations/issue. Works on assignment only. Prefers realistic, technical line renderings of automotive parts and systems. Send query letter with résumé and photocopies to be kept on file. Will call for appointment to see further samples. Samples not filed are not returned. Reports only if interested. Buys one-time rights. Write for appointment to show portfolio of final reproduction/product and color tearsheets. **Pays on acceptance**; negotiable for cover, basically $300-1,500; $50-500 for b&w inside.
Tips: "*Motor* is an educational, technical magazine and is basically immune to illustration trends because our drawings *must* be realistic and technical. As design trends change we try to incorporate these into our magazine (within reason). Though *Motor* is a trade publication, we approach it, design-wise, as if it were a

consumer magazine. We make use of white space when possible and use creative, abstract and impact photographs and illustration for our opening pages and covers. But we must always retain a 'technical look' to reflect our editorial subject matter. Publication graphics is becoming like TV programming, more calculating and imitative and less creative."

‡**MS. MAGAZINE**, 230 Park Ave., New York NY 10169. (212)551-9595. Fax: (212)551-9384. Estab. 1972. Bimonthly consumer magazine emphasizing feminist news, essays, arts. Circ. 150,000. Originals returned at job's completion. Art guidelines not available.
Cartoons: Approached by 50 cartoonists/year. Buys 3-4 cartoons/issue. Prefers women's issues. Prefers single panel political, humorous b&w line drawings. Send query letter with photocopied finished cartoons. Samples sometimes filed or returned by SASE if requested by artist. Does not report back. Buys one-time rights. Pays $100 for b&w.
Illustrations: Approached by hundreds of illustrators/year. Buys 10 illustrations/issue. Works on assignment only. "Work must reproduce well in 2-color." Considers pen & ink, mixed media and collage. Send postcard-size sample. Samples sometimes filed and are not returned. Does not report back. Portfolio review not required. Portfolios may be dropped off every Tuesday. Publication will contact artist for portfolio review of final art if interested. Buys one time rights. Pays on publication.
Tips: Finds artists through word of mouth and artists' submissions.

‡✿**MUSCLEMAG INTERNATIONAL**, 6465 Airport Rd., Mississauga, Ontario L4V 1E4 Canada. (905)678-7311. Contact: Robert Kennedy. Estab. 1974. Monthly consumer magazine. Magazine emphasizes bodybuilding and fitness for men and women. Circ. 300,000. Originals returned at job's completion. Sample copies available for $5. Art guidelines available.
Cartoons: "We are interested in acquiring a cartoonist to produce one full-page cartoon each month. Send photocopy of your work." Pays $650.
Illustrations: Approached by 200 illustrators/year. Buys 70 illustrations/year. Prefers bodybuilding themes. Considers all media. Send query letter with photocopies. Samples are filed. Reports back within 1 month. Portfolio review not required. Buys all rights. **Pays on acceptance**; $100 for b&w, $150 for color inside. "Higher pay for high-quality work."
Tips: Needs line drawings of bodybuilders exercizing. "Finds artists through submissions from artists who see our magazine."

MUSHING, P.O. Box 149, Ester AK 99725-0149. Phone/Fax: (907)479-0454. Publisher: Todd Hoener. Estab. 1988. Bimonthly "year-round, international magazine for all dog-powered sports, from sledding to skijoring to weight pulling to carting to packing. We seek to educate and entertain." Circ. 10,000. Photo/art originals are returned at job's completion. Sample copies available for $4. Art guidelines available for SASE with first-class postage.
Cartoons: Approached by 10 cartoonists/year. Buys 1 cartoon/issue. Prefers humorous cartoons; single panel b&w line drawings with gagline. Send query letter with roughs. Samples are not filed and are returned by SASE if requested by artist. Reports back with 1-6 months. Buys first rights and reprint rights. Pays $25 for b&w and color.
Illustrations: Approached by 10 illustrators/year. Buys 0-1 illustrations/issue. Prefers simple; healthy, happy sled dogs; some silhouettes. Considers pen & ink and charcoal. Send query letter with SASE and photocopies. Samples are returned by SASE if requested by artist. Reports back within 1-6 months. Portfolio review not required. Buys first rights. Pays on publication; $130 for color cover; $25 for b&w, $25 for color inside; $25 for spots.
Tips: Finds artists through artists' submissions. "Be familiar with sled dogs and sled dog sports. We're most open to using freelance illustrations with articles on dog behavior, adventure stories, health and nutrition. Illustrations should be faithful and/or accurate to the sport. Cartoons should be faithful and tasteful (e.g., not inhumane to dogs)."

MY FRIEND, 50 St. Paul's Ave., Boston MA 02130-3491. (617)522-8911. Contact: Graphic Design Dept. Estab. 1979. Monthly Catholic magazine for kids, b&w with 4-color cover, containing information, entertainment, and Christian information for young people ages 6-12. Circ. 14,000. Originals returned at job's completion. Sample copies free for 9×12 SASE with first-class postage. Art guidelines available.
Illustrations: Approached by 60 illustrators/year. Buys 6 illustrations/issue; 60/year. Works on assignment only. Prefers humorous, realistic portrayals of children. Considers pen & ink, watercolor, airbrush, acrylic,

The double dagger before a listing indicates that the listing is new in this edition. New markets are often more receptive to freelance submissions.

marker, colored pencil, oil, charcoal, mixed media and pastel. Send query letter with brochure, résumé, SASE, tearsheets, photographs, photocopies, slides and transparencies. Samples are filed or are returned by SASE if requested by artist. Reports back to the artist within 1-2 months only if interested. Portfolio review not required. Rights purchased vary according to project. Pays on publication; $200 for color cover; $100, for full page b&w and color inside.

NA'AMAT WOMAN, 200 Madison Ave., New York NY 10016. (212)725-8010. Fax: (212)447-5187. Editor: Judith Sokoloff. Estab. 1926. Jewish women's magazine published 5 times yearly, covering a wide variety of topics that are of interest to the Jewish community, affiliated with NA'AMAT USA (a nonprofit organization). Originals are returned at job's completion. Sample copies available for $1.
Cartoons: Approached by 5 cartoonists/year. Buys 4-5 cartoons/year. Prefers political cartoons; single panel b&w line drawings. Send query letter with brochure and finished cartoons. Samples are filed or are returned by SASE if requested by artist. Reports back to the artist only if interested. Rights purchased vary according to project. Pays $50 for b&w.
Illustrations: Approached by 10 illustrators/year. Buys 1-3 illustrations/issue. Works on assignment only. Considers pen & ink, collage, marker and charcoal. Send query letter with tearsheets. Samples are filed or are returned by SASE if requested by artist. Reports back to the artist only if interested. Publication will contact artist for portfolio review if interested. Portfolio should include b&w tearsheets and final art. Rights purchased vary according to project. Pays on publication; $150 for b&w cover; $50-75 for b&w inside.
Tips: Finds artists through sourcebooks, publications, word of mouth, artists' submissions. "Give us a try! We're small, but nice."

NAILS, 2512 Artesia Blvd., Redondo Beach CA 90278. (310)376-8788. Fax: (310)798-2472. Art Director: Jennifer Brandes. Estab. 1983. Monthly 4-color trade journal; "seeks to educate readers on new techniques and products, nail anatomy and health, customer relations, chemical safety, salon sanitation and business." Circ. 52,000. Originals are not returned at job's completion. Sample copies available. Art guidelines vary. Needs computer-literate freelancers for design, illustration and production. 30% of freelance work demands knowledge of QuarkXPress, Adobe Illustrator or Photoshop.
Cartoons: Prefers cartoons on "cities or caricatures, comic strip style if any." Payment depends on size and style of job.
Illustrations: Approached by 30 illustrators/year. Buys 2 illustrations/issue. Works on assignment only. Needs editorial and technical illustration; charts and sport art. Prefers "bright, upbeat styles." Interested in all media. Send query letter with brochure and tearsheets. Samples are filed. Reports back within 1 month or artist should follow-up with call. Call for an appointment to show a portfolio of tearsheets and transparencies. Buys all rights. **Pays on acceptance**; $200-500 (depending on size of job) for b&w and color inside.
Tips: Finds artists through self-promotion and word of mouth. "Professional presentation of artwork is important."

THE NATION, 72 Fifth Ave., New York NY 10011. (212)242-8400. Associate Editor: Micah Sifry. Estab. 1865. "We are a weekly journal of left/liberal political opinion, covering national and international affairs, literature and culture." Circ. 100,000. Originals are returned after publication upon request. Sample copies available. Art guidelines not available.
Illustrations: Approached by 50 illustrators/year. Buys illustrations mainly for spots and feature spreads. Buys 3-4 illustrations/issue. Works with 25 illustrators/year. Works on assignment only. Considers pen & ink, airbrush, mixed media and charcoal pencil; b&w only. Send query letter with tearsheets and photocopies. "On top of a defined style, artist must have a strong and original political sensibility." Samples are filed or are returned by SASE. Reports back only if interested. Call for appointment to show portfolio, or mail appropriate materials. Buys first rights. Pays $150 for b&w cover; $75 for b&w inside.

NATIONAL BUSINESS EMPLOYMENT WEEKLY, P.O. Box 300, Princeton NJ 08543-0300. (609)520-7311. Fax: (609)520-4309. Art Director: Larry Nanton. Estab. 1981. Weekly newspaper covering job search and career guidance for middle-senior level executives. Circ. 33,000. Originals returned at job's completion.
Cartoons: Buys 1 cartoon/issue. Subject must pertain to some aspect of job hunting; single panel b&w washes and line drawings with or without gagline. Send query letter with finished cartoons. Samples are not filed and are returned by SASE. Reports back to the artist only if interested. Buys first rights. Pays $50 for b&w.
Illustrations: Approached by 12 illustrators/year. Buys 2 illustrations/issue. Works on assignment only. Prefers b&w images and designs of people in all stages of the job search. Considers pen & ink, watercolor, airbrush and pencil. Send query letter with tearsheets. Samples are filed. Reports back to the artist only if interested. Portfolio review not required. Buys one-time rights and reprint rights. Pays on publication; $125 for b&w inside.
Tips: "Artist should have a good imagination, nice sense of design and be competent in drawing people."

NATIONAL DRAGSTER, 2220 E. Alosta Ave., Suite 101, Glendora CA 91740. Fax: (818)335-6651. Art Director: Jill Flores. Estab. 1959. Weekly drag racing b&w tabloid with 4-color cover and "tabazine" style

design distributed to 80,000 association (NHRA) members. "The nation's leading drag racing weekly." Circ. 80,000. Accepts previously published artwork. Originals are not returned after publication. Sample copies available upon request. Art guidelines not available.

Cartoons: Buys 5-10 cartoons/year. Prefers drag racing theme. Prefers single panel b&w line drawings and washes with gagline. Send query letter with samples of style. Samples are filed. Reports back only if interested. Negotiates rights purchased. Pays on publication: minimum $50 for b&w.

Illustrations: Buys illustrations for covers, full-page special features and spots. Buys 10-20 illustrations/year. Style is modern creative image, line or wash, sometimes humorous, style of Don Weller. Will accept computer-generated illustrations on disk, compatible with Macintosh programs: QuarkXPress, FreeHand, Adobe Illustrator and Photoshop. Needs editorial and technical illustration. Prefers drag racing-oriented theme, rendered in pen & ink, airbrush, mixed media or markers, with vibrant use of color. Send query letter with brochure showing art style, tearsheets, photostats and photocopies. Looks for realistic automotive renderings. Samples are filed. Reports back only if interested. Publication will contact artist for portfolio review if interested. Portfolio can include printed copies, tearsheets, photostats and photographs. Negotiates rights purchased. Pays on publication; $100 for b&w inside.

Tips: Send "concept drawings, drag racing illustrations (actual cars, cut-aways, etc.). Send me samples that knock me out of my chair. Do not have to be drag racing-related. I love to get samples."

‡NATIONAL ENQUIRER, Dept. AGDM, Lantana FL 33464. (407)586-1111. Assistant Editor: Joan Cannata-Fox. A weekly tabloid. Circ. 3.8 million. Originals are returned at job's completion.

Cartoons: "We get 1,500-2,000 cartoons weekly." Buys 7-10 cartoons/issue. Prefers animal, family, husband/wife and general themes. Nothing political or off-color. Prefers single panel b&w line drawings and washes with or without gagline. Send query letter with finished cartoons and SASE. Samples are not filed and are returned only by SASE. Reports back within 2-3 weeks. Buys first and one-time rights. Pays $300 for b&w plus $40 each additional panel.

Tips: "Study several issues to get a solid grasp of what we buy. Gear your work accordingly."

NATIONAL GARDENING, 180 Flynn Ave., Burlington VT 05401. (802)863-1308. Fax: (802)863-5962. E-mail: 76711.345@compuserve.com. Art Director: Linda Provost. Estab. 1980. Bimonthly magazine "specializing in edible and ornamental gardening; environmentally conscious; fun and informal but accurate; a gardener-to-gardener network." 4-color design is "crisp but not slick, fresh but not avant-garde—colorful, informative, friendly, practical." Circ. 200,000. Sometimes accepts previously published artwork. Original artwork returned after publication. Sample copies available. Art guidelines not available. Needs computer-literate freelancers for illustration. 5% of freelance work demands knowledge of Adobe Illustrator, QuarkX-Press, Aldus FreeHand, Photoshop or Fractal Painter.

Illustrations: Approached by 200 illustrators/year. Buys 10 illustrations/issue. Works on assignment only. Needs editorial and technical illustration. Preferred themes or styles "range from botanically accurate how-to illustrations to less literal, more interpretive styles. See the magazine. We use all media." Style of Kim Wilson Eversz, Andrea Eberbach, Amy Bartlett Wright. Send query letter with brochure, SASE, tearsheets, photostats and slides. Samples are filed or returned by SASE if requested. Reports back only if interested "i.e. ready to assign work." Publication will contact artist for portfolio review if interested. Portfolio should include "your best work in your best form." Buys one-time rights. Pays within 30 days of acceptance; $50-350 for b&w, $100-700 for color inside; approximately $125 for spots.

Tips: Finds artists through artists' submissions/self-promotions and *American Showcase*. "Send me a printed promotional four-color (stiff) sheet with your name, address, phone. Something I can see at a glance and file easily. We're interested in computer illustrations in *whatever* program. Artist should be able to help decode any computer problems that arise inputting into QuarkXPress and printing."

‡NATIONAL GEOGRAPHIC, 17th and M Streets NW, Washington DC 20036. (202)857-7000. Art Director: Allen Carroll. Estab. 1888. Monthly. Circ. 10 million. Original artwork returned 1 year after publication.

Illustrations: Works with 20 illustrators/year. Buys 50 illustrations/year. Interested in "full-color, representational renderings of historical and scientific subjects. Nothing that can be photographed is illustrated by artwork. No decorative, design material. We want scientific geological cut-aways, maps, historical paintings." Works on assignment only. Prefers to see portfolio and samples of style. Samples are returned by SASE. "The artist should be familiar with the type of painting we use." Provide brochure, flier or tearsheet to be kept on file for future assignments. **Pays on acceptance**; $3,500 for color and $750 for b&w inside.

Tips: "Send historical and scientific illustrations, ones that are very informative and very accurate. No decorative, abstract portraits."

NATIONAL REVIEW, 150 E. 35th St., New York NY 10016. (212)679-7330. Contact: Art Director. Emphasizes world events from a conservative viewpoint; bimonthly b&w with 4-color cover, design is "straight forward—the creativity comes out in the illustrations used." Originals are returned after publication. Uses freelancers mainly for illustrations of articles and book reviews, also covers.

Cartoons: Buys 15 cartoons/issue. Interested in "light political, social commentary on the conservative side." Send appropriate samples and SASE. Reports in 2 weeks. Buys first North American serial rights. Pays on publication; $50 for b&w.

Illustrations: Buys 15 illustrations/issue. Especially needs b&w ink illustration, portraits of political figures and conceptual editorial art (b&w line plus halftone work). "I look for a strong graphic style; well-developed ideas and well-executed drawings." Style of Tim Bower, Jennifer Lawson, Janet Hamlin, Alan Nahigian. Works on assignment only. Send query letter with brochure showing art style or tearsheets and photocopies. No samples returned. Reports back on future assignment possibilities. Call for an appointment to show portfolio of final art, final reproduction/product and b&w tearsheets. Include SASE. Buys first North American serial rights. Pays on publication; $100 for b&w inside; $500 for color cover.

Tips: "Tearsheets and mailers are helpful in remembering an artist's work. Artists ought to make sure their work is professional in quality, idea and execution. Recent printed samples alongside originals help. Changes in art and design in our field include fine art influence and use of more halftone illustration." A common mistake freelancers make in presenting their work is "not having a distinct style, i.e. they have a cross sample of too many different approaches to rendering their work. This leaves me questioning what kind of artwork I am going to get when I assign a piece."

‡NATIONAL RURAL LETTER CARRIER, 1630 Duke St., 4th Floor, Alexandria VA 22314. (703)684-5545. Managing Editor: RuthAnn Saenger. Emphasizes news and analysis of federal law and current events for rural letter carriers and family-oriented, middle-Americans; many are part-time teachers, businessmen and farmers. Biweekly; b&w, 8¼×11. Circ. 80,000. Mail art and SASE. Reports in 1 month. Original artwork returned after publication. Previously published, photocopied and simultaneous submissions OK. Buys first rights. Sample copy 24¢.

Illustrations: Receives 1 cartoon and 2 illustrations/month from freelance artists. Buys 12 covers/year on rural scenes, views of rural mailboxes and rural people. Buys 1 illustration/issue from freelancers. Interested in pen & ink or pencil on rural, seasonal and postal matter. Especially needs rural mailboxes and sketches of scenes on rural delivery. Works on assignment only. Send query letter with brochure showing art style or résumé, tearsheets, photocopies, slides and photographs. Samples returned by SASE. Reports in 1 week, if accepted; 1 month if not accepted. Write for appointment to show portfolio of original/final art, final reproduction/product, color and b&w tearsheets, photostats and photographs. Buys all rights on a work-for-hire basis. Pays on publication; $100 for b&w, $200 for color cover; by the project, $60-150.

Tips: "Please send in samples when you inquire about submitting material." Has a definite need for "realistic painting and sketches. We need a clean, crisp style. Subjects needed are rural scenes, mailboxes, animals and faces. We need fine black & white, pen & ink and watercolor."

‡NATURAL HISTORY, American Museum of Natural History, Central Park West and 79th St., New York NY 10024. (212)769-5500. Editor: Bruce Stutz. Designer: Tom Page. Emphasizes social and natural sciences. For well-educated professionals interested in the natural sciences. Monthly. Circ. 500,000. Previously published work OK.

Illustrations: Buys 23-25 illustrations/year; 25-35 maps or diagrams/year. Works on assignment only. Query with samples. Samples returned by SASE. Provide "any pertinent information" to be kept on file for future assignments. Buys one-time rights. Pays on publication; $200 and up for color inside.

Tips: "Be familiar with the publication. Always looking for accurate and creative scientific illustrations, good diagrams and maps."

NETWORK WORLD, 161 Worcester Rd., The Meadows, Framingham MA 01701. (508)875-6400. Fax: (508)820-3467. Art Director: Rob Stare. Weekly 4-color tabloid with "conservative but clean computer graphics intensive (meaning lots of charts)." Emphasizes news and features relating to the communications field. Accepts previously published artwork. Interested in buying second rights (reprint rights) to previously published artwork. Originals are returned after publication. Needs computer-literate freelancers for design and illustration. 10% of freelance work demands knowledge of Aldus FreeHand.

Illustrations: Themes depend on storyline. Works on assignment only. Send query letter with brochure and photocopies to be kept on file. Reports only if interested. Publication will contact artist for portfolio review if interested. Buys first rights. **Pays on acceptance**; $175 and up for b&w, $300 and up for color inside; $1,000 for color cover.

Tips: "All of our inhouse charts and graphics are done on the Mac. But most freelance illustration is not done on the Mac. My need for freelance artists to do illustration has actually increased a bit. Use one to three illustrations per week on average."

NEVADA, 1800 Hwy. 50 E., Suite 200, Carson City NV 89710. (702)687-6158. Fax: (702)687-6159. Estab. 1936. Bimonthly magazine "founded to promote tourism in Nevada." Features Nevada artists, history, recreation, photography, gaming. Traditional, 3-column layout with large (coffee table type) 4-color photos. Circ. 130,000. Accepts previously published artwork. Originals are returned to artist at job's completion. Sample copies for $3.50. Art guidelines available.

Cartoons: Prefers 4-color cartoons for humor pieces. Pays $40 for b&w, $60 for color.
Illustrations: Approached by 25 illustrators/year. Buys 2 illustrations/issue. Works on assignment only. Send query letter with brochure, résumé and slides. Samples are filed. Reports back within 2 months. To show portfolio, mail 20 slides and bio. Buys one-time rights. Pays $125 for color cover; $20 for b&w, $50 for color inside.

‡**NEW MYSTERY MAGAZINE**, 175 Fifth Ave., Room 2001, New York NY 10010. (212)353-1582. Art Director: Dana Irwin. Estab. 1989. Quarterly literary magazine—a collection of mystery, crime and suspense stories with b&w drawings, prints and various graphics. Circ. 100,000. Accepts previously published artwork. Originals are returned at job's completion. Sample copies available for $7 plus $1.24 postage and SASE. Needs computer-literate freelancers for illustration.
Cartoons: Approached by 100 cartoonists/year. Buys 1-3 cartoons/issue. Prefers themes relating to murder, heists, guns, knives, assault and various crimes; single or multiple panel, b&w line drawings. Send query letter with finished cartoon samples. Samples are filed and are returned by SASE if requested. Reports back within 1-2 months. Rights purchased vary according to project. Pays $20-50 for b&w, $20-100 for color.
Illustrations: Approached by 100 illustrators/year. Buys 12 illustrations/issue. Prefers themes surrounding crime, murder, suspense, noir. Considers pen & ink, watercolor and charcoal. Send query letter with résumé, SASE, photostats and transparencies. Samples are filed. Reports back within 1-2 months. To show a portfolio, mail appropriate materials: b&w photocopies and photographs. Rights purchased vary according to project. Pays on publication; $150 for color cover; $20-50 for b&w inside.
Tips: "Study an issue and send right-on illustrations. Do not send originals. Keep copies of your work. *NMM* is not responsible for unsolicited materials."

‡**THE NEW PHYSICIAN**, 1902 Association Dr., Reston VA 22091. (703)620-6600, ext. 246. Art Director: Julie Cherry. For physicians-in-training; concerns primary medical care, political and social issues relating to medicine; 4-color, contemporary design. Published 9 times/year. Circ. 22,000. Original artwork returned after publication. Buys one-time rights. Pays on publication.
• Design of this magazine used to be handled by a design firm. New art director Julie Cherry brought the design inhouse.
Cartoons: Cartoon submissions welcome. Send finished artwork.
Illustrations: Approached by 100-200 illustrators/year. Buys 3 illustrations/issue from freelancers, usually commissioned. Samples are filed. Submit résumé and samples of style. Will accept computer-generated artwork compatible with QuarkXPress 3.2, Illustrator 5.5, Photoshop 2.5.1, FreeHand or work that is saved as an EPS file. Reports in 6-8 weeks. Buys one-time rights. Pays $800-1,000 for color cover; $100 for b&w, $250 minimum for color inside; $200 minimum for spots.

the new renaissance, 9 Heath Rd., Arlington MA 02174. Editor: Louise T. Reynolds. Art Editor: Olivera Sajkovic. Estab. 1968. Biannual (spring and fall) magazine emphasizing literature, arts and opinion for "the general, literate public"; b&w with 2-color cover, 6×9. Circ. 1,600. Originals are returned after publication if SASE is enclosed, otherwise work is not accepted. Sample copy available. Current issue $8.50 US, $9 foreign. (US dollars only.)
Cartoons: Approached by 20-32 freelance artists/year. Pays $15-30 for b&w. Very few used in any given year.
Illustrations: Buys 6-8 illustrations/issue from freelancers and "occasional supplementary artwork (2-4 pages)." Works mainly on assignment. Send résumé, samples, photos and SASE. Reports within 2-4 months. Publication will contact artist for portfolio review if interested, "but only if artist has enclosed SASE." Portfolio should include roughs, b&w photographs and SASE. Buys one-time rights. Pays after publication; $25-30 for b&w.
Tips: "Only interested in b&w. We want artists who know what it means to illustrate a 'quality' (or 'serious' or 'literary') piece of fiction (or, occasionally, a poem) and for this we suggest they study our past illustrations. We are receiving work that is appropriate for a newsletter, newsprint or alternative-press magazines; *tnr* takes a classicist position in the arts—we want our work to hold up and we need work that shows an understanding of our audience. We will only consider work that is submitted with a SASE. No postcards, please. Artists are required buy a back issue ($5.50 or $7.65) so they can see the kind of fiction we publish and the type of illustrations that we need."

THE NEW REPUBLIC, 1220 19th St. NW, Washington DC 20036. (202)331-7494. Editor: Andrew Sullivan. Art Editor: Jed Perl. Estab. 1914. Weekly political/literary magazine; political journalism, current events in the front section, book reviews and literary essays in the back; b&w with 4-color cover. Circ. 100,000. Original artwork returned after publication. Sample copy for $3.50. Needs computer-literate freelancers for illustration. 15% of freelance work demands computer skills.
Illustrations: Approached by 400 illustrators/year. Buys up to 5 illustrations/issue. Uses freelancers mainly for cover art. Works on assignment only. Prefers caricatures, portraits, 4-color, "no cartoons." Style of Vint Lawrence. Considers airbrush, collage and mixed media. Send query letter with tearsheets. Samples returned by SASE if requested. Publication will contact artist for portfolio review if interested. Portfolio should include

Gail Duggan, working in alkyds, took an emotional approach to this illustration, portraying "haunting control" for a story in The New Yorker's *"For Kids" section about a marionette production of "The True Story of Rumpelstiltskin." Duggan got the job after sending a sample to the magazine's art director. "I had a lot of creative freedom on this," says Duggan. "The only limitation was that I capture the same mood as in the sample I had sent." The job, from sketches to final art, took two weeks and the artist received $500—plus great exposure in* The New Yorker.

color photocopies. Rights purchased vary according to project. Pays on publication; up to $600 for color cover; $250 for b&w and color inside.

NEW WRITER'S MAGAZINE, Box 5976, Sarasota FL 34277. (813)953-7903. Editor/Publisher: George J. Haborak. Estab. 1986. Bimonthly b&w magazine. Forum "where all writers can exchange thoughts, ideas and their own writing. It is focused on the needs of the aspiring or new writer." Rarely accepts previously published artwork. Original artwork returned after publication if requested. Sample copies for $3. Art guidelines not available.

Cartoons: Approached by 2-3 cartoonists/year. Buys 1-3 cartoons/issue. Prefers cartoons "that reflect the joys or frustrations of being a writer/author"; single panel b&w line drawings with gagline. Send query letter with samples of style. Samples are sometimes filed or returned if requested. Reports back within 1 month. Buys first rights. Pays on publication; $10 for b&w.
Illustrations: Buys 1 illustration/issue. Works on assignment only. Prefers line drawings. Considers watercolor, mixed media, colored pencil and pastel. Send query letter with brochure showing art style. Samples are filed or returned if requested by SASE. Reports within 1 month. To show portfolio, mail tearsheets. Buys first rights or negotiates rights purchased. Pays on publication. Payment negotiated.

‡**NEW YORK MAGAZINE**, 755 Second Ave., New York NY 10017. (212)880-0700. Design Director: Robert Best. Art Director: Syndi Becker. Emphasizes New York City life; also covers all boroughs for New Yorkers with upper-middle income and business people interested in what's happening in the city. Weekly. Original artwork returned after publication.
Illustrations: Works on assignment only. Send query letter with tearsheets to be kept on file. Prefers photostats as samples. Samples returned if requested. Call or write for appointment to show portfolio (drop-offs). Buys first rights. Pays on publication $1,000 for b&w and color cover; $800 for 4-color, $400 for b&w full page inside; $225 for 4-color, $150 for b&w spot inside.

‡**THE NEW YORKER**, 20 W. 43rd St., 16th Floor, New York NY 10036. (212)840-3800. Contact: Cartoon Editor. Emphasizes news analysis and lifestyle features.
Cartoons: Buys b&w cartoons. Receives 3,000 cartoons/week. Mail art or deliver sketches on Wednesdays. Include SASE. Strict standards regarding style, technique, plausibility of drawing. Especially looks for originality. Pays $575 minimum for cartoons.
Illustrations: All illustrations are commissioned. Portfolios may be dropped off Wednesdays between 10-6 and picked up on Thursdays. Mail samples, no originals. "Because of volume of submissions we are unable to respond to all submissions." No calls please. Emphasis on portraiture.
Tips: "Familiarize yourself with *The New Yorker*."

NORTH AMERICAN HUNTER/NORTH AMERICAN FISHERMAN, 12301 Whitewater Dr., Minnetonka MN 55343. (612)936-9333. Fax: (612)936-9755. Art Director: Mark Simpson. Estab. 1978 (*N.A. Hunter*) and 1988 (*N.A. Fisherman*). Bimonthly consumer magazines. *North American Hunter* and *Fisherman* are the official publications of the North American Hunting Club and the North American Fishing Club. Circ. 600,000 and 400,000. Accepts previously published artwork. Originals are returned at job's completion. Sample copies available. Art guidelines for SASE with first-class postage. Needs computer-literate freelancers for illustration. 20% of freelance work demands computer knowledge of Adobe Illustrator, QuarkXPress, Adobe Photoshop or Aldus FreeHand.
Cartoons: Approached by 20 cartoonists/year. Buys 3 cartoons/issue. Prefers humorous work portraying outdoorsmen in positive image; single panel b&w washes and line drawings with or without gagline. Send query letter with brochure. Samples are filed. Does not report back. Buys one-time rights.
Illustrations: Approached by 40 illustrators/year. Buys 3 illustrations/issue. Prefers illustrations that portray wildlife and hunting and fishing in an accurate and positive manner. Considers pen & ink, watercolor, airbrush, acrylic, colored pencil, oil, charcoal, mixed media and pastel. Send query letter with brochure, tearsheets, résumé, photographs and slides. Samples are filed. Does not report back. Portfolio review not required. Rights purchased vary according to project. **Pays on acceptance**.

‡**THE NORTH AMERICAN REVIEW**, University of Northern Iowa, Cedar Falls IA 50614. (319)273-2077. Art Directors: Gary Kelley and Osie L. Johnson, Jr. Estab. 1815. "General interest bimonthly, especially known for fiction (twice winner of National Magazine Award for fiction)." Accepts previously published work. Original artwork returned at job's completion. "Sample copies can be purchased on newsstand or examined in libraries."
Illustrations: Approached by 500 freelance artists/year. Buys 15 freelance illustrations/issue. Artists primarily work on assignment. Looks for "well-designed illustrations in any style. The magazine has won many illustration awards because of its insistence on quality. We prefer to use b&w media for illustrations reproduced in b&w and color for those reproduced in color. We prefer camera ready line art for spot illustrations." Send query letter with SASE, tearsheets, photocopies, slides, transparencies. Samples are filed if of interest or returned by SASE if requested by artist. Reports back to the artist only if interested. No portfolio reviews. Buys one-time rights. Contributors receive 2 copies of the issue. Pays on publication; $300 for color cover plus 50 tearsheets of cover only; $10 for b&w inside spot illustrations; $65 for b&w large illustration. No color inside.
Tips: "Send b&w photocopies of spot illustrations (printed size about 2×2). For the most part, our color covers and major b&w inside illustrations are obtained by direct assignment from illustrators we contact, e.g. Gary Kelley, Osie Johnson, Chris Payne, Skip Liepke and others. Write for guidelines for annual cover competition."

NORTH AMERICAN WHITETAIL MAGAZINE, 2250 Newmarket Pkwy., Suite 110, Marietta GA 30067. (404)953-9222. Fax: (404)933-9510. Editorial Director: Ken Dunwoody. Estab. 1982. Consumer magazine;

"designed for serious hunters who pursue whitetailed deer." 8 issues/year. Circ. 160,000. Accepts previously published artwork. Original artwork is returned at job's completion. Sample copies available for $3. Art guidelines not available.

Illustrations: Approached by 30 freelance illustrators/year. Buys 1-2 freelance illustrations/issue. Works on assignment only. Considers pen & ink and watercolor. Send query letter. Samples are filed or are returned by SASE if requested by artist. Reports back only if interested. To show a portfolio, mail appropriate materials. Rights purchased vary according to project. Pays 10 weeks prior to publication; $25 minimum for b&w, $75 minimum for color inside.

‡THE NORTHERN LOGGER & TIMBER PROCESSOR, Northeastern Loggers Association Inc., Box 69, Old Forge NY 13420. (315)369-3078. Editor: Eric A. Johnson. Trade publication (8½×11) with an emphasis on education. Focuses on methods, machinery and manufacturing as related to forestry. For loggers, timberland managers and processors of primary forest products. Monthly b&w with 4-color cover. Circ. 13,000. Previously published material OK. Free sample copy and guidelines available.

Cartoons: Buys 1 cartoon/issue. Receives 1 submission/week. Interested in "any cartoons involving forest industry situations." Send finished cartoons with SASE. Reports in 1 week. **Pays on acceptance**; $20 for b&w line drawings.

Illustrations: Pays $20 for b&w cover.

Tips: "Keep it simple and pertinent to the subjects we cover. Also, keep in mind that on-the-job safety is an issue that we like to promote."

‡NORTHWEST PRIME TIMES JOURNAL, 10827 NE 68th St., Kirkland WA 98033. (206)827-9737. Contact: Editor. Estab. 1982. Montyly tabloid; "for people 50 and older who live in Puget Sound region." Circ. 50,000. Original artwork is returned at job's completion.

Illustrations: Works on assignment only. Looking for originality, with emphasis on older audience. Send query letter with appropriate samples and SASE. Negotiates rights purchased. Pays on publication; $50 for b&w cover; $25 for b&w inside.

NOTRE DAME MAGAZINE, 415 Main Bldg., Notre Dame IN 46556. (219)631-4630. E-mail: donald.j.nelson.4@nd.edu. Art Director: Don Nelson. Estab. 1971. Quarterly 4-color university magazine for Notre Dame alumni and friends. Circ. 115,000. Accepts previously published artwork. Original artwork returned after publication. Sample copies and art guidelines not available.

Illustrations: Approached by 40 illustrators/year. Buys 5 illustrations/issue. Works on assignment only. Looking for "accomplished, experienced editorial artists only." Tearsheets, photostats, photographs, slides and photocopies OK for samples. Samples are filed "if they are good" or are returned by SASE if requested. "Don't send submissions—only tearsheets and samples." To show portfolio, mail published editorial art. Buys first rights. Pays $2,000 maximum for covers; $1,000 maximum for large color inside work and $275-500 for smaller pieces. Does not use spots.

Tips: "Don't send 'commercial art,' we only use editorial art."

NOW AND THEN, Box 70556 ETSU, Johnson City TN 37614-0556. (615)929-5348. Fax: (615)929-5348. Editor: Jane Harris Woodside. Estab. 1984. Magazine covering Appalachian issues and arts, published 3 times a year. Circ. 1,000. Accepts previously published artwork. Originals are returned at job's completion. Sample copies available for $4.50. Guidelines available. Needs computer-literate freelancers for illustration. Freelancers should be familiar with Aldus FreeHand or Aldus PageMaker.

Cartoons: Approached by 25 cartoonists/year. Prefers Appalachia issues, political and humorous cartoons; b&w washes and line drawings. Send query letter with brochure, roughs and finished cartoons. Samples not filed and are returned by SASE if requested by artist. Reports back within 4 months. Buys one-time rights. Pays $15 for b&w.

Illustrations: Approached by 3 illustrators/year. Buys 1-2 illustrations/issue. Prefers Appalachia, any style. Considers b&w or 2- or 4-color pen & ink, collage, airbrush, marker and charcoal. Send query letter with brochure, SASE and photocopies. Samples are not filed and are returned by SASE if requested by artist. Reports back within 4 months. Publication will contact artist for portfolio review if interested. Portfolio should include b&w tearsheets, slides, final art and photographs. Buys one-time rights. Pays on publication; $25-50 for b&w or color cover.

Tips: Area most open to freelancers is magazine cover. "We have special theme issues, illustrations have to have something to do with theme. Write for guidelines, enclose SASE."

NUGGET, Dugent Publishing Co., 2600 Douglas Rd., Suite 600, Coral Gables FL 33134. Editor: Christopher James. Illustration Assignments: Nye Willden. 4-color "electic, modern" magazine for men and women with fetishes. Published 9 times/year.

Cartoons: Buys 5 cartoons/issue. Receives 50 submissions/week. Interested in "funny fetish themes." B&w only for spots and for page. Prefers to see finished cartoons. Include SASE. Reports in 2 weeks. Buys first North American serial rights. Pays $75 for spot drawings; $125 for full page.

"This is a straightforward map, but we wanted to convey a sense of history," says illustrator Terry Lacy. He used ink and a crow quill pen to illustrate this map for a Notre Dame Magazine article entitled "A Schism to Heal." "The pen & ink gave it the feeling of an early map," says the artist, whose studio, Lacy Design, works primarily in watercolor.

Illustrations: Buys 2 illustrations/issue. Interested in "erotica, cartoon style, etc." Works on assignment only. Prefers to see samples of style. Send brochure, flier or other samples to be kept on file for future assignments. No samples returned. Publication will contact artist for portfolio review if interested. Buys first North American serial rights. Pays $200 for b&w.

Tips: Finds artists through artists' submissions/self-promotions. Especially interested in "the artist's anatomy skills, professionalism in rendering (whether he's published or not) and drawings which relate to our needs." Current trends include "a return to the 'classical' realistic form of illustration, which is fine with us because we prefer realistic and well-rendered illustrations."

NURSEWEEK, 1156-C Aster Ave., Sunnyvale CA 94086. (408)249-5877. Fax: (408)249-8204. Art Director: Young Kim. "*Nurseweek* is a biweekly 4-color tabloid mailed free to registered nurses in Los Angeles and Orange counties, the greater San Francisco Bay Area and 4 cities in Texas. Also publishes *Allied Health Week*. Combined circulation of all publications is over 400,000. Bimonthly to every RN in California. *Nurseweek* provides readers with nursing-related news and features that encourage and enable them to excel in their work and that enhance the profession's image by highlighting the many diverse contributions nurses make. In order to provide a complete and useful package, the publication's article mix includes late-breaking news stories, news features with analysis (including in-depth bimonthly special reports), interviews with industry leaders and achievers, continuing education articles, career option pieces (Spotlight, Entrepreneur), lifestyle features (After Hours) and reader dialogue (Letters, Commentary, First Person)." Sample copy $3. Art guidelines not available. Needs computer-literate freelancers for production. 90% of freelance work demands knowledge of Quark, PhotoShop, Adobe Illustrator, Ventura/CorelDraw.

Cartoons: Approached by 20 cartoonists/year. Buys cartoons "occasionally." Cartoons must portray positive image of nurses. Prefers single panel, b&w washes, color washes or b&w line drawings with gaglines. Send query letter with finished cartoon samples. Samples are not filed and are returned by SASE. Reports back within 1 month. Buys first rights. Pays $25 for b&w, $50 for color.

Illustrations: Approached by 10 illustrators/year. Buys 1 illustration/year. Prefers pen & ink, watercolor, airbrush, marker, colored pencil, mixed media and pastel. Needs medical illustration. Send query letter with brochure, tearsheets, photographs, photocopies, photostats, slides and transparencies. Samples are not filed and are returned by SASE if requested by artist. Publication will contact artist for portfolio review if interested. Portfolio should include final art samples, photographs. Buys all rights. Pays on publication; $150 for b&w, $250 for color cover; $100 for b&w, $175 for color inside.

Tips: Finds artists through sourcebooks.

THE OFFICIAL PRO RODEO SOUVENIR PROGRAM, 4565 Hilton Pkwy., Suite 205, Colorado Springs CO 80907. (719)531-0177. Fax: (719)531-0183. Director Publication Marketing: Mary Ellen Davis. Estab. 1973. An annual 4-color souvenir program for PRCA rodeo events. "This magazine is purchased by rodeo organizers, imprinted with rodeo name and sold to spectators at rodeo events." Circ. 400,000. Originals are returned at job's completion. Sample copies available. Art guidelines not available.
Illustrations: Works on assignment only. "We assign a rodeo event—50%-art, 50%-photos." Considers all media. Send query letter with brochure, résumé, SASE, tearsheets, photographs and photocopies. Samples are filed. Publication will contact artist for portfolio review if interested. Buys one-time rights. Pays on publication; $250 for color cover.
Tips: Finds artists through artists' submissions/self-promotions, sourcebooks, artists' agents and reps and attending art exhibitions. "Know about rodeos and show accurate (not necessarily photo-realistic) portrayal of event. Artwork is used on the cover about 50 percent of the time. Freelancers get more work now because our office staff is smaller."

OHIO MAGAZINE, 62 E. Broad St., Columbus OH 43215. (614)461-5083. Art Director: Brooke Wenstrup. Monthly publication emphasizing feature material of Ohio "for an educated, urban and urbane readership"; 4-color; design is "clean, with white-space." Circ. 90,000. Previously published work OK. Original artwork returned after publication. Sample copy $2.50. Needs computer-literate freelancers for design, illustration and production. 20% of freelance work demands knowledge of Adobe Illustrator, QuarkXPress, Adobe Photoshop or Aldus FreeHand.
Cartoons: Approached by 2 cartoonists/year. Buys 2 cartoons/year. Prefers b&w line drawings. Send brochure. Samples are filed or are returned by SASE. Reports back within 1 month. Buys one-time rights. Pays $50 for b&w and color.
Illustrations: Approached by 70 illustrators/year. Buys 2 illustrations/issue. Works on assignment only. Considers pen & ink, watercolor, collage, acrylic, marker, colored pencil, oil, mixed media and pastel. Send brochure, SASE, tearsheets and slides. Samples are filed or are returned by SASE. Reports back within 1 month. Request portfolio review in original query. Portfolio should include b&w and color tearsheets, slides, photostats, photocopies and final art. Buys one-time rights. **Pays on acceptance**; $350 for b&w, $350 for color cover; $75-350 for b&w, $100 for color inside.
Tips: Finds artists through artists' submissions and gallery shows. "Using more of a fine art-style to illustrate various essays—like folk art-style illustrators. Please take time to look at the magazine if possible before submitting."

OKLAHOMA TODAY MAGAZINE, 401 Will Rogers Bldg., Oklahoma City OK 73105. (405)521-2496. Fax: (405)521-3992. Editor: Jeanne Devlin. Estab. 1956. Bimonthly regional, upscale consumer magazine focusing on all things that define Oklahoma and interest Oklahomans. Circ. 43,000. Accepts previously published artwork. Originals are returned at job's completion. Sample copies and art guidelines available. Needs computer-literate freelancers for design, illustration, production and presentation. 20% of freelance work demands knowledge of Aldus PageMaker, Adobe Illustrator and Adobe Photoshop.
Cartoons: Buys 1 cartoon/issue. Prefers humorous cartoons focusing on Oklahoma, oil, cowboys or Indians with gagline. Send query letter with roughs. Samples are filed. Reports back within days if interested; months if not. Buys one-time rights. Pays $50 minimum for b&w, $75 minimum for color.
Illustrations: Approached by 24 illustrators/year. Buys 2-3 illustrations/issue. Considers pen & ink, watercolor, collage, airbrush, acrylic, marker, colored pencil, oil, charcoal and pastel. Send query letter with brochure, résumé, SASE, tearsheets and slides. Samples are filed. Reports back within days if interested; months if not. Portfolio review required if interested in artist's work. Portfolio should include b&w and color thumbnails, tearsheets and slides. Buys one-time rights. Pays $200-500 for b&w, $200-750 for color cover; $50-500 for b&w, $75-750 for color inside.
Tips: Finds artists through sourcebooks, other publications, word of mouth, artists' submissions and artist reps. Illustrations to accompany short stories and features are most open to freelancers. "Read the magazine; have a sense of the 'New West' spirit and do an illustration or cartoon that exhibits your understanding of *Oklahoma Today*."

‡OMNI, 277 Park Ave., 4th Floor, New York NY 10172. (212)702-6000. Art Director: Nick Torello. Estab. 1978. "A monthly general interest consumer publication with scientific slant." Circ. 850,000. Accepts previously published artwork. Sample copies and art guidelines available.
Illustrations: Approached by 500 illustrators/year. Buys 5-10 illustrations/issue. (Estimate includes spots.) Prefers "surreal subject matter (style is eclectic)" in pen & ink, airbrush, acrylic, oil. Send query letter with SASE. Samples are filed or returned by SASE if requested by artist. Reports back within 3 weeks. To show a portfolio, mail tearsheets and slides. Buys one-time rights. Pays $800 for color cover; $350/full page for b&w, $450/full page for color inside.
Tips: "We have a very open door policy for reviewing new illustrators. We have a drop-off (portfolio) day every Wednesday, and the illustrator can usually expect to get it back same day. Illustrators interested in

having their work published should research their sources carefully—and market their work with greater discrimination. Most publications are only interested in a specific niche of content and style."

ONLINE ACCESS MAGAZINE, 900 N. Franklin St., #310, Chicago IL 60610. (312)573-1700. Fax: (312)573-0520. Art Director: Jeff Burns. Estab. 1986. Monthly consumer magazine focusing on online computer services. "Your connection to Online Services, Bulletin Boards and the Internet. Magazine that makes modems work." Circ. 70,000. Accepts previously published artwork. Sample copies and art guidelines not available. Needs computer-literate freelancers for illustration.
Illustrations: Approached by 10 illustrators/year. Buys 8 illustrations/issue. Prefers colorful computer-related artwork. Considers pen & ink, watercolor, collage, airbrush, acrylic, marker, colored pencil, oil and mixed media. Send query letter with tearsheets. Samples are filed. Publication will contact artist for portfolio review if interested. Portfolio should include b&w and color tearsheets. Buys reprint rights. **Pays on acceptance**; $500 for color cover; $100 for color inside.

‡THE OPTIMIST, 4494 Lindell Blvd., St. Louis MO 63108. (314)371-6000. Graphic Designer: Andrea Renner. 4-color magazine with 4-color cover that emphasizes activities relating to Optimist clubs in US and Canada (civic-service clubs). "Magazine is mailed to all members of Optimist clubs. Average age is 42; most are management level with some college education." Circ. 170,000. Sample copy for SASE.
Cartoons: Buys 2 cartoons/issue. Prefers themes of general interest: family-orientation, sports, kids, civic clubs. Prefers single panel with gagline. No washes. Send query letter with samples. Submissions returned by SASE. Reports within 1 week. Buys one-time rights. **Pays on acceptance**; $30 for b&w.

OPTIONS, P.O. Box 470, Port Chester NY 10573. Contact: Wayne Shuster. E-mail: velvelny@aol.com. Estab. 1981. Bimonthly consumer magazine featuring erotic stories and letters, and informative items for gay and bisexual males and females. Circ. 60,000. Accepts previously published artwork. Originals are returned at job's completion. Sample copies available for $3.50 and 6×9 SASE with first-class postage.
Cartoons: Approached by 10 cartoonists/year. Buys 5 cartoons/issue. Prefers well drawn b&w, ironic, humorous cartoons; single panel b&w line drawings with or without gagline. Send query letter with finished cartoons. Samples are not filed and are returned by SASE if requested by artist. Reports back within 3 weeks. Buys all rights. Pays $20 for b&w.
Illustrations: Approached by 2-3 illustrators/year. Buys 2-4 illustrations/issue. Prefers gay male sexual situations. Considers pen & ink, airbrush b&w only. Also buys color or b&w slides (35mm) of illustrations. Send query letter with tearsheets, photocopies, slides and transparencies. "OK to submit computer illustration—Adobe Photoshop 2.5 and Adobe Illustrator 5.0 (Mac)." Samples are not filed and are returned by SASE if requested by artist. Reports back to the artist only if interested. Portfolio review not required. Buys all rights. Pays on publication; $50 for b&w inside; $25 for spots.
Tips: Finds artists through artists' submissions.

OREGON QUARTERLY, 5228 University of Oregon, Eugene OR 97403-5228. (503)346-5047. Fax: (503)346-2220. E-mail: quarterly@oregon.uoregon.edu. Executive Editor: Tom Hager. Estab. 1919. Quarterly 4-color alumni magazine. "The Northwest perspective. Regional issues and events as addressed by UO faculty members and alumni." Circ. 95,000. Accepts previously published artwork. Originals are returned at job's completion. Sample copies available for SASE with first-class postage.
Illustrations: Approached by 25 illustrators/year. Buys 1 illustration/issue. Prefers story-related themes and styles. Interested in all media. Send query letter with résumé, SASE and tearsheets. Samples are filed unless accompanied by SASE. Reports back only if interested. Buys one-time rights. Portfolio review not required. **Pays on acceptance**; $250 for b&w, $500 for color cover; $100 for b&w, $250 for color inside; $100 for spots.
Tips: "Send postcard, not portfolio."

‡OREGON RIVER WATCH, Box 294, Rhododendron OR 97049. (503)622-4798. Editor: Michael P. Jones. Estab. 1985. Quarterly b&w books published in volumes emphasizing "fisheries, fishing, camping, rafting, environment, wildlife, hiking, recreation, tourism, mountain and wilderness scenes and everything that can be related to Oregon's waterways. Down-home pleasant look, not polished, but practical—the '60s still live on." Circ. 2,000. Accepts previously published material. Original artwork returned after publication. Art guidelines for SASE with first-class postage.
Cartoons: Approached by 400 cartoonists/year. Buys 1-25 cartoons/issue. Cartoons need to be straightforward, about fish and wildlife/environmental/outdoor-related topics. Prefers single, double or multiple panel b&w line drawings, b&w or color washes with or without gagline. Send query letter with samples of style, roughs or finished cartoons. Samples are filed or are returned by SASE. Reports back within 2 months "or sooner—depending upon work load." Buys one-time rights. Pays in copies.
Illustrations: Approached by 600 illustrators/year. Works with 100 illustrators/year. Buys 225 illustrations/year. Needs editorial, humorous and technical illustration related to the environment. "We need b&w pen & ink sketches. We look for artists who are not afraid to be creative, rather than those who merely go along with trends." Send query letter with samples. "Include enough to show me your true style." Samples not

filed are returned by SASE. Reports back within 2 weeks. Buys one-time rights. Pays in copies. Needs computer-literate freelancers for illustration. 20% of freelance work demands computer skills.
Tips: "Freelancers must be patient. We have a lot of projects going on at once but cannot always find an immediate need for a freelancer's talent. Being pushy doesn't help. I want to see examples of the artist's expanding horizons, as well as their limitations."

‡ORGANIC GARDENING, 33 E. Minor St., Emmaus PA 18098. (610)967-8065. Art Director: Kim Harris. Magazine emphasizing gardening; 4-color; "uncluttered design." Published 9 times/year. Circ. 700,000. Original artwork returned after publication unless all rights are bought. Sample copies available only with SASE. Needs computer-literate freelancers for illustration. 15-20% of freelance work demands knowledge of of Adobe Illustrator, Quark XPress, Aldus FreeHand or Photoshop.
Illustrations: Buys 10 illustrations/issue. Works on assignment only. Prefers botanically accurate plants and, in general, very accurate drawing and rendering. Send query letter with brochure, tearsheets, slides and photographs. Samples are filed or are returned by SASE only. Reports back within 1 month. Call or write for an appointment to show portfolio of color or b&w final reproduction/product. Occasionally needs technical and medical illustration. Buys first rights or one-time rights. Pays $50-300 for b&w, $75-600 for color for spots art only. "We will pay more if size is larger than ¼ to ⅓ page."
Tips: "Work should be very accurate and realistic. Our emphasis is 'how-to' garden; therefore illustrators with experience in the field will have a greater chance of being published. Detailed and fine rendering quality is essential. We send sample issues to artists we publish—we do not provide tearsheets though."

ORLANDO MAGAZINE, 260 Maitland Ave., Altamonte Springs FL 32701. (407)539-3939. Fax: (407)539-0533. Art Director: Bruce Borich. Estab. 1946. "We are a 4-color monthly city/regional magazine covering the Central Florida area—local issues, sports, home and garden, business, entertainment and dining." Circ. 30,000. Accepts previously published artwork. Originals are returned at job's completion. Sample copies available. Art guidelines not available.
Illustrations: Buys 3-4 illustrations/issue. Works on assignment only. Needs editorial illustration. Send postcard, brochure or tearsheets. Samples are filed and are not returned. Reports back to the artist only if interested with a specific job. Portfolio review not required. Buys first rights, one-time rights or all rights (rarely). Pays on publication; $400 for color cover; $200-250 for color inside.
Tips: "Send appropriate samples. Most of my illustration hiring is via direct mail. The magazine field is still a great place for illustration."

THE OTHER SIDE, 300 W. Apsley St., Philadelphia PA 19144. (215)849-2178. Fax: (605)335-0368. Editor: Mark Olson. Art Director: Cathleen Benberg. "We are read by Christians with a radical commitment to social justice and a deep allegiance to biblical faith. We try to help readers put their faith into action." Publication is ¾ b&w, ¼ color with 4-color cover. Published 6 times/year. Circ. 14,000. Accepts previously published artwork. Sample copy available for $4.50.
Cartoons: Approached by 20-30 cartoonists/year. Buys 12-15 cartoons/year on current events, human interest, social commentary, environment, economics, politics and religion; single and multiple panel. Pays on publication; $25 for b&w line drawings. "Looking for cartoons with a radical political perspective."
Illustrations: Approached by 40-50 artists/year. Especially interested in original artwork in color and b&w. Send query letter with tearsheets, photocopies, slides, photographs and SASE. Reports in 6 weeks. Simultaneous submissions OK. Publication will contact artist for portfolio review if interested. Pays within 1 month of publication; $50-100 for 4-color; $30-50 for b&w line drawings and spots.
Tips: "We're looking for artists whose work shares our perspective on social, economic and political issues."

OUR SUNDAY VISITOR, 200 Noll Plaza, Huntington IN 46750. (219)356-8400. Fax: (219)356-8472. Contact: Managing Editor. Estab. 1912. Weekly magazine which focuses on Catholicism. Audience is mostly older, conservative; adheres to the teachings of the magisterium of the church. Circ. 120,000. Accepts previously published artwork. Originals are returned at job's completion. Sample copies available. Art guidelines not available.
Illustrations: Approached by 7-8 illustrators/year. Buys 10-12 illustrations/year. Works on assignment only. Preferred themes are religious and social issues. Considers pen & ink, watercolor, collage, airbrush, acrylic, marker, colored pencil, oil, charcoal, mixed media and pastel. Send query letter with photographs. Samples

How to Use Your **Artist's & Graphic Designer's Market** *offers suggestions for understanding and using the information in these listings. Read this and other articles in the front of this book for important business tips.*

are filed. Portfolio review not required. Buys first rights. Pays on publication; $250 for b&w, $400 for color cover; $150 for b&w, $250 for color inside.

‡✺OUTDOOR CANADA MAGAZINE, 703 Evans Ave., Suite 202, Toronto, Ontario M9C 5E9 Canada. Editor: Teddi Brown. 4-color magazine for the Canadian sportsman and his family. Stories on fishing, camping, hunting, canoeing, wildlife and outdoor adventures. Readers are 81% male. Publishes 7 regular issues/year and a fishing special in February. Circ. 95,000. Finds most artists through references/word of mouth.
Illustrations: Approached by 12-15 illustrators/year. Buys approximately 10 drawings/issue. Uses freelancers mainly for illustrating features and columns. Uses pen & ink, airbrush, acrylic, oil and pastel. Buys first rights. Pays up to $400. Artists should show a representative sampling of their work, including fishing illustrations.

‡OUTDOOR LIFE MAGAZINE, Dept. AGDM, 2 Park Ave., New York NY 10016. (212)779-5246. Fax: (212)686-6877. Contact: Art Director. Estab. 1897. Monthly magazine geared toward hunting, fishing and outdoor activities. Circ. 1,000,000. Original artwork is returned at job's completion. Sample copies not available. Art guidelines for SAE with first-class postage.
Cartoons: "Half of our artist mail is from cartoonists." Prefers hunting and fishing themes; single panel b&w line drawings with gagline. Send query letter with brochure and roughs. Reports back within a few weeks. Rights purchased vary according to project.
Illustrations: Works on assignment only. Considers mixed media. Send query letter with brochure, tearsheets, photographs and slides. Samples are filed. Reports back within a few weeks. Call for appointment to show a portfolio of tearsheets, slides, photocopies and photographs. Rights purchased vary according to project. **Pays on acceptance.**

OUTSIDE MAGAZINE, Outside Plaza, 400 Market St., Santa Fe NM 87501. (505)989-7100. Fax: (505)989-4700. Creative Director: Susan Casey. Estab. 1977. Monthly 4-color magazine with "clean, active, classic, service-oriented design. America's active lifestyle magazine." Circ. 475,000. Art guidelines for SASE with first-class postage. Needs occasional computer-literate freelancers for design, illustration and information graphics using Adobe Illustrator, QuarkXPress and Photoshop.
● This creative director says she receives too many inappropriate submissions from novice illustrators. She prefers to give assignments to experienced illustrators with proven track record and tearsheets.
Illustrations: Approached by 150-200 illustrators/year. Buys 75 illustrations/year. Works on assignment only. Prefers contemporary editorial styles. Needs maps. Considers watercolor, collage, airbrush, acrylic, colored pencil, oil, mixed media and pastel. Send query letter with brochure, tearsheets or slides. Most samples are filed. Those not filed will be returned by SASE. Publication will contact artist for portfolio review if interested. Portfolio should include original/final art, tearsheets and slides. Buys one-time rights. Pays on publication; $1,000-1,500 for large color single page and spreads; $250-350 for less than ¼ page (spots).
Tips: Finds artists through sourcebooks and word of mouth. "Establish target publications. Maintain contact through update mailings until assignment is received. Always get as many tearsheets from a job as you can. I'm seeing more and more portfolios on disks—getting portfolio on floppy (computer or conventional art) is convenient and interactive." Seeks contemporary, figurative/scenic images in photography and illustration.

‡PACIFIC PRESS PUBLISHING ASSOCIATION, 1350 North Kings Rd., Nampa ID 83687. (208)465-2500. Fax: (208)465-2531. Art Director, Books: Tim Larson. Art Director, Magazines: Merwin Stewart. Estab. 1875. Book and magazine publisher. Specializes in Christian lifestyles and Christian outreach.
● See *Sign of the Times* listing for needs. This association publishes magazines and books. The art director reports he has enough artwork for Pacific Press but he'd like submissions for *Signs of the Times.*

✺PACIFIC YACHTING MAGAZINE, 202-1132 Hamilton St., Vancouver, British Columbia V6B 2S2 Canada. (604)687-1581. Fax: (604)687-1925. Editor: Duart Snow. Estab. 1968. Monthly 4-color magazine focused on boating on the West Coast of Canada. Power/sail cruising only. Circ. 25,000. Accepts previously published artwork. Original artwork returned at job's completion. Sample copies available for $3. Art guidelines not available.
Cartoons: Approached by 12-20 cartoonists/year. Buys 1-2 cartoons/issue. Boating themes only; single panel b&w line drawings with gagline. Send query letter with brochure and roughs. Samples are filed or are returned by SASE if requested by artist. Reports back within 3 weeks. Buys one-time rights. Pays $25-50 for b&w.
Illustrations: Approached by 25 illustrators/year. Buys 6-8 illustrations/year. Prefers boating themes. Considers pen & ink, watercolor, airbrush, acrylic, colored pencil, oil and charcoal. Send query letter with brochure. Samples are filed or are returned by SASE if requested by artist. Reports back within 1 week only if interested. Call for appointment to show portfolio of all appropriate samples related to boating on the West

Coast. Buys one-time rights. Pays on publication; $300 for color cover; $50-100 for b&w and $200-300 for color inside; $25-50 for spots.
Tips: "Know boats and how to draw them correctly. Know and love my magazine."

‡PAINT HORSE JOURNAL, Box 961023, Fort Worth TX 76161-0023. (817)439-3412. Art Director: Allan Foster. Monthly 4-color official publication of breed registry of Paint horses for people who raise, breed and show Paint horses. Circ. 20,400. Original artwork returned after publication if requested. Sample copy for $3; artist's guidelines for SASE.
Cartoons: Approached by 10 or so cartoonists/year. Receives 8-10 cartoons/week. Buys 10-20 cartoons/ year. Must be "simple, unique, horse-related." Single panel with gagline. Material returned by SASE only if requested. Reports in 1 month. Buys first rights. **Pays on acceptance**; $10-15 for b&w line drawings.
Illustrations: Approached by 25-30 illustrators/year. Receives 4-5 illustrations/week. Buys a few illustrations each issue. Send business card and samples to be kept on file. Prefers snapshots of original art or photostats as samples. Samples returned by SASE if not filed. Reports within 1 month. Buys first rights on cover art, but would like to be able to use small, filler art many times. Pays on publication; $50 for b&w, $100-200 for color cover; $50 for b&w, $75-100 for color inside.
Tips: "No matter what style of art you use—you must include Paint horses with conformation acceptable (to the APHA). As horses are becoming more streamlined—as in race-bred Paints, the older style of horse seems outdated. Horses of Arabian-type conformation or with unnatural markings are incorrect. Action art and performance events are very nice to have."

PALO ALTO WEEKLY, 703 High St., Palo Alto CA 94301. (415)326-8210. Estab. 1979. Semiweekly newspaper. Circ. 45,000. Accepts previously published artwork. Originals returned at job's completion. Sample copies available. Rarely needs computer-literate freelancers for production. Freelancers should be familiar with Adobe Illustrator, QuarkXPress or Aldus FreeHand.
Illustrations: Buys 20-30 illustrations/year. Works on assignment only. Considers all media. Send query letter with brochure, résumé, SASE, tearsheets, photographs, photocopies, photostats, slides and transparencies. Samples are filed. Publication will contact artist for portfolio review if interested. Pays on publication; $150 for b&w, $175 for color cover; $75 for b&w, $100 for color inside.
Tips: Most often uses freelance illustration for covers and cover story, especially special section covers such as restaurant guides. "We call for artists' work in our classified ad section when we need some fresh work to look at. We like to work with local artists."

PARADE MAGAZINE, 750 Third Ave., New York NY 10017. (212)573-7187. Director of Design: Ira Yoffe. Photo Editor: Miriam White-Lorentzen. Weekly emphasizing general interest subjects. Circ. 38 million (readership is 81 million). Original artwork returned after publication. Sample copy and art guidelines available.
Illustrations: Uses varied number of illustrations/issue. Works on assignment only. Send query letter with brochure, résumé, business card and tearsheets to be kept on file. Call or write for appointment to show portfolio. Reports only if interested. Buys first rights, occasionally all rights.
Tips: "Provide a good balance of work."

PARAPLEGIA NEWS, 2111 E. Highland Ave., Suite 180, Phoenix AZ 85016-4702. (602)224-0500. Fax: (602)224-0507. Art Director: Susan Robbins. Estab. 1947. Monthly 4-color magazine emphasizing wheelchair living for wheelchair users, rehabilitation specialists. Circ. 27,000. Accepts previously published artwork. Original artwork not returned after publication. Sample copy free for large-size SASE with $3 postage. 50% of freelance work demands knowledge of QuarkXPress, PhotoShop or Adobe Illustrator.
Cartoons: Buys 3 cartoons/issue. Prefers line art with wheelchair theme. Prefers single panel b&w line drawings with or without gagline. Send query letter with finished cartoons to be kept on file. Write for appointment to show portfolio. Material not kept on file is returned by SASE. Reports only if interested. Buys all rights. **Pays on acceptance**; $10 for b&w.
Illustrations: Works with 1 illustrator/year. Buys 1 illustration/year from freelancers. Needs editorial and medical illustration "well executed and pertinent." Prefers wheelchair living or medical and financial topics as themes. Send query letter with brochure showing art style or tearsheets, photostats, photocopies and photographs. Samples not filed are returned by SASE. Publication will contact artist for portfolio review if interested. Portfolio should include final reproduction/product, color and b&w tearsheets, photostats, photographs. Negotiates payment ("usually around $250") and rights purchased.
Tips: "When sending samples, include something that shows a wheelchair-user."

PEDIATRIC ANNALS, 6900 Grove Rd., Thorofare NJ 08086. (609)848-1000. Managing Editor: Mary L. Jerrell. Monthly 4-color magazine emphasizing pediatrics for practicing pediatricians. "Conservative/traditional design." Circ. 33,000. Considers previously published artwork. Original artwork returned after publication. Sample copies available.
Illustrations: Prefers "technical and conceptual medical illustration which relate to pediatrics." Considers watercolor, acrylic, oil, pastel and mixed media. Send query letter with tearsheets, slides and photographs to

be kept on file. Publication will contact artist for portfolio review if interested. Buys one-time rights or reprint rights. Pays $250-600 for color cover.

Tips: Finds artists through artists' submissions/self-promotions and sourcebooks. "Illustrators must be able to treat medical subjects with a high degree of accuracy. We need people who are experienced in medical illustration, who can develop ideas from manuscripts on a variety of topics, and who can work independently (with some direction) and meet deadlines. Non-medical illustration is also used occasionally. We deal with medical topics specifically related to children. Include color work, previous medical illustrations and cover designs in a portfolio. Show a representative sampling of work."

PENNSYLVANIA MAGAZINE, Box 576, Camp Hill PA 17001-0576. (717)761-6620. Editor-in-Chief: Albert Holliday. Estab. 1981. "Bimonthly magazine for college-educated readers, ages 35-60, interested in Pennsylvania history, travel and personalities." Circ. 40,000. Sample copy for $2.95.

Cartoons: Buys 5-10 cartoons/year. Must be on Pennsylvania topics. Pays $25-50.

Illustrations: Buys 25 illustrations/year on history and travel-related themes. Query with samples. Include SASE. Reports in 3 weeks. Previously published, photocopied and simultaneous submissions OK. Buys first serial rights. **Pays on acceptance**; $100 for cover; $25-50 for b&w or color inside.

PENNSYLVANIA SPORTSMAN, Box 90, Lemoyne PA 17043. (717)761-1400. Publisher: Lou Hoffman. Managing Editor: Scott Rupp. Estab. 1959. Regional 4-color magazine featuring "outdoor sports, hunting, fishing, where to go, what to do, how to do it." 8 issues per year. Circ. 67,000. Original artwork is returned after publication. Sample copies available for $2. Art guidelines for SASE with first-class postage.

Cartoons: Buys 10 cartoons/year. Prefers hunting and fishing themes. Prefers single panel with gagline, b&w line drawings. Send query letter with samples of style. Samples are filed. Samples not filed are returned by SASE. Reports back regarding queries/submissions within 2 weeks. Buys one-time rights. **Pays on acceptance**; $10, b&w.

Illustrations: Buys editorial illustrations mainly for covers and feature spreads. Buys 2 or 3 illustrations/issue. Considers pen & ink and acrylics. Send query letter with brochure showing art style or tearsheets. Samples are filed. Samples not filed are returned by SASE. Publication will contact artist for portfolio review if interested. Portfolio should include slides. Requests work on spec before assigning job. Pays $150 for color cover. Buys one-time rights.

Tips: "Features needed in these areas: deer, turkey, bear, trout and bass. Buys little in way of illustrations—mainly photography."

PET BUSINESS, 5400 NW 84th Ave., Miami FL 33166. Editor: Rita Davis. A monthly 4-color news magazine for the pet industry (retailers, distributors, manufacturers, breeders, groomers). Circ. 17,000. Accepts previously published artwork. Sample copy $3.

Cartoons: Interested in pet-related themes; single panel. Include SASE. Pays on publication; $10.

Illustrations: Occasionally needs illustration for business-oriented cover stories. Portfolio review not required. Pays on publication; $200.

Tips: "Send two or three samples and a brief bio, only."

PHANTASM, 235 E. Colorado Blvd., Suite 1346, Pasadena CA 91101. E-mail: jgrive@aol.com. Editor and Publisher: J.F. Gonzales. Estab. 1990. Quarterly horror fiction magazine. Circ. 1,000. Sometimes accepts previously published artwork. Originals returned at job's completion. Sample copies available for $4.95. Art guidelines for SASE with first-class postage.

Illustrations: Approached by 10 illustrators/year. Buys 6-8 illustrations/issue. Works on assignment only. Prefers horrific, surrealism. Considers pen & ink, oil, airbrush and pencil. Send query letter with résumé, SASE, tearsheets, photographs, photocopies and slides. Samples are filed or are returned by SASE if requested by artist. Publication will contact artist for portfolio review if interested. Portfolio should include b&w thumbnails, tearsheets, slides, final art and photographs. Buys first rights. Pays on publication; $20 for cover; $10 for inside.

Tips: Finds artists through word of mouth and submissions. "We are a small publication and tend to use the same artists each issue, but will use someone new if the work impresses us. Be original, be familiar with other artists of this genre (horror)—Michael Whelan, J.K. Potter, Alan Clark, etc. Illustrations are done by assignment to illustrate the fiction we publish. We usually ask for one illustration per story. Illustration usually reflects some mood/theme of piece."

‡PHI DELTA KAPPAN, Box 789, Bloomington IN 47402. Design Director: Carol Bucheri. Emphasizes issues, policy, research findings and opinions in the field of education. For members of the educational organization Phi Delta Kappa and subscribers. Black & white with 4-color cover and "conservative, classic design." Published 20 times/year. Circ. 150,000. Include SASE. Reports in 2 months. "We return cartoons after publication." Sample copy for $4.50. "The journal is available in most public and college libraries."

Cartoons: Approached by over 100 cartoonists/year. Looks for "finely drawn cartoons, with attention to the fact that we live in a multi-racial, multi-ethnic world."

Illustrations: Approached by over 100 illustrators/year. Uses one 4-color cover and spread and approximately seven b&w illustrations/issue, all from freelancers who have worked on assignment. Prefers style of Rob Colvin, Mario Noche. Most illustrations depict some aspect of the education process (from pre-kindergarten to university level), often including human figures. Samples returned by SASE. To show a portfolio, mail a few slides or photocopies with SASE. "We can accept computer illustrations (Adobe Illustrator preferred. Check with design director for appropriate version.)" Buys one-time rights. Payment varies.

Tips: "We look for artists who can create a finely crafted image that holds up when translated onto the printed page. Our journal is edited for readers with master's or doctoral degrees, so we look for illustrators who can take abstract concepts and make them visual, often through the use of metaphor."

PHYSICIAN'S MANAGEMENT, 7500 Old Oak Blvd., Cleveland OH 44130. (216)243-8100. Fax: (216)891-2683. Editor-in-Chief: Robert A. Feigenbaum. Art Director: Louanne Senger. Monthly 4-color magazine emphasizing business, practice management and legal aspects of medical practice for primary care physicians. Circ. 120,000.

Cartoons: Receives 50-70 cartoons/week. Buys 5 cartoons/issue. Themes typically apply to medical and financial situations "although we do publish general humor cartoons." Prefers camera-ready, single and double panel b&w line drawings with gagline. Uses "only clean-cut line drawings." Send cartoons with SASE. **Pays on acceptance**; $80.

Illustrations: Buys 2-4 illustrations/issue. Accepts b&w and color illustrations. All work done on assignment. Send a query letter to editor or art director first or send examples of work. Publication will contact artist for portfolio review if interested. Fees negotiable. Buys first rights.

Tips: "Become familiar with our publication. Cartoons should be geared toward the physician—not the patient. No cartoons about drug companies or medicine men. No sexist cartoons. Illustrations should be appropriate for a serious business publication. We do not use cartoonish or comic book styles to illustrate our articles. We work with artists nationwide." Impressed by freelancers who "do high quality work, have an excellent track record, charge reasonable fees and are able to work under deadline pressure."

PICTURE PERFECT, Box 15760, Stanford CT 06901. Phone/fax: (203)967-9952. Publisher: Andres Aquino. Estab. 1989. Monthly 4-color photography magazine covering fashion, commercial travel, beauty photography and illustration. Circ. 140,000. Original artwork returned at job's completion. Sample copy $4. Needs computer-literate freelancers for design. 5-10% of freelance work demands knowledge of Aldus PageMaker.

Cartoons: Pays $15 for b&w cartoons.

Illustrations: Buys 5 illustrations/issue. Prefers computer generated images. Considers pen & ink, airbrush and mixed media. Send query letter with tearsheets, photostats and SASE. Samples are filed or returned by SASE if requested by artist. Reports back within 3 weeks. Portfolio review not required. Rights purchased vary according to project. Pays on publication; $25 for b&w, $35 for color spot fillers.

Tips: "Review the material and editorials covered in our magazine. Your work should have excellent visual impact. We are photography oriented."

PLANNING, American Planning Association, 1313 E. 60th St., Chicago IL 60637. (312)955-9100. Editor and Associate Publisher: Sylvia Lewis. Art Director: Richard Sessions. Monthly b&w magazine with 4-color cover for urban and regional planners interested in land use, housing, transportation and the environment. Circ. 30,000. Previously published work OK. Original artwork returned after publication, upon request. Free sample copy and artist's guidelines available.

Cartoons: Buys 2 cartoons/year on the environment, city/regional planning, energy, garbage, transportation, housing, power plants, agriculture and land use. Prefers single panel with gaglines ("provide outside of cartoon body if possible"). Include SASE. Reports in 2 weeks. Buys all rights. Pays on publication; $50 minimum for b&w line drawings.

Illustrations: Buys 20 illustrations/year on the environment, city/regional planning, energy, garbage, transportation, housing, power plants, agriculture and land use. Send roughs and samples of style with SASE. Reports in 2 weeks. Buys all rights. Pays on publication; $250 maximum for b&w cover drawings; $100 minimum for b&w line drawings inside.

Tips: "Don't send portfolio. No corny cartoons. Don't try to figure out what's funny to planners. All attempts seen so far are way off base."

PLAY MAGAZINE, 3620 NW 43rd St., Gainesville FL 32606. (904)375-3705. Fax: (904)375-7268. Art Director: Cindy Troupin. "A quarterly 4-color magazine for parents covering quality entertainment and educational products for children: music, video, audio, toys, computers, books, interactive technologies of all sorts, as well as feature stories on entertainers and family interest topics." Circ. 116,000. Accepts previously published artwork. Originals are returned at job's completion.

Illustrations: Approached by 50-100 illustrators/year. Buys 4-8 illustrations/issue. Works on assignment only. Considers mixed media. Send query letter with résumé, tearsheets and samples. Samples are filed and are returned by SASE if requested by artist. Publication will contact artist for portfolio review if interested. Portfolio should include thumbnails, roughs, color tearsheets and photographs. Rights purchased vary accord-

ing to project. Sometimes requests work on spec before assigning job. Pays on publication; $75-150.

‡PLAYBOY MAGAZINE, 680 Lakeshore Dr., Chicago IL 60611. (312)751-8000. Managing Art Director: Kerig Pope. Estab. 1952. Monthly magazine. Circ. 3.5 million. Originals returned at job's completion. Sample copies available. Art guidelines not available.
Cartoons: Cartoonists should contact Michelle Urry, 747 Third Ave., New York NY 10017. "Please do not send cartoons to Kerig Pope!" Samples are filed or returned. Reports back within 2 weeks. Buys all rights.
Illustrations: Approached by 700 illustrators/year. Buys 30 illustrations/issue. Prefers "uncommercial looking" artwork. Considers all media. Send query letter with slides. Samples are filed or returned. Reports back within 2 weeks. Portfolio review not required. Buys all rights. **Pays on acceptance**; $1,200/page; $2,000/spread; $250 for spots.

‡POCKET GUIDE, 9650 Clayton Rd., St. Louis MO 63124-1569. (314)991-5222. Publisher: Jackson Waterbury. Managing Editor: Robert Donnelly. Estab. 1983. Publishes bimonthly, quarterly and annual visitor magazines for 35 resorts, cities, areas. Accepts previously published artwork. Originals returned at job's completion. Sample copies free for #10 SASE with first-class postage. Art guidelines vary. Needs computer-literate freelancers. 100% of freelance work demands knowledge of QuarkXPress and Word.
Cartoons: Approached by 8-10 freelancers/year. Prefers sports, families, travel themes. Prefers humorous, single panel, color washes and b&w line drawings with or without gagline. Send postcard-size sample or query letter with finished cartoons. Samples are filed or returned by SASE if requested by artist. Reports back within 10-14 days. Rights purchased vary according to project (usually one-time rights).
Illustrations: Approached by 8-10 illustrators/year. Buys 1-2 illustrations/issue. Prefers sports, travel and families. Considers pen & ink, watercolor, pastel and marker. Send postcard-size sample. Samples are filed or returned by SASE. Reports back within 10-14 days. Publication will contact artist for portfolio review of thumbnails, roughs, tearsheets and photocopies if interested. Rights purchased vary according to project (usually one-time rights). Pays on publication.

POCKETS, Box 189, 1908 Grand Ave., Nashville TN 37202. (615)340-7333. Editor: Janet Knight. Devotional magazine for children 6-12. 4-color with some 2-color. Monthly except January/February. Circ. 75,000. Accepts previously published material. Original artwork returned after publication. Sample copy for SASE with 4 first-class stamps.
Illustrations: Approached by 50-60 illustrators/year. Uses variety of styles; 4-color, 2-color, flapped art appropriate for children. Realistic fable and cartoon styles. Accepts tearsheets, photostats and slides. Also open to more unusual art forms: cut paper, embroidery, etc. Samples not filed are returned by SASE. Reports only if interested. Buys one-time or reprint rights. **Pays on acceptance**; $50-550 depending on size.
Tips: "Decisions made in consultation with out-of-house designer. Send samples to our designer: Chris Schechner, 3100 Carlisle Plaza, Suite 207, Dallas, TX 75204."

POPULAR ELECTRONICS, 500 B Bi-County Blvd., Farmingdale NY 11735. (516)293-3000. Editor: Carl Laron. Monthly 4-color magazine emphasizing hobby electronics for consumer and hobby-oriented electronics buffs. Circ. 87,287. Original artwork not returned after publication. Sample copy free.
Cartoons: Approached by over 20 cartoonists/year. Buys 3-5 cartoons/issue. Prefers single panel b&w line drawings and b&w washes with or without gagline. Considers a diversity of styles and subjects: electronics, radio, audio, video. Send finished cartoons. "We purchase and keep! Unused ones returned." Samples are returned. Portfolio review not required. Reports within 2 weeks. Buys all rights. Pays $25 for b&w.

POTATO EYES, Box 76, Troy ME 04987. (207)948-3427. Co-Editor: Carolyn Page. Estab. 1988. A biannual literary magazine; b&w with 2-color cover. Design features "strong art showing rural places, people and objects in a new light of respect and regard. Focuses on the Appalachian chain from the Laurentians to Alabama but not limited to same. We publish people from all over the U.S. and Canada." Circ. 800. Original artwork returned at job's completion. Sample copies available: $5 for back issues, $6 for current issue.
Illustrations: Prefers detailed pen & ink drawings or block prints, primarily realistic. No cartoons. Send query letter with photocopies. Samples are filed and are not returned. Reports back within 2 months. Acquires one-time rights. Requests work on spec before assigning job. Pays on publication; $25 and up for b&w cover. Inside illustrations are paid for in contributor's copies.

Tips: "Our *Artist's & Graphic Designer's Market* listing has sent us dozens of artists. The rest have come through word of mouth or our magazine display at book fairs. We plan to utilize more b&w photography to complement the b&w artwork. An artist working with quill pens and a bottle of India ink could do work for us. A woodcarver cutting on basswood using 19th-century tools could work for us. Published artists include Lynn Holt, Sushanna Cohen and Roxanne Burger. A Vermont artist, Kathryn DiLego, has done four 4-color covers for us." Also publishes yearly *The Nightshade Short Story Reader*, same format, and 10 poetry chapbooks.

POWER AND LIGHT, 6401 The Paseo, Kansas City MO 64131. (816)333-7000, ext. 2243. Fax: (816)333-4439. Editor: Beula Postlewait. Associate Editor: Melissa Hammer. Estab. 1992. "*Power and Light* is a weekly 8 page, 2- and 4-color story paper that focuses on the interests and concerns of the preteen (11- to 12-year-old). We try to connect what they learn in Sunday School with their daily lives." Circ. 41,000. Originals are not returned. Sample copies and art guidelines free for SASE with first-class postage.
Cartoons: Buys 1 cartoon/issue. Prefers humor for the preteen; single panel b&w line drawings with gagline. Send query letter with brochure, roughs and finished cartoon samples. Samples are filed or are returned by SASE if requested. Reports back within 90 days. Buys multi-use rights. Pays $15 for b&w.
Illustrations: Buys 1 illustration/issue. Works on assignment only. Should relate to preteens. Considers airbrush, marker and pastel. Send query letter with brochure, résumé, SASE, photographs and photocopies. Request portfolio review in original query. Samples are filed. Reports back only if interested. Artist should follow up with letter after initial query. Portfolios may be dropped off every Monday-Thursday. Portfolio should include roughs, final art samples, b&w, color photographs. Buys all rights. Sometimes requests work on spec before assigning job. Pays on publication; $40 for b&w cover and inside; $75 for color cover and inside.
Tips: Finds artists through artists' submissions. "Send a résumé, photographs or photocopies of artwork and a SASE to the office. A follow-up call is appropriate within the month. Adult humor is not appropriate."

PRAIRIE SCHOONER, 201 Andrews Hall, University of Nebraska, Lincoln NE 68588-0334. (402)472-3191. Fax: (402)472-9771. Editor: Hilda Raz. Managing Editor: Kate Flaherty. Estab. 1927. Quarterly b&w literary magazine with 2-color cover. "*Prairie Schooner*, now in its 69th year of continuous publication, is called 'one of the top literary magazines in America,' by *Literary Magazine Review*. Each of the four issues contains short stories, poetry, book reviews, personal essays, interviews or some mix of these genres. Contributors are both established and beginning writers. Readers live in all states in the U.S. and in most countries outside the U.S." Circ. 3,200. Original artwork is returned after publication. "We rarely have the space or funds to reproduce artwork in the magazine but hope to do more in the future." Sample copies for $3.50.
Illustrations: Approached by 1-5 illustrators/year. Uses freelancers mainly for cover art. "Before submitting, artist should be familiar with our cover and format, 6×9, black and one color or b&w, vertical images work best; artist should look at previous issues of *Prairie Schooner*. Portfolio review not required. We are rarely able to pay for artwork; have paid $50 to $100."
Tips: Finds artists through word of mouth. "We're trying for some 4-color covers."

‡PRAYING, Box 419335, Kansas City MO 64141. (816)531-0538. Editor: Arthur N. Winter. Estab. 1984. Bimonthly 2-color magazine emphasizing spirituality for everyday living for lay Catholics and members of mainline Protestant churches; primarily Catholic, non-fundamentalist. "Starting point: The daily world of living, family, job, politics, is the stuff of religious experience and Christian living." Circ. 20,000. Accepts previously published material. Original artwork not returned after publication. Sample copy and art guidelines available.
Cartoons: Approached by about 24 cartoonists/year. Buys 1-2 cartoons/issue. Especially interested in cartoons that spoof fads and jargon in contemporary spirituality, prayer and religion. Prefers single panel b&w line drawings with gagline. Send query letter with samples of style to be kept on file. Material not filed is returned by SASE. Reports within 2 weeks. Buys one-time rights. **Pays on acceptance**; $50 for b&w.
Illustrations: Approached by about 24 illustrators/year. Works with 6 illustrators/year. Buys 2-3 illustrations/issue. Prefers contemporary interpretations of traditional Christian symbols to be used as incidental art; also drawings to illustrate articles. Send query letter with samples to be kept on file. Prefers photostats, tearsheets and photocopies as samples. Samples returned if not interested or return requested by SASE. Reports within 2 weeks. Buys one-time rights. **Pays on acceptance**; $50 for b&w.
Tips: "No old-fashioned church cartoons centering on traditional church humor—windy sermons, altar boy jokes, etc. Know our content. We'd like cartoons making fun of contemporary Catholic spirituality."

‡PREMIERE MAGAZINE, Dept. AGDM, 2 Park Ave., New York NY 10016. (212)545-3500. Design Director: John Korpics. Estab. 1987. "Monthly popular culture magazine about movies and the movie industry in the U.S. and the world. Of interest to both a general audience and people involved in the film business." Circ. 500,000. Original artwork is returned after publication.
Illustrations: Approached by 250 illustrators/year. Works with 150 illustrators/year. Buys 15-25 illustrations/issue. Buys illustrations mainly for spots and feature spreads. Works on assignment only. Considers all styles depending on needs. Send query letter with tearsheets, photostats and photocopies. Samples are filed. Samples

not filed are returned by SASE. Reports back about queries/submissions only if interested. Call for an appointment to show a porfolio which should include tearsheets. Buys first rights or one-time rights. Pays $350 for b&w, $375-1,200 for color inside.

Tips: "I do not want to see originals or too much work. Show only your best work."

‡❤**THE PRESBYTERIAN RECORD**, 50 Wynford Dr., North York, Ontario M3C 1J7 Canada. (416)441-1111. E-mail: tim_faller@magic.ca. Production and Design: Tim Faller. Published 11 times/year. Deals with family-oriented religious themes. Circ. 60,000. Original artwork returned after publication. Simultaneous submissions and previously published work OK. Free sample copy and artists' guidelines.

Cartoons: Approached by 12 cartoonists/year. Buys 1-2 cartoons/issue. Interested in some theme or connection to religion. Send roughs and SAE (nonresidents include IRC). Reports in 1 month. Pays on publication; $25-50 for b&w.

Illustrations: Approached by 6 illustrators/year. Buys 1 illustration/year on religion. "We are interested in excellent color artwork for cover." Any line style acceptable— should reproduce well on newsprint. Works on assignment only. Send query letter with brochure showing art style or tearsheets, photocopies and photographs. Will accept computer illustrations compatible with QuarkXPress 3.31, Adobe Illustrator 5.5, Adobe Photoshop 3.0. Samples returned by SAE (nonresidents include IRC). Reports in 1 month. To show a portfolio, mail final art and color and b&w tearsheets. Buys all rights on a work-for-hire basis. Pays on publication; $50-100 for color washes and opaque watercolors cover; $30-50 for b&w line drawings inside.

Tips: "We don't want any 'cute' samples (in cartoons). Prefer some theological insight in cartoons; some comment on religious trends and practices."

‡**PRESBYTERIAN SURVEY**, 100 Witherspoon St., Louisville KY 40202. (502)569-5636. Fax: (502)596-5018. Art Director: Linda Crittenden. Estab. 1830. 4-color; official church magazine emphasizing religious world news and inspirational features. Publishes 10 issues year. Circ. 90,000. Originals are returned after publication if requested. Sample copies for SASE with first-class postage. Art guidelines not available.

Cartoons: Approached by 20-30 cartoonists/year. Buys 1 freelance cartoon/issue. Prefers general religious material; single panel. Send query letter with brochure, roughs and/or finished cartoons. Samples are filed or are returned. Reports back within 1 month. Rights purchased vary according to project. Pays $20-25, b&w.

Illustrations: Approached by more than 50 illustrators/year. Buys 2-6 illustrations/issue, 50 illustrations/year from freelancers. Works on assignment only. Prefers ethnic, mixed groups and symbolic world unity themes. Media varies according to need. Send query letter with slides. Samples are filed or are returned by SASE. Reports back only if interested. Buys one-time rights. Pays $150-350, cover; $80-250, inside.

‡**PRIVATE PILOT**, Box 6050, Mission Viejo CA 92690. (714)855-8822. Contact: Editor. Estab. 1965. Monthly magazine for owners/pilots of private aircraft, student pilots and others aspiring to attain additional ratings and experience. Circ. 105,000. Receives 5 cartoons and 3 illustrations/week from freelance artists.

Cartoons: Buys 1 cartoon/issue on flying. Send finished artwork and SASE. Reports in 3 months. Pays on publication; $35 for b&w.

Illustrations: Works with 2 illustrators/year. Buys 12-18 illustrations/year. Uses artists mainly for spot art. Send query letter with samples and SASE. Reports in 3 months. Pays $100-150 for color. "We also use spot illustrations as column fillers." Buys 1-2 spot illustrations/issue. Pays $35/spot."

Tips: "Know the field you wish to represent; we specialize in general aviation aircraft, not jets, military or spacecraft."

PROCEEDINGS, U.S. Naval Institute, 118 Maryland Ave., Annapolis MD 21402-5035. (301)268-6110. Art Director: LeAnn Bauer. Monthly b&w magazine with 4-color cover emphasizing naval and maritime subjects. "*Proceedings* is an independent forum for the sea services." Design is clean, uncluttered layout, "sophisticated." Circ. 110,000. Accepts previously published material. Sample copies and art guidelines available.

Cartoons: Buys 23 cartoons/year from freelancers. Prefers cartoons assigned to tie in with editorial topics. Send query letter with samples of style to be kept on file. Material not filed is returned if requested by artist. Reports within 1 month. Negotiates rights purchased. Pays $25-50 for b&w, $50 for color.

Illustrations: Buys 1 illustration/issue. Works on assignment only. Needs editorial and technical illustration. "Like a variety of styles if possible. Do excellent illustrations and meet the requirement for military appeal." Prefers illustrations assigned to tie in with editorial topics. Send query letter with brochure, résumé, tearsheets, photostats, photocopies and photographs; computer-generated work compatible with QuarkXPress 3.3. Samples are filed or are returned only if requested by artist. Artist should follow up after initial query. Publication will contact artist for portfolio review if interested. Negotiates rights purchased. Sometimes requests work on spec before assigning job. Pays $50 for b&w, $50-75 for color inside; $150-200 for color cover; $25 minimum for spots. "Contact us first to see what our needs are."

Tips: "Magazines such as *Proceedings* that rely on ads from defense contractors will have rough going in the future."

‡**PROFESSIONAL TOOL & EQUIPMENT NEWS and BODYSHOP TOOL & EQUIPMENT NEWS**, 23121 Plaza Pointe Dr., Suite 130, Laguna Hills CA 92653. (714)830-7520. Fax: (714)830-7523. Publisher: Rudy

Wolf. Estab. 1990. Bimonthly trade journals. "*PTEN* covers tools and equipment used in the automotive repair industry. *BTEN* covers tools and equipment used in the automotive bodyshop industry." Circ. 105,000. Originals returned at job's completion. Sample copies for $2.25. Art guidelines free for SASE with first-class postage.

Cartoons: Approached by 3 cartoonists/year. Buys 2 cartoons/issue. Prefers auto service and tool-related, single panel color washes with gaglines. Send query letter with finished cartoons. Samples are not filed and are returned by SASE if requested by artist. Reports back within 2 weeks. Buys one-time rights. Pays $50 for b&w.

Illustrations: Approached by 3 illustrators/year. Buys 2 illustrations/issue. Works on assignment only. Considers pen & ink and airbrush. Send query letter with brochure and tearsheets. Samples are not filed and returned by SASE. Reports back within 2 weeks.To show a portfolio, mail thumbnails and roughs. Buys one-time rights. **Pays on acceptance**; $100-200 for b&w, $200-500 for color inside.

THE PROGRESSIVE, 409 E. Main St., Madison WI 53703. Art Director: Patrick JB Flynn. Estab. 1909. Monthly b&w plus 4-color cover. Circ. 35,000. Originals returned at job's completion. Free sample copy and art guidelines.

Illustrations: Works with 50 illustrators/year. Buys 12 b&w illustrations/issue. Needs editorial illustration that is "smart, bold, expressive." Works on assignment only. Send query letter with tearsheets and/or photocopies. Samples returned by SASE. Reports in 6 weeks. Portfolio review not required. Pays $400 for cover; $100-200 for b&w line or tone drawings/paintings/collage inside. Buys first rights.

Tips: Do not send original art. Send direct mail samples, postcards or photocopies and appropriate return postage. "The successful art direction of a magazine allows for personal interpretation of an assignment."

‡PSYCHOLOGY TODAY, 49 E. 21st St., 11th Floor, New York NY 10010. Picture Editor: Elizabeth Sinsabough. Estab. 1991. Bimonthly consumer magazine for professionals and academics, men and women. Circ. 200,000. Accepts previously published artwork. Originals returned at job's completion. Sample copies and art guidelines not available.

Illustrations: Approached by 250 illustrators/year. Buys 5 illustrations/issue. Works on assignment only. Prefers psychological, humorous, interpersonal studies. Considers all media. Needs editorial, technical and medical illustration. Needs computer-literate freelancers for illustrations. 20% of freelance work demands knowledge of QuarkXPress or Photoshop. Send query letter with brochure, photostats and photocopies. Samples are filed and are not returned. Reports back only if interested. Call for an appointment to show portfolio of b&w/color tearsheets, slides and photographs. Buys one-time rights. Pays on publication; $400 for ¼ page, $800 for full page inside; cover negotiable.

PUBLIC CITIZEN, 2000 P St. NW, Suite 610, Washington DC 20036. (202)833-3000. Editor: Peter Nye. Contact: Lauren Marshall. Bimonthly magazine emphasizing consumer issues for the membership of Public Citizen, a group founded by Ralph Nader in 1971. Circ. 150,000. Accepts previously published material. Returns original artwork after publication. Sample copy available with 9 × 12 SASE with first-class postage.

Illustrations: Buys up to 10 illustrations/issue. Prefers contemporary styles in pen & ink; uses computer illustration also. "I use computer art when it is appropriate for a particular article." Send query letter with samples to be kept on file. Samples not filed are returned by SASE. Reports only if interested. Buys first rights or one-time rights. Pays on publication; $300 for 3-color cover; $50-200 for b&w or 2-color inside.

Tips: "Frequently commission more than one spot per artist. Also, send several keepable samples that show a range of styles and the ability to conceptualize."

PUBLISHERS WEEKLY, Dept. AGDM, 249 W. 17th St., 6th Floor, New York NY 10011. (212)645-9700. Art Director: Karen E. Jones. Weekly magazine emphasizing book publishing for "people involved in the creative or the technical side of publishing." Circ. 50,000. Original artwork is returned to the artist after publication.

Illustrations: Buys 75 illustrations/year. Works on assignment only. "Open to all styles." Send query letter with brochure, tearsheets, photostats, photocopies, slides and photographs. Samples are not returned. Reports back only if interested. To show a portfolio, mail appropriate materials. **Pays on acceptance**; $350-400 for color inside; $50-100 for spots.

‡♣QUARRY MAGAZINE, Box 1061, Kingston, Ontario K7L 4Y5 Canada. (613)548-8429. Editor: Mary Cameron. Black & white with 4-color cover, (perfect bound, book-form,) "classic" design. Emphasizes poetry, fiction, short plays, book reviews—Canadian literature. "Audience: Canadian writers; libraries (public, high school, college, university); persons interested in current new writing." Quarterly. Circ. 1,000. Original artwork returned after publication. Sample copy for $5.

Illustrations: Buys 3-5 illustrations/issue from freelancers. Uses freelance artists mainly for cover of magazine. No set preference on themes or styles; "we need high quality line drawings." Send query letter with

originals or good photostats to be kept on file. Contact only by mail. Reports within 3 months. Buys first rights. Pays $100, b&w, cover; on publication.

ELLERY QUEEN'S MYSTERY MAGAZINE, 1540 Broadway, New York NY 10036. (212)782-8546. Editor: Janet Hutchings. Emphasizes mystery stories and reviews of mystery books.
Cartoons: "We are looking for cartoons with an emphasis on mystery, crime and suspense."
Illustrations: Prefers line drawings. All other artwork is done inhouse. Reports within 3 months. **Pays on acceptance**; $25 minimum for line drawings.

RACQUETBALL MAGAZINE, 1685 W. Uintah, Colorado Springs CO 80904-2921. (719)535-9648. Fax: (719)535-0685. Director of Communications/Editor: Linda Mojer. Bimonthly publication of The American Amateur Racquetball Association. "Distributed to members of AARA and industry leaders in racquetball. Focuses on both amateur and professional athletes." Circ. 50,000. Accepts previously published artwork. Originals returned at job's completion. Sample copies and art guidelines available. Needs computer-literate freelancers. Freelancers should be familiar with Aldus PageMaker.
Cartoons: Needs editorial illustration. Prefers racquetball themes. Send query letter with roughs. Samples are filed. Reports back within 2 months. Publication will contact artist for portfolio review if interested. Negotiates rights purchased. Pays $50 for b&w, $50 for color (payment negotiable).
Illustrations: Approached by 5-10 illustrators/year. Usually works on assignment. Prefers racquetball themes. Send query letter with samples. Samples are filed. Publication will contact artist for portfolio review if interested. Negotiates rights purchased. Pays on publication; $200 for color cover; $50 for b&w, $50 for color inside (all fees negotiable).

R-A-D-A-R, 8121 Hamilton Ave., Cincinnati OH 45231. Editor: Elaina Meyers. Weekly 4-color magazine for children 3rd-6th grade in Christian Sunday schools. Original artwork not returned after publication.
Cartoons: Buys 1 cartoon/month on animals, school and sports. "We want cartoons that appeal to children—but do not put down any group of people; clean humor." Prefers to see finished cartoons. Reports in 1-2 months. **Pays on acceptance**; $17.50.
Illustrations: Buys 5 or more illustrations/issue. "Art that accompanies nature or handicraft articles may be purchased, but almost everything is assigned." Send tearsheets to be kept on file. Samples returned by SASE. Publication will contact artist for portfolio review if interested. Buys all rights on a work-for-hire basis. Sometimes requests work on spec before assigning job. Pays $150 for full-color cover; $70 for inside.
Tips: Finds artists through word of mouth, artists' submissions/self-promotions. "Know how to illustrate 3rd- to 6th-grade children well."

RADIANCE, The Magazine for Large Women, P.O. Box 30246, Oakland CA 94604. Phone/fax: (510)482-0680. Publisher/Editor: Alice Ansfield. Estab. 1984. Quarterly consumer magazine "for women *all* sizes of large—encouraging them to live fully *now*." Circ. 8,000-10,000. Accepts previously published artwork. Original artwork returned at job's completion. Sample copy for $3 plus postage. Art guidelines not available. Needs computer-literate freelancers for design and production. 10% of freelance works demands knowledge of Adobe Illustrator, QuarkXPress, Adobe Photoshop, Aldus FreeHand on Macintosh.
Cartoons: Approached by 200 cartoonists/year. Buys 1-3 cartoons/issue. Wants empowering messages for large women, with humor and perspective on women's issues; single, double or multiple panel b&w or 2-color line drawings with gagline. "We'd like to see any format." Send query letter with brochure, roughs and finished cartoons or postcard-size sample. Samples are filed or are returned by SASE if requested by artist. Buys one-time rights. Pays $15-100 for b&w.
Illustrations: Approached by 200 illustrators/year. Buys 3-5 illustrations/issue. Considers pen & ink, watercolor, airbrush, acrylic, colored pencil, collage and mixed media. Send query letter with appropriate samples—whatever works! Samples are filed or are returned by SASE if requested by artist. Reports back in 3-4 months. Buys one-time rights. Pays on publication; $50-75 for b&w; $50-150 for color cover; $25-75 for b&w or color inside; $10-35 for spots.
Tips: "Read our magazine. Find a way to help us with our goals and message."

‡RAPPORT, 5265 Fountain Ave., Los Angeles CA 90029. (213)660-0433. Art Director: Crane Jackson. Estab. 1974. Bimonthly entertainment magazine featuring book and CD reviews; music focus is on jazz, some popular music. Circ. 60,000. Originals not returned. Samples copies are available. Art guidelines not available.

The double dagger before a listing indicates that the listing is new in this edition. New markets are often more receptive to freelance submissions.

Illustrations: Approached by 12 illustrators/year. Buys 6 illustrations/issue. Works on assignment only. Prefers airbrush and acrylic. Send query letter with brochure and transparencies. Samples are filed. Reports back within 2 months.

Tips: "As a small publication, we try to pay the best we can. We do not want artists who have a fixed amount for payment when they see us. We give good exposure for artists who will illustrate our articles. If we find good artists, they'll get a lot of work plus payment on receipt plus plenty of copies of the magazine to fill their portfolios. Several artists have been recruited by book publishers who have seen their work in our magazine, which reviews more than 100 books from all publishers. One mistake illustrators frequently make is that they don't adapt their artwork to our needs. We often OK a rough then find them deviating from that rough. Many times we will explain or give the article to the illustrator to come up with a concept and find they don't serve the article. Art for art's sake is disappearing from magazines."

REAL PEOPLE MAGAZINE, 950 Third Ave., 16th Floor, New York NY 10022. (212)371-4932. Fax: (212)838-8420. Editor: Alex Polner. Estab. 1988. "Bimonthly 4-color and b&w entertainment magazine featuring celebrities and show business articles, profiles for men and women ages 35 and up." Circ. 125,000. Original artwork returned after publication. Sample copy for $3.50 plus postage. Art guidelines not available.

Illustrations: Buys 1-2 color illustrations/issue and 4-6 b&w/issue. Works on assignment only. Theme or style depends on the article. Prefers pen & ink, watercolor, acrylic and collage with strong concept and/or sense of humor. Send query letter with tearsheets. Samples are filed. Artist should follow up after initial query. Publication will contact artist for portfolio review if interested. Buys all rights. Pays on publication; $50-150 for b&w, $200-350 for color inside; $75 for spots.

Tips: "We prefer illustration with a sense of humor."

‡REDBOOK MAGAZINE, Dept. AM, 224 W. 57th St., New York NY 10019. (212)649-2000. Art Director: Ed Melnitsky. Monthly magazine "geared to baby boomers with busy lives. Interests in fashion, food, beauty, health, etc." Circ. 7 million. Accepts previously published artwork. Original artwork returned after publication with additional tearsheet if requested. Art guidelines not available.

Illustrations: Buys 3-4 illustrations/issue. "We prefer photo illustration for fiction and more serious articles, loose or humorous illustrations for lighter articles; the only thing we don't use is high realism. Illustrations can be in any medium. Portfolio drop off any day, pick up the next day. To show a portfolio, mail work samples that will represent the artist and do not have to be returned. This way the sample can remain on file, and the artist will be called if the appropriate job comes up." Buys reprint rights or negotiates rights. Payment for accepted work only: $150-600 for b&w, $400-1,200 for color.

Tips: "Look at the magazine before you send anything, we might not be right for you. Generally, illustrations should look new, of the moment, intelligent."

REFORM JUDAISM, 838 Fifth Ave., New York NY 10021-7046. (212)249-0100. Managing Editor: Joy Weinberg. Estab. 1972. Quarterly magazine. "The official magazine of the Reform Jewish movement. It covers development within the movement and interprets world events and Jewish tradition from a Reform perspective." Circ. 295,000. Accepts previously published artwork. Originals returned at job's completion. Sample copies available for $3.50. Art guidelines not available. 5% of freelance work demands computer skills.

Cartoons: Prefers political themes tying into editorial coverage. Send query letter with finished cartoons. Samples are filed. Reports back within 3-4 weeks. Buys first firghts, one-time rights and reprint rights. Pays $50 for b&w, $75 for color.

Illustrations: Buys 8-10 illustrations/issue. Works on assignment. Send query letter with brochure, résumé, SASE and tearsheets. Samples are filed. Reports back within 3-4 weeks. Publication will contact artist for portfolio review if interested. Portfolio should include tearsheets, slides and final art. Rights purchased vary according to project. **Pays on acceptance**; $600 for color cover; $150-200 for b&w, $250-400 for color inside.

Tips: Finds artists through sourcebooks and artists' submissions.

RELIX MAGAZINE, P.O. Box 94, Brooklyn NY 11229. (718)258-0009. Fax: (718)692-4345. Publisher: Toni Brown. Estab. 1974. Bimonthly consumer magazine emphasizing the Grateful Dead and psychedelic music. Circ. 50,000. Does not accept previously published artwork. Sample copies or art guidelines not available.

Cartoons: Approached by 20 cartoonists/year. Prefers Grateful Dead-related humorous cartoons, single or multiple panel b&w line drawings. Send query letter with finished cartoons. Samples are not filed and are returned by SASE if requested by artist. Reports back to the artist only if interested. Pays $25-75 for b&w, $100-200 for color. Buys all rights.

Illustrations: Approached by 100 illustrators/year. Buys multiple illustrations/issue. Prefers Grateful Dead-related. Considers pen & ink, airbrush and marker. Send query letter with SASE and photostasts. Samples are not filed and are returned by SASE if requested by artist. Reports back to the artist only if interested. Portfolio review not required. Buys all rights. Pays on publication; $100-500 for color cover; $25-75 for b&w, $75-150 for color inside.

Tips: Finds artists through word of mouth. "Looking for skeleton artwork—happy, not gorey."

RENOVATED LIGHTHOUSE, P.O. Box 340251, Columbus OH 43234-0251. Editor: R. Allen Dodson. Estab. 1986. Irregularly published 72-page literary magazine; "quality literary work by amateurs and professionals." Circ. 200. Sample copy (current) $4.25; (back) $4; contributor copies $3.75. Art guidelines for SASE with first-class postage (55¢).

Cartoons: "We need cartoon fillers." Prefers "dry humor, subtle sometimes, often political, but not necessarily timely, more a signpost of the times." Pays 1 copy of issue.

Illustrations: Approached by 36 illustrators/year. "We use one artist/issue. This artist is required to provide: (1) an unpublished original drawing (5.5×8.5) of a lighthouse, preferably, for the cover; (2) 3-4 unpublished or previously published works for the gallery column; (3) a biographical sketch for inclusion in the gallery; (4) 2-4 illustrations of a story in the same issue. We aim for a publication that belongs in the library, not a periodical to throw away after reading it." Prefers "disk submissions. Artwork must be retrievable into Word Perfect 6.1 for Windows." Considers pen & ink. Send query letter with SASE and photocopies. Samples are filed. Reports back within 1 month. To show a portfolio, mail b&w tearsheets and photocopies. Rights purchased vary according to project. Pays $20/issue.

Tips: "Publications are suffering at the hands of computer entertainment much as what happened with the advent of TV. Eventually, all magazines will have to be on disk. Tell us whether the work is a submission, to be filed or to be returned. We publish very irregularly."

THE REPORTER, Women's American ORT, 315 Park Ave. S., New York NY 10010. (212)505-7700. Fax: (212)674-3057. Editor: Dana B. Asher. Estab. 1966. Quarterly organization magazine for Jewish women emphasizing issues, lifestyle, education. *The Reporter* is the magazine of Women's ORT, a membership organization supporting a worldwide network of technical and vocational schools. Circ. 110,000. Original artwork returned at job's completion. Sample copies for SASE with first-class postage.

Illustrations: Approached by 25 illustrators/year. Buys 2 illustration/issue. Works on assignment only. Prefers contemporary art. Considers pen & ink, mixed media, watercolor, acrylic, oil, charcoal, airbrush, collage and marker. Send query letter with brochure, résumé, tearsheets, photographs, photocopies, photostats and slides. Samples are filed or returned by SASE if requested by artist. Reports back to the artist only if interested. Rights purchased vary according to project. Pays on publication; $150 for color cover; $50 for b&w, $75 for color inside.

‡THE RESIDENT, 6900 Grove Rd., Thorofare NJ 08086. (609)848-1000. Fax: (609)853-5991. Art Director: Linda Baker. Estab. 1990. "This is a series of bimonthly publications (11 in total) directed at medical residents in 11 different subspecialties. Articles deal with 'lifestyle' issues facing people during their residency years." Circ. 13,000 Accepts previously published artwork. Originals returned at job's completion. Sample copies and art guidelines available. Needs computer-literate freelancers for illustration. 10% of freelance work demands knowledge of Adobe Illustrator.

Cartoons: Approached by 12 cartoonists/year. Buys 1 cartoon/issue. Prefers color washes or b&w line drawings without gagline. Send query letter with samples. Samples are filed and are returned by SASE if requested by artist. Reports back to the artist only if interested. Negotiates rights purchased. Pays $150 for b&w, $250 for color.

Illustrations: Approached by 50 illustrators/year. Buys 5 illustrations/issue. Works on assignment only. Prefers watercolor, airbrush, acrylic, oil and mixed media. Send query letter with tearsheets, photographs, photocopies, slides and transparencies. Samples are filed and are returned by SASE if requested by artist. Reports back to the artist only if interested. To show a portfolio, mail b&w and color tearsheets, slides, photostats, photocopies and photographs. Negotiates rights purchased. Pays on publication; $400 for color cover; $200 for b&w, $300 for color inside.

RESIDENT AND STAFF PHYSICIAN, 80 Shore Rd., Port Washington NY 11050. (516)883-6350. Executive Editor: Anne Mattarella. Monthly publication emphasizing hospital medical practice from clinical, educational, economic and human standpoints. For hospital physicians, interns and residents. Circ. 100,000.

Cartoons: Buys 3-4 cartoons/year from freelancers. "We occasionally publish sophisticated cartoons in good taste dealing with medical themes." Reports in 2 weeks. Buys all rights. **Pays on acceptance**; $25.

Illustrations: "We commission qualified freelance medical illustrators to do covers and inside material. Artists should send sample work." Send query letter with brochure showing art style or résumé, tearsheets, photostats, photocopies, slides and photographs. Call or write to schedule appointment to show portfolio of color and b&w final reproduction/product and tearsheets. **Pays on acceptance**; $700 for color cover; payment varies for inside work.

Tips: "We like to look at previous work to give us an idea of the artist's style. Since our publication is clinical, we require highly qualified technical artists who are very familiar with medical illustration. Sometimes we have use for nontechnical work. We like to look at everything. We need material from the *doctor's* point of view, *not* the patient's."

‡THE RETIRED OFFICER, 201 N. Washington St., Alexandria VA 22314. (703)549-2311. Art Director: M.L. Woychik. Estab. 1945. Four-color magazine for retired officers of the uniformed services; concerns current military/political affairs; recent military history, especially Vietnam and Korea; holiday anecdotes; travel;

human interest; humor; hobbies; second-career job opportunities and military family lifestyle. **Illustrations:** Works with 9-10 illustrators/year. Buys 15-20 illustrations/year. Buys illustrations on assigned themes. (Generally uses Washington DC area artists.) Uses freelancers mainly for features and covers. Send samples.
Tips: "We look for artists who can take a concept and amplify it editorially."

RHODE ISLAND MONTHLY, 18 Imperial Place, Providence RI 02903. (401)421-2552. Fax: (401)831-5624. Art Director: Donna Chludzinski. Estab. 1988. Monthly 4-color magazine which focuses on life in Rhode Island. Provides the reader with in-depth reporting, service and entertainment features and dining and calendar listings. Circ. 32,000. Accepts previously published artwork. Art guidelines not available.
Illustrations: Approached by 20 freelance illustrators/year. Buys 1-2 illustrations/issue. Works on assignment and sometimes on spec. Considers all media. Send query letter with SASE, tearsheets, photographs and slides. Samples are filed. Request portfolio review in original query. Publication will contact artist for portfolio review if interested. Portfolio should include b&w and color tearsheets. Buys one-time rights. Sometimes requests work on spec before assigning job. Pays on publication; $150 for b&w, $250 minimum for color inside, depending on the job.
Tips: Finds artists through word of mouth, artists' submissions/self-promotions and sourcebooks. "Ninety-five percent of our visual work is done by photographers. That's what works for us. We are glad to file illustration samples and hire people with appropriate styles at the appropriate time. I need to look at portfolios quickly. I like to know the illustrator knows a little bit about *RI Monthly* and has therefore edited his/her work down to a manageable amount to view in a short time."

‡RISK MANAGEMENT, 655 Third Ave., 2nd Floor, New York NY 10017. (212)286-9292. Art Director: Craig Goldberg. "Updated redesign has more color and '90s graphics." Emphasizes the risk management and insurance fields; 4-color. Monthly. Circ. 11,600.
Cartoons: "Follow current trends in humorous illustration—emphasize business-related themes." Pays minimum $100, b&w; $250, color.
Illustrations: Buys 5-8 freelance illustrations/issue. Uses artists for covers, 4-color inside and spots. Works on assignment only. Send card showing art style or tearsheets. Drop-off policy. To show a portfolio, mail original art and tearsheets. Printed pieces as samples only. Samples are returned only if requested. Buys one-time rights. Needs technical illustration. Needs computer-literate freelancers for illustration and production. 15% of freelance work demands computer literacy in Adobe Illustrator or Quark XPress.
Tips: When reviewing an artist's work, looks for "strong concepts, creativity and craftsmanship. Our current design uses more illustration and photography."

ROANOKER MAGAZINE, 3424 Brambleton Ave., Roanoke VA 24018. (703)989-6138. Art Director: Tim Brown. Estab. 1974. Monthly general interest magazine for the city of Roanoke, Virginia and the Roanoke valley. Circ. 10,000. Originals are not returned. Art guidelines not available.
Illustrations: Approached by 20-25 freelance illustrators/year. Buys 5-10 illustrations/year. Works on assignment only. Send query letter with brochure, tearsheets and photocopies. Samples are filed. Reports back only if interested. No portfolio reviews. Buys one-time rights. Pays on publication; $100 for b&w or color cover; $75 for b&w or color inside.
Tips: "Please *do not* call or send any material that needs to be returned."

ROBB REPORT, One Acton Place, Acton MA 01720. (508)263-7749. Fax: (508)263-0722. Design Director: Russ Rocknak. Monthly 4-color consumer magazine "for the affluent lifestyle, featuring exotic cars, investment, entrepreneur, boats, etc." Circ. 50,000. Accepts previously published artwork. Original artwork is returned at job's completion. Sample copies not available. Art guidelines for SASE with first-class postage.
Cartoons: Prefers upscale lifestyle cartoons. Send query letter with finished cartoons. Samples are filed. Reports back only if interested. Buys one-time rights. Pays $150 for b&w, $250 for color.
Illustrations: Approached by 50 freelance illustrators/year. Buys 5 freelance illustrations/year. Send query letter with tearsheets, photographs, slides and transparencies. Samples are filed. Portfolio should include b&w and color tearsheets, slides and photographs. Buys one-time rights. Sometimes requests work on spec before assigning job. Pays within 60-90 days of acceptance. Payment varies.

ROCK PRODUCTS, 29 N. Wacker Dr., Chicago IL 60606. (312)726-2802. Fax: (312)726-2574. E-mail: illnoise@aol.com. Art Director: Bryan O. Bedell. Estab. 1894. Monthly 4-color trade journal. Circ. 30,000. Accepts previously published artwork. Needs computer-literate freelancers for illustration. 75% of freelance work demands knowledge of Adobe Illustrator.
Cartoons: "We use very few cartoons. They would need to be industry-related."
Illustrations: Approached by 20 illustrators/year. Buys 3 illustrations/year. Works on assignment only. Looking for realistic, technical style. Send query letter with brochure, samples, slides or disk. Samples are filed or are returned by SASE if requested by artist. Publication will contact artist for portfolio review if interested. Portfolio should include thumbnails, roughs, final art, b&w and color tearsheets. Rights purchased vary according to project. Pays $300 for color cover; $100 for b&w, $200 for color inside.

Tips: Finds artists through word of mouth and self-promotion. Prefers local artists. "Approach me at a lucky time. A follow-up call is fine. This may not be true of most art directors, but I prefer a casual, friendly approach. Also, being 'established' means nothing. I prefer to use new illustrators as long as they are professional and original."

‡ROCKFORD REVIEW, P.O. Box 858, Rockford IL 61105. Editor: David Ross. Estab. 1971. Quarterly literary magazine emphasizing literature and art which contain fresh insights into the human condition. Circ. 1,000. Sample copy for $5. Art guidelines free for SASE with first-class postage. Needs computer-literate freelancers for illustration.
Illustrations: Approached by 8-10 illustrators/year. Buys 1-2 illustrations/issue. Prefers satire/human condition. Considers pen & ink and marker. Send query letter with photographs, SASE and photocopies. Samples are not filed and are returned by SASE. Reports back within 2 months. Portfolio review not required. Publication will contact artist for portfolio review if interested. Portfolio should include final art and photocopies. Buys first rights. Pays on publication; 1 copy plus eligiblity for $25 Editor's Choice Prize (8 each year)— and guest of honor at fall party.
Tips: Finds artists through word of mouth and artists' submissions.

‡ROCKY MOUNTAIN SPORTS, 2025 Pearl St., Boulder CO 80302. (303)440-5111. Fax: (303)440-3313. Art Director: Tom Wallis. Estab. 1985. Monthly consumer magazine; "the recognized authority on sports that epitomize the Rocky Mountain Region." Circ. 42,000. Accepts previously published artwork. Original artwork is returned at job's completion. Sample copies for SASE with first-class postage. Art guidelines available.
Illustrations: Approached by 20 freelance illustrators/year. Buys 1-2 freelance illustrations/issue. Works on assignment only. Generally prefers humorous themes and styles. Considers pen & ink and charcoal. Send query letter with brochure and tearsheets. Samples are filed and are not returned. Reports back only if interested. Call or write to schedule appointment to show portfolio of original/final art, b&w tearsheets and photographs. Buys one-time rights. Pays 30 days after publication; $150, b&w, $200, color, cover; $25, b&w, inside.
Tips: "Send me a promotional piece and follow up with a call so we can discuss style, fees, interests and schedules (turn-around time) and editorial line-up."

‡ROLLING STONE MAGAZINE, 1290 Avenue of the Americas, New York NY 10104. (212)484-1616. Estab. 1967. Bimonthly magazine. Circ. 1.4 million. Originals returned at job's completion. Sample copies available. Art guidelines not available. Needs computer-literate freelancers for design and production. 100% of freelance work demands knowledge of Adobe Illustrator, QuarkXPress and Adobe Photoshop.
Illustrations: Approached by "tons" of illustrators/year. Buys 8 illustrations/issue. Works on assignment only. Considers pen & ink, airbrush, colored pencil, mixed media, collage, charcoal, watercolor, acrylic, oil and pastel. Send query letter with tearsheets and photocopies. Samples are filed. Does not report back. Portfolios may be dropped off every Tuesday 11-3 and should include final art and tearsheets. Publication will contact artist for portfolio review if interested. Buys first and one-time rights. **Pays on acceptance**; payment for cover and inside illustration varies; pays $250-400 for spots.
Tips: Finds artists through word of mouth, *American Illustration, California Illustration* and drop-offs.

THE ROTARIAN, 1560 Sherman Ave., Evanston IL 60201. Editor: Willmon L. White. Art Director: P. Limbos. Estab. 1911. Monthly 4-color publication emphasizing general interest, business and management articles. Service organization for business and professional men and women, their families, and other subscribers. Accepts previously published artwork. Sample copy and editorial fact sheet available.
Cartoons: Approached by 14 cartoonists/year. Buys 5-8 cartoons/issue. Interested in general themes with emphasis on business, sports and animals. Avoid topics of sex, national origin, politics. Send query letter to Cartoon Editor, Charles Pratt, with brochure showing art style. Reports in 1-2 weeks. Buys all rights. **Pays on acceptance**; $75.
Illustrations: Approached by 8 illustrators/year. Buys 10-20 illustrations/year; 7-8 humorous illustrations/year from freelancers. Uses freelance artwork mainly for covers and feature illustrations. Most editorial illustrations are commissioned. Send query letter to Art Director with brochure showing art style. Artist should follow-up with a call or letter after initial query. Portfolio should include original/final art, final reproduction/product, color and photographs. Sometimes requests work on spec before assigning job. Buys all rights. **Pays on acceptance**; payment negotiable, depending on size, medium, etc.; $800-1,000 for color cover; $200-700 for color inside full page.
Tips: "Preference given to area talent." Conservative style and subject matter.

ROUGH NOTES, 1200 N. Meridian, P.O. Box 564, Indianapolis IN 46204. Publications Production Manager: Evelyn Egan. Estab. 1878. Monthly 4-color magazine with a contemporary design. Does not accept previously published artwork.
Cartoons: Buys 3-5 cartoons/issue on property and casualty insurance, automation, office life (manager/subordinate relations) and general humor. No risqué material. Receives 30-40 cartoons/week from freelance

Robert Zammarchi's "cracked-up" collage style was the perfect medium for a short article in Running Times *about athletes dealing with the pain of exercise-induced headaches. Zammarchi used magazine cut-outs and color photocopying for the job for which he received $300. Zammarchi has done a number of assignments for* Running Times's *Art Director John Hall. "I did a piece for John at another magazine in 1990," says Zammarchi. "He actually gave me my first published assignment with my new collage style." Later when Hall moved to* Running Times *he contacted Zammarchi again "and it was just like old times."*

artists. Submit art every 3-4 months. Include SASE. Reports in 1 month. Buys all rights. Prefers 5×8 or 8×10 finished art. Will accept computer generated work compatible with QuarkXPress 3.3 and Adobe Illustrator 5.0. **Pays on acceptance**; $20, line drawings and halftones.

Tips: "Do not submit sexually discriminating materials. I have a tendency to disregard all of the material if I find any submissions of this type. Send several items for more variety in selection. We would prefer to deal only in finished art, not sketches."

RUNNER'S WORLD, 33 E. Minor St., Emmaus PA 18098. (610)967-5171. Fax: (610)967-7725. Art Director: Ken Kleppert. Estab. 1965. Monthly 4-color with a "contemporary, clean" design emphasizing serious, recreational running. Circ. 470,000. Accepts previously published artwork "if appropriate." Returns original artwork after publication. Needs computer-literate freelancers. 30% of freelance work demands knowledge of Adobe Illustrator, Adobe Photoshop or Aldus FreeHand.

Illustrations: Approached by hundreds of illustrators/year. Works with 50 illustrators/year. Buys average of 10 illustrations/issue. Needs editorial, technical and medical illustrations. "Styles include tightly rendered human athletes, graphic and cerebral interpretations of running themes. Also, *RW* uses medical illustration for features on biomechanics." Style of David Suter, Tom Bloom, John Segal, Enos. Prefers pen & ink, airbrush, charcoal/pencil, colored pencil, watercolor, acrylic, oil, pastel, collage and mixed media. "No cartoons or originals larger than 11 × 14." Works on assignment only. Send samples to be kept on file. (Prefers tearsheets.) Publication will contact artist for portfolio review if interested. Buys one-time international rights. Pays $350 and up for color inside.

Tips: Finds artists through word of mouth, magazines, artists' submissions/self-promotions, sourcebooks, artists' agents and reps, and attending art exhibitions. Portfolio should include "a maximum of 12 images. Show a clean presentation, lots of ideas and few samples. Don't show disorganized thinking. Portfolio samples should be uniform in size."

‡RUNNING TIMES, 98 N. Washington St., Boston MA 02114. (617)367-2228. Fax: (617)367-2350. Art Director: John Hall. Estab. 1977. Monthly consumer magazine. Publication covers sports, running. Circ. 70,000. Accepts previously published work. Originals returned at job's completion. Sample copies available. Art guidelines not available. Needs computer-literate freelancers for design, illustration and production. 100% of freelance work demands knowledge of QuarkXPress, Adobe Photoshop and Aldus FreeHand.

Cartoons: "We haven't used cartoons but may be interested in future." Prefers sports/running themes.

Illustrations: Buys 2-3 illustrations/issue. Works on assignment only. Considers pen & ink, colored pencil, mixed media, collage, charcoal, watercolor, acrylic, oil, pastel and marker. Send postcard-size sample. Samples are filed. Publication will contact artist for portfolio review of roughs, final art and tearsheets if interested. Buys one-time rights. Pays on publication; $500-800 for color cover; $300-700 for color inside; $250-300 for spots.

Tips: Finds artists through illustration annuals, mailed samples, published work in other magazines. "We plan on redesigning—looking to expand use of quality art and design."

RUTGERS MAGAZINE, Alexander Johnston Hall, New Brunswick NJ 08903. Fax: (908)932-8412. Editor: Lori Chambers. Estab. 1987. Quarterly 4-color general interest magazine covering research, events, art programs, etc. that relate to Rutgers University; "conservative design." Readership consists of alumni, parents of students and University staff. Circ. 110,000. Accepts previously published artwork. Original artwork is returned after publication. Sample copies available. Needs computer-literate freelancers for illustration. 10% of freelance work demands computer literacy in QuarkXPress or Aldus FreeHand.

Illustrations: Buys illustrations mainly for covers and feature spreads. Buys 4 illustrations/issue, 16 illustrations/year. Considers mixed media, watercolor, pastel and collage. Send query letter with brochure. "Show a strong conceptual approach." Editorial illustration "varies from serious to humorous, conceptual to realistic." Samples are filed. Publication will contact artist for portfolio review if interested. Buys one-time rights. Pays on publication; $800-1,000 for color cover; $100-800 for color inside.

Tips: Finds artists through sourcebooks and artists' submissions. "Open to new ideas. See a trend away from perfect realism in illustration. See a willingness to experiment with type in design."

SACRAMENTO MAGAZINE, 4471 D Street, Sacramento CA 95819. (916)452-6200. Fax: (916)452-6061. Art Director: Rebecca McKee. Estab. 1975. Monthly consumer lifestyle magazine with emphasis on home and garden, women, health features and stories of local interest. Circ. 20,000. Accepts previously published artwork. Originals returned to artist at job's completion. Sample copies available. Art guidelines not available. Needs computer-literate freelancers for production. 70% of freelance work demands computer knowledge of Aldus PageMaker 4.2-5.0, Adobe Photoshop and Aldus FreeHand.

Illustrations: Approached by 100 illustrators/year. Buys 1-2 illustrations/issue. Works on assignment only. Considers pen & ink, collage, airbrush, acrylic, colored pencil, oil, collage, marker and pastel. Send postcard-size sample. Samples are filed and are not returned. Publication will contact artist for portfolio review if interested. Portfolio should include b&w and color tearsheets and final art. Buys one-time rights. Pays on publication; $300 for b&w, $350 for color cover; $350 for b&w, $400 for color inside; $50 for spots.

Tips: Finds artists through artists' submissions. Sections most open to freelancers are departments and some feature stories. "We have a cartoonist that we publish regularly."

SACRAMENTO NEWS & REVIEW, 2210 21st St., Sacramento CA 95818. (916)737-1234. Fax: (916)737-1437. Art Director: Don Button. Estab. 1989. "An award-winning b&w with 4-color cover alternative newsweekly for the Sacramento area. We combine a commitment to investigative and interpretive journalism with coverage of our area's growing arts and entertainment scene." Circ. 90,000. Occasionally accepts previously published artwork. Originals returned at job's completion. Sample copies and art guidelines available.

Cartoons: Approached by 100 cartoonists/year. Buys 1 cartoon/issue. Prefers political and off-beat single panel, b&w line drawings. Send query letter with copies. Samples are filed. Reports back to the artist only if interested. Rights purchased vary according to project. Pays $15 for b&w.

Illustrations: Approached by 50 illustrators/year. Buys 1 illustration/issue. Works on assignment only. For cover art, needs themes that reflect content. Send query letter with tearsheets. Samples are filed. Publication will contact artist for portfolio review if interested. Portfolio may be dropped off every Monday-Saturday. Portfolio should include mail tearsheets, slides, photocopies and photographs. Buys first rights. **Pays on acceptance**; $100 for b&w and $150 for color cover; $50 for b&w inside.

Tips: Finds artists through artists' submissions.

SALT WATER SPORTSMAN, 77 Franklin St., Boston MA 02210. (617)338-2300. Fax: (617)338-2309. Art Director: Chris Powers. Estab. 1939. Monthly consumer magazine describing the how-to and where-to of salt water sport fishing in the US, Caribbean and Central America. Circ. 140,000. Accepts previously published artwork. Originals returned at job's completion. Sample copies for 8½ × 11 SASE and 6 first-class stamps. Art guidelines available for SASE with first-class postage. Needs computer-literate freelancers for illustration. 10% of freelance work demands computer skills.

Illustrations: Buys 4-5 illustrations/issue. Works on assignment only. Considers pen & ink, watercolor, acrylic and charcoal. Send query letter with tearsheets, photocopies and transparencies. Samples are not filed

and are returned by SASE if requested by artist. Publication will contact artist for portfolio review if interested. Portfolio should include b&w and color tearsheets and final art. Buys first rights. **Pays on acceptance**; $50 for b&w, $100 for color inside.

Tips: Finds artists mostly through artists' submissions. Areas most open to freelancers are how-to, semi-technical drawings for instructional features and columns; occasional artwork to represent fishing action or scenes. "Look the magazine over carefully to see the kind of art we run—focus on these styles."

‡**SAN FRANCISCO BAY GUARDIAN**, 520 Hampshire St., San Francisco CA 94110. (415)255-3100. E-mail: ondine_kilker@bayguardiancom.internet. Art Director: Ondine Kilker. For "a young, liberal, well-educated audience." Circ. 130,000. Weekly newspaper; tabloid format, b&w with 4-color cover, "progressive design."

Cartoons: Run weekly. "Cartoons need to be anti-establishment, nothing 'run-of-the-mill.'" Cartoons focus on political and social commentary. Prefers local cartoonists. Pays $50-75.

Illustrations: Weekly assignments given to local artists. Subjects include political and feature subjects. Preferred styles include contemporary, painterly and graphic line—pen and woodcut. "We like intense and we like fun." Artists who exemplify desired style include Tom Tommorow, George Rieman and Bonnie To. Pays 2 months after publication; $200 for b&w, $300 for color cover; $50 for b&w, $75 for color inside and cover spots.

Tips: "Please submit samples and letter before calling. Turnaround time is generally short, so long-distance artists generally will not work out." Advises freelancers to "have awesome work—but be modest."

‡**SAN JOSE STUDIES, A Journal of Bay Area and California Cultures**, San Jose State University, San Jose CA 95192. (408)924-4476. Co-Editors: John Engell and D. Mesher. Estab. 1974. Triannual scholarly publication emphasizing the arts, humanities, business, science, social science. Black and white with 2-color cover; digest format with good quality paper, perfect-binding and "conservative design." Circ. 500. Original artwork returned after publication. Sample copy for $5. Emphasizes California artists and/or materials.

Cartoons: Acquires 3-4 cartoons/issue. Cartoons need to be intellectual or campus-related. Prefers single panel b&w line drawings. Send photocopies and SASE. Reports in 2 months. Acquires first North American serial rights. Pays in 2 copies of publication, plus entry in $100 annual contest.

Illustrations: Approached by 3-4 illustrators/year. "We have used several pieces of work in a special section and have used details of work on our covers." Prefers line drawings; "political, literary or philosophical in content, decorative and small." Style of Judy Rosenblatt. Pays in 2 copies of publication in which art appears.

Tips: "We are interested in cartoons and other drawings with visible detail even if reduced in size. We like art that relieves the reader faced with type-filled pages."

SANTA BARBARA MAGAZINE, 226 E. Canon Perdido St., Suite H, Santa Barbara CA 93101. (805)965-5999. Art Director: Kimberly Kavish. Estab. 1975. Quarterly 4-color magazine with classic design emphasizing Santa Barbara culture and community. Circ. 14,000. Original artwork returned after publication if requested. Sample copy for $3.50.

● Also publishes *Pasadena Magazine* which has the same illustration needs and policies.

Illustrations: Approached by 20 illustrators/year. Works with 2-3 illustrators/year. Buys about 1-3 illustrations/year. Uses freelance artwork mainly for departments. Works on assignment only. Send query letter with brochure, résumé, tearsheets and photocopies. Reports back within 6 weeks. To show a portfolio, mail b&w and color art, final reproduction/product and tearsheets; will contact if interested. Buys first rights. **Pays on acceptance**; approximately $275 for color cover; $175 for color inside. "Payment varies."

Tips: "Be familiar with our magazines."

SATELLITE ORBIT, 8330 Boone Blvd., Suite 600, Vienna VA 22182. (703)827-0511. Fax: (703)356-6179. Contact: Art Director. Monthly 4-color magazine emphasizing satellite television industry for home satellite dish owners and dealers. Design is "reader friendly, with small copy blocks—large TV listing section." Circ. 450,000. Accepts previously published material. Original artwork returned after publication. 50% of freelance work demands knowledge of Adobe Illustrator or Photoshop.

Illustrations: Buys 1 illustration/issue. Needs "inventive, clearly drawn spots that get the point across." Style of John Cuneo, Gil Eisner, Joe Murray, Seymour Chwast. Needs editorial illustration. Works on assignment only. Send query letter with tearsheets, photocopies, slides and photographs. Samples not filed are returned only if requested. Reports within 1 month. Portfolio review not required. Negotiates rights purchased and payment. Pays on publication; $450 for b&w, $1,500 for color cover; $150 for b&w, $250 for color inside.

Tips: Finds artists through sourcebooks and self-promotions. "I usually only use spot illustration work. Black & white work usually gets overlooked and I don't like to see uninventive poorly-drawn stuff. I predict the magazine field will be electronic within ten years with moving video clips."

‡**SAVINGS & COMMUNITY BANKER**, 900 19th St. NW, Washington DC 20006. (202)857-3162. Fax: (202)857-5581. Art Director: Tony Frye. Estab. 1992. Monthly trade journal targeting senior executives of

community banks. Circ. 12,000. Accepts previously published artwork. Originals returned at job's completion. Sample copies free for #10 SASE with first-class postage.

Illustrations: Approached by 150 illustrators/year. Buys 5-6 illustrations/issue. Works on assignment only. Considers all media and any style. Send postcard-size sample. Samples are filed. Does not report back. "Artists should be patient and continue to update our files with future mailings. We will contact artist when the right story comes along." Publication will contact artist for portfolio review if interested. Portfolio should include mostly finished work, some sketches. Buys one-time rights. **Pays on acceptance:** $800-1,200 for color cover; $250-400 for b&w, $250-800 for color inside; $250-300 for spots.

Tips: Finds artists primarily through word of mouth.

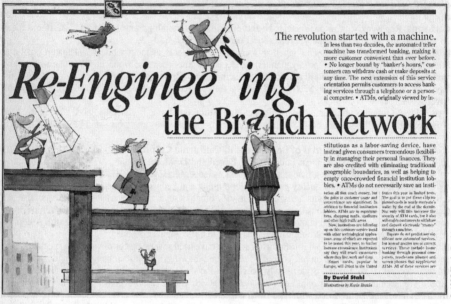

These playful little guys created by Kevin Rechin appeared in a two-page spread in Savings & Community Banker with an article about changes in retail banking. "The subject was very dry, so I wanted to make it more approachable and funny," says Rechin. "I though putting people in business attire working together in a construction-type setting made for a humorous contrast." Art Director Tony Frye likes "all styles of art—from wild and crazy to very realistic. We're trying to open the minds of a very conservative audience." Rechin's watercolor and pen & ink piece has been entered by Frye in some major national competitions, and has earned the artist work with other publications.

‡**SCHOOL BUSINESS AFFAIRS**, 11401 N. Shore Dr., Reston VA 22090-4232. (703)478-0405. Fax: (703)478-0205. Production Coordinator: Peggy Gartner. Monthly trade publication for school business managers. Circ. 6,000. Accepts previously published artwork. Originals are returned at job's completion. Sample copies available. Art guidelines not available.

Illustrations: Approached by 15 illustrators/year. Buys 2 illustrations/issue. Works on assignment only. Prefers business-related themes. Considers pen & ink, colored pencil and collage. Send postcard-size sample. Samples are filed. Reports back to the artist only if interested. Portfolio review not required. Rights purchased vary according to project. Pays on publication; $500 for color cover; $200 for b&w, $350 for color inside.

Tips: Finds artists through *Atlantic Creative Sourcebook.*

SCIENCE FICTION CHRONICLE, Box 022730, Brooklyn NY 11202-0056. (718)643-9011. Fax: (718)643-9011. E-mail: a.porter2@genie.geis.com. Editor/Publisher: Andrew Porter. Estab. 1979. Monthly magazine/trade journal covering science fiction, fantasy and horror; includes news, letters, reviews, market reports, etc. Black & white with 4-color cover. Circ. 6,000. Accepts previously published work. Sample copies for 9×12 SASE with $1.24 first-class postage.

Illustrations: Uses illustration for covers only. Approached by 50-70 illustrators/year. Prefers science fiction and fantasy themes. Considers airbrush and acrylic. Send query letter with transparencies or slides only. Samples are not filed and are returned by SASE. Reports back within 6-8 weeks. Portfolio review not required. Buys one-time or reprint rights. Pays on publication; $125 for color cover.

‡SCIENCE NEWS, 1719 N St. NW, Washington DC 20036. (202)785-2255. Art Director: Dan Skripkar. Weekly magazine emphasizing all sciences for teachers, students and scientists. Circ. 261,000. Accepts previously published material. Original artwork returned after publication. Sample copy for SASE with 42¢ postage.

Illustrations: Buys 6 illustrations/year. Prefers realistic style, scientific themes; uses some cartoon-style illustrations. Works on assignment only. Send query letter with photostats or photocopies to be kept on file. Samples returned by SASE. Reports only if interested. Buys one-time rights. Write for appointment to show portfolio of original/final art. **Pays on acceptance**; $50-200; $50 for spots.

THE SCIENCE TEACHER, 1840 Wilson, Arlington VA 22201-3000. (703)243-7100. Fax: (703)243-7177. Design Editor: Kim Alberto. Estab. 1958. Monthly education association magazine; 4-color with straight forward design. "A journal for high school science teachers, science educators and secondary school curriculum specialists." Circ. 27,000. Accepts previously published work. Original artwork returned at job's completion. Sample copies and art guidelines available.

Cartoons: Approached by 6 cartoonists/year. Buys 0-1 cartoon/issue. "Science or education humor is all we publish but cartoons must not be insulting or controversial. Animal testing, dissection, creationism or Darwinism cartoons will not be published." Prefers single panel b&w line drawings or b&w washes with or without gagline. Send query letter with non-returnable samples. Reports back to the artist if interested. Buys one-time rights. Pays $35 for b&w.

Illustrations: Approached by 75 illustrators/year. Buys 2 illustrations/issue. Works on assignment only. Considers pen & ink, airbrush, collage and charcoal. Need conceptual pieces to fit specific articles. Send query letter with tearsheets and photocopies. Samples are filed. Publication will contact artist for portfolio review if interested. Portfolio should include b&w final art. Buys one-time rights. Pays on publication; budget limited, but rates negotiable.

Tips: Prefers experienced freelancers with knowledge of the publication. "I have found a very talented artist through his own self-promotion, yet I also use a local sourcebook to determine artists' styles before calling them in to see their portfolios."

‡SCREEN ACTOR, 5757 Wilshire Blvd., Los Angeles CA 90036. (213)954-1600. Editor: Harry Medved. Estab. 1934. Quarterly trade journal; magazine format. "*Screen Actor* is the official publication of the Screen Actors Guild; covers issues of concern to performers." Circ. 75,000. Accepts previously published work. Sample copies available.

Cartoons: Approached by 4 cartoonists/year. Buys 2 cartoons/year. Prefers entertainment, movies, TV themes. Prefers single panel, b&w line drawings with gagline. Send query letter with finished cartoons. Samples are filed. Reports back to the artist only if interested. Rights purchased vary according to project. Pays $200, b&w.

Illustrations: Approached by 3 freelance illustrators/year. Buys 3 freelance illustrations/issue. Works on assignment only. Prefers entertainment, movies, TV themes. Considers pen & ink, airbrush, watercolor and acrylic. Send query letter with brochure, résumé and tearsheets. Samples are filed. Reports back to the artist only if interested. Rights purchased vary according to project. **Pays on acceptance**; $200 for b&w, $500 for color cover; $200 for b&w, $500 for color inside.

Tips: Looking for "clever use of entertainment themes."

SCUBA TIMES MAGAZINE, 14110 Perdido Key Dr., Pensacola FL 32507. (904)492-7805. Fax: (904)492-7807. Art Director: Trisha Russell. Bimonthly magazine for scuba enthusiasts. Originals returned at job's completion. Editorial schedule is available. 5% of freelance work demands knowledge of CorelDraw.

Cartoons: Approached by 2 cartoonists/year. Buys 0-1 cartoon/issue. Prefers humorous cartoons, single panel b&w and color washes with gagline. Send query letter with finished cartoons. Samples are filed. Reports back to the artist only if interested. Pays $25 for b&w/color.

Illustrations: Approached by 10 illustrators/year. Buys 0-1 illustration/issue. Considers all media. Send query letter with SASE, tearsheets, photostats and slides. Samples are filed. Publication will contact artist for portfolio review if interested. Portfolio should include b&w and color tearsheets, slides and final art. Buys one-time rights. Pays on publication; $125 for color cover; $25-125 for b&w/color inside.

Tips: Finds artists through artists' submissions and word of mouth. "Be familiar with our magazine. Show us you can draw divers and their gear. Our readers will catch even the smallest mistake. Also a good thing to try would be to get an old issue and pick a story from either the advanced diving journal or the departments where we used a photo and show us how you would have used your art instead. This will show us your ability to conceptualize and your skill as an artist."

SEA MAGAZINE, Box 17782 Cowan, Irvine CA 92714. Art Director: Jeffrey Fleming. Estab. 1908. Monthly 4-color magazine emphasizing recreational boating for owners or users of recreational powerboats, primarily for cruising and general recreation; some interest in boating competition; regionally oriented to 13 Western states. Circ. 60,000. Accepts previously published artwork. Return of original artwork depends upon terms of purchase. Sample copy for SASE with first-class postage.

• Also needs freelancers fluent in Quark and PageMaker for production.

Illustrations: Approached by 20 illustators/year. Buys 10 illustrations/year mainly for editorial. Prefers pen & ink. Also considers airbrush, watercolor, acrylic and calligraphy. Send query letter with brochure showing art style. Samples are returned only if requested. Publication will contact artist for portfolio review if interested. Portfolio should include tearsheets and cover letter indicating price range. Negotiates rights purchased. Pays on publication; $50 for b&w; $225 for color inside (negotiable).

Tips: "We will accept students for portfolio review with an eye to obtaining quality art at a reasonable price. We will help start career for illustrators and hope that they will remain loyal to our publication."

‡**SEAFOOD LEADER,** 5305 Shilshole Ave. NW, Suite 200, Seattle WA 98107. (206)547-6030. Fax: (206)548-9346. Contact: Photo Editor. Estab. 1981. Bimonthly trade journal. Full-color magazine about seafood, distributed to major seafood buyers. Circ. 20,000. Accepts previously published artwork. Original artwork returned at job's completion. Sample copies and art guidelines for SASE with first-class postage.

Cartoons: Approached by 8 cartoonists/year. Buys 4 cartoons/year. Prefers depictions of consumers buying or eating seafood; single panel color washes with gagline. Send query letter with roughs and SASE. Samples are filed. Reports back only if interested. Buys one-time rights or reprint rights. Pays $50 for b&w; $75 for color.

Illustrations: Approached by 6 illustrators/year. Buys 4 illustrations/year. Works on assignment only. Considers watercolor, acrylic and colored pencil. Send query letter with SASE, tearsheets and "good samples of previously published work." Samples are filed. Reports back only if interested. To show a portfolio, mail final art, tearsheets and slides. Buys one-time rights or reprint rights. **Pays on acceptance**; $200 for color cover; $100 for color inside.

‡**SEATTLE WEEKLY,** 1008 Western Ave., Suite 300, Seattle WA 98104. (206)623-0500. Fax: (206)467-4338. Contact: Art Director. Estab. 1975. Weekly consumer magazine; tabloid format; news with emphasis on local issues and arts events. Circ. 35,000. Accepts previously published artwork. Original artwork is not returned at job's completion; "but you can come and get them if you're local." Sample copies available for SASE with first-class postage. Art guidelines not available.

Illustrations: Approached by 30-50 freelance illustrators/year. Buys 3 freelance illustrations/issue. Works on assignment only. Prefers "sophisticated themes and styles, usually b&w." Considers pen & ink, charcoal, mixed media and scratchboard. Send query letter with tearsheets and photocopies. Samples are filed and are not returned. Does not report back, in which case the artists should "revise work and try again." To show a portfolio, mail b&w and color photocopies; "always leave us something to file." Buys first rights. Pays on publication; $200-250 for color, cover; $60-75 for b&w inside.

Tips: "Give us a sample we won't forget. A really beautiful mailer might even end up on our wall, and when we assign an illustration, you won't be forgotten."

THE SECRETARY®, 2800 Shirlington Rd., Suite 706, Arlington VA 22206. (703)998-2534. Fax: (703)379-4561. Managing Editor: Tracy Fellin Savidge. Estab. 1945. Trade journal published 9 times/year. Publication directed to the office support professional. Emphasis is on workplace technology, issues and trends. Readership is 98% female. Circ. 40,000. Accepts previously published artwork. Originals returned at job's completion upon request only. Samples copies available (contact subscription office at (816)891-6600, ext. 235). Art guidelines not available. Needs computer-literate freelancers for illustration. Freelancers should be familiar with Adobe Illustrator, QuarkXPress, Adobe Photoshop and Aldus FreeHand.

Illustrations: Approached by 50 illustrators/year. Buys 25-30 illustrations/year. Works on assignment only. Prefers communication, travel, meetings and international business themes. Considers pen & ink, airbrush, colored pencil, mixed media, collage, charcoal, watercolor, acrylic, oil, pastel, marker and computer. Send postcard-size sample or send query letter with brochure, tearsheets and photocopies. Samples are filed. Reports back to the artist only if interested. Publication will contact artist for portfolio review if interested. Portfolio should include final art and tearsheets. Buys one-time rights usually, but rights purchased vary according to project. **Pays on acceptance** (net 30 days); $500-600 for color cover; $60-150 for b&w, $200-400 for color inside; $60 for b&w spots.

Tips: Finds artists through word of mouth and artists' samples.

‡**SEEK,** 8121 Hamilton Ave., Cincinnati OH 45231. (513)931-4050, ext. 365. Cartoon editor: Eileen H. Wilmoth. Emphasizes religion/faith. Readers are young adult to middle-aged adults who attend church and Bible classes. Quarterly in weekly issues. Circ. 45,000. Sample copy and art guidelines for SASE.

Cartoons: Approached by 6 cartoonists/year. Buys 8-10 cartoons/year. Buys "church or Bible themes—contemporary situations of applied Christianity." Prefers single panel b&w line drawings with gagline. Send finished cartoons, photocopies and photographs. Include SASE. Reports in 3-4 months. Buys first North American serial rights. **Pays on acceptance**; $15-18.

‡**SENIOR MAGAZINE,** 3565 S. Higuera, San Luis Obispo CA 93401. (805)544-8711. Fax: (805)544-4450. Publisher: Gary Suggs. Estab. 1981. A monthly tabloid-sized magazine for people ages 40 and up. Circ. 300,000. Accepts previously published work. Original artwork returned at job's completion. Sample copies for SASE with first-class postage. Art guidelines available for SASE.

Cartoons: Buys 1-2 freelance cartoons/issue. Prefers themes appropriate for mature 40 and older people. Prefers single panel with gagline. Send query letter with finished cartoons. Samples are filed. Reports back within 15 days. Pays $25 for b&w.

Illustrations: Works on assignment only. "Would like cover drawings of famous people." Considers pen & ink. Send query letter with photostats. Samples are filed. Reports back within 15 days. Buys first rights or one-time rights. Pays on publication; $100 for b&w.

THE $ENSIBLE SOUND, 403 Darwin Dr., Snyder NY 14226. (716)681-3513. Fax: (716)681-9373. E-mail: sensisound@aol.com. Publisher: John A. Horan. Editor: Karl Nehring. Quarterly publication emphasizing audio equipment for hobbyists. Circ. 10,500. Accepts previously published material and simultaneous submissions. Original artwork returned after publication. Sample copy for $2.

Cartoons: Uses 4 cartoons/year. Prefers single panel, with or without gagline; b&w line drawings. Send samples of style and roughs to be kept on file. Material not kept on file is returned by SASE. Will accept material on mal-formatted disk or format via e-mail. Reports within 1 month. Negotiates rights purchased. Pays on publication; rate varies.

Tips: "Learn how your work is printed; provide camera-ready material."

SHEEP! MAGAZINE, W. 2997 Markert Rd., Helenville WI 53137. (414)593-8385. Fax: (414)593-8384. Estab. 1980. A monthly tabloid covering sheep, wool and woolcrafts. Circ. 15,000. Accepts previously published work. Original artwork returned at job's completion. Sample copies available.

Cartoons: Approached by 30 cartoonists/year. Buys 6-8 cartoons/issue. Considers all themes and styles. Prefers single panel with gagline. Send query letter with brochure and finished cartoons. Samples are returned. Reports back within 3 weeks. Buys first rights or all rights. Pays $15-25 for b&w; $50-100 for color.

Illustrations: Approached by 10 illustrators/year. Buys 5 illustrations/year. Works on assignment only. Considers pen & ink, colored pencil, watercolor. Send query letter with brochure, SASE and tearsheets. Samples are filed or returned. Reports back within 3 weeks. To show a portfolio, mail thumbnails and b&w tearsheets. Buys first rights or all rights. **Pays on acceptance**; $45-75 for b&w, $75-150 for color cover; $45-75 for b&w, $50-125 for color inside.

Tips: "Demonstrate creativity and quality work. We're eager to help out beginners."

‡SHEPHERD EXPRESS, 1123 N. Water St., Milwaukee WI 53202. (414)276-2222. Fax: (414)276-3312. Production Manager: Jeff Hansen. Estab. 1982. "A free weekly newspaper that covers news, entertainment and opinions that don't get covered in our daily paper. We are an alternative paper in the same genre as *LA Weekly* or New York's *Village Voice.*" Circ. 55,000. Accepts previously published artwork. Sample copies free for SASE with first-class postage. Art guidelines not available.

Cartoons: Approached by 130 cartoonists/year. Buys 2-3 cartoons/issue. Prefers single panel, b&w line drawings. Send query letter with finished cartoon samples. Samples are filed. Reports back only if interested. Buys one-time rights. Pays $15 for b&w.

Illustrations: Approached by 25 illustrators/year. Buys 1-2 illustrations/week. Works on assignment only. Considers pen & ink, watercolor, airbrush, acrylic, marker, colored pencil, oil, charcoal and pastel. Send query letter with tearsheets and photographs. Samples are not filed and are returned by SASE if requested by artist. Reports back within 3-4 weeks. Write for an appointment to show a portfolio of final art, b&w and color tearsheets and photographs. Buys one-time rights. Pays on publication; $35 for b&w, $50 for color cover; $30 for b&w inside.

Tips: "Freelance artists must be good and fast, work on tight deadlines and have a real grasp at illustrating articles that complement the print. I hate it when someone shows up unannounced to show me work. I usually turn them away because I can't take time from my work. It's better to schedule a showing."

SHOFAR, 43 Northcote Dr., Melville NY 11747. (516)643-4598. Publisher: Gerald H. Grayson. Estab. 1984. Monthly magazine emphasizing Jewish religious education published October through May—double issues December/January and April/May. Circ. 15,000. Accepts previously published artwork. Originals returned at job's completion. Sample copies free for 9×12 SASE and 3 first-class stamps. Art guidelines available.

Illustrations: Buys 3-4 illustrations/issue. Works on assignment only. Send query letter with tearsheets. Reports back to the artist only if interested. Pays on publication; $25-100 for b&w, $50-150 for color cover.

SIGNS OF THE TIMES, 1350 N. King's Rd., Nampa ID 83687. (208)465-2500. Fax: (208)465-2531. Art Director: Merwin Stewart. A monthly Seventh-day Adventist 4-color publication that examines contemporary issues such as health, finances, diet, family issues, exercise, child development, spiritual growth and end-

time events. "We attempt to show that Biblical principles are relevant to everyone." Circ. 200,000. Original artwork returned to artist after publication. Art guidelines available.

• They accept illustrations produced or converted to electronic form. File sizes for full-page illustrations requires 55 MB of artist's disk space. Write for complete information.

Illustrations: Buys 6-10 illustrations/issue. Works on assignment only. Prefers contemporary "realistic, stylistic, or humorous styles (but not cartoons)." Considers any media. Call or send query letter with nonreturnable samples. "Tearsheets or color photos (prints) are best, although color slides are acceptable." Samples are filed for future consideration and are not returned. Publication will contact artist for portfolio review if interested. Buys first-time North American publication rights. **Pays on acceptance** (30 days); approximately $700 for color cover; $100-300 for b&w, $400-600 for color inside. Fees negotiable depending on needs and placement, size, etc. in magazine.

Tips: Finds artists through artists' submissions, sourcebooks, and sometimes by referral from other art directors. "Most of the magazine illustrations feature people. Approximately 20 visual images (photography as well as artwork) are acquired for the production of each issue, half in b&w, half in color, and the customary working time frame is three weeks. Quality artwork and timely delivery are mandatory for continued assignments. It is customary for us to work with highly-skilled and dependable illustrators for many years."

THE SINGLE PARENT, 401 N. Michigan Ave., Chicago IL 60611-4267. (312)644-6610. Editor: Mercedes M. Vance. Estab. 1958. Emphasizes family life in all aspects—raising children, psychology, divorce, remarriage, etc.—for all single parents and their children; quarterly 2-color magazine with 4-color cover. Circ. 80,000. Accepts simultaneous submissions and occasionally, previously published material. Original artwork not returned.

Cartoons: Prefers cartoons with single parent family/singles themes.

Illustrations: Prefers working with desktop/computer art, IBM or Macintosh (encapsulated postscript filed, or scanned images). Please send photostats or hardcopy with diskette. Art non-returnable.

Tips: *The Single Parent* does not usually pay for photographs or illustrations, however welcomes art from those who wish to become contributing illustrators.

‡**SKI MAGAZINE**, Dept. AGDM, 2 Park Ave., New York NY 10016. (212)779-5000. Art Director: Doug Rosensweig. Estab. 1936. Emphasizes instruction, resorts, equipment and personality profiles. For new, intermediate and expert skiers. Published 8 times/year. Circ. 600,000. Previously published work OK "if we're notified."

Illustrations: Approached by 30-40 freelance illustrators/year. Buys 40-50 illustrations/year. Mail art and SASE. Reports immediately. Buys one-time rights. **Pays on acceptance**; $1,000 for color cover; $150 for b&w and color inside.

Tips: "The best way to break in is an interview and showing a consistent style portfolio. Then, keep us on your mailing list."

SKYDIVING MAGAZINE, 1725 N. Lexington Ave., DeLand FL 32724. (904)736-4793. Fax: (904)736-9786. Designer: Sue Clifton. Estab. 1979. "Monthly magazine on the equipment, techniques, people, places and events of sport parachuting." Circ. 10,100. Originals returned at job's completion. Sample copies and art guidlines available.

Cartoons: Approached by 10 cartoonists/year. Buys 2 cartoons/issue. Prefers skydiving themes; single panel, with gagline. Send query letter with roughs. Samples are filed. Reports back within 2 weeks. Buys one-time rights. Pays $25 for b&w.

‡**SMALL PRESS**, Kymbolde Way, Wakefield RI 02879. (401)789-0074. Fax: (401)789-3793. Managing Editor: Janet Heffernan. Estab. 1983. Quarterly trade journal for independent publishers. Articles feature areas of interest for anyone in field of publishing; up to 200 reviews of books in each issue. Circ. 9,000. Accepts previously published artwork. Originals returned at job's completion. Sample copies for $5.95.

Illustrations: Approached by 75 illustrators/year. Uses 10-20 illustrations. Considers pen & ink, airbrush, colored pencil, mixed media, collage, charcoal, watercolor, acrylic, oil and pastel. Send postcard-size sample or query letter with brochure, photographs, photocopies, photostats, slides and transparencies. Samples are not filed and are returned only by SASE if provided by artist. Publication will contact artist for portfolio review of photographs if interested. Rights purchased vary according to project. Compensation: short bio of artist on Portfolio page and 5 copies of magazine.

‡**SMART MONEY**, 1790 Broadway, New York NY 10019. (212)492-1300. Fax: (212)399-2119. Art Director: Joe Paschke. Estab. 1992. Monthly consumer magazine. Circ. 500,000. Originals returned at job's completion. Sample copies available.

Illustrations: Approached by 200-300 illustrators/year. Buys 6 illustrations/issue. Works on assignment only. Considers pen & ink, airbrush, colored pencil, mixed media, collage, charcoal, watercolor, acrylic, oil, pastel and digital. Send postcard-size sample. Samples are filed. Publication will contact artist for portfolio review if interested. Portfolio should include tearsheets and photocopies. Buys first and one-time rights. Pays 30 days from invoice; $1,500 for color cover; $400-700 for spots.

Tips: Finds artists through sourcebooks and artists' submissions.

‡**SOAP OPERA DIGEST**, 45 W. 25th St., New York NY 10010. (212)645-2100. Art Director: Catherine Connors. Estab. 1976. Emphasizes soap opera and prime-time drama synopses and news. Biweekly. Circ. 1 million. Accepts previously published material. Returns original artwork after publication upon request. Sample copy available for SASE.
Illustrations: Buys 25 freelance illustrations/year. Works on assignment only. Prefers humor; pen & ink, airbrush and watercolor. Send query letter with brochure showing art style or résumé, tearsheets and photocopies to be kept on file. Negotiates rights purchased. Pays on publication; $50-100 for b&w; $200-400 for color inside. All original artwork is returned after publication.
Tips: "Review the magazine before submitting work."

SOAP OPERA UPDATE MAGAZINE, 270 Sylvan Ave., Englewood Cliffs NJ 07632. (201)569-6699, ext. 226. Fax: (201)569-2510. Art Director: Catherine McCarthy. Estab. 1988. Biweekly consumer magazine geared toward fans of soap operas and the actors who work in soaps. It is "the only full-size, all color soap magazine in the industry." Circ. 700,000. Originals are not returned. Sample copies and art guidelines available.
Illustrations: Approached by 100 illustrators/year. Buys 1 or 2 illustrations/issue. Works on assignment only. Prefers illustrations showing a likeness of an actor/actress in soap operas. Considers any and all media. Send query letter with tearsheets. Samples are filed. Publication will contact artist for portfolio review if interested. Portfolio should include color tearsheets and final art. Buys all rights usually. Pays on publication; $200 maximum for color inside and/or spots.
Tips: Finds artists through promo pieces. Needs caricatures of actors in storyline-related illustration. "Please send self-promotion cards along with a letter if you feel your work is consistent with what we publish."

SOAP OPERA WEEKLY, 41 W. 25th St., New York NY 10010. (212)645-2100. Creative Director: S. Rohall. Estab. 1989. Weekly 4-color consumer magazine; tabloid format. Circ. 600,000-700,000. Original artwork returned at job's completion. Sample copies not available.
Cartoons: Prefers cartoons with gagline, color washes. Send query letter with brochure. Samples are filed. Reports back only if interested. Buys one-time rights. Pays $200, color.
Illustrations: Approached by 50 freelance illustrators/year. Works on assignment only. Send query letter with brochure and soap-related samples. Samples are filed. Request portfolio review in original query. Publication will contact artist for portfolio review if interested. Portfolio should include original/final art. Buys first rights. **Pays on acceptance**; $1,500 for color cover; $750 for color, full page.

SOCIAL POLICY, 25 W. 43rd St., New York NY 10036. (212)642-2929. Managing Editor: Audrey Gartner. Estab. 1970. Emphasizes the human services—education, health, mental health, self-help, consumer action, voter registration, employment. Quarterly magazine for social action leaders, academics and social welfare practitioners. Black & white with 2-color cover and eclectic design. Circ. 5,000. Accepts simultaneous submissions. Original artwork returned after publication. Sample copy for $2.50.
Illustrations: Approached by 10 illustrators/year. Works with 4 illustrators/year. Buys 6-8 illustrations/issue. Accepts b&w only, illustration "with social consciousness." Prefers pen & ink and charcoal/pencil. Send query letter and tearsheets to be kept on file. Call for appointment to show portfolio, which should include b&w final art, final reproduction/product and tearsheets. Reports only if interested. Buys one-time rights. Pays on publication; $100 for cover; $25 for b&w inside.
Tips: When reviewing an artist's work, looks for "sensitivity to the subject matter being illustrated."

‡**SOLDIERS MAGAZINE**, 9325 Gunston Rd., Suite S108, Ft. Belvoir VA 22060-5548. (703)806-4486. Fax: (703)806-4566. Editor-in-Chief: Lt. Col. Richard F. Machamer, Jr. Lighter Side Compiler: Steve Harding. Monthly 4-color magazine that provides "timely and factual information on topics of interest to members of the Active Army, Army National Guard, Army Reserve and Department of Army civilian employees and Army family members." Circ. 225,000. Previously published material and simultaneous submissions OK. Samples available upon request.
Cartoons: Purchases approximately 60 cartoons/year. Should be single panel with or without gagline. "Those without gaglines need to be self-explanatory. Cartoons should have a military or general interest theme." Buys all rights. **Pays on acceptance**; $25/cartoon.
Tips: "We are actively seeking new ideas and fresh humor, and are looking for new contributors. However, we require professional-quality material, professionally presented. We will not use anti-Army, sexist or racist material. We suggest you review recent back issues before submitting."

SOLIDARITY MAGAZINE, Published by United Auto Workers, 8000 E. Jefferson, Detroit MI 48214. (313)926-5291. E-mail: 71112.363@compuserve.com. Editor: David Elsila. Four-color magazine for "1.3 million member trade union representing U.S. workers in auto, aerospace, agricultural-implement, public employment and other areas." Contemporary design.

Cartoons: Carries "labor/political" cartoons. Pays $75 for b&w, $125 for color.

Illustrations: Works with 10-12 illustrators/year for posters and magazine illustrations. Interested in graphic designs of publications, topical art for magazine covers with liberal-labor political slant. Especially needs illustrations for articles on unemployment and economy. Looks for "ability to grasp publication's editorial slant." Send query letter with résumé, flier and/or tearsheet. Computer-generated material should be compatible with QuarkXPress. Samples are filed. Pays $300 for b&w, $500 for color cover; $200 for b&w, $300 for color inside; $125 for color and $75 for b&w spots; $400 minimum for small pamphlet design.

‡**SONGWRITER'S MONTHLY**, 332 Eastwood Ave., Feasterville PA 19053. Phone/fax: (215)953-0952. Editor/Publisher: Allen Foster. Estab. 1992. Monthly trade journal. "We are a cross between a trade journal and a magazine—our focus is songwriting and the music business." Circ. 1,000. Accepts previously published artwork. Originals returned at job's completion with SASE. Sample copy for $1. Art guidelines free for SASE with first-class postage.

Cartoons: Approached by 2-4 cartoonists/year. "We're a pretty new market." Buys 1 cartoon/issue. Cartoons must deal with some aspect of songwriting or the music business. Prefers single panel, hurmorous, b&w line drawings with or without gagline. Send query letter with finished cartoons. Samples are not filed and are returned by SASE if requested by artist. Reports back within 2-4 weeks. Buys one-time rights. Pays $5 for b&w.

Illustration: Prefers music themes. Considers pen & ink. Send query letter with SASE and photocopies. Samples are filed. Reports back within 2-4 weeks. Portfolio review not required. Buys one-time rights. **Pays on acceptance**; $5 for spots.

Tips: "We're just beginning to introduce some artwork to break up the text. We're a publication that's growing fast and turning a lot of heads in the music industry."

‡**SONOMA BUSINESS MAGAZINE**, 50 Old Courthouse Square #105, Santa Rosa CA 95404. Art Director: Angela Treftz. Monthly tabloid emphasizing business and culture with local editorial content. Relates to business owners in Sonoma County. Circ. 10,000. Accepts previously published material. Returns original artwork after publication. Sample copy $5 with 9×12 SASE. Art guidelines not available. Needs computer-literate freelancers for design, illustration, production and presentation. 10% of freelance work demands knowledge of QuarkXPress or Adobe Illustrator.

Cartoons: Needs humor relating to business. Pays $10-30 for b&w.

Illustrations: Approached by 25 illustrators/year. Works with 5-6 illustrators/year. Buys 20 illustrations/year. Uses artists mainly for showing concepts a photo can't manage. Works on assignment only. Send query letter with brochure. Samples are filed. Reports back only if interested. Write for appointment to show portfolio of b&w and color final art, tearsheets and final reproduction/product. Buys one-time rights. **Pays on acceptance**; $175 for color cover; $75 for b&w inside.

Tips: "Must be well-drawn, clever. We usually buy b&w."

SOUTH CAROLINA WILDLIFE, Box 167, Columbia SC 29202. (803)734-3972. Editor: John Davis. Art Director: Linda Laffitte. Bimonthly 4-color magazine covering wildlife, water and land resources, outdoor recreation, natural history and environmental concerns. Circ. 70,000. Accepts previously published artwork.

• *South Carolina Wildlife* is low-key, relying on photos and art to attract/support editorial content.

Illustrations: Uses 5-10 illustrations/issue. Interested in wildlife art; all media; b&w line drawings, washes, full-color illustrations. "Particular need for natural history illustrations of good quality. They must be technically accurate." Subject matter must be appropriate for South Carolina. Prefers to see printed samples or slides of work, which will be filed with résumé. *Please note that samples will not be returned.* Publication will contact artist for portfolio review if interested. Sometimes requests work on spec before assigning job. Payment is negotiable. Acquires one-time rights.

Tips: Finds artists through word of mouth, magazines, artists' submissions/self-promotions, books and publications other than magazines. "We are interested in unique illustrations—something that would be impossible to photograph. Make sure proper research has been done and that the art is technically accurate."

‡**SOUTHERN EXPOSURE**, Box 531, Durham NC 27702. (919)419-8311. Editor: Pat Arnow. Estab. 1972. A quarterly magazine of Southern politics and culture. Circ. 5,000. Accepts previously published artwork. Original artwork returned at job's completion. Sample copies available for $5.

Illustrations: Buys 2 freelance illustrations/issue. Send query letter with nonreturnable samples. Pays $100, color, cover; $50-100, b&w, inside.

SOUTHERN LIVING, 2100 Lakeshore Dr., Birmingham AL 35209. (205)877-6347. Art Director: Lane Gregory. Monthly 4-color magazine emphasizing interiors, gardening, food and travel. Circ. 2 million. Original artwork returned after publication.

Illustrations: Approached by 30-40 illustrators/year. Buys 2 illustrations/issue. Uses freelance artists mainly for illustrating monthly columns. Works on assignment only. Prefers watercolor, colored pencil or pen & ink. Needs editorial and technical illustration. Send query letter with brochure showing art style or résumé and samples. Samples returned only if requested. Publication will contact artist for portfolio review if inter-

ested. Portfolio should include b&w and color tearsheets and slides. Buys one-time rights. **Pays on acceptance**; $300, b&w; $500 color, inside.

Tips: In a portfolio include "four to five best pieces to show strengths and/or versatility. Smaller pieces are much easier to handle than large. It's best not to have to return samples but to keep them for reference files." Don't send "too much. It's difficult to take time to plow through mountains of examples." Notices trend toward "lighter, fresher illustration."

THE SPIRIT THAT MOVES US, P.O. Box 720820, Jackson Heights NY 11372-0820. (718)426-8788. Editor: Morty Sklar. Estab. 1975. Irregularly published literary magazine featuring "fiction, poetry, essays and art on any subject, in any style." Circ. 2,000. Accepts previously published artwork. Originals returned at job's completion. Sample copies available for $5; must "ask for issue that contains artwork." Art guidelines provided at query.

Illustrations: Approached by 100 illustrators/year. Buys 15 illustrations/issue. Considers pen & ink, airbrush, acrylic and oil. Send query letter with SASE; "ask about our present need." Samples are filed or are returned by SASE if requested by artist. Publication will contact artist for portfolio review if interested. Portfolio should include b&w and color tearsheets, photostats and photocopies. Rights purchased vary according to project. Pays on publication; $100 for b&w cover.

Tips: Finds artists through other publications, word of mouth and artists' submissions. "Send what you love best. Query first to see what our themes and time frames might be."

SPITBALL, The Literary Baseball Magazine, 5560 Fox Rd., Cincinnati OH 45239. (513)385-2268. Editor: Mike Shannon. Quarterly 2-color magazine emphasizing baseball exclusively, for "well-educated, literate baseball fans." Sometimes prints color material in b&w on cover. Returns original artwork after publication if the work is donated; does not return if purchases work. Sample copy for $2.

Cartoons: Prefers single panel b&w line drawings with or without gagline. Prefers "old fashioned *Sport Magazine/New Yorker* type. Please, cartoonists. . . . make them funny, or what's the point!" Query with samples of style, roughs and finished cartoons. Samples not filed are returned by SASE. Reports back within 1 week. Negotiates rights purchased. Pays $10, minimum.

Illustrations: "We need three types of art: cover work, illustration (for a story, essay or poem) and filler. All work must be baseball-related; prefers pen & ink, airbrush, charcoal/pencil and collage. Sometimes we assign the cover piece on a particular subject; sometimes we just use a drawing we like. Interested artists should write to find out needs for covers and specific illustration." Buys 3 or 4 illustrations/issue. Send query letter with b&w illustrations or slides. Target samples to magazine's needs. Samples not filed are returned by SASE. Reports back within 1 week. Negotiates rights purchased. **Pays on acceptance**; $100 for color cover; $20-40 b&w inside. Needs short story illustration.

Tips: "Usually artists contact us and if we hit it off, we form a long-lasting mutual admiration society. Please, you cartoonists out there, drag your bats up to the *Spitball* plate! We like to use a variety of artists."

SPORTS 'N SPOKES, 2111 E. Highland Ave., Suite 180, Phoenix AZ 85016-4702. (602)224-0500. Fax: (602)224-0507. Art and Production Director: Susan Robbins. Bimonthly consumer magazine with emphasis on sports and recreation for the wheelchair user. Circ. 15,000. Accepts previously published artwork. Sample copies for 11×14 SASE and 6 first-class stamps. Art guidelines not available. Needs computer-literate freelancers for illustration. 50% of freelance work demands knowledge of Adobe Illustrator, QuarkXPress or Adobe Photoshop.

Cartoons: Approached by 10 cartoonists/year. Buys 3-5 cartoons/issue. Prefers humorous cartoons; single panel b&w line drawings with or without gagline. Send query letter with finished cartoons. Samples are filed or returned by SASE if requested by artist. Reports back within 3 months. Buys all rights. Pays $10 for b&w.

Illustrations: Approached by 5 illustrators/year. Buys 1 illustration/year. Works on assignment only. Considers pen & ink, watercolor and computer-generated. Send query letter with résumé and tearsheets. Samples are filed or returned by SASE if requested by artist. Reports back to the artist only if interested. Publication will contact artist for portfolio review if interested. Portfolio should include color tearsheets. Buys one-time rights and reprint rights. Pays on publication; $250 for color cover; $25 for color inside.

Tips: Finds artists through word of mouth. Areas most open to freelancers are illustrations to establish theme for survey of lightweight-wheelchair manufacturers.

‡SPY MAGAZINE, 49 E. 21st St., New York NY 10010. (212)260-7210. Fax: (212)260-7445. Design Director: Robert J. George. Estab. 1986. Bimonthly consumer magazine of humor, parody, satirical observation. Originals returned at job's completion. Sample copies free for #10 SASE with first-class postage. Needs computer-literate freelancers for illustration and production. 95% of freelance work demands knowledge of Adobe Illustrator, QuarkXPress, Adobe Photoshop, Aldus FreeHand and Fontographer.

Cartoons: Approached by 100 cartoonists/year. Buys 1 cartoon/issue. Prefers humorous. Send postcard-size sample. Samples are filed. Reports back to the artist only if interested. Buys one-time rights. Pays $100 for b&w, $150 for color.

Illustrations: Approached by 200 illustrators/year. Buys 10 illustrations/issue. Works on assignment only. Considers pen & ink, mixed media, collage, watercolor, acrylic and oil. Send postcard-size sample or query

letter with tearsheets. Samples are filed. Reports back to the artist only if interested. Buys one-time rights. Pays on publication; $600-750 for b&w, $750-1,000 for color cover; $150-300 for b&w, $300-500 for color inside; $100 for spots.

Tips: Finds artists through most of the creative competitive annuals, mailers, word of mouth.

‡**STANFORD MAGAZINE**, Bowman Alumni House, Stanford CA 94305-4005. (415)725-1085. Fax: (415)725-8676. Art Director: Paul Carstensen. Estab. 1973. Consumer magazine, "geared toward the alumni of Stanford University. Articles vary from photo essays to fiction to academic subjects." Circ. 105,000. Accepts previously published artwork. Original artwork is returned at job's completion. Sample copies available. Art guidelines not available.

Illustrations: Approached by 150-200 illustrators/year. Buys 4-6 illustrations/issue. Works on assignment only. Interested in a variety of themes "but a few are scientific research, historical, fiction, photo essays." Interested in all styles—"social commentary, light and whimsical, bold wood art." Considers pen & ink, watercolor, collage, airbrush, acrylic, color pencil, oil, mixed media, pastel and computer illustration. Send samples only. Samples are filed. "Follow-up with a phone call." Reports back within 2 weeks. Call for appointment to show a portfolio of b&w tearsheets, slides, photocopies and photographs. Buys one-time rights. **Pays on acceptance**; $600 for b&w, $700 for color cover; $500 for b&w, $600 for color inside.

Tips: "We're always looking for unique styles, as well as excellent traditional work. We like to give enough time for the artist to produce the piece, but sometimes tight deadlines are needed and appreciated."

STEREOPHILE, 208 Delgado, Sante Fe NM 87501. (505)982-2366. Fax: (505)989-8791. Production Director: Reb Willard. Estab. 1962. "We're the oldest and largest subject review high-end audio magazine in the country, approximately 220 pages/monthly." Circ. 60,000. Accepts previously published artwork. Original artwork not returned at job's completion.

Cartoons: Send query letter with appropriate samples. Reports back only if interested. Rights purchased vary according to project. Pays $200 for b&w and color inside; $900 for cover.

Illustrations: Approached by 50 illustrators/year. Buys 3-5 illustrations/issue. Works on assignment only. Interested in all media. Send query letter with brochure and tearsheets. Samples are filed. Reports back only if interested. Portfolio should include original/final art, tearsheets or other appropriate samples. Rights purchased vary according to project. Pays on publication; $900 for color cover; $150-350 for b&w and color inside.

Tips: "Be able to turn a job in three to five days and have it look professional. Letters from previous clients to this effect help."

STL MAGAZINE: THE ART OF LIVING IN ST. LOUIS, 6996 Millbrook Blvd., St. Louis MO 63130. (314)726-7685. Fax: (314)726-0677. Creative Director: Suzanne Griffin. Art Director: Kathy Sewing. Estab. 1991. Company magazine of KETC/Channel 9. Monthly 4-color magazine and program guide going to over 50,000 members of Channel 9, a PBS station. Age group of members is between ages 35 and 64, with a household income of $50,000 average. Circ. 52,000. Accepts previously published artwork. Originals returned at job's completion. Sample copies available. Art guidelines not available. Needs computer-literate freelancers for design and production. 20% of freelance work demands knowledge of Adobe Illustrator, QuarkXPress or Photoshop.

Illustrations: Buys 2 illustrations/issue. Works on assignment only. Looking for unusual and artistic approaches to story illustration. Considers pen & ink, collage, acrylic, colored pencil, oil, mixed media and pastel. Send query letter with brochure, SASE, tearsheets, photographs and photocopies. Samples are filed or returned by SASE. Publication will contact artist for portfolio review if interested. Portfolio should include final art samples, color tearsheets and slides. Rights purchased vary according to project. **Pays on acceptance**; $300 for color cover; $75 for b&w, $100 for color inside or spots.

Tips: Finds artists through word of mouth, magazines, artists' submissions/self-promotions and artists' agents and reps. Send printed samples of work to Creative or Art Director. There is no point in cold-calling if we have no visual reference of the work. We have a limited budget, but a high circulation. We offer longer deadlines, so we find many good illustrators will contribute."

STONE SOUP, The Magazine by Young Writers and Artists, P.O. Box 83, Santa Cruz CA 95063. (408)426-5557. Editor: Gerry Mandel. Bimonthly 4-color magazine with "simple and conservative design" emphasizing writing and art by children through age 13. Features adventure, ethnic, experimental, fantasy, humorous and science fiction articles. "We only publish writing and art by children through age 13. We look

For a list of markets interested in humorous illustration, cartooning and caricatures, refer to the Humor Index at the back of this book.

for artwork that reveals that the artist is closely observing his or her world." Circ. 20,000. Original artwork is returned after publication. Sample copies available for $3. Art guidelines for SASE with first-class postage.
Illustrations: Buys 8 illustrations/issue. Prefers complete and detailed scenes from real life. Send query letter with photostats, photocopies, slides and photographs. Samples are filed or are returned by SASE. Reports back within 1 month. Buys all rights. Pays on publication; $25 for color cover; $8 for b&w or color inside and spots.
Tips: "We accept artwork by children only, through age 13."

STRAIGHT, 8121 Hamilton Ave., Cincinnati OH 45231. (513)931-4050. Fax: (513)931-0904. Editor: Carla J. Crane. Estab. 1950. Weekly Sunday school take-home paper for Christian teens ages 13-19. Circ. 35,000. Sample copies for #10 SASE with first-class postage. Art guidelines for SASE with first-class postage.
Illustrations: Approached by 40-50 illustrators/year. Buys 50-60 illustrations/year. Prefers realistic and cartoon. Considers pen & ink, watercolor, collage, airbrush, colored pencil and oil. Send query letter with brochure and tearsheets. Samples are filed. Reports back to the artist only if interested. Portfolio review not required. Buys all rights. **Pays on acceptance**; $250 for color cover; $150 for color inside.
Tips: Finds artists through artists' submissions, other publications and word of mouth. Areas most open to freelancers are "realistic and cartoon illustrations for our stories and articles."

‡STUDENT LAWYER, 750 N. Lake Shore Dr., Chicago IL 60611. (312)988-6049. Art Director: Frank Valick. Estab. 1972. Trade journal, 4-color, emphasizing legal education and social/legal issues. *"Student Lawyer* is a legal affairs magazine published by the Law Student Division of the American Bar Association. It is not a legal journal. It is a features magazine, competing for a share of law students' limited spare time— so the articles we publish must be informative, lively, good reads. We have no interest whatsoever in anything that resembles a footnoted, academic article. We are interested in professional and legal education issues, sociolegal phenomena, legal career features, profiles of lawyers who are making an impact on the profession and the (very) occasional piece of fiction." Monthly (September-May). Circ. 35,000. Accepts previously published material. Original artwork is returned to the artist after publication. Sample copies for $4. Art guidelines for SASE with first-class postage. Needs computer-literate freelancers for illustration.
Illustrations: Approached by 20 illustrators/year. Buys 8 illustrations/issue. Needs editorial illustration with an "innovative, intelligent style." Works on assignment only. Send query letter with brochure, tearsheets and photographs. Samples are filed or returned by SASE. Reports back within 3 weeks only if interested. Call for appointment to show portfolio of final art and tearsheets. Buys one-time rights. **Pays on acceptance**; $450 for b&w, $500 for color cover; $250 for b&w, $350 for color inside features; $100 for b&w department pieces.
Tips: "In your portfolio, show a variety of color and b&w, plus editorial work."

STUDENT LEADERSHIP JOURNAL, P.O. Box 7895, Madison WI 53707-7895. (608)274-9001. Fax: (608)274-7882. Editor: Jeff Yourison. Estab. 1988. Quarterly nonprofit organizational journal. "Offers training, encouragement and news to college-age student leaders of Christian fellowship groups, specifically those affiliated with InterVarsity." Circ. 8,000. Originals returned at job's completion. Sample copies available for $3. Art guidelines not available. Needs computer-literate freelancers for illustration and production. 50% of freelance work demands knowledge of CorelDraw or QuarkXPress.
Cartoons: Approached by 2-4 cartoonists/year. Buys 2-3 cartoons/issue. Prefers campus-related, cultural commentary; humorous insight; single and multiple panel b&w line drawings with gagline. Send query letter with brochure, roughs and past clips or tearsheets. Samples are filed or returned by SASE if requested by artist. Reports back to the artist only if interested. Rights purchased vary according to project. Pays $50 for b&w.
Illustrations: Approached by 1-2 illustrators/year. Buys 1-3 illustrations/year. Works on assignment only. Prefers scratchboard, pen & ink line drawings, "some computer-generated stuff" that is generally symbolic; illustrative of key moods and themes. Send query letter with brochure, SASE, tearsheets and photocopies. Samples are filed or returned by SASE if requested by artist. Publication will contact artist for portfolio review if interested. Portfolio should include thumbnails and tearsheets. Rights purchased vary according to project. Pays on publication; $100-150 for b&w cover; $50-75 for b&w inside.
Tips: Finds artists through "our designer, who knows a lot of beginning artists. Cartoonists are found by sheer luck, or pursued once we see good work. Please try to understand our university audience. They are sophisticated yet young, fragile and occasionally cynical or suspicious. We strive for empathy and support, helping students to look at themselves with insight and humor."

‡STYGIAN VORTEX PUBLICATIONS, 6634 Atlanta St., Hollywood FL 33024-2965. (305)653-9458. Art Director: Coyote Osborne. Estab. 1990. Annual literary magazines "featuring adult tales with unnerving or unusual twists where all is not as it seems; for a mature audience." Publications include *Area of Operations, Tales from the Baleful Gaze Tavern, In Darkness Eternal, NeuroNet: Stories from the Cyberland, Shapeshifer!, Shadow Sword: The Magazine of Adventure Fantasy, Lords of the Abyss: Tales of Supernatural Horror* and *Faerywood: Twisted Tales for Adults.* Circ. 100. Originals returned at job's completion. Sample copies available for $5.25. Art guidelines free for SASE with first-class postage. Needs computer-literate freelancers

for illustration and presentation. 5-10% of work demands knowledge of Adobe Illustrator, QuarkXPress, Adobe Photoshop and Aldus FreeHand.

Cartoons: Buys 1-4 cartoons/issue. Prefers twisted artwork and illustrations otherwise appropriate to publication. Prefers single, double and multiple panels; humorous, b&w washes and line drawings, with or without gagline. Send query letter with finished cartoons. Samples are filed. Reports back within 2 months. Buys one-time rights. Pays cartoonists in copies and $2-5 token payment.

Illustrations: Buys 40-50 illustrations/issue. Works on assignment only. Considers pen & ink, collage and charcoal. Send query letter with SASE and photocopies, include phone number. Samples are filed. Reports back within 2 months. Request portfolio review in original query. Portfolio should include thumbnails and final art. Buys one-time rights. Pays on publication; $10 for front cover; $5 for back cover; minimum 1 copy for b&w inside.

Tips: Finds artists through *Scavenger's Newsletter*, word of mouth, market listings, bulletin boards, notices in papers.

SUMMIT: THE MOUNTAIN JOURNAL, 1221 May St., Hood River OR 97031. Art Director: Adele Hammond. Estab. 1990. Literary magazine. Circ. 30,000. Sample copies for SASE with first-class postage and $6. Art guidelines for SASE with first-class postage.

Cartoons: Approached by 5 cartoonists/year. Buys 3-5 cartoons/year. Prefers single panel, b&w washes and line drawings. Send query letter with finished cartoons. Samples are filed. Reports back within 3 weeks. Buys one-time rights. Pays $50 for b&w.

Illustrations: Approached by 10 illustrators/year. Buys 5-10 illustrations/issue. Considers pen & ink, watercolor, collage, colored pencil, oil, charcoal, mixed media and pastel. Send query letter with résumé and tearsheets. Samples are filed. Reports back within 3 weeks. Call for appointment to show portfolio of final art, tearsheets photographs and slides. Buys one-time rights. Pays on publication; $50-200 for b&w and color inside.

Tips: "Study the magazine for its spirit and focus. Only illustrations/cartoons relating to mountains will be considered."

‡THE SUN, 15 Kearney Square, Lowell MA 01852. (508)458-7100. Fax: (508)453-7177. Graphics Director: Jeffrey Walsh. Estab. 1878. Daily newspaper emphasizing lifestyle, business, home, fashion, food and entertainment; 4-color. "*The Sun* is a progressive mid-size newspaper." Circ. 58,000. Accepts previously published material. Returns original artwork to the artist after publication.

Illustrations: Works with approximately 20 freelance illustrators/year. Buys approximately 125-200 freelance illustrations/year. Prefers bold woodcut style or scratch board for b&w, and all types of color work for color assignments. Majority of illustration is color. Works on assignment only. Send query letter with brochure or samples. Samples are filed and are not returned. Will call if interested. Pays on publication; $75-100 for b&w; $150-300 for color.

Tips: "Although we don't have a large budget, we do provide excellent tearsheets and little art direction. Through these practices we have been able to use established and talented illustrators who prefer the freedom from demanding art directors."

THE SUN, 107 N. Roberson, Chapel Hill NC 27516. (919)942-5282. Editor: Sy Safransky. Monthly magazine of ideas. Circ. 27,000. Accepts previously published material. Original artwork returned after publication. Sample copy for $3.50. Art guidelines for SASE with first-class postage.

Cartoons: "We accept very few cartoons." Material not kept on file is returned by SASE. Reports within 3 months. Buys first rights. Pays $25 plus copies and subscription.

Illustrations: Send query letter with samples. Needs illustrations that reproduce well in b&w. Accepts abstract and representational work. Samples not filed are returned by SASE. Reports within 3 months. Buys one-time rights. Pays on publication; $50 for cover; $25 minimum for inside; $25 for spots; plus copies and 1 year subscription.

‡SUNSHINE MAGAZINE, 200 E. Las Olas Blvd., Ft. Lauderdale FL 33301. (305)356-4690. Art Director: Greg Carannante. Estab. 1983. Consumer magazine; the Sunday magazine for the *Sun Sentinel* newspaper; "featuring anything that would interest an intelligent adult reader living on South Florida's famous 'gold coast.'" Circ. 350,000. Accepts previously published artwork. Original artwork returned to artist at the job's completion. Sample copies and art guidelines available.

Illustrations: Approached by 100 illustrators/year. Buys 60-70 freelance illustrations/year. Works on assignment only. Preferred themes and styles vary. Considers all color media. Send query letter with any available samples. Will accept computer art—Quark/Scitex interface. Samples are filed or are returned by SASE. Reports back to the artist only if interested. To show a portfolio, mail color tearsheets, photostats, slides and photocopies. Buys first rights, one-time rights. **Pays on acceptance**; $600 for color cover; $500 for color full page, $250 for ¼ page inside.

TAMPA BAY MAGAZINE, 2531 Landmark Dr., Clearwater FL 34621. (813)791-4800. Editor: Aaron Fodiman. Estab. 1986. Bimonthly local lifestyle magazine with upscale readership. Circ. 35,000. Accepts pre-

viously published artwork. Sample copy available for $4.50. Art guidelines not available.

Cartoons: Approached by 30 cartoonists/year. Buys 6 cartoons/issue. Prefers single panel color washes with gagline. Send query letter with finished cartoon samples. Samples are not filed and are returned by SASE if requested. Buys one-time rights. Pays $15 for b&w, $20 for color.

Illustrations: Approached by 100 illustrators/year. Buys 5 illustrations/issue. Prefers happy, stylish themes. Considers watercolor, collage, airbrush, acrylic, marker, colored pencil, oil and mixed media. Send query letter with photographs and transparencies. Samples are not filed and are returned by SASE if requested. To show a portfolio, mail color tearsheets, slides, photocopies, finished samples and photographs. Buys one-time rights. Pays on publication; $150 for color cover; $75 for color inside.

TECHNICAL ANALYSIS OF STOCKS & COMMODITIES, 4757 California Ave. SW, Seattle WA 98116-4499. (206)938-0570. Publisher: Jack K. Hutson. Estab. 1982. Monthly traders' magazine for stocks, bonds, futures, commodities, options, mutual funds. Circ. 43,000. Accepts previously published artwork. Sample copies available for $5. Art guidelines for SASE with first-class postage. Needs computer-literate freelancers for production. 10% of freelance work demands knowledge of Aldus PageMaker or Adobe Photoshop.

Cartoons: Approached by 10 cartoonists/year. Buys 1 cartoon/issue. Prefers humorous cartoons, single panel b&w line drawings with gagline. Send query letter with finished cartoons. Samples are filed or are returned by SASE if requested by artist. Reports back within 3 weeks. Buys one-time rights and reprint rights. Pays $30 for b&w.

Illustrations: Approached by 25 illustrators/year. Buys 6 illustrations/issue. Works on assignment only. Send query letter with brochure, tearsheets, photographs, photocopies, photostats, slides. Samples are filed or are returned by SASE if requested by artist. Reports back within 3 weeks. Publication will contact artist for portfolio review if interested. Portfolio should include b&w and color tearsheets, slides, photostats, photocopies, final art and photographs. Buys one-time rights and reprint rights. Pays on publication; $160 for color cover; $120 for color, $60 for b&w inside.

Tips: Areas most open to freelancers are caricatures with market charts or computers.

TENNIS, Dept. AGDM, 5520 Park Ave., Trumbull CT 06611. (203)373-7000. Art Director: Lori Wendin. For young, affluent tennis players. Monthly. Circ. 750,000.

Illustrations: Works with 15-20 illustrators/year. Buys 50 illustrations/year. Uses artists mainly for spots and openers. Works on assignment only. Send query letter with tearsheets. Mail printed samples of work. **Pays on acceptance**; $400-800 for color.

Tips: "Prospective contributors should first look through an issue of the magazine to make sure their style is appropriate for us."

TEXAS CONNECTION MAGAZINE, P.O. Box 541805, Dallas TX 75354-1805. (214)951-0316. Fax: (214)951-0349. Editor: Nanci Drewer. Estab. 1988. Monthly adult magazine. Circ. 25,000. Originals returned at job's completion. Sample copies available for $10. Art guidelines available for SASE with first-class postage.

Cartoons: Buys 4-6 cartoons/issue. Prefers adult; single panel b&w washes and line drawings with gagline. Send query letter with finished cartoons. Samples are filed or not filed at artist's request. Samples are returned. Reports back to the artist only if interested. Buys first rights. Pays $25 for b&w.

Illustrations: Approached by 12 illustrators/year. Buys 12 illustrations/issue. Prefers adult. Send query letter with photocopies. Samples that are not filed are returned. Publication will contact artist for portfolio review if interested. Portfolio should include b&w and color photocopies and final art. Buys one-time rights. Pays on publication; $50 for b&w, $100 for color inside.

Tips: Finds artists through artists' submissions. Areas most open to freelancers are "adult situations normally—some editorial and feature illustrations. Give us something fresh—some new twist on adult situations—not the same old, tired grind."

‡TEXAS MONTHLY, P.O. Box 1569, Austin TX 78967-1569. (512)320-6900. Fax: (512)476-9007. Art Director: D.J. Stout. Estab. 1973. Monthly general interest magazine about Texas. Circ. 350,000. Accepts previously published artwork. Originals are returned to artist at job's completion.

Illustrations: Approached by hundreds of illustrators/year. Works on assignment only. Considers all media. Send postcard sample of work or send query letter with tearsheets, photographs, photocopies. Samples are filed "if I like them," or returned by SASE if requested by artist. Publication will contact artist for portfolio review if interested. Portfolio should include tearsheets, photographs, photocopies. Buys one-time rights. Pays on publication; $1,000 for color cover; $800-2,000 for color inside; $150-400 for spots.

THE TEXAS OBSERVER, 307 W. Seventh, Austin TX 78701. (512)477-0746. E-mail: 71632.46@compuserve.com. Contact: Editor. Estab. 1954. Biweekly b&w magazine emphasizing Texas political, social and literary topics. Circ. 10,000. Accepts previously published material. Returns original artwork after publication. Sample copy for SASE with postage for 2 ounces; art guidelines for SASE with first-class postage.

Gain National Exposure Through Regional Magazines

Regional magazines are great outlets for illustrators who want to break into the magazine market, according to D.J. Stout, art director of *Texas Monthly.*

There are hundreds of city and state magazines published. *Baltimore Magazine, Nevada, The Washingtonian* and *Southern Living* are examples of regional publications. Their content focuses on matters pertaining to specific geographical areas. "It's always a challenge to come up with interesting articles about one state, but we have a pretty big and diverse state to write about," says Stout.

Well-designed regional magazines are known nationally, explains Stout. Art directors browse the best to see work they have never seen before. "So in that way being published regionally helps artists

D.J. Stout

just starting out become recognized nationally. Even though our magazine is mostly distributed in Texas, it gets looked at pretty widely by art directors and people who buy art. "*Texas Monthly* has, in a sense, become a clearinghouse for regional talent. We get calls every day asking about artists. Art directors take our word for it, they trust our tastes."

Though Stout uses illustrators from all over the world, he tries to use local talent when he can, depending on the project. He generally chooses local talent for the smaller pieces, spot illustrations and art for regular monthly features.

"Anymore, as long as you get someone to do it in the constraints of time, it doesn't matter where they live. But for certain stories, local illustrators have more sense for Texas lore and symbolism."

Once the assignment is complete, Stout asks the following questions: "Did they deliver on time? Did they give me something I liked? Did they grasp the story and were they able to communicate the story idea?" If the answer to each question is "yes," Stout will make sure the artist's name is added to the art department's Rolodex. Like all magazine art directors, Stout depends on a stable of reliable artists to meet his tight deadlines. "I use some of the same people over and over again who have a nice grasp of what *Texas Monthly* is about, and so they start to, in a sense, set a bit of a *Texas Monthly* style," says Stout.

Stout has no rules for the media or techniques used as long as the form conveys the message. Artists are free to use watercolor, pen and ink or whatever materials best illustrate the story. He has even used 3-D pieces that arrive at *Texas*

Monthly in a crate. Lately, artists have started sending illustrations via modem.

Experience can play a role in who Stout hires but not always. "I tend to use experienced illustrators for bigger projects, like features," says Stout. "In that case I will go for an artist whose style I have a feel for. But there are other sections where I use smaller spot-like art, not a full page, and that is a good place to break in someone who is inexperienced. I try them out there and if I don't like it that much it's not the end of the world. It's a good testing ground."

When reviewing an artist's work Stout looks for consistency. "I don't like to see a portfolio with a whole grab bag of styles. Not that you have to be completely rigid, but a consistent methodology of using your art to solve a problem, that's good." There is a certain professional quality art directors look for, says Stout. If your work is uneven, it shows you haven't developed your style to the point where you are comfortable with it.

If you're interested in sending samples to Stout, he requests postcards or printed pages from an annual. "If I see something I like," he says, "I tack it to a big bulletin board. It's easier for me to remember someone's work [that way]."

The best regional magazines to submit to are those in your own hometown or state. Your familiarity with the region and your close proximity to the editorial offices will be a definite attraction to the art director. Once you have some good regional tearsheets and get used to working with art directors, you can head confidently toward national publications.

—*Neil Burns*

Reprinted with permission of *Texas Monthly.*

For a ten-page Texas Monthly feature entitled "Animal Writes," Art Director D.J. Stout asked eight prominent illustrators to create their own interpretations of Texas animals that have been written about in Texas literature, myths, legends and songs, pairing the art with excerpts from famous Texas writers. Brad Holland chose the rattlesnake and the mountain lion—here ridden bronco-style by the legendary Pecos Bill.

Cartoons: "Our style varies; content is political/satirical or feature illustrations." Also uses caricatures.
Illustrations: Buys 4 illustrations/issue. Needs editorial illustration with political content. "We only print b&w, so pen & ink is best; washes are fine." Send photostats, tearsheets, photocopies, slides or photographs to be kept on file. Samples not filed are returned by SASE. Reports within 1 month. Request portfolio review in original query. Buys one-time rights. Pays on publication; $50 for b&w cover; $25 for inside.
Tips: "No color. We use mainly local artists usually to illustrate features. We also require a fast turnaround."

THEMA, Box 74109, Metairie LA 70033-4109. (504)568-6268. Editor: Virginia Howard. Estab. 1988. Tri-quarterly. Circ. 300. Sample copies are available for $8. Art guidelines for SASE with first-class postage. Needs computer-literate freelancers for illustration. Freelancers should be familiar with CorelDraw.
 • Each issue of *Thema* is based on a different, unusual theme, such as "Is it a Fossil, Higgins?" Upcoming themes and deadlines include "A Visit from the Imp" (March 1, 1996); *I Know Who You Are!* (July 1, 1996); "Too Proud to Ask" (November 1, 1996).
Cartoons: Approached by 10 cartoonists/year. Buys 1 cartoon/issue. Preferred themes are specified for individual issue (see Tips). Prefers humorous cartoons; b&w line drawings without gagline. Send query letter with finished cartoons. Samples are filed or are returned by SASE if requested by artist. Buys one-time rights. Pays $10 for b&w.
Illustrations: Approached by 10 illustrators/year. Buys 1 illustration/issue. Preferred themes are specified for target issue (see Tips). Considers pen & ink. Send query letter with SASE. Samples are returned by SASE if requested by artist. Portfolio review not required. Buys one-time rights. **Pays on acceptance**; $10 for b&w inside.
Tips: Finds artists through word of mouth. "Generally, artwork goes on the left-hand page facing the first story. It should try to depict the theme for that issue. With more submissions, we would expand the use of art throughout the journal. Request list of upcoming themes (with SASE) before submitting work. Submit b&w renderings only."

THRASHER, 1303 Underwood Ave., San Francisco CA 94124. (415)822-3083. Fax: (415)822-8359. Contact: Managing Editor. Estab. 1981. Monthly 4-color magazine. "*Thrasher* is the dominant publication devoted to the latest in extreme youth lifestyle, focusing on skateboarding, snowboarding, new music, videogames, etc." Circ. 200,000. Accepts previously published artwork. Originals returned at job's completion. Sample copies for SASE with first-class postage. Art guidelines not available. Needs computer-literate freelancers for illustration. Freelancers should be familiar with Adobe Illustrator or Photoshop.
Cartoons: Approached by 100 cartoonists/year. Buys 2-5 cartoons/issue. Prefers skateboard, snowboard, music, youth-oriented themes. Send query letter with brochure and roughs. Samples are filed and are not returned. Reports back to the artist only if interested. Rights purchased vary according to project. Pays $50 for b&w, $75 for color.
Illustrations: Approached by 100 illustrators/year. Buys 2-3 illustrations/issue. Prefers themes surrounding skateboarding/skateboarders, snowboard/music (rap, hip hop, metal) and characters and commentary of an extreme nature. Prefers pen & ink, collage, airbrush, marker, charcoal, mixed media and computer media (Mac format). Send query letter with brochure, résumé, SASE, tearsheets, photographs and photocopies. Samples are filed. Publication will contact artist for portfolio review if interested. Portfolio should include b&w and color tearsheets, photocopies and photographs. Rights purchased vary according to project. Negotiates payment for covers. Sometimes requests work on spec before assigning job. Pays on publication; $75 for b&w, $100 for color inside.
Tips: "Send finished quality examples of relevant work with a bio/intro/résumé that we can keep on file and update contact info. Artists sometimes make the mistake of submitting examples of work inappropriate to the content of the magazine. Buy/borrow/steal an issue and do a little research. Read it. Desktop publishing is now sophisticated enough to replace all high-end prepress systems. Buy a Mac. Use it. Live it."

‡TIKKUN MAGAZINE, Dept. AGDM, 251 W. 100th St., New York NY 10025. (212)864-4110. Fax: (212)864-4137. Publisher: Michael Lerner. Contact: Eric Goldhagen. Estab. 1986. "A bimonthly Jewish critique of politics, culture and society. Includes articles regarding Jewish and non-Jewish issues, left-of-center politically." Circ. 40,000. Accepts previously published material. Original artwork returned after publication. Sample copies for $6 plus $2 postage or "call our distributor for local availability at (800)846-8575."
Illustrations: Approached by 50-100 illustrators/year. Buys 0-8 illustrations/issue. Prefers line drawings. Send brochure, résumé, tearsheets, photostats, photocopies. Slides and photographs for color artwork only. Buys one time rights. Slides and photographs returned if not interested. "Often we hold onto line drawings for last-minute use." Pays on publication; $40 for b&w inside; $150 for color cover.
Tips: No "computer graphics, sculpture, heavy religious content."

‡THE TOASTMASTER, 23182 Arroyo Vista, Rancho Santa Margarita CA 92688. (714)858-8255. Editor: Suzanne Frey. Estab. 1924. Monthly trade journal for association members. "Language, public speaking, communication are our topics." Circ. 170,000. Accepts previously published artwork. Originals returned at job's completion. Sample copies available. Art guidelines not available.

Illustrations: Buys 6 illustrations/issue. Works on assignment only. Prefers communications themes. Considers watercolor and collage. Send query letter with any samples. Samples are filed or returned by SASE if requested by artist. Reports back to the artist only if interested. Portfolio should include b&w tearsheets and photocopies. Negotiates rights purchased. **Pays on acceptance**; $200 for b&w, $300-500 for color inside.

TOLE WORLD, 1041 Shary Circle, Concord CA 94518. (510)671-9852. Editor: Judy Swager. Estab. 1977. Bimonthly 4-color magazine with creative designs for decorative painters. "*Tole* incorporates all forms of craft painting including folk art. Manuscripts on techniques encouraged." Circ. 100,000. Accepts previously published artwork. Original artwork returned after publication. Sample copies and art guidelines available.
Cartoons: Buys 3-6 cartoons/year. Prefers simple, tasteful, traditional, jocular. Prefers single, double or multiple panel b&w line drawings and washes with or without gagline. Send roughs. Samples are not filed and are returned only by SASE. Reports back regarding queries/submissions within 1 month. Buys first rights. Pays $25 for b&w.
Illustrations: Buys illustrations mainly for step-by-step project articles. Buys 8-10 illustrations/issue. Prefers acrylics and oils. Considers alkyds, pen & ink, mixed media, colored pencil, watercolor and pastels. Needs editorial and technical illustration. Send query letter with photographs. Samples are not filed and are returned. Reports back about queries/submissions within 1 month. Pays $150 for color cover; $25-100 b&w, $150 for color inside.
Tips: "Submissions should be neat, evocative and well-balanced in color scheme with traditional themes, though style can be modern."

‡TOURIST ATTRACTIONS AND PARKS, 7000 Terminal Square, Suite 210, Upper Darby PA 19082. (610)734-2420. President: Scott C. Borowsky. Estab. 1972. Deals with arenas, attractions, fairgrounds, stadiums, concerts, theme and amusement parks. Published 7 times/year. Circ. 23,000.
Illustrations: Buys 6 illustrations/issue. Uses freelance artists for illustration, promotional pieces, covers, layout and paste-up (each issue). Send query letter with résumé and samples. Include SASE. Buys all rights. Pays on publication; $50 minimum cover, gray opaques. Buys gray opaques for inside.
Tips: "Part-time work available for paste-up and mechanicals. Pays $7-8/hour for paste-up."

TQ, 2221 Walnut Hill Lane, Irving TX 75038. (214)570-7599. Art Director: Rebekah Lyon. "Our main purpose is to help Christian teens live consistently for Christ, and to help them grow in their knowledge of the Bible and its principles for living"; 4-color monthly magazine, "lively, fun design." Circ. 50,000. Accepts previously published artwork. Original artwork returned after publication. Free sample copy. Needs computer-literate freelancers for illustration. 10% of freelance work demands computer literacy in Adobe Illustrator or Aldus FreeHand.
Cartoons: Contact: Chris Lyon, Managing Editor. Receives 4 submissions/week. Buys 2-3 cartoons/issue. Interested in wholesome offbeat humor for teens; prefers cartoons with teens as main characters; single panel. Prefers to see finished cartoons. Reports in 6 weeks. Buys first rights on a work-for-hire basis. Pays $25 for b&w; $50 for color cartoons.
Illustrations: Some illustrations purchased on assignment. Needs illustration for fiction, comedic with teen appeal. Submit samples with query letter. Artist should follow up with letter after initial query. Publication will contact artist for portfolio review if interested. Sometimes requests work on spec before assigning job. Pays $500 for color cover; $250 for color inside.

TRADITION, Box 438, Walnut IA 51577. (712)366-1136. Editor-in-Chief/Art Director: Robert Everhart. "For players and listeners of traditional and country music. We are a small bimonthly nonprofit publication and will use whatever is sent to us. A first-time gratis use is the best way to establish communication." Circ. 2,500. Previously published work OK. Sample copy $1 to cover postage and handling.
Cartoons: Buys 1 cartoon/issue from freelancers on country music; single panel with gagline. Receives 10-15 cartoons/week. To show a portfolio, mail roughs. Pays on publication; $5 for b&w line drawings.
Illustrations: Buys 1 illustration/issue on country music. Query with résumé and samples. Send SASE. Buys one-time rights. Pays on publication; $5 for b&w line drawings, cover; $5 for b&w line drawings, inside. Reports in 1 month.
Tips: "We'd like to see an emphasis on traditional country music."

‡TRAINING & DEVELOPMENT MAGAZINE, 1640 King St., Box 1443, Alexandria VA 22313-2043. (703)683-8146. Fax: (703)683-8103. Art Director: Elizabeth Jones. Estab. 1945. Monthly trade journal that covers training and development in all fields of business. Circ. 30,000. Accepts previously published artwork. Original artwork is returned at job's completion. Sample copies available. Art guidelines not available.
Illustrations: Approached by 20 freelance illustrators/year. Buys 5-6 freelance illustrations/issue. Works on assignment only. Prefers sophisticated business style, Anthony Russo style. Considers collage, pen & ink, airbrush, acrylic, oil, mixed media, pastel. Send query letter with tearsheets. Samples are filed. Reports back to the artist only if interested. Write for an appointment to show a portfolio of tearsheets, slides. Buys one-time rights or reprint rights. Pays on publication; $800 for color cover; $300-400 for color inside.

TRAINING MAGAZINE, The Human Side of Business, 50 S. Ninth St., Minneapolis MN 55402. (612)333-0471. Fax: (612)333-6526. Art Director: Jodi Boren Scharff. Estab. 1964. Monthly 4-color trade journal covering job-related training and education in business and industry, both theory and practice. Audience: training directors, personnel managers, sales and data processing managers, general managers, etc. "We use a variety of styles, but it is a business-looking magazine." Circ. 51,000. Sample copies for SASE with first-class postage. Art guidelines not available.
Cartoons: Approached by 20-25 cartoonists/year. Buys 1-2 cartoons/issue. "We buy a wide variety of styles. The themes relate directly to our editorial content, which is training in the workplace." Prefers single panel, b&w line drawings or washes with and without gagline. Send query letter with brochure and finished cartoons. Samples are filed or are returned by SASE if requested by artist. Reports back within 1 month. Buys first rights or one-time rights. Pays $25 for b&w.
Illustrations: Buys 6-8 illustrations/issue. Works on assignment only. Prefers themes that relate directly to editorial content. Styles are varied. Considers pen & ink, airbrush, mixed media, watercolor, acrylic, oil, pastel and collage. Send query letter with brochure, résumé, tearsheets, photocopies and photostats. Samples are filed or are returned by SASE if requested by artist. Reports back to the artist only if interested. Call or write for appointment to show portfolio of final art and b&w and color tearsheets, photostats, photographs, slides and photocopies. Buys first rights or one-time rights. **Pays on acceptance**; $500 minimum for color cover; $75-200 for b&w, $200-250 for color inside.
Tips: "Show a wide variety of work in different media and with different subject matter. Good renditions of people are extremely important."

TRANSITIONS ABROAD: The Magazine of Overseas Opportunities, 18 Hulst Rd., Box 1300, Amherst MA 01004. (800)293-0373. Editor: Clayton A. Hubbs. Bimonthly b&w magazine with 2-color cover emphasizing "educational, low-budget and special interest overseas travel for those who travel to learn and to participate." Circ. 20,000. Accepts previously published artwork. Original artwork returned after publication. Sample copy for $5; art guidelines for SASE.
Illustrations: Buys 3 illustrations/issue. Especially needs illustrations of American travelers and natives in overseas settings (work, travel and study). Send roughs to be kept on file. Samples not filed are returned by SASE. Reports in 1 month. Request portfolio review in original query. Buys one-time rights. Pays on publication; $25-100 for b&w line drawings, $30-150 for b&w washes, $125-250 for b&w cover.
Tips: "There is more interest in travel which involves interaction with people in the host country, with a formal or informal educational component. We usually commission graphics to fit specific features. Inclusion of article with graphics increases likelihood of acceptance. Study the publication and determine its needs."

‡TRAVEL & LEISURE, Dept. AGDM, 1120 Sixth Ave., New York NY 10036. (212)382-5600. Art Director: Giovanni Russo. Associate Art Director: Gaemer Gutierrez. Monthly magazine emphasizing travel, resorts, dining and entertainment. Circ. 1 million. Original artwork returned after publication. Art guidelines for SASE.
Illustrations: Approached by 250-350 illustrators/year. Buys 1-15 illustrations/issue. Interested in travel and leisure-related themes. Prefers pen & ink, airbrush, colored pencil, watercolor, acrylic, oil, pastel, collage, mixed media and calligraphy. Does not use b&w work. "Illustrators are selected by excellence and relevance to the subject." Works on assignment only. Provide business card to be kept on file for future assignment; samples returned by SASE. Reports in 1 week. Buys world serial rights. Pays on publication; $800-1,500 maximum for color inside; $1,500 for color cover.
Tips: No cartoons. Also needs freelancers fluent in Quark, FreeHand, Photoshop and Fontographer for production work.

‡TRAVEL MEXICO MAGAZINE GROUP, Box 188037 Place, Carlsbad CA 92009. (619)929-0707. Fax: (619)929-0714. Group Editor: Gabriela Flores. Estab. 1992. Quarterly magazine covering travel and events in Mexico. "Audience includes U.S. and Canadian travelers. Philosophy: Mexico and its people are respected. Any artwork should reflect that respect." Circ. 100,000. Accepts previously published artwork. Originals are returned at job's completion. Sample copies and art guidelines free for SASE with first-class postage.
Illustrations: Approached by 50 freelance illustrators/year. Works on assignment only. "We're looking for a design style consistent with the magazine's philosophy—a light touch, colorful, yet respectful of Hispanic culture." All media reviewed. Send query letter with brochure, résumé, SASE and slides. Samples are filed. Reports back within 2 months. Buys one-time rights. Pays on publication; $300 for cover; $50-300 for inside (negotiable).
Tips: "Send in rough color sketches that would work to illustrate departments in the magazine. Or, if fine art on Mexico, send a slide sleeve and bio. It's best to send work in and let us review it at our leisure. The work speaks for itself and the artist."

TRIQUARTERLY, 2020 Ridge Ave., Evanston IL 60208-4302. (708)491-3490. Fax: (708)467-2096. Editor: Reginald Gibbons. Estab. 1964. Triquarterly literary magazine, "dedicated to publishing writing and graphics which are fresh, adventureous, artistically challenging and never predictable." Circ. 5,000. Originals returned at job's completion. Sample copies for $4. Art guidelines not available.

Illustrations: Approached by 3-4 illustrators/year. Considers only work that can be reproduced in b&w as line art or screen for pages; all media; 4-color for cover. Send query letter with SASE, tearsheets, photographs, photocopies and photostats. Samples are filed or are returned by SASE. Reports back within 3 months (if SASE is supplied). Publication will contact artist for portfolio review if interested. Portfolio should include b&w and color thumbnails, tearsheets, slides, photostats, photocopies, final art and photographs. Buys first rights. Pays on publication; $300 for b&w/color cover; $30 for b&w inside.

TRUE WEST/OLD WEST, Box 2107, Stillwater OK 74076. (405)743-3370. Editor: John Joerschke. Monthly/ quarterly b&w magazine with 4-color cover emphasizing American Western history from 1830 to 1910. For a primarily rural and suburban audience, middle-age and older, interested in Old West history, horses, cowboys, art, clothing and all things Western. Circ. 30,000. Accepts previously published material and considers some simultaneous submissions. Original artwork returned after publication. Sample copy for $2. Art guidelines for SASE.
Illustrations: Approached by 75 illustrators/year. Buys 5-10 illustrations/issue (2 or 3 humorous). "Inside illustrations are usually, but not always, pen & ink line drawings; covers are Western paintings." Send query letter with samples to be kept on file; "We return anything on request. For inside illustrations, we want samples of artist's line drawings. For covers, we need to see full-color transparencies." Publication will contact artist for portfolio review if interested. Buys one-time rights. Sometimes requests work on spec before assigning job. "**Pays on acceptance for new artists, on assignment for established contributors.**" Pays $100-150 for color transparency for cover; $20-50 for b&w inside.
Tips: "We think the mainstream of interest in Western Americana has moved in the direction of fine art, and we're looking for more material along those lines. Our magazine has an old-fashioned Western history design with a few modern touches. We use a wide variety of styles so long as they are historically accurate and have an old-time flavor."

TURTLE MAGAZINE, For Preschool Kids, Children's Better Health Institute, 1100 Waterway Blvd., Box 567, Indianapolis IN 46206. (317)636-8881. Art Director: Bart Rivers. Estab. 1979. Emphasizes health, nutrition, exercise and safety for children 2-5 years. Published 8 times/year; 4-color. Original artwork not returned after publication. Sample copy for 5 first-class stamps; art guidelines for SASE. Needs computer-literate freelancers familiar with Aldus FreeHand and Photoshop for illustrations.
• Also publishes *Child Life, Children's Digest, Children's Playmate, Humpty Dumpty's Magazine* and *Jack and Jill*.
Illustrations: Approached by 100 illustrators/year. Works with 20 illustrators/year. Buys 15-30 illustrations/ issue. Interested in "stylized, humorous, realistic and cartooned themes; also nature and health." Works on assignment only. Send query letter with résumé, photostats or good photocopies, slides and tearsheets. Samples are filed or are returned by SASE. Reports only if interested. Portfolio review not required. Buys all rights. Pays on publication; $275 for cover; $80-190 for pre-separated 4-color, $70-155 for 4-color, $60-120 for 2-color; $35-90 for b&w inside.
Tips: Finds most artists through samples received in mail. "Familiarize yourself with our magazine and other children's publications before you submit any samples. The samples you send should demonstrate your ability to support a story with illustration."

TWINS MAGAZINE, 6740 Antioch, Suite 155, Merriam KS 66204. (913)722-1090. Fax: (913)722-1767. Art Director: Cindy Himmelberg. Estab. 1984. Bimonthly 4-color international magazine designed to give professional guidance to multiples, their parents and professionals who care for them. Circ. 55,000. Sample copies available. Art guidelines for SASE with first-class postage.
Cartoons: Pays $25 for b&w, $50 for color.
Illustrations: Approached by 10 illustrators/year. Buys 10 illustrations/issue. Works on assignment only. Prefers children (twins) in assigned situations. Considers watercolor, airbrush, acrylic, marker, colored pencil and pastel. Send query letter with résumé, tearsheets, photocopies, slides. Samples are filed or returned by SASE if requested by artist. Request portfolio review in original query. Reports back to the artist only if interested. Portfolio should include final art, color tearsheets, photographs and photocopies. Buys all rights. Pays on publication; $100 for color cover; $75 for color inside.
Tips: Finds artists through artists' submissions.

2 AM MAGAZINE, Box 6754, Rockford IL 61125-1754. Publisher: Gretta M. Anderson. E-mail: p.anderson21@genie.geis.com. Estab. 1986. Quarterly literary magazine featuring stories and reviews, primarily horror, science fiction and fantasy. Circ. 2,000. Originals returned at job's completion. Sample copies available for $4.95 and $1 postage. Art guidelines for SASE with first-class postage.
Illustrations: Approached by 30 illustrators/year. Buys 5 illustrations/issue. Works mostly on assignment. Considers pen & ink, airbrush, marker, charcoal and mixed media. Send query letter with SASE, photographs, photocopies, slides and transparencies—"whatever is convenient." Samples are filed or are returned by SASE if requested by artist. Reports back within 3 months. Publication will contact artist for portfolio review if interested. Portfolio should include b&w photocopies. Buys first rights. **Pays on acceptance**; $20 for b&w cover; $8 for b&w inside; $4 for spots.

Tips: Finds artists through artists' submissions. "Interior art most open to new artists, chosen by story and samples on file. Only publish b&w line art. Looking for uniqueness and polish."

‡UNION ELECTRIC NEWS, Box 149, St. Louis MO 63166. Supervisor, Public Information: D.J. Walther. Monthly b&w tabloid. Design is conservative with contemporary touches. For employees and retirees. Circ. 10,200. Previously published material and simultaneous submissions OK. Original work not returned after publication. Sample copy and art guidelines for SASE.

Cartoons: Uses 0-1 cartoon/issue. Interested in cartoons illustrative for workplace issues, article embellishment; b&w line drawings or washes. Send query letter with samples of style and résumé. Samples returned by SASE. Reports in 2 weeks. Pays $100 for b&w.

Illustrations: Uses 1 illustration/issue; buys all from freelancers. Works on assignment only. Interested in clean, current styles. Send query letter with résumé and samples of style, prices and turn-around times. Provide résumé, brochure, samples and tearsheets to be kept on file for possible future assignments. Samples not kept on file are returned by SASE. Reports in 2 weeks. **Pays on acceptance**; $200 for b&w inside.

Tips: "Style—light but dignified; content—workplace commentary. Prices must be negotiable."

‡UNIQUE OPPORTUNITIES, The Physicians' Resource, 455 S. Fourth Ave., Louisville KY 40202-2582. (502)589-8250. Fax: (502)587-0848. E-mail: bettuo@aol.com. Publisher and Design Director: Barbara Barry. Estab. 1991. Bimonthly trade journal. "Our audience is physicians looking for jobs. Editorial focus is on practice-related issues." Circ. 80,000. Originals returned at job's completion. Sample copies available. Freelancers should be familiar with QuarkXPress, Adobe Photoshop and Aldus FreeHand.

Illustrations: Approached by 10 illustrators/year. Buys 1-2 illustrations/issue. Works on assignment only. Considers pen & ink, mixed media, collage, watercolor and pastel. Send postcard-size sample or query letter with tearsheets. Samples are filed and are not returned. Publication will contact artist for portfolio of final art, tearsheets, eps files on a floppy disk if interested. Buys first or one-time rights. **Pays on acceptance** plus 30 days; $700 for color cover; $400 for color inside; $100 for spots.

Tips: Finds artists through sourcebooks such as *Workbook*, artists' submissions and other magazines. "We have possible plans for a new publication."

© Lonni Sue Johnson for *Unique Opportunities.*

Lonni Sue Johnson's watercolor painting appeared in a special issue of Unique Opportunities, The Physicians' Resource *devoted to setting up a new practice. Design Director Barbara Barry found Johnson's work while browsing through the* Workbook. *Both Barry and her audience liked the "playful" style of the painting—one* Unique Opportunities *subscriber inquired about purchasing the original.*

‡VANITY FAIR, 350 Madison Ave., New York NY 10017. (212)880-8800. Fax: (212)880-6707. E-mail: vfmail@vf.com. Art Director: David Harris. Estab. 1983. Monthly consumer magazine. Circ. 1.1 million. Does not use previously published artwork. Original artwork returned at job's completion. Needs computer-

literate freelancers for design. 100% of freelance design work demands knowledge of QuarkXPress and Adobe Photoshop.
Illustrations: Approached by "hundreds" of illustrators/year. Buys 3-4 illustrations/issue. Works on assignment only. "Mostly uses artists under contract."

VEGETARIAN JOURNAL, P.O. Box 1463, Baltimore MD 21203-1463. (410)366-8343. Editor: Debra Wasserman. Estab. 1982. Bimonthly nonprofit vegetarian magazine that examines the health, ecological and ethical aspects of vegetarianism. "Highly educated audience including health professionals." Circ. 27,000. Accepts previously published artwork. Originals returned at job's completion upon request. Sample copies available for $3.
Cartoons: Approached by 4 cartoonists/year. Buys 1 cartoon/issue. Prefers humorous cartoons; single panel b&w line drawings. Send query letter with roughs. Samples are not filed and are returned by SASE if requested by artist. Reports back within 2 weeks. Rights purchased vary according to project. Pays $25 for b&w.
Illustrations: Approached by 20 illustrators/year. Buys 6 illustrations/issue. Works on assignment only. Prefers strict vegetarian food scenes (no animal products). Considers pen & ink, watercolor, collage, charcoal and mixed media. Send query letter with photostats. Samples are not filed and are returned by SASE if requested by artist. Reports back within 2 weeks. Portfolio review not required. Rights purchased vary according to project. **Pays on acceptance**; $25 for b&w/color inside.
Tips: Finds artists through word of mouth and job listings in art schools. Areas most open to freelancers are recipe section and feature articles. "Review magazine first to learn our style. Send query letter with photocopy sample of line drawings of food."

VELONEWS, 1830 N. 55th St., Boulder CO 80301. (303)440-0601. Fax: (303)444-6788. Art Director: Charles Chamberlin. Estab. 1972. Consumer magazine; tabloid format; timely coverage of bicycle racing (no tours, triathlons or fun rides). Occasional features on people and subjects related to racing. Published 8 times/year. Circ. 45,000. Original artwork returned at job's completion. Sample copies available for $6 for back issues. Art guidelines not available.
Cartoons: Approached by 5-10 freelance cartoonists/year. Buys 1 freelance cartoon/issue. Prefers "pointed commentary on issues relating to bicycle racing"; single panel with gagline, b&w washes. Send query letter with finished cartoons. Samples are filed or are returned by SASE. Reports back only if interested. Buys one-time rights. Pays $35 for b&w, $75 for color.
Illustrations: Approached by 10-20 freelance illustrators/year. Works on assignment only. Considers pen & ink, watercolor, marker and color pencil. Send query letter with SASE and photocopies. Samples are filed or are returned by SASE. Reports back only if interested. To show a portfolio, mail roughs and b&w photocopies. Buys one-time rights. Pays on publication; $40 for b&w, $70 for color cover; $40 for b&w, $70 for color inside.
Tips: "Our stock in trade is timeliness, so an artist must be willing to work quickly. Knowledge of the sport of bicycle racing is essential. We have plenty of interview features, so a good caricaturist could break in without much difficulty."

VENTURE, Box 150, Wheaton IL 60189. (708)665-0630. Fax: (708)665-0372. Art Director: Robert Fine. Estab. 1959. Bimonthly 4-color magazine for boys 8-11. "Our aim is to promote Christian values and awareness of social and ethical issues." Circ. 20,000. Accepts previously published artwork. Original artwork returned after publication if requested. Sample copy $1.85 with large SASE; art guidelines for SASE.
Cartoons: Send to attention of cartoon editor. Approached by 20 cartoonists/year. Buys 1-3 cartoons/issue on nature, family life, sports, school, camping, hiking. Prefers single panel with gagline. Send finished cartoons. Include SASE. Reports in 1 month. Buys first-time rights. **Pays on acceptance**; $30 minimum.
Illustrations: Approached by 50 illustrators/year. Buys 3-4 color illustrations/issue. Subjects include education, nature, family life, sports and camping. Works on assignment only. Send business card, tearsheets and photocopies of samples to be kept on file for future assignments. Samples returned by SASE. Publication will contact artist for portfolio review if interested. Buys one-time rights. Pays on publication; $300 minimum for cover; $200 minimum inside.

VERMONT MAGAZINE, 14 School St., P.O. Box 288, Bristol VT 05443. (802)453-3200. Fax: (802)453-3940. Art Director: Susan Romanoff. Estab. 1989. Bimonthly regional publication "aiming to explore what life in Vermont is like: its politics, social issues and scenic beauty." Circ. 50,000. Accepts previously published artwork. Original artwork returned at job's completion. Sample copies and art guidelines for SASE with first-class postage.
Illustrations: Approached by 100-150 illustrators/year. Buys 2-3 illustrations/issue. Works on assignment only. "Particularly interested in creativity and uniqueness of approach." Considers pen & ink, watercolor, colored pencil, oil, charcoal, mixed media and pastel. Send query letter with tearsheets, "something that I can keep." Materials of interest are filed. Publication will contact artist for portfolio review if interested. Portfolio should include final art and tearsheets. Buys one-time rights. Considers buying second rights (reprint

rights) to previously published work. Pays $800 for color cover; $250 for b&w, $600 for color inside depending on assignment and size.

Tips: Finds artists mostly through submissions/self-promos and from other art directors. "Please send me a personalized note that indicates you've seen our magazine and you think your artwork would fit in; give reasons. Handwritten and informal is just fine. We will continue to see lean times in the magazine field. Assignment fees for most magazines will probably stay where they are for awhile and contributors who are unwilling to work in this tough market will probably lose jobs. In return, art directors will begin to give illustrators more creative freedom."

VETTE MAGAZINE, 299 Market St., Saddle Brook NJ 07663. (201)488-7171. Fax: (201)712-9899. Editor-in-Chief: D. Randy Riggs. Art Director: Kathleen Patti. Estab. 1976. Monthly 4-color magazine "devoted exclusively to the Corvette automobile and the hobby of Corvetting." Circ. 60,000. Original artwork returned after publication. Art guidelines not available.

Cartoons: Approached by 5 cartoonists/year. Prefers spot illustrations and humorous drawings about Corvettes or the Corvette industry. Pays $50 for b&w, $100 for color.

Illustrations: Buys illustrations mainly for spots and feature spreads. Buys 1-2 illustrations/issue. Needs editorial illustration. Works on assignment only. Considers pen & ink, airbrush, colored pencil, watercolor, acrylic, oil, pastel, marker and charcoal/pencil. Send query letter with brochure, tearsheets, photostats and photocopies. "Black & white, pen & ink, spot drawings of Corvettes are encouraged. Humorous drawings are also accepted. We accept drawings done in Aldus FreeHand, b&w or color." Samples not filed are returned only if requested. Publication will contact artist for portfolio review if interested. Buys first rights. Requests work on spec before assigning job. **Pays on acceptance**; $150 for b&w, $500 for color inside; $50 for b&w, $100 for color spots.

Tips: Finds artists through artists' submissions/self-promotions. The best way to break in is to send "spot illustrations for fillers. Major art is assigned according to articles. Label back of art with name and address. Send no originals."

‡VIBE, 205 Lexington Ave., New York NY 10016. (212)522-7092. Fax: (212)522-4578. Art Director: Diddo Ramm. Estab. 1993. Monthly consumer magazine focused on music, urban culture. Circ. 300,000. Accepts previously published artwork. Originals returned at job's completion. Sample copies available. Art guidelines not available. 100% of freelance work demands knowledge of QuarkXPress and Adobe Photoshop.

Cartoons: Approached by 20 cartoonists/year. Buys 2 cartoons/issue. Prefers humorous urban culture themes. Send postcard-size sample or query letter with brochure and finished cartoons. Samples are filed. Reports back to the artist only if interested. Buys one-time rights.

Illustrations: Approached by 50 illustrators/year. Buys 2 illustrations/issue. Works on assignment only. Prefers urban culture themes. Considers all media. Send postcard-size sample or query letter with photocopies. Samples are filed. Portfolios may be dropped off every Thursday. Publication will contact artist for portfolio review of roughs, final art and photocopies if interested. Buys one-time or all rights.

Tips: Finds artists through portfolio drop-off.

VICA JOURNAL, 14001 James Monroe Hwy., Box 3000, Leesburg VA 22075. (703)777-8810. Fax: (703)777-8999. E-mail: etomhall@aol.com. Editor: Tom Hall. Estab. 1965. Quarterly tabloid, b&w with 4-color cover and center spread. "*VICA Journal* helps high school and post-secondary students learn about careers, educational opportunities and activities of VICA chapters. VICA is an organization of 250,000 students and teachers in trade, industrial, technical and health occupations education." Circ. 250,000. Accepts previously published artwork. Originals returned at job's completion (if requested). Sample copies available. Art guidelines not available. Needs computer-literate freelancers for design and illustration. Freelancers should be familiar with Aldus PageMaker 5.0a or Aldus FreeHand 4.0.

Illustrations: Approached by 4 illustrators/year. Works on assignment only. Prefers positive, youthful, innovative, action-oriented images. Considers pen & ink, watercolor, collage, airbrush and acrylic. Send query letter with photographs, photocopies and photostats. Samples are filed. Portfolio should include printed samples, b&w and color tearsheets and photographs. Rights purchased vary according to project. **Pays on acceptance**; $400 for color cover; $150 for b&w and $200 for color inside; $200 for spots.

Tips: "Send samples or a brochure. These will be kept on file until illustrations are needed. Don't call! Fast turnaround helpful. Due to the unique nature of our audience, most illustrations are not re-usable; we prefer to keep art."

‡VIDEO GAMES & COMPUTER ENTERTAINMENT, 9171 Wilshire Blvd., Suite 300, Beverly Hills CA 90210. (310)858-7155. Fax: (310)274-7985. Art Director: Jim Loftus. Estab. 1989. "Deals only with video and computer games (Nintendo, Sega, etc.). Primarily a young, male audience 10-20 years-old." Monthly. Circ. 130,000. Original artwork is returned at job's completion. Sample copies and art guidelines available.

Cartoons: Approached by 5 cartoonists/year. Buys 0-1 cartoon/issue. Prefers bright, Disney-styles. Send query letter with brochure. Samples are filed. Does not report back, in which case the artist should follow up with phone call. Buys one-time rights. Pays $450 for color.

Illustrations: Approached by 15-20 illustrators/year. Buys 1-2 illustrations/issue. Prefers bright, realistic, fantasy or cartoonish, full-color. Considers airbrush, acrylic, colored pencil and oil. Send query letter with brochure, tearsheets, résumé and photographs. Samples are filed. Reports back only if interested. Call for appointment to show portfolio of original/final art, tearsheets, photographs and slides. Buys one-time rights. Pays $1,300 for color cover; $750 for color full page, $1,200 for spread, $450 for spots inside.
Tips: "Present work that follows our style, which (unfortunately) does not include free form art. Must be tight and realistic in nature. Make an appointment; if the work is good, we'll try to use you."

VIDEOMAKER MAGAZINE, Box 4591, Chico CA 95927. (916)891-8410. Fax: (916)891-8443. Art Director: Janet Souza. Monthly 4-color magazine for video camera users with "contemporary, stylish yet technical design." Circ. 150,000. Accepts previously published artwork. Original artwork returned at job's completion. Sample copies are available. Art guidelines not available. Needs computer-literate freelancers for illustration. 75% of freelance work demands knowledge of Aldus PageMaker, Adobe Illustrator or Aldus FreeHand.
Cartoons: Prefers technical illustrations with a humorous twist. Pays $30-200 for b&w; $200-800 for color.
Illustrations: Approached by 30 illustrators/year. Buys 3 illustrations/issue. Works on assignment only. Likes "illustration with a humorous twist." Considers pen & ink, airbrush, colored pencil, mixed media, watercolor, acrylic, oil, pastel, collage, marker and charcoal. Needs editorial and technical illustration. Send query letter with photocopies. Samples are filed. Publication will contact artist for portfolio review. Portfolio should include thumbnails, tearsheets and photographs. Negotiates rights purchased. Sometimes requests work on spec before assigning job. Pays on publication; $30-800 for b&w, $50-1,000 for color inside.
Tips: Finds artists through artists' submissions/self-promotions. "Read a previous article from the magazine and show how it could have been illustrated. The idea is to take highly technical and esoteric material and translate that into something the layman can understand. Since our magazine is mostly designed on desktop, we are increasingly more inclined to use computer illustrations along with conventional art. We constantly need people who can interpret our information accurately for the satisfaction of our readership."

‡VIM & VIGOR, 8805 N. 23rd Ave., Phoenix AZ 85021. (602)395-5850. Fax: (602)395-5853. Managing Art Director: Randi Karabin. Estab. 1985. Quarterly consumer magazine focusing on health. Circ. 900,000. Originals returned at job's completion. Sample copies available. Art guidelines not available.
Illustrations: Approached by 50 illustrators/year. Buys 12 illustrations/issue. Works on assignment only. Considers mixed media, collage, charcoal, acrylic, oil, pastel and computer. Send query letter with tearsheets, photocopies and transparencies. Samples are filed. Publication will contact artist for portfolio review of slides and photocopies if interested. Rights purchased vary according to project. **Pays on acceptance**; $800-1,000 for color inside; $300 for spots.
Tips: Finds artists through agents, sourcebooks, word of mouth and artists' submissions.

VIRGINIA TOWN & CITY, P.O. Box 12164, Richmond VA 23241. (804)649-8471. Fax: (804)343-3758. Editor: David Parsons. Estab. 1965. Monthly b&w magazine with 4-color cover for Virginia local government officials (elected and appointed) published by nonprofit association. Circ. 5,000. Accepts previously published artwork. Originals returned at job's completion. Sample copies available. Art guidelines not available.
Cartoons: "Currently none appear, but we would use cartoons focusing on local government problems and issues." Pays $25 for b&w.
Illustrations: Publication will contact artist for portfolio review if interested. Rights purchased vary according to project. **Pays on acceptance**; $50-75 for b&w and $55 for color cover; $25-45 for b&w and $35 for color inside.
Tips: "We occasionally need illustrations of local government services. For example, police, firefighters, education, transportation, public works, utilities, cable TV, meetings, personnel management, taxes, etc. Usually b&w. Illustrators who can afford to work or sell for our low fees, and who can provide rapid turnaround should send samples of their style and information on how we can contact them."

VOCATIONAL EDUCATION JOURNAL, 1410 King St., Alexandria VA 22314. (703)683-3111. Fax: (703)683-7424. Contact: Managing Editor. Estab. 1924. Monthly 4-color trade journal. "We publish articles on teaching for educators in the field of vocational education." Circ. 45,000. Accepts previously published artwork. Originals returned at job's completion. Sample copies with 9×11 SASE and first-class postage. Art guidelines not available. Needs computer-literate freelancers for illustration.
Cartoons: "We rarely use cartoons." Pays $100 for b&w, $200-300 for color.
Illustrations: Approached by 50 illustrators/year. Buys 3-6 illustrations/year. Works on assignment only. Considers pen & ink, watercolor, colored pencil, oil and pastel. Send query letter with brochure and photographs. Samples are filed. Reports back within 3 weeks. Portfolio review not required. Rights purchased vary according to project. Sometimes requests work on spec before assigning job. Pays on publication; $600-800 for color cover; $100 for b&w, $250 for color inside.

‡VOGUE PATTERNS, 161 Sixth Ave., New York NY 10013. (212)620-2733. Associate Art Director: Christine Lipert. Manufacturer of clothing patterns with the Vogue label. Uses freelance artists mainly for fashion illustration for the *Vogue Patterns* catalog and editorial illustration for *Vogue Patterns* magazine. "The nature

of catalog illustration is specialized; every button, every piece of top-stitching has to be accurately represented. Editorial illustration assigned for our magazine should have a looser-editorial style. We are open to all media."

Illustrations: Approached by 50 freelancers/year. Works with 10-20 illustrators and 1-5 graphic designers/year. Assigns 18 editorial illustration jobs and 100-150 fashion illustration jobs/year. Looking for "sophisticated modern fashion and intelligent creative and fresh editorial." Send query letter with résumé, tearsheets, slides or photographs. Samples not filed are returned by SASE. Call or write for appointment to drop-off portfolio. Pays by the hour, $15-25; for illustration by the project, $150-300.

Tips: "Drop off comprehensive portfolio with a current business card and sample. Make sure name is on outside of portfolio. When a job becomes available, we will call illustrator to view portfolio again."

WASHINGTON FLYER MAGAZINE, 3104 Omega Office Park, Fairfax VA 22031. (703)359-8847. Art Editor: Charlene Duryea. Estab. 1989. Bimonthly 4-color consumer magazine. "In-airport publication focusing on travel, transportation, trade and communications for frequent business and pleasure travelers." Circ. 180,000. Accepts previously published artwork. Original artwork is returned to the artist at the job's completion. Sample copies available. Art guidelines not available. Needs computer-literate freelancers for illustration. 20% of freelance work demands knowledge of QuarkXPress, Aldus FreeHand or Adobe Illustrator.

Illustrations: Approached by 100 illustrators/year. Buys 3 freelance illustrations/issue. Needs editorial illustration—"clear, upbeat, sometimes serious, positive, bright." Works on assignment only. Considers all media. Send query letter with brochure, tearsheets, photostats, photographs, slides, SASE, photocopies and transparencies. Samples are filed. Publication will contact artist for portfolio review if interested. Portfolio should include color tearsheets, photostats, photographs, slides and color photocopies. Buys reprint rights or all rights. **Pays on acceptance**; $600 for color cover; $250 for color inside.

Tips: "We are very interested in reprint rights."

WASHINGTON PHARMACIST, 1501 Taylor Ave. SW, Renton WA 98055-3139. (206)228-7171. Fax: (206)277-3897. Publications Director: Sheri Ray. Estab. 1959. Bimonthly association trade magazine, b&w with 2- and 4-color covers, emphasizing pharmaceuticals, professional issues and management for pharmacists. Circ. 2,000. Accepts previously published artwork. Sample copies available.

Cartoons: Approached by 15 cartoonists/year. Buys fewer than 5 cartoons/year. Themes vary. Send query letter with brochure and roughs. Samples are filed. Reports back only if interested. Rights purchased vary according to project. Pays $15 for b&w.

Illustrations: Approached by 15 illustrators/year. Buys 0-5 illustrations/year. Prefers pen & ink. Send query letter with brochure and photocopies. Publication will contact artist for portfolio review if interested. Rights purchased vary according to project. **Pays on acceptance**; $25 cover, $15 inside.

Tips: Finds artists through artists' submissions and word of mouth.

WEEKLY READER/SECONDARY, Weekly Reader Corp., 245 Long Hill Rd., Middletown CT 06457. (203)638-2420. Fax: (203)346-5964. Contact: Mike DiGiorgio. Estab. 1928. Educational newspaper, magazine, posters and books. *Weekly Reader* and *Secondary* periodicals have a newspaper format. The *Weekly Reader* emphasizes news and education for children 4-14. The philosophy is to connect students to the world. Publications are 4-color or 2-color; b&w with 4-color or 2-color cover. Design is "clean, straight-forward." Accepts previously published artwork. Original artwork is returned at job's completion. Sample copies are available.

Cartoons: Approached by 10 cartoonists/year. Prefers contempory, humorous line work. Preferred themes and styles vary according to the needs of the story/articles; single panel. Send query letter with printed samples. Samples filed or are returned by SASE if requested by artist. Rights purchased vary according to project. Pays $75 for b&w; $250-300 for color (full page).

Illustrations: Needs editorial, technical and medical illustration. Style should be "contemporary and age level appropriate for the juvenile audience. Style of Janet Hamlin, Janet Street, Joe Locco, Joe Klein and Mas Mianot." Approached by 60-70 illustrators/year. Buys more than 50/week. Works on assignment only. Prefers pen & ink, airbrush, colored pencil, mixed media, watercolor, acrylic, pastel, collage and charcoal. Send query letter with brochure, tearsheets, slides, SASE and photocopies. Samples are filed or are returned by SASE if requested by artist. Request portfolio review in original query. Artist should follow up with letter after initial query. Payment is usually made within 3 weeks of receiving the invoice. Pays $250 for b&w, $300 for color cover; $250 for b&w, $300 for color inside.

Tips: Finds artists through artists' submissions/self-promotions, sourcebooks, agents and reps. "Our primary focus is the children's marketplace; figures must be drawn well if style is realistic. Art should reflect creativity and knowledge of audience's sophistication needs. Our budgets are tight and we have very little flexibility in our rates. We need artists who can work with our budgets. Still seeking out artists of all styles—professionals!"

WESTERN TALES MAGAZINE, P.O. Box 33842, Granada Hills CA 91394. Publisher: Dorman Nelson. Estab. 1993. Quarterly magazine featuring Western fiction and poetry. Circ. 5,000. Originals returned at job's completion. Sample copies available for $6. Art guidelines available.

Cartoons: Approached by 10 cartoonists/year. Buys 2 cartoons/issue. Prefers Western/Native American genre humorous cartoons; single panel b&w line drawings with gagline. Send query letter with roughs or finished cartoons. Samples are not filed and are returned by SASE. Reports in 2 months. Buys first rights. Pays $10-50 for b&w.

Illustrations: Approached by 10-15 illustrators/year. Buys 30 illustrations/issue. Prefers Western genre—animals, 1800s depictions, horse-oriented. Considers pen & ink, watercolor and collage. Send query letter with SASE and photocopies. Samples are not filed and are returned by SASE. Reports back within 2 months. Artist should follow up with call and/or letter after initial query. Portfolio should include b&w and color roughs and final art. Buys first rights. Pays on publication; $250 for color cover.

Tips: Finds artists through word of mouth, art galleries and art shows. Work most open to freelancers is art for color cover, b&w pen & ink or brush watercolor in reference to stories and poetry.

‡WESTWAYS, 2601 S. Figueroa, Los Angeles CA 90007. (213)741-4850. Fax: (213)741-3033. Art Director: Holly Caporale. Estab. 1918. A monthly magazine covering travel and people; reaches an upscale audience through AAA membership as well as newsstand and subscription sales. Circ. 450,000. Original artwork returned at job's completion. Sample copies and art guidelines available for SASE.

Illustrations: Approached by 20 illustrators/year. Buys 2-6 illustrations/issue. Works on assignment only. Preferred style is arty-tasteful, colorful. Considers pen & ink, watercolor, collage, airbrush, acrylic, colored pencil, oil, mixed media and pastel. Send query letter with brochure, tearsheets and samples. Samples are filed. Reports back within 1-2 weeks only if interested. To show a portfolio, mail appropriate materials. Portfolio should include thumbnails, final art, b&w and color tearsheets. Buys first rights. Pays on publication; $250 minimum for color inside.

‡WILDLIFE CONSERVATION/BRONX ZOO, 185th and Southern Blvd., Bronx NY 10460. (212)220-5121. Fax: (212)584-2625. Art Director: Julie Maher. Estab. 1895. Bimonthly magazine that covers endangered species and conservation issues. Circ. 200,000. Accepts previously published artwork. Original artwork returned at job's completion. Sample copies and art guidelines available for SASE.

Cartoons: Approached by 100 cartoonists/year. Buys 5 cartoons/issue. Prefers color washes. Send query letter with brochure, roughs, finished cartoon samples. Samples are filed. Does not report back on queries and submissions. Buys first rights. Pays $350-850 for color.

Illustrations: Approached by 100 illustrators/year. Buys 10 illustrations/issue. Works on assignment only. Prefers animal illustrations. Considers watercolor, collage, acrylic, mixed media. Send query letter with brochure, résumé, tearsheets. Samples are filed. Does not report back on queries and submissions. Write for appointment to show portfolio or mail appropriate materials. Portfolio should include photostats, photocopies, photographs. Buys first rights. **Pays on acceptance**; $75-350 for color cover; $350-850 for color inside (payment varies with size of art).

WILSON LIBRARY BULLETIN, 950 University Ave., Bronx NY 10452. (212)588-8400. Editor: Grace Anne DeCandido. Art Director: Lynn Amos. Emphasizes the issues and the practice of library science; 4-color. "We showcase one full-page color illustration per issue." Published 10 times/year. Circ. 13,500. Free sample copy. Needs computer-literate freelancers for illustration. 10% of freelance work demands knowledge of Adobe Illustrator or Photoshop.

Cartoons: Approached by 25-30 cartoonists/year. Buys 2-3 cartoons/issue on education, publishing, reading, technology and libraries; single panel with gagline. Mail finished art samples and SASE. Reports back only if interested. Buys first and electronic rights. Pays on publication; $100 for b&w line drawings and washes.

Illustrations: Approached by 20-30 illustrators/year. Buys 1-2 illustrations/issue. Uses freelancers mainly for feature articles. Works on assignment only. Send query letter, business card and samples to be kept on file. Do not send original work that must be returned. Publication will contact artist for portfolio review if interested. Buys first rights. Pays on publication; $400 for color cover; $300 for color washes; $100-200 for b&w line drawings and washes inside; $25 for spot drawings.

Tips: Finds artists through self-promotions, "including a business reply postcard is helpful." Artist should have "knowledge of our publication and its needs."

WIN, 120 S. San Fernando Blvd., Suite 439, Burbank CA 91502. Fax: (818)845-0325. E-mail: ag497@lafn. org. Art Director: Joey Sinatra. A monthly 4-color consumer magazine. "The only magazine in the country devoted to all aspects of legal gambling." Accepts previously published artwork. Original artwork returned at job's completion.

Cartoons: Buys 5-12 freelance cartoons/year. Must be gambling related, hip/insider gags. Prefers single panel, with gagline, b&w line drawings, color washes. Send query letter with finished cartoons. Samples are filed or returned by SASE if requested by artist. Reports back to the artist only if interested. Buys first rights. Pays $25/cartoon.

Illustrations: Buys 1-2 freelance illustrations/issue. Works on assignment only. Prefers a contemporary look. Considers pen & ink, watercolor, collage, airbrush, acrylic, color pencil and mixed media. "Send query letter with non-returnable promotional materials; we can't guarantee return of originals or slides." Samples are filed. Publication will contact artist for portfolio review if interested. Portfolio should include b&w and

color tearsheets and slides. Buys first rights. Pays $200 color, cover; pays $100, color, inside; $75 for spots.

"I have a love of words, too."

"Benita Epstein has a real sense of 'library humor' and a deliciously wry way of look-ing at things," says Grace Anne DeCandido, editor of **Wilson Library Bulletin**. **This cartoon by Epstein appeared in the magazine's May 1994 issue. "We have used a lot of Benita's work. She actually reads the magazine and responds to our readers' con-cerns," DeCandido says. Epstein found the magazine through Artist's & Graphic De-signer's Market**. **She used this cartoon in her promotional material, which led to a number of magazine sales and a book contract.**

‡WINDSURFING MAGAZINE, 330 W. Canton Ave., Winter Park FL 32789. (407)628-4802. Fax: (407)628-7061. E-mail: windsurf@gate.net. Art Director: Lisa Damerst. Estab. 1981. Consumer magazine "for winds-urfers and those interested in the sport. Audience is 30ish, mostly male and affluent." 8 issues/year. Circ. 75,000. Original artwork returned if requested at job's completion. One sample copy available to the artist. Art guidelines not available.

Illustrations: Approached by 1-2 illustrators/year. Buys 15-20 illustrations/year, mostly maps. Works on assignment only. Prefers "maps and a fun cartoon-like style." Considers airbrush, watercolor and collage. Send query letter with SASE, "samples of various styles and short bio listing where published material has appeared." Samples are filed or are returned by SASE if requested by artist. Reports back only if interested as need arises. "Please do not call." To show a portfolio, mail color tearsheets, photostats, photographs and photocopies. Rights purchased vary according to project. Pays on publication; $50-400 average for color inside.

Tips: "Send a good selection of styles for us to review."

‡WISCONSIN RESTAURATEUR, 31 S. Henry St., #300, Madison WI 53703. (608)251-3663. Fax: (608)251-3666. Editor: Sonya Knecht Bice. Bimonthly magazine emphasizing the restaurant industry. Readers are "restaurateurs, hospitals, schools, institutions, cafeterias, food service students, chefs, etc." Circ. 4,000, except convention issue (January), 8,000. Original artwork returned after publication. Sample copy and art guidelines for SASE.

Cartoons: Buys 1 cartoon/issue. Receives 5 cartoons/week. "Uses much material pertaining to sanitation issues, employees. No off-color material." Prefers b&w line drawings with gaglines. Send finished cartoons and SASE. Reports in 2 weeks. Buys first rights. Pays $8 on publication.

Illustrations: Buys 1 illustration/issue. Freelancers chosen "at random, depending on theme and articles featured for the month." Looks for "the unusual, pertaining to the food service industry." Send brochure showing art style or résumé to be kept on file for future assignments. Buys first rights. To show a portfolio, mail roughs, final art and b&w samples. **Pays on acceptance**; $25 for b&w cover; $15 for b&w, $20 for color inside; $25 for spots.

WISCONSIN TRAILS, Box 5650, Madison WI 53705. (608)231-2444. Production Manager: Nancy Mead. 4-color publication concerning travel, recreation, history, industry and personalities in Wisconsin. Published 6 times/year. Circ. 35,000. Previously published and photocopied submissions OK. Art guidelines for SASE.
Illustrations: Buys 6 illustrations/issue. "Art work is done on assignment, to illustrate specific articles. All articles deal with Wisconsin. We allow artists considerable stylistic latitude." Send samples (photocopies OK) of style to be kept on file for future assignments. Indicate artist's favorite topics; name, address and phone number. Include SASE. Publication will contact artist for portfolio review if interested. Buys one-time rights on a work-for-hire basis. Pays on publication; $50-350 for inside.
Tips: Finds artists through magazines, artists' submissions/self-promotions, artists' agents and reps and attending art exhibitions.

WOMEN'S GLIB™, Box 259, Bala Cynwyd PA 19004. Editor: Roz Warren. Estab. 1991. Yearly anthologies of cartoons, by women, and books that highlight the best contemporary women's humor (humor by women). Circ. 20,000. Accepts previously published artwork. Originals are not returned. Sample copies available for $10 payable to Roz Warren (not Women's Glib). Art guidelines for SASE with first-class postage.
Cartoons: Approached by 1,000 cartoonists/year. Buys 100-200 cartoons/issue. Prefers feminist humorous cartoons. Send query letter with finished cartoons. Samples are filed or returned by SASE if requested by artist. Reports back within 5 days. Buys one-time rights. Pays $10-20 for b&w.
Illustrations: Approached by 50 illustrators/year. Buys 5 illustrations/issue. Works on assignment only. Send query letter. Samples are filed. Reports back within 5 days. Portfolio review not required. Buys one-time rights. Pays on publication; $20 for b&w.
Tips: Finds artists through word of mouth and calls for submissions in journals and magazines. "Almost all the work I use is freelance. Women's Glib is a terrific break-in market. In each book I publish many women for the first time. I use work by women only. Please take a look at one of the prior books in this series before submitting work. They are available at your local bookstore or library or may be ordered directly from my publisher by phoning (800)777-1048."

‡WONDER TIME, 6401 The Paseo, Kansas City MO 64131. (816)333-7000. Fax: (816)3331-4439. Editor: Lois Perrigo. Estab. 1969. Weekly 4-color Sunday school "story paper" emphasizing inspiration and character-building material for first and second graders, 6-8 years old, for Sunday School curriculum. Circ. 40,000. Sample copies for SASE with 56¢ postage.
Illustrations: Buys 1 illustration/issue. Works on assignment only. Send query letter with tearsheets or photocopies to be kept on file. Buys all rights. **Pays on acceptance**; $40 for b&w; $75 for color.
Tips: "Include illustrations of 6-8 year old ethnic children in your portfolio. We use some full-color cartoons to illustrate our Bible-in-Action stories."

‡WOODENBOAT, Box 78, Brooklin ME 04616. (207)359-4651. Art Director: Lindy Gifford. Concerns designing, building, repairing, using and maintaining wooden boats. Bimonthly. Circ. 106,000. Previously published work OK. Sample copy for $4.
Illustrations: Buys 48 illustrations/year on wooden boats or related items. Send query letter with samples and SASE. Reports in 1-2 months. "We are always in need of high quality technical drawings. Buys first North American serial rights. Pays on publication. Rates vary, but usually $25-350."
Tips: "We work with several professionals on an assignment basis, but most of the illustrative material that we use in the magazine is submitted with a feature article. When we need additional material, however, we will try to contact a good freelancer in the appropriate geographic area."

WORDPERFECT MAGAZINE and WORDPERFECT FOR WINDOWS MAGAZINE, 270 W. Center St., Orem UT 84057-4683. (801)226-5555. Fax: (801)226-8804. E-mail: donla@wordperfect.com. Assistant Art Director: Don Lambson. Estab. 1989. Monthly 4-color consumer magazine for WordPerfect users (nearly 10,000,000 in the US). Circ. 250,000. Accepts previously published artwork. Originals and 10 tearsheets returned at job's completion.
● These publications have been awarded Certificates of Design Excellence in *PRINT's Regional Design Annual* for 1994. Nine of their spreads were included in the annual. They also were honored for best magazine design in the Society of Publication Design's 29th design annual.
Illustrations: Approached by 100 illustrators/year. Buys 10 illustrations/issue. Works on assignment only. Prefers conceptual work in any style or medium. Send query letter with tearsheets and photocopies. Samples filed or returned by SASE if requested. Publication will contact artist for portfolio review if interested. Portfolio should include color tearsheets and finished art samples. Buys one-time rights. **Pays on acceptance**; $1,500 for color cover; $800 for color inside; $500-600 for spots.
Tips: Finds artists through *Showcase, Workbook* and self-promotions. "In the future, increased availability of stock illustrations will result in extra reimbursement for quality conceptual illustrations."

WORKBENCH, K.C. Publishing, Inc., 700 W. 47th St., Suite 300, Kansas City MO 64112. Executive Editor: A. Robert Gould. Estab. 1957. Bimonthly 4-color magazine for woodworkers and do-it-yourselfers. Circ.

750,000. Needs computer-literate freelancers for design and illustration. 100% of freelance work demands knowledge of Adobe Illustrator or QuarkXPress on the Macintosh.

Cartoons: Buys 15 cartoons/year. Interested in woodworking and do-it-yourself themes; single panel with gagline. Submit samples with SASE. Reports in 1 month. Buys all rights, but may reassign rights to artist after publication. **Pays on acceptance**; $40 minimum for b&w line drawings.

Illustrations: Works with 10 illustrators/year. Buys 100 illustrations/year. Artists with experience in the area of technical drawings, especially house plans, exploded views of furniture construction, power tool and appliance cutaways, should send SASE for sample copy and art guidelines. Style of Eugene Thompson, Don Mannes and Mario Ferro. Publication will contact artist for portfolio review if interested. Sometimes requests work on spec before assigning job. Pays $50-1,200 for b&w, $100-1,500 for color inside.

Tips: "We have cut back on the number of stories purchased, though not necessarily the amount of art."

‡WORKING MOTHER MAGAZINE, 230 Park Ave., New York NY 10169. (212)551-9533. Fax: (212)599-5008. Art Assistant: Anna Balaguer. Estab. 1979. "A monthly service magazine for working mothers focusing on work, money, children, food and fashion." Original artwork is returned at job's completion. Sample copies and art guidelines available.

Illustrations: Approached by 100 illustrators/year. Buys 3-5 illustrations/issue. Works on assignment only. Prefers light humor and child/parent, work themes. Considers watercolor, collage, airbrush, acrylic, colored pencil, oil, mixed media and pastel. Send query letter with brochure and tearsheets. Samples are filed and are not returned. Does not report back, in which case the artist should call or drop off portfolio. Portfolio should include tearsheets, slides and photographs. Buys first rights. **Pays on acceptance**; $150-2,000 for color inside.

Tips: "Portfolios are viewed every Wednesday afternoon, preferably after 2 p.m."

WORLD TRADE, 17702 Cowan, Irvine CA 92714. (714)798-3506. Fax: (714)798-3501. Photo Editor: Craig Peterson. Estab. 1988. Bimonthly 4-color trade journal; "read by upper management, presidents and CEOs of companies with international sales." Circ. 37,000. Accepts previously published artwork. Original artwork is returned to artist at job's completion. Sample copies and art guidelines not available. Needs computer-literate freelancers for illustration. 20-30% of freelance work demands computer skills.

Cartoons: Prefers business/social issues. "We have a staff cartoonist." Samples are filed. Reports back to the artist only if interested. Buys first rights or reprint rights.

Illustrations: Approached by 15-20 illustrators/year. Buys 2-3 illustrations/issue. Works on assignment only. "We are open to all kinds of themes and styles." Considers pen & ink, colored pencil, mixed media and watercolor. Send query letter with brochure and tearsheets. Samples are filed. Reports back to the artist only if interested. Portfolio review not required. Buys first rights or reprint rights. Pays on publication; $350 for color cover; $200 for color inside.

Tips: "Send an example of your work. We prefer previous work to be in business publications. Artists need to understand we work from a budget to produce the magazine and budget controls are closely watched."

WRITER'S DIGEST, 1507 Dana Avenue, Cincinnati OH 45207. Art Director: Daniel T. Pessell. Editor: Tom Clark (for cartoons). Monthly magazine emphasizing freelance writing for freelance writers. Circ. 250,000. Original artwork returned after publication. Sample copy for $3.
 • Cartoons submitted are also considered for inclusion in annual *Writer's Yearbook.*

Cartoons: Buys 3 cartoons/issue. Theme: the writing life. Needs cartoons that deal with writers and the trials of writing and selling their work. Also, writing from a historical standpoint (past works), language use and other literary themes. Prefers single panel with or without gagline. Send finished cartoons. Material returned by SASE. Reports back within 1 month. Buys first rights or one-time rights. **Pays on acceptance**; $50-85 for b&w.

Illustrations: Buys 5 illustrations/month. Theme: the writing life. Prefers b&w line art primarily. Works on assignment only. Send nonreturnable samples to be kept on file. Accepts photocopies as samples. Buys one-time rights. **Pays on acceptance**; $400-500 for color cover; $50-350 for inside b&w.

Tips: "We're also looking for b&w spots of writing-related subjects. We buy all rights; $15-25/spot."

WRITER'S YEARBOOK, 1507 Dana Ave., Cincinnati OH 45207. Submissions Editor: Jo Gilbert. Annual publication featuring "the best writing on writing." Topics include writing and marketing techniques, business issues for writers and writing opportunities for freelance writers and people getting started in writing. Original artwork returned with 1 copy of the issue in which it appears. Sample copy $6.25. Affiliated with *Writer's Digest.* Cartoons submitted to either publication are considered for both.

Cartoons: Uses 3-6 cartoons in yearbook. "All cartoons must pertain to writing—its joys, agonies, quirks. All styles accepted, but high-quality art is a must." Prefers single panel, with or without gagline, b&w line drawings or washes. Send finished cartoons. Samples returned by SASE. Reports in 1-2 months. Buys first North American serial rights for one-time use. **Pays on acceptance**; $50 minimum for b&w.

Tips: "A cluttery style does not appeal to us. Send finished, not rough art, with clearly typed gaglines. Cartoons without gaglines must be particularly well-executed."

YOGA JOURNAL, 2054 University Ave., Berkeley CA 94704-1082. (510)841-9200. Fax: (510)644-3101. E-mail: yogajml@aol.com. Art Director: Tricia McGillis. Estab. 1975. Bimonthly consumer magazine emphasizing health, consciousness, yoga, holistic healing, transpersonal psychology, body work and massage, martial arts, meditation and Eastern spirituality. Circ. 80,000. Originals returned at job's completion. Sample copies available. Art guidelines not available.

Illustrations: Approached by 50 illustrators/year. Buys 8 illustrations/issue. Works on assignment only. Considers all media, including electronic (Mac). Send query letter with any reproductions. Samples are filed. Publication will contact artist for portfolio review if interested. Buys one-time rights. **Pays on acceptance**; $800 for color cover; $125 for b&w, $175 for color inside and spots.

Tips: "Send plenty of samples in a convenient form (i.e. 8½×11 color photocopies with name and phone number on each sample) that don't need to be returned."

YOU! MAGAZINE, 31194 La Baya Dr., Suite 200, Westlake Village CA 91362. (818)991-1813. Fax: (818)991-2024. E-mail: youmag@aol.com. Art Director: Chris Taleck. Estab. 1986. Magazine for Catholic and Christian high school and college youth, published 10 times yearly. Circ. 375,000. Originals are not returned. Sample copies available for $2.98. Art guidelines for SASE with first-class postage. Needs computer-literate freelancers for design and illustration. 50% of freelance work demands computer knowledge of Adobe Illustrator, QuarkXPress, Adobe Photoshop or Aldus FreeHand.

Cartoons: Approached by 30-40 cartoonists/year. Buys 2 cartoons/issue. Prefers Catholic youth, political and humorous cartoons; single or multiple panel b&w line drawings. Send query letter with brochure, roughs and finished cartoons. Samples are filed. Reports back to the artist only if interested. Rights purchased vary according to project. Pays $50 for b&w, $60 for color.

Illustrations: Approached by 100 illustrators/year. Buys 20 illustrations/issue. Prefers spiritual themes. Considers pen & ink, watercolor, collage, airbrush, acrylic, marker, oil, charcoal, mixed media, pastel and computer. Send query letter with brochure, résumé, SASE, tearsheets, photographs, photocopies, slides and transparencies. Samples are filed. Request portfolio review in original query. Publication will contact artist for portfolio review if interested. Portfolio should include b&w thumbnails, tearsheets, slides, roughs, photocopies, final art and photographs. Rights purchased vary according to project. Pays on publication; $70 for b&w, $80 for color inside.

YOUR HEALTH, 5401 NW Broken Sound Blvd., Boca Raton FL 33487. (407)989-1176. Fax: (407)997-9210. Photo Editor: Judy Browne. Estab. 1960. Biweekly health and fitness magazine for the general public. Circ. 50,000. Accepts previously published artwork. Originals returned at job's completion. Sample copies and art guidelines available.

Cartoons: Approached by 30 cartoonists/year. Buys 10 cartoons/year. Prefers health and fitness humorous cartoons; b&w line drawings. Send query letter with roughs. Samples are filed. Reports back within 1 month. Buys one-time rights. Pays $50 for b&w/color.

Illustrations: Approached by 5 illustrators/year. Buys 2 illustrations/issue. Prefers health and fitness themes. Considers all media. Send query letter with tearsheets, photographs and photocopies. Samples are filed. Reports back within 1 month. Publication will contact artist for portfolio review if interested. Portfolio should include any samples. Buys one-time rights. Pays on publication; $100 for b&w, $200 for color inside; $50-75 for spots.

Tips: Finds artists through other publications. Features and departments are both open to freelancers.

YOUR HEALTH & FITNESS, 60 Revere Dr., Northbrook IL 60062-1563. (708)205-3000. Fax:(708)564-8197. Supervisor of Art Direction: Kristi Johnson Simkins. Estab. 1978. Quarterly consumer and company magazine. "*Your Health & Fitness* is a magazine that allows clients to customize up to eight pages. Clients consist of hospitals, HMOs and corporations." Circ. 600,000. Accepts previously published artwork. Originals are returned at job's completion. Sample copies available. Guidelines not available. Needs computer-literate freelancers for design and illustration. 70% of freelance work demands knowledge of Adobe Illustrator, QuarkXPress, Adobe Photoshop and Aldus Freehand.

Cartoons: Approached by 12 cartoonists/year. Buys 1 cartoon/issue. Prefers humorous, health, fitness and food cartoons; single panel, b&w line drawings with gaglines. Send query letter with finished cartoons. Samples are filed or are returned. Reports back to the artist only if interested. Buys one-time or reprint rights. Pays $150 for b&w, $200 for color.

Illustrations: Approached by 200 illustrators/year. Buys 6 illustrations/issue. Works on assignment only. Prefers exercise, fitness, psychology, drug data, health cost, first aid, diseases, safety and nutrition themes; any style. Considers pen & ink, watercolor, collage, airbrush, acrylic, oil, mixed media and pastel. Send query letter with tearsheets, photostats, photographs, slides, photocopies and transparencies. Samples are filed or are returned. Reports back to the artist only if interested. Publication will contact artist for portfolio review if interested. Portfolio should include b&w and color tearsheets and slides. Buys one-time or reprint rights. Pays on publication; $500 for color cover; $150 for b&w, $250 for color inside.

Tips: "Fast Facts" section of magazine is most open to freelancers; uses health- or fitness-related cartoons.

YOUR MONEY MAGAZINE, 5705 N. Lincoln Ave., Chicago IL 60659. (312)275-3590. Art Director: Beth Ceisel. Estab. 1980. Bimonthly 4-color personal finance magazine. "Provides useful advice on saving, investing and spending. Design is accessible and reader-friendly." Circ. 500,000. Original artwork returned after publication. Art guidelines for SASE with first-class postage. Needs computer-literate freelancers for illustration, charts/graphs. 30% of freelance work demands knowledge of in Aldus FreeHand, Adobe Illustrator or Photoshop.

Illustrations: Buys 10-12 illustrations/issue. Works on assignment only. Editorial illustration is used based upon specific needs of an article, therefore style, tone and content will vary. Send query letter with brochure, tearsheets, photocopies and/or promotional pieces. Samples not filed are returned by SASE. Publication will contact artist for portfolio review if interested. Buys first rights or one-time rights. Sometimes requests work on spec before assigning job. Pays $300-800 for b&w, $300-1,000 for cover; $300-1,100 for color inside; $200-400 for spots.

Magazines/'95-'96 changes

The following magazines were listed in the 1995 edition but do not have listings in this edition. The majority did not respond to our request to update their listings.

Aboriginal Science Fiction
Accent on Living
The Aguilar Expression
The American Spectator
Art Business News
Automundo
Baby Connection News Journal
Ball Magazine
Balls & Strikes Softball
Baltimore Jewish Times
Bend of the River® Magazine
Best of the Midwest's Science
 Fiction, Fantasy & Horror
Better Health Magazine
Beverly Hills 213
Bicycling Magazine
Bird Watcher's Digest
Bone & Flesh
Bow & Arrow Magazine
Breaking In
Campus Life
Chicago Life Magazine
The Christian Science Monitor
The Church Herald
Cobblestone
College Broadcaster Magazine
Common Lives/Lesbian Lives
Confetti Magazine
Conservatory of American Letters
Contact Advertising
Crafts 'N Things
Creative Child & Adult Quarterly
Currents
Diablo Magazine
Dog Fancy
Doll Collector's Price Guide
Eidos
The Electron
Employee Services Management
Equilibrium[10]
Family Motor Coaching
FFA New Horizons
Fifty Something Magazine
Fighting Woman News Magazine
The Final Edition
Fish Drum Magazine

Fling International
Floral & Nursery Times
Front Page Detective
Genre
Gent
Healthcare Forum Journal
Heaven Bone
Historic Preservation News
Home Education Magazine
Home Times
Honolulu Magazine
Housewife-Writers Forum
The Humorous Vein (ceased pub-
 lication)
International Doll World
International Insider
The International Saddlery and
 Apparel Journal
Japanophile
Jazziz
Jewish Weekly News
Kalliope
Kashrus
Kentucky Living
Kite Lines
LACMA Physician
Luna Ventures
The Lutheran Journal
Made to Measure
Magic Changes
Malibu Comics
Martical Arts Training
Medical Economics Magazine
The Meeting Manager
Memco News
Metrosports Magazine
Mid-American Review
Midnight Zoo
Military Market Magazine
Modern Drummer
National Trail Lawyer Magazine
Negative Capability
New Age Journal
The New Crucible
New Letters
Next Phase

On Our Backs
Open Computing Magazine
Outdoor America Magazine
Overseas!
Owner-Manager Magazine
The Pinehurst Journal
Poor Katy's Almanac
Prairie Journal Trust
Prism International
Professional Agent
Queen of All Hearts
Quilt World
Rag Mag
Rip off Press
River Styx
Room of One's Own
The St. Louis Journalism Review
Salt Lick Press
Shareware Magazine
The Silver Web
Silverfish Review
Sinister Wisdom
Small Pond
South Coast Poetry Journal
Southwest Art
Sports Car International
The Strain
Tamaqua
Tampa Review
Thedamu Arts Magazine
THIS: A Serial Review
Videomania
Visions—International
Washington Flyer Magazine
The Water Skier
Westart
The James White Review
Wildfire (discontinued)
Wines & Vines
Wisconsin Review
Writer's Guidelines
Wy'East Historical Journal
Yellow Silk
Zuzu's Petals

Record Companies

When Jay Barbieri, art director for Angel Records, envisioned monks floating in a cloudy sky for the cover of *Chant* he chose freelancer Marvin Mattelson to illustrate the cover. The ethereal image helped the CD rise to the top of the charts. Record companies are keenly aware great packaging boosts sales. Art directors turn to freelancers to provide the design, illustration, typography and lettering for customer-luring covers.

This burgeoning market has seen steady growth, nearly tripling in the last decade. According to the Recording Industry Association of America, the industry exceeded $12 billion in sales in 1994—a record 20 percent increase over 1993's figure of $10 billion. This multi-billion dollar market is waiting for you. All it takes is a lot of talent, determination, and some research into the market and its popular recording formats.

The recording industry is dominated by a handful of major labels. "The big six"— Polygram, Warner, Thorn-EMI, BMG, MCA and Sony—take in more than 90% of industry sales. But there are thousands of independent labels. Some are thriving, others struggling, but they are a big part of the industry. And you'll find the "indies" are great places to start when looking for freelance assignments.

Changing formats, changing needs

CDs continue to dominate the other full-length formats with a healthy 58.4 percent of the market. CD sales have doubled in the last five years. Full-length cassettes remain a viable alternative for today's consumer, with 32.1 percent of the market. So art directors look for freelancers who can create dynamic work with those formats.

When the predominant format was 12×12 LPs, designers had plenty of space to work with, both on the front and back of the album. But since the CD was introduced in 1983, designers have faced the challenge of creating compelling covers within a much smaller format. Nearly all CDs are designed in either 6×12 or 5×5 formats. In the past several years, the 6×12 packaging was abandoned by most record companies as ecologically unsound. The majority are now packaged in 5×5 jewel boxes. Included in an average CD package is an inlay card and a 4- to 5-page fold-out booklet. But some booklets run as long as 128 pages. In addition to the list of songs and credits, booklets include material such as lyrics, written or photographic essays, biographies and artwork.

In addition to the CD destined for retail outlets, record companies produce promotional and limited-edition versions of the same release, which feature lavish design, bold use of material and expensive touches, such as leather-bound packaging, slipcases, wood boxes and other extraordinary touches. Several examples of elaborate promotional CDs are featured in *CD Packaging & Graphics*, by Ken Pfeifer, a Rockport Book.

It's not unusual for an art director to work with several freelancers on one project. For example, one person might handle typography, another illustration; a photographer is sometimes used and a designer can be hired for layout. Labels also turn to outside creatives for display design, promotional materials, collateral pieces or video production.

It will benefit you to keep up with new technology within the music industry. The digital compact cassette (DCC) and the mini-disk, for instance, have entered the arena

to compete with CD and cassette sales. Ultimately, the consumer will determine the winning format.

Landing the assignment

Submit your work to record companies the same way you would approach any market. Check the listings in the following section to see how the art director prefers to be approached and what type of samples to send. Check also to see what type music they produce. If the company produces classical recordings, don't send images more appropriate to a heavy metal band. Assemble a portfolio of your best work in case an art director wants to see more of your work.

Be sure your portfolio includes quality samples. It doesn't matter if the work is of a different genre—quality is key. To find out what kind of work Angel Records looks for read Jay Barbieri's Insider Report, page 602. Get the name of the art director or creative director from the listings in this section and send a cover letter that asks for a portfolio review. If you are not contacted within a couple of weeks, make a polite follow-up call to the office manager. (Most art directors prefer not to be called directly. If they are interested, they will call.)

Another route of entry is through management companies who work for recording artists. They represent musicians in the many facets of their business, one being control over the artwork used in releases. Follow the steps already listed to get a portfolio review. Lists of management companies can be found in *Songwriter's Market* published by Writer's Digest Books and the *Recording Industry Sourcebook* published by Ascona Group, Inc.

Once you nail down an assignment, get an advance and a contract. Independent labels usually provide an advance and payment in full when a project is done. When negotiating a contract, ask for a credit line on the finished piece and samples for your portfolio.

You don't have to live in one of the recording capitals to land an assignment, but it does help to familiarize yourself with the business. Visit record stores and study the releases of various labels. Ask to see any catalogs or promotional materials the store may have received from the companies you're interested in. Read music industry trade magazines, like *Spin*, *Rolling Stone*, *Ray Gun* and *Billboard*. For further information about CD design read *Rock Art*, by Spencer Drate (PBC International).

‡**A&R RECORDS/RDS PROMOTIONS**, 900 19th Ave. S., Suite 207, Nashville TN 37212. (615)329-9127. President: Ruth Steele. Estab. 1986. Produces CDs, tapes and videos: rock, R&B, folk, gospel, country/western, alternative by solo artists and groups. Recent releases: "It's Not Over Till The Fat Lady Sings," by Kitty Kelley; "Fighting Another Man's War," by David Steele.
Needs: Works with 2 freelancers/year. Prefers local artists only. Uses freelancers for CD cover, tape cover, advertising and brochure design and illustration; direct mail packages; posters. Needs computer-literate freelancers for design, illustration and production. 90% of freelance work demands computer skills.
First Contact & Terms: Send query letter with résumé, photographs and SASE. Samples are filed or returned by SASE if requested by artist. May not report back. Artist should re-submit in 6 months. Art Director will contact artist for portfolio review if interested. Portfolio should include b&w and color final art, photocopies and photographs. Pays by the project. Rights purchased vary according to project.
Tips: Finds artists through sourcebooks and artists' submissions. "Contact everyone—study industry directories/lists and do a blanket mailing. Be flexible with charges."

AFTERSCHOOL PUBLISHING COMPANY, P.O. Box 14157, Detroit MI 48214. (313)571-0363. President: Herman Kelly. Estab. 1978. Produces CDs and tapes: rock, jazz, rap, R&B, soul, pop, classical, folk, educational, country/western, dance and new wave. Recent releases: "Garden of Garments" and "Funkamataz," both by Herman Kelly and *Festival of Cultures*.
Needs: Produces 1 solo artist/year. Works with 10 freelance designers and 10 illustrators/year. Prefers professional artists with experience in all forms of the arts. Uses artists for CD cover design, tape cover and advertising design and illustration, brochure design and posters. Needs computer-literate freelancers for production. 25% of freelance work demands computer skills.

First Contact & Terms: Send query letter with brochure, résumé, SASE and appropriate samples. Samples are filed or are returned by SASE. Reports back within 2-4 weeks. Requests work on spec before assigning a job. To show portfolio, mail roughs, printed samples, b&w/color tearsheets, photographs, slides and transparencies. Pays by the project. Negotiates rights purchased. Interested in buying second rights (reprint rights) to previously published work.
Tips: Finds artists through Michigan Council for the Arts' Artist Directory and Detroit Arts Council.

ALEAR RECORDS, Rt. 2, Box 114, Berkeley Springs WV 25411. (304)258-2175. Owner: Jim McCoy. Estab. 1973. Produces tapes and albums: country/western. Releases: "The Taking Kind," by J.B. Miller; "If I Throw away My Pride," by R.L. Gray; and "Portrait of a Fool," by Kevin Wray.
Needs: Produces 12 solo artists and 6 groups/year. Works with 3 freelancers/year. Works on assignment only. Uses artists for CD cover design and album/tape cover illustration.
First Contact & Terms: Send query letter with résumé and SASE. Samples are filed. Reports back within 1 month. To show portfolio, mail roughs and b&w samples. Pays by the project, $50-250.

***ALPHABEAT**, Box 12 01, D-97862 Wertheim/Main, West Germany. Phone/fax: 09342-841 55. Owner: Stephan Dehn. A&R: Marga Zimmerman. Produces CDs, tapes and albums: R&B, soul, dance, rap, pop, new wave, electronic and house; solo artists and groups.
Needs: Uses freelancers for CD/album/tape cover, brochure and advertising design and illustration; catalog design, illustration and layout; and direct mail packages.
First Contact & Terms: Send query letter with brochure, tearsheets, photostats, résumé, photographs, slides, SASE, photocopies and IRCs. Samples are returned by SAE with IRCs. To show portfolio, mail appropriate materials. Payment depends on product. Rights purchased vary according to project.

THE AMETHYST GROUP LTD., 273 Chippewa Dr., Columbia SC 29210-6508. Contact: Management. Produces rock, dance, soul, R&B; solo artists. Releases: "Silhouette" and "New Fire Ceremony."
Needs: Produces 3 solo artists and 5 groups/year. Uses freelancers for album cover and brochure design, direct mail packages and promotional materials. Prefers b&w or color, abstract designs.
First Contact & Terms: Send query letter with résumé and samples. Samples are returned by SASE. Reports back within 2 months. Write for appointment to show portfolio of b&w photographs. Pays by the project, $25 minimum. Considers available budget and rights purchased when establishing payment. Negotiates rights purchased. Must sign release forms.
Tips: "Be realistic and practical. Remember that b&w is the industry standard; color is used a great deal with major companies. Express talent, not hype; be persistent. Always include proper postage for any reply and/or return of materials. Give us an idea of how you expect to be paid and/or credited."

‡ANGEL/EMI RECORDS, 810 Seventh Ave., 4th Floor, New York NY 10019. (212)603-8631. Fax: (212)603-8648. Vice President, Creative Services: J. Barbieri. Produces CDs and tapes: pop, classical, adult, by solo artists and groups. Recent releases: *Chant*, by Benedictine Monks; and *Vision, The Music of Hildergard von Bingen*.
Needs: Produces 40 releases/year. Works with 5 freelancers/year. Uses freelancers for CD cover design and illustration. Needs computer-literate freelancers for design, illustration, production. 70% of freelance work demands knowledge of Adobe Illustrator, QuarkXPress, Adobe Photoshop, Aldus FreeHand.
First Contact & Terms: Send postcard sample of work. Samples are filed and not returned. Reports back to the artist only if interested. Call for appointment to show portfolio of b&w and color final art. Pays for design by the project, $1,000. Pays for illustration by the project, $600. Buys all rights or negotiates rights purchased.
Tips: Finds artists through word of mouth, sourcebooks. "Learn the industry standards—lingo, standard specs, etc."

ANTELOPE PUBLISHING, 23 Lover's Lane, Wilton CT 06897. (203)834-9884. President: Tony LaVorgna. Estab. 1982. Produces CDs and tapes: jazz and middle of the road by solo artists and groups. Recent releases: *Eiderdown*, by Tony LaVorgna; and *Swing Fever*, by Swing Fever.
Needs: Produces 1 solo artist and 1 group/year. Works with 2 freelancers/year. Works on assignment only. Uses artists for CD/tape cover design and illustration, brochure illustration, direct mail packages and poster.
First Contact & Terms: Send query letter with brochure, résumé, photocopies, photographs, tearsheets. Samples are filed. Reports back to the artist only if interested. To show portfolio, mail b&w final art. Pays for design by the project. Negotiates rights purchased.
Tips: "Start with a small company where more attention will be received."

APON RECORD COMPANY, INC., Steinway Station, Box 3082, Long Island City NY 11103. (212)721-8599. President: Andre M. Poncic. Produces classical, folk, pop and video tapes from eastern Europe.
Needs: Produces 20 records/year. Works with 20 designers and 20 illustrators/year. Uses freelancers for album cover design and illustration, catalog illustration and layout, posters.

Enchant Record Companies with Adventurous Artwork

If you haven't seen *Chant*, the multi-platinum Gregorian chant CD recorded by the Benedictine Monks of Santo Domingo de Silos, you must have been vacationing on the moon. This 1994 release is by far Angel Records' biggest seller. It's been called a phenomenon in the classical and pop world, and is probably the biggest crossover record ever, selling more than five million copies worldwide. And many have speculated that a great deal of its success is due to the album's eye-catching cover.

Jay Barbieri

You won't get much disagreement on that point from Jay Barbieri. He's Angel Records' vice president of creative services and production. "I handle all the album cover concepts from start to finish," he says.

This includes finding freelance artists for many projects, such as the *Chant* cover. Barbieri works together with company president Steve Murphy and Angel's A&R department (the department that finds and develops new recording artists) to decide on a general cover concept. "If I have a certain vision that I want to portray, I'll go to all the books I can possibly get my hands on that advertise artists and illustrators, put all my contacts aside and look for something really fresh."

That's how Barbieri found Marvin Mattelson, whose work graces the cover of the *Chant* CD. "His work was the style I had envisioned, and I got in touch with Marvin through an artist rep publication. He had a lot of input on tweaking the design and came up with some great suggestions." Since then, Mattelson has worked on several more Angel covers, including *Vision, the Music of Hildegard von Bingen*, the follow-up album to *Chant*.

Barbieri gets a slew of samples from artists and reviews portfolios constantly. "I like to see as much as possible, especially from young artists." To catch an art director's eye, Barbieri says half the battle is presentation, "and I don't mean just a slick presentation. If someone sends me something really unusual and creative, that really makes a difference. Postcards are one thing—I receive dozens at a time. But once in a while I get an interesting package that really catches my attention."

Barbieri advises artists to be flexible and be good listeners when dealing with music industry art directors. "Record companies have a pretty good idea of the markets they want to target. And it makes all the difference in the world to work with an artist who is attentive to their needs."

And just as an artist's work must grab an art director's attention, so must a CD cover grab the consumer's attention. With *Chant* for instance, Barbieri and Murphy wanted a package to appeal to the age-group that used to walk in the store and buy The Who and Led Zeppelin albums. "We wanted a cover that jumped off the shelf and said the same thing to that audience—this is cool, this is really exciting, this is something that's of interest, visually and spiritually."

Many people might envision "scrolly, scripty" lettering and a photo of a monastery for the cover of an album like *Chant*. But to achieve buyer appeal, Barbieri's *Chant* concept leans to the surreal, featuring monks that seem young and contemporary, and lettering chiseled out of granite floating in an ethereal sky "as if you were to see a prayer chiseled into the wall of an ancient monastery. We wanted it to have the concrete appeal of a monument.

"We believe in honest music. We want the true reflection of the (recording) artist to be portrayed through the package." But a good package also must stand out on a shelf. "It has to be able to be read from across the room. You should be able to step back ten feet from it and notice it among the others."

With this in mind, artists should not be shy about breaking away from the norm when it comes to appealing to record company art directors. "Don't be afraid to put certain elements together that contrast each other," says Barbieri. "Don't be afraid to be adventurous."

—*Alice P. Buening*

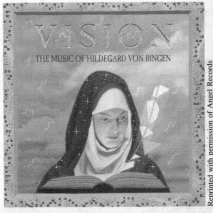

Marvin Mattelson's ethereal oil painting helped spark multi-platinum sales for Chant, Angel Records' biggest selling CD. "Marvin is a great talent. He was a real asset to the project," says Angel's Jay Barbieri. "He was always open to suggestions, very cooperative, and met his deadlines." Following this success, Barbieri chose Mattelson to create the cover art for Chant's follow-up CD, Vision, as well as several other Angel covers.

First Contact & Terms: Works on assignment only. Send brochure and samples to be kept on file. Write for art guidelines. Samples not filed are returned by SASE. Reports to the artist within 60 days only if interested. Considers available budget when establishing payment. Buys all rights.

ART ATTACK RECORDINGS/MIGHTY FINE RECORDS, 3305 North Dodge Blvd., Tucson AZ 85716. (602)881-1212. President: William Cashman. Produces rock, country/western, jazz, pop, R&B; solo artists.
Needs: Produces 4 albums/year. Works with 1-2 freelance designers and 1-2 illustrators/year. Uses freelancers for CD/album/tape cover design and illustration; catalog design and layout; advertising design, illustration and layout; posters.
First Contact & Terms: Works on assignment only. Send query letter with brochure, business card, tearsheets or photographs to be kept on file. Samples not filed are returned by SASE only if requested. Reports back only if interested. Write for appointment to show portfolio. Original artwork is not returned. Pays for design by the hour, $15-25; by the project, $100-500. Pays for illustration by the project, $100-500. Considers complexity of project and available budget when establishing payment. Buys all rights. Sometimes interested in buying second rights (reprint rights) to previously published artwork.

‡BABY FAZE RECORDS & TAPES, 45 Pearl St., San Francisco CA 94103. (415)495-5312. Owner: G. Miller Marlin. Estab. 1989. Produces tapes and vinyl: rock, jazz, pop, R&B, soul, progressive, classical, folk, country/western, rap, industrial. Recent releases: *Don't Dis Courage* (AIDS tape), by Cat Howdy; *Pets & Supplies & Business Opportunities*, by Pandora's Lunch Box.
Needs: Produces 24 releases/year.
First Contact & Terms: Send postcard sample of work or send query letter with brochure, photocopies and photographs. Samples are filed and are not returned. Reports back to the artist only if interested. Portfolio should include b&w and color final art, photographs. No payment—credit line given. Negotiates rights purchased.
Tips: Finds artists through artists' submissions. Impressed by "talent and a willingness to work easily for exposure. Don't expect too much, too soon in the record business."

‡BABY SUE, P.O. Box 1111, Decatur GA 30031-1111. (404)875-8951. President: Don W. Seven. Estab. 1983. Produces CDs, tapes and albums: rock, jazz, classical, country/western, folk and pop. Releases: *Mnemonic*, by LMNOP; *Homo Trip*, by The Stereotypes; and *Bad is Good*, by Lisa Shame.
Needs: Produces 6 solo artists and 10 groups/year. Uses 5 freelancers/year for CD/album/tape cover design and illustration, catalog design, advertising design and illustration and posters.
First Contact & Terms: Send query letter with SASE, photographs, photostats and slides. Samples are not filed and are not returned. Reports back to the artist only if interested. To show portfolio, mail roughs, b&w and color photostats and photographs. Pays by the day, $250-500. Rights purchased vary according to project.
Tips: "Be persistent. We are open minded."

B-ATLAS & JODY RECORDS, 2557 E. First St., Brooklyn NY 11223. (718)339-8047. Vice President/A&R Director: Vincent Vallis. Vice President/Sales: Ron Alexander. Estab. 1979. Produces CDs, tapes and albums: rock, jazz, rap, R&B, soul, pop, country/western and dance. Releases: "Where Did Our Love Go," by Demetrius Dollar Bill; "Master Plan," by Keylo; and "Our Lives," and "Alone," both by Alan Whitfield.
Needs: Produces 20 solo artists and 10 groups/year. Works with 5 freelancers/year on assignment only. Uses artists for CD cover design and illustration; brochure illustration.
First Contact & Terms: Send query letter with SASE and photocopies. Samples are filed. Reports back to the artist only if interested. To show portfolio, mail photographs. Pays by the project, $50-100. Rights purchased vary according to project.

BEACON RECORDS, P.O. Box 3129, Peabody MA 01961. (508)762-8400. Fax: (508)762-8467. Principal: Tony Ritchie. Estab. 1992. Produces CDs and tapes: folk, Celtic, alternative by solo artists and groups. Releases: "Of Age," by Aztec Two-Step; "Were You At The Rock," by A¡ne Minogue.
Needs: Produces 10-15 solo artists and groups/year. Work with 2-3 visual artists/year. Prefers artists with experience in music industry graphics. Uses artists for CD cover design and illustration; tape cover design and illustration; brochure design and illustration; catalog design, illustration and layout; direct mail packages; advertising design and illustration; and posters. Needs computer-literate freelancers for design, illustration and production. 75% of freelance work demands computer skills.
First Contact & Terms: Send query letter with brochure and samples. Samples are filed. Reports back to the artist only if interested. Write for appointment to show portfolio of b&w and color final art and photographs. Pays for design, by the project. Buys all rights.

***BIG BEAR RECORDS**, P.O. Box, Birmingham B16 8UT England. (021)454-7020. Fax: (21)454-9996. Managing Director: Jim Simpson. Produces CDs and tapes: jazz, R&B. Recent releases: *Let's Face the Music*, by Bruce Adams/Alan Barnes Quintet and *Blues & Rhythm, Volume One*, by King Pleasure & The Biscuit Boys; and *The Boss Is Here*, by Kenny Bakers Dozen.

Needs: Produces 8-10 records/year. Works with 4-6 illustrators/year. Uses freelancers for album cover design and illustration. Needs computer-literate freelancers for illustration.
First Contact & Terms: Works on assignment only. Send query letter with photographs or photocopies to be kept on file. Samples not filed are returned only by SAE (nonresidents include IRC). Negotiates payment. Considers complexity of project and how work will be used when establishing payment. Buys all rights. Interested in buying second rights (reprint rights) to previously published work.

‡**BLACK & BLUE RECORDS**, 400D Putnam Pike, Suite, 152, Smithfield RI 02917. (401)949-4887. Art Dept: Boris Ofterhaul. Estab. 1988. Produces CDs, tapes and albums: rock, punk rock, underground and country/western. Releases: *Darkness In Me*, by Blue Nouveaux; *Sleep With Evil*, by Northwinds; and *6th Grade Field Trip*, by Bloody Mess and The Skabs.
Needs: Produces 1 solo artist and 4-8 groups/year. Works with 1-3 freelancers/year on assignment only. Uses freelancers for CD/album/tape cover and advertising design and illustration; and catalog design, illustration and layout. 10% of freelance work demands computer skills.
First Contact & Terms: Send query letter with "any type of sample work and description of limitations." Samples are not filed and are not returned. Reports back only if interested. To show portfolio, mail appropriate materials. Pays by the project, $25-500. Rights purchased vary according to project.

BLACK DIAMOND RECORDS INCORPORATED, P.O. Box 8073, Pittsburg CA 94565. (510)980-0893. Fax: (510)458-0915. Art Management: B.D.R. Art Dept. Estab. 1988. Produces tapes, CDs and vinyl 12-inch and 7-inch records: jazz, pop, R&B, soul, rap by solo artists and groups. Recent releases: "Can't Do Without My Baby," by Deanna Dixon; "So Hard to Leave Without U," by Proper J; and "Something, Somethin," by 3-Part.
Needs: Produces 2 solo artists and 3 groups/year. Works with 2 freelancers/year. Prefers freelancers with experience in album cover and insert design. Uses freelancers for CD/tape cover and advertising design and illustration; direct mail packages; and posters. Needs computer-literate freelancers for production. 85% of freelance work demands knowledge of Aldus PageMaker, Aldus FreeHand.
First Contact & Terms: Send query letter with résumé. Samples are filed and are returned. Reports back within 3 months. Write for appointment to show portfolio of b&w roughs and photographs. Pays for design by the hour, $100; by the project, $100. Rights purchased vary according to project.
Tips: "Be creative, be patient, be assertive, be on time."

BLAIR VIZZION MUSIC, 1315 Simpson Rd. NW, Suite 5, Atlanta GA 30314. (404)642-2645. Managing Director: Willie W. Hunter. Estab. 1989. Produces pop, R&B, soul by solo artists and groups. Releases: "Rockin You Tonight" and "Anytime Anyplace," by Gary Adkins.
Needs: Produces 4 solo artists and 1 group/year. Works on assignment only. Uses freelancers for CD cover and advertising illustration; tape cover design; and posters. Needs computer-literate freelancers.
First Contact & Terms: Send query letter with résumé, photographs and SASE. Samples are returned. Reports back within 2 months. To show portfolio, mail b&w and color roughs and photographs. Pays for design by the project. Rights purchased vary according to project.

BLASTER BOXX HITS, 519 N. Halifax Ave., Daytona Beach FL 32118. (904)252-0381. Fax: (904)252-0381. C.E.O.: Bobby Lee Cude. Estab. 1978. Produces CDs, tapes and albums: rock, R&B, folk, educational, country/western and marching band music. Releases: "Blow Blow Stero" and "Shot In The Dark," by Zonky Honky.
Needs: Produces 6 CDs and tapes/year. Works on assignment only. Uses freelancers for CD cover design and illustration.
First Contact & Terms: Send query letter with appropriate samples. Samples are filed. Reports back within 1 week. To show portfolio, mail thumbnails. Sometimes requests work on spec before assigning a job. Pays by the project. Buys all rights.

‡**BOLIVIA RECORDS**, 1219 Kerliw Ave., Brewton AL 36426. (205)867-2228. Contact: Roy Edwards. Estab. 1972. Produces CDs and records: jazz, pop, R&B, folk, country/western. Recent releases: "Make Me Forget," by Bobbie Roberson; and "If You Only Knew," by Roy Edwards.
Needs: Produces 3 solo artist and 6 groups/year. Works with 12 freelancers/year. Uses freelancers for CD cover illustration, tape cover design and illustration; advertising design. 20% of freelance work demands knowledge of Aldus Photoshop.
First Contact & Terms: Send query letter with résumé, photostats, tearsheets. Samples are filed or returned by SASE if requested by artist. Reports back within 1 month. Mail appropriate materials. Portfolio should include b&w photographs. Pays by the project. Buys all rights.

BOUQUET-ORCHID ENTERPRISES, P.O. Box 1335, Norcross GA 30091. (404)798-7999. President: Bill Bohannon. Estab. 1972. Produces CDs and tapes: rock, country, pop and contemporary Christian by solo artists and groups. Releases: *Blue As Your Eyes*, by Adam Day; and *Take Care Of My World*, by Bandoleers.

Needs: Produces 6 solo artists and 4 groups/year. Works with 8-10 freelancers/year. Works on assignment only. Uses freelancers for CD/tape cover and brochure design; direct mail packages; advertising illustration. Needs computer-literate freelancers for design and illustration. 25% of freelance work demands knowledge of Aldus PageMaker, Adobe Illustrator and QuarkXPress.

First Contact & Terms: Send query letter with brochure, SASE, résumé and samples. "I prefer a brief but concise overview of an artist's background and works showing the range of his talents." Include SASE. Samples are not filed and returned by SASE if requested by artist. Reports within 1 month. To show a portfolio, mail b&w and color tearsheets and photographs. Pays for design by the project, $100-500. Rights purchased vary according to project.

Tips: "Keep being persistent in sending out samples of your work and inquiry letters as to needs. Always strive to be creative and willing to work within guidelines, as well as budgets."

BRIARHILL RECORDS, 3484 Nicolette Dr., Crete IL 60417. (708)672-6457. President/A&R Director: Danny Mack. Estab. 1984. Produces tapes, CDs and records: pop, gospel, country/western, polka, Christmas by solo artists and groups. Recent releases: "Old Rockers Never Die," and "There's No Place Like Home for Christmas," by Danny Mack.

Needs: Produces 2-5 solo artists/year. Work with 2 freelancers/year. Prefers artists with experience in album covers. Works on assignment only. Uses freelancers for CD/tape cover design and illustration; brochure design and advertising illustration. 20% of freelance work demands knowledge of Adobe Illustrator.

First Contact & Terms: Send query letter with photocopies and SASE. Samples are filed and are not returned. Reports back within 3 weeks. To show portfolio, mail photostats. Pays for design by the project, $100 minimum. Buys all rights.

Tips: "Especially for the new freelance artist, get acquainted with as many recording studio operators as you can and show your work. Ask for referrals. They can be a big help in getting you established locally."

BSW RECORDS, Box 2297, Universal City TX 78148. (210)659-2338. Fax: (210)659-2557. President: Frank Willson. Estab. 1987. Produces tapes and albums: rock, country/western by solo artists. Releases 8 CDs/tapes each year. Recent releases: *Takin The Reins*, by Harold Dean; *Tomahawk Hill*, by Don Grantham.

Needs: Produces 25 solo artists and 5 groups/year. Works with 4-5 freelance designers, 4-5 illustrators/year. Uses 3-4 freelancers/year for CD cover design; album/tape cover, advertising and brochure design and illustration; direct mail packages; and posters. 25% of freelance work demands knowledge of Aldus FreeHand.

First Contact & Terms: Send query letter with SASE. Samples are filed. Reports back within 1 month. To show portfolio, mail photographs. Requests work on spec before assigning a job. Pays by the project. Buys all rights. Sometimes interested in buying second rights (reprint rights) to previously published work.

Tips: Finds new artists through artists' submissions and self-promotions.

‡BUSINESS DEVELOPMENT CONSULTANTS, Box 16540, Plantation FL 33318. (305)741-7766. President: Phyllis Finney Loconto. Estab. 1980. Produces CDs, tapes and albums: rock, jazz, rap, R&B, soul, pop, classical, folk, educational, country/western, disco by groups and solo artists. Releases: "Come Follow Me," by Frank X. Loconto (inspirational); "Back in Bimini," by The Calypsonians; and "Out of the Darkness," by June and Jr. Battiest.

Needs: Produces 50 solo artists and 20 groups/year. Works with 10 local freelancers/year. Works on assignment only. Uses artists for CD/album/tape cover, brochure and advertising design and illustration; catalog design, illustration and layout; direct mail packages; and posters.

First Contact & Terms: Send query letter with samples. Samples are filed and returned by SASE if requested. Reports back only if interested. To show portfolio, mail thumbnails and other samples. Pays by the project. Rights purchased vary according to project.

Tips: "Freelance artists need to be able to communicate/negotiate."

‡C.L.R. INC., (formerly Calvert Street Records), 1400 Aliceanna St., Baltimore MD 21231. (410)522-1001. President of A&R: Stephen Janis. Estab. 1992. Produces CDs, cassstettes, albums: dance and rap. Recent releases: *D.J. Kool*; *Blood Sky*; *San Francisco House Culture*.

Needs: Produces 4-5 groups/year. Works with 2-5 freelancers/year on assignment only. Uses freelancers for CD cover design and illustration, album/tape cover and advertising design and posters.

How to Use Your **Artist's & Graphic Designer's Market** *offers suggestions for understanding and using the information in these listings. Read this and other articles in the front of this book for important business tips.*

First Contact & Terms: Send query letter with brochure, tearsheets, photostats, résumé, slides and transparencies. Samples are filed and are not returned. Call for appointment to show portfolio of roughs, original/final art, b&w tearsheets. Pays by the project, $750-3,000. Buys all rights.

‡C&S PRODUCTIONS, P.O Box 91492, Anchorage AK 99509-1492. (907)522-3228. Fax: (907)265-4822. Partner: Tim Crawford. Estab. 1992. Produces CDs and tapes: Native American flute. Recent releases: *Mystic Visions* and *Guardian Spirits*, by Time Crawford and Paul Stavenjord.
Needs: Produces 1 release/year. Works with 1 freelancer/year. Uses freelancers for tape/CD cover illustration.
First Contact & Terms: Send query letter with photostats, photocopies, photographs. Samples are not filed and are returned by SASE if requested by artist. Reports back to the artist only if interested. Pays for illustration by the project,$100-250. Rights purchsed vary according to project.
Tips: Finds artists typically through Southwest publications. "Keep making contacts and do not get discouraged."

CASH PRODUCTIONS, INC. (Recording Artist Development Corporation), 744 Joppa Farm Rd., Joppatowne MD 21085. Phone/Fax: (410)679-2262. President/CEO: Ernest W. Cash. Estab. 1987. Produces CDs and tapes: country/western by solo artists and groups. Releases: "Family Ties," by The Short Brothers.
Needs: Produces 8-10 solo artists and 8-10 groups/year. Works with 10-12 freelancers/year. Works only with artist reps. Works on assignment only. Uses artists for CD cover design and illustration; brochure design; catalog design and layout; direct mail packages; advertising design; posters. Needs computer-literate freelancers for design, illustration and presentation. 20% of freelance work demands computer skills.
First Contact & Terms: Send query letter with résumé. Samples are filed. Reports back to the artist only if interested. To show portfolio, mail final art. Pays for design by the project. "Price will be worked out with rep or artist." Buys all rights.

CASTLE RECORDS, P.O. Box 1130, Tallevast FL 34270-1130. Phone/fax: (813)351-3253. Vice President: Bob Francis. Estab. 1964. Produces CDs, tapes and albums: rock, R&B, jazz, soul, dance and pop. Recent releases: *Rat Pack Rules*, by Big Cheese; *Thunderfoot*, by David Isley.
Needs: Produces 3-4 solo artists and 6-10 groups/year. Works with 3-4 freelance designers, 3-4 freelance illustrators/year for CD and album/tape cover and catalog illustration; posters; artist and label logos.
First Contact & Terms: Send query letter with tearsheets, résumé, photographs and SASE. Samples are filed or are returned by SASE. Reports back within 2 weeks. To show a portfolio, mail b&w and color photographs. Sometimes requests work on spec before assigning a job. Pays by the hour, $7.50-15; by the project, $100-2,500. Interested in buying second rights (reprint rights) to previously published work. Rights purchased vary according to project.
Tips: Finds new artists through *Artist's & Graphic Designer's Market* and referrals.

CAT'S VOICE PRODUCTIONS, P.O. Box 1361, Sanford ME 04073-7361. (800)284-1730. Owner: Tom Reeves. Estab. 1982. Produces tapes, CDs and multimedia: rock, R&B, progressive, folk, country/western, New Age. Recent releases: *Man Left Behind*, by Danny Wood; *One Groove At A Time*, by Cleanshot; and *Loaded Soul*, by Loaded Soul.
Needs: Produces 4 solo artists and 18 groups/year. Works with 2-4 freelancers/year. Prefers freelancers with experience in album and rock media. Works on assignment only. Uses artists for CD/tape cover and brochure design and illustration; catalog design, illustration and layout; direct mail packages; advertising illustration; posters. Needs computer-literate freelancers for design, illustration, production and presentation. 100% of freelance work demands knowledge of Aldus PageMaker, QuarkXPress, Aldus FreeHand, Adobe Illustrator, Adobe Photoshop and Claris Works.
First Contact & Terms: Send query letter with résumé, photographs and SASE. Samples are filed and are returned by SASE if requested by artist. Reports back within 1 month. Write for apointment to show portfolio or mail appropriate materials including b&w and color final art and photographs. Pays for design by the hour, $15-75; by the project, $125-500; by the day, $200-400. Buys all rights.
Tips: Ability to produce camera-ready art and video or CD-ROM experience helpful.

***CELESTIAL SOUND PRODUCTIONS**, 23 Selby Rd. E. 113LT, London England. 081503-1687. Managing Director: Ron Warren Ganderton. Produces rock, classical, soul, country/western, jazz, pop, R&B by group and solo artists. Recent releases: "Dancing with My Shadow," by Sound Ceremony; and "Shame on You," by Carole Boyce.
Needs: Works with "many" freelancers/year. Uses freelancers for album cover, advertising and brochure design and illustration; and posters.
First Contact & Terms: Send query letter with brochure showing art style or send résumé, business card and photographs to be kept on file "for a reasonable time." Samples not filed are returned by SASE only if requested. Reports within 5 days. Call for appointment to show portfolio of roughs, color and b&w photographs. Original artwork returned after job's completion. Pays by the project. Considers available budget,

how work will be used and rights purchased when establishing payment. Buys all rights, reprint rights or negotiates rights purchased.
Tips: "We are searching for revolutionary developments and those who have ideas and inspirations to express in creative progress."

CHERRY STREET RECORDS, INC., P.O. Box 52681, Tulsa OK 74152. (918)742-8087. President: Rodney Young. Estab. 1991. Produces CDs and tapes: rock, R&B, country/western, soul, folk by solo and group artists. Releases: *Blue Dancer*, by Chris Blevins; and *Tulsa Style*, by Brad Absher.
Needs: Produces 2 solo artists/year. Works with 2 designers and 2 illustrators/year. Prefers freelancers with experience in CD and cassette design. Works on assignment only. Uses freelancers for CD/album/tape cover design and illustration; catalog design; and advertising illustration. Needs computer-literate freelancers for design, illustration, production and presentation. 50-75% of freelance work demands computer skills.
First Contact & Terms: Send query letter with SASE. Samples are filed or are returned by SASE. Reports back only if interested. Write for appointment to show portfolio of printed samples, b&w and color photographs. Pays by the project, $50-1,000. Buys all rights.
Tips: "Compact disc covers and cassettes are small—your art must get consumer attention."

***COMMA RECORDS & TAPES**, Box 2148, D-63243, Neu Isenburg, Germany. 06102-51065. Fax: 06102-52696. Contact: Marketing Department. Estab. 1972. Produces CDs, tapes and albums: rock, R&B, classical, country/western, soul, folk, dance, pop by group and solo artists.
Needs: Produces 70 solo artists and 40 groups/year. Uses 10 freelancers/year for CD/album/tape cover and brochure design and illustration; posters.
First Contact & Terms: Send query letter with brochure, tearsheets, photostats, photographs, SASE, photocopies and transparencies. Samples are not filed and are returned by SASE if requested by artist. Reports back to the artist only if interested and SASE enclosed. To show portfolio, mail copies of final art and b&w photostats, tearsheets, photographs and transparencies. Payment negotiated. Buys first rights and all rights.

COWBOY JUNCTION FLEA MARKET & PUBLISHING CO., Highway 44 and Junction 490, Lecanto FL 34461. (904)746-4754. Secretary: Elizabeth Thompson. Estab. 1957. Produces tapes, albums and CDs: country/western and bluegrass. Recent releases: "And I Hung up My Cowboy Hat" and "Pretty Girls on TV," by Buddy Max.
Needs: Produces 3 albums/year by soloists and groups. Uses 12 freelancers/year for album/tape cover illustration and design; and direct mail packages.
First Contact & Terms: Send query letter with SASE. Samples are not filed and are returned by SASE. Portfolio review not required. Requests work on spec before assigning a job.
Tips: "Display at Cowboy Junction Flea Market on Tuesday or Friday; come to our Country/Western—Bluegrass Music Show Saturday at 2 p.m. and show us and all involved your work." Closed July and August.

CREATIVE NETWORK INC., Box 2818, Newport Beach CA 92663. (714)494-0181. Fax: (714)494-0982. President: J. Nicoletti. Estab. 1976. Produces CDs, tapes and albums: rock, jazz, rap, group artists, rhythm and blues, soul, pop, folk, country/western, dance and solo artists. Recent releases include: *My Bible Tells Me So*, by Don Simmons (CD and video); and *Amelia's Themes*, by Amelia Homer.
Needs: Produces 3 soloists/year. Works with 10 freelancers/year. Uses freelancers for all design, illustration and layout work.
First Contact & Terms: Send query letter with tearsheets, photostats, résumé, SASE, photographs, slides, photocopies and transparencies—present "a clean package of your best work." Samples are filed. Reports back within 3 weeks. Call for appointment to show portfolio, or mail appropriate materials. Negotiates payment and rights purchased.
Tips: Finds new artists through artists' submissions/self-promotional material.

‡DISC-TINCT MUSIC, INC., 95 Cedar Land, Englewood NJ 07631. (201)568-0040. Fax: (201)568-8699. President: Jeffrey Collins Estab. 1985. Produces CDs tapes and posters: rock, jazz, pop, R&B, soul, rap. Recent releases: *Live in '62*, by The Beatles; and *Music for the '90s*, by G. Simone & KRSI.
Needs: Produces 20 releases/year. Works with 2-3 freelancers/year. Prefers local freelancers with experience in record album covers. Uses freelancers for CD design and illustration; tape cover illustration; catalog design and layout; posters; and advertising design. Needs computer-literate freelancers for design, illustration, production. 75% of freelance work demands knowledge of Aldus PageMaker, QuarkXPress, Aldus FreeHand.
First Contact & Terms: Send query letter with résumé, photocopes. Samples are filed or returned by SASE if requested by artist. Reports back within 3 weeks if interested. Portfolio may be dropped every Wednesday or Thursday. Artist should follow up with call. Portfolio should include b&w and color final art, photocopies. Pays for design by the project, $300-1,000. Rights purchased vary according to project.
Tips: "Listen carefully to what the record company's production manager is requesting."

‡❀DMT RECORDS, 11714-113th Ave., Edmonton, Alberta T5G 0J8 Canada. (403)454-6848. Fax: (403)454-9291. Producer: Gerry Dere. Estab. 1986. Produces CDs and tapes: rock, jazz, pop, R&B, soul,

country/western by solo artists and groups. Recent releases: *She Ain't Use to Tellin' Lies*, by Kidd Country; and *Seattle Rain*, by High Park.

Needs: Produces 4 releases/year. Works with 1-2 freelancers/year. Prefers freelancers with experience in computers. Uses freelancers for CD/tape cover design and illustration; and posters. Needs computer-literate freelancers. 100% of freelance work demands knowledge of Corel Draw 4.0

First Contact & Terms: Send postcard sample of work. Samples are filed. Reports back within 1 month. Art Director will contact artist for portfolio review if interested. Portfolio should include color photocopies, photographs. Payment negotiated. Negotiates rights purchased.

Tips: Finds artists through submissions.

DOC HOLIDAY PRODUCTIONS, 10 Luanita Lane, Newport News VA 23606. (804)930-1814. Fax (804)930-1814. President: Doc Holiday. Estab. 1971. Produces CDs and tapes: rock, R&B, soul, country/western, rap by solo artists and groups. Releases: "Cajun Baby," by Hank Williams Jr. and Doug Kershaw; "Don't Mess With My Toot Toot," by Fats Domino and Doug Kershaw.

Needs: Produces 30-40 solo artists and 15-20 groups/year. Work with 3-5 freelancers/year. Works on assignment only. Uses freelancers for CD/tape cover design and illustration; brochure and catalog design; and posters. 25% of freelance work demands computer skills.

First Contact & Terms: Send query letter with brochure, résumé, photocopies, photographs and tearsheets. Samples are filed. Reports back within 2 weeks only if interested. To show portfolio, mail b&w and color final art, tearsheets and photographs. Pays for design by the project. Buys first rights, one-time rights or all rights.

DRAGON STREET RECORDS, INC., P.O. Box 670714, Dallas TX 75367-0714. (214)750-4584. Fax: (214)369-5972. President/Art Director: David Dennard. Estab. 1989. Produces CDs and tapes: rock and roll, pop and alternative/commercial. Releases: *Six*, by The Nixons; *Bill*, by Tripping Daisy; and *Buick Men*, by Hagfish.

Needs: Produces 6 groups/year. Works with 3-6 designers and 2-4 illustrators/year. Prefers artists with experience in cutting-edge graphic layouts and visuals. Also prefers PC or Mac-based artists with color scanning and 4-color output experience. Works on assignment only. Uses artists for CD cover design and illustration, album/tape cover design; catalog and advertising design; posters; and merchandising materials design (T-shirts, stickers, etc.). Needs comptuer-literate freelancers for design, illustration and production. 85% of freelance work demands computer skills in QuarkXPress, Photoshop or Streamliner.

First Contact & Terms: Send query letter with résumé and any appropriate materials. Samples are filed or are returned by SASE if requested by artist. Reports back only if interested. Call for appointment to show portfolio which should include original/final art, photostats, photographs and slides. Pays by the project, $350-1,000. "Most projects are by bid." Rights purchased vary according to project.

Tips: "As the image area decreases on new formats, high-impact, attention-getting graphics are essential in the retail arena of record stores."

‡THE ETERNAL SONG AGENCY, 6326 E. Livingston Ave., #153, Reynoldsburg OH 43068. (614)834-1272. Art Director: Sharon Crawford. Estab. 1986. Produces CDs, tapes and videos: rock, jazz, pop, R&B, soul, progressive, classical, gospel, country/western. Recent releases: *Escape*, by Robin Curenton; and *You Make Me New*, by Greg Whigtscel.

Needs: Produces 6 releases/year. Works with 5-7 freelancers/year. Prefers freelancers with experience in illustration and layout. "Designers need to be computer-literate and aware of latest illustration technology." Uses freelancers for CD/tape cover, and advertising design and illustration, direct mail packages, posters, catalog design and layout. Needs computer-literate freelancers for design, illustration, production. 65% of freelance work demands knowledge of Aldus PageMaker, Adobe Illustrator, Adobe Photoshop, Aldus Free-Hand. "Other programs may be acceptable."

First Contact & Terms: Send postcard sample of work or send query letter with brochure, photocopies, résumé photographs. Samples are filed. Reports back within 4-5 weeks. Art Director will contact artist for portfolio review if interested. Portfolio should include b&w and color final art and photocopies. Pays for design by the project, $300-5,000. Pays for illustration by the hour, $15-35; by the project, $300-5,000.

Tips: Finds artists through word of mouth, seeing previously released albums and illustration, art colleges and universities. "Be persistent. Know your trade. Become familiar with technical advances as related to your chosen profession."

ETHEREAN MUSIC/ELATION ARTISTS, 9200 W. Cross Dr., #510, Littleton CO 80123-2225. (303)973-8291. Fax: (303)973-8499. E-mail: etherean@aol.com. Contact: Chad Darnell. Estab. 1988. Produces 4-10 CDs and tapes/year: jazz and New Age/Native American. Recent releases: *Night Fire*, by Bryan Savage; *Twelve Twelve*, by Kenny Passarelli.

Needs: Produces 2-6 soloists and 2-6 groups/year. Works with 1 designer and 1 illustrator/year for CD and tape cover design and illustration. Needs computer-literate freelancers for illustration. 80% of freelance work demands knowledge of Director 4.0, QuarkXPress, Adobe Illustrator and Photoshop.

First Contact & Terms: Send query letter with brochure, résumé, photostats and photocopies. "No original artwork." Samples are filed or are returned by SASE if requested. Reports back only if interested. Write for appointment to show portfolio. Sometimes requests work on spec before assigning a job. Pays for design by the project, $200-1,000. Pays for illustration by the hour, $100-500. Rights purchased vary according to project.

Tips: "Design jobs may be sent in QuarkXPress format or as screen captured pict/tiff."

FARR MUSIC AND RECORDS, Box 1098, Somerville NJ 08876. (201)722-2304. Contact: Candace Campbell. Produces CDs, tapes and albums: rock, dance, soul, country/western, folk and pop by group and solo artists.

Needs: Produces 12 records/year by 8 groups and 4 solo artists. Works with 12 freelance designers and 20 illustrators/year. Uses freelancers for album cover and advertising design and illustration; brochure and catalog design; and posters.

First Contact & Terms: Send query letter with résumé, tearsheets, photostats, photocopies, slides and photographs to be kept on file. Samples not filed are returned by SASE. Reports back within 3 weeks. To show portfolio, mail roughs, final reproduction/product and color photographs. Original art returned to the artist at job's completion. Pays for design by the hour, $30-150; pays for illustration by the hour, $130-150. Buys first rights or all rights.

FINER ARTS RECORDS/TRANSWORLD RECORDS, 2170 S. Parker Rd., Suite 115, Denver CO 80231. (303)755-2546. Fax: (303)755-2617. President: R. Bernstein. Produces CDs and tapes: rock, dance, soul, country/western, jazz, pop and R&B by group and solo artists. Releases: *Miracles and Dreams*, original cast recording; and *Israel, Oh Israel*, by the Leningrad Philharmonic Orchestra.

Needs: Produces 3 CDs, tapes/year. Works with 1-2 designers and 1-2 illustrators/year. Uses freelancers for album cover design and illustration and posters. Needs computer-literate freelancers for production. 50% of freelance work demands knowledge of Aldus PageMaker.

First Contact & Terms: Send query letter with brochure showing art style or résumé and tearsheets, photostats and photocopies. Samples are filed or returned only if requested. Reports back only if interested. Write for appointment to show portfolio. Negotiates pay by the project, $500 minimum. Considers complexity of project, available budget and turnaround time when establishing payment. Negotiates rights purchased.

‡FRESHWATER RECORDS, P.O. Box 27713, Los Angeles CA 90027-0713. (213)660-5444. Fax: (213)660-2743. E-mail: tspw91a@prodigy.com. Estab. 1989. Produces CDs, tapes and promotional materials: jazz, progressive, classical, country/western, New Age by solo artists and groups. Recent releases: *The Waterways Album*, by Lightstream; and *Out of the Blue*, by David Wheatley.

Needs: Produces 7 releases/year. Works with 10 freelancers/year. Uses freelancers for CD/tape cover, brochure and advertising design and illustration; direct mail packages; posters; catalog design, illustration and layout. Needs computer-literate freelancers for design, illustration, production. 80% of freelance work demands computer skills.

First Contact & Terms: Send query letter or call first. Samples are filed. Reports back to the artist only if interested. Artist should follow up with call. Portfolio should include b&w photocopies, roughs, photographs and transparencies. Pays for design and illustration by the project. Rights purchased vary according to project.

Tips: Finds artists through referrals, directories. Impressed by "enthusiasm, talent, artistic judgment, reliability, persistence and faith in your work."

GOLDBAND RECORDS, P.O. Box 1485, Lake Charles LA 70602. (318)439-8839 or (318)439-4295. Fax: (318)491-0994. President: Eddie Shuler. Estab. 1944. Produces CDs and tapes: rock & roll, jazz, R&B, progressive, folk, gospel, country/western, cajun, zydeco. Releases: *Cajun Troubadour*, by Jo'el Sonnier; *Making Love In Chicken Koop*, by Willis Prudhomme; *Spicy Cajun*, by Mel Pellerin; and *Hackberry Ramblers* featuring Linda Dodd LaPointe (Cajun French).

Needs: Produces 3 groups/year. Uses artists for CD cover design and direct mail packages. Needs computer-literate freelancers for design.

First Contact & Terms: Send query letter with brochure and résumé. Samples are filed and are returned by SASE if requested by artist. Reports back to the artists only if interested. Call to show portfolio of roughs and photographs. Pays for design by the project. Negotiates rights purchased.

‡GREEN LINNET RECORDS, INC., 43 Beaver Brook Rd., Danbury CT 06810. (203)730-0333. Production Manager: Kevin Yatarola. Estab. 1975. Produces CDs and tapes: folk, world music (Irish, African, Cuban).

Always enclose a self-addressed, stamped envelope (SASE) with queries and sample packages.

Needs: Produces 40 releases/year. Works with 5 freelancers/year. Prefers local freelancers with experience in CD packaging. Uses freelancers for CD cover design and illustration; catalog design; direct mail packages, posters. Needs computer-literate freelancers for production.

First Contact & Terms: Samples are not filed. Does not report back. Artist should send only disposable reproductions (no originals). Art Director will contact artist for portfolio review if interested. Rights purchased vary according to project.

‡HAMMERHEAD RECORDS, 41 E. University Ave., Champaign IL 61820. (217)355-9052. Fax: (217)355-9057. E-mail: hammerhd@prairienet.org. President: Todd Thorstenson. Estab. 1993. Produces CDs and tapes: rock, by groups. Recent releases: *Plankton Comes Alive*, by The Mess; and *Hack*, by Third Stone.

Needs: Produces 4 releases/year. Works with 3-4 freelancers/year. Uses freelancers for CD/tape cover design and illustration; posters. Needs computer-literate freelancers for design, production. 80% of freelance work demands knowledge of Aldus PageMaker 5.0, Adobe Illustrator (version 4 for Windows).

First Contact & Terms: Send query letter with résumé, photographs, tearsheets. Samples are filed or returned by SASE if requested by artist. Reports back to the artist only if interested. Artist should follow-up with call and/or letter after initial query. Portfolio should include b&w and color roughs, photostats. Pays for design and illustration by the project. Rights purchased vary according to project.

HARD HAT RECORDS AND CASSETTE TAPES, 519 N. Halifax Ave., Daytona Beach FL 32118-4017. (904)252-0381. Fax: (904)252-0381. CEO: Bobby Lee Cude. Produces rock, country/western, folk and educational by group and solo artists. Publishes high school/college marching band arrangements. Recent releases include: "Coming Out" and "Medicine Man," by Frederick-the-Great.

• Also owns Blaster Boxx Hits.

Needs: Produces 6-12 records/year. Works with 2 designers and 1 illustrator/year. Works on assignment only. Uses freelancers for album cover design and illustration; advertising design; and sheet music covers. Prefers "modern, up-to-date, on the cutting edge" promotional material and cover designs that fit the music style. Needs computer-literate freelancers for design. 60% of freelance work demands knowledge of Photoshop.

First Contact & Terms: Send query letter with brochure to be kept on file one year. Samples not filed are returned by SASE. Reports within 2 weeks. Write for appointment to show portfolio. Sometimes requests work on spec before assigning a job. Pays by the project. Buys all rights.

♣HICKORY LANE RECORDS, Box 2275, Vancouver, British Columbia V6B 3W5 Canada. (604)465-1408. President: Chris Michaels. Estab. 1985. Produces CDs and tapes: rock, pop, folk, gospel, country/western. Recent releases: "So In Love," by Chris Michaels; and "Tear & Tease," by Steve Mitchell/Chris Michaels.

Needs: Produces 5 solo artists and 2 groups/year. Works with 13 freelancers/year. Works on assignment only. Uses freelancers for CD/tape cover, brochure and advertising design and illustration; and posters. Needs computer-literate freelancers for design. 25% of freelance work demands knowledge of Aldus PageMaker, Adobe Illustrator, QuarkXPress, Adobe Photoshop, Aldus FreeHand.

First Contact & Terms: Send query letter with brochure, résumé, photostats, transparencies, photocopies, photographs, SASE and tearsheets. Samples are filed and are returned by SASE if requested by artist. Reports back within 6 weeks. Call or write for appointment to show portfolio of b&w and color roughs, final art, tearsheets, photostats, photographs, transparencies and computer disks. Pays for design by the project, $250-650. Negotiates rights purchased.

Tips: "Keep ideas simple and original. If there is potential in the submission we will contact you. Be patient and accept criticism."

HOLLYROCK RECORDS, 40303 Walcott Lane, Temecula CA 92591. (909)699-3338. Fax: (909)699-0533. A&R: Dave Paton. Estab. 1985. Produces CDs and tapes: rock, pop, country/western by solo artists and groups. Recent releases: *Gett Outta Town*, by Linda Rae and Breakheart Pass; and *Headline News*, by Brett Duncan.

Needs: Produces 4 solo artists and 3-5 groups/year. Works with 3-5 freelancers/year. Works only with artist reps. Prefers local artists with experience in music covers. Uses artists for CD cover design and illustration; tape cover design and illustration; and direct mail packages. Needs computer-literate freelancers for design, illustration, production and presentation. 50% of freelance work demands knowledge of Aldus PageMaker and Adobe Photoshop.

First Contact & Terms: Send query letter with brochure, résumé, photostats, photographs. Samples are filed and are returned by SASE. Reports back in 1 month. Write for appointment to show portfolio of b&w and color thumbnails and photographs. Pays for design by the project. Buys all rights.

HOTTRAX RECORDS, 1957 Kilburn Dr., Atlanta GA 30324. (404)662-6661. Publicity and Promotion: Teri Blackman. Estab. 1975. Produces CDs and tapes: rock, R&B, country/western, jazz, pop and blues/novelties by solo and group artists. Recent releases: *Poor Man Shuffle*, by The Bob Page Project; and *Hurricane Blues*, by Roger Hurricane Wilson.

Needs: Produces 2 solo artists and 4 groups/year. Works with 2-4 freelancers/year. Prefers freelancers with experience in multimedia—mixing art with photographs—and caricatures. Uses freelancers for CD/tape cover, catalog and advertising design and illustration; and posters. Needs computer-literate freelancers for design and illustration. 25% of freelance work demands knowledge of Aldus PageMaker, Adobe Illustrator and Photoshop.

First Contact & Terms: Send query letter with samples (color photocopies OK). Some samples are filed. If not filed samples are not returned. Reports back only if interested. Pays by the project, $100-1,000. Buys all rights.

‡ICHIBAN RECORDS, INC., P.O. Box 724677, Atlanta GA 31139-1677. (404)419-1414. Fax: (404)419-1230. Art Director: Frank Dreyer. Estab. 1985. Produces CDs, tapes, LPs, singles: rock, jazz, pop, R&B, soul, progressive, folk, rap, by solo artists and groups. Recent releases: *Funkafied*, by MC Breed; and *A Different Story*, by Deadeye Dick.

Needs: Produces 75 releases/year. Works with 5-10 freelancers/year. Uses freelancers for CD/tape cover design and illustration; catalog design; direct mail packages; and posters. Needs computer-literate freelancers for design, illustration, production. 30% of freelance work demands knowledge of Aldus PageMaker 5.0, Adobe Illustrator 5.0, QuarkXPress 3.3, Adobe Photoshop 3.0, Aldus FreeHand 4.0.

First Contact & Terms: Send query letter with photocopies. Samples are filed. Art Director will contact artist for portfolio review if interested. Portfolio should include b&w and color photocopies, photographs, tearsheets. Pays for design by the project, $150 minimum. Pays for illustration by the project, $50 minimum. Buys all rights.

Tips: Finds artists through self-promotion mailings, word of mouth.

‡IMAGINARY ENTERTAINMENT CORP., 5324 Buena Vista Pike, Nashville TN 37218-1214. (615)299-9237. Proprietor: Lloyd Townsend. Estab. 1982. Produces CDs, tapes and albums: rock, jazz, classical, folk and spoken word. Releases include: *Bone Dali*, by Bone Dali and *One of a Kind*, by Stevens, Siegel and Ferguson.

Needs: Produces 1-2 solo artists and 1-2 groups/year. Works with 1-2 freelancers/year. Works on assignment only. Uses artists for CD/album/tape cover design and illustration and catalog design.

First Contact & Terms: Send query letter with brochure, tearsheets, photographs and SASE. Samples are filed or returned by SASE if requested by artist. Reports back within 2-3 months. To show portfolio, mail thumbnails, roughs and photographs. Pays by the project, $25-500. Negotiates rights purchased.

Tips: "I always need one or two dependable artists who can deliver appropriate artwork within a reasonable time frame."

J & J MUSICAL ENTERTAINMENT, 156 Fifth Ave., Suite 434, New York NY 10010. (212)691-5630. Fax: (212)645-5038. President: Jeneane Claps. Estab. 1979. Produces CDs, tapes and albums: jazz and rap. Releases: *Textile*, by Freeway Fusion; and *Summer Set*, by Jeneane.

Needs: Produces 4 solo artists and 2 groups/year. Prefers local freelancers only. Works on assignment only. Uses freelancers for CD/album/tape cover design and illustration; brochure design; catalog design, illustration and layout; direct mail packages; advertising illustration; and posters.

First Contact & Terms: Send query letter with brochure, résumé and SASE. Samples are not filed and are returned by SASE if requested by artist. Reports back within 6 weeks. Write for appointment to show portfolio or mail thumbnails, b&w and color photostats, tearsheets and photographs. Pays by the project. Buys first rights or all rights.

JAY JAY, NE 35 62nd St., Miami FL 33138. (305)758-0000. President: Walter Jagiello. Produces CDs and tapes: country/western, jazz and polkas. Recent releases: *National Hits* and *Fantastic*, by Li'l Wally.

Needs: Produces 7 CDs, tapes and albums/year. Works with 3 freelance designers and 2 illustrators/year. Works on assignment only. Uses freelancers for album cover design and illustration; brochure design; catalog layout; advertising design, illustration and layout; and posters. Sometimes uses freelancers for newspaper ads. Knowledge of midi-music lead sheets helpful for freelancers.

First Contact & Terms: Send brochure and tearsheets to be kept on file. Call or write for appointment to show portfolio. Samples not filed are returned by SASE. Reports within 2 months. Requests work on spec before assigning a job. Pays for design by the project, $20-50. Considers skill and experience of artist when establishing payment. Buys all rights.

JAZZAND, 12 Micieli Place, Brooklyn NY 11218. (718)972-1220. Proprietor: Rick Stone. Estab. 1984. Produces CDs and tapes: jazz. Releases: *Far East*, by Rick Stone Quartet; and *Blues for Nobody*, by Rick Stone.

Needs: Produces 1 solo artist and 1 group/year. Works with 2 designers/year. Prefers local freelancers with experience in cover and poster design. Works on assignment only. Uses freelancers for CD/album/tape cover design and illustration; brochure and catalog design and layout; direct mail packages; advertising design; and posters. Needs computer-literate freelancers for design and production. 100% of freelance work demands knowledge of QuarkXPress, Adobe Illustrator and Photoshop.

First Contact & Terms: Send query letter with résumé, tearsheets and photocopies. Samples are filed. Reports back within 1 month. Call for appointment to show portfolio or mail appropriate materials, including tearsheets and photographs. Pays by the project, $150-750.
Tips: "Get to know people at labels, producers, etc. Establish *personal* contacts; even if someone can't use your services right now, six months from now he may be in need of someone. People in the music business tend to move around frequently to other record companies, agencies, etc. If you've developed a good rapport with someone and he leaves, find out where he's gone; the next company he works for might hire you."

LITTLE RICHIE JOHNSON AGENCY, Box 3, Belen NM 87002. (505)864-7442. Fax: (505)864-7442. General Manager: Tony Palmer. Produces tapes and albums: country/western. Releases: *At His Best*, by Albert Young Eagle; and *She's Back*, by Myrna Lorrie.
Needs: Produces 5 soloists and 2 groups/year. Works with "a few" freelance designers and illustrators/year on assignment only. Prefers local artists. Uses freelancers for album/tape cover design and advertising design.
First Contact & Terms: Send query letter with brochure showing art style or photographs. Samples are filed or are returned by SASE only if requested. Reports back only if interested. To show portfolio, mail photographs. Pays for design and illustration by the project. Considers complexity of project and available budget when establishing payment. Rights purchased vary according to project.

‡❦K.S.M. RECORDS, 2305 Vista Court, Coquitlam, British Columbia V3J 6W2 Canada. (604)671-0444. Fax: (604)469-9359. Art Director: David London. Estab. 1991. Produces CDs: alternative. Recent releases: *Gala*, by DAED21; and *Rain Creature*, by Colour Clique, Red Sector 1, X-Drone etc.
Needs: Produces 2-5 releases/year. Works with 2-5 freelancers/year. Prefers artists with experience in surrealism. Uses freelancers for CD covers and advertising design and illustration; and posters.
First Contact & Terms: Send query letter with résumé, photographs. Samples are filed or returned. Reports back within 1 month only if interested. Art Director will contact artist for portfolio if interested. Portfolio should include b&w and color samples. Pays for illustration by the project, negotiable. Buys one-time rights.
Tips: Finds artists through artists' submissions. Impressed by Salvadore Dali influence in an artist's work.

‡KEPT IN THE DARK RECORDS, 332 Bleeker St., K-138, New York NY 10014 or 7151 E. Speedway Blvd., #105, Tucson AZ 85710. (602)298-8627. Fax: (602)290-5795. E-mail: sakin@rtd.com. President: Larry A. Sakin. Estab. 1988. Produces CDs, tapes and 7-inch singles: rock, jazz, pop, R&B, folk, country/western. Recent releases: *Earl's Family Bombers*, by Earl's Family Bombers; *You're Not the Boss of Me*, by The Eyepennies; and *Grimble Wedge*, by Grimble Wedge.
Needs: Produces 4-6 releases/year. Works with 5 freelancers/year. Uses freelancers for CD cover, catalog and advertising design and illustration; tape cover illustration. Needs computer-literate freelancers for design, illustration, production, presentation. 40-60% of freelance work demands knowledge of Adobe Illustrator, QuarkXPress, Adobe Photoshop.
First Contact & Terms: Send query letter with photocopies, SASE, tearsheets. Samples are filed or returned by SASE if requested by artist. Reports back within 2 weeks. Portfolio review not required. Pays for design and illustration by the project. Rights purchased vary according to project.
Tips: "Many artists send their work to me, without copyright which is a dangerous habit. I do not consider material without copyright. If interested, I help with copyright procedure. Original designs are very important; I like very creative and off-the-beaten-path work. Patience is very impressive."

KIMBO EDUCATIONAL, 10 N. Third Ave., Long Branch NJ 07740. Production Manager: Amy Laufer. Educational record/cassette company. Produces 8 records, cassettes and compact discs/year for schools, teacher supply stores and parents. Primarily early childhood physical fitness, although other materials are produced for all ages.
Needs: Works with 3 freelancers/year. Prefers local artists on assignment only. Uses artists for CD/cassette/album covers; catalog and flier design; and ads. Helpful if artist has experience in the preparation of album jackets or cassette inserts.
First Contact & Terms: "It is very hard to do this type of material via mail." Write or call for appointment to show portfolio. Prefers photographs or actual samples of past work. Reports only if interested. Pays for design and illustration by the project, $200-500. Considers complexity of project and budget when establishing payment. Buys all rights.
Tips: "The jobs at Kimbo vary tremendously. We produce material for various levels—infant to senior citizen. Sometimes we need cute 'kid-like' illustrations and sometimes graphic design will suffice. A person

 The maple leaf before a listing indicates that the market is Canadian.

experienced in preparing an album cover would certainly have an edge. We are an educational firm so we cannot pay commercial record/cassette/CD art prices."

‡K-TEL INTERNATIONAL, 15535 Medina Rd., Plymouth MN 55447. (612)559-6800. Director of Creative Services: Max Mashek. Creative Manager: Karen Hacking. Estab. 1969. Produces CDs and tapes: rock, jazz, rap, R&B, soul, pop, classical, country/western and dance. Also produces books on cassette and CD-ROM. Releases: *Sheet Reggae II* and *Cajun Party*, by various artists.
Needs: "Frequently uses freelancers for illustration and design. Works on assignment only. Uses freelancers for CD/cassette/tape package design and illustration for books and CD-ROM. Needs illustration in all media. Needs computer-literate freelancers for design. Freelance designers should be familiar with Adobe Illustrator and Photoshop.
First Contact & Terms: Send query letter with résumé and tearsheets. Samples are filed. Reports back only if interested. Pays by project, $500-1,500.

‡K2B2 RECORDS, 1748 Roosevelt Ave., Los Angeles CA 90006. (213)732-1602. Fax: (213)731-2758. President: Marv Moses. Estab. 1979. Produces CDs: jazz, classical by solo artists. Recent releases: *Big Drum*, by Buell Neidlinger; and *Ivo*, by Ivo Perelman.
Needs: Produces 1 release/year. Works with 2 freelancers/year. Uses freelancers for CD cover and catalog design and illustration; brochure and advertising design. Needs computer-literate freelancers for design, illustration. 100% of freelance work demands knowledge of Aldus PageMaker, Adobe Illustrator, Adobe Photoshop, Aldus FreeHand, Painter.
First Contact & Terms: Send query letter with brochure, résumé. Samples are filed and not returned. Does not report back. Artist should follow-up with letter after initial query. Art Director will contact artist for portfolio review if interested. Portfolio should include color samples. Pays for design and illustration by the project, $400-2,500. Buys all rights.

‡♥L.A. RECORDS, 2864 Steeple Chase, St. Lazure, Quebec J0P 1V0 Canada. (613)762-0749. Fax: (514)458-2819. Manager: Tina Sexton. Estab. 1991. Produces CD and tapes: rock, pop, R&B, soul, progressive, folk, country/western, dance; solo artists and groups. Recent releases: *Lion de Juda*, by A.D.P.; and *Distant is My Weather*, by Imaginary Heaven.
Needs: Produces 8-12 releases/year. Works with 2-5 freelancers/year. Prefers local freelancers only. Uses freelancers for CD/tape cover, brochure and advertising design and illustration. Needs computer-literate freelancers for design and illustration. 80% of freelance work demands computer skills.
First Contact & Terms: Send postcard sample of work or query letter with brochure, résumé, photostats, photocopies, photographs and SASE. Samples are filed or returned by SASE if requested by artist. Art Director will contact artist for portfolio review if interested. Portfolio should include color photocopies and photographs. Pays for design and illustration by the project. Rights purchased vary according to project.
Tips: Finds artists through word of mouth.

‡LaFACE RECORDS, 3350 Peachtree Rd., Suite 1500, Atlanta GA 30326. (404)848-8050. Fax: (404)848-8051. Senior National Director of Marketing & Artist Development: Davett Singletary. Estab. 1989. Produces CD and tapes: pop, R&B, rap. Recent releases: Toni Braxton and TLC.
Needs: Produces 10 releases/year. Works with 10-15 freelancers/year. Uses freelancers for CD cover design; advertising design and illustration; and posters. Needs computer-literate freelancers for design.
First Contact & Terms: Send postcard sample of work or query letter with résumé and tearsheets. Samples are filed or returned. Reports back within 3 weeks. Portfolios may be dropped off anytime. Art Director will contact artist for portfolio review if interested. Portfolio should include b&w and color samples. Rights purchased vary according to project.
Tips: Finds artists through *Black Book*, magazines, *The Alternative Pick*, etc.

LAMBSBREAD INTERNATIONAL RECORD COMPANY/LBI, Box 328, Jericho VT 05465. (802)899-3787. Creative Director: Robert Dean. Estab. 1983. Produces CDs, tapes and albums: R&B, reggae. Recent releases: *Reggae Mood*, by Lambsbread; and *African Princess*, by Mikey Drrad.
Needs: Produces 2 soloists and 2 groups/year. Works with 3 designers and 2 illustrators/year. Works on assignment only. Uses freelancers for CD cover, catalog and advertising design; album/tape cover design and illustration; direct mail packages; and posters. Needs competent freelancers for design, illustration, production and presentation. 70% of freelance work demands computer skills.
First Contact & Terms: Send query letter with brochure, tearsheets, résumé, photographs, SASE and photocopies. Samples are filed. Reports back only if interested. To show a portfolio, mail thumbnails, roughs, photostats and tearsheets. Sometimes requests work on spec before assigning a job. Payment negotiated by the project. Buys all rights or negotiates rights purchased according to project.
Tips: "Become more familiar with the way music companies deal with artists. Also check for the small labels which may be active in your area. The technology is unreal regarding computer images and graphics. So don't over price yourself right out of work."

‡LAMON RECORDS INC., P.O. Box 25371, Charlotte NC 28229. (704)882-8845. Fax: (704)545-1940. Chairman of Board: Dwight L. Moody Jr. Produces CDs and tapes: rock, country/western, folk, R&B and religious music; groups. Releases: *Going Home*, by Moody Brothers; and *The Woman Can Love*, by Billy Marshall.
Needs: Works on assignment only. Works with 3 designers and 4 illustrators/year. Uses freelancers for album cover design and illustration, brochure and advertising design, and direct mail packages. 50% of freelance work demands knowledge of Photoshop.
First Contact & Terms: Send brochure and tearsheets. Samples are filed and are not returned. Reports back only if interested. Call for appointment to show portfolio or mail appropriate materials. Considers skill and experience of artist and how work will be used when establishing payment. Buys all rights.
Tips: "Include work that has been used on album, CD or cassette covers."

LBJ PRODUCTIONS, 8608 W. College St., French Lick IN 47432. (812)936-7318. Executive Producer: Larry B. Jones. Estab. 1989. Produces tapes, CDs, records, posters: rock, gospel, country/western by solo artists and groups. Recent releases: *Comin' Back Country*, by Bobby Easterday; and *Sounds of A Hillbilly Song*.
Needs: Produces 5-6 solo artists and 2-3 groups/year. Works with 1-2 freelancers/year. Prefers local artists with experience in music industry. Works on assignment only. Uses freelancers for CD/tape cover and advertising design and illustration; brochure design; and posters. Needs computer-literate freelancers for design and production. 50% of freelance work demands knowledge of Aldus PageMaker, Adobe Illustrator, Adobe Photoshop and Autocad.
First Contact & Terms: Send query letter with résumé, photocopies, SASE and tearsheets. Samples are filed and are returned by SASE if requested by artist. Reports back within 6 weeks. Call for appointment to show portfolio of b&w thumbnails, final art and tearsheets. Pays for design by the project, $75-500. Rights purchased vary according to project.

‡✤LCDM ENTERTAINMENT, Box 79564, 1995 Weston Rd., Weston, Ontario M9N 3W9 Canada. (416)242-7391. Fax: (416)743-6682. Publisher: Lee. Estab. 1991. Produces CDs, tapes, publications (quarterly): pop, folk, country/western and original. Recent releases: "Glitters & Tumbles," by Liana; and *Indie Tips & the Arts* (publication).
Needs: Prefers local artists but open to others. Uses freelancers for CD cover design, brochure illustration, posters. Needs computer-literate freelancers for production and presentation.
First Contact & Terms: Send query letter with brochure, résumé, photocopies, photographs, SASE, tearsheets, terms of renumeration (i.e. pay/non-pay/alternative). Samples are filed. Art Director will contact artist for portfolio review if interested. Pays for design and illustration by the project. Rights purchased vary according to project.

PATTY LEE RECORDS, 6034 Graciosa Dr., Hollywood CA 90068. (213)469-5431. Contact: Susan Neidhart. Estab. 1986. Produces CDs and tapes: New Orleans rock, jazz, folk, country/western, cowboy poetry and eclectic by solo artists. Recent releases: *Return to Be Bop*, by Jim Sharpe; *Alligator Ball*, by Armand St. Martin; and *Horseshoe Basin Ranch*, by Timm Daughtry.
Needs: Produces 4-5 soloists/year. Works with 1 designer and 2 illustrators/year. Works on assignment only. Uses freelancers for CD/tape cover, sign and brochure design; and posters.
First Contact & Terms: Send query letter. Samples are filed or are returned by SASE. Reports back only if interested. Write for appointment to show portfolio. "Do not send anything other than an introductory letter." Payment varies. Rights purchased vary according to project.
Tips: Finds new artists through word of mouth, magazines, artists' submissions/self-promotional material, sourcebooks, artists' agents and reps and design studios. "Our label is small but growing. The economy has not affected our need for artists. Sending a postcard representing your 'style' is very smart. It's inexpensive and we can keep the card on file."

***LEMATT MUSIC LTD., Pogo Records Ltd., Swoop Records, Grenouille Records, Zarg Records, Lee Sound Productions, R.T.F.M., Lee Music Ltd., Check Records, Value For Money Productions**, % Stewart House, Hill Bottom Rd., Sands, IND, EST, Highwycombe, Buckinghamshire, England. (01630) 647374. Fax: (01630)647612. Manager, Director: Ron Lee. Produces CDs, tapes and albums: rock, dance, country/western, pop, and R&B by group and solo artists. Recent releases: "I Hate School," by Suburban Studs and "Fly Angel Fly," by Nightmare.
Needs: Produces 25 CDs, tapes/year. Works with 3-4 freelance designers and 3-4 illustrators/year. Works on assignment only. Uses a few cartoons and humorous and cartoon-style illustrations where applicable. Uses freelancers for album cover design and illustration; advertising design, illustration and layout; and posters. Needs computer-literate freelancers for design, illustration and presentation. 30% of freelance work demands computer skills.
First Contact & Terms: Send query letter with brochure, résumé, business card, slides, photographs and videos to be kept on file. Samples not filed are returned by SASE (nonresidents send IRCs). Reports within

3 weeks. To show portfolio mail final reproduction/product and photographs. Original artwork sometimes returned to artist. Payment negotiated.

Tips: Finds new artists through artists' submissions and design studios.

‡LIVING MUSIC RECORDS, P.O. Box 72, Litchfield CT 06759. (203)567-8796. Fax: (203)567-4276. Director of Communications: Chantal Harris. Estab. 1980. Produces CDs and tapes: classical, jazz, folk, progressive, New Age. Recent releases: *Prayer for the Wild Things*, by Paul Winter and The Earth Band; and *Spanish Angel*, by Paul Winter Consort.

Needs: Produces 1-3 releases/year. Works with 1-5 freelancers/year. Uses freelancers for CD/tape cover and brochure design and illustration; direct mail packages; advertising design; catalog design, illustration and layout; and posters. Needs computer literate freelancers for design, illustration, production and presentation. 70% of freelance work demands knowledge of Aldus PageMaker, Adobe Illustrator, QuarkXPress, Adobe Photoshop, Aldus FreeHand.

First Contact & Terms: Send postcard sample of work or query letter with brochure, transparencies, photographs, slides, SASE, tearsheets. Samples are filed or returned by SASE if requested by artist. Reports back to the artist only if interested. Art Director will contact artist for portfolio review of b&w and color roughs, photographs, slides, transparencies and tearsheets. Pays for design by the project. Rights purchased vary according to project.

Tips: "We look for distinct earthy style; sometimes look for likenesses."

LSR RECORDS, 81 N. Forest, Rockville Centre NY 11570. (516)764-6315. Fax: (516)764-6200. Production Manager: Alan Mann. Estab. 1980. Produces CDs, 7-inch and LPs: alternative rock. Recent releases: *Bonsai Superstar*, by Brainiac; and *Cryptology*, by David S. Ware.

Needs: Produces 50-100 CDs, tapes/year. Prefers local freelancers with experience in Mac System 7, Quark, Illustrator, Photoshop and Typestyler. Uses freelancers for catalog and advertising design; computer "paste-up" and separations from 4-color process. Needs computer-literate freelancers for design and production. 100% of freelance work demands computer skills.

First Contact & Terms: Send query letter with résumé. Samples are filed or returned by SASE if requested. Reports back only if interested. Pays by the hour, $10-18; or by the project, $50-200. Buys all rights.

Tips: "Sell yourself to *bands* on independent labels to gain experience."

LUCIFER RECORDS, INC., Box 263, Brigantine NJ 08203. (609)266-2623. President: Ron Luciano. Produces pop, dance and rock.

Needs: Produces 2-12 records/year. Prefers experienced freelancers. Works on assignment only. Uses freelancers for album cover and catalog design; brochure and advertising design, illustration and layout; direct mail packages; and posters.

First Contact & Terms: Send query letter with résumé, business card, tearsheets, photostats or photocopies. Reports only if interested. Original art sometimes returned to artist. Write for appointment to show portfolio, or mail tearsheets and photostats. Pays by the project. Negotiates pay and rights purchased.

"People find this art vivid, intriguing and catchy," says Patty Lee, president of Patty Lee Records of Armand St. Martin's **Alligator Ball** CD cover. The work was a collaborative effort including St. Martin with computer work by Dale Hergstad, John Blizek and Lance Brisson; photography by Blizek and Richard C. Lee; and the art direction of Tim Bryant. Such elements as paper sculpture, construction paper, aluminum foil

GET YOUR WORK INTO THE RIGHT BUYERS' HANDS!

You work hard... and your hard work deserves to be seen by the right buyers. But with the constant changes in the industry, it's not always easy to know who those buyers are. That's why you'll want to keep up-to-date and on top with the most current edition of this indispensable market guide.

Totally Updated Each Year

Keep ahead of the changes by ordering *1997 Artist's & Graphic Designer's Market* today. You'll save the frustration of getting your work returned in the mail, stamped MOVED: ADDRESS UNKNOWN. And of NOT submitting your work to new listings because you don't know they exist. All you have to do to order the upcoming 1997 edition is complete the attached order card and return it with your payment or credit card information. Order now and you'll get the 1997 edition at the 1996 price—just $23.99—no matter how much the regular price may increase! *1997 Artist's & Graphic Designer's Market* will be published and ready for shipment in September 1996.

Keep on top of the fast-changing industry and get a jump on selling your work with help from the *1997 Artist's & Graphic Designer's Market*. Order today! You deserve it!

1997 ARTIST'S & GRAPHIC DESIGNER'S MARKET

WHERE & HOW TO SELL YOUR ILLUSTRATION, FINE ART, GRAPHIC DESIGN & CARTOONS

2,500 markets, including magazine, book and greeting card publishers; galleries; art publishers; and ad agencies!

Totally Updated! Plus **800** New Markets!

Turn over for more books to help you sell your work →

NO POSTAGE
NECESSARY
IF MAILED
IN THE
UNITED STATES

BUSINESS REPLY MAIL
FIRST CLASS MAIL PERMIT NO. 17 CINCINNATI OHIO

POSTAGE PAID BY ADDRESSEE

WRITER'S DIGEST BOOKS
1507 DANA AVENUE
CINCINNATI OH 45207-9965

M.O.R. RECORDS & TAPES, 17596 Corbel Court, San Diego CA 92128. (619)485-1550. Fax: (619)485-1883. President/Owner: Stuart L. Glassman. Estab. 1980. Produces CDs and tapes: jazz and pop. Recent releases: *Kory Livingstone Plays Jazz*, by Kory Livingstone; *A Passion For The Piano*, by Zach Davids; and *The Hour Of Love*, by Dennis Russell.

• M.O.R. has added a new department, M.O.R. Jazz.

Needs: Produces 3 CDs, tapes/year. Prefers freelancers with experience in pop/M.O.R. music. Uses freelancers for CD cover design and tape cover illustration.

First Contact & Terms: Send query letter with résumé. Samples are filed. Reports back within 2 months. Portfolio should include thumbnails. Sometimes requests work on spec before assigning a job. Pays by the project. Rights purchased vary according to project.

Tips: "Clean lines are in; erotic, exotic covers/designs are out. No more 'comic book' covers."

MAGGIE'S MUSIC, INC., Box 4144, Annapolis MD 21403. (410)268-3394. Fax: (410)267-7061. President: Maggie Sansone. Estab. 1984. Produces CDs and tapes: traditional, Celtic and new acoustic music. Recent releases *Midsummer Moon*, by Al Petteway; *Dance Upon the Shore*, by Maggie Sansone; *Hills of Erin*, by Karen Ashbrook; and *Celtic Circles*, by Bonnie Rideout.

Needs: Produces 3-4 albums/year. Works with 2 freelance designers and 2 illustrators/year. Prefers freelancers with experience in album covers, Celtic and folk art. Works on assignment only. Uses artists for CD/album/tape cover and brochure design and illustration; and catalog design, illustration and layout. Needs computer-literate freelancers for design and production.

First Contact & Terms: Send query letter with color and b&w samples, brochure. Samples are filed. Reports back only if interested. Company will contact artist for portfolio review if interested. Requests work on spec before assigning a job. Pays for design by the hour, $30-60. Pays for illustration by the project, $500-1,000. Sometimes interested in buying second rights (reprint rights) to previously published work, or as edited. Buys all rights.

‡MECHANIC RECORDS, INC., Dept. AGDM, 6 Greene St., 2nd Floor, New York NY 10013. (212)226-7272. Fax: (212)941-9401. Production Manager: Chad Marlowe. Estab. 1988. Produces CDs, tapes and albums: pop and rock. Recent releases: *Live Aliein Broadcast*, by Tad; and *Progress of Decadence*, by Overdose.

Needs: Produces 10 albums/year. Works with 7 freelance designers and 7 illustrators/year. Uses freelancers for CD/album/tape cover; brochure and advertising design and illustration; direct mail packages, and posters. Needs computer-literate freelancers for design and production. 100% of freelance work demands computer skills.

First Contact & Terms: Send query letter with brochure, résumé, tearsheets, photostats, photocopies. Samples are filed and not returned. Reports back only if interested. To show portfolio, mail appropriate materials. Payment varies. Rights purchased vary according to project.

© 1995 Patty Lee Records.

and computer animation give the work its unique look. "We like to think of it as a tweaky combination of low tech and high tech," says Lee. "We love the whole concept and design because it's bold, bright and direct. The quality of the cover is an ideal representation of the 'New Orleans Rock 'n' Roll' style of music." The company has gotten great reaction to the fold-out cover, and numerous requests for posters.

‡**METAL BLADE RECORDS, INC.**, 2345 Erringer Rd., Suite 108, Simi Valley CA 93065. (805)522-9111. Fax: (805)522-9380. E-mail: mtlbldrcds@aol.com. Vice President/General Manager: Tracy Vera. Estab. 1982. Produces CDs and tapes: rock by solo artists and groups. Recent releases: *Time* by Merciful Fate; and *Deaf Dumb Blind*, by Clawfinger.

Needs: Produces 10-20 releases/year. Works with 5-10 freelancers/year. Prefers freelancers with experience in album cover art. Uses freelancers for CD cover design and illustration. Needs computer-literate freelancers for design and illustration. 80% of freelance work demands knowledge of Aldus PageMaker, Adobe Illustrator, QuarkXPress, Adobe Photoshop.

First Contact & Terms: Send postcard sample of work or query letter with brochure, résumé, photostats, photocopies, photographs, SASE, tearsheets. Samples are filed or returned by SASE if requested by artist. Reports back to the artist only if interested. Art Director will contact artist for portfolio review if interested. Portfolio should include b&w and color, final art, photocopies, photographs, photostats, roughs, slides, tearsheets. Pays for design and illustration by the project. Buys all rights.

Tips: Finds artists through *Black Book*, magazines and artists' submissions.

MIA MIND MUSIC, 500½ E. 84th St., Suite 4B, New York NY 10028. (212)861-8745. Fax: (212)439-9109. Producer: Steven Bentzel. Director Art Department: Ashley Wilkes. Produces tapes, CDs, DATs, demos, records: rock, pop, R&B, soul, progressive, folk, gospel, rap, alternative; by solo artists and groups. Recent releases: "What's It Gonna Be, Boy," by Ouriel; and "My Reputation," by Ashley Wilkes.

Needs: Produces 15 solo artists and 5 groups/year. Works with 12 freelancers/year. Prefers freelancers with experience in rock/pop art. Works on assignment only. Uses artists for CD/tape cover design and illustration; brochure design and illustration; direct mail packages; advertising design; posters. Needs computer-literate freelancers. 75% of freelance work demands knowledge of Adobe Illustrator, Adobe Photoshop, Performer Paint Box, QuarkXPress.

First Contact & Terms: Send query letter with brochure, résumé, photocopies, photographs. Samples are filed. Reports back within 15 days. Call for appointment to show portfolio of b&w and color final art and photographs or mail appropriate materials. Pays for design by the project, $50-500. Rights purchased vary according to project.

MIGHTY RECORDS, Rockford Music Publishing Co.—BMI, Stateside Music Publishing Co.—BMI, Stateside Music Co.—ASCAP, 150 West End Ave., Suite 6-D, New York NY 10023. (212)873-5968. Manager: Danny Darrow. Estab. 1958. Produces CDs and tapes: jazz, pop, country/western; by solo artists. Recent releases: "Falling In Love," by Brian Dowen; and "A Part of You," by Brian Dowen/Randy Lakeman.

Needs: Produces 1-2 solo artists/year. Works on assignment only. Uses freelancers for CD/tape cover, brochure and advertising design and illustration; catalog design and layout; and posters.

First Contact & Terms: Send query letter with SASE. Samples are not filed and are returned by SASE if requested by artist. Reports back within 1 week. To show portfolio, mail photocopies with SASE. Pays for design by the project. Rights purchased vary according to project.

MIRAMAR PRODUCTIONS, 200 Second Ave., Seattle WA 98119. (206)284-4700. Fax:(206)286-4433. Vice President of Production: David Newsom. Estab. 1984. Produces CDs, tapes and videos: rock, R&B, jazz, progressive and adult contemporary by solo artists and groups. Recent releases: *The Gate to the Mind's Eye*, by Thomas Dolby; *Turn of the Tides*, by Tangerine Dream; and *Opera Imaginaire*, by various artists.

● Miramar has a worldwide web site: http://useattle.uspan.com/miramar/.

Needs: Produces 10 soloists and 10 groups/year. Works with 10 freelancers/year. Works on assignment only. Uses freelancers for CD/tape cover; brochure and advertising design and illustration; posters; and videotape packaging. Needs computer-literate freelancers for design, illustration, production and presentation. 90% of freelance work demands knowledge of QuarkXPress, Aldus FreeHand, Adobe Illustrator and Photoshop.

First Contact & Terms: Send query letter with brochure, tearsheets, résumé and photocopies. Samples are filed. Reports back only if interested. Write for appointment to show portfolio of b&w and color photostats, tearsheets, photographs, slides and printed pieces. Pays by the project. Rights purchased vary according to project.

‡**MUSIC FOR LITTLE PEOPLE/EARTHBEAT! RECORD COMPANY**, P.O. Box 1460, Redway CA 95560. (707)923-3991. Fax: (707)923-3241. Creative Director: Sandy Bassett. Estab. 1984. Produces music, interactive CD-ROM and collateral materials. "The Music For Little People label specializes in culturally diverse, nurturing music for families and children. EarthBeat! promotes an eclectic, global vision that allows cultural barriers to disappear and reveals music to be a truly unifying force." Recent releases: *Driver*, by Ferron; *Papa's Dream*, by Los Lobos; *Hand in Hand*, by various artists; and *Choo Choo Boogaloo*, by Buckwheat Zydeco.

Needs: Produces 6-10 releases/year. All work done on a freelance, contractual basis. Prefers illustrators specializing in portraying diverse cultures: kids and adults in imaginative, lively scenes for CD/cassette cover and booklet art. Works on assignment only. Freelancers should be familiar with QuarkXPress, Photoshop and Illustrator.

First Contact & Terms: Send query letter with résumé, tearsheets, photocopies and/or Macintosh compatible floppy disk. Samples are filed or are returned by SASE if requested by artist. Reports back only if interested. Frequently reviews portfolios. To show portfolio, mail or fax roughs.

‡*NERVOUS RECORDS, 7-11 Minerva Rd., London NW10 6HJ England. (01)963-0352. Fax: (01)963-1170. Contact: R. Williams. Produces CDs, tapes and albums: rock and rockabilly. Recent releases: *Virtual Rockabilly*, by Tim Polecat; and *Ghost of Your Love*, by The Mean Cat Daddies.
Needs: Produces 9 albums/year. Works with 5 freelance designers and 2 illustrators/year. Uses freelancers for album cover, brochure, catalog and advertising design.
First Contact & Terms: Send query letter with samples; material may be kept on file. Write for appointment to show portfolio. Prefers tearsheets as samples. Samples not filed are returned by SAE (nonresidents include IRC). Reports only if interested. Original art returned at job's completion. Pays for design by the project, $10-500. Pays for illustration by the project, $10-100. Considers available budget and how work will be used when establishing payment. Needs computer-literate freelancers for presentation. 10% of freelance work demands knowledge of Page Plus 3.0. Buys first rights.
Tips: "We have noticed more use of imagery and caricatures in our field so fewer actual photographs are used." Wants to see "examples of previous album sleeves, in keeping with the style of our music. Remember, we're a rockabilly label."

NEW EXPERIENCE RECORDS/GRAND SLAM RECORDS, P.O. Box 683, Lima OH 45802. President: James Milligan. Estab. 1989. Produces tapes, CDs and records: rock, jazz, pop, R&B, soul, folk, gospel, country/western, rap by solo artists and groups. Recent releases: "You Promise Me Love," by The Impressions; and "He'll Steal Your Heart," by Barbara Lomus/BT Express.
Needs: Produces 5-10 solo artists and 4-6 groups/year. Works with 2-3 freelancers/year. Works with artist reps. Prefers freelancers with experience in album cover design. "Will consider other ideas." Works on assignment only. Uses freelancers for CD/tape cover design and illustration; brochure and advertising design; catalog layout; posters. Needs computer-literate freelancers for design and production. 50% of freelance work demands knowledge of Aldus PageMaker.
First Contact & Terms: Send query letter with brochure, résumé, photocopies, photographs, SASE and tearsheets. Samples are filed. Reports back within 6 weeks. Artist should follow up with letter or phone call. Call or write for appointment to show portfolio of b&w roughs, final art and photographs. Pays for design by the project, $250-500. Buys one-time rights or reprint rights.

NORTH STAR RECORDS INC., 22 London St., East Greenwich RI 02818. (401)886-8888. Fax: (401)886-8886. Vice President: Paul Mason. Estab. 1985. Produces CDs and tapes: jazz, classical, folk, traditional, contemporary, world beat, New Age by solo artists and groups. Recent releases: *Unchained Melodies*, by Robin Spielberg; and *Tropical Night*, by Calido.
Needs: Produces 5 solo artists and 5 groups/year. Works with 4 freelancers/year. Prefers freelancers with experience in CD and cassette cover design. Works on assignment only. Uses artists for CD/tape cover and brochure design and illustration; catalog design, illustration and layout; direct mail packages. Needs computer-literate freelancers for design and presentation. 10% of freelance work demands knowledge of QuarkXPress 3.3.
First Contact & Terms: Send query letter with brochure. Samples are filed. Reports back to the artist only if interested. To show portfolio, mail color roughs and final art. Pays for design by the project, $500-1,000. Buys first rights, one-time rights or all rights.

NUCLEUS RECORDS, Box 111, Sea Bright NJ 07760. President: Robert Bowden. Produces albums and tapes: country/western, folk and pop. Recent releases: "4 O'clock Rock" and "Always," by Marco Sission.
Needs: Produces 2 records/year. Artists with 3 years' experience only. Works with 1 freelance designer and 2 illustrators/year on assignment only. Uses freelancers for album cover design. 10% of freelance work demands knowledge of Adobe Illustrator and Photoshop.
First Contact & Terms: Send query letter with résumés, printed samples and photographs. Write for appointment to show portfolio of photographs. Samples are returned. Sometimes requests work on spec before assigning a job. Pays for design by the project, $150-200. Pays for illustration by the project, $125-150. Reports within 1 month. Originals returned at job's completion. Considers skill and experience of artist when establishing payment. Buys all rights.
Tips: Finds new artists through artists' submissions and design studios.

The double dagger before a listing indicates that the listing is new in this edition. New markets are often more receptive to freelance submissions.

‡**OMEGA ORGANIZATION INTERNATIONAL**, P.O. Box 33623, Dept. AGDM, Seattle WA 98133-0623. Communications: M. Beaumont. Estab. 1970. Produces CDs and tapes: folk, New Age, electronic, eclectic, adult alternative, by solo artists and groups. Recent releases: *Affinity*, by Affinity; and *Ladies Not For Burning*, by Coventry.
Needs: Produces 15-30 releases/year. Works with 5-12 freelancers/year. Prefers freelancers with experience in surrealism. Uses freelancers for CD/tape cover illustration. 10% of freelance work demands computer skills.
First Contact & Terms: Send query letter with résumé, photographs, slides and SASE. Samples are filed or returned by SASE if requested by artist. Art Director will contact artist for portfolio review if interested. Portfolio should include color final art, photographs, roughs, slides, tearsheets, transparencies. Payment negotiated per project. Rights purchased vary according to project.
Tips: Finds artists through artists' submissions and referrals from recording artists. "Be excellent and unique. Research artists you would be interested in creating artwork for, beforehand if possible."

ONE STEP TO HAPPINESS MUSIC, % Jacobson & Colfin, P.C., 156 Fifth Ave., New York NY 10010. (212)691-5630. Fax: (212)645-5038. Attorney: Bruce E. Colfin. Produces CDs, tapes and albums: reggae group and solo artists. Release: "Make Place for the Youth," by Andrew Tosh.
Needs: Produces 1-2 soloists and 1-2 groups/year. Works with 1-2 freelancers/year on assignment only. Uses artists for CD/album/tape cover design and illustration.
First Contact & Terms: Send query letter with brochure, résumé and SASE. Samples are filed or returned by SASE if requested by artist. Reports back within 6-8 weeks. Call or write for appointment to show portfolio of tearsheets. Pays by the project. Rights purchased vary according to project.

‡**OPUS ONE**, Box 604, Greenville ME 04441. (207)997-3581. President: Max Schubel. Estab. 1966. Produces CDs, LPs, 78s, contemporary American concert and electronic music.
Needs: Produces 6 releases/year. Works with 1-2 freelancers/year. Prefers freelancers with experience in commercial graphics. Uses freelancers for CD cover design.
First Contact & Terms: Send query letter with example of previous artwork. Samples are filed. Reports back within 3-5 days. Pays for design by the project. Buys all rights.
Tips: Finds artists through meeting them in arts colonies, galleries or by chance. "Contact record producer directly."

‡**PAINT CHIP RECORDS**, Design Dept., P.O. Box 12401, Albany NY 12212. Phone/fax: (518)765-4027. Vice President: Billy Riley. Estab. 1992. Produces CDs, 7-inch singles. Produces alternative rock by solo artists and groups. Recent releases *Fear Into Fuel*, by various artists; and *One More Monster*, by Bloom.
Needs: Produces 8 releases/year. Works with 2 freelancers/year. Prefers local freelancers (Albany NY or Memphis TN area). Uses freelancers for CD cover illustration.
First Contact & Terms: Send query letter with résumé and applicable samples. Samples are filed and are not returned. Art Director will contract artist for portfolio review if interested. Payment negotiable. Negotiates rights purchased.
Tips: Finds artists through published works, magazines, artists' submissions. Likes "distinct and recognizable style."

‡**PANDISC RECORDS**, 843 Washington Ave., Miami Beach FL 33139. (305)538-4880. Fax: (305)538-9187. Production Director: Nat Rew. Estab. 1982. Produces CDs and tapes: rap, bass, dance. Recent releases: "Happy & You Kno It," by Crazy L'eggs; and "Uhh, Ohh," by Splack Pack.
Needs: Produces 15-20 releases/year. Works with 4 freelancers/year. Prefers freelancers with experience in record industry. Uses freelancers for CD cover design and illustration; brochure, advertising and tape cover design; direct mail packages; posters. Needs computer-literate freelancers for design and production. 75% of freelance work demands knowledge of CorelDraw.
First Contact & Terms: Send query letter with sample of work. Samples are filed. Art Director will contact artist for portfolio review if interested. Pays for design by the hour, $10 minimum. Buys all rights.
Tips: Finds artists through word of mouth. "Know your specs!"

‡**PAVEMENT MUSIC, INC.**, 17W703A Butterfield Rd., Oakbrook Terrace IL 60181. (708)916-1155. Fax: (708)916-1159. Vice President: Lorraine Margala. Estab. 1993. Produces CDs, tapes and video: rock, pop, alternative, metal. Recent releases: *Earth*, by Crawl; *Eternal*, by Malevolent Creation; *Death Row*, by Accept; and *Time Heals Nothing*, by Crowbar.
Needs: Produces 24 releases/year. Works with 20 freelancers/year. Prefers computer-literate freelancers for design, illustration, presentation. Most of freelance work demands knowledge of QuarkXPress and Adobe Photoshop.
First Contact & Terms: Send query letter with brochure, SASE. Samples are filed or returned by SASE if requested by artist. Art Director will contact artist for portfolio review if interested. Portfolio should include photocopies. Pays for design by the project, $100-1,000. Pays for illustration by the project, $100-1,000. Rights purchased vary according to project.

Tips: "We're mostly looking for cover art. Many of the artists we hire were suggested to us by the group in question—befriend a band."

PINEWOOD PRODUCTIONS/BAYPORT RECORDS, P.O. Box 5241, Chesapeake VA 23324. (804)627-0957. Producer: Bill Johnson. Estab. 1954. Produces tapes and vinyl records: soul, gospel, blues by solo artists and groups.
Needs: Uses freelancers for tape cover and advertising design; brochure design and illustration; catalog illustration; and direct mail packages.
First Contact & Terms: Send query letter with photographs, information. Samples are not filed and are returned by SASE if requested by artist. Reports back within 1 month. Write for appointment to show portfolio of color photographs. Buys one-time rights; or rights purchased vary according to project.

‡PRAIRIE MUSIC LTD., Box 438, Walnut IA 51577. (712)784-3001. President: Bob Everhart. Estab. 1967. Produces tapes and albums: folk, traditional, country and bluegrass. Releases: "Time After Time" and "Fishpole John,"by Bob Everhart; and "Smoky Mountain Heartbreak," by Bonnie Sanford.
Needs: Produces 2 solo artists and 2 groups/year. Prefers freelancers with experience in traditional rural values. Works on assignment only. Uses artists for album/tape cover design and illustration and posters.
First Contact & Terms: Send query letter with résumé, photocopies and photostats. Samples are filed. Reports back within 4 months only if interested. To show portfolio, mail b&w photostats. Pays by the project, $100-250. Buys one-time rights.

‡PRAVDA RECORDS, 3823 N. Southport Ave., Chicago IL 60613. (312)549-3776. Fax: (312)549-3411. Contact: Kenn Goodman. Estab. 1986. Produces CDs, tapes and posters: rock, progressive by solo artists and groups. Recent releases: *Parlez-Vous Francais?*, by Willie Wisely Trio; and *Loserville*, by New Duncan Imperials.
Needs: Produce 1 solo artist and 3-6 groups/year. Works with 1-2 freelancers/year. Works on assignment only. Uses freelancers for CD/tape covers and advertising design and illustration; catalog design and layout; posters. Needs computer-literate freelancers for design and production. 100% of freelance work demands knowledge of Adobe Illustrator, QuarkXPress and Adobe Photoshop.
First Contact & Terms: Send query letter with résumé, photocopes, SASE. Samples are not filed and are returned by SASE if requested by artist. Reports back within 2 months. Portfolio should include roughs, tearsheets, slides, photostats, photographs. Pays for design by the project, $250-1,000. Rights purchased vary according to project.

THE PRESCRIPTION CO., 70 Murray Ave., Port Washington NY 11050. (516)767-1929. President: D. F. Gasman. Estab. 1976. Produces CDs, tapes and albums: rock, pop, folk, country/western by group and solo artists. Releases include: "You Came In" and "Rock and Roll Blues," by Medicine Mike.
Needs: Works on assignment only. Uses artists for all types of design and illustration.
First Contact & Terms: Send query letter with brochure, résumé and "whatever it takes to demonstrate talent." Samples are filed and are not returned. Reports back only if interested. To show portfolio, mail b&w and color photostats and photographs. Payment depends on nature of project. Rights purchased vary according to project.

R.E.F. RECORDING CO./FRICK MUSIC PUBLISHING CO., 404 Bluegrass Ave., Madison TN 37115. (615)865-6380. Contact: Bob Frick. Produces CDs and tapes: country/western and gospel. Recent releases: "I Found Jesus in Nashville," by Bob Scott Frick; and "He Sat Where You Sit," by Teresa Ford.
Needs: Produces 30 records/year. Works with 10 freelancers/year on assignment only.
First Contact & Terms: Send résumé and photocopies to be kept on file. Write for appointment to show portfolio. Samples not filed are returned by SASE. Reports within 10 days only if interested.

RAGE-N-RECORDS, 212 N. 12th St., #3, Philadelphia PA 19107. (215)977-9777. Fax: (215)496-9321. E-mail: rage@netaxs.com. Creative Director: Vincent Kershner. Estab. 1984. Produces CDs and tapes: rock, pop, R&B, blues by solo artists and groups. Recent releases: "Ah Ho, Ah Ho & Nittany Joe," by The Anzalone Brothers; and "It's A Tough Town," by The Cutaways).
Needs: Produces 10 solo artists and 10 groups/year. Works with 5-10 freelancers/year. Prefers artists with experience in rock designs. Works on assignment only. Uses artists for CD/tape cover design and illustration; and posters.
First Contact & Terms: Samples are not filed and are returned by SASE if requested by artist. Does not report back. Artist should follow up. Call for appointment to show portfolio. Pays for design by the project.

‡❧RAMMIT RECORDS, 414 Ontario St., Toronto, Ontario M5A 2W1 Canada. (416)923-7611. Fax: (416)923-3352. President: Trevor G. Shelton. Estab. 1988. Produces CDs, tapes and 12-inch vinyl promos for CDs: rock, pop, R&B and soul by solo artists and groups. Recent releases: *2 Versatile*, by 2 Versatile, hip hop/R&B, A&M distribution; *Hopping Penguins*, by Trombone Chromosome, reggae, MCA distribution; *Line Up In Paris*, by Line Up in Paris, rock, A&M distribution.

Needs: Produces 4 releases/year. Works with 3-5 freelancers/year. Uses freelancers for CD cover design and illustration, tape cover illustration, advertising design and posters. 75% of freelance work demands computer skills.

First Contact & Terms: Send query letter with "whatever represents you the best." Reports back to the artist only if interested. Artist should follow-up with call and/or letter after initial query. Portfolio should include b&w and color photostats. Pays for design by the project, $1,000-3,000. Negotiates rights purchased.

Tips: Finds artists through word of mouth, referrals and directories.

RELATIVITY RECORDS, 79 Fifth Ave., New York NY 11003. (212)337-5200. Fax: (212)337-5374. Art Director: David Bett. Estab. 1979. Produces CDs and tapes: rock, jazz, rap, pop and heavy metal. Recent releases by Bone Thugs N Harmony, Steve Vai, Common Sense and Our Lady Peace.

Needs: Produces 30-50 groups/year. Works with 1-2 designers and 10-20 illustrators/year. Prefers artists with experience in "anything from underground comic-book art to mainstream commercial illustration." Works on assignment only. Uses artists for CD and album cover, brochure and catalog illustration; posters; logo art; and lettering. Helpful to have knowledge of QuarkXPress, Aldus FreeHand, Adobe Illustrator or Photoshop (Adobe). Style and tone for design includes "the full spectrum of styles."

First Contact & Terms: Send promotional piece, slides, tearsheets or photostats. Samples are filed or returned with SASE. Reports back only if interested. Call or write to show portfolio of color and b&w slides or transparencies or printed samples. Pays by the project, $500-3,500. Considers complexity of project, available budget and rights purchased when establishing payment. Rights purchased vary according to project.

Tips: "We seek creative people with imagination. Avoid the obvious"

‡RHYTHMS PRODUCTIONS, Box 34485, Los Angeles CA 90034. President: R.S. White. Estab. 1955. Produces albums, tapes, multimedia items and books: educational children's. Release: *First Reader's Kit*.

Needs: Works on assignment only. Prefers Los Angeles artists. All cassettes have covers/jackets designed and illustrated by freelance artists. Works with 1-2 artists/year with experience in cartooning. Uses freelance artists for album/tape cover design and illustration and children's books. Needs computer-literate freelancers for design animation, illustration and production.

First Contact & Terms: Send query letter photocopies and SASE. Samples are filed or are returned by SASE if requested. Reports within 1 month. "We do not review portfolios unless we have seen photocopies we like." Pays by the project. Buys all rights.

Tips: "We like illustration that is suitable for children. We find that cartoonists have the look we prefer. However, we also like art that is finer and that reflects a 'quality look' for some of our more classical publications."

RISING STAR RECORDS, 710 Lakeview Ave. NE, Atlanta GA 30308. (404)872-1431. Fax: (404)876-1218. President: Barbara Taylor. General Manager: Lyndell Massengale. Estab. 1987. Produces CDs, tapes, print music and music industry directories: contemporary instrumental—jazz, New Age, classical and Celtic by solo artists and groups. Recent releases: *The Second Time*, by Pruett & Davis; and *Heartkeys: The AIDS Memorial Album*, by various artists.

Needs: Produces 6 albums/year. Works with 3 freelancers/year. Prefers freelancers with experience in album design. Works on assignment only. Uses freelancers for CD/tape and advertising design and illustration. Needs computer-literate freelancers for design, illustration, production and presentation. 100% of freelance work demands knowledge of Aldus PageMaker and Mac system.

First Contact & Terms: Send query letter with résumé, photocopies and SASE. Follow up with phone call. Samples are filed and are returned by SASE if requested by artist. Reports back within 2 months. To show portfolio, mail roughs and photographs. Pays for design by the project.

ROCK DOG RECORDS, P.O. Box 3687, Hollywood CA 90028-9998. (213)661-0259. President, A&R and Promotion: Gerry North. Estab. 1987. Produces CDs and tapes: rock, R&B, dance, New Age, contemporary instrumental and music for film, TV and video productions. Recent releases: *Variations on a Dream*, by Brainstorm; and *Internal Peace*, by Elijah.

Needs: Produces 2-3 solo artists and 2-3 groups/year. Works with 5-6 freelance illustrators/year. Prefers freelancers with experience in album art. Uses artists for CD album/tape cover design and illustration, direct mail packages, ad design and posters. Needs computer-literate freelancers for illustration. 50% of freelance work demands knowledge of Print Shop or Photoshop.

First Contact & Terms: Send query letter with photographs and photocopies. Samples are filed or are returned by SASE. Reports back within 2 weeks. To show portfolio, mail photocopies. Sometimes requests work on spec before assigning a job. Pays for design by the project, $50-500. Pays for illustration by the project, $50-500. Interested in buying second rights (reprint rights) to previously published work.

Tips: Finds new artists through submissions from artists who use *Artist's & Graphic Designer's Market*. "Be open to suggestions; follow directions."

‡ROTTEN RECORDS, P.O. Box 2157, Montclair CA 91763. (909)624-2332. Fax: (909)624-2392. President: Ron Peterson. Estab. 1988. Produces CDs and tapes: rock by groups. Recent releases: *When the Kite String Pops*, by Acid Bath; and *Live*, by D.R.I.

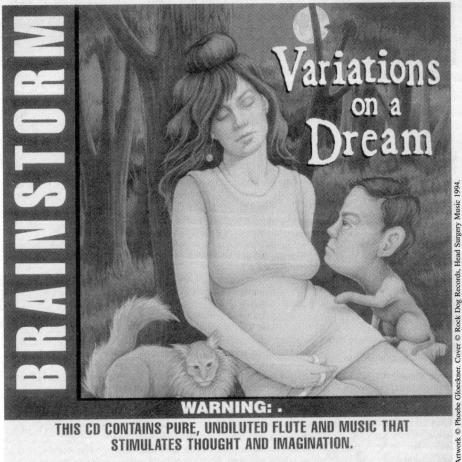

BRAINSTORM

Variations on a Dream

Artwork © Phoebe Gloeckner. Cover © Rock Dog Records, Head Surgery Music 1994.

WARNING: ·
THIS CD CONTAINS PURE, UNDILUTED FLUTE AND MUSIC THAT
STIMULATES THOUGHT AND IMAGINATION.

Phoebe Gloeckner's piece "conveys the mystery of exploring the twilight realm. It's dark, yet intriguing," says Gerry North of Rock Dog Records. North chose this piece for the cover of Variations on a Dream *by Brainstorm from among samples Gloeckner sent after seeing Rock Dog's listing in* Artist's & Graphic Designer's Market. *"The music of Brainstorm could best be described as New Age meets sci-fi. It's like the Jules Verne or H.G. Wells of the ambient/instrumental scene," North says. "The print we chose fits perfectly with this theme. It gets people's attention right away."*

Needs: Produces 4-5 releases/year. Works with 3-4 freelancers/year. Uses freelancers for CD/tape cover design; and posters. Needs computer-literate freelancers for desigin, illustration, production.
First Contact & Terms: Send postcard sample of work or query letter with photocopies, tearsheets (any color copies samples). Samples are filed and not returned. Reports back to the artist only if interested. Artist should follow-up with call. Portfolio should include color photocopies. Pays for design and illustration by the project.

‡ROWENA RECORDS & TAPES, 195 S. 26th St., San Jose CA 95116. (408)286-9840. Owner: Jeannine O'Neal. Estab. 1967. Produces CDs, tapes and albums: rock, rhythm and blues, country/western, soul, rap, pop and New Age; by groups. Recent releases: *I Know That I Know*, by Jeannine O'Neal (contemporary Christian); *Palomite Triste*, by Jaque Lynn (Mexican music); and *Visions of Chance*, by Sharon Roni Greer (hi-energy contemporary pop).
Needs: Produces 20 solo artists and 5 groups/year. Uses freelancers for CD/album/tape cover design and illustration and posters.
First Contact & Terms: Send query letter with brochure, résumé, SASE, tearsheets, photographs, photocopies and photostats. Samples are filed or are returned by SASE. Reports back within 1 month. To show a portfolio, mail original/final art. "Artist should submit prices."

‡SAN FRANCISCO SOUND, 29903 Harvester Rd., Malibu CA 90265. (310)457-4844. Fax: (310)457-1855. Owner: Matthew Katz. Produces CDs and tapes: rock and jazz. Recent releases: *Then and Now*, Volumes 1 and 2, featuring Jefferson Airplane, Moby Grape and many others; *Fraternity of Man*, by Tripsichord; and *It's a Beautiful Day*, by Indian Puddin and Pipe.
Needs: Produces 2 soloists and 2 groups/year. Works with 2 artists/year with experience in airbrush and computer graphics. Works on assignment only. Uses artists for CD cover, brochure and advertising design; catalog and advertising illustration; posters; and catalog layout.
First Contact & Terms: Send query letter with brochure, tearsheets, photographs, photocopies, photostats, slides and transparencies. Samples are filed. Reports back to the artist only if interested. Call or mail appropriate materials. Portfolio should include photostats, slides, color tearsheets, printed samples and photographs. Pays by the project, $250-1,200. Buys all rights.
Tips: "Know the style of 1960s San Francisco artists—Mause, Kelley-Moscoso, Griffin— and bring it up to date. Know our products."

‡SCRUTCHINGS MUSIC, 429 Homestead St., Akron OH 44306. (216)773-8529 or (216)724-6940. Owner/ President: Walter Scrutchings. Estab. 1980. Produces CDs, tapes and albums: gospel music (black). Recent releases: *Follow Jesus*; *The Joy He Brings*, by The Akron City Family Mass Choir; *He Keeps Blessing Me*, by The Arch Angel Concert Choir; and *You're Worthy of All The Praise*, by Elvin Dent Jr. and the United Voices.
Needs: Produces 2-5 solo artists and 2-5 groups/year. Works with 2-3 freelancers/year. Prefers freelancers with experience in jacket and cover design. Works on assignment only. Uses artists for CD/album/tape cover and brochure design, direct mail packages and posters.
First Contact & Terms: Send query letter with résumé. Samples are filed or are returned by SASE if requested by artist. Reports back only if interested. To show portfolio, mail b&w and color photographs. Pays by the project, $200-2,000. Buys all rights.

‡SELECT RECORDS, 16 W. 22nd St., 10th Floor, New York NY 10010. (212)691-1200. Fax: (212)691-3375. Art Director: Ian Thornell. Produces CDs, tapes, 12-inch singles and marketing products: rock, R&B, rap and comedy solo artists and groups. Recent releases: *Jerky Boys II*, by Jerky Boys; and *To the Death*, by M.O.P.
Needs: Produces 6-10 releases/year. Works with 6-8 freelancers/year. Prefers local freelancers with experience in computer (Mac). Uses freelancers for CD/tape cover design and illustration, brochure design, posters. Needs computer-literate freelancers for design. 70-80% of freelance work demands knowledge of Adobe Illustrator, QuarkXPress, Adobe Photoshop and Aldus FreeHand.
First Contact & Terms: Send postcard sample of work or query letter with photostats, transparencies, slides and tearsheets. Samples are not filed or returned. Portfolios may be dropped off Monday-Friday. Art Director will contact artist for portfolio review if interested. Portfolio should include slides, transparencies, final art and photostats. Payment depends on project and need. Rights purchased vary according to project.
Tips: Finds artists through submissions, *Black Book*, agents. Impressed by "good creative work that shows you took chances; clean presentation."

‡JERRY SIMS RECORDS, Box 648, Woodacre CA 94973. (415)488-1171. Owner: Jerry Sims. Estab. 1984. Produces CDs and tapes: rock, R&B, classical. Recent releases: *Viaggio* and *December Days*, by Coral; and *King of California*, by Chuck Vincent.
Needs: Produces 4-5 releases/year. Works with 4-5 freelancers/year. Prefers local artists with experience in album cover art. Uses freelancers for CD cover design and illustration; tape cover and advertising illustration; catalog design; posters. Needs computer-literate freelancers for design, illustration, production and presentation. 50% of freelance work demands computer skills.
First Contact & Terms: Send query letter with brochure and résumé. Samples are filed. Art Director will contact artist for portfolio review if interested. Portfolio should include photographs. Pays for design and illustration by the project. Buys one-time rights.

SIRR RODD RECORD & PUBLISHING COMPANY, 2453 77th Ave., Philadelphia PA 19150-1820. President: Rodney J. Keitt. Estab. 1985. Produces disco, soul, jazz, pop, R&B by group and solo artists. Releases: *Fashion & West Oak Lane Jam*, by Klassy K; and *The Essence of Love/Ghetto Jazz*, by Rodney Jerome Keitt.
Needs: Produces 2 solo artists and 3 groups/year. Works with 1 freelancer/year on assignment only. Uses freelancers for album cover and advertising design and illustration, direct mail packages and posters.
First Contact & Terms: Send query letter with résumé, photostats, photocopies and slides. Samples are filed and are not returned. Reports back within 2 months. Write for appointment to show portfolio of color thumbnails, roughs, final reproduction/product, photostats and photographs. Pays by the project, $100-3,500. Buys reprint rights or negotiates rights purchased.
Tips: "Treat every project as though it were a major project. Always request comments and criticism of your work."

THE SONIC GROUP, LTD., 15 Gloria Lane, Fairfield NJ 07004. (201)575-7460. Fax: (201)575-2749. President: Mark Berry. Estab. 1984. Produces CDs and tapes: progressive and alternative metal. Recent releases: *Love Chain, Bootsauce* and *Headstones*.
Needs: Produces 2 solo artists and 2-3 groups/year. Works with 2-3 freelancers/year. Works on assignment only. Uses freelancers for CD cover design and posters.
First Contact & Terms: Samples are filed and are returned by SASE. Does not report back. To show portfolio, mail portfolio of roughs, final art and photographs. Pays for design by the project. Buys all rights.

‡**SONIC IMAGES RECORDS**, P.O. Box 691626, W. Hollywood CA 90069. (213)650-1000. Fax: (213)650-1016. Estab. 1990. Produces CDs and tapes: jazz, progressive by solo artists and groups. Recent releases: *London Concert*, by Christopher Franke; and *What They Don't Tell You*, by Rain-Bo Tribe.
Needs: Produces 10 releases/year. Works with 10 freelancers/year. Prefers artists with experience in Macintosh. Uses freelancers for CD cover design; tape cover illustration. Needs computer-literate freelancers for design. 50% of freelance work demands computer skills.
First Contact & Terms: Send query letter with brochure. Samples are filed. Reports back within 5 weeks. Portfolios of color final art may be dropped off every Friday. Pays $1,200 minimum for design. Buys all rights.
Tips: Finds artists through word of mouth.

‡**SOUND SOUND SAVAGE FRUITARIAN PRODUCTIONS**, P.O. Box 22999, Seattle WA 98122-0999. (206)322-6866. Fax: (206)720-0075. Owner: Tom Fallat. Estab. 1991. Produces CDs and tapes: rock, jazz, pop, R&B, soul, progressive, classical, folk, gospel, country/western, rap. Recent releases: *Victim of the Gat*, by Lethal Crew; and *The Ocean Shows The Sky*, by Joe Panzetta.
Needs: Produces 5 releases/year. Works with 6 freelancers/year. Needs computer-literate freelancers for design, illustration, production and presentations. Freelancers should be familiar with Aldus PageMaker, Adobe Illustrator and Adobe Photoshop.
First Contact & Terms: Send postcard sample of work or send query letter with brochure, photocopies, photographs and SASE. Samples are not filed and are returned by SASE if requested by artist. Reports back within 2 months. Art Director will contact artist for portfolio review if interested. Portfolio should include b&w and color final art, photocopies, photographs. Pays for design and illustration by the project. Negotiates rights purchased.
Tips: Finds artists through word of mouth or by seeing their existing work. "Volunteer to do first project for a reduced fee to have work to submit to different companies."

‡*****SPHEMUSATIONS**, 12 Northfield Rd., One House, Stowmarket, Suffolk IP14 3HE England. 0449-613388. General Manager: James Butt. Produces classical, country/western, jazz and educational records. Recent releases: *Beethoven & James Butt*, by James Maddocks and James Butt; and *Kaleidoscope*, by South Suffolk Sinfonia.
Needs: Produces 6 solo artiists and 6 groups/year. Works with 6-7 freelancers/year on assignment only. Uses artists for album cover, brochure and advertising design and illustration; catalog design and layout; direct mail packages; and posters. Needs computer-literate freelancers for design, illustration and presentation. Freelancers should be familiar with QuarkXPress, Aldus FreeHand or Atari PaintBox.
First Contact & Terms: Contact through agent or send query letter with résumé, tearsheets, photostats and photocopies. Samples are filed or are returned only if requested. Reports back within 6 weeks. Write for appointment to show portfolio of final reproduction/product and color and b&w photostats and photographs. Pays by the project; $25-500 for design and $25-1,000 for illustration. Considers complexity of project, available budget, skills and experience of artist, how work will be used, turnaround time and rights purchased when establishing payment. Buys reprint rights, all rights or negotiates rights purchased.
Tips: Looks for "economy, simplicity and directness" in artwork for album covers.

STARDUST RECORDS/WIZARD RECORDS, Drawer 40, Estill Springs TN 37330. Contact: Col. Buster Doss, Box 13, Estill Springs TN 37330. (615)649-2577. Produces CDs, tapes and albums: rock, folk, country/western. Recent releases: *Movin' Out, Movin' Up, Movin' On*, by "Danny Boy" Squire; *Rainbow of Roses*, by Larry Johnson; and *Keeping Country, Country*, by Dwane Hall.
Needs: Produces 12-20 CDs and tapes/year. Works with 2-3 freelance designers and 1-2 illustrators/year on assignment only. Uses freelancers for CD/album/tape cover design and illustration; brochure design; and posters.
First Contact & Terms: Send query letter with brochure, tearsheets, résumé and SASE. Samples are filed. Reports back within 1 week. Call for appointment to show portfolio of thumbnails, b&w photostats. Pays by the project, $300. Buys all rights.
Tips: Finds new artists through *Artist's & Graphic Designer's Market*.

MICK TAYLOR MUSIC, % Jacobson & Colfin, P.C., 156 Fifth Ave., New York NY 10010. (212)691-5630. Fax: (212)645-5038. Attorney: Bruce E. Colfin. Estab. 1985. Produces CDs, tapes and albums: rock, R&B by solo artists and groups. Releases: "Stranger in This Town," by Mick Taylor (MAZE Records).

Needs: Produces 1 solo artist and 1-2 groups/year. Works with 2-3 freelancers/year on assignment only. Uses freelancers for CD/album/tape cover design and illustration.

First Contact & Terms: Send query letter with brochure, résumé, SASE. Samples are filed or returned by SASE if requested. Reports back within 6-8 weeks. Call or write for appointment to show portfolio of tearsheets. Pays by the project. Rights purchased vary according to project.

‡TOM THUMB MUSIC, (division of Rhythms Productions), Box 34485, Los Angeles CA 90034. President: Ruth White. Record and book publisher for children's market.

Needs: Works on assignment only. Prefers local freelancers with cartooning talents and animation background. Uses freelancers for catalog cover and book illustration, direct mail brochures, layout, magazine ads, multimedia kits, paste-up and album design. Needs computer-literate freelancers for animation. Artists must have a style that appeals to children.

First Contact & Terms: Buys 3-4 designs/year. Send query letter with brochure showing art style or résumé, tearsheets and photocopies. Samples are filed or are returned by SASE. Reports back within 3 weeks. Pays by the project. Considers complexity of project, available budget and rights purchased when establishing payment. Buys all rights on a work-for-hire basis.

***TOP RECORDS,** 4, Galleria del Corso, Milano Italy. (02)76021141. Fax: 0039/2/76021141. Estab. 1975. Produces CDs, tapes, albums: rock, rap, R&B, soul, pop, folk, country/western, disco; solo and group artists. Recent releases *Per cambiarci per cambiare,* by P. Pellegrino; "Basta con le favole," by Dario Gay; and *Stammi Vicino,* by Rosanna Fratello.
Fratello.

Needs: Produces 5 solo artists and 5 groups/year. Works with 2 freelancer/year on assignment only.

First Contact & Terms: Send query letter with brochure. Samples are filed but not returned, unless requested and paid for by the artist. Reports back within 1 month. Call for appointment to show portfolio or mail appropriate materials. Portfolio should include original/final art and photographs. Buys all rights.

‡VITAL MUSIC, 2591 Pomona Blvd., Pomona CA 91768. (909)613-1323. Fax: (909)594-9652. Sales Manager: Kathleen Cherrier. Estab. 1989. Produces CDs and LPs: jazz, pop, R&B (traditional), classical, blues, New Age, world. Recent releases: *VF004/Bellflower Mood,* by The Curbfeelers; *VC003/Piano Music of Brahams, Wagner & Stevermann,* by Bruce Brubaker.

Needs: Produces 8-12 releases/year. Works with 5-10 freelancers/year. Prefers innovative and flexible artists. Uses freelancers for CD/tape cover, brochure and advertising design and illustration; catalog design, illustration and layout; posters. Needs computer-literate freelancers for design, illustration, production and presentation. 80% of freelance work demands computer skills.

First Contact & Terms: Send postcard sample of work or send query letter with brochure, résumé, photostats, transparencies, photocopies, photographs, SASE, tearsheets and references. Samples are filed. Reports back to the artist only if interested. Artist should follow-up with call and/or letter after initial query. Portfolio should include b&w and color final art, photocopies, photographs, photostats. "All projects are unique and negotiated on a job by job basis." Rights purchased vary according to project.

WARNER BROS. RECORDS, 3300 Warner Blvd., Burbank CA 91505. (818)953-3361. Fax: (818)953-3232. Art Dept. Assistant: Michelle Barish. Produces the artwork for CDs, tapes and sometimes albums: rock jazz, rap, R&B, soul, pop, folk, country/western by solo and group artists. Releases include: *Automatic for the People,* by R.E.M.; and *Erotica,* by Madonna. Releases approximately 300 total packages/year.

Needs: Works with freelance art directors, designers, photographers and illustrators on assignment only. Uses freelancers for CD and album tape cover design and illustration; brochure design and illustration; catalog design, illustration and layout; advertising design and illustration; and posters. Needs computer-literate freelancers for design and production. 100% of freelance work demands knowledge of Aldus Page-Maker, QuarkXPress, Aldus FreeHand, Adobe Illustrator or Photoshop.

First Contact & Terms: Send query letter with brochure, tearsheets, résumé, slides and photographs. Samples are filed or are returned by SASE if requested by artist. Reports back to the artist only if interested. Submissions should include roughs, printed samples and b&w and color tearsheets, photographs, slides and transparencies. "Any of these are acceptable." Do not submit original artwork. Pays by the project.

Tips: "Send a portfolio—we tend to use artists or illustrators with distinct/stylized work—rarely do we call on the illustrators to render likenesses; more often we are looking for someone with a conceptual or humorous approach."

The asterisk before a listing indicates that the market is located outside the United States and Canada.

WATCHESGRO MUSIC, BMI—INTERSTATE 40 RECORDS, 9208 Spruce Mountain Way, Las Vegas NV 89134. (702)363-8506. President: Eddie Lee Carr. Estab. 1975. Produces CDs, tapes and albums: rock, country/western and country rock. Releases include: *The Old Cowboy*, by Don Williams; *What About Us*, by Scott Ellison; and *Eldorado*, by Del Reeves.

Needs: Produces 8 solo artists/year. Works with 3 freelancers/year for CD/album/tape cover design and illustration; and videos.

First Contact & Terms: Send query letter with photographs. Samples are filed or are returned by SASE. Reports back within 1 week only if interested. To show portfolio, mail b&w samples. Pays by the project. Negotiates rights purchased.

YOUNG COUNTRY RECORDS/PLAIN COUNTRY RECORDS/NAPOLEON COUNTRY RECORDS, P.O. Box 5412, Buena Park CA 90620. (909)371-2973. Owner: Leo J. Eiffert, Jr. Estab. 1968. Produces tapes and records: gospel and country/western by solo artists and groups. Releases: "The Singing Housewife," by Pam Bellows; "Little Miss Candy Jones," by Johnny Horton; and "My Friend," by Leo J. Eiffert, Jr.

Needs: Produces 7 solo artists and 3 groups/year. Works with 40-60 freelancers/year. 10% of freelance work demands computer skills.

First Contact & Terms: Send query letter with tearsheets. Samples are filed. Reports back within 3-4 weeks. To show portfolio, mail b&w and color samples. Pays for design by the project, $150-500. Buys all rights.

Record Companies/'95-'96 changes

The following companies were listed in the 1995 edition but do not have listings in this edition. The majority did not respond to our request to update their listings. If a reason was given for exclusion, it appears in parentheses after the company's name.

Americatone International—USA
AVC Entertainment Inc.
Azra International
Aztlan Records
Bal Records
Bovine Record Company
Broken Records International
Chattahoochee Records
Cornell Entertainment Group
CRS Artists
Cymbal Records
Direct Records
Direct Force Productions
Dreambox Media (E.A.R.S., Inc.)
Emperor of Emperors
Emzee Records
1st Coast Posse records/Hallway
 Intern'l Records

FMG Graphics
Folk Era Records, Division of
 Aztec Corp. (no longer uses
 freelancers)
Genesee Records Inc.
Instinct Records
Landmark Communications
 Group
Limited Potential Records
Jim McCoy Music
MCI Entertainment Group
Miles Ahead Records
New South Records
Orinda Records
Plankton Records
Rainforest Records, Inc.
Rapp Produciton, Inc./R.R.R.
 Music

Re-Bop Records
Lonny Schonfeld & Assoc./G-
 Town Records
Shore Records
Slamdek Record Company
Sound Achievement Group
Starcrest Productions
Statue Records
T.O.G. Music Enterprises
Touche Records Co.
Trend® Recording and Distribut-
 ing Co.
Typetoken Records
Varese Sarabanda Records
Warlock Records, Inc.
Zylon Discs

Syndicate/Clip Art Firms

If you're a cartoonist dreaming of seeing your characters in the funny papers, you must first sell the idea to a syndicate. Syndicates basically act as agents for cartoonists, selling comic strips, panels and editorial cartoons to newspapers and magazines. Newspaper features can be daily, daily and Sunday, Sunday only, or weekly (with no day specified). Magazine features are usually monthly or bimonthly. The syndicate edits, promotes and distributes the cartoonist's work, and keeps careful records of sales in exchange for a cut of the profits. Some syndicates also handle merchandising of licensed products, such as mugs, T-shirts and calendars.

The syndicate business is one of the hardest to break into. Even BC's creator, Johnny Hart, had a hard time attracting its attention (see this section's Insider Report on page 632). There are an overwhelming number of aspiring cartoonists competing for a very limited number of jobs. And these are jobs that don't open up often. Editors are always reluctant to drop a long-established strip for a new one, as such action often results in a deluge of reader complaints.

Selling to syndicates is not an easy task, but it is achievable. Most syndicates say they're looking for a "sure thing," a feature in which they'll feel comfortable investing the more than $25,000 needed for promotion and marketing. Work worthy of syndication must be original, saleable and timely, and characters must have universal appeal in order to attract a diversity of readers.

Keep in mind that to succeed in the syndicate market, you have to be more than a fabulous cartoonist. You must also be a good writer and stay in touch with current events and public concerns. Cartooning is an idea business just as much as it is an art business—and the art won't sell if the idea isn't there in the first place.

How to approach a syndicate

If you're an editorial cartoonist, you'll need to start out selling your cartoons to a base newspaper (probably in your hometown) and build up some clips before approaching a syndicate. Submitting published clips will prove to the syndicate that you have established a loyal following and are able to produce cartoons on a regular basis. Once you've built up a good collection of clips, submit at least 12 photocopied samples of your published work along with a brief cover letter.

Strips are handled a bit differently. Since they usually originate with the syndicate, it's not always necessary for them to have been previously published. Some syndicates even prefer to "discover" new strip artists and introduce them fresh to newspapers.

To submit a strip idea, send a brief cover letter that summarizes your idea, along with a character sheet (this shows your major characters along with their names and a description of each), and 24 strip samples on 8½ × 11 paper. By sending four weeks worth of samples, you'll show the syndicate that you're capable of rendering consistent characters, and that your idea is a lasting one. Don't ever submit originals; always make photocopies of your work and send those. It's OK to make simultaneous submissions to various syndicates.

Payment and contracts

Should you be one of the lucky few to be picked up by a syndicate, the amount you earn will depend on the number of publications in which your work appears and the

size of those publications. Whereas a top strip such as Garfield may be in as many as 2,000 papers worldwide, it takes a minimum of about 60 interested newspapers to make it worthwhile and profitable for a syndicate to distribute a strip.

Newspapers pay in the area of $10-15 a week for a daily feature. Your payment will be a percentage of gross or net receipts. Contracts usually involve a 50/50 split between the syndicate and the cartoonist. Magazine rates, however, tend to vary a bit more. Check the listings in this section for more specific information about terms of payment.

Before signing a contract with a syndicate, be sure you understand the terms and are comfortable with them. The most favorable contracts will offer the following:
- Creator ownership of the strip and its characters.
- Periodic evaluation of the syndicate's performance.
- A five-year contract without automatic renewal.
- A percentage of gross, instead of net, receipts.

Self-syndication

An alternative to consider is self-syndication. Self-syndicated cartoonists retain all rights to their work and keep all profits, but they also have to act as their own salespeople, sending packets to newspapers and other likely outlets. This requires developing a mailing list, promoting the strip (or panel) periodically, and developing a pricing, billing and collections structure. If you're a good businessperson and have the required time and energy, this might be the route for you.

Clip art

Clip art firms provide their clients—individuals, associations and businesses—with camera-ready illustrations, cartoons, spot drawings, borders and dingbat symbols. Some clip art books can be purchased in bookstores, but clients who are frequent users normally subscribe to a service and receive collections by mail once a month on disk, CD-ROM or in booklet format. Clip art is used in a variety of capacities, from newsletters to brochures to advertisements and more. In subscribing to a clip art service, clients buy the right to use the artwork as frequently as they wish.

Most clip art is b&w representational line art, rendered in a realistic or stylized manner. However, many firms are now offering a few special color reproductions with each monthly package. Collections usually fall into certain subject areas, such as animals, food, clothing or medicine. Most clip art firms keep track of consumer demands and try to offer images that cover current topics and issues. For example, many have begun to market more images with multicultural and environmental themes.

Artists cannot retain rights to work sold as clip art, since clip art is, by nature, virtually copyright free. Consequently, name credits are rarely given, although some firms will allow inclusion of a small monogram or logo alongside the artwork. Payment rates aren't astronomical, but there are advantages to working with clip art firms. For example, most give long lead times, which allow freelancers to work projects into their schedules at their convenience. Moreover, clip art businesses tend to pay in a very timely manner (some within 10 days of invoice).

ALLIED FEATURE SYNDICATE, P.O. Drawer 48, Joplin MO 64802-0048. (417)673-2860. Fax: (417)673-4743. Editor: Robert Blanset. Estab. 1940. Syndicate serving 50 outlets: newspapers, magazines, etc.
- Allied Features is the only agency syndicating cartoons solely geared toward electronics. Also owns separate syndicates for environmental, telecommunications, space and medical instruments fields. The same company also owns *ENN*, *The Lead Trader* and *Circuit News Digest*, a monthly electronics news magazine.

Needs: Approached by 100 freelancers/year. Buys from 1-10 freelancers/year. Introduces 25 new strips/year. Introductions include Outer Space by Ken Muse and Shuttlebutt by James Wright. Considers comic strips, gag cartoons, editorial/political cartoons. Considers single or multiple panel, b&w line drawings, with gagline. Prefers creative works geared toward business, the Space Program, electronics, engineering and environmental topics.

First Contact & Terms: Sample package should include cover letter, roughs, photocopies and 3 finished cartoon samples. One sample of each should be included. Samples are filed or are returned by SASE if requested by artist. Reports back within 90 days. Portfolio review requested if interested in artist's work. **Pays on acceptance**; flat fee of $10-50; or 50% of net proceeds. Negotiates rights purchased. Interested in buying second rights (reprint rights) to previously published artwork. Minimum length of contract is 5 years. Freelancer owns original art and the characters. "This is negotiable with artist. We always negotiate."

ART PLUS REPRO RESOURCE, P.O. Box 4710, Sarasota FL 34230-4710. (813)925-7754. Publisher: Wayne Hepburn. Estab. 1983. Clip art firm serving about 6,000 outlets, primarily churches, schools, associations and ministries.
- This clip art firm works one year ahead of publication, pays within 90 days of acceptance, accepts any seasonal material at any time, and has been using more digitized and computer images. They will furnish a list of topics needed for illustration.

Needs: Buys 40-60 cartoons and 500-1,000 freelance illustrations/year. Prefers illustrations and single panel cartoons and b&w line art with gagline. Maximum size is 7×10 and must be reducible to 20% of size without losing detail. "We need very graphic material." Prefers religious, educational and seasonal themes. Accepts camera ready line art or digital files: CDR, CGM, EPS, PCX, TIFF formats for Windows or Mac if digitized, perfers CGM.

First Contact & Terms: Send photocopies. Samples not filed are returned by SASE. Guidelines, catalog and sample available for 9×12 SAE with 4 first-class stamps. Reports back within 2 months. Portfolio review not required. Pays $15 for cartoons; $15-40 for spot or clip art. Buys all rights.

Tips: Finds artists through *Artist's & Graphic Designer's Market*. "All our images are published as clip art to be reproduced by readers in their bulletins and newsletters for churches, schools, associations, etc. We need art for holidays, seasons and activities; new material every three months. We want single panel cartoons, not continuity strips. We're currently looking for people images, ethnic and mixed races."

BENNETT PUBLISHING, 3400 Monroe Ave., Rochester NY 14618. (716)381-5450. President: Lois B. Bennett. Estab. 1978. Clip art firm serving schools. Guidelines not available.

Needs: Approached by 20 freelancers/year. Buys from 1 freelancer/year. Considers illustrations, spot drawings. Prefers educational themes.

First Contact & Terms: Sample package should include cover letter, résumé. "We contact artist when needed." **Pays on acceptance**. Buys all rights. Syndicate owns original art and characters.

BLACK CONSCIENCE SYNDICATION, INC., Dept. AGDM, 21 Bedford St., Wyandanch NY 11798. (516)491-7774. President: Clyde R. Davis. Estab. 1987. Syndicate serving regional magazines, schools, daily newspapers and television.

Needs: Considers comic strips, gag cartoons, caricatures, editorial or political cartoons, illustrations and spot drawings. Prefers single, double or multipanel cartoons. "All material must be of importance to the Black community in America and the world." Especially needs material on gospel music and its history. "Our new format is a TV video magazine project. This half hour TV program highlights our clients' material. We are accepting ½" tapes, 2 minutes maximum. Tape must describe the artist's work and provide brief bio of the artist. Mailed to 25 different Afrocentric publications every other month."

First Contact & Terms: Send query letter with résumé, tearsheets and photocopies. Samples are filed or are returned by SASE only if requested by artist. Reports back within 2 months. Portfolio review not required. Pays on publication; 50% of net proceeds. Considers client's preferences when establishing payment. Buys first rights.

Tips: "We need positive Afro-centric information. All material must be inspiring as well as informative. Our main search is for the truth."

ASHLEIGH BRILLIANT ENTERPRISES, 117 W. Valerio St., Santa Barbara CA 93101. (805)682-0531. Art Director: Ashleigh Brilliant. Estab. 1967. Syndicate and publisher. Outlets vary. "We supply a catalog and samples for $2 plus SASE."

Needs: Considers illustrations and complete word and picture designs. Prefers single panel. Maximum size of artwork 5½×3½, horizontal only.

These three images are just a few examples of clip art available through Dynamic Graphics Inc.'s Clipper Service. Subscribers to the service have access to "one of the world's largest clip art libraries," receiving more than 70 camera-ready images each month, which are also available on floppy disk or CD-ROM. Dynamic Graphics buys about 2,500 images a year (mostly black & white) for their products, 90-95% from freelancers. All images are purchased on a work-for-hire basis, with fees ranging from $50-1,000 depending on size, color and complexity of the work.

Tap the Power of Positive Cartooning

Johnny Hart remembers his first cartoon sale well. It was April of 1954 when Hart's wife, Bobby, came screaming from the mailbox of their small Georgia farm waving an envelope from *The Saturday Evening Post*. "We danced and sang and gorged ourselves on chocolate cake," recalls Hart.

The occasional sale wasn't enough to live on, so Hart took a day job at General Electric. Every night after dinner, no matter how tired he felt, Hart sat down at a rickety card table, took out his pen, dipped it in a fresh bottle of India ink, and drew until the white sheet came alive with characters.

Johnny Hart

One night none of his sketches seemed right. The characters he envisioned so clearly in his mind looked all wrong on the page. One after another, he scrunched each botched cartoon into a ball and threw it against the wall. Hours passed before he looked up and wearily rubbed his eyes, surrounded by piles of crumpled paper.

Hart reached for a fresh sheet. But as he did, his elbow jarred the unsteady table, causing the ink bottle to topple. Black ink splattered everywhere, soaking the night's best work. The normally laid back cartoonist lost it. He kicked over that wobbly table and hurled a fist full of pens and brushes across the room.

Bobby ran to the doorway to investigate the crash. After a moment of silence Hart looked up at her and stated with conviction: "Before my 27th birthday I'm going to have a nationally syndicated comic strip!"

Prophetically, B.C., Hart's first syndicated feature, appeared nationally on February 17, 1958, the eve of his 27th birthday. Today, B.C. is carried by more than 1,100 newspapers, has a worldwide readership of more than 100 million, and was awarded the Reuben, the National Cartoonist Society's highest honor.

Hart continued his nightly draw and pitch routine until he got some needed advice. "I thought I had to create characters unlike anyone had ever seen. I tried to invent original noses but my people looked like they had bird beaks. The characters looked grotesque instead of funny. Then somebody told me it was OK to borrow from other cartoonists."

So he analyzed the work of his idols. "I thought Virgil Partch was the Picasso of cartoonists; I liked the way John Gallagher drew feet, and how Dick Cavalli drew noses." He took what he liked from each cartoonist and pretty soon a style emerged. "You can't keep from bringing your own style to everything you do."

It was Bobby who suggested Hart base B.C.'s cavemen on people he knew "like those crazy guys at work you're always talking about." Once Hart pictured

his GE buddies in prehistoric garb, the ideas began to flow.

More help came from Brant Parker, the first gainfully employed cartoonist Hart ever met. Over pizza, Parker enlightened Hart about the finer points of their mutual profession. Years later the two collaborated on The Wizard of Id.

There's a lot to learn, says Hart, beginning with the profession's vocabulary. Some cartoonists use "ZZZZZZ" to indicate sleep or snoring, "I use the single 'Z' like Charles Schulz." Make up your own descriptive noises, or borrow "doink!," "gnidge!" and "bonk!" from Hart or other cartoonists. Develop expressions such as Schulz's "Good Grief!" (Hart uses "Great Zot!")

Keep drawings simple. Many of Hart's panels consist of a horizon, with an ant hill or a rock. "Focus on what's important." Use as few words as possible. "Hold impact words so they come last." Notice how comedians set up their jokes. Hart emulates the timing and delivery of Jack Benny.

Hart works out gags on 3×5 cards, then draws for maximum surprise. In B.C., a club appears in the third panel when Fat Broad pounds the snake. "If she had the club in the first panel, it would give the joke away."

After perfecting a gag for hours, you'll start to doubt if it's funny. "If you chuckled when you thought of it, it's funny," If an idea doesn't work, save it for later. Wizard of Id was an idea "laying on the shelf for six years" until he found a way to develop it.

"Have faith," advises Hart. When warned "Nobody buys cavemen," Hart kept at it. After B.C. was rejected by five major syndicates, Hart didn't give up. Faith kept him going. "I believed without a shadow of a doubt I would succeed."

—Mary Cox

Here's a look at the entire cast of Johnny Hart's well-known B.C. comic strip, syndicated by Creators Syndicate, Inc. to more than 1,000 newspapers daily.

First Contact & Terms: Samples are returned by SASE if requested by artist. Reports back within 2 weeks. **Pays on acceptance**; minimum flat fee of $50. Buys all rights. Syndicate owns original art.

Tips: "Our product is so unusual that freelancers will be wasting their time and ours unless they first carefully study our catalog."

CAROL BRYAN IMAGINES, THE LIBRARY IMAGINATION PAPER, 1000 Byus Dr., Charleston WV 25311. Editor: Carol Bryan. Estab. 1978. Syndicates clip art for 3,000 public and school libraries. Sample issue $1.

Needs: Buys 6-15 freelance illustrations/issue. Considers gag cartoons, illustrations and spot drawings. Prefers single panel; b&w line drawings. Prefers library themes—"not negative towards library or stereotyped (example: showing a spinster librarian with glasses and bun)." Prefers subjects dealing with "today's libraries—fax mediums, computers, equipment—good-looking librarians—upbeat ideas. It's a more-than-books-world now—it's the complete information place. Need more focus on school library items."

First Contact & Terms: Send query letter with tearsheets, photocopies and finished cartoons. Send no more than 6 samples. Samples are filed or are returned by SASE. Reports back within 3 weeks. Pays on publication; flat fee of $25. Buys one-time or reprint rights.

Tips: "Seeing a sample issue is mandatory—we have a specific, very successful style. Your style may blend with our philosophy. Need great cartoons that libraries can publish in their newsletters. We are interested in seeing more cartoons about the school library, fun and upbeat; and cartoons which show the latest, trendiest library activities and more of a multicultural consideration when drawing figures."

‡CATHOLIC NEWS SERVICE, 3211 Fourth St. NE, Washington DC 20017. (202)541-3250. Fax: (202)541-3255. Photos/Graphics Editor: Nancy Wiechec. Estab. 1920. Syndicate serving 160 Catholic newspapers. Guidelines not available.

Needs: Buys from 3 cartoonists and 3-5 illustrators/year. Considers single panel, editorial political cartoons and illustrations. Prefers religious, church or family themes.

First Contact & Terms: Sample package should include cover letter and roughs. Pays on publication. Rights purchased vary according to project.

CHRONICLE FEATURES, 870 Market St., Suite 1011, San Francisco CA 94102. (415)777-7212. Comics Editor: Susan Peters. Syndicate serving 1,600 daily, weekly and monthly newspapers, occasionally magazines. Guidelines available for #10 SASE.

Needs: Approached by 2,000 illustrators/year. Introduces 1 or 2 new strips/year. Considers comic strips and panels. "We have no preferred format, as long as the work is stellar and has a style all its own. We do not need spot drawings, caricatures or editorial/political cartoons. We already have artists covering these areas." Maximum size of artwork 8½×11; must be reducible to standard newspaper strip/panel size.

First Contact & Terms: Sample package should include cover letter, photocopies and SASE large enough to return response and/or work. 24 samples should be included. Samples are not filed and are returned by SASE only if requested by artist, otherwise not returned. Reports back within 6 weeks. To show portfolio, mail appropriate materials. Pays 50% of gross income. Buys all rights. Minimum length of contract is 5 years. Artist owns the original art and characters.

Tips: "Please send all inquiries by mail. We prefer to minimize telephone contact, as it interrupts the flow of our work."

COMMUNITY PRESS SERVICE, P.O. Box 639, Frankfort KY 40602. (502)223-1736. Editor: Gail Combs. Estab. 1990. Syndicate serving 200 weekly and monthly periodicals.

Needs: Approached by 15-20 cartoonists and 30-40 illustrators/year. Buys from 8-10 cartoonists and 4-5 illustrators/year. Introduces 1-2 new strips/year. Considers comic strips. Prefers single panel b&w line drawings with or without gagline. Maximum size of artwork 8½×11; must be reducible to 50% of original size.

First Contact & Terms: Sample package should include cover letter, finished cartoons, photocopies. 5-10 samples should be included. Samples are filed. Reports back within 2 months. Call for appointment to show portfolio of b&w final art. **Pays on acceptance**. Buys all rights. Offers automatic renewal. Syndicate owns original art; artist owns characters.

‡CONTINENTAL FEATURES/CONTINENTAL NEWS SERVICE, 341 W. Broadway, Suite 265, San Diego CA 92101. (619)492-8696. Director: Gary P. Salamone. Parent firm established August, 1981. Syndicate serving 3 outlets: house publication, publishing business and the general public through the *Continental Newstime* magazine.

● This syndicate is putting less emphasis on children's material in their mix of cartoon/comic features.

Needs: Approached by 200 cartoonists/year. Number of new strips introduced each year varies. Considers comic strips and gag cartoons. Does not consider highly abstract, computer-produced or stick-figure art. Prefers single panel with gagline. Maximum size of artwork 8×10, must be reducible to 65% of original size.

Jon Carter continually tries to make people laugh "through a variety of ridiculous, yet instantly recognizable scenarios." The cartoonist is represented by Future Features Syndicate, which he found through Artist's & Graphic Designer's Market. "Jon's drawing is clean and to the point," says Jerry Forney of Future Features. "His style is consistent, both in quality and character." Both Forney and Carter believe the marketplace is expanding for cartoonists with the growth of electronic media. For example, Carter's work will be distributed globally by a software company through e-mail programs. "You can (make it as a cartoonist) if you work hard and investigate your options," says Carter.

First Contact & Terms: Sample package should include cover letter, photocopies (10-15 samples). Samples are filed or are returned by SASE if requested by artist. Reports back within 1 month with SASE only if interested. To show portfolio, mail photocopies and cover letter. Pays 70% of gross income on publication. Rights purchased vary according to project. Minimum length of contract is 1 year. The artist owns the original art and the characters.

Tips: "We need single-panel cartoon and comic strips appropriate for adult readers of *Continental Newstime*."

‡CREATIVE SYNDICATION SUS, Box 40, Eureka MO 63025. (314)587-7126. Editor: Debbie Holly. Syndicate serving 400 daily and weekly newspapers. Guidelines not available.

Needs: Approached by 2-3 illustrators/year. Buys from 2-3 illustrators/year. Considers illustrations. Prefers double panel b&w line drawings. Maximum size of artwork 8½×11.

First Contact & Terms: Sample package should include roughs. 1-2 samples should be included. Samples are not filed. Reports back within 1 month. Mail appropriate materials. Portfolio should include roughs. Pays on publication; net proceeds. Rights purchased vary according to project. Offers automatic renewal. Syndicate owns original art; artist owns characters.

CREATORS SYNDICATE, INC., 5777 W. Century Blvd., Los Angeles CA 90045. (310)337-7003. Address work to Editorial Review Board—Comics. President: Richard S. Newcombe. Executive Vice President: Anita Tobias. Estab. 1987. Serves 2,400 daily newspapers, weekly and monthly magazines worldwide.

Needs: Syndicates 100 writers and artists/year. Considers comic strips, caricatures, editorial or political cartoons and "all types of newspaper columns."

First Contact & Terms: Send query letter with brochure showing art style or résumé and "anything but originals." Samples are not filed and are returned by SASE. Reports back in a minimum of ten weeks. Pays 50% of net proceeds. Considers saleability of artwork and client's preferences when establishing payment. Negotiates rights purchased.

Tips: "If you have a cartoon or comic strip you would like us to consider, we will need to see at least four weeks of samples, but not more than six weeks of dailies and two Sundays. If you are submitting a comic strip, you should include a note about the characters in it and how they relate to each other. As a general rule, drawings are most easily reproduced if clearly drawn in black ink on white paper, with shading executed in ink wash or Benday® or other dot-transfer. However, we welcome any creative approach to a new comic strip or cartoon idea. Your name(s) and the title of the comic or cartoon should appear on every piece of artwork. If you are already syndicated elsewhere, or if someone else owns the copyright to the work, please indicate this."

‡DEAR NEWSPAPERS, (publisher of *McLean Providence Journal, Arlington Courier* and *Great Falls Current*), Box 580, McLean VA 22101. (703)356-3320. Managing Editor: R. Cort Kirkwood. Estab. 1986. Publishes weekly newspapers covering Arlington, Great Falls, Falls Church, McLean and Tysons Corner, Virginia. Syndicates to weekly newspapers and local guide books.

Needs: Buys from 2 freelancers/year. Prefers local or Virginia artists. Considers comic strips, gag cartoons, caricatures, editorial or political cartoons, illustrations and spot drawings. Prefers pen & ink with washes.

First Contact & Terms: Send query letter with brochure or résumé and tearsheets. Samples are filed or are returned by SASE. Reports back only if interested. To show portfolio, mail tearsheets. Pays on publication; flat fee, $5-90. Considers clients' preferences when establishing payment. Negotiates rights purchased.

Tips: "We prefer local Northern Virginia freelancers who have local themes in their work."

DREAM MAKER SOFTWARE, 925 W. Kenyon Ave., #16, Englewood CO 80110. (303)762-1001. Fax: (303)762-0762. E-mail: dreammaker@eworld.com. Art Director: David Sutphin. Estab. 1986. Clip art firm, computer software publisher serving homes, schools, businesses, publishers, designers, ad agencies. Guidelines available for #10 SASE.

Needs: Approached by 6 freelancers/year. Considers cartoons, illustrations, spot drawings, "all work suitable for publication as clip art."

First Contact & Terms: Sample package should include cover letter. 8-12 samples should be included. Samples are not filed and are returned by SASE. Reports back to the artist in 1 month only if interested. Call for appointment to show portfolio of b&w final art. Pays 5-10% of gross income or $10-50 flat fee on publication. Rights purchased vary according to project.

DYNAMIC GRAPHICS INC., 6000 N. Forest Park Dr., Peoria IL 61614-3592. (309)688-8800. Art Director: Frank Antal. Distributes to thousands of magazines, newspapers, agencies, industries and educational institutions.

• Dynamic Graphics is a clip art firm and publisher of *Step-by-Step Graphics* magazine. Uses illustrators from all over the world; 99 percent of all artwork sold as clip art is done by freelancers. .

Needs: Works with 30-40 freelancers/year. Prefers illustration, graphic design and elements; primarily b&w, but will consider some 2- and full-color. "We are currently seeking to contact established illustrators capable of handling b&w and highly realistic illustrations of contemporary people and situations."

First Contact & Terms: Submit portfolio with SASE. Reports within 1 month. Buys all rights. Negotiates payment. **Pays on acceptance.**
Tips: "Concentrate on mastering the basics in anatomy and figure illustration before settling into a 'personal' or 'interpretive' style!"

THE ECONOMIC MONITOR WRITERS GROUP, P.O. Box 2268, Winter Park FL 32790-2268. Fax: (407)629-0762. Editor: Stephen Combs. Estab. 1995. Sample copies for 52¢ postage. Art guidelines not available.
Cartoons: Send query letter with roughs or finished cartoons. Samples are not filed. Reports back within 2 weeks. Buys one-time rights. Payment determined by number of subscribers.
Tips: "The Economic Monitor Writers Groups is a weekly syndicate for weekly newspapers and small dailies. We seek editorial cartoons from those who can produce at least one good cartoon a month. Our politics lean to the libertarian viewpoint: conservative, free market economics, low taxes, limited government. We do use other viewpoints occasionally, even those that conflict with our own. We also seek humor strips and one-panel cartoons (non-political) and illustrations for news features."

‡EDITORS PRESS SERVICE, INC., 330 W. 42nd St., 15th Floor, New York NY 10036. (212)563-2252. Fax: (212)563-2517. President: John P. Klem. Estab. 1933. Syndicate representative servicing 1,700 publications: daily and weekly newspapers and magazines. International sales only.
Needs: Buys from 3-5 freelancers/year. Introduces 1-2 new strips/year. Considers comic strips, gag cartoons, caricatures, editorial/political cartoons and illustrations. Considers single, double and multiple panel, pen & ink. Prefers non-American themes. Maximum size of artwork: 11 × 17. Does not accept unsolicited submissions.
First Contact & Terms: Send cover letter, finished cartoons, tearsheets and photocopies. Include 24-48 strips/panels. Does not want to see original artwork. Include SASE for return of materials. Pays 50% of gross income. Buys all rights. Minimum length of contract: 2 years. Artist owns original art and characters.
Tips: "Look for niches. Study, but do not copy the existing competition. Read the newspaper!" Looking for "well written gags and strong character development."

FILLERS FOR PUBLICATIONS, 7015 Prospect Place NE, Albuquerque NM 87110. (505)884-7636. President: Lucie Dubovik. Distributes to magazines and newspapers.
Needs: Buys 72 pieces/year from freelancers. Considers single panel, 4 × 6 or 5 × 7 cartoons on current events, education, family life, retirement, factory and office themes; clip art and crossword puzzles. Inquire for subject matter and format.
First Contact & Terms: Send query letter with samples of style and SASE. Samples are returned. Reports in 3 weeks. Previously published and simultaneous submissions OK. Buys first rights. **Pays on acceptance;** $7 for cartoons and line drawings; $25/page of clip art.
Tips: Does not want to see comic strips.

✦FOTO EXPRESSION INTERNATIONAL, Box 1268, Station "Q," Toronto, Ontario M4T 2P4 Canada. (905)935-2887. Fax: (905)935-2770. Director: M.J. Kubik. Serving 35 outlets.
Needs: Buys from 80 freelancers/year. Considers b&w and color single, double and multiple panel cartoons, illustrations and spot drawings.
First Contact & Terms: Send query letter with brochure showing art style or résumé, tearsheets, slides and photographs. Samples not filed are returned by SASE. Reports within 1 month. To show portfolio, mail final reproduction/product and color and b&w photographs. Pays on publication; artist receives percentage. Considers skill and experience of artist and rights purchased when establishing payment. Negotiates rights purchased.
Tips: "Quality and content are essential. Résumé and samples must be accompanied by a SASE; out of Canada, International Reply Coupon is required."

FUTURE FEATURES SYNDICATE, 1923 Wickham Rd., Suite 117, Melbourne FL 32935. (407)259-3822. Fax: (407)259-1471. E-mail: futrfeat@iu.net and penninc@aol.com. Creative Director: Jerry Forney. Estab. 1989. Syndicate markets to 1,500 daily/weekly newspapers. "Follow standard newspaper guidelines."
 • Future Features is introducing a home page on World Wide Web (http://spindara.iu.net/futrfeat/) that will give them global exposure with links to various other sites on a first come, first serve basis. They hope to market clip art and cartoon services this way, in addition to building a suscriber base for their features.
Needs: Approached by 400 freelancers/year. Introduces 5-10 new strips/year. Considers comic strips, gag cartoons, editorial/political cartoons, humorous strips featuring animals and contemporary drawing styles and clip art. Recent introductions include Fractured Facts by John Locke and Funny Files by Jon Carter. Prefers single, double and multiple panel with or without gagline; b&w line drawings. Prefers "unpublished, well designed art, themed for general newspaper audiences." Maximum size of artwork 8½ × 11 panel, 3½ × 14 strip: must be reducible to 25% of original size, suitable for scanning purposes. "We are interested

in cartoons produced on the Macintosh in illustrator, FreeHand, Photoshop, or Ray Dream Designer. We can review files saved as Pict, Tiff, Gif, Jpeg or Adobe Acrobat files."

First Contact & Terms: Sample package should include cover letter, photocopies and a short paragraph stating why you want to be a syndicated cartoonist. 12 samples should be included. Samples are filed or are returned only if SASE is included. Reports back within 4-6 weeks. Portfolio review not required, but portfolio should not include original/final art. Pays on publication; 50% of gross income. Buys first rights. Minimum length of contract is 2 years. Artist owns original art; syndicate owns characters.

Tips: "Avoid elaborate résumés; short bio with important career highlights/achievements is preferable. Include clean, clear copies of your best work. Don't send binders or bound collections of features; loose samples on 8½×11 bond paper are preferable."

‡GRAHAM NEWS SERVICE, (formerly Paula Royce Graham), 2770 W. Fifth St., Suite 20 G, Brooklyn NY 11224. (718)372-1920. Contact: Paula Royce Graham. Syndicates to newspapers and magazines.

Needs: Considers b&w illustrations. Uses freelancers for advertising and graphics.

First Contact & Terms: Send business card and samples to be kept on file. Samples returned by SASE only if requested. Reports within days. Write for appointment to show portfolio. Pays on publication; negotiable. Considers skill of artist, client's preferences and rights purchased when establishing payment. Buys all rights.

Tips: "Keep it simple—one or two samples."

‡GROUP PUBLISHING-BOOK & CURRICULUM DIVISION, 2890 N. Monroe, Loveland CO 80538. (303)669-3836. Fax: (303)669-3269. Art Director: Lisa Smith. Clip art firm. Publishes clip art and curriculum products for use in Christian education (Sunday school, youth ministry, etc.) for children, youth and adults.

• This company also publishes books and magazines, and produces posters and puzzles. See listing in Magazines section for more information.

HISPANIC LINK NEWS SERVICE, 1420 N St. NW, Washington DC 20005. (202)234-0737. Fax: (202)234-4090. Editor: Jonathan J. Higuera. Syndicated column service to 100 newspapers and a newsletter serving 1,300 subscribers: "movers and shakers in the Hispanic community in U.S., plus others interested in Hispanics."

Needs: Buys from 20 freelancers/year. Considers single panel cartoons; b&w, pen & ink line drawings. Introductions include In the Dark by Clyde James Aragon and Editorial by Alex Gonzalez. Work should have a Hispanic angle; "most are editorial cartoons, some straight humor."

First Contact & Terms: Send query letter with résumé and photocopies to be kept on file. Samples not filed are returned by SASE. Reports within 3 weeks. Portfolio review not required. **Pays on acceptance**; $25 flat fee (average). Considers clients' preferences when establishing payment. Buys reprint rights and negotiates rights purchased. "While we ask for reprint rights, we also allow the artist to sell later."

Tips: Interested in seeing more cultural humor. "While we accept work from all artists, we are particularly interested in helping Hispanic artists showcase their work. Cartoons should offer a Hispanic perspective on current events or a Hispanic view of life."

‡INTERPRESS OF LONDON AND NEW YORK, 400 Madison Ave., New York NY 10017. (212)832-2839. Editor/Publisher: Jeffrey Blyth. Syndicates to several dozen European magazines and newspapers.

Needs: Buys from 4-5 freelancers/year. Prefers material which is universal in appeal; no "American only" material.

First Contact & Terms: Send query letter and photographs; write for artists' guidelines. Samples not kept on file are returned by SASE. Reports within 3 weeks. Purchases European rights. Pays 60% of net proceeds on publication.

JODI JILL FEATURES, 1705 14th St., Suite 321, Boulder CO 80302. Art Editor/President: Jodi Jill. Estab. 1983. Syndicate serving "hundreds" of newspapers, magazines, publications. Art guidelines not available.

Needs: Approached by 250 freelancers/year. "We try to average ten new strips per year." Considers comic strips, editorial/political cartoons and gag cartoons. "Looking for silly, funny material, not sick humor on lifestyles or ethnic groups." Introductions include From My Eyes by Arnold Peters and Why Now? by Ralph Stevens. Prefers single, double and multiple panel b&w line drawings. Needs art, photos and columns that are visual puzzles. Maximum size of artwork 8½×11.

First Contact & Terms: Sample package should include cover letter, résumé, tearsheets, finished cartoons and photocopies. 6 samples should be included. Samples are not filed and are returned by SASE if requested by artist. Portfolio review requested if interested in artist's work. Reports back within 1 month. Portfolio should include b&w roughs and tearsheets. **Pays on acceptance**; 40-50% of net proceeds. Negotiates rights purchased. Minimum length of contract is 1 year. The artist owns original art and characters.

Tips: Finds artists "by keeping our eyes open and looking at every source possible. Would like to see more puzzles with puns in their wording and visual effects that say one thing and look like another. We like to deal in columns. If you have a visual puzzle column we would like to look it over. Some of the best work is unsolicited."

A.D. KAHN, INC., 24901 Northwestern, Suite 3168, Southfield MI 48057-2207. (810)355-4100. Fax: (810)356-4344. President/Editor: David Kahn. Estab. 1960. Syndicate serving daily and weekly newspapers, monthly magazines. Art guidelines not available. Introductions include Zoolies (captionless cartoon).
Needs: Approached by 24-30 freelancers/year. Represents 1-2 freelancers/year. Introduces 1-2 new strips/year. Considers comic strips, editorial/political cartoons, gag cartoons, puzzles/games.
First Contact & Terms: Sample package should include material that best represents artist's work. Files samples of interest; others returned by SASE if requested by artist. Pays 50% of net proceeds. Negotiates rights purchased according to project. The artist owns original art and characters.

KING FEATURES SYNDICATE, 235 E. 45th St., New York NY 10017. (212)455-4000. Comics Editor: Jay Kennedy. Estab. 1915. Syndicate servicing 3,000 newspapers. Guidelines available for #10 SASE.
- This is one of the oldest, most established syndicates in the business. It runs such classics as Blondie, Hagar, Dennis the Menace and Beetle Bailey and such contemporary strips as Zippy the Pinhead and Ernie. If you are interested in selling your cartoons on an occasional rather than fulltime basis, refer to the listings for The New Breed and Laff-A-Day (also run by King Features).
Needs: Approached by 6,000 freelancers/year. Introduces 3 new strips/year. Considers comic strips and single panel cartoons. Prefers humorous single or multiple panel, and b&w line drawings. Maximum size of artwork 8½×11. Comic strips must be reducible to 6½″ wide; single panel cartoons must be reducible to 3½″ wide.
First Contact & Terms: Sample package should include cover letter, character sheet that names and describes major characters and photocopies of finished cartoons. "Résumé optional but appreciated." 24 samples should be included. Returned by SASE. Reports back within 6 weeks. Pays 50% of net proceeds. Rights purchased vary according to project. Artist owns original art and characters. Length of contract and other terms negotiated.
Tips: "We look for a uniqueness that reflects the cartoonist's own individual slant on the world and humor. If we see that slant, we look to see if the cartoonist is turning his or her attention to events that other people can relate to. We also very carefully study a cartoonist's writing ability. Good writing helps weak art, better than good art helps weak writing."

LAFF-A-DAY, %King Features Syndicate, 235 E. 45th St., New York NY 10017. (212)455-4000. Contact: Laff-A-Day Editors. Estab. 1936. Syndicated feature. "Showcases single panel gag cartoons with a more traditional approach."
Needs: Reviews 3,000 cartoons/year. Buys 312 cartoons/year. Maximum size of artwork 8½×11. Must be reducible to 3½″ wide.
First Contact & Terms: "Submissions should include 10-25 single panel cartoons per batch. Cartoons should be photocopied 1 per page and each page should have cartoonist's name and address on back. All submissions must include SASE large enough and with enough postage to return work. No original art." Reports back within 6 weeks. **Pays on acceptance**; flat fee of $50.

LEW LITTLE ENTERPRISES, INC., P.O. Box 47, Bisbee AZ 85603-0047. (520)432-8003. Editor: Lew Little. Estab. 1986. Syndicate serving all daily and weekly newspapers. Guidelines available for legal SAE with 1 first-class stamp.
Needs: Approached by 300-400 artists/year. Buys from 1-2 artists/year. Introduces 1-2 new strips/year. Considers comic strips, editorial/political cartoons and gag cartoons. Prefers single or multiple panel with gagline.
First Contact & Terms: Sample package should include cover letter ("would like to see an intelligent cover letter"), résumé, roughs and photocopies of finished cartoons. Minimum of 12 samples should be included. Samples are not filed and are returned by SASE. Reports back within 6 weeks. Schedule appointment to show portfolio or mail final reproduction/product, b&w roughs, tearsheets and SASE. Pays on publication; negotiable percentage of net proceeds. Negotiates rights purchased. Minimum length of contract 5 years. Offers automatic renewal. Artist owns original art and syndicate owns characters during the contract term, after which rights revert to artist.
Tips: Does not want to see "bulky portfolios or elaborate presentations."

LOS ANGELES TIMES SYNDICATE, 218 S. Spring St., Los Angeles CA 90012. (213)237-7987. General Manager: Steven Christensen. (213)237-3213.
Needs: Considers comic strips, panel cartoons and editorial cartoons. "We prefer humor to dramatic continuity and general illustrations for political commentary. We consider only cartoons that run six or seven days/week. Cartoons may be of any size, as long as they're to scale with cartoons running in newspapers." (Strips usually run approximately 6⅞6×2; panel cartoons 3⅛×4; editorial cartoons vary.)
First Contact & Terms: Submit photocopies or photostats of 24 dailies. Submitting Sunday cartoons is optional; if you choose to submit them, send at least four. Reports within 2 months. Include SASE.
Tips: Finds artists through word of mouth, submissions, newspapers. "Don't imitate cartoons that are already in the paper. Avoid linework or details that might bleed together, fade out or reproduce too small to be seen

clearly. We hardly ever match artists with writers or vice versa. We prefer people or teams who can do the entire job of creating a feature."

‡MASTERS AGENCY, 703 Ridgemark Dr., Hollister CA 95023. (408)637-9795. Publisher: George Crenshaw. Estab. 1961. Magazine gag-cartoon publisher.
Cartoons: Buys 100 cartoons/year. Prefers single panel with gagline. Wants finished roughs, accepts previously published clips. Samples are not filed and are returned by SASE. Reports back within 1 month. Buys reprint rights. Pays $20/cartoon.
Tips: "We carefully review all submissions." Seeks cartoons on the following topics: computers, environment, farm, motor homes and rec vehicles, physical fitness, industrial safety, senior citizens, trucks, ecology, medical, hospitals, women executives, women winning, sales and insurance. Write for additional categories needed.

METRO CREATIVE GRAPHICS, INC., 33 W. 34th St., New York NY 10001. (212)947-5100. Fax: (212)714-9139. Contact: Linda Kennedy. Estab. 1910. Creative graphics/art firm. Distributes to 6,000 daily and weekly paid and free circulation newspapers, schools, graphics and ad agencies and retail chains.
Needs: Buys from 100 freelancers/year. Considers all styles of illustrations and spot drawings; b&w and color. Editorial art or cartoons for syndication not considered. Special emphasis on computer-generated art for Macintosh. Send floppy disk samples using Adobe Illustrator 5.0. Prefers all categories of themes associated with retail, classified, promotion and advertising. Also needs covers for special-interest tabloid sections.
First Contact & Terms: Send query letter with brochure, photostats, photocopies, slides, photographs or tearsheets to be kept on file. Samples not filed are returned by SASE. Reports only if interested. Works on assignment only. **Pays on acceptance**; flat fee of $25-1,500. Considers skill and experience of artist, saleability of artwork and clients' preferences when establishing payment.
Tips: "We are extremely impressed by illustrators who have a working knowledge of trapping for 4-color artwork. This makes the printing of the artwork much easier."

MIDWEST FEATURES INC., P.O. Box 9907, Madison WI 53715-0907. (608)274-8925. Editor/Founder: Mary Bergin. Estab. 1991. Syndicate serving daily/weekly newspapers and other Wisconsin/Midwest publications. Guidelines not available.
Needs: Approached by dozens of freelancers/year. Buys from 2-3 freelancers/year. Freelaners most likely to get 1-shot assignments. Considers comic strips, editorial/political cartoons and illustrations. Prefers single panel and b&w line drawings without gagline. Emphasis on Wisconsin/Midwest material is mandatory.
First Contact & Terms: Sample package should include cover letter, résumé, tearsheets and 8½ × 11 photocopies. "No originals!" 6 samples should be included. Samples are filed. Reports back to the artist only if interested or if artist sends SASE. Pays on publication; 50% of gross income. Rights purchased vary according to project. Minimum length of contract one year for syndication work. Offers automatic renewal. Artist owns original art and characters.
Tips: "Do not send originals. Phone calls are not appreciated."

‡MILESTONE GRAPHICS, 1093 A1A Beach Blvd., #388, St. Augustine FL 32084. (904)823-9962. Owner: Jill O. Miles. Estab. 1993. Clip art firm providing targeted markets with electronic graphic images.
Needs: Buys from 20 illustrators/year.
First Contact & Terms: Sample package should include non-returnable photocopies or samples on computer disk. Interested in b&w and some color illustrations. All styles and media are considered. Macintosh computer drawings accepted (Adobe Illustrator preferred). "Ability to draw people a plus, buy many other subject matters needed as well." Reports back to the artist only if interested. Pays flat fee of $25 minimum/illustration, based on skill and experience. A series of illustrations is often needed.

‡PEDRO MORENO'S ENTERPRISES, 4035 W. Vanderbilt, Corpus Christi TX 78415. (512)853-5406. Fax: (512)857-2424. Art Director: Pedro Moreno. Estab. 1975. Syndicate serving 100 daily, weekly and monthly newsletters, magazines and newspapers. Guidelines available for $10.
Needs: Approached by 200 cartoonists and 100 illustrators/year. Buys from 25 cartoonists and 10 artists/year. Considers comic strips, editorial political cartoons, gag cartoons, illustrations, caricatures, spot drawings, Sunday strips. Prefers single or multiple panel b&w line drawings. Family-oriented comic material only. Also uses freelancers for book covers, illustrations. Artwork must be reducible to 65% of original size.
First Contact & Terms: Sample package should include cover letter, résumé, tearsheets, finished cartoons, newspaper comic page size. 6-12 samples should be included. Samples are not filed and are returned only if SASE is included. Reports back within 1-2 weeks. To show portfolio, mail b&w final art. Pays on publication; 50% of gross income. Negotiates rights purchased. Minimum length of contact is 3 years. The artist owns original art and characters.
Tips: "I want to receive comic features for the family audience. Submit reduced comic feature plus photo of artist and résumé. Request guidelines before submission."

NATIONAL NEWS BUREAU, Box 43039, Philadelphia PA 19129. (215)546-8088. Editor: Harry Jay Katz. Syndicates to 300 outlets and publishes entertainment newspapers on a contract basis.

Needs: Buys from 500 freelancers/year. Prefers entertainment themes. Uses single, double and multiple panel cartoons, illustrations; line and spot drawings.
First Contact & Terms: To show portfolio, send samples and résumé. Samples returned by SASE. Reports within 2 weeks. Returns original art after reproduction. Send résumé and samples to be kept on file for future assignments. Negotiates rights purchased. Pays on publication; flat fee of $5-100 for each piece.

THE NEW BREED, %King Features Syndicate, 235 E. 45th St., New York NY 10017. (212)455-4000. Contact: *The New Breed* Editors. Estab. 1989. Syndicated feature.
• *The New Breed* showcases single panel gag cartoons done by cartoonists with a contemporary or wild sense of humor. *The New Breed* is a place where people can break into newspaper syndication without making a commitment to producing a comic on a daily basis. The feature is intended as a means for King Features to encourage and stay in touch with promising cartoonists who might one day develop a successful strip for regular syndication.
Needs: Reviews 30,000 cartoons/year. Buys 500 cartoons/year. Maximum size of artwork 8½×11; must be reducible to 3½ wide.
First Contact & Terms: "Submissions should include 10-25 single panel cartoons per batch. The cartoons should be photocopied one per page and each page should have cartoonist's name and address on back. All submissions must include SASE large enough and with enough postage to return work. Do not send originals." Reports back within 6 weeks. **Pays on acceptance**; flat fee of $50. Buys first worldwide serial rights.

NEW ENGLAND MOTORSPORTS/INTERNATIONAL MOTORSPORTS SYNDICATES, 84 Smith Ave., Stoughton MA 02072. (617)344-3827. Estab. 1988. Syndicate serving 15 daily newspapers, motorsports trade weeklies. Art guidelines not available.
Needs: Considers sports pages material. Prefers single panel, motorsports motif. Maximum size 1 column.
First Contact & Terms: Sample package should include cover letter and 1 sample. Samples are filed. Reports back within 1 week. To show a portfolio, mail original/final art. **Pays on acceptance**; flat fee of $5. Syndicate owns original art and characters.

REPORTER, YOUR EDITORIAL ASSISTANT, 7015 Prospect Place NE, Albuquerque NM 87110. (505)884-7636. Editor: George Dubow. Syndicates to newspapers and magazines for secondary level schools and colleges.
Needs: Considers single panel cartoons on teenage themes.
First Contact & Terms: Mail art and SASE. Reports in 3 weeks. Buys first rights. Originals returned to artist only upon request. Pays $5-10.
Tips: Does not want to see comic strips.

‡SALMON SYNDICATION, 717 Alabama St., Vallejo CA 94590-4403. (707)552-1699. Syndicated comics serving 42 newspapers. Guidelines not available.
Needs: Approached by 25-50 freelancers/year. Prefers single panel. Prefers subtle, mature material.
First Contact & Terms: Sample package should include cover letter and photocopies. 6-18 samples should be included. Samples are filed or are returned by SASE if requested. Reports back to the artist only if interested. To show portfolio, mail appropriate materials, including photostats. Artist owns original art and characters.
Tips: "We're not looking for material at this time, but will consult with SASE."

SAM MANTICS ENTERPRISES, P.O. Box 77727, Menlo Park CA 94026. (415)854-9698. E-mail: corrcook @syndicate.com or corrcook@aol.com. President: Carey Cook. Estab. 1988. Syndicate serving schools, weekly newspapers. Guidelines not available.
• Sam Mantics has an Internet home page at URL of http://syndicate.com.
Needs: Approached by 25-40 artists/year. Considers comic strips, word puzzles, word games and educational text. Prefers multiple panel comic strips and b&w line drawings. Prefers themes relating to educational stimulating, training and vocabulary. Maximum size of artwork 11×17; must be reducible to 65% of original size.
First Contact & Terms: Sample package should include cover letter, photocopies of finished cartoons. 20 samples should be included. Samples not filed and are returned by SASE if requested by artist. Reports back within 1 month. To show portfolio, mail tearsheets. Pays on publication. Rights purchased vary according to project. The artist owns original art and characters.

A bullet introduces comments by the editor of Artist's & Graphic Designer's Market *indicating special information about the listing.*

Tips: Finds artists through submissions. "The World Wide Web and the Internet have become the preferred way to communicate educational ideas. Stimulating products can now be shown on the Internet with instantaneous distribution."

SINGER MEDIA CORP., 1030 Calle Cordillera, Unit #106, San Clemente CA 92673-6234. (714)498-7227. Executive Vice President: Katherine Han. Syndicates to 300 worldwide magazines, newspapers, book publishers and poster firms. Geared toward the family, business management. Artists' guidelines $2.
 • Oceanic Press Service is also run by this company. This syndicate provides a list of subjects they're interested in covering through cartoons. Ask for this list when you write for guidelines.
Needs: Syndicates several hundred pieces/year. Considers single, double and multiple panel cartoon strips; family, children, juvenile activities, games and puzzles themes. Especially needs business, outer space, credit card and computer cartoons of 3-4 panels. Cartoonists who exemplify tone and style we want are Shirvanian, Stein, Day. Introductions include Golf by Lo Linkert and Fantastic Facts by Fred Treadgold. Prefers to buy reprints or clips of previously published material. Prefers color cartoons.
First Contact & Terms: To show portfolio, send query letter with tearsheets. Show 10-12 samples. "Prefer to see tearsheets or camera ready copy or clippings. No computer-generated art." Include SASE. Reports within 2-3 weeks. Returns cartoons to artist at job's completion if requested at time of submission with SASE. Licenses reprint or all rights; prefers foreign reprint rights. Do not send originals. Pays 50% of gross income. Pays a $5-200 flat fee/cartoon.
Tips: "Current daily themes needed: phone answering machines, credit card, job hunting, computers, fax, technology, golf, baseball, women executives (positive), lay offs, world trade. Good cartoonists show more than 2 people talking. They give detailed backgrounds. More sophisticated people are needed. Study *The New Yorker*'s cartoons. We have opened up worldwide markets."

STATON GRAPHICS, P.O. Box 618, Winterville GA 30683-0618. President: Bill Staton. Syndicates almost exclusively to weekly newspapers. Art guidelines available for #10 SASE.
Needs: Approached by 100 cartoonists/year. Buys from 1-2/year. Introduces 1-2 new strips/year. Considers comic strips and gag cartoons.
First Contact & Terms: Sample package should include minimum of 12 photocopied samples. Samples not filed are returned by SASE. Pays 50% of gross income at time of sale. Rights purchased vary according to project. Artist owns original art and characters.
Tips: Finds artists through word of mouth, sourcebooks. Also offers critique service for $15 fee. "Sloppy lettering is an automatic rejection. We are not looking for the next Far Side, so don't send us your version. We are impressed with funny, well-drawn cartoons."

TRIBUNE MEDIA SERVICES, INC., 435 N. Michigan Ave., Suite 1500, Chicago IL 60611. (312)222-4444. Editor: Michael A. Silver. Syndicate serving daily and Sunday newspapers. Introductions include Bound & Gagged (strip) by Dana Summers, Dave (strip) by David Miller, Pluggers (comic panel) by Jeff Macnelly, Bottom Liners (comic panel) by Eric and Bill Teitelbaum. "All are original comic strips, visually appealing with excellent gags."
Needs: Seeks comic strips and newspaper panels. Prefers original comic ideas, with excellent art and timely, funny gags; original art styles; inventive concepts; crisp, funny humor and dialogue.
First Contact & Terms: Send query letter with résumé and photocopies. Sample package should include 2-3 weeks of daily strips or panels. Samples not filed are returned only if SASE is enclosed. Reports within 4-6 weeks. Pays 50% of net proceeds.

‡UNITED NEWS SERVICE, 48 Scribner Ave., Staten Island NY 10301. (718)981-2365. Fax: (718)981-6292. Assignment Desk: Jane Marie Johnson. Estab. 1979. Syndicate servicing 600 regional newspapers. Guidelines not available. Considers caricatures, editorial political cartoons, illustrations and spot drawings. Prefers b&w line drawings.
First Contact & Terms: Sample package should include cover letter and résumé. Samples are filed or returned by SASE if requested. Reports back within weeks. Mail appropriate materials. Pays on publication; $50-100. Buys reprint rights. Syndicate owns original art; artist owns characters.

WHITEGATE FEATURES SYNDICATE, 71 Faunce Dr., Providence RI 02906. (401)274-2149. Talent Manager: Eve Green. Estab. 1988. Syndicate serving daily newspapers internationally, book publishers and magazines. Introduced Dave Berg's Roger Kaputnik.

For a list of markets interested in humorous illustration, cartooning and caricatures, refer to the Humor Index at the back of this book.

• Whitegate is looking for fine artists and illustrators for book publishing projects.

Needs: "We're planning on introducing more strips next year." Considers comic strips, gag cartoons, editorial/political cartoons, illustrations and spot drawings; single, double and multiple panel. Work must be reducible to strip size. Also needs artists for advertising and publicity.

First Contact & Terms: Send cover letter, résumé, tearsheets, photostats and photocopies. Include about 12 strips. To show portfolio, mail tearsheets, photostats, photographs and slides; include b&w. Pays 50% of net proceeds upon syndication. Negotiates rights purchased. Minimum length of contract 5 years (flexible). Artists owns original art; syndicate owns characters (negotiable).

Tips: Include in a small sample package "info about yourself, tearsheets of previous work, notes about the strip and enough samples to tell what it is. Please don't write asking if we want to see; just send samples." Looks for "good writing, strong characters, good taste in humor. No hostile comics. We like people who have been cartooning for a while and have been printed. Try to get published in local newspapers first."

Syndicate/Clip Art Firms/'95-'96 changes

The following companies were listed in the 1995 edition but do not have listings in this edition. The majority did not respond to our request to update their listings. If a reason was given for exclusion, it appears in parentheses after the company's name.

City News Service
Comic Art Therapy Services
Graphic News Bureau

Health Care PR Graphics
Oceanic Press Service
Teenage Corner Inc.

T/Maker Company
United Cartoonist Syndicate
United Media

Resources

Artists' Reps

What if you are so busy *creating* work you don't have time to market it? Many artists find leaving the promotion to an artists' rep allows them more time to devote to the creative process. In exchange for actively promoting an artist's career, the representative receives a percentage of the artist's sales (usually 25-30%).

The listings in this section include fine art and commercial artists' reps (for illustrators). Reps concentrate on either the commercial or fine art markets, rarely both. Very few reps handle designers.

Reps are responsible for presenting artwork to the right people so that it sells. Fine art reps promote the work of fine artists, sculptors, craftspeople and fine art photographers to galleries, museums, corporate art collectors, interior designers and art publishers. Commercial art reps help illustrators obtain assignments from advertising agencies, publishers, corporations, magazines and other art buyers; negotiate contracts; and handle billing and collection of invoices.

An artist's rep will often work with an illustrator to help bring a portfolio up-to-speed. The rep might recommend purchasing an advertisement in one of the many creative directories such as *American Showcase* or *Creative Illustrator* so that your work will be seen by hundreds of art directors or advise advertising in a fine arts magazine. Expect to make an initial investment in costs for duplicate portfolios and mailings. Rep Bob Berendsen explains how this investment can pay off for illustrators on page 648.

Getting representation isn't as easy as you might think. Reps are very choosy about who they will represent, not just in terms of talent, but in terms of marketability and professionalism. They have extensive knowledge of various markets, trends and prices. A rep will only take on talent she believes in and knows will sell.

Start by approaching a rep with a brief query letter and direct mail piece, if you have one. If you do not have a flier or brochure, send photocopies or (duplicate) slides along with a self-addressed, stamped envelope. Check the listings in this section for more specific submission information.

The Society of Photographers and Artists Representatives (SPAR) is an organization for professional representatives. SPAR members are required to maintain certain standards and follow a code of ethics. For more information on the group, write to SPAR, 60 E. 42nd St., Suite 1166, New York NY 10165, phone (212)779-7464.

One final note: artists' reps are hired to sell artwork. Artists' advisors, on the other hand, are consultants hired by artists to advise them on marketing strategies. Advisors usually work short term and are paid hourly rates. They advertise in arts magazines, or find clients through word of mouth. Some write books on the subject and/or offer marketing seminars. So if you feel you aren't ready to contract with a rep, you might want to seek out an advisor who can help get your career rolling.

ADMINISTRATIVE ARTS, INC., P.O. Box 547935, Orlando FL 32854-1266. (407)849-9744. President: Brenda B. Harris. Fine art advisor. Estab. 1983. Registry includes 1,000 fine artists (includes fine art crafts). Markets include: architects; corporate collections; developers; private collections; public art.
Handles: Fine art. "We prefer artists with established regional and national credentials. We also review and encourage emerging talent."
Terms: "Trade discount requested varies from 15-50% depending on project and medium."
How to Contact: "For first contact, submissions must include: (1) complete résumé; (2) artist's statement or brief profile; (3) labeled slides (artist's name, title of work, date, medium, image size and *retail price*); (4) availability of works submitted."SASE. Reports in 1-3 weeks.
Tips: "Artists are generally referred by their business or art agent, another artist or art professional, educators, or art editors who know our firm. A good impression starts with a cover letter and a well organized, typed résumé. *Always place your name and slide identification on each slide.* Make sure that slides are good representations of your work. Know your retail and net pricing and the standard industry discounts. Invite the art professional to visit your studio. To get placements, be cooperative in getting art to the art professional when and where it's needed."

‡AIR STUDIO, INC., The Illustrators' Representative, 203 E. Seventh St., Cincinnati OH 45202. (513)721-1193. Fax: (513)721-1202. Illustrators' Rep.: Gregg Martini. Commercial illustration representative. Estab. 1982. Markets include: advertising agencies, corporations/client direct, design firms, editorial/magazines, publishing/books, packaging.
Handles: Illustration.
Terms: Rep receives 30% commission. Advertising costs are split: 70% paid by talent; 30% paid by representative. For promotional purposes, "talent must provide original art that we shoot to 4×5 transparencies."
How to Contact: For first contact, send query letter. Reports back within 15 days. After initial contact, call to schedule an appointment for portfolio review. Portfolio should include original art, tearsheets, slides, photographs.
Tips: "I look for strong ethical guidelines, communication skills, work ethic and, above all, talent with a specific, recognizable style in work."

‡ANNE ALBRECHT AND ASSOCIATES, 68 E. Wacker Place, Suite 200, Chicago IL 60601. Agent: Anne Albrecht. Commercial illustration, photography representative. Estab. 1991. Member of SPAR, Graphic Artists Guild. Represents 7 illustrators, 3 photographers. Markets include advertising agencies, corporations/client direct, design firms, editorial/magazines.
Handles: Illustration, photography.
Terms: Rep receives 25% commission. Exclusive area representation is required. For promotional purposes, talent must provide a presentation portfolio and advertise in a national sourcebook. Advertises in *American Showcase, Creative Black Book, The Workbook.*
How to Contact: For first contact, send direct mail flier/brochure, tearsheets. Reports back within 2 days. After initial contact drop off or mail in appropriate materials. Portfolio should include tearsheets, slides, photographs.
Tips: Looks for artists who are "motivated, easy to work with, and have great portfolios."

‡FRANCE ALINE ASSOCIATES, 1076 S. Ogden Dr., Los Angeles CA 90019. (213)933-2500. Fax: (213)933-2081. Owner: France Aline. Commercial illustration, photography and graphic design representative. Represents illustrators, photographers, designers. Specializes in advertising. Markets include: advertising, corporations, design firms, movie studios, record companies.
Handles: Illustration, photography. Sometimes needs illustrations for movie posters.
Terms: Rep receives 25% commission. Exclusive area representation is required. 100% of advertising costs paid by the talent. Advertises in *American Showcase, The Workbook.*
How to Contact: For first contact, send tearsheets. Reports back within a few days. Mail in appropriate materials. Portfolio should include tearsheets, photographs.

AMERICAN ARTISTS, REP. INC., 353 W. 53rd St., #1W, New York NY 10019. (212)582-0023. Fax: (212)582-0090. Commercial illustration representative. Estab. 1930. Member of SPAR. Represents 30 illustrators. Markets include: advertising agencies; corporations/client direct; design firms; editorial/magazines; paper products/greeting cards; publishing/books; sales/promotion firms.
Handles: Illustration, design.
Terms: Rep receives 30% commission. "All portfolio expenses billed to artist." Advertising costs are split: 70% paid by talent; 30% paid by representative. "Promotion is encouraged; portfolio must be presented in a professional manner—8×10, 4×5, tearsheets, etc." Advertises in *American Showcase, Creative Black Book, RSVP, The Workbook,* medical and Graphic Artist Guild publications.
How to Contact: For first contact, send query letter, direct mail flier/brochure, tearsheets. Reports in 1 week if interested. After initial contact, drop off or mail appropriate materials for review. Portfolio should include tearsheets, slides.
Tips: Obtains new talent through recommendations from others, solicitation, conferences.

JACK ARNOLD FINE ART, 5 E. 67th St., New York NY 10021. (212)249-7218. Fax: (212)249-7232. Contact: Jack Arnold. Fine art representative. Estab. 1979. Represents 15 fine artists (includes 1 sculptor). Specializes in contemporary graphics and paintings. Markets include: galleries; museums; private collections; corporate collections.
Handles: Looking for contemporary impressionists and realists.
Terms: Agent receives 50% commission. Exclusive area representation preferred. No geographic restrictions. To be considered, talent must provide color prints or slides.
How to Contact: For first contact, send bio, photographs, retail prices and SASE. Reports in days. After initial contact, drop off or mail in portfolios of slides, photographs.
Tips: Obtains new talent through referrals.

‡THE ART DIRECTOR'S STUDIO, INC., 419 Park Ave. S., Suite 907, New York NY 10016. (212)689-9888. Fax: (212)689-7548. President: Meredith Stern. Commercial illustration representative. Estab. 1985. Member of Graphic Artists Guild. Represents 20 illustrators. Specializes in comp art, storyboards, animatics. Markets include advertising agencies.
Handles: Wants illustrators experienced in magic marker comp art.
Terms: 100% of advertising costs paid by the representative. Advertises in *American Showcase*.
How to Contact: For first contact, send résumé, direct mail flier/brochure, photostats. Reports back within 10 days. After initial contact, call to schedule an appointment for portfolio review. Portfolio should include original art and photocopies.
Tips: "The art you send should be tight and finished-looking even though it's for presentation only."

ART EMOTION CORP., 26 E. Piper Lane, Prospect Heights IL 60070. (708)459-0209. E-mail: gperez@interaccess.com. Contact: Gerard V. Perez. Estab. 1977. Represents 45 fine artists. Specializes in "selling to art galleries." Markets include: corporate collections; galleries; interior decorators.
Handles: Fine art.
Terms: "We buy for resale." Exclusive area representation is required. For promotional purposes talent must provide slides, color prints, "any visuals." Advertises in *Art News*, *Decor*, *Art Business News*.
How to Contact: For first contact, send tearsheets, slides, photographs and SASE. Reports in 1 month, only if interested. "Don't call us—if interested, we will call you." Portfolio should include slides, photographs.
Tips: Obtains new talent "through recommendations from others and word of mouth."

‡ARTISAN PROFESSIONAL FREELANCE REPS, INC., 1950 S. Sawtelle, Suite 333, Los Angeles CA 90025. (310)312-2062. Fax: (310)312-0670. Creative Recruiter: Tracy Forsythe. Commercial illustration, graphic design representative. Estab. 1988. Represents 100 illustrators, 15 photographers, 200 designers. Markets include: advertising agencies, corporations/client direct, design firms.
Handles: Illustration, photography, design, multimedia. Looking for multimedia and 3-D artists for CD-ROM and interactive projects.
Terms: Rep receives 20-30% commission. 100% of advertising costs paid by the representative. For promotional purposes, talent must provide 8½×11 color photocopies in a mini-portfolio. Advertises in *Creative Black Book*, *The Workbook*, magazines for the trade.
How to Contact: For first contact, send résumé, photocopies. Reports in 1 week. After initial contact, call to schedule an appointment for portfolio review. Portfolio should include roughs, tearsheets, slides, photographs, photocopies.

ARTIST DEVELOPMENT GROUP, 21 Emmett St., Suite 2, Providence RI 02903-4503. (401)521-5774. Fax: (401)521-5176. Contact: Rita Campbell. Represents photography, fine art, graphic design, as well as performing talent to advertising agencies, corporate clients/direct. Staff includes Rita Campbell. Estab. 1982. Member of Rhode Island Women's Advertising Club, NE Collaborative of Artist's Representatives. Markets include: advertising agencies; corporations/client direct. Clients include Hasbro, Etonic, Puma, Tretorn, Federal Computer Week. Client list available upon request.
Handles: Illustration, photography.
Terms: Rep receives 20-25% commission. Advertising costs are split: 50% paid by talent; 50% paid by representative. For promotional purposes, talent must provide direct mail promotional piece; samples in book for sales meetings.
How to Contact: For first contact, send résumé, bio, direct mail flier/brochure. Reports in 3 weeks. After initial contact, drop off or mail in appropriate materials for review. Portfolios should include tearsheets, photographs.
Tips: Obtains new talent through "referrals as well as inquiries from talent exposed to agency promo."

‡ARTIST REPRESENTATIVES OF TEXAS, 3352 Walnut Bend Lane, Houston TX 77042. (713)781-6226. Fax: (713)781-0957. Sales: Mary Margaret Loos. Commercial illustration representative. Estab. 1993. Member of Society of Illustrators. Represents 10 illustrators, 1 photographer, 2 designers, 2 fine artists. Guidelines available for #10 SASE. Markets include: advertising agencies; corporations/client direct; design firms; editorial/magazines; art publishers; galleries; private collections; publishing/books.

Handles: Illustration, fine art.

Terms: Rep receives 25% commission. Advertising costs are split: 75% paid by talent; 25% paid by representative. Advertises in *Texas Source Book, Houston Pro.*

How to Contact: For first contact, send bio, direct mail flier/brochure, tearsheets, photographs, SASE. Reports back within 1 week. After initial contact, call to schedule an appointment then drop off or mail in appropriate materials. Portfolio should include "a little of everything."

ARTISTS ASSOCIATES, 4416 La Jolla Dr., Bradenton FL 34210-3927. (813)756-8445. Fax: (813)727-8840. Contact: Bill Erlacher. Commercial illustration representative. Estab. 1964. Member of Society of Illustrators, Graphic Artists Guild, AIGA. Represents 11 illustrators. Markets include: advertising agencies; corporations/client direct; design firms; editorial/magazines; paper products/greeting cards; publishing/books; sales/promotion firms.

Handles: Illustration, fine art, design.

Terms: Rep receives 25% commission. Advertises in *American Showcase, RSVP, The Workbook, Society of Illustrators Annual.*

How to Contact: For first contact, send direct mail flier/brochure.

ARTISTS INTERNATIONAL, 320 Bee Brook Rd., Washington CT 06777-1911. (203)868-1011. Fax: (203)868-1272. Contact: Michael Brodie. Commercial illustration representative. Estab. 1970. Represents 20 illustrators. Specializes in children's books. Markets include: advertising agencies; design firms; editorial/magazines; licensing.

Handles: Illustration.

Terms: Rep receives 30% commission. No geographic restrictions. Advertising costs are split: 70% paid by talent; 30% paid by representative. For promotional purposes, talent must provide 2 portfolios. "We have our own full-color brochure, 24 pages, and do our own promotions."

How to Contact: For first contact, send slides, photocopies and SASE. Reports in 1 week. Portfolio should include slides, photostats.

Tips: Obtains new talent through recommendations from others, solicitation, conferences, *Literary Market Place,* etc. "Send SAE with example of your work; no résumés required."

ATELIER KIMBERLEY BOEGE, P.O. Box 7544, Phoenix AZ 85011-7544. Phone/fax: (602)265-4389. Owner: Kimberley Boege. Commercial illustration, photography representative. Estab. 1992. Represents 17 illustrators, 3 photographers. Markets include: advertising agencies, corporations/client direct, design firms, editorial/magazines.

Handles: Illustration.

Terms: Rep receives 25% commission. Advertising costs are split: 75% paid by talent; 25% paid by representative. For promotional purposes, talent should provide 1-3 portfolios. Advertises in *The Workbook, Southwest.*

How to Contact: For first contact, send query letter, tearsheets, photocopies. Reports back in 2 weeks. After initial contact, call to schedule an appointment for portfolio review. Portfolio should include 4×5 transparencies or laminated samples/printed pieces.

Tips: Wants artists with experience working in the freelance illustration/commercial illustration market.

CAROL BANCROFT & FRIENDS, 7 Ivy Hill Rd., P.O. Box 959, Ridgefield CT 06877. (203)438-8386. Fax: (203)438-7615. Owner: Carol Bancroft. Promotion Manager: Janet DeCarlo. Illustration representative for children's publishing. Estab. 1972. Member of SPAR, Society of Illustrators, Graphic Artists Guild. Represents 40 illustrators. Specializes in illustration for children's publishing—text and trade; any children's-related material. Clients include Scholastic, Houghton Mifflin, Franklin Mint. Client list available upon request.

Handles: Illustration for children of all ages. Looking for multicultural and fine artists.

Terms: Rep receives 25-30% commission. Advertising costs are split: 75% paid by talent; 25% paid by representative. For promotional purposes, talent must provide "flat copy (not slides), tearsheets, promo pieces, good color photocopies, etc.; 6 pieces or more is best; narrative scenes and children interacting." Advertises in *RSVP.*

How to Contact: For contact, "call Janet for information or send samples and SASE." Reports in 1 month.

Tips: "We're looking for artists who can draw animals and people well. They need to show characters in an engaging way with action in situational settings. Must be able to take a character through a story."

Artists' Rep Shares Marketing Strategies

Bob Berendsen was once a freelance artist with dreams of becoming "the best illustrator in the world." These days his focus is on advancing the careers of others. "I found that I was good at getting work for everybody else, and it worked out better for me if I didn't try to be an illustrator too. One day I got to the point where I could afford to not do illustration, so I began devoting all my time to getting work for other artists."

Today, his firm, Berendsen & Associates in Cincinnati, Ohio, consists of three art reps including him. They've represented between 20 and 40 artists around the country and in Canada for almost a decade. When Berendsen started his business, he was the only rep in town. Now he has a little competition, but continues to be successful in promoting his artists' work through direct mail, advertising and other strategies.

Bob Berendsen

As an art rep, Berendsen never knows what will happen once he ascends the stairs to his office, puts on a pot of coffee, and makes his long to-do list each day—a trip downtown to show a portfolio; a frantic call from a New York City art director; a fax from Tokyo detailing a several-thousand-dollar job. He took some time out between his dozens of phone calls to answer some common questions artists have about using reps.

What advice can you give an artist on preparing for a freelance career? One of the biggest problems artists have when they start out is that they're not financially ready to be freelancers. They go to school, learn their trade the best they can, then they come and see me. It's very difficult for someone to make it when he doesn't have any money saved. With a lot of jobs it's 30, 60, 90 days before you get paid. So when artists finally dive into their careers and begin to work, the money doesn't come in quickly enough and they have to resort to working at an art supply store to pay the bills.

I also recommend artists get some experience before they come to me. Get into a studio, get your feet wet and work for a while before you decide to go freelance. Or use books like *Artist's & Graphic Designer's Market*; produce a tearsheet, send it out to people in the book you feel do the kind of work you want to get.

Have a specific style. Get a niche and stick with it. I always ask artists "What do you want to do? Covers of romance novels? Comair jets? Package illustrations?" Pick out your favorite thing and pursue it.

Subscribe to *The Artist's Magazine*
AND GET A FREE GIFT!

You'll get this inspiring "Guide to More Creative Painting" as a FREE GIFT with your paid subscription to *The Artist's Magazine*.

Inside you'll discover how to use your unique experiences and innermost feelings to generate new, exciting ideas for your artwork. How to make the most of your creative flow. How to experiment with your personal style including the use of unconventional materials and indulging in a few "painting no-nos"... plus much more! Subscribe today and this invaluable guide is yours free!

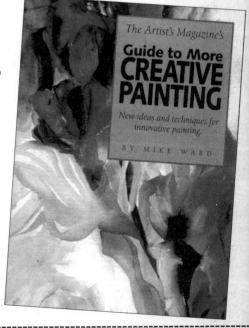

The Artist's Magazine's
Guide to More CREATIVE PAINTING
New ideas and techniques for innovative painting.

BY MIKE WARD

The Artist's
MAGAZINE

INTRODUCTORY SUBSCRIPTION SAVINGS

Yes! Start my subscription to *The Artist's Magazine* at the low introductory rate of just $19.99 for 12 monthly issues. **I save 44% off the newsstand price!**

☐ Payment enclosed. Please send my FREE "Guide to More Creative Painting" immediately.

☐ Bill me and send my free guide upon payment.

Name _____

Address _____ Apt. _____

City _____ State _____ Zip _____

* Outside U.S. add $10 (includes GST in Canada) and remit in U.S. funds. Allow 4-6 weeks for first-issue delivery. Newsstand rate: $35.88.

Mail this card today! No postage needed.

The Artist's

SAVE 44% OFF THE NEWSSTAND PRICE!

TEAM7

A subscription to *The Artist's Magazine* is the perfect companion for the new edition of *Artist's Market.* Every issue provides...

- The very hottest market information—how and where and when to show and sell art, plus news of regional and national competitions and more than 1,300 workshops... revised and updated as needed throughout the year so you're never stuck with outdated information.

- Monthly reports on materials, methods and publications for artists—If there's a new product or technique that can benefit your work, you'll read about it first in *The Artist's Magazine.*

- Interviews with top professional artists—Their tips and techniques can be applied to any level of skill to develop personal style, fresh ideas and inspiration.

- Step-by-step instruction—Whether it's capturing crisp details in watercolor, painting sensuous realism in oils, or preserving your paintings, you'll find clear, detailed directions in every issue.

Mail the postpaid card below to start your subscription today!

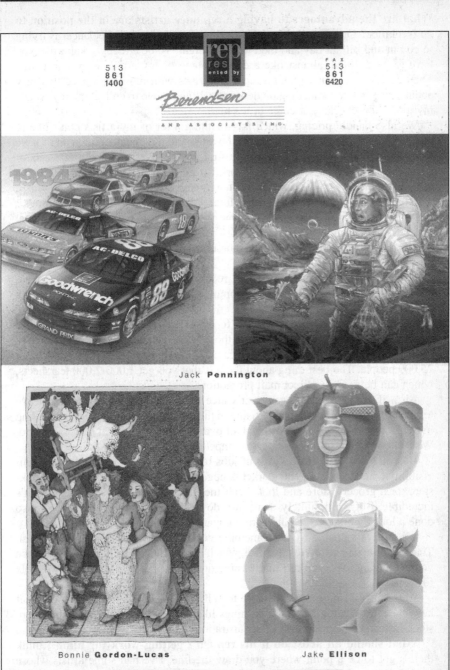

rep
res
ented by

513
861
1400

FAX
513
861
6420

Berendsen

AND ASSOCIATES, INC.

Jack **Pennington**

Bonnie **Gordon-Lucas**

Jake **Ellison**

2233 Kemper Lane · Cincinnati, OH · 45206

Reprinted with permission of Berendsen & Associates.

This tearsheet was one of six in American Showcase '95 *exhibiting the work of artists represented by Berendsen & Associates. The 2,000 tearsheets Showcase provides are also used as part of Berendsen's promotional package, offering "optimum exposure at an affordable cost."*

What are the advantages to having a rep once artists are in the position to go freelance? One of the most difficult things about being a freelancer is trying to go out and sell all day and then work all night. To be a really good artist, you have to be devoted, almost like a doctor. Many of my artists work constantly. They couldn't do that without a rep. And artists with reps don't need to worry about going out and knocking on doors or calling people to collect money. That's my job. Their checks just come in the mail.

We also handle pricing, which is something a lot of my artists don't like to deal with. We act as a go-between for the artist and the client, so they don't have to butt heads. Also, all my reps are illustrators, too. We have about 50 years of experience between us. We review work before it's sent off to the client. If it's not acceptable to us, nine times out of ten, it isn't acceptable to the client, either.

How does a rep generally promote artists' work? I have specific things I feel my artists should do to get work. One of the keys is to have good professional samples that potential clients can file. I recommend my artists do at least one direct mail campaign a year, be in our master portfolio, and advertise in the *American Showcase.*

I never push things on my artists, I recommend things. Last year there were two artists who did exactly what I recommended and they're the busiest artists I have.

Why do you think it's necessary to advertise in the sourcebooks? I'm a firm believer that you should get into those books. Unless you're in that arena, you're not going to be able to play the game. Those books are distributed to about 25,000 people. The best thing about them is that you get 1,000-2,000 tearsheets, which can be used for direct mail promotions.

Also, if we stop in an agency, it's nice to show them portfolios and leave tearsheets behind. I've been advertising in the books almost since I started calling myself a rep. Now we get calls from all over the country and all over the world. We feel that being in them helps us compete with all the other great talent.

Do you look for certain kinds of jobs for your artists? We really like high-visibility consumer jobs. The market is huge. Walk into Toys 'R' Us, or a bookstore, or a grocery store and look at all the illustrations on the packaging—it's incredible. But we definitely don't turn down any publishing jobs. We've also done a lot of work for greeting card companies.

It's always valuable to get something consistent, even if it's not top dollar. That way you can afford to advertise, which helps you get the big jobs. And once you get the big jobs, you can start turning down the ones that aren't as profitable for you.

We're also trying more and more to sell one-time rights to illustrations, but keep the reproduction rights. With things like CD-ROMs people are using more stock instead of having us do new illustrations.

What should an artist do if his rep isn't getting work for him? I think there's got to be a point where you draw the line. I've had some artists whose work I thought for sure I could sell, but I didn't. I definitely think artists should set a time limit, and move on if it isn't working. There are a lot of reps out there. Some do some things well and others do other things well. Find one that fits your niche.

—*Alice P. Buening*

‡BEATE WORKS, 7916 Melrose Ave., Suite 2, Los Angeles CA 90046. (213)653-5088. Fax: (213)653-5089. E-mail: beateworks@aol.com. President: Beate Chelette. Commercial illustration, photography, graphic design representative. Estab. 1992. Represents 2 illustrators, 5 photographers, 1 designer, 1 fine artist. Markets include: advertising agencies; corporations/client direct; design firms; editorial/magazines; paper products/greeting cards.
Handles: Illustration, photography. Looking for well-established, versatile artists with existing clientele.
Terms: Rep receives 25-30% commission. Charges special mailing fees. Exclusive area representation is required. Advertising costs are split: 75% paid by talent; 25% paid by representative. For promotional purposes, talent must provide direct mailers, portfolio 11 × 14 (2 minimum) with logo and type.
How to Contact: For first contact, send query letter, direct mail flier/brochure. Reports back within 1 week. After initial contact, call to schedule an appointment for portfolio review. Portfolio should include tearsheets, slides, photographs, photocopies.
Tips: Likes artists who possess "business sense, ability to keep clients and strong flexible personalities."

BERENDSEN & ASSOCIATES, INC., 2233 Kemper Lane, Cincinnati OH 45206. (513)861-1400. Fax: (513)861-6420. President: Bob Berendsen. Commercial illustration, photography, graphic design representative. Estab. 1986. Represents 24 illustrators, 2 photographers, 2 designers/illustrators. Specializes in "high-visibility consumer accounts." Markets include: advertising agencies; corporations/client direct; design firms; editorial/magazines; paper products/greeting cards; publishing/books; sales/promotion firms. Clients include Northlich Stolley Lewarre (Cincinnati), LPK, F&W Publications. Client list available upon request.
Handles: Illustration, photography. "We are always looking for illustrators who can draw people, product and action well. Also, we look for styles that are unique."
Terms: Rep receives 25% commission. Charges "mostly for postage but figures not available." No geographic restrictions. Advertising costs are split: 75% paid by talent; 25% paid by representative. For promotional purposes, "artist must co-op in our direct mail promotions, and sourcebooks are recommended. Portfolios are updated regularly." Advertises in *RSVP*, *Creative Illustration Book*, *The Ohio Source Book* and *American Showcase*.
How to Contact: For first contact, send query letter, résumé, tearsheets, slides, photographs, photocopies and SASE. Follow up with a phone call. After initial contact, drop off or mail appropriate materials for review. Portfolios should include tearsheets, slides, photographs, photostats, photocopies.
Tips: Obtains new talent "through recommendations from other professionals. Contact Bob Berendsen for first meeting."

SAM BRODY, ARTISTS & PHOTOGRAPHERS REPRESENTATIVE & CONSULTANT, 15 W. Terrace Rd., Great Neck NY 11021-1513. Phone/fax: (516)482-2835. Contact: Sam Brody. Commercial illustration and photography representative and broker. Estab. 1948. Member of SPAR. Represents 4 illustrators, 3 photographers, 2 designers. Markets include: advertising agencies; corporations/client direct; design firms; editorial/magazines; publishing/books; sales/promotion firms.
Handles: Illustration, photography, design, "great film directors."
Terms: Agent receives 30% commission. Exclusive area representation is required. Advertising costs are split: 75% paid by talent; 25% paid by representative. For promotional purposes, talent must provide 8 × 10 transparencies (dupes only) with case, plus back-up advertising material, i.e., cards (reprints—*Workbook*, etc.) and self-promos.
How to Contact: For first contact, send bio, direct mail flier/brochure, tearsheets. Reports in 3 days or within 1 day if interested. After initial contact, call for appointment or drop off or mail in appropriate materials for review. Portfolio should include tearsheets, slides, photographs.
Tips: Obtains new talent through recommendations from others, solicitation. In obtaining representation, artist/photographer should "talk to parties he has worked with in the past year."

BROOKE & COMPANY, 4323 Bluffview, Dallas TX 75209. (214)352-9192. Fax: (214)350-2101. Contact: Brooke Davis. Commercial illustration and photography representative. Estab. 1988. Represents 10 illustrators, 2 photographers. "Owner has 18 years experience in sales and marketing in the advertising and design fields."
Terms: No information provided.
How to Contact: For first contact, send bio, direct mail flier/brochure, "samples we can keep on file if possible" and SASE. Reports in 2 weeks. After initial contact, write for appointment to show portfolio or drop off or mail portfolio of tearsheets, slides or photographs.
Tips: Obtains new talent through referral or by an interest in a specific style. "Only show your best work. Develop an individual style. Show the type of work that you enjoy doing and want to do more often. Must have a sample to leave with potential clients."

PEMA BROWNE LTD., HCR Box 104B, Pine Rd., Neversink NY 12765. (914)985-2936. Fax: (914)985-7635. Contact: Pema Browne or Perry Browne. Commercial illustration representative. Estab. 1966. Represents 12 illustrators. Specializes in general commercial. Markets include: all publishing areas; children's picture books; collector plates and dolls; advertising agencies; editorial/magazines. Clients include Harper-

Collins, Thomas Nelson, Bradford Exchange. Client list available upon request.

Handles: Illustration. Looking for "professional and unique" talent.

Terms: Rep receives 30% commission. Exclusive area representation is required. For promotional purposes, talent must provide color mailers to distribute. Representative pays mailing costs on promotion mailings.

How to Contact: For first contact, send query letter, direct mail flier/brochure and SASE. If interested will ask to mail appropriate materials for review. Portfolios should include tearsheets and transparencies or good color photocopies.

Tips: Obtains new talent through recommendations. "Be familiar with the marketplace."

BRUCK AND MOSS ASSOCIATES, 333 E. 49th St,. New York NY 10017. (212)980-8061 or (212)982-6533. Fax: (212)832-8778 or (212)674-0194. Contact: Eileen Moss or Nancy Bruck. Commercial illustration representative. Estab. 1978. Represents 12 illustrators. Markets include: advertising agencies; corporations/client direct; design firms; editorial/magazines; publishing/books; sales/promotion firms; direct marketing.

Handles: Illustration.

Terms: Rep receives 30% commission. Exclusive representation is required. No geographic restrictions. Advertising costs are split: 70% paid by talent; 30% paid by representative. For promotional purposes, talent must provide "4×5 transparencies mounted on 7×9 black board. Talent pays for promotional card for the first year and for trade ad." Advertises in *American Showcase* and *The Workbook*.

How to Contact: For first contact, send tearsheets, "if sending slides, include SASE." After initial contact, drop off or mail in appropriate materials for review. Portfolios should include tearsheets. If mailing portfolio include SASE or Federal Express form.

Tips: Obtains new talent through referrals by art directors and art buyers, mailings of promo card, source books, art shows, *American Illustration* and *Print Annual*. "Make sure you have had experience repping yourself. Don't approach a rep on the phone, they are too busy for this. Put them on a mailing list and mail samples. Don't approach a rep who is already repping someone with the same style."

‡SID BUCK AND BARNEY KANE, 135 W. 41st St., #408, New York NY 10036. (212)221-8090. Fax: (212)221-8092. President: Sid Buck. Commercial illustration representative. Estab. 1964. Markets include: advertising agencies; corporations/client direct; design firms; editorial/magazines; paper products/greeting cards; publishing/books.

Handles: Illustration.

Terms: Rep receives 25% commission. Exclusive area represention is required. Advertising costs are split: 75% paid by talent; 25% paid by representative. Advertises in *American Showcase*, *Creative Black Book*, *The Workbook*.

How to Contact: For first contact, send photocopies, photostats. Reports in 1 week. After initial contact, call to schedule an appointment for portfolio review. Portfolio should include photostats, photocopies.

WOODY COLEMAN PRESENTS INC., 490 Rockside Rd., Cleveland OH 44131. (216)661-4222. Fax: (216)661-2879. Contact: Woody. Creative services representative. Estab. 1978. Member of Graphic Artists Guild. Specializes in illustration. Markets include: advertising agencies; corporations/client direct; design firms; editorial/magazines; paper products/greeting cards; publishing/books; sales/promotion firms; public relations firms.

Handles: Illustration.

Terms: Rep receives 25% commission. Advertising costs are split: 75% paid by talent; 25% paid by representative. For promotional purposes, talent must provide "all portfolios in 4×5 transparencies." Advertises in *American Showcase*, *Creative Black Book*, *The Workbook*, other publications.

How to Contact: For first contact, send query letter, tearsheets, slides, SASE. Reports in 7 days, only if interested. Portfolio should include tearsheets, 4×5 transparencies.

Tips: "Solicitations are made directly to our agency. Concentrate on developing 8-10 specific examples of a single style exhibiting work aimed at a particular specialty, such as fantasy, realism, Americana or a particular industry such as food, medical, architecture, transportation, film, etc." Specializes in "quality service based on being the 'world's best listeners.' We know the business, ask good questions and simplify an often confusing process. We are truly representative of a 'service' industry."

‡DANIELE COLLIGNON, 200 W. 15th St., New York NY 10011. (212)243-4209. Contact: Daniele Collignon. Commercial illustration representative. Estab. 1981. Member of SPAR, Graphic Artists Guild, Art Director's Club. Represents 12 illustrators. Markets include: advertising agencies; corporations/client direct; design firms; editorial/magazines; publishing/books.

Handles: Illustration.

Terms: Rep receives 30% commission. Exclusive area representation is required. No geographic restrictions. Advertising costs are split: 75% paid by talent; 25% paid by representative. For promotional purposes, talent must provide 8×10 transparencies (for portfolio) to be mounted, printed samples, professional pieces. Advertises in *American Showcase*, *Creative Black Book*, *The Workbook*.

How to Contact: For first contact, send direct mail flier/brochure, tearsheets. Reports in 3-5 days, only if interested. After initial contact, drop off or mail in appropriate materials for review. Portfolio should include tearsheets, transparencies.

CORPORATE ART ASSOCIATES, LTD., 270 Lafayette St., Suite 402, New York NY 10012. (212)941-9685. Director: James Cavello. Art consultant and curator. Sales, lease and rentals; special exhibitons. Estab. 1987. Markets include: advertising agencies; corporations; design firms; sales/promotion firms; architects; developers; galleries; interior decorators; private collections; hospitals/health care centers; TV/motion picture productions.
Handles: Fine art, illustration, photography.
Terms: Agent receives 20% commission. No geographic restrictions. Advertising costs are paid by talent.
How to Contact: For first contact, send query letter, résumé, tearsheets, 5 slides, photographs, color photocopies and SASE.
Tips: Obtains new talent through recommendations from others.

‡CORPORATE ART PLANNING, 16 W. 16th, New York NY 10011. (212)645-3490, (800)645-3432. Fax: (212)645-3489. Principal: Maureen McGovern. Fine art representative. Estab. 1986. Represents 2 illustrators, 2 photographers, 5 fine artists (includes 1 sculptor). Guidelines available for #10 SASE. Markets include: advertising agencies; corporations/client direct; design firms; editorial/magazines; publishing/books; architects; art publishers; corporate collections; private collections.
Handles: Fine art.
Terms: Rep receives 15%. Advertising costs are split: 50% paid by talent; 50% paid by representative. For promotional purposes, prefers all artists have museum connections and professional portfolios. Advertises in *Creative Black Book*, *The Workbook*, *Art in America*.
How to Contact: Reports back in 10 days. After initial contact, write to schedule an appointment for portfolio review. Portfolio should include color photocopies.

‡CREATIVE ARTS OF VENTURA, P.O. Box 684, Ventura CA 93002. Owners: Don and Lamia Ulrich. Representative not currently seeking new talent. Clients include Tempe Arts Center, Arizona; Beverly Hills Recreation Parks Dept.
Tips: "High quality photographic imagery of artist's art form or product is important. Lengthy résumés are of secondary value to us."

‡CREATIVE FREELANCERS MANAGEMENT, INC., 25 W. 45th St., New York NY 10036. (212)398-9540. Fax: (212)398-9547. Contact: Marilyn Howard. Commercial illustration representative. Estab. 1988. Represents 30 illustrators. "Our staff members have art direction, art buying or illustration backgrounds." Specializes in children's books, advertising, architectural, conceptual. Markets include: advertising agencies; corporations/client direct; design firms; editorial/magazines; paper products/greeting cards; publishing/books; sales/promotion firms.
Handles: Illustration. Artists must have published work.
Terms: Rep receives 30% commission. Exclusive area representation is preferred. Advertising costs are split: 70% paid by talent; 30% paid by representative. For promotional purposes, talent must provide "printed pages to leave with clients. Co-op advertising with our firm could also provide this. Transparency portfolio preferred if we take you on but we are flexible." Advertises in *American Showcase*, *Creative Black Book*.
How to Contact: For first contact, send tearsheets or "whatever best shows work. We also have a portfolio drop off policy on Wednesdays." Reports only if interested. After initial contact, drop off or mail in appropriate materials for review. Portfolios should include tearsheets, slides, photographs, photostats, photocopies.
Tips: Obtains new talent through "word of mouth and advertising."

LINDA DE MORETA REPRESENTS, 1839 Ninth St., Alameda CA 94501. (510)769-1421. Fax: (510)521-1674. Contact: Linda de Moreta. Commercial illustration and photography representative; also portfolio and career consultant. Estab. 1988. Represents 11 illustrators, 4 photographers. Markets include: advertising agencies; corporations/client direct; design firms; editorial/magazines; paper products/greeting cards; publishing/books; sales/promotion firms.
Handles: Illustration, calligraphy, photography.
Terms: Rep receives 25% commission. Exclusive representation requirements vary. Advertising costs are split according to individual agreements. Materials for promotional purposes vary with each artist. Advertises in *The Workbook*, *The Creative Black Book*, *Creative Sourcebook*, *American Showcase*.
How to Contact: For first contact, send direct mail flier/brochure, tearsheets, slides, photocopies, photostats and SASE. "Please do *not* send original art. SASE for any items you wish returned." Responds to any inquiry in which there is an interest. Portfolios are individually developed for each artist and may include tearsheets, prints, transparencies.
Tips: Obtains new talent through client and artist referrals primarily, some solicitation. "I look for great creativity, a personal vision and style of illustration or photography combined with professionalism, maturity and a willingness to work hard."

DWYER & O'GRADY, INC., P.O. Box 239, Mountain Rd., East Lempster NH 03605. (603)863-9347. Fax: (603)863-9346. Contact: Elizabeth O'Grady. Agents for children's picture book artists and writers. Estab. 1990. Member of Society of Illustrators, Graphic Artists Guild, SCBWI, ABA. Represents 26 illustrators and 12 writers. Staff includes Elizabeth O'Grady, Jeffrey Dwyer. Specializes in children's picture books. Markets include: publishing/books.

Handles: Illustrators and writers of children's books. "Favor realistic and representational work for the older age picture book. Artist must have full command of the figure and facial expressions."

Terms: Rep receives 15% commission. Additional fees are negotiable. Exclusive area representation is required (world rights). Advertising costs are paid by representative. For promotional purposes, talent must provide both color slides and prints of at least 20 sample illustrations depicting the figure with facial expression.

How to Contact: When making first contact, send query letter, slides, photographs and SASE. Reports in 1½ months. After initial contact, call for appointment and drop off or mail in appropriate materials for review. Portfolio should include slides, photographs.

Tips: Obtains new talent through "referrals from people we trust and personal search."

ELLIOTT/OREMAN ARTISTS' REPRESENTATIVES, 25 Drury Lane, Rochester NY 14625-2013. Contact: Shannon Elliott. Commercial illustration representative. Estab. 1983. Represents 10 illustrators. Markets include: advertising agencies; corporations/client direct; design firms; editorial/magazines; paper products/greeting cards; publishing/books; architectural firms.

Handles: Illustration.

Terms: For promotional purposes, talent must have a tearsheet, which will be combined with others in a sample folder.

How to Contact: For first contact, send query letter, tearsheets, slides. "I will call to schedule an appointment, if interested."

Tips: Obtains new talent through recommendations from others, solicitation.

‡RANDI FIAT & ASSOCIATES, 1727 S. Indiana, Chicago IL 60616. (312)663-5300. Fax: (312)554-1729. Contact: Randi Fiat. Commercial illustration and photography representative. Estab. 1980. Member of SPAR and CAR. Represents 4 illustrators and 8 photographers. "We represent talent with a strong fine art orientation in the commercial arena." Markets include: advertising agencies; corporations/client direct; design firms; editorial/magazines; paper products/greeting cards; publishing books; sales/promotion firms.

Handles: Illustration, photography.

Terms: Rep receives 25% commission. "We have a nominal 'per job' fee ($50) to cover incidentals." Tries to represent talent nationally. Advertising costs are split: 75% paid by talent; 25% paid by representative. "We work with talent to create portfolio and promotional look." Advertises in *American Showcase*, *Creative Black Book*, *The Workbook*, *AR 100*.

How to Contact: For first contact, send query letter, bio, tearsheets, photocopies and SASE. Reports in 1 week if interested. After initial contact, call for appointment for portfolio review.

Tips: Obtains new talent through recommendations from others. "Send the best work only."

‡FORTUNI, 2508 E. Belleview Place, Milwaukee WI 53211. (414)964-8088. Fax: (414)332-9629. Contact: Marian F. Deegan. Commercial illustration, photography representative. Estab. 1990. Member of Graphic Artists Guild. Represents 3 illustrators, 1 photographer. Markets include: advertising agencies; corporations/client direct; design firms; editorial/magazines; publishing/books.

Handles: Illustration, photography. "I am interested in artists who have developed a consistent, distinctive style of illustration."

Terms: Rep receives 25% commission. Advertising costs are split: 75% paid by talent; 25% paid by representative. For promotional purposes, talent must provide direct mail support, advertising, and a minimum of 4 duplicate transparency portfolios. "All promotional materials are developed and produced within my advertising specifications." Advertises in *Directory of Illustration*.

How to Contact: For first contact, send direct mail flier/brochure, slides, photographs, photocopies, SASE. Reports in 2 weeks if SASE is enclosed. After initial contact, call to schedule an appointment for portfolio review. Portfolio should include roughs, original art, tearsheets, slides, photographs, photocopies, transparencies (if available).

How to Use Your **Artist's & Graphic Designer's Market** *offers suggestions for understanding and using the information in these listings. Read this and other articles in the front of this book for important business tips.*

‡FREELANCE ADVANCERS, INC., 441 Lexington Ave., Suite 408, New York NY 10017. (212)661-0900. Fax: (212)661-1883. President: Gary Glauber. Commercial illustration, graphic design, freelance artist representative. Estab. 1987. Member of Society of Illustrators. Represents 150 illustrators, 250 designers. Specializes in freelance project work. Markets include: advertising agencies; corporations/client direct; design firms; editorial/magazines; publishing/books.
Handles: Illustration, design. Looks for artists with Macintosh software and multimedia expertise.
Terms: Rep receives 20% commission. 100% paid by the representative. Advertises in *Art Direction Adweek*.
How to Contact: For first contact, send query letter, résumé, tearsheets. Reports back within 1 week. After initial contact, call to schedule an appointment.
Tips: Looking for "talent, flexibility and reliability" in an artist.

FREELANCE HOTLINE, INC., 311 First Ave. N., Suite 405, Minneapolis MN 55401. (612)341-4411. Fax: (612)341-0229. Contact: Elisa Soper. Commercial illustration, graphic design, desktop and keyline artists representative. Estab. Chicago 1987, Minneapolis 1992. Member of AIGA. Specializes in desktop and keyline artists. Markets include: advertising agencies; corporations/client direct; design firms; sales/promotion firms.
Handles: Illustration, design, desktop publishing/graphic arts. Artists should have "Two years professional desktop and/or keylining experience (Mac, IBM platforms)."
Terms: Have set fee and pay rate. Exclusive area representation is required in Twin Cities Metro and surrounding areas. Independent contractor pays no fees. "All talents have their own portfolios, etc. Freelance Hotline also has a portfolio." Advertises in *Creative Black Book*, *Gold Book*, magazines, newspapers, *Mac-Chicago*, *Computer User Format*, etc.
How to Contact: For first contact, send query letter, résumé, bio, direct mail flier/brochure (samples not necessary). Reports in 2 weeks (always contacted, qualified or not). After initial contact, Freelance Hotline calls to set up appointment to test desktop/keyline skills, followed by portfolio review. Portfolio should include thumbnails, roughs, original art, tearsheets, slides, photographs, photostats, photocopies (variety of materials, concept to print). After testing and portfolio review, 3 professional references are checked.
Tips: Obtains new talent through Yellow Pages, magazines, newspapers, conferences, seminars, Macshows, *Gold/Black Books*, etc.

ROBERT GALITZ FINE ART/ACCENT ART, 166 Hilltop Court, Sleepy Hollow IL 60118. (708)426-8842. Fax: (708)426-8846. Contact: Robert Galitz. Fine art representative. Estab. 1985. Represents 100 fine artists (includes 2 sculptors). Specializes in contemporary/abstract corporate art. Markets include: architects; corporate collections; galleries; interior decorators; private collections. Clients include Graphique Du Jour, Editions Limited Inc.
Handles: Fine art.
Terms: Agent receives 25-40% commission. No geographic restrictions; sells mainly in Chicago, Illinois, Wisconsin, Indiana and Kentucky. For promotional purposes talent must provide "good photos and slides." Advertises in monthly art publications and guides.
How to Contact: For first contact, send query letter, slides, photographs. Reports in 2 weeks. After initial contact, call for appointment to show portfolio of original art.
Tips: Obtains new talent through recommendations from others, solicitation, conferences. "Be confident, persistent. Never give up or quit."

‡RITA GATLIN REPRESENTS, 83 Walnut Ave., Costa Mesa CA 94925. (415)924-7881. Fax: (415)924-7891. Agent: Rita Gatlin. Commercial illustration. Estab. 1991. Member of Society of Illustrators. Represents 10 illustrators. Markets include: advertising agencies; corporations/client direct; design firms; editorial/magazines; paper products/greeting cards; publishing/books.
Handles: Commercial illustrators only.
Terms: Rep receives 25% commission. Charges fees for portfolio materials (mounting and matting); postage for yearly direct mail divided among artists. Advertising costs are split: 75% paid by talent; 25% paid by representative. For promotional purposes, talent must provide at least one 8½×11 printed page. Prefers portfolios in transparency form. Advertises in *American Showcase*, *The Workbook*, *Creative Illustration*, *Directory of Illustration*.
How to Contact: For first contact, send query letter and tearsheets. Reports back within 5 days. After initial contact, call to schedule an appointment for portfolio review. Portfolio should include tearsheets, slides.
Tips: "Artists must have a minimum of five years experience as commercial illustrators."

DENNIS GODFREY REPRESENTING ARTISTS, 231 W. 25th St., Suite 6E, New York NY 10001. Phone/fax: (212)807-0840. Contact: Dennis Godfrey. Commercial illustration representative. Estab. 1985. Represents 6 illustrators. Specializes in publishing. Markets include: advertising agencies; corporations/client direct; design firms; publishing/books. Clients include Putnam Berkley, Dell, Avon, Ogilvy & Mather.
Handles: Illustration.
Terms: Rep receives 25% commission. Prefers exclusive area representation in NYC/Eastern US. Advertising costs are split: 75% paid by talent; 25% paid by representative. For promotional purposes, talent must

provide mounted portfolio (at least 20 pieces), as well as promotional pieces. Advertises in *The Workbook*.
How to Contact: For first contact, send tearsheets. Reports in 2 weeks, only if interested. After initial contact, write for appointment to show portfolio of tearsheets, slides, photographs, photostats.
Tips: Obtains new talent through recommendations from others, occasionally by solicitation.

BARBARA GORDON ASSOCIATES LTD., 165 E. 32nd St., New York NY 10016. (212)686-3514. Fax: (212)532-4302. Contact: Barbara Gordon. Commercial illustration and photography representative. Estab. 1969. Member of SPAR, Society of Illustrators, Graphic Artists Guild. Represents 9 illustrators, 1 photographer. "I represent only a small, select group of people and therefore give a great deal of personal time and attention to the people I represent."
Terms: No information provided. No geographic restrictions in continental US.
How to Contact: For first contact, send direct mail flier/brochure. Reports in 2 weeks. After initial contact, drop off or mail appropriate materials for review. Portfolio should include tearsheets, slides, photographs; "if the talent wants materials or promotion piece returned, include SASE."
Tips: Obtains new talent through recommendations from others, solicitation, conferences, etc. "I have obtained talent from all of the above. I do not care if an artist or photographer has been published or is experienced. I am essentially interested in people with a good, commercial style. Don't send résumés and don't call to give me a verbal description of your work. Send promotion pieces. *Never* send original art. If you want something back, include a SASE. Always label your slides in case they get separated from your cover letter. And always include a phone number where you can be reached."

‡T.J. GORDON/ARTIST REPRESENTATIVE, P.O. Box 4112, Montebello CA 90640. (213)887-8958. Contact: Tami Gordon. Commercial illustration, photography and graphic design representative; also illustration or photography broker. Estab. 1990. Represents 8 illustrators, 3 photographers. Markets include: advertising agencies; corporations/client direct; design firms; editorial/magazines.
Handles: Illustration, photography, design.
Terms: Rep receives 30% commission. Advertising costs are paid by talent (direct mail costs, billable at end of each month). Represents "illustrators from anywhere in US; designers and photographers normally LA only, unless photographer can deliver a product so unique that it is unavailable in LA." For promotional purposes, talent must provide "a minimum of three pieces to begin a six-month trial period. These pieces will be used as mailers and leave behinds. Portfolio is to be professional and consistent (pieces of the same size, etc.) At the end of the trial period agreement will be made on production of future promotional pieces."
How to Contact: For first contact, send bio, direct mail flier/brochure. Reports in 2 weeks, if interested. After initial contact, call for appointment to show portfolio of tearsheets.
Tips: Obtains new talent "primarily through recommendations and as the result of artists' solicitations. Have an understanding of what it is you do, do not be afraid to specialize. If you do everything, then you will always conflict with the interests of the representatives' other artists. Find your strongest selling point, vocalize it and make sure that your promos and portfolio show that point."

‡COREY GRAHAM REPRESENTS, Pier 33 N., San Francisco CA 94111. (415)956-4750. Fax: (415)391-6104. Contact: Corey Graham. Commercial illustration, photography representative. Estab. 1983. Represents 15 illustrators, 3 photographers. Markets include: advertising agencies; corporations/client direct; design firms.
Handles: Illustration, photography.
Terms: Rep receives 25% commission. Exclusive area representation is sometimes required. Advertising costs are split: 75% paid by talent; 25% paid by representative. Advertises in *American Showcase*, *The Workbook*.
How to Contact: For first contact, send query letter and tearsheets. Reports back within a few days. After initial contact, drop off or mail in appropriate materials. Portfolio should include tearsheets.

‡ANITA GRIEN—REPRESENTING ARTISTS, 155 E. 38th St., New York NY 10016. Representative not currently seeking new talent.

‡CAROL GUENZI AGENTS, INC., 1863 S. Pearl St., Denver CO 80210. (303)733-0128. Contact: Carol Guenzi. Commercial illustration, film and animation representative. Estab. 1984. Member of Denver Advertising Federation and Art Directors Club of Denver. Represents 23 illustrators, 3 photographers, 1 computer designer. Specializes in a "wide selection of talent in all areas of visual communications." Markets include: advertising agencies; corporations/client direct; design firms; editorial/magazine, paper products/greeting cards, sales/promotions firms. Clients include The Integer Group, Karsh & Hagan, Barnhart. Partial client list available upon request.
Handles: Illustration, photography. Looking for "unique style application."
Terms: Rep receives 25% commission. Exclusive area representative is required. Advertising costs are split: 75% paid by talent; 25% paid by the representation. For promotional purposes, talent must provide "promotional material after six months, some restrictions on portfolios." Advertises in *American Showcase*, *Creative Black Book*, *The Workbook*, "periodically."

How to Contact: For first contact, send direct mail flier/brochure. Reports in 2-3 weeks, only if interested. Call or write for appointment to drop off or mail in appropriate materials for review, depending on artist's location. Portfolio should include tearsheets, slides, photographs.

Tips: Obtains new talent through solicitation, art directors' referrals, an active pursuit by individual artist. "Show your strongest style and have at least 12 samples of that style, before introducing all your capabilities. Be prepared to add additional work to your portfolio to help round out your style."

‡GUIDED IMAGERY PRODUCTIONS, 2995 Woodside Rd., #400, Woodside CA 94062. (415)324-0323. Fax: (415)324-9962. Owner/Director: Linda Hoffman. Fine art representative. Estab. 1978. Member of Hospitality Industry Association. Represents 2 illustrators, 12 fine artists. Guidelines available for #10 SASE. Specializes in large art production—perspective murals (trompe l'oiel); unusual painted furniture/screens. Markets include: design firms; interior decorators; hospitality industry.

Handles: Looking for "mural artists (realistic or trompe l'oiel) with good understanding of perspectives—humor helps too."

Terms: Rep receives 25-33% commission. 100% of advertising costs paid by representative. For promotional purposes, talent must provide a direct mail piece to preview work along with color copies of work (SASE too). Advertises in *The Workbook*.

How to Contact: For first contact, send query letter, résumé, photographs, photocopies and SASE. Reports in 2-3 weeks. After initical contact drop off or mail in appropriate materials. Portfolio should include photographs.

Tips: Wants artists with talent, references and follow through.

‡PAT HACKETT/ARTIST REPRESENTATIVE, 101 Yesler Way, Suite 502, Seattle WA 98104-2552. (206)447-1600. Fax: (206)447-0739. E-mail: pathackett@aol.com. Contact: Pat Hackett. Commercial illustration and photography representative. Estab. 1979. Represents 27 illustrators, 2 photographers. Markets include: advertising agencies; corporations/client direct; design firms; editorial/magazines. Clients include Microsoft Inc., Rodale Press.

Handles: Illustration.

Terms: Rep receives 25-33% commission. Exclusive area representation is required. No geographic restrictions, but sells mostly in Washington, Oregon, Idaho, Montana, Alaska and Hawaii. Advertising costs are split: 75% paid by talent; 25% paid by representative. For promotional purposes, talent must provide "standardized portfolio, i.e., all pieces within the book are the same format. Reprints are nice, but not absolutely required." Advertises in *American Showcase*, *Creative Black Book*, *The Workbook*, *Creative Illustration*, *Medical Illustration Source Book*.

How to Contact: For first contact, send direct mail flier/brochure. Reports in 1 week, only if interested. After initial contact, drop off or mail in appropriate materials: tearsheets, slides, photographs, photostats, photocopies.

Tips: Obtains new talent through "recommendations and calls/letters from artists moving to the area. We prefer to handle artists who live in the area unless they do something that is not available locally."

‡HOLLY HAHN & CO., 770 N. Halsted, P102, Chicago IL 60622. (312)338-7110. Fax: (312)338-7004. Commercial illustration, photography, graphic design representative. Estab. 1988. Member of CAR (Chicago Artists Representatives). Represents 7 illustrators, 2 photographers, 2 designers. Markets include: advertising agencies; corporations/client direct; design firms; editorial/magazines; paper products/greeting cards; publishing/books.

Handles: Illustration, photography.

Terms: Rep receives 30% commission. Advertises in *The Workbook*, *Directory of Illustration*.

How to Contact: For first contact, send direct mail flier/brochure and tearsheets. After initial contact, call to schedule an appointment then drop off or mail in appropriate materials. Portfolio should include tearsheets, slides, photographs, photocopies.

Tips: Wants artists with "professional attitudes and knowledge, unique abilities or application, interest and motivation."

‡HANKINS & TEGENBORG, LTD., 60 E. 42nd St., Suite 1940, New York NY 10165. (212)867-8092. Fax: (212)949-1977. Commercial illustration representative. Estab. 1980. Member of Society of Illustrators, Graphic Artists Guild. Represents 65 illustrators. Specializes in realistic illustration. Markets include: advertising agencies; paper products/greeting cards; publishing/books.

Handles: Illustration, computer illustration. Specializes in fantasy and wildlife art.

Terms: Rep receives 25% commission. "All additional fees are charged per job if applicable." Exclusive area representation is required. Advertising costs are split: 75% paid by talent; 25% paid by representative. For promotional purposes, talent must provide 8 × 10 transparencies. Advertises in *American Showcase* "and own promotion book."

How to Handle: For first contact, send query letter, direct mail flier/brochure, tearsheets and SASE. Reports back within days if SASE is included. After initial contact, call to schedule an appointment. Portfolio should include original art, tearsheets, slides.

‡**HK PORTFOLIO**, 666 Greenwich St., New York NY 10014. (212)675-5719. Contact: Harriet Kasak. Commercial illustration representative. Estab. 1986. Member of SPAR. Represents 30 illustrators. Specializes in illustration for juvenile markets. Markets include: advertising agencies; editorial/magazines; publishing/books.
Handles: Illustration.
Terms: Rep receives 25% commission. No geographic restrictions. Advertising costs are split: 75% paid by talent; 25% paid by representative. Advertises in *American Showcase, RSVP, The Workbook*.
How to Contact: No geographic restrictions. For first contact, send query letter, direct mail flier/brochure, tearsheets, slides, photographs, photostats and SASE. Reports in 1 week. After initial contact, drop off or mail in appropriate materials for review. Portfolio should include tearsheets, slides, photographs, photostats, photocopies.
Tips: Leans toward highly individual personal styles.

‡**MARY HOLLAND & COMPANY, INC.**, 6638 N. 13th St., Phoenix AZ 85014. (602)263-8990. Fax: (602)277-0680. Owner: Mary Holland. Assistant: Holly Heath. Commercial illustration, photography representative. Estab. 1984. Member of SPAR, Graphic Artists Guild. Represents 18 illustrators, 2 photographers. Markets include: advertising agencies; corporations/client direct; design firms; editorial/magazines; paper products/greeting cards; publishing/books.
Handles: Illustration, photography.
Terms: Rep receives 25% commission. Advertising costs are split: 75% paid by talent; 25% paid by representative. For promotional purposes, talent must provide direct mail piece, tearsheets, slides or promotional material. Advertises in *American Showcase, Creative Black Book, Southwest Portfolio*.
How to Contact: For first contact, send query letter, direct mail flier/brochure, tearsheets, slides, photocopies. Reports back within 2 weeks. After initial contact, call to schedule an appointment. Portfolio should include tearsheets, slides, photographs.
Tips: Looking for "good conceptual styles."

‡**IRMEL HOLMBERG**, 280 Madison Ave., Suite 1010, New York NY 10016. (212)545-9155. Fax: (212)545-9462. Rep: I. Holmberg. Commercial illustration representative. Estab. 1980. Member of SPAR. Represents 26 illustrators. Markets include: advertising agencies; corporations/client direct; design firms; editorial/magazines; publishing/books.
Terms: Rep receives 30% commission. Exclusive area representation is required. Advertising costs are split: 70% paid by talent; 30% paid by representative. For promotional purposes, talent must provide versatile portfolio with new fresh work. Advertises in *American Showcase, The Workbook*.
How to Handle: For first contact, send direct mail flier/brochure. Reports back within 2 weeks. After initial contact, call to schedule an appointment. Portfolio should include original art, tearsheets, slides, photocopies.

‡**MELISSA HOPSON REPRESENTING**, 2400 McKinney Ave., Dallas TX 75201. (214)747-3122. Fax: (214)720-0080. Owner: Melissa Hopson. Commercial illustration, digital/computer representative. Estab. 1982. Member of Society of Illustrators. Represents 6 illustrators. Specializes in comps/presentations and high-end computer illustration.
Handles: Illustration (commercial), design. Specializes in illustration and photo manipulation.
Terms: Rep receives 25-30% commission. Exclusive area representation is required. Advertising costs are split: 75% paid by talent; 25% paid by representative. For promotional purposes, requires ads in national books, leave behinds and 2 full portfolios.
How to Contact: For first contact, send query letter, tearsheets and slides. Reports in 1-2 weeks, only if interested. After initial contact, call to schedule an appointment. Portfolio should include transparencies of work (mounted).
Tips: Impressed by "upbeat personality, willingness to work hard, friendliness—does not mind client changes, professional appearance, professionally put together portfolio."

SCOTT HULL ASSOCIATES, 68 E. Franklin S., Dayton OH 45459. (513)433-8383. Fax: (513)433-0434. Contact: Scott Hull or Frank Sturges. Commercial illustration representative. Estab. 1981. Represents 20 illustrators.

Always enclose a self-addressed, stamped envelope (SASE) with queries and sample packages.

Terms: No information provided.
How to Contact: Contact by sending slides, tearsheets or appropriate materials for review. Follow up with phone call. Reports within 2 weeks.
Tips: Obtains new talent through solicitation.

JEDELL PRODUCTIONS, INC., 370 E. 76th St., New York NY 10021. (212)861-7861. Contact: Joan Jedell. Commercial photography representative. Estab. 1969. Member of SPAR. Specializes in photography. Markets include: advertising agencies.
Handles: Photography, fine art.
How to Contact: After initial contact, drop off or mail in portfolio of photographs. For returns, include SASE or Federal Express number.

‡JOHNSON REPRESENTS, 1643 W. Swallow Rd., Fort Collins CO 80526. (303)223-3027. Contact: Sally Johnson. Commercial illustration representative. Estab. 1992. Represents 5 illustrators. Markets include: advertising agencies; corporations/client direct; design firms; editorial/magazines.
Handles: Illustration.
Terms: Rep receives 25% commission. Exclusive area representation is required. For promotional purposes, talent must provide promo piece with current images.
How to Contact: For first contact, send query letter, direct mail flier/brochure and tearsheets. Reports in 1 month only if interested. After initial contact, call to schedule an appointment. Portfolio should include tearsheets, transparencies.

‡VINCENT KAMIN & ASSOCIATES, 260 E. Chestnut, Suite 3005, Chicago IL 60611. (312)787-8834. Commercial photography, graphic design representative. Estab. 1971. Member of CAR (Chicago Artists Representatives). Represents 6 illustrators, 6 photographers, 1 designer, 1 fine artist (includes 1 sculptor). Markets include: advertising agencies.
Handles: Illustration, photography.
Terms: Rep receives 30% commission. Advertising costs are split: 90% paid by talent; 10% paid by representative. Advertises in *The Workbook*.
How to Contact: For first contact, send tearsheets. Reports back within 10 days. After initial contact, call to schedule an appointment. Portfolio should include tearsheets.

‡KELLOGG CREATIVE SERVICES, 525 E. Flower, Phoenix AZ 85012. (602)241-1828. Contact: Mollie Cirino. Clients include Scottsdale RMG, City of Phoenix, Stonebroke.
How to Contact: "Send information I can keep on file."

KIRCHOFF/WOHLBERG, ARTISTS REPRESENTATION DIVISION, 866 United Nations Plaza, #525, New York NY 10017. (212)644-2020. Fax: (212)223-4387. Director of Operations: John R. Whitman. Estab. 1930s. Member of SPAR, Society of Illustrators, AIGA, Associaton of American Publishers, Bookbuilders of Boston, New York Bookbinders' Guild. Represents over 50 illustrators. Artist's Represenative: Elizabeth Ford (juvenile and young adult trade book and textbook illustrators). Specializes in juvenile and young adult trade books and textbooks. Markets include: publishing/books.
Handles: Illustration and photography (juvenile and young adult). Please send all correspondence to the attention of Elizabeth Ford.
Terms: Rep receives 25% commission. Exclusive representation to book publishers is usually required. Advertising costs paid by representative ("for all Kirchoff/Wohlberg advertisements only"). "We will make transparencies from portfolio samples; keep some original work on file." Advertises in *American Showcase*, *Art Directors' Index*, *Society of Illustrators Annual*, children's book issue of *Publishers Weekly*.
How to Contact: For first contact, send query letter, "any materials artists feel are appropriate." Reports in 4-6 weeks. "We will contact you for additional materials." Portfolios should include "whatever artists feel best represents their work. We like to see children's illustration in any style."

BILL AND MAURINE KLIMT, 15 W. 72nd St., 7-U, New York NY 10023. (212)799-2231. Contact: Bill or Maurine. Commercial illustration representative. Estab. 1978. Member of Society of Illustrators, Graphic Artists Guild. Represents 14 illustrators. Specializes in paperback covers, young adult, romance, science fiction, mystery, etc. Markets include: advertising agencies; corporations/client direct; design firms; editorial/magazines; paper products/greeting cards; publishing/books; sales/promotion firms.
Handles: Illustration.
Terms: Rep receives 25% commission, 30% commission for "out of town if we do shoots. The artist is responsible for only his own portfolio. We supply all promotion and mailings other than the publications." Exclusive area representation is required. No geographic restrictions. Advertising costs are split: 75% paid by talent; 25% paid by representative. For promotional purposes, talent must provide 4×5 or 8×10 mounted transparencies. Advertises in *American Showcase*, *RSVP*.

How to Contact: For first contact, send direct mail flier/brochure, and "any image that doesn't have to be returned unless supplied with SASE." Reports in 5 days. After initial contact, call for appointment to show portfolio of professional, mounted transparencies.

Tips: Obtains new talent through recommendations from others and solicitation.

ELLEN KNABLE & ASSOCIATES, INC., 1233 S. LaCienega Blvd., Los Angeles CA 90035. (310)855-8855. (310)657-0265. Contact: Ellen Knable, Kathee Toyama. Commercial illustration, photography and production representative. Estab. 1978. Member of SPAR, Graphic Artists Guild. Represents 6 illustrators, 5 photographers. Markets include: advertising agencies; corporations/client direct; design firms. Clients include Chiat/Day, BBDO, J.W. Thompson/SF, Ketchum/SF. Client list available upon request.

Terms: Rep receives 25-30% commission. Exclusive West Coast/Southern California representation is required. Advertising costs and payment split varies. Advertises in *The Workbook*.

How to Contact: For first contact, send query letter, direct mail flier/brochure and tearsheets. Reports within 2 weeks. Call for appointment to show portfolio.

Tips: Obtains new talent from creatives/artists. "Have patience and persistence!"

SHARON KURLANSKY ASSOCIATES, 192 Southville Rd., Southborough MA 01772. (508)872-4549. Fax: (508)460-6058. Contact: Sharon Kurlansky. Commercial illustration representative. Estab. 1978. Represents 9 illustrators. Markets include: advertising agencies; corporations/client direct; design firms; editorial/magazines; paper products/greeting cards; publishing/books; sales/promotion firms. Client list available upon request.

Handles: Illustration.

Terms: Rep receives 25% commission. Exclusive area representation is required. Advertising costs are split: 75% paid by talent; 25% paid by representative. "Will develop promotional materials with talent. Portfolio presentation formatted and developed with talent also." Advertises in *American Showcase*, *The Creative Illustration Book*, under artist's name.

How to Contact: For first contact, send direct mail flier/brochure, tearsheets, slides and SASE. Reports in 1 month if interested. After initial contact, call for appointment to show portfolio of tearsheets, photocopies.

Tips: Obtains new talent through various means.

‡MARY LAMONT, 56 Washington Ave., Brentwood NY 11717. Representative not currently seeking new talent.

‡SHARON LANGLEY REPRESENTS!, 4300 N. Narragansett Ave., Chicago IL 60634-1591. Contact: Sharon Langley. Commercial illustration and photography representative. Estab. 1988. Member of CAR (Chicago Artists Representatives). Represents 15 illustrators and 1 photographer. Markets include: advertising agencies; corporations/client direct; design firms; editorial/magazines; publishing/books; sales/promotion firms. Clients include Leo Burnett Advertising, *The Chicago Tribune*, Chicago Mercantile Exchange. Client list available upon request.

Handles: Illustration and photography. Although representative prefers to work with established talent, "I am always receptive to reviewing illustrators' work."

Terms: Rep receives 25% commission. Exclusive area representation is preferred. Advertising costs are split: 75% paid by talent; 25% paid by representative. For promotional purposes, talent must provide printed promotional piece, well organized portfolio. Advertises in *Creative Black Book*, *The Workbook*, *Chicago Source Book*, *Creative Illustration*.

How to Contact: For first contact, send printed promotional piece. Reports in 2 weeks if interested. After initial contact, call for appointment to show portfolio of tearsheets, transparencies.

Tips: Obtains new talent through art directors, clients, referrals. "When an artist just starts freelancing it's a good idea to represent yourself for a while. Only then are you able to appreciate a professional agent. Don't be discouraged when one rep turns you down. Contact the next one on your list!"

JEFF LAVATY & ASSOCIATES, 217 E. 86th St., Suite 212, New York NY 10028-3617. (212)427-5632. Commercial illustration and fine art representative. Represents 15 illustrators.

Handles: Illustration.

Terms: No information provided.

How to Contact: For first contact, send query letter, direct mail flier/brochure, tearsheets, slides and SASE. Reports in 1 week. After initial contact, call for appointment to show portfolio of tearsheets, 8×10 or 4×5 transparencies.

Tips: Obtains new talent through solicitation. "Specialize! Your portfolio must be focused."

For a list of markets interested in humorous illustration, cartooning and caricatures, refer to the Humor Index at the back of this book.

NELDA LEE INC., 2610 21st St., Odessa TX 79761. (915)366-8426. Fax: (915)550-2830. President: Nelda Lee. Vice President: Cory Ricot. Fine art representative. Estab. 1967. Senior member of American Society of Appraisers, Past President of Texas Association of Art Dealers. Represents 50-60 artists (includes 4 sculptors). Markets include: corporate collections; developers; galleries; interior decorators; museums; private collections. Client list available upon request.
Handles: Fine art, illustration.
Terms: Agent receives 40-50% commission. Exclusive area representation is required. No geographic restrictions. Advertising costs are paid by representative. Advertises in *Texas Monthly*, *Southwest Art*, local TV and newspapers.
How to Contact: For first contact, send query letter and photographs ("include phone number"). Reports back only if interested.

‡LEHMEN DABNEY INC., 1431 35th Ave. S., Seattle WA 98144. (206)325-8595. Fax: (206)325-8594. Principals: Nathan Dabney, Connie Lehmen. Commercial illustration, photography representative. Estab. 1989. Represents 20 illustrators, 1 photographer. Specializes in commercial art. Markets include: advertising agencies; corporations/client direct; design firms; editorial/magazines; paper products/greeting cards; publishing/books.
Handles: Illustration, photography.
Terms: Rep receives 25% commission. "Artists are responsible for providing portfolio pieces and cases." Exclusive area representation is required. Advertising costs are split: 75% paid by talent; 25% paid by representative. For promotional purposes, talent must provide transparencies or printed art on 11 × 14 art boards with museum box case; backlog of printed samples 1,000-1,500 minimum. Advertises in *American Showcase*, *The Workbook*, *Alternative Pic*.
How to Contact: For first contact, send direct mail flier/brochure and tearsheets. Reports in 10 days. After initial contact, call to schedule an appointment. Portfolio should include tearsheets, photographs, photocopies, transparencies (4 × 5), proofs.
Tips: Artists "must have published work, experience working with art directors and designers; computer skills a plus."

LEIGHTON & COMPANY, 4 Prospect St., Beverly MA 01915. (508)921-0887. Fax: (508)921-0223. Contact: Leighton O'Connor. Commercial illustration and photography representative. Estab. 1986. Member of Graphic Artists Guild, ASMP. Represents 8 illustrators and 3 photographers. Markets include: advertising agencies; corporations/clients direct; design firms; editorial/magazines; publishing/books.
Handles: Illustration, photography. "Looking for photographers and illustrators who can create their work on computer."
Terms: Rep receives 25% commission. Advertising costs are split: 75% paid by talent; 25% paid by representative. For promotional purposes, "talent is required to supply me with 6 × 9 color mailer(s) and laminated portfolios as well as two 4 × 5 color transparency portfolios." Advertises in *Creative Illustration*, *Graphic Artist Guild Directory of Illustration*.
How to Contact: For first contact, send query letter, direct mail flier/brochure, tearsheets and SASE. Reports in 1 week if interested. After initial contact, drop off or mail in appropriate materials with SASE for review. Portfolio should include tearsheets, slides, photographs.
Tips: "My new talent is almost always obtained through referrals. Occasionally, I will solicit new talent from direct mail pieces they have sent to me. It is best to send work first, i.e., tearsheet or direct mail pieces. Only send a portfolio when asked to. If you need your samples returned, always include a SASE. Follow up with one phone call. It is very important to get the correct spelling and address of the representative. Also, make sure you are financially ready for a representative, having the resources available to create a portfolio and direct mail campaign."

LESLI ART, INC., Box 6693, Woodland Hills CA 91364. (818)999-9228. Fax: (818)999-0833. Contact: Stan Shevrin. Fine art agent, publisher and advisor. Estab. 1965. Represents emerging, mid-career and established artists. Specializes in artists painting in oil or acrylic, in traditional subject matter in realistic or impressionist style. Also represents illustrators who want to establish themselves in the fine art market.
Terms: Receives 50% commission. Pays all expenses including advertising and promotion. Artist pays one-way shipping. All artwork accepted unframed. Exclusives preferred. Contract provided.
How to Contact: For first contact, send either color prints or slides with short bio and SASE. Material will be filed if SASE is not included. Reports in 2 weeks.
Tips: Obtains new talent through "reviewing portfolios. Artists should show their most current works and state a preference for subject matter and medium."

‡LINDGREN & SMITH, 250 W. 57th St., #916, New York NY 10107. (212)397-7330. Receptionist: Miel Roman. Commercial illustration representative. Estab. 1984. Member of SPAR. Represents 25 illustrators. Markets include advertising agencies; corporations/client direct; design firms; editorial/magazines; paper products/greeting cards; publishing/books.

Handles: Illustration.
Terms: Exclusive representation is required. Advertises in *American Showcase, The Workbook*.
How to Contact: For first contact, send direct mail flier/brochure, tearsheets, photocopies. Call for response."

LONDON CONTEMPORARY ART, 729 Pine Crest, Prospect Heights IL 60070. (708)459-3990. Contact: Marketing Manager. Fine art representative and publisher. Estab. 1977. Represents 45 fine artists. Specializes in "selling to art galleries." Markets include: galleries; corporate collections; interior designers.
Handles: Fine art.
Terms: Publisher of original art. Exclusive representation is required. For promotional purposes talent must provide slides, color prints, "any visuals." Advertises in *Art Business News, Art & Antiques, Preview, Sunstorm*.
How to Contact: For first contact, send tearsheets, slides, photographs and SASE. LCA will report in 1 month, only if interested. "If interested, we will call you." Portfolio should include slides, photographs.
Tips: Obtains new talent through recommendations from others and word of mouth.

‡LULU CREATIVES, 4645 Colfax Ave. S., Minneapolis MN 55409. Phone/fax: (612)825-7564. Creative Representative: Lulu Zabowski. Commercial illustration representative. Estab. 1983. Represents 12 illustrators, 1 photographer. Markets include: advertising agencies; corporations/client direct; design firms; editorial/magazines; paper products/greeting cards; publishing/books.
Handles: Illustration, photography.
Terms: Rep receives 25% commission. Exclusive area representation is required. Advertising costs are split: 75% paid by talent; 25% paid by representative. For promotional purposes, talent must provide yearly national advertising, direct mailers (2 to 3 times yearly). Advertises in *American Showcase, Creative Black Book, The Workbook*.
How to Contact: For first contact, send tearsheets. Reports immediately if interested. After initial contact, call to schedule an appointment.
Tips: Artists must have "good telephone communication skills."

‡MARY MALOOLY REPRESENTS, 6203 St. Moritz, Dallas TX 75214. (214)827-9975. Fax: (214)827-9935. Owner: Mary Malooly. Commercial illustration, photography representative. Estab. 1993. Represents 8 illustrators, 2 photographers. Markets include: advertising agencies; corporations/client direct; design firms; editorial/magazines; publishing/books.
Handles: Illustration, photography.
Terms: Rep receives 25% commission. Exclusive area representation is required. Advertising costs are split: 75% paid by talent; 25% paid by representative. For promotional purposes, talent must provide printed samples of work.
How to Contact: For first contact, send query letter, bio, direct mail flier/brochure, tearsheets and slides. Reports back within 2 weeks. After initial contact, call to schedule an appointment, drop off or mail in appropriate materials. Portfolio should include tearsheets, slides, photographs.
Tips: Looking for "unique style with a consistent look."

‡MARLENA AGENCY, 211 E. 89th St., S.A-1, New York NY 10128. (212)289-5514. Fax: (212)987-2855. Artist Rep: Marlena Torzecka. Commercial illustration representative. Estab. 1990. Member of Art Directors Club of New York. Represents 14 illustrators. Specializes in conceptual illustration. Markets include: advertising agencies; corporations/client direct; design firms; editorial/magazines; publishing/books; theaters.
Handles: Illustration, fine art.
Terms: Rep receives 30% commission. Costs are shared by all artists. Exclusive area representation is required. Advertising costs are split: 70% paid by talent; 30% paid by representative. For promotional purposes, talent must provide slides (preferably 8×10 framed); direct mail piece helpful. Advertises in *American Showcase, Creative Black Book, Illustrators 35* (New York City).
How to Contact: For first contact send tearsheets. Reports back within 1 week only if interested. After initial contact, drop off or mail appropriate materials. Portfolio should include tearsheets.
Tips: Wants artists with "talent, good concepts—intelligent illustration, promptness in keeping up with projects, deadlines, etc."

MARTHA PRODUCTIONS, INC., 11936 W. Jefferson, Suite C, Culver City CA 90230. (310)390-8663. Fax: (310)390-3161. Contact: Martha Spelman. Commercial illustration and graphic design representative. Estab. 1978. Member of Graphic Artists Guild. Represents 25 illustrators. Staff includes Jennifer Broughton (artist representative), Martha Spelman (artist representative), K. Powell (artist representative). Specializes in b&w and 4-color illustration. Markets include: advertising agencies; corporations/client direct; design firms; editorial/magazines; paper products/greeting cards.
Handles: Illustration.
Terms: Rep receives 30% commission. Exclusive area representation is required. No geographic restrictions. Advertising costs are split: 70% paid by talent; 30% paid by representative. For promotional purposes, talent

must provide "a minimum of 12 images, 4×5 transparencies of each. (We put the transparencies into our own format.) In addition to the transparencies, we require 4-color promo/tearsheets and participation in the biannual Martha Productions brochure." Advertises in *The Workbook, Single Image.*
How to Contact: For first contact, send query letter, direct mail flier/brochure, tearsheets, slides and SASE (if materials are to be returned). Reports only if interested. After initial contact, drop off or mail in appropriate materials for review. Portfolio should include tearsheets, slides, photographs, photostats.
Tips: Obtains new talent through recommendations and solicitation.

‡MASON ILLUSTRATION, 3825 E. 26th St., Minneapolis MN 55406. (612)729-1774. Fax: (612)729-0133. Creative Rep/Owner: Marietta. Commercial illustration representative. Estab. 1984. Represents 10 illustrators. Markets include advertising agencies; corporations/client direct; design firms; editorial/magazines; publishing/books; sales; promotion; incentives.
Handles: Illustration.
Terms: Rep receives 25% commission. Exclusive area representation is required. Advertising costs are split: 75% paid by talent; 25% paid by representative. For promotional purposes, talent must provide 2 complete portfolios of transparencies or reflective samples, "unmounted as we mount to coordinate as group."
How to Contact: For first contact, send query letter, bio, direct mail flier/brochure, tearsheets, slides, photocopies and SASE. Reports in 1 month. After initial contact, drop off or mail in appropriate materials. Portfolio should include tearsheets, slides, photocopies, 4×5 transparencies.
Tips: Artist must have "good communication/visual/verbal skills."

MATTELSON ASSOCIATES LTD., 37 Cary Rd., Great Neck NY 11021. (212)684-2974. Fax: (516)466-5835. Contact: Judy Mattelson. Commercial illustration representative. Estab. 1980. Member of SPAR, Graphic Artists Guild. Represents 3 illustrators. Markets include: advertising agencies; corporations/client direct; design firms; editorial/magazines; paper products/greeting cards; publishing/books; sales/promotion firms.
Handles: Illustration.
Terms: Rep receives 25-30% commission. Exclusive area representation is required. No geographic restrictions. Advertising costs are split: 75% paid by talent; 25% paid by representative. For promotional purposes, talent must provide c-prints and tearsheets, custom-made portfolio. Advertises in *American Showcase, RSVP.*
How to Contact: For first contact, send direct mail flier/brochure, tearsheets and SASE. Reports in 2 weeks, if interested. After initial contact, call for appointment to show portfolio of tearsheets, c-prints.
Tips: Obtains new talent through "recommendations from others, solicitation. Illustrator should have ability to do consistent, professional-quality work that shows a singular direction and a variety of subject matter. You should have a portfolio that shows the full range of your current abilities. Work should show strong draftsmanship and technical facility. Person should love her work and be willing to put forth great effort in each assignment."

‡MONTAGANO & ASSOCIATES, 211 E. Ohio St., #212, Chicago IL 60611. (312)527-3283. Fax: (312)527-9091. Contact: David Montagano. Commercial illustration, photography and television production representative and broker. Estab. 1983. Represents 7 illustrators, 2 photographers. Markets include: advertising agencies; corporations/client direct; design firms; editorial/magazines; paper products/greeting cards.
Handles: Illustration, photography, design.
Terms: Rep receives 30% commission. No geographic restrictions. Advertises in *American Showcase, The Workbook.*
How to Contact: For first contact, send direct mail flier/brochure, tearsheets, photographs. Portfolio should include original art, tearsheets, photographs.
Tips: Obtains new talent through recommendations from others.

VICKI MORGAN ASSOCIATES, 194 Third Ave., New York NY 10003. (212)475-0440. Contact: Vicki Morgan. Commercial illustration representative. Estab. 1974. Member of SPAR, Graphic Artists Guild, Society of Illustrators. Represents 12 illustrators. Markets include: advertising agencies; corporations/client direct; design firms; editorial/magazines; paper products; publishing/books; sales/promotion firms.
Handles: Illustration. "Fulltime illustrators only."
Terms: Rep receives 25-30% commission. Exclusive area representation is required. No geographic restrictions. Advertising costs are split: 75% paid by talent; 25% paid by representative. "We require samples for three duplicate portfolios; the presentation form is flexible." Advertises in *American Showcase.*
How to Contact: For first contact, send any of the following: direct mail flier/brochure, tearsheets, slides with SASE. "If interested, we keep on file and consult these samples first when considering additional artists. No drop-off policy."
Tips: Obtains new talent through "recommendations from artists I represent and mail solicitation."

‡MUNRO GOODMAN, 405 N. Wabash, Suite 2405, Chicago IL 60611. (312)321-1336. Fax: (312)321-1350. President: Steve Munro. Commercial illustration, photography representative. Estab. 1987. Member of SPAR, CAR (Chicago Artists Representatives). Represents 22 illustrators, 2 photographers. Markets include

advertising agencies; corporations/client direct; design firms; publishing/books.

Handles: Illustration.

Terms: Rep receives 25-30% commission. Exclusive area representation is required. Advertising costs are split: 75% paid by talent; 25% paid by representative. For promotional purposes, talent must provide 2 portfolios. Advertises in *American Showcase*, *Creative Black Book*, *The Workbook*.

How to Contact: For first contact, send query letter, bio, tearsheets and SASE. Reports back within 2 weeks. After initial contact, write to schedule an appointment. Portfolio should include 4×5 or 8×10 transparencies.

THE NEIS GROUP, 11440 Oak Dr., P.O. Box 174, Shelbyville MI 49344. (616)672-5756. Fax: (616)672-5757. Contact: Judy Neis. Commercial illustration and photography representative. Estab. 1982. Represents 30 illustrators, 7 photographers. Markets include: advertising agencies; design firms; editorial/magazines; publishing/books.

Handles: Illustration, photography.

Terms: Rep receives 25% commission. Advertising costs are split: 75% paid by talent; 25% paid by representative. Advertises in *The American Showcase*.

How to Contact: For first contact, send direct mail flier/brochure, tearsheets, photographs. "Send nothing that has to be returned." Reports only if interested. After initial contact, drop off or mail appropriate materials for review. Portfolio should include tearsheets, photographs.

Tips: "I am mostly sought out by the talent. If I pursue, I call and request a portfolio review."

THE NEWBORN GROUP, 270 Park Ave. S., Apt. 8E, New York NY 10010-6105. (212)260-6700. Fax: (212)260-9600. Owner: Joan Sigman. Commercial illustration representative. Estab. 1964. Member of SPAR, Society of Illustrators, Graphic Artists Guild. Represents 12 illustrators. Markets include: advertising agencies; design firms; editorial/magazines; publishing/books. Clients include Leo Burnett, Berkley Publishing, Weschler Inc.

Handles: Illustration.

Terms: Rep receives 25% commission. Exclusive area representation is required. Advertising costs are split: 75% paid by talent; 25% paid by representative. Advertises in *American Showcase*, *The Workbook*.

How to Contact: "Not reviewing new talent."

Tips: Obtains new talent through recommendations from other talent or art directors.

‡LORI NOWICKI AND ASSOCIATES, 33 Cogswell Ave., Suite #7, Cambridge MA 02140. (617)497-5336. Fax: (617)441-0674. E-mail: lanow@aol.com. Artist Representative: Lori Nowicki. Commercial illustration representative. Estab. 1993. Represents 6 illustrators. Markets include: advertising agencies; design firms; editorial/magazines; publishing/books.

Handles: Illustration.

Terms: Rep receives 25-30% commission. Cost for direct mail promotional pieces is paid by illustrator. Exclusive area representation is required. Advertising costs are split: 75% paid by talent; 25% paid by representative. Advertises in *American Showcase*, *The Workbook*.

How to Contact: For first contact, send query letter, résumé, tearsheets and SASE. Reports back within a month. After initial contact, call to schedule an appointment. Portfolio should include tearsheets, transparencies.

Tips: Wants artists with consistent style.

‡100 ARTISTS, 4170 S. Arbor Circle, Marietta GA 30066. (404)924-4793. Fax: (404)924-7174. Owner: Brenda Bender. Commercial illustration, photography, graphic design representative. Estab. 1990. Member of Society of Illustration, Graphic Artists Guild. Represents 40 illustrators, 8 photographers, 8 designers. Markets include: advertising agencies; corporations/client direct; design firms; editorial/magazines; publishing/books.

Handles: Illustration, photography.

Terms: Rep receives 30% commission. $30-50 is added to all out-of-town projects for miscellaneous expenses, i.e. long distance calls, fax, etc. Exclusive area representation is required. Advertising costs are split: 70% paid by talent; 30% paid by representative. For promotional purposes, talent must provide direct mail/self-mailer (no overlarge or bulky promos), new material every 3 months Advertises in *American Showcase*, *The Workbook*.

How to Contact: For first contact, send query letter, direct mail flier/brochure or tearsheets. Reports back within 2 weeks. After initial contact, call to schedule an appointment or drop off or mail in appropriate materials. Portfolio should include roughs, tearsheets, slides or photographs.

Tips: Needs artists with "originality who do not conflict with talent we already represent."

‡PENNAMENITIES, R.D. #2, Box 1080, Schuylkill Haven PA 17972. (717)754-7744. Fax: (717)754-7744. Director: Deborah A. Miller. Fine art representative. Estab. 1988. Member of NYU School of Appraisal; Schuylkill County Council for the Arts, Board of Directors; New Arts Program. Represents 40 fine artists.

Markets include: commercial and academic galleries; private collectors. "Currently working with 14 galleries located in Pennsylvania and New York City."
Handles: Two dimensional fine art in all media (originals and prints).
Terms: Agent receives 25-50% commission. Charges $350 annual fee which covers correspondence, copies, phone and fax or services involved in setting up exhibits. New York City expenses, if applicable, are additional
How to Contact: Send bio, slides, transparencies, photos or laser prints labeled with size, medium, title and artist's name; include corresponding price list which refelcts price to artist and SASE.
Tips: Currently seeking great art at marketable prices.

THE PENNY & STERMER GROUP, 19 Stuyvesant Oval, Suite 2D, New York NY 10009-2021. (212)505-9342. Fax: (212)505-1844. Contact: Carol Lee Stermer. Commercial illustration representative. Estab. 1975. Member of Graphic Artists Guild. Represents 9 illustrators, animation artists. Specializes in illustration for packaging. Markets include: advertising agencies; corporations/client direct; design firms; editorial/magazines; paper products/greeting cards; publishing/books; sales/promotion firms.
Handles: Illustration. Looking for highly conceptual artists and established food packaging artists.
Terms: Rep receives 25-30% commission. Artists billed for portfolio supplies and bulk mailings. Advertising costs are split: 70-75% paid by talent; 30-25% paid by representative. For promotional purposes, talent must provide direct mail pieces. Advertises in *American Showcase, Creative Black Book, RSVP, The Workbook*.
How to Contact: For first contact, send nonreturnable promos, direct mailers, etc. Reports only if interested. After initial contact, "I'll call." Portfolio should include tearsheets, 4×5 or 8×10 chromes.

‡CAROLYN POTTS & ASSOC. INC., 1872 N. Clybourn, Suite 404, Chicago IL 60614. (312)935-1707. President: Carolyn Potts. Commercial illustration, photography representative. Estab. 1976. Member of SPAR, CAR (Chicago Artists Reps). Represents 12 illustrators, 7 photographers. Specializes in contemporary advertising and design. Markets include: advertising agencies; corporations/client direct; design firms; publishing/books.
Handles: Illustration, photography. Looking for "artists able to work with new technologies (interactive, computer, etc.)."
Terms: Rep receives 30-35% commission. Artists share cost of their direct mail postage and preparation. Exclusive area representation is required. Advertising costs are split: 70% paid by the talent; 30% paid by the representative after initial trial period wherein artist pays 100%. For promotional purposes, talent must provide direct mail piece and multiple portfolios. Advertises in *American Showcase, Creative Black Book, The Workbook, Single Image*.
How to Contact: For first contact, send direct mail flier/brochure and SASE. Reports back within 3 days. After initial contact, write to schedule an appointment. Portfolio should include tearsheets, slides, photographs.
Tips: Looking for artists with high level of professionalism, awareness of current advertising market, professional presentation materials and positive attitude.

CHRISTINE PRAPAS/ARTIST REPRESENTATIVE, 12480 SE Wiese Rd., Boring OR 97009. (503)246-9511. Fax: (503)658-3960. Contact: Christine Prapas. Commercial illustration and photography representative. Estab. 1978. Member of AIGA. "Promotional material welcome."

GERALD & CULLEN RAPP, INC., 108 E. 35th St., New York NY 10016. (212)889-3337. Fax: (212)889-3341. Contact: John Knepper. Commercial illustration, graphic design representative. Estab. 1944. Member of SPAR, Society of Illustrators, Graphic Artists Guild. Represents 34 illustrators. Markets include: advertising agencies; corporations/client direct; design firms; editorial/magazines; paper products/greeting cards; publishing/books; sales/promotion firms.
Handles: Illustration.
Terms: Rep receives 25-30% commission. Exclusive area representation is required. No geographic restrictions. Split of advertising costs is negotiated. Advertises in *American Showcase, The Workbook, Graphic Artists Guild Directory* and *CA, Print, Art Direction* magazines. "Conducts active direct mail program."
How to Contact: For first contact, send query letter, direct mail flier/brochure. Reports in 1 week. After initial contact, call for appointment to show portfolio of tearsheets, slides.
Tips: Obtains new talent through recommendations from others, solicitations.

The double dagger before a listing indicates that the listing is new in this edition. New markets are often more receptive to freelance submissions.

KERRY REILLY: REPS, 1826 Asheville Place, Charlotte NC 28203. Phone/fax: (704)372-6007. Contact: Kerry Reilly. Commercial illustration and photography representative. Estab. 1990. Represents 16 illustrators, 3 photographers. Markets include: advertising agencies; corporations/client direct; design firms; editorial/magazines. Clients include Paramount Parks, Price/McNabb Advertising, Indigo Design.
Handles: Illustration, photography. Looking for computer graphics: Photoshop, Illustrator, FreeHand, etc.
Terms: Rep receives 25% commission. Exclusive area representation is required. No geographic restrictions. Advertising costs are split: 75% paid by talent; 25% paid by representative. For promotional purposes, talent must provide at least 2 pages printed leave-behind samples. Preferred format is 9×12 pages, portfolio work on 4×5 transparencies. Advertises in *American Showcase*, *Workbook*.
How to Contact: For first contact, send direct mail flier/brochure or samples of work. Reports in 2 weeks. After initial contact, call for appointment to show portfolio or drop off or mail tearsheets, slides, 4×5 transparencies.
Tips: Obtains new talent through recommendations from others. "It's essential to have printed samples—a lot of printed samples."

RIDGEWAY ARTISTS REPRESENTATIVE, 712 Terminal Rd., Lansing MI 48906. (517)321-2777. Fax: (517)321-2815. Contact: Edwin Bonnen. Commercial illustration and photography representative. Estab. 1984. Member of AAF, AIGA. Represents 3 illustrators, 1 photographer. Markets include: advertising agencies; corporations/client direct; design firms; editorial/magazines.
Handles: Illustration, photography, fine art. "We are primarily looking for individuals who have developed a distinctive style, whether they be a photographer or illustrator. Photographers must have an area they specialize in. We want artists who are pros in the commercial world, i.e., working with tight deadlines in sometimes less than ideal situations. We would consider a fine artist looking for commercial outlet if it was a good fit."
Terms: Rep receives 25% commission in the state of Michigan, 35% out of state. Exclusive area representation is required. Advertising costs are split: 75% paid by talent; 25% paid by representative. For promotional purposes, talent must provide portfolio of laminated color prints. "Direct mail is primary method of advertising; use of sourcebooks is secondary."
How to Contact: For first contact, send query letter, bio, direct mail flier/brochure. Reports in 3 weeks, only if interested. After initial contact, call for appointment to show portfolio of photographs.
Tips: Obtains talent through recommendations, sourcebooks and solicitations.

‡THE ROLAND GROUP, 4948 St. Elmo Ave., Suite 201, Bethesda MD 20814. (301)718-7955. Fax: (301)718-7958. Production: Thomas Gibbs. Commercial illustration, photography, graphic design representative. Estab. 1988. Member of SPAR, Society of Illustrators, Ad Club, Production Club. Represents 20 illustrators, 40 photographers, 7 designers. Markets include: advertising agencies; corporations/client direct; design firms; editorial/magazines; paper products/greeting cards; publishing books.
Handles: Illustration, photography, design.
Terms: Rep receives 25-30% commission. Charges $150 marketing fee. Exclusive area representation is required. 100% of costs paid by talent. For promotional purposes, talent must provide 8½×11 promo sheet. Advertises in *American Showcase*, *The Creative Black Book*, *The Workbook*, *Sourcebook*.
How to Contact: For first contact, send query letter, résumé, tearsheets and photocopies. Reports back within 2 weeks. Portfolio should include tearsheets, photocopies (items not needed to be returned).

ROSENTHAL REPRESENTS, 3443 Wade St., Los Angeles CA 90066. (310)390-9595. Fax: (310)306-6878. Commercial illustration representative and licensing agent for artists who do advertising, entertainment, action/sports, children's humorous, storyboard, animal, graphic, floral, realistic, impressionistic and game packaging art. Estab. 1979. Member of SPAR, Society of Illustrators, Graphic Artists Guild, Women in Design and Art Directors Club. Represents 100 illustrators, 2 designers and 5 fine artists. Specializes in game packaging, personalities, licensing, merchandising art and storyboard artists. Markets include: advertising agencies; corporations/client direct; paper products/greeting cards; sales/promotion firms; licensees and manufacturers.
Handles: Illustration.
Terms: Rep receives 25-30% as a rep; 40% as a licensing agent. Exclusive area representation is required. No geographic restrictions. Advertising costs are paid by talent. For promotion purposes, talent must provide 1-2 sets of transparencies (mounted and labeled), 10 sets of slides of your best work (labeled with name on each slide), 1-3 promos. Advertises in *American Showcase* and *The Workbook*.
How to Contact: For first contact, send direct mail flier/brochure, tearsheets, slides, photocopies, photostats and SASE. Reports in 1 week. After initial contact, call for appointment to show portfolio of tearsheets, slides, photographs, photocopies.
Tips: Obtains new talent through seeing their work in an advertising book or at an award show.

‡S.I. INTERNATIONAL, 43 E. 19th St., New York NY 10003. (212)254-4996. Fax: (212)995-0911. Commercial illustration representative. Estab. 1973. Member of SPAR, Graphic Artists Guild. Represents 50 illustrators, 1 photographer. Specializes in license characters, educational publishing and children's illustration,

mass market paperbacks. Markets include design firms; publishing/books; sales/promotion firms; licensing firms.

Handles: Illustration. Looking for artists "who have the ability to do children's illustration and to do licensed characters."

Terms: Rep receives 25-30% commission. Advertising costs are split: 70% paid by talent; 30% paid by representative. "Contact agency for details. Must have mailer." Advertises in *RSVP*.

How to Contact: For first contact, send query letter, tearsheets. Reports in 3 weeks. After initial contact, write for appointment to show portfolio of tearsheets, slides.

TRUDY SANDS & ASSOCIATES, 1350 Chemical St., Dallas TX 75207. (214)905-9037. Fax: (214)905-9038. Contact: Trudy Sands. Commercial illustration and photography representative. Estab. 1984. Member of AIGA. Represents 7 illustrators, 1 photographer. Markets include: advertising agencies; corporations/client direct; design firms; editorial/magazines; publishing/books.

Handles: Illustration.

Terms: Rep receives 25% commission. Charges 75% of Federal Express bills. Exclusive representation is required. 25% of advertising costs paid by representative when billing $10,000 or more a year. For promotional purposes, talent must provide "four mailers a year with rep's name and phone number. Two new portfolio pieces a month. Certain format agreed upon by rep and illustrator." Advertises in *RSVP*, *The Workbook*, *Japanese Sourcebook*.

How to Contact: For first contact, send direct mail flier/brochure. Reports in 1 month if interested. After initial contact, call for appointment to show portfolio of 4×5 transparencies or laminated photocopies.

Tips: Obtains new talent through direct mail or sourcebooks. "Have an interesting style. Good promo pieces. Be willing to advertise. Don't expect reps to call you back long distance. Ask art directors which reps they like."

JOAN SAPIRO ART CONSULTANTS, 4750 E. Belleview Ave., Littleton CO 80121. (303)793-0792. Fax: (303)721-1401. Fax: (303)290-9204. Contact: Joan Sapiro. Art consultant. Estab. 1980. Specializes in "corporate art with other emphasis on hospitality, health care and art consulting/advising to private collectors."

Handles: All mediums of artwork and all prices if applicable for clientele.

Terms: "50/50. Artist must be flexible and willing to ship work on consignment. Also must be able to provide sketches, etc. if commission piece involved." No geographic restrictions.

How to Contact: For first contact, send résumé, bio, direct mail flier/brochure, tearsheets, slides, photographs, price list—net (wholesale) and SASE. Reports in 2 weeks. After initial contact, drop off or mail in appropriate materials for review. Portfolios should include tearsheets, slides, price list and SASE.

Tips: Obtains new talent through recommendations, publications, travel, research, university faculty.

FREDA SCOTT, INC., 1015 Battery St., Suite B, San Francisco CA 94111. (415)398-9121. Fax: (415)398-6136. Contact: Wendy Fuchs or Freda Scott. Commercial illustration and photography representative. Estab. 1980. Member of SPAR. Represents 10 illustrators, 6 photographers. Markets include: advertising agencies; corporations/client direct; design firms; editorial/magazines; paper products/greeting cards; publishing/books; sales/promotion firms. Clients include Saatchi & Saatchi, Young & Rubicam, J. Walter Thompson, Anderson & Lembke, *Smart Money*, *Travel & Leisure*, Oracle Corp., Sun Microsystems. Client list available upon request.

Handles: Illustration, photography.

Terms: Rep receives 25% commission. No geographic restrictions. Advertising costs are split: 75% paid by talent; 25% paid by representative. For promotional purposes, talent must provide "promotion piece and ad in a directory. I also need at least three portfolios." Advertises in *American Showcase*, *Creative Black Book*, *The Workbook*.

How to Contact: For first contact, send direct mail flier/brochure, tearsheets and SASE. If you send transparencies, reports in 1 week, if interested. "You need to make follow up calls." After initial contact, call for appointment to show portfolio of tearsheets, photographs, 4×5 or 8×10.

Tips: Obtains new talent sometimes through recommendations, sometimes solicitation. "If you are seriously interested in getting repped, keep sending promos—once every six months or so. Do it yourself a year or two until you know what you need a rep to do."

SEIFFER & ASSOCIATES, 19 Stony Hill Rd., Bethel CT 06801. (203)794-9550. Fax: (203)794-9054. Contact: Barbara Chriswell. Licensing agency. Estab. 1987. "We license artwork to be reproduced on posters and prints, collectible plates, apparel, mugs, music boxes, puzzles, cards, calendars and other gift and stationery items. We're a full-scale licensing agency specializing in fine art. Collectible plates and apparel are our strongest areas. Our licensed products are featured at The Nature Company, Spiegel, L.L. Bean and at fine shops world-wide. Our clients include Turner Publications, Lenox, The Danbury Mint, The Franklin Mint." Staff includes Wendy Seiffer, president (marketing); Barbara Chriswell (artist relations); and John Seiffer, vice president (operations).

Handles: Fine art and exceptional illustration. Looking for "colorful, well-executed and realistic or photorealistic work. Purely decorative is fine as well."

Terms: Agent receives 50% commission. Exclusive worldwide representation is standard. For promotional purposes, "great visuals are essential. Photographs or tearsheets and reproduction-quality transparencies (supplied by the artist) are required."
How to Contact: For first contact, send résumé, comprehensive portfolio (no originals) and SASE. Reports in 2 months. Portfolio should include at least 12-24 images presenting a wide range of work.
Tips: "Have great visuals—at least 12-24 images to show consistency. Include a bio/artist's statement. For successful licensing, artist should have a healthy inventory of work, including work done in series. Reproduction quality transparencies (4×5 or bigger) are required."

‡FRAN SEIGEL, ARTIST REPRESENTATIVE, 515 Madison Ave., Suite 2200, New York NY 10022. (212)486-9644. Fax: (212)486-9646. Commercial illustration. Estab. 1982. Member of SPAR, Graphic Artists Guild. Represents 7 illustrators. Specializes in "stylized realism leaning toward the conceptual." Markets include advertising agencies; corporations/client direct; design firms; editorial/magazines; paper products/greeting cards; publishing/books.
Handles: Illustration, fine art. "Artists in my group must have work applicable to wide commercial market; a unique marketable style for book jackets and/or corporate and packaging is a plus."
Terms: Rep receives 30% commission. Artists pay mass mailing and folio charge (approximately $500/year). Exclusive national representation is required. Advertising costs are split: 70% paid paid by talent; 30% paid by representative. "First promotion is designed by both of us paid for by talent; subsequent promotion costs are split." Advertises in *American Showcase*, *Graphic Artists Guild Directory of Illustration*.
How to Contact: For first contact, send 12-20 images, direct mail flier/brochure, tearsheets, slides and SASE. Reports in 2 weeks only if SASE is included.
Tips: Looking for artists with " 'uniquely wonderful' artwork, vision and energy toward developing market-oriented portfolio, and absolute reliability and professionalism."

SIMPATICO ART & STONE, 1221 Demaret Lane, Houston TX 77055-6115. (713)467-7123. Contact: Billie Blake Fant. Fine art broker/consultant/exhibitor. Estab. 1973. Specializes in unique fine art, sculpture and Texas domestic stone furniture, carvings, architectural elements. Market includes: corporate; institutional and residential clients.
Handles: Looking for unique fine art and sculpture not presently represented in Houston, Texas.
Terms: Standard commission. Exclusive area representation required.
How to Contact: For first contact, send query letter, résumé, slides.
Tips: Obtains new talent through travel, publications, exhibits and referrals.

DANE SONNEVILLE ASSOC. INC., 67 Upper Mountain Ave., Montclair NJ 07042. (201)744-4465. Fax: (201)744-4467. Contact: Dane. Commercial illustration, photography and graphic design representative, illustration or photography broker, paste up, printing, hair and make up, all type stylists, computer image artists, writers. Estab. 1971. Represents 20 illustrators, 10 photographers and 10 designers. Specializes in "resourcefulness and expeditious service." Markets include: advertising agencies; corporations/client direct; design firms; editorial/magazines; publishing/books; sales/promotion firms. Clients include Merrill Lynch Inc., Q.L.M. Advertising, GWP Advertising.
Handles: Illustration, photography, design, writing, all creative support personnel.
Terms: Rep receives 25% commission. Advertising costs are paid by talent. For promotional purposes, talent must provide unlimited promo pieces (to leave behind). Advertises in *American Showcase*, *Creative Black Book*, *RSVP*, *The Workbook*.
How to Contact: For first contact, send résumé, direct mail flier/brochure, tearsheets. Reports in 1 week if interested. After initial contact, call for appointment to show portfolio of original art, tearsheets, slides, photographs.
Tips: Obtains new talent through recommendations from others. "Knock on every door."

‡TORREY SPENCER—ARTIST REPRESENTATIVE, 11201 Valley Spring Lane, Studio City CA 91602. (818)505-1124. Fax: (818)753-5921. Contact: Torrey Spencer. Commercial illustration, photography representative. Estab. 1980. Represents 4 illustrators, 5 photographers. Specializes in advertising/design markets. Markets include advertising agencies; corporations/client direct; design firms.
Handles: Wants "realistic illustration with action and perspective edges."
Terms: Rep receives 25% commission (in Los Angeles), 30% commission (out of Los Angeles). Advertising costs are negotiable. "I need artist to be prepared to regularly produce direct mail pieces and to advertise in *The Workbook*."
How to Contact: For first contact, send query letter, résumé, direct mail flier/brochure, tearsheets, slides, photographs, photocopies, photostats and SASE. Reports back within 2 weeks. After initial contact, drop off or mail in appropriate materials. Portfolio should include tearsheets (4×5 or 8×10).
Tips: Artists must be "easy to work with, honest and willing to produce new images regularly for the portfolio."

SULLIVAN & ASSOCIATES, 3805 Maple Court, Marietta GA 30066. (404)971-6782. Fax: (404)973-3331. Contact: Tom Sullivan. Commercial illustration, commercial photography and graphic design representative. Estab. 1988. Member of Creative Club of Atlanta, Atlanta Ad Club. Represents 14 illustrators, 7 photographers and 7 designers, including those with computer graphic skills in illustration/design/production and photography. Staff includes Tom Sullivan (sales, talent evaluation, management); Debbie Sullivan (accounting, administration). Specializes in "providing whatever creative or production resource the client needs." Markets include: advertising agencies, corporations/client direct; design firms; editorial/magazines; publishing/books; sales/promotion firms.
Handles: Illustration, photography. "Open to what is marketable; computer graphics skills."
Terms: Rep receives 25% commission. Exclusive area representation in Southeastern US is required. Advertising costs are split: 75-100% paid by talent; 0-25% paid by representative. "Negotiated on individual basis depending on: (1) length of time worked with; (2) area of representation; (3) scope of exclusive representation." For promotional purposes, talent must provide "direct mail piece, portfolio in form of 8½×11 (8×10 prints) pages in 22-ring presentation book." Advertises in *American Showcase*, *The Workbook*.
How to Contact: For first contact, send bio, direct mail flier/brochure; "follow up with phone call." Reports in 2 weeks if interested. After initial contact, call for appointment to show portfolio of tearsheets, photographs, photostats, photocopies, "anything appropriate in nothing larger than 8½×11 print format."
Tips: Obtains new talent through referrals and direct contact from creative person. "Have direct mail piece or be ready to produce it immediately upon reaching an agreement with a rep. Be prepared to immediately put together a portfolio based on what the rep needs for that specific market area."

‡**SUSAN AND CO.**, 2717 Western Ave., Seattle WA 98121. (206)728-1300. Fax: (206)728-7522. Owner: Susan Trimpe. Commercial illustration, photography representative. Estab. 1979. Member of SPGA. Represents 19 illustrators, 2 photographers. Specializes in commercial illustrators and photographers. Markets include advertising agencies; corporations/client direct; design firms; publishing/books.
Handles: Illustration, photography. Looks for "computer illustration, realism, corporate, conceptual."
Terms: Rep receives 30% commission. Charges postage if portfolios are shipped out of town. Exclusive area representation is required. Advertising costs are split: 70% paid by talent; 30% paid by representative. "Artists must take out a page in a publication, i.e. *American Showcase*, *CIB*, *Workbook* with rep."
How to Contact: For first contact, send query letter and direct mail flier/brochure. Reports back within 2 weeks only if interested. After initial contact, call to schedule an appointment. Portfolio should include tearsheets, slides, photographs, photostats, photocopies.
Tips: Wants artists with "unique well-defined style and experience."

‡**THOSE 3 REPS**, 2909 Cole, Suite #118, Dallas TX 75204. (214)871-1316. Fax: (214)880-0337. Partners: Debbie Bozeman, Carol Considine, Jill Belcher. Artist representative. Estab. 1989. Member of Dallas Society of Visual Community. Represents 15 illustrators, 3 photographers. Specializes in commercial art. Markets include: advertising agencies; corporations/client direct; design firms; editorial/magazines.
Handles: Illustration, photography.
Terms: Rep receives 25% commission; 30% for out-of-town jobs. Exclusive area representation is required. Advertising costs are split: 75% paid by talent; 25% paid by representative. For promotional purposes, talent must provide 2 new pieces every 2 months, national advertising in sourcebooks and at least 1 mailer. Advertises in *American Showcase*, *Texas Source Book*, own book.
How to Contact: For first contact, send query letter and tearsheets. Reports within days or weeks only if interested. After initial contact, call to schedule an appointment, drop off or mail in appropriate materials. Portfolio should include tearsheets, photostats, transparencies.
Tips: Wants artists with "strong unique consistent style."

‡**JOSEPH TRIBELLI DESIGNS, LTD.**, 254-33 Iowa Rd., Great Neck NY 11020. (516)482-2699. Contact: Joseph Tribelli. Representative of textile designers only. Estab. 1988. Member of Graphic Artists Guild. Represents 9 designers. Specializes in textile surface design for apparel (women and men). "All designs are on paper."
Handles: Textile design for apparel and home furnishings.
Terms: Rep receives 40% commission. Exclusive area representation is required.
How to Contact: "Telephone first." Reports back in 2 weeks. After initial contact, drop off or mail appropriate materials. Portfolio should include original art.
Tips: Obtains new talent through "placing ads, recommendations. I am interested in only textile designers who can paint on paper. Do not apply unless you have a flair for fashion."

‡**T-SQUARE, ETC.**, 1990 S. Bundy Dr., Suite #190, Los Angeles CA 90025. (310)826-7033. Fax: (310)826-7133. Managing Director: Diane Pirritino. Graphic design representative. Estab. 1990. Member of Advertising Production Association of California, Ad Club of LA. Represents 50 illustrators, 100 designers. Specializes in computer graphics. Markets include advertising agencies; corporations/client direct; design firms; editorial/magazines.

Handles: Design.

Terms: Rep receives 25% commission. Advertising costs are split: 25% paid by talent; 75% paid by representative. For promotional purposes, talent must provide samples from their portfolio (their choice).

How to Contact: For first contact, send résumé. Reports back within 5 days. After initial contact, call to schedule an appointment. Portfolio should include thumbnails, roughs, original art, tearsheets, slides.

Tips: Artists must possess "good design, computer skills, flexibility, professionalism."

‡*URSULA INTERNATIONAL CREATIVES, Ottostrasse 92, 26135 Oldenburg Germany. Specializing in the European markets.

‡VARGO BOCKOS, 500 N. Michigan Ave., Suite 2000, Chicago IL 60611. (312)661-1717. Fax: (312)661-0043. Partners: Julie Vargo, Patrice Bockos. Commercial illustration, photography, film production representative. Estab. 1974. Member of CAR (Chicago Artists Reps). Represents 2 photographers. Markets include: advertising agencies; design firms.

Handles: Illustration, photography.

Terms: Rep receives 30% commission. Advertising costs are split: 70% paid by talent; 30% paid by representative. "Direct mail pieces are great bonuses. The portfolio must be professionally presented." Advertises in *The Workbook*.

How to Contact: For first contact, send query letter and direct mail flier/brochure. Reports back within 2 days if interested. After initial contact, call to schedule an appointment. Portfolio should include original art, tearsheets, photographs.

PHILIP M. VELORIC, ARTIST REPRESENTATIVE, 128 Beechtree Dr., Broomall PA 19008. (610)356-0362. Fax: (610)353-7531. Contact: Philip M. Veloric. Commercial illustration representative. Estab. 1963. Member of Art Directors Club of Philadelphia. Represents 22 illustrators. "Most of my business is from textbook publishing, but not all of it." Markets include: advertising agencies; design firms; publishing/books; collectibles.

Handles: Illustration. "Artists should be able to do (and have samples to show) all ethnic children (getting ages right; tell a story; develop a character); earth science, life and physical science; some trade books also."

Terms: Rep receives 25% commission. Exclusive area representation is required. Advertising costs are split: 75% paid by talent; 25% paid by representative. Advertises in *RSVP*.

How to Contact: For first contact call. After initial contact, send samples of original art, tearsheets, photocopies, laser copies.

Tips: Obtains new talent through recommendations from others.

‡GWEN WALTERS, 50 Fuller Brook Rd., Wellesley MA 02181. (617)235-8658. Commercial illustration representative. Estab. 1976. Member of Graphic Artists Guild. Represents 17 illustrators. "I lean more toward book publishing." Markets include: advertising agencies; corporations/client direct; editorial/ magazines; paper products/greeting cards; publishing/books; sales/promotion firms.

Handles: Illustration.

Terms: Rep receives 30% commission. Charges for color photocopies. Advertising costs are split; 70% paid by talent; 25% paid by representative. For promotional purposes, talent must provide direct mail pieces. Advertises in *American Showcase* (sometimes), *Creative Black Book, RSVP*.

How to Contact: For first contact, send résumé, bio, direct mail flier/brochure. After initial contact, representaive will call. Portfolio should include "as much as possible."

Tips: Obtains new talent "from all directions."

‡WARNER & ASSOCIATES, 1425 Belleview Ave., Plainfield NJ 07060. (908)755-7236. Contact: Bob Warner. Commercial illustration and photography representative. Estab. 1986. Represents 4 illustrators, 4 photographers. "My specialized markets are advertising agencies that service pharmaceutical, medical, health care clients."

Handles: Illustration, photography. Looking for medical illustrators: microscope photographers (photomicrography), science illustrators, special effects photographers.

Terms: Rep receives 25% commission. "Promo pieces and portfolios obviously are needed; who makes up what and at what costs and to whom, varies widely in this business."

How to Contact: For first contact send query letter "or phone me." Reports back in days. Portfolio should include "anything that talent considers good sample material."

Tips: Obtains new talent "by word-of-mouth and recommendations. Also, specialists in my line of work often hear about my work from art directors and they call me."

‡W/C STUDIO INC., 750 94th Ave. N, Suite #203, St. Petersburg FL 33702. (813)579-4499. Fax: (813)579-4585. Artist's Representative: Allan Comport. Commercial illustration, photography representative. Estab. 1983. Member of SPAR, Society of Illustrators. Represents 6 illustrators, 2 photographers. Markets include: advertising agencies; design firms; editorial/magazines.

Handles: Illustration, photography.

Terms: Rep receives 25% commission. Advertising costs are split: 75% paid by talent; 25% paid by representative. For promotional purposes, talent must provide 4×5 transparencies; "We put them into our own 11×12 format." Advertises in *American Showcase*, *Creative Black Book*, *The Workbook*.

How to Contact: For first contact, send query letter, direct mail flier/brochure, tearsheets, photocopies and SASE. Reports in 1 month. After initial contact, drop off or mail in appropriate materials. Portfolio should include tearsheets.

Tips: Artists must have "strong conceptual talent, highest professional/work ethic, good attitude."

DAVID WILEY, 282 Second St., 2nd Floor, San Francisco CA 94105. (415)442-1822. Fax: (415)442-1823. E-mail: davewiley@aol.com. Contact: David Wiley. Commercial illustration and photography representative. Estab. 1984. Member of AIP (Artists in Print). Represents 7 illustrators. Specializes in "reliability and quality!" Clients include McCann Erickson/SF, Candor Assoc. SF, Primo Angeli: Design, Junt/SF. Client list available upon request; "depends who and why."

Terms: No information provided.

How to Contact: For first contact, send direct mail flier/brochure, tearsheets, slides, photographs, and SASE ("very important"). Will call back, if requested, within 48 hours. After initial contact, call for appointment or drop off appropriate materials. Portfolio should include, roughs, original art, tearsheets.

Tips: Obtains new clients through creative directory listings and direct mail.

DEBORAH WOLFE LTD., 731 N. 24th St., Philadelphia PA 19130. (215)232-6666. Fax: (215)232-6585. Contact: Deborah Wolfe. Commercial illustration representative. Estab. 1978. Represents 25 illustrators. Markets include: advertising agencies; corporations/client direct; design firms; editorial/magazines; publishing/books.

Handles: Illustration.

Terms: Rep receives 25% commission. Advertises in *American Showcase* and *Creative Black Book*.

How to Contact: For first contact, send direct mail flier/brochure, tearsheets, slides. Reports in 3 weeks.

Tips: "Artists usually contact us through mail or drop off at our office. If interested, we ask to see more work (including originals)."

Artists' Reps/'95-'96 changes

The following reps were listed in the 1995 edition but do not have listings in this edition. The majority did not respond to our request to update their listings. If a reason was given for exclusion, it appears in parentheses after the rep's name.

Albrecht & Jennings Art Enterprises
Art Source L.A., Inc.
Artco Incorporated
Asciutto Art Reps., Inc.
Sal Barracca Assoc. Inc.
Ceci Bartels Associates
Noel Becker Associates
Barbara Beidler Inc.
Chip Caton Artist Representative
Carol Chislovsky Design Inc.
Conrad Represents

Corcoran Fine Arts Limited, Inc.
Cornell & McCarthy
CVB Creative Resource
Sharon Dodge and Associates
Robert Galitz Fine Art/Accent Art
David Goldman Agency
Barb Hauser, Another Girl Rep
Kastaris & Associates
Peggy Keating
Cliff Knecht—Artist Representative
Jim Lilie Artist's Representative

John Locke Studios, Inc.
Peter & George Lott
Media Gallery/Enterprises
Pacific Design Studio
Publishers' Gaphics
Redmond Represents
Richard Salzman
Soldat & Associates
Warshaw Blumenthal, Inc.
The Weber Group

Organizations

Organizations provide a myriad of services and opportunities to assist artists with business and professional development. These benefits come in many forms: support services, hotlines, seminars, workshops, conferences, advocacy programs, legal advice, publications, referral services, and even group insurance plans. Many organizations offer funding opportunities as well. Some of the larger organizations, such as the Graphic Artists Guild and Society of Illustrators, have built enough solidarity to influence industry standards regarding payment and copyright protection.

Call or write for membership and complete funding information. To find out about other artists' organizations, refer to the Gale *Encyclopedia of Associations* in your local library.

EDWARD F. ALBEE FOUNDATION, 14 Harrison St., New York NY 10013. (212)226-2020. Foundation Secretary: David Briggs. Residency program for visual artists and writers.
Offerings: Offers one-month residency at the William Flanagan Memorial Creative Persons Center (The Barn) in Montauk, Long Island NY. Information and application forms are available on request. **Offers Foundation Residency to provide a private, peaceful atmosphere in which artists can work.** For information contact: David Briggs, Foundation Secretary. **Awards 24 residencies/year (summer season only); no cash awards.** Deadline for application: April 1 (postmark). Interested artists should send for application form.

ALTERNATIVE WORKSITE/BEMIS CENTER FOR CONTEMPORARY ARTS, 724 S. 12th St., Omaha NE 68102. (402)341-7130. Fax: (402)341-9791. Executive Director: Ree Schonlau. Assistant Director: Karen Frank. Estab. 1981. "We provide well-equipped studios, living spaces and a monthly stipend to visual artists who are awarded residencies here. The artists come from across the United States and all over the world to work within a supportive community of like-minded people. For many artists this is one of the only rare venues for their work. The Bemis is housed in a renovated factory building on the fringe of downtown Omaha. It is a unique opportunity made possible through the efforts of a nonprofit organization of art people established in 1981."

AMERICAN SOCIETY OF ARCHITECTURAL PERSPECTIVISTS, 52 Broad St., Boston MA 02109. (617)951-1433, ext. 225. Executive Director: Alexandra Lee. Estab. 1986.
Purpose: Nonprofit business organization promoting the professional interest of architectural illustrators and establishing a communication network among members throughout the US, Canada, Japan, England, Australia and other countries. Approximate current membership: 400.

AMERICAN SOCIETY OF ARTISTS, INC., P.O. Box 1326, Palatine IL 60078. (312)751-2500 or (708)991-4748. Membership Chairman: Helen Del Valle. Estab. 1972. National professional membership organization of fine artists (has a crafts division of American Artisans.)

AMERICAN SOCIETY OF AVIATION ARTISTS, 1805 Meadowbrook Heights Rd., Charlottesville VA 22901. (804)296-9771. Fax: (804)293-5185. E-mail: lyg@virginia.edu. Executive Secretary: Luther Y. Gore. Estab. 1986. "An organization to promote high standards in aviation art and to encourage artists to record, celebrate and interpret aviation/aerospace history. Also provides a means of bringing artists and collectors together."

ART ASSOCIATION OF HARRISBURG, 21 N. Front St., Harrisburg PA 17101. (717)236-1432. Fax: (717)236-6631. President/Sales Gallery Manager: Carrie Wissler-Thomas. Estab. 1926. "The Art Association of Harrisburg promotes the visual arts through exhibitions and education. AAH maintains a year-round art school for students of all ages and skill levels, and we mount 10 in-house exhibitions annually as well as 36 shows in community locations per year. We also maintain a Sales Gallery wherein members' artwork is offered for sale on a consignment basis."

ART INFORMATION CENTER, 280 Broadway, Suite 412, New York NY 10007. (212)227-0282. Director: Dan Concholar. Estab. 1959. "A networking referral service for fine art, with a staff of one, interns and volunteers."

ART ON THE MOVE TOURS, INC., 1171 Linden Ave., Highland Park IL 60035. (708)432-6265. Fax: (708)433-6265. President: Joan Arenberg. Estab. 1986. Conducts tours visiting museums, galleries, artists' studios and private collections regularly in Chicago area and selected US destinations to learn more about how art is made and why. Generally tours are conceptualized to fit a special subject (i.e., contemporary surrealism or women artists).

THE ART STUDIO, INC., 720 Franklin, Beaumont TX 77701. (409)838-5393. Executive Director: Greg Busceme. Estab. 1984. An alternative artist space, currently 20 artists strong.

ARTISTS IN PRINT, 665 Third St., Suite 530, San Francisco CA 94107. (415)243-8244. Fax: (415)495-3155. President: Patti Mangan. Estab. 1974. A nonprofit resource/support center for the local graphic arts community with more than 500 members.

ARTS & SCIENCE COUNCIL—CHARLOTTE/MECKLENBURG, INC., Suite 250, 227 W. Trade St., Charlotte NC 28202. (704)372-9667. Fax: (704)372-8210. President: Michael Marsicano. Estab. 1959. "A multi-faceted private nonprofit organization that raises funds for cultural organizations, provides planning to ensure the long-term health of the cultural community and provides technical services to cultural organizations."

ARTS EXTENSION SERVICE, Division of Continuing Education, 602 Goodell Bldg., University of Massachusetts, Amherst MA 01003. (413)545-2360. Fax: (413)545-3351. Director: Craig Dreeszen. Estab. 1973. "AES is a national arts service organization which has worked to achieve access to and integration of the arts in communities through continuing education for artists, arts organizations and community leaders. Our services include consulting, teaching, publishing and research."

ARTS MIDWEST, Suite 310, 528 Hennepin Ave., Minneapolis MN 55403. (612)341-0755. Fax: (612)341-0902. Public Relations: Susan T. Chandler. Estab. 1985. "Arts Midwest is a regional organization which provides funding, training, and publications to Illinois, Indiana, Iowa, Michigan, Minnesota, North Dakota, Ohio, South Dakota, and Wisconsin."

ARTSWATCH, 2337 Frankfort Ave., Louisville KY 40206. (502)893-9661. Executive Director: Andy Perry. Estab. 1985. ARTSWATCH is dedicated to providing the opportunity and means for the development of innovations in the arts through educational activities, exhibits and performance.

ASSOCIATED ARTISTS OF WINSTON-SALEM, 226 N. Marshall St., Winston-Salem NC 27101. (910)722-0340. Executive Director: Rosemary H. Martin. Estab. 1956. "Associated Artists' goals are to conduct and promote activities which support the awareness, enjoyment and appreciation of fine art, with a special emphasis on education. AAWS encourages the creative talent of individual artists, from novice to professional."

ASSOCIATION OF COMMUNITY ARTS AGENCIES OF KANSAS (ACAAK), P.O. Box 1363, Salina KS 67402-1363. (913)825-2700. Executive Director: Ellen Morgan. Estab. 1973. "A statewide assembly of community arts agencies/organizations, ACAAK fosters excellence in the arts for the benefit of all Kansans."
 • ACAAK has sponsored the Kansas Artists Postcard Series for the past 18 years. The contest is designed to promote the work of Kansas artists and is available for exhibits throughout the state.

ATLANTIC CENTER FOR THE ARTS, INC., 1414 Art Center Ave., New Smyrna Beach FL 32168. (904)427-6975 or (800)393-6975. Fax: (904)427-5669. Executive Director: Suzanne Fetscher. Grants Specialist: Ann Brady. Estab. 1980. Interdisciplinary artists in residence facility, located on 67 acres. Provides an informal work environment for accomplished and creative artists from all disciplines to work with outstanding Master Artists.

CALIFORNIA CONFEDERATION OF THE ARTS, 704 O St., 2nd Floor, Sacramento CA 95814. (916)447-7811. Fax: (916)447-7891. Associate Director: Ken Larsen. Estab. 1976. "The Confederation, with 1,000 organizational and individual members, serves as an advocate for a wide range of state arts programs and legislation."

‡CALIFORNIA SOCIETY OF PRINTMAKERS, P.O. Box 9479, Berkeley CA 94709-9479. Contact: Art Hazelwood. Estab. 1913. A nonprofit arts organization which promotes the appreciation of prints and printmaking. Membership extends throughout the United States, Canada, Mexico, Europe and Asia.

CHICAGO ARTISTS' COALITION, 5 W. Grand Ave., Chicago IL 60610. (312)670-2060. Executive Director: Arlene Rakoncay. Estab. 1974. An artist-run, nonprofit service organization for visual artists. "Our purpose is to create a positive environment in which artists can live and work. Our primary objectives are improved benefits, services and networking opportunities for artists, education of the general public regarding the value of the visual arts, and protection of artists from unfair business practices and censorship."

CITY OF CINCINNATI, HUMAN SERVICES DIVISION, 801 Plum St., Room 158, Cincinnati OH 45202. (513)352-1592. Fax: (513)352-5241. Human Services Analyst: Carolyn Gutjahr. Arts grant programs estab. 1989. The City has a grant program to provide support for emerging and established artists; to encourage excellence and professionalism in the arts and development of new work; to encourage access to the arts for Cincinnati residents and to encourage through the arts an understanding among diverse cultures in Cincinnati.

CITYARTS, INC., 225 Lafayette St., Suite 911, New York NY 10012. (212)966-0377. Fax: (212)966-0551. Executive Director: Tsipi Ben-Haim. Estab. 1968. "We are a pioneering nonprofit arts organization dedicated to the creation of public art in all media, but particularly murals. We maintain a slide file of artists who wish to make public art. Artists should be professional sculptors or painters who wish to work with and in the community to be included in the slide file."
- CityArts completed a mural based on an Alice Walker poem and she attended the ribbon cutting ceremony.

COALITION OF WOMEN'S ART ORGANIZATIONS, 123 E. Beutel Rd., Port Washington WI 53074-1103. (414)284-4458. Fax: (414)284-8875. E-mail: dprovis@omnifest.uwm.edu. President: Dorothy Provis. Estab. 1977. "We are a national advocacy organization and have a membership of 3,000 plus individuals and organizations, such as Chicago Artists' Coalition and National Women's Caucus for Art."

COLORADO COUNCIL ON THE ARTS, 750 Pennsylvania St., Denver CO 80203-3699. (303)894-2617. Fax: (303)894-2615. Associate Director: Daniel Salazar. Estab. 1967. State Art Agency.

COMMUNITY FINE ARTS CENTER, 400 C, Rock Springs WY 82901. (307)362-6212. Fax: (307)382-4640. Director: Gregory Gaylor. Estab. 1966. "We curate a permanent collection of American Art original paintings dated 1892-present, belonging to the Rock Springs High School-School District #1. Includes paintings by Grandma Moses, Norman Rockwell, Rufino Tamayo, Edward Chavez, Elliot Orr, Loren McGiver, etc. We exhibit artists nationwide as well as area/regional artists."

CONNECTICUT VOLUNTEER LAWYERS FOR THE ARTS (CTVLA), Connecticut Commission on the Arts, 227 Lawrence St., Hartford CT 06106. (203)566-4770. CTVLA Coordinator: Linda Dente. Estab. 1974. "Pro bono lawyer association made up of about 200 attorneys throughout Connecticut. The purpose of the CTVLA is to supply free legal help to Connecticut artists and arts organizations."

COUPEVILLE ARTS CENTER/PALETTES PLUS, P.O. Box 171, Coupeville WA 98239. (360)678-3396. Fax: (360)678-7420. Director: Judy Lynn. Estab. 1987. "Our purpose is to 'enhance the arts learning experience. We are a nonprofit organization producing workshops in painting, photography and fiber arts."

CREATIVE ARTS GUILD, 520 W. Waugh St., Dalton GA 30720. (706)278-0168. Fax: (706)278-6996. Executive Director: Ann Treadwell. Estab. 1963. Community arts agency specializing in the visual and performing arts. "The mission of the organization is to recognize, stimulate, encourage, and popularize creative excellence in the arts for the benefit of everyone in the community."

CREATIVE GROWTH ART CENTER, 355 24th St., Oakland CA 94612. (510)836-2340. Fax: (510)836-2349. Executive Director: Irene Brydon. Gallery Manager: Bonnie Haight. Estab. 1974. Creative Growth Art Center is a nonprofit art studio/gallery for artists with disabilities—the gallery features the work of NAIVE, NAIF or outsider artists.

DUTCHESS COUNTY ARTS COUNCIL, 39 Market St., Poughkeepsie NY 12601. (914)454-3222. Fax: (914)454-6902. Executive Director: Sherre Wesley. Estab. 1964. "A private, nonprofit arts service organization that promotes and coordinates cultural activity and development in the Mid-Hudson Valley. DCAC's goals are to strengthen and support the artistic, administrative, marketing and cooperative capabilities of cultural organizations and individual artists; and to integrate its efforts with other segments of the community, including business, tourism, government, schools, human service, recreation and media."

‡ENABLED ARTISTS UNITED, P.O. Box 178, Dobbins CA 95935. (916)692-1581. Director: Marjorie Giles. Estab. 1989. Organization for advocacy, synergy and opportunity for artists with disabilities and without. Promoting partnerships among artists, focusing on access for all persons to cultural and other facilities without regard to disabilities, ethnicity, culture, sexual orientation, religion or none of the above.

FARMINGTON VALLEY ARTS CENTER, 25 Arts Center Lane, Avon CT 06001. (203)678-1867. Executive Director: Betty Friedman. Estab. 1972. "An arts center where 40 visual artists work in studios, 1,500 students take art classes, and the home of the Fisher Gallery Shop featuring the finest in American craft."

FRIENDSHIP ART WORKSHOPS, 1340 Neans Dr., Austin TX 78758. (512)834-9129. President: Patrick Conway. Estab. 1988. "We provide the highest level of art instruction in exotic locations at an easily affordable price."

GEORGIA COUNCIL FOR THE ARTS, 530 Means St., Suite 115, Atlanta GA 30318-5793. (404)651-7926. Fax: (404)651-7922. Visual Arts Manager: Richard Waterhouse. Estab. 1976. "The Georgia Council for the Arts, a state agency, is designed to encourage excellence in the arts, to support its many forms of expression, and to make the arts available to all Georgians."

VIRGINIA A. GROOT FOUNDATION, P.O. Box 1050, Evanston IL 60204-1050. Estab. 1988. "We give grants to artists working in ceramic sculpture and sculpture." **Offers Virginia A. Groot Foundation Grant.** Requirements: must be age 21 and above, no students, ceramic sculpture and sculpture artists only. **Awards vary from year to year, usually $25,000 (one) and several smaller grants. Average grant length: 1 year.** Deadline for application: March 1. Interested artists should send SASE for an application form.

INDIANA ARTS COMMISSION, 402 W. Washington St., Room 072, Indianapolis IN 46204. (317)232-1268. Fax: (317)232-5595. Director of Programs: Julie Murphy. Estab. 1969. "The Indiana Arts Commission is a state agency. As public catalyst, partner, and investor, the IAC serves the citizens of Indiana by funding, encouraging, promoting and expanding all the arts."

‡INTERNATIONAL SCULPTURE CENTER (ISC), 1050 17th St. NW, Suite 250, Washington DC 20036. (202)785-1144. Fax: (202)785-0810. Executive Director: David Furchgott. Estab. 1960.
Purpose: "A nonprofit organization of 11,000 members; devoted to advancement and promotion of contemporary sculpture and sculptors worldwide."

INTERNATIONAL SOCIETY OF COPIER ARTISTS, 759 President St., Brooklyn NY 11215. (718)638-3264 or (914)687-7769. Director: Louise Neaderland. Estab. 1981. "There are 110 contributing artist members and 40 institutional subscribers to the *I.S.C.A. Quarterly* of original xerographic art. The purpose is to promote the use of the copier as a creative tool and educate the public through exhibitions, lectures, slide shows and workshops."

INTERNATIONAL SOCIETY OF MARINE PAINTERS, P.O. Box 13, Oneco FL 34264. (813)758-0802. Fax: (813)755-1042. President: Jerry McClish. Estab. 1974. "We promote painting the marine scene. Exhibitions are held each year in museums or large art centers. No entry fee is charged and no ribbons or prizes are awarded."

THE JAPAN FOUNDATION, 152 W. 57th St., 39th Floor, New York NY 10019. (212)489-0299. Fax: (212)489-0409. Program Assistant: Maki Uchiyama. Estab. 1972. "The Japan Foundation is a nonprofit organization whose objective is to promote international cultural exchange and mutual understanding between Japan and other countries through the exchange of persons, support of Japanese studies, support of Japanese-language instruction, and arts-related exchanges."

KANSAS CITY ARTISTS COALITION, 201 Wyandotte, Kansas City MO 64105. (816)421-5222. Executive Director: Janet Simpson. Estab. 1976. A nonprofit, visual arts organization that promotes contemporary art and artists; membership includes 500 plus artists and supporters.

JOHN MICHAEL KOHLER ARTS CENTER, 608 New York Ave., P.O. Box 489, Sheboygan WI 53082-0489. (414)458-6144. Fax: (414)458-4473. Publicity Administrator: Patti Glaser-Martin. Contemporary, visual and performing arts center devoted to encouraging and supporting innovative explorations in the arts.

LACHENMEYER ARTS CENTER, 700 S. Little St., P.O. Box 586, Cushing OK 74023. Director: Rob Smith. Estab. 1984. "We are a nonprofit fine arts center offering art classes to all ages. We also offer art shows and organize an annual arts festival. We have an art resource library and studio equipment available to the public."

LAWYERS FOR THE CREATIVE ARTS, 213 W. Institute Place, Suite 411, Chicago IL 60610. (312)944-2787. In Illinois (800)525-ARTS. Fax: (312)944-2195. Estab. 1972. Offers legal assistance and education to artists and arts organizations. Services available in English and Spanish.

THE LOONIES (A Humor Salon), P.O. Box 20443, Oakland CA 94620. (510)451-6248. Contact: Barry Gantt. Estab. 1978. "We provide an informal and comfortable gathering place for writers, artists and creative types engaged in professional humor."

THE MACDOWELL COLONY, INC., 100 High St., Peterborough NH 03458. (603)924-3886. Fax: (603)924-9142. Contact: Admissions Coordinator. Estab. 1907. "MacDowell is the oldest and largest artist colony in the U.S. providing writers, composers, visual artists, photographers, printmakers, architects and filmmakers a place where they may work uninterrupted. Interdisciplinary and collaborating artists are welcome."
Offerings: Publishes a newsletter and an annual report. **Offers artist residency.** For information contact: Admissions Coordinator. Requirements: talent is the only criteria for admission. **Awards about 200 residencies annually including room and board and use of private studio. Length of residency: up to 2 months.**

Deadline for application: January 15, April 15, September 15. Interested artists should send for application form.

MICHIGAN GUILD OF ARTISTS AND ARTISANS, 118 N. Fourth Ave., Ann Arbor MI 48104. (313)662-3382. Director: Mary C. Strope. Estab. 1971. "A nonprofit membership organization of artists, providing marketing, educational and other services to individual artists and crafts persons."

MIDWEST WATERCOLOR SOCIETY, 111 W. Washington Blvd., Lombard IL 60148. No central office; for general information call (708)629-0443. Estab. 1976. Organization "to preserve the integrity of transparent watercolor by sponsoring an annual juried national exhibition at a Midwestern museum, and an annual workshop." Members, no entry fee; non-members, $15. Submit 2 slides. Limit one acceptance. Three show acceptances within 10 years qualifies artist to receive MWS letters.

NEW JERSEY STATE COUNCIL ON THE ARTS, CN 306, Trenton NJ 08625. (609)292-6130. Fax: (609)989-1440. Grants Coordinator: Steven R. Runk. Estab. 1966. "Agency of New Jersey state government supporting the arts through fellowships, grants, programs and services to artists, arts organizations and arts projects."

NEW YORK FOUNDATION FOR THE ARTS, 155 Avenue of the Americas, New York NY 10013. (212)366-6900, ext. 212. Fax: (212)366-1778. E-mail: green@tmn.com. Director of Communications: David Green. Estab. 1971.

✦NEWFOUNDLAND & LABRADOR ARTS COUNCIL, P.O. Box 98, St. John's, Newfoundland A1C 5H5 Canada. (709)726-2212. Fax: (709)726-0619. E-mail: rfollett@porthole.entnet.nf.ca. Executive Director: Randy Follett. Estab. 1980. The Newfoundland and Labrador Arts Council is a nonprofit organization whose purpose is to foster the arts of the province by carrying on financial assistance programs and by working with government and the community for development in the arts.

NORTHWOOD UNIVERSITY ALDEN B. DOW CREATIVITY CENTER, 3225 Cook Rd., Midland MI 48640-2398. (517)837-4478. Fax: (517)837-4468. Executive Director: Carol B. Coppage. Estab. 1978. "The Alden B. Dow Creativity Center offers four fellowships each summer for individuals in any field or profession, including the arts, humanities and sciences, who wish to pursue an innovative project or creative idea."

OCEAN STATE LAWYERS FOR THE ARTS (OSLA), Box 19, Saunderstown RI 02874-0019. (401)789-5686. Executive Director: David M. Spatt, Esq. Estab. 1984. Rhode Island affiliate of the nationwide Volunteer Lawyers for the Arts network providing free and reduced fee legal counsel to artists and arts organizations, as well as lectures, seminars and workshops.

ORGANIZATION OF INDEPENDENT ARTISTS, 19 Hudson St., Suite 402, New York NY 10013. (212)219-9213. Fax: (212)219-9216. Estab. 1976. "A nonprofit organization run by and for artists providing exhibition opportunities in public spaces throughout New York City—OIA also provides artists with a range of support services designed to help get their work out to the public." Represents emerging and mid-career artists. Interested in emerging artists. "We have about 1,000 artists in our slide registry." Sponsors 15 shows/year. Average display time 1 month. Office is open Tuesday, 1-7; Wednesday, Thursday and Friday, 1-5.

✦PEI COUNCIL OF THE ARTS, P.O. Box 2234, Charlottetown, Prince Edward Island C1A 8B9 Canada. (902)368-4410. Fax: (902)368-4418. E-mail: artsccl@bud.peinet.pe.ca. Executive Director: Judy MacDonald. Estab. 1974. Organization "to promote the enjoyment of, participation in and accessibility to the Arts, for all people throughout the province."

PENNSYLVANIA WATERCOLOR SOCIETY, P.O. Box 626, Mechanicsburg PA 17055-0626. Estab. 1979. Nonprofit organization "to promote the art of watercolor to artists and general public, to expose watercolor to the public."

PINELLAS COUNTY ARTS COUNCIL, 400 Pierce Blvd., Clearwater FL 34616. (813)464-3327. Fax: (813)464-4608. Director: Judith Powers-Jones. Estab. 1976. "Designated the official local arts agency of Pinellas County, The Arts Council is dedicated to establishing the arts as a vital part of the county's infrastructure through the growth and development of programs and services to the arts, government and the community at large."

PRINTED MATTER, INC., 77 Wooster St., New York NY 10012. (212)925-0325. Fax: (212)925-0464. Director: David Dean. Estab. 1976. Organization to foster the dissemination, appreciation and understanding of artists' publications.

SAN LUIS OBISPO ART CENTER, 1010 Broad St., P.O. Box 813, San Luis Obispo CA 93406. (805)543-8562. Executive Director: Carol Dunn. Estab. 1958. "A visual arts center with a mission to provide and promote ongoing diversity of visual arts experience through education, inspiration, expression and interaction."

SECOND STREET GALLERY, 201 Second St. NW, Charlottesville VA 22902. (804)977-7284. Director: Sarah Sargent. Estab. 1973. "A nonprofit arts organization that serves the artistic community and the public at large through exhibitions of contemporary art by regional and national emerging and established artists. Sponsors education programs and workshops."

THE SOCIETY FOR CALLIGRAPHY & HANDWRITING, Box 31963, Seattle WA 98103. Contact: Secretary. Estab. 1975. "To promote interest and knowledge in the artform of beautiful lettering."
 • A sponsor of "Soundings" the 16th annual International Calligraphy Conference, to be held in 1996.

SOCIETY OF ILLUSTRATORS OF LOS ANGELES, 116 The Plaza Pasadena, Pasadena CA 91101. (818)952-SILA (7452). Director: Monica Heath. Estab. 1955. Organization "to maintain and advance the highest standards of professionalism in illustration in the service of the communities of art and humanities."

‡SOCIETY OF NEWSPAPER DESIGN, The Newspaper Center, Box 4075, Reston VA 22090. (703)620-1083. E-mail: snd@plink.geis.com. Executive Director: Ray Chattman. Estab. 1979. "Dedicated to the betterment of newspapers through design. Its more than 2,700 members worldwide represent the full spectrum of newspaper disciplines from the art department through the publisher's office."

SOUTHERN ARTS FEDERATION (SAF), 181 14th St. NE, Suite 400, Atlanta GA 30309. (404)874-7244. Fax: (404)873-2148. Visual & Media Arts Coordinator: Lisa Richmond. Estab. 1975. "Nonprofit, regional arts agency dedicated to providing leadership and support to affect positive change in all art forms throughout the South."

SUMTER GALLERY OF ART, P.O. Box 1316, Sumter SC 29151 or 421 N. Main St. Sumter SC 29150. (803)775-0543. Executive Director: Mary Jane Caison. Estab. 1969. "The object of the Sumter Gallery of Art shall be to promote the visual arts and to increase and diffuse the knowledge and appreciation thereof; to maintain in the City of Sumter a Gallery of Art; to collect, to preserve and to exhibit objects of artistic interest to the public."

‡TEMPE ARTS CENTER & SCULPTURE GARDEN, Box 549, Tempe AZ 85280-0549. (602)968-0888. Education/Exhibits Coordinator: Patty Haberman. Estab. 1982.
Purpose: "A private, nonprofit organization dedicated to exhibiting the highest quality contemporary crafts and sculpture and to fostering understanding and appreciation through education and community outreach."

TEXAS ACCOUNTANTS & LAWYERS FOR THE ARTS, 1540 Sul Ross, Houston TX 77006. (713)526-4876. Contact: Program Director. Estab. 1979. "TALA provides free legal and accounting services to arts organizations and low-income artists in Texas."

‡TEXTILE ARTS CENTRE, 916 W. Diversey, Chicago IL 60614. (312)929-5655. Contact: Director. Estab. 1986.
Purpose: Nonprofit organization promoting the education and presentation of textile art.

TOLEDO VOLUNTEER LAWYERS FOR THE ARTS, Suite 1523, 608 Madison Ave., Toledo OH 43604. (419)255-3344. Executive Director: Arnold N. Gottlieb. Estab. 1988. Offers legal services to individuals and organizations on art related issues.
Offerings: Offers periodic seminars on legal rights and responsibilities, taxation, contracts, copyrights, etc. Other services include a lending library.

UTAH ARTS COUNCIL, 617 E. South Temple, Salt Lake City UT 84102. (801)533-5895. Artist's Services: Tay Haines. Estab. 1880s. A state arts agency. Programs include visual arts, folk arts, funding resources, literary arts, design arts, arts in education, artists' services.

VAGA (VISUAL ARTISTS & GALLERIES ASSOCIATION), 521 Fifth Ave., Suite 800, New York NY 10175. (212)808-0616. Fax: (212)808-0064. Executive Director: Robert Panzer. Estab. 1976. "An artists' membership society and copyright collective, licensing reproduction rights in the U.S. and worldwide through affiliates worldwide."

VERMONT STATE CRAFT CENTER AT FROG HOLLOW, 1 Mill St., Middlebury VT 05753. (802)388-3177. Marketing: Kirt Zimmer. Estab. 1971. "The Vermont State Craft Center/Frog Hollow is a nonprofit

visual arts organization dedicated to advancing appreciation of fine Vermont craft through education and exhibition."

VERY SPECIAL ARTS NEVADA (VSAN), 200 Flint St., Reno NV 89501. (702)329-1401. Fax: (702)329-1328. Executive Director: M.E. Horan. Estab. 1986. "We provide hands-on visual and performing art programs for populations with special needs and the general public."

VOLCANO ART CENTER, P.O. Box 104, Hawaii National Park HI 96718. (808)967-8222. Fax: (808)967-8512. Executive Director: Marilyn Nicholson. Estab. 1974. "Nonprofit educational institution located within Hawaii Volcanoes National Park, with the purpose of promoting, developing and perpetuating the artistic and cultural heritage of Hawaii's people and environment through activities in the visual, literary and performing arts."

VOLUNTEER LAWYERS FOR THE ARTS, One E. 53rd St., Sixth Floor, New York NY 10022. (212)319-2910. Executive Director: Daniel Y. Mayer, Esq. Estab. 1969. VLA operates a legal hotline for any artist or arts organization that needs quick answers to arts-related questions. "Organization to provide the low-income arts community with free legal assistance and education. Conferences and publications provide artists and arts organizations with easy-to-understand information on art law issues. Also works to protect artists' rights. Referrals available to volunteer lawyer organizations nationwide."

WESTERN STATES ARTS FEDERATION (WESTAF), 236 Montezuma Ave., Santa Fe NM 87501. (505)988-1166. Fax: (505)982-9207. E-mail: westaf@tmn.com. Contact: Visual Arts Program or Technical Assistance Services. Estab. 1974. "Western States Arts Federation is a private not-for-profit corporation serving as a regional consortium of the western state arts agencies of Alaska, Arizona, California, Colorado, Idaho, Montana, Nevada, New Mexico, Oregon, Utah, Washington and Wyoming. It promotes artists and arts organizations through national programs and special programs and services designed to support the unique regional needs of the vast and varied West."

WOMEN IN DESIGN/CHICAGO, 400 W. Madison, Suite 2400, Chicago IL 60606. (312)648-1874. President: Carolyn Aronson. Estab. 1977. A locally based, nonprofit organization. "We focus on the goals and interests of women designers and women in design related professions." Promotes greater recognition of women's contributions to design.

WOMEN IN DESIGN/LOS ANGELES, 1875 Oak Tree Dr., Los Angeles CA 90041. (213)251-3737. Contact: Membership Chairperson. Estab. 1977. Professional organization of designers, artists, illustrators, art directors and others.

WOMEN IN THE DIRECTOR'S CHAIR, 3435 N. Sheffield, #202, Chicago IL 60657. (312)281-4988. Fax: (312)281-4999. Program Director: Dalida Maria Benfield. Estab. 1980. "Not-for-profit media arts organization dedicated to exhibiting and promoting films and videos by women who reflect a diversity of cultures and experiences."

WYOMING ARTS COUNCIL, 2320 Capitol Ave., Cheyenne WY 82002. (307)777-7742. Fax: (307)777-5499. Director: John Coe. Estab. 1967. The Wyoming Arts Council is a nonprofit arm of the National Endowment for the Arts and the State of Wyoming. It is a service organization providing information, resource and direct programming for artists and arts organizations.

Publications of Interest

Artist's & Graphic Designer's Market recommends the following publications as valuable sources that will help in your freelancing efforts, assist you in staying informed of market trends, or provide you with additional names and addresses of art buyers. A few offer advertising opportunities for artists. Most are available either in a library or bookstore or from the publisher.

Directories

AMERICAN SHOWCASE, *915 Broadway, 14th Floor, New York NY 10010. (212)673-6600. Annual hardcover directory of illustrators. Most often used by art directors and artist representatives to find new talent.*

ART BUSINESS NEWS, *19 Old Kings Hwy. S., Darien CT 06820-4526. (203)656-3402. Monthly magazine covering business issues in the art industry.*

ART NOW GALLERY GUIDE, *97 Grayrock Rd., P.O. Box 5541, Clinton NJ 08809. (908)638-5255. Monthly guide listing galleries by region. Also publishes international guide.*

AUDIO VIDEO MARKETPLACE, *R.R. Bowker, A Reed Reference Publishing Co., 121 Chanlon Rd., New Providence NJ 07974. (908)464-6800. Annual directory listing audiovisual companies and related services.*

CREATIVE BLACK BOOK, *Black Book Marketing, Inc., 10 Astor Place, New York NY 10003. (800)841-1246. Annual directory listing illustrators, photographers, printers and service houses. Also publishes regional directories.*

CREATIVE ILLUSTRATION BOOK, *Black Book Marketing, Inc., 10 Astor Place, New York NY 10003. (800)841-1246. Annual directory of illustration.*

ENCYCLOPEDIA OF ASSOCIATIONS, *Gale Research Co., 835 Penobscot Bldg., Detroit MI 48226-4094. (313)961-2242. Annual directory listing active organizations.*

FINE ART INDEX, *International Art Reference, 938 N. Honore, Chicago IL 60622. (312)384-1113. Biannual hardcover directory listing national and international contemporary fine artists and galleries.*

GRAPHIC ARTISTS GUILD'S DIRECTORY OF ILLUSTRATION, *Serbin Communications, 511 Olive St., Santa Barbara CA 93101. (805)963-0439. Annual directory of illustration.*

LITERARY MARKET PLACE, *R.R. Bowker, A Reed Reference Publishing Co., 121 Chanlon Rd., New Providence NJ 07974. (908)464-6800. Annual directory listing book publishers and related services.*

O'DWYER'S DIRECTORY OF PUBLIC RELATIONS FIRMS, *J.R. O'Dwyer Company, Inc., 271 Madison Ave., New York NY 10016. (212)679-2471. Annual directory listing PR firms, indexed by specialties.*

RSVP, *The Directory of Illustration and Design, P.O. Box 050314, Brooklyn NY 11205. (718)857-9267. Annual directory in which designers and illustrators can advertise their services. Most often used by art directors seeking new talent.*

STANDARD DIRECTORY OF ADVERTISING AGENCIES (The Redbook), *National Register Publishing, A Reed Reference Publishing Co., 121 Chanlon Rd., New Providence NJ 07974. (908)464-6800. Annual directory listing advertising agencies.*

STANDARD RATE AND DATA SERVICE (SRDS), *1700 W. Higgins Rd., Des Plains IL 60018. (708)256-6067. Monthly directory listing magazines, plus their advertising rates and related information.*

Magazines

ADVERTISING AGE, *Crain Communications, 740 N. Rush St., Chicago IL 60611-2590. (312)649-5200. Weekly trade tabloid covering the ad industry.*

ADWEEK, *Adweek Magazines, 1515 Broadway, New York NY 10036. (212)536-5336. Weekly advertising and marketing magazine. Also publishes annual directory of ad agencies.*

ART CALENDAR, *P.O. Box 199, Upper Fairmont MD 21867-0199. (410)651-9150. Monthly magazine listing galleries, juried shows, percent-for-art programs, scholarships and art colonies, plus other art-related articles.*

ART IN AMERICA, *Brant Publications, Inc., 575 Broadway, New York NY 10012. (212)941-2800. Monthly magazine covering national and international news and issues relating to the fine art world. Also publishes annual guide to museums, galleries and artists (August issue).*

THE ARTIST'S MAGAZINE, *F&W Publications, Inc., 1507 Dana Ave., Cincinnati OH 45207. (513)531-2222. Monthly magazine for fine artists, illustrators and cartoonists. Features how-to articles on techniques and business issues.*

ARTNEWS, *Artnews Associates, 48 W. 38th St., New York NY 10018. (212)398-1690. Magazine published 10 times/year covering the latest issues in national and international fine art, plus reviews and other feature articles.*

ARTWEEK, *2149 Paragon Dr., Suite 100, San Jose CA 95131-1312. (408)441-7065. Biweekly magazine covering fine art issues, galleries and other events on the West Coast.*

BILLBOARD, *1515 Broadway, New York NY 10036. (212)536-5055. Weekly magazine covering the music industry.*

COMMUNICATION ARTS, *410 Sherman Ave., Box 10300, Palo Alto CA 94303. Magazine published 8 times/year covering design, illustration and photography.*

DECOR, *Commerce Publishing Co., 330 N. Fourth St., St. Louis MO 63102. (314)421-5445. Monthly trade magazine for gallery owners and gallery directors. Also publishes an annual buyers' guide directory.*

EDITOR & PUBLISHER, *The Editor & Publisher Co. Inc., 11 W. 19th St., New York NY 10011. (212)675-4380. Weekly magazine covering latest developments in journalism and newspaper production. Publishes annual directory issue listing syndicates and another directory listing newspapers.*

FOLIO, *Cowles Business Media, 911 Hope St., Box 4949, Stamford CT 06907-0949. (203)358-9900. Biweekly magazine featuring trends in magazine circulation, production and editorial.*

GIFTWARE NEWS, *Talcott Communications Corp., 3405 Empire State Bldg., New York NY 10118. (212)629-0819. Monthly trade magazine covering the giftware and paper products industry.*

GREETINGS MAGAZINE, *Mackay Publishing Corp., 307 Fifth Ave., 16th Floor, New York NY 10016. (212)679-6677. Monthly trade magazine covering the greeting card and stationery industry.*

HOW, *F&W Publications, Inc., 1507 Dana Ave., Cincinnati OH 45207. (513)531-2222. Monthly magazine for graphic design professionals.*

PARTY & PAPER RETAILER, *4Ward Corp., 70 New Canaan Ave., Norwalk CT 06850. (203)845-8020. Monthly magazine covering the giftware and paper products industry.*

PRINT, *RC Publications, 104 Fifth Ave., 9th Floor, New York NY 10011. (212)463-0600. Bimonthly magazine focusing on creative trends and technological advances in illustration, design, photography and printing. Also publishes* Regional Design Annual *featuring the year's best in design and illustration.*

PUBLISHERS WEEKLY, *Cahners Publishing Co., 249 W. 17th St., New York NY 10011. (212)463-6758. Weekly trade magazine covering industry trends and news in book publishing, book reviews and interviews.*

SOUTHWEST ART, *CBH Publishing, 5444 Westheimer, Suite 1440, Houston TX 77056. (713)850-0990. Monthly magazine covering fine arts in the Southwest.*

STEP-BY-STEP GRAPHICS, *Dynamic Graphics Inc., 6000 N. Forest Park Dr., Peoria IL 61614. (800)255-8800. Bimonthly magazine featuring step-by-step demonstrations for designers and illustrators.*

UPPER & LOWER CASE (U & lc), *International Typeface Corp., 866 Second Ave., New York NY 10017. (212)371-0699. Quarterly publication covering the latest in typography and issues relating to type designers.*

Get to
Know
HOW

Order Form

yes

Start my 1-year subscription to HOW and send me the next 6 issues for just $39...a savings of more than $15 off the newsstand price. Upon payment, send my free copy of *Making Marketing Manageable*, HOW's guide to self-promotion.

❑ Payment enclosed ❑ Bill me Charge my ❑ Visa ❑ Mastercard

Signature _____

Acct. # _____ Exp. _____ / _____

NAME _____

COMPANY _____

JOB TITLE_____

ADDRESS_____

CITY _____ STATE _____ ZIP _____

IMPORTANT! Please take a moment to complete the following information.

My company is best described as:
(choose one)
1 ❑ Advertising agency 3 ❑ Design studio
4 ❑ Graphic arts vendor 2 ❑ Company
7 ❑ Educational institution
63 ❑ Other (specify) _____

My job title/occupation is:
(choose one)
16 ❑ Owner/management 22 ❑ Creative director
12 ❑ Art director /designer
13 ❑ Advertising/marketing staff
25 ❑ Instructor 19 ❑ Student
63 ❑ Other (specify) _____

TEAM7-HOW

* In Canada add $15 (includes GST); overseas, add $22; airmail, add $65. Remit in U.S. funds. Allow 4-6 weeks for first issue delivery. Annual newsstand rate $54.85.

save more than $15

Glossary

Acceptance (payment on). An artist is paid for his work as soon as a buyer decides to use it.

Adobe Illustrator®. Drawing and painting computer software.

Adobe PhotoShop®. Photo manipulation computer program.

Advance. Amount paid to an artist before beginning work on an assigned project. Often paid to cover preliminary expenses.

Airbrush. Small pencil-shaped pressure gun used to spray ink, paint or dye to obtain gradated tonal effects.

Aldus Freehand. Illustration computer software.

Aldus PageMaker. Page layout computer software.

Art director. In commercial markets, the person responsible for choosing and purchasing artwork and supervising the design process.

Biannually. Occurring twice a year.

Biennially. Occurring once every two years.

Bimonthly. Occurring once every two months.

Biweekly. Occurring once every two weeks.

Book. Another term for a portfolio.

Buy-out. The sale of all reproduction rights (and sometimes the original work) by the artist; also subcontracted portions of a job resold at a cost or profit to the end client by the artist.

Calligraphy. The art of fine handwriting.

Camera-ready. Art that is completely prepared for copy camera platemaking.

Capabilities brochure. A brochure, similar to an annual report, outlining for prospective clients the nature of a company's business and the range of products or services it provides.

Caption. See gagline.

CD-ROM. Compact disc read-only memory; non-erasable electronic medium used for digitized image and document storage and retrieval on computers.

Collateral. Accompanying or auxiliary pieces, such as brochures, especially used in advertising.

Color separation. Photographic process of separating any multi-color image into its primary component parts (cyan, magenta, yellow and black) for printing.

Commission. 1) Percentage of retail price taken by a sponsor/salesman on artwork sold. 2) Assignment given to an artist.

Comprehensive. Complete sketch of layout showing how a finished illustration will look when printed; also called a comp.

Copyright. The exclusive legal right to reproduce, publish and sell the matter and form of a literary or artistic work.

Consignment. Arrangement by which items are sent by an artist to a sales agent (gallery, shop, sales rep, etc.) for sale with the understanding the artist will not receive payment until work is sold. A commission is almost always charged for this service.

Direct-mail package. Sales or promotional material that is distributed by mail. Usually consists of an outer envelope, a cover letter, brochure or flyer, SASE, and postpaid reply card, or order form with business reply envelope.

Dummy. A rough model of a book or multi-page piece, created as a preliminary step in determining page layout and length. Also, a rough model of a card with an unusual fold or die cut.

Edition. The total number of prints published of one piece of art.

Elhi. Abbreviation for elementary/high school used by publishers to describe young audiences.

Environmental graphic design (EGD). The planning, designing and specifying of graphic elements in the built and natural environment; signage.

Estimate. A ballpark figure given to a client by a designer anticipating the final cost of a project.

Etching. A print made by the intaglio process, creating a design in the surface of a metal or other plate with a needle and using a mordant to bite out the design.

Exclusive area representation. Requirement that an artist's work appear in only one outlet within a defined geographical area.

Finished art. A completed illustration, mechanical, photo, or combination of the three that is ready to go to the printer. Also called camera-ready art.

Gagline. The words printed with a cartoon (usually directly beneath); also called a caption.

Gouache. Opaque watercolor with definite, appreciable film thickness and an actual paint layer.

Halftone. Reproduction of a continuous tone illustration with the image formed by dots produced by a camera lens screen.

IRC. International Reply Coupon; purchased at the post office to enclose with artwork sent to a foreign buyer to cover his postage cost when replying.

Keyline. Identification of the positions of illustrations and copy for the printer.

Kill fee. Portion of an agreed-upon payment an artist receives for a job that was assigned, started, but then canceled.

Layout. Arrangement of photographs, illustrations, text and headlines for printed material.

Lithography. Printing process based on a design made with a greasy substance on a limestone slab or metal plate and chemically treated so image areas take ink and non-image areas repel ink.

Logo. Name or design of a company or product used as a trademark on letterhead, direct mail packages, in advertising, etc., to establish visual identity.

Mechanicals. Paste-up or preparation of work for printing.

Multimedia. A generic term used by advertising, public relations and audiovisual firms to describe productions involving more than one medium to create a variety of visual effects. Also, a term used to reflect the varied inhouse capabilities of an agency.

Naif. Native art of such cultures as African, Eskimo, Native American, etc., usually associated with daily life.

Offset. Printing process in which a flat printing plate is treated to be ink-receptive in image areas and ink-repellent in non-image areas. Ink is transferred from the printing plate to a rubber plate, and then to the paper.

Overlay. Transparent cover over copy, on which instruction, corrections or color location directions are given.

Panel. In cartooning, the boxed-in illustration; can be single panel, double panel or multiple panel.

Paste-up. Procedure involving coating the backside of art, type, Photostats, etc., with rubber cement or wax and adhering them in their proper positions to the mechanical board. The boards are then used as finished art by the printer.

Photostat. Black & white copies produced by an inexpensive photographic process using paper negatives; only line values are held with accuracy. Also called stat.

PMT. Photomechanical transfer; Photostat produced without a negative.

P-O-P. Point-of-purchase; in-store marketing display which promotes a product.

Print. An impression pulled from an original plate, stone, block screen or negative; also a positive made from a photographic negative.

Production artist. In the final phases of the design process, the artist responsible for mechanicals, paste up, and sometimes the overseeing of printing.

QuarkXPress. Page layout computer program.

Query. Letter to an art director or buyer eliciting interest in a work an artist wants to illustrate or sell.

Quotation. Set fee proposed to a client prior to commencing work on a project.

Rendering. A drawn representation of a building, interior, etc., in perspective.

Retail. The sale of goods in small quantities directly to the consumer.

Roughs. Preliminary sketches or drawings.

Royalty. An agreed percentage paid by a publisher to an artist for each copy of a work sold.

SASE. Self-addressed, stamped envelope.

Self-publishing. In this arrangement, an artist coordinates and pays for printing, distribution and marketing of his/her own artwork and in turn keeps all ensuing profits.

Semiannual. Occuring twice a year.

Semimonthly. Occurring twice a month.

Semiweekly. Occuring twice a week.

Serigraph. Silkscreen; method of printing in which a stencil is adhered to a fine mesh cloth stretched over a wooden frame. Paint is forced through the area not blocked by the stencil.

Simultaneous submissions. Submission of the same artwork to more than one potential buyer at the same time.

Speculation. Creating artwork with no assurance that a potential buyer will purchase it or reimburse expenses in any way; referred to as work on spec.

Spot drawing. Small illustration used to decorate a page of type, or to serve as a column ending.

Storyboard. Series of panels which illustrate a progressive sequence or graphics and story copy of a TV commercial, film or filmstrip. Serves as a guide for the eventual finished product.

Tabloid. Publication whose format is an ordinary newspaper page turned sideways.

Tearsheet. Published page containing an artist's illustration, cartoon, design or photograph.

Thumbnail. A rough layout in miniature.

Transparency. A photographic positive film such as a color slide.

Type spec. Type specification; determination of the size and style of type to be used in a layout.

Velox. Photoprint of a continuous tone subject that has been transformed into line art by means of a halftone screen.

VHS. Video Home System; a standard videotape format for recording consumer-quality videotape, most commonly used in home videocassette recording and portable camcorders.

Video. General category comprised of videocassettes and videotapes.

Wash. Thin application of transparent color or watercolor black for a pastel or gray tonal effect.

Wholesale. The sale of commodities in large quantities usually for resale (as by a retail merchant).

Humor Index

If you are a cartoonist, caricaturist or humorous illustrator, this index will help you narrow your search for appropriate markets. The companies listed here have indicated an interest in humorous material. Check individual listings for specific information about each market's needs and submission requirements.

General Index

More Great Books
for Your Art and Graphic Design!

Graphic Design Basics: Marketing & Promoting Your Work—Learn how to establish goals and actions in a written marketing plan, target the right markets, create self-promotions that get noticed, warm up cold calls, and much more. Plus, successful designers share their own "Super Strategies" for marketing— proven ideas on such topics as establishing recognition and avoiding miscommunication with clients. *#30706/$27.99/128 pages/25 color, 10 b&w illus.*

Make Your Watercolors Look Professional—Discover how to paint polished, confident, and commanding watercolors. With advice, instruction and 23 step-by-step demonstrations from the pros themselves, you'll learn what makes professional-looking paintings stand out and how to achieve the same qualities in your own work. *#30707/$28.99/144 pages/248 color, 26 b&w illus.*

Make Your Scanner A Great Design & Production Tool—Discover powerful techniques and time-saving tips to help you get quick, clean scans and "just right" images. You'll learn how to make the most of your scanning equipment with step-by-step instructions on everything from cleaning up undesirable moire patterns to creating special effects. *#30661/$27.99/144 pages/117 color, 103 b&w illus./paperback*

How to Discover Your Personal Painting Style—Explore your unique way of seeing to create expressive paintings. Richly illustrated with work from various artists and mediums, this book will lead you on a satisfying path to creative self-discovery by showing the emotional effects of various painting techniques. *#30702/$27.99/144 pages/200 color, 25 b&w illus.*

The Designer's Commonsense Business Book, Revised Edition—Find guidance on setting up shop, networking, pricing, self-promotion and record keeping to help you meet your long-term goals. Completely updated and revised, this book will help you learn the nuts-and-bolts business practices for freelance success. *#30663/$27.99/224 pages/paperback*

Painting with the White of Your Paper—Discover how to make the most of your paper, to take full advantage of watercolor's alluring transparency and create sparkling paintings. You'll find insights into creative processes and materials, and step-by-step instructions on particular techniques. *#30657/ $27.99/144 pages/181 color illus.*

More Great Design Using 1, 2 & 3 Colors—Discover the graphic impact possible using fewer colors—and spending fewer dollars! In this follow up edition, you will see how limiting your color choices to one, two or three colors can help you make strong, creative graphic choices that keep your standards high and your expenses low. *#30664/$39.95/192 pages/225 color illus.*

Color Mixing the Van Wyk Way—Learn how to put color theory into action! You'll see how to paint any subject with the six basic colors plus white and gray. Van Wyk makes the frustrating task of color mixing easy to understand and put in action. *#30658/$24.95/128 pages/230 color, 15 b&w illus.*

Creating Textures in Pen & Ink with Watercolor—Learn how to use pen and ink and watercolors to suggest a wide range of textures from moss to metal to animal hair. You'll discover ways to use such diverse materials as technical pens, paint brushes, colored inks and liquid acrylics, and ways to alter and combine ink and watercolor for exciting texturing effects. *#30712/$27.99/144 pages/120 color, 10 b&w illus.*